Errata

ESSAYS

Page xviii. Column 2, paragraph 4, last line: after *Sarcophagus of Filial Piety* insert [4].

Page xxxiii. Caption for Figure 2, line 2: *for* Present whereabouts unknown *read* Nelson Gallery-Atkins Museum.

Page xxxvi. Column 1, line 2: *for* 1417 *read* 1416; column 2, line 17, *for* 130-132 *read* 131.

Page xli. Column 1, paragraph 3, line 2: *for* 69-74, 76, 77 *read* 26-29, 31, 32, 35-41, 43, 45, 57, 59-60; column 2, line 6, *for* 118 *read* 110.

Page xlii. Column 1, line 3 from bottom: *for* 130 *read* 132; last line, *for* 61, 91, 98 *read* 64-67.

Page xliv. Column 1, line 3 from bottom: *for* 113 *read* 114; column 2, line 6, *for* 116, 117 *read* 117, 118.

Page xlviii. Column 1, line 21: *for* 225 *read* 255; line 9 from bottom, *for* 1618/19 *read* ca. 1619.

Page l. Column 2, line 2: *for* 213-219 *read* 213-217.

CATALOGUE ENTRIES

[1] Page 2, column 1, line 15 from bottom: *for* "Tan Ch'angsha *read* "T'an Ch'ang-sha.

[3] Page 4, column 1, line 23: *for* at similar shrines *read* on disassembled shrines.

[8] Page 12, line 5: *for* eight *read* eighth; line 12, *for* on pedestals – a small circle *read* on pedestals. A small circle.

[9] Page 12, line 3 of artist's name and provenance: *for* Shenhsi *read* Shanhsi.

[10] Page 14, column 2, line 3 from bottom: *for* thepurpose *read* the purpose.
Page 15, column 1, lines 3 and 4: *for* controll- ing *read* control-ling.

[11] Page 15, column 2, line 11 of Remarks: *for* strokes are *read* stroke is; line 20 from bottom, for *yuan-chou* read *yüan-chou*; line 16 from bottom, for *P'ing-shen* read *P'ing-sheng*.
Page 16, column 2, line 19 from bottom: *for* Chi-ch'a-ssuyin *read* Chi-ch'a-ssu yin.
Page 17, column 1, line 8: for *kuo-yen-lu* read *kuo-yen lu*; line 26, *for* Lung-t'u-ke *read* Lung-t'u-ko; line 32, *for* T'ai-ch'ing--lou *read* T'ai-ch'ing-lou; line 33, *for* tung-ke *read* tung-ko; line 36, *for* Rh'i-hsi-tien *read* Ch'i-hsi-tien; paragraph 3, lines 4, 10, and 14, *for* Mi-ke *read* Mi-ko; column 2, line 12, *for* Tsui *read* Ts'ui; line 16 from bottom, *for* Mi-ke *read* Mi-ko; line 9 from bottom, for *kuan-ke* read *kuan-ko*.
Page 18, column 1, line 9 from bottom: for *Hsiao-I* read *Hsiao I*; column 2, line 8, for *T'u-hua-ke* read *T'u-hua-ko*; line 12, for *Meng-hsi* read *Meng-ch'i*; line 37, for *sheng-mo* read *shen-mo*.
Page 19, column 1, line 22: for *sheng-yüan* read *shen-yüan*.

[17] Page 29, column 2, lines 4 and 5 (with Artist unknown): *for* Chin Dynasty *read* Southern Sung Dynasty.

[18] Page 32, column 2, line 1: *for* Kaang-cheng-tzu *read* Kuang-cheng-tzu.

[19] Page 34, column 1, line 33: *for* stela *read* stelae; column 2, line 23, *for* Hsuan-ho *read* Hsüan-ho.

[23] Page 41, line 13: *after* emperor *insert* (r. 1736-95).

[27] Page 48, column 2, line 3 of Remarks: *for* Huich'ung *read* Hui-ch'ung; line 6 of Remarks, *for* Huang Ch'uan *read* Huang Ch'üan.

[34] Page 52, line 8: *for* yüan-pien *read* Yüan-pien.

[36] Page 54, line 13 of Remarks: *for* National Palace Museum *read* Palace Museum.

[37] Page 54, line 2 from bottom: *for* Hayasaki *read* Hayazaki.

[39] Page 55, line 8 from bottom: *for* (see the *Hundred* read (for a Sung prototype, see the *Hundred*.

[42] Page 57, line above Remarks: *for* 1 official seal of Ming Dynasty *read* 4 seals: 1 official seal of Ming Dynasty; 1 of Wang Shih-chen (1526-1592); 1 of Hsiang Yüan-pien (1525-1590); 1 indecipherable.

[44] Page 59, lines 7 and 8: *for* 1 unidentified partial seal *read* 1 partial official seal of Ming Dynasty.

[48] Page 63, column 2, line 7, and page 65, column 1, line 31: *for* Shan Tao *read* Shan-tao.

[58] Page 75, column 1, line 35: *for* Ku-ksiang *read* Ku-hsiang.

[60] Page 77, *after* Artist's signature: Hsia Sheng. *insert* 2 inscriptions and 14 seals on mounting: 3 seals of Hsiang Yüan-pien (1525-1590); 1 seal of Ssu-ma Yin (15th c.); 1 seal unidentified; 1 seal indecipherable; 2 inscriptions and 8 seals of Ch'eng Ch'i (20th c.).

[61] Page 78, column 1, line above title: *after* Southern Sung Dynasty *insert new line* From Tung-p'ing, Shantung Province; column 2, line 3 from bottom, *for* Yü-ch'ieng *read* Yü-ch'ien.

[62] Page 80, column 2, line 18: *for* Kung-ch'k *read* Kung-ch'u.
Page 82, line 3 under Exhibitions: *for* 1962 *read* 1972.

[65] Page 83, column 1, line 16: *for* Ch'un-yu *read* Shun-yu.

[66] Page 84, column 2, line 18 of Remarks: *for* "Klienkunst," *read* "Kleinkunst."

[67] Page 85, column 2, line 21 of Remarks: *for* Potolaka *read* Potalaka.

[71] Page 90, column 2, line 15 of Remarks: *after* (1260-64) *insert* of Southern Sung.
Page 91, column 1, line 15: *after* hsien-yin *insert* comma; line 34, for *Confucius* read *Confucian*; line 35, for *Ch'ün-ch'iu* read *Ch'un-ch'iu*.

[72] Page 91, column 2, line 3 of artist's name and provenance: *for* Tung-wu-yeh-jen *read* Tung-Wu yeh-jen; line 12 of Artist's poems and seals, *for* Tung-Wu-yeh-jen *read* Tung-Wu yeh-jen.
Page 92, line 15: for *Pavillion* read *Pavilion*.

[76] Page 96, line 18: for *Museums* read *Museum*.

[77] Page 97, column 1, line 37: *for* Barrnhart *read* Barnhart.

[78] Page 97, column 2, line above WKH: *for* tzu-wen *read* Tzu-wen.

[79] Page 99, column 1, line 8: *for* "Yung't'ien" *read* "Yung-t'ien"; lines 11 and 12, *for* Mu Ch'i (Fa Ch'ang) *read* Mu-ch'i (Fa-ch'ang); line 13, *for* Mu Ch'i *read* Mu-ch'i.

[81] Page 101, column 1, line 5: *for* hsing *read* Hsing; line 18, *for* Hsi-shih *read* Hsi-chih; line 19, *for* Hsien-shih *read* Hsien-chih.

[82] Page 101, column 2, line 3 from bottom: *for* Li H. C. *read* Li H. L.; line 2 from bottom, *after* 1959 *delete* parenthesis.

[83] Page 102, line 11 of colophons and seals: *for* Seallsf *read* Seals of.
Page 104, column 1, line 22 of Remarks: *for* Chu Tsing-li *read* Chu-tsing Li.

[86] Page 107, column 1, line 23 of Remarks: *for* plane was *read* planes were.

[87] Page 108, column 1, line 7 under Literature: *after* 32 *insert* opening parenthesis.

[90] Page 110, column 2, line 1 of Remarks: *for* Chaung *read* Chuang.

[91] Page 111, line 12 from bottom: *for* shan-hen *read* shan-jen.
Page 112, column 1, line 2 under Literature: for *(1682)* read *(1682)*.

[92] Page 113, column 1, line 6 from bottom, and column 2, line 10 from bottom: for *shu hua* read *shu-hua*.

[94] Page 115, line 2; *for* Ch'ing-pu *read* Ch'ing-p'u.

[96] Page 122, line 5 under Exhibitions: *for* no. catalogue *read* no catalogue.

[97] Page 122, line 4 from bottom: for *Hsueh-shih ch'uan-* read *Hsüeh-shih ch'üan-*.

[102] Page 126, line above title: *for* Chih Ch'üan *read* Chih-ch'uan.

[104] Page 129, line 17: for *Yen yuan-chi* read *Yen-yüan-chi*; line 17 from bottom, *for* Kao K'e-kung *read* Kao K'o-kung; line 8 from bottom, *for* with genre such as *read* with the genre of *sung-shih* such as.

[110] Page 135, line 7 of Artist's inscription: *for* wind *read* wine; line 16 of Remarks *for* Kuang-yuan *read* Kuang-yüan.

[112] Page 138, column 2, line 6 of Remarks: for *Tung wei-tzu* read *Tung-wei-tzu*; line 12 under Literature, *for* Yen-ch-ing *read* Yen-ch'ing.

[114] Page 140, column 1, line 3: *for* Wei-yun *read* Wei-yün; column 2, line 12 of Remarks, *for* Yang-tzu *read* Yangtze.

[134] Page 157, paragraph 2, line 10 of Remarks: *for* bruststrokes *read* brushstrokes; line 17, *for* ae *read* as.

[136] Page 159, line 8 of inscriptions and seals: line 8: *for* Yüan-kui *read* Yüan-hui.

[146] Page 173, line above Remarks: *after* Ch'eng Ch'i *insert* (20th c.).

[148] Page 176, line 5 of Remarks: *for* grandson *read* son; lines 7 and 8, *for* Ch'i's *read* Chi's.

[149] Page 178, column 2, line 9: *for* Yueh *read* Yüeh; line 3 above Literature, for *Shih-t-ien* read *Shih-t'ien*; line 1 under Literature, for *Bunjin gasen* read *Bunjinga-sen*.

[150] Page 180, line 4 under Literature: for *Bunjin gasen* read *Bunjinga-sen*.

[154] Page 187, column 1, line 25: *for* 960-980 *read* 960-985.

[155] Page 189, line 24: *for* Li-Keng *read* Li-keng.

[160] Page 196: illustration should show no breaks, since p[...] mounted as a continuous scroll.

[161] Page 197, paragraph 3, line 4 of Remarks: for *KKSHL* [...] *Ku-kung shu-hua lu*, 1965.

[163] Page 200, line 2 under Literature: for *Bunjin gasen* read [...] *Bunjinga-sen*.

[165] Page 204, lines 1 and 13 under Colophon by Wang Sh[...] Yü-shün *read* Yü-shun.
Page 205, column 1, line 10: for Yü-shün *read* Yü-shun; [...] Yu-shün *read* Yü-shun; column 2, line 14, *for* feng-lai *r*[...] Feng-lai.

[166] Page 209, column 2, line 4: *for* 1955 *read* 1855.

[172] Page 217, line 8 from bottom: *for* wrote in *read* wrote (in.

[173] Page 219, last line: delete *beside a Stream*.

[176] Page 222, lines 17 and 18 of Remarks: *for* Chih-ch'üan *read* Chih-ch'uan.

[177] Page 223, column 1, line 7 above MFW: *for* Lord *read* lord.

[178] Page 225, last line: after *pieh-yeh* insert closing parenthesis.

[179] Page 227, line 16 of Remarks: for KKSHL read *Ku-kung shu-hua lu*.

[181] Page 231, column 2, line 9 of Remarks: *for* rhemical *read* chemical.

Page 232, column 2, line 13: for *chih-shih* read *chin-shih*.

[191] Page 246, column 1, line 1 under Literature: for *Shih-ch'u* read Shih-ch'ü; line 7 under Literature, *for* Ch'i-Ch'ang *read* Ch'i-ch'ang.

[192] Page 246, column 2, in title, line 2 of Artist's inscriptions, and line 12 of Remarks: for *Mountains* read *Mountain*.

[193] Page 247, line 2 of artist's name and provenance: *for* Hsi-hsien *read* Hsieh-hsien.

[196] Page 253, line 17 of Remarks: *for* Wu-yuň *read* Wu-yün.

[197] Page 255, column 1, line 2 below HK: *for* 71.23 *read* 71.231.

[202] Page 258, column 2, line 2 of Chinese title: for *Ro-ying* read *Jo-ying*.

[208] Page 273, column 1, line 7: *for* "Shangtung" *read* "Shantung"; line 1 of additional seals, *for* Hsu Wei-jen (dates unknown) *read* Hsü Wei-jen (d. 1853).

[210] Page 274, line 4 from bottom: for KKSHL read *Ku-kung shu-hua lu*.

[212] Page 276, column 2, line 12 of Remarks: *for* Shen-chou album *read* *Shen-chou* album.

[213] Page 278, line 6 from bottom: *for* 1671 *read* 1689.

[217] Page 285, column 2, line 8 of Remarks: *for* Tu'shou *read* Tu-shou.

[219] Page 290, column 2, line 9 from bottom: for Yuan read *Yüan*.

[231] Page 311, column 2, line 14: *after* Huang I *insert* semi-colon; line 15, *for* 3)93 *read* 3.

[235] Page 318, column 2, line 5 from bottom: *for* the same city, Tatung *read* the old prefecture of Tat'ung.

[238] Page 323, column 1, line 8: *for* Album of leaves *read* Album of 8 leaves.

[244b] Page 329, column 2, line 3 from bottom: *for* 960-980 *read* 960-985.

[251] Page 339, line 1 under Literature: for *Hsu-chai* read *Hsü-chai*, and *for* Yuan *read* Yüan.

[265] Page 362, column 1, line 5 under Literature: *for* 1946 *read* 1964.

[266] Page 364, column 2, line 13 from bottom: *for* deing *read* being.

[267] Page 365, lines 1 and 2 above WKH/LYSL: *for* Shih-sheng *read* Shih-shen; lines 2 and 3 of colophons and additional inscriptions, *for* Yin-k'uei *read* Ying-k'uei; line 2 of Remarks, *for* Great Canal *read* Grand Canal.

Page 366, column 1, lines 24 and 25: *for* Ying-kuei *read* Ying-k'uei.

[268] Page 366, column 2, line 9: *for* Chung-yang *read* Tsung-yang.

Page 367, Recent provenance: *for* Cheng *read* Ch'eng.

[271] Page 369, line 2 of artist's name and provenance: *for* Hsi-hsien *read* Hsieh-hsien.

[272] Page 371, lines 1 and 2 of Remarks: *for* neither close *read* close neither.

[273] Page 371, line 3 from bottom: *after* grasses *insert* comma.

[275] Page 373, column 2, lines 12, 30, and 37: *for* Hsi-hsien *read* Hsieh-hsien.

Addendum

[20] Page 384, column 1, paragraph 2, line 9: *for* placemenature *read* placement of signature.

Additions To Literature And/Or Exhibitions

[81] Literature:
Ch'en Pao-chen, "Kuan Tao-sheng" (1977), p. 1965, pl. 22.
Ho, Iriya, Nakada, *Kō Kōbō, Gei San* (1979), p. 170, pl. 50.
Lee, "River Village — Fisherman's Joy" (1979), p. 271, fig. 2.

[81] Exhibitions:
The Taft Museum, Cincinnati, 1976: Looking East, no catalogue.

[88] Literature:
CMA *Handbook* (1978), p. 344.
Ho, Iriya, Nakada, *Kō Kōbō, Gei San* (1979), p. 178, pl. 89.

[94] Literature:
CMA *Handbook* (1978), p. 346 (detail).

[96] Literature:
Brinker, *Chinesischen Fächers* (1979), p. 27, fig. 13.
Ho, Iriya, Nakada, *Kō Kōbō, Gei San* (1979), pp. 173-74, pls. 57, 58.

[101] Literature:
Ho, Iriya, Nakada, *Kō Kōbō, Gei San* (1979), p. 177, pl. 81.

[106] Literature:
Ho, Iriya, Nakada, *Kō Kōbō, Gei San* (1979), p. 176, pl. 74.

[108] Exhibitions:
Smith College Museum of Art, Northampton, Mass., 1964: Fifteen Chinese Paintings from The Cleveland Museum of Art, no catalogue.

[109] Literature:
Ch'en Ch'ing-kuang, "Yüan-tai" (1977), pp. 1852, 1856, 1887-89, pls. 12A-D.
Ho, Iriya, Nakada, *Kō Kōbō, Gei San* (1979), p. 162, pl. 11, and pp. 152 (seal), 153 (signature).

[111] Literature:
Ho, Iriya, Nakada, *Kō Kōbō, Gei San* (1979), p. 167, pl. 42.
Sullivan, *Symbols of Eternity* (1979), p. 105, pl. 62 (color).

[112] Literature:
CMA *Handbook* (1978), p. 347.
Ho, Iriya, Nakada, *Kō Kōbō, Gei San* (1979), pp. 177-78, pl. 84.

[115] Literature
Ho, Iriya, Nakada, *Kō Kōbō, Gei San* (1979), p. 178, pl. 86.

CHRONOLOGICAL LIST OF ARTISTS

Page 387. The following artists should have been included:
Shen Ying, act. late 17th-early 18th c. [258] (insert between Yü Chih-ting and Wang Yüan-ch'i).
Kao Ch'i-p'ei, 1672-1734 [264] (insert between Yang Chin and Wang Yün).

LIST OF CLEVELAND DONORS

Page 389. Line 3 from bottom: *for* 2 *read* 1.

BIBLIOGRAPHY

Page 391, column 1, Chang Kuang-yuan: *read* Chang Kuang-yüan; column 2, Chang Wan-li and Hu Jen-mou, in third publication, line 1 for *shu hua* read *shu-hua*; column 2, Ch'en, J. D., in first publication, line 2, *for* King Kuei *read* Chin-kuei (King Kuei), and in fourth publication, line 1, for *shu hua* read *shu-hua*; Ch'en K'uei-lin, line 1: *for* Pao yü-ko *read* Pao-yü-ko.

Page 392, column 1, *Chiao-yü-pu*, line 1: for *chan'lan* read *chan-lan*; column 1, Chin Wei-no, line 1, *for* Tan *read* T'an; column 2, Ch'in-t'u Hsien-yang . . . , lines 2 and 3: *for* I-hao *read* i-hao.

Page 393, column 1, *Chūgoku bijutsu-ten* . . . , line 2: *after* Takashima insert closing bracket.

Page 394, column 1, Fu, Marilyn and Fu Shen: *after* Shen insert period; Fu Yung-k'uei and Yü K'an-tseng, line 2, *for* shih chüeh" *read* shih-chieh' "

Page 395, column 1, Hu Ching, in second publication, line 1: for *Yüan-hua lu* read *yüan hua lu*.

Page 396, column 2, *Kundaikan-sayū-chōki*, line 1: *for* (Naomi's) *read* (Nōami's).

Page 398, column 1, Loehr, George R.: last four publications should be listed under separate author, Max Loehr.

Page 399, column 2, Rosenzweig, line 2: *for* Yun-ts'ung *read* Yün-ts'ung.

Page 400, columns 1 and 2, Sirén, *delete* last publication (duplicates his second publication).

Page 401, column 1, Sung Lien, line 1: for *Sung-Hsueh-shih* read *Sung-Hsüeh-shih*.

Page 402, column 1, T'ien Hsiu, line 3: *for* Mu Ch'i *read* Mu-ch'i.

Page 403, column 1, Whitfield, line 1: for Robert *read* Roderick.

The following publications should have been included:

Cahill, James. *The Compelling Image: Nature and Style in Seventeenth-Century Chinese Painting*. The Charles Elliot Norton Lectures for 1978-79. Cambridge, Mass., forthcoming.

Urban Council and the Min Chiu Society. *Exhibition of Paintings of the Ming and Ch'ing Periods*. Exh. cat.: City Museum and Art Gallery, Hong Kong. Hong Kong, 1970.

Whitfield, Roderick. *In Pursuit of Antiquity: Chinese Paintings of the Ming and Ch'ing Dynasties from the Collection of Mr. and Mrs. Earl Morse*. Exh. cat.: The Art Museum, Princeton University. Princeton, 1969.

Zainie, Carla M. "Sources for Some Japanese Ink Paintings." *The Bulletin of The Cleveland Museum of Art* LXV (September 1978), 232-46.

ADDITIONS TO INDEX

Page 407. Column 1, Liu Sung-nien: *after* 61 *insert* 92; column 2, *Pai-miao* style: *after* 97 *insert* 167.

Page 408. Column 1, The Three Religions: *after* 89 *insert* 135; *after* Wang Hsi-chih, *insert* 145.

Eight Dynasties of Chinese Painting

Frontispiece overleaf

On the right, the picture of streams and mountains has a free and leisurely air.
The sight of it provokes unworldly thoughts. It is truly a painting worth careful keeping.
In addition there are poetical colophons by eminent scholars of the former Chin Dynasty.
Its survival from the danger of war and fire is a rarity.

> Chih-shun, third year (1332), the month of late spring, K'ang-li Tzu-shan.
> Colophon six from *Streams and Mountains without End*, catalogue number 21.

君溪山圖意顧蕭滿
一見使人了子煙霞之志
真可弥玩又看金
諸名勝題詠其右乎
夫之相洋不易得也
至順三年以書之
月康里子山後

EIGHT DYNASTIES OF CHINESE PAINTING:

The Collections of the Nelson Gallery-Atkins Museum, Kansas City, and The Cleveland Museum of Art

WITH ESSAYS BY

Wai-kam Ho
Sherman E. Lee
Laurence Sickman
Marc F. Wilson

Published by The Cleveland Museum of Art
in cooperation with Indiana University Press

Trustees of
The Cleveland Museum of Art

University Trustees of the
William Rockhill Nelson Trust
and the Nelson Gallery Foundation

George P. Bickford
James H. Dempsey, Jr.
George M. Humphrey II
James D. Ireland
Mrs. Edward A. Kilroy, Jr.
Severance A. Millikin
Mrs. R. Henry Norweb
George Oliva, Jr.
A. Dean Perry
Mrs. Alfred M. Rankin
Daniel Jeremy Silver
Mrs. Seth C. Taft
Paul J. Vignos, Jr.
Alton W. Whitehouse, Jr.
John S. Wilbur
Lewis C. Williams
Norman W. Zaworski

Menefee D. Blackwell
Herman R. Sutherland
Donald J. Hall

The exhibition is supported in part by grants from the National Endowment for the Humanities,
the National Endowment for the Arts, and the Ohio Arts Council

©1980 by The Cleveland Museum of Art,
11150 East Boulevard, Cleveland, Ohio 44106

Designed by Merald E. Wrolstad
Edited by Sally W. Goodfellow
Printed in the United States of America
Typesetting by Creative Composition, Inc., Ashland, Ohio 44805
Printing by Great Lakes Lithograph Company, Cleveland, Ohio 44109

Distributed by Indiana University Press, Bloomington, Indiana 47401

Library of Congress Catalogue Card Number: 80-66110
ISBN: 0-910386-53-6

DABNEY LANCASTER LIBRARY
LONGWOOD COLLEGE
FARMVILLE, VIRGINIA 23901

Contents

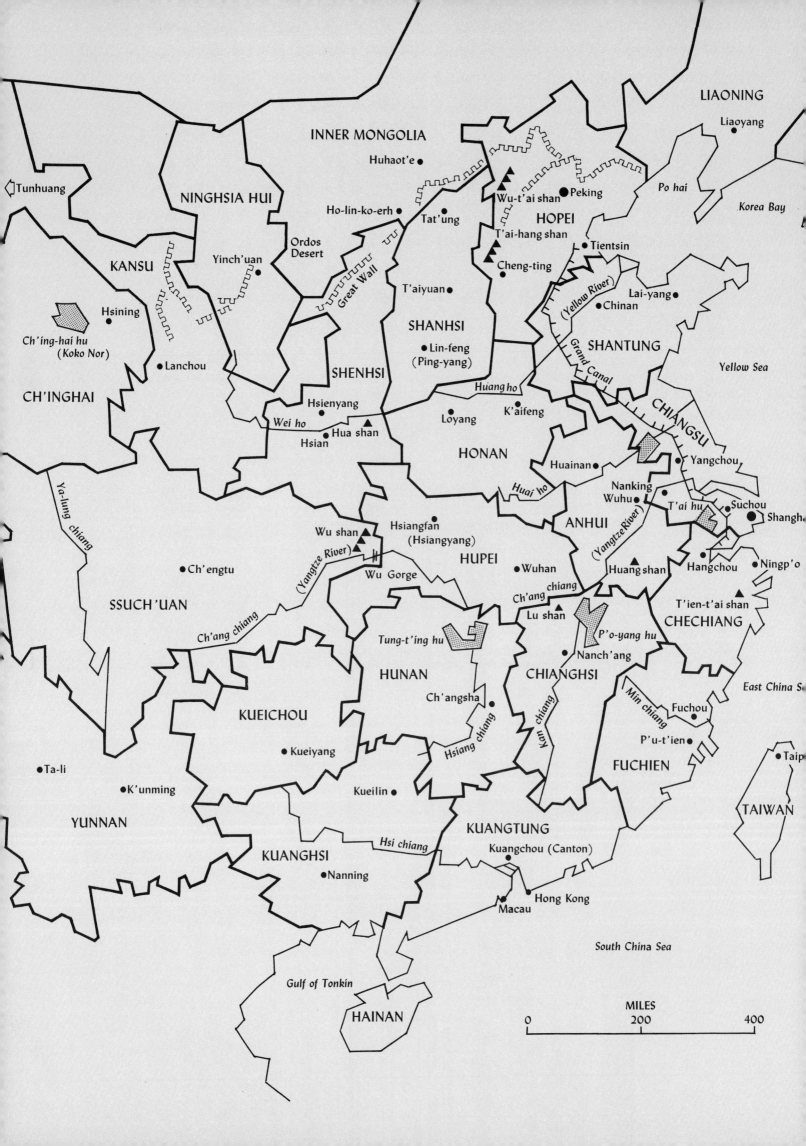

China

with a detail showing major centers of later Chinese painting (below)

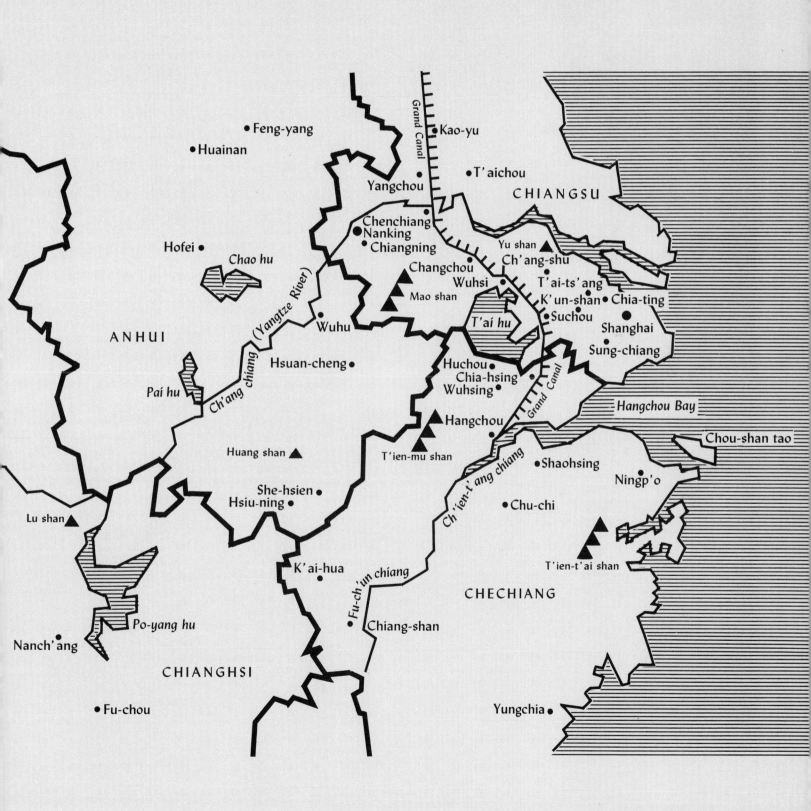

Preface

Serious thought about this exhibition began in conversations between Laurence Sickman and Sherman Lee some five years past. Their enthusiasm for a joint exhibition of the Chinese paintings owned by the two museums was quickly shared by the curators, Wai-kam Ho (Cleveland) and Marc Wilson (Kansas City), and by the trustees of both institutions. The compelling reasons for such an enterprise were as follows.

The number and quality of Chinese paintings involved were substantial and excellent. Furthermore, the two collections complemented each other in a most meaningful fashion – Kansas City's particular strength in early paintings being matched by Cleveland's large holdings in works created after the Sung Dynasty. Even within those areas where each collection had good representation, the particular artists or subjects can be seen to be complementary. The resulting display of two hundred and eighty-two works would provide, almost literally and relatively completely, a rich survey of the history of Chinese painting from 300 BC to AD 1850 – hence, the "fancy title": Eight Dynasties of Chinese Painting.

Aside from the excellent selection of 112 Chinese paintings from the National Palace collection in Taiwan, shown in this country during 1961 and 1962, there had been no major survey exhibition on this subject in the United States. In Europe the painting section of the great International Exhibition of Chinese Art in London and the exhibition 1000 Jahre Chinesische Malerei in Munich and Amsterdam were excellent surveys, but they had been held years before – in 1934/35 and 1959, respectively.

Of the four major collections of Chinese painting in the Western world, those of the Museum of Fine Arts, Boston, and of the Freer Gallery of Art, Washington, were heavily restricted by charter so that most of Boston's major works and all of the Freer's could not be lent to any outside loan exhibition. Clearly, if a major survey were to be attempted, it was incumbent on Kansas City and Cleveland to make the effort. Furthermore, the serious and complex problems of organizing such a show could be made far more manageable by the close cooperation of only two institutions – which, in this instance, have enjoyed a tradition of friendship and cooperation.

Both museums are similar in organization and programs, being private corporations not for profit and controlled by trustees dedicated to private effort for the public good. Both museums had long records of achievement in the collection, display, and elucidation of Far Eastern art in general and Chinese painting in particular. And both museums had the specialized staff necessary to organize and complete the innumerable scholarly and administrative requirements for such a major exhibition.

Finally, the exhibition would provide the impetus for the cataloguing and publication of the two collections, a scholarly responsibility of the first order, making the paintings available in catalogue form to a wide public – including those unable to attend the exhibitions in Kansas City (November 7, 1980, through January 4, 1981), Cleveland (February 11 through March 29, 1981), or Tokyo (October 6 through – tentatively – November 23, 1981). A selection of paintings will be exhibited later at the Asia House Gallery in New York City.

Having made the decision to go ahead, work began; and the educational process for the trustees, curators, researchers, registrars, and various assistants likewise began. There were times when despair and confusion reigned; at other times the initial optimism was fortified and justified. The results must be judged by others; but we are satisfied that the effort was worth it and that, however imperfect any exhibition and catalogue may be, the results make a contribution to scholarship and will provide both delight and education for the general public. Chinese painting is one of man's greatest aesthetic achievements; therefore, any growth in the understanding of and joy in viewing such paintings is worthwhile.

It was agreed that Kansas City would be responsible for the educational aids and devices that accompany the exhibition in the United States, as well as for any special cases or equipment required for display. Cleveland was to be responsible for the organization and editing of the catalogue and for the necessary arrangements to take the exhibition to Tokyo so that interested people in the Far East might see the paintings – under the official auspices of the Japanese Ministry of Education (Cultural Section) and the Tokyo National Museum.

The following acknowledgements are, by their very nature as print, poor substitutes for the enormous debt we owe to all who helped – for the task was huge and the detail seemingly endless. Anyone who knows the concern for accuracy and completeness in these matters, compounded by the particular problems inherent in the cataloguing of Chinese paintings with their innumerable seals, colophons, and literary associations, will understand why the thanks given here is only a small part of what is due the persons we mention.

Jean K. Cassill and Elinor Pearlstein, Assistants in the Department of Oriental Art at the Cleveland Museum, bore the brunt of the work on the catalogue. Intelligence, patience, tenacity, and forebearance marked their work at all stages. Mrs. Cassill was responsible for pre-editing catalogue entries, much typing and proofreading, and collecting all of the photographs. She also helped with the arrangements for packing and shipping. Miss Pearlstein prepared the bibliographic materials, checked publication references, compiled the dynastic and reign tables, and provided map information – along with a considerable amount of typing, editing, and proofreading. Jane Berger, Departmental Secretary, typed entries and indexes with speed, accuracy, and good humor – a rarity in such activities. Leona Miller assisted in typing. Hiroko Aikawa of the Library's Catalog Section was most helpful in transcribing the titles for many of the Japanese publications.

The design of the catalogue was accomplished with his customary flair and professionalism by the Editor of Publications, Merald E. Wrolstad. Assistant Editor Sally W. Goodfellow was responsible for all final editing and for coordinating the many aspects of manuscript preparation. Her patience and occasional spurs to action were combined with an awesome command of detail. Joseph Finizia, Assistant Museum Designer, designed and prepared the maps; while Nicholas C. Hlobeczy, Museum Photographer, and David Heald, Assistant Photographer, were responsible for Cleveland's photographic work.

The installation of the exhibition in Cleveland was once again in the tasteful hands of the Museum Designer, William E. Ward, who is by now – through experience and capability – particularly sensitive to the display needs of Oriental works of art. John Yencho, Plant Operations Manager, and Ezekiel Williams, Utility Foreman, were unusually helpful in the complex installation.

The numerous and important problems involving insurance, as well as the reception and inspection of the works of art, were efficiently handled by the Registrar, Delbert R. Gutridge, and his assistants – particularly, Carol T. Thum. The Director's secretary, June I. Barbish, was most helpful in administrative matters connected with organizing the exhibition in this country and in Tokyo, and in typing Sherman Lee's essay and some of the catalogue entries.

For the Cleveland catalogue entries, thanks must be given to many persons – not least, Nora Liu (Ling-yün Shih Liu: LYSL), who compiled the chronological list of collectors, did considerable research for entries, and checked and identified seals on the paintings. She also provided the preliminary translation of records and of many of the inscriptions and colophons. Howard Rogers (HR) was most helpful, working both here and in Japan as a research fellow for the exhibition. His enthusiasm, knowledge, and promptness were exemplary. Dr. Henry Kleinhenz (HK), formerly the Assistant to the Chief Curator of Oriental Art and a recent graduate of the Joint Program in Art History of The Cleveland Museum of Art and Case Western Reserve University, was responsible for many of the entries for Cleveland paintings of the Ming and Ch'ing dynasties. Elinor Pearlstein (EP) produced entries in the particular area of her expertise, early

Chinese art and archaeology. The Curator of Chinese Art, Wai-kam Ho (WKH), was responsible for most of the entries on paintings produced before 1350; the importance and length of certain of these entries will no doubt astonish both scholar and layman. Other entries for paintings of various periods were prepared by the Director and Chief Curator of Oriental Art, Sherman E. Lee (SEL).

Very special thanks go to the generous private lenders to the exhibition from Cleveland. Mr. and Mrs. A. Dean Perry have gathered a most significant and beautiful collection of Chinese paintings; indeed, the Cleveland portion would be far poorer without their loans. Mr. Kelvin Smith has relatively recently acquired some Chinese paintings, in addition to his important holdings of Japanese *ukiyo-e*, and he has generously made these works available. Mr. and Mrs. Severance A. Millikin most kindly lent the hanging scroll by Lin Liang, a well-known but little-seen masterpiece of the Che school. In the case of all these fine works, the owners have indicated that it is their intention to give or bequeath them to The Cleveland Museum of Art. We also wish to thank the private lenders from Kansas City, Mrs. George H. Bunting, Jr. and Mr. Laurence Sickman, who have indicated a similar intention with respect to the Nelson Gallery.

In Kansas City, final preparation of the Nelson Gallery's catalogue entries was undertaken by Laurence Sickman (LS), Director Emeritus and Curator Emeritus of Oriental Art; by Marc F. Wilson (MFW), Curator of Oriental Art; and by Kwan S. Wong (KSW), Research Fellow. Working daily with one another, each has contributed to the work of the others. Mr. Wong's fund of sinological expertise provided an essential resource for his colleagues. To Mr. Wilson fell the task of checking and editing the entries for uniformity, as well as the responsibility for other production details.

Preparatory research on the Nelson Gallery's paintings proceeded over a number of years. Apart from the principal authors, many people contributed to this effort. Special attention must be drawn to Wu Tung, now of the Museum of Fine Arts, Boston, in identifying seals and citations to traditional texts. His work and that of Mr. Wong were supported by grants from the Ford Foundation, the Kansas City Association of Trusts and Foundations, and the National Endowment for the Arts.

No catalogue of this magnitude and complexity appears without an excellent typist. Sincere appreciation is extended for the dedication of Mrs. Jean Drotts, Curatorial Secretary, who typed and retyped the Nelson Gallery's manuscripts with unfailing cheerfulness.

The overall conception and management of the exhibition in Kansas City belongs to Marc F. Wilson, whose thoroughness made an enormous undertaking easier for all. As so often in the past, Mr. Wilson and the Gallery's Curator of Exhibitions and Design, Michael Hagler, formed an effective team for the design and production of the installation. Additionally, Mr. Hagler bore responsibility for the countless day-to-day details of production. Special thanks must go to Carl Stacer and his small but dedicated construction crew; with exceptional efficiency they transformed 15,000 square feet of recalcitrant architecture into a unified, modern facility capable of housing an exhibition of this scale. Leon Graven and helpers

worked long weeks to provide the lighting; and Bobby Hornaday performed with his usual alacrity to assure the safe and speedy hanging of the paintings. George McKenna secured insurance for the domestic showings of the exhibition with his customary ingenuity and atttention to economy.

The Nelson Gallery's Education Department, headed by Ann Brubaker, coordinated a complex educational program to supplement the exhibition. Special thanks go to Beverly Haskins, Public Information Officer of the Nelson Gallery, for her unstinting efforts to make the exhibition known to the American public.

Without the generous support of the National Endowment for the Humanities, which provided major funding to both institutions, and the National Endowment for the Arts, which granted substantial support to the showing in Kansas City, this exhibition and its programs could not exist. We are deeply indebted to both agencies. We also wish to recognize the generosity of the Jacob L. & Ella C. Loose Foundation in Kansas City for its support of the catalogue and the Ohio Arts Council for its support of the Cleveland showing.

Ralph T. Coe, Director
Nelson Gallery-Atkins Museum

Sherman E. Lee, Director
The Cleveland Museum of Art

Chronology of Dynastic China

HSIA DYNASTY (unconfirmed)	21st c.-16th c. BC
SHANG DYNASTY	16th c.-1045 BC*
CHOU DYNASTY	1045-256 BC
Western Chou	1045-771 BC
Eastern Chou	771-256 BC
Spring and Autumn period	722-481 BC
Warring States period	480-221 BC
CH'IN DYNASTY	221-206 BC
HAN DYNASTY	206 BC-AD 220
Western (Former) Han	206 BC-AD 9
Wang Mang interregnum	9-23
Eastern (Later) Han	25-220
THREE KINGDOMS	220-265
WESTERN CHIN DYNASTY	265-317

SOUTHERN DYNASTIES 317-589		NORTHERN DYNASTIES 386-581	
Eastern Chin	317-420	Northern Wei	386-534
Liu Sung	420-479	Eastern Wei	534-549
Southern Ch'i	479-502	Western Wei	535-556
Liang	502-557	Northern Ch'i	550-577
Ch'en	557-589	Northern Chou	557-581

SUI DYNASTY	581-618
T'ANG DYNASTY	618-906

FIVE DYNASTIES 907-960		Northern China and Manchuria	
Later Liang	907-923	Liao Dynasty	907-1125
Later T'ang	923-937		
Later Chin	937-946		
Later Han	947-950		
Later Chou	951-960		

SUNG DYNASTY 960-1279			
Northern Sung	960-1127	Chin Dynasty	1115-1234
Southern Sung	1127-1279		

YUAN DYNASTY	1279-1368
MING DYNASTY	1368-1644
CH'ING DYNASTY	1644-1911

* Date proposed by Professor David S. Nivison, Stanford University,
 in paper delivered to the Symposium on the Bronze Age of China,
 Metropolitan Museum of Art, New York, 1980

Emperors of Sung, Yüan, Ming, and Ch'ing

Year of Accession	Emperor's Posthumous Temple Title (*miao hao*)	Reign Title (*nien hao*)	Year of Adoption
SUNG DYNASTY			
Northern Sung			
960	T'ai-tsu	Chien-lung	960
		Ch'ien-te	963
		K'ai-pao	968
976	T'ai-tsung	T'ai-p'ing-hsing-kuo	976
		Yung-hsi	984
		Tuan-kung	988
		Shun-hua	990
		Chih-tao	995
997	Chen-tsung	Hsien-p'ing	998
		Ching-te	1004
		Ta-chung-hsiang-fu	1008
		T'ien-hsi	1017
1022	Jen-tsung	Ch'ien-hsing	1022
		T'ien-sheng	1023
		Ming-tao	1032
		Ching-yu	1034
		Pao-yüan	1038
		K'ang-ting	1040
		Ch'ing-li	1041
		Huang-yu	1049
		Chih-ho	1054
		Chia-yu	1056
1063	Ying-tsung	Chih-p'ing	1064
1067	Shen-tsung	Hsi-ning	1068
		Yüan-feng	1078
1085	Che-tsung	Yüan-yu	1086
		Shao-sheng	1094
		Yüan-fu	1098
1100	Hui-tsung	Chien-chung-ching-kuo	1101
		Ch'ung-ning	1102
		Ta-kuan	1107
		Cheng-ho	1111
		Ch'ung-ho	1118
		Hsüan-ho	1119
1126	Ch'in-tsung	Ch'ing-k'ang	1126
Southern Sung			
1127	Kao-tsung	Chien-yen	1127
		Ming-shou	1129
		Shao-hsing	1131
1162	Hsiao-tsung	Lung-hsing	1163
		Ch'ien-tao	1165
		Shun-hsi	1174
1189	Kuang-tsung	Shao-hsi	1190
1194	Ning-tsung	Ch'ing-yüan	1195
		Chia-t'ai	1201
		K'ai-hsi	1205
		Chia-ting	1208
1224	Li-tsung	Pao-ch'ing	1225
		Shao-ting	1228
		Tuan-p'ing	1234
		Chia-hsi	1237
		Shun-yu	1241
		Pao-yu	1253
		K'ai-ch'ing	1259
		Ching-ting	1260
1264	Tu-tsung	Hsien-shun	1265
1274	Kung-tsung	Te-yu	1275
1276	Tuan-tsung	Ching-yen	1276
1278	(Ti Ping)	Hsiang-hsing	1278

Year of Accession	Emperor's Posthumous Temple Title (*miao hao*)	Reign Title (*nien hao*)	Year of Adoption
YUAN DYNASTY			
1260	Shih-tsu	Chung-t'ung	1260
		Chih-yüan	1264
1294	Ch'eng-tsung	Yüan-cheng	1295
		Ta-te	1297
1307	Wu-tsung	Chih-ta	1308
1311	Jen-tsung	Huang-ch'ing	1312
		Yen-yu	1314
1320	Ying-tsung	Chih-chih	1321
1323	(T'ai-ting Ti)	T'ai-ting	1324
		Chih-ho	1328
		T'ien-shun	1328
1328	Wen-tsung	T'ien-li	1328
1329	Ming-tsung		
1329	Wen-tsung*	Chih-shun	1330
1332	Ning-tsung		
1333	(Shun Ti)	Yüan-t'ung	1333
		(Hou) Chih-yüan	1335
		Chih-cheng	1341
MING DYNASTY			
1356	T'ai-tsu	Hung-wu	1368
1398	(Hui Ti)	Chien-wen	1399
1402	Ch'eng-tsu	Yung-lo	1403
1424	Jen-tsung	Hung-hsi	1425
1425	Hsüan-tsung	Hsüan-te	1426
1435	Ying-tsung	Cheng-t'ung	1436
1449	Ching Ti	Ching-t'ai	1450
1457	Ying-tsung*	T'ien-shun	1457
1464	Hsien-tsung	Ch'eng-hua	1465
1487	Hsiao-tsung	Hung-chih	1488
1505	Wu-tsung	Cheng-te	1506
1521	Shih-tsung	Chia-ching	1522
1567	Mu-tsung	Lung-ch'ing	1567
1572	Shen-tsung	Wan-li	1573
1620	Kuang-tsung	T'ai-ch'ang	1620
1620	Hsi-tsung	T'ien-ch'i	1621
1627	(Ssu-tsung)	Ch'ung-cheng	1628
1644	(Fu Wang)	Hung-kuang	1645
1645	(T'ang Wang)	Lung-wu	1645
1646	(T'ang Wang)	Shao-wu	1646
1646	(Yung-ming Wang)	Yung-li	1647
CH'ING DYNASTY			
1643	Shih-tsu	Shun-chih	1644
1661	Sheng-tsu	K'ang-hsi	1662
1722	Shih-tsung	Yung-cheng	1723
1735	Kao-tsung	Ch'ien-lung	1736
1796	Jen-tsung	Chia-ch'ing	1796
1820	Hsüan-tsung	Tao-kuang	1821
1850	Wen-tsung	Hsien-feng	1851
1861	Mu-tsung	Tung-chih	1862
1875	Te-tsung	Kuang-hsü	1875
1908	(Pu-i)	Hsüan-t'ung	1909

An emperor for which no temple title was designated is identified by his personal name (*ming*) or posthumous memorial title (*shih*) in parentheses.

*Restored to throne.

Chinese Painting before 1100

Laurence Sickman

The Han Dynasty to the Six Dynasties

The representation of identifiable human and animal figures came into Chinese art at a date relatively late compared with the Mediterranean world. From the beginnings of the bronze age in China, about 2000 BC, until the period of the Warring States (480 to 221 BC), ornament dominated in the decoration of ritual vessels and such miscellaneous objects as chariot fittings and weapons. The zoomorphic creatures – hook-beaked bird forms, dragons, and particularly the so-called *t'ao-t'ieh* frontal mask – all were elements of a rich and impressively complex vocabulary of ornament devoid of any reference to the natural world.

Toward the end of the Chou Dynasty, in the period known as the Spring and Autumn Annals (722-481 BC), a quite new style emerged – that of the inlaid bronze – a style in which decoration in a contrasting color of metal, such as copper, was inlaid on the otherwise plain surface of a bronze vessel. Among these inlaid vessels a few displayed for the first time decoration with representational motifs of animals, birds, and fantastic creatures. Such elements may have derived from the animal-style art of the steppes penetrating China from the regions of Central Asia and those outside the Great Wall. About the same time, there appeared among the inlaid bronzes some vessels with representational designs of purely Chinese content: figures engaged in archery contests, ritual music, dancing and feasting, hunting, and battles on land and water. The drawing is stiff and archaic, with all figures shown in silhouette, and there is no attempt to suggest spatial relationships. In the words of Jenny F. So, "The scenes resemble line diagrams, and each individual scene functions more like an elaborate pictograph to be *read* for its contents rather than as a convincing pictorial evocation of an event."[1]

It must have been as early as the period of the Spring and Autumn Annals that Chinese artists became aware of the numerous problems involved in depicting figures in action. Above all, a representational art required a convincing area for action, three-dimensional space on a two-dimensional surface, spatial relationships, directional movement, and a stock of occupational postures and gestures.

One must postulate a school of painting that paralleled the art of the bronze caster and employed the same motifs of decorative style. It probably would have been in the more fluid and direct medium of painting that the break-through to a representational style could be most successfully exploited. In the painted clamshell [1] from the late Warring States period, the artist's concern for spatial relationships is shown in the slight overlapping of the horses in one instance, the quadriga depicted face-on in another, and the artist's command of action and movement in the kneeling hunter and wounded deer.

Thanks to the phenomenal activities of Chinese archaeologists, materials relevant to the pictorial art of the Han Dynasty (206 BC–AD 220) have been enriched to the point that even the briefest survey would be beyond the scope of this essay. With few exceptions, the examples of this flowering of the representational style are funerary in nature, executed for tombs and offering shrines. It is safe to assume that a number of these mortuary decorations reflected, in their more durable material, the painting styles and themes that adorned the palaces, pavilions, and ritual halls of the living.

The patrons of art in the Han Dynasty were, as they had been during the Bronze Age, the ruling elite. Throughout the dynasty the subjects depicted were derived from the philosophical concepts and political theories of this aristocracy.[2] The power of the celestial spirits controlling the cosmic forces was elicited to assure order – a natural order that brought such beneficial results as the proper rotation of the seasons and the avoidance of natural disaster.

A prime example that depicts such cosmic power is the lacquer decoration (Figure 1) on the outer of the three coffins that contained the remarkably well-preserved body of the wife of the Marquis of Tai. (The tomb was discovered at Ma-wang-tui in the vicinity of Ch'angsha, Hunan, south of the Yangtze River, and can be assigned to the first quarter of the second century BC, a probable date being between 193 and 186 BC.) The design, executed in lacquer, is composed of cosmic cloud forms that swirl and twist with a rushing motion, expanding and contracting, ending in long, pointed lines as though their volume were constantly expended and renewed. The spirit denizens of this vaporous world include, among others, goat-like figures with deer antlers (many carrying various weapons), horned quadrupeds leaping headlong, oxen, birds, snakes, and tigers. To quote Martin Joseph Powers, "Clouds, vapors, wind and rain were the visible expressions of the active matter of the cosmos, the *yin* and *yang ch'i*. These forces comprised the proper arena of activity for the many spirits who could influence them, and even,

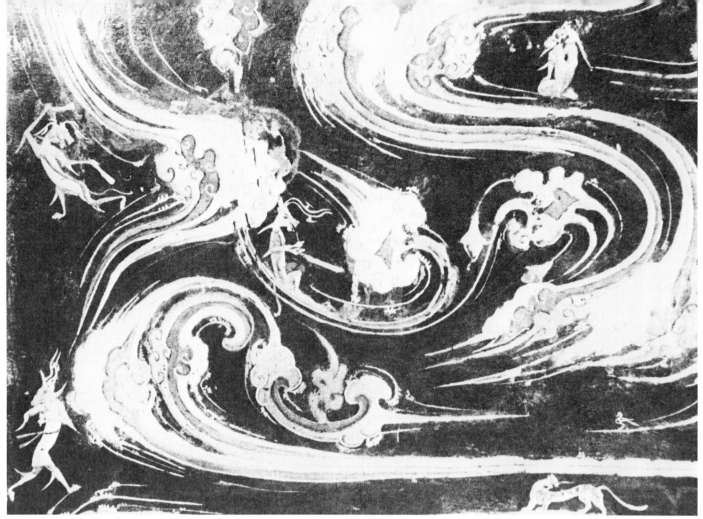

Figure 1. Detail of coffin from Tomb I, Ma-wang-tui. Western Han Dynasty, early second century BC. (After *Ch'ang-sha Ma-wang-tui i-hao Han-mu*, vol. I, Peking, 1973)

in a sense, embodied them bringing good luck or ill luck with them."[3]

The most remarkable object recovered from this grave, designated as Tomb I of Ma-wang-tui, was a T-shaped silk banner painted with a design of considerable complexity executed in ink outline and polychrome coloring. The subject of the painted banner, it is generally agreed, is based on Taoist cosmology and represents the journey of the soul.[4] The journey, as presented, occupies three areas: on the lower third is the nether world of water and darkness, above this is the region of the living, and in the upper third the spirit passes through a guarded gate with such celestial symbols as the sun and moon. Our concern here is with the character of the painting itself rather than what can be learned from it about Han cosmology and mythology.

The composition shows a high level of sophistication, with the multiple figures from mythology and worldly life bound together in a unified design. The technique throughout employs thin, bounding outlines of even thickness in black ink, with the inner areas filled with appropriate colors and the descriptive inner marking added on top of the color.

Creatures of pure fantasy are combined with others displaying a surprising realism, as in the case of two owls resting on the backs of tortoises; and the figure of the occupant of the tomb, a middle-aged lady in a stooping posture who leans on a long staff, is painted with the veracity of true portraiture. A number of devices have been evolved that give credibility to a three-dimensional field for action. Base lines are firmly established; figures are shown in three-quarter view or with successful foreshortening as they turn in space; and figures overlap one another. In a ritual scene, two facing rows of seated figures not only overlap but recede into the background at strong diagonals. The whole banner displays a command of composition and the sureness and verve of a skilled artist with more than a few generations of experience behind him.

The Han tombs with mural decorations that so far have been published by the Chinese archaeologists date from the years of Eastern Han (AD 25-220), with at least two exceptions. One tomb, designated as Tomb 61, was excavated in the region of Old Loyang and is assigned to the late first century BC. (Full information and detailed descriptions of a number of the most important Han tombs with paintings are given in *Han and T'ang Murals* by Jan Fontein and Wu Tung.)[5] The main chamber is divided by a reticulated pediment resting on a lintel, both made of tile, and similar in construction to the well known painted Han tiles in the Museum of Fine Arts, Boston. The painting on the lintel illustrates the story of "Killing Three Warriors with Two Peaches" – a cautionary tale with strong Confucian moral overtones. The same story may be depicted on the tile [3] in the Cleveland Museum. Since the constellations, together with the sun and moon, are painted on the ceiling of Tomb 61, the decoration combines elements of ancient cosmology with illustrations

xiv

carrying a Confucian message of the virtues by which a mortal gains and exercises earthly power. In contrast to the controlled, even lines of the Ma-wang-tui banner, here the brushwork is loose – with broadening and thinning lines – and sketchy, as though done in haste. Heavy lines accent the garments, and the faces of the knights are wildly distorted in their intensity of expression.

Broad brushstrokes combined with a fine, defining outline are carried further and with considerably more competence in the paintings of officials on the walls of a tomb at Wang-tu county, Hopei Province, and assigned a date in the late second century AD. They depict the various officials and guards who would have served the high-ranking occupant of the tomb. Whether standing or seated, each official leans slightly forward in a pose of deep respect, as though awaiting the master's orders. In a lower register are a number of creatures of good omen – among them, a winged ram and deer, a white rabbit, and a mandarin duck. These animals, like the figures, are drawn with impressive skill and a surprising naturalism heightened by a limited amount of shading. The variety among the facial types of the officials borders on portraiture and the stolid officials in their voluminous robes may well reflect the artist's impression of the Han bureaucrats he had seen about him. Although the outline of the figures is done with fine, even brushstrokes, the folds of the robes are painted with broad, sweeping strokes, definitely employed to indicate light and shade – an early use of chiaroscuro to give volume and mass rather than to indicate a source of light.

A tomb dating from the late Eastern Han period with features of considerable importance in the history of Chinese painting was excavated at Holingol on the banks of the Red River in Inner Mongolia. Of particular interest in the development of Han representational art is the view of Ningch'eng city.[6] The city with its outer walls, stable, service quarters, and official dwelling is shown from a viewpoint employed in much of later Chinese painting. The city walls form a rectangle with parallel sides, and the walls to right and left do not recede diagonally. In contrast, the buildings within the walls recede at strong diagonals in a studied attempt to represent recession in three-dimensional space. Curiously enough, the diagonals of the buildings on the right half of the picture are arranged in an orderly manner with a series of focal points rising one above the other along an imaginary vertical line bisecting the composition. However, the buildings on the right side of the painting are arranged in a rather haphazard and confused manner, some with focal points far to the left beyond the right border. As the buildings recede, they mount one above the other; but throughout the composition, in both the buildings and figures, there is no diminution in scale as they recede from the viewer. "The Chinese solution" [to recession into depth], Margaret Medley has written, "was to combine diminution with a changing viewpoint which could be raised or lowered or moved to right or left as desired. As objects farther away are painted, the viewpoint is raised so that in the finished work there is almost always more than one viewpoint."[7] The ground plane is tilted forward, resulting in the effect of the viewer seeming to be on a high eminence, often very near the horizon

line looking down on the scene, a bird's-eye view that allows a maximum of descriptive detail.

By the first century BC the Han scholars, from whom the ruling class was drawn, had thoroughly embraced a syncretic Confucianism that stressed the moral virtues, the ritual, and the etiquette embodied in the sage's teachings. But with this was a mixture of older beliefs, superstitions, elements of Taoist mythology, and such cosmic concepts as the interaction of *yin* and *yang* and the value of correct directional orientation. A wide variety of portents became of signal importance – some derived from mythology, some from natural phenomena; some signified the presence of virtue and good fortune, others that of evil and disaster. Heaven granted power to the ruler by reason of his great virtue, and the emperor's appointed officials exercised a portion of that power only so long as they acted in accordance with moral virtues of Confucianism. Hence, ancient rulers and sages to be emulated and notorious villains to be abhorred became popular subjects of narrative illustration.

No better example could be found of the combination of ancient mythological themes and the more recent political and philosophical concepts than the numerous engraved stone slabs of the Wu family offering-shrines at Chia-hsiang in the province of Shantung, homeland of Confucius. The stones comprise three shrines and remainders of a fourth.[8] They are too well known and widely published to warrant any more than a brief comment on style.

The Wu family slabs differ in many ways from the Han funerary art of southern and western China. Figures and horses are strung along a single base line, and there is little use either of objects or groups of figures receding at a diagonal or overlapping. The character of the drawing throughout is set by the large circles of the chariot wheels, with the curvature of the wheels echoed in the swelling chests and rumps of the horses and in the voluminous robes of the figures. By comparison with the swift, vital movement seen in much of the Han art to the west and south, as at Nan-yang in southwest Honan Province, the Wu family compositions, in which all available space is filled, are curiously static. Even in the scenes of celestial beings rushing through cosmic space, there is no headlong dash, and the clouds are little more than flat ribbons ending in circular puffs.

When representational art of a high order developed a century or two later, its homeland appears to have been the valley of the Yangtze River, the Chiang-nan area, famous throughout the history of Chinese painting. Lively drawing and, above all, the depiction of movement in space, is to be found in the most accomplished representational art of Eastern Han, as on the impressed tiles found in the neighborhood of Ch'engtu, Ssuch'uan Province, and dating, in all likelihood, from the third century AD. The great majority draw their themes from daily life; a series of scenes of entertainment show musicians, dancers, acrobats, and jugglers performing before seated couples (Figure 2). In others, guests are entertained with wine. Space is handled with far more sophistication than in any earlier works. Floor mats and tables recede along strong diagonals, their sides in parallel perspective. Profile, three-quarter profile, full face, and even figures seen

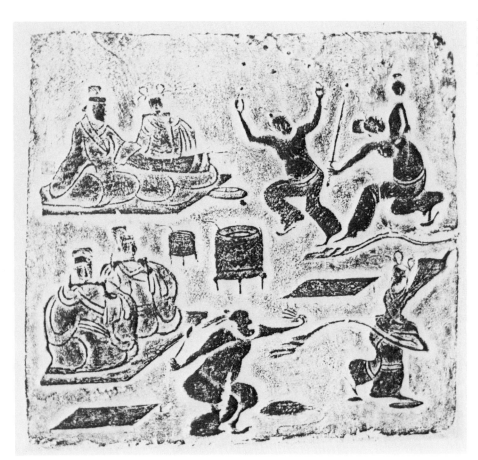

Figure 2. Rubbing: entertainment scene from impressed tile. Ch'engtu, Ssuch'uan Province, Eastern Han Dynasty, third century AD.

Figure 3. Detail of wall painting, Tomb I, Jin-pa-ri. Korea, sixth century AD. (Photograph courtesy of Professor Sueji Umehara)

from the back, as well as overlappings, are all treated in a convincing manner. There is also an impressive command of stance and gesture, especially with the dancers and acrobats.

The tiles most indicative of the advances made by the end of the Han Dynasty are those with figures placed in a landscape setting. The most famous of these are a picture of a salt mine with its laborers, and another scene of shooting ducks beside a pond – the latter combined on the same tile with a harvest scene. This is no mere conceptional art, but one in which movement, posture, and descriptive gestures are based on a good observation of the natural world. The accomplishment shown in the drawing of the figures and even some elements of the style lead without too much gap into the first important school of figure painting in the second half of the fourth century centered around the name of Ku K'ai-chih.

If much attention has been devoted to the centuries of the Han Dynasty, it is because during those four hundred years, Chinese representational art evolved from archaic "pictographs" and purely conceptual forms of the Chou style to the sophistication of the Ssuch'uan tiles. Among the devices developed to depict action as well as objects and figures in three-dimensional space and a narrative art form were: the three-quarter view and full face; overlapping; foreshortening; diagonal recession of objects or groups of figures; isometric projection; a tilted ground plane creating a bird's-eye view; chiaroscuro, gestures and stances descriptive of motion and of occupation; and, finally, figures in a landscape setting.

Period of the Northern and Southern Dynasties

With Ku K'ai-chih (ca. 344 – ca. 406) we come to the first celebrated artist whose name is associated with paintings that have survived into our own time. The most famous of these is the scroll entitled *Admonitions of the Imperial Instructress*, now in the British Museum. Like earlier subjects of art, the *Admonitions* carries a moral message – the proper conduct of ladies of quality. The series of illustrations, separated by a section of text, are presented against a plain ground. The painting is executed in fine, even lines that describe the drapery without any extraneous strokes. There is also a definite use of shading within the drapery folds of a kind practiced in Han times. One of the most successful scenes is that of a lady seated in a testered bed conversing with her husband. The bed is shown in isometric projection receding at a strong angle in plausible three-dimensional space. A feature of the style of Ku K'ai-chih is found in the long, trailing skirts and the scarves or ribbons worn by the ladies that billow back, twisting and turning, as though caught in a light wind. The artist, well aware of the psychological interactions between the persons in his illustrations, has admirably conveyed the emotions of the admonisher and the admonished by posture and gesture rather than by facial expression. The scroll throughout has an aura of antique charm and unobtrusive elegance. There is much debate as to the actual date of the British Museum painting, but there can be no doubt that it is of great age and embodies, for the most part, a style current in the late fourth to early fifth century.

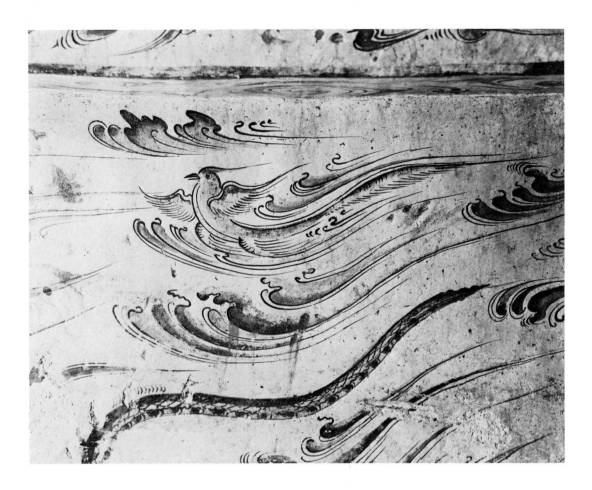

Three other scrolls all traditionally attributed to Ku K'ai-chih illustrate a poem, "The Nymph of the Lo River," written by Ts'ao Chih (AD 192-232). One scroll is in the Liaoning Provincial Museum;[9] one is in the Palace Museum, Peking;[10] and the third, which is missing the opening section, is in the Freer Gallery of Art, Washington.[11] This last painting is considered to be a copy of the Sung period, and the version in Liaoning may be of approximately the same date – tenth to thirteenth century. An adequate illustration of the poem demands a number of figures, human and superhuman, in the landscape setting of the Lo River. Little in these scrolls recall the *Admonitions* scroll in London, save the trailing skirts and floating ribbons of the nymph and her attendant. Among the most archaic elements in all three versions is the discrepancy in scale; the figures are much too large in relation to the mountain forms, as are the distant trees on mountaintops.

It is difficult to suggest a date for the obviously ancient painting behind this composition. The rocks and mountain formations are suggestive of those on a pictorial pressed tile depicting the *Four Graybeards of Mt. Shang*, from Teng-hsien in southwestern Honan, near the Hupei border.[12] Additional similarities on other Teng-hsien tiles occur in the flying scarves of immortals and elongated dragons of the kind that draw the Lo River Nymph's car. The Teng-hsien tiles are variously placed between AD 450 and 500 or, roughly, some two generations after Ku K'ai-chih.

The *Admonitions* scroll and versions of the *Nymph of the Lo River*, as well as the pressed tiles of Teng-hsien, are all logical predecessors to the considerably more complex and sophisticated compositions on the *Sarcophagus of Filial Piety* [4] from the Nelson Gallery.

One of the most striking aspects in the composition engraved on these stones is that the artist felt the need to include, however tentatively, some suggestion of far distance. The foreground is firmly established by rocks, a flowing stream, animals, and trees. A complex pattern of rock slabs, with jagged, overhanging caps, is arranged much like the flats of a stage set, forming a deep middle distance with space cells for action, as well as separating one illustration from another. The surface of these rock slabs are perfectly flat, with minimal inner markings. In a number of areas where the narrower, shorter slabs overlap larger slabs behind, tufts of long grass emphasize the point of juncture and separate one from another. Quantities of small, oval stones, their long axes parallel with the picture plane, are scattered about and indicate the relatively flat surface of the middle ground. Foreground and middle ground established, the artist was conscious of the necessity in some areas, but not all, to include a far distance by means of ranges of low, rounded peaks strung along the line of the far horizon at the very top of the composition. In the story of the Filial Shun the artist has assayed four layers of such ranges one above the other. No attempt is made to blend the middle distance with the far horizon, so this extensive gap is hidden behind banks of clouds. In fact, the transition from middle distance to far distance was a problem that plagued the Chinese landscape painter for a long time. Here the clouds below the distant mountains and those separating one layer of peaks from another are merely narrow, flat bands. These, as well as the windblown clouds that

accompany the many flying ducks, herons, and long-tailed birds were, without doubt, considerably more ethereal when painted than when translated into the intractable medium of engraved stone.

There are wall paintings in a sixth-century tomb at Jinpa-ri, Korea, that illustrate to perfection how the blowing clouds and flying birds that fill the sky on the sarcophagus would appear if painted (Figure 3). Successful foreshortening is evident in all the figures, but especially in the two horses – one entering the foreground, the other turning back into the landscape in the closing scene at the far left. Youth, middle age, and old age are easily distinguished by facial types, but the emotions of the protagonist and their interactions are shown by gesture and stance, as in Ku K'ai-chih's *Admonitions* scroll.

In essence, these illustrations are imbued with an air of delicate charm and some naiveté in settings that are elegant, decorative, rich in detail, and somewhat mannered. It is an art still in the freshness of its youth. Whatever became of the style and how it evolved in later years is impossible to say at present. If one might hazard a guess, such illustrations may have been the progenitors of the blue-and-green style that is characterized by fantasy, richness of color, and devotion to detail.

T'ang Figure Painting

China can boast the earliest and most continuous writings on the art of painting of any nation in the world, and in no country has connoisseurship been taken more seriously or been more thoroughly analyzed. For the history of painting in the T'ang Dynasty (618-906) there are three invaluable texts. Foremost among them is *Record of Famous Paintings of Successive Dynasties (Li-tai ming-hua chi)* by Chang Yen-yüan, with preface dated 847.[13] Then there is *Celebrated Paintings of the T'ang Dynasty (T'ang-chao ming-hua lu)* written in the 840s by Chu Ching-hsüan.[14] Finally, there is an account of later T'ang artists in Kuo Jo-hsü's *Experiences in Painting (T'u-hua chien-wen chih)* written in the 1070s.[15] These texts supply not only the biographies of the painters but also critical comments and qualitative classifications of their work as well as the titles of paintings that had survived into the time of the writer, many of which he had seen. All Occidental writers on the history of Chinese painting – Osvald Sirén and, more recently, Michael Sullivan among them – have drawn extensively on these texts in their reconstructions and evaluations of early Chinese painting. It is highly doubtful, however, that a single painting listed in any of the three texts mentioned above has survived into our own time. Incidentally, these early texts must have been useful compendiums for collectors in the Sung Dynasty and later by supplying them with a host of names to choose from in making their attributions.

The patrons of painting throughout the T'ang Dynasty were the Buddhist church, to a lesser extent the Taoist church, and lastly the imperial court together with the princes and high officials attached to it. Judging from literary accounts concerning the number and scale of the wall paintings adorning great temples of metropolitan centers and the number of religious icons painted by the leading artists of the seventh and eighth centuries, a great part of the national artistic energy must have been devoted to religion. A short-lived but devastating Buddhist persecution, initiated in 845, resulted in the destruction of most of the celebrated wall paintings and the religious banners belonging to the temples and their clergy. Such losses, plus the normal wear of time, and an indifference that grew through the centuries toward collecting religious icons resulted in the loss of practically all religious paintings from metropolitan centers and certainly all those by leading masters of the T'ang period. A few early Buddhist paintings are preserved in Japan – notably a series of patriarchs by Li Chen; but for Buddhist painting in any quantity, one must turn to the great series of frescoed cave-chapels at Tunhuang, Kansu Province, on the western borders of China proper, and the hoard of painted banners discovered in a walled-up storage cave.

In the area of T'ang court painting a few scrolls may serve to illustrate the subject matter and general style. The T'ang court and its entourage were both hedonistic and anthropocentric. Fine horses and lovely ladies, such royal pastimes as hunting and polo, tribute bearers, or a stately progress encompassed the repertory of artists invited to paint for the court and its courtiers. Curiously enough, a number of the leading artists appear to have executed such worldly themes and at the same time painted religious subjects with fervor.

It is only in very recent years that one can comment on T'ang court painting with any conviction. This fortunate state has come about through the excavation of four tombs belonging to members of the T'ang imperial house and lavishly decorated with wall paintings depicting all the subjects mentioned above.[16] The four underground tombs are in the imperial necropolis in present Ch'ienhsien county not far from the T'ang imperial capital at Ch'angan (modern Hsian), Shenhsi Province.

The earliest of these is the tomb of Prince Huai-an (Li Shou), built in 632. In its scene of mounted hunters pursuing stag and wild boar, the drawing is animated but lacks vigor and clear definition. The landscape is simple, done in line alone without inner markings, and some of the slab-like extrusions hark back to the landscape on the *Sarcophagus of Filial Piety.*

The three later tombs were all constructed at the same time, 705-706, to contain the remains of three unfortunate members of the imperial house who had died before their time as a result of court intrigues and had previously been buried some distance from the court. With the accession of a new emperor, all were disinterred and reburied in the imperial burial grounds in a manner proper to their rank. The three were Prince I-te (Li Chung-jun), Prince Chiang-huai (Li Hsien), and the Princess Yung-t'ai (Li Hsien-huai). These tombs offer such a quantity of wall paintings – Prince I-te's alone contains some 3,600 square feet of murals – and so great a variety of subject matter that the murals comprise an almost complete panorama of paintings from the early eighth century. In all three tombs the drawing of horsemen and male and female figures is firmer, more sure and competent in its description of form than is the drawing in the earlier tomb of 632. Furthermore, the landscape settings are considerably more advanced.

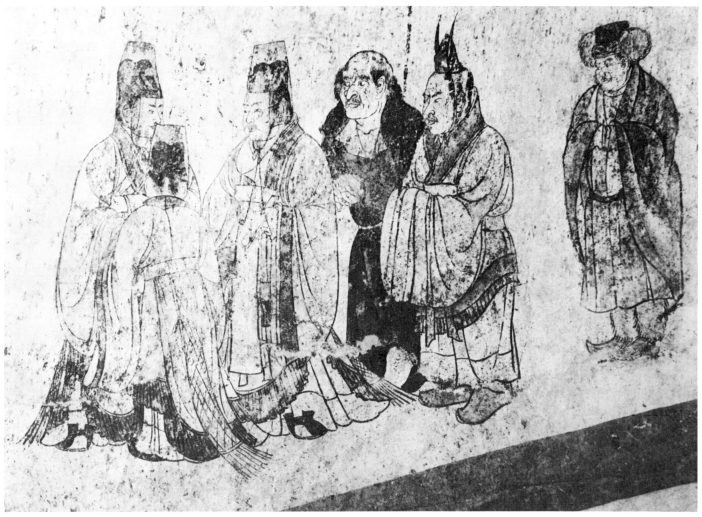

Figure 4. *T'ang Officials Greeting Foreign Envoys.* Detail of wall painting, tomb of Prince Chang-huai. T'ang Dynasty, AD 706. (After *T'ang Li Hsien mu pi-hua*, Peking, 1974)

An important aspect of T'ang figure painting is that the drawing of the garments is relatively simple, limited to a few telling strokes that, with economy, convincingly describe the natural fall of the material and the solidity of the form beneath. In these wall paintings the bounding outlines and inner markings are all done in a fine, strong even line, with drapery folds shaded in many instances, some quite heavily. Perhaps the most impressive aspect of the paintings is the artist's mastery of figural compositions.

A masterpiece of such groupings in the tomb of Prince Chang-huai shows three foreign envoys, a Korean among them, standing slightly bowed in respect while they presumably are greeted by three stately mandarins from the palace (Figure 4). These latter, perhaps in the way of high T'ang officials, pay the foreigners little attention and chat among themselves. The ethnic types of the envoys are faithfully portrayed and bring to mind that exotic people and tribute bearers from foreign lands were favored T'ang subjects.

By far the most elaborate paintings occur in the tomb of Prince I-te, who was posthumously raised to the rank of Crown Prince. Here there is little action of the kind shown in the hunt and polo game in the tomb of Prince

Chang-huai, but an enormous painting, some thirty feet long, showing the pomp and pageantry of the T'ang court occupies one wall. Inside the city wall the imperial guard is drawn up in a courtyard before a palace gate marked by four high *chüeh* towers. This huge composition is backed by a landscape of considerable complexity which, together with another landscape in the tomb murals, is discussed briefly below.

As a foil to all the martial display and to illustrate a more amiable aspect of court life, two panels in the inner chamber are each decorated with nine female attendants, a few dressed as young men, and the others in the high style of the early eighth century.

A wall painting similar to that in the rear chamber of Prince I-te's tomb but more carefully composed decorates a side wall in the antechamber of the tomb of Princess Yung-t'ai.[17] Two groups of ladies-in-waiting face one another, eight in one group and seven in the other, separated by a large red pillar. They carry such objects as a *ju-i* scepter, fans, and various bundles and boxes. Four are shown face-on, the rest in three-quarter view. The drawing is stereotyped, with precisely the same number of strokes being used for each face. The artist, nonetheless, has given just enough variety – an upturned nose, the glance of an eye, or the turn of a head – to avoid monotony, and the repetition of the facial types lends consistency to a monumental composition.

Another feature in T'ang figure painting is the minimal description of the setting. A slim tree or two, a rock, or a few birds create a garden. But objects such as a stool, an embroidery frame, or a gameboard do not necessarily suggest an interior. In many paintings, as here, there is no indication of setting at all. Without the aid of landscape or objects, the space occupied by figures must be defined by their placement within the picture frame. The composition in the Yung-t'ai tomb is constructed with this aim in view. The ladies stand in groups of either three, two, or four in modulated intervals; and their placement in foreground, middle distance, and background creates a perfectly plausible space relationship.

Among artists especially praised in early writings for their ability as figure painters were Chang Hsüan (act. 713-742) and the somewhat later artist, Chou Fang (act. 766–after 796). *Palace Ladies Playing Double-Sixes* was attributed to Chou Fang when it entered the collection of the Freer Gallery in Washington. That institution, on the basis of the brushwork and drapery folds, now attributes the scroll to an unknown artist of the tenth to eleventh century following a T'ang design.[18] For many of the same reasons, the Nelson Gallery believes *Palace Ladies Tuning the Lute and Drinking Tea* [6], also attributed to Chou Fang, may be a work of the late T'ang period or Five Dynasties, say ninth to tenth century. Nonetheless, both the Freer and the Nelson Gallery paintings adhere faithfully to T'ang compositions and figure style and retain the curious atmosphere of a timeless calm that pervades the best paintings of this kind carrying T'ang Dynasty attribution.

Since none of the paintings attributed to Chou Fang is signed and none of the attributions can be traced to a time earlier than the Sung Dynasty, it is apparent that this artist was much favored by post-T'ang collectors in making their attributions.

The best painting associated with Chang Hsüan is a superb copy by the Northern Sung emperor, Hui-tsung (r. 1100-25). Entitled *Ladies Preparing Newly Woven Silk*, the scroll, now in the Museum of Fine Arts, Boston,[19] betrays its later date by a certain elegance and refinement, especially notable in the brushwork; otherwise, it preserves the composition, figure types, textile patterns, and, very probably, the color of an important T'ang original.

It is practical only up to a point to compare small-scale paintings on silk with the very large wall paintings in the imperial tombs of the early eighth century. However, among recent finds by Chinese archaelogists working at Astana, Turfan, Hsinchiang, are a number of painted screen panels and the fragments of a handscroll on silk depicting the typical robust T'ang beauties with slimmer maids and two small boys. Because of the very arid climate of Hsinchiang, the remarkably brilliant colors of these paintings have retained their original intensity. The tomb where the scroll was found can be dated to the years before 744, roughly within the time of the court painter Chang Hsüan.[20] When these fragments are assembled and mounted, there will be at least one undoubtedly genuine T'ang painting on silk of palace beauties.

Figure painting involved many other subjects, often with moral overtones, such as loyal ministers, famous scholars, worthies of old, powerful rulers of the past, and foreign envoys who represented the exotic nations under T'ang rule. For almost all such subjects, the great seventh-century artist Yen Li-pen (d. 673) is favored in the attributions of post-T'ang collectors. Best known and probably the oldest painting bearing this attribution is the scroll of *Thirteen Emperors,* now in the Museum of Fine Arts, Boston.[21] The emperors and their attendants are shown against a plain ground without suggestion of setting. This same concentration on the essential subject is employed in the only painting of this kind in the exhibition, the *Eight Noble Officials* [5], attributed to Ch'en Hung. Both Chang Yen-yüan and Chu Ching-hsüan mention Ch'en Hung's special gift as a portrait painter, and it is evident here that the artist has skillfully differentiated between the ministers of Chinese stock and those of Tartar origins or affiliations.

T'ang Landscape Painting

Numerous references to landscape paintings of the seventh and eighth centuries appear in the literary works on painting mentioned earlier. Of particular interest are the accounts, often tantalizingly nebulous, of the developments in techniques that eventually made possible the masterpieces of landscape painting in the tenth and eleventh centuries. Kiyohiko Munakata, in "The Rise of Ink-Wash Landscape Painting in the T'ang Dynasty,"[22] has made a penetrating study of literary sources and has correlated the writings with such original materials available as the wall paintings and banners of Tunhuang and the eighth-century paintings and decorative material in the Shōsōin, Nara. Most recently, Michael Sullivan in his richly illustrated work, *Chinese Landscape Painting – Sui and T'ang Dynasties,* has expanded the theme and been able, advantageously, to include the new materials revealed by Chinese archaeologists.[23]

The majority of T'ang landscapes, painted on walls and screens, had color added to the ink drawing in either heavy pigments or light color washes. But at times the coloring was omitted, resulting in a composition of trees and rocks or of landscape in ink alone – a kind of painting called *pai-hua* by Chang Yen-yüan. The problem was how to make such a landscape, probably drawn in the linear style, more solid and convincingly natural. Inner markings could indicate cleavages and wear of irregular rocks or mountain shapes, but it was not until the inner markings and the outlines of the shapes could be bound together and blended by means of graded ink washes that real progress was possible. It is Munakata's conclusion that "the technique for using a gradation of tones for shading developed to a high level of sophistication during the eighth century."[24] In any event, it is certain that post-T'ang art historians credited Wang Wei (699-759) as the painter who firmly established the validity of landscape in ink alone, much as they judged Li Ssu-hsün and Li Chao-tao as the founding masters of the colored style.

Landscape plays a minor role in the murals of the imperial T'ang tombs, where it is used, in varying degrees, to

describe the setting. But what landscape is present can be dated definitely and, by the greatest good fortune, illustrates the two different styles in the two tombs where it is most prominent.

The sumptuous decorations of the tomb of Prince I-te include a large passage of landscape in the scene with towers occupying the west wall of the passageway.[25] It begins with low, rolling hillocks inside the city wall and continues outside the wall with higher formations in a wild jumble of fractured, faceted rocks piled up at various angles. A few have parallel lines along the edge, echoing the old slab-like shapes. All forms are bounded by strong, black lines of even thickness. Unlike the other tombs in the imperial necropolis, color has been added to the linear style of landscapes – a dark-to-light ocher and varying shades of malachite green, the latter color heaviest on the upper surface edge of the rocks. The color has been applied not with any idea of light and shade but to emphasize mass and the separation of shapes.

Of all the T'ang tomb murals, only those in the tomb of Prince I-te are signed by the artist. Some difficulties have been encountered in the proper reading and identification of the artist's name, but as deduced by Fontein and Wu,[26] apparently it was a certain Ch'ang Pien. This man is noted briefly by Chang Yen-yüan: "Ch'ang Pien excelled in [painting] landscapes, which resemble those of the General Li [Ssu-hsün]." If this identification is correct, it goes a long way toward fortifying the tradition that Li Ssu-hsün (651 – d. ca. 716/18) and his son Li Chao-tao (active at the time the tomb of I-te was decorated) were, in fact, among the T'ang masters who codified the linear blue-and-green manner.

A beautiful archaic landscape, *Traveling in the Spring-time*, attributed to Chan Tzu-ch'ien, a Sui Dynasty (581-618) artist, is in the Palace Museum, Peking.[27] The colors are a soft ocher, malachite green, cinnabar red for bits of architecture, and white for the clouds and tree blossoms. The scroll is a convincing, very early painting; but a date near the turn of the sixth century, only some seventy-five years after the *Sarcophagus of Filial Piety,* seems premature for so accomplished a work. A date near the latter part of the T'ang Dynasty seems more credible.

The fate of the linear, blue-and-green style can be traced only briefly here. Under such a leading master of Southern Sung as Chao Po-chü (act. ca. 1150), the style was handled with consummate mastery, especially if one can accept as his work *Autumn Colors on Streams and Mountains* in the Palace Museum, Peking.[28] In later centuries the style in its purest and early form inspired archaistic paintings of great beauty and emotional content. Examples of such revivals of an ancient style are the *Mind Landscape of Hsieh Yu-yü* by Chao Meng-fu (1254-1322) in Princeton and Ch'en Ju-yen's (act. ca. 1340-1370) *The Land of Immortals* [114] in Cleveland.

Somewhere along the line, azurite blue and touches of gold in outlines and texturing strokes were added to the more simple ocher, green, and white of the earliest style. In post-T'ang centuries this brilliant palette was useful in the ultimate direction taken by the blue-and-green style. It was employed in opulent scenes of palaces and pavilions in landscape of rather fantastic complexity [e.g., 14],

the dream landscapes of Taoist paradise scenes [e.g., 114, 142], or when the Ming artist, Ch'iu Ying, illustrated a T'ang Dynasty theme [see 164].

After the great masters of landscape painting, working mainly in ink alone, had made their appearance in the tenth and eleventh centuries, the blue-and-green style was no longer viable in the mainstream of Chinese painting. It was universally condemned by the literati for its superficial attractiveness and painstaking attention to detail. Unsuited to intense personal expression or truth to nature, and unrelated in any way to the art of calligraphy, the blue-and-green style was eventually relegated to the studios of professional craftsmen. By the seventeenth and eighteenth centuries, veritable factories were in operation at such centers as Suchou, producing brilliantly colored, decorative scrolls.

Turning back then, to the T'ang imperial tomb of Prince Chang-huai, decorated in 706, a landscape of a very different kind, where a polo game is in progress, is painted on the west wall of the entranceway (Figure 5).[29] The game is played on relatively level ground, the rolling terrain shown by long sloping lines. There are numerous outcroppings of rock, some done in the traditional linear style but others painted with a new freedom. As pressure is either applied or lifted from the pliant tip of the brush, the outlines become thin or thick for emphasis. Within the outlines, modelling or texturing is accomplished with washes and broad strokes varying in intensity from pale to almost black, the darkest shading often on top of the rocks and along the lines of cleavage. Some of these strokes are clearly precursors of the "large axe-stroke" texturing method (*ta-fu-p'i-ts'un*) in which the broad side of the brush is dragged down the rock surface, producing an effect of sharp cleavage. As in an earlier style, oval rocks are scattered about the bases of the outcroppings and the roots of trees. On the whole, this landscape introduces a lively, direct kind of brushwork and ink that Michael Sullivan rightly calls the "painterly style."

Landscape painting had come a long way from the "primitives" of the late fifth and early sixth centuries and had initiated conventions and techniques that made possible the great naturalistic landscapes of the tenth and eleventh centuries.

Landscape Painting:
Five Dynasties and Early Northern Sung

By the latter part of the ninth century, the long rule of the T'ang Dynasty was drawing to a close. Buddhism was no longer a factor of national importance, and as the power of the central government waned, so did the pomp and glory of the court. Palace ladies at their pastimes, fine saddle horses, and loyal ministers as subjects of painting had lost all appeal to creative artists. By the later decades of the tenth century, landscape had become the dominant theme.

In the evolution of landscape painting, Ching Hao (ca. 870/80 – ca. 935/40) played a leading role as a painter, theorist, and technical innovator. The essay attributed to him, *A Note on the Art of the Brush (Pi-fa-chi)*,[30] discusses both the painter's emotional and philosophical rela-

Figure 5. *Landscape.* Detail of wall painting, tomb of Prince Chang-huai. T'ang Dynasty, AD 706. (After *T'ang Li Hsien mu pi-hua*, Peking, 1974)

tionship to nature and detailed technical advice on how its wonders could be translated into terms of brush and ink. Ching Hao advocated a fluid brush, the tip now thinning, now thickening, now slow, now swift – in short, all the variety of strokes used in cursive calligraphic script. The all-important ink wash was employed to model the forms, uniting and blending the outline drawing and inner texturing. This texturing of surfaces may be his most important contribution, one that led to the rich variety of texturing strokes known as *ts'un-fa*.

Whether or not the painting *Travelers in Snow-Covered Mountains* [9] is by Ching Hao or another, it has all the aspects of an early tenth-century work. The composition is characteristic; a single dominating peak is supported by lesser mountains and there is an opening (which can be on either side) over a lake or river to a view of the distant horizon. The forms are extremely complex, outlined in strong calligraphic strokes. Surfaces are boldly textured, with a wide variety of strokes executed on top of the heavy application of lead white. In its present state, the violent contrast in tonal qualities which led Max Loehr to describe its "chaotic furor and harsh technique" is probably misleading. The white pigment has lost little of its original brilliance, whereas the silk ground has darkened

to the point where it matches the lighter ink washes – resulting in a far more powerful chiaroscuro than was the artist's intent.

As with the breakthrough in representational art that occurred between Western and Eastern Han, so after the opening decades of the tenth century, advances in landscape painting moved at an impressive pace. Development involved a simplification of over-complex forms and rather drastic limitation of the divers kinds of brushstrokes used in texturing in order to produce an overall sense of unity.

In *A Solitary Temple amid Clearing Peaks* [10], attributed to Li Ch'eng (919-967), the artist has achieved both simplification of form as well as technical unity. His aim is truth to nature and clarity of vision in a new kind of realism. A delicate, silvery atmosphere illuminates rather than conceals the deep valleys and gorges, blending the various elements into a single, continuous aspect of nature. Technical unity is achieved by the consistent use of innumerable small dabs of ink (a kind of texturing called "raindrop" *ts'un*) and a few delicate, long strokes to portray the steep verticality of the central massive and lesser peaks. Much as in *Travelers in Snow-Covered Mountains*, and actually in all tenth- and eleventh-century landscapes, the small human figures who go about their affairs, and the details of architecture are as much a part of the natural scene as are the rocks and trees and are

painted with the same clarity. It is not until the Southern Sung period that one will find the poet-scholar bemused as he gazes at a waterfall or into the void.

To the south, in the city of Nanking, the painter Tung Yüan (ca. 900-962) produced a different kind of landscape. Among his landscapes, those that attained the greatest fame, largely in the Yüan Dynasty, were subdued views of his native countryside – the low hills, marshlands, and lakes of Chiang-nan Province. These scrolls had no towering peaks or clarity of detail as did the landscapes of the north. The nature of Tung Yüan's unique contribution may be found in at least three handscrolls – one in the Shanghai Museum; one in the Palace Museum, Peking; and a third in the Liaoning Provincial Museum. Regardless of when the scrolls were painted and their relationship to one another (the subject of an informative monograph by Richard Barnhart),[31] all three scrolls, with variations in quality, present a certain unity of style. The brushwork is rather heavy, with a lavish use of wet ink; little drawing is involved; and the horizontal compositions are assembled in simple rhythms. Tung Yüan had no followers in the Sung Dynasty, and it was not until the late thirteenth and fourteenth centuries of the Yüan Dynasty that his style was "rediscovered" and found to be adaptable to the intensely personal styles of the literati.

Chü-jan (act. ca. 960-985) a monk-painter at the Nanking court of Southern T'ang, was Tung Yüan's only immediate follower. At the fall of his native state, Chü-jan migrated to Pien-liang (K'aifeng), the capital of Northern Sung. A small group of hanging scrolls attributed to him present a unified style and some technical devices possibly derived from Tung Yüan. *Mountains and Woods* and *Hsiao I Seizing the Lan-t'ing Manuscript,* both in the National Palace Museum, Taipei,[32] together with *Buddhist Retreat by Streams and Mountains* [11] in the Cleveland Museum, seem related in theme and style. Instead of the low rolling hills and long, horizontal marshlands of the Tung Yüan scrolls, the central theme in all three of these pictures is a dominant peak with smaller, supporting mountains, all with flattened or softly rounded tops. These caps and their approaches are covered with a multitude of rounded boulders of a kind called "alum heads" that have become a hallmark of the Chü-jan style. In both *Mountain Woods* and *Buddhist Retreat,* extensive areas of mist create a rhythmic pattern of delicately shaded tones playing throughout. The vegetation surrounding the "alum head" boulders is painted with closely packed dots, possibly derived from Tung Yüan, as are the long, vertical strokes that so successfully model the sides of mountains and cliffs.

The style of Chü-jan, as exemplified in the three scrolls mentioned above, became a lasting influence in landscape painting, with such characteristic elements as the piled-up boulders on mountain slopes and summits becoming a mannerism perfectly exemplified in the twelfth-century handscroll by Chiang Shen [see 23].

The greatest signed masterwork of the early Northern Sung Dynasty is *Traveling among Mountains and Streams* by Fan K'uan (ca. 1030), now in the National Palace Museum, Taipei.[33] Simplification has been carried to the point where a single towering, granite cliff entirely dominates the composition. The furrowing and clefts of the peak are so reduced that the sheer bulk is almost overpowering. Huge boulders, supporting a close-packed mass of gnarled trees, and scattered rocks fill the foreground; all are silhouetted against the mist drifting through the valley at the base of the peak. At the extreme right are the travelers, two drivers, and four loaded donkeys, almost miniature in scale, who make their way toward a stream.

Among the greatest landscape painters of the eleventh century who developed a style quite different from that of any of his peers was Hsü Tao-ning (ca. 970-1051/52). Hsü profoundly admired the landscapes of Li Ch'eng, and the latter's influence may account for the twisted trees with their "dragon-claw" roots in what is probably an early work, *Desolate Temple amid Autumn Mountains*, in the Fujii Yurinkan, Kyoto. Later in his long career, Hsü Tao-ning evolved a unique style characterized by loose, rapid drawing and wet ink washes of the most subtle tonal values. It is a style demanding the highest level of technical virtuosity, allowing the painter's concept to flow from the tip of his brush without an instant of hesitation. Armed with complete technical perfection, Hsü could let flow from his brush the scroll of *Fishermen* [12], with its majestic rhythms, bleak mountain masses, and deep, moist valleys penetrating far into the distance. The style of Hsü Tao-ning had no following among later artists for the simple reason that a painting like *Fishermen* "could only come from a lifetime of devotion to the perfection of an intuitive manner beyond duplication."

Around the middle of the eleventh century, new concepts shifted away from the quest for naturalism in landscape that had been the aim of Ching Hao, Li Ch'eng, Hsü Tao-ning, and Fan K'uan. The impressive and important scroll *Early Spring,* signed by Kuo Hsi and dated to 1072, in the National Palace Museum, Taipei,[34] epitomizes the new direction in landscape. The Kuo Hsi style is admirably described by Max Loehr: "Everything is seized by a restless upsurge, and the solids are treated as though they were in a state of flux or about to take shape. There are no straight lines but only curves, and the light-and-dark areas intensify their unstatic character by their scattered and flickering appearance."[35] Nor is it always possible to judge where forms begin or end, and the strong tonal contrasts lead to ambiguities in spatial relationships.

After Kuo Hsi, Chinese painting in the late eleventh and early twelfth centuries entered a new and different epoch, with ever more consideration given to the self-expression of the artist's own personality. Concepts of man's relationship to nature may have changed and the works of the earlier masters may have become old-fashioned, but they were never forgotten. Later, especially in the Yüan Dynasty, the styles of the earlier painters became codified, so that an artist would be said to work in the Li Ch'eng–Kuo Hsi (Li–Kuo) style or the Tung Yüan and Chü-jan (Tung–Chü) style. But the great epoch of realism and the artist's identity with the natural world was never revitalized, and Chinese painters went on to different and equally valid styles and techniques.

1. Wen Fong, ed., *The Great Bronze Age of China*, exh. cat. (New York: Metropolitan Museum of Art, 1980), p. 309.

2. Martin Joseph Powers, "The Shapes of Power in Han Pictorial Art" (Ph.D. diss., University of Chicago, 1978). A detailed study of the cosmology, philosophy, and political theories affecting the subject matter and style of Han representational art.

3. Powers, dissertation proposal, p. 6.

4. For the subject matter of the Ma-wang-tui banner see: Fong Chow, "Ma-wang-tui, a Treasure Trove from the Western Han Dynasty," *Artibus Asiae* xxxv (1973), 2-24; see also A. Gutkind Bulling, "The Guide of the Soul's Picture in the Western Han Tomb in Ma-wang-tui near Ch'angsha," *Oriental Art* xx (1974), 158-73.

5. Jan Fontein and Wu Tung, *Han and T'ang Murals*, exh. cat. (Boston: Museum of Fine Arts, 1976).

6. Archaeological Team of Inner Mongolia and Museum of the Inner Mongolia Autonomous Region, "Ho-lin-k'o-erh fa-hsien i tso chung-yao te Tung Han pi-hua mu" [An important Eastern Han tomb with wall paintings found at Ho-lin-k'o-erh, Inner Mongolia], *Wen wu* (1974), no. 1, p. 16, fig. 8.

7. Margaret Medley, "Certain Technical Aspects of Chinese Landscape Painting," *Oriental Art* v (1959), 20-28.

8. Wilma Fairbank, "The Offering Shrines of Wu-liang-tz'u," *Harvard Journal of Asiatic Studies* vi (1941), 1-35.

9. *Liao-ning-sheng po-wu-kuan ts'ang-hua chi* [A collection of paintings in Liaoning Provincial Museum] (Peking: Wen wu Press, 1962), pls. 1-12.

10. Osvald Sirén, *Chinese Painting: Leading Masters and Principles*, 7 vols. (New York: Ronald Press, 1956-58), iii, pls. 9A, B.

11. Thomas Lawton, *Chinese Figure Painting*, exh. cat. (Washington: Freer Gallery of Art, 1973), no. 1, pp. 18-29.

12. *Teng-hsien ts'ai-se hua-hsiang chuan-mu* [Painted figure tiles from the brick tomb at Teng-hsien] (Peking: Wen wu Press, 1958), pl. 31; see also Terukazu Akiyama et al., *Arts of China*, vol. i, *Recent Discoveries* (Tokyo: Kodansha International, 1968), 121, fig. 215.

13. William R.B. Acker, *Some T'ang and Pre-T'ang Texts On Chinese Painting*, i (Leiden: E.J. Brill, 1954).

14. Alexander C. Soper, "T'ang Ch'ao Ming Hua Lu, Celebrated Painters of the T'ang Dynasty by Chu Ching-hsüan of T'ang," *Artibus Asiae* xxi (1958), 204-30.

15. Soper, *Kuo Jo-hsü's Experiences in Painting (T'u-hua chien-wen chih): An Eleventh-Century History of Chinese Painting*, American Council of Learned Societies, Studies in Chinese and Related Civilizations, no. 6 (Washington, D.C., 1951).

16. See the following: Fontein and Wu, *Han and T'ang*; *Han-T'ang pi-hua* [Murals from the Han to the T'ang Dynasty] (Peking: Foreign Language Press, 1974); *T'ang Li Chung-jun mu pi-hua* [Murals in the tomb of Li Chung-jun of the T'ang Dynasty] (Peking: Wen wu Press, 1974); *T'ang Li Hsien mu pi-hua* [Murals in the tomb of Li Hsien of the T'ang Dynasty] (Peking: Wen wu Press, 1974; *T'ang Yung-t'ai kung-chu mu pi-hua-chi* [Wall paintings from the tomb of Princess Yung-t'ai of the T'ang Dynasty] (Peking: Jen-min mei-shu Press, 1963); Mary H. Fong, "Four Chinese Royal Tombs of the Early Eighth Century," *Artibus Asiae* xxxv (1973), 307-34.

17. Fontein and Wu, *Han and T'ang*, p. 19, p. 123; see also *T'ang Yung-t'ai*, pl. 1.

18. Lawton, *Figure Painting*, no. 51, pp. 201-2.

19. Sirén, *Masters and Principles*, iii, pls. 105-6; discussed in Jan Fontein and Wu Tung, *Unearthing China's Past*, exh. cat. (Boston: Museum of Fine Arts, 1973), no. 119, pp. 225-58.

20. Chin Wei-no and Wei Pien, "T'ang-tai Hsi-chou mu chung te chüan-hua" [The T'ang silk paintings unearthed from the tombs at Astana, Turfan, Hsinchiang], *Wen wu* (1975), no. 10, pp. 36-43 and pls. 1-4; see also *Hsin-chiang ch'u-t'u wen wu, Cultural Relics Unearthed in Sinkiang* (Peking: Wen wu Press, 1975), pls. 112-13.

21. Sirén, *Masters and Principles*, iii, pls. 72-75.

22. Kiyohiko Munakata, "The Rise of Ink-Wash Landscape Painting, in the T'ang Dynasty" (Ph.D. diss., Princeton University, 1965; Ann Arbor, Mich., University Microfilms).

23. Michael Sullivan, *Chinese Landscape Painting*, vol. ii, *The Sui and T'ang Dynasties* (Berkeley: University of California Press, 1980).

24. Munakata, "Ink-Wash Landscape Painting," p. 97.

25. Fontein and Wu, *Han and T'ang*, pls. 128-30; Sullivan, *Sui and T'ang*, pls. 34-36.

26. Fontein and Wu, *Han and T'ang*, pp. 105-6.

27. Sirén, *Masters and Principles*, iii, pls. 79, 80.

28. Ibid., pl. 271.

29. Fontein and Wu, *Han and T'ang*, pls. 123-25; Sullivan, *Sui and T'ang*, pls. 46-49; *T'ang Li Hsien*, pls. 19, 21-22.

30. Kiyohiko Munakata, *Ching Hao's "Pi-fa-chi": A Note on the Art of the Brush* (Ascona: Artibus Asiae, 1974).

31. Richard Barnhart, *"Marriage of the Lord of the River": A Lost Landscape by Tung Yüan* (Ascona: Artibus Asiae, 1970).

32. Max Loehr, *The Great Painters of China* (Oxford: Phaidon Press, 1980), figs. 64, 65.

33. Sirén, *Masters and Principles*, iii, pl. 154.

34. Ibid., pl. 175.

35. Laurence Sickman, ed., *Chinese Calligraphy and Painting in the Collection of John M. Crawford, Jr.*, exh. cat. (New York: Pierpont Morgan Library, 1962), p. 34.

Aspects of Chinese Painting from 1100 to 1350

Wai-kam Ho

The Sung Academy of Painting

From the very beginning of the dynasty, the development of Sung painting had been largely inseparable from the development of the Sung "Academy." The Sung Academy was founded on the basis of similar Bureaus of Painting of the Five Dynasties, especially those of the Former Shu (907-925), Later Shu (934-965), and Southern T'ang (937-975). The Sung court took over most of the royal collections of these conquered states and summoned their court painters to the capital, Pienching (K'aifeng, Honan). Pienching in the late tenth century not only was the political center of a new imperial order which had just reunited China after half a century of social disorder and cultural division but also was the undisputed center of art where painters representing different regional traditions came to compete with and learn from each other under the benign supervision of the early administration of the Sung. Thus, from Ch'engtu in Ssuch'uan came Huang Chü-tsai, Kao Wen-chin, and many others; from the Chiang-nan area (Nanking, Chiangsu) came the monk Chü-jan [see 11] and Tung Yü, whose works very quickly adorned the Jade Hall of the Hanlin Academy. Even eccentrics such as Shih K'o were welcomed to this "forest of brushes" (*Han-lin*). New talents were continuously discovered and recruited from all walks of life: coppersmiths like Ts'ai Jun, carpenters like T'ao I, or house painters like Chao Yüan-ch'ang. There was no other period in Chinese history in which court patronage played such a vigorous and vital role in the recruitment and training of artists, and in the arbitration of taste in art. What is more, the influence of the court was not confined within the "Academy," for many of the non-Academic painters were either employed by the court (Mi Fu) or were closely affiliated with it (Wang Shen, Chao Ta-nien, Chao Po-chü).

But artistic predominance sustained by temporal authorities without a solid social and moral base was usually too thinly covered to prevent the exposure of its own innate weaknesses. The inclination to dogmatism, the tendency towards institutionalization, the encouragement of over-specialization, and the temptation to be isolated and wrapped up in a theoretical cocoon of an intoxicated state of narcissism – these were some of the negative aspects of the Academy which were bound to arouse outside reactions. It was against some of these excesses as well as omissions of the Academy, reinforced by a deeply rooted social and cultural pride of the intellectual class that one must view the emergence of "scholar-official painting" (*shih-ta-fu hua*) in the second half of the eleventh century. One cannot help but be convinced that the rise of scholar-official painting was directly caused, stimulated, and conditioned by the conspicuous presence of the Academy. It was an inevitable antithesis in such a dialectical historical development. In other words, without the Academy, the development of scholar-official painting may possibly have taken a different course, or have been delayed until a more urgent or logical moment (such as the Mongol invasion?). Hence, a brief outline of the Academy is essential to any discussion of Sung painting.

First, however, we must clarify the problem of terminology. The European-inspired term "Academy" grossly underrates the vitality and innovation of the Sung court painters; on the other hand, its association with the *haute bourgeoisie* is a far cry from Sung social reality. Its usage in connection with Sung painting has been ambiguous, if not misleading. First, it has confused the *Han-lin T'u-hua yüan* (The Hanlin Bureau of Painting) with the *Han-lin Hsüeh-shih yüan* (The Hanlin Bureau of Academicians). The Hanlin Academicians were grade-3 officials in the government hierarchy. They represented the cream of the intellectual elites known as *ch'ing-hua chih-hsüan* (the selected few of the pure and splendid), who were chosen to be prepared for the highest civil positions in the empire. The Hanlin painters, on the other hand, were *petit* functionaries in the palace service who usually carried no official rank and were known as *liu-wai* (outside the system of civil service). Their promotions or transfers were stringently regulated, and under normal conditions the highest position they might hope to attain was grade 9, provided they had been awarded the title of *ch'eng-chung-lang*. Secondly, when the term "Academy" was applied during a period of six years (1104-1110) under Emperor Hui-tsung, it could mean either of two things – the Bureau of Painting (*Hua-yüan*) or the Institute of Painting (*Hua-hsüeh*). These were two separate organs that were often confused and misunderstood by later historians. Generally speaking, perhaps "court painting" more accurately describes this officially sponsored art produced in the Sung period. But since the term "Academy" does encompass both the bureaucratic and the educational aspects of the institution under Emperor Hui-tsung, perhaps it should be retained, if only for purposes of convenience.

We have already noted that the Academy in early Sung had been a melting pot for various regional traditions which were brought together in K'aifeng to provide an

enormously rich and divergent background for the creation of what may be called the Sung tradition of painting. The tendency toward specialization is a natural instinct, if also a necessary evil, to assure technical proficiency and professional monopoly; and it was, from the start, a characteristic of the Academy. In the beginning of Sung, paintings were usually classified into six categories, which were then expanded or refined to ten in the compilation of the *Hsüan-ho* catalogue, and finally to thirteen during the thirteenth and fourteenth centuries. Chao Sheng, writing in 1234 during the Southern Sung reign of Li-tsung, mentioned "the thirteen diciplines [of specialization] spoken of by contemporary painters." As an example he gave "the branches of the Hanlin Bureau, such as the Sheng-chiht'ang [Hall] established in the Te-shou-kung [Palace] with painters like Li Tsung-shun." This statement seems to imply that the special branch of the Painting Bureau set up to serve the art-loving retired emperor, Kao-tsung, was fully staffed by painters specializing in all thirteen areas.

According to T'ao Tsung-i, these thirteen categories were: 1) Buddha and bodhisattvas; 2) Taoist portraits of the Jade Emperors and other celestial kings; 3) rajapani, deities, demons, arhats, and holy priests; 4) the dragon and tiger; 5) historical figures; 6) landscape in full compositions; 7) flowers, bamboo, and birds; 8) wild donkeys and other animals; 9) human activities; 10) boundary painting; 11) all forms of lower existence; 12) agriculture and sericulture; 13) decorative paintings in blue-and-green. Usually, painters of the Bureau were known for one or two specialities. However, there were a few all-round masters. Sun Shang-tze from P'ing-yang (Shanhsi), for instance, was famous in the Chin Dynasty for his mastery of all thirteen subjects.

The main traditions of the Sung Academy of course were represented by the three major subject areas – figures (including Buddhist and Taoist), flower-and-bird, and landscape. The shift of dominating positions among these areas not only reflected the change of interest in different periods but also showed the ebb and flow of influences of the regional schools.

The accompanying tables – I through V, based primarily on the *T'u-hua chien-wen chih* and *Hua chi* with supplementary data derived from other sources – are designed to show the general trends of development (and their historical and geographical backgrounds) of the Sung Academy from the beginning of the dynasty to the early reigns of Southern Sung, as seen through the geographical origins of the artists active in the Bureau of Painting. For the period between 1074-1167, two separate tables are provided to compare the developments within the Academy and the rise of the scholar-official painters.

From a study of these tables, telling patterns emerge and come into focus. Some of the hitherto unsuspected findings are of compelling art-historical interest. Among the most significant are: 1) the absolute predominance from late T'ang through early Sung of Buddhist, Taoist, and other figure painting over all other subjects, and 2) the overwhelming majority of the Ssuch'uan painters originally from the courts of Shu. By the third quarter of the eleventh century, however, this situation was completely reversed by the rapid ascendance of landscape painting, with the painters from Chung-chou (i.e., Honan and its

I Late T'ang (842-907)

	Figures	Flower-and-bird	Landscape	Total
Shu (Ssuch'uan)	21		1	22
Chiang-nan (Yangtze Valley)	1			1
Hua-pei (N. China)	1	1	1	3
Other areas	1			1
Total	24	1	2	

neighboring provinces) having replaced the Ssuch'uanese as the majority either inside or outside the Academy. On the other hand, while religious subjects were in decline, flower-and-bird paintings held their places throughout this period and commanded a continuous popularity, undoubtedly sustained first by the authoritative guidance of Huang Chü-ts'ai and later by the powerful patronage of Emperor Hui-tsung.

Another revelation is the surprisingly large number of southern artists who resettled in K'aifeng during the early part of the dynasty and provided the only challenge to the supremacy of the Shu school of flower-and-bird painting. In religious and figure painting, the rivalry was between the Ssuch'uan group, with Kao Wen-chin as its leader, and the Honan, Hopei, and Shanhsi artists centered around such masters as Kao I, Wu Tsung-yüan, and the father-and-son team of Wang Jen-shou and Wang Shih-yüan. In the area of landscape painting, however, no such rivalry seems to have been recorded. This was no doubt due to the undisputed leadership of the Li Ch'eng school. At the beginning of the Northern Sung, Li Ch'eng, Kuan T'ung, and Fan K'uan were still considered equals – "like three legs of a tripod." By the time of the Hsi-ning period (1068-1077), however, the primacy of the Li Ch'eng school had already been firmly established – partly because of its receptive and synthetic capacity which exerted a unifying influence over regional and individual diversities, and partly because of the continuous strengthening and expansion of its tradition by great masters such as Yen Wen-kuei, Hsü Tao-ning, and Kuo Hsi. The Li Ch'eng school also enjoyed enthusiastic support from Emperor Shen-tsung and his court.

The Sung Academy was officially founded in 984 when new quarters for the Hanlin Bureau of Painting were established near the east gate inside the palace. In 998 it was moved to another site outside the imperial city. In that same year, the organization of the Bureau of Painting was also formalized. Its regular professional staff was made up of three *tai-chao* (painters-in-attendance), six *i-hsüeh* (painters-in-apprentice), four *chih-hou* (attendants), and forty *hsüeh-sheng* (students). Different ranks of the court painters were distinguished by the colors of their official gowns, which were strictly regulated according to a

II Five Dynasties (907-960)

	Figures	Flower-and-bird	Landscape	Bamboo	Total
Shu	25	4	4		33
Chiang-nan	7	6	3	1	17
Hua-pei	16	4	2	2	24
Other areas	13	5			18
Total	61	19	9	3	

III Early Northern Sung (960-1074)

	Figures	Flower-and-bird	Landscape	Miscellaneous (architecture, animals, etc.)	Ink, bamboo, and plum	Total
Shu	15	10		2	1	28
Chiang-nan	13	15	4	14		46
Hua-pei	30	16	29	8		83
Other areas	1	1	1	8		11
Total	59	42	34	32	1	

IV Late Northern Sung to Early Southern Sung (1074-1167)
Professional painters in the *Hua-yüan*

	Figures	Flower-and-bird	Landscape	Miscellaneous	Bamboo and plum	Total
Shu	4	5	1			10
Chiang-nan	3	2	4			9
Hua-pei	10	14	23			47
Other areas	1	1	2			4
Total	18	22	30			

V Late Northern Sung to Early Southern Sung (1074-1167)
Non-professional painters including scholar-officials, royalty, Buddhist and Taoist monks

	Figures	Flower and-bird	Landscape	Miscellaneous	Bamboo and Plum	Total
Shu	9		10	1	7	27
Chiang-nan	4	5	9	1	3	22
Hua-pei	3	5	20	5	3	36
Other areas	2	2	4	2	2	12
Total	18	12	43	9	15	

system of seniority. For example, it would take fifteen years for a *chih-hou* to be eligible for the rank of *ch'eng-hsin-lang*; ten years for an *i-hsüeh* to be eligible for the rank of *pao-i-lang*; and five years for a *tai-chao* to be eligible for the rank of *ch'eng-chung-lang*. And there were three grades of *tai-chao*: painters-in-attendance who received special permission to dress in purple (this being the most senior), followed by those dressed in crimson, and then those in green. Originally, the Bureau of Painting was under the jurisdiction of the Han-lin-ssu, an office in charge of wide varieties of palace workshops, including the Imperial Kitchen and Imperial Wardrobe. It was considered a kind of private service attending to the personal needs and pleasures of the emperors. In 1095 the name *T'u-hua-yüan* was changed to *T'u-hua-chü*; and along with three other bureaus (astronomy, medicine, and calligraphy), it was placed under the direct supervision of one of the deputy chiefs of the Directorate of Inner Palace Services. The Directorate sometimes played an extremely vital role in steering the general direction or policy of court art. Sung Yung-ch'en, for instance, a confidante of Emperor Shen-tsung and a respectable connoisseur in his own right, was probably instrumental in converting the court into a fan club of Li Ch'eng and his school.

In the early years of Sung, under the reigns of T'ai-tsu and T'ai-tsung, painters who worked in the court enjoyed considerably greater liberty and respect in regard to their promotions or transfers into the regular system of civil service. Then, as a measure against frequent abuses, stringent rules were set up to regulate these matters. A series of imperial orders issued by Emperor Jen-tsung forbade any such transfers. According to a decree of 1056, the true reasons behind these regulations seemed to be twofold: to prevent the mixing of the technocrats (*chi-shu-tsa-liu*) with officials of scholarly background (*shih-liu*), and to assure the transmission of specific skills within those families, "so that their arts can be handed down and specialized for the generations to come." This government policy provides an explanation for the emergence of so many artist-families (Huang Chü-ts'ai, Kao Wen-chin, Ma Yüan, Hsia Kuei, and others) whose members often served a succession of emperors – a phenomenon closely paralleled by the tradition of provincial or folk artisans.

As the urban culture of the Sung Dynasty reached its culmination in K'aifeng at the turn of the twelfth century, painting also enjoyed an unprecedented popularity. At the time when the palace could boast a collection of 6,396 paintings (around 1126), restaurants in the city also advertised and competed with each other by displaying old masters in a fashion comparable to painting galleries. The height of this vogue not only witnessed a certain vulgarization of the art (for example, the widespread practice of using paintings as gifts for bribery), but was a premonition of spent momentum in the development of Northern Sung painting, especially in the area of religious subjects.

A turning point in the history of the Academy came in the summer of 1104 when two separate institutes, *Hua-hsüeh* (Institute of Painting) and *Shu-hsüeh* (Institute of Calligraphy) were proposed by the State Council and were established by imperial order. This was the first and only time in Chinese history when government schools were especially set up for art education under state (*not* palace) auspices. Its significance cannot be overstated. According to Sung tradition, the immediate cause for this unusual move was the emperor's disappointment in the somewhat decadent state of the pictorial art. It was said that at the completion of the Wu-yao Kuan (Temple of the Five Sacred Mountains), several hundred painters were summoned to the capital to work on its wall paintings; the sad results forced the realization of the importance of formal training. Actually, the idea for the two institutes can be traced back to the first educational reform initiated by Wang An-shih in 1071. Under Emperor Hui-tsung and his chief counselor, Tsai Ching, the earlier program was greatly expanded and codified into a law known as *San-she fa* (the three-campus system). The institutes of painting and calligraphy were only parts of this grand design for the unification and systemization of public education and government recruitment. It was, indeed, part of the obsessive attempt by Emperor Hui-tsung to establish a homogeneous Sung culture according to his own vision – a vision reflected in his ambitious plan to standardize religion, classical studies, music, fine and decorative arts, and many other areas in the upper structure of ideology.

In brief, this important development can be seen in chronological order as follows:

1104

The time-honored examination system was abolished. For a period of seventeen years (1104-1121), government officials were recruited exclusively through state-supported education, and the disciplines for painting became an integral part of this system.

1106

The four independent institutes (painting, calligraphy, mathematics, and medicine) in the capital were abolished. The Institutes of Painting and Calligraphy were incorporated into the national university under the direct supervision of the Directorate of Education. Regulations for the Institute of Painting (*Ch'ung-ning Kuo-tzu-chien Hua-hsüeh Le-ning-ke-shih*) were published.

1107

Admissions to the Institute of Painting were limited to thirty students (but expanded later to forty), whose room and board was provided by the government. Entrance examinations were designed to test the students' literary facilities, knowledge of Confucian classics, and accomplishments in their chosen fields of painting.

1110

The institutes were finally separated from the national university and became part of the Bureau of Painting in the Imperial Palace. Students selected their majors corresponding to the six official categories of paintings. They were grouped in three classes – ten each in the upper and middle classes, twenty in the lower class. The program was constructed on the basis of a general classical education. Disciplines in philology, particularly etymology, were stressed as prerequisites for the mastery of "seal scripts" and accuracy in "developmental iconography." Students' achievements were partly evaluated by their abilities to relate their interpretations of classical literature

to "the idea of a picture." For instance, periodical examinations comprised of questions such as:

"In the butterfly's dream, home is far away in
thousands of miles,
Over the azalea branches the moon is rising to the third
watch of the night."

The pictorial interpretation of these lines was measured by the following specific criteria established by the Hsüan-ho Academy:

"Highest grade: the animated appearance and the emotional state of the subject is perfectly represented with simple brushwork and fully developed ideas without imitating any ancient masters. At the same time, forms and colors are rendered naturally and endowed with lofty concepts and archaic flavors.

"Middle grade: The seeming imitation of old masters is amplified and transcended by a heightened sense of antiquity. Forms and colors of the subject are simulated with fidelity and propriety with elegant colors and a cleverly conceived design.

"Lower grade: The ability to make imitations or copies that are close approximations to the true character of the original."

One of the main concerns constantly emphasized by the Sung Academy was the ingenious and proper treatment of the *hua-i*, or idea of a picture. The sought-after objective was not so much the reality of life but the poetry of life. The demand for such a brilliantly rendered illusion of the subject was not only for purely visual enchantment or persuasiveness but also the realization of the idea behind it that made the imageries "picture-like." In other words, a picture was evaluated not merely by its quality of "form-likeness," which is basic, but more importantly by its quality of "picture-likeness," which was on a supposedly higher level – on a par with literature.

This problem of the interrelationship between *hua-i* and *shih-i* ("the idea of a poem") went back much earlier in Chinese history and was a frequent topic for elucidation among Sung scholars. It was, however, only under the Sung Academy that their evocation was accompanied by a peculiar bent of the critical consciousness as well as an empirical program of training and testing which received the stamp of official sanction and imperial blessing.

Ke-fa – regulation and standardization – was the burning issue; in a way it was the outgrowth of the fumbling political reform of the Ch'ung-ning–Hsüan-ho period (1102-1125). But another issue of far-reaching implications was the unimproved low social status of the court painters. It is true that under Emperor Hui-tsung the painters were treated with much greater respect and granted more privileges than other "artisans" in the court, such as sculptors, musicians, or even astronomers. But as long as a painter was continuously regarded as a mere "technician," shut out from the mainstream of bureaucratic advancement, the improvements would remain superficial. This became even more obvious and humiliating when social segregation was an official policy enforced within the Academy, where students of different family background – the scholar family and the non-scholar family – were given separate entrance examinations and course assignments and were housed in separate dormi-

tories. There is no doubt that among the many factors behind the rise of the scholar-offical painting in the late eleventh century, the one powerful impetus not to be neglected was the ardent desire of the scholar-artists to liberate and raise the art of painting from the stigma of a "minor trade skill" by remodelling it (with an entirely new philosophic and aesthetic outlook) into a noble undertaking (*sheng-yeh*), respectable enough for the self-enjoyment and self-realization of the intellectuals.

If Northern Sung art was greatly enriched and revitalized by the tension between scholar-official painting and court painting, then the Academy of the succeeding Chin Dynasty in the north was a model of reconciliation which succeeded to a considerable degree in harmonizing this contradiction. The early history of the Chin "Academy" is not clear, although references to individual court painters in Chin and Yüan literature definitely suggest its existence. In the middle of the twelfth century, two official organs directly involved in the production and conservation of paintings are recorded in the dynastic history: *Shu-hua chü* (Bureau of Calligraphy and Painting), under the Directorate of the Imperial Archive; and *T'u-hua ch'u* (Department of Painting), under the Directorate of Construction and Manufacture. The former was a government bureau supervising state projects of painting and calligraphy. The latter seemed to be responsible for decorative paintings produced for the palace, and in 1196 it was reorganized and became part of the Commission of Palace Services. In addition, there were keepers of calligraphy and painting who were conservators of the imperial collection.

I have pointed out elsewhere that the continuous development of the *shih-ta-fu hua* from the mid-twelfth to early thirteenth centuries was carried on not in the south by Southern Sung artists (except in isolated pockets such as Chenchiang and Wuhsing) but in the north by the Chin artists. In this crucial chapter of scholarly painting, the contribution of the Chin Academy has never been recognized. This is especially regrettable in view of the fact that without this important link provided by the Chin Academy and the circle of art critics associated with it, the eventual convergence of the Li – Kuo and Tung – Chü traditions in the Yüan period would be difficult to explain. Perhaps due to the nomadic background of the Chin society and its traditional respect for crafts and craftsmen, the social demarcation between professionals and non-professionals, scholars and non-scholars was never clear-cut or rigid. This provided a social climate in which the coexistence and cooperation of the court painters and the scholar-official painters was not only tolerated but indeed encouraged. From the early years of the dynasty, the Chin Academy had been known for its efforts to attract the services of the scholar-artists. Two of the "Four Late Chin Masters" were directly affiliated with the Bureau of Calligraphy and Painting – Yang Pang-chi (*t.* Te-mou, an 1139 graduate of the *chin-shih* degree and the leading follower of Li Ch'eng) was Director of the Imperial Archive, and Wang T'ing-yün (*t.* Tzu-tuan, 1151-1202, perhaps the most admired painter-calligrapher in the Chin period and also a Hanlin Academician and the principal advocate of literati art in the Su Shih – Mi Fu tradition of Northern Sung) served as a chief supervisor

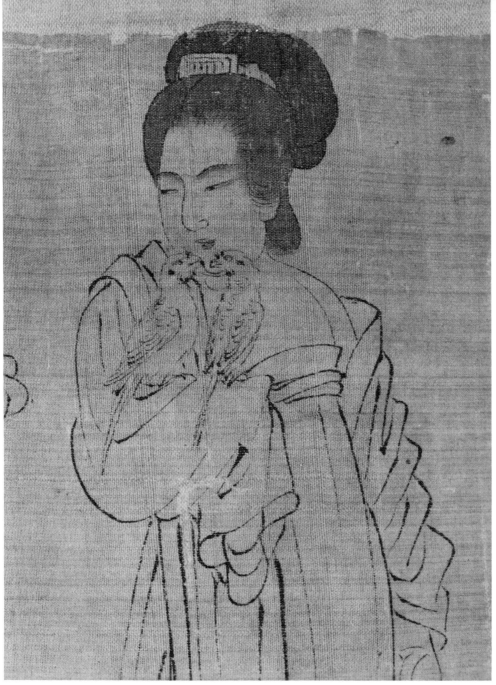

Figure 1. Detail of [16].

during the Ming-ch'ang era (1190-1195). At about the same time, the Director of the Bureau was Wu Yüan-chih, who, despite being a court painter, was a close friend of many of the leading scholars. Even a lesser-known member of the Painting Bureau such as Ch'ang Kuei (artist of the handscroll *Sacred Tortoise* in the Palace Museum, Peking, and who has never been known as an intellectual) was a graduate of the *chin-shih* degree in 1224, specializing in classical studies. This would have been unthinkable in the Sung Academy.

One of the ideals among the art theories of Sung literati was the combination of the "Three Excellences" – poetry, calligraphy, and painting. While Su Shih, the great founder of this school of thought, was generally recognized as the paragon of this ideal, most practicing artists deemed such a goal remote and unattainable. But all four of the late Chin masters were well known for their accomplishments in the "Three Excellences."

Another aspect of the late Northern Sung movement of literati painting was the attempted revival of the Tung

Yüan – Chü-jan tradition as a challenge to the overriding authority of the Li – Kuo school. This could not have been accomplished in the Yüan period were it not for the critical farsightedness and aggressive connoisseurship developed by a group of scholars, collectors, and painters in the southern Chin capital at K'aifeng, under the leadership of Yüan Hao-wen (1190-1257) and his literary associates in the court. Certainly, as compared to its counterpart in Sourthern Sung, the Chin Academy seems to have shown a greater sensibility in responding to this important historical controversy, as witnessed by the surprising number of Tung – Chü paintings in the imperial collection.

During the fourteenth century, the Bureau of Painting was discontinued under the Mongols. The confrontation between the "Academic" and the "non-Academic" now became the problem of the "professional" versus the "non-professional," and with this clear confrontation a new age of literati painting was in sight.

The Ssuch'uan Tradition of Figure Painting

The evolution of Chinese religious and figure paintings from the tenth to the early thirteenth centuries may be considered in two phases marked by the prevalence of different formats. The earlier phase in the Five Dynasties and Northern Sung was represented by large compositions in wall paintings, with main centers in Ch'engtu, Ssuch'uan; Pienching (K'aifeng), Honan; and Chinling (Nanking), Chiangsu. In the later phase of Chin and Southern Sung, smaller compositions in scroll form were produced in greater numbers; although in the north, wall paintings of monumental scale still continued to be in vogue and production. The centers of this phase were in P'ing-yang and Ho-chung (both Shanhsi); Hangchou, Ningpo, and to a lesser degree, Wuhsing (all in Chechiang).

The figure paintings in the Southern T'ang court at Chinling were illuminated by the names of Chou Wen-chü [see 16], Ts'ao Chung-yüan, Wang Ch'i-han, and Ku Hung-chung. Ts'ao Chung-yüan, for instance, was singled out in the *Hsüan-ho* catalogue for the highest praise as the foremost Buddhist and Taoist painter after Wu Tao-tzu, surpassing all other predecessors. Unfortunately, almost nothing has survived from the hands of these masters. Among the few important scrolls attributed to Southern T'ang, the early twelfth-century copy of Chou Wen-chü's *Court Ladies* (Figure 1) is perhaps the best documented. When compared with funerary art such as the wall paintings in the tomb of Princess Yung-t'ai, the work of Chou Wen-chü was clearly a far more elegant and brilliant summing-up of the T'ang tradition, which fully justified his extensive influence in the Hsüan-ho Academy. But at the beginning of the Sung Dynasty, the Ssuch'uan school was preeminent. All others paled under the near-hegemony of the painters from Shu who flocked to Pienching, not only as heirs to the legacy of T'ang but also enviably armed with invaluable, unique professional trade secrets – such as voluminous sketches of Buddhist iconography and copies of designs by old masters originally brought from the T'ang capital at Ch'angan.

Because of its geographical isolation and mild, bountiful, natural environment, the Ssuch'uan Basin had always been a political haven for Chinese courts in peril. Twice during the T'ang period the imperial courts took refuge in Shu – first the court of Emperor Hsüan-tsung in 755 during the An Lu-shan Rebellion, then the court of Emperor Hsi-tsung in 881 during the uprising of Huang Ch'ao. On both occasions painters-in-attendance attached to the court were included in the imperial entourage. Many of them, according to the 1006 preface by Li T'ien to *I-chou ming-hua lu (Eminent Painters of Ssuch'uan)*, had chosen to settle down in Ch'engtu and carry on the tradition of Ch'angan. As a result, the region was provided with "all the criteria and models for different styles." At the same time, according to another Sung art historian, Teng Chun, over fifty to sixty percent of the old families had followed the court and moved to Ssuch'uan, bringing with them their collections of ancient paintings. The imperial sojourn brought about an outburst of construction of Buddhist monasteries in

Ch'engtu. Although most of these were destroyed in the Buddhist persecution in 845, and again in a local disturbance in 994, a few did survive (with their wall paintings intact) – including Ta-sheng-tz'u-ssu, which was known nationwide as a great center of Buddhist art and Buddhist propagation. I mention Buddhist propagation especially, because in those days illustrated sutras were undoubtedly the most effective vehicle for introducing Buddhist art from one community, or country, to others.)

Geographically, Ssuch'uan occupies a strategic position for cultural exchanges between China proper and Ta-li (Yunnan), Tibet, India, and the general "Western Region" in Central Asia. Many familiar traditions in Buddhist art – whether stylistic, iconographic, or technical, and whose direct or indirect origins had been relatively unknown – have proved to have come from this great cultural storehouse in Ssuch'uan. One better-known example is the popular cult of the Guardian King of the North (Vaiśravana), especially the type known in Japan as Toba Bishamonten. It probably originated in Khotan but was introduced to China proper through Ssuch'uan. Ssuch'uan should also be remembered for technical innovations, such as its coloring methods. One mistake commonly made by art historians is the attribution of the systematic use of heavy colors to T'ang; they overlook the fact that in the *"pai-hua"* (uncolored painting) tradition, most T'ang masters concerned themselves only with the linear representation of the forms and left the unworthy task of "filling in the color" (*ch'eng-se*) largely to their pupils or assisting artisans.

The first appearance of color specialists in figure painting was probably also made in Ssuch'uan. One of these specialists was Tu Tzu-kuei, a Ch'engtu painter active during the reign of Wang Chien (r. 907-925). It was said that in his wall paintings of Vairocana, the Buddha was depicted sitting on a green lotus throne with a red halo; and "the halo looks just like the rising morning sun. Its tonal gradation was so subtle and luminous that all traces of the brush were obliterated." This reminds us immediately of some fragments of wall paintings exhibited in 1949 by C.T. Loo under the title "Chinese Frescoes of Northern Sung" (Figure 2) and now scattered in American museum collections, including Kansas City. Among the fragments are bodhisattvas "attending the incense burner" and "offering the followers," two subjects particularly associated with the name Shen Ch'ing – another Ch'engtu painter of the tenth century. Thus, despite the allegation that the fragments came from the Honan-Shanhsi border, a Ssuch'uan origin for their style and iconography seems to be plausible.

We can go on with enumerations of this kind of Ssuch'uan-originated tradition in Buddhist art, such as the icon of Buddha Ch'i-sheng-kuang as seen in Tunhuang, or the earlier version of the Twenty-eight Constellations, and so on. But I would like to return briefly to the mention of illustrated sutras to explain the unique and far-reaching influences exerted by the Ssuch'uan artists both inside and outside China proper.

References to illustrated sutras are found in Sung literature, but existing examples are extremely rare. Before the recent discovery of the seven late T'ang or early Five

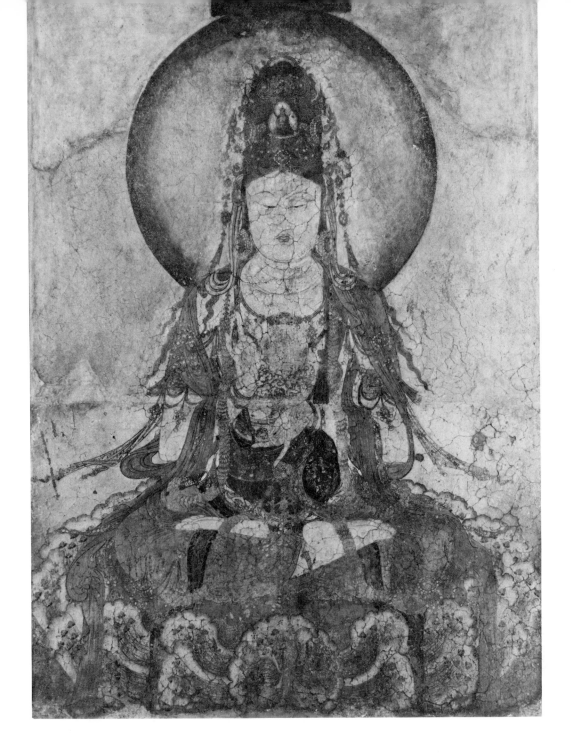

Dynasties scrolls of the *Lotus Sutra* (restoration dates of 931 to 956) from the Pagoda of Jui-kuang-ssu in Suchou, the only known illustrated sutras of Sung date were two nearly identical scrolls of the *Lotus* – one in Cleveland and one in the Spencer Collection in the New York Public Library. Other examples (in the Kyoto National Museum) are later works of the Yüan period: the four scrolls of *Ta-fang-kuang-fo Hua-yen ching (Buddhabhadra)* illustrated in 1291 by Shen Ching-hu and his son, who were Buddhist painters from Hangchou. In the Cleveland and New York scrolls, the highlights of the whole sutra are condensed in one intricately designed panoramic view, beginning with the Great Assembly at the Vulture Peak (*Grdhrakūta*) and ending with *P'u-hsien lai-i (Samantabhadra Coming in State;* [see 47]). This condensation of a monumental composition into a kind of pictorial outline or synopsis of the text in miniature scale seems to suggest one very likely possibility – that it is an adaptation of a wall painting. The Kyoto scrolls, on the other hand, present the central

drama of each chapter in separate scenes – a compositional device comparable to such Southern Sung handscrolls as a Confucian classic illustrated by Ma Ho-chih, or an historical event by Li T'ang or Hsiao Chao.

The underlying differences between these two types of illustrated sutras are not only ones of format, style, and chronology but also of geographic origins. While the 1291 scrolls in Kyoto represent a continuation of the southern tradition in sutra illustration, as seen in the late T'ang or Five Dynasties examples from Jui-kuang-ssu, Suchou, the Cleveland and New York scrolls suggest an origin in Ssuch'uan. In fact, I am inclined to believe that most illustrated sutras which start with the majestic scene of Buddha preaching at Vulture Peak on a raised Terrace of the Seven Jewels, surrounded by the celestial hosts of bodhisattvas, arhats, and guardian kings and attended by groups of donors and adoring royalty (Figure 3) are typical products of the western Chinese tradition centered in Ch'engtu in Ssuch'uan.

Figure 2. *Mahāvairocana*. Fresco. China.
Late 10th-early 11th century. Nelson Gallery-Atkins Museum.

Color Plate I. Detail of *Palace Ladies Tuning the Lute*. Chou Fang (attributed to). [6]

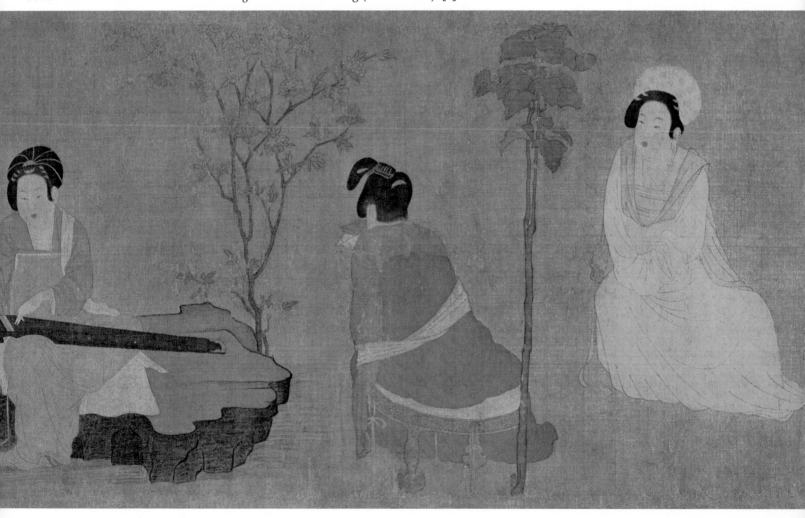

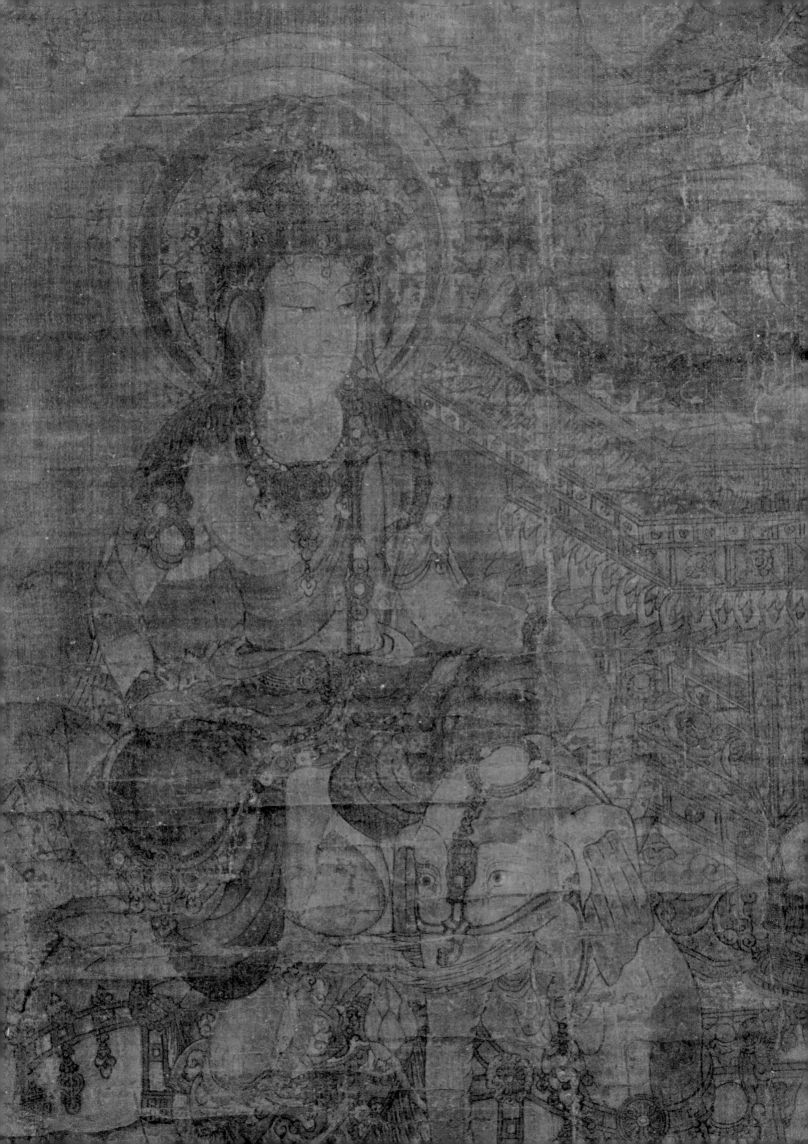

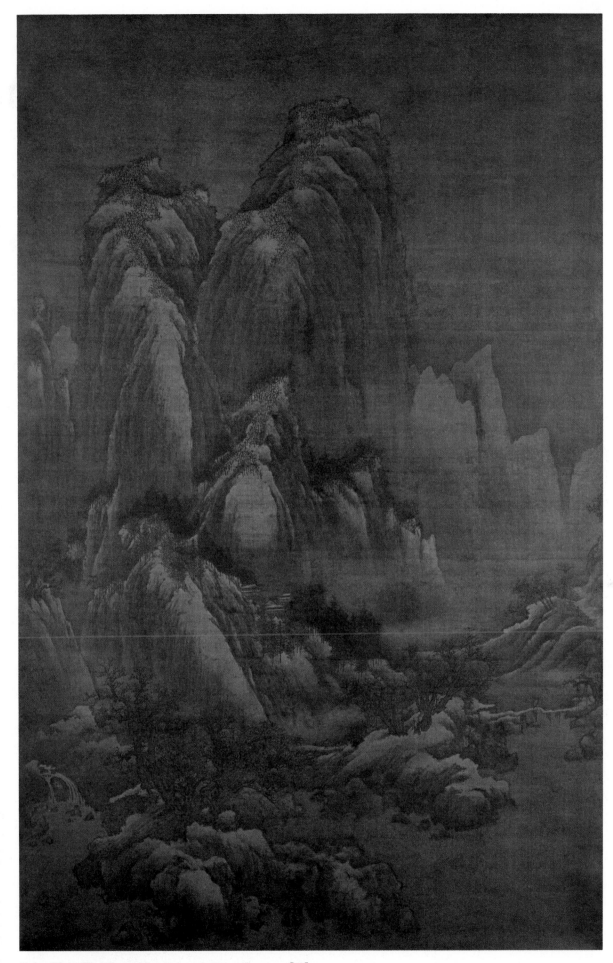

Color Plate III. *Winter Mountains*. Artist unknown. [13]

Color Plate II. Detail of *Shakymuni Triad:*
Buddha Attended by Manjushri and Samantabhadra. Artist unknown. [7]

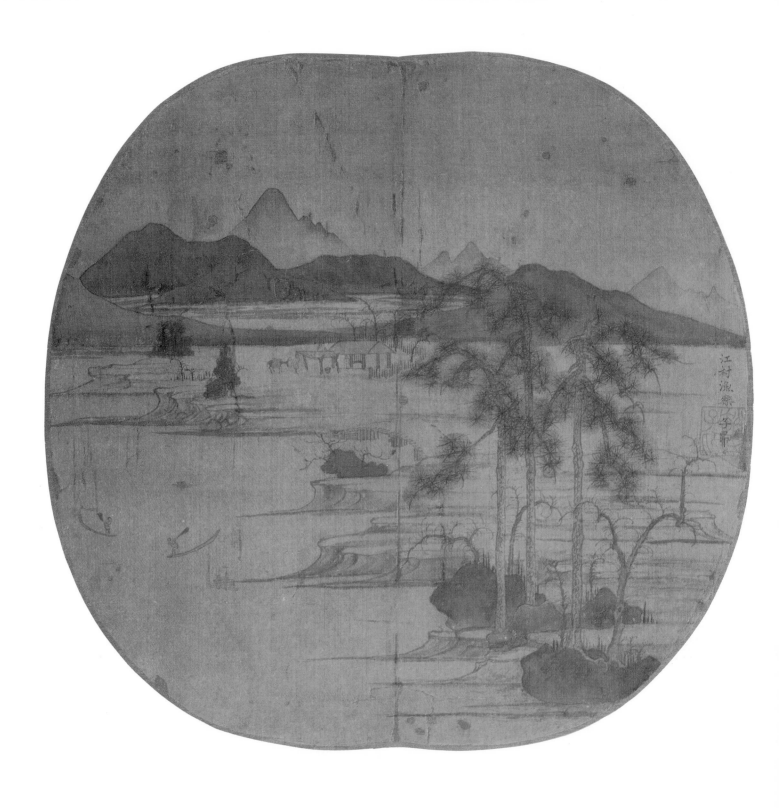

Color Plate IV. *River Village—Fisherman's Joy*. Chao Meng-fu. [80]

Color Plate V. Detail of *Nine Horses*. Jen Jen-fa. [95]

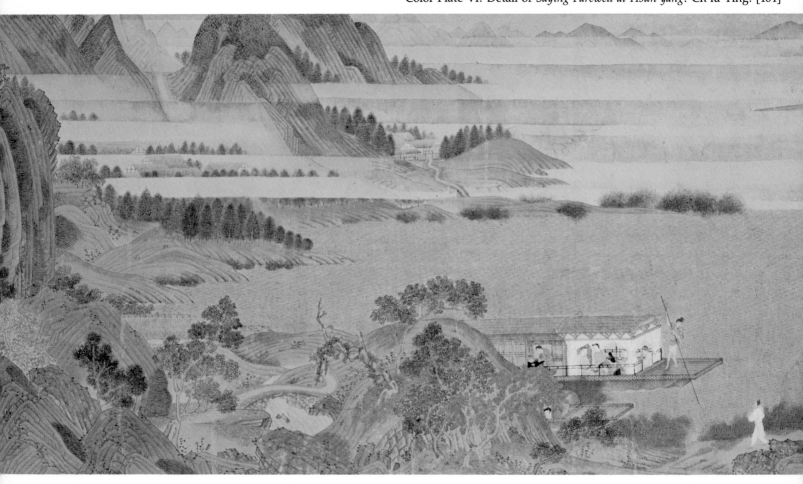

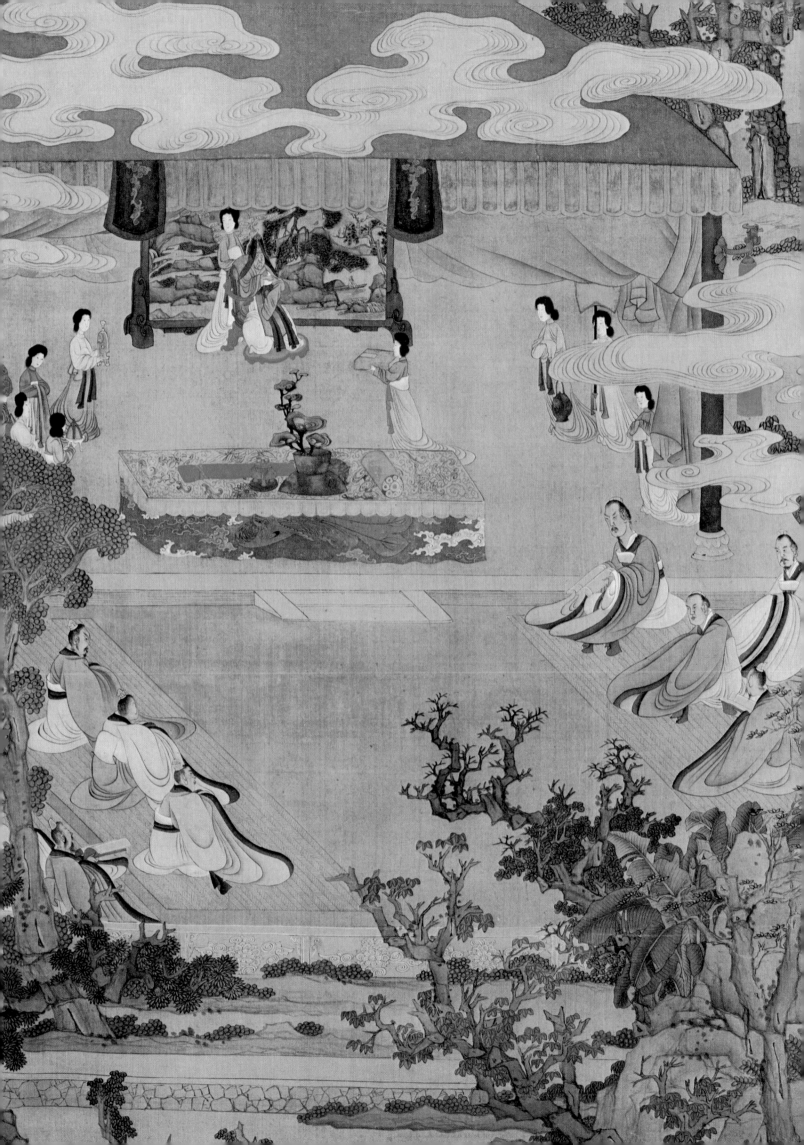

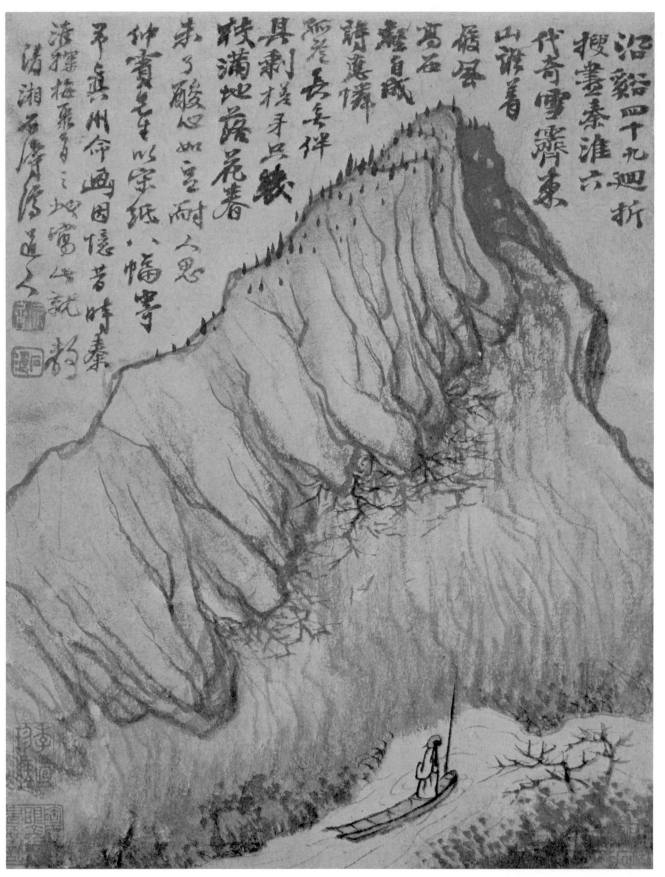

沿谿四十九迴折
搜書秦淮六
代奇雪霽東
山谁著
巘屧
高石
壁自成
詩邊嶂
爾登長嘉伴
其剩棋子只載
秧滿地巖花春
赤多酸心如童耐人思
紳賓毛生以宣紙八幅寧
平真州命画因憶昔時秦
淮探梅羅罵之地富作就粉
瀟湘石濤濟道人

Color Plate VIII. *Reminiscences of the Ch'in-huai River* (leaf H). Tao-chi. [238]

Figure 3. Detail of [49].

The earliest evidence for this theory is the well-known late T'ang woodblock print, dated 868, illustrated with the same assembly scene for the *Vajracchedikā Prajñāpāramita Sūtra* (now in the British Museum), which was found by Sir Aurel Stein in Tunhuang. It is safe to say that most of this printed material found inTunhuang, dated from late T'ang to Northern Sung, was probably made in Ch'engtu, which, as noted above, was the long-standing center of propagation in western China. The first government-sponsored printing of the Northern Sung *Tripitaka*, the so-called *K'ai-pao* edition, was printed in Ch'engtu between 971 and 983. As late as 1177 in the Southern Sung period, according to the poet Fan Ch'eng-ta, a collection of the *Tripitaka* with each volume illustrated in gold on glazed blue paper (in a manner similar to the Cleveland scroll) was made in Ch'engtu and distributed as an imperial donation.

The frontispiece designs of both these printed and painted sutras are now lost or as-yet unidentified, but examples from a different series of illustrated sutras are extant. Among these are the *Yen-lo-wang chou-chi-ssu-tsung i-hsiu-shen-ch'i wang-shen-ching-t'u ching*, one of which is in the collection of the Freer Gallery of Art, Washington, and is illustrated with the familiar scene of the Great Assembly at Vulture Peak. The interesting thing is that each existing copy of this series bears an identical inscription: "Tsang-ch'un, priest from the Ta-sheng-tz'u-ssu Monastery in Ch'eng-tu fu, sings the praises [of Buddha]."

In an unpublished paper delivered in 1973 (Freer symposium), I tried to establish, on the grounds of both the donor's inscription and the particular regional style, that the Freer manuscript is a work of the Ta-li kingdom (937-1253) in Yunnan. In addition to the Freer version, there are at least twenty-two more copies of the same sutra with exactly the same inscriptions – all found in Tunhuang – including ten in the Stein collection in London and two in the Pelliot collection in Paris. This means the

original manuscript in Ta-sheng-tz'u-ssu in Ch'engtu must have served as the model for numerous copies distributed in a wide area from Chinese Turkestan to Yunnan. Again, in the Chin Dynasty, an illustration for the famous *Chao-ch'eng* edition of the *Tripitaka* was apparently based on the Ta-sheng-tz'u-ssu design. This is also true of the Korean *Tripitaka*. In short, with only a few exceptions, almost all sutras illustrated with similar scenes of the Great Assembly at Vulture Peak were derived from the Ch'engtu prototypes.

Among other iconographic features which relate the *Lotus Sutra* in Cleveland to the Ssuch'uan school, perhaps the Water-and-Moon (or Potalaka) Kuan-yin calls for a few comments as one of the major image-types in Buddhist painting from the tenth to fourteenth centuries. The early representations of the Water-and-Moon Kuan-yin in the Chou Fang style were distinguished by a new sense of decorative exuberance that was so compatible with the late T'ang fascination with formal beauty that it was quickly introduced to Ssuch'uan in the ninth century and took root there as part of the local tradition. The representation was gradually formulated with even richer surface ornamentation and iconographic additions, such as the adoration of Shan-ts'ai (Sudhana), and the congregation of the seaborne creatures. In the tenth century the formula was perfected in the hands of the Ssuch'uan painter Kou-lung Shuan, whose Potalaka was "resplendent as the rays of the moon" and "complete with all the special trimmings and attributes of a heavenly being."

One of the major differences distinguishing the earlier and later types of this icon is the position of the bodhisattva. Before the thirteenth century he was usually seated in the *lalitasana* (with one foot pendant), but in late Sung and early Yüan he was more often seated in the *mahārajalila asana* (with one leg propped up and the other flexed on the rocky throne). The first type seems to have spread to central China and the Yangtze Valley rather early and was already very popular in the eleventh century. The copy preserved in the *Besson zakki;* the statues in Cave 1 in Wan-fo-tung, Yenan (Shenhsi; dated 1078-1083); and the statues in Caves 5 and 6 in Shih-hung-ssu, Lu-hsien (Shenhsi; datable to 1141-1154) are typical dated, or datable, examples. The wall paintings seen by the Japanese pilgrim monk Jojin in Shanhsi and Honan in 1072 and 1073 probably also belonged to this early type.

It was this same type of Water-and-Moon Kuan-yin that the Koreans had been willing to purchase at high prices in the markets or from monasteries in Shantung and the lower Yangtze Valley since the Chen-yüan era (785-804). Of the Chou Fang tradition, the images were lavishly elaborated by the court painters in Ch'engtu. In contrast to these earlier versions, the Potalaka Kuan-yin in the Cleveland sutra is seated in a more meditative manner (*pratisamlayana?*) and seems to be transitional in style – perhaps indicative of a twelfth-century date.

One of the earliest paintings in the Ssuch'uan tradition is the *Five Planets and Twenty-Eight Constellations*, now in the Soraikan collection (Osaka Municipal Museum). While its attribution either to Chang Seng-yu or Liang Ling-tsan cannot be substantiated, its pre-Hui-tsung Northern Sung date is assured simply because in 1119 an imperial decree had specifically forbidden nudity and alien faces and costumes to be represented in this particular subject. In fact, an exemplary scroll by the emperor himself was made public to set a universal standard.

In Japan, a number of late Heian icon drawings of related astronomical subjects – such as the *Kuyosei zusho*, dated 1164, in To-ji and Daigo-ji, or the *Hokuto mandara* in Tokyo Geijutsu Daigaku – are most probably copies of Chinese versions of the Hsüan-ho archetype. It has been suggested that the *Constellation* scroll epitomizes the early Wu Tao-tzu style – that is, when the T'ang master was still under the influence of the classical mode of the Six Dynasties, when Chang Yen-yüan's description of Ku K'ai-chih's precise linear manner still applied. This fine-line style – "tight, vigorous, continuous, and supple, moving in circles with no trace of beginning or end" – was one of two Ssuch'uan styles in figure painting introduced to the early Sung Academy. The eventual assimilation and compromise between the two styles resulted in what may be called Sung eclecticism. In short, the main trend of development can be summarized as follows:

The "tight" tradition (*mi-t'i*) of the Six Dynasties – *Ts'ao-i ch'u-shui* (the Ts'ao [Chung-ta] draperies [cling to the body] as if just emerging from the water) was the main Ssuch'uan court style represented by Sun Wei and Sun Chih-wei. It paved the way for Kao Wen-chin's dominance in the early Sung Academy (the tradition of the Ta-hsiang-kuo-ssu).

The "sparse" tradition (*shu-t'i*) of the Six Dynasties – *Wu-tai tang-feng* (the Wu [Tao-tzu] scarf [fluttering] as if standing against the wind) was the secondary Ssuch'uan court style represented by Lu Leng-chia and Chang Hsüan. It was integrated into the local school of Pien-ching and enriched by artisan traditions of the area, resulting in Wu Tsung-yüan's dominance of the Academy during the reign of Chen-tsung – as exemplified by wall paintings of the Yü-ch'ing Ch'ao-ying kung (Taoist temple).

Although greatly oversimplified, this outline indicates one thing – the lasting influence of Wu Tao-tzu in Chinese figure painting. The two leading masters of figure painting in the Sung Academy, Kao Wen-chin and Wu Tsung-yüan, were basically followers of the two different phases – early and late – of Wu Tao-tzu's art. Even subsequent developments, from Li Kung-lin's *pai-miao* to Liang K'ai's *chiang-pi* [see 61], were never able to make a clear break from the tradition of this great T'ang master.

Chinese Painting from 1350 to 1650

Sherman E. Lee

Paintings made before 1350 look radically different from those of a later date. A good indication of this truth lies in the Western study and appreciation of Chinese painting. Before World War II and the ensuing increase in accurate historical knowledge of the Far East, later Chinese painting, largely embodied in the literary men's (wen-jen) tradition, was little appreciated and, when studied at all, was relegated to a position inferior to that of early Chinese painting. Later art was clearly *seen* to be different from that of earlier times, and the dividing line was unconsciously – but accurately – placed at about 1350. Thus, early Yüan works were accepted as final manifestations of classic Sung or earlier styles, while the later literati paintings were seen as abnegations of a classic style. The understanding was indeed correct, but the evaluation was in error. Two major considerations led to a new evaluation after 1945: the acceptance of Chinese historical records and evaluations, both as a result of confirming excavations and studies and because of an overdue acceptance of the Chinese as reliable and important historical witnesses;[1] and an increased aesthetic sophistication derived from growing understanding of modern Western art, which in turn led to more open and knowing ways of looking at formal and abstract modes of visual expression.

Chinese painting after 1350 *does* look different, even strange, when compared with Sung or earlier work. Except for a few early eccentrics made to seem even more so by the ex post facto creation of the artistic and theoretical lineage of *wen-jen* painting, and for the true and few forerunners of the new tradition such as Chao Meng-fu and Ch'ien Hsüan, there are no general precedents for the look of later Chinese painting. A revolution had been accomplished as radical as that of "Phidias," the Masters of Mt. Sinai, Giotto, Masaccio, Caravaggio, Cézanne, or Picasso and Braque. The very fact that such an aesthetic revolution was possible sets Chinese art and society apart from others of the Orient and allies it, to a degree, with the art and society of the West. How did this revolution come about? How can we understand it? What did it accomplish?

Patronage

We can begin with patronage. The highest patronage had come from the courts of Southern T'ang, Northern and Southern Sung, and Chin when the empire was viable, or from courts when it was fragmented into principalities. The courts of emperors and princes had the largest collections of art as well as painters-in-attendance more numerous than those serving any other authority. Such patronage was not only personal – as in the case of a deeply involved emperor like Hui-tsung – but also official, in that many bureaucratic offices required decoration and numerous official and academic occasions required ratification by pictorial records. During the late Yüan period, however, this official patronage subsided because of the weakening of political power and a waning interest on the part of a declining foreign court.

The revival of Chinese hegemony in Ming led, both naturally and by design, to a revival of court patronage for the arts in general and painting in particular. The nature of that patronage, however, was extremely conservative. The triumphant and longed-for return of native power brought with it not only nostalgia but also a claim for "dynastic legitimacy" requiring a return to native Chinese and Confucian tradition. The artistic styles associated with pre-Yüan Chinese imperial patronage were a symbol of restoration, of a return to normality. Porcelains, lacquers, and other applied arts could be developed in the new and radical directions of late Yüan, but paintings (and calligraphy) were concerned with ideas: these were to be traditional and celebratory. The misfortune of those *wen-jen* artists still active at the beginning of the Ming Dynasty was that their art developed in the "foreign" Yüan Dynasty. The decimation of *wen-jen* by the victorious first Ming emperor was logically necessary; not only because their independence in painting mirrored an independence in thought, but because they had particularly and generally been identified with Suchou and the whole landed-gentry class in the Chiang-nan area who opposed the peasants' uprisings. The more fortunate and clever *wen-jen,* like Ni Tsan, removed themselves from the political and tax arena by adopting, literally, floating abodes. Less fortunate scholars were transported, jailed, or executed. The death or removal of almost a whole generation of the best of the new style intellectual-artist delayed the fruition of the *wen-jen* style in Ming by a half century – that is, Shen Chou's first dated work (1464) and his slightly later work (1468; see

[148]) followed nearly fifty years after the works of Wang Fu [see 116, 117], who died in 1417.

The official painters to the court practiced styles other than *wen-jen*; the numerous court paintings illustrated here are all of a conservative nature and, in particular, owe much to traditions stemming from the last previous native "academy," that of Southern Sung in Hangchou. Aside from narrative or commemorative commissions the greatest emphasis in a court painter's production was on decorative painting, usually large hanging scrolls of moralizing figures in landscapes [e.g., 134] or bird-and-flower paintings with only slightly less explicit, auspicious overtones [cf. 121, 124-126]. It was only natural that the "Ma–Hsia" style of Southern Sung should have dominated in the courtly landscapes, along with a minor strain of the Li–Kuo style popular in North China under the Chin, for these had been the last of the remembered styles officially patronized by imperial establishments and which had continued into Yüan times. If earlier inspiration was sought, it was usually in a tradition of a more distant and hallowed past – that of Six Dynasties and T'ang, especially in the "blue-and green" manner [see 136].

Court patronage was reasonably strong during the fifteenth century; but, if we are to judge from extant published or collected works, such patronage declined as the dynasty continued and the personal interest of later emperors diminished. It is possible, of course, that many of the academic and secondary-quality decorative pictures that either float about the art market or reside in minor collections were products of continued court patronage; it seems highly unlikely, however, since they almost never bear any genuine seals or inscriptions attesting to their late Ming origin. The usual assumption that these scrolls are artisan's copies of late Ming and Ch'ing is more plausible; but this in itself represents a type of patronage – albeit little-studied and evaluated – that of a non-official middle or mercantile class aspiring to higher levels. In any event, this "patronage" followed, in a properly obedient but debased way, the standards set by the imperial court. The next foreign reign, the Ch'ing Dynasty of the Manchus, was to reestablish a strong court patronage, both in contemporary art and in collecting the art of the past.

It should be recognized that there was no real imperial painting academy between 1350 and 1650. Painters were summoned to the court or, more rarely, arrived through the examination system and were given a rank with emoluments at rather low levels. They were expected to produce pictures for decoration, anniversaries, annual festivals, or commemorative occasions. They came as fully fledged artists, not to be taught or to teach, and not registered in a painting academy as was done in Southern Sung;[2] rather they were given varying ranks in the Embroidered Uniform Guard (*Chin-i-wei*, the emperor's honorary personal bodyguard) and assigned symbolic places in the Jen-chih-tien (Hall of Wise Humanity) or the Wu-ying-tien (Hall of Heroic Military) – whether or not they worked in these locations.[3] Some, if they had realized literary achievements and had passed the imperial examinations, might have become members of the Hanlin Academy – a scholarly rather than an artistic conclave. For most, however, the epithet used often in their signatures, "painter-in-attendance at the Jen-chih-tien," indicates the proper description of their status: court painters, not academicians.

Still another semi-official area of patronage was that provided by the Buddhist temples – less influential by far than in earlier times, but still active. Some Buddhist works were initially ordered from the court at Peking and were probably commissioned as offerings to be supervised by court officials – in this case, eunuchs. Only recently (Chinese Figure Painting Symposium, Freer Gallery of Art, Washington, 1973) has attention been given by Teisuke Toda, Kei Suzuki, Toshio Ebine, and others to the continuation of traditional Buddhist figure painting in the Ming Dynasty. One hopes, if we consider the sound achievement of the scrolls illustrated here [see 130-132], that much more material will be discovered, particularly in Japanese temple collections.

The Ch'an Buddhist temples of the Hangchou area were active long after 1350, but the rough, abbreviated style associated with this sect in Sung and Yüan [see 63-68, 97-99] seems to have disappeared without a trace, or is as yet unrecognized or undiscovered. Even the revival of Ch'an in the Wan-li reign (1573-1620) seems to have produced few pictorial results: isolated examples are the *Pu-tai* by Chang Hung in Taipei or a *Han-shan and Shih-te* by Sun K'o-hung. A few late individualist echoes of this lost mode are still extant, notably the Kansas City *Han-shan and Shih-te* by Lo P'ing [272].

On the other hand, Buddhist paintings of the Lamaist sect, introduced in the Yüan period, are occasionally to be found, though many excellent examples of this patronage may well be hidden among the myriad extant "Tibetan" tankas. In conclusion, though a few Buddhist subjects were assayed by *wen-jen* and professional artists, one can say that Buddhist temple patronage was of decreasing significance from 1350 to 1650. This is true as well for the Taoists. Though private donor groups continued to patronize paintings as donations to both orders, the key fact is that true monk-artists associated with temples largely disappeared. The few Taoist works extant [cf. 130, 132] only whet one's appetite for more material and further study.

Patronage by the wealthy was a major factor in later Chinese painting and not only for the professional painters. Some of these, notably Ch'iu Ying [see 164-166], made a good living by painting pictures – even forgeries – for money. As James Cahill has pointed out, the Chinese system of stylized barter and obligations connected to favors provided a lucrative source of money-equivalents for the needy artist. In fact, the famous collector Hsiang Yüan-pien [see 18, 34, 42, 54, 60, 77, 84, 91, 114, 133, 166, 182] operated a pawn shop with scrolls as part of his stock. The decoration of the substantial houses and villas of the wealthy landlords and merchants must have mirrored on a lesser scale imperial and princely layouts, and such paintings would have been bought from professional painters, whether "officials" at court or local luminaries. The concentration of wealth in Nanking, Hangchou, Suchou, Wu-hsing, and other Lake T'ai-area centers attracted not only scholar-painters (because of the

intellectual activity sponsored by the wealthy) but also professionals in search of a lucrative market. As we shall see, the few painters originating in areas remote from the Lake T'ai heartland soon rectified the error of their birth by moving to the golden center.

Wealth not only was used to purchase paintings; one could also acquire a painter-in-residence,[4] a practice usually reserved in the West for universities. Furthermore, a cultivated, wealthy patron of Nanking, Suchou, or Hangchou could pride himself on providing a kind of cultural center – an environment in which literature, music, calligraphy, and painting mixed with conviviality to produce a Parnassus on earth. The number of these patrons in the Lake T'ai heartland was large, so it is no wonder that the best painters came to that area.

Still another advantage of patronage by the wealthy was an aesthetic by-product. Such patrons usually had collections of old paintings, some genuine, some spurious, but always with a few works of authority and influence. Such key works, immensely valuable, could only be seen in collections of this sort. The influence of Wang Meng's scroll of Mt. T'ai-po [see 147] or of an old work attributed to Li T'ang was enormous, if hard to imagine for modern painters and scholars brought up on catalogs of exhibitions, photographs, slides, and public collections. As time went on, references to the past increased, and the referents were to be found only in the holdings of the court, the princes, the wealthy, or a few discerning and fortunate heirs or artists – usually *wen-jen* with some status or money, or both.

This leads us to the next important source of patronage: the *wen-jen* themselves, who have been sufficiently proved to be a quintessential "in-group" in both extended time and limited place. The scholarly tradition lasted in self-conscious fullness from about 1350 to the present day. Much of the People's Republic's strictures against elitism and encouragement of popular art can be traced not necessarily to Marxist theory but to a reaction against the *wen-jen* tradition. In place, the scholars' homeland, whether by birth or by choice, was severely limited to what Fu Shen calls the "eye area" of later Chinese painting, centering on Lake T'ai – among other things, a favorite retirement center for scholars and officials. The characteristic innovative and esoteric art the *wen-jen* practiced was closely allied to literature and calligraphy and was valued particularly for its revelation of the profound, noble character believed implicitly to be the prerogative of the scholar-official class. However galling this may be to past and present sensibilities, the exalted estimate by the *wen-jen* of their own virtues seems largely justified. Like the hermetic innovators of modern avant-garde art, they lived for and in their art without regard to commercial or political considerations. It was an art about art; or as Max Loehr puts it, "an art-historical art," learned pictorial and calligraphic commentaries on previous art made by subtle and profound students of that art. Hidden and overt allusions to past styles, studied and cloaked clumsiness – these and other hyper-aesthetic devices were second nature to them. Small wonder that the *wen-jen* were their own best patrons.

Though varied, the manner of this patronage rested on the single foundation of in-group relationships. Thus, an artist might paint a major picture to present to someone, perhaps a relative, on a significant birthday (the fiftieth of a friend or the all-important sixtieth of an aunt [cf. 203 and 208]). Scrolls, on the other hand, were often presented on lesser occasions, usually as a part of the "obligation" system within the in-group. For example, Lu Chih painted a free variation on a scroll by Ni Tsan [183] shown him by a friend and then presented the "copy" as a memento of the occasion. Such acts were common; any auspicious occasion might call forth the memento-gift.

Particularly important events were the gatherings of scholar-friends at rural parties consciously sensed as re-creations of earlier historic gatherings, such as the Lan-t'ing party (AD 353) of Wang Hsi-chih. These Yüan and Ming parties were of a complex nature and could be lengthy. Poetry would be recited and written, music played, and much wine and liquor consumed; very often, a commemorative picture would be painted during or after the event. The subjects of such scrolls probably mirrored the discussion at the party, whether celebrating the scholars' leisure [112] or, in a more belligerent mood, making an apparently humble plant – the cabbage – bear the weight of political and social criticism [145]. In either instance, dozens of inscriptions by participants attested to the significance of the occasion in the participants' minds.

In traditional China, especially during the Ming period, wealth and political and social influence were all in the same hands – the scholar-official-gentry class. Consequently, a patronage of wealth was actually no different from political, social, or scholarly patronage. Outside of governmental patronage, there was essentially only one type – "class patronage." Because it was the original or adopted home of the largest number of the official-gentry class with the status and means to support art, the Lake T'ai area became the artistic center of the time.[5] But scholarly patronage was not confined solely to the in-group. For example, the young K'un-shan collector Chou Feng-lai prevailed upon both Ch'iu Ying and Wen Cheng-ming to "embellish" a poem he owned, composed and written by Chao Meng-fu, the first acknowledged master of the *wen-jen* style. The poem records Chao's historic exchange of a bowl of tea in return for his writing out a Buddhist text. The professional, Ch'iu Ying, was asked to paint the event; Wen Cheng-ming provided a transcription of the text from the *Lotus Sutra* originally copied by Chao Meng-fu. The proud owner had all three items mounted in a handscroll and, according to colophons on the scroll [165], each was considered the equal of the other. As such, the boundaries between amateur and professional become blurred, thereby confirming the stylistic evidence that there is more connection between the two groups than the *wen-jen* partisans would be prepared to admit.

The collections of historic painting formed in the Ming and early Ch'ing dynasties confirm this relatively even-handed appreciation of artistic talent – whether *wen-jen* or professional. Yüan and Ming works with the seals of

such formidable collectors as Hsiang Yüan-pien, Liang Ch'ing-piao, Keng Chao-chung, and An Ch'i are not all of the scholarly persuasion. Ch'iu Ying, Tai Chin, T'ang Yin, and Chou Ch'en – all professionals – were well represented in such collections and have generally received favorable attention in all but the most snobbish Ming and Ch'ing scholarly histories and collectanea.

Geographic and Social Origins of the Artists

We should not be surprised if the majority of late Yüan and Ming artists were located in the lower Yangtze valley of South China, since patronage was concentrated there. Successive foreign conquests of North China – by the Chin Tartars who sent the Sung court fleeing from K'aifeng south to Hangchou, and by the Mongols who established their Yüan capital at Peking – contributed significantly to the growing attraction of the South to patrons of native culture.[6] However, the one-sidedness of statistics on the geographic origin of these artists is surprising. In the Five Dynasties period (907-960), roughly half of the artists named in Osvald Sirén's *Lists*[7] (thirteen of twenty-seven) came from the South. In Sung (960-1279) the proportion had barely begun to shift – sixty-one of one hundred twenty. In early Yüan (before 1350) the shift had occurred; fifty-five of seventy-five were Southerners. In the period we are concerned with, forty-nine of the fifty-eight artists in this catalog were from the South, forty-three were from the Lake T'ai area or Nanking. The nature of this overwhelming disproportion in location has been considered before and recently by both Chinese and Japanese scholars.[8]

It should be recognized that the argument for the priority of the lower Yangtze valley and the surrounding area is, to a degree, a circular one.[9] From late Yüan on, with increasing power – overwhelming after the critical theories of Tung Ch'i-ch'ang (1555-1636) and his followers – the *wen-jen* from the Lake T'ai area were a tight in-group whose preeminent position in the official-scholarly-wealthy world pulled all aspirants to it. In effect, they decided who was an artist and who was not. *Wen-jen* collectors prized and saved those paintings that confirmed their position (indeed, much of what we have received of later Chinese painting is what the *wen-jen* preserved for us). The lowly artists outside their circles, however competent, were largely ignored, then forgotten, and their works presumably lost or absorbed into the vast realm of unattributed works. The situation changed but little with the revival of strong official and court patronage in the Ch'ing Dynasty.

We have already seen patronage to be a reason for this geographic limitation. The transfer of the court to the North (Peking) after 1421, combined with the weakening of imperial patronage, is another factor. Certainly climate and the abundance of marvelous scenery in the Lake T'ai area is another. Furthermore, it was economically advantageous to live in the milder climate of the South. The unfortunate experience of the *wen-jen* at the beginning of Ming and on the few subsequent occasions when they did try official duties made it convenient to be away from the court and close to the retirement centers of the southern gentry.

Evidence concerning the economic and social status of these painters is inconclusive. Of the nearly sixty painters considered here, biographies of twenty-seven reveal nothing that allows even a guess as to their status. Of the remainder, twelve were wealthy and, of these, seven were prosperous landlords; thirteen were reasonably well-to-do or middle class; while ten appear to have been poor by official biographic standards. Presumably, many in the last group were poor because of career problems or by hermetic choice. It is unlikely, in view of the literacy required for advancement, that many came from dirt-poor peasant origins.

Productivity and Preservation

As we come to consideration of the paintings themselves, still other questions must be asked. How many paintings have we to deal with? What proportion of the original output do they represent and, therefore, how broad are the foundations for analyses of subject matter and style? The answers are unsatisfactory. We have seen how the geographic bias offers a limited, quantitative view of later Chinese painting. The same limitations are present when we consider the possibilities of production and the facts that remain. There are few indications known to this writer of the number of paintings produced by a painter in the period we are considering here. And the numbers of paintings in collections can only be conjectural, for no numbered catalogs or lists are extant. That the Ashikaga shogun Yoshimitsu had some eight hundred Chinese paintings of Sung, Yüan, and early Ming is interesting but not too helpful. That Sirén lists some one hundred ninety scrolls and albums by, or attributed to, Shen Chou is also not helpful, since there is more than a considerable difference of opinion as to the authenticity of many works in the list.

One of the nebulous records we have is that Ch'eng Cheng-kuei (1604-1677) produced a numbered series of handscrolls called *Dream Journey among Rivers and Mountains* [231] and that the highest recorded number on any of these works surviving (K. Koshima collection) is one hundred fifty-three. Ch'eng also painted hanging scrolls and other handscrolls outside the designated sequence, such as the early handscroll[10] now in The Art Institute of Chicago. Ch'eng had written on his seventy-fourth *Dream Journey*, now in the Museum of Fine Arts, Boston, that he planned to finish one hundred such scrolls. But his contemporary, Chou Liang-kung (1612-1672), mentioned that he actually had seen three hundred in the sequence.[11] Ch'eng Cheng-kuei's estimate was evidently a modest one, for his one hundred fifty-third scroll still survives. Nevertheless, Chou Liang-kung's statement may have been an exaggeration. All we know is that few of Ch'eng's scrolls remain; Sirén lists five, and one can add only a few – unknown to Sirén – to that number.

From this symbolic statistic we should assume an average production of paintings, to say nothing of calligraphies, for a reasonably active artist to be in the magnitude of the high hundreds or low thousands. If we then contemplate the number of preserved, authentic works we are confronted with a devastating percentage

of loss – perhaps in the neighborhood of ninety percent. The remaining production is still impressive, both in quality and, to a certain extent, in variety, but we should always remember that we have a relatively small sampling of the range of Chinese painting and that that sampling is distorted both by the willfullness of choice inherent in the preferences of Ming and Ch'ing collectors (largely formed by the *wen-jen* tradition) and by that most powerful of winnowers, chance.

Ch'en Chi-ju (1558-1639) was not being merely quaint or amusing when he listed the "Twenty-eight Conditions" either unfavorable to paintings themselves or for their preservation. Even if we eliminate the more whimsical conditions and those simply producing annoyance to the connoisseur, we are left with recipes for catastrophes – for example:

> The humid season. Below a lamp. After drinking. To use pictures as cushions. A hurried visitor at one's side. A room where water is dripping in. Rainy season or a parching wind. The hands covered with grease or sweat. To dry pictures in the sun on a dirty ground. Poor mounting and repairing. Eaten by bookworms. To unroll pictures violently. Rats. Servants standing about. Marks of fingernails. To cut, to fold, or to wrinkle the pictures.... To fall into the hands of a peasant. To be pawned. To be cut up for making coats or stockings. To be left to an unworthy son. To be stolen by thieves. To be bartered for wine and food. Calamities of water and fire. To be buried in a tomb.[12]

Subject Matter

An analysis of the subject matter of late Yüan and Ming painting reveals disproportions comparable in magnitude to those found in patronage and the geographic origins of painters. To put it simply, landscape became the major subject for pictorial art, overwhelmingly so for the literati painters. Statistics here are superfluous; one need only leaf through any corpus of reproductions for the period. What happened to other subjects? And why?

Religous subject matter in particular depended upon patronage outside the scholar-official classes, and we have seen that this source declined.

A few icons of high quality in traditional styles remain [130-132], including some produced for the imperial court [e.g., 131]. Undoubtedly there were many more frescoed temple walls than those that have survived – the Yung-lo-kung (1358) and the Fa-hai-ssu (1439-1444) being the most important. But all such paintings were ignored by orthodox *wen-jen* criticism; they were dismissed as "artisan work."

The long decline in the use of Buddhist subject matter was partially modified after 1600 with the appearance of scrolls by professionals with *wen-jen* connections, such as Wu Pin [see 205] and Ting Yün-p'eng [see 202]. Significantly, these are most often representations of *lohan*, disciples of the Buddha who are usually depicted as grotesque types. This passion for expressive deformity parallels comparable distortions in landscape representation [cf. 204] and in historical and moralistic figure painting [cf. 208].

Paintings in this last category fared little better than religous painting. One might have expected subjects such as the Hermit Hsü Yu [134] or the Haven of T'ao Yüan-ming [137], with their moral-scholarly overtones, to appeal to the *wen-jen* as well as to the patrons of the professional painters, but major figural representation of such themes did not. It was almost as if there were a unanimously held tabu against figure painting. When subjects with such representational potential were tried, the figural component was suppressed and lost in the dominant landscape setting [cf. 185]. Even after the considerable and interesting figure painting of the Che school of professionals in the fifteenth century [see 134, 157], only a few major professional artists assayed and succeeded in figure painting, most notably Chou Ch'en [see 160] and Ch'iu Ying [see 165, 166].

As we have indicated, late Ming witnessed a more general interest in historical-moral subjects with figural emphases – Wu Pin, Ting Yün-p'eng, Ch'en Hung-shou, and Ts'ui Tzu-chung being the most prominent artists. All four were hardly pure in their ancestry and allegiances as far as scholarly and professional matters are concerned, but it is significant that they were accepted as peers by contemporary *wen-jen* artists and, even more important, by the *wen-jen* critics and historians. The different brush styles of all four artists, heavily dependent on the great figure-painting traditions of the Six Dynasties and T'ang periods, are applied to a uniform way of representing people. While earlier figure-painting traditions had depicted virtuous or regal individuals as classical, beautiful, and serene, with even, flowing lines and smooth profiles, these late Ming artists depicted *all* people, good, bad, holy or mundane as grotesque. Perhaps they derived this manner from the old methods of depicting Buddhist disciples or Taoist immortals. While figure painting of historical and moral subjects was still a minor category compared to the dominance of landscape, a real innovation was achieved by these artists.

Portraiture is known from the period we now consider; it was, however, even more than history painting a province for the lowly artisan, in contrast to the honorable place of portraiture in Sung and earlier times. A few exceptions prove the rule: Hsieh Huan [see 133] painted a garden party with portraits, but then he was a court painter. The "ancestor" portraits of Ming and Ch'ing go back to imperial and official prototypes designed as historical records rather than works of art. While we do have portraits of *wen-jen* painters – even of such scholars in landscapes or gardens painted by other *wen-jen* [see 275] – the physiognomies are, almost without exception, by unknown or unidentified artisans, considered "hacks" by the literati.[13] None of these works have received systematic, much less sympathetic, study, but to date so little of any conceivable significance has been collected, much less published, that we must tentatively guess that this lacuna does represent a fact that relatively little of permanent value was accomplished in portraiture from 1350 to 1650 – though one notes Tseng Ch'ing (1568-1650) as a recognized and important portrait and figure painter.

There is even less genre painting in this period. But the little that survives is of surpassing interest, and today the major achievement is associated with one artist, the professional master Chou Ch'en. While genre was a recognized category in early Chinese painting, and Sung and early Yüan masters had depicted commonplace subjects in a reasonably direct way [cf. 35, 61], most often such subject matter was confined to staffage in large compositions. (The titles of early landscapes from South China, such as those by Tung Yüan, reflect folk and genre interests.) This continued on a lesser scale with the early *wen-jen* [see 80], and in the fisherman and fishing-village subjects [139, 187] particularly associated with the Che school. Chou Ch'en produced at least two pure genre pictures, one of them in a traditional Sung genre-in-landscape arrangement,[14] the other, a masterpiece of social observation and criticism [160], rare in Chinese painting until recent times. Its isolated position only emphasizes the non-existence of genre as a legitimate subject for the progressive artist from 1350 to 1650.

Still another subject to become scarce was the traditional category of "fur and feathers." At the beginning of Ming there was an understandable revival at court [see 121] very similar to Sung prototypes. This was followed, as in figure painting, with some brush experimentation in the category leading to some large-scale free improvisations on decorative bird-and-flower painting [see 124], as well as boldly brushed subjects such as those of Lin Liang [123]. Although the academic painters maintained "fur and feathers" into the sixteenth century [see 119-127], it was never a serious subject for *wen-jen* painters. The exceptions are just that – early works based on acceptable Yüan *wen-jen* precursors or an occasional scroll or a leaf in an album of assorted subjects.

There was, however, one traditional subject category suitable to amateur specialization: the "Three Friends" – bamboo, prunus, and pine. These were symbolic of *wen-jen* ideals – strength, purity, and longevity – and also relatively easy to depict by following accepted models. Prunus, chrysanthemum, and other flowers were symbolic of the scholar's privileged place in an unsympathetic world. The prunus was popular in late Yüan and early Ming, but its later support depended in part upon family rather than general tradition [see 144]. Bamboo [173] continued to be popular, not least because of its connections with calligraphy.

These subjects were little practiced in themselves by the great painters, whether *wen-jen* or professional. When they were systematically attempted, it was by the minor master, the calligrapher, but especially by the gentleman-amateur. The omnipresent subject was landscape. Because it received particular and compulsive attention, landscape was subdivided as a category into numerous parts. Even though the traditional generalized landscape of Five Dynasties and Sung was continued, paintings of recognized sites of distinction increased: for example, Lofty Mount Lu, Wu-shan Gorge [169], or Mt. T'ai-po [147]. Records or mementos of excursions increased: see, for example, the *Famous Sites of Wu* [152] and *Twelve Views of Tiger Hill, Suchou* [155]. Imaginary landscapes [see 231] and complex or slight renditions

commemorating a chance meeting or a formal gathering were a part of this growing landscape iconography. Not least were the re-creations, almost critical visual commentaries on earlier visions of nature – landscapes seen through the brush of some ancestor of the *wen-jen* tradition. The resulting large numbers of landscapes in all formats provide a dense collectanea of shared visual and mental experiences, making the study of style and personalities of the period an analysis of subject-landscape. If the iconography of medieval Christian Europe was composed of human and semi-human figures, that of late Yüan and Ming was overwhelmingly dominated by nature.

Formats

The well-established formats of Chinese painting were also affected by the new *wen-jen* orientation. Wall paintings, usually dry fresco and confined to religious establishments, continued to be done, but in declining numbers. We have almost nothing left of screen painting, but the visual evidence to be seen in some figure and architectural subjects clearly indicates that at least the single-panel screen continued to be used. (Perhaps such squarish hanging scrolls were remounted from panels.) Like wall painting, this format was also associated with the artisans and was considered unsuitable for the *wen-jen*, though we do have records of wall painting by Wang Meng and of screens by Chao Yüan. The story of Shen Chou being humbled by painting a wall by order, followed by the apology from the official who had unwittingly made the demand, seems significant in this respect.

For all of these formats, paper became the principal ground for painting. Silk was used seldom by the *wen-jen*, more often by others. The dominance of paper was a natural effect of the rise of the literati, whose beloved books and calligraphies were normally on paper. Further, the varieties of paper available from the various regions of China and from Korea permitted far greater flexibility for brushwork than did silk. Brushwork based on the various styles of calligraphy was held to be of overwhelming importance, and required the textures of different paper surfaces. For the professionals, including those working in the even more wire-like lines required for pre- Sung-style figure painting, silk was more usually chosen. The Che school masters, with their more calligraphic Southern Sung styles, used both materials. Indeed, the differences between the pure *wen-jen* members of the Wu school and some of the more calligraphic and complex works of the professional Che school artists become less apparent if one imagines away the darkened silk used by the latter and mentally restores the sharp contrasts in dark and light, brushstroke and ground, that must have been found originally on the "icy" white silk. Nevertheless, paper was the most widely used material for late Yüan and Ming painting.

The proportions of the hanging scroll were modified considerably after 1500, particularly by Wen Cheng-ming [see 171, 173, 174, 176] and his followers. Tall, narrow formats were increasingly employed for the densely and delicately brushed landscapes of the school. Perhaps the

more constricted format appealed to the growing compulsive interest of the *wen-jen* in detail and complexity. Certainly the narrow shape was like that of the handscroll, a favorite format, and could be said to be "read" rather than seen as a total image. And, except for works by some professionals (usually associated with interior decoration), there seem to be fewer enormous hanging scrolls by the *wen-jen*.

Although the handscroll remained virtually unchanged, album and fan-painting formats were seriously modified – the former in the use of its sequential pages, the latter in shape and function. The Sung album was usually a compendium of various works selected by a collector to form an album. Towards the end of Sung, exceptions began to occur, notably in the two albums by Ma Yüan, one of branches (now in Taipei), the other of waves (now in Peking).[15] This book-like sequence of closely related pictures of one subject was also to be found in Yüan, as in the Wu Chen album in Taipei[16] and the remaining Ni Tsan album leaf in Washington.[17] But in Ming a more flexible attitude developed, and the sequential album (as large as twenty-four leaves) or even double albums became a flexible medium for the artist. One could have different views of a famous site; or of widely separated sites; landscapes of the seasons or months; flowers of different types and seasons; alternating subjects of figures and flowers or other flora, unified by some personal or moral tone; or landscapes in the styles of masters of the past. Such albums could be small or large; the paintings could be on one leaf faced by a page of calligraphy or across the centerfold of a double leaf. The increasing use of this flexible format would simply be inexplicable without the book and literature-oriented *wen-jen* dominance.

The format and function of fan painting was radically changed. Sung examples [see 69-74, 76, 77], and those of early Yüan emulating them, were most often actual fans of the "stiff-leaf" Chinese type – a broadly oval piece of silk bisected by a fine bamboo slat mounted as a handle. The typical later fan [cf. 261] is well known in the West; indeed, it was the ultimate prototype via its originator, Japan, for many Western imitations by Degas, Conder, and others. Made of paper with thin slivers of bamboo as spines inserted between the two layers, the accordian-pleated system permitted the fan to collapse into a compact rectangular staff, almost like a small baton. It was useful both as a fan and as a "worry-stick." In format, the curving, longitudinal open folding fan was more closely analogous to the handscroll than to the earlier framed oval. These new-style *wen-jen* fans, sometimes containing extensive calligraphy on front and back, were executed in great quantity and used by scholars as presents or as mementos of memorable occasions. However charming they may be, they usually cannot be taken seriously when compared with the major formats of hanging scroll, handscroll, and album.

Accepted and Assumed Concepts of Style

There is now little question that the radical innovation in Chinese painting represented by the *wen-jen* movement – begun by Chao Meng-fu [see 80, 81] and consolidated by the Four Great Masters, Huang Kung-wang, Ni Tsan [see 118], Wu Chen [see 109], and Wang Meng [see 111] – was the desire to change pictorial and realistic images into written and symbolic ones. The literati (*wen-jen*) were just that, men of the word – and in China this meant the word as written by calligraphic means. Realism, a prime concern of earlier painting and of certain early Yüan masters like Yen Hui [see 90] was "finessed" by the recognition that landscapes of the mind (and of calligraphy) could be a major concern of an in-group capable, above all, of recognizing integrity of brushwork based on the brush discipline required for the infinitely flexible and historically conscious presentation of calligraphic ideographs. To state the proposition baldly, if one could write well, one could paint well. The proposition is probably a half-truth: if one could write well *and* had a command of visual imagery, one could paint well – and so the best *wen-jen* did. Calligraphic brush discipline, however, was not an infallible passkey to artistic creativity. The unfortunate story of the late Yüan artist Chao Yüan may be more than a tale of imperial cruelty. Chao was executed by the founder of the Ming Dynasty, the Hung-wu emperor, ostensibly for his unsatisfactory renditions of portraits of past royalty. Was it because of the low-born emperor's preference for professional-artisan renderings of these traditional subjects? Or was it because an early *wen-jen* could not "do" figures? Short of seeing the paintings, we shall never know.

After the initial enthusiasm of its invention, *wen-jen* production is most uneven, particularly in late Ming and Ch'ing – indeed, the isolated and important work of Tung Ch'i-ch'ang in the early 1600s and that of the Four Individualists of late Ming and early Ch'ing – Kung Hsien, Chu Ta, K'un-ts'an, and Tao-chi – can be reasonably interpreted as a "pictorial" attack on the platitudes of what had become *wen-jen* orthodoxy. But the innovative stylistic initiative was with the *wen-jen* until the death of Wen Cheng-ming in 1559.

The literati painters, as conscious of the past as the more traditional artists, were particularly aware of the Yüan founding fathers. For example, Tu Ch'iung bowed in his title to Wang Meng [147] and in his execution to Huang Kung-wang; Shen Chou [in 148] paid homage to Wang Yüan [see 87]. Despite their dispositions, the literati painters conformed to traditional Chinese attitudes toward the past – attitudes mirrored by all artists, *wen-jen* or professional – when they considered what style might be appropriate for a given subject. Ch'en Ju-yen painted two quite different pictures [cf. 113, 114], almost inconceivably disparate unless one knows that *The Woodcutter of Mount Lo-fou* is a rustic subject appropriate to the wild, natural styles of Chü-jan [see 11] and Tung Yüan of the Five Dynasties period; while *The Land of Immortals* is a subject going even further back to the archaic blue-green-gold style of the Six Dynasties and

Figure 1. *Water Village*. Handscroll, ink on paper. Chao Meng-fu, 1254-1322, Yüan Dynasty. Palace Museum, Peking.

early T'ang. It is notable that the pure and revered Ni Tsan inscribed the *Immortals* scroll, a work far removed in appearance from the accepted *wen-jen* style of the late Yüan.

So, too, Ch'iu Ying displays different modes in *Saying Farewell at Hsün-yang* [164] and in *Chao Meng-fu Writing the "Heart" Sutra in Exchange for Tea* [165]. The former is in the blue-green-gold archaic landscape style associated with the T'ang era of the poet Po Chü-i, while the latter is a tour de force of the *pai-miao* (fine-line) style used by Chao Meng-fu but derived from the patron-saint of *wen-jen* figure painting, Li Lung-mien (Li Kung-lin) of the Northern Sung Dynasty. In later albums, such stylistic adjustments become just hints in the right direction, subtle allusions to the past while indulging in the untrammeled delights of the present.

The selection of styles, whether from current or past modes, was considered not only for treatment of certain subjects but also for appropriate response to particular social and political situations. Future study will undoubtedly unravel numerous threads in this fabric; within the present context we can only point to two specific examples. Chou Ch'en's scroll of *Beggars and Street Characters* [160] is an unusually specific appeal, in a Ming work, for consideration of the plight of the masses during a particularly difficult time of economic and social troubles. The tragic figures in the handscroll are depicted by means of an expressive and deliberately ragged use of the brush, one clearly indebted to a classical tradition of representing sages, immortals, and damned souls as bedraggled unfortunates or recluses in self-chosen rags of poverty. The most readily available tradition was that of Che-school figure painting [e.g., 130, 134], which in turn went back to late thirteenth-century artists specializing in Ch'an, Taoist, and secular subject matter [cf. 61, 91, 98].

Of course, Chou Ch'en was a professional painter with ready access to academic traditions, but his more typical works [158, 159] are certainly more restrained and less expressionistic than the *Beggars* scroll. What could be more suitable for social protest than visually equating the unfortunates of the years just before 1516 with those in the Buddhist hell scenes by the artisan painters of late Sung and Yüan?

The second example of the appropriate use of earlier styles for social comment is the more indirect but equally moving usage of archaism by that quirky representative of the late Ming official-gentry class, Ch'en Hung-shou [see 206-208]. Living during the rapidly declining power of Ming and the triumph of the foreign Manchus, and confronted with the suicides of at least five of his scholar-official friends, Ch'en only heightened his predeliction for the figural styles of much earlier, more glorious dynasties. Following the linear and fluttering drapery style of Ku K'ai-chih (d. ca. 406) and the wire-like delineation of grotesque Buddhist figures by Kuan-hsiu (832-912), he developed a masterful manner which upheld the moral virtues of the past as reproaches to the present.[18]

The general development of Chinese painting between 1350 and 1650 has been described often and variously. The orthodox Chinese interpretation, admittedly derived from firm positions assumed after 1600, sees a glorious development of *wen-jen* painting with a fitful accompaniment of professional or academic artists surfacing from time to time as they personally impinge upon the literati heroes. This tradition was either ignored or downgraded by early Western historians and critics until just before 1950 in favor of an analysis finding a gradual decline from the glories of Sung to the vapidities

of Ming and Ch'ing, always excepting precisely those few professional or academic masters who recalled earlier achievements. A more balanced position has been achieved in later years; but until very recent studies, the orthodox Chinese *wen-jen* position has been dominant in Western scholarship. Rumblings of a future reexamination of tradition are now discernible, for both Chinese and Western scholarship are under pressure from populist and Marxist movements in all historical studies. Thus, there are indications that the professional tradition, disdained by the *wen-jen* critics and theoreticians, is under reevaluation – and with good reason, since much of it requires re-study in its own right, regardless of ideology.

One can add little here to the most recent and successful critical histories of Chinese painting from late Yüan through the Ming Dynasty – those of James Cahill in the first two volumes of his projected history of later Chinese painting: *Hills Beyond a River* (1976) and *Parting at the Shore* (1978). The relatively even-handed treatment of professional and *wen-jen* artists in these studies is certainly excellent: what is offered here is intended only as a supplement to Cahill's arguments and perhaps as an indication of certain grand designs inherent in the historical drama of the main lines of development in both the literati and professional traditions.

We can begin with a crude, quantitative effort to place the Chinese accomplishment in painting from 1350 to 1650 in a European perspective. The most recent large-scale history of Western art[19] reproduces works by approximately seventy artists active in Italy, Spain, France, the Low Countries, and Germany during this period; while the two most widely used general surveys of Eastern art[20] both illustrate works by about twenty-five to twenty-seven Chinese artists. Clearly the level of

activity for major artists is at least even in East and West if we allow that European countries, with a population of about 100,000,000 in 1350 are matched against China alone with its population of 56,700,000 in 1391. We ignore the argument that a comparable number of names must be found to fill comparable chronological areas and a like number of printed pages. All we imply is that the artistic activity in both Europe and China was comparable, and that reasonably valid generalizations can be made for both.

The theoretical development of, first, the concept of the scholar-official-artist of the Sung Dynasty, and, second, of the *wen-jen* attitude has already been considered by Wai-kam Ho. It is important to stress the words "theoretical" and "concept," for it was this ideal, unmatched by any recognizable *wen-jen* style, that preceded the actual achievement of its pictorial embodiment. Briefly put, there is no clearly identifiable and unified literati style before Chao Meng-fu's *Water Village* handscroll (Figure 1) of 1302. This work stands with little visible support until 1350, when Huang Kung-wang completed his masterpiece, *Dwelling in the Fu-ch'un Mountains* (Figure 2), begun in 1347.

This latter scroll is important not only because of its subtle and complex aesthetic content, containing as it does in one part or another so many varying elements of what was to be late Yüan painting practice, but also because it subsequently belonged to the founder and leading master of the Wu school in middle Ming, Shen Chou, and hence was a crucial influence on him and his circle. Later owned by the late Ming theoretician and practitioner of *wen-jen* matters, Tung Ch'i-ch'ang, the *Fu-ch'un* scroll carries within its length of slightly over twenty-one feet a more complex and more tolerant vision of the past than was commonly assigned to it by

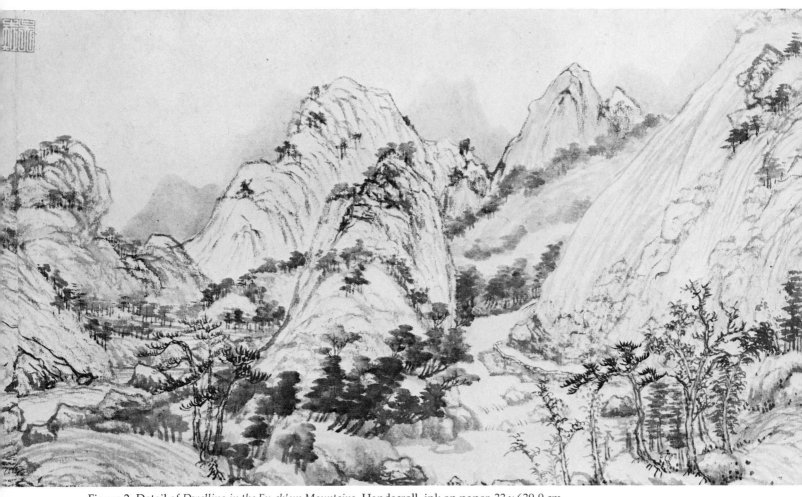

Figure 2. Detail of *Dwelling in the Fu-ch'un Mountains*. Handscroll, ink on paper, 33 x 639.9 cm. Huang Kung-wang, 1269-1354, Yüan Dynasty. National Palace Museum, Taipei.

later *wen-jen* critics and theorists. While it owes much to the early southern masters Tung Yüan and Chü-jan, there are northern elements present in its latter half, where the usually rich and complicated landscape views become sparser and level distance comes into view. Thus, one can find richly moist and complex parallels to the work of Wang Meng in the former passages and dry elegances like those of Ni Tsan in the latter passages. Indeed, almost all of the varied stylistic elements to be found among the literati at the end of Yüan [see 109-118] are imbedded at some point in the *Fu-ch'un* scroll. It would be too much to say that it or Huang influenced all of these masters in their ways, but it is not too much to suggest that by 1350 Huang Kung-wang was aware of the many possibilities within a now rapidly evolving *wen-jen* style and utilized most of them within the boundaries of his latest work, thus summarizing in lengthy form the state of literati painting in 1350.

What we witness between 1350 and the initiation of a revived Chinese dynasty in 1368 is a flowering of activity among the literati and a real variety of results that augured well for further development on many fronts and levels – even the hoary traditional one of "blue-and-green" landscape painting [see 113], virtually untouched by the literati since the beginning of the century in the work of Ch'ien Hsüan and Chao Meng-fu.

Unfortunately, this flourishing of numerous gardens was effectively blighted by the suspicions and persecutions of the Hung-wu emperor (r. 1368-98). What had begun so well about 1350 ended with almost all of the *wen-jen* artists executed or driven to suicide by 1385, with only Wang Fu [see 116, 117] remaining as a major practitioner after 1400. If we look then at the fifteenth century, we find a quantitative and qualitative dominance of all types of non-*wen-jen* painting – academics, professionals, artisans, specialists, and isolated recluse types; in short, only those who were dominant in the Southern Sung and early Yüan periods. This dominance diminishes somewhat in the sixteenth century, but the *wen-jen* is only slightly more important, and certainly far from being dominant. Thus, for the period 1400 to 1600, Cahill illustrates the work of thirty "traditional" masters as compared with paintings by only twelve *wen-jen*. Plainly the history of early Ming painting is not that of *wen-jen* works; it is one of the great virtues of Cahill's recent two volumes that the fashionable *wen-jen* imbalance of the last two decades has been redressed.

With Shen Chou [see 148-156], preceded by a very few isolated and rather conservative figures such as his mentors Tu Ch'iung and Liu Chüeh, the *wen-jen* style was re-created through an eclectic selection of models and a brilliant exploitation of brushwork increasingly indebted

to Wu Chen. Shen owned not only the *Fu-ch'un* hand-scroll but also works by Che school and other professional masters. He worked on a large scale as well as on the more intimate compositions characteristic of *wen-jen*. His dominant position in the Suchou area at the turn of the century was complete. From him and his artistic disciple Wen Cheng-ming [see 170-176] comes the whole of the Wu school, the sole significant manifestation of *wen-jen* painting during the Ming Dynasty before 1600.

The Wu school did not exist in splendid isolation from the burgeoning activity among the professionals in both Suchou and Hangchou. The interrelationships of such great masters as Chou Ch'en [see 158-160], T'ang Yin [see 161-163], and Ch'iu Ying [see 164-166] with the literati circles and wealthy patron groups of the area are well known. There was undoubtedly a wider freedom and exchange of ideas, both artistic and intellectual, than we have been prepared to accept. All were united in a relatively prosperous, developing secular society in a privileged geographic area. Poetry, the new secular drama, tales of mystery and imagination – all of this and much more must have given a sense of both unity and ferment to the period which we tend to distort by our overemphasis on separating the literatus from the professional.

Such a separation, motivated by a high moral sense of purpose and identity did occur – but not until the appearance of Tung Ch'i-ch'ang [see 190-192] at a time which coincided with the time of troubles that was to initiate the fall of Ming and the triumph of yet another foreign rule – an identity crisis of native subjection. The traditional viewpoint of the time, conservative and inclusive of both "academic" and literati traditions in all the arts, was exemplified by the famous and all-powerful Wang Shih-chen (1526-1590), President of the Southern Board of Justice.[21]

Tung Ch'i-ch'ang's solutions to both declining social and aesthetic forces depended much upon the study of the Southern school of Ch'an Buddhist thought with its "sudden enlightenment," the neo-Confucian moral concept of energy, a concept of transmission from the great early Sung landscapists through Yüan *wen-jen* to the present, and a thoroughly confident sense of being in the right in-group capable of a drastic reformation of increasingly moribund traditions – the tired and now-patronless Che school, and the small-scale, unambitious work of the followers of Wen Cheng-ming. With Tung was born the critical division of Northern and Southern schools of painting, the former retrograde and morally suspect, the latter defined by a rigidly orthodox lineage of *wen-jen* tradition – Wang Wei to Tung Yüan and Chü-jan, to the Four Great Masters of Yüan, and thence to Tung.

The designation "Four Great Masters of Yüan" is one example of the kind of modification and adjustment made by Tung to achieve his complicated balance.[22] The earliest such listing was a relatively casual statement of preference by Ni Tsan for Kao K'o-kung, Chao Meng-fu, Huang Kung-wang, and Wang Meng. This provides the linchpin, Huang, found on all later lists, supported by the early Yüan scholar-officials, Chao and Kao, with the addition of the most traditional and complex of the last Yüan *wen-jen*, Wang. The famous Wang Shih-chen opted for Chao, Huang, and Wang, adding the middle Yüan *wen-*

jen Wu Chen. The substitution of Wu for Kao is in the direction of full *wen-jen* recognition, but it is also sensible in view of Kao's limited technical repertory. T'u Lung (1542-1605) repeats Wang's list but adds, as almost as worthy, Ch'ien Hsüan, Ni Tsan, and Chao Yung (!). Tung Ch'i-ch'ang comes out flatly for Huang, Wu, Wang, and Ni – thus eliminating any trace of early Yüan or official success (Chao and Kao). His prescription is a moral one: the medicine is made up of the anti-foreign ingredients of a declining native dynasty. This is really what the *wen-jen* tradition is all about. Its strength, in late Yüan and late Ming, occurred in periods of declining official patronage; its weakness occurred during the stronger economic and political periods of early Yüan and early to middle Ming. It was a Chinese intellectual response to adversity. And Tung provided the climactic formulation that wove classic, orthodox, and retroactive styles into a general intellectual and moral proposition, thereby placing subsequent constraints upon the later history and criticism of Chinese painting. These constraints, not immediately acceptable or apparent, influenced the period from about 1600 to 1650 by bringing about an even more complex and spirited efflorescence of painting than that of the time of troubles at the end of the Yüan Dynasty.

The final decline of both Wu and Che schools was evident by 1600; the severe constrictions imposed by Tung Ch'i-ch'ang had, paradoxically, no particular means of domination until the unification of culture under a new foreign Manchu dynasty, the Ch'ing. The resulting vacuum in late Ming was filled by an extraordinary beehive of activity appropriately designated by most writers as "late Ming individualists" [cf. 195-209]. This veritable melting pot included the beginnings of Western influence, principally through engravings; the accommodation of "scholar" artists to the increasingly popular forms of woodblock printing; and the unabashed rummaging through all the art of the past, whether *wen-jen* or professional, for a point of departure into an unknown future. This future unfolded after 1650 through the official recognition of Tung Ch'i-ch'ang's criteria and the imperial triumph of the Four Wangs and their epigones, but was countered by continued resistance within a particularly anti-establishment tradition of genuine individualism [cf 264-273]. While the accomplishments of these post-1650 individualists is undeniable, they would have been unimaginable without the creative anarchy of the half-century before the founding of the Manchu dynasty in 1644.

1. Charles S. Gardner, *Chinese Traditional Historiography,* 2nd ed. rev. (Cambridge: Harvard University Press, 1961).

2. Harrie Vanderstappen, "Painters at the Early Ming Court (1368-1435) and the Problem of a Ming Painting Academy," *Monumenta Serica* xv (1956), 258-302; xvi (1957), 315-46.

3. The complexities of Ming court organization are demonstrated in Charles O. Hucker, "Governmental Organization of the Ming Dynasty," *Harvard Journal of Asiatic Studies* xxi (1958), 1-74, especially p. 60 for the *Chin-i-wei.*

4. See James Cahill, *Parting at the Shore: Chinese Painting of the Early and Middle Ming Dynasty, 1368-1580* (New York and Tokyo: Weatherhill, Inc., 1978), p. 201.

5. Fei Hsiao-tung, "Peasantry and Gentry: An Interpretation of Chinese Social Structure and its Changes," *American Journal of Sociology* lii, no. 1 (July 1946), 1-17.

6. See Ho Ping-ti, *The Ladder of Success in Imperial China: Aspects of Social Mobility, 1368-1911* (New York: John Wiley & Sons, 1962), especially chapter 6 for the academic dominance of the region.

7. The figures mentioned here are hardly definitive, but the implications are clear. All are based on the *Annotated Lists* in Osvald Sirén, *Chinese Painting: Leading Masters and Principles* (New York: Ronald Press, 1956-58), ii, 14-95 (T'ang, Five Dynasties, Sung); and vii, 97-466 (Yüan, Ming, Ch'ing), unless otherwise specified.

8. See Li Chu-tsing, "The Development of Painting in Soochow during the Yüan Dynasty," in *Proceedings of the International Symposium on Chinese Painting,* National Palace Museum, Republic of China, 1970 (Taipei: National Palace Museum, 1972), pp. 483-505; Marilyn and Shen Fu, *Studies in Connoisseurship: Chinese Paintings from the Arthur M. Sackler Collection,* exh. cat. (Princeton: Princeton University Press, 1973), especially part I: "Geography: The 'Eye Area' in Chinese Painting," 1-13; Shizuichi Shimomise, "Rekidai Shina gajin no shuseitei ni tsuite" [The birthplace of Chinese painters from all periods], *Gaisetsu,* nos. 28 and 31.

9. See the rather overtly pointed paragraphs on the Suchou bias in Richard Barnhart, "Yao Yen-ching, T'ing-mei, of Wu-hsing," *Artibus Asiae* xxxix, 2 (1977), 106-7.

10. Sherman E. Lee, *Chinese Landscape Painting,* 2nd ed. rev. (Cleveland: The Cleveland Museum of Art, 1962), no. 70.

11. Chou Liang-kung, *Tu-hua-lu,* epilogue 1673, *Hua-shih ts'ung-shu* ed., *ch.* 2, 22.

12. Osvald Sirén, *The Chinese on the Art of Painting: Translations and Comments* (Peking: H. Vetch, 1936), p. 168.

13. See, for example, the portraits of Shen Chou and Wen Cheng-ming in Richard Edwards, *The Art of Wen Cheng-ming (1470-1559),* exh. cat. (Ann Arbor: The University of Michigan Museum of Art, 1976), pp. 20-23. The way in which Wen is portrayed is not unlike the shading and line method seen in Ch'iu Ying's handscroll (cat. no. 166). It is essentially based on the line manner of Li Kung-lin with the earlier shading methods of early T'ang.

14. Sirén, *Masters and Principles,* vi, pl. 236: *A Cockfight in a Village* (now in The Art Museum, Princeton University).

15. The album of branches is inventoried in *Ku-kung shu-hua lu* [Catalogue of calligraphy and paintings in the Palace Museum], 2nd ed. rev. (Taipei: National Palace Museum, 1965), *ch.* 6, p. 10. Only the first six leaves seem authentic. The waves are published in *Sung Ma Yuan shui t'u* [Water paintings by Ma Yüan of the Sung Dynasty] (Peking: Wen wu Press, 1958).

16. The Wu Chen Album, *Twenty Studies of Bamboo,* is dated 1350 and is published in *Yüan-ssu ta-chia* [The Four Great Masters of the Yüan Dynasty], exh. cat. (Taipei: National Palace Museum, 1975), cat. no. 210: 1-20

17. Ni Tsan, *Bamboo,* album leaf, Freer Gallery of Art, Washington, D.C. Published: Wang Chi-ch'ien, "Ni Yun-lin chih hua" [The paintings of Ni Yün-lin] *National Palace Museum Quarterly* i, no. 3 (January 1967), pl. 25; Li Lin-ts'an, "Chung-kuo mo-chu hua-fa te tuan tai yen-chiu" [A study of Chinese ink bamboo painting], *National Palace Museum Quarterly* i, no. 4 (April 1967), pl. 16.

18. See Wen C. Fong, "Archaism as a 'Primitive' Style," in *Artists and Traditions: Uses of the Past in Chinese Culture,* ed. Christian F. Murck (Princeton: The Art Museum, Princeton University, 1976), pp. 101-9.

19. Frederick Hartt, *Art: A History of Painting, Sculpture, and Architecture* (New York: Harry N. Abrams, 1976).

20. Laurence Sickman and Alexander C. Soper, *The Art and Architecture of China,* The Pelican History of Art, ed. Nikolaus Pevsner, 3rd ed. (Harmondsworth, England: Penguin Books, 1968); Sherman E. Lee, *A History of Far Eastern Art,* rev. ed. (New York: Prentice-Hall and Harry N. Abrams, 1973).

21. See the discussion by Wai-kam Ho, "Tung Ch'i-ch'ang's New Orthodoxy and the Southern School Theory," in *Artists and Traditions,* especially pp. 117-29.

22. See *Yüan-ssu ta-chia,* p. 11.

Continuity and Change in Chinese Painting from 1650 to 1850

Marc F. Wilson

The fabric of Chinese painting is richer and more complex in the two centuries between 1650 and 1850 than at any other time. More painters produced more works, more of which have survived. Records about painters and paintings survive in abundance. Building on earlier theoretical concerns, the art of painting was subjected to thoroughgoing analyses. Concepts of subject matter, style, meaning, and even the process of art changed dramatically, but without severing links to the past. The status of the artist continued to be a burning issue. Professionalism and "professional" styles were denigrated, while the literary man's approach to painting was upheld. Many innovative masters relied on painting for their livelihood, whereas the literary man's painting became the officially sponsored academic style. The Chiang-nan region continued to be the seat of creativity, although some of its styles were practiced avidly in Peking. Patronage for the arts burgeoned, but the growth of huge imperial and princely collections undermined sources of inspiration for renewed creativity. "Orthodox" painters established schools and lineages, thereby forming a mainstream. "Individualists" were more innovative, and therefore made more history; but theirs is a history without tradition, without followers. Originality was seen as essential, but none would deny the authority of the past.

Much remains to be explored in this fascinating period of intense creativity, despite prodigious scholarly effort in the past several decades. The proximity to our own time assures that a substantial portion of the artistic output survives, thus allowing us to reconstruct the artistic careers of major artists more fully than is possible even for such prolific earlier Ming artists as Shen Chou (1427-1509; see [148-156]). The completeness of the record is characteristic of the period but does not properly begin with it. Like much else that is typical of early Ch'ing painting, this phenomenon carries over from the early decades of the seventeenth century, the waning days of the Ming Dynasty.

The artistic output during the Ch'ing period is staggering. Not only have a higher percentage of works survived, but painting witnessed a burgeoning number of practitioners – a trend motivated largely by the thoroughgoing acceptance during the seventeenth century of the ideal image of the elite scholar-gentleman. The image of the Confucian scholar had been perfected earlier, during the middle years of the Ming Dynasty, in Suchou by artists such as Shen Chou [see 148-156] and Wen Cheng-ming [see 170-176]. But it was during the Ch'ing period that the practice of these arts became institutionalized to a degree and magnitude that marked something new. No one with pretensions to refinement and a profound scholarly air could neglect cultivating those pastimes thought to be essential to personal development – poetry, calligraphy, music, and painting. The arts were integrated to a level never before realized. "Poetry clubs" sprouted up in unprecedented numbers. Gatherings of members brought together calligraphers, poets, and painters – usually under the sponsorship of a wealthy patron [e.g., 275]. And the best of the painters were almost always poets of some account.

For the Confucian scholar-gentleman who would paint, two things fostered his endeavor. One was the universal acceptance of the theory of literary-man's painting (wen-jen-hua), which had minimized the importance of elaborate technical training and had emphasized painting as a spontaneous means of expression and self-realization. The other was the publication of comprehensive, illustrated manuals on how to paint. Neither was new in the Ch'ing period, but what was new was the compulsion toward encyclopedic comprehensiveness and systematic unity.

Illustrated painting manuals had existed at least since the early fourteenth century. They were of limited scope, however, and did not become a major force in painting until late in the Ming Dynasty when the first part of the *Ten Bamboo Studio Manual on Calligraphy and Painting* was published in about 1627. It remains a modest endeavor when compared with the comprehensiveness of the *Mustard Seed Garden Manual of Painting,* published in two installments, in 1679 and 1701. Edited by Kung Hsien's pupil, Wang Kai (act. ca. 1677-1705; see [220]), this manual illustrates, through technically superb color and black-and-white printing, step-by-step instructions on how to paint every conceivable subject in the repertory of literary man's painting. From small rocks to mountain ranges, from twigs to forest groves – all are covered in essential detail. It is significant for the definition of literati painting and for the character of the epoch that stylistic type-forms associated with each hallowed ancient master are presented and dissected. Should you wish to paint a landscape in the style of Ni Tsan (1301-1374; see [110]), then turn to any one of several pages where his particular manner of painting rocks, trees, and mountains is presented. However, if your mood should incline toward

something a little less detached, a little less intellectually cool, the manual will guide you to the gratifying elegance of the literatus par excellence, Wen Cheng-ming.

The *Mustard Seed Garden Manual of Painting* proved to be a highly successful commercial venture: by the end of the dynasty it had gone through several editions. Had the manual (or one like it) never appeared, it remains doubtful whether more truly inventive artists would have arisen. The crux of talent and creativity lies ultimately with the character of the artist. There can be no doubt, however, that these manuals contributed to the proliferation of pictures and picture-makers. That most of the latter show no sign of having been touched by creative inspiration is to be expected. But what is surprising is the high level of technical accomplishment exhibited by these amateur painters.

Adding yet another dimension to Ch'ing Dynasty painting that is missing in earlier periods is the presence in works, names, and records of so many accomplished artisan-painters – those who plied their craft in portraiture [see 225, 258, 260, 262] or in exquisitely detailed accounts of literary gatherings [see 275] or imperial progresses. There has, of course, always been a need in China, as elsewhere, for portraiture and historical painting, but works of these kinds surviving from the Ming or earlier periods are relatively rare.

Further enriching the period from 1650 to 1850 is the prodigious amount of extant literature on painting and painters. At no other time in Chinese history had so much effort been expended on culling the past with an eye toward preserving the best, rearranging it, codifying it, and presenting it refreshed in systematic form. Much of what remains of earlier writing (no matter what the subject) survives in Ch'ing reprints or in those vast collectanea called *ts'ung-shu*. In the field of painting, scholars delved into obscure historical sources to illuminate the lives and works of ancient masters. This intense interest in the past spurred a sense of urgency to record the present, for we find a comparative wealth of accounts about contemporary activities in painting. Just as the number of painters grew remarkably during the period, so did the number of collectors. In keeping with the spirit of the times, collectors – whether prince or merchant – produced catalogues of their collections in far greater numbers than ever before, thus providing invaluable records for today's scholars.

Painters seemed compelled to theorize on painting – an impulse not resisted by connoisseurs, collectors, and critics. For many artists, the very constitution of painting as an art was a profoundly serious matter involving abstruse philosophical concepts. Other artists embodied their theories in the concrete form of sketchbooks, of which those of Kung Hsien (1618/19-1689; see [213-217]) have received greatest attention. With the mind of a technician, Kung systematically detailed how to paint trees, rocks, and the like for his students. He pointed out practical errors to be avoided and right ways to draw a motif.

Viewed in one way, the range of subject matter seen in early Ch'ing painting appears to perpetuate the repertory inherited from the Ming Dynasty and even, in certain respects, to expand it. But viewed another way, we sense that the very conception of what subject matter is, and what its role in the creative process should be, underwent profound change during the first century of the Ch'ing Dynasty.

Looking first to the simpler view of subject matter as the aggregation of natural motifs popular with painters of varying artistic complexion, those subjects reserved for the unequivocal professional – portraiture and historical narrative – witnessed a substantial growth in production. This is not to imply, however, that the status of this kind of subject matter in a hierarchy of artistic values enjoyed an upward reevaluation. If anything, it suffered further isolation from those acceptable currents of painting that were seen to advance the definition of art and make history.

In speaking of subject matter in Chinese painting, it must be noted that by the end of the seventeenth century, if not before, artistic conception and stylistic treatment counted far more than subject matter per se in evaluating a picture. There are two exceptional cases. One is iconic religious painting; the other is portraiture. Both had become so severely limited by the stylistic treatments deemed appropriate to them that they were not considered part of the mainstream of true art.

Attractive iconic Buddhist paintings were produced for temples newly built and remodelled under Manchu sponsorship, but such painting had long before ceased to engage the energies of creative artists. With the exception of the introduction of Sino-Tibetan stylistic elements and subject matter demanded by Lamaism (a form of Buddhism embraced by the new Manchu nobility), iconic religious painting leaned upon dry, lifeless formulae inherited from the Ming and Yüan dynasties.

Realistic portraiture occupies one extreme in a Ch'ing hierarchy of values in art. Since meticulous, labored techniques had become inalterably associated with it, it followed that the literati arbiters of value and taste, who saw in painting a means for spontaneous expression and self-realization, scorned it as being mere "craft." The status of its practitioners is not unlike the modern Western view of commercial illustrators.

Within the category of realistic portraiture, Mang-ku-li's *Portrait of Prince Kuo* [260] stands at one end of a spectrum balanced at the other by the Cleveland scroll of *Inauguration Portraits of Emperor Ch'ien-lung, the Empress, and the Eleven Imperial Consorts* [262], by the Italian Jesuit painter, Guiseppe Castiglione, and Chinese assistants. Mang-ku-li's portrait is informal. He built the structure of the sitter's face with finely applied color washes, and he labored over a minute rendering of the finely figured silk robe. The consistent variation of light and dark in the modelling of rocks and trees, which imbues them with a sense of plausible volume and texture, and the intent to depict the sitter realistically probably register the influence of European illusionism through Castiglione.

A more typical and traditional portrait is Ku Chien-lung's *Portrait of Ma Shih-chi* [255]. It is unlikely that Ku was influenced by European techniques. His portrait, nonetheless, shows an interest in realistic effects not seen in earlier portraiture; this in turn suggests that portraiture was ready for Castiglione's illusionistic representation.

Castiglione's scroll of imperial portraits is not a particularly poignant example of his way of bending traditional Chinese materials to the illusionistic rendition of traditional Chinese subjects. Because of the identity of the sitters and the occasion, these portraits are extremely formal and, therefore, are subject to the weight of conservative tradition. The starkness of the wide-eyed frontality and schematic disposition of the facial features endow the figures with an effigy-like quality reminiscent of the familiar ancestor portrait. For the Chinese, conveying the essential, permanent spirit of the sitter was the goal. This was not to be achieved by a faithful likeness of the outer flesh, but by revealing the inner *structure* of the physiognomy of the sitter. Behind this conception lay centuries-old physiognomic practices (*hsiang-fa*) rooted in Taoist theory. Another factor is the technical process wherein a "portrait" is constructed as a composite selected from a catalogue of facial features similar to "identi-kits" used in modern police work. This process undoubtedly influenced the Cleveland scroll of imperial portraits, since it is highly unlikely that the subjects would actually have "sat" for the painters.

The abstract treatment of the faces contrasts with the meticulously realistic depiction of the garments. Garments and accoutrements are often just as important in Chinese portraiture as the proper representation of the face, for it is through the garment and the symbols it bears that we recognize the status and role of the sitter. In China's traditional Confucian society, maintaining harmony through the observance of rank and relationship was among the greatest social values.

Consideration of the importance of the garment leads to another type of portraiture, one in which the character of the sitter is evident not only in his costume but also by his depicted activity and the setting – all of which establish class affiliation. Yü Chih-ting's *Kao Shih-ch'i Whiling away the Summer* [258] and *Portrait of An Ch'i* [259] by T'u Lo, Wang Hui, and Yang Chin are examples. The garments of both sitters identify them with the scholarly elite, a connection further affirmed by the garden setting in *Portrait of An Ch'i*. Kao is shown affecting the simple virtues of the rustic fisherman, but the coral knob atop his hat precludes mistaking him for a rustic simpleton. It announces his status as a powerful official of the first grade. It is indicative of the low esteem for the portraitist's craft that Wang Hui, Yang Chin, and Yü Chih-ting did not paint the figures but left the actual portraits to craftsmen whose names have barely been recorded.

In general, figure painting was disdained by most major artists during the period from 1650 to 1850. There are notable exceptions: Ch'en Hung-shou [see 207, 208], Huang Shen [see 269], and Lo P'ing [see 271-273]. But it is in the artistic conception and stylistic manipulations to which the motifs (the human figure) are subjected that the real meaning of their pictures resides. For Ch'en Hung-shou the aim is an astringent archaizing quality obtained through forceful, hard-edge abstraction and "iron-wire" drawing. For Huang Shen it matters not whether the ostensible subject is a bird or a human figure. In his hands they are vehicles for displays of energetic brushwork that test the limits of calligraphic control and press the boundaries between abstraction and recognition of the natural image. Lo P'ing, too, shows an interest in abstract forces found in rough brushwork, but with more attention to the tidy composition of these forces than is exhibited in Huang Shen's works.

More than ever before, painters tended to focus their creative energies on a single category of subject matter; and although some made perfectly successful forays into other subjects, we rightly associate each with a specific range of subject matter. There are few early Ch'ing painters who moved with ease and sustained creativity from landscape to flowers as did Shen Chou or Ch'en Shun [see 177-179] in the middle Ming.

Despite the existence of superb landscapes from the brush of Hua Yen [see 265] and, to a lesser extent, from Lo P'ing, the "Eight Eccentrics of Yangchou" are typified by bamboo, plum, flowers and birds, and animals. Daunted by the protean genius of the earlier master Tao-chi (Yüan-chi; see [238, 239]), Cheng Hsieh (1693-1765) retreated from a broad range of subject matter to a specialty in bamboo and orchids. The most numerous and typical of Chin Nung's works are his bamboo and plums [270]. For Wang Shih-shen it was a branch of plum [267] – spare, facile exercises in abstraction on a time-honored theme.

Although a high portion of the output of the Eight Eccentrics of Yangchou was devoted to subjects other than landscape, this was not characteristic of the age. Measured in terms of invention, it was landscape that commanded the field. The greatest of the Ch'ing orthodox painters and theorists, Wang Yüan-ch'i, could turn out a perfectly pleasant picture of *The Three Friends of Winter* [249]; but this picture has none of the heady encounter between the artist's need for creativity in the present and the authority of tradition – an encounter seen in his best landscapes [250-252], where orthodoxy verges on individualism.

Tao-chi, an individualist of consummate originality, frequently painted bamboo, plum, and pictures of vegetables. But in these we do not sense, as we do in his landscapes, that burning drive – perhaps compulsion – to invent new conceptual and stylistic modes that capture and mirror the generative forces of nature in a way that both makes us see mountains as never before and imposes a new perspective on the accomplishments of his predecessors.

At the risk of overstatement, there is perhaps one exception to the generalization that Ch'ing painters tended to concentrate their talents in a single category of subject. This was Chu Ta [see 235-237]. Taken in all ways, he was a true "eccentric" outside the norms of conformity and non-conformity. This applies to his personal behavior and to his art. No matter what the subject – flower, bird, rock, or landscape – all is, in the end, Chu Ta. Despite the extraordinary, somber worlds conjured up by Kung Hsien [see 213-217]; the awesome power of Tao-chi's conceptions of art; or the latent visions of nature overripe and disordered in K'un-ts'an's paintings [see 232, 233], these artists remain penetrable. We recognize their intent, and we perceive their meaning, however imperfectly.

Chu Ta's paintings may be subjected to formal analysis, and such features as distortion, spatial ambiguity, and kinetic roughness of brushwork are readily recognized. But Chu Ta's intent and meaning elude even the finest net. Terms such as "cryptic" and "enigmatic" become substitutes for understanding. His works form an extreme case in Chinese painting where the subject matter is not the subject and resemblance is not what it appears to be.

It is not unreasonable to ask why Chinese painters for centuries have predominantly, but not exclusively, invested their best creative talents in landscape painting. This remained true, especially in that long and robust reign titled K'ang-hsi (1662-1722). Experiments and solutions devised then charted courses in painting until the middle of the nineteenth century.

In landscape, the Chinese painter found an inexhaustible source for artistic experimentation and expression that embraced a gamut from persuasive naturalistic depiction [see 10], in which the landscape was the true subject, to arbitrary graphic structures, in which the construction of rhythmic forces of brushstrokes and of larger compositional elements counted far more than the elucidation of or comment on natural motifs as commonly observed.

Other subject matter – pines, plums, flowers, and animals – is bound by the specificity of the motif, which limits experimentation. Much of whatever potential these subjects possessed for artistic exploitation had been realized long before, in the Yüan and Ming Dynasties. Seen in perspective, the Yangchou painters' manipulations of these motifs [cf. 267-270] remain polite exercises in benignly eccentric stylistic effects. Often stunning, always pleasing, their pictures of bamboo, pine, or plum lack the conviction of a Li K'an [see 83] or the intense absorption with the profundity of art that marks a work by Tao-chi [see 238, 239].

It is in the landscape painting of the major masters of the late Ming and especially of the K'ang-hsi reign that we sense most clearly fundamental shifts in attitudes toward the very idea of subject matter and its role in the creative process. We commonly make distinctions among subject matter, meaning, and style, but these are not necessarily categorical or clear-cut. Separation is a matter of degree. It was the boundaries separating these concepts that eroded during the K'ang-hsi period as never before.

The everyday definition of subject matter as a motif taken from the natural or man-made world implies that there is an external, independent objective reality. Accordingly, a painting is an elucidation of or comment on some aspect of that objective world as perceived by the artist. One of the triumphs of early Ch'ing painting is that it severed the last link between the natural motif and the implied objective reality of that motif apart from its painted existence. The only reality in art became the painted reality; and to be successful, a painting had to compel the viewer to believe in the reality of its image, its vision. It is not that we cannot identify trees or rocks or streams. It is that they are mere vehicles no longer referring to a separate reality, or even to an a priori idea of tree, rock, and water.

This view of subject matter does not preclude effective symbolism. Kung Hsien's landscapes [213-219], for instance, are somber and devoid of human figures. We may justifiably view these traits as symbolizing his anguish over the fall of the Ming Dynasty to "barbarian" conquerors who, in his mind, had turned his native land to desolation.

The theoretical foundations on which these attitudes about subject matter and about the constitution of art rest may be traced ultimately to seminal ideas postulated by late Northern Sung painters. The immediate source, however, is found in Tung Ch'i-ch'ang's (1555-1636; see [190-192]) formulations, which were so pervasive that most theoretical writings of early Ch'ing painters are either offshoots from or responses to his ideas. One of his important propositions denies the correlation between physical appearances in nature and representation in painting. Carried to its logical conclusion, Tung's pronouncement implies that mimesis, as normally understood, is unrelated to the ultimate goal and process of painting as an art. Perhaps the most brilliantly insightful exposition of the relationship between nature and painting is Tao-chi's "Theory of the Primordial Line" (i-hua lun).[1] For Tao-chi it is the process of painting – as distinct from the resultant painted forms – and the laws inherent in each stage of the process that are analogous to the process and laws inherent in natural creation. The process of painting obeys its own laws, however. It neither copies nor distills the laws of natural creation; nor does it comment on them, but it is like them.

At this point, we have reached a theoretical foundation for pure abstraction; though, in fact, it is apparent from other of Tao-chi's writings that the idea of pure abstraction never really occurred to him. A number of paintings by Ch'ing "individualist" masters verge on pure abstraction. That they never made the final leap should probably be attributed to the authority of the past, which served to check aberrance in the present,[2] and to centuries-old traditions of calligraphy, which provided a ready outlet for residual impulses toward pure abstraction.

Given the above considerations, ideas, styles, and even art itself could, and did, become grist for the painter's genius in the Ch'ing period. Style, both one's own and that of another, appears as the subject matter with unprecedented prominence, especially among the "orthodox" masters. Commonly encountered is the album of multiple leaves, each leaf of which is acknowledged to be "in the style" of a certain approved old master.[3] In two scrolls [245, 247], Wang Hui acknowledges indebtedness to Wang Meng [see 111] and Huang Kung-wang (1269-1354). Wang Yüan-ch'i [see 250-251] claims inspiration from Huang Kung-wang, Ni Tsan [see 110], Hui-ch'ung (early 11th c.), and Chao Meng-fu [see 80, 81].

References to Ni Tsan's style in early Ch'ing painting provide the simplest example for understanding how style may be used as subject matter and symbol. Low-lying banks spreading horizontally in the foreground are separated by a broad passage of water from distant peaks appropriately diminished in scale. A cluster of tall trees in the foreground links the major compositional masses. The brushwork is spare, lean, and dry, imparting an over-

all impression of cool transparency. These are the essentials of Ni's style as grasped by early Ch'ing painters. The subject matter may be Ni's style (not rocks and water), but the meaning resides in the detached expressive quality, which, to the initiated, clearly symbolized the aloof dissent of the scholar-gentleman in the face of the fall of the Ming.

This kind of symbolic association accounts in part for the widespread use of the style at the beginning of the Ch'ing. The dry-brush technique associated with this style can yield similar symbolic meaning. Furthermore, the kinds of skills in brushwork needed to paint such a picture are just those learned in calligraphy. Calligraphic strokes carried a potential for abstract, graphic, rhythmic effects valued by Tung Ch'i-ch'ang and all major Ch'ing painters.

Wang Yüan-ch'i's use of the styles of Huang Kung-wang and Ni Tsan is a more complex matter. In *Green Peaks under Clear Sky after Huang Kung-wang* [250] a group of stylistic traits identify Huang Kung-wang's manner. They bear no overt symbolic meaning; rather, they embody, or are graphs of, Huang Kung-wang's innate perceptions, which Wang Yüan-ch'i transforms according to his own innate perceptions to make a new work of art. Again, the process is the crucial component. There is a fragile duet between Wang Yüan-ch'i, as he strives for creativity, and the ancient master as he is present in the style of his paintings. Wang's painting is inwardly directed: he is not aiming at an elucidation of Huang's art but at his own self-realization by communing with the mind of his predecessor.

The geographical distribution of activity in painting, patronage, and collecting retained many patterns familiar from the Ming Dynasty. Other changes occurred, some of which were to have dire consequences for creativity in Chinese painting as the period 1650 to 1850 unfolded.

The political capital continued to be Peking. As early as the T'ang Dynasty the economic heart of the nation had begun shifting southward. With it went education and artistic accomplishment, settling finally in a region known as Chiang-nan, an area south of the Yangtze River centering on Lake T'ai, with Suchou just to the east, and extending southward to the Ch'ien-t'ang and Fu-ch'un Rivers. By the end of the Ming Dynasty, Suchou's preeminence in painting had begun to decline. Inspiration faded from the works of its late Wu school followers, while other cities in the area arose to rival it with fresh artistic impulses that would have profound effect on painters of the early Ch'ing. Nanking, Sung-chiang, and Chia-hsing became centers of artistic ferment.

Despite the devastation wrought on many cities by the Manchu conquest, the Chiang-nan area rebounded quickly and became ever stronger. To those artistically prominent centers at the end of the Ming must be added a number of others whose increasing wealth spurred the patronage necessary for artistic vitality. In the eastern zone of the region, T'ai-ts'ang, Ch'ang-shu, and Yangchou became especially influential. To the west, cities in that part of Anhui south of the Yangtze produced a number of artists of originality, so much so that some are grouped into schools under such names as the Hsin-an school or the "Painters of Mt. Huang."

By expanding the geographical extent from the Lake T'ai area to include Mt. Huang and even further southwest to the city of Nanch'ang (where Chu Ta was born and passed the greater part of his life) the shape of this cradle of creativity resembles the human eye. The term "eye area" is a useful mnemonic device: it denotes the crucial importance of the area in fostering epoch-making originality in painting during the early Ch'ing.[4] It is not an exaggeration to claim that virtually every important innovation of the period in painting arose in the eye area.

Even styles of painting sponsored in the North at the court in Peking originated in the region around Lake T'ai. Peking as a center of artistic activity had become progressively moribund as the Ming Dynasty declined. Once the Manchu conquest of China was secure, resources could be directed toward rebuilding and refurbishing the palaces and government halls in Peking. The task of restoring Peking to the glory and finish befitting the newly won majesty of the Manchu rulers provided an enormous demand for pictures to decorate private quarters and state offices.

Unlike the Mongols, who had proved so "barbaric" when they conquered the Sung in the late thirteenth century, the Manchu embraced Chinese cultural values. Three early emperors were painters of some accomplishment, albeit at rather modest levels. In 1705 the orthodox literati painter and theorist Wang Yüan-ch'i was appointed by the K'ang-hsi emperor to supervise the compilation of the *P'ei-wen-chai shu-hua p'u*. Completed three years later, in 1708, it was the grandest compilation ever on Chinese painting and calligraphy. It remains a monument to Manchu determination to preserve and foster traditional Chinese culture.

In choosing the kind of painting to be sponsored by the court, Ming academic styles were not revived; rather, the court looked to the kind of painting espoused by China's traditional scholarly elite class – literati painting in the orthodox descent from Tung Ch'i-ch'ang through Wang Shih-min [see 240] and Wang Chien [see 241] to Wang Hui [see 244b-247] and Wang Yüan-ch'i [see 249-252].

Wang Yüan-ch'i was doubtless influential in the development of court tastes. He first served at the court in Peking in 1690, and in 1700 he was appointed to authenticate calligraphy and painting in the imperial collection. He was joined by Wang Hui in 1691, who stayed in Peking until 1698, when he returned to his home in Yü-shan in the South.

Wang Hui was the epitome of orthodox literati painting in the Ch'ing Dynasty. His formulations, which "synthesized" stylistic elements from approved ancient masters of the Sung and Yüan into prim graphic orders of rarified expressive restraint, became the dominant academic style at the court for the remainder of the dynasty. This strikes us today as an anomaly, because among the cardinal tenets of literati painting is the rejection of the notion that the true artist paints on demand. To do so would violate the contention that true painting results from a spontaneous, expressive outpouring. The influence of Wang Hui and Wang Yüan-ch'i on the formation of court patronage ended in the unprecedented alignment of literati painting with academic practices.

From our twentieth-century perspective, the orthodox literati styles of Wang Yüan-ch'i, and especially of Wang Hui, represent the conservative side of Ch'ing painting, whether practiced in the southern eye area or at the court in Peking. Peking had been and continued to be a bastion of conservatism in painting.

This conservatism carried over into collecting habits, which set the North apart from the South. The great private collectors of the North – Keng Chao-chung (1640-1686), Liang Ch'ing-piao (1620-1691), and An Ch'i (1683-ca. 1746) – almost exclusively favored ancient masterpieces from the Sung and Yüan dynasties.

The conservatism of the North is also evident in the contents of the imperial collection as formed by the late eighteenth century. Most types of pre-Ch'ing paintings are represented, but with a perceptible emphasis on masters and styles in the literati lineage. In the case of contemporary painting, the orthodox conservatives are amply represented. The only representation of forceful Chiang-nan individualist styles is confined to an isolated album.[5] The imperial collection grew to enormous proportions. The concentration of so many ancient masterpieces in a single, inaccessible collection deprived the Chinese painter of a source that had renewed his creativity for centuries.

In contrast to the conservatism of the North, southern collectors in the eye area not only sought ancient works but also patronized contemporary art. Their catholicity of taste may be attributed to the wealth of the area, to long traditions of avid interest in painting, and to the generally freer, less rigid social conditions that prevailed there. During the opening decades of the Ch'ing Dynasty, Nanking and Yangchou, for instance, provided environments congenial to artistic vitality. Kung Hsien moved back and forth between the two cities, spending long periods in each. So, too, did Tao-chi in his later years. Ch'eng Cheng-k'uei [see 231] settled in Nanking after an official career that served the fallen Ming and the Manchu. K'un-ts'an [see 232, 233] arrived in Nanking in 1654 and apparently felt no need to leave; he devoted the remainder of his life to painting and Buddhism.

Perhaps the most poignant example of patronage for contemporary painters is provided by Yangchou. The city had not enjoyed much of a reputation for cultural activity during the Ming. From the 1650s onward, however, it became a crossroads for painters and a point of exchange for new ideas in painting. It was in Yangchou that painters and poets from Anhui introduced the styles and landscape images of their region, particularly those of Hung-jen [see 225], to painters from Nanking. And influences went in the other direction, back to Anhui [see 223], through the agency of Yangchou.

While other cities began to decline as centers of creativity during the eighteenth century, Yangchou's steadily growing mercantile wealth continued to support facile eccentric stylists – the Eight Eccentrics of Yangchou [see 267-273] – and suave conservatives [see 275].

It must not be imagined that all masters working in the eye area came from that area; many were drawn there by its magnetic vitality. Of the Eight Eccentrics of Yangchou, less than half were natives of that city. Two of the eight, Wang Shih-shen [see 267] and Lo P'ing [see 271-273], came from Anhui; one, Huang Shen [see 269], was from Fuchien. Hua Yen, who was active in Yangchou from the 1730s onward, had moved there from Fuchien. Tao-chi came from Kuanghsi but passed his active years in the eye area. Hupei and Hunan contributed two of Nanking's individualists – Ch'eng Cheng-k'uei and K'un-ts'an.

The peripatetic life led by so many early Ch'ing painters is characteristic of the period and distinguishes it from much of the Ming. Middle Ming Suchou painters seem sedentary by comparison.

The phenomenon of moving from city to city contributed to the complex web of cross-influences that marks the careers of many painters. If we are to understand the painting of this period, it is not enough to limit the investigation to a particular artist's vertical relationships in time to the past. Lateral relationships with painters of his own time are equally or more important.

Since the eleventh century, the status and class affiliation of the painter have been matters of critical concern to the Chinese. For proponents of literati painting, the true artist and real talent could only arise within the scholarly elite. They were the wealthy landed gentry and the educated elite who staffed the politically powerful bureaucracy. Since painting was to be an expressive pastime – a form of communication between kindred spirits – it followed that the cultivated gentleman did not paint on demand or with commercial motives. He was to be the disinterested "amateur." In theory, his paintings were to be given to those who could appreciate them. Only "professionals" sold paintings; therefore, in this view, it was impossible for a professional to produce profound painting. Professionalism and elaborate technical skill were stigmatized. Since the literary elite provided the critics, wrote history, and held the reigns of political power and cultural dominance, their views prevailed.

Today, we might have dismissed the professional-amateur question had the Chinese not made such an issue of it. The matter was brought to a head by Tung Ch'i-ch'ang and has influenced the way we view Ch'ing painters.

Originally, there was no specific style, or even range of styles, identified with literati (or amateur) painting. There was an appreciation for calligraphic values in brushwork, for abstract graphic values in composition and depiction, and for reverting to the past for inspiration and to secure an "antique flavor" for one's own painting. The image of a specifically literary man's style began to coalesce in the Ming Dynasty around the practices of Shen Chou and Wen Cheng-ming. They and their followers found congenial sources for their own art in the painting of the Four Great Masters of the late Yüan – Wu Chen, Huang Kung-wang, Ni Tsan, and Wang Meng. But the situation was by no means rigid, and many different stylistic options remained viable.

Tung Ch'i-ch'ang fixed the correlation between the definition of acceptable painting – literati painting – and a specific range of stylistic types. These he drew from masters of the past in whom he saw a lineage that transmitted the best of all that was worthwhile in the heritage of Chinese painting.

We should expect, therefore, to be able to judge a painter's status and allegiances vis-a-vis professionalism by his style. Just the opposite proved to be the case in early Ch'ing painting. Excluding unequivocal professionals – portraitists principally – from consideration, professional painters abounded, and at the most creative levels of artistic invention. Nor were these professionals aligned with one artistic current or another. They may be found in all lines, from orthodox to individualist. They practiced their profession in the citadels of conservatism and in the heartland of individualism.

Simply put, a professional painter is one whose status and livelihood depend upon his painting. Viewed in this way, the prince of orthodox literati painting, Wang Hui, was a professional. So, too, was Kung Hsien, an individualist of intensely personal vision. For his entire adult life, Kung relied upon selling his poetry and painting and upon teaching painting to earn a living.

Tao-chi could lean on the monastic order of his Buddhist faith for lodging and food. When he left the order in about 1697, the bitter wind of secular necessity forced him to sell paintings. Other examples such as Yün Shou-p'ing [see 242-244a] could be cited, but these few suffice to demonstrate that there is no substantial correlation between style and professional practices in early Ch'ing painting.

Of course, true amateurs may be identified; but they are not amateurish in technical accomplishment or expressive originality. Mei Ch'ing's [see 228, 229] family was wealthy enough to allow him to indulge his interests in painting without thought of monetary recompense. The monastic vows of Chu Ta and K'un-ts'an sheltered them from commercial necessity. Cha Shih-piao [see 226, 227] is an ambiguous case. His family was wealthy enough to gain fame for its collection of antiquities; yet, it appears that he augmented his material well-being with commissions for painting and calligraphy.

Whether a painter was "professional" or "amateur," he remained part of the unitary elite that had characterized China for centuries.[6] When Kung Hsien complains of poverty, he does not mean that he is peasant poor, but only that he is at the lower end of the elevated economic spectrum enjoyed by that elite.

The Ch'ing mania for classification touched the grouping of painters of the period. Some classifications are meaningless, such as the "Four Monks." This refers to Hung-jen, K'un-ts'an, Chu Ta, and Tao-chi. There is nothing inherently monkish about their personal styles. And only between Hung-jen and Tao-chi can stylistic links be identified.

Regional or school designations are more useful, for they help organize a complex mass of material; but these are not without limitations. The Eight Eccentrics of Yangchou share common characteristics – most notably, a calculated, facile approach to eccentric brushwork and composition. By the middle of the eighteenth century, eccentric styles in Yangchou had become glib and eminently fashionable. Eccentricity had turned into a kind of orthodoxy.

It is meaningful, despite qualifications, to speak of an Anhui school [see 222-230] in general, and to use the term

"Four Masters of Hsin-an" to refer to Sun I, Hung-jen, Wang Chih-jui, and Cha Shih-piao. All are indebted to Ni Tsan. All share preferences for tree types, moss dotting, and a particular geometric arrangement of architectural elements. They prefer lean, usually dry, brushstrokes for major outlines. The interiors of major mountain masses tend to be sparely modelled, leaving broad areas of pale, smooth surface.

In Nanking we see more diversity, less of the cohesiveness we associate with the idea of a school. Kung Hsien has been wrongly included in the Eight Masters of Nanking.[7] As originally listed, the group shows a degree of homogeneity. They share preferences for compositional types; for effects of luminosity; for pale washes and elegant, transparent tree groupings. Lyricism imbues most of their works. But diversity is evident in the number of painters who defy ready classification. K'un-ts'an and his friend, Ch'eng Cheng-k'uei, are called individualists. Although stylistic affinities and influences may be pointed out, they remained, like Kung Hsien, truly independent – and without artistic posterity.

Other classificatory terms indicate clear-cut schools and lineages. The Yü-shan school refers to the followers of Wang Hui. Within his own family nine generations perpetuated his manner.[8] Lou-tung refers to the host of painters who cranked out pictures in the style of Wang Yüan-ch'i: there were over a thousand of them.[9]

In 1635 the Manchu Khan, Abahai (1592-1643), announced the Ch'ing Dynasty, proclaimed himself emperor, and sent armies to invade China and Korea. Korea was subdued within two years. Peking fell in 1644, as did Nanking in the next year.

Dynastic change has always been viewed as a catastrophic event in China. That the native Ming Dynasty should fall to alien "barbarians" was unthinkable. China's elite owed allegiance to the Ming. Suddenly they had become individually and severally culpable for the fall. For many young men who later became prominent painters and poets, the anguish of one's own moral culpability was made all the more urgent by having participated in reform societies that had sought to reverse the obvious decline of the Ming. They had failed. Many were overcome by a sense of futility, a feeling of helplessness to change the forces of history and avert catastrophe. Cultural preeminence clearly did not assure political sovereignty.

Claims have been made for the influence of the fall of the Ming on the course of Ch'ing painting. Precedents suggest that the very fact of dynastic change (whether from internal rebellion or external invasion) releases forces that send men into eremitic retreat, diverting their energies from traditional public service to personal cultivation through the pursuit of the arts. That the collapse was precipitated by barbarian conquest made these forces all the more grave and undoubtedly impelled more men to seek refuge in art.

There is no perceptible pattern of relationship between a painter's political and social responses to the conquest and the style he adopted. His agony, if deeply felt, might have spurred him to seek new stylistic modes to express his anguish, but in the end, stylistic solutions must come

from art – not from politics. Ni Tsan's style, widely employed at the beginning of the Ch'ing to symbolize the aloof dissent of the scholar-gentleman, had already been growing in popularity by the end of the Ming Dynasty; its symbolic meaning had existed long before the conquest.

In responding to the new alien rule, one had to weigh the consequences carefully. At stake were one's life, family, and even city. For Tao-chi and Chu Ta, who were scions of the Ming imperial family, dynastic change jeopardized their very lives. A life of wandering or adoption of monastic vows announced one's withdrawal from the world of politics and denied any threat to the new order. Tao-chi continued to deny his social and political heritage until the last decade of his life, when he seems to have renewed his pride in being a prince of the fallen house. By then, safety was no longer a question. The new dynasty was secure: Manchu and Chinese had learned to live with one another, if not like each other.

Many Ming loyalists sought solace, or even escape, in spiritual transcendence. A renewed interest in religion is characteristic of the post-conquest decades. Some took Buddhist monastic vows. Others would not go so far, but, like Kung Hsien, developed a deep interest in Taoism. The orthodox painter Wu Li [see 248] strikes us as being an extreme case. Having tried Buddhism, he eventually embraced Christianity and became a Roman Catholic priest. Retirement from the world, in whatever form, meant purification.

The examples of Yün Shou-p'ing [see 242-244a] and Ch'eng Cheng-k'uei [see 231], among others, demonstrate that correlations do not exist between style, or artistic outlook, and response to dynastic change. Yün's father engaged in anti-Manchu activity; consequently, Yün refused to seek office under the Manchu. However, the style of his works aligns him unequivocally with orthodoxy. Ch'eng Cheng-k'uei apparently had fewer qualms about dynastic change. He served both Ming and Manchu, and yet practiced eccentricity in painting.

Whether orthodox or individualist, all subscribed to certain values in art. Belief in the intrinsic value of art was assumed. Nor did anyone question the notions that true art could only come from a person of the right intellectual and class background and that it could only be understood by a kindred spirit. All accepted the proposition that the fundamental purpose of painting was self-expression and self-realization. All inherited Tung Ch'i-ch'ang's emphasis on an overall, ordered structure that would imbue a composition with force and monumentality. Calligraphic values in brushwork and abstract animation in the application of ink were exploited. All were intensely concerned with the process of painting and with the contention that painted forms have their own reality. And all recognized the need for creativity, and rejected slavish imitation of the past.

At this point the orthodox and individualist parted company. The orthodox painter placed rules before inspiration, stability before instability, calm before excitement. The individualist inverted the emphasis. Neither one denied the value of heritage and the power of the past to judge the present. The individualist, however, gave primacy to his own creative powers and independence. For the orthodox painter, it was impossible not to rely on ancient masters for inspiration and understanding. From the ancients and their solutions could come one's own awakening and self-realization.

No matter what orthodox theory maintained, the primacy of pedigree and the practice of confirming one's own artistic worth by adhering to an approved lineage ultimately stifled creativity in orthodox schools. Had the Ming never fallen to the Ch'ing, it still seems likely that orthodox painting would have followed the course it did.

Originality in individualist approaches to painting inherently provided no means for perpetuating itself, precisely because it depended for success solely upon the character and inspiration of the individual artist. Both withered in the benign embrace of fashionability. Some expressive visions seen in paintings by individualists of the K'ang-hsi reign might have occurred without dynastic change. It is unlikely, however, that the historical configuration would have been the same, or that the intensity would have been so compelling. Perhaps the best that can be said about dynastic change is that it releases talent and *may* foster ferment and experimentation in art.

By the middle of the nineteenth century the creative avenues in painting laid out during the K'ang-hsi reign had reached a dead end. New interests appeared, and new styles arose. Subject matter that had lain dormant or that had been eclipsed by landscape became the stuff of new vitality; and different cities played host to originality. Together with the revolution of the industrial world, these changes built a framework for modern Chinese painting on the foundations of the past.

1. The most complete exposition of the theory appears in Ju-hsi Chou, "In Quest of the Primordial Line: The Genesis and Content of Tao-chi's *Hua-yü-lu*" (Ph.D. diss., Princeton University, 1970).

2. F.W. Mote, "The Arts and the 'Theorizing Mode' of Civilization," in *Artists and Traditions: Uses of the Past in Chinese Culture*, ed. Christian F. Murck (Princeton: The Art Museum, Princeton University, 1976), pp. 3-8.

3. Max Loehr, "Art-Historical Art: One Aspect of Ch'ing Painting," *Oriental Art* XVI, no. 1 (Spring 1970), 35.

4. Marilyn and Shen Fu, *Studies in Connoisseurship: Chinese Painting from the Arthur M. Sackler Collection*, exh. cat. (Princeton: Princeton University Press, 1973), pp. 2-13.

5. *Ku-kung shu-hua lu* [Catalogue of calligraphy and paintings in the Palace Museum], 2nd ed. rev. (Taipei: National Palace Museum, 1965), *ch.* 6, pp. 273-81.

6. Mote, '"Theorizing Mode,'" in *Artists and Traditions*.

7. William Ding-yee Wu, "Kung Hsien" (Ph.D. diss., Princeton University, 1979), pp. 20-22.

8. Chu-tsing Li, *A Thousand Peaks and Myriad Ravines* (Ascona: Artibus Asiae, 1974), I, 163.

9. Ibid., p. 152.

10. Wen C. Fong, "Orthodoxy and Change in Early-Ch'ing Landscape Painting," *Oriental Art* XVI, no. 1 (Spring 1970), 38-44.

Catalogue

The sequence of paintings in the catalogue (indicated here by catalogue numbers rather than by page numbers) is not precisely chronological. The following divisions, however imperfect they may be, reflect the rationale for the organization of the catalogue:

Notes to the Reader

Catalogue entries and translated material are followed by the initials of the authors:

Wai-kam Ho	WKH
Henry Kleinhenz	HK
Sherman E. Lee	SEL
Ling-yun Shih Liu	LYSL
Elinor Pearlstein	EP
Howard Rogers	HR
Laurence Sickman	LS
Marc F. Wilson	MFW
Kwan-shut Wong	KSW

In a few instances translations were used which appeared in earlier publications; in those cases the translators are credited individually.

Catalogue Format

1. When known, the artist's surname, personal name, and dates are followed by his *tzu* (*t.*) and *hao* (*h.*). The *tzu* is a courtesy name used socially; the *hao* is a style or studio name chosen by the artist for signatures and seals. The *hao* may allude to the artist's hometown, ancestral home, or a literary quotation. The best-known *hao* have been selected for artists who adopted numerous studio names.

2. Unless otherwise noted, the artist's home and center of activity are the same. Place names cited, whether contemporary with the artist or current, are those most likely to be familiar to Western readers. For some cities of special historical importance, both old and modern names are given—e.g., Ch'angan (Hsian). Modern names appear on the maps.

3. The Chinese painting title may be the one inscribed on the painting, or as recorded in literature or assigned by the catalogue authors (depending on the painting's history and its subject matter).

4. The painting formats distinguished are: hanging scroll, handscroll, album leaf, and folding fan. A hanging scroll stretched over a wooden frame (tablet mounting) is designated as paneled. Album leaves include pictures designed for, or shaped like, stiff-leaf fans, as well as pictures originally mounted as a single leaf. Dimensions of the painting surface, exclusive of the mounting, are given in centimeters; height precedes width.

5. Documentation by the artist precedes that by owners and beholders, who are listed in chronological order. Inscriptions refer to calligraphy written on the painting surface. Colophons refer to calligraphy written on any component part of the mounting, except for the frontispiece title which is identified separately. Literal transcription of seals follows [seal].

6. A selective list of sources where the painting is recorded or published appears under *Literature*. The list is chronological, with the earliest edition being cited for books with successive editions; however, only the current *Handbook* is cited for the Cleveland Museum and the Nelson Gallery. Here, and in *Remarks*, articles and books are cited in shortened form: author's last name (if two with the same name, first name is added); abbreviated title; date (year of publication, date of preface, or century of authorship—whichever most accurately places the source in history); citation, including *chüan* (*ch.*). Full references, including editions for Chinese collectanea (*ts'ung-shu*), are cited in the *Bibliography*. Abbreviations for *ts'ung-shu* and special shortened forms for frequently used sources are listed at the front of the *Bibliography*.

7. Under *Exhibitions*, published catalogues are cited in shortened form; full references appear in the *Bibliography*. For exhibitions with multiple showings and catalogues in different languages, only the initial sponsoring museum and its accompanying catalogue are listed.

8. *Recent provenance* refers to twentieth-century owners as well as earlier Japanese collectors who did not affix seals on the painting.

Romanization

Chinese: The romanization of Chinese characters follows the modified Wade-Giles system of Mathews' *Chinese-English Dictionary*, omitting the retroflex and maintaining the umlaut *ü*, except in names of provinces. This system applies to all place names except those for which the Post Office system is universally familiar: Peking, Tientsin, Nanking, Canton, Taipei, Yangtze.

Provinces and cities are hyphenated only in romanized publication titles; in the text they are spelled as one word. Compound names of all other geographic divisions and topographic features are hyphenated, with or without their generic suffixes: -chou (prefecture), -hsien (county), -hsia (gorge), -hu (lake), etc. Thus Suchou and Hangchou refer to cities, Shou-chou refers to an old prefecture, and Fu-chou to a modern district; Huainan refers to a city, and Chiang-nan to the Yangtze Delta area. These distinctions have been observed wherever site-names could be identified in the literature, but with some inevitable inconsistencies.

Personal names appear in the traditional Chinese order: surname first, followed by the prename (usually hyphenated; e.g., Liu Kuan-tao). Emperors through the Yüan Dynasty are normally referred to by their posthumous temple titles, or *miao-hao* (e.g., Emperor Hui-tsung of Sung, or Sung Hui-tsung), and emperors of Ming and Ch'ing by their reign titles, or *nien-hao* (e.g., the Ch'ien-lung emperor of Ch'ing).

Japanese: The romanization of Japanese follows the modified Hepburn system of Kenkyusha's *New Japanese-English Dictionary*, maintaining the macron for long vowels whenever the character could be verified.

Personal names appear with the surname following the prename, except in those instances where pre-twentieth-century collectors' names were traditionally recorded with surname preceding prename.

Artist unknown, third–second century BC, late
 Chou, Ch'in, or early Han Dynasty

1 *The Hunt* and *The Kill*
 (Shou-lieh t'u)

 Painted clamshells *(Meretrex lusoria)*, each. approx.
 7.5 x 9 cm.

Remarks: Recent geological studies (1980) have con-
firmed that the species of marine clam to which these
shells belong is exclusive to the Western Pacific: China,
Japan, the Philippines, and the East Indies (M. J. Tevesz,
Cleveland State University, and J. Rosewater, Smithso-
nian Institution). If even remotely accurate, the dealer's
report of a Loyang, Honan, provenance suggests that
they had been carried from the east coast to north-
central China. Supportive evidence for the ornamental
use and burial of clamshells in this region appears in a
group of a different, but also oceanic, type, smeared
with red and pierced near the hinges, excavated from a
Western Chou tomb southeast of Loyang (Ho-nan
sheng, "Ho-nan-sheng Hsiang-hsien," 1977, p. 15 and
fig. 13).

 The outermost organic layer remains only in spots on
the exterior of both shells. Whether or not the interior
bowls were coated before painting could not be deter-
mined during successive cleanings in 1957 and 1963. The
original black and cinnabar earth pigments, too scarce
for analysis, are clearly distinct from neutral gray and
transparent red used to restore areas of dissolved color.
Most boundaries of representation are raised in slight
relief, which has prompted the question of whether the
negative ground was manipulated by hand or naturally
eroded around the pigments. At least two kinds of evi-
dence point to the first, and to carving: smooth contours
that run against the shells' natural strata (e.g., along the

top of the banner and bottom of the fourth horse in the
Hunt), and painted dots raised in relief above flat areas,
also painted, in the figures' garments. The theory of
deliberate carving presupposes meticulous skill in these
dots and other details revealed under high magnifica-
tion. It appears that only the broad, upper surface of
each bowl had been carved, but it is virtually impossible
to determine exactly where the carving stopped.

 While this medium and technique appear novel in ear-
ly Chinese painting history, the subject depicted is famil-
iar in a Chou, Ch'in, or Han Dynasty context. Both the
Shih-ching (Book of Poetry) and *Chou Li* (Institutes of
Chou) describe the chariot hunt as training for military
maneuvers, while the *Chan-kuo-ts'e* (Intrigues of the
Warring States) portrays it as a sport for imperial plea-
sure, anticipating the spirit of Han hunting parks
(Hayashi, "Sengoku jidai," pt. II, 1962, pp. 31, 32). Pas-
sages in the *Shih-ching* and *Chan-kuo-ts'e,* with imagery of
four-horse chariots decorated with banners and pen-
nons, seem relevant to both of the shells (Creel, *Origins
of Statecraft,* I, 1970, pp. 285, 286; Crump, trans., *Chan-
kuo Ts'e,* 1970, pp. 228, 229). Archaeological remains of
vehicles with two inside *(fu)* and two outside *(tsan)*
horses aligned abreast are pervasive in chariot pits dat-
able to the Western and Eastern Chou (Yang, "Chan-
che," 1977, pp. 82-90) as well as Ch'in (Shih-huang ling,
"Ch'in Shih-huang ling," 1978, figs. 1, 3). However,
these pits represent actual or simulated military forma-
tions, and Ch'in cannot be regarded as a terminal date
for this construction, since few chariot burials of any
kind postdate this period. Extensive study of early hunt-
ing costume, for everyday use and ritual ceremony,
would be required to identify the wide-sleeved gowns
and peaked or loop-tied caps of the charioteers and the
tunic and pants of the footmen.

1

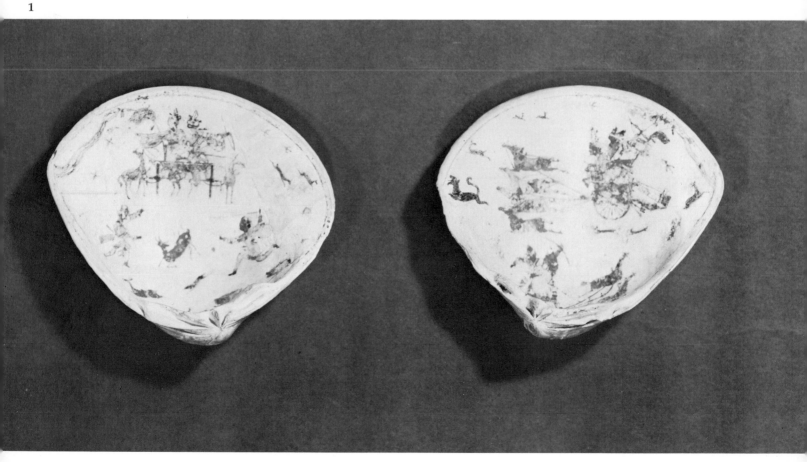

Compositional analogies to both the *Hunt* and *Kill* appear among the earliest evidence for Chinese representational art – pictorial bronze vessels decorated in flat relief or recessed inlay. These are two-dimensional, additive scenes with silhouette figures in profile or composite frontal-profile view superimposed to fill the allotted surface or zone. One scene of convincing authenticity encircles the shoulder of a *hu* vase in the Pillsbury Collection, The Minneapolis Institute of Arts: a four-horse chariot manned by a driver, and an archer clad in trailing scarf, followed by hunters on foot. More closely paralleling the *Hunt* are two-and four-horse chariots approaching each other on a *chien* basin, in the Freer Gallery of Art, Washington. In his comprehensive analysis of these bronzes, Charles Weber dates both vessels by external evidence within the second half of the fifth century BC (early Warring States) and accounts for the basin's more varied and natural depiction of human activity by the artistic progress of approximately one generation (Weber, "Chinese Pictorial Bronze Vessels," pt. III, 1967, p. 149, figs. 33, 47e; pt. IV, 1968, pp. 159, 160, 194, 195, figs. 57, 69f).

To what extent the shells' greater coherence and realism can be gauged chronologically can only be conjectured from their unique example. Tradition-bound vessel images most likely were based on paintings of freer and more progressive style (Lee, "Painted Shells," 1957, pp. 72, 73). Yet if the shells and vessels were contemporary, perhaps sharing a common derivation in full-scale murals, one would expect some reflection in the bronzes of these shells' more advanced arrangement of figures in space. Only around the periphery of each shell are motifs resembling the pictorial bronzes–animals in "flying-gallop" posture (forelegs extended forward and hindlegs backward) with either profile or reverted head. However, by adopting this posture as well, the *Hunt*'s two- and four-horse chariot teams are advanced from conceptual stereotypes in bronze, which consistently, if incongruously, show "running" chariot steeds with legs converged as if reclining, the one or two on the far side of the chariot shaft "floating" upside down (Weber, op. cit., pt. IV, 1968, pp. 208, 209, figs. 79yy-zz). The *Hunt*'s alternative – horses vertically aligned and overlapping slightly at the forelegs – is perceptual, if not yet visually convincing. This "bird's-eye view" had no apparent counterpart in early Chinese painting until the excavation in 1973-74 of a silk banner from Tomb 3 at Ma-wang-tui, Ch'angsha, Hunan, dated 168 BC. Depicted in an agricultural procession are chariots pulled by stationary and striding horses arranged in vertical rows of six-twelve deep, with recessive space between each horse indicated somewhat more successfully than on the shells by greater overlapping (Chin, "Tan Ch'angsha Ma-wang-tui," 1974, p. 41, pls. 1, 2). Two more naturalistic sytems – horizontal overlapping; and diagonal echelon, with horses and chariot wheels projected successively back at the same angle to establish a ground plane – are common to tomb paintings and reliefs of the second century AD. Their adoption as early as the second or first century BC is indicated by scattered objects of reputedly Western Han date, e.g., four-horse chariots painted on a bronze mirror from Shenhsi (*Chūka Jimmin Kyowakoku*, 1979, cat. no. 12) and a wood board from Kansu (Chang P'eng-ch'uan, "Ho-hsi ch'u-t'u," 1978, pp. 59, 60, fig. 6).

More ambitious are the frontal view of the chariot team in the *Kill*, and in both shells, the combination of human figures in frontal, three-quarter, and profile

view. Details such as the foreshortened shoulder of the driver at the top of the *Hunt* and the baggy open sleeve of the archer and spear-bearer in the *Kill* are especially telling of careful and direct observation. In the *Kill*, the more coherent of the two scenes, the footmen believably interact in front of the static chariot. The presence of their ground plane depends on one's interpretation of patches to the far right and left, which have been read as trees, and hence as settings which define middle distance (Lee, op. cit., p. 70, fig. 3b). Space and gravity are less certain in the *Kill*, particularly across the top where a beast and bird glide at equal height.

There remains the primary issue of dating. It is tempting, on the one hand, to project a chronological sequence of motifs such as the four-horse chariot and "insert" the shells between pictorial bronzes of the late fifth century BC and actual painting of the second and first centuries BC. On the other hand, these materials are still too diverse and scanty to assume steady progress. Han paintings excavated since the shells were first published as "third – second century BC" (ibid.) have yet to provide conclusive points of correspondence. Pending future discoveries, these shells still seem credible as painting that one might expect a master of that period to produce. Their clarity, liveliness, and organized picture surfaces all indicate a high level of artistic competence and imagination. EP

Literature
Lee, "Painted Shells" (1957).
Shih, "Pictorial Style" (1961), pp. 254-56; idem, "Arts of the Han" (1962), pp. 21, fig. 6 (reply, Lee, 1962, pp. 143, 144).
Hulsewe, "Early Chinese Culture" (1962), illus.
Sullivan, *Birth of Landscape Painting* (1962), p. 19.
Lee, *Far Eastern Art* (1964), color pl. 6.
Kodai Chūgoku (1967-), color pl. on p. 83.
Li Dun J., *Ageless Chinese* (1965), illus. p. 114.
Toynbee, *Half the World* (1973), p. 37, pl. 12 (color; *Hunt* only).
CMA *Handbook* (1978), p. 327 (*Kill* only).

Exhibitions
Vassar College Art Gallery, Poughkeepsie, New York, 1940: *Chinese Painting*, cat. nos. 1, 2, pl. 1.
Haus der Kunst, Munich, 1959: *1000 Jahre*, cat. no. 1 (*Hunt* only).
Asia House Gallery, New York, 1961: Trubner, *Arts of the Han*, cat. no. 85.
Smith College Museum of Art, Northampton, Mass., 1962: *Chinese Art*, cat. no. 1, pl. 1 (*Hunt* only).

Recent provenance: S. H. Minkenhof; Frank Caro.

The Cleveland Museum of Art 57.139, 57.141

Artist unknown, Western Han Dynasty
(206 BC – AD 9)

2 *Painted Bronze Jar*

Pien-hu type, 16.5 x 16 cm. max. width.

Remarks: The entire surface of the vessel, except the top of the lid ornamented with a quatrefoil in low relief, is painted with a rather thick pigment suggesting a lacquer-like substance. The colors are white, two shades of red, two shades of green, and black that is limited to thick, thread-like outlines. All the colors are much darkened, especially the white, and the design is worn in areas to the degree that the theme can only be determined with difficulty and under strong illumination.

The same subject, with minor variations, occupies both sides. A male figure with a moustache and a female with flowing hair are shown seated in three-quarters view facing one another. They appear to be seated on long,

oval mats that rest on cloud formations. A green rectangular object, possibly a *lien* wine vessel or a gaming board, is between the figures. On one side only there also appears a thin oval object, which may be a tray. Each of the facing figures holds up a green cup, as though they were toasting one another. The figure on the left holds the cup in the right hand, and, so that the raised arm will not interfere with the pattern, the opposite figure supports the cup in the left hand. That these personages are no ordinary mortals is made evident by the sweeping clouds that rise from the bottom of the vessel to the top and surround them. Painted in shades of green and red against a white ground, the clouds undulate in swirling S–curves of marked elegance and clearly indicate the cosmic nature of the setting. Identification of the scene is problematic, but it is tempting to suggest the myth of the Queen Mother of the West, Hsi-wang-mu, entertaining the Chou ruler, Mu Wang, on his western travels.

The great freedom and vitality in the painting of the clouds and the delicate drawing of the figures might place this painted bronze vessel somewhere in the second century BC, but a lack of comparative material makes even so broad a dating speculative. LS

Nelson Gallery-Atkins Museum 73-46
Gift of John M. Crawford, Jr.

Artist unknown, first century BC – AD first century,
Han Dynasty

3 *The Killing of Three Warriors with Two Peaches
(Erh t'ao sha san shih)*

Painted tile, black and red color on slip over gray
earthenware, 47 x 104.2 cm.

Remarks: That this painted surface is one face of a hollow tile appears likely from the back, which is roughly concave and unevenly thickened along the top and bottom edges. If the tile were intact, the space between this and the reverse face, probably stuffed with coarse material when shaped, would form an oblong perforation through both lateral sections. Hollow tiles were initially adopted for construction of underground tomb chambers in the late Warring States. Through the late Western Han and early Eastern Han, they were supplemented and gradually replaced by solid bricks (Bulling, "Hollow Tomb Tiles," 1965, pp. 7-17; Juliano, *Teng-hsien*, 1980, p. 16). Tiles also may have been used for structures above ground – important residential buildings (cf. Ch'in palace site, Ch'in-tu Hsien-yang, "I-hao Kung-tien," 1976, p. 19 and fig. 12) as well as towers and mortuary shrines, of which only stone examples survive. A tomb context for this tile still seems most probable.

Discoveries of painted tomb tiles, far scarcer than those with impressed decoration, are thus far concentrated in the well-explored area around Loyang, Honan. For many years, the closest stylistic analogy to this tile was the painted lintel and pediment in Boston, reputedly recovered from a tomb west of Loyang (Museum of Fine Arts, Boston, *Portfolio*, 1933, pls. 1-8), and dated by most Western scholars between the second and fourth centuries AD. This has been augmented by two composite brick-and-tile tombs excavated in 1957 and 1976 from the Loyang area: Tomb 61, of unknown ownership, reconstructed in Wang-ch'eng Park (Ho-nan sheng, "Lo-yang Hsi-Han," 1964, pp. 107-24; Chaves, "Han Painted Tomb," 1968, pp. 5-27) and the tomb of Pu Ch'ien-ch'iu

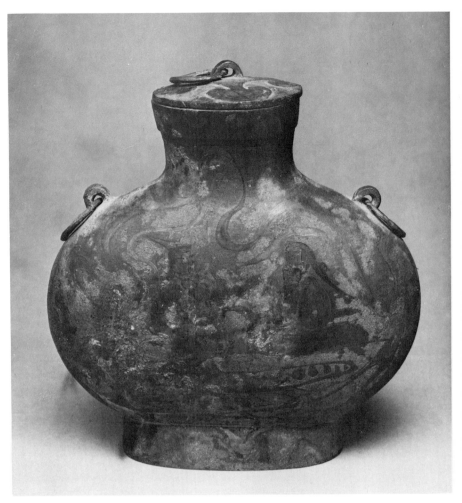

2

(Lo-yang, "Pu Ch'ien-ch'iu," 1977, pp. 1-12; Ch'en and Kung, "Pu Ch'ien-ch'iu," 1977, pp. 13-16). Both have been dated by excavation teams to the first century BC on the basis of construction and burial objects. In each tomb, hollow tiles resembling the Cleveland piece in their thick margins were painted with sections of a continuous frieze and aligned horizontally to form a ceiling under the pitched roof. However, their proportionately shorter widths and cosmological subjects deem unlikely a similar position for the Cleveland tile. What structural function this piece may have served has not been determined – it seems too tall for a lintel and too long for a pediment rectangle. Thus, it is problematic whether the painted composition was originally complete in itself or continued to the left and right on adjacent tiles.

The painting's effaced condition allows only general description. Pictorial space is defined by seven figures (an eighth to the far left?), one tree, and the fragmentary branches of a second. All of these elements appear to be original, except for the branches of the main tree, which floresce darker than the trunk under ultraviolet light and may have been reinforced. As far as can be seen, the figures, all male, wear robes with V-shaped collars and wide cuffs (one seems to have baggy pants) and several carry staffs or swords. These features signify aristocratic dress. The various hat brims, some clearly tied under the chin, may correspond to status distinctions prescribed in Han texts (Harada, *Kan Rikuchō*, 1967, English summary, pp. 23-25). While each figure is unique in stance and pose, two groups can be distinguished: Figures to the left of the tree are straightforwardly descriptive, sober and sedate in facial features and movements. Most robe outlines follow body contours, bunching realistically

around bent knees and enfolded arms. But what details remain of three figures to the right of the tree are animated on the verge of caricature. Their heads are disproportionately large, alternatively angular or rounded, with wide almond eyes set askew, and long, wiry moustaches and wispy tufts of beard. Sleeves and hems of the first and third figures are drawn in round, sweeping lines, billowing and flaring as if windblown. All seem to be caught in momentarily arrested action.

While narrative drama clearly unfolds, the plot has not been positively identified. Wai-kam Ho has suggested the theme of "Two Peaches Kill Three Warriors," traditionally set in the sixth century BC and relating Prime Minister Yen-tzu's deception of three court warriors before the Duke of Ch'i. The story of the warriors' successive suicides in competition for the peaches – presented to them as symbols of valor – has been extensively discussed in context of its depiction on the partition lintel of Tomb 61 (Kuo Mo-jo, "Lo-yang Han mu," 1964, p. 27; Chaves, op. cit., pp. 8-11; Bulling, "Historical Plays," 1967-68, pp. 21-25). Among stone reliefs datable to Han, it also appears at Wu Liang tz'u (Chavannes, *Mission*, I, 1909, pl. 127 – center), at similar shrines from Sung-shan in the same district of Shantung, (Chia-hsiang hsien, "Shan-tung," 1979, illus. p. 3, third stone), and at Nan-yang in Honan (Nagahiro, *Nanyō*, 1969, pl. 22). Although personalities were named in cartouche only at Wu Liang tz'u, a table or pedestal holding two round objects gives the cue to the story line at all four sites. On this tile it may have appeared in the disintegrated area before the man bending down and gesturing. He and the two other wild-eyed figures would then be the warriors. Among other depictions of "Two Peaches," which vary considerably, only the Tomb 61 mural includes a kneeling figure. Chaves interprets him to be Yen-tzu, arguing his case before the duke. However, unlike Tomb 61, the man next to "Yen-tzu" on this tile is not large and prominent as befits the duke's role.

Regardless of exact subject, it appears that the three figures to the right on this tile are true antagonists and that familiarity with comparable tales must have facilitated instant understanding of their actions. Literary records and extant works of art indicate that illustrations of political intrigue were pervasive in living quarters and mortuary shrines of the Han artistocracy. Along with historical portraits and morality tales, they demonstrated virtues and vices to be emulated or shunned. Artistic license evidently varied within this standard Confucian repertoire, but exaggeration was a common expressive device. The warriors' bulging eyes outlined in red are common also to the lintel of Tomb 61 and to a guardian-like figure painted on a pottery house in the Tenri Museum (Mizuno, *Kandai*, 1957, pl. 9 – right). Even on pictorial bronze mirrors, historical personages often are flamboyant, if not grotesque (Wang shih-lun, *Che-chiang*, 1957, pl. 10). Collectively, these agitated figures seem more stereotyped than believable in character.

The tree, by contrast, is extremely naturalistic in its asymmetry and fluent, unoutlined brushwork. Partly owing to this most advanced element, the tile has been dated to the late Han or early Six Dynasties, third – fifth centuries AD (Lee, *Chinese Landscape Painting*, 1962, no. 5). Since then, trees similar in concept but cruder in execution have been discovered on the tiles of Tomb 26 (Kuo Mo-jo, op. cit., color pl. 1) and of Pu Ch'ien-ch'iu's tomb (Ch'en and Kung, op. cit., pl. 3, tile 18).

In some opinions, these Loyang excavations have suggested a comparably early date for the Boston painting, in which lintel figures are more briskly drawn, more elegantly proportioned, and more subtly interactive than on the Cleveland tile. Yet this tile shares with the paintings in Boston and Loyang basic elements of large-scale figure composition, a combination of even and slightly modulated outlines, and certain facial details. The date of first century BC – first century AD recently

3

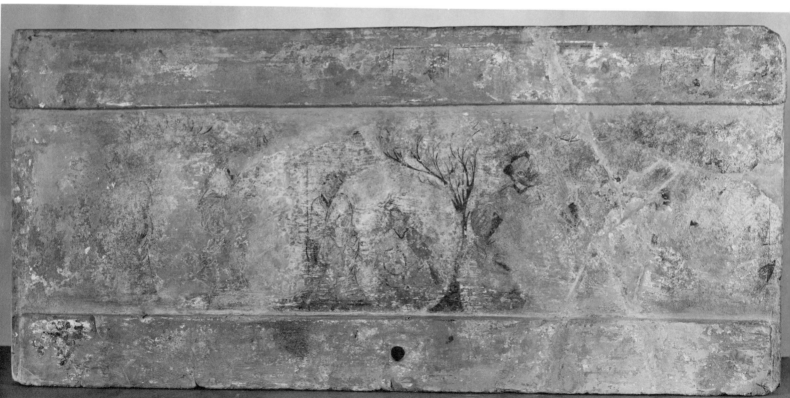

proposed for the Boston tiles (Fontein and Wu, *Unearthing*, 1973, pp. 99, 100) may also be surmised here. Since the tombs of the Han emperors have yet to be opened, one can only speculate about how this tile might compare with the most prestigious wall-painting commissions of its time. EP

Literature
Lee, *Chinese Landscape Painting* (1962), p. 13, pl. 5.
Sullivan, *Birth of Landscape Painting* (1962), p. 39, pl. 20.

Exhibitions
Cleveland Museum of Art, 1954: Lee, *Chinese Landscape Painting*, cat. no. 5.

The Cleveland Museum of Art 46.238

Artist unknown, ca. 525, Northern Wei Dynasty

4 *Two Sides and the Foot-Slab of a Stone Sarcophagus*

Engraved gray limestone, max. H. of sides 64 x 225 cm., of foot-slab 69 x 47.3 cm. (Only the rubbings are on exhibit.)

Remarks: The composition has been transferred from a cartoon onto slabs of smoothed, light gray limestone. All outlines and inner markings have been lightly cut into the stone with an engraving tool, and the background has been slightly cut away, or textured, by narrow chisel strokes. It is a technique perfected, so far as we know, in the first and second centuries during the Eastern Han Dynasty.

Each side slab is decorated with three illustrations (with identifying cartouches) to stories concerning paragons of filial piety. On the right side, from right to left, the cartouches read: The Filial Grandson Yüan Ku, The Son Kuo Chü, and The Son Shun. On the left side, from right to left, they read: The Son Tung Yung, The Son Ts'ai Shun, and *wei* (from Chü-wei, the familiar name of Wang Lin). This end of the left slab has been hastily finished, certainly with less skill than the preceding scenes. The slab that formed the head of the sarcophagus is lost. The design on the foot-slab is the Hsüan-wu (The Somber Warrior), a tortoise and serpent in combat surrounding a man holding a club or sheathed sword: the symbol of the North quadrant.

Although no specific date is firmly associated with the sarcophagus, the date suggested here is based on the costumes, the style of the landscape, the drawing, and particularly on the decorative borders which can be compared with dated monuments – especially funerary epitaphs from the Northern Wei Dynasty. There is reason to believe the sarcophagus may be associated with the epitaph, dated 522, of Lady Yüan, now in the Museum of Fine Arts, Boston. The cloud designs on the sides of the epitaph and those bordering the sarcophagus are not identical – nor should they necessarily be so – but a strong similarity of the basic cloud units and the rhythms of the drawing establish a close affinity between the two. In addition, there is the fact that within the relatively short period of some sixty to ninety days, both the epitaph of Lady Yüan and the sarcophagus

4 Right Side

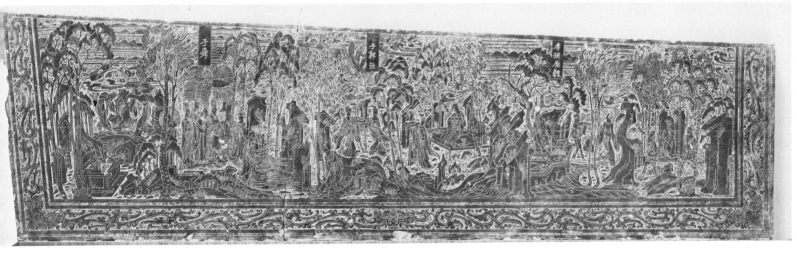

4 Left Side

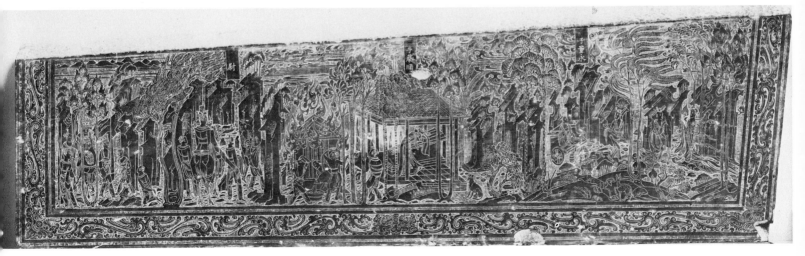

were in the hands of the same Peking dealer in antiquities.

It is improbable that the sophisticated composition and accomplished drawing on the sarcophagus originated with the artisans who prepared and engraved the stones. One must search elsewhere for the source of the design that lay behind the engraver's cartoon. Considering the two side slabs as a unit, there is good reason to believe that the composition was adapted from a horizontal scroll painting intended to be viewed from right to left. The narrative illustrations begin with Yüan Ku, his father, and his grandfather – all of whom enter from the right. The elaborate scenes of Shun and Tung Yung form a central, compositional climax, while in the scene of Wang Lin and the bandits at the extreme left, the final group of figures turns back, facing right, thereby making a satisfactory conclusion. Additional support for the supposition that the original composition was a handscroll is the fact that the character *hsiao* (filial) occurs only once, in the first cartouche at the extreme right, and is omitted to avoid redundance in all those that follow.

The presence in the composition of large bamboo shoots, a banana tree, and a gibbon suggest a southern origin in the Yangtze valley rather than in the area of the Northern Wei capital at Loyang in northern Honan. The Northern Wei rulers, in their desire to absorb all aspects of Chinese culture, drew heavily upon the rich heritage of the Han Chinese in the Southern courts. In 491, the Wei Emperor Kao-tsu sent Chang Shao-yu, who was both a painter and an architect, to the court of Southern Ch'i at Nanking to acquire ideas and inspiration for the palaces and embellishments of his new capital at Loyang. Also, as the Southern Ch'i began to disintegrate in the late 490s, under debauched and tyrannical rulers, a number of the ruling class and literati, probably painters among them, went north and took refuge in the Wei capital (Soper, "South Chinese Influence," 1960, pp. 47-107).

One of the significant aspects of these designs is the clear evidence of a fresh interest in the rich variety of nature, shown in the representation of a wide variety of identifiable trees – among them, the ginkgo, two or more varieties of pines, willow, catalpa, bamboo, banana, and the *wu-t'ung* tree. A feature of special interest is that throughout the design the trees have double trunks or trunks that bifurcate a short distance above the roots, while branches and leaves are intermingled. A similar treatment is observable on tomb bricks with pressed designs of a somewhat earlier date, toward the end of the fifth century, recovered in the neighborhood of Nanking. The design shows the Seven Sages of the Bamboo Grove plus Jung Ch'i-ch'i. Each sage is separated from his neighbor by tall trees, and here again the trunks are double or bifurcate just above the roots (Soper, "New Chinese Tomb Discovery," 1961, pp. 79-86).

That such double trees are neither fortuitous nor a mere device was brought to our attention by Wai-kam Ho. Several passages in Han Dynasty texts express the view that when the imperial virtue permeates all things, then the double trees, called *mu-lien-li*, will appear. Two such quotations must suffice here: "When the virtue of the ruler [imperial virtue] extends to the grasses and trees then the trees will [grow] conjoined" (*Po-hu-t'ung*, compiled by Pan Ku [1st c. AD], quoted in *T'ai-p'ing yü-lan*, completed 983, *ch*. 83, p. 3975). And again: "When the favor of imperial virtue is widely spread, then all will be as one family and trees will be conjoined. It is also said that if the ruler does not lose the affection of the people, trees will [grow] conjoined" (*Sun-shih Jui-ying-t'u*, quoted in op. cit., p. 3974.)

Considering that in Han Dynasty times the supreme imperial virtue was filial piety, it is clear that the double trees on the Nelson Gallery sarcophagus are in every way appropriate.

Yet another feature is the relative sophistication shown in the treatment of figures in relation to one another and their movements in three-dimensional space, indicative of the progress in representing credible recession and foreshortening since its beginnings in Eastern Han and Western Chin, that is, the first to the fourth centuries.

In the flowing, twisting scarves and drapery of the princess in the story of Shun, as well as in the garments of the weaving maiden in the Tung Yung scene, the tradition of Ku K'ai-chih (ca. 344-ca. 406), as seen in the *Admonitions* scroll (British Museum, London), is still alive. LS

Literature
Okamura, *Urinasu* (1939), pp. 259-300, illus. (reduction of the rubbings) opp. p. 259.
Soper, "Early Chinese Landscape Painting" (1941), pp. 141-64, figs, 19, 20.
Bachhofer, *Short History* (1944), pp. 96, 97, pl. 88.
Cohn, *Chinese Painting* (1948), p. 31, figs. 8, 9.
Soper, "Life-Motion" (1948), pp. 167-86, figs. 6, 7.
Munsterberg, *Landscape Painting* (1955), p. 17, pl. 3.
Sickman and Soper, *Art and Architecture* (1956), pp. 58, 59, pls. 52, 53.
Sirén, *Masters and Principles* (1956-58), I, 56-61; III, pls. 24-28.
Medley, "Certain Technical Aspects" (1959), pp. 26-28, figs. 8a, b.
Sullivan, *Introduction* (1961), p. 103, pl. 53; idem, *Birth of Landscape Painting* (1962), pp. 159-61, pls. 123-28.
Lee, *Far Eastern Art* (1964, 1973), p. 259, fig. 129.
Nagahiro, *Rokuchō jidai* (1969), pp. 181-84 (English summary pp. xxiii-xxv), pls. 37, 38.
Hayashi, "Tamamushi-no-zushi" (1971), pp. 16, 17.
Sullivan, *Arts of China* (1973), pp. 100, 101, fig. 74.
NG-AM Handbook (1973), II, 44.
Capon, *Art and Archaeology* (1977), p. 120, pl. 79.
Sullivan, *Symbols of Eternity* (1979), p. 35, fig. 20.
Watson, *L' Ancienne Chine* (1979), p. 405, pls. 337-39.

Exhibitions
Royal Academy of Arts, London, 1935/36: *Chinese Exhibition*, cat. no. 1273.
China House Gallery, New York, 1975/76: Juliano, *Art of the Six Dynasties*, cat. no. 48 (represented by rubbings from the original stones).

Nelson Gallery-Atkins Museum 33-1543/1,2,3

Ch'en Hung (attributed to), active K'ai-yüan era (713-742) – after 756, T'ang Dynasty
Born K'uai-chi, Chechiang Province, active at Ch'angan (Hsian), Shenhsi Province

5 *The Eight Noble Officials (Pa-kung-hsiang)*

Handscroll, ink, color, silver, and gold on silk, 25.2 x 82 cm.

5 inscriptions, 3 colophons, and 38 seals: 1 seal of Sung Hui-tsung (r. 1100-25); 2 seals of Huang Ssu (act. Ch'eng-hua era [1465-87]; 1 colophon and 1 seal of Wen Chia (1501-1581); 1 colophon and 2 seals of Chang Feng-i (1527-1613); 9 seals of Liang Ch'ing-piao (1620-1691); 1 colophon by Wang Chien and others, compilers of the *Shih-ch'ü pao-chi hsü-pien* (1793), with 2 seals of Tung Kao

(1740-1810); 6 seals of Yang Ch'ung-ying (act. Ch'ien-lung era [1736-95]); 9 seals of the Ch'ien-lung emperor (r. 1736-95); 1 seal of the Chia-ch'ing emperor (r. 1796-1820); 5 seals of the Hsüan-t'ung emperor (r. 1909-11).

Remarks: Identifying names written above the figures are: 1) Wang Chien, 2) unreadable because of damage, 3) Ts'ui Hung, 4) Kao Chiung, 5) Chang-sun Sung, and 6) Lo Chieh. The style of writing suggests that these names may have been added in Southern Sung times.

Wen Chia, in his colophon of 1579, states that the painting is by Ch'en Hung of the T'ang Dynasty and represents the Eight Noble Officials, whom he identifies as a group "directed [by the emperor] to sit at the right of the Chih-ch'e Gate and attend to confidential affairs of state" in the Shen-jui era (414-416) of Northern Wei. He gives four of the names written on the scroll as examples. He further states that "at the beginning and end of the scroll, at the juncture of the mounting are the small imperial seals of Hsüan [-ho] and Cheng [-ho]."

In the second colophon, Chang Feng-i, writing in 1596, praises the painting as a T'ang Dynasty work but points out that of the names on the painting not all are those of officials of Northern Wei. He takes Wen Chia to task for mentioning Kao Chiung among the Eight Noble Officials, when in fact he was a high official of the early Sui Dynasty.

The compilers of the *Shih-ch'ü pao-chi hsü-pien* also praise the painting as a "true antiquity of the T'ang Dynasty" and, like Chang Feng-i, are mainly concerned with the identity of the figures, pointing out that of the names then on the scroll, one was from the Southern Ch'i Dynasty, one from the Sui, and a third was in no way associated with the Eight Noble Officials of the Northern Wei Dynasty. They conclude that the names were written on the scroll by "some unlettered person" at an undetermined time.

Wen Chia's colophon states that the Hsüan-ho seal of Sung Hui-tsung was at the beginning of the scroll, complementing the Cheng-ho seal at the end. This first seal was lost, together with the first two figures, when the scroll was last remounted. The two seals, Huai-te t'ang and Ssu-li t'ai-chien Huang Ssu t'u-shu, are those of Huang Ssu (2nd half 15th c.), a powerful eunuch who owned a large collection.

The painting is in dilapidated condition. It appears that when the scroll was last remounted, probably in the seventeenth century for Liang Ch'ing-piao, the first two figures were beyond repair and were discarded together with what seals there may have been on the opening section. Of the first figure (originally the third) now at the opening of the scroll, only the head, hat, chest, and hands are original – the rest being a pastiche of original pieces and restoration. Although the background silk is badly worn, the other five figures are in good condition, with only minor retouchings. Considering the symmetry of the composition, it is safe to postulate that the missing two figures on the right were generals in armor, balancing the two at the extreme left.

The confusion in the identification of the officials has two possible explanations. One is that the names now on the scroll are for the most part incorrect, since only two are recorded as being among the Eight Officials of Northern Wei. Of the others, Wang Chien was a prime minister of Southern Ch'i, and Kao Chiung first served under Northern Chou and later became prime minister under the Sui Dynasty. In fact, all of the officials named, including the generals, became prime ministers at one

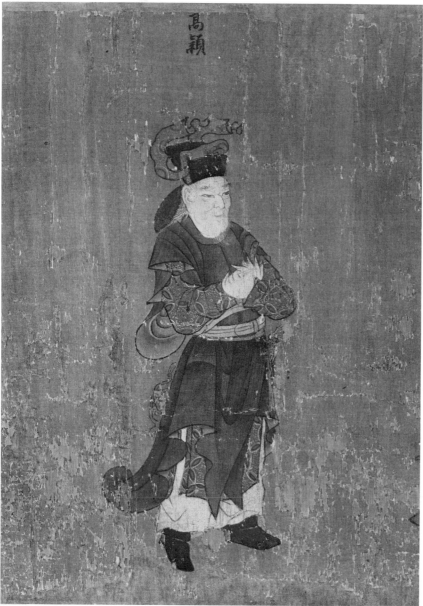

高顗

5 Detail

time or another during their careers. The second explanation is that Wen Chia was wrong in his identification, and the names are correct. The eight officials originally intended were eight prime ministers of the Northern and Southern Dynasties, with the Southern ministers facing left and the Northern ministers facing right. The attribution to Ch'en Hung cannot be affirmed any more than it can be denied. However, in an overall assessment of style, character of drawing, details of dress and accoutrements, color, and general presentation of the theme, there is nothing that would preclude a date near the middle of the eighth century and the time of T'ang Ming-huang. LS/KSW

Literature
Wu Ch'i-chen, *Shu hua chi* (ca. 1677), pp. 158-60, 607-8.
Shih ch'ü II (1793), *ch*. 52, pp. 175b, 176a.
Juan, *Shih-ch'ü sui-pi* (1842), *ch*. 1, pp. 10a-11a.
Sirén, *Masters and Principles* (1956-58), I, 139, 140; III, pl. 103.
NG-AM Handbook (1973), II, 47.
Wilson, "Vision" (1973), nos. 3, 4, pp. 228-30.

Recent provenance: Chang Nai-chi; Arthur Rothwell.

Nelson Gallery-Atkins Museum 49-40

8

Chou Fang (attributed to), active 766 – after 796, T'ang Dynasty
 t. Chung-lan, Ching-hsüan; from Ch'angan (Hsian), Shenhsi Province

6 *Palace Ladies Tuning the Lute*
 (*Kung-chi t'iao-ch'in t'u*)

Alternate title
Tuning the Lute and Drinking Tea
(*T'iao-ch'in cho-ming t'u*)

Handscroll, ink and color on silk, 28 x 75.3 cm.

1 inscription, 1 colophon, and 24 seals: 1 seal of the Shen-hsiao Library (early 12th c. ?); 1 inscription and 5 seals of Chang Ch'ien (late 13th-early 14th c.); 2 seals (one in black ink) of Chao Meng-fu (1254-1322); 1 seal of T'an Shen-hsin (late 17th c. ?); 2 seals of Liang Ch'ing-piao (1620-1691); 1 seal of Wang T'ing-ch'ien (early to mid-18th c.); 2 seals of Chang Ssu-k'o (act. 1750-60); 1 seal of Li Wen-kang (1762-1838?); 1 colophon and 4 seals of Ch'en Chung-pen (late 18th-early 19th c.); 2 seals of Liang Chang-chü (1775-1849); 1 seal of Huang Chü (d. 1860); 1 seal of Feng Kung-tu (d. 1948); 1 seal unidentified.

Remarks: The earliest seal, Shen-hsiao shu-fu, is that of a Taoist temple library. Emperor Sung Hui-tsung (r. 1100-25) ordered a large number of Taoist temples to be built bearing the name Shen-hsiao wan-shou kung (*Sung-shih*, compiled 1343-45, *ch*. 462; *Lin Ling-su*).

Only two characters, *ku-chai*, remain of the inscription of Chang Ch'ien. The single colophon, written by Ch'en Ch'ung-pen in 1805, has attached to it a copy of a poem by Li O (1692-1752), purportedly written for the painting when it belonged to Chang Ssu-k'o, two of whose seals are on the scroll. Ch'en states that he acquired the painting from the artist Lo P'ing (1733-1799) of Yang-chou. No seals of the latter, however, are on the painting.

The dates of Chou Fang's birth and death are unknown, and there is some uncertainty about the exact years of his activity. Sirén places them between 780 and 810 (*Masters and Principles*, 1956-58, II, 16) while Wang Po-min (*Chou Fang*, 1958, pp. 4-6), estimates that he was born about 740 and that his most active period would have been the thirty years between 766 and 796. He may well have been active for another decade, into the early years of the ninth century.

In his brief entry on Chou Fang, Chang Yen-yüan (in *Li-tai ming-hua chi*, completed 847) states that Chou rose to be lieutenant-governor of a province and devoted his art to those of wealth and position, avoiding any contact with rustic life. He began by imitating Chang Hsüan but later modified the style somewhat. His garments had a strong simplicity; his color, a gentle elegance (Acker, *T'ang and Pre-T'ang Texts*, 1954, II, pt. 1, 290). Chu Ching-hsüan (in *T'ang-ch'ao ming-hua lu*, early 840s) places Chou Fang in the inspired class, middle grade. He executed a number of Buddhist wall-paintings, also painted Taoist and Confucian themes and picture screens, and excelled in portraiture. In Chu's evaluation "the paintings he did of gentlewomen have been unsurpassed in any generation"; Chu concludes, "Chou's paintings of Buddhist icons, of Taoist immortals, of secular figure subjects in general, and of gentlewomen in particular, all belong to the inspired class. Only in his saddle horses, birds and beasts, plants and trees, and woodland rocks did he fail to realize completely their form" (Soper, "T'ang Ch'ao," 1958, pp. 210-12).

An interesting question arises about the origin of the composition, because an apparently identical theme and arrangement of five figures occurred in a painting with an earlier attribution to Chang Hsüan (act. 713-742), a celebrated figure painter at the court a generation before Chou Fang. The history of this painting can be traced with some confidence from the early twelfth century to the early eighteenth century. In Sung Hui-tsung's catalogue, *Hsüan-ho hua-p'u,* two scrolls are listed under the name of Chang Hsüan with the title of *Court Ladies Playing the Ch'in (Ku-ch'in shih-nü t'u; Hsüan-ho,* preface 1120, *ch.* 5, p. 6b). Subsequently, what was in all probability one of these scrolls passed into the hands of the Chin emperor Chang-tsung (r. 1190-1208), and from him to the notorious Southern Sung prime minister, Chia Ssu-tao (d. 1276). The painting then passed to Ch'iao Kuei-ch'eng (ca. late 13th c.) and then to Chuang Su (late 13th-early 14th c.), where it was seen by Chou Mi (1232-ca. 1298; Chou, *Yün-yen, ch. hsia,* p. 63). The painting was next heard of when Wu Ch'i-chen acquired it in 1636. He mentioned the seals of Chin Chang-tsung on the scroll and commented that the silk was in worn condition.

The most detailed description of the Chang Hsüan scroll is given in Wu Sheng's *Ta-kuan lu* (prefaces 1712). Since there are no references to the painting after Wu Sheng's, it may be assumed to have been worn out or lost. His entry (*ch.* 1, pp. 49, 50) reads, in part: "Chang Hsüan, *Ku-ch'in shih-nü t'u.* On yellow silk, 1 foot 1.3 inches high, 1 foot 8.3 inches wide. On the painting is a seven-character inscription written by Emperor Chang-tsung, *Chang Hsüan ku-ch'in shih-nü t'u.* Originally the painting was in the Hsüan-ho collection The painting is done in bright color with three ladies in palace garb six inches high [Wu Ch'i-chen says the figures are five to six inches tall]. One, seated on a flat stone, a lute across her knees, is tuning the string with the lute pegs. One lady is seated beneath a flowering [tree], facing the lute player and with a teacup in her hand, while another is seated turning slightly toward the lute player. There are two serving girls; one holds a tray of lute strings and the other, standing, holds a

teacup. All have full cheeks and are of ample proportions. The drapery is done in fine line of even thickness [*ch'un-t'an t'u-ssu*]. The rock is in outline with short shading strokes [*ts'un*] and without wash. The silk [of the painting] is broken and cracked, nevertheless it is worth preserving because of its value for research in antiquity.''

This description admirably fits the Nelson Gallery scroll. Although the title in the *Hsüan-ho hua-p'u* and that inscribed on the painting seen by Wu Sheng is *Ladies Playing the Ch'in,* it is clear from the description that the *ch'in* is being tuned (as in the Nelson scroll) rather than played. A striking difference, however, lies in the proportions of the two paintings; the Chang Hsüan version is only seven inches wider than high, while the Nelson scroll is much narrower in relation to its length. Even granting that the latter has been trimmed somewhat along both the upper and lower edges, it is difficult to envisage it being high enough to approach the proportions of that attributed to Chang Hsüan.

With scarcely half a dozen old paintings or relatively early copies of good quality surviving (all unsigned but attributed to one or the other of the two artists), it is not possible to distinguish with any confidence the distinctive styles of Chang Hsüan and Chou Fang. Since both artists were celebrated for their depiction of noble ladies and both worked at the T'ang imperial court and were scarcely a generation apart, it is conceivable that in the Yüan and Ming dynasties the two names were used almost interchangeably in assigning attributions to unsigned paintings of this kind.

Several versions of the composition are known. In one on silk, the figures are spread out at considerable distance one from another with the result that the important sense of intimacy is lost. It is not of high quality, judging from the reproductions, while two seals of Chang Ch'ien and one of Hsiang Yüan-pien are not convincing. The painting formerly belonged to Lo Chen-yü (1866-1940); however, its present whereabouts is unknown (see Lo, *Er-shih-chia,* 1918, pl. 1; *Tō-Sō-Gen-Min,* 1930, II, pl. 14). A version on silk with the signature and seal of Ch'iu Ying (ca. 1494/95-1552), formerly

6

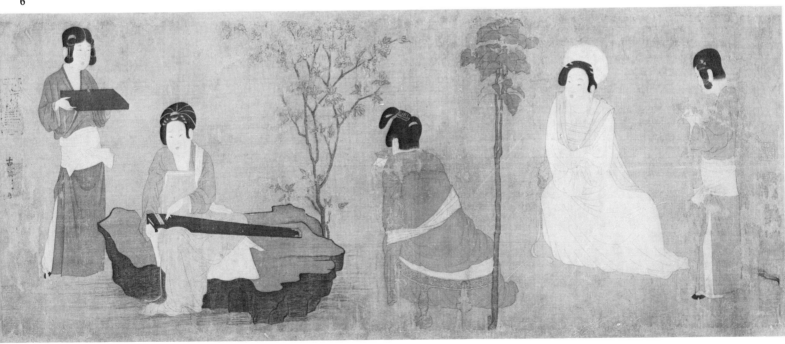

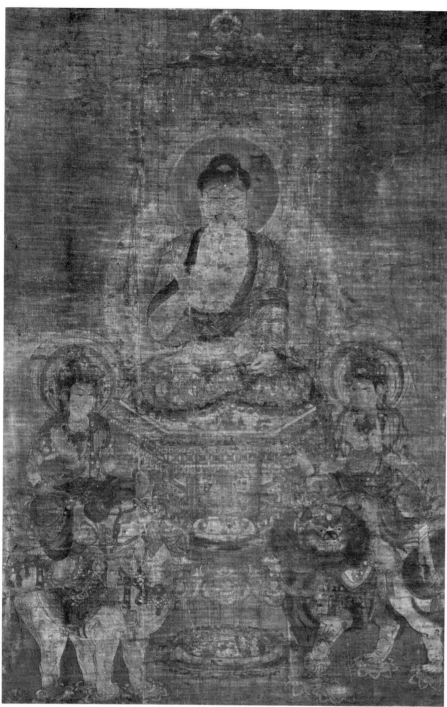

7

Lute and Drinking Tea (T'iao-ch'in cho-ming t'u). The painting, now apparently lost, carried a colophon by Mi Yu-jen (1072-1151), dated 1086, which cannot be right: Mi would have been only fourteen years old. Two seals of Chang Ch'ien apparently bear the same legend as two of the five on the Nelson scroll. This scroll, therefore, may well be a copy of the Nelson scroll.

Of all the versions of this well-known theme and composition, the Nelson Gallery scroll is by far the oldest as well as the best in quality.

LS/KSW

Literature
Sirén, *Early* (1933), I, 99,100.
Binyon, *Spirit of Man* (1935), pp. 77, 78, pl. 19.
Sirén, *Kinas Konst* (1943), pp. 241, 242, pl. 37b.
Cohn, *Chinese Painting* (1948), p. 54, fig. 20.
Cheng Chen-to, *Wei-ta-te* (1951-52), *ch. shang*, pls. 8, 9.
Sirén, *Masters and Principles* (1956-58), I, 143-48; III, pl. 110.
Wang Po-min, *Chou Fang* (1958), p. 11, figs. 3, 4.
Janson, ed., *Key Monuments* (1959), pl. 341.
Moskowitz, ed., *Great Drawings* (1962), IV, color pl. 881.
Lee, *Far Eastern Art* (1964, 1973), pp. 266-68, color pl. 22.
NG-AM Handbook (1973), II, 46.
Watson, *L'Ancienne Chine* (1979), p. 434, pl. 470.

Note: All reproductions in the above publications, except the last, were made before the painting was remounted in 1976 by Sanji Meguro.

Nelson Gallery-Atkins Museum 32-159/1

Artist unknown, ca. 900 AD, T'ang Dynasty

7 *Shakyamuni Triad: Buddha Attended by Manjushri and Samantabhadra*
(*Shih-chia san-tsun*)

Hanging scroll, ink and color on silk,
94 x 61.5 cm.

Remarks: This damaged and darkened hanging scroll executed on two strips of silk is one of the rare surviving early Chinese Buddhist paintings, other than those preserved in (and from) the cave-temple complexes of Tun-huang, Mai-ch'i-shan, and Wan-fo-hsia. It is also probably the earliest-surviving painted icon of what was to become a most popular type during the Sung and Yüan Dynasties in China and in medieval Japan – the historic Buddha, Shakyamuni, flanked by the attending bodhisattvas, Manjushri (Wen-shu in China, Monju in Japan) and Samantabhadra (P'u-hsien in China, Fugen in Japan), each on their vehicles, a lion and an elephant, respectively. Such portable Shaka trinities have hitherto been represented by the Sung examples, traditionally attributed to Chang Ssu-kung at Kencho-ji in Kanagawa-ken (*Chūgoku Sō Gen*, 1961, cat. no. 72) and the Yüan triptych in the Nison-in, Kyoto (Lee and Ho, *Yüan*, 1968, cat. no. 194).

The iconography is based on the *Avatamsaka Sūtra* and would seem to have appeared in mid- to late T'ang in connection with the Hua-yen sect. The later examples of Sung and Yüan seem connected with the South – especially the T'ien-t'ai sect in Chechiang. Whether a single combined image as here, or in triptych form, the icon was used in the "secret rite of the Lotus" (*Fa-hua-pi-fa*), involving confession and forgiveness. The bodhisattvas Wen-shu and Pu-hsien were particularly noted for their compassion and powers of intercession. P'u-hsien alone is represented as early as the late Six Dynasties period on a stone stele from Cave 133 at Mai-ch'i-shan (Sullivan, *Maichishan*, 1969, p. 37), and also singly at

in the Ueno collection and now in the Kyoto National Museum (mounted as a hanging scroll), is of some interest in that the proportions, 53 x 67.3 cm., approximate those of the version attributed to Chang Hsüan. It may just possibly be a copy of the scroll owned by Wu Ch'i-chen and described by Wu Sheng (Lo, op. cit., pl. 2).

A third version reproduced by Lo Chen-yü is one on paper by Kuan Hsi-ming (act. ca. 1770-85) of Chiangtu (Yangchou), done in 1775; it is close in proportions and figure arrangement to the Nelson scroll. Yet another copy in color on paper, close to the Nelson version and probably of the Ming period, is in the Freer Gallery of Art, Washington. In the imperial catalogue *Shih-ch'ü pao-chi hsü-pien* (1793), Yang-hsin-tien, under the name of Chou Fang a painting is listed with the title *Tuning the*

Horyu-ji about 710AD on Wall II of the Kondo (Naitō, *Hōryūji*, 1943, I, 105; II, pl. 28), where he is associated with Shaka's Paradise of the South. But the first surviving icon of the Shakyamuni triad appears to be the present one.

The date assigned here is ca. 900 AD, which puts the scroll into the late T'ang or early Five Dynasties period. This dating depends primarily on stylistic comparisons with earlier paintings of different subjects. The Sung examples are not at all germane – with their linear outlining; elaborate draperies with long, hanging folds and sashes; and their cooler color arrangements using much green and blue. In the Cleveland *Triad* red predominates; there is much shading in the tightly controlled draperies, and the smoothly curving lines delineating faces and limbs are cinnabar red, producing disappearing, and therefore more modelled, edges. The closest parallel to this *Triad* is the *Hokke Mandala* in the Museum of Fine Arts, Boston – in the svelte body types of the figures, and especially in the canopy above the Shakyamuni with its reverse scalloped edges, circular hanging valance, and lotus wheel suspended underneath the center of the camopy. The *Hokke Mandala*, previously tossed between T'ang and Tempyo in date, now seems secure in eighth-century Japan, reflecting T'ang models. The fierce, round-eyed lion vehicle and the elephant in the *Triad* are related to their counterparts on the walls of Tun-huang in Cave 159, dated to about 900 AD (Gray, *Tun-huang*, 1959, pls. 65, 66). One unusual, but not unique, feature of the *Triad* is the halo type on the two bodhisattvas – repeated circles, although not concentric – making the alternating bands of color narrower at the lower part of the halo than those above. This feature is conspicuous in the superb but fragmentary eighth-century bronze halo from the *Kannon Bosatsu* in the Nigatsudo of Tōdai-ji.

Nearly all of these parallels are considerably earlier than 900 AD, at the end of the T'ang Dynasty. But the imperial proscription of Buddhism in 845 was an effective, if temporary, barrier to the production of sophisticated Buddhist art during the middle years of the century. Also, the hair type of the Shakyamuni in the Cleveland painting seems related to those works found slightly later in the archaizing T'ang style popular in the early Liao reign in Manchuria. This prompts a more cautious assignment of a tentative date – ca. 900 AD. SEL

Literature
CMA *Handbook* (1978), illus. p. 331.

Recent provenance: Kinkichi Yamaoka.

The Cleveland Museum of Art 75.92

Artist unknown, late ninth-early tenth century, late T'ang to Five Dynasties

8 *Sketches on the Back of a Sutra Fragment*

Handscroll, from Tun-huang, Kansu Province, ink on paper, 22.1 x 141 cm.

Remarks: The paper on which the sketches are drawn is a fragment from *chüan* 2 of the *Mahāparinirvāna Sūtra*, first translated by Fa-hsien (act. ca. 399-422). The style of the calligraphy strongly suggests that the sutra was written in the sixth century. At some time the scroll was damaged, and the reverse side of a small section of the paper was then used by an amateur to practice drawing. The sketches reflect various periods and styles based on

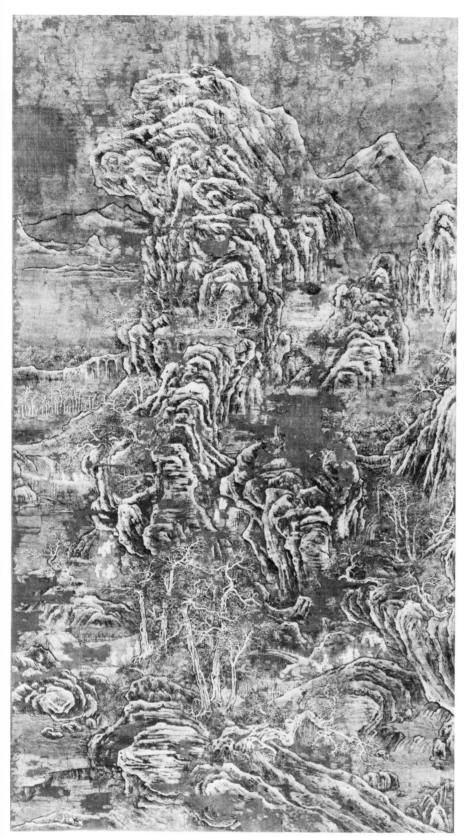

what the artist saw about him at the Buddhist cave-temples of Tun-huang, Kansu Province.

From right to left the sketches and approximate dates of subjects copied are: 1) Head of a male donor, T'ang Dynasty, eight century (?); 2) Standing bodhisattva, Six Dynasties to Sui, mid- to late sixth century; 3) Western Paradise of Amitābha with a trinity, a dancer, and musicians in an architectural setting, T'ang Dynasty; 4) Studies of eyes, two bodhisattva heads, two hands in *vitarka mūdra*, head of a male donor, and head of a guardian, T'ang Dynasty; 5) a buddha and a bodhisattva image, haloed and seated on pedestals – a small circle indicating the absence of hair curls just below the *ushnisha* indicates a date in the late ninth or early tenth century, the terminus ad quem for the execution of the sketches. LS

Literature
Sekai bijutsu zenshū (1928), VIII, 57.
Nihonga taisei (1931-34), XLIX, pl. 31.
Trubner, "Arts of the T'ang" (1959), pp. 147-52, fig. 4.
NG-AM Handbook (1959), p. 195.

Exhibitions
Los Angeles County Museum, 1957: Trubner, *Art of the T'ang*, cat. no. 23.
Philadelphia Museum, of Art, 1971: Ecke, *Chinese Calligraphy*, cat. no. 12.

Recent provenance: Toyozō Tanaka.

Nelson Gallery-Atkins Museum 51-78

Ching Hao, ca. 870-880 to ca. 935-940, Five Dynasties
t. Hao-jan, *h.* Hung-ku-tzu; from Ch'in-shui, Shenshi Province or the more general area of Ho-nei, north of the Yellow River, active at K'aifeng and T'ai-hang mountain area, Honan Province

9 *Travelers in Snow-Covered Mountains*

Hanging scroll (now paneled), ink, white pigment and slight color on silk, 136 x 75 cm.

Artist's signature: Hung-ku-tzu [Master of the Ku-hung Valley].

Remarks: Ching Hao, a celebrated landscape painter active in the first half of the tenth century, is also widely known as the author of an essay on the art of landscape, the *Pi-fa-chi*, translated by Kiyohiko Munakata (*Ching Hao's "Pi-fa-chi,"* 1974) as "A Note on the Art of the Brush." Munakata gives an account of the artist's life based on the brief biographical notes in Liu Tao-ch'un's *Wu-tai ming-hua pu-i* (preface 1060); Kuo Jo-hsü's *Tu-hua chien-wen chih* (ca. 1075); and information culled from Ching Hao's essay (ibid., appendix, pp. 50-56).

Ching Hao was born between 870 and 880, Munakata estimates, north of the Yellow River at Ch'in-shui in a general area known as Ho-nei, embracing southern Shanhsi and northwestern Honan. In his mid-twenties he painted a mural of Avalokiteśvara on Mt. Potalaka for a temple in K'aifeng, Honan. At the collapse of the T'ang Dynasty in 907, or shortly after, when Ching Hao was about thirty-five, he retired to the T'ai-hang mountains in Shanhsi and afterwards adopted the sobriquet Hung-ku-tzu, as in the signature on this painting. Munakata suggests that the *Pi-fa-chi* may have been written in about 925, when Ching would have been approximately sixty years old. Assuming that he lived several years longer, he may have died around 935 to 940.

It is clear from the statements in the *Pi-fa-chi* that Ching Hao was a master deeply concerned with the use of the

brush in a wide variety of strokes and of ink, especially ink washes, to model and define his forms. There can be little doubt about the originality and creative powers of Ching Hao as he sought innovative techniques in his quest for naturalism and similitude.

This painting of travelers in wintry mountains was recovered in the late 1930s, reportedly from a tomb in Shanhsi Province. It is in a tattered, fragmentary condition, with some areas missing altogether. It was rebacked by a painting-mounter in Peking in 1939 when, contrary to instructions, some restoration was done. Fortunately, the mounter limited his in-painting to strengthening the outlines in only a few areas and re-enforcing some of the figures with white pigment. Although regrettable, the retouchings are minor with two exceptions: one occurs at the top of the central mountain, on the right side where the restorer continued the line from the top of the peak on toward the right, joining it with the outline of the distant peak rather than continuing this strong outline down the right side of the central mountain; the second error occurs in the center of the composition where three small trees have been strengthened and a white line drawn below them, suggesting a small plateau which is not part of the original composition. The retouching is readable in a series of photographs made under ultraviolet fluorescence by Thomas Chase at the Freer Gallery. In its original condition the silk ground must have been considerably lighter in tone, so the extensive use of lead-white pigment would not be as stark nor the contrast so great as they are today.

From Ching Hao's *Pi-fa-chi* one gathers that in the definition of form and the texturing of surfaces he advocated fluid brushwork — broadening and thinning, turning, pausing, now slow, now swift — with all the variety of that used in the cursive style of calligraphy. The all-important ink wash was employed to model the forms, defining highlight and shadow, uniting and blending with the outline drawing and inner texturing so that they are muted.

In *Travelers in Snow-Covered Mountains*, what may be an early characteristic, among others, is the texturing method (*ts'un*) employed to show the weathering of rocks and to distinguish highlight from shadow. A great variety of brushstrokes are used — thin and thick, straight or wavering — together with numerous dots and dabs. It is evident that these strokes had not yet evolved into a consistent system, harmonious throughout, and susceptible to codification. The general method of modeling form in a somewhat sketchy manner with broad ink washes seems to evolve from techniques already present in the T'ang Dynasty, as may be seen in the mid-eighth-century landscape painted on a plectrum guard of a *biwa* preserved in the Shōsōin, Nara (Sullivan, *Symbols of Eternity*, 1979, pl. 28). A closer parallel may be found in the landscape background of a Buddhist painting, the *Hokkedō Kampon Mandala* of the late eighth to ninth century, now in the Museum of Fine Arts, Boston (*Portfolio*, 1933, pl. 30).

Another early manner is evident in the mountain masses and rock formations built up of overlapping forms — those in front separated from the larger shapes behind by the use of vegetation, texturing, or ink washes. The way such a device was used in the mid-eighth century is well illustrated by the decoration in gold and silver lacquer on a persimmon wood box preserved in the Shōsōin, Nara (*Shōsōin no kaiga*, 1968, pl. 102). In the Nelson Gallery painting there is sufficient repetition to insure continuity

and a unity of the whole with, at the same time, such gentle or abrupt changes in direction and thrust as are needed to give movement and animation in an organized, harmonious orchestration.

To point out only one additional detail for comparison, the trunks of the trees in the sparse background grove as well as the cypress overhanging the pool to the right are deeply furrowed with many knots and the trees "expose their winding roots out of the ground" (Munakata, op. cit., p. 39, note 47). The inner markings of the trunks are done with a variety of heavy or light, continuous, vertical brushstrokes. Such inner markings of tree trunks are well documented by the early eighth-century mural paintings in the tomb of Prince Chang-huai (*Han T'ang pi-hua*, 1974, pl. 72). A close parallel to the brushwork may be seen on a fragment of an eighth-ninth-century Buddhist silk banner depicting an ancient pine, recovered from eastern Turkistan by the Otani expedition (Sullivan, op. cit., pl. 30). The limbs of many of the trees are contorted, but the drawing itself is soft and flowing. This again reflects an archaic style that is as early as the persimmon wood box mentioned above, and that also may be found in the trees of the landscape background of the *Hokkedō Mandala* in Boston.

The overall impression is that of a painting done by a man innovative in his day, a highly accomplished artist in full command of the techniques available to him. At the same time, however, there are certain archaic elements. Basically, the forms still lack a convincing three-dimensionality; nor do the valleys and far-off hills recede into the distance as they will in the landscape paintings of a generation or so later. Equally archaic are the multiplicity of overlapping shapes and the ponderous overhang of the mountain crest. LS

Literature
Munsterberg, *Landscape Painting* (1955), p. 42, pl. 23.
Sirén, *Chinese on the Art* (1963), pl. iv.
Akiyama et al., *Chūgoku bijutsu* (1973), I, 217, pl. 1.
NG-AM Handbook (1973), II, 49.
Sofukawa, "Go-dai Hoku Sō" (1977), pp. 184-200, pl. 2.
Barnhart, Iriya, Nakada, *Tō Gen, Kyonen* (1977), pp. 18, 19, color pls. 12, 13.
Sullivan, *Symbols of Eternity* (1979), pl. 32; idem, *Sui and T'ang Landscape Painting* (1980), pp. 154-56, pls. 106-9.
Loehr, *Great Painters* (1980), pp. 85, 86, 90, fig. 43.

Nelson Gallery-Atkins Museum 40-15

Li Ch'eng (attributed to), 919-967, Sung Dynasty
t. Hsien-hsi, also known as Ying-ch'iu; from Ying-ch'iu, Shantung Province

10 *A Solitary Temple amid Clearing Peaks (Ch'ing-luan hsiao-ssu)*

Hanging scroll, ink and slight color on silk, 111.8 x 56 cm.

No artist's signature or seal.

16 seals: 1 reading "Shang-shu-sheng yin" (Northern Sung official seal, ca. 1083-1126); 4 of Liang Ch'ing-piao (1620-1691); 3 of Hsü Wei-jen (d. 1853); 2 of Shen Shu-yung (1832-1873); 5 of Lin Hsiung-kuang (d. 1971); 1 undeciperable (probably Northern Sung).

Remarks: Although Li Ch'eng was among the greatest Chinese masters of landscape painting, genuine works by him became extremely rare centuries ago. Today it is impossible to tell with any degree of certainty which, if any, of the paintings attributed to him are truly by him,

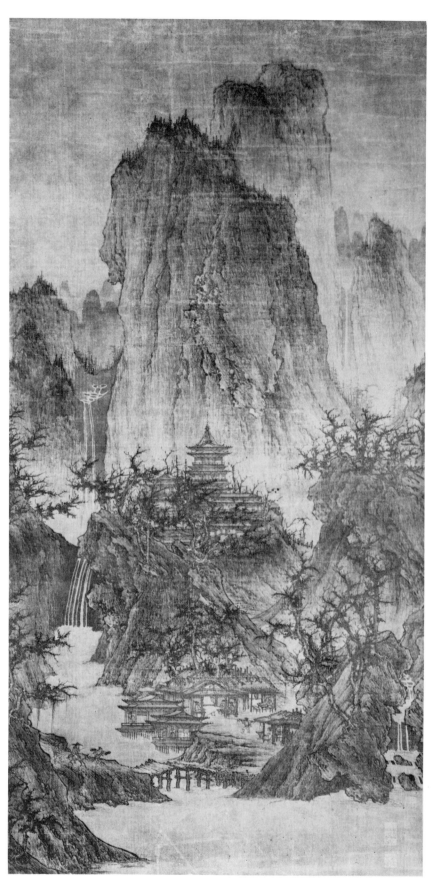

nor can the individual characteristic of his personal style be clearly defined. The well-known Northern Sung art historian Liu Tao-ch'un (ca. mid–11th c.) has described the style of Li Ch'eng's painting: "Within the piled-up peaks and mountains of his paintings, temples and villas appear; this is the best thing of his art. The dense or sparse trees and the deep and shallow streams are depicted as the real scenery" (Liu, *Sung-ch'ao,* 3rd qtr. 11th c., *ch.* 2, pp. 1, 2). Liu also mentioned a poem describing a Li Ch'eng painting as "High peaks, piled-up mountains, compete in their loftiness."

Another celebrated art historian of the mid-eleventh century, Kuo Jo-hsü, wrote of Li Ch'eng, in part, "In addition to being widely versed in the canonical books and histories, he was a most excellent painter of landscapes with wintry forests....There are still in existence pictures by [Ch'eng] representing *A Hazy View of Dawn, Wind and Rain,* landscapes of the four seasons, pine, cypress, winter forests, etc." (Soper, *Experiences,* 1951, p. 46).

Another painting attributed to Li Ch'eng, but in all likelihood an early copy of a scroll from the second half of the tenth century, is that published some years ago (Laufer, *T'ang, Sung, and Yüan Paintings,* 1924, pl. 11). The outlining, texturing, shading of rocks and trees, and the treatment of the small hamlet may be recognized as copying an original by the same hand as the Nelson Gallery landscape.

Technically, the Nelson Gallery scroll in the outlining of forms and texturing method is close to the great early-eleventh-century landscape *Travelers among Mountains and Streams* (Sirén, *Masters and Principles,* 1956-58, III, pl. 154) by Fan K'uan, although in the latter the brushwork is somewhat looser.

Few paintings better embody the achievements of early Northern Sung landscape painters. Not only is the landscape believable in its substance and solidity, but the artist has united his technical means and grammar to a conceptual foundation so sweeping in its sense of order and system that he is impelled to catalogue and to describe the subtlest nuances. Landscape painting, at this point, has overcome representational awkwardness and the "primitive" ornamentality of T'ang and early Five Dynasties painting but has not yet given way to the ornamental mannerism that imbues the works of twelfth-century and later painters working in conservative styles based upon those of the first century of the Sung. The number of major landscape elements is reduced to a few masses: each unit is isolated from its neighbors by atmospheric effects; by overlapping darker, nearer motifs on lighter, farther passages; and by shifts in the density and complexity of modelling strokes.

The outcropping of rock in the lower right foreground is just such a discrete unit. One of the idiosyncrasies of the artist is the opposition of a sharply tilted, flinty surface on one side to densely clustered, jagged rocks skirting the other. The combination produces an exceptionally convincing sense of volume and weight, enlivened by surface texture and detail that persuade the viewer of the reality of the fractured, granitic substance. The subtle variation in density of the interior modelling strokes (which here are called "rain-drop") and the sinewy, tensile outline srokes in dark ink are perfectly joined to thepurpose of naturalistic depiction. Neither is self-assertive at the expense of the other; they are interdependent.

10

Late tenth- and early eleventh-century landscape paintings of this general school reveal a technical process and sequence of strokes that echo a higher, controlling order that is preconceived in the mind of the artist.

The precision of the architectural drawing and the very prominence of the buildings, with their eaves seen from below, correspond to traditional descriptions of Li Ch'eng's manner, as do the meticulous fineness of the brushwork and ink and the shapes of the contorted, twisting trees, whose branches terminate in furcular patterns termed "crab-claw." It is important to note that the outlines of the trunks and the brushwork of the "crab-claw" branches not only are imbued with tensile muscularity but also are subtly animated by means of slight variations in width and elasticity. The artist has meticulously applied layers of brown and black ink, and irregular ink-wash strokes and finely drawn descriptive details complete the depiction. The rhythmic animation and naturalism of these trees leave the viewer with a conviction of their rightness, their "truth-to-self" (t'ien-chen). Despite the obvious energy seen in the trees, they retain a classical equipose void of all traces of the mannerism that begins to appear in paintings of this type at the end of the eleventh century.

There appear to be but two alternatives in identifying the style of Li Ch'eng. One is represented by *A Solitary Temple amid Clearing Peaks*. The other is best seen in a short handscroll in the Liaoning Provinical Museum entitled *Small Wintry Grove* (Hsiao han-lin; see *Liao-ning sheng po-wu-kuan*, 1962, I, 22). Both must antedate, not follow, Fan K'uan's masterpiece, *Travelers among Mountains and Streams*. LS/MFW

Literature

Shen Shu-yung, *Yang-hua-kuan* (before 1873), p. 105.
Munsterberg, *Landscape Painting* (1955), p. 36, pl. 16.
Sickman and Soper, *Art and Architecture* (1956), p. 107, pl. 86.
Sirén, *Masters and Principles* (1956-68), II, 199; III, pl. 151.
Grousset, *Chinese Art and Culture* (1959), pl. 42.
Cahill, *Chinese Painting* (1960), pp. 30, 32.
Sirén, *Chinese on the Art* (1963), pl. VII.
Horizon, Arts (1969), pp. 144, 145.
Barnhart, "Snowscape" (1970-71), fig. 5.
Akiyama et al., *Chūgoku bijutsu* (1973), I, 217, pl. 2.
NG-AM Handbook (1973), II, 50.
Wilson, "Vision" (1973), no. 1, pp. 226, 227.
K. Suzuki, *Ri Tō* (1974), pp. 13, 155, pl. 1.
Maeda, "Chieh-hua" (1975), pp. 131, 132, pls. 6, 7.
Barnhart, Iriya, Nakada, *Tō Gen, Kyonen* (1977), pp. 20, 21, 133, pls. 14, 15.
Sofukawa, "Go-dai Hoku Sō" (1977), pp. 160, 163, fig. 15.
Sullivan, *Symbols of Eternity* (1979), pp. 61-63, pls. 34, 35.
Watson, *L'Ancienne Chine* (1979), nos. 463-66, p. 431; and p. 333, pl. 145.

Exhibitions

Cleveland Museum of Art, 1954: Lee, *Chinese Landscape Painting*, cat. no. 11, pp. 22, 23, 144.
Asia House Gallery, New York, 1970: *Masterpieces II*, cat. no. 36, pp. 90, 91.

Recent provenance: Michelangelo Piacentini.

Nelson Gallery-Atkins Museum 47-71

Chü-jan, active ca. 960-985, Northern Sung Dynasty
From Nanking, Chiangsu Province, moved to
K'aifeng, Honan Province after 976

11 *Buddhist Retreat by Stream and Mountain (Ch'i-shan lan-jo)*

Hanging scroll, ink on silk, 185.4 x 57.5 cm.

10 seals: 1 of Northern Sung government; 1 of Ming government; 1 of Liang Ch'ing-piao (1620-1691); 1 of An I-chou (1683-ca. 1742); 2 of the Ch'ien-lung emperor (r. 1736-95); 2 of Keng Chao-chung (1640-1686); 1 of Wu T'ing (ca. 1600).

Remarks: This painting was recorded by An Ch'i in *Mo-yüan hui-kuan* (preface 1742, *ch.* 3, pp. 137, 138) as follows:

Painting on silk. Medium-size hanging scroll. Length: 5 feet 4.6 inches. Width: 1 foot 6.8 inches. Ink monochrome. A big mountain, filling a large part of the panel, is softened and blurred by mist. Underneath, a Buddhist monastery is deeply secluded in a luxuriant forest. The top of the peak is built up by the accumulation of *fan-t'ou* [alum crystals, i.e., rocks or boulders of various sizes]. For both the contour and the texture of the mountain, a type of "long hemp-fibre" strokes are employed which come straight down to the rocky slope and sandbank [of the stream], as natural and as unified in effect as they were originally created. Under the group of trees [in the foreground] a lonely pavilion stands in peace and quietude. All the *t'ai-tien* [moss dots] applied on the top of the mountain and along the edge of the water are done with heavy ink and are as robust and plump as melon seeds.

The ink and brushwork of the painting are rich and wettish. The "spirit-resonance" is calm and deliberate. It is completely free from the conventions of Li Ch'eng, Kuo Hsi and Hsü Tao-ning. In the later period, Chiang Kuan-tao [Chiang Shen; see cat. no. 23] succeeded in continuing this tradition, and the masters of late Yüan were to inherit the same mantle.

Two of the Chü-jan paintings recorded in the *Hsüan-ho* catalogue, namely, *Buddhist Retreat by Stream and Mountain* and *Distant Peaks Floating in the Mist,* are each on six panels. On the upper right corner of the present scroll, an accession or inventory number, "Chü 5," [Chü-jan No. 5 ?] definitely suggests that this painting is numbered fifth in the original set of screens or hanging panels. However, the title of *Ch'i-shan lan-jo [Buddhist Retreat by Stream and Mountain]* has not been recorded in later collection catalogues. The *Yen-fou yuan-chou [Distant Peaks Floating in the Mist]* on the other hand, not only bears a label written by the Hsüan-ho emperor [Hui-tsung], but has been published in detail in *Chiang-ts'un hsiao-hsia lu* by Kao [Shih-ch'i] and in *P'ing-shen chuang-kuan lu* by Ku [Fu]. Moreover, its measurements as recorded [in the above-mentioned catalogues], plus the texture strokes for its mountains and the placement of its forest and trees [as described] are all rather similar to the present painting. I wonder whether perhaps this is actually one of the panels of the *Distant Peaks Floating in the Mist*. I regret to say that I have never seen the *Distant Peaks* painting which has been in the collection of the Wang family in Sung-chiang [Chiangsu Province]. I have no doubt, however, about the authenticity of the present scroll, which is so superbly wonderful and so genuinely archaic. What's more, the condition of its silk is perfect. The large seal with characters in red ink on the top and the old seal on the upper right corner are both undecipherable. In addition to these there is the half-

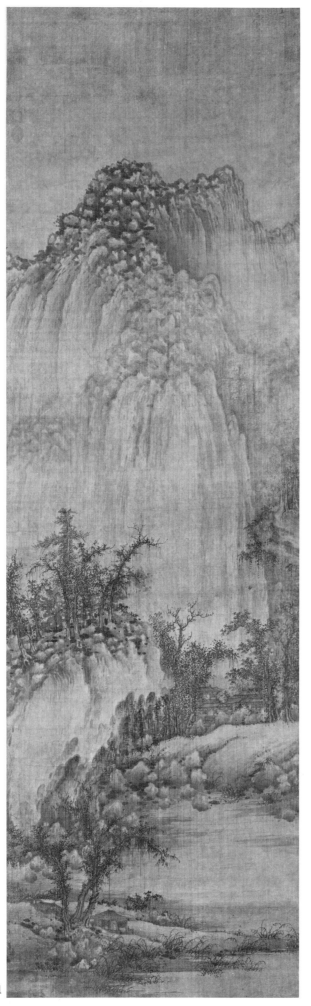

seal of "Chi-ch'a-ssu yin" [the early Ming official seal of the bureau supervising palace services used between 1374-84]. In the lower corner there is the seal of Wu T'ing, which means the painting was once in the collection of Wu Chiang-ts'un [active ca. 1600].

Among the paintings attributed to Chü-jan that I have seen, the *Wan-mu ch'i-feng [Ten Thousand Trees and One Spectacular Peak]* and *Shan-ch'i kao-yin [A Hermitage by the Stream and Mountain]* are all inferior to the present painting by comparison. The *Ten Thousand Trees*, a large panel of two joined pieces of silk, was once in the family of Keng Tu-wei [Keng Chao-chung, the princess-consort]. Later it went to the Sung [Lo] family of Shang-ch'iu [Honan Province]. Some people are more inclined to regard it as "Tung Yüan." As for the *Hermitage* picture, it is undoubtedly a Southern Sung work. I have also seen another "Chü-jan" in the Keng family collection. This is again a large hanging scroll painted on a joined double panel of silk. The fact that it lacks the spirit and flavor of antiquity indicates that it is merely a masterful work of the Yüan period.

The present painting is so convincing that it commands unreserved admiration from the bottom of our hearts. It should indeed be considered a supreme treasure by all discerning connoisseurs.

This detailed account by one of the most "discerning connoisseurs" in early Ch'ing is quoted here in full because it has provided the basic framework for our investigation. Among the observations made or questions raised by An Ch'i, four points are especially noteworthy: 1) He considered the present painting the best of all Chü-jan works he had seen from private collections in the early eighteenth century; 2) none of the paintings he cited for comparison can be identified with the better-known Chü-jan works extant today (a few highly dubious works published with familiar titles such as *Wan-mu ch'i-fang* are obviously either poor copies or forgeries of a much later date); 3) he questioned the validity of the present title, and suggested the possibility that the painting may well be the fifth-numbered panel from the set known as *Distant Peaks Floating in the Mist* in the Hsüan-ho collection; and 4) he drew attention to the two large old seals which he could not read.

Let us start with the most crucial of external evidence – these old seals. The first, fragmentary, seal in the upper right corner of the painting is hopelessly unintelligible, but looks as if it were a Sung imperial seal because of its characteristic margin. The second, complete, seal, which appears to be slightly covered by the early Ming official seal of Chi-ch'a-ssuyin, is identified as "Shang-shu-sheng yin" (seal of the Council of State), and its significance has been recognized for the first time in connection with our study of the present painting when it was discovered that it is the same as a seal affixed on the Li Ch'eng painting in Kansas City (cat. no. 10). It is so rare that the only other example to be found in Western collections (unfortunately, an obvious fake in this case) is on a handscroll in the Royal Ontario Museum, Toronto – a modern imitation based loosely on the *Lu-ting mi-hsüeh (River View in Winter with Ducks)* by the Northern Sung artist Liang Shih-min and now in the Peking Palace Museum. But despite its obscurity, the documentary value of the seal is beyond doubt – it is one of the few official seals that can actually help date an early Chinese painting. This is possible because, in my opinion, the seal had been employed on paintings and calligraphies of the Sung government collection for only a limited period of time – from 1083 to 1126.

Chou Mi (1232-1298), the late Sung poet and art critic, first mentioned the seal on three occasions. In 1275 he had a chance to view part of the government collection in the Mi-shu-sheng (The Imperial Library) in Hang-chou. He saw some 160 paintings, all bearing the seal "Shang-shu-sheng yin" on both the fronts and the backs of the scrolls (Chou Mi, *Ch'i-tung yeh-yü*, preface 1291, *ch.* 14, p. 173; *Yün-yen kuo-yen-lu*, late 13th c., *ch.* 2, p. 58). Then in 1291 and 1292 he was shown three paintings attributed to Wu Tao-tzu of the T'ang Dynasty from two private collections. "Each bears the seals of Shang-shu-sheng yin and Mi-shu-sheng yin, as they belonged originally to the Imperial Library" (idem, *Chih ya-t'ang*, pt. 3, bk. 3, p. 228). Chou Mi did not make any suggestions as to when these two seals were applied on the paintings of the government collection. To answer this question, we must go back briefly to the history of imperial collecting during the Sung Dynasty, paying special attention to the different places where these collections were kept.

Generally speaking, the Sung imperial collection was divided into two parts according to their different purposes, locations, custodianships, and degree of accessibility. These were known as Nei-fu (the inner palace) and Wai-mi (the outer library) (see Ch'en Ku, *Hsi-t'ang, ch.* 3, p. 19). The "inner palace" collection was housed mainly in the Lung-t'u-ke at the beginning of the dynasty. An inventory made at the time of Emperor T'ai-tsung registered 703 paintings (*Sung hui-yao, chi-kuan* 7, p. 2540). This was greatly expanded under Emperor Hui-tsung, whose personal collection was kept at several famous buildings, including Pao-ho-tien (or Hsüan-ho-tien), T'ai-ch'ing-lou, and the Eastern Pavilion of Jui-ssu-tien (or Jui-ssu tung-ke). During the Southern Sung period, Jui-ssu-tien continued to serve as the main depository along with a number of other halls reserved for the same purpose, such as the Rh'i-hsi-tien, Hsüan-te-tien, Fu-ku-tien, etc. But these are secondary problems. Our primary concern here is with the imperial collection in the Wai-mi, or outer library.

At the beginning of the dynasty, the imperial library consisted of four pavilions, known collectively as Ch'ung-wen-yüan. Among these, the most important was the Mi-ke (Secret Pavilion), which not only housed the largest public collection of books but also became a sort of museum for most of the government art collection. Paintings and calligraphies of the imperial libraries came mainly from two sources: transfers from the palace collection, and periodical new acquisitions. For example, in 988, 140 scrolls of paintings were given to the Mi-ke from the palace collection (*Sung hui-yao, chi-kuan* 18, p. 2778). In 996 agents were sent to the Chiang-nan area, who returned with forty-five paintings, among other objects, all purchased for the Mi-ke (*Sung T'ai-tsung shih-lu, ch.* 76; *Ku-hsüeh hui-k'an,* I, no. 5, p. 32). Thus, the Ch'ung-wen-yüan remained as the custodian of the outer branch of the imperial collection until 1082, when the civil government of Northern Sung was completely restructured in a sweeping change known in history as the Yüan-feng Reform.

Before 1082 the Ch'ung-wen-yüan was under the jurisdiction of Chung-shu-sheng, the Imperial Secretariat. From 1082 on, the administrative power was concentrated in Shang-shu-sheng, the Council of State. As part of the reform, the Ch'ung-wen-yüan was abolished, and the imperial libraries were reorganized as the Mi-shu-sheng and put under the direct control of the Shang-shu-sheng. In other words, the custodianship of the imperial collection kept in the "outer court" had changed

hands. The reorganization of the government was finalized and approved in the tenth month of 1082. A massive construction project for a new headquarters of the Shang-shu-sheng, the new seat of the central bureaucracy, was completed in the sixth month of 1083 under the direction of the eminent architect and painter Li Chieh (author of *Ying-tsao fa-shih,* ca. 1097-1100; ibid., *chi-kuan* 4, pp. 2439, 2440). In order to decorate these numerous new offices, paintings and other art collections previously kept in various departments of the Chung-shu-sheng were moved to the new buildings. A famous picture of *Wild Geese* by Tsui Po for instance, was ordered to be removed from the old quarter of the Commissioner of Finance and reinstalled in his new office by the Chief Councilor, Wang Kuei (see P'ang Yüan-ying, *Wen-ch'ang tsa-lu, ch.* 4, p. 43). The Jade Hall of the Han-lin Academy, one of the most splendid new buildings located inside the palace, had the partition-screen in its front hall decorated with heavy fabric to prepare for a magnificent Kuo Hsi landscape, *Morning over the Spring River* (Yeh Meng-te, *Shih-lin yen-yü, ch.* 4, p. 37). Presumably, celebrated paintings in the old buildings of the Academy such as *Water* by Tung Yü or *A Morning Landscape Enveloped in Mist* by Chü-jan (Wang P'i-chih, *Hsing-sui yen-t'an lu, ch.* 7, p. 66), were also removed to their new locations.

In short, since the Mi-shu-sheng, now under the jurisdiction of the Shang-shu-sheng, had become the new custodian of the government collection, it would be only logical that the official seals of these two organs be applied for identification and inventory purposes on paintings and calligraphies in the collections, as customarily required in any transfer of government properties. In other words, it is my belief that the "Shang-shu-sheng yin" on the upper right corner of the present painting in Cleveland was affixed during the transferential proceedings, sometime in the winter of 1083 or shortly afterwards. Were this the case, then the Cleveland scroll must have entered the Sung imperial collection before 1083; and the loss of other official seals is probably the result of repeated remounting in later days.

One might argue: could the seal have been applied during the Southern Sung periods? The chances are extremely slim – for these reasons:

1. The collection of the Mi-shu-sheng in Southern Sung can be divided into three groups. The first group consisted of paintings originally from the Northern Sung imperial collection which the government was able to recover through the border trading posts by special agents such as Lung Ta-yüan and Pi Liang-shih. These paintings would carry the seals of Shang-shu-sheng yin and Mi-shu-sheng yin if they were accessioned after 1083, or the seal of Mi-ke chih-yin if accessioned before 1082 (Kao Ssu-sun, *Wei-lüeh,* p. 81).

2. The second, and by far the largest, group of paintings in the Mi-shu-sheng in Hangchou had been transferred from the palace collection. In 1199, during the reign of Emperor Ning-tsung, an inventory was made and 1,098 scrolls plus two albums were counted in the collection (Ch'en Kuei, *Nan-Sung kuan-ke hsü-lu,* 1210, III, 1-19). The majority of these paintings had come from the palace. The official seals employed on these paintings had been explicitly specified by regulations established by Emperor Kao-tsung. This palace manual, *Shao-hsing yü-fu shu-hua shih* (Regulations for painting and calligraphy formats in the imperial collections of the Shao-hsing era), fortunately had been preserved and published by Chou Mi (*Ch'i-tung yeh-yü,*

ch.6, pp. 63-72). According to its rules, three imperial seals were to be used on paintings dated from the Six Dynasties to the end of Northern Sung – the "Trigram," the "Hsi-shih," and the "Shao-hsing." No government seal was ever used along with the imperial seals on these paintings. And from what we can see and verify from surviving examples from this period, such regulations seemed to have been closely followed through the various reigns until the end of the dynasty.

3. A small number of these 1,098 paintings were found to be without seals, either imperial or governmental. Subsequently, two seals were ordered to be added on these paintings – the seal of Tu-t'ang on the front and the seal of Mi-shu-sheng yin on the back. We are not completely sure whether the term "Tu-t'ang" referred to the "Shang-shu-sheng." Even if it did, the newly cast Shang-shu-sheng yin of the Southern Sung period showed marked differences in design from its prototype, especially with the two characters "shu" and "yin" (see examples in *T'ai-chou chin-chih lu*, XV, 1136; and Tokiwa and Sekino, *Chūgoku bunka shiseki*, 1975, IV, pl. 49). The "Shang-shu-sheng yin" of Northern Sung, on the other hand, reportedly measured two [Sung] square inches, which is the same dimension as the seal on our painting (*Sung-shih*, compiled 1343-45, p. 4846).

4. Since the majority of the Hsüan-ho collection had been removed by the Chin invaders after the fall of Pien-ching in 1126, most of them remained in the North and were handed down to the succeeding dynasties. These must have accounted for most of the surviving paintings from the Northern Sung imperial collection, including perhaps the Chü-jan now in Cleveland.

Having thus eliminated the possibility of a post-Northern Sung date for our painting and any related attribution such as Chiang Kuan-tao, we now come to the question of authorship. And because it is too lengthy to discuss here, we shall content ourselves with a few preliminary remarks. At present, three groups of paintings are attributed to Chü-jan: the "standard works," represented by the *Ch'iu-shan wen-tao (Seeking the Way in the Autumn Mountain)* in the National Palace Museum, Taipei; *Tseng-yen tsung-shu (Mountains and Woods)* and *Hsiao I Chuan Lan-t'ing (Hsiao I Conspiring for Wang Hsi-chih's Orchid Pavilion)* in the same collection; and some seemingly unrelated paintings – *Snowscape* and *Sung-yen hsiao-ssu (Solitary Monastery on a Pine Hill)* in Taipei, the so-called *Liu Tao-shih* in New York, and one version of the *Wan-ho t'u (The Myriad Valleys)*, once belonging to Wang To's family. For a long time *The Autumn Mountains* had been taken for granted by most Chinese connoisseurs as the supreme example of Chü-jan and the only criterion for passing judgment. No one seems to have raised the question that the preeminence of this painting has been based solely on the authority of Tung Ch'i-ch'ang. Before Tung Ch'i-ch'ang the painting was neither recorded nor discussed in any Ming writings, nor was it known to be associated with the name of Chü-jan. Even Tung Ch'i-ch'ang's opinions about Chü-jan were inconsistent and unpredictable. The attribution of the *Hsiao-I*, for example, was changed at one time by Tung Ch'i-ch'ang from Chü-jan to Tung Yüan. And this won the unreserved approval of the Ch'ing critic Wu Hsiu, who declared, "A single colophon establishes the authorship of Pei-yüan [Tung Yüan]; the name of Ssu-ong [Tung Ch'i-ch'ang] is to be cherished in a thousand years!" (*Ch'ing-hsia kuan*, preface 1824, XVI, 191). That is exactly what happened. Today, when we try to reappraise the problem of Chü-jan, we must carefully bal-

ance the unquestionable historical insight of Tung Ch'i-ch'ang against his critical bias. The best way to begin is to go back to the early literary sources with an open mind and fresh curiosity.

Among these early materials on Chü-jan, there is one most useful item which remains largely unused. This is the simple statement made by the great Northern Sung scholar Shen Kua (1031-1095) in his *T'u-hua-ke (A Song on the History of Painting)*, "In the south of the River there were Tung Yüan and the monk Chü-jan, who established their independent styles by [the use] of pale ink and light mist" (*Meng-hsi pi-t'an chiao-cheng*, 1955, I, 567). This is remarkable because no one had said anything like that before him. Su Shih had made note of the intervention of the mist-filled space in a monumental landscape as a serious departure from the "T'ang" tradition. But it certainly took a great perceptive mind such as Shen Kua's to sense the extraordinary significance of this aspect of Chü-jan's art, which in the tenth century was undoubtedly revolutionary. This is so because the use of pale ink not only underlaid an important experiment, but to some extent was a rebellion against the Northern orthodoxy. The pale ink, which lends itself to the creation of a certain atmospheric ambiguity, had always been related to the type of "level-distance" landscape dear to the hearts of the Chiang-nan artists. It represented a Southern consciousness of the lyrical and transient aspects of nature. It helped to soften the definite outlines of forms, dilute the descriptive details, and enliven a more fluid and suggestive space with a broader, more relaxed outlook to replace the "iron-house and stone-people" of Northern landscape. By contrast, the tradition of landscape painting in the North had been basically a "dark-ink" tradition which emphasized a stronger tactile presence with mass, substance, and well-defined forms. Late T'ang literature speaks often of this type of *sheng-mo* ("deep-ink") landscape. Even at the beginning of the Sung Dynasty, the two major schools of Li Ch'eng and Fan K'uan had been compared partly in terms of the contrast between their ink methods. Whereas Li Ch'eng's *hsi-mo* technique with pale ink was described as "dream-like," Fan K'uan's paintings were "as dark as nightfall on a gloomy day," and "his excessive use of ink in his late years...had made his soil indistinguishable from his rocks" (Mi Fu, *Hua-shih*, compiled ca. 1100). There seems to be no doubt that Li Ch'eng's interest in the pale ink had been an influence from the South. Yet within this reciprocal relationship, Chü-jan's indebtedness to Li Ch'eng was apparently much greater and many-sided. This crucial historical fact appears to have been ignored by most later critics, except the unpredictable Tung Ch'i-ch'ang. When he assigned the *Snowscape* (in the National Palace Museum, Taipei) to Chü-jan, no one, from his contemporaries in late Ming to modern scholars, took him seriously – as if within the halo of "Tung-Chü" there can be no room for any sacrilegious Li Ch'eng – Chü-jan relationship. While we are not prepared to argue this case for Tung Ch'i-ch'ang, we cannot help but admire his keen observation.

Chü-jan was indeed influenced by Li Ch'eng after he moved to K'aifeng. And this was testified to by a Sung scholar who came from a prominent family of connoisseurs with first-hand personal knowledge. In his history of the Hanlin Academy in early Sung, Su Ch'i (987-1035) described the two pavilions behind the Jade Hall built by his father, Su I-chien (957-995), who was the head of the Academy from 985-993 and a contemporary of Chü-jan: "My [father] commissioned the monk Chü-jan to deco-

rate both the upper and lower floors of the pavilion with the wall painting *Morning Landscape in Mist.* His brush-work was unconventional and free. He imitated the works of Li Ch'eng, but at the same time retained the fine qualities of his own style" (Su Ch'i, *Tz'u Hsü Han-lin chih,* v. 2, p. 23). Certainly one may expect that in this stage of a sylistic marriage, the dominating features of each school would most likely remain to be read on the surface, and the result would have to be refreshingly unconventional, with perhaps an occasional touch of arbitrariness or impetuousity. These are exactly some of the qualities to be found in the Cleveland painting and traits of such an incomplete synthesis tend to support the early date of the painting:

1. The lucid division of the three grounds (front, middle, and back) had been a basic compositional device inherent in the "level-distance" landscape, a device which probably originated in the T'ang period but further developed in the South by the Tung-Chü school. This was adopted by Li Ch'eng who incorporated it with the "high-distance" to consolidate an emerging theory of spatial concept and organization, *sheng-yüan* ("deep-distance"), which was to play a key role in the development of Northern Sung landscape painting. The *Buddhist Retreat* suggests an adaptation of Li Ch'eng's method with a slight uneasiness, which of course can be explained by the fragmented composition, being only "No. 5" in an original set of six panels.

2. The main mountain range structured in an S-shape was one of the most innovative and fundamental contributions of the Li Ch'eng school. This was utilized in the painting, along with a Chü-jan hallmark – the *fan-t'ou* stacked up on top of the peak. The distant trees of a type typical of the Tung-Chü school, and depicted with saturated pale ink, can barely be seen in the mist-filled valleys deep in the mountains. These are echoed by and contrasted with the sharply silhouetted tree groups atop the cliff in the middle ground – another "Li Ch'eng" scheme such as may be seen in the hanging scroll in Kansas City (see cat. no. 10).

3. The texture strokes for the main mountain are again executed with diluted pale ink. They appear to be a compromise between the "long hemp-fibre" of the Tung-Chü tradition and the *chi-ch'a ts'un* (vertically rubbed strokes) of Li Ch'eng.

4. The sandbanks along the river are depicted with washes of pale ink. These, together with the water reeds (similar to those in the *Hsiao-Hsiang t'u* but markedly different from the *yen-ts'ao* ["wind-blown grass"] common in Yüan painting), seem to belong to an early tradition associated with Tung Yüan. On the other hand, the rocks in the water along the earthen bank, according to Mi Fu, was a motif favored by Li Ch'eng (*Hua-shih,* p. 24).

5. The many varieties of trees in the painting are all endowed with a wonderfully expressive spontaneity, and sparkle with calligraphic elegance. On close examination, it is clear that they are like the bare trees in a Li Ch'eng-school *Wintry Forest,* complete with the "crab-claw" and "deer-horn" branches (under or above the foliage).

6. Finally, it should be pointed out that in addition to the influences of Li Ch'eng, there are also elements derived from other sources. For example, the T'ai-hu rock-like indentations modelled with pale inks on the cliff are clearly borrowed from the Ssuch'uan tradition. We are told by the Yüan painter Kuo Pi in his diary of 1308 that this particular technique executed with the side of the brush in circular movements, was known as *yeh-ch'iao ch'i* (wings of a wild bird) among artists, a technique definitely traced back to Huang Ch'üan in the Five Dynasties *(Ke-Hang jih-chih,* p. 14).

The problem of Chü-jan will remain unsolved if the relationship between his early and late styles is not clarified. One must recognize the fact that among surviving Sung paintings associated with the Li Ch'eng school, the possibility exists that some of them may eventually turn out to be works by Southern masters from the Chiang-nan area who had simply elected to adapt themselves to the artistic mainstream of the time – the Li Ch'eng tradition. In this respect, the *Ch'i-shan lan-jo* in Cleveland is an important work which presents invaluable material for further study. WKH

Literature
Hsüan-ho (1120), *ch.* 12, p. 139.
An, *Mo-yüan* (1742), *ch.* 1, pp. 13(b)-14(a).
Shao Sung-nien, *Ku-yüan* (1904), *ch.* 1, pp. 8(b)-9(b).
Sirén, *Early* (1933), I, 134, pl. 97.
Lee, *Chinese Landscape Painting* (1962), p. 21, no. 13; idem, *Far Eastern Art* (1964), p. 346, fig. 447.
Sullivan, *Chinese and Japanese* (1965), p. 45, fig. B (p. 45).
Fu Shen, "Chü-jan" (1967), pp. 73, 74, fig. 21 A-B (English summary, p. 20).
Lee "Painting," (1969), p. 121, illus. p. 122
Contag, *Chinese Masters* (1970), pp. 9, 31, pls. 1, 1A, 1B.
Barnhart, Iriya, Nakada, *Tō Gen, Kyonen* (1977), p. 133, pl. 10.
CMA *Handbook* (1978), illus. p. 339.
F. Cheng, *Vide et plein* (1979), pl. XIX.

Exhibitions
Asia House Gallery, New York, 1974: Lee, *Colors of Ink,* cat. no. 1.

Recent provenance: Shao Fu-hsing; Frank F. Chow.

The Cleveland Museum of Art 59.348

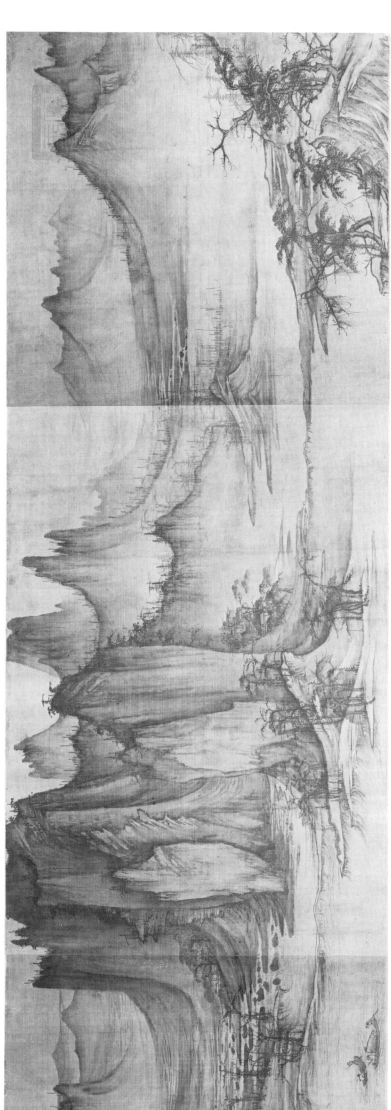

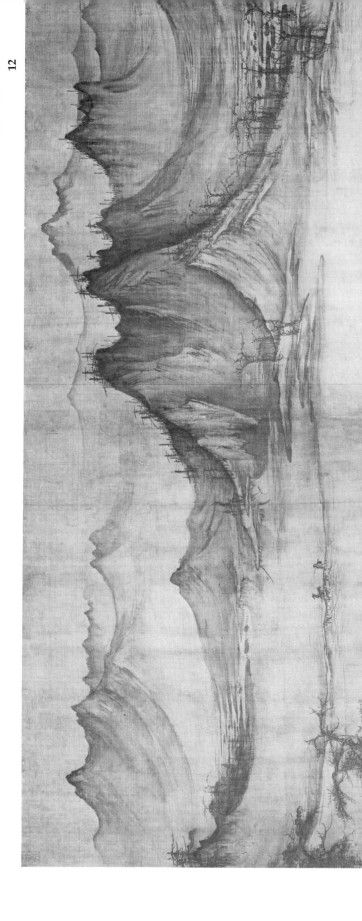

Hsü Tao-ning, ca. 970-1051/52,
 Northern Sung Dynasty
From Ch'angan (Hsian), Shenhsi Province

12 *Fishermen*
(Yü-fu)

Handscroll, ink and slight color on silk, 48.9 x
209.6 cm.

No signature or seal of the artist.

25 seals: 1 of Sung Kao-tsung (r. 1127-62); 1 of Ch'en
Ting (early 17th c.); 12 of Keng Chao-chung (1640-1686);
3 of An Yüan-chung (act. mid-18th c., son of An Ch'i
[1683-ca. 1746]); 2 of Hung-hsiao (2nd Prince I, d. 1778);
5 unidentified.

Remarks: Over the centuries, history's judgment of Hsü
Tao-ning has been neither favorable nor correct.
Tendentious critics of the literati persuasion repeated as
gospel derisive judgments first pronounced by the in-
fluential critic Mi Fu (1051-1107). Mi had damned Hsü
Tao-ning with socially grounded criticism typical of the
new criticism of the late eleventh century. In a passage in
his *Hua-shih* (p. 6a-b), where he prescribed rules for dis-
playing vertical scrolls, Mi had said, "Hsü Tao-ning can-
not be used. The paintings of that person are too ple-
beian." Since Mi offered no further justification for his
judgment, it is impossible to tell whether his disdain for
Hsü Tao-ning arose as a reaction to Hsü's outrageous
behavior or to the obvious, inimitable virtuosity of Hsü's
brush – a virtuosity that won such wide acclaim it may
have prickled the self-esteem of the righteous Mi.

Along with the amplification of Mi's judgment as it
was glibly reiterated by later critics, confusion arose
(compounding in time) about Hsü Tao-ning's dates and
his place of birth. Despite recent adherents to Ho-chien,
Hopei Province, or to Ho-chung, Shanhsi Province, the
preponderance of reliable evidence favors Ch'angan
(Hsian) as the place where Hsü was born and passed his
youth. The Mao Chin (1599-1659) editions of Kuo Jo-
hsü's *T'u-hua chien-wen chih* (ca. 1075) and of the *Hsüan-
ho hua-p'u* (preface 1120) give Ch'angan, as does the *Ssu-
k'u ch'üan-shu* edition of Liu Tao-ch'un's *Sung-ch'ao
ming-hua p'ing* (3rd qtr. 11th c., also known as *Sheng-ch'ao
ming-hua p'ing*). Chang Pang-chi (d. after 1150; *Mo-
chuang*, ca. 1050, p. 1163), writing in the last years of the
Northern Sung period and opening decades of the
Southern Sung, confirms Ch'angan.

Decisive evidence comes from notices in the collected
papers of authors who were well acquainted with Hsü.
Huang T'ing-chien's (1045-1105) father, Huang Shu
(1018-1058), admired Hsü's work and knew him
personally. Huang consistently refers to Hsü as "Hsü of
Ch'angan" (*Fa-t'an chi*, 1053, ch. 26, pp. 18a, 19b). Chang
Shih-sun (964-1049), a prime minister intermittently
from 1028 to 1040, was a patron of Hsü's, and is known
to have treated him with exceptional hospitality, given
the abyss in rank between the two. He, too, refers to
Hsü as coming from Ch'angan (*Hsüan-ho hua-p'u, ch.* 11,
p. 118).

There is little doubt that Hsü Tao-ning's behavior was,
indeed, outrageous and uncouth: he was abrupt, loud,
and given to mocking others. He paid slight attention to
the condition of his clothing or to whether he wore it
properly. Fittingly, his approach to painting was neither
prim nor contemplative. In his later years he painted
impulsively, with an abandon that could jeopardize the
furnishings around him.

If Mi Fu viewed Hsü as a loathesome, vulgar
character, then Huang T'ing-chien saw him more as a
lovable old rascal. In his long poem written in 1087 and
addressed to a certain Junior Secretary Wang Tao-chi
(see *Shan-ku shih chi*, 1111, *wai-chi*, ch. 15, pp. 401, 402),
Huang sympathetically portrays Hsü's unconventional
behavior and spontaneous – almost reckless – manner
of painting. The poem is translated here, in part:

Ch'angan it was, when I encountered the Drunken Hsü,
Grinding pine-soot ink on a large Man-hsi inkstone.
Suddenly, he would shout for silk, upsetting the fluid in
 the inkstone;
For long periods he would not engage his brush –
 perhaps for a whole year.
At times, treading on the sill, he would thrust his
 whitened head through the door;
Scarfed cap askew, he would still importune for wine.
In his manner of quaffing, he was wont to tip the bowl
 bottom up;
Soon, eight or nine beakers would be laid over upside
 down.
Quite tipsy, he would pluck up a worn brush, dripping
 with ink;
With force like an avalanche, his hand never stopped.
In a few feet, mountains and rivers stretched ten
 thousand miles,
Filling the hall with the feel of bleak chill.
A rustic monk returns to his temple – a boy following
 behind;
A fisherman is beckoned by a traveller wanting to ford
 the stream.
My late father laughingly pointed to the riverside house;
The egrets and cormorants were as though he recog-
 nized them.
Master Hsü bowed repeatedly, claiming not his own
 ability,
But that the motivating forces of Nature are prime – not
 the effort of the brush.
He himself said, "In my younger years, when my eyes
 were bright and keen,
I executed eight panels of silk from Chin-chiang.
"These valedictory scrolls I presented to the Metropoli-
 tan Mayor Chang on his departure;
I know within that Li Ch'eng is my master."

Early sources note other of Hsü's activities which by
implication were not only unconventional but somewhat
less than dignified. Liu Tao-ch'un (op. cit., *ch.* 2, p. 5a)
and the *Hsüan-ho hua-p'u* (*ch.* 11, p. 118) note that early in
his career Hsü Tao-ning sold medicine at the gates of
Ch'angan and attracted customers with performances of
painting. Chang Pang-chi (op. cit.) recounts two perti-
nent anecdotes. In one, where Chang reports that Hsü
Tao-ning was good at portraiture, it seems that every
time Hsü saw an ugly person, he could not help drawing
caricatures of them in the wine shops. While some were
amused, others were provoked to fisticuffs. Battered
and defeated though he might be, Hsü never repented.

Through some ingenious bit of chicanery Hsü managed
to offend the prefect of Ch'angan, Tu Yen (978-1057),
and, fearing arrest and punishment, fled to Huan-chou,
in present-day Kansu Province, where he apparently
stayed a year under the patronage of Ch'ung Shih-heng
(985-1045). Tu was, in fact, amused by the escapade.

Hsü Tao-ning lived to be slightly over eighty. That in-
formation is supplied by Huang Shu (op. cit., *ch.* 26,

pp. 19b, 20a) in a note appended to a poem by Huang in which he praises Hsü and expresses regret that Hsü Tao-ning had died. The word used by Huang, *yü*, suggests just over eighty *(sui)*, perhaps eighty-one or eighty-two, but not as old as eighty-three. Huang edited his collected works himself in 1053 and provided a preface dated that year. On the basis of internal evidence and placement, therefore, the poem was probably written about 1053. Allowing a lapse of a year or so between Hsü's death and Huang's notice of it yields a date around 1051 or 1052 for Hsü's death, which in turn yields a date of about 970 for Hsü's birth.

It was not until the late 1030s and 1040s that Hsü Tao-ning's activities are datable with any frequency. Painting "eight panels of silks from Chin-chiang" for "Metropolitan Mayor Chang" is the earliest datable incident. Metropolitan Mayor Chang has been identified with Chang Yung (946-1015) (Weng T'ung-wen, "Hua-jen," 1970, pt. 2, p. 47), who served as the principal administrative officer of Ch'angan in 1003. Hsü's mention of "silk from Chin-chiang" is probably not fortuitous. Chang Yung had served as prefect of Ch'engtu, Ssuch'uan Province, the previous year, 1002 (Franke, ed., *Sung Biographies,* 1976, I, 48). Silk renowned for its quality had long been produced in the Ch'engtu area, most notably in the riverine area southwest of Ch'engtu along the river Chin-chiang, whose name became synonymous with fine silk. The production was of such economic importance that early in the dynasty the government established a major bureau at Ch'engtu for the administration of fine-silk production. In view of the cost of Chin-chiang silk, it seems likely that Chang Yung gave the silk to Hsü Tao-ning along with the expectation that it would be returned graced with landscapes.

Hsü was by no means averse to painting on commission. This, together with his fame, made him a familiar guest of rich and powerful officials, both in Ch'angan and in the Sung capital, Pienliang (K'aifeng). It was probably during one of his trips to Pienliang that Hsü visited Mt. Hua, whose majesty had inspired Chinese painters and poets for centuries and which, if we are to believe Chang Pang-chi (op. cit.), exercised pivotal influence on Hsü's painting.

Hsü Tao-ning was active in Pienliang around 1040. Mei Yao-ch'en (1002-1060; *Wan-ling,* 1046, *ch.* 18, p. 153) notes in a poem to Liu Ch'ang (1019-1068) that Hsü had decorated the walls of Fu Pi's (1004-1083) office when the latter was an assistant supervisory official in one of the ministries. Fu was at the capital serving as an assistant commissioner in the Office of Salt and Iron in 1040. Hsü is also known (Liu Tao-ch'un, op. cit., *ch.* 2, p. 5b) to have painted a number of pictures for the prime minister, Chang Shih-sun (964-1049), who served as prime minister on three occasions – the latest, from 1038 to 1040. It was probably during this period, or slightly later, after Chang's retirement, that Hsü filled these commissions.

Hsü returned to Ch'angan in the early 1040s; it was during this period, probably 1042, that Hsü became embroiled with Tu Yen, who was at the time serving as prefect of Ch'angan, a post he filled through 1042. That was also the year Ch'ung Shih-heng served as prefect of Huan-chou, to where Hsü fled seeking Ch'ung's protection. Since Hsü returned to Ch'angan after a little more than a year, he can be placed in Ch'angan again sometime beginning about 1043-44.

It is not known at present whether Hsü subsequently left Ch'angan. His latest datable activity centers on his association with Huang Shu, for whom Hsü painted the picture mentioned in Huang T'ing-chien's poem quoted above. Huang Shu served in Ch'angan for about two years, during 1049-50 (Sofukawa, "Kyo Dō-nei," 1980, p. 458). In view of the wording and date of Huang's poem in which he mentions the death of Hsü Tao-ning, it seems likely that Hsü died after Huang left Ch'angan, thus confirming the period 1051-52 for Hsü's death.

Fishermen is recorded under its present title, *Yü-fu,* in Wu Sheng's *Ta-kuan lu* (prefaces 1712, *ch.* 13, p. 25a). This title is probably not the original title; but the subject matter is typical of Hsü Tao-ning. Few writers fail to comment on his penchant for scenes of rivers and mountains set in autumn's chill or winter's snow. A review of titles of Hsü's paintings listed in the *Hsüan-ho hua-p'u* (*ch.* 11, pp. 119-21) demonstrates this amply, and suggests that the original title might have been something like *Anglers at Leisure on an Autumn River* or *Angling amid Peaks on a Fair Day.* Attempts to link *Fishermen* with poems about fishing that were popular during the eleventh century have proved inconclusive, as these poems could easily apply to any one of a number of recorded painting titles.

Recently, the remnant of a seal in the lower left corner has been identified as belonging to Sung Kao-tsung's (r. 1127-62) linked seal, Shao-hsing. Comparison of the fragmentary impression with reliable examples preserved on other works leaves no doubt that it is authentic.

The *Nan-Sung kuan-ko hsü-lu* (late 13th c., *ch.* 3, p. 2770) lists the titles of a number of paintings by Hsü Tao-ning preserved in the imperial collection at the time. Only two titles seem to fit the present scroll: *Evening Crossing on a Wintry River (Han-chiang wan-tu)* and *A Rustic Crossing on an Autumn River (Ch'iu-chiang yeh-tu).*

A number of other fragmentary seals, which also appear on other important early paintings, appear in the corners of *Fishermen.* These, together with the Shao-hsing seal, indicate that the scroll has been cut at the top and bottom over the centuries. About an inch and one-half has been lost at the bottom, and at least an inch at the top. The summits of the central mountain mass, now trimmed of their crowns by the upper edge, would all have been within the original upper border. On the other hand, the placement of the fragmentary seals and the way in which the composition opens and closes confirm that the scroll has been only slightly trimmed at the beginning and end, probably not more than an inch at either end.

Early critics emphasize the change in Hsü Tao-ning's style from early to late years. His early manner is described in such terms as "meticulous" and "painstaking," and with the implication that it had little substantive meaning or spirit. Brevity; speed; overwhelming animation of form; and a stirring, expressive content tied to the colder side of Nature's grandeur are descriptions applied to his later style. The image of power – "like an avalanche" – rings through the words of those describing his mature works. Critics also remark on the wetness of his ink, which had a fresh, graceful quality.

Two surviving paintings are here taken to be authentic works from the hand of Hsü Tao-ning. One is the present scroll, *Fishermen,* which answers to all the characteristics of his late style. The other is *Desolate Temple amid Autumn Mountains (Ch'iu-shan hsiao-ssu)* in the Fujii Yurinkan, Kyoto (Kawakami et al., *Tōyō bijutsu,* I, 1967, pp. 57, 58, pls. 14-16), which should be a much earlier work.

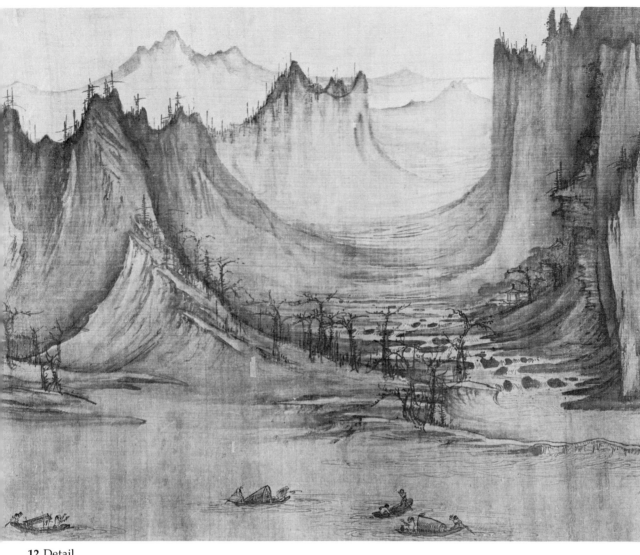

12 Detail

Precisely how many years may lie between these two paintings cannot be estimated with accuracy, but it is evident that there is a considerable conceptual and technical gap between them. *Fishermen* is a grand drama, one in which the power and vastness of Nature speak in bleak, chilling but compellingly beautiful terms, detached from the ordinary world of man. Gigantic cones of granitic mountain masses, shattered and desolate but unassailably permanent, give way to voids stretching gradually into infinite distance. Technically, the picture is a virtuoso performance that could only come from a lifetime of devotion to the perfection of an intuitive manner beyond duplication. The ink washes modelling rocks and mountains are indeed wet and diaphanous; and they are applied with terrific speed. So subtle are the shifts in tone and limpidity that contour and bulk are perfectly realized, even as a mountain recedes, curving into the distance. These subtle shifts of light and dark washes *suggest* what they depict rather than describe it in a literal, meticulous manner; and they lend a special animation to surfaces that implies an appreciation for abstract graphic effects, without, however, sacrificing an ultimate committment to naturalistic depiction.

The brushwork is vigorous, ragged, and spontaneous. Although it, too, never abandons its function in naturalistic depiction, there is a seed of the realization that plays of outline brushwork can take a more self-assertive, more independent graphic role. Both of these

developments – in brushwork and ink-wash technique – are necessary first steps before a painting such as Kuo Hsi's (ca. 1020-1090) *Early Spring* (Sirén, *Masters and Principles*, 1956-58, III, pl. 175) can appear.

Missing from *Desolate Temple amid Autumn Mountains* is the heroic conception and technical virtuosity seen in *Fishermen*. Although distant mountains, rendered in familiar but more timidly applied washes, are present, they are not well integrated with the low-lying bluffs which establish a slightly disturbing, exaggerated diagonal in the middle ground. Washes and strokes modeling rocks and mountains lack the subtlety of tone and modulation seen in *Fishermen*, thereby failing to invest the motifs with as convincing bulk or as informative textures. Nor is the kind of surface animation and animation of tonal shifts as fully developed.

To anyone thoroughly familiar with both pictures at first hand, the differences are a matter of evolution. This is most especially apparent in the drawing of the trees, figures, bridge, and architecture. The trees twist and turn and end in similar flourishes of bare branches dotted with moss or hung with creepers; but the drawing of the trunks in *Desolate Temple amid Autumn Mountains* is lumpy and hesitant, lacking the smooth, confident flow of muscular rhythms seen in *Fishermen*. The connections between the bare branches are drawn more literally, so that the force and energy that passes from one stroke to the next is held in check, instead of leaping and flowing from one to the next, as in *Fishermen*. Familiar, too, are

23

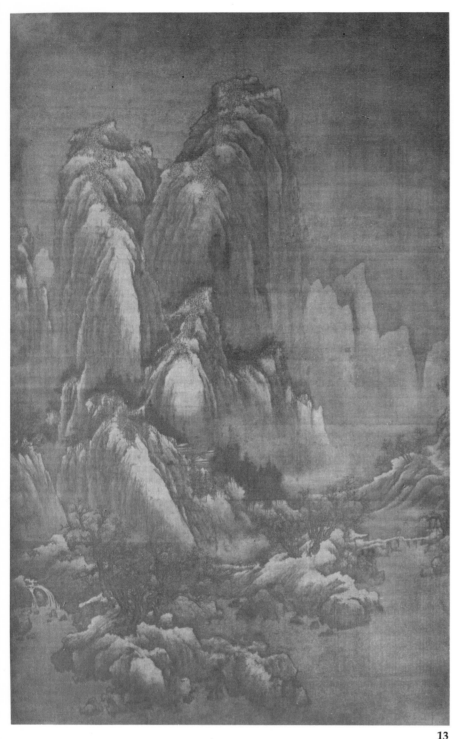

13

Literature

Wu Sheng, *Ta-kuan lu* (1712), *ch.* 13, p. 25a.
Hu-she yüeh-k'an, no. 53 (April 1932), p. 1; no. 54 (May 1932), p. 1.
Cheng Chen-to, *Wei-ta-te i-shu* (1951-52), I, pls. 2-4.
Burling and Burling, *Chinese Art* (1953), p. 106.
Sickman and Soper, *Art and Architecture* (1956), pp. 108, 109, pl. 85.
Sirén, *Masters and Principles* (1956-58), II, 207, 208; III, pl. 158.
Swann, *Chinese Painting* (1958), pp. 62-64.
Grousset, *Chinese Art and Culture* (1959), pl. 44.
Janson, ed., *Key Monuments* (1959), pl. 343.
Fontein, "Chinese Art" (1960), pl. 262.
Moskowitz, ed., *Great Drawings* (1962), IV, pl. 886.
Horizon, Arts (1969), pp. 148, 149.
Barnhart, "Snowscape" (1970-71), fig. 7.
Akiyama et al., *Chūgoku bijutsu* (1973), I, 218, pl. 3.
NG-AM Handbook (1973), II, 51.
Wilson, "Vision" (1973), no. 2, pp. 226-29.
K. Suzuki, *Ri Tō* (1974), pp. 155, 156, pl. 6.
Barnhart, Iriya, Nakada, *Tō Gen, Kyonen* (1977), pp. 36, 37, pl. 28.
Watson, *L'Ancienne Chine* (1979), no. 481, pp. 436, 437.
Sofukawa, "Kyo Dō-nei" (1980), pp. 484-88, 491, 492, figs. 10, 11, 14, 15.
Loehr, *Great Painters* (1980), pp. 140-44, pls. 68A-D.

Exhibitions

Cleveland Museum of Art, 1954: Lee, *Chinese Landscape Painting,* cat. no. 12, pp. 24, 25, 144.
Asia House Gallery, New York, 1960: *Masterpieces,* unpaginated.
Jewett Arts Center, Wellesley, Mass., 1967: Loehr, *Symbols and Images,* cat. no. 21, pp. 39-41.

Nelson Gallery-Atkins Museum 33-1559

Artist unknown, late eleventh-twelfth century, Northern Sung Dynasty

13 *Winter Mountains*
 (Hsüeh-shan)

Hanging scroll, ink on silk, 144.5 x 92.5 cm.

3 seals on the painting: 1 of the Wang family (unidentified); 1 of John M. Crawford, Jr. (20th c.); 1 undecipherable.

3 spurious seals on the mounting: 1 of Sung Ch'üan (1598-1652); 2 of Sung Lo (1634-1713).

Remarks: The large seal on the mounting purportedly belonging to Sung Ch'üan, the father of the famous collector Sung Lo reads, "Ta Ch'ing Shun-chih, twelfth year [1655], first month ____ bestowed upon ____ [by the authority of] Grand Secretary servant Sung Ch'üan" (trans. Max Loehr). The blank spaces were reserved for the day and name of the grantee to be filled in as appropriate. Since Sung Ch'üan had already been dead for three years by the time of the date given in the seal, the seal can hardly be genuine. The fact that it is spurious also calls into question the accompanying seal of Sung Lo on the mounting, who would certainly have known the date of his father's death. The source of the forgery is probably another large, genuine seal used by Sung Ch'üan, which appears on the mounting of *Snow-Covered Mountains,* a large landscape hanging scroll attributed to Fan K'uan (*Three Hundred Masterpieces,* 1959, no. 66; *Shih-ch'ü* III, 1816, p. 1377). It reads, "Shun chih, third year [1646], second day of the seventh month, bestowed by the emperor on the Grand Secretary servant Sung Ch'üan, [who] records it with respect."

Although one seal on the painting appears to be of some antiquity, it is unreadable, and, therefore, of no help in reconstructing the history of the scroll. The label

the stucture of wash strokes in background mountains and even some fast, dry-brush strokes in dark ink in the drawing of the foreground banks and bluffs. *Desolate Temple amid Autumn Mountains* also appears to have suffered from trimming, especially at the bottom, even more than has *Fishermen*.

 Desolate Temple amid Autumn Mountains cannot be placed, as have some scholars, toward the end of the eleventh century. This scroll and the progress of early Northern Sung landscape styles only make sense when it is seen as an early work of Hsü Tao-ning from the early part of the century. If *Fishermen* is a late work, probably from the 1040s, then *Desolate Temple amid Autumn Mountains* probably represents his manner prior to about 1030.

 MFW

gives a glimpse into its late history. Written by Chao Chih-ch'en (1781-1860), it reads, *"A Genuine Landscape by Fan Hua-yüan [Fan K'uan] – appreciated by Hsiao-t'ien-lai-ko."* (Hsiao-t'ien-lai-ko is the studio of the early nineteenth-century collector Hsiang Han-yüan.)

This type of picture is almost always associated with Fan K'uan (active ca. 990-1030). The blunt, tapering shape of the principal peak, to which lesser mountains in the back- and middle ground respond in clearly organized harmony, and the layering of fissures and crevices on its flanks to convey volume and depth are features of the tradition, as is capping distant summits and ridges with a dense growth of stubby vegetation. The stout foreground trees are also characteristic, not only in their proportions and in the way the branches spread but also in the heaviness of the strokes used for outlining the trunks and drawing the branches and twigs.

The jagged, cusped silhouettes of rocks and peaks are part of the idiom, but in other ways the artist of *Winter Mountains* departs significantly from the tradition and from Fan K'uan as seen in *Travelers among Mountains and Streams* in the National Palace Museum, Taipei (Sirén, *Masters and Principles*, 1956-58, III, pl. 154). Fan K'uan's outline drawing of rocks and mountains consists for the most part of heavy, rugged, short strokes whose movement and variation bear no sense of formula or pat convention. The outline drawing in *Winter Mountains* uses longer, softer strokes that not only are wet and lack the adamantine sturdiness seen in the Palace Museum picture but meld with the moist, interior modelling strokes. Fan K'uan relies on subtly varied layers of short, dragged, or dotted texturing strokes to complete the modelling of volume and to convey surface textures. In *Winter Mountains* the artist retains a much older, anonymous tradition of using layers of long, wet strokes to model the flanks of major mountain motifs; in places, these gradually dissolve into areas rendered only in ink wash. Clear distinctions between layers and facets are not sharply marked: planes and surfaces fuse with those next to them, thus indicating the later date of *Winter Mountains.*

A pronounced effect of unbroken planar recession appears on the top surfaces of the foreground clusters of rocks and summits of distant peaks. The artist exploits the planar fusion of these light areas with particular effect in the case of the diagonally tilted ridge of the low mountain in the left middle ground, where the stark continuity of the snow-clad ridge reinforces the diagonal recession of the flank. Such effects as these are significant for the date, and in later paintings will be subjected to conventionalized formula that aim ever more at ornamental, abstract values. The alteration of light and dark is pronounced in *Winter Mountains,* as would be expected in a snow scene such as this. This, too, will devolve in later paintings of the same type to banal artificiality.

In all, the artist of *Winter Mountains* retains the economy of intent and means expected of early landscape painting from the eleventh and early twelfth centuries. The landscape itself, here shrouded in dim and melancholy vapors, remains the true subject. KSW/MFW

Literature
Bush, "'Clearing after Snow'" (1965), pp. 167, 169, fig. 9.
Barnhart, Iriya, Nakada, *Tō Gen, Kyonen* (1977), pp. 34, 136,
 pl. 26.

Exhibitions
Pierpont Morgan Library, New York, 1962: Sickman, ed.,
 Collection of John M. Crawford, Jr., cat. no. 6, pp. 57-59.

Nelson Gallery-Atkins Museum 79-9
Gift of John M. Crawford, Jr. in honor of
Laurence Sickman

Artist unknown, eleventh century, Northern Sung
 Dynasty

14 *Palace Landscape*
 (Kung-yüan t'u)

Album leaf, ink, color, and gold on silk,
33 x 40.6 cm.

2 unidentified seals on mounting.

Remarks: Paintings such as *Palace Landscape,* which include extensive architectural complexes, are frequently regarded as examples of *chieh-hua* (ruled-line painting) and are evaluated on the standards proper to that category of painting. The nature and standards of this type are defined by the Yüan critic T'ang Hou (*Hua-chien,* 1329): "When ordinary people discuss painting they will always say 'painting has thirteen classes going from landscape at the top to *chieh-hua* at the bottom,' and hence regard *chieh-hua* as an easy thing. They don't realize that even among woodworkers and craftsmen are those incapable of exhausting the wonders of [the full range between] squares and circles, curves and straights, highs and lows, ups and downs, near and far, concavities and convexities, the skillful and the clumsy, and the artful and the beautiful, so when brush, ink, the inkstone, and the ruler convey ideas onto gauze silk and mulberry paper and seek accord with their methods, rules, and measures, this is the most difficult."

The goal of such painting is thus held to be the closest approximation possible of three-dimensional constructions on a two-dimensional surface by means of such mechanical aids as a ruler. However, while the use of mechanical aids to drawing is common both before and after the Sung, such usage seems most uncommon during the Sung period itself, if judged by extant paintings. This impression is confirmed by early texts which suggest that a major aesthetic change occurred during the eleventh century which ended the T'ang tradition of *chieh-hua,* until its revival in the fourteenth century. The present painting would perforce be dated either to the T'ang (as was done by P'an Cheng-wei in the *T'ing-fan-lou* catalogue of 1843) or to the later fourteenth century.

Although architecture figured in paintings from the Han Dynasty onward, it was not, according to the *Hsüan-ho hua-p'u* of 1120, until the late T'ang established as a separate category of painting. By then there was conceived to be one continuous tradition spanning the transition from the late T'ang to the early Sung and illustrating a development from buildings with figures to buildings placed within landscape settings.

The greatest tenth-century *chieh-hua* master was Kuo Chung-shu (ca. 910-977). According to the *T'u-hua chien-wen chih* (ca. 1075), Kuo "excelled in painting buildings, trees, groves, and rocks in a style not learnt from any teacher." Working in a type of painting noted for its adherence to rules and for its use of mechanical aids, Kuo was unique in creating a personal style of expression which could not be codified and transmitted. While none, perhaps, could capture the spirit of Kuo Chung-shu's paintings, a number of early Sung artists followed

their forms, such as Lü Cho (painter-in-attendance, Chih-tao era, 995-998), and Wang Shih-yüan, who also painted figures for Kuo Chung-shu.

By the early eleventh century, the T'ang tradition of *chieh-hua* painting – which took verisimilitude as its goal and which found an analogy between the firmness of mechanically drawn lines and the solidity of the structures themselves – was ended by changing goals which required new methods. Both painting and poetry were held capable of expressing concepts that were neither integral parts of the concrete imagery nor required distortion of the objective subject matter. Neither Su Shih (1036-1101) nor Wang Shen (ca. 1046- ca. 1100), leaders of this new movement, found anything inherently inimical between evocative expression and sound technical skills, and Su, in fact, demanded both: "Poetry and pictures at root follow the same standard, heaven [-like] craftsmen together with pure originality." For this reason the paintings of Kuo Chung-shu – whose "lofty antiqueness" had been misunderstood and ridiculed in his own day – were highly prized by Su Shih (who wrote a eulogy for

Kuo) and Wang Shen (who owned a painting by Kuo).

Kuo Chung-shu is also known to have copied a "Wintry Groves on Evening Mountains" by Li Ch'eng, and hence worked in the same traditions drawn upon by Wang Shen in his eleventh-century transformation of the Li Ch'eng tradition of ink-wash landscapes by melding it with a striking use of blue, green, and gold colors. Such coloristic and impressionistic scenes were ancestors to the later eleventh-century tradition represented by *Palace Landscape*. This relies on its coloring and on the spontaneous freedom of its drawing to avoid the constraints of mundane reality.

HR

Literature
P'an, *Ting-fan-lou* (1843), *ch.* 1 (under T'ang anonymous).
Chinese Paintings from the Chiang Er-shih Collection [sale cat.] (Parke Bernet Galleries, 1971), no. 1.
CMA *Handbook* (1978), illus. p. 340.
Lee, "River Village" (1979), p. 276, fig. 8.

Recent provenance: Chiang Er-shih.

The Cleveland Museum of Art 71.40

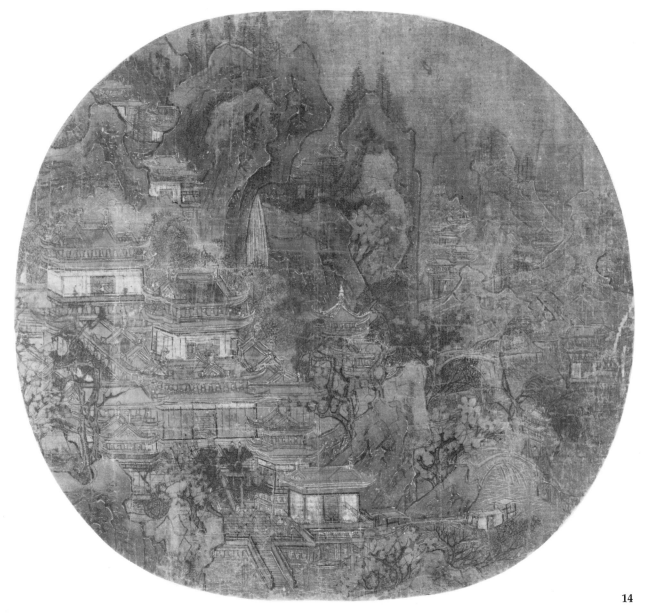

14

Artist unknown, twelfth century, Sung Dynasty

15 *Peony*
(Mu-tan)

Album leaf, ink and color on silk, 24.2 x 24.8 cm.

Spurious signature: Your servitor Hsü Hsi
[Ch'en Hsü Hsi].

15 seals: 6 of Keng Chao-chung (1640-1686); 3 of Keng
Chia-tso (son of Keng Chao-chung); 2 of Li Tsai-hsien
(1818-1902); 4 unidentified.

Remarks: On the basis of the spurious signature, prob-
ably a nineteenth-century addition, the painting had
been formerly attributed to that tenth-century artist.

<div align="right">LS/KSW</div>

Exhibitions
Fogg Art Museum, Cambridge, Mass., 1951: Rowland, *Bird and
 Flower,* cat. no. 3, p. 13.
China House Gallery, New York, 1970: Wang, *Album Leaves,* cat.
 no. 13, illus. p. 40.

Recent provenance: Yamanaka & Co.

Nelson Gallery-Atkins Museum 33-8/2

Artist unknown, Southern Sung Dynasty

16 *Ladies of the Court*
(Kung-chung t'u)

After a painting by Chou Wen-chü of the tenth
 century

Handscroll, datable before 1140, ink and slight color
 on silk, 28.3 x 168.5 cm.

1 colophon and 13 seals: 1 colophon and 1 seal of Chang
Ch'eng (12th c.); 12 seals unidentified.

Colophon by Chang Ch'eng:
[This is] Chou Wen-chü's picture *In the Palace.* Women
and children are numbered eighty with a single man. All
are drawn to life, but these do not include things such as
the cosmetic equipment, musical instruments, basins,
pots, fans, chairs, mattresses, parakeets, dogs, and a
butterfly. Wen-chü was a native of Chü-jung. He was a
painter-in-attendance in the Hanlin Academy in the
Southern T'ang Dynasty. His paintings of genteel ladies
are close to Chou Fang in style, with greater delicacy and
beauty. Once he painted a picture of the "southern villa"
for the last emperor of Southern T'ang which was consid-
ered a supreme masterpiece of the time. Later on, the
painting was presented to the court and was ordered to
be kept in the Imperial Library. The picture *In the Palace* is
said to be a genuine work [by Chou Wen-chü]. It was in
the family collection of the former Lord of the Imperial

15

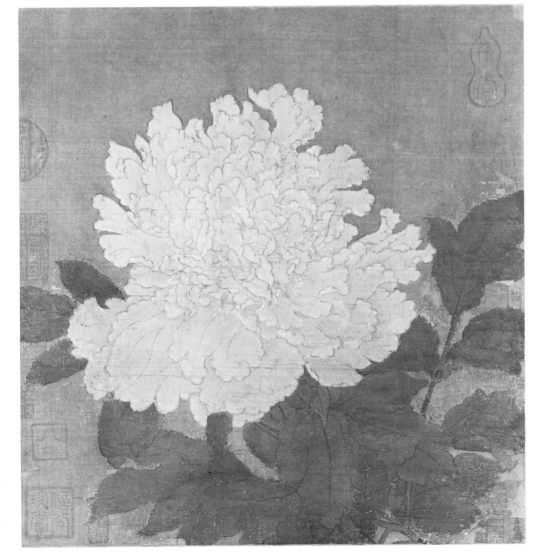

Sacrifice, Chu Tsai. Someone made a copy and presented [it to me].

The woman dressing up her hair in a high chignon has been so since the T'ang Dynasty. In this scroll [the ladies are depicted] in plump beauty and in long undergarments and skirts. This is the style of Chou Fang. When I was in Chiao-nan I saw in Tuan-ch'i at the home of a descendant of the first emperor of the Ch'en Dynasty an emperor's scroll from his family collection. The attending court ladies dress their hair in a high chignon more or less similar to this. But the maidservants dress their hair into two large loops hanging down between the shoulder and the neck. Although these were unattractive, they looked real. The house of Li called itself Southern T'ang. Consequently, their style of dressing was adopted mostly from the custom of the T'ang period. However, their high sense of fashion actually followed the tradition of the Six Dynasties. When the painters say that in examining ancient pictures one should first investigate [the style of] dressing, furnishings, and carriages, this is what they meant. This is written by Tan-yen-chu-shih in the fifth month of the *keng-shen* year in the Shao-hsing era [1140].

trans. WKH

Remarks: Chang Ch'eng's colophon describes how this painting came to be copied for him from a painting by Chou Wen-chü that at the time was in the collection of Chu Tsai. According to Chang, the original painting was of "women and children…numbered eighty with a single man." The section owned by the Cleveland Museum has twenty-two figures. When published by Helen Fernald ("Ladies of the Court," 1928, pp. 333-49), she brought up a second section (then owned by Bernard Berenson; now in I Tatti, Florence, Italy) that she felt belonged with the Cleveland section. Two more sections were found by Yukio Yashiro ("So bo Shū-Bunka Kyūchū zu," 1934, pp. 1-12, pls. VII, VIII) in the Fogg Art Museum at Harvard University, and the David collection, London (now in The Metropolitan Museum of Art). Yashiro, believing that the four sections belonged together and noting that they made a total of eighty figures, put them in the sequence of (1) the Berenson section, (2) the Cleveland section, (3) the Fogg Museum section, and (4) the Metropolitan Museum section. He concluded that all four sections were parts of the scroll inscribed by Chang Ch'eng.

Three titles appear in the seventeenth- and eighteenth-century catalogues which record this painting (see Literature). *Kung-chung t'u (In the Palace)*, used in the inscription of Chang Ch'eng, is the title of the original painting by Chou Wen-chü. *T'ang-kung ch'un-hsiao t'u (Spring Morning in the T'ang Palace)* is another title. However, since *Kung-chung t'u* is the title of the original Chou Wen-chü painting, this is probably a title given to differentiate the original from the copy. *Hsieh-chao t'u (Painting a Portrait)* is yet another title that may have been made up by Ku Fu and is based on the beginning scene, which shows a court painter making a portrait of a noble lady. All the records mention that the painting had an inscription by Chang Ch'eng.

Among the four sections of the *Ladies of the Court*, at least two different hands can be distinguished. After close comparison between the Cleveland and Metropolitan scrolls, it seems evident that they were done by different painters. Comparison between the Fogg Museum and Berenson sections was made with photographs. The conclusion is that the Cleveland and Berenson sections came from the same scroll and that the Fogg and Metropolitan sections are works of another painter.

The painting is datable before 1140 by inscription, so the authenticity of the inscription is all-important. Of the writer Chang Ch'eng we know almost nothing except that he was a nephew of Li Kung-lin and was the author of a short collection of notes on Sung painting, *Hua-lu kuang-i.* Recent study by Wai-kam Ho has gathered considerable new material to fill this gap. However, since his research involved a complicated reconstruction of the chronology of Chang Ch'eng which proved that the dates of his activities corresponded to the date and event given in the inscription on this scroll, it will be published in full at a later date.

(from research notes compiled by Hou-mei Ishida)

Literature
Chang Ch'ou, *Chen-chi* (ca. 1620-30), pt. 1, p.3.
Yü Feng-ch'ing, *Shu-hua* (1634).
Wang K'o-yü, *Shan-hu-wang* (preface 1634), *ch.* 1, p. 23.
Pien, *Shih-ku-t'ang* (1682), *ch.* 11, p. 16 (a-b).
Ku Fu, *P'ing-sheng* (preface 1692), *ch.* 7, pp. 20, 21.
P'ei-wen-chai (1708), *ch.* 82, p. 2(b).
Fernald, "Ladies of the Court" (1928), pp. 333-49.
Ferguson, *Li-tai* (1934), II, 166(b).
Yashiro, "So bo Shū-Bunku Kyūchū zu" (1934), pp. 1-12, pls. VII, VIII.
Jayne, "The Chinese Collection" (1941), pp. 31-34, fig. 27.
Yashiro, *Tōyō bijutsu ronko* (1942), pp. 85-97, pls. 24, 25.
Cheng Chen-to, *Yü-wai so-ts'ang* (1947), ser. 4, pt. 1, pls. 37, 38.
Sirén, *Masters and Principles* (1956-58), I, 171; II, *Lists,* 26.
Loehr, "Sung Dated Inscriptions" (1961), p. 252.
CMA *Handbook* (1978), illus. p. 339.
Yashiro, *Nippon bijutsu* (1978), fig. 102 (detail).
Watson, *L'Ancienne Chine* (1979), pl. 41 (color detail).

Exhibitions
University Museum, University of Pennsylvania, 1917, 1922: Exhibition of Oriental Art, no. catalogue.
Royal Academy of Arts, London, 1935/36: *Chinese Exhibition,* cat. no. 894.
Golden Gate International Exhibition, San Francisco, 1939: Pacific Cultures, *China,* no. 154, pl. N.

Recent provenance: The University Museum, The University of Pennsylvania.

The Cleveland Museum of Art 76.1

Artist unknown, early twelfth century, Chin Dynasty

17 *Portrait of Priest Ta-chih, the Master of Law (1048-1116)*
(Ta-chih Lü-shih hsiang)
Hanging scroll, ink and slight color on silk, 92.5 x 40.5 cm.

Inscription by Liu T'ao (late 11th-early 12th c.):

Dignified with the perfection of the *upasampada,*
His appearance is like his mind;
Uncompromising and loftily aloof,
His mind is like his appearance.
To say he is square, he proves to be round;
He looks timid, yet his spirit is unbound.
Having no attachment, and holding no reins,
Man and deities alike take refuge in him.

WKH

Literature
Mutō, *Chōsho* (1928), III, pl. 13.
Brinker, *Die Zen-Buddhistische* (1973), pl. 25.
Lee, "Portraiture" (1977), pp. 127, 128, figs. 10, 11.
Bush and Mair "Some Buddhist Portraits" (1977-78), pp. 32-35, figs. 1, 2 (detail), and 4 (inscription).

Exhibitions
Nara National Museum, 1978: *Nihon Bukkyo,* cat. no. 63.

Recent provenance: Mutō Collection; Nisaburo Mizutani.

The Cleveland Museum of Art 74.29

16 Detail

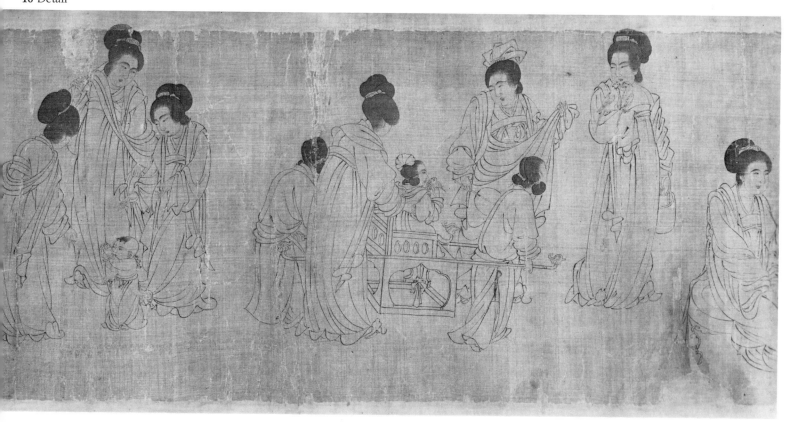

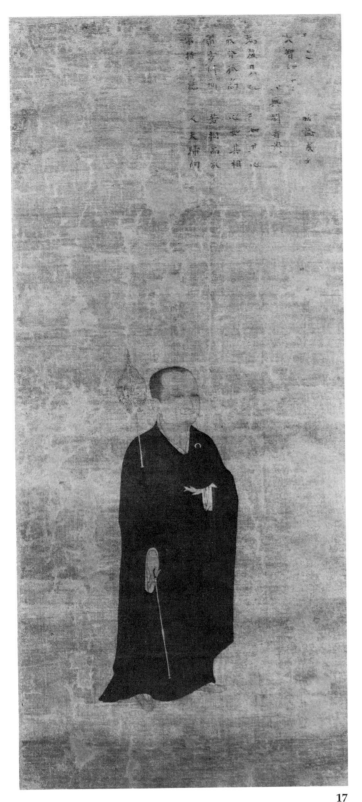

17

Wang Li-yung, active 1120-after 1145, Sung Dynasty
t. Pin-wang; from T'ung-ch'üan, Ssuch'uan
Province, active at Hangchou, Chechiang
Province

18 *The Transformations of Lao-chün*
(Lao-chün pien-hua shih-shih)

Handscroll, ink and color on silk, 44.7 x 188.4 cm.

Artist's signature: Respectfully presented by your servitor Wang Li-yung.

1 inscription, 2 colophons, and 82 seals: 1 inscription in
11 sections and 5 seals of Sung Kao-tsung (r. 1127-62);
1 Yüan Dynasty official seal (1279-1368); 2 colophons and
75 seals of Hsiang Yüan-pien (1525-1590); 1 Chang family
seal, unidentified.
2 forged seals of Sung Hui-tsung (r. 1100-25).

Remarks: The Hsüan-ho and Cheng-ho seals of Hui-tsung are not convincing, and considering Wang Li-yung's period of activity, they are obviously forgeries. Also, the upper of the two Shao-hsing seals of Kao-tsung appears to have been added at a later time. One can postulate how this may have come about. At the opening of the painting, seals had been impressed along the juncture of the painting silk and the damask panel of the mounting *(ko-shui)*. Originally there were but two seals, the Ch'ien-kua and Shao-hsing seals of Kao-tsung. In a subsequent remounting of the scroll the original damask panel was replaced, resulting in the loss of the right half of both seals. Following this remounting it is probable that the remaining portion of the seals were only partially visible and, therefore, not readily identifiable. To remedy this, some owner or dealer impressed a spurious Shao-hsing seal on the juncture line of the painting and new mounting and, to add age and prestige, impressed a Hsüan-ho seal over the scarcely visible Ch'ien-kua seal of Kao-tsung, at the same time complementing the Hsüan-ho seal with a Cheng-ho at the end of the painting. This was the condition of the opening line of seals when the scroll was acquired by Hsiang Yüan-pien, who added his own seal, Mo-lin pi-wan, over the juncture of the painting and mounting in the lower right corner. In yet another, later remounting the damask was again replaced, with the result that the right-hand sides of all the seals, including that of Hsiang Yüan-pien, were lost, leaving only the left halves of five seals on the painting, as they are today.

Hsiang Yüan-pien, in his first colophon, writes an account of Wang Li-yung and then praises the scroll as an harmonious combination of the calligraphy of Sung Kao-tsung and Wang's skill. He adds: "The works of Wang Li-yung are very rare, and this is the only one I have seen. Therefore, I did not hesitate to pay a great price to acquire it as an example of a well-known painter for my collection and shall ever treasure it."

The opening paragraph of the inscription attributed to Kao-tsung gives a general idea of the imaginative and rather bizarre nature of the texts inscribed on the painting. "Lao-chün dwelt quiescent in the Region of Ultimate Purity, Lord of the Thirty-Six Heavens. Throughout the generations of man, transforming himself [from epoch to epoch] he became the teacher of sovereigns of successive dynasties. Following the separation of Heaven and Earth, Nature bestowed on him the title of Master of the Innermost Mystery. He descended among men and taught the scriptures for eon upon eon. At that time all rulers and ministers were

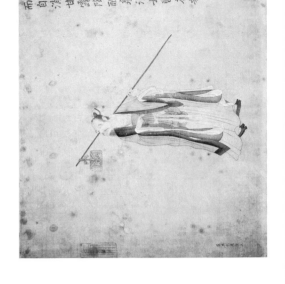

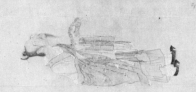

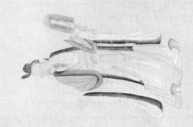

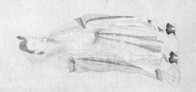

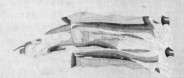

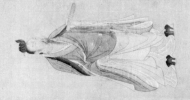

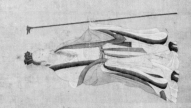

sages subsisting on clouds and the multi-colored mists of sunrise and of sunset. The many kinds of evil had not yet emerged, and the life span of man was ninety thousand years. To perfect his virtue he had only to follow his true nature. Such were the years of the Lung-hua era [when] the Tao of the Supreme Purity brought about the salvation of mankind. After the Lung-hua era came the period of Yen-k'ang, a time when Heaven and Earth collapsed into ruin – an era of long duration."

This introductory passage is followed by ten accounts of the names and manifestations assumed by Lao-chün during divers epochs of the remote past, the texts he taught, how long he preached, and the spiritual and civilizing benefits he brought to the world of men. These passages are evenly spaced and each interval carries a representation of Lao-chün in the manifestation described to the right of the figure.

The ten incarnations described and illustrated on the scroll are: 1) In the former times of the Three Emperors (of Heaven, of Earth, and of Man), Lao-chün was named Ku Hsien-sheng; 2) in the time of Sui-jen, he was called Chin-ch'üeh ti-chün; 3) in the time of Fu-hsi, Yü-hua-tzu; 4) in the time of Shen-nung, Ta-ch'eng-tzu; 5) in the time of Chu-jung, Kuang-shou-tzu; 6) in the time of the

18 Detail

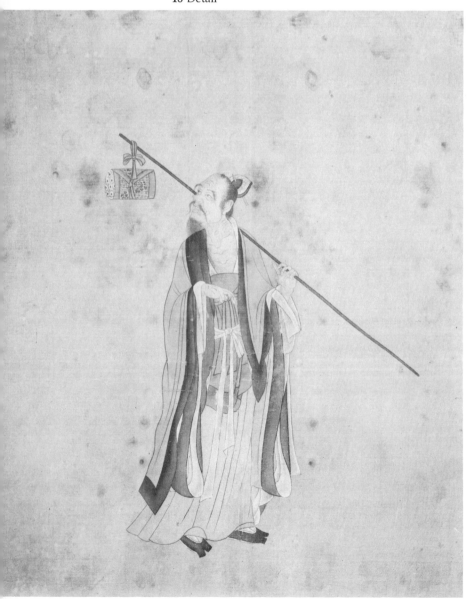

Yellow Emperor, Kaang-ch'eng-tzu; 7) in the time of the Emperor Yao, Chen-hsing-tzu; 8) in the time of the Emperor Shun, Hsüeh-i-tzu; 9) in the time of the Emperor Yü of the Hsia Dynasty, Wu-ch'eng-tzu; 10) and in the time of the Emperor T'ang of the Yin Dynasty, Ch'üan-yü-tzu.

The subject of the scroll, with its texts and illustrations, derives from an old stratagem devised to identify the supreme Taoist divinity with time-honored Chinese culture heroes and rulers of remote antiquity. To claim the latter as successive manifestations of Lao-chün gave the faith an unassailable pedigree in its rivalry with Buddhism and Confucianism.

An account of various manifestations of Lao-chün and the names by which he was known at different times occurs in the Taoist scriptures in a section compiled by Hsieh Shou-hao in 1191 and entitled *An Outline Chronology of the Supreme Lao-chün (T'ai-shang Lao-chün nien-p'u yao-lüeh*, in *Tao-tsang, erh-pien, t'ung-chüan*, pp. 1a-4a). Here nineteen manifestations of Lao-chün are given with the times of his appearances and his specific names; in two instances, however, only the times of his appearances are given without the names. Of the remaining seventeen, only four agree with the Nelson Gallery scroll inscriptions in both times and names; in five instances, either the names or the times are the same but not both. For example, the chronology of Lao-chün cited above states that in the time of the Emperor Yü of Hsia, Lao-chün was known as Chen-hsing-tzu, while the Nelson scroll has the name of Wa-ch'eng-tzu for the time of Yü and Chen-hsing-tzu as the name used in the time of the Emperor Yao. Of the remaining eight, neither the names nor times agree with any of the ten entries on the Nelson scroll. Moreover, the texts accompanying the lists in Hsieh Shou-hao's chronology of Lao-chün are briefer and substantially different from those on the Nelson scroll.

It is evident that the texts attributed to Kao-tsung on the scroll do not follow the Taoist scriptures found in the version current today. There can be several explanations. One is that the texts of the scroll were original compositions by the writer. This seems most unlikely, because in that case the texts would lack the weight of tradition or the prestige of scriptural veracity. A second explanation would be that the text comes from a different version of the canon. If this is the case, which seems probable, then the text may well have been that prepared under the direction of Ts'ai Ching (1047-1126), prime minister under Sung Hui-tsung in the Northern Sung – a text subsequently lost. Yet another possibility is that it may have come from an unidentified text of the T'ang Dynasty, a time when many Taoist texts and inscriptions were composed.

The earliest accounts of Wang Li-yung are found in the works of his contemporary, Liu I-chih (1078-1160; Liu, *T'iao-hsi chi, ch.* 31 p. 5, *ch.* 37 p. 2, and *ch.* 45 p. 1); then in an account given by Teng Ch'un (*Hua chi*, preface 1167, *ch.* 4, p. 42); and in a third by Ch'en K'uei (1128-1203; *Nan-Sung*, compiled 1177, *ch.* 7, p. 9b).

Wang Li-yung passed the metropolitan examinations with high honors (*chin-shih shang-she chi-ti*) in 1120, in the reign of Sung Hui-tsung, and was known as a specialist in the *Book of Changes (I-ching)*, an ancient text much favored by the Taoists. In 1134, the eighth year of the Shao-hsing era, he became a secretary in the Imperial Library under Emperor Kao-tsung. A year later he was appointed to the censorate, and his final promotion was to the post of provincial judge in Ssuch'uan (*Ch'eng-tu*

fu-lu). Wang was gifted both as a painter and a calligrapher, and Kao-tsung especially admired his calligraphy. Although he did landscape paintings, he was better at figures, which were carefully executed and refined. The time of his death is not known, but based on the evidence of the Kao-tsung seals on the scroll, it must have been painted in the years between his first appointment in 1134 and the end of the Shao-hsing era in 1162.

The mode of presenting the ten portraits, with fine lines of even thickness and with shading in the pigments, especially the white garments and linings, is all in a diluted style of the T'ang Dynasty. An eighth-century prototype for the stance of the figures, the robes, caps, and shoes, may be seen in a series of donor portraits engraved on the stone pedestal for a Taoist image and dated to 719 (seventh year of K'ai-yüan) found in An-i-hsien, Shanhsi *(Wen wu,* 1961, no. 12, pp. 56, 57). LS

Literature
NG-AM Handbook (1973), II, 47.
Watson, *L'Ancienne Chine* (1979), p. 441, pls. 494-96.

Exhibitions
C. T. Loo & Co., New York, 1948: Wang, *Authenticated,* cat. no. 2.

Recent provenance: Jean-Pierre Dubosc.

Nelson Gallery-Atkins Museum 48-17

Li An-chung, active ca. 1100-40, Northern and
 Southern Sung Dynasties
From K'aifeng, Honan, moved to Hangchou,
 Chechiang Province

19 *Cottages in a Misty Grove in Autumn*
 (Yen-ts'un ch'iu-ai)

Album leaf, dated 1117, ink and light color on silk,
24.2 x 26.3 cm.

Artist's inscription: In the *ting-yu* year [1117], Li An-chung painted.

2 seals of Wu T'ing (ca. 1600).

Remarks: There have been two conflicting theories on the dates of Li An-chung. The first was offered by Hsia Wen-yen: "Li An-Chung served in the Bureau of Painting [Hua-yüan] in the Hsüan-ho era [1119-25] and achieved the rank of *ch'eng-chung-lang.* During the Shao-hsing era [1131-62], he was reappointed to the Painting Bureau, and was awarded the Golden Girdle...." *(T'u-hui pao-chien,* preface 1365, *ch.* 4, p. 67). This view was a deviation from the earlier *Hua-chi pu-i* (preface 1298, *ch.* 2, p. 13) by Chuang Su, who stated that Li An-chung was a contemporary of Li Ti and both had served in the Painting Bureau during the three Southern Sung reigns of emperors Hsiao-tsung (r. 1162-89), Kuang-tsung (r. 1189-94), and Ning-tsung (r. 1194-1224).

In a recent article this chronological discrepency is attributed to the error of the *T'u-hui pao-chien.* Contesting

19

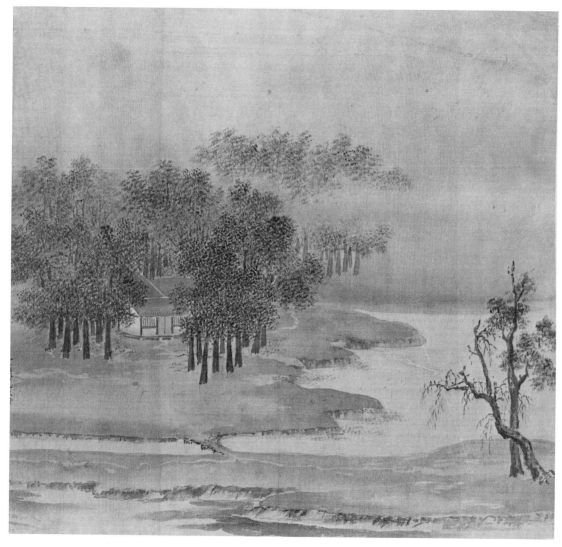

the dating by Sirén (as well as Loehr, "Sung Dated Inscriptions," 1961, p. 243), the article suggests that the two known dated works of Li An-chung, namely the landscape of the *ting-yu* year (in Cleveland) and the *Eagle Chasing a Pheasant* of the *chi-yu* year (in the Seattle Art Museum) should be redated to 1177 and 1189, respectively, "as Sirén and his assistants had been misled by the *T'u-hui pao-chien* to move up the date of these two works by a full cycle [60 years] too early, resulting in their being listed erroneously after Chao Ling-liang of Northern Sung and before Emperor Hui-tsung" (Weng T'ung-wen, " 'T'u-hui pao-chien,'" 1969, p. 33).

So the actual date of Li An-chung's career in the Sung "Academies" is significant, since it involves not just one individual artist but such broader historical issues as the interrelationship between a new landscape style and the court art during this dynastic transition. To help clarify the problem, we offer here two pieces of archaeological evidence in support of the earlier dating by the *T'u-hui pao-chien*.

The name of Li An-chung is found in two Northern Sung epitaphs (both dated to the third year of the Yüan-fu era, 1100) of members of the imperial family: namely, the Princess of the State of Yang, who was the fourth daughter of Emperor Che-tsung *(Yang-kuo kung-chu mu-chi-ming);* and Lady P'u-ning, wife of the Duke of Yin *(Yin-kuo-kung ch'i P'u-ning-chün-chün mu-chi-ming).* Both tombstones, found in Kung-hsien, Honan Province, have been published in the local gazetteer *(Kung-hsien-chih*, 1937, ch. 17, pp. 15-20), and a rubbing of the first is reproduced (Fu and Yü, "Tsang-shuang," 1976, p. 90). In both cases, Li An-chung was the court-appointed calligrapher who wrote the titles and text for the stela, with his official titles given as *Han-lin Shu-i-chü i-hsüeh* (artist-in-apprentice of the Han-lin Bureau of Calligraphy) and *chiang-yen ying-feng yü-shu* (calligrapher-in-attendance at the court lectures). It is remarkable to note that:

1. Under Emperor Che-tsung (1086-1101), perhaps toward the end of his reign, Li An-chung already served in the court. He served simultaneously in double capacities, but carried only one official title. Officially, he was attached to the Bureau of Calligraphy as an *i-hsüeh* where he actually worked as a painter. Semi-officially, with the adjunct appointment of *Ying-feng yü-shu*, he was called upon occasionally to work as a calligrapher. This arrangement may seem strange, but it was common during the Northern Sung period. Kuo Hsi, for instance, perhaps the most prominent court painter of his time, had also been an *i-hsüeh* of the Yü-shu-yüan — another palace service attending to imperial commissions for calligraphy (see Kuo Jo-hsü, *T'u-hua*, ca. 1075, ch. 4, p. 152). This situation is perfectly understandable if we remember that from 1060 on, the number of *tai-chao* (painters-in-attendance) in the Bureau of Painting was limited to three positions at one time, and even the most qualified candidate was required to wait for an opening.

2. Li An-chung was one of the court-related painters who also excelled in calligraphy. This was by no means unique in the Sung period. Kuo Chung-shu, Chao Ta-nien, Li Kung-lin, Hsü ching, and Wang Li-yung are a few other examples. And Mao I, according to his good friend, the historian of calligraphy, Tung Shih, to whom the handscroll *Beating the Clothes* in the National Palace Museum, Taipei (Edwards, "Mou I's Colophon", 1964, pp. 7-11) was dedicated, was an outstanding specialist in the seal script during the Southern Sung period (*Huang-Sung shu-lu*, II, 9).

3. Li An-chung was already an *i-hsüeh* in 1100, the second highest position in the Bureau. He was later given the rank of *ch'eng-chung-lang*, a new rank which appeared on the list of protocol only after the government reorganized in 1082. According to a new regulation enacted at the same time, a painter-in-attendance must serve five years before he could be considered for *ch'eng-chung-lang*. This means Li An-chung must have been promoted to *tai-chao* sometime after 1100 and five years later became qualified for this higher rank.

However, the *T'u-hui pao-chien* may have made a mistake here by assigning this event to the Hsüan-ho period (1119-1125). A fan painting of *Bamboo and Dove* attributed to Li An-chung, in the National Palace Museum, Taipei, is signed with the title *wu-ching lang*. The fan also bears the half-seal of Ta-kuan, which means Li An-chung had been awarded this rank in the Ta-kuan period (1107-1110; *Ku-kung shu-hua lu*, 1965, IV, 247). While the *ch'eng-chung lang* rank was a lowly forty-sixth on the ladder of fifty-three "military ranks," the *wu-ching lang* was much higher — thirty-seventh (Ma, *Wen-hsien*, 1959, ch. 64, pp. 579-80). How was it possible that Li An-chung's position in the Hsuan-ho era was much lower than what he had held in the earlier Ta-kuan period? There must be an error somewhere among these dates.

Nevertheless, all of these points seem to fit perfectly with the institutional development at the end of Northern Sung and make the case of *T'u-hui pao-chien* generally convincing. With the date of Li An-chung thus firmly established by the new archeological evidence, perhaps we can accept this enchanting leaf not only as one of the earliest-dated Chinese paintings but also as "a document of the changing interest of the artists in the early twelfth century" (Lee, "Scattered Pearls", 1964, p. 26) — a rare example of the new landscape style which emphasized intimate, near, flat views executed with a sensitive, painterly technique, and associated with the names of Chao Ta-nien, the Buddhist monk Hui-ch'ung (Maeda, "Chao Ta-nien," 1970), Hua-kuang (Chung-jen) and Sung Ti. To this list of pioneers can be added the name of Li An-chung, who probably should be considered more as a painter of Northern Sung than of Southern Sung, and whose significance in this transitional period has long been overlooked.

WKH

Literature

Sirén, *Masters and Principles* (1956-58), II, 74, and *Lists*, 58; III, pl. 228.
Goepper, *Im Schatten* (1958), pl. 3; idem, *Chinesische Malerei* (1960), p. 18, illus. p. 19.
Loehr, "Sung Dated Inscriptions" (1961), p. 243.
Lee, *Chinese Landscape Painting* (1962), color pl. 1; idem, "Scattered Pearls" (1964), p. 26, no. 2.
Maeda, "Chao Ta-nien" (1970), p. 248, fig. 1.
CMA *Handbook* (1978), illus. p. 341.
Loehr, *Great Painters* (1980), p. 158, fig. 77.

Exhibitions

Haus der Kunst, Munich, 1959: *1000 Jahre*, cat. no. 13.
China House Gallery, New York, 1970: Wang Chi-ch'ien, *Album Leaves*, cat. no. 4.

Recent provenance: Walter Hochstadter.

The Cleveland Museum of Art 63.588

Kao Tao (?), first quarter of the thirteenth century,
Chin Dynasty

20 *Birds in a Grove in a Mountainous Landscape in
Winter*
(Han-lin chü ch'in)

Hanging scroll, ink and slight color on silk,
175 x 90.2 cm.

Artist's signature and seal at lower left edge: Kao Tao (?);
seal undecipherable.

10 additional seals: 1 of Prince Chin, Chu Kang (d. 1398);
3 of So-nge-t'u (18th c.?); 2 of A-erh-hsi-p'u (18th c.?); 1
of Weng Fang-kang (1733-1818); 3 unidentified.

<div align="right">WKH</div>

Literature
K. Suzuki, *Ri Tō* (1974) p. 173, pl. 125.
CMA *Handbook* (1978), illus. p. 342.

Recent provenance: Frank Caro.

The Cleveland Museum of Art 66.115

Artist unknown, first quarter of the twelfth century
or earlier, Northern Sung Dynasty

21 *Streams and Mountains without End*
(Ch'i-shan wu-chin)

Handscroll, ink and slight color on silk, 35.1 x
213 cm.

9 colophons and 48 seals: 1 colophon, dated 1205, of
Wang Wen-wei (dates unknown); 1 colophon, dated
1205, of Li Hui (dates unknown); 1 colophon of T'ien
Hsieh (dates unknown); 1 colophon, dated 1214, of Ho
Yen (dates unknown); 1 colophon, dated 1326, of Ts'ao
Yüan-yung (dates unknown); 1 colophon, dated 1332, of
K'ang-li K'uei-k'uei (Nao-nao; 1295-1345); 1 colophon,
dated 1336, of Liu Tsai (dates unknown); 1 colophon,
dated 1380, and 4 seals of Yang Mou (ca. 1330-after 1380);
4 seals of the Hou family (ca. 1340); 1 colophon of Wang
To (1592-1652); 4 seals of Chang Ping-ch'ien (1670 *chin-
shih)*; 8 seals of Liang Ch'ing-piao (1620-1691); 2 seals of
the Ch'ien-lung emperor (r. 1736-95); 4 seals of the Chia-
ch'ing emperor (r. 1796-1820); 3 seals of the Hsüan-t'ung
emperor (r. 1908-12); 2 seals of Yeh Kung-ch'o (1880-
1965); 17 seals of Chang Yüan (Chang Ta-chien; 20th c.).

Remarks: In 1205 Wang Wen-wei wrote his colophon
for *Ch'i-shan wu-chin* in the Hall of Rustic Pleasure of the
Ho-tung district office. The reign-title used by Wang was
that of Emperor Chang-tsung of the Chin (r. 1190-1208),
who controlled then-Shenhsi Province, where Ho-tung
was located. The second colophon was added very
shortly thereafter by Li Hui, who wrote in the Hall of
Nine Thoughts of the prefectural office of the "city of
Shun," or Ho-tung. While there are no pre-Ming seals
on the painting itself, its presence in the district and
prefectural offices suggest that its early thirteenth-
century owner was an official of the Chin.

T'ien Hsieh, writing the third colophon before 1214
(the date of the fourth colophon), was the first to specu-
late on the stylistic lineage of the artist, bringing up the
name of Kuo Hsi. The fourth writer, Ho Yen, was also a
northerner, apparently from Tung-ying in the far north-
east. In 1234 the Chin dynasty was overthrown by the
Mongols, and the scholar Ts'ao Yüan-yung, the fifth to
inscribe the scroll, used a Mongol reign-era when writ-
ing his colophon in 1326.

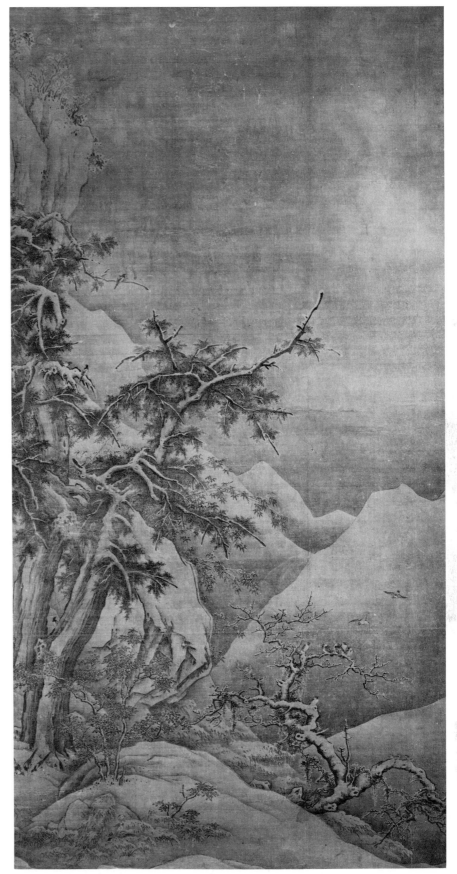

20

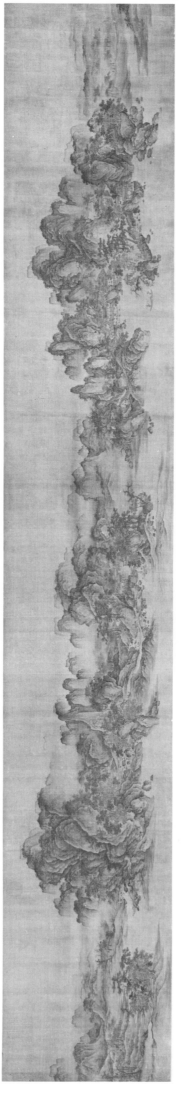

Six years later Ts'ao was followed by one of the most eminent of Yüan Dynasty calligraphers, K'ang-li Kuei-kuei, who in 1332 wrote: "In the *Streams and Mountains* picture to the right, the overtones of the conception are free and untrammeled. A single look causes one to have thoughts of mists and clouds. Truly can this be prized and treasured. To its left it also has inscriptions and poems by various famous worthies of the Sung and Chin. Survivors from troops and fire are extremely difficult to obtain."

Kang-li's colophon is most important in reconstructing the history of the scroll. He mentions colophons by Sung writers which are no longer attached to the scroll but which, in the fourteenth century, must have been held to be by Northern Sung writers. Loss of the artist's name had evidently already occurred by the first colophon of 1205, which in itself implies some lapse of time since the scroll's execution. The scroll's presence in Chin territory from then onwards is well documented. Northern Sung scrolls which survived the Chin conquest, and which subsequently were not destroyed by the Mongol armies were truly "prized and treasured" and "extremely difficult to obtain." Yang Mou in his colophon of 1380, during the early years of the Ming Dynasty, commented, "We need not ask whose this is but can regard [the artist] as of the divine class. Since that which was written by famous masters of the three dynasties of Sung, Chin, and Yüan is still incapable of calling [his identity] to mind, his origins [must be] still more distant." The colophons themselves thus constitute a compelling argument for a date of execution for the painting before 1127, which fully accords with the conclusion of Lee and Fong (*Streams and Mountains*, 1955, 1967), based on stylistic grounds, that the painting dates to the first quarter of the twelfth century.

To Tung Yüan, Yen Wen-kuei, and Fan K'uan — models mentioned for the artist of *Ch'i-shan wu-chin* by Lee (*Chinese Landscape Painting*, 1954, p. 24) — can be added Chao Ling-jan, whose hallmark of misty banks of fog drifting among groves of trees appears here in the opening and closing sections, and Kuo Hsi, mentioned in T'ien Hsieh's colophon. The styles of a total of five major artists active between the tenth and late eleventh centuries were drawn upon by the present artist as the sources for his conception. To remark thus does not discredit the painter as an uninspired eclectic but rather associates him with the redefinition of some of the basic goals of painting that occurred in the decades immediately prior to the year 1100.

An approach, if not conclusion, to the identity of the artist may be made through examination of biographical records of the artists known to have followed the styles of the previously mentioned artists. In particular, let us look at Liang Ching-hsin, who "in the reign of Jen-tsung [1023-63] was painter-in-attendance in the Painting Academy. He was skilled in painting landscapes, in style close to Kao K'o-ming but with brush and ink a bit immature. Moreover, his temples and buildings being overly plenteous, and his boardwalks equally complicated, people sometimes criticize him — perhaps his inconsistent height [relationships] cause these to stand out" (Kuo Jo-hsü, *T'u-hua*, ca. 1075). This stylistic characterization of a second-generation eclectic comes fairly close to what can be observed in the *Ch'i-shan wu-chin* itself, even to the profusion of architecture and mountain causeways, which are indeed made the more noticeable because consistent scale is not scrupulously maintained throughout. While it is thus impossible on the basis of

present evidence to attribute the scroll to any artist in particular, the present dating to the first quarter of the twelfth century may in fact be on the conservative side.

<div align="right">HR</div>

Literature

Shih-ch'ü III (1816), *Yen-ch'un-ko, ch.* 14, pp. 1534-36.
Lee, "Landscape" (1954), p. 200, cover pl. (detail).
Lee and Fong, *Streams and Mountains* (1955).
Ch'en J.D., *Ku-kung* (1956), p. 10(b).
Sirén, *Masters and Principles* (1956-58), II, *Lists,* 94.
Fontein, "Chinese Art" (1960), pl. 269.
Goepper, *Im Schatten* (1959), pl. 2 (detail).
Goepper, *Chinesische Malerei* (1960), unpaginated.
Loehr, "Sung Dated Inscriptions" (1961), p. 262.
MacKenzie, *Chinese Art* (1961), color pl. XXXVII.
Lee, *Chinese Landscape Painting* (1962), p. 24, no. 16; idem, *Far Eastern Art* (1964), p. 348, fig. 453.
Barnhart, *Marriage* (1970), p. 31, fig. 16 (detail).
Akiyama et al., *Chūgoku bijutsu* (1972), I, pt. 1, p. 233, color pl. 13.
Fong Wen, *Summer Mountains* (1975), figs. 36, 37.
Barnhart, Iriya, Nakada, *Tō Gen, Kyōnen* (1977), p. 144, pl. 49.
CMA *Handbook* (1978), illus. p. 341 (detail).
Watson, *L'Ancienne Chine* (1979), pl. 140 (color detail).

Exhibitions

Cleveland Museum of Art, 1954: Lee, *Chinese Landscape Painting,* cat. no. 16.
Musée Cernushi, Paris, 1956: La Chinese des Song (Paris, 1956), no catalogue.
Haus der Kunst, Munich, 1959: *1000 Jahre,* cat. no. 11.
Cleveland Museum of Art, 1960: Chinese Painting, no catalogue.
Metropolitan Museum of Art, New York, 1976: Summer Mountains: The Timeless Landscape, no catalogue.

Recent provenance: Yeh Kung-ch'o; Chang Yüan (Chang Ta-chien); Walter Hochstadter.

The Cleveland Museum of Art 53.126

Artist unknown, second half of the twelfth century, Chin Dynasty

22 *Chao Yü's Pacification of the Barbarians South of Lü by a Sung Artist (Sung-jen hua Chao Yü Lü-nan p'ing i t'u)*

Handscroll, ink and color on silk, 39.3 x 396.2 cm.

1 frontispiece, 6 inscriptions, 3 colophons, and 89 seals: 1 Sanskrit letter seal, Yüan Dynasty (?); frontispiece, 1 colophon, and 10 seals of Mu Hsin (first half 15th c., a son-in-law of the Yung-lo emperor [r. 1403-24]); 1 colophon, dated 1435, and 5 seals of Wu No (1372-1447); 14 seals of Shen Chien (act. Wan-li era, 1573-1619); preface, 6 inscriptions, and 38 seals of the Ch'ien-lung emperor (r. 1736-95); 1 colophon by Ho-shen (1750-1799) and others, with 2 seals of P'eng Yüan-jui (1731-1803); 1 seal of the Chia-ch'ing emperor (r. 1796-1820), 1 seal of the Hsüan-t'ung emperor (r. 1909-11), 2 seals of T'an Ching (20th c.); 6 seals unidentified.

1 forged colophon and 10 forged seals: 2 seals of Sung Hui-tsung (r. 1100-25); 1 seal of Chia Hsün (act. early 12th c.); 1 colophon dated 1343, signature, and 3 seals of Yü Ch'üeh ((1303-1358); 1 Yüan Dynasty imperial palace seal; 1 seal of Chao Meng-fu (1254-1322); 2 seals of K'o Chiu-ssu (1312-1343).

Remarks: The Sanskrit seal possibly may be read *aṁ,* the seed syllable for the mantra calling on Amitābha. This scroll is a prime example of a good painting of considerable age that had been extensively tampered with beginning some three hundred years ago.

Late in the eighteenth century, when the scroll entered the Ch'ing imperial collection it bore the title *Cal-*

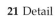

21 Detail

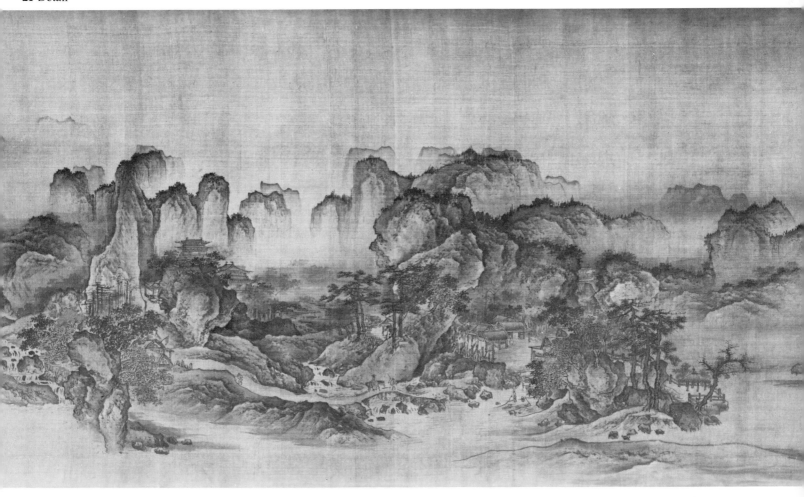

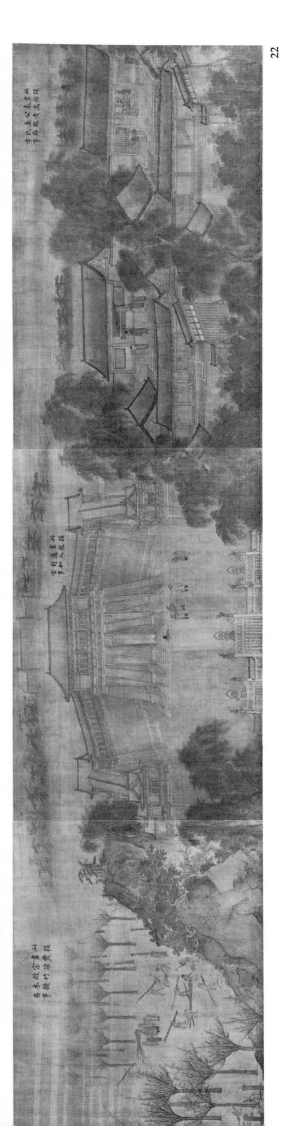

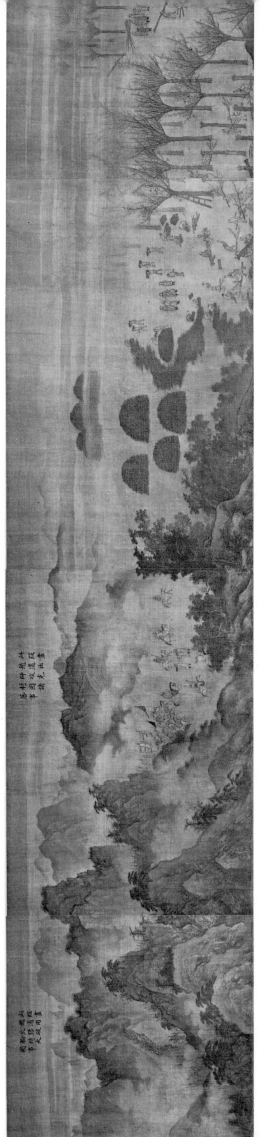

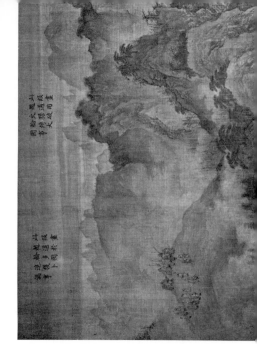

22

ligraphy by Sung Hui-tsung Together with a Painting of Li Sung (Sung Hui-tsung shu Li Sung hua ho-chüan). The Ch'ien-lung emperor at once observed that the painting in no way reflected the style of the Southern Sung Academy painter, Li Sung (see cat. nos. 35-37); that the calligraphy was not the "slender gold" style of Hui-tsung (r. 1100-25); and, moreover, that it was written on a sheet of imperial paper bearing the name of a Yüan Dynasty palace hall. However, the Ch'ien-lung emperor did accept the subject as one depicting the exploits of Chao Yü.

The studies involved in reaching a plausible solution to the problems of this painting, including how the painting came to be joined with its present colophons, are too detailed to recount here, so a resume of the conclusions must suffice.

Sometime in the sixteenth century an ingenious but unscrupulous person owned two scrolls. One scroll carried a sheet of paper ornamented with a dragon among clouds in gold, and stamped with an oblong cartouche bearing the characters *Ming-jen-tien (Hall of Radiant Benevolence).* In addition, two large characters, *Tu Kung (Sincerity - Reverence),* are written without the writer's signature. Through a lack of connoisseurship in the fifteenth century, the writing was attributed to Sung Hui-tsung. This calligraphy was mounted with a forepaper carrying four large characters in seal script, *Hui-tsung ch'en-han (The Imperial Script of Hui-tsung),* signed by Mu Hsin (a son-in-law of the Yung-lo emperor) and followed by five of his seals. Also mounted with it were two colophons relating to the calligraphy, which in the original mounting must have followed it. The first is by the same Mu Hsin, who wrote at the request of a friend, Li Lung, Marquis of Hsien-ch'eng (1393-1447). The second, dated 1435, is by Wu No, a physician, scholar, and official who held office in the Hsüan-te era (1425-36). Both colophons are written on gold-flecked paper and both speak in vague and fatuous terms of the virtues and faults of Hui-tsung, but neither makes any mention whatever of a painting by Li Sung or anyone else.

The person who owned this scroll of calligraphy also owned, or came across, a painting in handscroll form that, by happenstance, was the same height. It may have been this similarity in size that generated the idea of combining the two. In any event, the two were combined, with the so-called Hui-tsung calligraphy preceding the painting. In order to explain the combination and make the now-single scroll more interesting and valuable, it was necessary to concoct a fraudulent colophon. This was done, and the faked colophon was mounted directly following the painting and preceding the two genuine early Ming Dynasty colophons – regardless of the fact that the latter two made no mention of the painting.

As the purported author, the forger chose a well-known Yüan Dynasty scholar, Yü Ch'üeh (1303-1358). Since the calligraphy was thought to be by Sung Hui-tsung, the exploits of an official contemporary with that emperor were taken as the subject of the painting – hence the campaign of 1115 against the barbarians south of Lü under the command of Chao Yü, a military official active in the Cheng-ho (1111-17) and Hsüan-ho (1118-25) eras. The fraudulent colophon states that it was written at the request of a certain Chao K'ang (otherwise unknown), who claimed to be a descendant of General Chao Yü, and tells how this Chao K'ang related to Yü Ch'üeh the circumstances of how this precious scroll

came to be assembled and descended in his family. The story told in part is that following Chao Yü's successful campaign (against the rebel aborigine chieftain, T'u-lou, at Yen-chou in Ssuch'uan), he was received at court by Emperor Hui-tsung, who presented him with the inscription *Sincerity - Reverence,* written by the imperial brush. After this impressive event, it is recounted that Chao Yü requested Li Sung to paint a scroll illustrating the events of his campaign and the great honor paid him at the imperial court. It was this scroll and the imperial calligraphy that supposedly had come down to Chao K'ang. The colophon concludes "He himself narrated the whole story as [recorded] on the left, and I have written it down for him. In the spring of the *kuei-wei* year of the Chih-cheng era [1343], Yü Ch'üeh."

It is difficult to believe, were the colophon genuine, that Yü Ch'üeh, a distinguished scholar and a councillor of state, was unaware of the fact that Ming-jen-tien was the name of a palace hall in the court he served, or was unaware of the one hundred years or so that separated the time of Hui-tsung from that of the artist Li Sung. The style of writing in this colophon is not that of the fourteenth century: there are some indications it was written by a person influenced by the calligraphic style of Wen Cheng-ming (1470-1559) – which suggests that the colophon was written in the Suchou area in the first half of the sixteenth century at the earliest. Also, it is written on gold-flecked paper remarkably similar to the paper of the two following Ming Dynasty colophons.

At this time, or possibly later, further embellishments were added in the form of fraudulent seals: two seals of Sung Hui-tsung on the calligraphy, a large Yüan Dynasty official seal in the upper left corner of the painting, and at the beginning, seals of Chao Meng-fu and K'o Chiu-ssu.

Although the Ch'ien-lung emperor and the compilers of his catalogue took the painting of this much-doctored scroll to be the work of an anonymous Sung artist, here it is attributed to an unknown painter of the northern dynasty of Chin (1125-1234) in the second half of the twelfth century. The mountain forms are defined with heavy, dark outlines, and the dense texturing *(ts'un)* of the rocks includes a number of parallel strokes; there are strong and sudden contrasts in the chiaroscuro and an emphasis on atmospheric effect with a plethora of clouds. Distant, bare trees are topped by horizontal, hook-like branches, and distant mountain ranges include several double- or triple-fingered peaks. These stylistic elements were ably isolated and assembled by Susan Bush in her analysis of northern landscape painting under the Chin (" 'Clearing after Snow,' " 1965, pp. 163-72). It is a style that derives ultimately from such Northern Sung innovators as Li Ch'eng and Kuo Hsi and emphasizes the definition of form, but at the same time reduces the precision of the earlier artists by a loose, sketchy quality in the texturing strokes. An additional confirmation for a Chin dating is the similarity between the palace gate and forecourt, in the second scene, and an almost identical gate and forecourt on a bronze bell of Liao or Chin date (Sekino and Takeshima, *Ryō-Kin,* 1934-36, II, pls. 128-31; see also Sekino, *"Ryō no dō shō,"* 1934, pp. 14-17).

If the scroll is the work of a Chin painter, as we take it to be, then the exploits of a Northern Sung general in far-off Ssuch'uan would be a most unlikely subject. The scroll is a narrative picture with a series of events run

together to form a continuous composition that exhibits little regard for variations in scale or the relationships of near and far distance.

The historical event illustrated has not been identified as yet. Among the subjects that suggest themselves is that of a Sung Dynasty official going over to the service of the Chin, as did, for example, Chang Chung-yen (ca. 1098-1173), who served as a military commander under both the Sung and Chin (*Chin-shih*, compiled 1343-45, *ch.* 79, pp. 8a-10a).

The central theme of the scroll – cutting down the trees – may well reflect the kinds of conditions and events mentioned in the history of the Liao Dynasty at an earlier date. Among the devices employed by Sung officials to protect their northern borders from invasion was the close planting of thousands of trees to hinder the Tartar cavalry. In one instance, some three million elm and willow trees were planted for this purpose in Shanhsi Province. To counteract this measure, the Liao armies either rounded up the peasants or used conscripts to cut down the trees, using the trunks for stockade or siege material and the branches to repair the roads and fill up ditches and moats. Some action very much of this sort seems to be in progress (Wittfogel and Feng, *Liao*, 1949, pp. 532, 536, 563, and n. 30).

As more is learned about painting under these northern dynasties, it becomes evident that during the twelfth and thirteenth centuries, a style of painting evolved from the Northern Sung masters different and distinct from the evolution that occurred over the same centuries in the regions under the control of the Southern Sung Dynasty. A more accomplished example of the same style is the long landscape (cat. no. 25) signed T'ai-ku i-min.

This so-called Chao Yü painting, in spite of its alterations, is of particular value as an example of an illustration of an historical event – a class of narrative painting that must have been relatively common at one time but already had become extremely rare by the eighteenth century.

LS/KSW

Literature

Shih-ch'ü II (1793), Ch'ien-ch'ing-kung, pp. 106a-107b.
Bush, "'Clearing after Snow'" (1965), pp. 163-72, fig. 7.
Horizon, History (1969), pp. 180, 181.
Akiyama et al., *Chūgoku bijutsu* (1973), I, 222, 223, pl. 12.
NG-AM Handbook (1973), II, 53.
K. Suzuki, "Nihon no sansui-ga" (1977), p. 18, fig. 9.

Exhibitions

Royal Ontario Museum of Archaeology, Toronto, 1956: Tseng, *Loan Exhibition,* cat. no. 2.
Asia House Gallery, New York, 1962: Cahill, *Southern Sung,* cat. no. 6, pl. 29.

Nelson Gallery-Atkins Museum 58-10

22 Detail

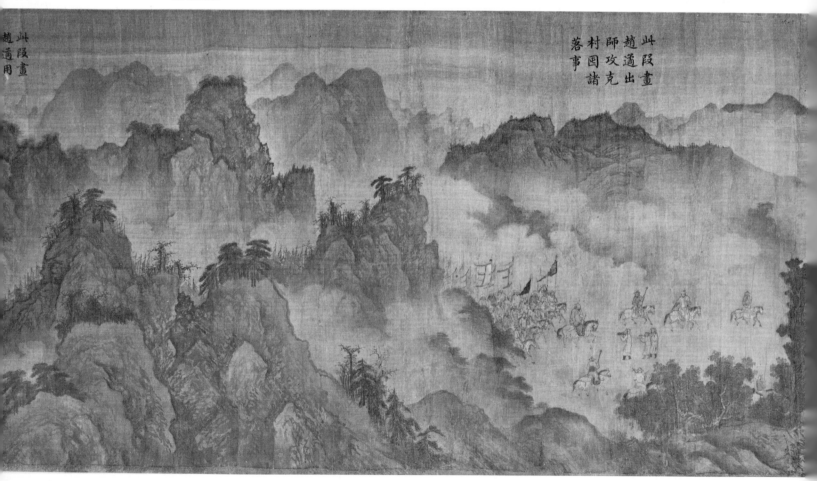

Chiang Shen, ca. 1090-1138, Northern Sung to early
Southern Sung Dynasty
t. Kuan-tao; from K'ai-hua, Chechiang Province

23 *Verdant Mountains*
(*Lin-luan chi-ts'ui*)

Handscroll, ink and slight color on silk,
30.6 x 296 cm.

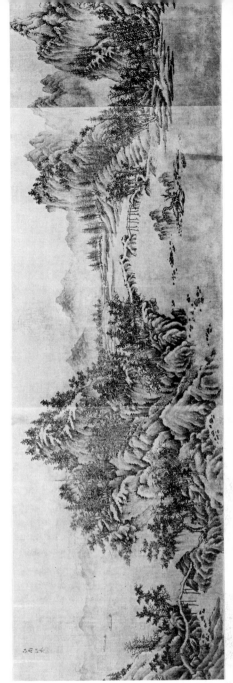

Spurious artist's signature and 2 spurious seals: Chiang
Shen of Chiang-nan [seals] Chiang Shen; Kuan-tao.

1 colophon and 22 additional seals: 5 seals of Liang
Ch'ing-piao (1620-1691); 1 seal of Sung Lo (1634-1713);
1 colophon, dated 1785, and 13 seals of the Ch'ien-lung
emperor; 1 seal of the Chia-ch'ing emperor (r. 1796-
1820); 1 seal of the Hsüan-t'ung emperor (r. 1909-11);
1 seal unidentified.

Remarks: Teng Ch'un in his *Hua-chi* (preface 1167, *ch.* 3,
p. 22) expresses great admiration for Chiang Shen, but
wrongly states that he was from the large area known as
Chiang-nan. It is clear from the epitaph of Chiang
Shen's father, Ta-fang, that he was a native of Hsin-an,
Chechiang (Hsin-an is the old name of Chü-chou-fu,
and Chiang Shen's home town is K'ai-hua-hsien within
Chü-chou-fu). After his marriage to the niece of Wang
Han-chih (1054-1123), Marquis of Hsin-an, he moved to
Chen-chiang, Chiangsu, and remained there until the
Chin Tartars invaded the Chiang-nan region in 1128.

Teng Ch'un also mentions that Chiang Shen was
recommended to do some paintings for Yü-wen Chih-
chung (ca. 1085-1150), prefect of Hu-chou (modern Wu-
hsing, Chechiang) around 1136-37. In about early 1138
Chiang Shen was summoned to the imperial court at
Hangchou but regrettably died suddenly in the night
before meeting Emperor Kao-tsung (r. 1127-62).

While still a young man, Chiang Shen became famous
as a landscape painter. Wu Tse-li (d. 1121), who visited
Chen-chiang about 1114, wrote several poems praising
Chiang as an outstanding painter of the time, mention-
ing also, that Chiang, like his father, was a good *ch'in*
player and, incidentally, a skillful archer as well (Wu,
Pei-hu chi, early 12th c., *ch.* 2). Chiang Shen's painting is
traditionally said to have followed the styles of the
tenth-century artists Tung Yüan and Chü-jan. However,
Wu Tse-li and another Southern Sung scholar, Lin Hsi-i
(1235 *chin-shih*), said that Chiang was a follower of Li
Ch'eng and Kuo Hsi. But judging from Chiang's extant
paintings – a long handscroll, *Ch'ien-li chiang-shan (A
Thousand Miles of Rivers and Mountains)*, and a section of a
handscroll, *Ch'iu-shan (Autumn Mountains)*, both in the
Palace Museum, Taipei – and the scroll here in the Nel-
son Gallery, it is apparent that he was in fact greatly
influenced by the styles of Tung and Chü.

Chiang stayed many years in Chen-chiang, where Mi
Fu and Mi Yu-jen lived for a long time. The Mis, father
and son, were good friends of the family of Chiang
Shen's wife. The two Mis are known as the earliest fol-
lowers of Tung Yüan and Chü-jan. However, the elegant
washes and some trees with crab-claw branches in
Chiang's paintings also indicate that Chiang might have
studied the Li-Kuo style in his early period.

It is apparent that the composition at the end of the
Nelson scroll is incomplete and that a section of un-
known length has been removed, probably in the seven-
teenth century. Doubtless, it was then that the signature
and seals of the artist were added; from the style of both
the calligraphy and the seal cutting, they are obvious
interpolations. KSW

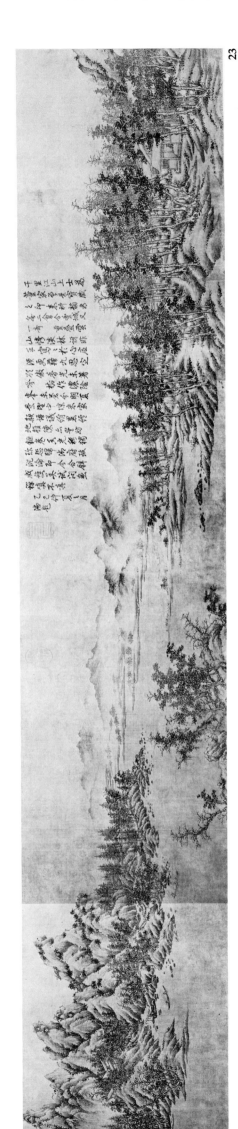

Literature

Shih-ch'ü II (1793), Yü-shu-fang, *ch.* 36, pp. 13a, b.
Sickman and Soper, *Art and Architecture* (1956), pl. 104.
Sirén, *Masters and Principles* (1956-58), II, 99; III, pls. 257, 258.
NG-AM Handbook (1973), II, 52.
Barnhart, Iriya, Nakada, *Tō Gen, Kyonen* (1977), pp. 91, 142, 152,
 pl. 75, fig. 29.

Exhibitions

Cleveland Museum of Art, 1954: Lee, *Chinese Landscape Painting*,
 cat. no. 16, pp. 30, 31.

Recent provenance: C. T. Loo & Co.

Nelson Gallery-Atkins Museum 53-49

Mi Yu-jen, 1072-1151, Southern Sung Dynasty
t. Yüan-hui; from Hsiang-yang, Hupei Province

24 *Cloudy Mountains*
 (Yün-shan t'u)

Handscroll, dated 1130, ink, lead-white, and slight
color on silk, 43.4 x 194.3 cm.

Artist's inscription, signature, and seal:

Innumerable are the wonderful mountain peaks which
 join the end of the sky,
Clear or cloudy, day or night, the misty atmosphere is
 lovely.
To make known that the gentleman has been here,
I am leaving traces of my playful brush at your house.

Keng-hsü year [1130, fourth year of the Chien-yen era],
done at Hsing-ch'ang. Yüan-hui [seal] Yüan-hui shih.

 trans. WKH

3 colophons, 1 inscription, and 16 additional seals: 2
colophons (1 dated 1650), 1 inscription dated 1647, and 2
seals of Wang To (1592-1652); 1 colophon, dated 1650,
and 2 seals of Ch'en Kuan (1646 *chin-shih*); 1 seal of Pi
Lung (18th-19th c.); 1 seal of Yung Hsing (Prince Ch'eng;
1752-1823); 1 seal of Lo Chen-yü (1866-1940); 1 seal of Li
Chih-kai (Ch'ing Dynasty); 8 seals unidentified.

6 colophons mounted on a separate scroll: 1 colophon,
dated 1914, by Lo Chen-yü (1866-1940); 3 colophons (1
dated 1914 and 1 dated 1918) of Tora Naitō (1886-1934); 1
colophon, dated 1915, of Kō Nagao (20th c.); 1 colophon,
dated 1917, of Wu Ch'ang-shih (1844-1927).

Remarks: After the sack of K'aifeng in 1126 by the Chin
invaders, Mi Yu-jen journeyed southward, and by the
end of the decade had found refuge in Chiangsu Prov-
ince. This painting was done as a remembrance of the
unnamed recipient's hospitality. In his choice of
subject — the visual aspect of mountains under given
conditions of light and atmosphere — Mi Yu-jen fol-
lowed a tradition that extended through his illustrious
father, Mi Fu, back to the late eleventh-century artist
Sung Ti. Sung's series of eight impressionistic level-
distance landscapes, each poetically titled, were similar-
ly concerned with specifics of time and season. These
Eight Views of the Hsiao and Hsiang, named by collectors
and connoisseurs after their location at the confluence of
two rivers in Hunan Province, were highly admired in
court circles. Though unacknowledged, Sung Ti must
have strongly influenced the art of Mi Fu. Mi un-
doubtedly appreciated the tranquil understatement and
naturalness of Sung Ti's compositions, for such qualities

23 Detail

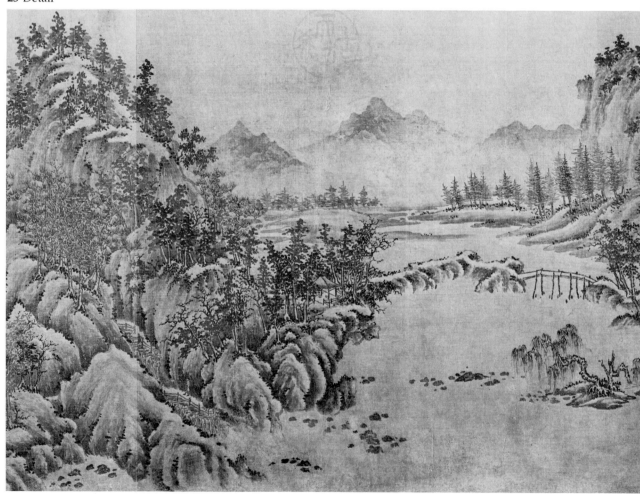

were precisely what he sought in his own calligraphy and painting. A *Hsiao and Hsiang* picture by Mi Fu is one of the small handful of his works mentioned in early records, although no paintings by Mi Fu are known to have survived to the present day.

One twelfth-century *Hsiao and Hsiang* painting, accepted and praised by Tung Ch'i-ch'ang and Kao Shih-ch'i as a masterwork by Li Kung-lin (ca. 1040-1106), fortunately is preserved in the Tokyo National Museum. The relationship between the style of Mi Fu and the Tokyo *Hsiao and Hsiang* painting is noted by Shujirō Shimada (Shimada and Yonezawa, *Sung and Yüan*, 1952, p. 30): "No authentic work of Mi Fu is in existence. *The Scenery of Hsiao Hsiang* may be considered to come near to his style.... All details are abbreviated in gatherings of dots and blendings of the ink tone...the depiction depends more on subtle blending of the ink tone than dense gathering of Mi's dots." In 1103, some three years after Li Kung-lin had been compelled by rheumatism to cease painting, Mi Fu, according to his own testimony *(Hua-shih)*, took up painting. While it is clear that his statement cannot be taken literally, it is true that calligraphy had been his major interest in earlier years and that even after 1103 he produced very few paintings. The landscape style of Mi Fu, as well as the earliest style of Mi Yu-jen, thus may be closely related to that of the Tokyo National Museum's *Hsiao and Hsiang* painting.

Mi Yu-jen "in everything continued his family teachings, and did landscapes that conveyed a purity which could be grasped. He also somewhat transformed that which was done by his venerated [father] and perfected the school's methods. Mist and clouds change and disappear, groves and streams are dotted and connected, and conceptions are produced without exhaustion" (T'ang Hou, *Hua-chien*, 1329, p. 38). This fourteenth-century account suggests a change in style between Mi Yu-jen's earliest works directly influenced by his father, and those from his more mature and independent period. Some features of *Cloudy Mountains*, dated to 1130, place it convincingly at the mid-point of Mi Yu-jen's artistic career. From 1140 on, Mi rose steadily in the Southern Sung civil bureaucracy and, in like pace, became increasingly loath to part with his paintings. According to T'eng Chun's *Hua-chi* (preface 1167): "In the time when he had not met [the emperor], scholar-officials could frequently get his brushworks, but when he was elevated he took himself to be extremely private and important, and even kinship and friendship were insufficient cause to obtain them."

According to Chao Hsi-ku of the thirteenth century, Mi Yu-jen's paintings were done in ink on unsized paper, and the green color used here, as well as the silk ground, suggest that it was done relatively early in his career. This "colored style" of painting was in fact that continued by Hsü Lung-ch'iu, Hsiung Ying-chou, and Chu Shih (the wife of Emperor Ch'in-tsung, r. 1126-27), who were Mi Yu-jen's immediate followers, and, further, was that occasionally taken up in the Yüan by Kao K'o-kung.

In comparison to the *Hsiao and Hsiang* picture, Mi Yu-jen's *Cloudy Mountains* displays the more architectonic composition and the greater interest in formal patterns of brushwork which are appropriate to such a *mo-hsi* (ink performance). In accord with the transformation of style that was suggested by T'ang Hou, the blunt strokes are here massed and dotted in some areas for a rich, compact solidity, while in other passages they are connected and drawn out in more linear and dramatic patterns. The scroll thus marks a most important aesthetic change in

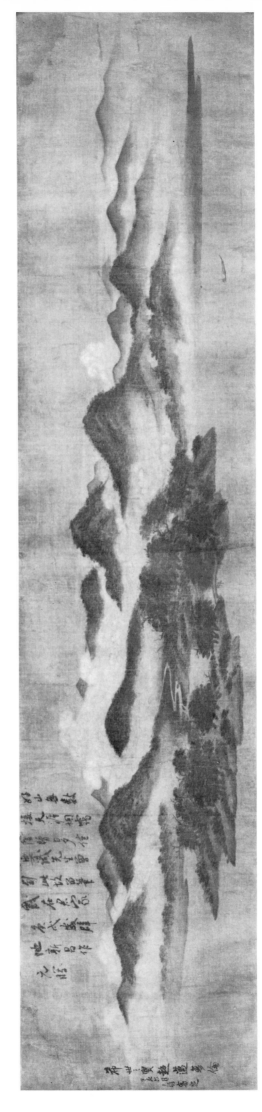

the stylistic continuum between the original emphasis of Sung Ti on the visual properties of the scene itself and the Yüan insistence of such as Kuo Pi on the formal properties of brush and ink.

HR

Literature

Sun, *Keng-tzu* (1660), *ch.* 3, pp. 15(a), 15(b), under title *Pai-yün ch'u hsiu t'u.*
Yamamoto, *Sō Gen Min Shin* (1927), I, 101-8, pls. following; idem, *Chōkaidō* (1932), I, 98-102.
Harada, *Shina* (1936), p. 102 (top pl.).
Shina (1935-37), III (text), fig. 14, XIV, pl. 25.
Nihon genzai Shina (1938), p. 33.
Cheng Chen-to, *Yü-wai so-ts'ang* (1947), ser. 4, pt. 2, pls. 57, 58.
Cohn, *Chinese Painting* (1948), p. 68, pls. 58, 59.
Sirén, *Masters and Principles* (1956-58), II, 78, *Lists*, 35, 36; III, pl. 189.
Vandier-Nicolas, "Mi Fou" (1960), fig. 4.
Loehr, "Sung Dated Inscriptions" (1961), p. 247.
Lee, *Chinese Landscape Painting* (1962), pp. 28, 31, no. 17; idem, *Far Eastern Art* (1964), p. 350, fig. 455.
Sullivan, *Chinese and Japanese* (1965), p. 47, illus. p. 238.
Goepper, *Kunst* (1968), pl. 90.
Barnhart, *Marriage* (1970), p. 20, fig. 8.
Akiyama et al., *Chūgoku bijutsu* (1972), I, pt. 1, 221, 222, pl. 10, color pl. 10.
Ch'en, Ho Chih-hua, "Yün-shan te-i t'u" (1974), p. 34.
T'ang Sung Yüan Ming (1976), I, pl. 53.
CMA *Handbook* (1978), illus. p. 341.
Capon, *Chinese Paintings* (1979), pl. 17.
Lee, "River Village" (1979), fig. 11, n. 47.
K. Suzuki, "Shō-Shō Gakuyu" (1979), illus. pp. 21, 31, 35, 36.
T'eng, *T'ang Sung* (n.d.), p. 76.

Exhibitions

Tokyo Imperial Museum, 1928: *Tō-Sō-Gen-Min*, p. 56.
Royal Academy of Arts, London, 1935/36: *Chinese Exhibition*, cat. no. 1140.
Cleveland Museum of Art, 1936: *Twentieth*, cat. no. 382.
Golden Gate International Exhibition, San Francisco, 1939: *Pacific Cultures*, cat. no. 126.
Cleveland Museum of Art, 1954: Lee, *Chinese Landscape Painting*, cat. no. 15.
Recent provenance: Lo Chen-yü; Teijirō Yamamoto; Yamanaka & Co.

The Cleveland Museum of Art 33.220

T'ai-ku i-min (unidentified), first half of the thirteenth century, Chin Dynasty
h. T'ai-ku i-min, Tung-kao

25 *Traveling among Streams and Mountains (Chiang-shan hsing-lü)*

Handscroll, ink on paper, 38.4 x 418 cm.

Artist's signature and seal: T'ai-ku i-min [seal] Tung-kao.

1 frontispiece, 1 inscription, 2 colophons, and 42 additional seals: 1 seal of Ni Tsan (1301-1374); 1 colophon, dated 1501, and 1 seal of Wu K'uan (1435-1504); 6 seals of Pien Yung-yü (1645-1712); 1 inscription and 11 seals of the Ch'ien-lung emperor (r. 1736-95); 1 seal of the Chia-ch'ing emperor (r. 1796-1820); 3 seals of the Hsüan-t'ung emperor (r. 1909-11); 1 colophon, dated 1951, and 19 seals of J. D. Ch'en (20th c.).

24 Detail

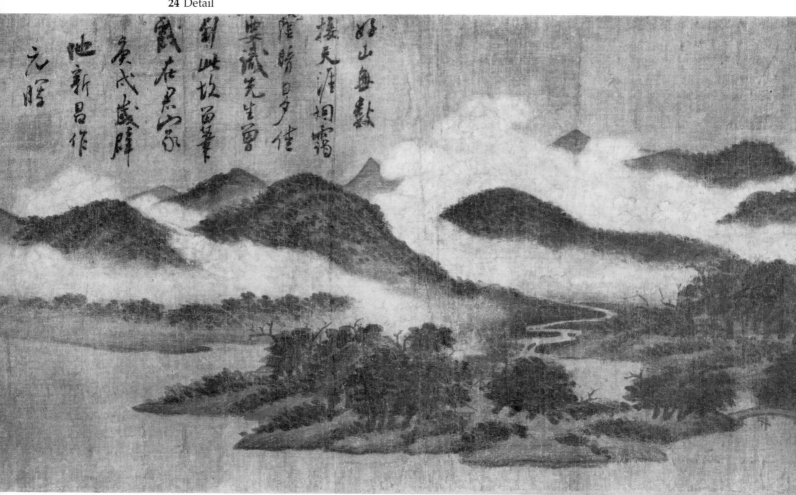

Remarks: For about five hundred years this scroll has been attributed to Sun Chih-wei (act. late 10th c.), and it appears under his name in traditional literature. Whether or not the attribution originated with Wu K'uan (1435-1504), his colophon of 1501, written for a certain Mr. Lu, who should probably be identified with Lu Wan (1458-1526), is the earliest source linking the picture with Sun Chih-wei.

T'ai-ku is a sobriquet of Sun Chih-wei, but the attribution to Sun or his time is untenable. It is tempting to see in Wu K'uan's enumeration of Sung painters of the twelfth and thirteenth centuries, who have no connection with Sun or even with early Sung painting styles, a hint that Wu, too, thought the painting dated from those later centuries. The opening sentences of his colophon read: "Sun [Chih-wei], Liu [Sung-nien], Ma [Yüan], and Hsia [Kuei] all achieved fame for painting during the Sung. One often sees [works] from the brushes of Kuei, Yüan, and Sung-nien passed on to later periods. It is only the works of T'ai-ku that the world seldom sees."

The artistic accomplishment seen in *Traveling among Streams and Mountains* suggests an artist important enough to be recorded in traditional literature. He defies identification, however. His signature reads: T'ai-ku i-min (A Leftover from Remote Antiquity). This is a sobriquet appropriate to anyone who feels out of tune with his own time and who sees himself playing a defiant or at least challenging, role. Its use is compatible with both Taoist and Confucian tenets; it is especially apt in the case of a person who lives on in the turbulent aftermath of the fall of a dynasty that had commanded his loyalties.

The wording of the artist's seal is another sobriquet. It reads: Tung-kao (Eastern Bank). Together with the name T'ai-ku i-min, it places the artist squarely in the continuum of Northern Sung literati values maintained by twelfth- and early thirteenth-century poets, painters, and scholars of the Chin Dynasty. Both names associate the painter and his view of himself with the poet T'ao Ch'ien (356-427), whose moral probity, couched in simple devotion to Confucian ethical discipline, and whose self-imposed rustification made him a hero to literati poet-painters. In speaking of his own withdrawal from urbane society, T'ao often refers to himself as a man of remote antiquity. The name Tung-kao has been drawn from the fifth of T'ao Ch'ien's series of five verses entitled "Returning Home," where the context extols retirement to rural occupations.

Stylistic features also link T'ai-ku i-min with aesthetic values of late Northern Sung literati painters. The descriptive naturalism of early Northern Sung masters (see cat. no. 10) is left aside in favor of a formalism that embraces abstract effects of fluctuating brushwork, odd or intentionally irrational spatial juxtapositions, and patterning that has a life independent of descriptive function.

Rocks and mountains have begun to lose substance, their weight and bulk dissolving in flourishes of brushwork and plays of texturing. In early Northern Sung painting, outline drawing of these elements thickens and thins with intent to suggest volume – volume naturally coordinated with surface modelling. Here, however, the artist's interest is as much directed to the irregular abstract, rhythmic energy of his drawing and to register-

25 Detail

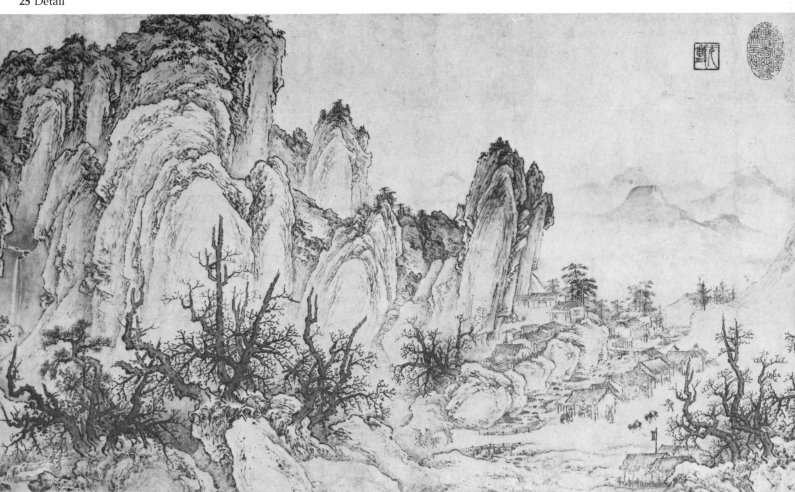

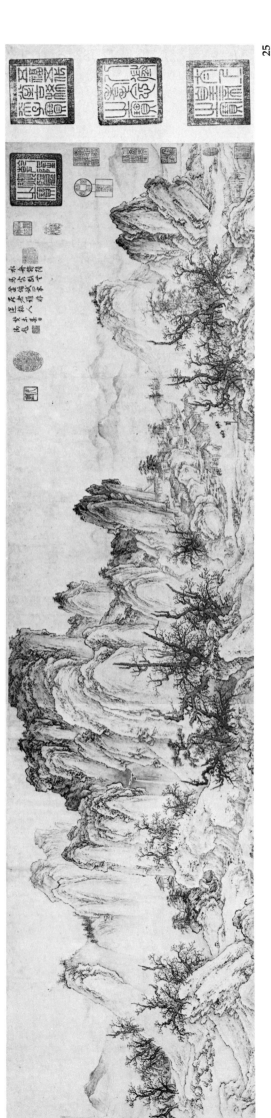

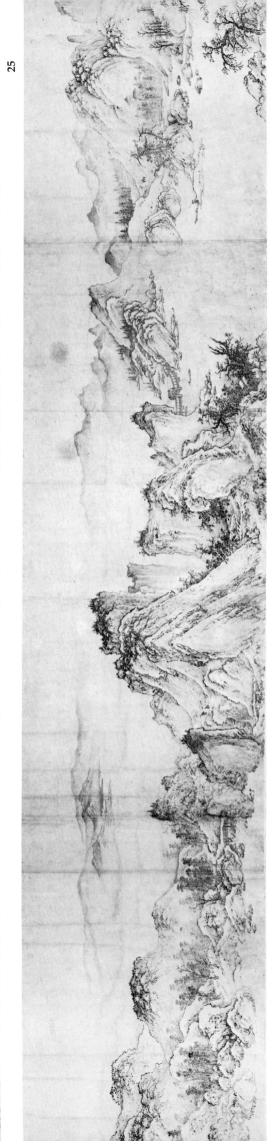

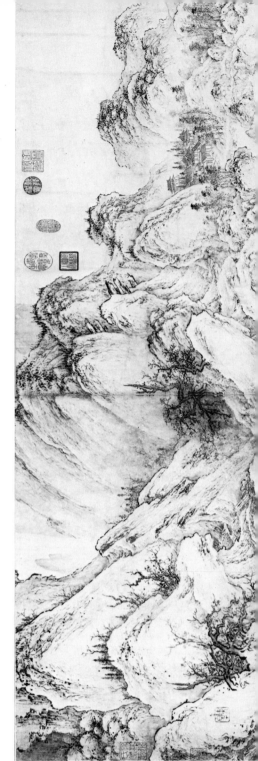

ing the speed of his brush as it is to depicting solid shapes. Essays in scribbly, vibrant brushwork appear as well in the interior texturing strokes that complete the modelling of foreground rocks and middle-ground mountains.

Rivalry between the demands of descriptive depiction and the artist's interest in graphic effects of brushwork and texture is nowhere more evident than in the opening cluster of mountain slabs. Mannerism appears here, and elsewhere, in the staccato, linked dotting used for the outlines and in the unstable tilting of the front slabs.

A preference for arbitrary graphic effects is seen again in the application of washes to large mountain masses in the middle ground. Here, formula confines the washes to upper zones of the mountains and deep crevices, thus providing contrast and plastic relief to the lower masses in front. Gone is the gradual building of volume and surface characteristic of early Northern Sung painting.

Also indicative of the date and of T'ai-ku i-min's artist allegiances are the sudden jumps from middle-ground hills to far peaks. Abruptness appears not only in spatial terms but in the sudden change from the dry, dragged brushwork of middle-ground hills to the broad, loose, ink-wash strokes of distant mountains.

Yet another characteristic of the time and the tradition of *Traveling among Streams and Mountains* is the isolation and subsequent emphasis of individual motifs. This is most apparent in the treatment of foreground trees, made to stand out starkly on the surface of the paper. Visual interest is concentrated in choreographed patterns of branches and in plays of tensile strokes.

Expressively, the picture is in keeping with literati values. Since the landscape is not the true subject, but is only a vehicle, it is bland. Adherence to spontaneity is affirmed by much of the brushwork and by the elimination of colors. The arbitrary manipulation of form for abstract graphic purposes and the manipulation of the viewer's experience appear throughout, the latter most prominently at the end. It is also apparent that T'ai-ku i-min is aware of earlier masters held dear by literati connoisseurs. Allusions to earlier Northern painters, such as Fan K'uan, give way to passages that recall Tung Yüan (d. 962) and Chü-jan (see cat. no. 11). Style and meaning coincide in these art-historical essays.

The date assigned to the scroll is based upon the above considerations and upon striking affinities to the *Red Cliff* handscroll (Barnhart, Iriya, Nakada, *Tō Gen, Kyonen*, 1977, no. 50) attributed to the Chin Dynasty scholar-painter Wu Yüan-chih (act. late 12th- early 13th c.). One of the distinctive features shared by the two scrolls is the staccato, linked dotting used for certain outlines. In the *Red Cliff* handscroll this type of outline is largely limited to the outlines of tree trunks and to the drawing of the boat. The hatching on the surface of the rocks is another mannerism common to both scrolls. Close similarities may also be found in the combination of the broken, dragged strokes used for outlines of rocks and the interior modelling of them with short, jabbing strokes. The flat, finger-like shapes of the middle-ground mountains in the *Red Cliff* recur in *Traveling among Streams and Mountains*. Moreover, both artists frequently cap middle-ground mountains with a dense growth of scrubby bushes. Even the arbitrary distribution of ink washes on the upper zones of mountains and the handling of distant mountains are not unrelated.

Despite these similarities, the *Red Cliff* is more conservative, its forms more substantial, and its brushwork heavier and more closely wedded to naturalistic depic-

tion. These differences, together with the stylistic traits seen in *Traveling among Streams and Mountains*, suggest that T'ai-ku i-min was familiar with the works of Wu Yüan-chih, but worked a generation or so later. MFW

Literature
Pien, *Shih-ku-t'ang* (1682), *Hua*, *ch.* 11, pp. 7a, b.
Shih-ch'ü I (1745), *ch.* 14, Yang-hsin-tien, pp. 32a-33a.
Ch'en J. D., *Chin-Kuei lun hua* (1956), pl. 1; idem, *Chin-Kuei ts'ang-hua p'ing-shih* (1956), I, 38-42; idem, *Chin-Kuei ts'ang-hua chi* (1956), II, no. 5.
Bush, "'Clearing after Snow'" (1965), pp. 168, 170-72, fig. 11.
Barnhart, Iriya, Nakada, *Tō Gen, Kyonen* (1977), pp. 68, 69, 138, 145, pl. 51, fig. 22.

Recent provenance: M. F. Ch'en.

Nelson Gallery-Atkins Museum F74-35
Gift of the Kenneth A. and Helen F. Spencer Foundation Fund

Artist unknown, mid-thirteenth century, Southern Sung Dynasty

26 *Birds and Ducks on a Snowy Islet (Hsüeh-ting shui-ch'in)*

Album leaf, ink and slight color on silk, 24.6 × 25.9 cm.

3 additional seals: 1 of Wu T'ing (ca. 1600); 2 of Li Pao-hsün (1858-1915).

Remarks: Small-format landscapes depicting rather close-up and level-distance scenes in fan, album leaf, or handscroll format, were a speciality of the Fuchien monk Hui-ch'ung (ca. 965-1017). These were especially appreciated by the literati of the late Northern Sung era. Hui-ch'ung's art was characterized as presenting river fowl within specific seasonal settings in the *T'u-hua chien-wen chih* (ca. 1075): "The priest Hui-ch'ung, from Chien-yang, was skilled in painting domestic and wild geese and egrets. He was especially skilled in small scenes, and excelled in doing likenesses of wintry spits and distant banks, desolate and scattered in empty wastes—what [other] men with difficulty achieve."

In the late eleventh century the subjects and style of Hui-ch'ung were adopted by such officials as Liang Shih-min and members of the imperial house, such as Chao Ling-jang (act. ca. 1070-1100), who had studied with Su Shih (1036-1101). The Sung writer Wang T'ing-kuei (1079-1171) noted that Chao Ling-jang "liked to do rivers, lakes, mountain groves, figures, and pitted and burrowed [rocks]. He painted level groves and distant waters with wild and domestic ducks in evening scenes which cause one on a single look [to feel] as though traveling through Chiang-nan. Where the banks end and the water descends stones protrude from the sand, and birds wait on the waves as though about to start up in alarm" (quoted in *Pei-wen-chai*, 1708). The immediate influence of Chao Ling-jang appears to have been limited to other members of the imperial house who would have had easier access to his works.

The Cleveland Museum possesses another anonymous fan painting (see cat. no. 27) which also falls within the Hui-ch'ung—Chao Ling-jang tradition of small-scale landscapes. In *Birds and Ducks on a Snowy Islet* the trees in a misty grove set on the far bank of the river are similar to those appearing on a screen drawn within a painting done between 1238 and 1240

by the artist Mou I (1178-1242). That relationship would date the painting approximately to the Shun-yu era (1241-52) when Li Kung-mao (the son of Li An-chung; see cat. no. 19) was a painter-in-waiting in the Painting Academy and specialized in "hunting falcons in rural settings," which may not have differed greatly from the present work. HR

Literature
Lee, "Scattered Pearls" (1964), no. 2.

Exhibitions
Asia House Gallery, New York, 1962: Cahill, *Southern Sung*, cat. no. 9.
China House Gallery, New York, 1970: Wang Chi-ch'ien, *Album Leaves*, cat. no. 6.

Recent provenance: J. T. Tai.

The Cleveland Museum of Art 61.260

Artist unknown, ca. 1200, Southern Sung Dynasty

27 *Birds on an Autumn Inlet*
(Ch'iu-t'ing yeh-fu)

Album leaf, ink and light color on silk, 22.4 × 24 cm.

Remarks: *Birds on an Autumn Inlet* falls, as does *Birds and Ducks on a Snowy Islet* (cat no. 26), within the stylistic tradition stemming from Huich'ung and Chao Ling-jang of the Northern Sung period.

The foreground includes the "pitted and burrowed" rocks traditionally associated with Huang Ch'uan and his sons. However, the emphasis found here on evocative space at the expense of descriptive detail would place this painting among the late twelfth-thirteenth century followers of that tradition. Apparently the sole Southern Sung follower of Hui-ch'ung to be noted as such in standard biographical sources was Wang Tsung-yüan. According to the *Hua chi pu-i* of 1298, Wang "specialized in the study of Hui-ch'ung and did pond-embankments in small scenes which really have a rural flavor." HR

Recent provenance: Ch'eng Ch'i.

Intended gift to The Cleveland Museum of Art, Kelvin Smith

Artist unknown, late twelfth–early thirteenth century, Southern Sung Dynasty

28 *Returning Birds and Old Cypress*
(Ku-po kuei-ch'in)

Album leaf, ink on silk, 23.8 × 24.9 cm.

1 unidentified seal reads: Yün-chou shan-jen [Mountain dweller of the cloudy islet].

Remarks: In Chinese folklore, magpies (*hsi-ch'üeh*) are auspicious birds whose caw heralds the approach of good fortune. In the present painting each bird faces one of the four directions from whence the imminent blessing may appear. Fans with such bird-and-flower motifs, as well as landscape scenes, were sold in speciality shops located within the market areas of Hang-chou. Academy artists such as Lin Ch'un (active late 12th c.) and his followers are known to have done these subjects using comparable compositions. The crease down the center of the painting indicates that it was originally mounted and used as a fan; its high quality and spacious composition associate it with the Academy productions of this subject.

In this Southern Sung rendition, the brushwork in the cypress is subordinated to descriptive intent. The reliance on monochrome washes and the lack of linear contours for the birds suggests a late twelfth-thirteenth century date of execution. HR

Exhibitions
China House Gallery, New York, 1970: Wang Chi-ch'ien, *Album Leaves*, cat. no. 24.
Asia House Gallery, New York, 1974: Lee, *Colors of Ink*, cat. no. 7.

Recent provenance: Dr. and Mrs. Sherman E. Lee.

The Cleveland Museum of Art 69.305

26

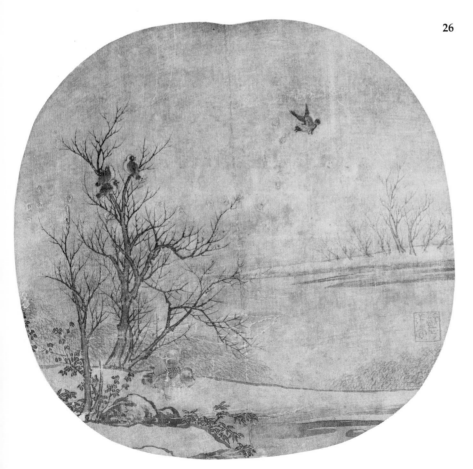

Artist unknown, twelfth century, Northern Sung
 Dynasty

29 *Fighting Birds*
 (Tou-ch'iao)

 Album leaf, ink and color on silk, 23.5 x 26.8 cm.

8 seals: 1 of Feng Tzu-chen (1257-1327 or later); 2 of Ku-
ting Tsu-ming (1280-1358); 2 of Liang Ch'ing-piao (1620-
1691); 1 of Yung-hsing (Prince Ch'eng, 1752-1823); 2 un-
identified.

Remarks: A reproduction of this album leaf (in *Sung Yüan
pao-hui*, 1930, pl. 65) shows a colophon by Ti P'ing-tzu
(early 20th c.) beside it. This colophon is now missing. In
it Ti P'ing-tzu states that he acquired this leaf, together
with two others, from an album entitled *Sung Yüan chi-
ts'e* that originally belonged to P'ei Ching-fu (1854-1926),
but no album of this title is recorded in P'ei's catalogue,
Chuang-t'ao-ko shu-hua lu (preface 1924).

KSW/LS

Literature
Sung Yüan pao-hui (1930), pl. 65.
NG-AM Handbook (1973), II, 54.

Exhibitions
Asia House Gallery, New York, 1962: Cahill, *Southern Sung*, cat.
 no. 7, pl. 30.

Nelson GalleryAtkins Museum 49-13

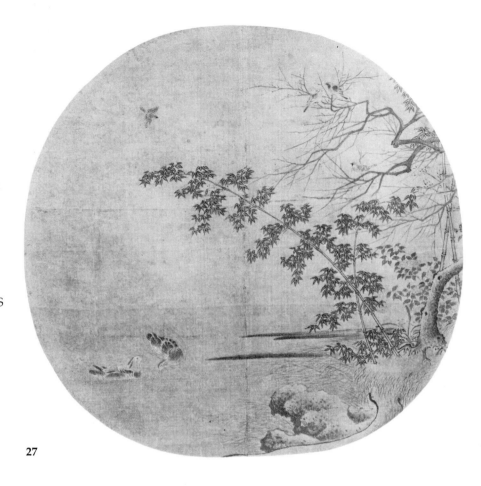

27

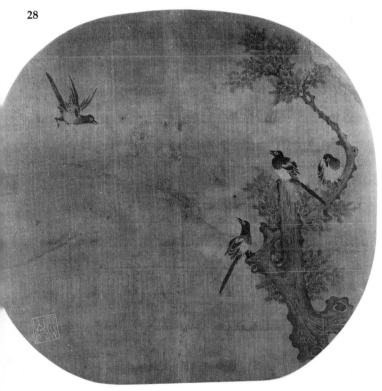

28

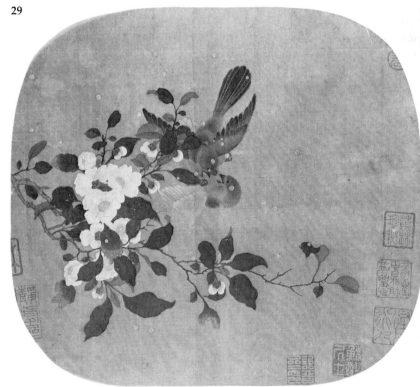

29

Artist unknown, mid-twelfth century, Southern
Sung Dynasty

30 *Gazing at a Waterfall*
(Kuan p'u)

Album leaf, ink and color on silk, 23.9 x 25.1 cm.

1 unidentified seal.

Remarks: The stylistic elements of this picture derive ex-
clusively from Li T'ang (d. after 1130), thus placing the
artist among a number of early Southern Sung academic
painters who fell under the spell of Li's influence.
Among the more readily recognized idioms are the
shapes and modelling of the rocks. The attenuation of the
middle-ground cliff towering above the waterfall and its
treatment – layers of lithic flakes with notched profiles
and undercut angular bases – are characteristic. So, too,
are the slender, flat spires with squared or angled sum-
mits in the background, and the profile of the nearest of
the distant peaks. The forms of the large foreground
rocks follow an underlying rectilinear order whose angles
and crisp sides have been rounded to conceal and soften
the architectonic structure.

The drawing of the cascades, with their particular dis-
tribution of pattern and pale blue wash, again find

antecedents in Li T'ang, as do the shapes and drawing of
the trees, both near and far. Notable here is the tapering
trunks of the distant fir trees – outlined with a firm, rel-
atively even stroke – and the cottony texture of their
boughs. The dense beds of dark green and brown dots
representing vegetation in which the firs stand is a favor-
ite device, as is the thick, grassy ground cover spreading
out around the trunks of the foreground pines. The
graceful twisting and turning of these pines, forming
complex but clear patterns, reflect the manner as well.

The overall quality of the picture, the particular hand-
ling of the brushwork, and the Li T'ang stylistic elements
suggest that *Gazing at a Waterfall* represents a phase in the
Li T'ang tradition immediately after him but earlier than
that registered in the works of Chia Shih-ku (act. mid-
12th c.) and the brothers Yen Tz'u-p'ing and Yen Tz'u-yü
(see Edwards, "The Yen Family," 1975, pls. 1, 3, 4). The
extreme asymmetry, which packs the principal pictorial
elements into one corner, marks these later painters but is
absent in *Gazing at a Waterfall*.

The approach to building form with closer attention to
naturalistic depiction signals the earlier date of *Gazing at a
Waterfall*. The foreground rocks and cliff are modelled
with layers of carefully applied washes that aim at a gra-
dual formation and change of volume and surface. In the
works of the Yen brothers or Chia Shih-ku, however,
these shifts are more abrupt and are imbued with an urge
toward ornamental pattern.

The same kind of distinction may be seen in the out-
lining and interior modelling of rocks. In *Gazing at a
Waterfall* outlines and short modelling strokes are closely
bound to the demands of depiction, and function with
economy to suggest substance and weight. In the works
of Chia and the Yen brothers, abstract values indepen-
dent of depiction begin to appear in the brushwork and
washes. And there is a self-conscious artistry about their
work – the intent to dazzle – that marks a slightly
later phase.

It is precisely the kind of painting seen in *Gazing at a
Waterfall* that lies behind the landscape painting of the
middle Ming artist Chou Ch'en (see cat. nos. 158, 159). A
comparison between Chou's pine trees in *The North Sea*
and those in *Gazing at a Waterfall* is telling. There is a light,
crisp, choreography to Chou's pines that strives for ing-
ratiating elegance, wheras the pines in the album leaf are
rhythmically slower, heavier; they posture, but with less
self-consciously appealing artistry.

The modelling of the trunks and branches in *Gazing at
a Waterfall* lends believable bulk to the pines. The artist
first uses an underlayer of brown outline and wash, subt-
ly shaded, to establish volume. This is then reinforced by
heavy black outlines, whose width fluctuates slightly, so
that solidity is again enhanced. Clusters of small, dark
brown and black dots distributed along the inside edges
of the outlines complete the modelling.

Chou Ch'en's pines, on the other hand, are flatter. His
outlines are thin, even, and graceful. Nor does Chou use
layers of underwash with intent to build bulk and sub-
stance. His picture is about an elegant aestheticism – the
drama of self-conscious artistry. *Gazing at a Waterfall*
makes a quieter statement about simpler values in art.

MFW

Literature
NG-AM Handbook (1973), II, 53.

Nelson Gallery-Atkins Museum R70-2
Gift of Robert H. Ellsworth

30

Yen Tz'u-p'ing, active ca. 1164-81, Southern Sung
Dynasty

31 *Buffalo Boy*
(Chiang-t'i fang-mu)

Album leaf, ink and light color on silk, 21.6 ×
22.9 cm.

5 seals: 3 unidentified; 2 indecipherable.

WKH

Recent provenance: Ch'eng Ch'i.

Intended gift to The Cleveland Museum of Art,
Mr. and Mrs. A. Dean Perry

Wu Ping, active 1190-94, Southern Sung Dynasty
From P'i-ling, Chiangsu Province

32 *Bamboo and Insects*
(Chu ch'ung t'u)

Album leaf, ink and color on silk, 24.2 x 27 cm.

Artist's signature at lower left: Wu Ping.

1 unidentified seal reading ''Lo-hsi.''

Remarks: ''Wu Ping, from P'i-ling, was skilled in
painting flowers, fruit, and birds. Truly could he draw
from life and was able to capture Nature.'' Thus reads
the biography of Wu Ping (Chuang Su, *Hua chi pu-i*,
1298), painter-in-waiting to the court of Kuang-tsung
(r. 1190-94). Admired especially for the subtle richness
of his color and for his evocative themes, he was gen-
erously rewarded by such court personages as the em-
press of Kuang-tsung.

Wu Ping stands near the head of a lineage of P'i-ling
artists that began in the early Sung period and extend-
ed through Yün Shou-p'ing (see cat. nos. 242, 243) of
the Ch'ing. The school specialized in close observation
and accurate depiction of birds, insects, and flowers,
and is notable for compositions of great formal
strength and clarity. In this painting a dragonfly and a
grasshopper define a compositional diagonal which is
counterbalanced by an opposing diagonal thrust from
the stalk of bamboo to the hovering wasp. The strong-
ly delineated bamboo, so admirably adjusted to the
format, provides the fan with an immediate decorative
appeal, while the more subtle rendition of insects am-
ply repays closer inspection. HR

Exhibitions
China House Gallery, New York, 1970: Wang Chi-ch'ien,
 Album Leaves, cat. no. 33.

Recent provenance: Wang Chi-ch'ien.

Intended gift to The Cleveland Museum of Art,
Mr. and Mrs. A. Dean Perry

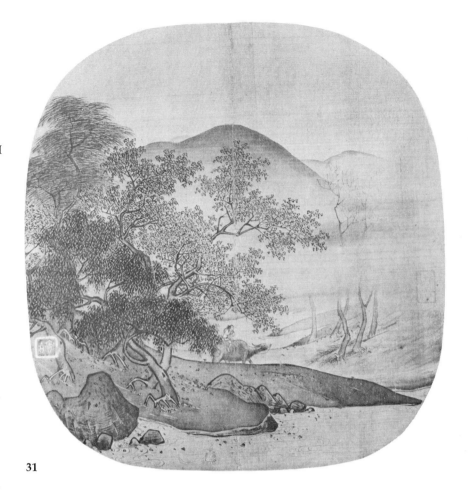

31

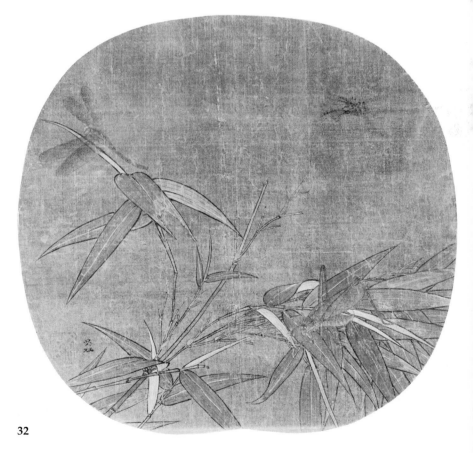

32

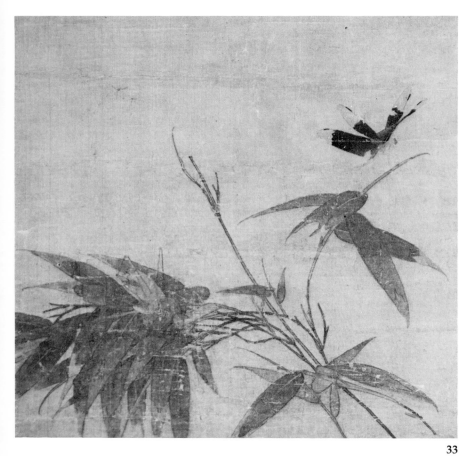

Artist unknown, thirteenth century, Southern
 Sung Dynasty

33 *Insects and Bamboo*
(Chu-ch'ung t'u)

Album leaf, ink and light color on silk, 23.8
×25.6 cm.

1 unidentified seal.

Remarks: Comparison of *Insects and Bamboo* with the
picture by Wu Ping (see cat. no. 32) suggests immedi-
ately a P'i-ling school provenance for the former, while
illustrating the variety of individual styles possible
within the school. A softening of contour drawing and
greater modulation in washes allow here a pictorial fu-
sion of forms which, with the lightly drawn insects in
the upper left, creates a more compelling illusion of at-
mosphere and recession. In the two paintings, the
hovering dragonfly, whose weight does not disturb
the bamboo stalk possessing one desiccated leaf out of
four, and the grasshopper, which walks atop clustered
stalks, are similar enough in motif and composition
as to suggest that were both drawn from a stock
repertoire common to all members of the school.

A closely comparable painting, the *Dragonfly and
Bamboo* in the Museum of Fine Arts, Boston (*Portfolio*,
1961, pl. 4), bears seals of the Yüan artist Ch'ien
Hsüan but more likely comes from the hand of the
same thirteenth-century P'i-ling painter who did *Insects
and Bamboo*. HR

33

Recent provenance: Heisando Co.

Intended gift to The Cleveland Museum of Art,
Kelvin Smith

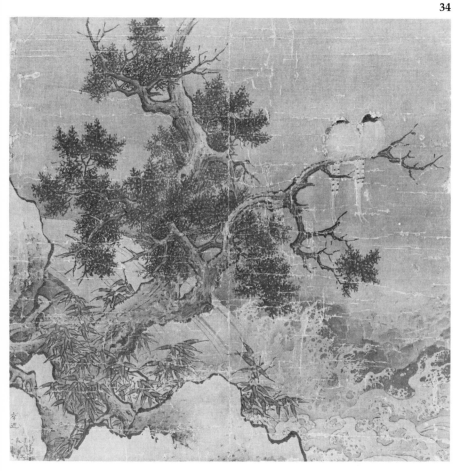

34

Li Ti, ca. 1100-after 1197, Southern Sung Dynasty
From Ho-yang, Honan Province

34 *Birds on a Tree above a Cataract*
(Shu-ch'in chi-t'uan)

Album leaf, ink and light color on silk, 24.8 ×
26 cm.

Artist's signature at lower left edge.

3 additional seals: 1 of Hsiang yüan-pien (1525-1590),
2 of Wu Mou-ho (dates unknown).

Remarks: Mnemonic groupings of artists are a practical
and efficient method of associating them in time and
place. Of the major artists active in the early Southern
Sung period, Li T'ang, Li Ti, and Li An-chung were
known as the "Three Li" and frequently were men-
tioned together in the literature of the time. Some con-
fusion resulted from the fact that one of the three, Li
T'ang, had come from Ho-yang in the north and had
served at court during the reign of Hui-tsung
(1101-25). Later fourteenth-century writers such as the
author of *T'u-hui pao-chien* of 1365 came to believe that
Li An-chung and Li Ti had been active in the north
during the reign of Hui-tsung, while Li Ti was sup-
posedly born in Ho-yang as well. The biographical
source closest to their time, Chuang Su's *Hua chi pu-i*
(1298), states that both Li An-chung and Li Ti were
from Ch'ien-t'ang, the area around the Southern Sung
capital of Hangchou, and that Li Ti was "a painter-
in-attendance in the Painting Academy during [the
reigns of] Hsiao-[1163-89], Kuang-[1190-94], and
Ning-[tsung, 1194-1224]. He painted a variety of sub-

52

jects, and his drawings of flying and walking [creatures], flowers and bamboo have much vitality. His landscapes and figures have nothing at all to recommend them."

Some post-Sung accounts of Li Ti's life maintain that he directed the Painting Academy under Hui-tsung and that he was vice-director of that institution as reconstituted under Kao-tsung. These eminent positions imply special recognition of his artistic skills at some variance with the impression gained from the accounts quoted above.. There is no question, however, that Li Ti was as valued in his own time as he is today for his delightful vignettes of the plant and animal worlds. HR

Literature
Goepper, *Essence* (1963), pp. 64,65, pl. 19.
Edwards, *Li Ti* (1968), p. 19, pl. 10.
Goepper, *Kunst* (1968), pl. 92.

Exhibitions
Haus der Kunst, Munich, 1969: *1000 Jahre*, cat. no. 16.
Asia House Gallery, New York, 1962: Cahill, *Southern Sung*, cat. no. 8.
China House Gallery, New York, 1970: Wang Chi-ch'ien, *Album Leaves*, cat. no. 12.

Recent provenance: Wang Chi-ch'ien.

Intended gift to The Cleveland Museum of Art, Mr. and Mrs. A. Dean Perry

Li Sung, active 1190-1230, Southern Sung Dynasty
From Hangchou, Chechiang Province

35 *The Knickknack Peddler*
(Ying-hsi hou-lang t'u)

Album leaf, dated 1212, ink and light color on silk, 24.2 × 26 cm.

Artist's inscription: Li Sung painted this in the *jen-shen* year of the Chia-ting era [1212].

1 colophon and 4 seals: 1 colophon and 3 seals of Li Tso-hsien (19th c.); 1 seal unidentified.

Remarks: This masterpiece of Southern Sung figure painting is in extraordinarily good condition. Li Sung began life as a carpenter in Hangchou, but after being adopted by an Academy painter, Li Ts'ung-hsün, he rose to be a member of that group and painted for three emperors, Kuang-tsung (r. 1190-94), Ning-tsung (r. 1195-1224), and Li-tsung (r. 1225-64). A very similar painting in the National Palace Museum is dated nine years later (*Chinese Art Treasures*, 1961, cat. no. 50). Still another, badly damaged, is now in the collection of The Metropolitan Museum of Art (Fong and Fu, *Sung and Yüan Paintings*, 1973, cat. no. 8), while a similar subject, in handscroll form, is in the Palace Museum, Peking (Cheng Chen-to, *Wei-ta-te*, 1951-1952, II, pl. 9). All show tremendous virtuosity in fine-line painting (*kung-pi*) with the brush, and the "five hundred articles" traditionally painted into the baskets is a quantitative boast for a qualitative performance.

While the peddler attempts to scatter the five urchins who are attacking a tiny snake with sticks and stones, a boy on the right seems to join the fun, and another, more timid, hides behind the second basket, perhaps hoping to appropriate a free toy. The characterization of the different boys and of the peddler is accomplished by a master of line and of psychology.

A skull, upside down, near the top of the first bas-

ket recalls Li Sung's album painting (Palace Museum, Peking; see *Sung-jen hua-ts'e*, 1957, pl. 58) showing a "live" skeleton tempting a crawling boy with a toy skeleton – a Chinese *memento mori*. The swift and flowing painting of the tree branch is also notable.

This leaf orginally was number thirteen in a large album entitled *I-ch'ing shan-shang (Gratifications from Casual Enjoyment)*, which was made up of twenty-four Sung and Yüan paintings from the collections of Ch'en Yüan-shu, Hsiang Yüan-pien, Pao Hsi-chih, and Keng Chao-chung. SEL

Literature
Li Tso-hsien, *Shu-hua* (1871), *ch.* 12, pp. 10(b)-11(b).
Lee, "Scattered Pearls" (1964), no. 3.
Chiang Chao-shen, "Album Leaves" (1966), p. 8.
Jobu, *Chūgoku bunka* (1967), color pl. on p. 2.
Laing, "Li Sung" (1975), pp. 7-9, figs. 6-9.
CMA *Handbook* (1978), illus. p. 342.

Exhibitions
China House Gallery, New York, 1970: Wang Chi-ch'ien, *Album Leaves*, cat. no.16.

Recent provenance: N. V. Hammer.

The Cleveland Museum of Art 63.582

35

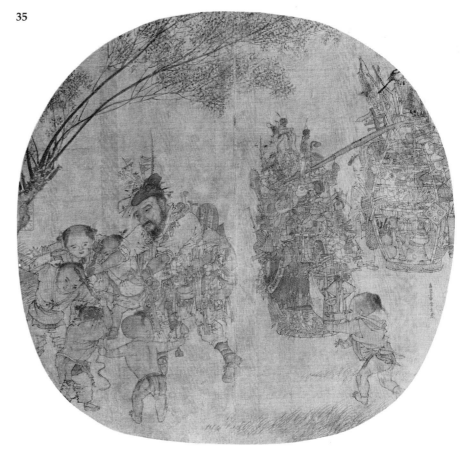

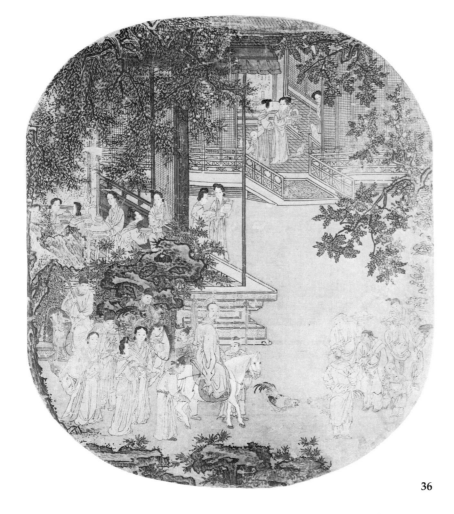

Li Sung

36 *Emperor Ming-huang Watching a Cockfight
(Ming-huang tou-chi t'u)*

 Album leaf, ink and slight color on silk,
23.5 x 21 cm.

Artist's inscription and signature on the large pillar
slightly left of center: Painted by Li Sung of Ch'ien-t'ang,
painter-in-attendance through three reigns.

Remarks: Li Sung proudly includes in his signature a
reference to the imperial favor he enjoyed throughout
his long career, serving as painter-in-attendance at the
Painting Academy during the reigns of three emperors:
Kuang-tsung (r. 1190-94), Ning-tsung (r. 1195-1224), and
into the reign of Li-tsung (r. 1224-64). The artist's men-
tion of three reigns makes it certain that this fan-shaped
painting was executed sometime after 1224. Li Sung was
especially gifted in figure painting and in the rendering
of architecture *(chieh-hua)*. A number of his small paint-
ings are notable for beautifully drawn palaces and
pavilions.

In the National Palace Museum, Peking, there is a
later copy, possibly fifteenth century (with variations, as
in the architecture, rocks, and drapery folds), painted in
a somewhat heavier manner *(Yüan-jen hua-ts'e*, 1959,
vol. I). LS

Literature
Sickman, "Four Album Leaves by Li Sung" (1959), pp. 5-10,
 fig. 1.
Laing, "Six Late Yüan Dynasty Figure Paintings" (1974),
 pp. 305-16, fig. 7.

Exhibitions
Asia House Gallery, New York, 1962: Cahill, *Southern Sung,* cat.
 no. 23, pp. 56,57.

Nelson Gallery-Atkins Museum 59-17

36

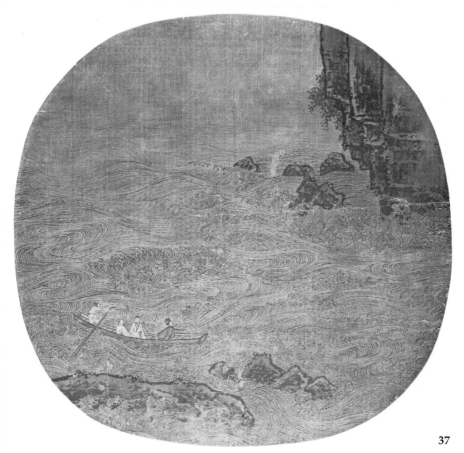

Li Sung

37 *The Red Cliff
(Ch'ih-pi t'u)*

Album leaf mounted as a hanging scroll, ink and
slight color on silk, 24.8 x 26 cm.

Artist's signature: Li Sung.

KSW

Literature
Nihonga taisei (1931-34), L, pl. 53.
Sirén, *Early* (1933), I, pl. 71.
Harada, *Shina* (1936), pl. 140.
Nihon genzai Shina (1938), p. 42.
Cohn, *Chinese Painting* (1948), pl. 120.
Burling and Burling, *Chinese Art* (1953), pl. 111.
Sirén, *Masters and Principles* (1956-58), II, 128; III, pl. 313.
Cahill, "Plum Tree" (1962), pp. 26-29, 49, 50, color cover
 (detail).
Lee, *Chinese Landscape Painting* (1962), no. 21, p. 31.
Horizon, History (1969), p. 301.
Maeda, "'Water' Theme" (1971), pl. 41.
Akiyama et al., *Chūgoku bijutsu* (1973), I, pl. 17.
NG-AM Handbook (1973), II, 4.

Exhibitions
Tokyo Imperial Museum, 1928: *Tō-Sō-Gen-Min,* I, pl. 76.
Asia House Gallery, New York, 1962: Cahill, *Southern Sung,* cat.
 no. 22, pp. 54, 55 (illus.), color cover (detail).
China House Gallery, New York, 1970: Wang, *Album Leaves,* cat.
 no. 17, p. 56.

Recent provenance: Kaukichi Hayasaki.

Nelson Gallery-Atkins Museum 49-79

37

Artist unknown, early twelfth century, Sung
Dynasty

38 *Boats at Anchor*
(*Tsao-ch'iu yeh-p'o*)

Album leaf, ink and color on silk, 25 × 19.2 cm.
WKH

Literature
Takeishi, "So ga sō-shū" (1935), pl. 2.
Harada, *Shina* (1936), pl. 116 (as Ma Ho-chih).
Shina koki zukō (1932-37), II, 2, pl. IV (1).
Sirén, *Masters and Principles* (1956-58), II, *Lists*, 72.

Exhibitions
Tokyo Imperial Museum, 1928: *Tō-Sō-Gen-Min*, p. 63.

Recent provenance: Hayazaki Collection; Masao Suzuki;
Kochukyo Co.

The Cleveland Museum of Art 78.68

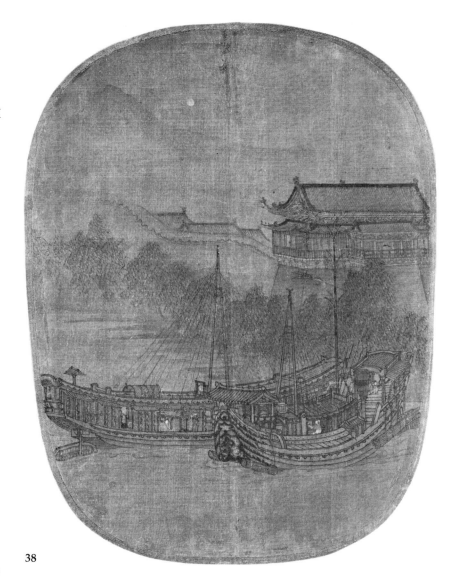

38

Artist unknown (tradition of Su Han-ch'en and
Wang Chü-chen), Southern Sung Dynasty

39 *One Hundred Children at Play*
(*Pai-tzu t'u*)

Album leaf, ink and slight color on silk, 28.8 ×
31.3 cm.

1 seal unidentified.

Remarks: The theme of *pai-tzu*, "one hundred chil-
dren," apparently originated in the T'ang Dynasty
when *pai-tzu-chang*, "one-hundred children curtains,"
were used in marriage ceremonies. These, however,
were symbols neither of fecundity nor of the blessings
of progeny but rather were meant to emphasize the
name and marriage suitability of the bridegroom.
Houses of the nomadic Mongols were composed of
frames of adjustable willow rings covered by heavy
felt rugs; the numerous rings were referred to as
pai-tzu, and the rugs as *pai-tzu-chang*. The wedding gift
would thus introduce the bridegroom as a substantial
man of property. While the original *pai-tzu-chang* had
nothing to do with "one hundred children," but were
manifestations of a lifestyle and custom which by the
Sung were forgotten, the name itself survived and was
interpreted literally as "one hundred children" and at-
tached to a new ceremony. Following the birth of a
child, ceremonies and festivities marked his successive
attainment of thirty days, one hundred days, and one
year in age. Pictures such as the present one would
have been suitable for presentation on either of the
latter occasions.

Other explanations of the *pai-tzu* theme find their
source in history and mythology. For example,
T'ai-ssu, the wife of Wen Wang and mother of the
Chou Dynasty founder, had ten sons; so the con-
cubines of Wen Wang were permitted a total of one
hundred sons. *Wen Wang pai-tzu t'u* (*The Hundred Sons
of Wen Wang*) thus occurs as the title of paintings. By
the Ming period, however, *pai-tzu* pictures had numer-
ous but not exactly one hundred children, and includ-
ed such seasonal activities as kite-flying (see the *Hundred
Children Enjoying Spring* attributed to Su Han-ch'en in
Sung-jen hua-ts'e, 1957, pl. 85).

A majority of the children here imitate the dress,
manners, and activities of the adult world. Whatever
the exact significance of the subject, the artist of *One
Hundred Children at Play* clearly intended it to be savor-
ed figure by individual figure. With seemingly inex-

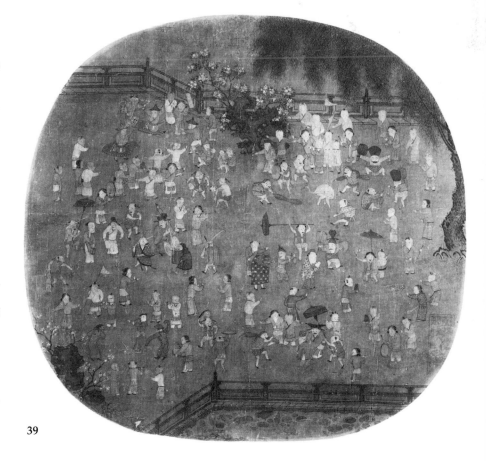

39

haustible invention, the artist characterized each performer in the colorful pageant with unique accoutrements and action. The avoidance of overlapping allows each figure to be seen in clear detail, while all the figures are organized into a coherent composition. Garden settings with decorative rocks, blossoming shrubs, graceful willows, and lotus ponds had become fairly standard environments for late twelfth-thirteenth century scenes of palace ladies as well as of playing children. Therefore, this associates the painting with the school of Su Han-ch'en. HR

Literature
Lee, "Scattered Pearls" (1964), no. 8.

Exhibitions
Asia House Gallery, New York, 1962: Cahill, *Southern Sung*, cat. no. 11.
International Fine Arts Exhibition, EXPO, Montreal, 1967: *Man and His World*, cat. no. 49.
China House Gallery, New York, 1970: Wang Chi-ch'ien, *Album Leaves*, cat. no. 30.

Recent provenance: Wang Chi-ch'ien.

The Cleveland Museum of Art 61.261

Ch'en Chü-chung (attributed to), active 1201-04,
 Southern Sung Dynasty
From Hangchou, Chechiang Province

40 *Tartar Horseman Hunting*
 (*Hu-ch'i ch'iu-lieh*)

Album leaf, ink and light color on silk, 23.6 × 27.3 cm.

Remarks: Ch'en Chü-chung entered the Painting Academy of the Hangchou court in the Chia-t'ai era

(1201-04) and served while painter-in-waiting as a specialist in figure and animal subjects. A majority of the former were illustrations of historical tales which entailed precise depiction of nomadic life and customs, while in the latter category he was known especially for his hunting and herding scenes.

Ch'en is mentioned in Chuang Su's *Hua chi pu-i* (1298, *ch.* 2, p. 16) for his "skill in painting Tartar horsemen and figures" and then is compared to Huang Tsung-tao, the twelfth-century artist who had earlier achieved fame for similar subjects.

Other artists who painted similar subjects were Chang Ch'ien, Chang K'an, and Hu Huai. Chang Ch'ien, a student of Chao Kuang-fu (act. 960-975) and therefore, active in the late tenth century, had in fact been criticized by earlier critics for "making the faces and eyes of his Tartar clansmen too much like those of the Han [Chinese]" (Liu Tao-ch'un, *Sheng-ch'ao*, 11th c., *ch.* 3). Chang K'an "lived near Mount Yen [in Hopei] and thus caught the subtleties of barbarian form and structure and exhaustively detailed their weapons, clothes, saddles, and bridles" (Kuo Jo-hsü, *T'u-hua*, ca. 1075). Hu Huai, the father of Hu Ch'ien, was in fact a Khitan and had settled in Hopei after the 905 alliance between the Khitans and the Sha-t'a Turkish leader Li K'o-yung.

Obviously then, the tradition followed by Ch'en Chü-chung went back to those tenth-century artists who painted scenes they had personally experienced. It is highly unlikely that Ch'en himself ever saw the wind-swept plain of the present painting; probably he knew it only through earlier paintings. The broad strokes of ink which model the rolling hills, and the dotting of vegetation relate to the tenth-century style of Hu Huai; the shaven heads and branded horses also reflect Liao traditions.

A bolo-like weapon is used here by the galloping hunter as he displays his prowess to the princely audience. A painting in The Metropolitan Museum of Art (47.18.32), attributed to Ch'en Chü-chung, similarly depicts a group of horsemen watching one of their number in pursuit of game. HR

Literature
Hollis, "Album Painting" (1934), pp. 51-53.
Lee and Ho, "Three Horses" (1961), p. 69.
Lee, "Scattered Pearls" (1964), p. 29.
Mote, *China von der Sung-Dynastie* (n.d.), pl. opp. p. 305.
Horizon, Arts, (1969), illus. p. 21.

Exhibitions
Pomona College, Claremont, Calif., 1948: no catalogue.
Haus der Kunst, Munich, 1959: *1000 Jahre*, cat no. 20.
Arts Council Gallery, London, 1960: *Arts of the Sung*, cat. no. 6.
China House Gallery, New York, 1970: Wang Chi-ch'ien, *Album Leaves*, cat. no. 15.

Recent provenance: Edgar Worch.

The Cleveland Museum of Art 30.314

Li _?_, thirteenth century, Southern Sung Dynasty

41 *Boy, Buffalo, and Calf*
 (*Fan-mu t'u*)

Album leaf, dated 1205 or 1265, ink and light color on silk, 24.8 × 25.7 cm.

Artist's inscription [In] the *i-ch'ou* year, Li [second character not identified] painted.

40

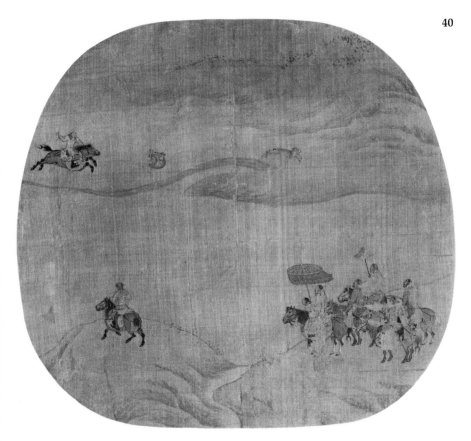

3 seals: 1 of Wu T'ing (ca. 1600); 1 of An Kuo (1481-1534); 1 of Li Pao-hsün (1858-1915).

Remarks: Late Sung and Yüan paintings of buffalo-and-herdboys are sometimes allegoric representations of the Ch'an process of attaining enlightenment, the difficulty of which was likened to that of finding a strayed buffalo. On the other hand, two temples had been erected in Hangchou to honor the buffalo that had quelled a flood threatening that city in the Six Dynasties period. The great popularity of buffalo paintings in the Southern Sung period – when disaster, in the form of the Chin and Mongol armies, again threatened the capital – may thus be propitiatory in nature as well.

The artist – whose surname, but not given name, is clearly legible in the inscription – has not been identified. The signature has been read as Li Ch'üan, Li Ch'üeh, and Li Ch'un; but none of these artists can be verified as the painter of this leaf.

The hand of the same artist – recognizable especially in the pointillistic treatment of tree foliage and somewhat mannered twisting of the tree trunk – may be recognized in the *Herding Sheep* fan painting in the National Palace Museum, Taipei (*Ku-kung shu-hua lu,* 1965, *ch.* 6, p. 264). The latter is a seasonal picture, one that symbolizes the passing of the winter solstice and the coming of spring, while *Boy, Buffalo, and Calf* is redolent with the languid warmth of full summer – when fans were in greatest demand. HR

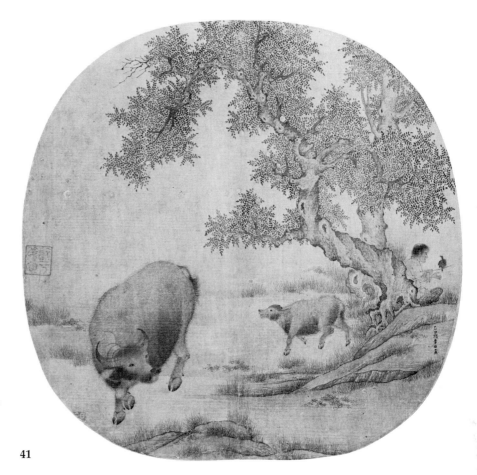

41

Literature
Cahill, "Plum Tree" (1962), p. 27.
Lee, "Scattered Pearls" (1964), no. 9.

Exhibitions
Asia House Gallery, New York, 1962: Cahill, *Southern Sung,* cat. no. 26.
China House Gallery, New York, 1970: Wang Chi-ch'ien, *Album Leaves,* cat. no. 26.

Recent provenance: J. T. Tai.

The Cleveland Museum of Art 60.41

Li Yung, thirteenth century, Sung Dynasty
From Ying-ch'iu, Shantung Province

42 *Magpies and Wild Rabbits*
(Hsi-ch'iao yeh-t'u)

Album leaf, ink and light color on silk, 24.7 × 24 cm.

1 official seal of Ming Dynasty.

Remarks: Li Yung is known only through records of a single painting – *Three Rabbits and Blossoming Peach.* The earliest record is Pien Yung-yü's *Shih-ku-t'ang shu-hua hui-k'ao* of 1682 (*ch.* 15, p. 41.) The first colophon of this painting begins: "Ying-ch'iu profoundly obtained an unworldly flavor, to which was blended only the marvels of Ts'ui [Po] and Hsü [Hsi]." Since the painting itself is apparently signed only "Li Yung," this colophon alone suggests that the artist was from Ying-ch'iu, in Shantung Province, the birthplace of the tenth-century master Li Ch'eng. The comparision with Ts'ui Po (or Ts'ui's younger brother, Ts'ui Ch'üeh) and Hsü Hsi (or Hsü's grandson, Hsü Ch'ung-ssu) suggests that Li Yung was active primarily as a bird-and-

42

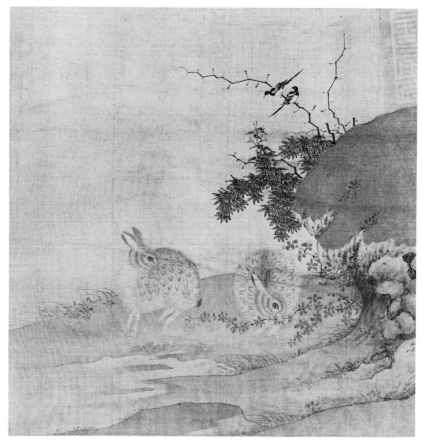

flower painter between the late eleventh century and 1195, the date of the first colophon, also inscribed with a reign-era of the Chin Dynasty (1115-1234). This further suggests that Li Yung was either active under the Chin or that his work was part of the spoils obtained by them on the fall of the Northern Sung in 1127. Support for the latter interpretation is contained in the fifth colophon: "Lung-sha destroyed the gardens, the grass has gone to smoke; ancient objects [after] Chin's and Yüan's two hundred years cause thoughts to return to events of those times...." Lung-sha (Dragon Desert), refers to the territory beyond the northwest passes through which the Chin invaded and conquered, while a Yüan period seal on the painting witnessed that period of upheaval.

It was undoubtedly Wang Chih-teng's (1535-1612) statements in the seventh and last colophon that "Li Ying-ch'iu was famed for painting landscapes, was number one in the Sung Painting Academy... and was not one with whom such as Li Ti could achieve parity in fame" that caused subsequent confusion as to Li Yung's period of activity. Far from being "number one in the Painting Academy," Li Yung was not mentioned in any biographical text until the eighteenth century (Li O, Nan-Sung, 1721) and was there recorded solely on the basis of the colophons to Three Rabbits and Blossoming Peach; for lack of corroborative information, he was placed at the very end of the book. Modern accounts give Li Yung's period of activity as the second half of the thirteenth century.

Paintings of rabbits were not uncommon during the Sung Dynasty, for they were displayed during the beginning of the "year of the rabbit" within each twelve-year cycle. An attribution of Magpies and Wild Rabbits to Li Yung would be meaningless were it not for the early characterization of Li's style as possessing "an unworldly flavor blended with the marvels of Ts'ui and Hsü," since this is a very accurate judgment of the present work. The somewhat loose and vague composition, with its tentative execution, creates the other-worldly context into which the timid creatures venture forth. The modelling strokes of the earth forms are akin to those of Ts'ui Po, and the delicately drawn rabbits accord with the "boneless" style of Hsü Ch'ung-ssu. HR

Recent provenance: Ch'eng Ch'i.

Intended gift to The Cleveland Museum of Art, Mr. and Mrs. A. Dean Perry

Artist unknown, twelfth century, Southern Sung Dynasty

43 *Willows*

(Liu-t'ang hsün-chü)

Album leaf, ink and light color on silk, 23.8 × 25.1 cm.

Remarks: A single scholar in a skiff drifts beneath shade-giving willows and savors his view of mountain peaks just emerging from the pervasive river mist. Round lotus leaves and vertical marsh-reeds join with the dotted grasses and curving willow leaves to provide considerable textural variety within the foreground area, which contrasts with the more irregular texturing of the distant mountains.

River scenes with the contours of low-lying spits of land softened by lotuses and with bands of mist floating amid overhanging willows are associated especially with the late-eleventh-century artist Chao Ling-jang. The present example, with misty space playing a more active part in the composition, and with the components of the picture organized around bisecting diagonals, may be dated to the Southern Sung period as a twelfth-century descendant of Chao's work. HR

Recent provenance: Walter Hochstadter; N. V. Hammer.

Intended gift to The Cleveland Museum of Art, Kelvin Smith

43

Artist unknown, twelfth century, Southern Sung
 Dynasty

44 *Bird on a Flowering Branch*
 (Pai-mei yu-ch'in)

Album leaf mounted as a hanging scroll, ink and
color on silk, 23.8 × 24.5 cm.

2 seals: 1 official seal of the Yüan Dynasty; 1 unidenti-
fied partial seal.

Remarks: A bird, poised in perfect profile, grasps a
branch of the blossoming tree, whose simple structure
is belied by the complex shapes its arrangement cre-
ates on the picture plane. Subtle tensions arise from
incompatibilities between the two-and three-dimen-
sional patterns of the picture, and thereby associate
the work with the early twelfth-century style of
Emperor Hui-tsung. Another component of this artist's
work is the evocation of intangible mood through
formal manipulation of realistically depicted subjects.

A seal at the upper left reads "Painting and calligra-
phy seal of the Tu-sheng," and is identified as an offi-
cial government seal used on paintings and calligra-
phies kept in the Mi-shu-chien (Fu Shen, "Mi-shu-
chien," pt. iv, 1979, pp. 1-24). The same seal appears
on Ma Lin's *Landscape with Flying Geese* (cat. no. 56),
which suggests that at one time they were part of
the same collected album.

The posture of the bird here and the composition as
a whole are similar to those in the upper portion of
Shrike on a Winter Branch (Shang-hai, 1959, pl. 3), which
is signed "Li Ti" and dated to 1187 – a date and aca-
demic provenance suitable as well for the rather calli-
graphically drawn contours of the branch in the
present painting. HR

Recent provenance: Marquis Inoue; Jean-Pierre Dubosc.

Intended gift to The Cleveland Museum of Art,
Kelvin Smith

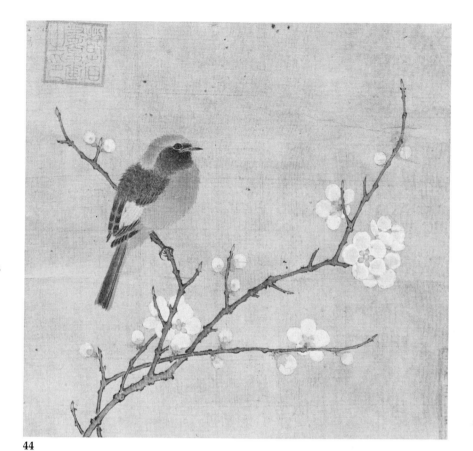

44

Artist unknown, twelfth-thirteenth century,
 Southern Sung Dynasty

45 *Wild Goose on a Bank of Reeds*
 (Ting-wei yen-o)

Album leaf, ink and color on silk,
23.5 x 21.9 cm.

3 seals: 1 of Liang Ch'ing-piao (1620-1691); 2 of Li Tsai-
hsien (1818-1902).

Remarks: The painting formerly had been attributed to
Ts'ui Po on the basis of a label attached to the mounting
of the album leaf reading *Wild Goose on a Bank of Reeds by
Ts'ui Po (Ts'ui Po ting-wei yen-o).* The style of the calligra-
phy suggests that it may have been written by the great
collector Liang Ch'ing-piao (1620-1691). The seal follow-
ing the label belongs to Fan Tseng-hsiang (1846-1931).
 KSW

Exhibitions
Fogg Art Museum, Cambridge, Mass., 1951: Rowland, *Bird and
 Flower,* cat. no. 5, pl. IIIa.

Recent provenance: Yamanaka & Co.

Nelson Gallery-Atkins Museum 33-8/3a

45

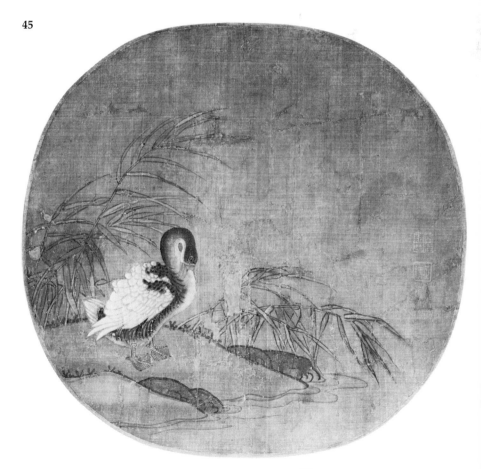

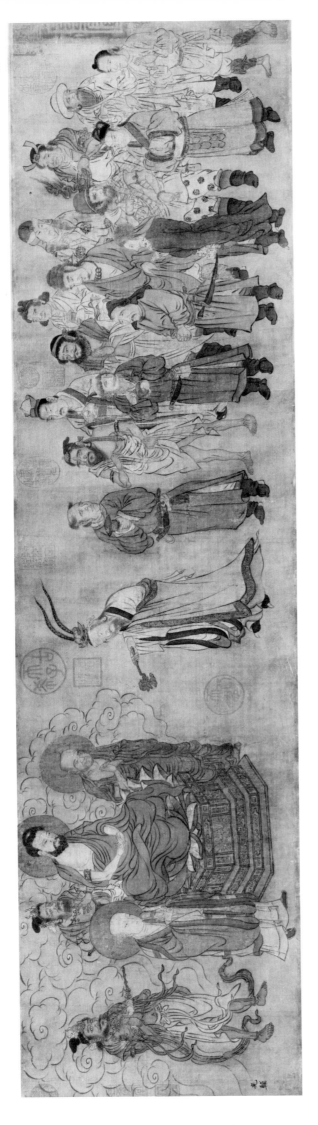

Tradition of Chao Kuang-fu, twelfth century,
 Northern Sung Dynasty

46 *Barbarian Royalty Worshipping Buddha*
 (Man-wang Li Fu t'u)

Handscroll, ink and color on silk, 28.6 x 103.5 cm.

Spurious artist's signature: Chao Kuang-fu.

2 colophons and 21 seals: 1 colophon and 1 seal of
Chao Meng-fu (1254-1322); 1 colophon and 2 seals of
Kuo Pi (1280-1335); 1 seal of Yüan Wen-tsung (r. 1329-32);
1 seal of the Li family (Yüan Dynasty); 14 seals of the
Ch'ien-lung emperor (r. 1736-95); 1 seal of the Chia-
ch'ing emperor (r. 1796-1820); 1 seal of the Hsüan-t'ung
emperor (r. 1909-11).

Colophon by Chao Meng-fu:

Buddha's religion reached China more than a thou-
sand years ago, and his image is probably in every
household. Whoever sees him is filled with reverence.
Nor should it make any difference whether the
painter is ancient or modern. Tzu-ang [seal] Chao
Tzu-ang shih. WKH

Literature
Pi-tien II (1973), Ch'ien-ch'ing-kung, *ch.* 2, p. 20(a).
Ch'en J.D., *Ku-kung* (1956), p. 37(b).
Sirén, *Masters and Principles* (1956-58), II, *Lists,* 40.
Goepper, *Chinesische Malerei* (1960), pp. 10, 11 (illus.); idem,
 Essence (1963), p. 43, color pl. 2.
Toynbee, *Half the World* (1973), illus. p. 84 (detail).
Mote, *China von der Sung-Dynastie* (n. d.), color pl. opp.
 p. 272.
CMA *Handbook* (1978), illus. p. 340.
Watson, *L'Ancienne Chine* (1979), pls. 40 (color detail), 468.

Exhibitions
Haus der Kunst, Munich, 1959: *1000 Jahre,* cat. no. 8.
Cleveland Museum of Art, 1960: Chinese Painting, no.
 catalogue.
International Fine Arts Exhibition, EXPO, Montreal, 1967:
 Man and His World, cat. no. 168.
Cleveland Museum of Art, 1968: Lee and Ho, *Yüan,* cat. no.
 275 (colophons only).
Philadelphia Museum of Art, 1971: Ecke, *Chinese Calligraphy,*
 cat. no. 36 (colophons only).

Recent provenance: Walter Hochstadter.

The Cleveland Museum of Art 57.358

Artist unknown, twelfth century, Southern Sung
 Dynasty

47 *Samantabhadra*
 (P'u-hsien)

Hanging scroll, ink and color on silk, 115.3 x
55.1 cm.

Remarks: The bodhisattva P'u-hsien (Samantabhadra)
in Chinese art appears mainly in two forms: indepen-
dently, or as a counterpart of Wen-shu (Manjushri)
attending the Buddha Shakyamuni (or sometimes Vair-
ocana) in a triad. The first type is in most cases based
on the closing chapter of the *Lotus Sutra,* known as
P'u-hsien p'u-sa ch'üan-fa-p'in (Samantabhadrotsanhana).
Second in importance in popular Buddhism only to
Chapter 25 (*P'u-men-p'in,* "the universal gate"), this
last chapter describes the majestic scene of *P'u-hsien
lai-i* or "Samantabhadra coming in state" (see cat. no.
49). Significantly, it is also in this chapter that the
Buddha proclaims that female believers are worthy of
being entrusted with the sacred scriptures, thus mak-
ing Samantabhadra a sort of patron saint of women.
Samantabhadra, in turn, promises to protect all devo-

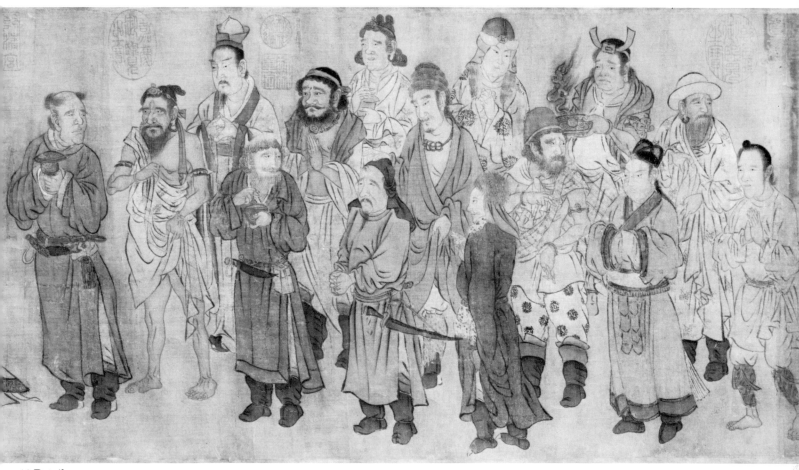

46 Detail

tees of the *Lotus:* "And if a person studies this *dharmaparyāya* so wholeheartedly even while walking or standing, then, O Lord, will I mount a six-tusked king of the white elephants, and with a train of great bodhisattvas manifest myself before this man so as to honor, protect him, and remove his grief and sorrow" (cf. translation by H. Kern in *Saddharma-pundarīka,* 1884). The earliest representation of this scene in Chinese art was recorded in 460 *(Fa-yüan chu-lin,* 8th c.), and the earliest surviving work is probably a Northern Wei high relief dated 484, in the "Buddha Cave" of Shih-k'ou at Ch'ing-yang, Kansu Province. This work, however, is still partly related to the concept of the Seven Buddhas of the Past – a popular theme in the Northern and Southern Dynasties that underlines other similar early examples of Samantabhadra, such as the ones in Cave 13 at Yün-kang, Shanhsi, or in Cave 159 at Tun-huang, Kansu.

While single representations of Samantabhadra are relatively rare, the joint appearance of P'u-hsien and Wen-shu as attending bodhisattvas of the Buddha are much more common. This is particularly true since the seventh century, when the Hua-yen sect was at its height of influence in the T'ang period, popularized by two new translations of the *Avataṁsaka.* In this most magnificent drama of Mahāyāna theology, Buddha was presiding at the "seven places and the eight assemblies," with some of the sermons jointly preached by P'u-hsien and Wen-shu. Although the concluding chapter, "On Entering the Dharma-World," is more commonly known for its narration of the pilgrimages of Sudhāna, a later and fuller version of this chapter translated by Prājña in 796-798 had been retitled "On the Deeds and Vows of Samantabhadra,"; it

established once and for all the highest importance of the bodhisattva in the climactic finale of this great Buddhist drama.

At about the same time, some esoteric elements entered the iconography and introduced the new formula of the Vairocana Trinity. According to Ch'ing-kuan (738-839), the foremost theoretician of the Hua-yen sect, "Vairocana is the entity of the two Holy Ones: Wen-shu who embodies the all-revealing wisdom, and P'u-hsien the fundamental truth to be revealed" *(Hua-yen-ching su,* ca. 800, *ch.* 49). This became known later as *San-sheng yüan-yung* or "the unity of the Three Holies," which virtually dictated the joint appearance of the two bodhisattvas in any iconic presentation. From the time of the ninth century this tradition had been firmly established (see cat. no. 7). In Tun-huang, for instance, the two deities appear in pairs no less than 105 times, by far the most frequently represented image-type in a single site (Sawa Ryuken, "Frescoes," p. 178).

Variations of the triad do exist – as in the unusual combination with the Eleven-Headed Kuan-yin in Cave 9 at T'ien-lung-shan, or the erratic representations of the bodhisattva's vehicles (1141-54) in Cave 6 at Shih-hung-ssu, Lu-hsien, Shenhsi. And later, when the Hua-yen text was superimposed and elaborated by various *dhāranī,* there emerged a whole new line of icons in the identification of P'u-hsien with Vajrasattva in the *Vajradhātu* of the two mandalas, or in the image of the so-called *Fugen-emmyo* (Vajramahāsamayasattva), known only in Japan during the late Heian and Kamakura periods.

This is the historical background for the Cleveland *Samantabhadra.* It will be best understood, therefore,

61

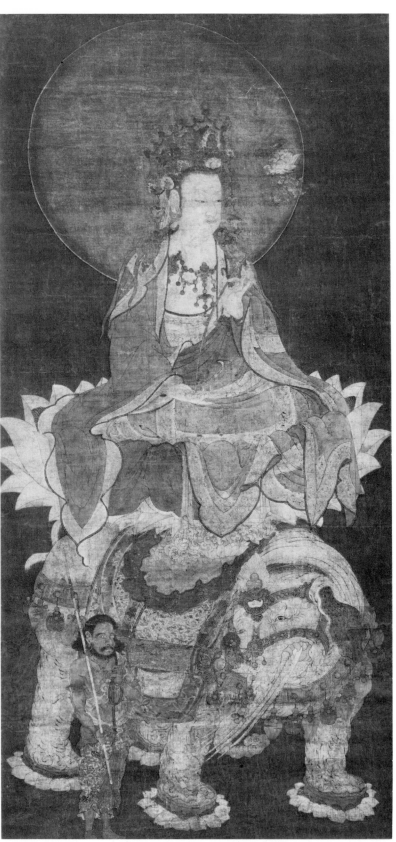

47

against the revival of the Tendai sect in the Five Dynasties and Northern Sung periods. The center of this revival was Mt. T'ien-t'ai in Chechiang, a geographically seclusive refuge from the Buddhist persecution in 845, and again during the political turmoil at the time of the disintegration of the T'ang Dynasty. There the basic literature of the faith of the *Lotus* was able to survive, and even to expand – with replacements from the Korean *Tripitaka*, brought over in 964 by the monk T'i-kuan at the request of the King of Wu-Yüeh. Jojin, the Japanese monk of the mystic *jimon* branch of the Tendai sect who went to China in 1072, left us a detailed account of his journey, which provides probably the most conclusive evidence for the iconography and dating of the Cleveland *Samantabhadra*. In his famous diary, the *San Tendai Godaisan ki* (1072, I, 14, 16; III, 56), Jojin described a variety of Samantabhadra images, some of which were dedicated by the king of Wu-Yüeh and served as the principal icons in the Fa-hua pi-fa (Secret Rites of the Lotus). The rite for confession and repentance is based primarily on the text of *Kuan P'u-hsien p'u-sa hsing-fa ching,* which provides the basic guidelines for most pictorial representations of Samantabhadra during the Sung and Chin periods. From the descriptions of Jojin, we can derive some significant features of these representations: 1) the bodhisattva was now always depicted as riding on a six-tusked white elephant; 2) he was holding in his left hand a lotus with a sutra on the top of the flower – an iconic innovation probably of the eleventh century never seen before by the Japanese pilgrim; and 3) "The *nirmana*-Buddhas are present as usual," which obviously refers to the "five-leaves diadem" dating back to earlier Sung and Liao periods. In general, the Cleveland *Samantabhadra* follows rather faithfully these contemporary practices. The *pustaka* placed on the top of the lotus blossom was definitely something new – perhaps a substitute for the Tantric symbol of *samaya.* When this same motif is seen in later Yüan sculpture, for example, the Fei-lai-feng group at Hangchou, the lotus branch is no longer held in the left hand, but seemingly emerges from the arm of the deity, in Nepalese fashion. At the same time, however, the Cleveland *Samantabhadra* has lost most of the late T'ang and Five Dynasties characteristics. He is seated on a "thousand-petals" lotus throne with both legs crossed in the pose of meditation instead of the earlier *ardhaparyankāsana* as seen in Tun-huang, in the *Shakyamuni Triad* (cat. no. 7), in Lung-hsing-ssu at Chengting (1052), or in Hsia Hua-yen-ssu at Tatung (1038).

If these iconic peculiarities are to be taken as criteria for the upper limit of the date of the Cleveland painting, then cues for the lower limit may come from its original overall design. The Cleveland painting was clearly the left panel of a triptych, which explains the off-center placement of the aureole and the three-quarter view of the bodhisattva, who is supposedly coming from the Buddha-land of Ratnatejobhyudgata in the east. The original format and composition can be seen in a series of later copies in China, Korea, and Japan, including complete examples from Nison-in (Kyoto); Tofuku-ji (Kyoto); the Nara National Museum; and the Brundage collection in the Asian Art Museum, San Francisco. The Nison-in triptych (Lee and Ho, *Yüan,* 1968, cat. no. 194) bears an inscription by the donor, Wang E. If this Wang E can be identified as the same scholar-official active in late Chin and

early Yüan whose dates have been established as 1190-1273 (Wang Ch'ang, *Chin-shih tsui-pien*, 18th c., ch. 158, p. 9), then the Nison-in version may well be a copy made in the first half of the thirteenth century when Wang E was still a young graduate of the *chin-shih* degree.

Nevertheless, according to the temple tradition, the Nison-in version was supposedly brought back by the pilgrim priest Chōgen in 1168—at the same time as the *Portraits of the Five Patriarchs of the Pure-Land Sect*. Although the present triptych cannot be accepted as from such an early date, one can surmise that among Chōgen's imported treasures there was indeed once a Shakyamuni Triad of the twelfth century (closely resembling the Cleveland scroll) that had served as the prototype for most later copies in Japan, and that the present triptych was a replacement after the original was lost from the temple. Votive representations of Wen-shu and P'u-hsien, whether in the mode of T'ien-t'ai or Hua-yen, were in high fashion during the transition of the Northern and Southern Sung periods (see Su Sung, *Wei-kung t'i-pa*, 11th c., p. 3). The Cleveland scroll conforms not only stylistically to the vogue of the twelfth century–down to details such as the schematic arrangement of draperies hanging over the pedestal, or the floral arabesque supporting the thousand-petaled lotus–but also in its painting technique which is typical of the period. The use of the *fan-t'o fa*, or the reinforcement of surface color in certain local areas by the application of the same pigment on the reverse side of the silk, was one of these Sung techniques introduced to Japan early in the Fujiwara period. The *fan-t'o-fa* was invented mainly for mineral pigments that had a tendency to gradually sink through the silk fibre. The subsequent loss of color on the surface would leave the area in question dull gray, were it not first reinforced by the same pigment on the back. The pale olive-green employed on the *samkaksika* of the Cleveland *Samantabhadra* was reinforced in this manner; the same technique was adopted in many Fujiwara paintings, such as *Fugen Riding on a White Elephant*, in the collection of the Tokyo National Museum. Indeed, one may even say that the linear eloquence, the ornamental delicacy, and the tonal subtlety of the shading and modelling in Fujiwara Buddhist art can all be traced to their continental sources, at least partially, in some of these Sung paintings. The prevailing color scheme exemplified by the contrast of the cool, pale green and the dusky powdered-rose as seen in the Cleveland painting also left its imprint on Fujiwara art. Its aristocratic aestheticism was imbued with an ever so gentle and dreamy touch of medieval melancholy that was utilized to full effect as early as the *Amida Raigo* in the Byodo-in, Uji. WKH

Literature
Sullivan, *Chinese and Japanese* (1965), p. 156.
CMA *Handbook* (1978), illus. p. 343.

Exhibitions
Asia House Gallery, New York, 1962: Cahill, *Southern Sung*, cat. no. 13.

Recent provenance: Victor L. Hauge.

The Cleveland Museum of Art 62.161

Artist unknown, twelfth century, Southern Sung Dynasty

48 *Amitābha with Two Attending Bodhisattvas (O-mi-t'o san-tsun)*

Hanging scroll, ink and color on silk, 133.5 x 79.3 cm.

Inscription and seal purportedly of Shan Tao (613-681).

Remarks: This is an icon painting originally made to serve as an object for meditation in a practice known as *pan-chou san-wei (pratyutpanasamādhi)*. Shan-tao, the T'ang founder of the Pure-Land sect which believed in the saving grace of Amitābha Buddha, preached the

48

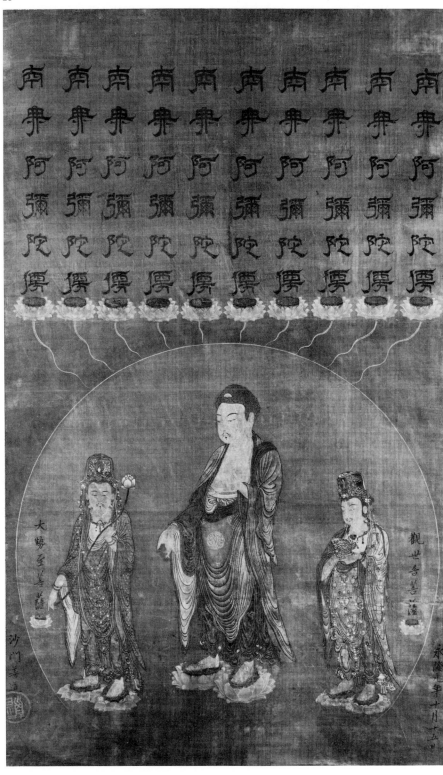

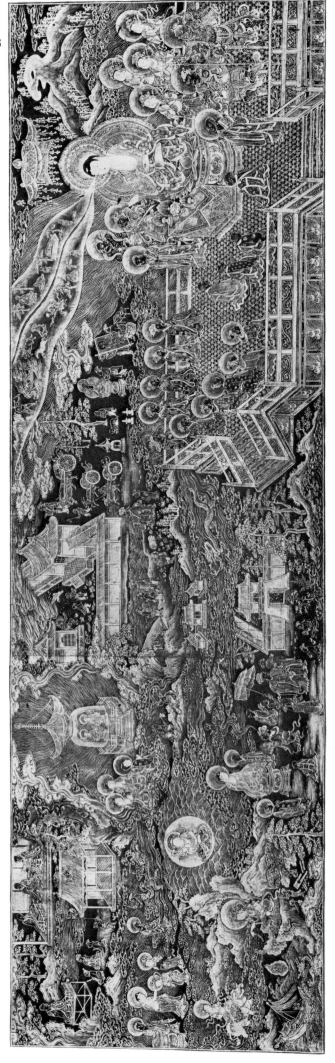

doctrine that the only way that will lead to rebirth in Amitābha's Western Paradise is the simultaneous and constant practice of *kuang-fo* (meditation on the Buddha) and *nien-fo* (invocation of the Buddha). With the former, it means that the faithful must, at all times, meditate on the "true golden body" of Amitābha, who descends with his attending bodhisattvas in full glory. The believer may first try to memorize all the body postures and hand gestures of the Buddha. Next he may meditate on the thirty-two distinctive marks of the Buddha *(dvātriṁśan mahā-purusa-lakśanani)*,starting from the *ushnisha* on top of the skull and working his way down to the signs of *dharma-cakra* on the soles. Then in reverse order he may make the same round. After this has been repeated sixteen times, the faithful may finally concentrate on the white tuft between the eyes, from which lights radiate in all directions to reveal the true nature of the Pure Land. With the latter, *nien-fo*, it means the faithful must, at all times during a period of seven days without any sleep, invoke the names of "Nan-mu O-mi-t'o-fu" *(namas Amitābha)*, which are represented visually and repeated in six *li*-styled characters on the upper section of the present painting, each issuing from the center of a lotus flower.

In recent years there has been a view popular among some scholars which insists that the medallion or whorl motif decorating the *saṁghātī* of the Buddha is a unique characteristic of Korean Buddhist painting (cf. Susumu Hayashi, "Koryo jidai," 1977, p. 112). Consequently, any Buddhist paintings with this decorative motif are to be suspected as being of Korean origin, even if most or all other more decisive factors, stylistic as well as iconographic, point to a different conclusion. While there are grounds for reconsideration of the origin of a few "Southern Sung" or "Yüan" paintings (one example is an *Amitābha Triad*, CMA 61.135, which has been excluded from this exhibition), a large part of the confusion caused by this view is certainly unwarranted. The problem is that this view has neglected the fact that the medallion decor has enjoyed a continuous popularity from the ninth to the fourteenth centuries in west and southwest China, especially in the area bordering the territories of the Uighurs (for example, *Uighurian Prince*, fragment, Berlin, Museum für Volkeskunde), the Tibetans (e.g., *Emperor T'ai-tsung Meeting with the Turfan Envoy*, Palace Museum, Peking), and the Hsi-hsia people (e.g., *Water and Moon Kuan-yin*, Leningrad, The Hermitage). In fact, the somewhat provincial character of the Cleveland painting suggests that it might well have been a product of this part of China. One can hardly fail to recognize the close resemblance between the Cleveland *Amitābha* and a similar standing image from Khara-khoto, discovered by the Koslov expedition of Russia (see Pchelina [Rudova], "The Descent of Amida Triad from Khara-khoto," 1969, no. 3, pp. 104-6). The hoods covering the crowns of the two attending bodhisattvas, while usually reserved for the White-robed Kuan-yin in paintings originating in central and east China, were a common headdress for various types of bodhisattvas in the Sung caves at Ta-chu-shan. One wonders if this peculiarity would connect the Cleveland painting to the Ssuch'uan area.

By far the most telling indicator of the date of this painting is to be found among the characters on the upper section. The character *fu*, "Buddha," from the

intonation "Nan-mu O-mi-t'o-fu," appears in a strikingly new form, never seen before or thereafter. It is so cleverly structured that the double meanings come through immediately. Taking its components apart, they mean "One who came from the Western [Paradise]." Putting them back together with a slight twist of imagination, they now form the character *hsien* – that is, strangely speaking, "a Taoist immortal."

The need and reason for coining such a character is comprehensible only in the context of a brief, yet bizarre, chapter in Chinese religious history. The man behind this was Emperor Hui-tsung who, as a Taoist zealot, fancied at one time that he could reinstate Taoism in a position of dominance once and for all. In 1119, the first year of the Hsüan-ho era, the emperor decreed that from then on, "Buddha" was to be restyled *Ta-chüeh chin-hsien,* or The Golden Immortal of Great Enlightenment (see *Li-tai Fo-tsu t'ung-tsai, Taishokyo,* 1930, v. 49, p. 2036). Although under pressure from many directions, the imperial order was withdrawn after a short while; but in the periphery of the empire the order must have stayed in effect longer. In short, it may be surmised that the character combining the meanings of both "Buddha" and "Immortal" was devised as a means of evasion under those circumstances. If so, there is reason to believe that the Cleveland painting was commissioned not long after 1119 – perhaps from an area remote enough to circumscribe the imperial interdiction.

The painting bears a signature and seal purportedly of the priest Shan Tao, and a date which coincided with the death date — 681 — of the T'ang patriarch. Such signing and dating was a fairly common practice to reinforce the authority of a work as an icon painting. No dishonest intention is to be suspected with these additions. WKH

Recent provenance: Bunzo Nakanishi.

The Cleveland Museum of Art 74.35

Artist unknown, twelfth century, Sung Dynasty

49 *Frontispiece for the Lotus Sutra*
(*Miao-fa Lien-hua ching*)

Handscroll, gold ink on indigo sutra paper, 24.2 x 78.7 cm.
 WKH

Literature
CMA *Handbook* (1978), illus. p. 340 (detail).
Recent provenance: Elm & Co.

The Cleveland Museum of Art 70.64

Artist unknown, late thirteenth century, Southern Sung Dynasty

50 *Seated Arhat with Two Attendants*
(*Lo-han t'u*)

Hanging scroll, ink, color, and gold on silk, 93.7 x 49.7 cm.

Remarks: Lohans, the disciples of the historical Buddha, were painted in China during the T'ang period, if not earlier, but became especially popular subjects from the twelfth century onward. Ch'an adherents especially admired those disciplined individuals who relied on their own efforts to achieve enlightenment,

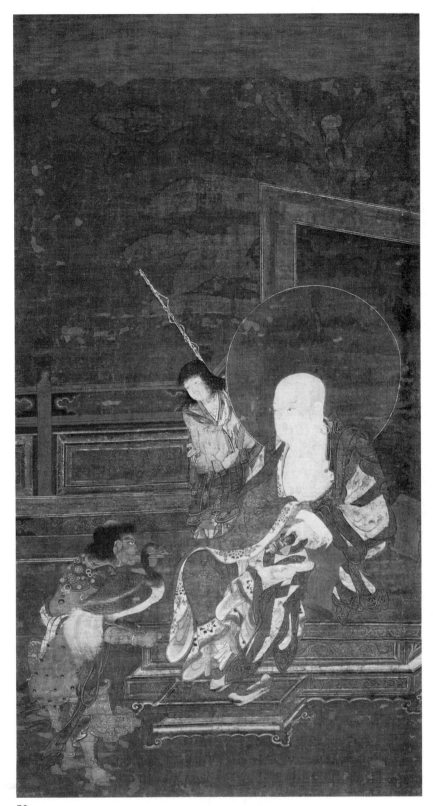

50

and pictures of lohans were painted individually or in sets ranging in number from a pair to one hundred paintings to provide a proper atmosphere for formal services of all sects. Two stylistic traditions were recognized by Southern Sung and Yüan artists – frequently professional painters – who supplied the large demand for such works. The earliest stemmed from the works of the Ch'an master Kuan-hsiu (832-912) and featured grotesque or foreign physiognomies on large figures who dominated their settings. The other was associated, though probably mistakenly, with the late-Northern-Sung literatus Li

Kung-lin (ca. 1049-1106), who was held to have initiated a more humane and worldly type of figure which was placed within a more spacious setting. The present painting falls within the latter category and well exemplifies the sophistication and urbanity of the best of this type.

The lohan sits on a dais backed by a landscape screen. An attendant holding a staff is at his side, and a worshipper bearing an offering of fowl stands before him. The attire and physiognomy of the latter suggests that he is a foreigner. The face of the lohan is individualized to an extent which suggests that a specific monk or abbot served as a model; the rolled sutra, held prominently in his hand, probably indicates that the work was commissioned for an orthodox rather than a Ch'an temple. The finely detailed textile patterns and painted architecture are rendered in the "Li Kung-lin" tradition of fine, even line work and heavy application of color. The vine-scrolls and other decorative motifs suggest, as does the misty space of the landscape screen, a date of execution in the later thirteenth century. Close stylistic parallels can be drawn between the present picture and those attributed to Lu Hsin-chung (see his *Sixteen Lohans* in the Museum of Fine Arts, Boston; *Portfolio*, 1933, pls. 110-124) and to Lu Chung-yüan (see his *Ten Kings of Hell, Gendai Dōshaku*, 1975, cat. no. 75.) These artists, who from their given names would seem to be related, are recorded only in the Japanese *Kundaikan* manuscript dated 1559 (with Lu Chung-yüan listed, probably erroneously, as Lu Chung-chien) as Yüan-period specialists in painting Buddhist subjects. They apparently were professional Chechiang artists who continued to supply ecumenically the ritual and devotional needs of Buddhist and Taoist temples. HR

Literature
Important Japanese Paintings [sale cat.] (Christie, Manson & Woods, 1976), no. 31.
CMA *Handbook* (1978), illus. p. 343.

Recent provenance: Matsukata Collection; Howard C. Hollis.

The Cleveland Museum of Art 76.91

Ma Yüan (attributed to), active before 1189 – after 1225, Southern Sung Dynasty
h. Ch'in-shan; native of Ho-chung, Shanhsi Province, born and active in Hangchou, Chechiang Province

51 *Composing Poetry on a Spring Outing (Ch'un yu fu-shih t'u)*

Handscroll, ink and color on silk, 29.3 x 302.3 cm.

8 seals: 3 of Liang Ch'ing-piao (1620-1691); 1 of An Ch'i (1683-ca. 1746); 2 of Hung-hsiao (d. 1778); 1 of Liang Kung-shih, unidentified; 1 seal unidentified.

Remarks: An unknown number of colophons followed the painting, but were removed, probably in the nineteenth century, by an unidentified descendant of the first Prince I, Yin-hsiang (1686-1730). By the early 1930s when the painting came to the United States, the only trace of the colophons was a note written in Chinese recording their removal. Through mischance, the note was lost prior to the acquisition of the scroll by the Nelson Gallery. Fortunately, however, an English translation by Chi-chen Wang, a professor of Chinese

literature formerly with Columbia University, still survives and reads: "This scroll was originally the property of the Na-lan [Manchu: *Nara*] Mansion and had been given to his patron by An Ch'i [1683-ca. 1746]. Later it came into the possession of our family. There were many colophons at the end of the scroll, but so worm-eaten and worn that they could not be read. It seemed a pity to throw them away, but seeing them would not make a pleasant appearance. Therefore, I had them cut off and mounted as a separate scroll so that one could enjoy looking at the beginning and not be disappointed at the end. [Signed] I-yen."

Although the end of the painting shows flaking damage from a poor mounting, there is no evidence of extensive worm damage to the painting itself. This fact, plus the better protection afforded colophons by virtue of their placement at the end of a scroll, makes one suspect the aesthetic altruism claimed by the writer of the note. It might well be conjectured that the colophons were written by eminent men whose calligraphy would have been prized in its own right. If so, a handsome return could be gained from the sale of the colophons, the removal of which necessitated the pious diversion of the note.

The loss of the colophons is especially lamentable, because efforts to reconstruct the history of transmission of the scroll by identifying it with a painting mentioned in early records have proved fruitless. The note does, however, enable a portion of the scroll's recent history to be reconstructed.

The patron mentioned in the note could be Mingju (1635-1708) or his son, K'uei-hsü (1674?-1717), both of whom ranked among the wealthiest and most powerful officials of their day. Mingju built the Nara clan fortunes through commercial enterprise and official position. Among his interests was the illicit financing and sponsoring of agents who sold salt obtained from the government monopoly through Mingju's influence. K'uei-hsü continued these operations, thus securing a family fortune that would last until the end of the century. One of the Nara family's principal agents in the salt business was their Korean bondservant, An Shang-i, father of An Ch'i.

In 1703 An Shang-i introduced his son to Mingju; subsequently, An Ch'i played an active and lucrative role in the salt business. It was sometime thereafter, then, that An Ch'i presented the painting to the Nara family. It may be surmised from the political difficulties members of the Nara family encountered after accession of the Yung-cheng emperor in 1723 that the scroll passed to Yin-hsiang's family in consideration of favors intended to mollify the emperor's hostility toward the Nara family. Whether the scroll passed to Yin-hsiang, who held the emperor's trust, or directly to his son Hung-hsiao (d. 1778) cannot be determined, but given Hung-hsiao's interest in literature and in collecting ancient paintings, the latter seems likely.

Hung-hsiao continued to build up the library collections begun by his father and housed them in his Ming-shan-t'ang, the name of which was indited in 1740 by his cousin, the Ch'ien-lung emperor (r. 1736-95). A survey of paintings bearing the Ming-shan-t'ang seal reveals that a large portion of the best paintings once belonged to An Ch'i; it is of further interest to note that those paintings generally do not appear in An Ch'i's collection catalogue *Mo-yüan hui kuan* (preface 1742). In 1746 the Ch'ien-lung emperor acquired a group of paintings from An Ch'i's

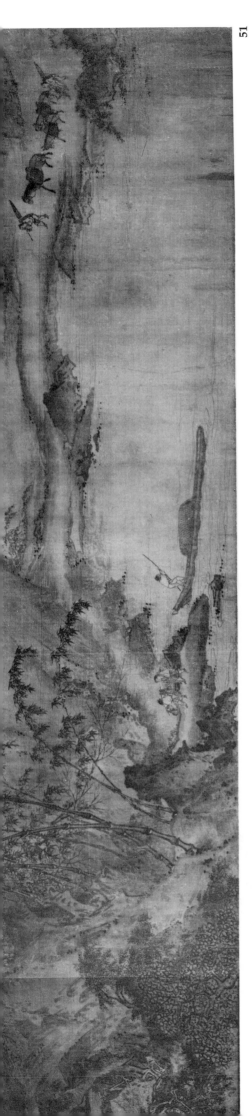

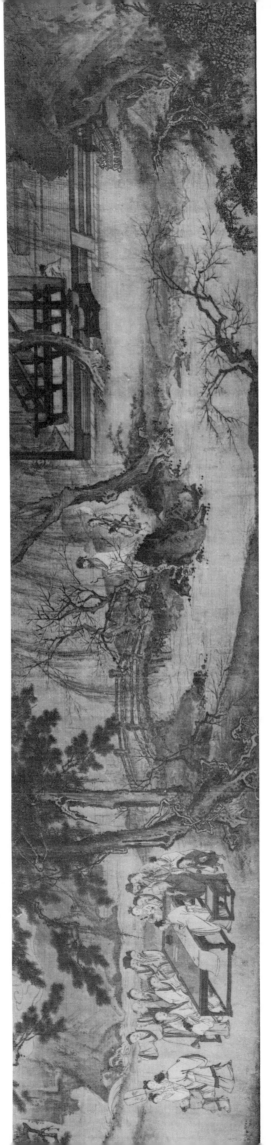

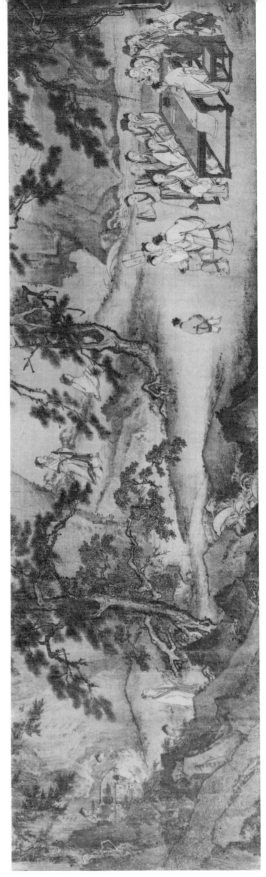

son, An Yüan-chung. The power of imperial prerogative makes it certain that the emperor could have commanded any painting he wished, and yet it seems improbable that he would have disdained such a superior scroll as Hsü Tao-ning's *Fishermen* (cat. no. 12) had it still been in the An collection. Although these scraps of evidence are wholly circumstantial, they do suggest that some sort of special relationship existed between the An family and Hung-hsiao that allowed the latter to acquire paintings in a preferential way.

The present painting is not signed, but the outer wrapper label reads *Sung Ma Yüan hui ch'un yu fu-shih t'u* (*Composing Poetry on a Spring Outing* drawn by Ma Yüan of the Sung [Dynasty]). A number of modern scholars have chosen to ignore the wrapper title and have identified the subject as *Elegant Gathering in the Western Garden* (e.g., Hsieh Chih-liu, *T'ang Wu-tai*, 1957, pls. 86-90; Kei Suzuki in Akiyama et al., *Chūgoku bijutsu*, 1973, I, 238, pls. 47-49; and again in Suzuki, *Ri Tō*, 1974, pls. 10, 11, p. 156).

"Elegant gatherings" brought together a group of kindred spirits bound by some common tie: perhaps the distinction of having attained exceptional longevity, an interest in poetry and its criticism, or simply the pleasure of fellowship among friends. Such gatherings answered a social, and even expressive, need for China's privileged and well-to-do literati elite; although the practice has long existed in one form or another for over two millenia, it was only after a more thoroughgoing secularization of society and the appearance of a self-conscious elite class of literati in the late T'ang and Sung periods that the practice became institutionalized and subject to convention not untouched by class narcissism.

The practice gained momentum during the Yüan Dynasty (1279-1368) and became an important theme in painting. Apart from poems and paintings occasioned at the time by an actual gathering, famous gatherings from the past were idealized, becoming, in the minds of painters and conveners alike, canonical precedents. The "elegant gathering in the western garden," which was thought to have gathered some sixteen of China's greatest literary and artistic geniuses together in a scenic garden in the Sung capital Pienliang in 1087, became an oft-used and painted model. It has been convincingly argued that the gathering never, in fact, occurred and that paintings showing the purported participants engaged in pursuits prescribed in later literature are apocryphal fabrications based upon earlier pictorial precedents (Laing, "Scholars and Sages," 1967, pp. 37-59). Although the historicity of the "elegant gathering in the western garden" may be successfully challenged, as may that of some other notable, hallowed gatherings, it is important to note the general approach to rendering the theme in the painting tradition that grew up around the apocryphal event.

The paintings that survive have the ring of a set-piece, with conventional groupings of figures engaged in activities more or less in accord with literary accounts. There is little sense of a specific moment, animated by individuals with distinctively expressive traits or colored by the particularities of an actual place. The resort to idealized stereotype marks the treatment of similar themes, such as the Nine Elders of Mount Hsiang. In contrast to the treatment of model gatherings are those paintings occasioned by an actual gathering at or near the time of the event. These normally include specific references

51 Detail

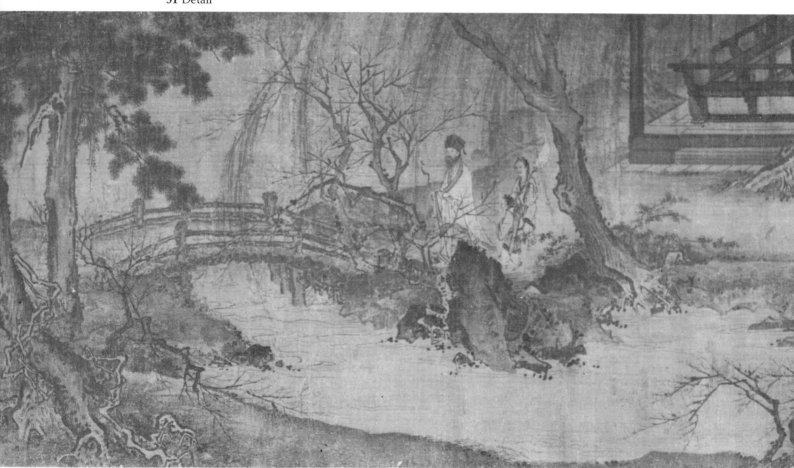

both to the particularities of the place and to an activity central to the gathering. A freshness of invention may also be expected of such paintings.

Composing Poetry on a Spring Outing bears the tone and freshness of a work born of an actual event. There is a casualness about the activities and groupings of figures that does not bespeak formula or any known convention. Instead of being placed on a well-staged display in conventional groupings, most of the participants gather about a large table where the center of attention is shown wielding brush and ink. Facial types are individualized, and their intent concentration on the scroll is convincingly realized. Some figures lean naturally on the top frame of the table, while others rest a hand casually on the shoulder of a neighbor. One stretches in lazy inattention, and yet another is distracted by a small child's importuning. So natural are the gestures, expressions, and postures that the viewer senses a candid glimpse of a specific moment.

The directness and candor with which the surroundings, furnishings, and figures are treated is at odds with the self-conscious choreography found in the tradition of paintings of the *Elegant Gathering in the Western Garden*, a subject which may be excluded as a possibility for *Composing Poetry* on the grounds of inconsistencies with the apocryphal literary account and with the painting tradition. There are, for instance, too many participants in *Composing Poetry,* too many of whom are monks. There are four large pines in the Nelson scroll, whereas the account of the gathering in the Western Garden stipulates a single pine. The references to springtime are unmistakable in the *Composing Poetry,* whereas there is no reference to any season in the accounts of the "elegant gathering in the western garden." Other inconsistencies extend through a catalogue of items, including vegetation, costumes, activities of the participants, and furnishings in the garden.

Detailed stylistic and technical analysis corroborates the traditional attribution to Ma Yüan, which offers the intriguing possibility of identifying the subject with a literary gathering in the famous garden of one of Ma Yüan's patron's, Chang Tzu (1147-after 1201). Poet, painter, official, and accomplished *bon vivant,* Chang Tzu served as a hub for literary and social activities in Hangchou at the end of the twelfth century. The fortunes he inherited, which had been built by his illustrious grandfather, Chang Chün (1086-1154), made him among the wealthiest men of the day; these monies he plied toward building gardens fabled for their size, luxury, and ingeniousness of composition. Temples, halls, pavilions, retreats, and grottoes – in all, numbering several tens – attracted the political and literary elite of Hangchou to a series of parties given according to an elaborate year-long schedule that matched a particular location with momentary seasonal glories.

According to Chou Mi's (1232-1298) accounts (*Ch'i-tung yeh-yü,* preface 1291, quoted in Chang Tzu's *Nan-hu chi,* preface 1189, *fu-lu, hsia,* p. 2235) and those left by Chang Tzu himself (*Chang Yüeh-chai shang-hsin lo-shih,* in Chou Mi, *Wu-lin,* late 13th c., pp. 4360-65), the delights that awaited his guests included singing girls whose artful costumes were considered the most beautiful in the realm, concubines who would inveigle poems in return for verse of their own making, and a freedom from convention induced by freely flowing wine that could end in rather bizarre carryings on. Chang was not only intimate with the famous literary figures of his day, such as Lu Yu (1125-1210) and Yang Wan-li (1127-1206), but was ranked by them as one of the foremost poets of the time. Political intrigues, which eventually brought ruin to his official career, assure that he was well acquainted with Empress Yang (1162-1232), Ma Yüan's most celebrated patron. Evidence for the fact that Chang Tzu was also one of Ma's patrons is found in a short prefatory note to a poem Chang composed for Ma eulogizing the painter's talent. In the note Chang says that he once had Ma paint the scenery beneath one of his groves (Chang Tzu, *Nan-hu chi,* p. 2120).

A number of the special features of Chang's garden tally with what is seen in *Composing Poetry on a Spring Outing.* The garden was situated on a lagoon of South Lake, the name for a small southwest extension of the West Lake. The scroll opens with a lagoon and shows a boatman pushing off from the shore after discharging his passengers. The scene is symbolic of the prevalence of boat travel in and around Hangchou and provides a rustic contrast to the well-contrived garden. Heavy-hanging green willows (at the upper edge of the scroll) mingle with the spiky branches of blossoming plums growing up from the bank of the stream. Chang Tzu, in the source cited above, indicates that his garden was known for its willows and plums. His schedule of pleasurable activities prescribes a number of springtime events whose stated purpose involved viewing plums and willows in different parts of his garden. It is tempting to identify the four large hoary pines which embrace the principal group of figures with the four large ancient pines noted by Chou Mi (*Ch'i-tung yeh-yü,* quoted in Chang Tzu, *Nan-hu chi, fu-lu, hsia,* p. 2235) in his account of Chang's garden. These pines apparently defined the locus of some of Chang's more ingenious entertainments. It is also tempting to see in the presence of the youthful female attendants representatives of the accomplished teen-age girls who plied Chang's guests with wine and amused them in courtly ways.

Although Ma Yüan in other paintings does create a stage-front space by screening the background from view with a rocky precipice, the large rock wall and cloud behind the central figure group tally well with a prominent feature of Chang's garden – a huge rock some twenty feet high and fourteen feet wide, known as the "Hanging Cloud Stone." That the one and only cloud appearing in the picture should appear prominently in association with just such a large rock begs coincidence; it suggests an allusion to the rock that verges on punning.

Other correspondences with Chang Tzu's garden, both in terms of its physical features as well as with the activities it hosted, may also be identified. The number and consistency of correspondences, together with Chang's relationship with Ma Yüan and the fact that Ma Yüan at least once painted a scene in his garden, furnish considerable circumstantial evidence for identifying the subject of the scroll with a gathering in Chang's Cassia Retreat. Although definitive substantiation awaits further research, this identification remains preferable to any yet suggested. MFW

Literature
Hsieh Chih-liu, *T'ang Wu-tai* (1957), pls. 86-90.
Akiyama et al., *Chūgoku bijutsu* (1973), I, 238, pls. 47-49.
NG-AM Handbook (1973), II, 55.
Wilson, "Vision" (1973), pp. 231-35, pl. 7.
K. Suzuki, *Ri Tō* (1974), p. 156, pls. 10, 11.

Recent provenance: Parke Bernet, Inc.

Nelson Gallery-Atkins Museum 63-19

52

53

Ma Yüan

52 *Watching the Deer by a Pine Shaded Stream*
(*Sung-hsi kuan-lu t'u*)

Album leaf, ink and light color on silk,
24.7 x 26.1 cm.

2 seals of Wang Chi-ch'ien (20th c.)

Remarks: Ts'ao Chao (*Ko-ku yao-lun*, 1387, quoted in
Li O, *Nan-Sung Yüan-hua lu*, 1721, *ch*. 7, p. 135) charac-
terized Ma Yüan's art as follows: "Ma Yüan studied
Li T'ang, and lowered his brush with strict order.
He used roasted ink to do trees and rocks, and a
squeezed brush on the leaves of trees. His rocks are
all square and hard – made as with large cuts of an
axe and girded with ink-wash texture strokes – and are
very antique. His complete scenes are not numerous.
In his small scenes precipitous peaks sometimes rise
perpendicularly, but their summits do not appear;
or sheer cliffs extend straight downward, but their
bases are not seen; or near mountains merge with the
sky, but distant mountains are low; or a solitary boat
floats beneath the moon, while a single man sits
alone: these are side-and-corner scenes."

Compositions in which the solid forms were evenly
dispersed so as to effect a pictorial balance were ap-
parently used by Ma Yüan only in large formats. In
his small album scenes he preferred the pictorial ten-
sions induced through calculated asymmetries and
oppositions. *Pien-chiao,* translated above as "side-and-
corner," implies just this dynamic competition be-
tween opposite sides of the picture.

Watching the Deer by a Pine-Shaded Stream is
similar in size, subject, and techniques to the *Scholar
by a Waterfall* in The Metropolitan Museum of Art
(1973.120.9), which is signed "Ma Yüan." Another ver-
sion of *Watching the Deer* – lacking the table, and with
distant peaks added – is found in a fan-shaped paint-
ing attributed to Yeh Hsiao-yen (*Nihon genzai Shina,*
1938, pp. 65, 66, leaf 9 in the ten-leaf collected album
Sung-jen chi-hui ts'e.) According to the *T'u-hui pao-chien*
(preface 1365, *ch*. 4, p. 107), "Yeh Hsiao-yen was from
Hangchou. He did figures and small scenes akin to
[those of] Ma Yüan, and was specially skilled in
copy-drawing. He was active in the Pao-yu era
[1253-58]." The difference between the two versions –
both of good quality and of Sung date – are illumina-
ting. While that attributed to Yeh Hsiao-yen
preserves the general features of Ma Yüan's com-
position, the addition of distant peaks in the upper
left eliminates the tensions which associate the
present painting with the essence of Ma Yüan's art.

HR

Literature
Strehlneek, *Collection* (1930?), pl. 211:4.
Cahill, *Chinese Painting* (1960), illus. p. 83.
Sullivan, *Chinese and Japanese* (1965), p. 261, fig. i.
Su, "Nine Sung Dynasty Album Paintings" (1972), pp. 38, 39,
 pl. X-C.
K. Suzuki, *Ri Tō* (1974), p. 50, text fig. 5.

Exhibitions
Asia House Gallery, New York, 1962: Cahill, *Southern Sung,*
 cat. no. 19.
China House Gallery, New York, 1970: Wang Chi-ch'ien,
 Album Leaves, cat. no. 18.

Recent provenance: E. A. Strehlneek; Wang Chi-ch'ien.

Intended gift to The Cleveland Museum of Art,
Mr. and Mrs. A. Dean Perry

Ma Yüan

53 *Drinking in the Moonlight*
(*Chü-pei yao-yüeh*)

Album leaf, ink and light color on silk, 25.4 x 24.1 cm.

1-1/2 seals: half-seal of Ming imperial collection (used 1372-84); 1 unidentified.

WKH

Recent provenance: Ch'eng Ch'i.

Intended gift to The Cleveland Museum of Art, Mr. and Mrs. A. Dean Perry

Ma Yüan

54 *Bamboo and Ducks by a Rushing Stream*
(*Chu-hsi shih-yü*)

Hanging scroll, ink and light color on silk, 61 x 37 cm.

Artist's signature: Ma Yüan.

12 additional seals: 1 of An Kuo (1481-1534); 7 of Hsiang Yüan-pien (1525-1590); 2 of Liang Ch'ing-piao (1620-1691); 2 unidentified.

WKH

Literature
Tu (trad. attr.), *T'ieh-wang* (preface 1758), *ch.* 8, p. 1(a).
Etō, "Ba En kan Chikuen zu Kinuhon" (1969), fig. 2.
Lee, "Painting" (1969), p. 121, color pl. on p. 137.
CMA *Handbook* (1978), illus. p. 341.

Recent provenance: Jean-Pierre Dubosc.

The Cleveland Museum of Art 67.145

Ma Yüan (attributed to)

55 *The Football Players*
(*Ts'u-chü t'u*)

Hanging scroll, ink and light color on silk, 115.6 x 55.3 cm.

WKH

Literature
CMA *Handbook* (1978), illus. p.343.

Recent provenance: Mr. and Mrs. Wilbur Cowett.

The Cleveland Museum of Art 71.26

Ma Lin, active mid-thirteenth century, Southern
 Sung Dynasty
From Ho-ching, Shanhsi Province

56 *Landscape with Flying Geese*
(*Ch'un-chiao hui-yen*)

Album leaf, ink and slight color on silk, 25.6 x 26.5 cm.

Artist's signature: Your subject, Ma Lin.

3 half-seals: 1 official seal of Yüan Dynasty; 1 of Ming imperial collection (used 1372-84); 1 official seal of Ming Dynasty.

WKH

Literature
Lee, "Scattered Pearls" (1964), no. 7, p. 32; idem, "Painting" (1969), p. 121, color pl. on p.137.

Exhibitions
Berea College, Berea, Ohio, 1962: Oriental Art, no. catalogue.
China House Gallery, New York, 1970: Wang Chi-ch'ien, *Album Leaves*, cat. no. 34.

Recent provenance: Vladimir G. Simkhovitch.

The Cleveland Museum of Art 52.285

54

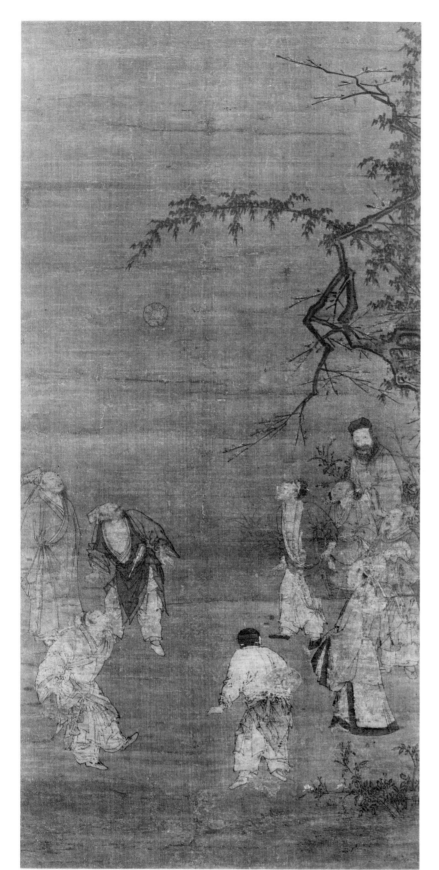

55

Ma Lin

57 *Scholar Reclining and Watching Rising Clouds*
(*Tso-k'an yün-ch'i*)

Album leaf, ink on silk, 25.1 x 25 cm.

Artist's signature: Your subject, Ma Lin.

2 seals on mounting of Chu Sheng-chai (20th c.).

WKH

Literature
Chu Sheng-chai, *Sheng-chai* (1952), pp. 46-48.
Lee, "Scattered Pearls" (1964), no. 6; idem,
 "To See Big within Small" (1972), p. 321, fig. 60.
CMA *Handbook* (1978), illus. p. 342.

Exhibitions
Asia House Gallery, New York, 1963: Lee, *Tea Taste*,
 cat. no. 1.
China House Gallery, New York, 1970: Wang Chi-ch'ien,
 Album Leaves, cat. no. 35.

Recent provenance: Nagatani, Inc.

The Cleveland Museum of Art 61.421

Hsia Kuei, active ca. 1180-1224, Southern Sung
 Dynasty
t. Yü-yü; from Hangchou, Chechiang Province

58 *Twelve Views of Landscape*
(*Shan-shui shih-erh-ching*)

Handscroll, ink on silk, 28 x 230.8 cm.

Artist's signature: Painted by Your Servitor Hsia Kuei
[Ch'en Hsia Kuei hua].

4 additional inscriptions, 9 colophons, and 43 seals: 4
inscriptions and 4 seals, possibly of Empress Yang (1162-
1232); 1 seal, possibly of Empress Hsieh (1208-1282); 1
seal, possibly of Ch'en Ta-yu (1259 *chin-shih);* 1 colophon
and 2 seals of Shao Heng-chen (1309-1401); 1 colophon,
dated 1562, and 4 seals of Wang Ku-hsiang (1501-1568);
1 colophon, dated 1627, and 1 seal of Tung Ch'i-ch'ang
(1555-1636); 1 colophon and 3 seals of Wang Hui (1632-
1717); 4 seals of Ts'ai Ch'i (late 17th c.); 1 seal of An
Yüan-chung (mid-18th c.); 1 seal of Li Tsai-hsien (1818-
1902 or later); 1 seal of Li Yü-fen (late 19th c.); 3 seals of
Ch'eng T'ing-i (act. late 19th-early 20th c.); 1 colophon,
dated 1908, and 1 seal of Tuan-fang (1861-1911); 1 col-
ophon, dated 1908, and 2 seals of Wang Jen-chün (act.
early 20th c.); 1 colophon, dated 1908, and 1 seal of
Ch'en Pao-shen (1848-1935); 1 colophon, dated 1909, and
2 seals of Lü Ching-tuan (act. early 20th c.); 1 colophon,
dated 1915, and 2 seals of Yen Shih-ch'ing (1873-1927);
2 seals of Feng Kung-tu (d. 1948); 7 seals unidentified.

Four captions, possibly by Empress Yang, are inscribed
on the painting: Like Writing Are the Wild Geese over
Distant Mountains, A Ferry Returns to the Misty Village,
Pure Serenity of the Fisherman's Flute, and Evening
Moorage by a Misty Bank.

Colophon by Shao-Heng-chen:

Yü-yü [Hsia Kuei] lived in Ch'ien-t'ang. In his youth he
specialized in figure painting, but then turned to land-
scapes. His brushwork has a seasoned maturity about it.
The tones of his ink are clear and unctuous. Vaporous
mists laid down in washes give the feeling of imminent
rain. Ink concentration varies from strong to weak in
rocks and trees, while distinctions in value mark far and
near. Thus, he is first among those of the Academy of
Painting. His snowscapes only he adapted from those
of Fan K'uan.

He may be thought incomparable in the field of art after Li T'ang [1049-after 1130], and in his own time he was treated with great concern. How much more is that so today!

Shao Heng-chen of Yen-ling.

Colophon by Tung Ch'i-ch'ang:

Hsia Kuei followed Li T'ang, but with even greater abbreviation and cursoriness, much as clay modellers speak of "reduced modelling." He intentionally sought to eschew imitation and the conventional path; and so, as though now dissolving, now disappearing, the ink-play of the two Mi [Mi Fu and Mi Yu-jen] dwelt in the tip of his brush. Others chip on the angular to make it rough, but this man facets the round to make it angular. Inscribed by Tung Ch'i-ch'ang in the sixth month of the *ting-mao* year [1627], in the reign T'ien-ch'i.

Remarks: Of the nine extant colophons attached to the painting, the first and third, by Shao Heng-chen (1309-1401) and Tung Ch'i-ch'ang (1555-1636) respectively, have entered the traditional critical literature on Hsia Kuei through repeated quotation and paraphrase.

Of the colophons known to have been attached to the scroll, one is now missing. In a rather pedestrian colophon dated 1906, a man who signs himself Hsia-huan chü-shih, noted that Ch'eng T'ing-i (act. late 19th-early 20th c.) paid a "fortune" for the scroll. The colophon originally preceded Tuan Fang's and was removed at some point after 1919 (see *Chung-kuo ming-hua*, 1904-25, v, pls. 1, 2).

The present composition of four scenes originally formed the second half of a longer scroll, totaling twelve captioned scenes in all, known in Ming and Ch'ing Dynasty records as *Twelve Views of Landscape (Shan-shui shih-erh ching)*, or simply *Landscape*. Even in Ming and Ch'ing recordings confusion existed about the identity of major Hsia Kuei handscroll compositions then current, creating a problem exacerbated by carelessness in the original recordings and confounded even further in modern writings. The entire composition of this painting is preserved in two copies, both of uncertain date. The older and better of the two, in a private collection in Taipei (see *Garland*, 1967, i, no. 27), bears the title *Ten Thousand Li of the Yangtze River (Ch'ang-chiang wan-li t'u)*. Since no pre-modern recording indicates that the composition consisted of two halves mounted as separate scrolls, it is especially puzzling to find the Taipei version cut into two parts, just a few inches forward of where the present fragment of *Twelve Views of Landscape* begins, and mounted as two separate scrolls.

Had *Twelve Views of Landscape* existed as a composition in two scrolls in the late Ming and early Ch'ing period, it seems unlikely that the more meticulously prepared recordings, such as the one in Kao Shih-ch'i's (1645-1705) *Chiang-ts'un hsiao-hsia lu* of 1693 (*ch.* 1, pp. 30b-31b), would have failed to note the fact. Evidence provided by seals and the recordings suggests that *Twelve Views of Landscape* was not cut in two until sometime between the middle of the eighteenth century and end of the nineteenth century. The first half has disappeared.

The possibility that *Twelve Views of Landscape* might have borne the title *Ten Thousand Li of the Yangtze River* prior to the Ch'ing Dynasty is broached by the existence of the Taipei version. A long colophon by Lu Wan (1458-1526) is attached to the second scroll of the Taipei version. Wang K'o-yü (b. 1587) records (*Shan-hu-wang*, preface 1643, *ch.* 6, p. 852) a painting attributed to Hsia Kuei entitled *Ten Thousand Li of the Yangtze River*. It bore a

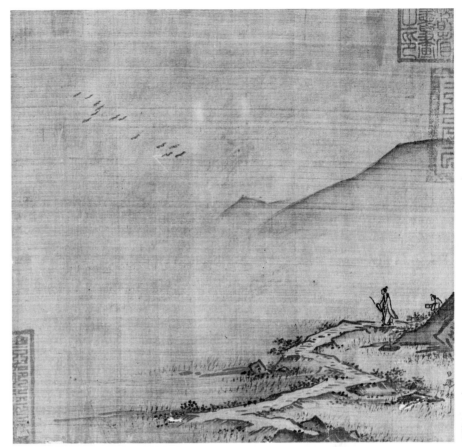

56

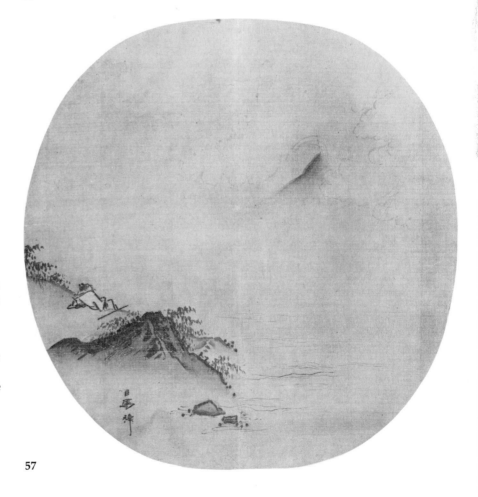

57

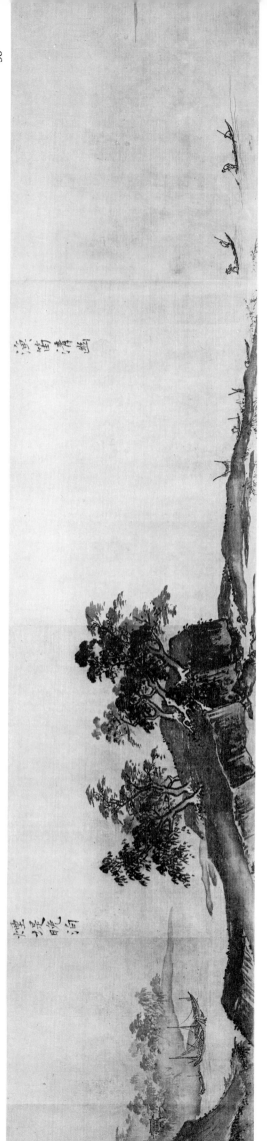

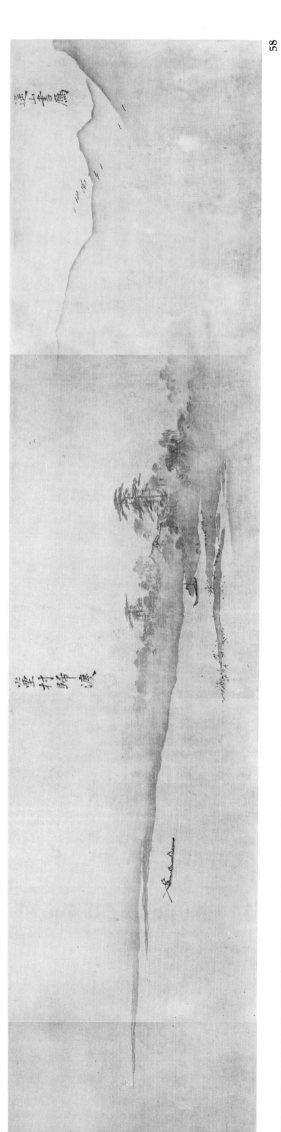

colophon by Lu Wan, the wording of which is precisely the same as the colophon attached to the second scroll of the Taipei version. According to Wang K'o-yü's recording, Lu Wan's colophon was, however, attached to a painting much longer than the combined length of the Taipei scrolls under consideration.

The third version of the composition attributed to Hsia Kuei, now in the Moore Collection, Yale University Art Gallery (see Hackney and Yau, *Collection of Ada Small Moore,* 1940, no. XVI) preserves the composition in a single scroll that shares the same height with the Taipei scrolls and with *Twelve Views of Landscape.* The length of the Yale version, varying little from the combined length of the Taipei scrolls, tends to confirm that the composition as represented by the Taipei scrolls and the Yale scroll is complete and that Lu Wan's colophon originally belonged to another, longer composition.

The first caption on *Twelve Views of Landscape,* which reads "Like Writing Are Wild Geese over Distant Mountains" *(Yao shan shu yen),* was at some time carefully cut out and replaced. There is no evidence to suggest that this is not the original caption or that it has been moved from some other part of the scroll. The silk, writing, appropriate placement, and position over a seal that is the same in all respects as the other three seals appearing under the captions confirm this strange bit of indecision.

The present wrapper label, unsigned and undated, reads: *Landscape by Hsia Kuei with Individual Captions by Li-tsung of the Sung (Sung Li-tsung fen-t'i Hsia Kuei shan-shui).* The attribution of the captions to Emperor Li-tsung (1205-1264; r. 1224-64) and the identification of the seals beneath with a double-dragon seal belonging to Li-tsung appear to originate with a speculative suggestion made by Wang Ku-ksiang (1501-1568) in his colophon. Wang's identification was repeated without challenge thereafter by other writers. The so-called double-dragon seals beneath the captions are in fact single-dragon seals of a type associated with Empress Yang (1162-1232), wife of Emperor Ning-tsung (1168-1224; r. 1194-1224). The closest comparable examples are impressed beneath her signature to two poems, each written on a round fan now mounted as an album leaf. Both are in the collection of John M. Crawford, Jr. (see Ecke, *Chinese Calligraphy,* 1971, no. 25; Chiang Chao-shen, "Yang Mei-tzu," 1967, pt. I, fig. 3).

The style of writing for the captions bears little or no relationship with known examples of Li-tsung's calligraphy. The structure of the characters, the nuances of brush rhythms, and the qualities of ink link the writing with the essentials of Empress Yang's calligraphy. Perceptible differences with other known examples of her calligraphy should probably be attributed to evolutionary changes in her style rather than to fundamental differences of another hand. The style of the writing, together with other external evidence, provide ample grounds for viewing the captions as examples of Yang Mei-tzu's mature, old-age calligraphy.

The appearance in the far upper-left corner of a large and now almost illegible seal, cut in official Southern Sung style, forces speculation about Empress Yang's relationship with Hsia Kuei; about her relationship with her successor, Empress Hsieh (1208-1282); and about the possibility that *Twelve Views of Landscape* may be an advanced–even late–work of Hsia Kuei dating from the end of Ning-tsung's reign or even from the early years of Li-tsung's reign.

The seal in question was already undecipherable by the early years of the Ch'ing Dynasty, if not before. Modern techniques allow the seal to be read as: Mei-hsia ch'ing-wan chih pao (Treasure of Pure Enjoyment of Beautiful Rose-Colored Cloud). Mei-hsia is an informal and probably self-styled nickname of Empress Hsieh (wife of Emperor Li-tsung) and is analogous to, and perhaps even modelled on, Empress Yang's nickname, Mei-tzu. Mei-tzu denotes Empress Yang's beauty, by virtue of which she was chosen to enter the palace and wedded as a secondary concubine to Emperor Ning-tsung. Empress Yang's pride in her own beauty is implied by her regular use of this unofficial, informal nickname. Her interest in painting and calligraphy and her close association with painters of the Academy of Painting, notably Ma Yüan (act. before 1189-after 1224), are well known and documented (ibid.).

An image of Yang Mei-tzu as a pretty dilettante in art and a patron of painters is belied by political intrigues that bespeak ruthless ambition bound by a well-developed taste for temporal power. By the end of Ning-tsung's reign, her position at court had grown to one of decisive power, so much so that at Ning-tsung's death she was able, with the connivance and persuasion of the Grand Councillor Shih Mi-yüan (d. after 1233) to put Li-tsung on the throne in place of the designated heir-apparent. It was she who not only forced Li-tsung to take Hsieh Tao-ch'ing to be his empress, but in effect also co-ruled the realm from "behind the screen" with Li-tsung. Given a grateful and pliant Li-tsung and a newly installed empress who owed her suddenly improved circumstances to Empress Yang, it seems likely that Empress Yang, whose power had only increased with the change of reigns, could have continued to use her single-dragon seal to the end of her life. It is also virtually certain that a patron-client relationship would have existed between Empress Yang and the young Empress Hsieh, which typically in Chinese tradition would have seen the client acquiesce in the interests of the patron. Whether Empress Hsieh maintained as fervent an interest in painting and calligraphy as Empress Yang is not known, but to judge from her later political decisions, she was a sensible and sensitive person.

The origin of Empress Hsieh's nickname, Mei-hsia (Beautiful Rose-Colored Cloud), has the ring of fabrication designed to provide auspicious signs of high destiny to the early life of a relatively undistinguished person. When pregnant, her mother dreamt that her body was enveloped by a beautiful rose-colored cloud. Whether fabrication or not, the name Mei-hsia, which typologically sounds like a baby name, was apparently used only during her younger years as empress, certainly at a time when she would still have felt a keen obligation to Empress Yang. It is not known precisely when she stopped using the name.

Given the connections between the two empresses postulated above, the presence of Empress Hsieh's seal using the name Mei-hsia, known only in this unique impression, strengthens the attribution of the captions and single-dragon seals to Empress Yang. It also lends confirming evidence to the case for the authenticity of the picture and to the argument that the painting should be a late work of Hsia Kuei. Although the exact circumstances under which the painting was produced may never be known, the most plausible hypothesis suggests that Hsia Kuei painted it for Empress Yang, who provided it with captions and presented it some time

thereafter to Empress Hsieh. Whether the picture was painted in response to captions pre-conceived by Empress Yang or vice versa, cannot be determined. Nor can the composition, with or without pre-conceived captions, be linked in any but the most general way with the earlier pictorial traditions of the *Eight Views of the Hsiao and Hsiang* and *Ten Thousand Li of the Yangtze River*. MFW

Literature
Pien, *Shih-ku-t'ang* (1682), *ch.* 14, pp. 64a-65b.
Ku Fu, *P'ing-sheng* (preface 1692), III, *ch.* 8, pp. 59-61.
Kao Shih-ch'i, *Chiang-ts'un hsiao-hsia lu* (1693), *ch.* 1, pp. 30b-31b.
Wu Sheng, *Ta-kuan lu* (prefaces 1712), *ch.* 15, pp. 2a, b.
Li O, *Nan-Sung* (1721), *ch.* 6, pp. 12a, b.
An, *Mo-yüan* (1742), sequel, *ch. hsia*, p. 3b.
Li Tiao-yüan, *Chu-chia* (preface 1778), *ch.* 9, p. 14.
 (The catalogues above list the painting as *Twelve Views of Landscape*.)

Chung-kuo ming-hua, 1904-25, V, pls. 1, 2.
Wan-yen, *San-yü-t'ang* (1933), p. 3b (as *Four Views of Landscape*).
Okamura, *Urinasu* (1939), pp. 117-27.
Munsterberg, *Short History* (1949), pl. 40.
Cheng Chen-to, *Wei-ta-te* (1951-52), II, coll. 7, pls. v-vii.
Burling and Burling, *Chinese Art* (1953), pl. 109.
Munsterberg, *Landscape Painting* (1955), pp. 55, 56, pls. 41-43.
Sickman and Soper, *Art and Architecture* (1956), p. 136, pls. 105-106b.
Sirén, *Masters and Principles* (1956-58), II, 122; III, pls. 303, 304.
Teng and Wu, *Ma Yüan yü Hsia Kuei* (1958), pp. 19, 20, pls. 8-10.
Fontein, "Chinese Art" (1960), pl. 263.
Lee, "Hsia Kuei" (1963), color pls. 652, 653; idem, *Far Eastern Art* (1964, 1973), p. 355, pls. 462, 463.
Willetts, *Foundations* (1965), pls. 215, 216.
Loehr, *Chinese Painting after Sung* (1967), fig. 8.
K. Suzuki, "Hsia Kuei" (1972), pp. 417, 425, 432, 433, pl. 2.
Akiyama et al., *Chūgoku bijutsu* (1973), I, pp. 224, 225, pl. 16.
NG-AM Handbook (1973), II, 56.
K. Suzuki, *Ri Tō* (1974), p. 157, pls. 45, 46.
Watson, *L'Ancienne Chine* (1979), p. 440, pls. 489-92.
Loehr, *Great Painters* (1980), pp. 208-10, figs. 99, 100.

58 Detail

Exhibitions
Royal Academy of Arts, London, 1935/36: *Chinese Exhibition*, cat. no. 1074, figs. a-d.
Cleveland Museum of Art, 1954: Lee, *Chinese Landscape Painting*, cat. no. 20, pp. 36-38, 145.

Recent provenance: Owen Roberts.

Nelson Gallery-Atkins Museum 32-159/2

Hsia Kuei (attributed to)

59 *Swinging Gibbon*
(*Hsi-yüan t'u*)

Album leaf, ink and light color on silk, 24.8 x 26.5 cm.

Artist's signature: Hsia ___?___.

Remarks: The artist's signature in the lower right has been read both as "Hsia Lin" and "Hsia Kuei." The former reading has given rise to the theory that Hsia Kuei had two sons: Lin, written with two "trees," being the elder, and Sen, written with three "trees," the younger. However, while Hsia Sen is well recorded as the son of Hsia Kuei, no mention is made of a Hsia Lin. The signature is thus more likely to be that of Hsia Kuei, written somewhat hastily and incompletely, than that of an otherwise unknown "Hsia Lin." Hence the painting was recorded as by Hsia Kuei (Harada, *Nihon genzai Shina*, 1938, pp. 65, 66, leaf 7 in the ten-leaf collected album *Sung-jen chi-hui ts'e*).

 The earliest biography of Hsia Kuei is that of 1298 by Chuang Su: "Hsia Kuei, from Ch'ien-t'ang, was a painter-in-attendance in the Painting Academy during the reign of Li-tsung [1225-65]. He painted landscapes and

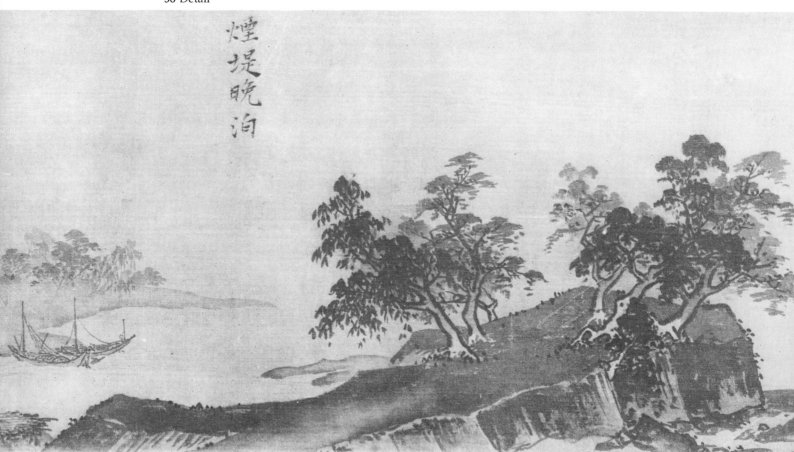

figures which are extremely vulgar and loathsome. At the end of the Sung, social morality withered and died, the hearts of people shifted and altered, and Kuei thus excessively achieved fame at that time. In reality [his art] had nothing to recommend it, and it is enough to know this period of activity and name and nothing more. His son, Sen, carried on his father's profession'' *(Hua chi pu-i, ch.* 2, p. 16.) This scathing and somewhat emotional denunciation of Hsia Kuei's art can only be understood in light of the political context in which Chuang wrote. The Mongols had then only recently conquered those men of Chuang's generation, who, suffering under foreign domination and discrimination and in understandable reaction to their own circumstances, condemned what they had admired under the Sung. Chuang's comments suggest not only that Hsia Kuei's paintings were tremendously popular but also – since they appealed to a people whose hearts had veered from traditional paths – that they were different from what had been done before him.

Chuang Su's most usual pejorative was ''weak brush-work,'' and its absence here implies that Hsia's brush-work was strong but was displeasing to the critic's eye. Since the firm, controlled, and continuous line of Wu Ping (see cat. no. 32) was admired by Chuang, it is reasonable to assume that the ''vulgar and loathsome'' line of Hsia Kuei represented the antithesis of that of Wu Ping.

Hsia Kuei had far fewer disciples and followers than did his near-contemporary, Ma Yüan (see cat. nos. 51-55), with whom Hsia is often paired. Freedom and spontaneity cannot, of course, be systematized and re-duced to a replicable formula; this truism must account in great part for the lack of any significant school follow-ing. The execution of the *Swinging Gibbon,* like the com-position itself, is deceptively simple. Close examination reveals an impressive variety of stroke-types as well as absolute control over ink tonality. Although the lack of clarity in the second character of the signature makes for uncertainty in attributing the painting to Hsia Kuei, the quality of the brushwork lends credibility to that assumption. HR

Recent provenance: Ch'eng Ch'i.

The Cleveland Museum of Art 78.1

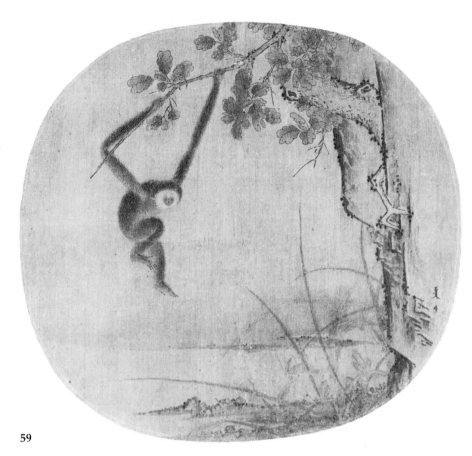

59

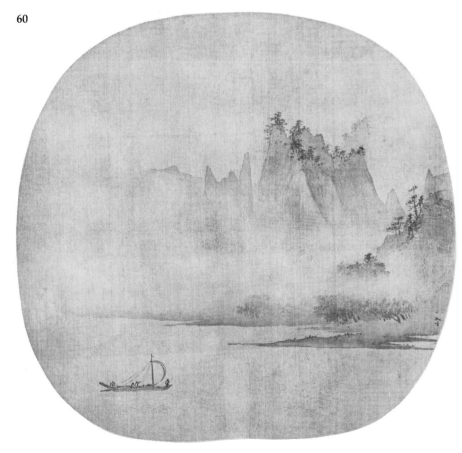

60

Hsia Sheng (?), thirteenth century, Southern Sung Dynasty

60 *Full Sail on the Misty River*
(*Yen-chiang Fan-ying t'u*)

Album leaf, ink on silk, 24.2 x 26.7 cm.

Artist's signature: Hsia Sheng.

Remarks: The name Hsia Sheng, with which the fan is signed, does not appear in any biographical compilation of painters. The high quality of the painting led the nineteenth-century collector Li Tso-hsien (*Shu-hua*, 1871) to list the work as by Hsia Kuei, while Ch'eng Ch'i (*Hsüan-hui-t'ang*, 1972) attributed the work – on the basis of the phonetic closeness of ''Sheng'' to ''Sen'' – to Hsia Sen, son of the early thirteenth-century master.

The masterful use of graded tonalities of ink to create a mist and cloud-filled ambiance from which the trees and mountains rise allies this painting very closely with the style of Hsia Kuei (see cat. no. 58). The abbreviated yet firmly drawn strokes of the figures, the varieties of

foliage patterns, and the suggestion in the upper mountain peaks of texture obtained through oblique strokes of the side of the brush are more specific elements of the Hsia Kuei style. In his extension of tendencies already present in the art of Hsia Kuei, however, the painter of this work stands in the same relationship to that master as does Ma Lin to Ma Yüan. That is, he would appear to be an immediate follower of Hsia, if not his son as well, and thus active toward the middle of the thirteenth century. HR

Literature
Li Tso-hsien, *Shu-hua* (1871), *ch.* 12, pp. 7(a)-7(b).
Ch'eng Ch'i, *Hsüan-hui-t'ang* (1972), Hua, pp. 15(a)-15(b).

Recent provenance: Ch'eng Ch'i.

Intended gift to The Cleveland Museum of Art, Mr. and Mrs. A. Dean Perry

Liang K'ai (attributed to), early thirteenth century, Southern Sung Dynasty

61 *Sericulture*
(*Chi t'u*)

Handscroll, ink and light color on silk, 26.5 x 98.5 cm. (first section), 27.5 x 92.2 cm. (second section), 27.3 x 93.5 cm. (third section).

3 colophons and 7 seals of Ch'eng Ch'i (20th c.).

Remarks: Before being restored to its original handscroll format, this painting had been cut up and mounted as three hanging scrolls; the original attribution was lost during the process. It was purely by luck that the separated sections were found in two different private collec-

tions in Japan and were reunited: Chinese connoisseurs termed this *Yen-tsin chih-ho* (the miraculous reunion of two lost swords of Lei Huan at the ferry of Yen-tsin).

According to tradition, the painting was once in the (Kishu) Tokugawa collection, which had possibly inherited it from the Ashikaga Shogunate of the Muromachi period. This conjecture is supported by an old Kano copy in the Tokyo National Museum, which is complete with the *Agriculture* section and which bears an inscription of Soami dated 1489 (see Kawakami et al., *Ryō Kai, Indara*, 1975, p. 41, comparative fig. 20). In his inscription, Soami reconfirmed the attribution of the original as "an authentic work by Liang K'ai."

In the fifteenth century most of these imported treasures *(Higashiyama gyomotsu)* had come through two channels: either as gifts from the Ming imperial court, or acquired through specially licensed trade. Thus, a painting like the Liang K'ai from the Ashikaga collection not only testifies to the aesthetic taste of the Higashiyama culture and the critical criteria of the Ami circle as reflected in the *Kundaikan* or the *Gyomotsu Gyoga Mokuroku* but also tells us something about things such as the art market or the state of connoisseurship in Sung and Yüan paintings on the Chinese side of these cultural exchanges.

Although earlier references had been made in Northern Sung, the first recorded painting of *Agriculture and Sericulture* was attributed to Lou Chu (1090-1162) in the Hsiao-hsing era. According to a colophon written for a copy of this early twelfth-century painting by Lou Chu's nephew, Lou Yao (1137-1213), the original scroll was made when his uncle was magistrate of the Yü-ch'ieng district near Hangchou, where he was able to acquire first-hand knowledge of farming activities and methods.

61 Detail

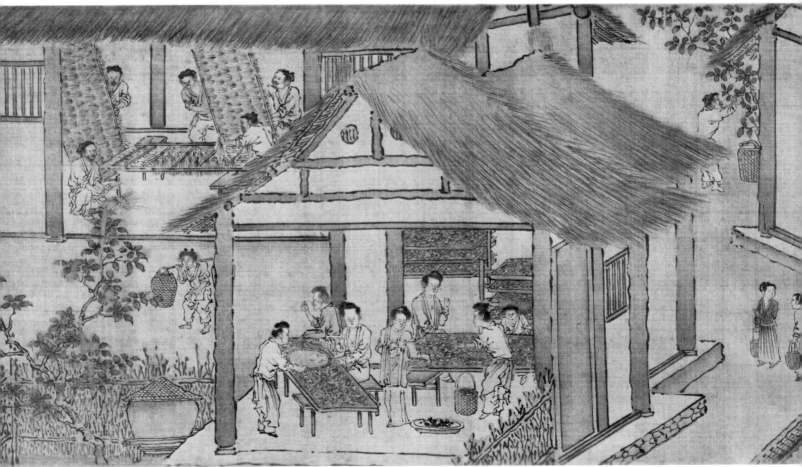

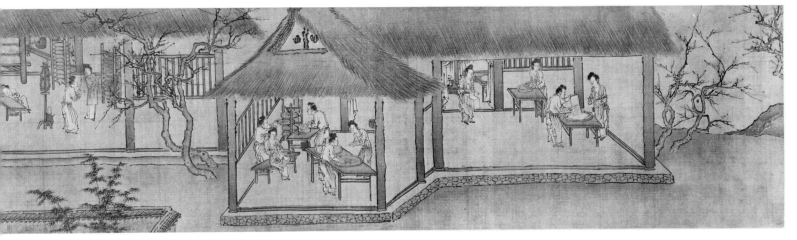

61A

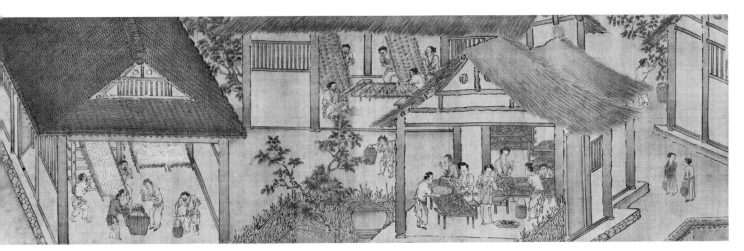

61B

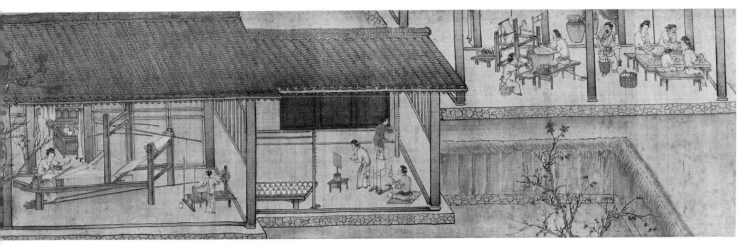

61C

On the basis of his observation, descriptive details were given in the painting on the complete processes of agriculture in twenty-one steps and of sericulture in twenty-four steps. Each step was illustrated by both painting and poetry. This painting was then presented to Emperor Kao-tsung – who was very much impressed and appreciative – and a copy was ordered to be kept in the palace (Lou Yao, "Pa Yang-chou po-fu *Keng-chi t'u*," *Kung-k'uei chi*, ch. 76, p. 1041).

Sometime later another copy was made for the heir-apparent, and a third copy was engraved on stone in 1210 as a permanent record. After the Southern Sung period, a number of copies in painting, woodblock prints, and stone are known to have been made after

the earlier versions. These include: 1) a Yüan copy by Ch'eng Ch'i; 2) Japanese prints made by Kano Eino in 1676, based on Chinese prints of the T'ien-shun period (1457-1464); 3) Ming reprints in the illustrated book *Pien-min t'u-chuan* of the Wan-li period (1573-1619); 4) early Ch'ing prints based on the modified copy of Chao Ping-chen in 1696, and 5) a stone engraving based on Ch'eng Ch'i's copy, made in 1769 by order of the Ch'ien-lung emperor (cf. Chiang Wen-kuang, "T'an Lou Chu 'Keng-chi t'u,' " 1979, pp. 61-63).

It should be pointed out that agriculture and sericulture had been a subject reserved almost exclusively for the court painters. Depictions of the life and hardships of the peasants as well as similar themes derived from

the *Shih-ching (The Book of Songs)* or other Confucian classics served as pictorial reminders for the ruling princes so they would not neglect the two "great foundations of the empire" (Lou Yao, *Kung-k'uei chi, ch.* 33, p. 443). Liu Sung-nien in particular is known to have been associated with this theme. However, among the few surviving examples of the subject, none seems to have shown any significant departures from their common model (probably the stone engraving of 1210) or possess any of the individual qualities that can be identified with the masters of the Southern Sung Academy.

The painting in Cleveland is perhaps the only exception that can be dated to the early thirteenth century with absolute certainty. Although similar in some details as in other examples, the sequential development of the painting has been completely reorganized. Separate scenes have been fused together into a continuous, unified composition. The shifts in time and space are subtly suggested by the advancing and receding architectural ground lines. From the beginning of the scroll, the narrative proceeds at a deliberate pace, its timing punctuated here by some trees at the corner of the house, or a pause there by two ladies conversing on the street. Within a general compositional scheme of two opposing sets of diagonals which converge in a mulberry tree (the self-renewing source of life for the cycle of sericulture), intersecting oblique lines change directions almost at every turn of the corners, and move in and out of the picture frame, creating a stage in depth where twenty-four acts from the drama of the transformation of silkworms into silk are to be performed successively and in order.

One has to look closer at the details, however, in order to experience, almost physically, the nervous vitality and intensity projected by the technique of *chien-pi-miao* – a technique usually associated with the name of Liang K'ai and sometimes translated as "abbreviated." Literally, it means "reduced brush drawing," so-called not merely because of its simplicity but because each stroke must perform the functions of several. Thus, the strokes characterizing the face must be at the same time descriptive and expressive. The lines contouring the body must both delineate and model, suggesting a sense of surface agitation and movement and invoking the excitement of interaction between the figure and its surroundings. One can find ample evidence of such effects in this painting. The attribution to Liang K'ai may be tentative, but the history of the painting is convincing. Above all, the quality of the painting is sufficient to speak eloquently for itself, as befits the hand of a great master who might have been part of the nonconformist undercurrent in the Southern Sung Academy. WKH

Recent provenance: Ch'eng Ch'i.

The Cleveland Museum of Art 77.5

Ch'en Jung (attributed to), ca. 1200-1266, Southern Sung Dynasty
t. Kung-ch'k, *h.* So-weng; from Fu-ch'ing, Fuchien Province

62 *Five Dragons*
(Wu-lung t'u)

Handscroll, ink on paper, 34.3 x 59.6 cm.

1 colophon and 16 seals: 13 seals of Chang Heng (1915-1963); 1 colophon, dated 1948, and 2 seals of Wang Shih-hsiang; 1 seal of Liu Ting-chih (20th c.).

Remarks: This painting has neither the signature nor seal of the artist. An almost identical composition of fighting dragons, however, occurs in a long scroll of eleven dragons now in the Freer Gallery of Art, Washington. The Freer painting carries an inscription and one seal of Ch'en Jung but is clearly a copy, probably from the seventeenth century. The Freer scroll opens with a short passage of rocks and trees; this is followed by six dragons shown

62

individually and rather widely spaced amid clouds and turbulent waves. Near the end comes the group of five dragons fighting among the clouds, and the composition closes with a longer passage of rocks, trees, and a winding, plunging stream.

Another scroll attributed to Ch'en Jung, recorded in the catalogue of the Ch'ien-lung emperor's collection (*Shih-ch'ü* II, 1793, Yü-shu-fang, 14b-15a) carries the same inscription and the same seal as the scroll in the Freer Gallery. From the catalogue description, which mentions trees and rocks, it is evident that there are only six dragons, as against the eleven in the Freer version.

Although the painting recorded in the imperial catalogue is not now available for comparison, it is tempting to speculate that the *Five Dragons* have been cut from the Palace painting, leaving only six dragons from the original eleven as they appear in the Freer version. If this is the case, then the Freer copy, which includes the inscription and seal, was made before the mutilation and the loss of the five fighting dragons. If the Freer copy is accurate, the

63A

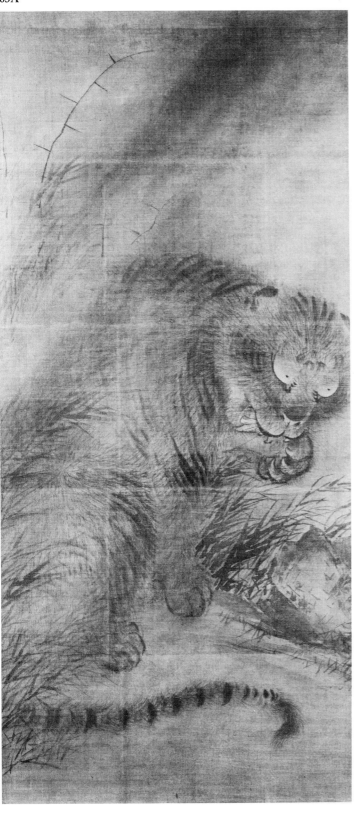

63B

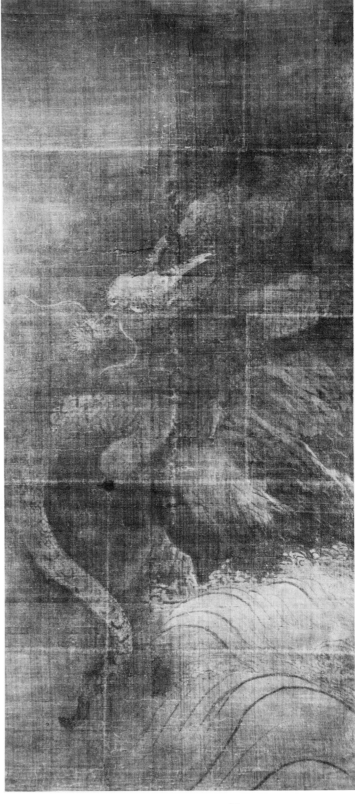

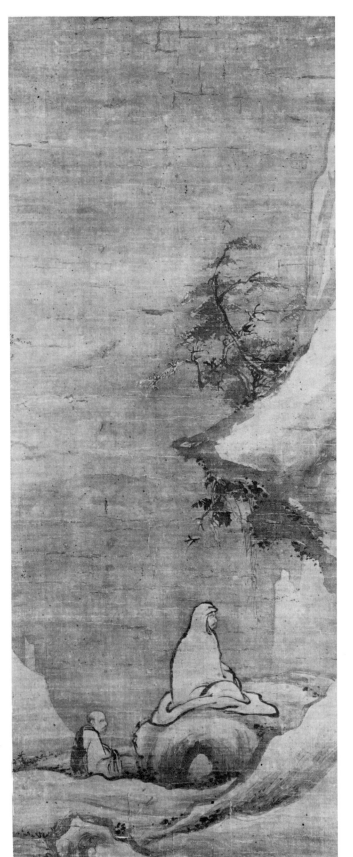

64

Nelson Gallery section was flanked by areas of clouds which could be joined together to make a presentable composition after the removal of the compact section of dragons in conflict. Unfortunately, the whereabouts of the Palace painting is unknown.

The Nelson Gallery *Five Dragons* is a work of the highest quality and compares favorably in drawing, style, and ink technique with Ch'en Jung's masterpiece, the *Nine Dragons*, now in the Museum of Fine Arts, Bofton.

When the *Five Dragons* came into the posession of the previous owner, Chang Heng, it was mounted as a large album leaf; it was he who had it remounted in its present form. KSW/LS

Literature
Sirén, *Masters and Principles* (1956-58), II, 150, 151; III, pl. 360.
NG-AM Handbook (1973), II, 58.

Exhibitions
Asia House Gallery, New York, 1962: Cahill, *Southern Sung*, cat. no. 29, pp. 63-65.
China House Gallery, New York, 1962: Munsterberg, *Dragons*, cat. no. 28, p. 32.

Nelson Gallery-Atkins Museum 48-15

Mu-ch'i (attributed to), active mid-thirteenth century, Southern Sung Dynasty
h. Fa-ch'ang; from Ssuch'uan, moved to Ch'ien-t'ang (Hangchou), and the Liu-t'ung Monastery, West Lake, Chechiang Province

63 *Dragon*
(Lung t'u)
and *Tiger*
Hu t'u)

Pair of hanging scrolls, ink on silk *(Dragon)*, ink and slight color on silk *(Tiger)*, each 123.8 x 55.9 cm.

2 seals: 1 of Ashikaga Yoshimitsu (r. 1368-94); 1 of Ashikaga Yoshimasa (r. 1449-73).

WKH

Literature
Lee, "Contrasts" (1962), p. 5, figs. 4, 6.
Sullivan, *Chinese and Japanese* (1965), p. 61, fig. D *(Tiger)*.
Lee "Zen in Art" (1972), p. 241, figs. 2, 3.
Toda, *Mokkei, Gyokukan* (1973), p. 186, pl. 29.
Yamane, *Kōetsu* (1975), p. 178, fig. 83 *(Tiger)*.
CMA *Handbook* (1978), illus. p. 343 *(Tiger)*.

Exhibitions
Haus der Kunst, Munich, 1959: *1000 Jahre*, cat. no. 24b.
Cleveland Museum of Art, 1960: Chinese Paintings, no catalogue.
Cleveland Museum of Art, 1961: Lee, *Japanese* (Cleveland, 1961), pp. 6, 7 (detail).
Smith College Museum of Art, Northampton, Mass., 1962: *Chinese Art*, cat. no. 3b, pl. V.
Asia House Gallery, New York, 1967: Cahill, *Southern Sung*, cat. no. 28.
Asia House Gallery, New York, 1974: Lee, *Colors of Ink*, cat. no. 4.

Recent provenance: Viscount Sakai; Howard C. Hollis.

The Cleveland Museum of Art 58.427, 58.428

Artist unknown, late thirteenth century, Southern
 Sung Dynasty

64 *Bodhidharma Meditating Facing a Cliff
 (Ta-mo mien-pi)*

Hanging scroll, ink on silk, 116.2 x 46.3 cm.

1 seal of Yen Tz'u-p'ing (a later addition).

<div align="right">WKH</div>

Literature
Tō-Sō-Gen-Min (1928), p. 32.
Nihonga taisei (1931-34), pt. II, vol. L, pl. 52.
Harada, *Shina* (1936), pl. 136.
Nihon genzai Shina (1938), p. 40.
Sirén, *Masters and Principles* (1956-58), II, *Lists*, 89 (under Yen
 Tz'u-p'ing).
Lee, "Zen in Art" (1972), p. 241, figs. 4, 4a.
Toda, *Mokkei, Gyokukan* (1973), p. 175, pl. 102.

Exhibitions
Tokyo Imperial Museum, 1930: *Tō-Sō-Gen-Min*, I, 72.
Asia House Gallery, New York, 1974: Lee, *Colors of Ink*, cat.
 no. 9.

Recent provenance: Kuniyoshi Miura.

The Cleveland Museum of Art 72.41

Artist unknown, first half of the thirteenth century,
 Southern Sung Dynasty

65 *Shakyamuni Coming Down from the Mountains
 (Shih-chia ch'u-shan)*

Hanging scroll, ink on paper, 74.6 x 32.5 cm.

Poem and inscription, dated 1244, and 1 seal of Ch'ih-
chüeh Tao-ch'ung (1170-1251).

Poem and inscription by Ch'ih-chüeh Tao-ch'ung:

Since entering the mountain, too dried out and
 emaciated,
Frosty cold over the snow,
After having a twinkling of revelation with
 impassioned eyes
Why then do you want to come back to the world?

The second day of the eighth month in the *chia-ch'en*
year of the Ch'un-yu reign [1244], eulogized by Tao-
ch'ung, resident of T'ai-po mountain. trans. WKH

Remarks: According to the orthodox (Mahāyānist)
Buddhist canon, Gautama Shakyamuni achieved en-
lightenment and became the Buddha while meditating
under a bodhi tree at Bōdhgayā. This event followed a
six-year fast in the mountains, which left him emaciated
and convinced that such asceticism was not the means
toward his ultimate goal. The theme of Shakyamuni
emerging from the mountains does not appear in ortho-
dox Buddhist texts or art but is distinctive to Ch'an biog-
raphies of the historical Buddha and to Ch'an
iconography.

Ch'an paintings of this theme, depicting Shakyamuni
with downcast eyes and still wearing his secular adorn-
ments of earrings and bracelets, are subject to contradic-
tory interpretations derived, in part, from differences in
Buddhist belief. One theory, in keeping with non-Ch'an
schools of thought, interprets Shakyamuni as being pre-
sented prior to enlightenment, to pictorialize the failure
of those stringent austerities that some Ch'an monks
demanded of themselves. From its inception, however,
Ch'an belief rejected the texts upon which such an inter-
pretation would be based, and created new themes to
embody its unique doctrines. Primary among them were
personal responsibility – hence the emphasis on the in-

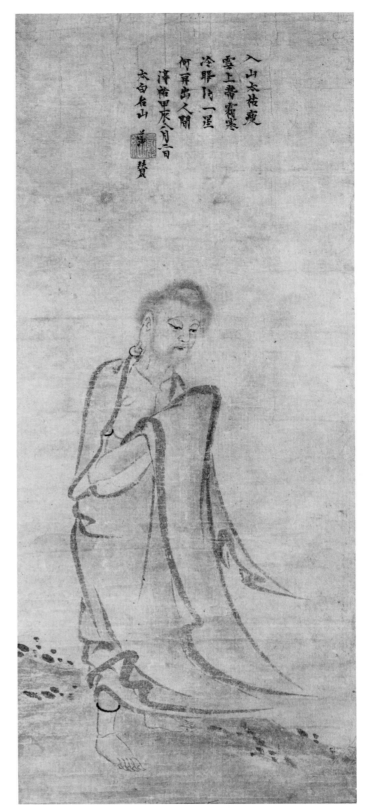

65

dividual Shakyamuni rather than on a hierarchy of bud-
dhas and bodhisattvas; and individual effort – hence the
absence of active proselytization. Thus the converse
Ch'an theory views Shakyamuni as having achieved en-
lightenment in the mountains after subduing the pas-
sions of the mind and body through severe self-
discipline and personal effort. Having fulfilled his per-
sonal imperative, Shakyamuni is depicted in this paint-
ing at a momentous juncture: He appears withdrawn
and lost in thought as he descends slowly and reluctant-

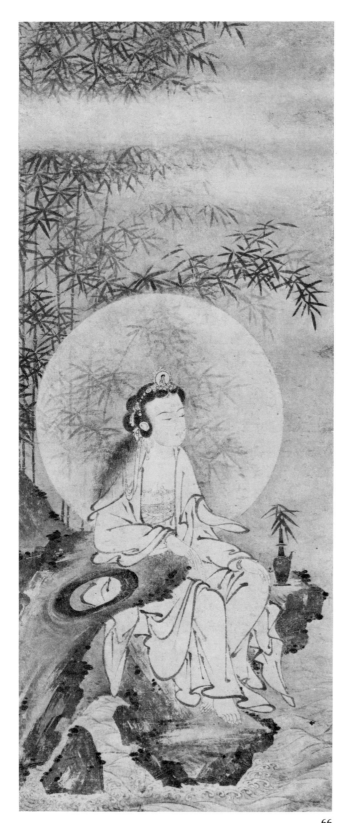

66

The body of Shakyamuni is rendered in lines whose thinness and fragility are appropriately analogous to his weakened physical state, while the thick, sweeping lines of the robe appear to impel the body forward. Geometrization of body parts and abbreviated rendition of the robe emphasize the facial features and their messages of introspection and austere strength. The style of this unknown artist is related to that of Li Ch'üeh, a thirteenth-century Hangchou follower of Liang K'ai, and provides an important prototype for Yüan renditions of this theme. HR

Literature
Lee, "To See Big within Small" (1972), pp. 317-18, figs. 54, 56; idem, "Zen in Art" (1972), p. 241, figs. 1, la.
Brinker, "Shussan Shaka" (1973), pp. 23, 33, 37, pl. 6, fig. 10.
Toda, *Mokkei, Gyokukan* (1973), p. 184, pl. 16.
Mayuyama (1976), II, pl. 163.
Zainie, "Sources" (1978), pp. 233-39, figs. 1, 4, 9.
CMA *Handbook* (1978), illus. p. 343.

Exhibitions
Asia House Gallery, New York, 1974: Lee *Colors of Ink,* cat. no. 6.

Recent provenance: Hisamatsu Family; Yamashita Family; Hara Family; Mayuyama & Co.

The Cleveland Museum of Art 70.2

Chang Yüeh-hu (attributed to), late thirteenth century, Southern Sung Dynasty

66 *White-Robed Kuan-yin*
 (Pai-i Kuan yin)

Hanging scroll, ink on paper, 104 x 42.3 cm.

Remarks: One of the most frequently depicted Buddhist deities in Ch'an painting is the Kuan-yin (Avalo-kiteśvara) of P'u-t'o-shan (Mt. Potalaka), reputedly situated in the South and eventually identified as the island of that name off Ningpo, Chechiang. This was a region of temperate clime, abundant springs, and luxuriant vegetation. Here the bodhisattva sat on an adamantine rock.

While some critics have had the mistaken idea that the image of Kuan-yin reclining on a rock was an innovation of Li Kung-lin (ca. 1049-1106), this iconography was already well known before his time. Two precedents among many of the tenth and early eleventh centuries are an incised mirror found in the back of the Shakyamuni Buddha from Seiryō-ji in Kyoto, datable before 984 (Henderson and Hurvitz, "Buddha of Seiryōji," 1956, pp. 32, 33) and a small wood figure of Potala Kuan-yin in the Cleveland Museum (65.556; Lee, "Klienkunst," 1966-67, p. 67), datable to the tenth century by comparison with sculptures from the Kuang-hsiao-ssu Monastery in Canton (Shang, *Kuang-chou Kuang-hsiao-ssu,* 1955). Moreover, texts mentioning this motif in relation to Li Kung-lin actually describe the bodhisattva as reclining on a rock (Teng, *Hua chi,* preface 1167, *ch.* 3; Li Ch'ih, *Te-yü-chai hua-p'in,* 11th-12th c., trans. Soper, "Descriptive Catalogue," 1949, p. 23) – pictorial examples of this alternative type have not survived. The only example of the reclining deity in any way connected to Li Kung-lin is an incised stone in Hangchou dated 1132 and purportedly designed after a painting by Li (cf. rubbing in Huang Yung-ch'üan, *Li Kung-lin,* 1963, text fig. 4).

In the Southern Sung and Yüan periods, Ningpo was an important pilgrimage center, and local professional artists were commissioned to supply the needs of the temples. One series of 100 scrolls representing the Five-

ly to the secular world, where his historical destiny as the proselytizing Buddha will begin.

The inscription on the present painting by Ch'ih-chüeh Tao-ch'ung (1170-1251) speaks eloquently of the austerities that created the disimpassioned state necessary to the enlightenment symbolized by the star, and questions the purpose for which Shakyamuni leaves the mountains.

hundred Lohan was completed between 1178 and 1188 by Lin T'ing-kuei and Chou Chi-ch'ang, who are otherwise unrecorded as artists. In one painting of this set, done in the orthodox fine-line style of drawing with colors added, a group of lohans is depicted viewing a painting of the *White-Robed Kuan-yin* (Toda, *Mokkei, Gyokukan*, 1973, text fig. p. 61). Since this painting-within-a-painting is done in a rougher style of monochrome drawing, it would suggest that such professional artists were accustomed already to handling the technical and iconographic requirements of Ch'an painting. Chechiang seems to have been the center for such professional production from the twelfth through the fourteenth centuries, and many of those paintings – including the set done by Lin and Chou – left via the port at Ningpo for Japan and the Zen temples in Kamakura.

A set of the *Five-Hundred Lohan* attributed to the late Sung artist Cheng Ssu-kung (in the Enkaku-ji, Japan), includes a painting-within-a-painting of the *White-Robed Kuan-yin* in ink monochrome. Representations of Lung-ch'üan ceramic ware in the set help to date these paintings to at least the late thirteenth century and to further associate them with the Chechiang center of such production.

This tradition was continued into the early Yüan period by one Chang Yüeh-hu, to whom the present painting is attributed. Not recorded in Chinese biographical records, the artist is known only from mention in the *Kundaikan* (MS. dated 1559). Pictures of Bodhidharma and, especially, of Kuan-yin have often been attributed to him on the basis of the loosest stylistic relationships (cf. *White-Robed Kuan-yin* attributed to Chang in *Choshunkaku kansho*, 1913, IV, pl. 17). "Yüeh-hu" (Moon-Lake, according to one reading) is located in the same area of Chechiang where Chang Ssu-hsün lived, and perhaps Chang Ssu-kung. Yüeh-hu may thus be a by-name used by one of these thirteenth-century artists.

In this painting the influence of literati values and taste in Ch'an iconography is especially evident in the extensive bamboo grove and in the calligraphic brushwork. Sprays of bamboo placed in a bowl or ewer were common in earlier renditions of the theme, but here a bamboo grove, drawn in several overlapping layers with strong variation of ink tonality, occupies a major portion of the painting and defines the extent of pictorial depth. The drapery lines function well to describe volume, but in their rhythmic alternation of width and emphasized stroke-endings have purely formal or abstract value as well. The rocks on which the bodhisattva sits and leans, however, are treated far less structurally and, like the water below, more as planar pattern. The figure thus appears somewhat separate – in, but not a part of its environment – as befits a god; while the revealed and crossed feet, the three-quarter view and relaxed posture, and the full disclosure of the head and pensive face enhance the approachability of the figure. The facial features here, sensitive in rendition and beautiful in aspect, ensured its success as a devotional image of the Bodhisattva of Infinite Compassion. HR

Literature
Mayuyama (1976), II, pl. 165.
CMA *Handbook* (1978), illus. p. 343.

Recent provenance: Mayuyama & Co.

The Cleveland Museum of Art 72.160

Artist unknown, thirteenth-early fourteenth century (?), Southern Sung to Yüan Dynasty

67 *Water and Moon Kuan-yin*
(Shui-yüeh Kuan-yin)

Hanging scroll, ink, slight color and gold on silk, 111.2 x 76.2 cm.

Remarks: The painting was formerly attributed to Yen Hui. The facts concerning Yen Hui's life are scanty, and even the dates of his working years are vague. The earliest reference, in Chuang Su's *Hua chi pu-i* (preface 1298), states that he was active in the late Sung Dynasty, but there is some evidence he may have lived into the early years of the Yüan Dynasty. Although almost unknown in China, numerous paintings attributed to Yen Hui are found in Japan.

In the *Water and Moon Kuan-yin* the deity (Avalokiteśvara Bodhisattva) is shown seated on a rocky ledge above a swirling pool fed by a waterfall plunging down from a towering cliff; the branches of a pine tree behind the figure spread above his head and a large, translucent halo, symbolic of the moon, surrounds him. Kuan-yin gazes on the waves and contemplates the transience of the phenomenal world – as ephemeral as the reflection of moonlight on water.

This particular manifestation of Kuan-yin developed from the older concept of the bodhisattva seated in his terrestrial home, Mt. Potolaka, thought to be an island off southern India, and described in the *Gandavyūha* section of the *Avatamsaka Sūtra* (Fontein, *Pilgrimage of Sudhana*, 1966, pl. 10). The iconography – with rocks, trees, and a waterfall in ink, with only slight or no color – could well have originated, as Munakata suggests in his *Ching Hao's "Pi-fa-chi"* (1974, pp. 43, 54), with such an early master of ink painting as Ching Hao at the turn of the ninth century.

The subject of Kuan-yin, seated by a pool, often called The White Robed Kuan-yin, was popular in Japan among the followers of the Zen sect. Numerous examples were executed in ink by Japanese artists of the fourrtenth and fifteenth centuries. Among these are several that reflect the composition of the Nelson Gallery picture (e. g., *Kannon no kaiga*, 1974, p. 25, upper right; Kawakami et al., *Ryō Kai, Indara*, 1974, pl. 4).

The Nelson Gallery Kuan-yin was long in Japan, possibly since the Yüan Dynasty when many Chinese Buddhist paintings, especially those in ink, were brought to Japan by returning monks and served as prototypes for Japanese artists. Later, in the seventeenth century, a sketch of the Nelson Gallery painting was made by Kanō Tanyū (1602-1674), to whom it had been sent for his expertise. The sketch, now in the Kimiko and John Powers collection, carries an annotation: "Kannon in a white robe. On the twentieth day, third month, same year [unspecified] this picture came from Lord Abe of Tamba, I sent word that it was a genuine work by Minchō, and splendid even for him" (Rosenfield and Shimada, *Traditions*, 1970, p. 202). Minchō (1352-1431) made copies, with variations, of the best authenticated Yen Hui paintings in Japan – a pair of scrolls depicting the Taoist immortals Liu Hai-chan and Li T'ieh-kuai, the latter bearing a seal of the artist (*Tō-Sō-Gen-Min*, 1930, pp. 166, 167). Minchō's copies are kept at the Tōshōdai-ji, Nara (Kawakami et al., op. cit., pls. 22, 130). It is by no means impossible that the painting seen by Kanō Tanyū was Minchō's version of the *Water and Moon uan-yin* now in the Nelson Gallery.

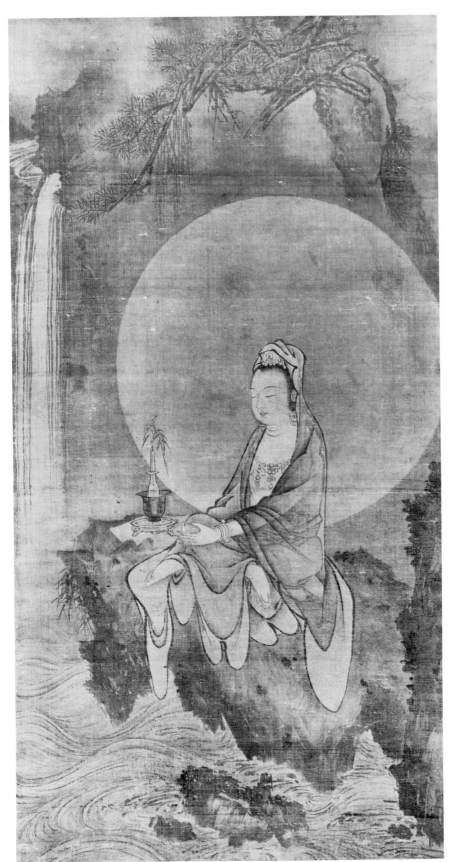

It is impossible to determine how long this painting has carried an attribution to Yen Hui. The mild and gentle Kuan-yin in a wilderness setting is done with far more elegance and restraint than the robust Taoist painting referred to above or such animated pictures as the hand-scroll of Chung K'uei and his demon retinue in The Cleveland Museum of Art (cat. no. 91). Unless Yen Hui painted in different styles, it seems more likely to be the work of a highly accomplished artist, as yet unidentified, working in a manner well established in the south during the thirteenth century, in the later years of the Southern Sung Dynasty.

On the interior of the old storage box is an inscription in gold lacquer: "Kannon Seated on a Rock [*Sekiza Kannon*], painted by Yen Hui, [signed] Tambi [Kanō Moritaka, 1840-1893]."
LS

Literature
Kokka, no. 297 (February 1915), p. 223.
Harada, *Shina* (1936), pl. 314.
Nihon genzai Shina (1938), p. 89.
Li-tai jen-wu-hua (1959), pl. 30.
Dubosc, "Plum Blossoms" (1972-73), p. 67, fig. 1.
NG-AM Handbook (1973), II, 57.
Kawakami et al., *Ryō Kai, Indara* (1975), pl. 101.

Exhibitions
San Francisco Museum of Art, 1957: Morley, *Asia and the West*, cat. no. 18*l*, p. 23.
Asia House Gallery, New York, 1963: Lee, *Tea Taste*, cat. no. 5, p. 19.
Cleveland Museum of Art, 1969: Lee and Ho, *Yüan*, cat. no. 207.

Recent provenance: Kawasaki Family.

Nelson Gallery-Atkins Museum 49-60

Artist unknown, thirteenth century, Southern Sung Dynasty

68 *The Sixteen Lohan by an Artist of T'ang (T'ang-jen hua shih-liu ying-chen)*

Handscroll, ink and slight color on paper, 32.7 x 374.5 cm.

1 frontispiece, 1 inscription, 4 colophons, and 61 seals: 14 seals of the Li family of Lung-hsi, unidentified (possibly 13th-14th c.); 3 colophons and 6 seals of Ch'iu Yüeh-hsiu (1712-1773); 1 frontispiece, 1 colophon, a long poem dated 1753, and 36 seals of the Ch'ien-lung emperor (r. 1736-95); 1 colophon by Wang Chieh and others, with 1 seal of Tung Kao (1740-1818); 1 seal of the Chia-ch'ing emperor (r. 1796-1820); 3 seals of the Hsüan-t'ung emperor (r. 1909-11).

Remarks: The frontispiece, written by the Ch'ien-lung emperor, comprises three large characters, *Te-san-mei* (Attainment of Samhādhi, or perfect absorption). Next, at the opening of the scroll, the emperor wrote a critique of the painting, praising it extravagantly as a work of the T'ang Dynasty and remarkable for the variety of calligraphic brushstrokes employed by the artist. The many creatures astonished him by their strangeness and caused wonder by their variety. He then appended a long poem, divided into fourteen sections, written above the lohan and describing them in terms of appropriate fantasy. The imperial inscription concludes, at the end of the scroll, with a poetic eulogy again lavishing the highest praise and declaring that the painting should be attributed to Lu Leng-chia (a pupil of the great eighth-century master, Wu Tao-tzu) or to the monk-painter Kuan-hsiu (832-912).

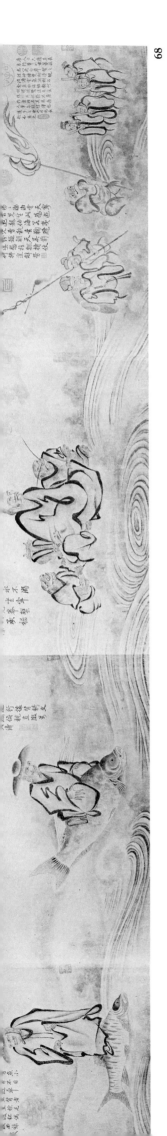
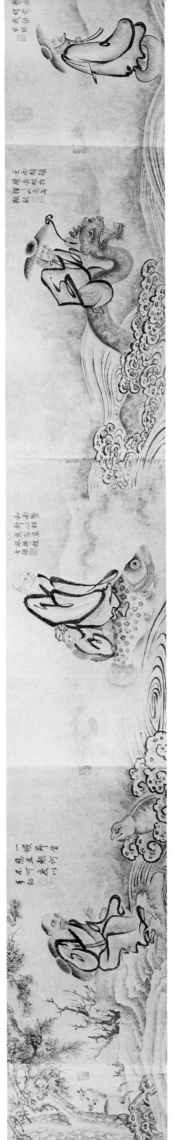
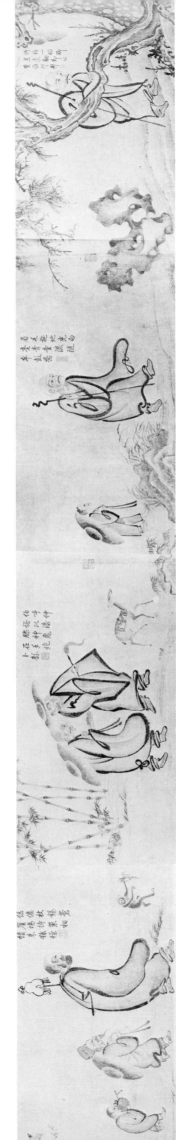

From the three colophons by Ch'iu Yüeh-hsiu (1712-1776) we learn some curious facts about the famous set of sixteen lohan paintings long attributed to Kuan-hsiu and now lost; how he acquired the present scroll; and how Ch'iu Yüeh-hsiu sought to display his acumen before presenting the painting to the throne.

Ch'iu Yüeh-hsiu, a high official of the Ch'ien-lung era, wrote his first colophon in 1752, recording how, in 1749, he saw for the first time the celebrated hanging scrolls believed to be original works by Kuan-hsiu and preserved in the Sheng-yin Temple at the West Lake, Hangchou. Later, in the spring or early summer of 1752, when Ch'iu was chief examiner in Chiang-nan, he met Ta-heng, the abbot of Sheng-yin-ssu. The latter told him the curious story that in the preceding year the paintings had been sent from Hangchou to Peking as a present to the empress dowager on her birthday. The gift was declined, however, by the Ch'ien-lung emperor on the grounds that these precious scrolls should remain in the temple where they had so long been treasured. Thus, they were returned.

Ch'iu Yüeh-hsiu must have let his interest in Kuan-hsiu be known in the Chiang-nan area because, his colophon continues, in the autumn of the same year when he had returned to Peking, a dealer of his acquaintance, Hu Ch'i-hsing of Suchou, sent him a package containing the present scroll with a note saying it was by Liang K'ai of the Five Dynasties period (907-960). (In fact, Liang K'ai was an artist of the Imperial Academy in the thirteenth century.) However, attached to the painting was a colophon by the celebrated critic Tung Ch'i-ch'ang, who opined that the painting was the work of an artist of the Kuan-hsiu school. Ch'iu, recalling the sixteen-lohan scrolls by Kuan-hsiu he had seen in Hangchou, readily agreed with this attribution and goes on to express his intent to present the painting to the emperor.

The next day Ch'iu examined the scroll with a more critical eye and judged that the calligraphy of the Tung Ch'i-ch'ang colophon was a forgery substituted for the original. This discovery is the subject of his second note. On the same day or the next, he further observed that Tung Ch'i-ch'ang mentioned some Buddhist text on the painting, and since no such text was then on the scroll, Ch'iu concluded that the texts had been removed. Moreover, he thought this would account for the half-seals and mutilated seals occurring at the junctures where the sheets of paper meet. (These would be the fourteen seals of the Li Family of Lung-hsi.) Having noted this in his third colophon, the scroll was ready for presentation to the throne. This must have been done in the fall or early winter of the same year because the emperor, in his enthusiasm, composed his long inscription and had thirty-six seals impressed on the painting in the New Year of 1753.

The fourth colophon, latest in date, but mounted first following the painting, is by the compilers of the second part of the imperial catalogue, *Pi-tien chu-lin hsü-pien*, completed in 1793. It briefly states that the colophon by Tung Ch'i-ch'ang did not belong with the *Sixteen Lohan* scroll at all, but was written for another painting in the imperial collection, *Portraits of Famous Monks (Ying-chen Kao-sheng hsiang)* by Kuan-hsiu. Consequently, the colophon was removed and mounted with the latter scroll (*Pi-tien* II, *ch.* 2, pp. 18a, b).

Both Ch'iu Yüeh-hsiu and the Ch'ien-lung emperor made references to the style of Kuan-hsiu; certainly the tradition, at least, of that artist's lohan types is preserved in the Nelson Gallery scroll. Nothing is known about the personal style of Kuan-hsiu (823-912), a monk of the Ch'an sect from Ssuch'uan famous for his poetry, calligraphy, and painting. Only his highly original manner of depicting Buddhist lohan is well established. Kuan-hsiu origi-

68 Detail

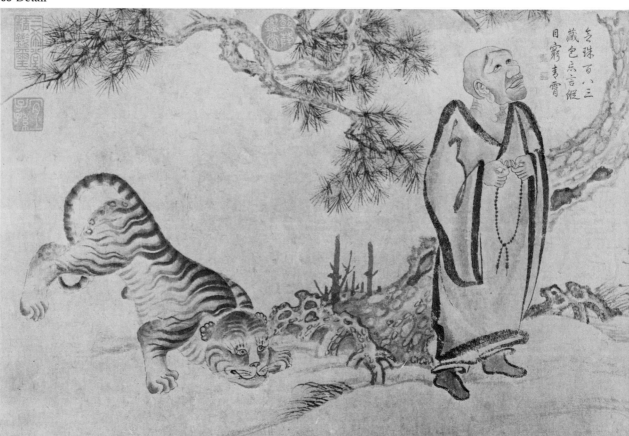

88

nated, or popularized, a distinctive type of Buddhist sage – weird, forceful, foreign, and generally ugly, placed in a setting of rocks and pines (Sirén *Masters and Principles,* 1956-58, I, 154-57). Huang Hsiu-fu, writing before 1005, who probably had seen original scrolls and wall paintings by the monk-artist, described his strange figures: "In painting he followed Yen Li-pen [act. ca. 640-680]. His sixteen lohan had shaggy eyebrows, large eyes, sagging jowls, and protruding noses. Some leaned on pine trees or rocks and some sat amidst hills and streams. They had the manner of foreigners form the West and the appearance of Indians. [In painting them] he exhausted every detail of their character. When someone asked him about them, he replied that he had encountered them in his dreams....People found his painting rather startling, but they were treasured by his disciples" (trans. Sirén, with changes; see also Huang Hsiu-fu, *I-chou,* preface 1006, pp. 35, 36).

The artist of the Nelson Gallery *Sixteen Lohan* has rendered the faces and hands in a fine, even line with the addition of light shading. In complete contrast to this controlled manner, the robes are done with broad, calligraphic brushstrokes, reminiscent of the cursive style of script, applied with slight concern for credible garment folds or underlying form but adding qualities of spontaneity and dynamic power. The lohan types clearly reflect the tradition of Kuan-hsiu as described by Huang Hsiu-fu. A date for the execution of the painting, most likely the work of a follower of the Ch'an sect, is suggested by the style of the waves, the fantastic rocks, bamboo, plants, animals, and fish, done for the most part in ink wash without outline. These details, taken together, point to a time in the thirteenth century during the later years of the Southern Sung Dynasty. LS

Literature
Pi-tien II, (1793), *ch.* 2, pp. 18a, b.

Nelson Gallery-Atkins Museum 50-11

Artist unknown, ca. late thirteenth century, Southern Sung Dynasty

69 *Conversation in a Thatched Hut*
(*Ts'ao-t'ang hsiao-hsia*)

Album leaf, ink and color on silk, 26 x 27.3 cm.
WKH

Literature
Lee, "River Village" (1978), p. 284, fig. 15.
Ho, Iriya, Nakada, *Kō Kōbō, Gei San* (1979), p. 117, text fig. 9.

Recent provenance: Ch'eng Ch'i.

The Cleveland Museum of Art 75.21

Artist unknown, twelfth century, Southern Sung Dynasty

70 *Birds on a Peach Branch*
(*T'ao-chih shuang-ch'üeh*)

Album leaf, ink and color on silk, 24.8 x 25.7 cm.

Remarks: The approach followed here in the omission of firmly drawn contours and the reliance on combinations of ink and color washes to define the forms places *Birds on a Peach Branch* within the stylistic tradition of Hsü Hsi, Chao Ch'ang, and Lin Ch'un. The asymmetrical dynamic composition relates especially well to those by the last-named master.

69

70

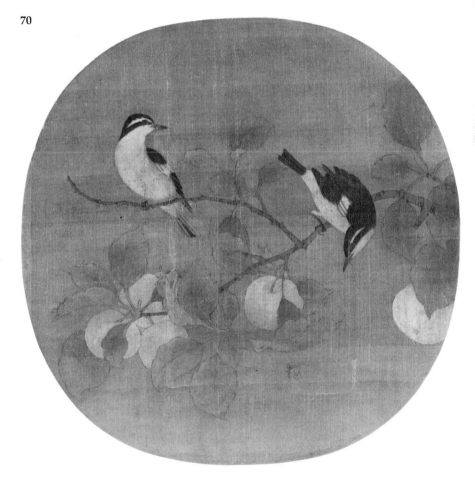

Lin Ch'un, a painter-in-waiting in the Painting Academy during the Shun-hsi era of 1174-89, was from the capital city of Hangchou. His style of painting was propagated within the Academy by P'eng Kao, also a painter-in-waiting during the Shun-hsi era, and by Chang Wan-ch'eng among the non-court artists of Hangchou. Lin and his followers were famed for depiction of birds, flowers, and fruits in light-colored washes, which conveyed compelling impressions of verisimilitude. According to critics of the time: "Following [the style of] Chao Ch'ang [Lin Ch'un] applied color in a light and dilute [manner] and profoundly obtained the wonders of Nature" (*T'u-hui pao-chien*, preface 1365, *ch.* 4, p. 74). "In placement and arrangement he reached the extremes of expression. Examine the things in the scene and they become animated, seeming about to move." These descriptions could well be applied to *Birds on a Peach Branch*, a later twelfth-century work in the style of Lin Ch'un. HR

Recent provenance: Heisando Co.

Intended gift to The Cleveland Museum of Art, Kelvin Smith

Style of Ch'ien Hsüan, first half of the fourteenth century, Yüan Dynasty

71 *Flowers and Birds*
(Hua-niao)

Album leaf, ink and color on paper, 29.4 x 28.8 cm.

Remarks: The artist of this unsigned leaf — or more likely — portion of a handscroll, appears to be one closely associated with Ch'ien Hsüan (ca. 1235-after 1300) of whom our knowledge is still surprisingly inadequate. Traditional literature about this important and influential painter of the Sung-Yüan transition tends to repeat the same few anecdotes that cannot be substantiated. Compared to other *i-min* painters such as Kung K'ai and Cheng Ssu-hsiao, Ch'ien Hsüan's life was undoubtedly the least recorded and the least understood. Certainly his withdrawal into anonymity had to be much more deliberate and complete than the other Sung loyalists to achieve this near total information blackout. For a once ambitious scholar with a *chin-shih* degree earned in the Ching-ting period (1260-64), and a literary celebrity ranked among "The Eight Talents of Wu-hsing", one wonders why the sudden disappearance of nearly all the fruits of his scholarly and poetic efforts. And who had received the mantle of his artistic heritage? Despite the fact that Ch'ien Hsüan's paintings were widely imitated during his lifetime, we know practically nothing about his pupils or successors — the transmission and perpetuation of his art. And was he really a professional painter as alleged by some of his contemporaries? Ch'ien Hsüan and his close friend Chao Meng-fu not only were the first to be involved in the historical dispute on *li-chia* (amateur) and *hang-chia* (professional); (see Ch'i-kung, "Li-chia K'ao," *I-lin tsung-lu*, v. 5, pp. 196-205), but both in their own way played a key role as precursors to the great literati tradition of the Yüan Dynasty.

In order to look into this crucial problem of professionalism and to substantiate suspicion that Ch'ien Hsüan's obscurity in history was self-imposed, it may be useful to paraphrase here a little-noted essay which has valuable information from two reliable sources: T'ang Ti (1296-ca. 1365), the Li-Kuo school painter and a fellow townsman from Wu-hsing (see Lee and Ho, *Yüan*, cat. no. 220); and Ch'ien Kuo-yung (*t.* Yen-pin), a nephew of Ch'ien Hsüan, the son of his older brother. In this essay entitled "A Preface Presented to Ch'ien Yen-pin" (*Tung-shan ch'uan-kao, ch.* 2, pp. 54b-56A), the Yüan neo-Confucianist scholar Chao Fang (1319-1369) first comments on the motivation and pitfalls of eremitism: "Since the ancient times, those who would have a true contempt for the world and an obsession with their own spiritual freedom, would, in spite of their extraordinary talents and wide learnings, often hide themselves in deep seclusion so as to avoid the knowledge of their fellow men, and to take refuge in whatever undertakings that may please their minds and anchor their interests. And when people identify them with these adopted means for their world-renunciation they would not make any disclaimer. The only sad thing is that usually within a hundred years their descendants would no longer be able to even understand their ancestor's motivation [and continue the family tradition]."

The author then relates a discussion with T'ang Ti, who had served as magistrate in the author's home district, Hsiu-ning (Anhui Province). T'ang Ti said when Chao Meng-fu was invited to serve in the court in the present dynasty because of his exceptional gifts and no-

71

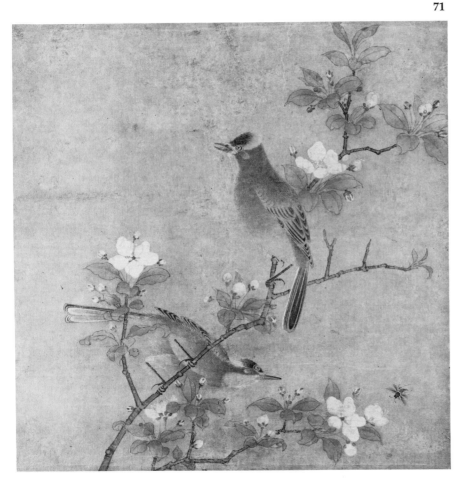

ble background, he could count as his peers in literary achievement such contemporary scholars as Mao Ch'eng-fu (Ying-lung, 1247-1324), Chang Kang-fu (Fu-heng), Yao Tzu-ching (Shih) and Ch'ien Shun-chü (Hsüan). Only Ch'ien Hsüan had made a name in painting and was especially respected by Chao Meng-fu. In one of the poems presented to Ch'ien Hsüan, Chao Meng-fu compared his friend with Yen Tzu-ling, the Han recluse who declined the emperor's invitation in favor of a fisherman's life on the Fu-ch'un River, "like a 'quest star' in the vast night sky of Han, all alone but proudly twinkling."

This conversation probably took place between 1345 and 1348, when T'ang Ti was the magistrate of Hsiu-ning (see Wei Su, "Hsiu-ning hsien-yin *ch.* 1, pp. 22, 23). Soon after T'ang Ti's departure, Chao Fang followed up their conversation by visiting T'ang at the latter's hometown, Wu-hsing, in the winter of 1349, and was able to secure from the painter some manuscripts of Mao Ying-lung for publication. On a second visit, probably sometime before 1351 when T'ang Ti left for Peking to serve as *lang-kuan* (division chief in the various ministries), Chao Fang again obtained from him some of the poetic works by Yao, Chang, and Ch'ien; and he was particularly impressed by Ch'ien Hsüan's "intellectual vigor and honesty in a calm and leisurely style totally devoid of anger, hatred, or any kind of unhappiness that is truly beyond imitation." He was, however, quite disappointed in his failure to locate the manuscripts of Ch'ien Hsüan's treatises on Confucian classics. He finally decided to visit the family, and interviewed the son of Ch'ien Hsüan's older brother, Ch'ien Kuo-yung. The nephew showed him a list of unpublished books written by Ch'ien Hsüan, including *Lun-lü shuo (On Confucius Analects), Ch'ün-ch'iu yü-lun (Additional Notes on the Annals of Spring and Autumn), I-shuo k'ao (A Study on I-ching and its Commentaries),* and *Heng-mi hsien-lan (Casual Readings on a Recluse's Life).* Unfortunately, according to Ch'ien Kuo-yung, all these manuscripts had been burned or destroyed by their authors. "For, unlike many of his scholar-friends who had accepted appointments to teach in the government schools, Ch'ien Hsüan alone chose to retreat to painting for all his life. As a result, he has been famous only as a painter," and apparently it was his desire to be known only as such and nothing else.

Deeply saddened, even somewhat puzzled by the extraordinary measures taken by Ch'ien Hsüan "to suppress and hide" his true image, Chao Fang nevertheless reports the reassuring news that the master did have a successor in his nephew. "Ch'ien Kuo-yung is a man of humility and prudence, a man of little worldly ambitions in complete accord with his forefathers. He is a capable painter of flowers and trees, and of fur and feathers. Inasmuch as Ch'ien Hsüan's studies and commentaries on the classics had not been handed down, it was probably his wish, as a perfect Confucianist, that his descendants should make their living solely from what may be provided by a recluse's life [which in their cases meant painting] and carry that on as a family tradition until the time comes [that merits a change]." Chao Fang's statement seems to confirm that not only his family members, but Ch'ien Hsüan himself indeed was, and not just mistakenly, regarded as a professional painter after the fall of Sung (see Cahill, *Hills,* 1976 p. 19). It also explains why Ch'ien Hsüan had to change his signature in order to protect his works from forgers (Liu Ch'iu-an, "Chu T'an mu," 1972, pp. 64-66). Such practice was perfectly

conceivable and acceptable for a professional, but not for a scholar. Hence the true and earlier identity of Ch'ien Hsüan as a scholar must be painfully buried, or hidden behind disguises.

It is partly through these disguises that we may take a glimpse of the archaism in Yüan art. The dilemma of the *i-min* painters in early Yüan was their inability to reconcile themselves, either rationally or emotionally, with political and social reality. This conflict may be seen in Kung K'ai's uglification of reality, or in Ch'ien Hsüan's purification and idealization of reality − their means were different, but the point of departure was the same (see Ho, Iriya, Nakada, *Kō Kōbō, Gei San,* 1979). The flowering branch and paired birds in the Cleveland leaf may seem to be partially indebted, compositionally and technically, to Emperor Hui-tsung of Northern Sung − perhaps even a bit more derivative than what would have been tolerated by Ch'ien Hsüan's own individualistic archaism. However, the ever-strong sensual instinct of the Sung artist toward Nature and his subject is replaced here by a keen response to the pure quality of linear pattern, presenting a vision of diaphonous clarity with an essentially *pai-miao* technique. With this technique, the subject is seemingly isolated from time and space, from the influence of natural elements, nuances of light and shadow, and the atmospheric changes of the hours or seasons. Deprived of any non-essential descriptions or color ornamentation, this is a reality purified, a reality disguised in the world of basic forms and concepts. WKH

Recent provenance: Setsu Gatodo Ltd.

The Cleveland Museum of Art 70.70

Chao Chung, active ca. second half of the
 fourteenth century, Yüan Dynasty

t. Yüan-ch'u, *h.* Tung-wu-yeh-jen; from Suchou,
 Chiangsu Province

72 *Ink Flowers*
 (Mo-hua)

Handscroll, dated 1361, ink on paper, 31.2 ×
153.2 cm.

Artist's 3 poems and 3 seals (not translated), artist's inscription and 2 seals: I did this scroll, using T'ang Cheng-chung's method of "ink-flower painting." I also composed poems in the style of Li Ho in praise of these flowers. My poems and painting may not be very good; they are nonetheless all derived from the heritage of the ancients. It is just as if one wants to draw a square or circle, one must first know how to use the ruler and the compass. May the connoisseur kindly refrain from laughing at them.

The fifteenth day of the eighth month in 1361. Respectfully inscribed by Tung-Wu-yeh-jen [a rustic of the Eastern Wu], Chao Chung, Yüan-ch'u. [seals] Chao Yüan-ch'u; Ch'uan-shih-ch'ing-wan.

4 additional seals: 1 of Ch'eng Ch'i (20th c.); 3 unidentified.

Remarks: The particular kind of sized paper, *feng-chien* (powdered paper), is by no means uncommon during the late fourteenth century, as some people thought. A late fourteenth-century scholar, Liu Chi, remarked: "Calligraphy written on *feng-chien* cannot last long; this is especially true in recent years as the products

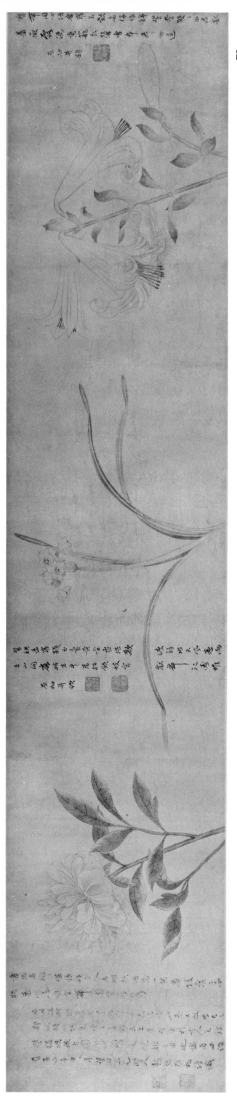

become rather crude and not refined enough. Writings on this kind of paper will begin to flake off in less than one or two years" (*Fei-hsüeh lu* [Notes in driven snow,] *Ku-chin shuo-hai* ed., *ch*. 2, p. 3a). This seems to be a perfect explanation for the present condition of the Cleveland scroll. Not only have the painter's inscriptions been seriously affected by the flaking-off of the powder on the paper surface, but the painting too has suffered considerably in its loss of the original richness of ink tones and the subtlety of the brush touch. The painting, however, remains a very rare example of ink-flowers in the *pai-miao* style of the fourteenth century and possibly the only published surviving work of the artist Chao Chung, not counting the handscroll *The Orchard Pavillion*, listed in the *Chien-mu*, or the secondary collection of the Palace Museum, Taipei, which has not been seen by the author. WKH

Literature
Hsieh, *T'ang Wu-tai* (1957), no. 35, pl. 107.
Lee, "To See Big within Small" (1972), pl. 318, fig. 58.
CMA *Handbook* (1978), illus. p. 346 (detail).

Exhibitions
Tokyo Imperial Museum, 1928: *Tō-Sō-Gen-Min*, p. 42.
Cleveland Museum of Art, 1968: Lee and Ho, *Yüan*, cat. no. 183.
Asia House Gallery, New York, 1974: Lee, *Colors of Ink*, cat. no. 20.

Recent provenance: Ch'eng Ch'i.

The Cleveland Museum of Art 67.36

72 Detail

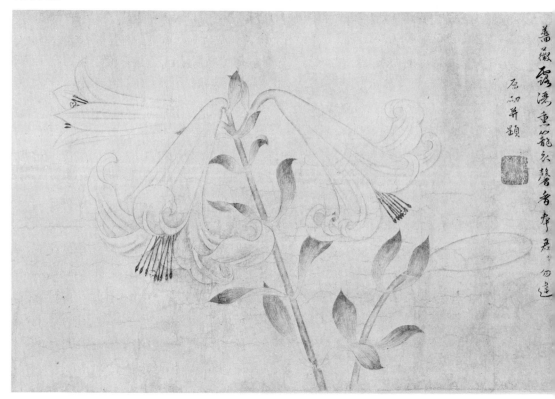

Artist unknown, late thirteenth century, Yüan
Dynasty

73 *Peonies*
(Mu-tan)

Hanging scroll, ink and color on silk, 145.4 × 88.3
cm.

<div align="right">WKH</div>

Literature
CMA *Handbook* (1978), illus. p. 344.

Recent provenance: Heisando Co.

The Cleveland Museum of Art 76.90

Artist unknown, thirteenth-fourteenth century, late
Southern Sung to early Yüan Dynasty

74 *Tree Peonies and Garden Rocks*
(Mu-tan hu-shih t'u)

Pair of hanging scrolls (paneled), ink and color on
silk, each 153 x 81 cm.

Remarks: Large, decorative flower paintings such as
these are difficult to assign to a specific era, even, at
times, within a century. They are almost invariably un-
signed, and when a seal is present its interpretation and
meaning is frequently problematic. Large paintings of
peonies in the tradition of the Southern Sung Academy,
often including garden rocks and insects, were probably
produced in considerable numbers in the general Suchou
area during the Southern Sung period, throughout the
Yüan Dynasty and on into the fifteenth and sixteenth
centuries of Ming. The trend over the years seems to be
toward a simplification in the drawing, a hardening of
outline, a coarsening of the shading, and a banality in the
compositions, producing in the early Ming period paint-
ing superficially decorative but stiff and lifeless — clearly
the product of professional craftsmen.

Among the best authenticated Southern Sung flower
paintings are the two hibiscus by Li Ti (ca. 1100-after 1197)
in the Tokyo National Museum (*Sō-Gen no kaiga*, 1962, pl.
53). The blossoms are exquisitely drawn in fine outline,
and delicate shading defines the complexity of the petals.
In these small paintings there is a freshness and ethereal
elegance that has come to be associated with the highest
standards of flower paintings in both the Northern and
Southern Sung Dynasties.

The most frequently reproduced paintings of peonies
on a large scale are the pair long kept in the Kōtō-in,
Kyoto, and now assigned to the Yüan Dynasty by
Japanese scholars (ibid., pls. 65, 66). Though lacking the
degree of elegance in Li Ti's hibiscus, a notably high
standard in drawing, coloring, and shading has been
maintained. In the Nelson Gallery pair the arrangement
of petals in some of the blossoms is more intricate, but the
composition, shading, and color, as well as the disposi-
tion of the blossoms against the dark green leaves, follow
much the same concept as that of the Kōtō-in scrolls.

Assuming a gradual decline in standards from the time
of Li Ti to the hard and static craftsmen's versions of the
fifteenth and sixteenth centuries, a wide chronological
latitude for both the Kōtō-in and Nelson Gallery paint-
ings seems advisable: a time within the century between
1250 and 1350 is suggested. LS

Nelson Gallery-Atkins Museum 76-10/7a, b
Given in memory of John B. Trevor by his son,
Bronson Trevor.

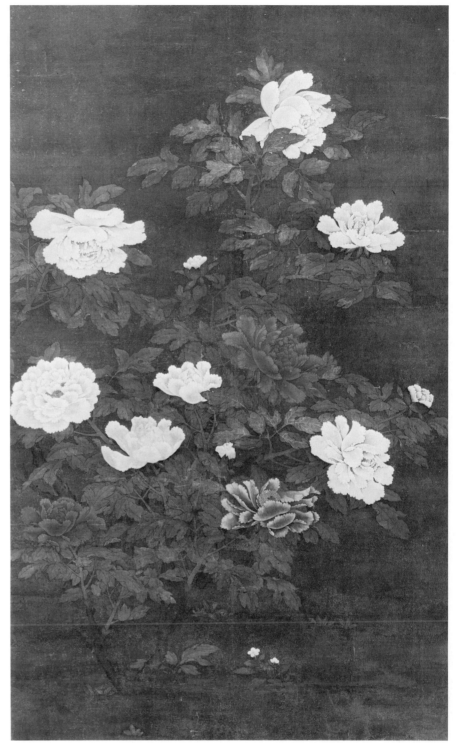

73

Artist unknown, thirteenth century, Southern Sung Dynasty

75 *Fish and Water Grasses*

(*Tsao yü t'u*)

Sometimes attributed to Fan An-jen or Lai-an

Hanging scroll, ink on silk, 70.5 x 45.1 cm.

Remarks: Very few of the surviving paintings of fish are signed or bear an artist's seal. Moreover, today it is a rare genre, a fact suggesting that paintings of fish were not popular with later collectors in China, where the best in quality are generally small pictures mounted as album leaves. The majority of paintings of this kind are preserved in Japan. In that country the earliest of them are attributed to Fan An-jen, a painter of the Southern Sung Academy active around the middle of the thirteenth century. Those judged to be somewhat later are frequent-

ly attributed to Lai-an, a Yüan Dynasty artist of the fourteenth century. None of the paintings attributed to the former artist are signed; of those assigned to Lai-an, only one is marked with his seal and another with a seal that may be his. With another painter of fish, Liu Chieh, one is on firmer ground. Teisuke Toda (in "Ryū Setsu," 1965, pp. 18-25) has identified a pair of paintings in Japan; on one is a seal that can be read as Liu Chieh. A third painting signed by the artist is in The Cleveland Museum of Art (cat. no. 129).

None of the paintings by, or attributed to, the artists named above is strikingly close to the Nelson Gallery picture. The closest parallels in style and detail are found in a few album leaves, notably one in The Metropolitan Museum of Art, purportedly in the manner of a Northern Sung painter, Chao K'o-hsiung (Toda, *Mokkei, Gyokukan,* 1973, pl. 132) and two album leaves in the Hui-hua-kuan,

74A

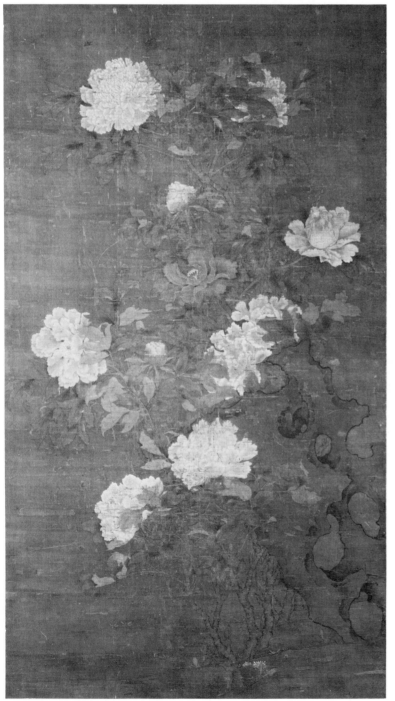

74B

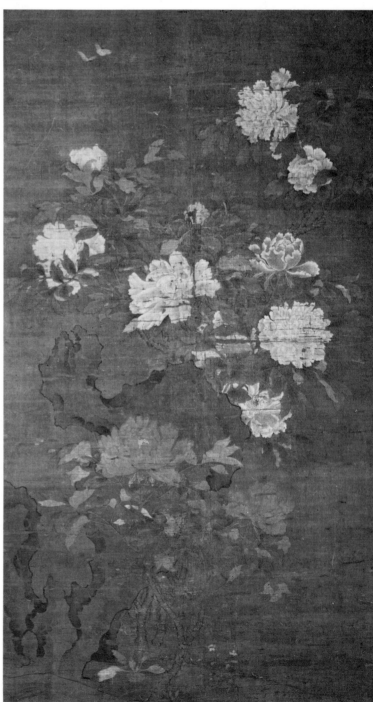

94

Peking (*Sung-jen hua-ts'e*, n. d., I, no. 3; III, no. 10). These anonymous works were probably done in the twelfth to thirteenth centuries.

Until a convincing comparison can be established between the Nelson Gallery scroll and another work that is well authenticated as by a given artist or of a given date, it seems prudent to forego an attribution and assign the painting to an unknown artist of the thirteenth century.

LS

Literature
Nihon genzai Shina (1938), p. 53.
Akiyama et al., *Chūgoku bijutsu* (1973), II, 245, 246, pl. 70.
Toda, *Mokkei, Gyokukan* (1973), p. 133, pl. 93.

Exhibitions
Cleveland Museum of Art, 1968: Lee and Ho, *Yüan,* cat. no. 231.

Recent provenance: Masanari Okazaki.

Nelson Gallery-Atkins Museum 46-54

Artist unknown, late thirteenth-early fourteenth century, Yüan Dynasty

76 *Water Buffalo and Herdboys*
(Mu-niao t'u)

Hanging scroll, ink on silk, 23.8 × 50.2 cm.

Remarks: Taoist practitioners of painting saw in the buffalo and herdsman the basic elements of nature and its rhythms, whereas in Ch'an Buddhist literature of the Sung period the pair appears as a metaphor for the path to enlightenment (Siren, *Masters and Principles,* 1956-58, II, 147; Fontein and Hickman, *Zen Painting,* 1970, cat. no. 49, pp. 113-18). The iconographic significance of the theme may have contributed to its popularity among painters during the Sung and Yüan periods. Two methods developed to portray the subject matter. Twelfth- and thirteenth-century academic painters at the Sung court rendered the beast, its master, and their landscape setting in soft color and meticulously laid ink outlines (see cat. no. 41). Taoist and

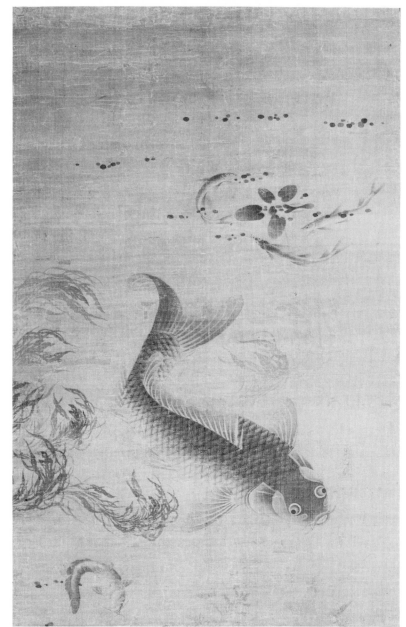

75

76

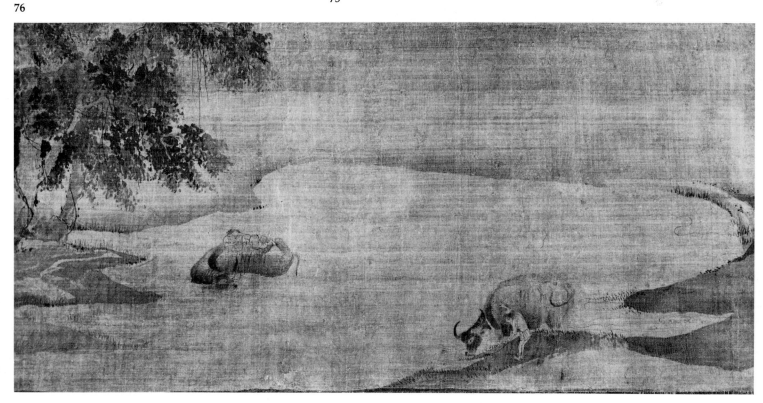

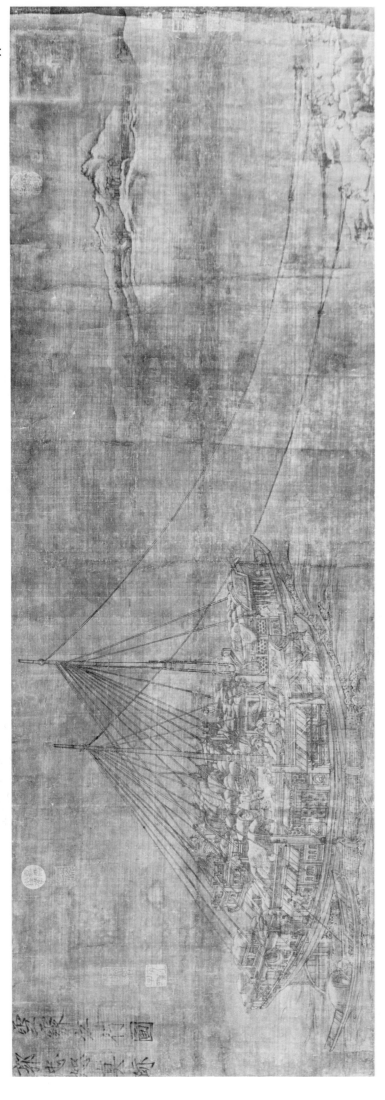

Buddhist priest-painters of the late Sung, whose works survive chiefly in Japanese collections, limited themselves to monochrome ink, and brushed the motif in an abbreviated, "untrammeled" manner associated with Mu-ch'i and Liang K'ai. This *Water Buffalo and Herdboys* combines both methods. Fine, dark lines over graded wash provides humorous portraits of the beasts and their boyish masters, reminiscent of the academic interest in genre-like realism. By contrast, the landscape setting is simplified, featuring sharply drawn dark grasses against a bare, graded-wash shoreline. The tree grove in the left middle ground, although meant as a freely brushed statement in the untrammeled manner, still exhibits a self-conscious patterning in the light and dark contrasts of the foliage.

A similarly hybrid style pervades the herdsmen and buffalo paintings of the Yüan master Mao Lun. His compositions in the Nezu Museums (Toda, *Mokkei, Gyokukan,* 1973, color pl. 25), Myoko-ji (temple), and a Japanese private collection (Kawakami et al., *Ryō Kai, Indara,* 1975, pls. 121, 122, color pl. 16) all exhibit the carefully painted buffalo and tree grove, placed within a spatial plane which is sparsely defined by flat, patterned wash areas similar to the Cleveland painting. The Mao Lun in the Japanese private collection is inscribed with a poem by the Yüan master Chao Meng-fu (1254-1322), indicating that Mao worked around the turn of the thirteenth century. The Cleveland buffalo-and-herdboys scroll seems not too removed from this milieu. HK

Recent provenance: Howard C. Hollis; Mr. and Mrs. Herbert F. Leisy.

The Cleveland Museum of Art 77.200

Artist unknown, probably thirteenth
century, Southern Sung or Chin Dynasty

77 *A Sung Copy after Kuo Chung-shu, "Towing Boats
under Clearing Skies after Snow"*
*(Sung-jen fang Kuo Chung-shu Hsüeh-chi
chiang-hsing t'u)*

Handscroll, ink on silk, 49 x 143 cm.

1 inscription and 19 Seals: 1 inscription and 1 seal purporting to be those of Sung Hui-tsung (r. 1100-25); 1 half-seal of the Ming imperial collection, era of Hung-wu (r. 1368-98); 1 seal of Prince Chin, probably Chu Chung-hsien, the 3rd Prince Chin (1428-1502); 4 seals of Hsiang Yüan-pien (1525-1590); 1 colophon, dated 1684, and 3 seals of Shen Ch'üan (1624-1684); 2 seals of the Ch'ien-lung emperor (r. 1736-95); 5 seals of the Chia-ch'ing emperor (r. 1796-1820); 2 seals of the Hsüan-t'ung emperor (r. 1909-11).

6 forged colophons and 20 forged seals: 1 colophon and 2 seals of Chao Meng-fu (1254-1322); 1 colophon and 2 seals of Chou Mi (1232-1298); 1 colophon and 1 seal of Yü Chi (1272-1348); 1 colophon, dated 1361, of Tai Pu-hua (1304-1352); 1 poem and 1 seal of Wu K'uan (1435-1504); 1 colophon and 1 seal of Yung Shun-chi (1456-1544); 13 seals of Hsiang Yüan-pien (1525-1590).

Remarks: The forged documents and seals must have been added to the scroll sometime between 1590, the year of the death of Hsiang Yüan-pien, and 1684, the date of the only genuine colophon, appended by Shen Ch'üan, and which is last in order, following the forgeries about which Shen wisely makes no comment.

The original storage box, the brocade wrapper, and the jade pin, all of the Ch'ien-lung era, carry the scroll's title and designate it as a Sung Dynasty copy *(Sung-jen fang...).* It is curious, then, that the third part of the imperial catalogue, completed in 1816 in the Chia-ch'ing era, upgrades the work and lists it under the name of Kuo Chung-shu.

In the time of Ch'ien-lung, the Nelson Gallery scroll was designated as a copy, probably because there was in the collection another version that is unquestionably of better quality. This superior version, now in the National Palace Museum, Taipei, has lost approximately the first two-thirds of the composition – that section originally including the landscape, the greater part of the tow-ropes, and the five men hauling them *(Three Hundred Masterpieces,* 1959, ii, pl. 52). The Taipei painting is 74.1 centimeters high, considerably more than the present 49-centimeter height of the Nelson Gallery version. The latter scroll has been trimmed somewhat along both the upper and lower edges, possibly as much as 6 to 8 centimeters. If the two paintings were originally roughly in the same proportion, then the Taipei painting has lost approximately 190 to 196 centimeters of the opening section. But with a present height of 74.1 centimeters, it is improbable that the Taipei painting was ever mounted as a handscroll. More likely it was in the form of a large wall scroll *(heng-p'i)* or was mounted as a single panel screen.

The Nelson Gallery painting, then, is a free version which deviates from the original in scale and format, but the copyist has included the inscription, rather clumsily written, exactly as it is on the older painting. This inscription, well-written on the Taipei version, purports to be by Sung Hui-tsung and reads: "Towing Boats amid Clearing Skys after Snow, a genuine work of Kuo Chung-shu." The accompanying large seal reads: "Written by the Emperor." Professor Barrnhart and others have pointed out that while the calligraphy on the Taipei painting is certainly in the style made famous by Hui-tsung, nevertheless it has certain variations from the script usually taken to be genuine. The suggestion is that the writing on the Taipei painting may be by the Chin Dynasty Emperor Chang-tsung (r. 1190-1208), who modeled his style closely on that of the Sung emperor.

In the Taipei scroll the drawing is far more sure and the details considerably more lucid than in the Nelson Gallery version. If the Taipei painting is not by Kuo Chung-shu himself, it still may well date from about that artist's time in the second half of the tenth century. Kuo Chung-shu was a northerner from Loyang in Honan who was celebrated for his "boundary paintings" *(chieh-hua)* of palaces and buildings and was also skilled in landscape and figures. The Nelson Gallery copy is a good painting done by a more than merely competent artist, the landscape and figures being especially well executed. Also , both the silk and general appearance suggest a painting of considerable age; therefore, it is here tentatively assigned to the thirteenth century and to an unknown artist probably working in North China.

The scroll is important not only in preserving an early composition virtually complete but also in providing a comparison between an ancient copy and its even earlier and better original. LS

Literature
Shih-ch'ü iii (1816), Ch'ien-ch'ing-kung, pp. 481, 482.
Hu, *Hsi-ch'ing* (1816), *ch.* 1, pp. 3, 4.
Ch'en J. D., *Ku-kung* (1956), p. 10a.
Maeda, "*Chieh-hua*" (1975), pp. 127-30, pl. 2.
Barnhart, Iriya, Nakada, *Tō Gen, Kyonen* (1977), pp. 100, 154, pl. 84.

Recent provenance: P'u-i, the Hsüan-t'ung emperor.

Nelson Gallery-Atkins Museum 31-135/33

Artist unknown, thirteenth century, late Sung to early Yüan Dynasty

78 *Waterfall*
(Yin-yen fei-p'u)

Hanging scroll, ink on silk, 83.9 × 36.5 cm.

Label on the mounting with 2 seals of T'ang _?_ of Pi-ling (16th c.); label on back of mounting of Kü Kuang-hsü (1731-1797).

1 colophon and 8 additional seals: 1 colophon, dated 1625, and 2 seals of Kao P'an-lung (1562-1626); 2 seals of Liu Shu (1759-1816); 1 seal of Pi Lung (late 18th c.); 1 seal of Ts'ao tzu-wen; 2 seals unidentified.

 WKH

Exhibitions
Asia House Gallery, New York, 1973: Lee, *Colors of Ink,* cat. no. 8.

Recent provenance: Kwan-shut Wong.

The Cleveland Musuem of Art 72.157

"Sung-t'ien" (attributed to), fourteenth century, Yüan Dynasty

79 *Squirrels*
(Sung-shu)

Hanging scroll, ink on paper, 97 × 39.4 cm.

Remarks: Both chestnuts and squirrels are rare subjects among extant Chinese paintings. Scrolls depicting squirrels are particularly rare; almost all are to be found in Japanese collections, with presumed histories going back to at least the fifteenth century, during the Muromachi Period. The *Kundaikan* (MS. dated 1559), recording the collection of the shogun Ashikaga Yoshimitsu, and the only early source in either China or Japan to mention the category, connects such paintings with a presumably fourteenth-century artist, Sung-t'ien and a *doppelgänger,* "Yung-t'ien." Extant works with the seal Sung-t'ien *(Kokka,* no. 554, 1937, pl. 6, Muto collection; *Kokka,* no. 403, 1924, pl. 2, Asano collection; and an unpublished scroll with signature and seal, K. Yabumoto collection) show the animal in activity by means of a lively, subtle, and evocative method of depiction.

A second group loosely associated with the name Yung-t'ien is characterized by a slightly more static, watchful type of composition and with darker ink, revealing a more explicit kind of depiction *(Kokka,* no. 522, 1934, pl. 5, Dan collection; *Kokka,* no. 413, 1925, pl. 4; *Kokka,* no. 460, 1929, pl. 4, Kawasaki collection; *T'ang Sung Yüan Ming,* 1976, pl. 166; and the present work, in *Shōbi shiryō,* 1917, ii, Kuroda collection). Two of the works called by Sung-t'ien are on silk; all of those called Yung-t'ien are on paper.

These two groups are matched by only one other published squirrel painting of any consequence – the

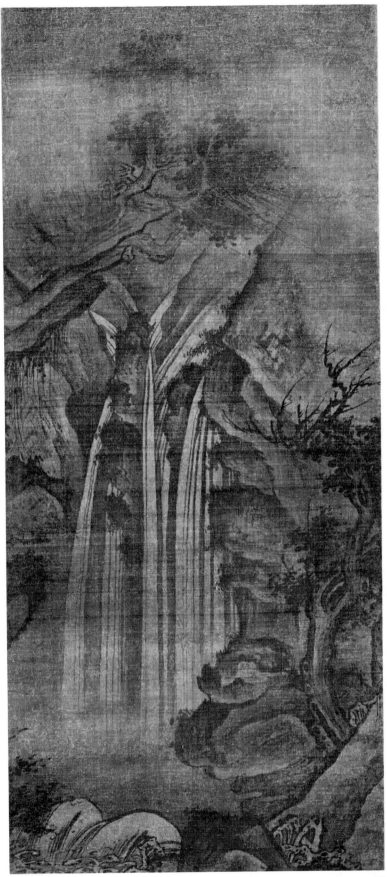

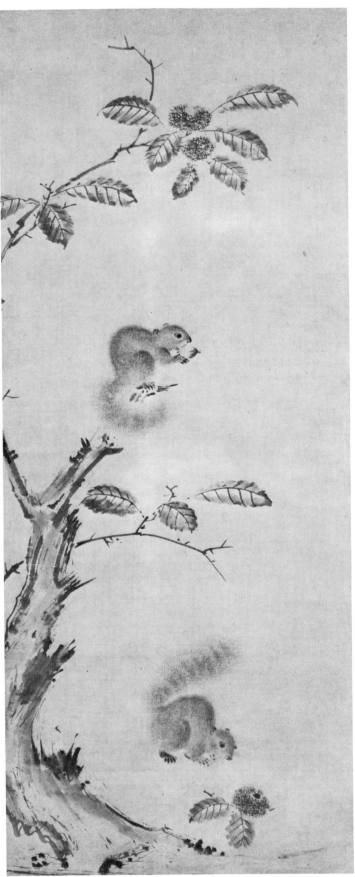

78

79

one attributed to Ch'ien Hsüan in the National Palace Museum, Taipei (*Illustrated Catalogue of Chinese Government Exhibits*, 1935-36, III, pl. 64). Only the subject of this latter picture is germane here, associating representations of the animal to the late Sung-early Yüan periods.

This time range is borne out by the style of both "Sung-t'ien" and "Yung't'ien" groups. The rapid, expressionistic brushwork with splashed and flung ink details is most closely paralleled by the works associated with and derived from Liang K'ai and Mu Ch'i (Fa Ch'ang) at the end of Southern Sung. One well-known work associated with Mu Ch'i, *Chestnuts* (Daitoku-ji, Kyoto; Harada, *Shina*, 1936, no. 193), is particularly close. One can only suggest that certain Taoist or Ch'an monk-painters of the Hangchou region, having close associations with Japan, specialized in this delightful subject and that their works, like those of other specialists in such genres, were ignored in late thirteenth-century China. Yet the respect for their works in Japan preserved a little-known aspect of Chinese painting. Perhaps the closest brush-and-ink parallels to the squirrel paintings are the flora details in a group of Ch'an paintings representing Lohan and attributed to Ch'an-yüeh (see *Gendai Dōshaku*, 1975, cat. no. 64, coll. of Fujita Art Museum, Osaka).

In the works we have cited there may be at least three hands discernible – the examples in *Kokka* nos. 413 and 460 being more rococo in delineation than the watchful subjects of the "Yung-t'ien" group. But "Yung-t'ien" has no real existence in any valid source, Chinese or Japanese. For the present, therefore, all these works are probably best included under the only-slightly-less-mythical name of "Sung-t'ien." The brilliant display of brush and ink in all the works, combined with the carefree and joyful nature of the subject matter, set them apart as a significant, if limited, category of late Sung and early Yüan painting. SEL

Literature
Shōbi shiryō, 1917, II, unnumbered pl.

Recent provenance: S. Yabumoto.

The Cleveland Museum of Art 79.70

Chao Meng-fu, 1254-1322, Yüan Dynasty
t. Tzu-ang, *h.* Sung-hsüeh; from Wu-hsing, Chechiang Province

80 *River Village – Fisherman's Joy*
(*Chiang-ts'un yü-le*)

Album leaf, ink and color on silk, 28.6 × 30 cm.

Artist's title, signature, and seal: *River Village – Fisherman's Joy*. Tzu-ang. [seal] Chao shih Tzu-ang.

1 colophon and 2 additional seals: 1 colophon, unsigned; 2 seals of Wang Chi-ch'ien (20th c.).

Colophon, unsigned:
The technique used for the mountains in this album leaf is that of "outline without texture strokes" [*k'ung-kou wu-ts'un*], after the painting *Fishing in Snow* by Yu-ch'en [Wang Wei, 699-759]. The wintry groves and pine needles follow those of Li Ying-ch'iu [Li Ch'eng, act. ca. 960-990]. The figures and houses are also wonderful; the coloring, solid and archaic. These methods, which are identical to his *Autumn Colors on the Ch'iao and Hua Mountains*, were not used after the Sung Dynasty [960-1279]. The inscription and signa-

ture must be written with the same brush used for the painting. That is why they appear slender and thin. However, they are strong and effortless, typical of his personal manner.

This painting should be considered equal to the *Snowscape* by Wang Wei in the same album. The latter surpasses by its careful detail, the former excels in its serene richness; both are masterpieces that are unprecedented in the past and to be unmatched in the future.

trans. LYSL/WKH

Remarks: Chao Meng-fu, posthumously entitled Duke of Wei, was born in Hu-chou, Chechiang Province. A descendant of the first emperor of the Sung Dynasty, Chao was educated at the Imperial College at the Southern Sung capital of Hangchou, and later accepted office in 1286 under Kublai Khan. He rose to high offices, including secretary to the Board of War and director of the Hanlin Academy. He was an immensely versatile and accomplished man – scholar, politician, statesman, calligrapher, and painter. Certainly in the latter two categories he was preeminent in his day and one of the greatest masters of these arts in Chinese history.

The colophon is an apt and succinct description of the historical origins of this important fan painting. The fusion of the Chinese landscape tradition of the North with that of the South is the essence of Chao's art and, in particular, of this painting. There is a careful analysis of the northern origins in Vinograd ("*River Village*," 1978), and of the influence and significance of the blue-green landscape tradition in relation to this

80

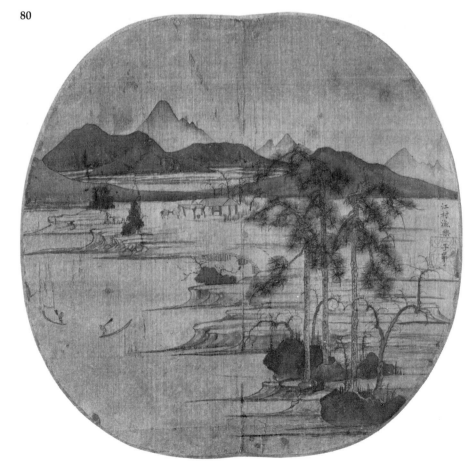

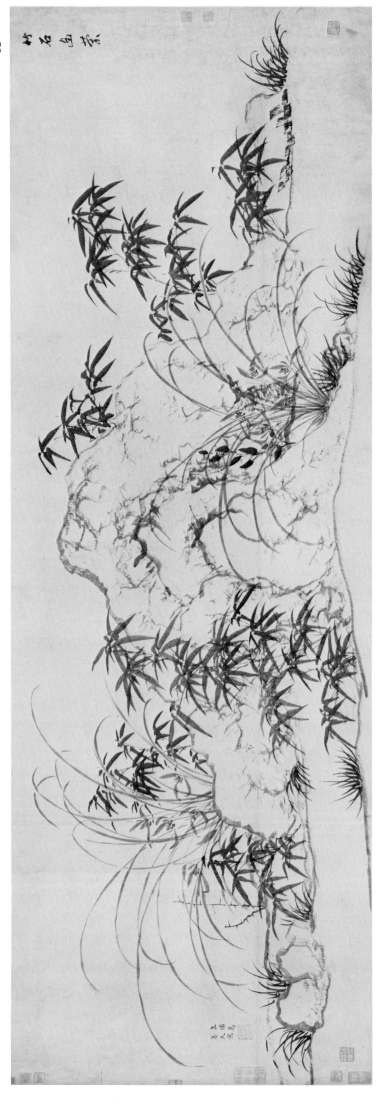

work in Lee ("River Village-Fisherman's Joy," 1979, pp. 283-85). The argument for dating the painting between 1286 and 1296 is given in the latter article.

This early *wen-jen* style, the invention of Chao at the very beginning of the Yüan Dynasty, is followed by the less traditional manner exemplified by the later monochrome handscroll, *Bamboo, Rocks, and Lonely Orchids* (cat. no. 81). SEL

Literature
Cahill, *Hills* (1976) p. 44, color pl. 2.
Vinograd, "River Village" (1978) pp. 124-34, fig. 1.
Yen, "Ch'ien Hsüan" (1978), p. 77, pl. 16.
Lee, "River Village – Fisherman's Joy" (1979), p. 271-88, cover, fig. 1.
Ho, Iriya, Nakada, *Kō Kōbō, Gei San* (1979), p. 176, pl. 66 (color).

Recent provenance: Wang Chi-ch'ien.

The Cleveland Museum of Art 78.66

Chao Meng-fu

81 *Bamboo, Rocks, and Lonely Orchids*
(Chu shih yu-lan)

Handscroll, ink on paper, 50.5 × 144.1 cm.

Artist's title: *Bamboo, Rocks, and Lonely Orchids.* Artist's inscription and 3 seals [lower left]: Meng-fu drew this for Shan-fu. [seals] Chao Tzu-ang shih; Sung-hsüeh-chai; T'ien-hsiu-chün t'u-shu-yin.

29 colophons and 86 additional seals (in order of appearance): 1 colophon and 2 seals of Han Hsing (1266-1341); 1 colophon of Ch'iu Yüan (b. 1261): 1 colophon of Cheng Yüan-yu (1292-1364); 1 colophon of Wu K'e-kung (d. after 1341); 1 colophon and 2 seals of Ang Chi (act. mid-14th c.); 1 colophon and 1 seal of Wang Tzu-fang; 1 colophon and 2 seals of K'o Chiu-ssu (1290-1343); 1 colophon and 1 seal of Yü Li (act. mid-14th c.); 1 colophon, dated 1351, and 1 seal of Chao I; 1 colophon and 1 seal of Yü Chi (1272-1348); 1 colophon and 2 seals of Sun Shih (act. early 15th c.); 1 colophon and 1 seal of Chang Chu (1287-1368); 1 colophon and 2 seals of Chang Wu (act. 1335-65); 1 colophon, dated 1348, and 1 seal of Ch'en Chi (1314-1370); 1 colophon of Chang Shen (act. 2nd half 14th c.); 1 colophon and 3 seals of Wang Hsün, 1 colophon and 2 seals of Hu Kuang-ta; 1 colophon and 3 seals of Wang Yin-shih; 1 colophon and 4 seals of Chang Yü-ch'u (d. 1410); 1 colophon and 1 seal of Yao Kuang-hsiao (1335-1419); 1 colophon and 3 seals of Wang Ning (late 14th-early 15th c.); 1 colophon and 5 seals of Ou-yang An (act. early 15th c.); 1 colophon and 3 seals of Ch'en Lien (ca. 1368-1398); 1 colophon, dated 1434, and 5 seals of Wei Chi (1374-1471); 1 colophon and 3 seals of Chang I (act. ca. 1465-87); 1 colophon and 5 seals of Yin Chih (act. ca. 1454); 1 colophon of Tsou Yü, 1 seal of Ch'eng Cheng-k'uei (act. 1631-74); 16 seals of Liang Ch'ing-piao (1620-1691); 1 colophon, dated 1629, and 2 seals of Hsü Shou-ho (act. ca. 1st half 17th c.); 1 colophon, dated 1802, and 2 seals of Hsü Shu-tung; 3 seals of Wu T'ing (ca. 1600); 5 seals of T'ang Tso-mei (late 18th-early 19th c.); 3 seals unidentified.

Colophon by Han Hsing:
Those ancients who excelled in calligraphy were also always good in painting. Even a random drop of ink, turned into a housefly [like Chang Sheng-yu] would

be full of life, befitting the object. These orchids and rocks by the venerable master Sung-hsüeh embrace both the brush method of the "running" style as well as the "flying white" manner in calligraphy. Indeed, it should be treasured. Han hsing of Anyang.

Colophon by Chao I, son of Chao Meng-fu:

Chi-cheng, eleventh year [1351], tenth moon, twentieth-eighth day [your] son, I, after paying respects, carefully examined [this].

Colophon by Ch'en Chi:

On seeing the *Bamboo, Rocks, and Lonely Orchids* by the Duke from Wu-hsing [Chao Meng-fu], one feels one is suddenly cleansed of lowly and narrow-minded sentiments. His brush moves so freely at his will, vertically and horizontally [as though meeting no resistance]. It comes so naturally with a disarming flair of naiveté and earnestness, as though coming directly from the calligraphies of the Two Wangs [Wang Hsi-shih and his son, Wang Hsien-shih]. No wonder it has been so much more treasured and enjoyed by Chung-ying [Ku Te-hui, or Ku Ying, 1310-1369] than other ordinary works. Written on the tenth day of the fourth month of the eighth year of Chih-cheng [1348]. Ch'en Chi of T'ien-t'ai.

Remarks: A discrepancy in the order of the colophons is found where the colophon of Chao I, dated 1351, precedes that of Ch'en Chi, dated 1348. The misplacement is confirmed by Yü Chi's poem which, by its position, was presumably written between 1348 and 1351. This poem, when printed in his collected works (*Tao-yüan-hsüeh-ku-lu*, preface 1346, XXIX, 11a-11b) indicated the owner of the painting at the time was no longer the Ku family but instead, Wang Hua-yü, whose son's poem appeared on the scroll just slightly after that of Yü Chi. The history of the painting (based on the rearrangement of these misplaced colophons) suggests that it was handed down first from Ku Hsin; then to his son, Ku Ying, around 1348; then to Wang Hua-yü; and then to Wang Hsün, sometime before 1351. The reversals in order must have occurred when the painting was remounted, probably at the time of Liang Ch'ing-piao, before the last remounting in 1802 by Hsü Shu-tung.

At some time during remounting the painting was slightly cut off at the end. As a result, the two "literary seals" of Chao Meng-fu were partially cut off at the left corner of the scroll, and his inscription and "name seal" may well be a later replacement copied after the original, now missing.

There were several people of note in the beginning of the Yüan period who shared the same first name –Shan-fu– of the person for whom the painting was made. Chao Meng-fu knew more than one of them. Our present identification of the man as Ku Hsin is verified by a rubbing from a stone carving of a bamboo and rock painting (now missing), reportedly from Suchou. The surviving inscription on the rubbing (recorded in Ch'eng Tsu-ch'ing, *Wu-chün chin-shih mu*, 1936, p. 32) reads, "Ku Shan-fu arrived at the capital on official business. Upon his return to the South, he came to me with these pieces of paper and asked for a painting. I therefore did this picture for him. [signed] Tzu-ang."

The "pieces of paper" appear to be of unusual significance, in that it would explain why the paper for the present scroll was pasted together in such peculiar divisions of four unevenly sized pieces. Presumably it

was to reconcile the artist's composition with the odd-sized, old papers presented to him. This would also limit the date of the painting to 1286-92 or 1314-19, when Chao Meng-fu resided in the capital. WKH

Literature
Wu Ch'i-chen, *Shu hua chi* (ca. 1677), ch. 6, p. 638.
Wu Hsiu, *Ch'ing-hsia-kuan* (1824), p. 204.
Liang, *Tui-an* (1845), ch. 13, p. 5.
Ferguson, *Li-tai* (1934), IV, 395 (a).
Hsieh Chih-liu, *T'ang Wu-tai* (1957), no. 25, pl. 94.
Siren, *Masters and Principles* (1956-58), IV, 23; VI, pl. 22; VII, Lists, 104.
Lee, "Water and Moon" (1970), p. 58, fig. 34.
CMA *Handbook* (1978), illus. p. 346.
Exhibitions
Cleveland Museum of Art, 1968: Lee and Ho, *Yüan*, cat. no. 235.
Asia House Gallery, New York, 1974: Lee, *Colors of Ink*, cat. no. 10.
Recent provenance: Frank Caro.
The Cleveland Museum of Art 63.515

Liu Shan-shou, active ca. fourteenth century, Yüan Dynasty
h. Sui-chai

82 *Lily and Butterflies*
(*Hsüan-tieh t'u*)

Hanging scroll, ink on silk, 160 × 58.4 cm.

Artist's title and 3 seals: *Lily and Butterflies*. [seals] Chung-hsiao ch'üan-chia; Liu yin Shan-shou; Sui-chai.

9 additional seals: 1 of Liang Ch'ing-piao (1620-1691); 1 of Na-lan Ch'eng-te (1655-1685); 3 of Chang Ta-ch'ien (20th c.); 1 of Wang Chi-ch'ien (20th c.); 3 unidentified.

Remarks: The artist is known only from this work; no trace of him has yet been found in records. The given name (good preserver) may imply a Confucian origin, as does the placement of the "idea seal," Chung-hsiao ch'üan-chia (filial loyalty handed down in family), above the name and nickname seals. The composition of the picture goes back to the Five Dynasties bird-and-flower painters, such as Huang Ch'üan and his son, Huang Chu-tsai (*Three Hundred Masterpieces*, 1959, II, pl. 57), while the style is based on that of Chao Meng-fu (see cat. no. 81) and Wang Yüan (see cat. no. 87). The even, black shading of the flowers and leaves of the day lily recalls Wang, while the "flying white" strokes in the rock and the wet manner of the bamboo echo Chao's methods. The painter was somewhat careless — witness the poor alignment of the three-character signature and the spilled wash of ink on the lower part — but the ink is rich, the brushwork good, and the composition unusual in its verticality supported only by the stalk of the lily.

The bird is the Chinese wagtail (*motacilla chinensis*) and is represented in pale ink, probably sketched in before the darker ink was used to finish the rock. Like the butterfly and moth above, his tail feathers echo the bamboo as well as the leaves and petals of the flowers. The wagtail can connote brotherly love, as implied in the "T'ang-ti" lyric of the *Shih ching* (*Book of Odes, Hsiao-ya* section), traditionally dating to the Chou Dynasty.

The flower itself is of iconographic interest, since the day lily originated in China and was not exported to the West until the fourth century BC (Li H. C., *Garden Flowers*, 1959), p. 109). It was used for various pharmaceutical purposes, especially for deadening

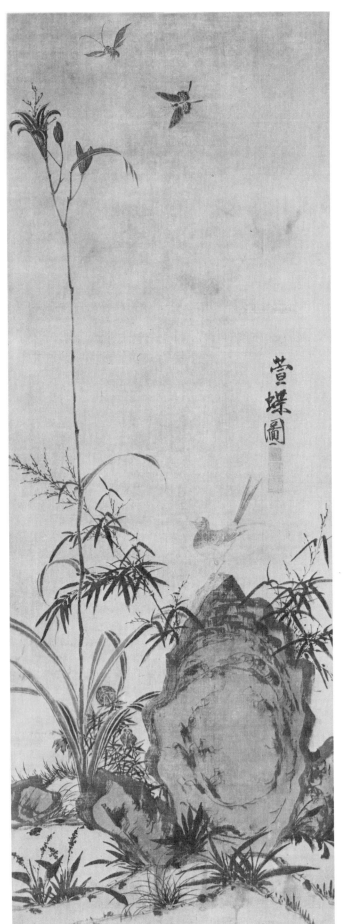

pain in childbirth. It was also considered efficacious in relieving grief and aiding in the production of sons. The lily (wang-yu ch'ao, or "free of sorrow") is in fact the real subject of this painting: it is the common symbol for motherly love. Hence, the lingering of the butterfly – a son's love, devotion, and yearning for his mother – the refuge from worldly woes. SEL/WKH

Literature
Chang Yüan, Ta-feng t'ang shu-hua lu (1943), p. 10(a); idem Ta-feng t'ang ming-chi (1955), I, pl. 18.
CMA Handbook (1978), illus. p. 347 (detail).

Exhibitions
Asia House Gallery, New York, 1974: Lee, Colors of Ink, cat. no. 21.

Recent provenance: Chang Ta-ch'ien; Wang Chi-ch'ien.

The Cleveland Museum of Art 71.132

Li K'an, 1245-1320, Yüan Dynasty
t. Chung-pin, h. Hsi-chai, Tsui-chu hsien-sheng; from Chi-ch'iu, Hopei Province

83 *Ink Bamboo*
(Mo-chu)

Handscroll, datable to 1308, ink on paper, 37.5 x 237.5 cm.

Artist's spurious inscription and spurious seal interpolated at middle left edge: Chung-pin painted this for Hsüan-ch'ing. [seal] Chung-pin.

2 colophons and 63 additional seals: 1 colophon, dated 1308, and 1 seal of Chao Meng-fu (1254-1322); 1 colophon, dated 1309, of Yüan Ming-shan (1269-1322); 1 seal of Lo-shan-weng (possibly Ku Hsin, early to mid-14th c.); 5 seals of Li T'ien-chih (mid-14th c. ?); 1 seal of Ku An (1292-after 1365); 2 seals of Chang Shen (act. ca. 1350-80); 1 seal of Yen Shih-fan (d. 1565); 2 seals of Shen Chien (act. ca. 1590-1620); 1 seal of Keng Chao-chung (1640-1686); 14 seals of Liang Ch'ing-piao (1620-1691); 1 seal of Sung Lo (1634-1713); 2 seals of Hsieh Sung-chou (act. ca. 1723-35); 1 seal of Yao Nai (1731-1815); 2 sealls f Huang Chao (early to mid-19th c.); 3 seals of Yüan Pao-heng (1826-1878); 14 seals of Chang Heng (1915-1963); 2 seals of Hsü An, friend of Chang Heng; 4 seals of T'an Ching (mid-20th c.); 3 seals of T. Kawai (d. 1969); 3 seals unidentified.

Colophon by Chao Meng-fu (partially translated):

The *tz'u* bamboo may enrich a man's moral sense;
The *fang* bamboo may make a dishonest man feel shame.
While the *kuei* bamboo has [by nature a myriad] shoots as the orchid has fragrance;
The rocks are elegant and moist and the ancient trees dark green.
Master Li is profoundly devoted to bamboo,
Fixing in his mind a thousand *mou* of bamboo along the River Wei.
He draws its image and rapturously calls it "Ink Gentleman";
Even if Yü-ko were living today he could not surpass such beauty.
The love my ancestor held for bamboo is well known in the world,
And [he, too,] respected it, calling it "This Gentleman."

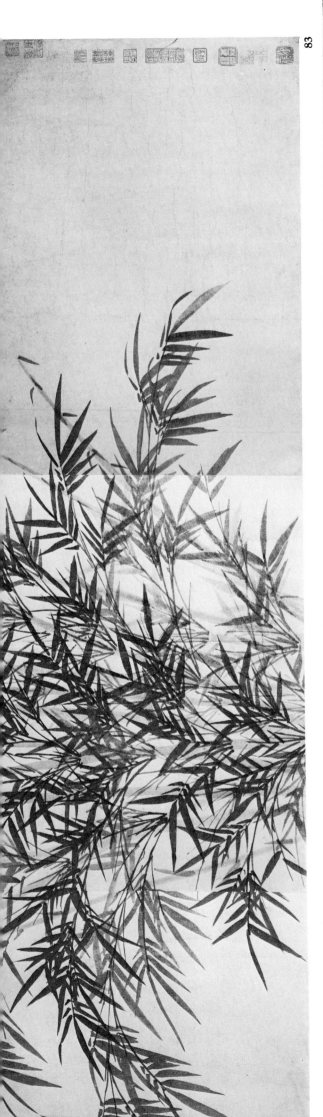

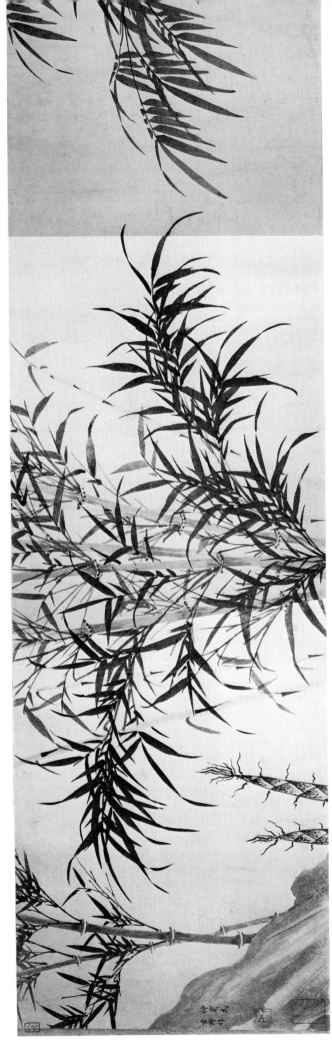

So Master Li in offering me this painting must have
 harbored a special meaning,
Wishing that the later generation might continue the
 pure thinking of the ancestors.

Chung-pin painted this ink bamboo for Hsüan-ch'ing,
and Hsüan-ch'ing composed this poem to eulogize the
scroll. I so love his untrammelled spirit that I copied his
poem here following the painting. Written by Chao
Meng-fu of Wu-hsing on the fourteenth day of mid-
spring, in the first year of the Chih-ta era [1308].

Remarks: *Tz'u-chu* is a kind of bamboo in which the
branches grow closely together, like a family. Here it is
the first clump in the painting. *Fang-chu*, a bamboo with
square stalks, is a symbol of uprightness. It is the second
clump. The third is *Kuei-chu*, a more generalized kind of
bamboo that grows luxuriantly in many parts of China.
Yü-k'o is the familiar name *(tzu)* of the most famous of
all bamboo painters, Wen T'ung (1018-1079). The ances-
tor referred to in Hsüan-ch'ing's poem was Wang Hui-
chih, born in AD 388.

Judging from the style of the signature on the Nelson
Gallery scroll, it could not have been written by Li K'an;
moreover, it would be most unusual for a Yüan Dynasty
artist to place his signature and dedication on a rock in
the lower left end of the painting. Clearly it has been
added at a later date.

Osvald Sirén was the first to point out that the Nelson
Gallery scroll might be the opening section of a much
longer painting, the concluding section being the scroll
of bamboo by Li K'an now in the Hui-hua-kuan of the
Palace Museum in Peking. Recently, thanks to the kind-
ness of Chu Tsing-li, the Gallery obtained photographs
of the Peking scroll that confirm Sirén's speculation. In
the poem by Wang Hsüan-ch'ing, quoted in Chao
Meng-fu's colophon, the author mentions impressive
rocks and ancient trees not in the Nelson section but
present in the Peking scroll. The paper, which is of the
finest quality, is the same. The small section of rock in
the lower left corner of the Nelson painting matches
properly in drawing and technique an incomplete rock
at the opening, right-hand edge of the Peking painting,
which at its conclusion at the extreme left carries the
genuine colophon and signature of Li K'an. This reads:
In the ninth month, autumn of the *ting-wei* year of the
Ta-te era [1307] Wang Hsüan-ch'ing, the Taoist official,
sent me this piece of paper, asking for my clumsy brush-
work. Since I was too occupied, I did not have time to
finish it until now, the first month, the spring of the
wu-shen year [January 24, 1308]. The lamplight is dim
and my vision so poor that I do not know how it looks
in daylight.
 Written by Hsi-chai-tao-jen, Li K'an, Chung-pin,
of Chi-ch'iu.

The Peking section of the scroll belonged, among
other collectors, to Hsiang Yüan-pien (1525-1590) and An
Ch'i (1683-ca. 1746), who recorded it in his *Mo-yüan hui-
kuan* (1742, I, *Yüan*, 6), before it entered the collection of
the Ch'ien-lung emperor. It is reasonable to postulate,
then, that the scroll, in its original long form, was cut
sometime in the late fifteenth to early sixteenth century,
before it entered the Hsiang collection, since none of the
latter's seals appear on the Nelson Gallery section. It is
evident that after the separation it was thought desirable
that both sections carry inscriptions of consequence; so
the Chao colophon of 1308, and that of Yüan Ming-shan,
dated 1309, were both removed from their original posi-
tion and attached to the end of the first section (now in

the Nelson Gallery), while the second section still car-
ried the all-important colophon, date, and signature of
the artist, Li K'an.

It is most fortunate that the original union of these two
scrolls has now been firmly established, uniting, as it
were, the masterpiece among the surviving works of Li
K'an, who was the greatest painter of bamboo in the
fourteenth century and remained unsurpassed in later
generations. KSW/LS

Literature
Wen Chia, *Ch'ien-shan-t'ang* (preface 1568), p. 58.
Pien, *Shih-ku-t'ang* (1682), *ch*. 18, pp. 192, 193.
Ku Fu, *P'ing-sheng* (preface 1692), *ch*. 9, p. 28.
Wu Sheng, *Ta-kuan lu* (prefaces 1712), *ch*. 18, p. 22.
Cheng Chen-to, *Yün-hui-chai* (1947), pls. 10, 11.
Wang Chi-ch'ien, "Introduction" (1947), pp. 21-27, fig. 4.
Wang Shih-hsiang, "Chinese Ink Bamboo Painting" (1948-49),
 pp. 49-58, pl. IIIb.
Burling and Burling, *Chinese Art* (1953), pl. 115.
Sickman and Soper, *Art and Architecture* (1956),
 pp. 159, 160, pl. 120B.
Sirén, *Masters and Principles* (1956-58), IV, 44, 45;
 VI, pls. 48, 49.
Janson, ed, *Key Monuments* (1959), pl. 348.
Lin, *Imperial Peking* (1961), pl. 85.
Lee, *Far Eastern Art* (1964, 1973), p. 407, fig. 539.
Willetts, *Foundations* (1965), pl. 200.
Li Lin-ts'an, "Chung-kuo mo-chu" (1967), pls. 4, 5.
Justema, *Pleasures of Pattern* (1968), p. 23.
NG-AM Handbook (1973), II, 58.
Wilson, "Vision" (1973), no. 8, pp. 234-36.

Exhibitions
Cleveland Museum of Art, 1968: Lee and Ho, *Yüan*, cat. no. 242.

Recent provenance: T'an Ching; Chang Heng; C. T. Loo & Co.

Nelson Gallery-Atkins Museum 48-16

Chang Yen-fu, active first half of the fourteenth
 century, Yüan Dynasty
h. Hsi-yü-tao-jen; birthplace unknown, probably
 from Central Asia, lived and active in Peking

84 *Thorns, Bamboo, and Quiet Birds*
 (Chi chu yu-ch'in t'u)

Hanging scroll, datable to 1343, ink on paper, 76.2 x
63.5 cm.

Unsigned; 2 artist's seals at left edge beside the rocks:
Yen-fu t'u-shu yu-hsi ch'ing-wan; Hsi-yü-tao-jen.

8 inscriptions and 23 additional seals: 1 inscription of
Wu Jui (1298-1355); 1 inscription of Tu Pen (1276-1350); 1
poem and 3 seals of Ling Han, unidentified (14th c.); 1
poem and 2 seals of Chu-an, unidentified (14th c.); 1
poem of Shao Hung-yüan, unidentified (14th c.); 1 poem
and 1 seal of Ya-fu (1328 *chin-shih*); 1 poem and 1 seal of
Lin Ch'üan-sheng (1299-1361); 1 poem of P'an Shun
(1292-1364); 8 seals of Hsiang Yüan-pien (1525-1590); 2
seals of Liang Ch'ing-piao (1620-1691); 1 seal of Ch'iao
Ch'ung-hsiu (1669-1744); 2 seals of Chang Heng (1915-
1963); 1 seal of Hsü An, friend of Chang Heng; 1 seal of
T'an Ching (mid-20th c.); 1 seal unidentified.

Inscription by Wu Jui: Tzu-chao [Chang Wen?, 1293-
1356], together with Chou Cheng-chi, visited the Taoist
temple, T'ai-i-kung, where [Chang] Yen-fu did this
painting of *Thorns, Bamboo, and Quiet Birds*, and pre-
sented it to him. This was on the seventh day of the third
month of the *kuei-wei* year in the Chih-cheng era [1343].
Written by Wu Meng-ssu, a native of P'u.

Inscription by Tu Pen: I have seen a painting of quiet birds with rocks on the waterside by Tung Pei-yüan [Tung Yüan] at the place of Mr. K'o [Chiu-ssu], the Curator of Calligraphy for the imperial collection. Here in the collection of Tzu-chao is a wonder of ink by Chang Yen-fu. The conceptions of both paintings are indeed similar to each other. [signed] Tu Pen.

trans.WKH

Remarks: Liu-i is often wrongly listed as one of Chang Yen-fu's alternate names (see, e.g., Sirén, *Masters and Principles*, 1956-58, VII, 100). The origin of the mistake apparently lies in a typographical misprint or in an error of transcription wherein T'ai-i, the name of a Taoist sect of which Chang was a devotee, was mistaken for Liu-i. The language used by Yü Chi (1272-1348) and Wei Su (1295-1372) in referring to Chang Yen-fu leaves no doubt that Chang was not ethnically Han Chinese, but a member of one of the "barbarian" ethnic groups associated with the ruling Mongols. In the lower of Chang's two seals on this picture, the term *hsi-yü* appears, which may be interpreted as an allusion to Central Asia. Chang's refusal to paint on command for the Grand Elder Princess of the State of Lu (the imperial Princess Sengge, d. 1331) also suggests a non-Chinese very confident of his position at the Mongol court.

Judging from what can be pieced together about Chang's circle of friends and admirers, it seems likely that the Tzu-chao referred to in the inscriptions by Wu Jui and Tu Pen is to be identified with Chang Wen (1293-1356), who was well known in literary and artistic circles of the day for his avid book collecting and love of paintings.

Wai-kam Ho has already called attention (see Lee and Ho, *Yüan*, 1968, cat. no. 243) to the important materials about Chang Yen-fu contained in Ch'en Chi's (1314-1370) "Postscript to the painting of Fu-lang [Farang] horses by Chang Yen-fu" (see *I-pai-chai*, 14th c., pp. 43b-44a). Ch'en's postscript indicates that Chang Yen-fu, a court painter skilled in painting horses, could break the bonds of convention with "original products of new ideas which went completely beyond any restrictions." Ch'en also comments that Chang's paintings in which his brushwork showed a "particular freedom" were most appreciated.

Additional, and perhaps the earliest, information about Chang Yen-fu is provided by the well-known scholar Yü Chi (1272-1348) in a preface to a poem written for a painting by Chang entitled *Thinking of the Autumn in Chiang-nan (Chiang-nan ch'iu ssu)*. The brief text reads: "Chang Yen-fu, a priest of the T'ai-i sect of Taoism, is a clansman of the nation, and he studies Taoism under Hsüan-te chen-jen [Wu Ch'üan-chieh, 1268-1346]. He is a youthful man of untrammelled interests and is especially skilled in painting. In painting this picture, *Thinking of the Autumn in Chiang-nan*, for his friend Hsü Chung-fu, he is following the style of Shang Chi-hsien [Shang Ch'i, act. ca. 1314-1342]" (*Tao-yüan*, 1346, ch. 3, p. 37).

A glimpse of Chang Yen-fu's esteemed position at court is provided by another noted scholar, Wei Su (1295-1372), in his preface to a picture by Chang titled *Mountain Retreat (Shan-an t'u)*, where he says: "Yen-fu, a native of the nation, retreats into the doctrine of Lao-tzu. He is excellent at depicting landscape. There were some officials in attendance who had presented his paintings to the Yen Ko [i.e., the Kuei-chang Ko, a repository where Emperor Wen-tsung (r. 1328-1332) housed his collections]. When I was taking turns on duty with other

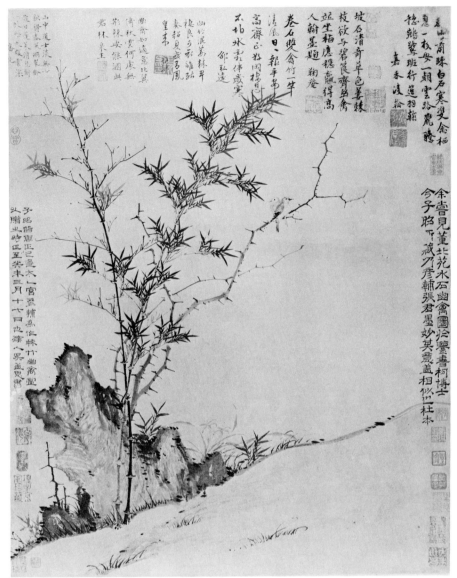

84

expository officials, I compared his works with ancient paintings in the collection and could almost not tell them apart. However, his paintings are seldom to be had. He even refused to dedicate a painting to the Grand Elder Princess of the State of Lu, who amused herself with famous paintings. One can thus understand how it is for others" (see Ch'en Huan, *Tao-chiao k'ao*, 1958, p. 149).

Chang Yü (1277-1348), a famous Taoist literatus, calligrapher, and painter of the late Yüan period, composed two poems to inscribe on paintings by Chang Yen-fu, the first entitled *Building a Taoist Temple in Snowy Mountains* and the second, *Hermit Dwelling in a Cloudy Grove*. In these poems Chang Yü expresses his admiration for Chang Yen-fu's "elegant talent," which he compares favorably with that of the model literati painter of the T'ang Dynasty, Wang Wei (699-759). These two poems form a single scroll, which is now in the collection of John M. Crawford, Jr. (see Ecke, *Chinese Calligraphy*, 1971, cat. no. 35).

Yet another comment which indicates the esteem in which Chang Yen-fu was held by literati critics of the day is expressed by the Korean scholar Li Ch'i-hsien (1287 to 1376), who spent from 1314 to 1322 in China. In a poem written after his return to Korea for a painting by

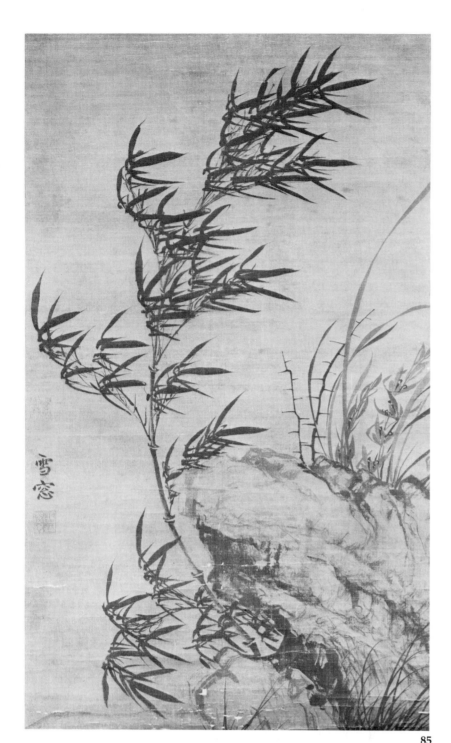

85

I am only fond of Hsi-chai [Li K'an, 1245-1320] and
 Sung-hsüeh [Chao Meng-fu, 1254-1322],
For all traces of the hackneyed commonplace have been
 cleansed from their works.
For landscapes, white clouds and green mountains,
 Chang the Taoist,
Although he appeared later, merits praise for his
 excellence. trans. MFW/KSW

The poem, translated only in part above, comes from
Li's collected works, *I-chai chi,* 14th c., *ch. 4,* p. 53).

The range of Chang Yen-fu's excellence including
bamboo, rocks, and old trees is attested to by yet
another author, Liu Sung (1321-1382), in a poem for a
painting by Chang of withered trees on a sloping bank
(see *Ch'a-weng shih-chi,* late 14th c., *ch. 6,* p. 3).

The case of Chang Yen-fu affords an illuminating
glimpse into Yüan Dynasty painting. An artist could be a
non-Chinese "barbarian" painter painting for the court
and yet could move among, and enjoy the critical
acclaim of, the leading Chinese literati of the day. In this
only known surviving work by Chang, the cool, intellec-
tualized expressive air of the picture, its subject matter,
and technical vocabulary link him with the artistic aims
revitalized by Chao Meng-fu (see cat. nos. 80, 81) and
Ch'ien Hsüan (ca. 1235-after 1300). KSW/MFW

Literature
I-lin yüeh-k'an, no. 37 (January 1933), pl. 11.
Harada, *Shina* (1936), pl. 391.
Cheng Chen-to, *Yün-hui-chai* (1947), pl. 52.
Sirén, *Masters and Principles* (1956-58), VI, pl. 55.
NG-AM Handbook (1973), II, 60.

Exhibitions
Tokyo National Museum, 1931: *Sō-Gen-Min-Shin,* pl. 74.
Fogg Art Museum, Cambridge, Mass., 1951: Rowland, *Bird and
 Flower,* cat. no. 18, p. 21, pl. X.
Cleveland Museum of Art, 1968: Lee and Ho, *Yüan,* cat. no. 243.

Recent provenance: T'an Ching; Chang Heng; C. T. Loo & Co.

Nelson Gallery-Atkins Museum 49-19

P'u-ming, active mid-fourteenth century, Yüan
 Dynasty
h. Hsüeh-ch'uang (family name, Ts'ao); from
 Sung-chiang, Chiangsu Province

85 *Bamboo in the Wind*
 (Feng-chu)

Hanging scroll, ink on silk, 76.2 × 44.8 cm.

Artist's signature and 2 seals, all reading:
Hsüeh-ch'uang.

WKH

Literature
"Sobo" (1926), pp. 68, 75, pl. V.
Harada, *Shina* (1936), pl. 397.
Lee, "A Bamboo" (1956), pp. 22-24, illus. p. 18.
Siren, *Masters and Principles* (1956-58), VII, *Lists,* 129.
Lee, "Zen in Art" (1972), p. 247, fig. 7.

Exhibitions
Palazzo Ducale, Venice, 1954: Dubosc, *Mostra,* cat. no. 788.
Asia House Gallery, New York, 1963: Lee, *Tea Taste,* cat.
 no. 6.
Cleveland Museum of Art, 1968: Lee and Ho, *Yüan,* cat.
 no. 244.
Asia House Gallery, New York, 1974: Lee, *Colors of Ink,* cat.
 no. 16.

Recent provenance: Howard C. Hollis.

The Cleveland Museum of Art 53.246

Chang (which he had apparently brought back with
him), Li offers his criticism of a number of painters:
Formerly, with Chu Te-jun [1294-1365] of Suchou,
East of Yen [Peking], I used to view screen paintings.
Landscapes of T'ieh-kuan have a monkish spirit,
While the flowers of Kung-yen are without literati air.
Yüeh-shan [Jen Jen-fa, 1255-1328] paints horses but
 leaves out the animating forces;
He likes to do fluffy manes and golden eyes.

(Lü) T'ien-ju, active first half of the fifteenth
century, Ming Dynasty
h. P'ien-yü; from Suchou, Chiangsu Province

86 *Narcissus and Rocks*
(Shui-hsien t'u)

Hanging scroll, ink on silk, 66.8 × 42.8 cm.

Artist's signature and 2 seals: T'ien-ju. [seals
indecipherable]

Remarks: When originally published, this painting was
attributed to the Korean painter Sin Seon Boo, who
used the characters "T'ien-ju" as his style name (Li
Eikai, *Chōsen*, 1972, p. 258). Recent research indicates
that the painting is actually the work of Lü T'ien-ju, a
Chinese monk who lived in Suchou during the first
half of the fifteenth century (Hsü Ch'in, *Ming hua lu*,
17th c., *ch.* 6, p. 89).

T'ien-ju studied with a fellow Ch'an monk, Sheng
Jih-nan, who painted landscapes in the manner of Ni
Tsan (ibid., *ch.* 5, pp. 68, 69). T'ien-ju preferred to
paint bamboo, rocks, and orchids. Among his most
prized works were those incorporating the theme of
the Three Fragrances – prunus, cassia, and narcissus.

One of T'ien-ju's Three-Fragrance compositions,
dated 1441, still survives in a Japanese collection
("Ritsu Tenjo," 1942, p. 368, pl. 5). T'ien-ju inscribed
the 1441 scroll with the same fluffy brushwork visible
in the remnants of his signature within the upper
left-hand corner of the Cleveland painting. The inti-
mate world of flowering nature is also captured in a
wholly consistent manner. In both paintings, summary
ground plane was indicated with a few horizontal
strokes of light ink, then dotting strokes of deeper
tone were added to provide decorative contrast. Indi-
vidual "boneless" ink strokes shape clumps of spiky
grasses and weeds. The rocks in the right corners are
also freely painted – light wash, wetly brushed "flying
white" strokes – and deep toned dotting strokes build
up a form with oblique angularity. By contrast, the
flowering narcissus plants are much more slowly and
patiently wrought with a thread-thin line, then care-
fully graded wash applied to differentiate the inner
from the outer surfaces of the foliage and to suggest
the rounded contours of the blossoms.

T'ien-ju's realistic treatment of these plants finds an
easy parallel in the *Ink Flowers* handscroll (cat. no. 72),
painted less than a century earlier by another Suchou
painter, the literati master Chao Chung. Both men in
turn continued the manner of narcissus painting gen-
erally associated with the late Sung scholar-official
Chao Meng-chien (1199-1295; see *T'ien-ching-shih*, 1959,
pls. 1-5). In addition, T'ien-ju's juxtaposition of tightly
controlled brushwork in the flowers with the loosely
painted rocks and ground plane suggests the influence
of one of the most popular Yüan priest-painters in Su-
chou — P'u-ming (see cat. no. 85). Although active in
the early Ming period, T'ien-ju clearly shares the inter-
ests of Yüan amateur painters, both lay and clerical,
who chose specific subjects – bamboo, rocks,
flowers — that could best exploit their calligraphic
training. LYSL/HK

Literature
Mayuyama (1976), II, pl. 255 (as Korean).
Recent provenance: Mayuyama & Co.

The Cleveland Museum of Art 74.28

Wang Yüan, active ca. 1328-after 1347, Yüan
Dynasty
t. Jo-shui, *h.* Tan-hsüan; from Hangchou,
Chechiang Province

87 *Quails and Sparrows in an Autumn Scene*
(Ch'iu-ching ch'un-ch'üeh)

Hanging scroll, dated 1347, ink and slight color on
paper, 114.3 × 55.9 cm.

Artist's inscription, signature, and 3 seals: In the year
of Chih-cheng, spring of *ting-hai* [1347], Wang Yüan,
Jo-shui of Ch'ien-t'ang, drew this picture of *Quails and
Sparrows in an Autumn Scene*. [seals] Tan-hsüan;
Jo-shui; Mo-miao pi-ching.

2 additional inscriptions and 16 additional seals: 1 po-
em and 2 seals of Yang Wei-cheng (1296-1370); 1 label
and 10 seals of the Ch'ien-lung emperor (r. 1736-95); 4
seals of Chang Heng (1915-1963).

WKH

86

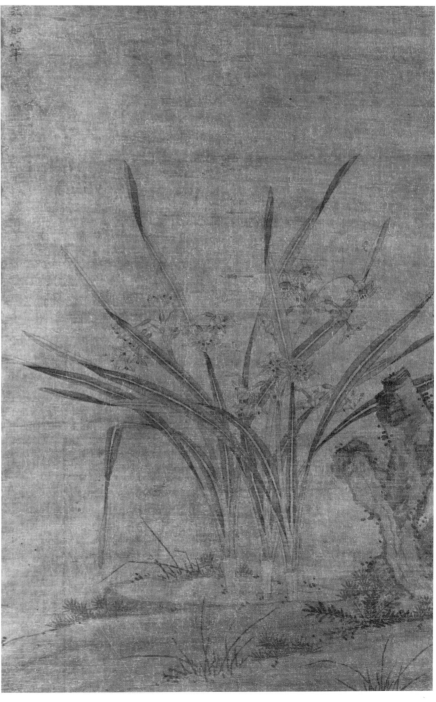

Literature
Shen-chou ta-kuan XIII (1919), pl. 10.
Contag and Wang, *Maler* (1940), p. 513.
Cheng Chen-to, *Yün-hui-chai* (1947), pl. 38.
Ch'en J.D., *Ku-kung* (1956), p. 42(a).
Sirén, *Masters and Principles* (1956-58), IV, 28; VI, pl. 30; VII, Lists, 140.
Goepper, *Chinesische Malerei* (1960), p. 32 illus.).
Edwards, *Field of Stones* (1962), pp. 14, 15, pl. 10-A.
Cahill, *Hills* (1976), pp. 151, 157, 158, pl. 73.

Exhibitions
Nanking Art Gallery, 1937: *Chiao-yü-pu*, I, cat. no. 68.
C. T. Loo & Co., New York, 1948: Wang Chi-ch'ien, *Authenticated*, cat. no. 8.
Fogg Art Museum, Cambridge, Mass., 1951: Rowland, *Bird and Flower*, cat. no. 15.
Royal Ontario Museum, Toronto, 1956: Tseng, *Loan Exhibition*, cat. no. 7.
Haus der Kunst, Munich, 1959: *1000 Jahre*, cat. no. 32.
Cleveland Museum of Art, 1968: Lee and Ho, *Yüan*, cat. no. 240.

Recent provenance: Chang Heng.

Intended gift to The Cleveland Museum of Art, Mr. and Mrs. A. Dean Perry

87

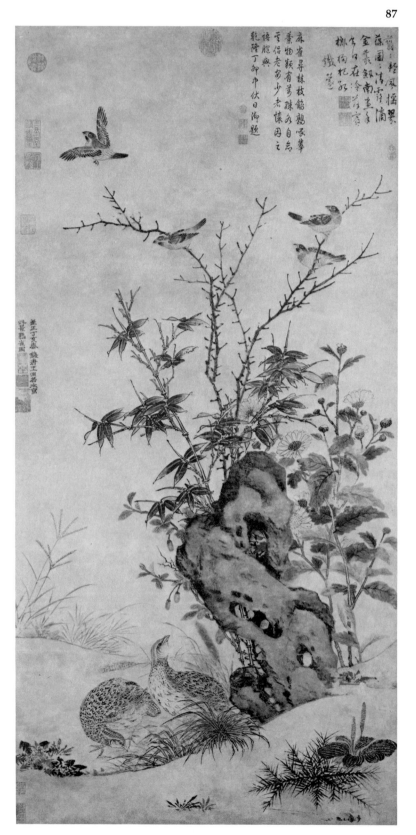

Wang Mien, 1287-1359, Yüan Dynasty
t. Yüan-chang, *h.* Lao-ts'un, Chu-shih Shan-nung; from Chu-chi, Chechiang Province

88 *A Prunus in the Moonlight*
(Yüeh-hsia mei-hua)

Hanging scroll, ink on silk, 164.5 × 94.5 cm.

Artist's inscription, signature, and 2 seals:

The full moon appears at the break of the sea of clouds,
The single crane is flying high before the night is gone.
Above the lake, the air is filled with the music of the flute and Pan-pipe,
And the "jade lady" is leaning against the railing with a smile.
Shan-nung, Wang Yüan-chang. [seals] Chu chai t'u-shu; Fang-wai ssu-ma.

8 additional seals: 6 of the Ch'ien-lung emperor (r. 1736-95); 2 of Tung Kao (1740-1818).

WKH

Literature
Mayuyama (1976), II, pl. 167.

Recent provenance: Yasuda Family (chief retainer of Asano Family); Mayuyama & Co.

The Cleveland Museum of Art 74.26

Wang Mien (attributed to)

89 *Ink Plum Blossoms*
(Mo-mei-hua)

Hanging scroll, ink on paper, 152 x 33 cm.

1 inscription (poem) and 4 seals of Fu-yüan (unidentified, 14th c.).

Poem by Fu-yüan:

The elegant brushwork of Master Wang is rare in this generation;
Flowering branches seem to stir in the spring breeze.
At the close of the year they bloom in all their purity,
When flurries of snow fill the skies of Chiang-nan.

Noted by Fu-yüan. [2 seals] Shih; Ko-ch'iu-sui kung-ming yüeh.

Remarks: The Master Wang of the poem is, in all probability, Wang Mien (1278-1359), the most celebrated painter of plum blossoms in the Yüan Dynasty. Of the two seals following the name Fu-yüan, the one, Shih, means a monk, and the other, Ko-ch'iu-sui kung-ming yüeh, may be translated, "[Although] separated, the autumn waters share the bright moonlight." Two additional

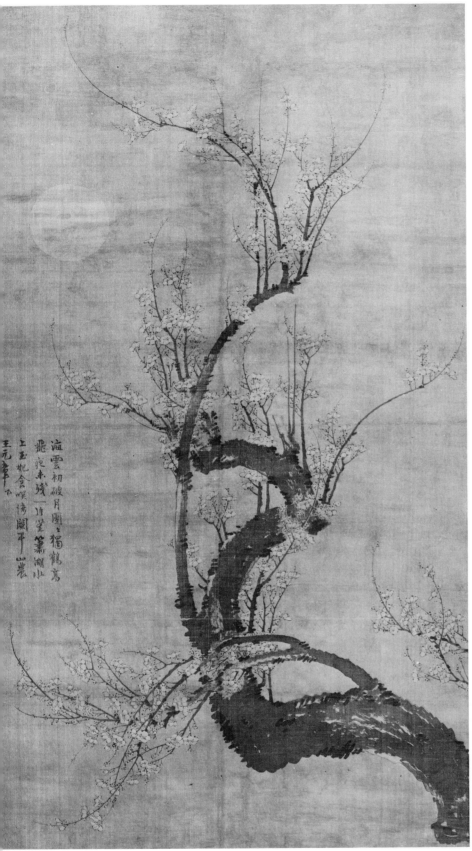

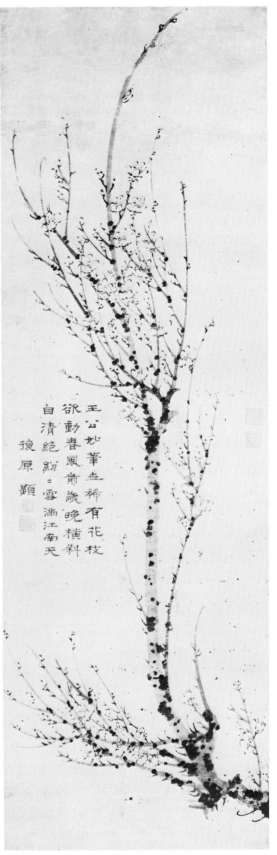

88

89

seals, midway on the right edge of the painting, are Tan-shan hsiao-shih ("The small official of Mt. Tan"; here Tan-shan may be taken in the sense of Tan-ch'iu, a dwelling place of Taoist immortals) and Fu-yüan. All four seals are similar in design, cutting, and color of the impressions; they are typically fourteenth century, with every appearance of belonging to the same person. The character *yüan* in the signature of the author of the poem, however, and the *yüan* of the seal on the right edge are not the same; one *yüan*, that of the signature, means "source" or "origin" (Giles, *Chinese-English Dictionary*, 1912, 13, 760), while the *yüan* of the seal has the meaning of "primary," "principal," or "absolute" (ibid., 13, 744). The meanings when combined with *fu* ("to return") are not dissimilar, especially when considered with Taoist connotations: "Returning to the source (or origin)" and "Returning to the principal (or that which is primary)." It is perfectly possible that an individual, especially a member of a religious order, might use one expression for his signature and another of different but similar meaning on his seal.

Another question might concern the seal Shih, because while *shih* generally refers to a Buddhist monk, the seal Tan-shan hsiao-shih and both forms of Fu-yüan have a distinct Taoist flavor. Such seeming contradictions are possible in the time of the Yüan Dynasty when the concept of "The Three Religions" – Confucianism, Buddhism and Taoism – enjoyed considerable favor among the literati. The individual, Fu-yüan, is unidentified, but there is a slight possibility he might be the fourteenth-century Tsou Fu-yüan, a bamboo painter and the elder brother of the Taoist painter of plum blossoms, Tsou Fu-lei. This elder brother is mentioned in a colophon by Yang Wei-chen (1296-1370), attached to the superb handscroll of plum blossoms by Tsou Fu-lei now in the Freer Gallery of Art, Washington.

Of the half-dozen dated paintings by Wang Mien that have been published, all but one are from the 1350s, so are relatively late in the artist's life. These paintings show a powerful and mature style. The one earlier work is dated in accordance with 1346 (Harada, *Shina*, 1936, pl. 387). It appears to be more delicate and carefully drawn than the robust later works and is the closest of all to the Nelson Gallery scroll. This painting can well be an early work from, say, the 1330s to early 1340s. Unsigned, it came into the hands of the Taoist Fu-yüan, possibly as a present, and he wrote the quatrain identifying the artist and praising the painting.

The Nelson Gallery scroll had long been in Japan. On the interior of the lid of the old box is an inscription, "Ink Plum Blossoms by Wang Yüan-chang," signed by the famous connoisseur-painter Kanō Tanyū (1602-1674).

KSW/LS

Literature
Harada, *Shina* (1936), pl. 387.
Nihon genzai Shina (1938), p. 104.
Cohn, *Chinese Painting* (1948), pl. 176.
Sirén, *Masters and Principles* (1956-58), VI, pl. 24.
Exhibitions
Tokyo Imperial Museum, 1928: *Tō-Sō-Gen-Min*, pl. 197.
Recent provenance: Marquis Maeda.
Nelson Gallery-Atkins Museum 51-76

Yen Hui, first half of the fourteenth century, Yüan Dynasty
t. Ch'iu-yüeh; from Chiang-shan, Chechiang Province

90 *Plum Blossoms in Moonlight (Yüeh-mei t'u)*

Album leaf, ink on silk, 25.5 x 27.6 cm.

Artist's signature: Yen Hui.

Remarks: According to Chaung Su's *Hua chi pu-i* of 1298, "At the time when the Sung was drawing to a close, [Yen Hui] was competent in painting landscapes, figures, demons, and deities, and the scholar-officials [*shih-ta-fu*], all respected and admired them." Thus, before 1279 and the fall of the Sung Dynasty, Yen Hui had already established a reputation among the gentry in subjects apart from the Taoist and Buddhist figures for which he is solely remarked in the *T'u-hui pao-chien* of 1365. This suggests a contraction in choice of subject matter during the latter part of his career to a functional speciality, a change perhaps dictated by the economic necessity of adjusting to a new clientele, following the establishment of the Yüan dynasty.

In *Plum Blossoms in Moonlight* ink tonality is masterfully controlled to evoke gracefully curving branches seen on a moonlit evening. The subtle blending of pictorial realism with formal interest in technique and media is to be found as well in the works of Yang Pu-chih (1097-1169), who was from Chianghsi and a specialist in the painting of blossoming plum. The close stylistic parallels between Yen's fan and one done by Yang Pu-chih (Tientsin Art Museum, *Sung-jen hua-ts'e*, n.d., XIX) suggest a late Sung date for this painting. HR

Literature
Dubosc, "Plum Blossoms" (1972-73), pp. 67-70.
Recent provenance: Akaboshi Collection; Jean-Pierre Dubosc.
The Cleveland Museum of Art 78.49

90

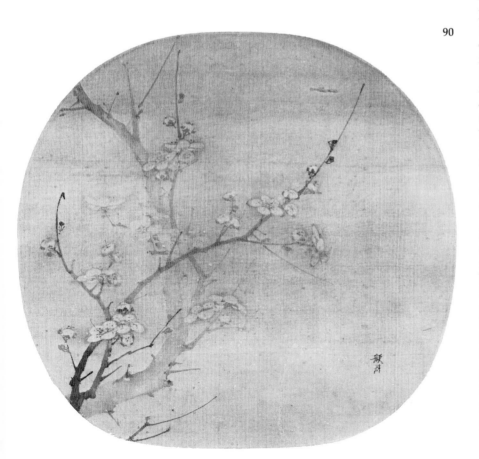

Yen Hui

91 *The Lantern Night Excursion of Chung K'uei*
(Chung K'uei yüeh-yeh ch'u-yu t'u)

Handscroll, ink and slight color on silk, 24.8 x
240.3 cm.

Artist's signature [and probable seal]: Yen Ch'iu-yüeh.

Title on frontispiece and 1 seal of Niu Shu-yü (1760-
1827): *Chiu-yüeh mo-huan [Chiu-yüeh's Ink Fantasy]*.

31 additional seals: 2 of Yang Shih-ch'i (1365-1444); 2 of
An Kuo (1481-1534); 8 of Hsiang Yüan-pien (1525-1590); 2
of Keng Chao-chung (1640-1686); 4 of P'u-t'ung (20th c.);
7 of T'an Ching (20th c.); 1 of Liu Ting-chih (20th c.);
5 unidentified.

Remarks: The artist's signature is somewhat obscured by
damage, but the painting is apparently identical with the
picture cited in *Shih-ku-t'ang shu-hua hui-k'ao* completed
in 1682 by Pien Yung-yü (1644-1712). In that work men-
tion is made of two colophons, one by Yü Ho (dated
1389), and the other by Wu K'uan (1435-1504). The
Cleveland scroll fits in perfectly with the description de-
tailed in Yü Ho's colophon which reads:

Mr. Sha Yen-te possesses the discriminating knowledge
of Chang Hua. He excels especially in connoisseurship
in ancient paintings. He rarely misses a chance to buy
paintings that are in the "inspired" category. On the
other hand, those imitations by incompetent artists with
only a superficial likeness could hardly fool his eyes.
Subsequently, his family collection of masterpieces from
the three periods of T'ang, Sung, and Yüan is very rich.
Scholars who love paintings always sought Yen-te's au-
thentication before they would make any purchase. For
this reason his opinion was even more valued.

One warm day this summer, Yen-te came to show me
a handscroll, saying "This is *Chung K'uei's Lantern Night
Excursion* by Yen Ch'iu-yüeh." Unrolling the scroll, I saw
a small platoon of demons leading a procession. One is
beating a drum; one is lifting a large rock; one is stand-
ing [on his hands] upside down and trying to drink; one
walks while balancing a jar on his elbow; one is wielding
a spear; one is brandishing a sword; one is dancing with
a buckler [offensive shield]; one is busy with a large
chopper; one holds a wine bottle, while the other is
about to present a drink; one carries a chair, the other
carries a *ch'in* [lute], books, brush, and inkstone. Follow-
ing this is Chung K'uei himself, carried by three de-
mons. Several demons walk behind as retainers; one
holds a canopy, while the others beat a drum, play a
flute, and sound musical clappers. The bizarre appear-
ance of these demons is indeed the ultimate of form and
gesture.

In the sixth month of the summer of the *chi-ssu* year
[1389], of the reign of Hung-wu, recorded by Tzu-chih
shan-hen [Mountain dweller of the purple fungus, *i.e.*,
Yü Ho].

These colophons by Yü Ho and Wu K'uan are now mis-
sing. However, according to the catalogue of Yeh Kung-
cho's collection (*Hsia-an*, 1964, *ch.* 2, pp. 154a-156a), the
original colophons of the Cleveland scroll recorded in the
Shih-ku-t'ang apparently were removed to another hand-
scroll of the same subject on paper that was once in that
collection. One wonders how closely the Yeh Kung-cho
painting is related to another handscroll of the same
subject and more or less similar composition, also on
paper, which was once in Chang Ts'ung-yü's collection

(Cheng Chen-to, *Yün-hui-chai*, 1947, pls. 14-27). Both, however, seem to be versions later than the Cleveland example. WKH

Literature
Wang K'o-yü, *Shan-hu-wang* (preface 1643), *ch.* 9, pp. 929, 930.
Pien, *Shih-ku-t'ang (1682)*, *ch.* 22, pp. 5(a)-6(a).
P'ei-wen-chai (1708), *ch.* 85, p. 11(b).
Wang Shih-yüan, *Lu-yün-lou* (1922), p. 5.
Ferguson, *Li-tai* (1934), p. 454(b).
Siren, *Masters and Principles* (1956-58), IV, 14; VII, *Lists*, 144.
Lee, "Yen Hui" (1962), pp. 36-42.
Dubosc, "Plum Blossoms" (1972-73), p. 67, fig. 4 (detail).
Fong, "Probable Second 'Chung K'uei'" (1977), p. 431, fig. 6.
CMA *Handbook* (1978), illus. p. 345.

Exhibitions
Haus der Kunst, Munich, 1959: *1000 Jahre*, cat. no. 27.
Cleveland Museum of Art, 1968: Lee and Ho, *Yüan*, cat. no. 206.
Asia House Gallery, New York, 1974: Lee, *Colors of Ink* cat. no. 14.
The Taft Museum, Cincinnati, 1976: Looking East, no catalogue.

Recent provenance: Frank Caro.

The Cleveland Museum of Art 61.206

Liu Kuan-tao, active ca. 1279-1300, Yüan Dynasty
t. Chung-hsien; from Chung-shan, Hopei Province

92 *Whiling away the Summer*
(Hsiao-hsia t'u)

Handscroll, ink and light color on silk, 30.5 x 71.1 cm.

Artist's signature: Kuan-tao.

1 title, 5 colophons, and 34 seals: 1 poem and 2 seals of Yü Ch'ien (1366-1427); 3 seals of Chu Kang (Prince of Chin, 1358-1398); 1 colophon, dated 1618, and 2 seals of Li Shih-ta (act. ca. 1580-1620); 1 seal of An Ch'i (1683- ca. 1746); 2 seals of Hung-hsiao (Prince of I, d. 1778); 2 seals of Hsieh Hsi-ts'eng (1748-after 1818); 2 seals of Lu Shu-sheng (act. late 19th c., third son of Lu Hsin-yüan [1834-1894]); 2 seals of Chiang Tsu-i (act. early 20th c.); 1 seal of Chiang Hsüeh-tsao (act. early 20th c.); 1 title, 3 colophons (one dated 1935), and 4 seals of Wu Hu-fan (1894-1964); 7 seals of Chang Heng (1915-1963); 2 seals of Hsü An, friend of Chang Heng; 1 seal of Wang Chi-ch'ien (20th c.); 3 seals unidentified.

Colophon by Yü Ch'ien:

Admirable! Oh, this gentleman of times gone by,
Who planted bamboo in the nook of the stream.

Clear water and pure bamboo;
Just here, he built his splendid home.

Shunning the world, his person found ease;
Through study, his mind deepened ever more.

91 Detail

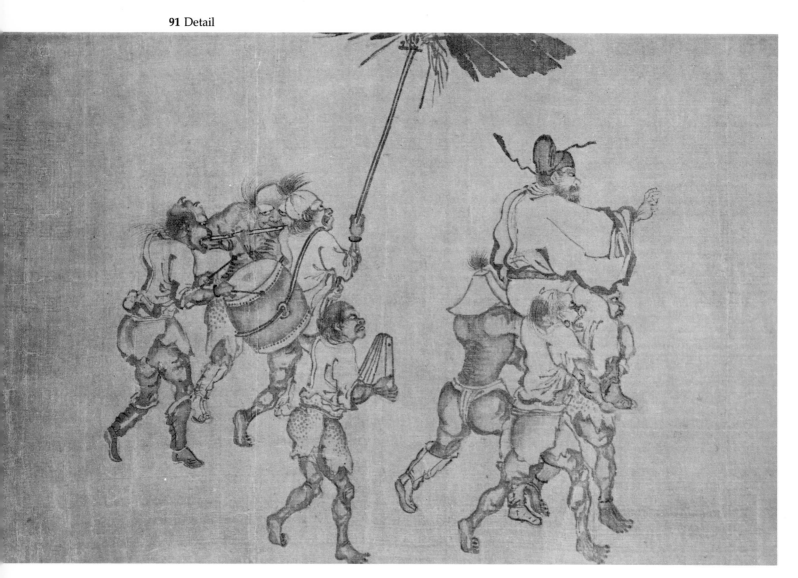

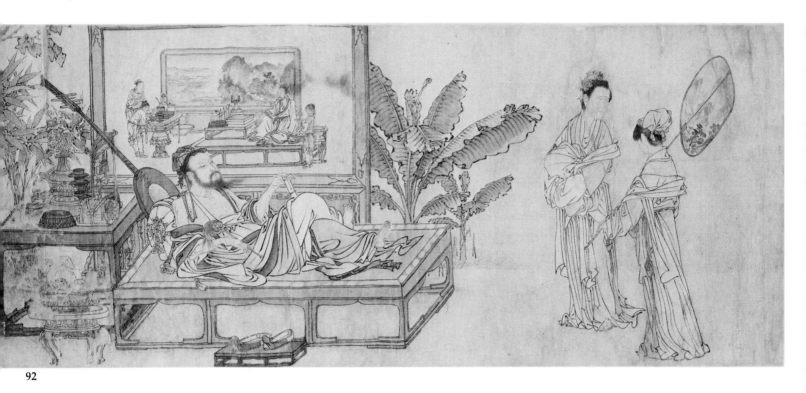

92

The window, vacant, embraces green bamboo shadows;
The waterfall, arcing, roars in the still of night.

Like phoenix feathers, bamboo leaves buffet against
　　cool gusts,
While scale-like waves ripple over fresh clear water.

Thirsty, he drinks from the source of the racing cascade;
Purified, he cuts bamboo shoots beneath the grove.

A temperament as dispassionate as ice and snow,
How can he mingle with the common lot?

Being just such a man as he,
My eyes and heart gladden in opening this scroll.

How I wish we might once meet,
Riding his Yellow Crane on an autumn wind.

[signed] Yü Ch'ien

trans. MFW

Remarks: The above poem is on the earliest colophon
following the painting proper. Yü Ch'ien held a series of
important official positions and was well known in his
day as a poet and versatile painter who favored rocks and
bamboo in the spirit of Ni Tsan (see cat. no. 110).

　The colophon by the Suchou school painter Li Shih-ta
(act. ca. 1580-1620), simply states that he saw the painting
in the winter of 1618.

　The three colophons of Wu Hu-fan (1894-1964) have
been translated in full by Wai-kam Ho (Lee and Ho, *Yüan*,
1968, cat. no. 198). The main theme in all three is the event
when, after Chang Heng (1915-1963) acquired the scroll,
he and Wu together examined it and discovered the sig-
nature, Kuan-tao, concealed among the bamboo leaves at
the left edge. Wu, justifiably, makes much of this final
identification of the true authorship; all the more because
the famous connoisseur Kao Shih-ch'i (1645-1704), in his
checklist of calligraphy and paintings, had accepted an
attribution to the Southern Sung painter Liu Sung-nien
(act. late 12th-early 13th c.; see Kao, *Chiang-ts'un shu hua
mu*, 17th c., sec. 3). There is no seal of Kao Shih-ch'i on
the painting, however.

　Wu Hu-fan on the basis of this scroll, in his colophon of
1935, declares Liu Kuan-tao to be the "anchoring pillar of
the Northern Sung among Yüan painters" and adds that

he based his figure style on that of Liu Sung-nien and his
landscape style on that of the Northern Sung painter Kuo
Hsi (ca. 1020-1090). Although Liu Kuan-tao's exact dates
are not known, he was already active in the fourth quarter
of the thirteenth century when, in 1279, he received an
honorary court appointment and in 1280 painted *Kublai
Khan Hunting* (*Ku-kung ming-hua*, 1966-69, v, pl. 17).
From the titles of paintings attributed to Liu Kuan-tao, he
appears to have been highly versatile, including in his
repertoire birds and flowers, bamboo, landscape, por-
traits, and a number of Taoist and Buddhist subjects. A
court artist, he derived elements of his style from South-
ern Sung Academy painters and the landscape painters of
Northern Sung and elements of composition and theme
from even earlier times. In *Whiling away the Summer* the
figure of the reclining scholar is based on representations
of the aging Buddhist sage-king, Vimilakirti, while the
decoration of the large screen behind the scholar, show-
ing a group of figures before a second screen with land-
scape in Northern Sung style, is equally traditional, hav-
ing been employed by the Five Dynasties artist Chou
Wen-chü (act. ca. 960-973) in a well-known painting,
The Double Screen (Cheng Chen-to, *Chung-kuo ku-tai*,
1963, pl. 26).

　A late, possibly sixteenth-century version of *Whiling
away the Summer* (with some compositional variations) is
in the Freer Gallery of Art, Washington (Lawton, *Chinese
Figure Painting*, 1973, no. 39). LS/KSW

Literature
Kao Shih-ch'i, *Chiang-ts'un shu hua mu* (17th c.), sec. 3.
Wu Hsiu, *Ch'ing-hsia-kuan* (preface 1824), II/6, p. 199.
　(The catalogues above list the painting under Liu Sung-nien.)

Sirén, *Masters and Principles* (1956-58), IV, 15; VI, pl. 43.
Li-tai jen-wu-hua (1959), pl. 29.
Cahill, *Hills* (1976), p. 153, pls. 68, 69.

Exhibitions
Cleveland Museum of Art, 1968: Lee and Ho, *Yüan,* cat. no. 198.

Recent provenance: Chang Heng; Wang Chi-ch'ien.

Nelson Gallery-Atkins Museum 48-5

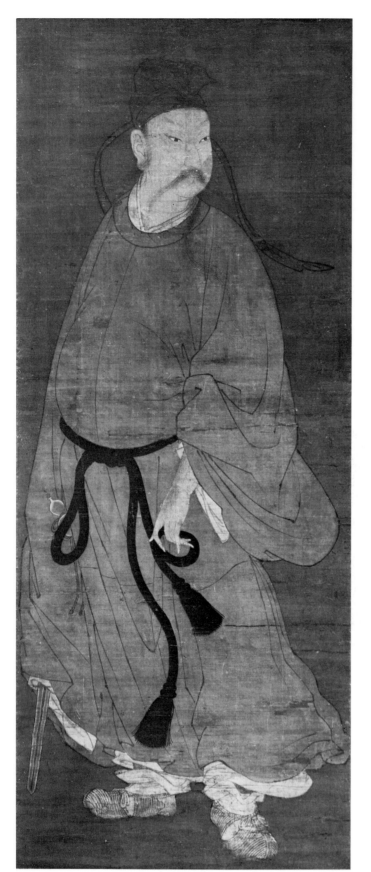

Artist unknown, late thirteenth-early fourteenth century, Yüan Dynasty

93 *The Taoist Immortal Lü Tung-pin (Lü Tung-pin hsiang)*

Hanging scroll, ink and color on silk, 110.5 x 44.4 cm.

Remarks: In the Yüan Dynasty, Lü Yen, or Lü Tung-pin, was one of the immortals most favored as a hero in popular Taoism. A great magician and defender of the righteous, he traveled throughout the country, especially the lake district of central China, with supernatural speed righting wrongs and destroying the wicked with his miraculous sword. In this spirited painting he is shown braced firmly in a defiant stance, the tip of his sword showing below the right sleeve of his voluminous yellow robe, his Taoist gourd-bottle at his waist.

Lü Tung-pin is believed to have been an historical person who took his first-rank degree (*chin-shih*) in 825, during the later years of the T'ang Dynasty. But before he assumed an official post, he was converted to Taoism by no less a teacher than the great immortal, Chung-li Ch'üan (see cat. no. 132). The latter instructed him in celestial sword play and initiated him into the innermost Taoist mysteries and the secret of immortality.

Taoism enjoyed an upsurge of popularity in the Yüan Dynasty; it was at that time, in the late thirteenth and early fourteenth century, that Lü T'ung-pin gained wide favor as an immortal and was chosen as the titulary deity of the Ch'üan-chen sect of Northern Taoism. His importance is evident in the scale and beauty of the mother church of his cult, the great Yung-lo-kung (Palace of Eternal Joy) recently identified in southwestern Shanhsi Province. A stele set up at this temple in 1252 carries an account of his biography (*Yung-lo-kung*, 1964; see also Wang Shih-jen, "'Yung-lo-kung,'" 1956, no. 9, pp. 32-40).

This scroll was once in Japan, where, at some undetermined time, it was flanked by two Japanese paintings of ducks and reeds by Tesshū (ca. 1342-d. 1366), forming the center painting of a triptych. The Nelson Gallery figure is somewhat cramped for space on all four sides and has evidently been cut down to match the size of the Japanese paintings that once accompanied it. Both the scrolls by Tesshū are now in The Metropolitan Museum of Art. LS

Literature
Watson, *L'Ancienne Chine* (1979), p. 441, pl. 498.

Exhibitions
Cleveland Museum of Art, 1968: Lee and Ho, *Yüan*, cat. no. 191.

Recent provenance: N. V. Hammer.

Nelson Gallery-Atkins Museum 62-25

Jen Jen-fa, 1255-1328, Yüan Dynasty
t. Tzu-ming, *h.* Yüeh-shan; from Ch'ing-pu,
Chiangsu Province

94 *Three Horses and Four Grooms*
(San-chün t'u)

Handscroll, ink and color on silk, 29.2 x 136.8 cm.

Artist's signature and seal: Yüeh-shan-tao-jen. [seal]
Jen Tzu-ming shih.

1 colophon and 16 additional seals: 1 poem, 1 colophon
dated 1552 or 1612, and 3 seals of Wang I-ying (16th c.); 2
seals of Liang Ch'ing-piao (1620-1691); 6 seals of the
Ch'ien-lung emperor (r. 1736-95); 3 seals of the Chia-
ch'ing emperor (r. 1796-1821); 1 seal of the Hsüan-tung
emperor (r. 1908-12); 1 seal of Yü Hsieh-chung (20th c.).

Poem and colophon by Wang I-ying:

As for painters of horses in the previous dynasty,
Surely the name of Yüeh-shan [Jen Jen-fa] must come first.
Under his brush and on his silk
They seem to have just galloped out from the
 imperial stud.
Now as the world overflows with inferiority,
Who, from the stable, can recognize a dragon-horse
 amidst mediocrity.

Jen Yüeh-shan [Jen Jen-fa] of the Yüan Dynasty was best
in horse paintings. The three fine steeds he painted in
this scroll are so dashing, so vigorous in spirit that they
have indeed grasped some of the ''brush-idea'' of Han
Kan. Not long ago this painting came into the posses-
sion of Mr. Kuei Shan-ch'üan, who asked for my inscrip-
tion. And I, while reading the old manuscripts of Heng-
shan [Wen Cheng-ming, 1470-1559], by accident, came
across the poem quoted above. As the ancients said ''in
painting horses, Master Han was [inspired by and pro-
duced] real horses; in composing poems, Master Su [Su
Tung-p'o, the leading Sung poet] wrote as if a painting
were before him.'' These are truly what should be
considered the two excellences; indeed, they are to be
treasured.

In the sixth month of the *jen-tzu* year [either 1552 or
1612]. Chien-feng-shan-jen [The Mountain Dweller of
the Sword Peak], Wang I-ying, written in the Ch'ü-ssu-
t'ing Pavilion at Ch'ih-yang.

<div align="right">WKH</div>

Literature
Shih-ch'ü II (1793), *ch.* 18, Yang-hsin-tien (3), p. 72(b).
Ferguson, *Li-tai* (1934), p. 81(b), listed as *San-chün t'u chüan.*
Ch'en J. D., *Ku-kung* (1956), p. 13(a).
Lee and Ho, ''Three Horses'' (1961), pp. 70, 71, fig. 1.
Lee, *Far Eastern Art* (1964), p. 405, fig. 536 (detail).
Sullivan, *Chinese and Japanese* (1965), p. 66, fig. A (detail).
Li Lin-ts'an, ''Ming Huang'' (1969), pl. 3.

Exhibitions
Smith College Museum of Art, Northampton, Mass., 1962:
 Chinese Art, cat. no. 14.
Cleveland Museum of Art, 1968: Lee and Ho, *Yüan,* cat. no. 188.

Recent provenance: Yü Hsieh-chung; Frank Caro.

The Cleveland Museum of Art 60.181

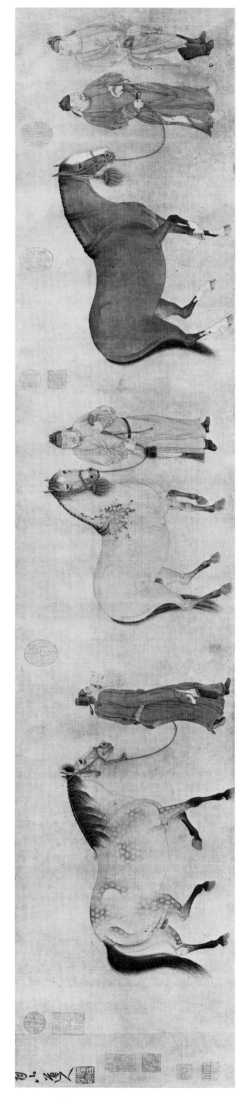

Jen Jen-fa

95 *Nine Horses*
(Chiu ma)

Handscroll, dated 1324, ink and color on silk, 31.2 x
262 cm.

Artist's inscription, signature and 2 seals: A picture of
nine horses done in the K'o-shih Hall in mid-spring of
the *chia-tzu* [year] of the T'ai-ting era [1324]. Yüen-shan
tao-jen. [seals] Jen shih Tzu-ming; Yüeh-shan tao-jen.

6 additional seals: 1 of the Mu family, probably Mu Lin
(d. ca. 1457-60); 5 of Ch'eng Ch'i (20th c.).

Remarks: Jen Jen-fa's importance in the history of
Chinese painting is far greater than is suggested by the
treatment accorded him in critical literature of the late
Ming and Ch'ing periods. He was the last great expo-
nent of a conservative tradition of horse painting that
reaches back to a period of florescence in the high T'ang
period. With horses and grooms gracefully posed
against an otherwise-blank silk ground, Jen Jen-fa per-
fected the ideal image of these imperial steeds. Once his
manner is recognized, and its idiosyncracies discerned,
the pervasiveness of his influence on later painters of
horses becomes clear; and a number of paintings usually
thought to bear the imprint of such illustrious T'ang
progenitors as Han Kan or Ts'ao Pa may rightly be iden-
tified with Jen's formulation.

If Jen Jen-fa crystallized the conservative, courtly im-
age of horse painting, then his contemporary, Chao
Meng-fu (see cat. nos. 80, 81), revived a style based on
the Northern Sung artist Li Kung-lin (d. 1106) that play-
ed upon the calligraphic and abstract graphic interests
valued by critics of the literati persuasion. With the
death of these two masters, Chinese horse painting wit-
nessed the end of history-making creativity. Their sons
and grandsons continued to produce pictures of horses
in the family manner, but fresh inspiration seems to
have failed them, as it did the nameless Ming profes-
sional painters who ground out anemic works based on
Jen Jen-fa.

Despite Jen Jen-fa's historical importance and the
esteem in which he was held by his contemporaries, a
puzzling silence surrounds him, both as a man and as an
artist. Hsia Wen-yen's *T'u-hui pao-chien* (preface 1365),
long considered to be a standard reference work, lists
virtually every important painter of the early Yüan
period, along with countless nobodies, but omits Jen
Jen-fa. So, too, does the *Yüan shih*, the official dynastic
history of the Yüan Dynasty compiled in the early years
of the Ming. These omissions are extraordinary, since
Jen Jen-fa was widely esteemed by the literati elite of the
day for his broad talents: painting and hydraulic en-
gineering, calligraphy and poetry, and devoted service
to the state. It was this last, perhaps, that rankled the
vindictive, self-righteous nationalism that accompanied

94 Detail

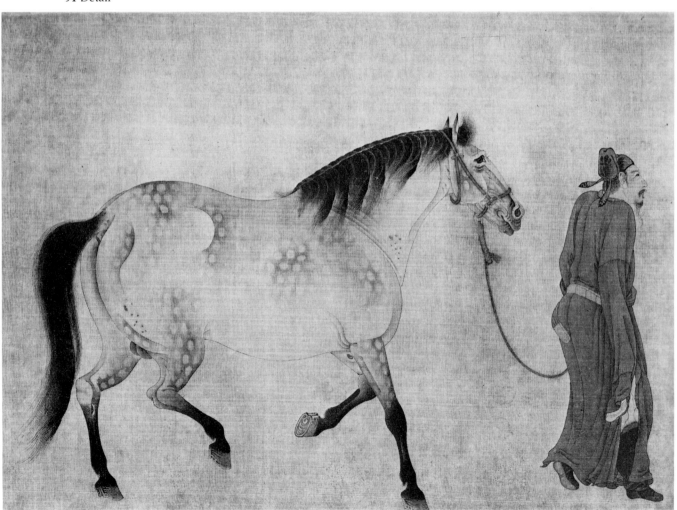

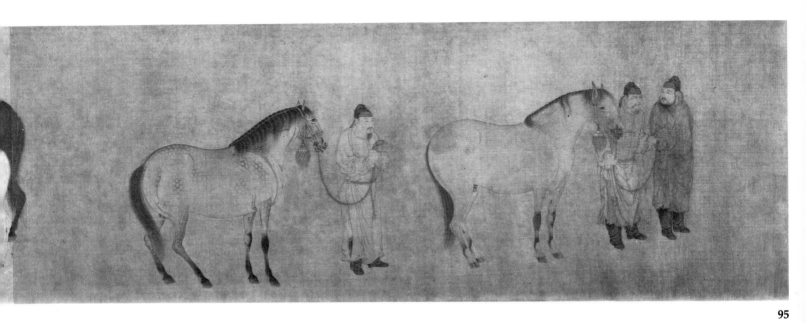

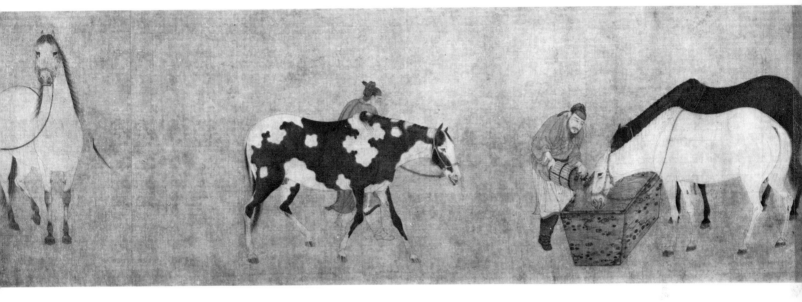

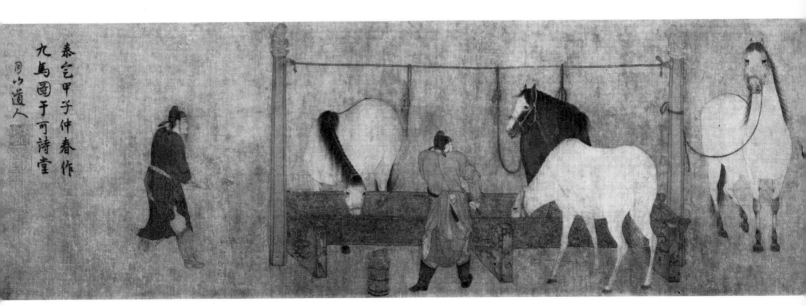

泰定甲子仲春作
九馬圖于可詩堂
月山道人

the early reigns of the Ming Dynasty and that prompted attacks on anything to do with the horse-loving, "barbaric" Mongols and those who had served them well. Jen had not only served the Mongol government with devotion, but had eagerly sought official position even as the pathetic last Sung emperor, who had a moral claim to Jen's loyalties, fled in despair to his death. Moreover, Jen's daughter married into the non-Chinese K'ang-li family, whose important members wielded considerable power at court and served in the Imperial Bodyguard.

What little we can piece together about Jen's life comes from a few meager sources. The two men who offer the keenest insight into his life are K'ang-li Nao-nao (1295-1345) and Wang Feng (1319-1388), both of whom were related to Jen by marriage. A little more can be added to the chronology of Jen's life from the much-damaged remains of his epitaph, unearthed when his tomb was discovered in 1953 (Tsung, "Jen Jen-fa mu-chih," 1959, p. 25). To these accounts may be added glimpses into his character gleaned from poems written to him by friends.

All late-Ch'ing and modern biographical accounts of Jen Jen-fa, such as those found in the *Sung-chiang-fu chih* (1917, II, 1117-18) and the *Hsin Yüan shih* (Jen-shou, ed., 1955-56, *ch.* 194/9a-10a), draw heavily upon a passage in Wang Feng's *Wu-hsi chi* (1346, pp. 7848-49) entitled, "A Visit to the Tombs of the Noble Jen, Vice-Commissioner of Pacification of the Che-tung Circuit, and his Son [Jen Hsien-tso], the Vice Prefect of T'ai-chou." Wang based his account of Jen Jen-fa's life and official career upon material prepared for Jen's epitaph, furnished him by Jen's grandson, Jen P'u (the son of Jen Hsien-tso), upon the occasion of Wang's visit to the Jen family tombs in the company of his eldest son, Wang Yeh, and his daughter-in-law (the daughter of Jen Hsien-tso).

Jen Jen-fa was born at noon on the fifteenth of August, 1255, to a family of modest means living in the tiny riverside hamlet of Ai-ch'i, on the remote eastern fringes of Ch'ing-p'u county, Chiangsu Province (which today lies just within the western limit of Shanghai). It seems likely that his personal name (*ming*) was originally T'ing-fa, changed to Jen-fa sometime prior to manhood. Jen and his younger brother, Chung-fu, devoted their energies to obtaining an education and cultivating the arts. Jen Jen-fa's successes began early, at the age of seventeen, when he took a first in the local examinations of the district advancement system in 1272. His official career began about 1279, when a private interview with Yu Hsien (1210-1283), who was then Chief Administrator of the Branch Secretariat of Chiang-che, won Jen a trial appointment as a petty police official.

A portrait of Jen Jen-fa drawn from his official career yields a profile of a man of earnest and systematic temperament, whose unmatched genius for practical matters, especially water control, made him indispensable to the state. After a stint as sheriff of Ch'ing-lung (his native area), the last years of the thirteenth century, beginning about 1288, and the opening years of the fourteenth find him rising in the ranks as a naval officer. During this period he participated in an expeditionary force to Vietnam. From 1303 onward, however, Jen's career was bound to his skill as a hydraulic engineer. Even his prefectural appointments were such that he was assigned to cities of strategic importance in water control. At the age of seventy (*sui*) he petitioned the throne to be allowed to retire. His request was met with denial and a further promotion. Finally, about 1327, he

was allowed to retire and was awarded the high-sounding title of Vice-Commissioner of the Pacification Commission of the Che-tung Circuit and was granted an honorary title of the fourth class, senior grade. His retirement proved to be pitifully short, for he died soon thereafter – in January 1328.

Jen Jen-fa was a reflective man, sensitive to the trials of his time. He felt keenly the dilemma of whether to "engage" or "withdraw," whether to serve and try to effect good or to retreat into comfortable, safe uselessness. The corruption and treachery he found in government service disappointed him. He embraced Confucian values and norms of social behavior fully, and counted himself a member of the literati class as he strove for attainment in pursuits revered by the literati: calligraphy, poetry, and painting.

How and where Jen Jen-fa learned painting remain a mystery. The earliest reliable painting by him is dated 1280 (*Chung-kuo ku-tai*, 1963, pl. 59) and reflects a fully developed formulation of style and motif. The same horse and grooms were to appear in different combinations in other scrolls throughout Jen's career. It is remarkable to find that there is virtually no stylistic change or evolution in Jen's paintings of horses. The only perceptible change is the gradual maturing of his brushwork. Whether in an early or late work, he begins with a meticulously applied combination of preliminary drawing and washes, often in red color in the case of human figures. This first step is not a sketch, but the integral foundation for subsequent layers of subtly modulated washes and fine outline drawing that remains full-bodied despite its thin, wire-like appearance.

As time goes on, his washes become ever more subtle and his line drawing ever more substantial. In fact, at no time in his career does he allow his line drawing to become light and scratchy. Drapery lines never lapse into inarticulate patterns divorced from the intent to describe voluminous folds. Although he limits himself to the rearrangement of stock motifs in his horse painting, each figure and each horse is delicately characterized to evoke an individual personality.

Nine Horses is Jen Jen-fa's most spectacular surviving work. It was also once his most famous work, until somehow, probably in the sixteenth century, it was carried to Japan, where it inspired Kanō artists. Today the scroll lacks the colophons that once accompanied it, and there is only one seal prior to the twentieth century. Part of the history of the scroll can, however, be reconstructed.

It appears that the picture was not painted for a friend or on commission but was intended to remain in the family. The first record of the painting can be found in Yang Wei-chen's (1296-1370) *T'ieh-yai chi* (in *Yüan-shih hsüan*, 1694, *hsin-chi*, p. 34). Yang was well regarded in his day as an historian, essayist, poet, and calligrapher. Jen Po-wen, Jen Jen-fa's grandson and his most accomplished copyist, took the *Nine Horses* scroll to Yang and asked him to write a colophon. Yang responded with a poem and preface in praise of Jen Jen-fa. Yang's preface concludes with fulsome hyperbole: "Nowadays, method brought to perfection and inspiration fully completed are to be found in whatever the noble gentleman [Jen] paints. Had he lived during the K'ai-yüan era [713-741], one does not know whether he or Ts'ao Pa would have been ranked first. How can he just be placed on a par with Han Kan!"

The next traceable location of the scroll is the collection of the Mu family, whose founder, Mu Ying (1343-

1392), had been raised by Ming T'ai-tsu (r. 1368-97) and posthumously ennobled Prince of Ch'ien-ning, a rank which the family was allowed to keep in perpetuity but which also entailed responsibility for the supervision of defense and pacification in the Yünnan Defense Area. The Mu family seal, stamped in the lower left corner of the scroll reads: "Mu shih chen-wan." It should probably be associated with Mu Lin (d. ca. 1457-60), a fourth generation descendant of Mu Ying in the secondary line. The Mu family fortunes had been declining steadily; after the death of Mu Lin, interest in the collection of paintings seems also to have dwindled, for it was sold to two powerful eunuchs who later lived in Nanking.

The return of the scroll to the Chiang-nan region is an essential step in its transmission, for the next colophon known to have been attached to the picture was written by Wu K'uan (1435-1504), who never traveled to Yünnan. It is not known when Wu wrote the colophon, or for whom. Entitled "Jen Yüeh-shan's Picture of Nine Horses," the poem appears in Wu's collected works, *P'ao-weng chia-ts'ang chi* (earliest preface 1508, *ch.* 8, p. 69). The last colophon known to have been composed for the scroll was written by the eminent calligrapher Chu Yün-ming (1461-1527). Apart from its importance in reconstructing the history of the scroll, Chu's colophon is not otherwise noteworthy (Chu, *Chu shih chi-lüeh*, preface 1557, *ch.* 5, p. 654).

Nine Horses disappears from Chinese literary sources after Chu Yün-ming's colophon, only to reappear in eighteenth-century Japan in the form of a very accurate copy by three minor Kanō school painters. Contributing one section each, Kin Jūrō copied the opening; Hashimoto Eiki (d. 1794), the second section; and Yamamoto Ikyū, the third. Their copy is unpublished and is preserved in the Tokyo National Museum. The existence of the copy and its date confirm the genuineness of a certificate of authenticity written by Kanō Eigawa (1730-1790) that still accompanies the original *Nine Horses* scroll. MFW

Literature
Yang Wei-chen, *T'ieh-yai chi* (in *Yüan-shih hsüan*, 1694, *hsin-chi*), p. 34.
Wu K'uan, *P'ao-weng chia-ts'ang chi* (earliest preface 1508), *ch.* 8, p. 69.
Chu Yün-ming, *Chu shih chi-lüeh* (preface 1557), *ch.* 5, p. 654.
Nihon genzai Shina (1938), p. 85.
NG-AM Handbook (1973), II, 59.
Wilson, "Vision" (1973), pp. 232, 236, color pl. 1.

Nelson Gallery-Atkins Museum 72-8

Chang Wu, active 1335-65, Yüan Dynasty
 t. Shu-hou, *h.* Chen-ch'i-sheng; from Huai-nan, Anhui (?), active in Hangchou, Chechiang

96 *The Nine Songs*
(Chiu-ko t'u)

Handscroll, dated 1361, ink on paper, 28 x 438.2 cm.

7 colophons and 47 seals: 1 colophon, dated 1361, and 28 seals of Ch'u Huan (14th c.); 1 colophon, dated 1785, and 1 seal of Lu Shih-hua (1714-1779); 2 seals of Lu Yü-ch'ing (18th c.); 1 colophon, dated 1935, of Yeh Kung-cho (20th c.); 1 colophon, dated 1935, of Wu Hu-fan (20th c.); 1 colophon, dated 1938, and 1 seal of Wang T'ung-yü (1855-ca. 1940); 1 colophon, dated 1941, of Wu Hua-yüan (20th c.); 1 colophon, dated 1942, and 9 seals of Hsü Pang-ta (20th c.); 1 colophon, dated 1942, of Lang Ching-shan (20th c.); 1 colophon, dated 1944, of T'ang Yün (20th c.); 6 seals of Wang Chi-ch'ien (20th c.).

Text of *The Nine Songs* written by Ch'u Huan at the end of each section.

Colophon by Ch'u Huan:

In the foregoing is *The Nine Songs* from *Li-sao* based on the original of Lung-mien-shü-shih [Li Kung-lin] and painted by Chang Wu, *t.* Shu-hou of Huai-nan. The painting is a wonder unsurpassed in our time. It has

96 Detail

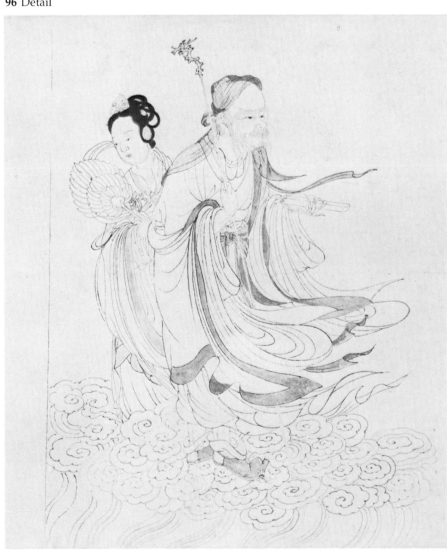

been in the family collection of…who has asked me to write the text. I therefore recorded this as above. Noted by Ch'u Huan of Honan on the first day of the third month of the *hsin-ch'ou* year, the twenty-first year of the Chih-cheng era [1361]. [3 seals] Ch'u Huan; Shih-wen-fu yin; Shih-hsüeh-chai.

Colophon by Lu Shih-hua:

This scroll is fortunate to have been handed down from collections of the right people. Now, after 500 years, its condition is as good as when it was painted. I acquired this from Mr. Shen Kuei-yü [1673-1769], the President of the Board of Rites. The label is in his handwriting when he was 95 years old. I submit that Ch'u Huan (*t*. Tzu-wen) of the Yüan Dynasty was a native of Ch'ien-t'ang. His "seal" and *li* writings are in the style of Wu Tsui. For example, in [Chu Kuei's] *Ming-chi-lu* [A list of masterpieces] is recorded the stele commemorating the restoration of the prefectural school of Kun-shan, the text of which was composed by Yang Wei-cheng in the twenty-first year of Chih-cheng [1361]; and the calligraphy as well as the title in *li* style was by Ch'u Huan, who was at that time an assistant judge of the prefecture of Hai-ning in the circuit of Hang-chou. Chang Wu's *tzu* is Shu-hou. His literary name is Chen-ch'i-sheng. According to [Ku Ying's] *Yü-shan-ts'ao-t'ang ya-chi*, he liked to paint in the *pai-miao* or the "pure delineation" style after the method of Li Lung-mien, which finds no peer among the ancient masters. This is agreed upon [by Pei Ch'iung] in his *Ch'ing-chiang-chi* who praised [Chang Wu] as being quite learned and well-versed in many branches of the arts, especially figure painting. Recorded by Lu Shih-hua [The mountain dweller], listening to the pine, in the twelfth month of the *yi-ssu* year [1785].

Remarks: Four handscrolls of the "Nine Songs" in *pai-miao* style are known to have been painted by Chang Wu. All are dated, or datable, and three still survive:

1. Version of 1346 (summer, sixth month) with text written in "seal" style by Wu Tsui and colophon by Chang Yü, with twenty-one figures in eleven sections (Collection of Shanghai Museum; cf. W. K. Ho, "Religious Paintings," 1980, p. 33).

2. Version of 1346 (winter, tenth month) painted for Yen Shih-hsien (*t*. Ssu-ch'i) with text written in *li* style by Wu Tsui and colophon by Ni Tsan (dated 1372), with twenty figures in eleven sections (Collection of Chilin Provincial Museum; cf. Hsieh Yung-mien, "T'an Chang Wu," 1977, pp. 64-68).

3. Version of 1356 painted for Chou Ke-fu (Tsung-jen, son of Chou Po-ch'i) with text written in "seal" style by Chou Po-ch'i (1298-1369) and colophon by Pei Ch'iung, with twenty-one figures in ten sections (now lost; cf. Pei Ch'iung, *Ch'ing-chiang chi*, late 14th-early 15th c., ch. 23, pp. 1-3).

4. Version of 1361 with text written in *li* style by Ch'u Huan (active mid-14th century) and colophon by Lu Shih-hua, with twenty-one figures in eleven sections (the Cleveland painting).

Although varied in composition and in the representations of individual figures, these four versions are supposedly based on a common model – Li Kung-lin's *Nine Songs* of the so-called "Shih Ming-ku type," which is characterized by the omission of any elaborate landscape and architectural settings (one ex-

ample of this type can be found in the Heilungchiang Provincial Museum, ex. coll. Sun Ch'eng-tse). The history of these four versions and their relations with Li Kung-lin's original are much too complicated to be discussed here. For a relatively complete reference, two books and one article are useful: Jao Tsung-i, *Ch'u-tzu shu-mu* (1956); Chiang Liang-fu, *Wu-chung* (1961); Ah Ying, "Ch'ü Yüan" (1957, pp. 309-17).

Among these four versions, only one (the Chilin Museum version) is signed by Chang Wu. Authenticity of the signature on the Shanghai Museum scroll has been questioned. The Cleveland scroll is also unsigned, and the painter is identified in the colophon by the well-known calligrapher, Ch'u Huan. The colophon was dated to the year 1361, when Ch'u Huan was serving in the prefectural government of Hai-ning in the Circuit of Hang-chou as *P'an-kuan*, a staff supervisor especially in charge of local law enforcement. A month earlier, in February of 1361, Ch'u Huan was known to be in Chiating, Chiangsu Province, to do the calligraphy for a stele commemorating the restoration of the prefectural school (*Chiang-su Chin-shih chih*, compiled 19th c., *ch*. 24, pp. 9-13). Earlier in January of that same year, Ch'u Huan was in the neighboring town of Kun-shan to do the calligraphy for a similar stele commemorating the restoration of the local Confucian temple (Chu Kuei, *Ming-chi lu*, 16th c., *ch*. 1, pp. 17, 18).

Since both Ch'u Huan, the calligrapher, and Chang Wu, our painter, were frequent guests in the literary gatherings at the Jade Mountain Retreat of Ku Ying (*t*. Chung-ying, 1310-1369), the prominent art patron and connoisseur of the Kun-shan district, it is not impossible that the two artists had collaborated in the spring of 1361 to create the Cleveland scroll at the request of their host. Another possibility is that Ch'u Huan was asked to write the text for a painting by Chang Wu completed slightly before 1361. In either case, these speculations provide possible explanations for the eradication of the name of the original owner of the scroll in Ch'u Huan's colophon. As we know, Ku Ying, one of the wealthiest titled landed gentry in the area, had become a natural target for the political persecution at the turn of the Ming Dynasty. Together with many of his scholars and artist friends, he was exiled to Lin-hao (Hao-liang) in Anhui Province and died there in lonely bitterness. His name, of course, would have been too much of an inconvenience for the new owner.

Although unsigned, the individual style of Chang Wu is unmistakable in the Cleveland painting. A comparison of the 1346 version in the Shanghai Museum shows exactly the same elegant handwriting of the artist – the underlying preparatory sketches in pale ink, the characteristic tonal nuances in his brushstrokes, the double delineation of his waves and clouds, the beautifully and firmly controlled linear patterns of his "floating clouds and flowing water" drawing. All these are almost identical in both scrolls despite the fact that their executions were fifteen years apart and that the earlier work in Shanghai displays a much more pronounced fidelity to the manner of Li Kung-lin. In this connection, the later example in Cleveland is much more spontaneous and provocative, representing the *pai-miao* style of the Sung-Yüan period at its most accomplished and mature.

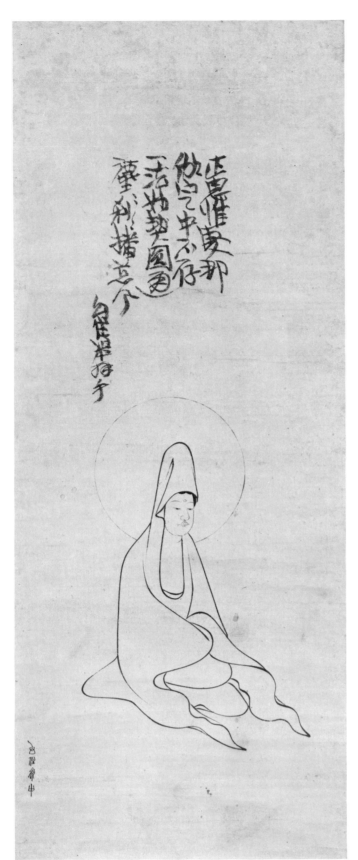

A faithful copy of the Cleveland scroll has been made by Hsü Pang-ta of the Palace Museum, Peking, and reproduced several times in mainland publications (Cheng Chen-to, ed., *Ch'u-tz'u t'u,* 1953; Hsü Pang-ta, *Chiu-ko t'u,* 1956). WKH

Literature

Lu Shih-hua, *Wu- Yuëh* (preface 1776), *ch.* 3, pp. 6(a)-6(b).
Ch'en J. D., *Ku-kung* (1956), p. 14(b).
Sirén, *Masters and Principles* (1956-58), IV, 36; VI, pls. 44, 45; VII, *Lists,* 100.
Cheng Chen-to, *Chung-kuo ku-tai* (1963), pl. 63 (detail).
Goepper, *Essence* (1963), pp. 60, 61, 100, 101, pls. 10, 11.
Yabe, "Dragon Motives" (1971), p. 19, fig. 11 (detail).
Barnhart, "Survivals, Revivals" (1972), p. 174, fig. 21.
Toynbee, *Half the World* (1973), p. 155 (detail).
Kawakami et al., *Ryō Kai, Indara* (1975), figs. 4-7, supp. pl. 25.
Cahill, *Hills* (1976), pp. 153, 154, pl. 70.
CMA *Handbook* (1978), illus. p. 346.
Oertling, "Ting Yün-p'eng" (1980), pp. 170, 180.

Exhibitions

Nanking Art Gallery, 1937: *Chiao-yü-pu,* I, cat. no. 75.
Palazzo Ducale, Venice, 1954: Dubosc, *Mostra,* cat. no. 785.
Haus der Kunst, Munich, 1959: *1000 Jahre,* cat. no. 36.
Cleveland Museum of Art, 1960: Chinese Paintings, no. catalogue.
Cleveland Museum of Art, 1968: Lee and Ho, *Yüan,* cat. no. 187.
Asia House Gallery, New York, 1974: Lee, *Colors of Ink,* cat. no. 15.

Recent provenance: Wang Chi-ch'ien.

The Cleveland Museum of Art 59.138

Chüeh-chi Yung-chung, thirteenth-fourteenth century, Yüan Dynasty
Inscription by Chung-feng Ming-pen, 1263-1323, Yüan Dynasty

97 *White-Robed Kuan-yin*
(Pai-i Kuan-yin)

Hanging scroll, ink on paper, 78.7 x 31.7 cm.

Artist's signature: Huan-chu Yung-chung.

Inscription by Chung-feng Ming-pen:

The right thinking [*Samkalpa*] is embodied within
His deep meditation on the Buddha [*naga-samadhi*].
Retaining not even one single object of thought,
A perfect harmony was wonderfully achieved.
In the endless time and space,
His all-embracing compassion prevails.

[signed] Ming-pen of Huan-chu paying his respects.

Remarks: This painting was first introduced to the West in 1968 by Teisuke Toda of Tokyo National University in a paper delivered at the Yüan Symposium in Cleveland. It has since become famous among students, partly because it is graced by an inscription by Chung-feng Ming-pen, probably the most widely respected and influential Ch'an master in the Yüan Dynasty, and partly because it is one of the rare examples of Chinese Ch'an paintings where the artist signed his work. The inscription gives no date, consequently it is uncertain whether the painting was made between 1301 and 1302 or between 1302 and 1323 (the death date of Chung-feng). In either case, the suggested dates are related to the history of Huan-chu An (The Ch'an Retreat of Illusionary Existence).

According to an essay by Sung Lien ("Wu-men ch'ung-chien Huan-chu ch'an-an chi," in *Sung Hsueh-shih ch'uan-chi*, late 14th c., supplement I, 1206, 1207) commemorating the rebuilding of the Retreat in 1368, the Retreat was established in 1300 by Chung-feng Ming-pen. The master

was then thirty-eight years old when he came to Suchou and fell in love with a piece of secluded woodland outside of the city gate, Ch'ang-men. He was overjoyed to learn that the village was called Yen-tang (The Wild Geese Pond) – the same name as a place in Chechiang that was the sacred mountain of No-chü-lo (Nakula), the fifth of the sixteen great arhats. As this was considered an auspicious omen for the spreading of Buddha's law, the land was immediately donated by its owner and a small monastery was built, consisting initially of only three thatched huts. Within a year the name "Huan-chu" had become so widely known that some of the best Buddhist scholars came from all over the country to seek instructions. Among them was Chüeh-chi Yung-chung, our painter. Two years later, in 1302, Master Chung-feng was invited to head the monastery Ta-chüeh-cheng ssu at Mt. T'ien-mu. He decided instead to flee and hide in Nan-hsü (Chenchiang, Chiangsu). Subsequently, his followers who had gathered in Suchou began to drift away, except for Yung-chung and one of his fellow disciples, who chose to remain to take care of the Huan-chu An, until he died – around 1300.

It is conceivable that this painting could have been done before the departure of the master in 1302 – the inscription does sound a little like farewell advice from a teacher. On the other hand, it would have been more appropriate and deferential for our painter to wait a little while before signing his name as "Yung-chung of Huan-chu" when he actually took charge of the Retreat after 1302.

There must be no more direct and effective pictorial means of expression than the *pai-miao* technique that can better convey the idea and feeling underlying the inscription by Chung-feng ming-pen. By reducing these pictorial means to the barest minimum, retaining only what is absolutely essential, "a perfect harmony is wonderfully achieved" between the contour lines and the interior void of the figure, which complete and illuminate each other. At the same time, a most delicate and assured control was exercised over the delineation, which moves deliberately in a studied pace with an even thickness to create one of the most elegant images ever conceived for the White-Robed Kuan-yin – simple, serene, and completely self-contained. It is this deceptive simplicity that moved one critic to compare the Cleveland painting with a woodblock print (see Toshio Ebine's note on fig. 90, in Kawakami et al., *Ryō Kai, Indara*, 1975, p. 161). And indeed he is probably right. We agree that if there was any model for this painting, it would most likely be either a print or a rubbing based on the design of a Sung master.

An interesting comparison can be found in a stone carving of a White-Robed Kuan-yin dated 1132 of Southern Sung and purportedly based on a rubbing by Li Kung-lin, now in Liu-ho-t'a (Pagoda of the Six Harmonies) at Hangchou (Tokiwa and Sekino, *Chūgoku bunka shiseki*, 1975, IV, pl. 52). Although the Sung carving was not by an expert artisan and was much cruder, its similarity to the Cleveland scroll is still quite striking. As a matter of fact, this is certainly not the only example. I would like to suggest that some ink paintings by amateur Ch'an monks, in China and in Japan, probably had similar models; and the delightfully refreshing originality or naiveté of their styles might not have been the result of any conscious efforts, but rather the happy misunderstanding or an over-literal translation of a rubbing or woodblock print (compare, for example, the *Avalokiteśvara Holding a Willow Branch* in the Koto-in, Kyoto, with a rubbing attributed to Wu Tao-tzu in the Pei-lin [Forest of Steles],

Hsian). Nevertheless, regardless of the real source of his design and inspiration, the early fourteenth-century artist-monk Yung-chung is still to be admired for giving us a classic example for a sometimes abused medium of expression – a "pure line drawing" at its purest. WKH

Literature
Kawakami et al., *Ryō Kai, Indara* (1975), p. 117, pl. 90.
Exhibitions
Yamato Bunkakan, Kyoto, 1974: *Kannon no kaiga*, p. 14.
Recent provenance: Yamanaka & Co.

The Cleveland Museum of Art 78.47

Yin-t'o-lo, active ca. mid-fourteenth century, Yüan Dynasty
t. Jen-fan; active in Pien-liang (K'aifeng), Honan Province

98 *The Second Coming of the Fifth Patriarch (Wu-tsu chai-lai t'u)*

Section of a handscroll mounted as a hanging scroll, ink on paper, 32.7 x 45.5 cm.

Artist's seal: Jen-yen tung-li t'ao-hua-yüan, wei-pi jen-chien yu tz'u-chih (People say in the Immortal's grottos the peach blossoms are blooming in the warmth of spring. I wonder if such flowering branches ever exist in our world).

1 inscription and 1 additional seal: Ch'u-shih Fan-ch'i (1297-1371).
Poem of Ch'u-shih Fan-ch'i:

This boy has no father, only a mother,
Master of Ch'an, please don't ask him when he was born –
The green pine is not yet old, and the yellow plum is ripe.
Two lives are but like fleeting moments of a dream.
[seal] Ch'u-shih.

WHK

Literature
Horizon, Arts, (1969), illus. pp. 126, 127.
Lee, "To See Big within Small" (1972), p. 317, pl. 57; idem, "Zen in Art" (1972), pp. 244-47, figs. 6, 6a.
Kawakami et al., *Ryō Kai, Indara* (1975), p. 137, pl. 114.
CMA *Handbook* (1978), illus. p. 345.

Exhibitions
Osaka Art Club, 1960: *Daibei*, cat. no. 6.
Cleveland Museum of Art, 1968: Lee and Ho, *Yüan*, cat. no. 208.
Asia House Gallery, New York, 1974: Lee, *Colors of Ink*, cat. no. 18.

Recent provenance: Masuda Family; Setsu Gatodo.

The Cleveland Museum of Art 67.211

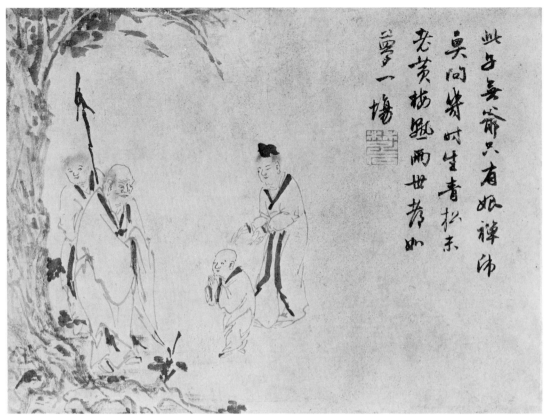

Artist unknown, fourteenth century, Yüan Dynasty

99 *Bodhidharma Crossing the Yangtze on a Reed (Ta-mo i-wei tu-chiang)*

Hanging scroll, ink on paper, 89.2 × 31.1 cm.

Poem and 2 seals of Liao-an Ch'ing-yü (1288-1363).

Poem by the priest Liao-an Ch'ing-yü:

Wind rises from the reed flowers, the waves are high,
It's a long way to go beyond the cliff of the Shao-shih mountain,
Above the worlds of kalpas a flower is opening into five petals,
So that your barefoot heels are just fine for the whipping rattans.

<div align="right">WKH</div>

Literature
Yonezawa, "Dharma" (1961), pp. 79, 80, pl. 8.
Lee, "Zen in Art" (1972), p. 247, fig. 5.
Akiyama et al., *Chūgoku bijutsu* (1972), I, pt. 1, 242, 243, color pl. 59.
Toda, *Mokkei, Gyokukan* (1973), p. 100, pl. 59.
M. Fong, "Probable Second 'Chung Kuei'" (1977), p. 435, fig. 14.
Zainie, "Sources" (1978), pp. 241-44, figs. 10, 12.
CMA *Handbook* (1978), illus. p. 346.
Oertling, "Ting Yün-p'eng" (1980), p. 236.

Exhibitions
Asia House Gallery, New York, 1963: Lee, *Tea Taste*, cat. no. 3.
Cleveland Museum of Art, 1968: Lee and Ho, *Yüan*, cat. no. 209.
Asia House Gallery, New York, 1974: Lee, *Colors of Ink*, cat. no. 24.

Recent provenance: N. V. Hammer.

The Cleveland Museum of Art 64.44

Artist unknown, thirteenth century, late Southern Sung to early Yüan Dynasty

100 *Waiting for the Ferry in the Chill of Winter (Han-chiang tai-tu)*

Album leaf, ink on silk,
22.2 x 25.1 cm.

1 seal of Shen Chou (1427-1509).

Remarks: The painting which has evidently been used as a fan, is a highly accomplished and sensitive work in the Li Ch'eng-Kuo Hsi tradition, close to the Southern Sung treatment of the style. Obviously, it is at variance with the mannered and at times heavy-handed way in which the style was employed by such archaistic Yüan Dynasty artists as T'ang Ti (1296-1364).

<div align="right">KSW</div>

Literature
NG-AM Handbook (1973), II, 60.

Exhibitions
China House Gallery, New York, 1970: Wang Chi-ch'ien, *Album Leaves*, cat. no. 54.

Nelson Gallery-Atkins Museum 46-52

Lo Chih-ch'uan, died before 1330, Yüan Dynasty
From Lin-chiang, Chianghsi Province

101 *Ramblers over a Windy Stream (Hsi-ch'iao ts'e-chang)*

Album leaf, ink on silk, 24.3 × 25.1 cm.

Artist's seal: Chih-ch'uan (partially obliterated but readable).

2 additional seals: 1 of Tuan-fang (1861-1911);
1 unidentified.

Remarks: A large hanging scroll by Lo Chih-ch'uan, *A Flock of Crows Returning to the Wintry Grove (Han-lin*

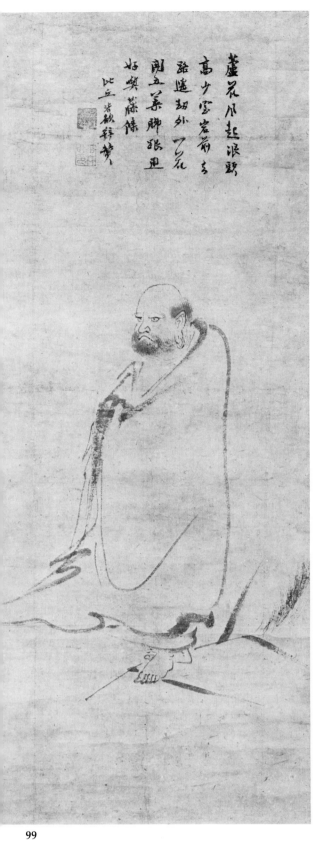

蘆花風起浪頭
高少室巖前言
路遙劫外別花
開五葉聯芳里
好繼藤像
比丘嗣敏釋夢

99

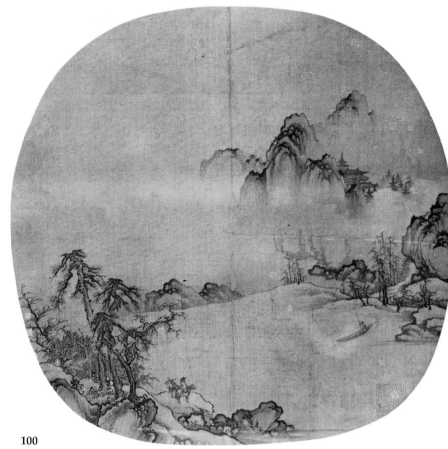

100

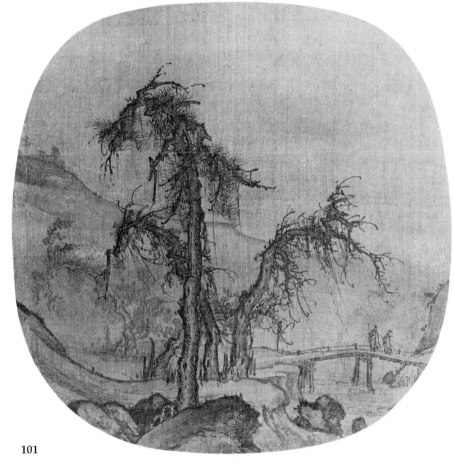

101

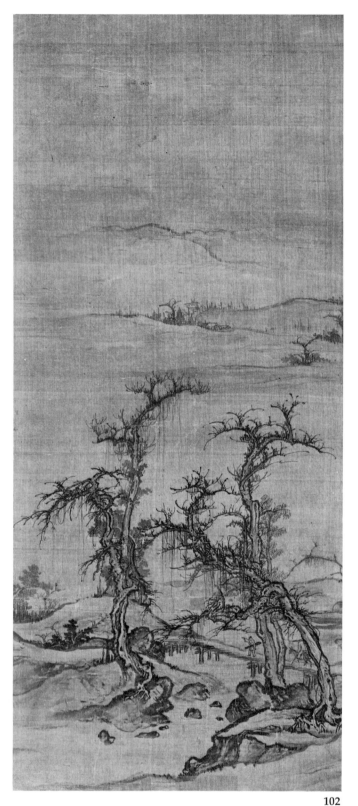

102

kuei-ya, or otherwise known as *Ku-mu han-ya),* ink on silk, was once in the early-Ming collection of Yüan Chung-ch'e (1376-1458). Badly restored and retouched in parts, and never published, it is now in a private collection, New York City. WKH

Literature
Lee, "Scattered Pearls" (1964), no. 11; idem, "To See Big within Small" (1972), p. 317, figs. 51, 52.

Exhibitions
Cleveland Museum of Art, 1968: Lee and Ho, *Yüan,* cat. no. 215.
China House Gallery, New York, 1970: Wang Chi-ch'ien, *Album Leaves,* cat. no. 55.
Asia House Gallery, New York, 1974: Lee, *Colors of Ink,* cat. no. 22.

Recent provenance: John C. Ferguson; John Huntington.

The Cleveland Museum of Art 15.536

Lo Chih-ch'üan (attributed to)

102 *Carrying a Ch'in on a Visit*
(*Hsieh-ch'in fan-yu t'u*)

Hanging scroll (now paneled), ink on silk, 81.2 × 35.2 cm.

WKH

Literature
Ho, Iriya, Nakada, *Kō Kōbō, Gei San* (1979), p. 177, pl. 82.

Exhibitions
Cleveland Museum of Art, 1968: Lee and Ho, *Yüan,* cat. no. 218.
Asia House Gallery, New York, 1974: Lee, *Colors of Ink,* cat. no. 23.

Recent provenance: Yamanaka & Co.

The Cleveland Museum of Art 19.974

Artist unknown, fourteenth century, Yüan Dynasty

103 *Fishing in the Chill of Autumn*
(*Ch'iu-shuang yü-p'u*)

Hanging scroll, ink and light color on silk, 116.8 × 56.2 cm.

11 spurious seals: 1 of Emperor Li-tsung of Sung (r. 1224-64); 1 of Chia Ssu-tao (1213-1275); 1 of Chu Kang (1358-1398) or Chu Chung-hsüan (15th c.); 1 of Sung Lo (1634-1713); 2 of An Ch'i (1683-ca. 1746); 5 of the Ch'ien-lung emperor (r. 1736-95).

Remarks: The painting follows, in a general way and with certain fourteenth-century mannerisms, the traditional style of Li Ch'eng, to whom the painting was once attributed. To quote Wai-kam Ho, "This apparently is a Yüan Dynasty variation of the Sung theme *Han-lin yü-fu.* One of the most popular compositions for this theme was supposedly derived from a famous painting attributed to Li Ch'eng, the great master of the tenth century. Its numerous versions usually bear the collection seal of Chao Ssu-tao (1213-1275) "

LS/KSW

Literature
Dōnomae, "Ri Ei-kyu" (1942), pp. 21-26.

Exhibitions
Cleveland Museum of Art, 1968: Lee and Ho, *Yüan,* cat. no. 221.

Nelson Gallery-Atkins Museum 46-55

Li Shih-hsing, 1283-1328, Yüan Dynasty
t. Tsun-tao, *h.* Hsi-shan-tao-jen; from Chi-ch'iu,
Hopei Province

104 *Old Trees by a Cool Spring*
(Ch'ing-ch'üan ch'iao-mu)

Hanging scroll, dated 1326, ink on silk, 165.7 ×
108.6 cm.

Artist's inscription, signature, and 3 seals: In the
twelfth month of winter, in the *ping-yin* year of the
T'ai-ting era [1326], Li Shih-hsing, Tsun-tao, of
Chi-ch'iu did this. [seals] Li Shih-hsing yin; Li
Tsun-tao shih; Yu-hsi-han-mo.

1 additional inscription and 3 additional seals: 1 in-
scription and 1 seal of Shen Meng-lin (mid-14th c.); 2
seals of Prince I (d. 1730).

Remarks: The epitaph of Li Shih-hsing by Su T'ien-
chüeh (1294-1352) provides the basic biographical
information for the artist: "[Li Shih-hsing] was a
son of the former Grand Academician of the Chi-
hsien-yüan, Wen-chien [Li Kan's posthumous title]
of Chi-ch'iu. Gifted with superior intelligence, he was
fortunate to be able to meet some of the *i-lao* [the
left-over elders] of the previous dynasty, during the
times when his father was serving in the provincial
governments of Wu and Yüeh. Among these elders,
Chao Meng-fu of Wu-hsing and Hsien-yü Shu of
Yü-yang were the ones with whom he had studied
regularly and continuously. As a result, his poetry,
calligraphy, and painting all have acquired the manner
and special flavor of his seniors. In those days, the
court nobles and high officials were biased toward
people with clerical or professional skills and disliked
Confucian scholars. Having met with no success in the
prime of life, he turned his interest to travelling to the
famous mountains to study 'the ultimate truth' with
Buddhist monks and was greatly enlightened. Some
time later, he began to enjoy himself with brush and
ink. Whenever he was sailing in the rivers and lakes,
and saw bamboo groves, old trees, half-sunken islets,
or crumbling cliffs, he would moor his boat, open
windows, and engage himself in quiet contemplation
or a leisurely walk. His mind was thus in constant
communion with the surroundings, and happily took
pleasure in all that was pleasurable.

"During the reign of Emperor Jen-tsung (r. 1311-20),
art and literature were respected and promoted. Li
Shih-hsing's name was presented to the throne by
some of the court officials and an imperial emissary
was sent to summon him to court. In the audience, Li
Shih-hsing presented his painting, the *Ta-ming-kung
Palaces.* The emperor was highly pleased and compli-
mentary of his talents and ordered the State Council
to give him a grade-5 position in the government.
Hence he was close to the throne, serving in the impe-
rial entourage together with [another painter] Shang
Ch'i, the reader-in-waiting at the Chi-hsien-yüan.

"When the time came for his father, Wen-chien (Li
K'an), to retire to Wei-yang (Yang-chou), Li Shih-hsing
was especially appointed Prefect of Ssu-chou so he
could accompany and attend to his father. He was
later transferred to administer the prefecture of
Huang-yen-chou. This happened at a time when the
district had been suffering from prolonged drought.
He prayed in a cold, dried ditch and the rain came,

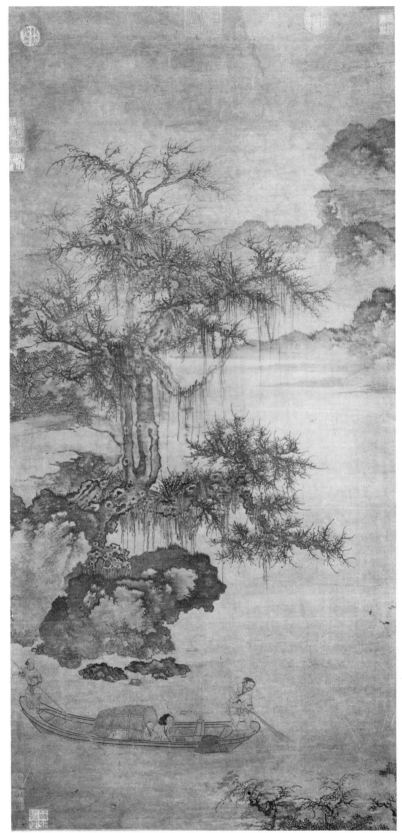

103

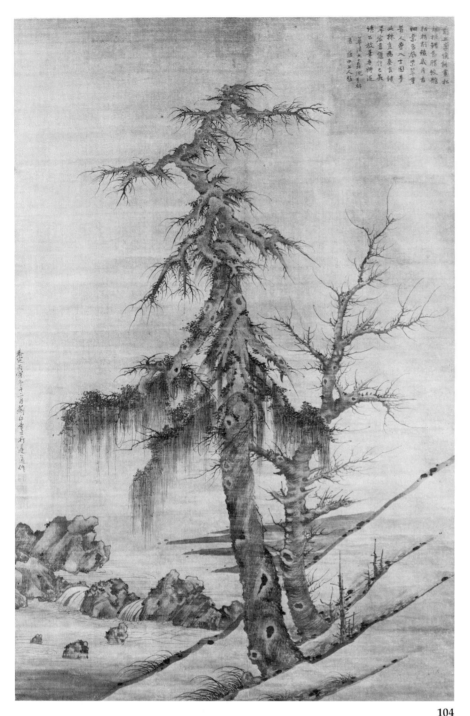

104

in the first year of the T'ien-li era [1328]...." (Su T'ien-chüeh, *Tzu-hsi wen-kao*, 14th c., *ch.* 19, pp. 7, 8).

Two things are of particular interest to the historians. First, while the age of Li Shih-hsing is given as forty-seven in the epitaph, it was forty-six according to a colophon by Kuo Pi (1280-1335) on a handscroll by Li entitled *Chiang-hsiang chiu-wan* (*Late Autumn at the River Village*, National Palace Museum, Taipei; *Ku-kung shu-hua lu*, 1965, IV, 14.) Since the epitaph was commissioned thirteen years after the burial, and since the colophon was written only two months after Li's death by one of his best friends, I am inclined to accept Kuo Pi's statement and put the birthdate of Li Shih-hsing at 1283, one year later than what has been commonly accepted. Secondly, while the epitaph simply says that Li Shih-hsing "died on his way" to Nanking, the cause of his death is omitted deliberately. A glance at Kuo Pi's poem on the scroll in Taipei (see accompanying reference) reveals that Li Shih-hsing was actually drowned in a flash flood:

Summer rainstorm poured down in torrents,
Raging waves suddenly surged up, flooding the
flat fields.
You were travelling on the highway of Tung-yüan;
The poor, feeble horse refused to move despite
whipping.
So the Earth Spirit was in a fit of bizarre madness,
And took away our "moon-catching immortal."
Unfair indeed for this master of brush and ink,
To find himself at the bottom of water forever asleep.
Good and bad deeds were thus wrongly rewarded;
Who would join me in demanding an answer from the
blue sky above?
From the cup of our life-long friendship
Not a drop can reach the other world of "the Yellow
Spring."
A man who passed away cannot be raised again,
My tears flow upon seeing this painting.
Wide rivers, in a night of rainbow and moon,
Where have you gone–your "Mi family boat" [of
calligraphy and paintings]?

I make a note here of this tragic accident of Li Shih-hsing, not only because it has somehow escaped the notice of almost all later historians but also because it bears witness to the formation of a fourteenth-century legend, hitherto unsuspected. In Yüan literature, no less than twenty poems can be found eulogizing the death of Li Shih-hsing, which far exceeds the number devoted to the memory of any other artist, with the sole exception of Chao Meng-fu. But as time went by, the cause of his death had become obscure and mythicized. By the time some of these poems were collected by the Taoist patriarch Wang Shou-yen (cf. Chu Ch'uan-li, *Shan-hu mu-nan*, late 16th c.), the manner and location of Li's death had already been distorted into something comparable to the fabled story of Li Po, who in the ecstasy of intoxication was said to have fallen into the river (at Tsai-shih-chi, a place not far from Li's accident) for wanting to catch the moon in the water–thus becoming an immortal. Indeed, in many of these Yüan poems, Li Shih-hsing was referred to as "the Immortal," a rare honor reserved for only four or five of the great geniuses in Chinese history, such as Li Po, Su Shih, Mi Fu, and Chao Meng-fu.

That such a romantic tradition was perpetuated, apparently intentionally, by so influential a Taoist leader as Wang Shou-yen of the diocese of Hangchou,

and the harvest of the year was bountiful. He was dispatched by the provincial government [Hsing Chung-shu-sheng] to Fuchien to make a census of prisoners and stayed there for more than a year. When he returned to his post, an inspector from the commission of surveillance had just arrived at the prefecture; he was terribly harsh in his fault-finding. Li Shih-hsing was unhappy. He soon resigned on excuse of illness. Meanwhile, having heard that the [future] Emperor Wen-tsung was enfeoffed [as the future heir-presumptive] with the seat [of his principality] at Chien-yeh [Nanking], and that the prince liked to receive and patronize men of letters, Li Shih-hsing decided to go to see him. He died on his way, at the border of the Shang-yüan district. His age was forty-seven. This was the first day of the sixth month

and that the historical image of Li Shih-hsing was presented in such a sequence of transformation – from a Confucian scholar to a Buddhist disciple, and finally a "moon-catching" Taoist immortal – are hardly accidental. It should be remembered that ideological and religious eclecticism was characteristic of the period. Li's father, Li K'an, for example, was considered a typical personification of the "unification of the Three Doctrines." In rhymed prose dedicated to Li K'an's famous studio, Shih-chai, the scholar Tai Piao-yüan (1244-1310) lauded the elder artist from Chi-ch'iu with the following words: "He is neither a hermit nor purely a government official; neither is he merely a Confucian nor is he merely a Taoist. As his spiritual wisdom and power have already transcended the material universe, his fame and accomplishments are still part of the mundane world" (*Yen-yuan-chi*, late 13th-early 14th c., *ch.* 21, p. 320.)

Such ideological congeniality and other family resemblances between Li K'an and Li Shih-hsing had been compared by Yüan and early Ming critics (e.g., Wang Wei, *Wang Chung-wen-kung chi*, late 14th c., *ch.* 13, p. 352) with Mi Fu and Mi Yu-jen. This comparison, however, often leads to the mistaken belief that the sons were direct and faithful descendants of their fathers in terms of artistic heritage. While this may be true to a certain extent, it will be more accurate, indeed more instructive, to consider Li K'an and Li Shih-hsing as artists from separate categories whose specialities were quite different from each other. Li K'an was a master of ink bamboo par excellence, a true successor of the Hu-chou school of Wen T'ung (1018-1079); Li Shih-hsing, on the other hand, was basically a specialist of the genre of *sung-shih* (pine trees and rocks) as well as *ku-mu chu-shih* (old trees, bamboo, and rocks) in the Li Ch'eng tradition modified by his teacher, Chao Meng-fu.

This observation was fully supported by contemporary opinions in the fourteenth century. In a poem on a wall painting by the lesser-known artist Mao Tse-min, the late-Yüan critic Yüan Hua (b. 1316) elucidated on the evolution of *sung-shih* tradition as follows: "Among the ancient masters of pine tree paintings who can be classified as 'from wondrous to inspired,' Pi Hung, Wei Yen, and Chang Tsao (all of the T'ang Dynasty) were outstanding. During the three hundred years of the Sung period, there was only one Li Ch'eng, whose rocky path leads to the misty forest in a heightened sense of spatial depth. In the recent age, the Duke Wen-min [Chao Meng-fu] was universally acclaimed as champion [of the school], followed by the minister [Kao K'e-kung] with his monumental compositions of cloudy mountains. Then later came the artist Li [Shih-hsing] of the prefecture of Huang-yen, whose tall bamboo groves and old trees were set against the overlapping contours of low hills."(*Keng-hsüeh-chai shih-chi*, 14th c., *ch.* 7, pp. 18, 19).

Here Li K'an was conspicuously excluded from the list of specialists. Some of the landscape elements underlying a parallel development with genre such as the mist-enveloped "wintry forest" of the Sung period, the revival of larger formats for the cloudy mountains in late thirteenth and fourteenth centuries, and the low, round-topped hills in a "level distance" landscape, are all duly noted in this poem. Since the late Chin and early Yüan periods, realistic elements derived from actual scenes were sometimes injected into

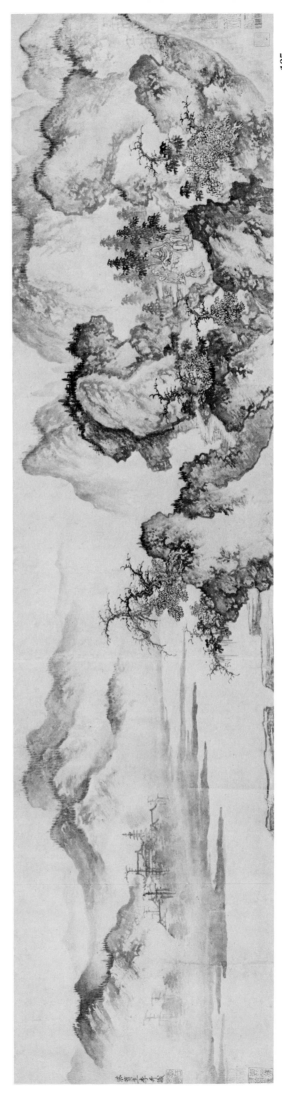

the theme, adding a certain sensuous delectation to the timeless universality of the symbolic meanings.

Among the old-tree paintings attributed to Li Shih-hsing, more than one are representations of the twin junipers by a stream in the vicinity of the monastery Ling-yin-ssu in Hangchou (Fu Yüeh-chin, *Fu Yü-li shih-chi*, 14th c., *ch.* 3, p. 10; Li E, *Yun-lin-ssu chih*, 18th c., *ch.* 6, p. 16). Although unspecifically titled, the Cleveland scroll may well be one of these paintings.

The Cleveland scroll bears a large seal of Prince I, the thirteenth son of the K'ang-hsi emperor, whose personal name was Yün-hsiang (1686-1730). An additional collection seal on the lower right corner of the hanging scroll, reading "Ming-shang-t'ang chien-tsang shu-hua yin-chi," not only confirms the provenance but also suggests that the painting probably entered that famous collection at the time of the second generation Prince I (Hung-hsiao, d. 1778), who was the most active and respected connoisseur of the family.

A second undated version of this painting in the collection of the Fogg Art Museum, Cambridge, Massachusetts (Lee and Ho, *Yüan*, 1968, cat. no. 225), also bears a similar official seal of Prince I on its upper center. But the lack of the supportive seal of "Ming-shang-t'ang" tends to leave some doubt as to its history. WKH

Literature
CMA *Handbook* (1978), illus. p. 346.

Exhibitions
Asia House Gallery, New York, 1974: Lee, *Colors of Ink*, cat. no. 11.

Recent provenance: A. W. Bahr; Ellsworth & Goldie.

The Cleveland Museum of Art 70.41

Li Sheng, active ca. mid-fourteenth century, Yüan Dynasty
t. Tzu-yün, *h.* Tzu-yün-sheng; from Feng-yang, Anhui Province

105 *Buddha's Conversion of the Five Bhiksu (Fo tu wu-pi ch'iu t'u)*

Handscroll, ink on paper, 29.2 × 110.5 cm.

Artist's signature and seal: Tzu-yün-sheng, Li Sheng signed. [seal] Li Tzu-yün shih.

4 colophons and 12 additional seals: The "Heart" Sutra (*Mahā Prajñāpāramitā*) text written by Wu Yü-ch'ing (early 15th c.); 2 seals of Hsü Ch'ien-hsüeh (1631-1694); 3 colophons, one dated 1929 and two dated 1936, and 9 seals of Wu Hu-fan; 1 colophon, dated 1932, of Ch'en Tieh-yeh; 1 seal unidentified.

 WKH

Literature
Ho, Iriya, Nakada, *Kō Kōbō, Gei San* (1979), p. 177, pl. 83.

Exhibitions
Cleveland Museum of Art, 1968: Lee and Ho, *Yüan*, cat. no. 222.

Recent provenance: Wu Hu-fan; Wang Chi-ch'ien.

Intended gift to The Cleveland Museum of Art, Mr. and Mrs. A. Dean Perry

105 Detail

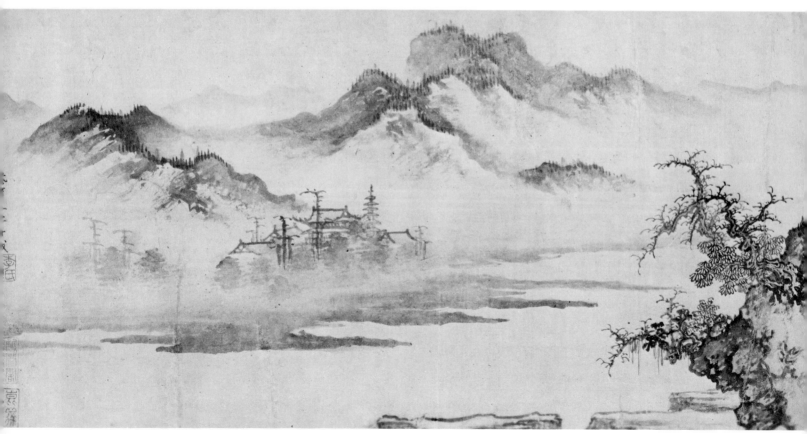
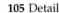

Chao Yung, 1289-ca. 1360, Yüan Dynasty
t. Chung-mu (son of Chao Meng-fu); from
Wu-hsing, Chechiang Province

106 *Fisherman-Hermit in Stream and Mountain
(Ch'i-shan yü-yin)*

Hanging scroll, ink and color on silk, 86.5 × 42.5 cm.

Artist's seal: Chung-mu.

3 additional seals of Chang Heng (1915-1963).

WKH

Literature
Harada, *Shina* (1936), pl. 269.
Cheng Chen-to, *Yün-hui-chai* (1947), pl. 12.
Sickman and Soper, *Art and Architecture* (1956), p. 151,
pl. 113.
Sirén, *Masters and Principles* (1956-58), VII, *Lists*, 105.
Lee, *Chinese Landscape Painting* (1962), p. 47, no. 27.
Sullivan, *Chinese and Japanese* (1965), p. 68, fig. A.

Exhibitions
Tokyo National Museum, 1931: *Sō-Gen-Min-Shin*, I, 34.
Cleveland Museum of Art, 1954: Lee, *Chinese Landscape
Painting*, cat. no. 27.
Royal Ontario Museum, Toronto, 1956: Tseng, *Loan
Exhibition*, cat. no. 10.
Cleveland Museum of Art, 1968: Lee and Ho, *Yüan*, cat.
no. 229.

Recent provenance: Chao Shih-kang; Chang Heng; C.T. Loo
& Co.

Intended gift to The Cleveland Museum of Art,
Mr. and Mrs. A. Dean Perry

Sheng Mou, active ca. 1330-69, Yüan Dynasty
t. Tzu-chao; from Chia-hsing, Chechiang Province

107 *Enjoying Fresh Air in a Mountain Retreat
(Shan-chü na liang)*

Hanging scroll, ink and color on silk, 120.9 ×
57 cm.

Unsigned; 2 artist's seals: Sheng Mou; Tzu-chao.

1 colophon and 3 additional seals: 1 colophon, on
the mounting above, and 1 seal of Tung Ch'i-ch'ang
(1555-1636); 1 seal of Li Tso-hsien (d. 1876); 1 seal
unidentified.

Remarks: The picture does not bear the signature of
the artist, but two of his seals have been impressed,
one above the other, on a bank at the lower left edge
of the painting. The only other seal of interest appears
in the lower right corner and belongs to the distin-
guished nineteenth-century collector Li Tso-hsien
(d. 1876), who not only recorded the picture in his
catalogue, *Shu-hua chien-ying* (1871, *ch*. 20, pp.
17b-18a), but also seems to have provided the present
label on the outer wrapper. Li's account is sufficiently
detailed to leave no doubt about the identification be-
tween *Enjoying Fresh Air in a Mountain Retreat* and the
painting he describes. It should be noted, however,
that Li's entry appears under a title which differs in
exact wording, though not in general meaning, from
the actual label as it now exists.

The influential late Ming painter and arbiter of aes-
thetics, Tung Ch'i-ch'ang (1555-1636), has left visible
evidence of his pervasive connoisseurship on the
mounting above the painting, where he writes that the
painting is an "authentic work of Sheng Tzu-chao of
the Yüan." The style of the calligraphy of this colo-
phon recurs in similar inscriptions, also written on the

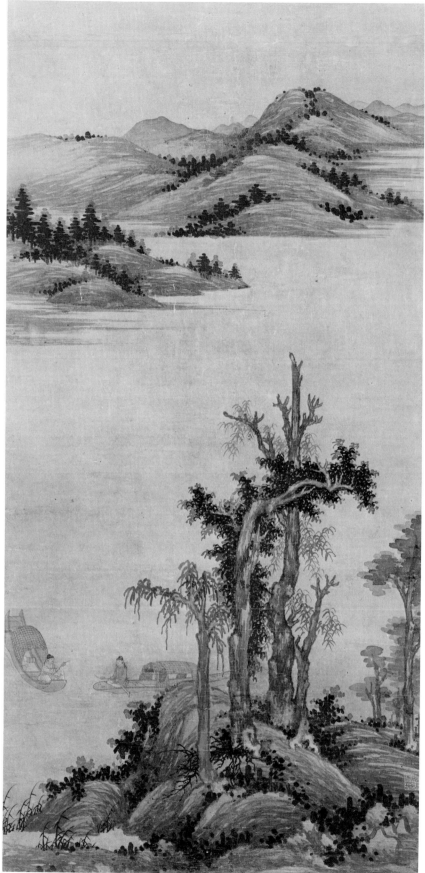

106

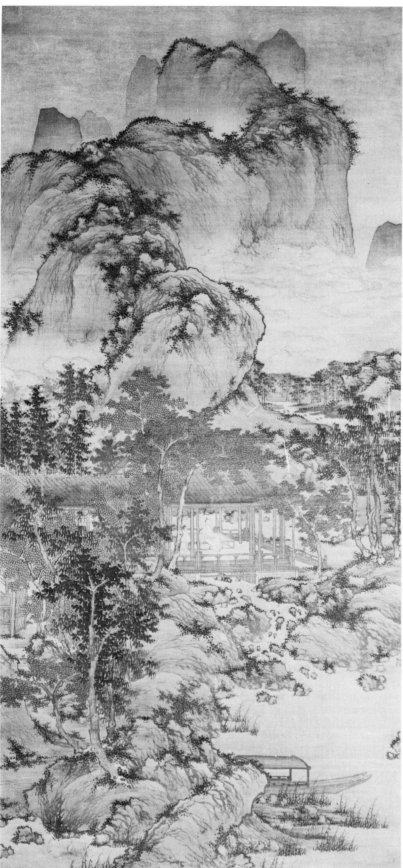

107

brocade of mountings, with an exclusiveness and regularity that suggests systematic practice.

Sheng Mou's style is one of the most distinctive and easily recognized in the history of Chinese painting. Whether from his early years or late, his painting makes an immediate appeal. It forsakes overt plays upon the intentional awkwardness of his contemporaries who worked in pronounced literati styles. There is nothing unkempt about his work. Nor is a hint of the spontaneous release of some momentary emotional state to be found. Instead, his polished brushwork and well-thought-out designs bring to mind such terms as suave, facile, and assured.

Sheng Mou's style and mannerisms as they had evolved by the end of his early phase or beginning of his middle phase are best seen in *Enjoying Fresh Air in a Mountain Retreat*, which probably dates from the 1340s. Despite a preference during this phase for fully packed compositions with a multiplicity of groupings, his spacing, recession, and the bonds of visual coherency retain a clear-cut coordination, albeit one tinged with overtones of a decorative urge toward expressively calculated pattern and self-conscious rhythmic intervals.

In Sheng's earlier paintings the distinctions among foreground, middle ground, and distant mountains are precisely acknowledged. And the scene itself would not only be far busier than here but also set at a much greater range from the viewer, thus recalling the spaciousness and monumentality of Northern Sung landscape painting. In *Enjoying Fresh Air in a Mountain Retreat* fore- and middle ground have been fused into a single continuum of compressed space. The tendency toward compression of space as the range of the scene draws nearer and a preference for reducing the compositional elements become ever more pronounced as Sheng's style evolves. In this respect *Enjoying Fresh Air in a Mountain Retreat* occupies a point midway in the evolution of Sheng's treatment of space and his move toward formal fusion.

Facile suavity and exploitation of the keenly refined rhythmic interval is also found in Sheng's brushwork. Sparkling vibrancy informs the interior modelling strokes. Seen as complexes, the modelling strokes fulfill the definition of the familiar "unravelled-rope" modelling strokes (*chieh-suo-ts'un*). The logical clarity of Sheng's "unravelled-rope" modelling leads to solid articulation of bulk and contour, so that the demands of representation and lively abstract play are both fulfilled.

Despite the distinctiveness of Sheng Mou's style, it remains something of an historical enigma – at times marked by touches that ally him with the great innovative literati masters of the Yüan Dynasty, and at times imbued with artistic impulses that isolate him in fundamental ways from literati concepts of painting and link him instead to earlier traditions. His art does not, in any case, lend itself to the simplistic historical formulations of later centuries.

The slim biographical materials that remain give little substantive information about the formation of Sheng's art. Painting seems to have been something of a family tradition. His father, Sheng Hung, is known only as a painter who moved from Hangchou to Wei-t'ang-chen, Chia-hsing. Standard sources suggest two other influences on the development of Sheng's art. The first is Ch'en Lin (ca. 1260-1320); the second is Chao Meng-fu (see cat. nos. 80, 81). It is difficult,

however, to point to any but the most tenuous and inconclusive sort of visual, or even spiritual, ties between Sheng Mou and these two masters.

Sheng Mou is sometimes linked with the tradition of Tung Yüan (d. 962) and Chü-jan (see cat. no. 11). The rounded main masses of his mountains and rocks, interspersed with clusters of small, lumpy rocks; his use of masses of wet dabs of color or ink for foliage; his handling of tree trunks; and his use of "unravelled-rope" modelling strokes may be associated with a Chiang-nan tradition of painting influenced by Tung Yüan and Chü-jan. Yet, in Sheng Mou's hands all of this seems to be signalling something other than the strident archaism of painters such as Chao Meng-fu or Ch'en Lin.

Although Sheng Mou shares an interest in the graphic possibilities of calligraphic brushwork with other artists of his period, his brushwork retains a pictorial quality and meaning quite at odds with the literati trend of the day. An indebtedness to Southern Sung sensibilities may be seen in Sheng's precise drawing of architectural motifs and in his subtle shading of rooftops. The strong emotional content of Southern Sung academic painting is not to be found, however, nor does his brushwork have the heaviness expected of Sung brushwork. Even Sheng's elegant style of figure drawing, with its nailhead strokes and its carefully shaded, harmoniously flowing lines, finds its source in his immediate heritage rather than in earlier sources.

One might well wonder whether the archaistic elements in Sheng's style might not be something of a survival – a continuance of an unbroken tradition of Chiang-nan painting which had survived as an undercurrent during the ascendancy of Southern Sung academic styles. If so, then the art of Sheng Mou, at least during his early and middle phases, denotes an historical process quite different from the one that leads to the tradition of genuinely archaizing reconstructions of such fourteenth-century literati masters as Chao Meng-fu and Sheng Mou's neighbor, Wu Chen. MFW

Literature
Li Tso-hsien, *Shu-hua* (1871), *ch.* 20, pp. 17b-18a.
Sickman and Soper, *Art and Architecture* (1956), p. 151, pl. 114a.
Sirén, *Masters and Principles* (1956-58), IV, 76; VI, pl. 90.
Speiser, Goepper, Fribourg, *Chinese Art* III (1964), p. 40, color pl. 16.
Akiyama et al., *Chūgoku bijutsu* (1973), II, 221, 222, pl. 16.
NG-AM Handbook (1973), II, 61.
Cahill, *Parting* (1978), p. 67, color pl. 3.

Exhibitions
Cleveland Museum of Art, 1968: Lee and Ho, *Yüan*, cat. no. 230.

Nelson Gallery-Atkins Museum 35-173

Sheng Mou

108 *Travelers in Autumn Mountains*
(Ch'iu-shan hsing-lü)

Album leaf, ink and slight color on silk, 24.4 x 26.5 cm.

Artist's signature upper right corner: Sheng ? .

10 seals: 8 of Keng Chao-chung (1640-1686); 2 of Keng Chia-tsu (son of Chao-chung).

Remarks: Most of the signature of the artist has been scraped away, so that only the character "Sheng" is legible. A spurious signature of Wang Meng that was written over Sheng Mou's signature was removed before the painting came into the Museum collection.
WKH

Literature
Lee, "Scattered Pearls" (1964), no. 10.
Sullivan, *Chinese and Japanese* (1965), pp. 69, 70, color pl. on p. 182.
Lee, "Early Ming Painting" (1975), p. 245, fig. 1.
Sullivan, *Symbols of Eternity* (1979), p. 105, pl. 61.

Exhibitions
Haus der Kunst, Munich, 1959: *1000 Jahre*, cat. no. 31.
Cleveland Museum of Art, 1968: Lee and Ho, *Yüan*, cat. no. 232.
China House Gallery, New York, 1970: Wang Chi-ch'ien, *Album Leaves*, cat. no. 49.
Asia House Gallery, New York, 1974: Lee, *Colors of Ink*, cat. no. 13.

Recent provenance: Wang Chi-ch'ien; Walter Hochstadter.

The Cleveland Museum of Art 63.589

108

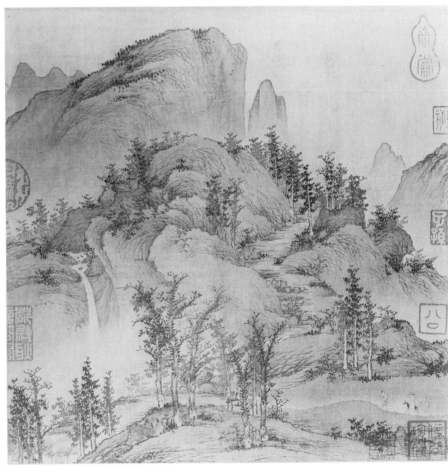

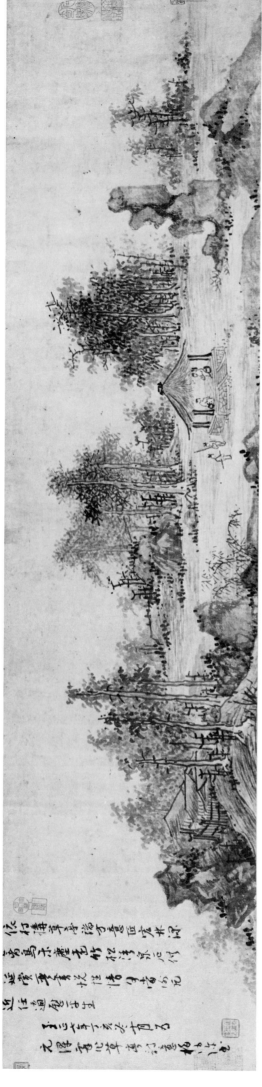

Wu Chen, 1280-1354, Yüan Dynasty
t. Chung-kuei, *h.* Mei-hua-tao-jen; from
Chia-hsing, Chechiang Province

109 *Poetic Feeling in a Thatched Pavilion*
(Ts'ao-t'ing shih-i)

Handscroll, dated 1347, ink on paper, 23.8
x 99.4 cm.

Artist's inscription, signature, and 2 seals:

By the side of the hamlet I built a thatched pavilion.
Balanced and squared, it is lofty in conception. The
woods being deep, birds are happy; the dust being
distant, bamboos and pines are clean. Streams and
rocks invite lingering enjoyment, lutes and books
please my temperament. How should I bid farewell to
the world of the ordinary and the familiar, and let my
heart go its own way for the gratification of my life?

In the tenth month of winter, in *ting-hai,* the sev-
enth year of Chih-cheng [1347], I did this *Poetic Feeling
in a Thatched Pavilion* playfully for Yüan-tse. Written by
Mei sha-mi [Novice of the Plum Blossom]. [seals]
Mei-hua-an; Chia-hsing Wu Chen Chung-kuei
shu-hua-chi.

Title on frontispiece by Li Tung-yang (1447-1516).

3 colophons and 33 additional seals: 1 colophon and 1
seal of Shen Chou (1427-1509); 1 seal of Li Chao-heng
(act. 1st half 17th c.); 9 seals of Liang Ch'ing-piao
(1620-1691); 1 seal of Wang I-jung (1848-1900); 1 seal of
Li Yen-shan (1898-1961); 1 seal of Huang Wen (20th c.);
2 colophons and 13 seals of Ch'en Jen-t'ao (20th c.); 6
seals unidentified.

Colophon by Shen Chou:

I love the Old Man of the Plum-blossom,
Who inherited the secrets of Chü-jan from heart
 to heart.
In cultivating this "water and ink kinship"
He was able to endow everything with a touch of
 aged mellowness.
Trees and rocks seem to fall from his brush [so
 effortlessly]
That even nature itself could hardly deny
 their emergence.
So now, under the grove of the oak trees,
I am willing to serve him with all humility.
Shen Chou, a later follower.

 WKH

Literature
Chang Ch'ou, *Ch'ing-ho shu-hua piao* (n.d.), unpagi-
 nated; idem, *Ch'ing ho shu-hua fang* (preface 1616),
 ch. 7, p. 48(b); idem, *Chen-chi* (ca. 1620-30), ɪ, 55(b).
Wang K'o-yü, *Shan-hu-wang* (preface 1643), *ch.* 9, p. 919.
Pien, *Shih-ku-t'ang* (1682), *ch.* 19, pp. 1(a)-2(a).
Ku Fu, *P'ing-sheng* (preface 1692), *ch.* 9, p. 62.
P'ei-wen-chai (1708), *ch.* 100, p. 6.
Ferguson, *Li-tai* (1934), pp. 105(b), 106(a).
Chu Sheng-chai, *Chung-kuo* (1961), p. 21.
Lee, "Literati and Professionals" (1966), p. 4, fig. 1.
CMA *Handbook* (1978), illus. p. 347.

Exhibitions
Musée Cernushi, Paris, 1959/60: *Seize peintures,* cat.
 no. 2, cover.
Cleveland Museum of Art, 1968: Lee and Ho, *Yüan,*
 cat. no. 252.
Asia House Gallery, New York, 1974: Lee, *Colors of Ink,*
 cat. no. 12.
The Taft Museum, Cincinnati, 1976: Looking East,
 no catalogue.
Yale University Art Gallery, 1977: Fu Shen, *Traces,*
 cat. no. 24a-b (inscription and frontispiece).

Recent provenance: Chiang Er-shih.

The Cleveland Museum of Art 63.259

Ni Tsan, 1301-1374, Yüan Dynasty
t. Yüan-chen, *h.* Yün-lin; from Wu-hsi,
Chiangsu Province

110 *Bamboo, Rock, and Tall Tree*
(Yün-shih ch'iao-k'o)

Hanging scroll, ink on paper, 67.3 x 36.8 cm.

Artist's inscription, signature, and seal:

Windy and rainy days – what a chilly wheat-harvesting
 season,
With brush in hand, I fight depression by copying.
Fortunately, I can depend upon you, my friend, to
 send me consolation –
"Pine-lard" wind, and meat with bamboo shoots that
 never fail to awaken appetite.

Yün-lin-tzu, Tsan. [seal] Tzu-i-yüeh.

4 additional inscriptions and 14 additional seals: 1 po-
em and 3 seals, possibly of Chang Yü (1277-1350);
1 poem and 1 seal of Yüan Hua (1316-end of 14th c.);
1 poem and 2 seals of Lu P'ing (1438-1521); 1 seal of
Liang Ch'ing-piao (1620-1691); 1 poem and 1 seal of
Chao Yü (1638-1713); 1 seal of _?_ Jen-lan (dates
unknown); 2 seals of Ku Wen-pin (1811-1889); 1 seal of
Wang Chi-ch'ien (20th c.); 2 seals unidentified.

Poem possibly by Chang Yü:

The Taoist of the Cloudy Forest, Ni Yüan-chen,
How many people can enjoy a fame in old age
 like yours?
Seeing the painting, I wrote the poem in fond
 memories.
I feel as if I am bathed in the light of the fading moon
Which shines on your spirit as always.

Remarks: The identity of all the writers of the inscrip-
tions on this poetic work are known, save for the one
at the far left with the signature "Chih-po Tao-jen"
(The Taoist of Knowing the White). In a previous cata-
logue entry (Lee and Ho, *Yüan*, 1968, cat. no. 259), the
suggestion was made that the writer was the eminent
Taoist Chang Yü, Wai-shih of Kou-ch'ü. This identifi-
cation can still be maintained as the most likely one de-
spite the second line of the poem, "How many people
can enjoy a fame in old age like yours." Granted that
Chang died in 1350 and Ni in 1374, and that an older
man is commenting on a younger man's work, the po-
lite and self-effacing tone is to be expected. Further,
the calligraphy is consistent with at least some of
Chang's well-established writings, notably the wood-
block edition of *Mao-shan chih* (Chang Kuang-yuan,
"Dates of Chang Yü," 1976, fig. 2). The seals are not
known as Chang's, but little is known about the range
and type he used – the seal characters are not inappro-
priate for him.

Chang Yü was a good friend of Ni Tsan and trav-
eled with him in January 1348, and saw him again on
March 11 in Suchou. All of this is perfectly in har-
mony with Ni's poem and mood. It should also be
noted that Ni Tsan's calligraphy in the present case
seems to support a date of about 1348. The characteris-
tic Ni style is not as firmly established and consistent-
ly applied as in later examples of his writing (cf. *The
Jung-hsi Studio*, 1372, National Palace Museum, Taipei,
in Cahill, *Hills*, 1976, pl. 50; the letter to Chen Chih of

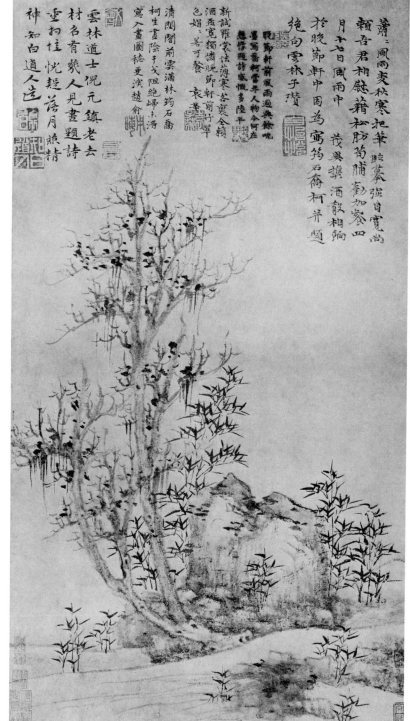

110

ca. 1360-62 in Fu Shen, *Traces*, 1977, fig. 67; and the
Keng-yü Studio, 1373, also in *Traces*, fig. 25a).

The other possibility previously mentioned (Lee and
Ho, *Yüan*, cat. no. 254) for the author of the fourth in-
scription – the famous painter Ts'ao Chih-po – seems
unlikely, since his calligraphy simply does not seem
related to that of the inscription in question.

The painting may have been recorded. The entries
in Pien Yung-yü's *Shih-ku-t'ang shu hua hui-k'ao* (preface
1682, *ch.* 20, pp. 23b, 28b), refer to this or a closely
analogous composition but with different inscriptions.
The Cleveland scroll may well be the one mentioned
in the diary of Li Jih-hua (1565-1635) under the entry

of 1614.10.13, where the author says he had viewed *Bamboo, Rocks, and Tall Trees* by Ni Tsan. The best evidence for the authenticity of the painting is the relatively continuous sequence of time represented by the collectors' inscriptions, the seal of the great connoisseur Liang Ch'ing-piao – properly and discreetly placed – and the quality of the painting itself, with its range of wet-to-dry and dark-to-light ink; its subtle composition; and its moving, elegiac mood of the images embodied both in the painting and the poem.

SEL

Literature
Chang Ch'ou, *Chen-chi* (ca. 1620-30), I, 6a.
Sirén, *Masters and Principles* (1956-58), VII, *Lists*, 128.
Lee, *Chinese Landscape Painting* (1962), p. 50, no. 34.
Goepper, *Essence* (1963), pls. 48-50.
Wang Chi-ch'ien, "Ni Yün-lin" (1967), p. 36.
Ho, Iriya, Nakada, *Kō Kōbō, Gei San* (1979), pp. 154 (signature), 165, pl. 24 (color).

Exhibitions
Haus der Kunst, Munich, 1959: *1000 Jahre,* cat. no. 29.
Cleveland Museum of Art, 1958: Lee and Ho, *Yüan,* cat. no. 254.
China House Gallery, New York, 1973: Barnhart, *Wintry Forests,* cat. no. 11.

Recent provenance: Wang Chi-ch'ien.

The Cleveland Museum of Art 78.65

Wang Meng, ca. 1301-1385, Yüan Dynasty
t. Shu-ming, *h.* Huang-ho-shan-ch'iao; born in Hu-chou, Chechiang Province

111 *Writing Books under the Pine Trees (Sung-hsia chu-shu)*

Double album leaf mounted as a hanging scroll, ink and light color on paper, 38.7 x 71.1 cm.

Artist's inscription, signature, and seal:

Many years and months passed by the locked gate
Behind which the scholar has been immersed in
 writing his books;
While the pine trees he had planted
Have all grown up with old dragon scales.

The Yellow Crane Mountain Woodcutter [Huang-ho-shan-ch'iao] painted this for Chen-su [the *h.* of Ts'ao Chih-po]. [seal] Wang Meng yin.

2 additional seals: 1 of Ts'ao Chih-po (1271-1355); 1 unidentified.

Remarks: This was the fifth leaf of an album called *Shen-kuo shih-erh ming-chia ts'e,* or *Yüan-chi shih-erh ming-chia chi-ts'e.* It has been recorded in both Wang K'o-yü, *Shan-hu-wang* (preface 1643), and Pien Yung-yü, *Shih-ku-t'ang shu hua hui-k'ao* (1682) under the title *Wei Chen-su hsieh-chü,* where it is said to have had colophons of Shen Chou and Tung Ch'i-ch'ang.

WKH

111

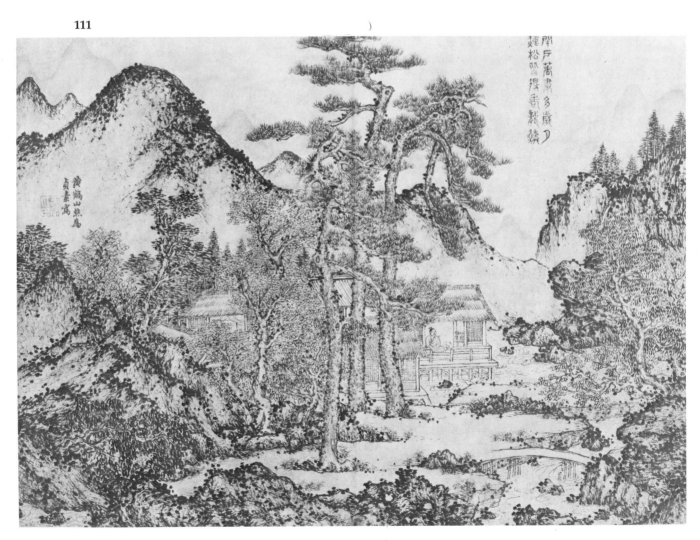

Literature
Wang K'o-yü, *Shan-hu-wang* (preface 1643), *ch.* 20, p. 1247.
Pien Yung-yü, *Shih-ku-t'ang* (1682), *ch.* 4, p. 48(a).
Sullivan, *Chinese and Japanese*, p. 73, color pl. on p. 179.
Lee, "Water and Moon" (1970), p. 58, fig. 33.

Exhibitions
Cleveland Museum of Art, 1968: Lee and Ho, *Yüan*, cat.
 no. 257.

Intended gift to The Cleveland Museum of Art,
Mr. and Mrs. A. Dean Perry

Yao T'ing-mei, active fourteenth century, Yüan
 Dynasty
From Wu-hsing, Chechiang Province

112 *Leisure Enough to Spare*
 (Yu-yü-hsien t'u)

Handscroll, dated 1360, ink on paper, 23 × 84 cm.

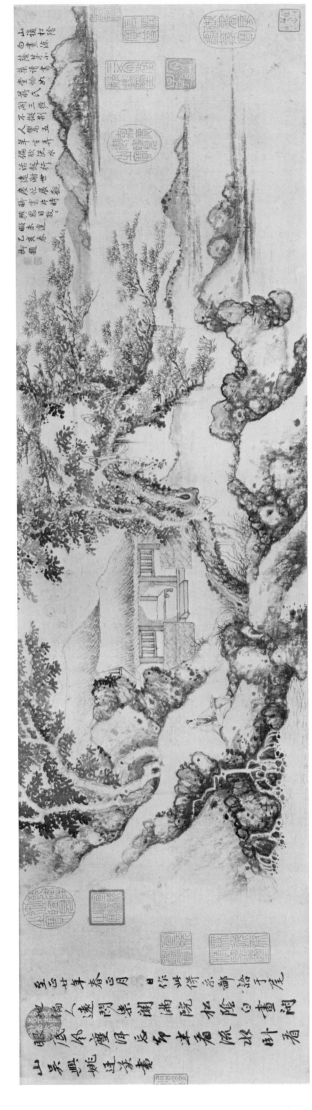

Artist's inscription, poem, and signature: In the first
month of spring in the twentieth year of the reign of
Chih-cheng [1360], I painted this and attached a few
rustic words at the end of the scroll.

The place is remote and people far away.
The wooden gate is kept closed always,
The courtyard is covered by the pine shade,
Daytime passes by idly.
Thus you may well forget the wind and dust in
 your eyes,
And look at the flowing waters only while at ease,
And at the distant mountains, lying down.

Yao T'ing-mei of Wu-hsing.

Title on frontispiece by Chang Pi.

23 colophons and 53 seals (dates unavailable for
some): 1 colophon, dated 1360, and 2 seals of Yang
Wei-cheng (1296-1370); 1 colophon and 3 seals of Wan
I; 1 colophon of Chang Chün-te; 1 colophon and 3
seals of Ang Chi (act. ca. mid-14th c.); 1 colophon and
1 seal of Hsü Shih-ch'üan; 1 colophon and 3 seals of
Kao Yü; 1 colophon and 2 seals of Li Ming-fu; 1 colo-
phon and 2 seals of Lü Lin; 1 colophon and 1 seal of
Chang Ch'ien; 1 colophon of T'ao T'ang-wen; 1 colo-
phon and 1 seal of Wu Yüan-kuei (act. ca. 1300-60); 1
colophon of Pao Chiung; 1 colophon of Wang Tsao; 1
colophon and 1 seal of Ma Ch'u-i; 1 colophon and 1
seal of Lin I-chuang; 1 colophon and 1 seal of Ku
Shun-chü; 1 colophon and 2 seals of Wang Ching; 1
colophon and 2 seals of Lin Shou-ch'ang; 1 colophon
and 1 seal of Kao Chih-tao; 1 colophon of Lin Hsün; 1
colophon, dated 1359, and 2 seals of Meng Wei-ch'eng
(act. mid-14th c.); 1 colophon and 1 seal of Meng
Chih-ch'i (act. mid-14th c.); 14 seals of Liang Ch'ing-
piao (1620-1691); 1 poem dated 1755 and 5 seals of the
Ch'ien-lung emperor (r. 1736-95); 2 seals of the Chia-
ch'ing emperor (r. 1796-1821); 3 seals of the Hsüan-
t'ung emperor (r. 1908-12).

Colophon by Yang Wei-cheng, "An Essay on Leisure
to Spare":

Master Ou-yang [Ou-yang Hsiu, 1007-1072] says in
one of his poems, "To have good company is such a
joy. It provides the rare excuse to steal away leisure
from one's life." Now, if leisure could be acquired on-
ly by stealing, this certainly could not be said to be
abundant enough to spare. In the poetry of Su
Tung-p'o [1036-1101] he says, "It is indeed not bad to
be able to secure leisure because of illness." Now if
leisure should have been obtained from an illness that

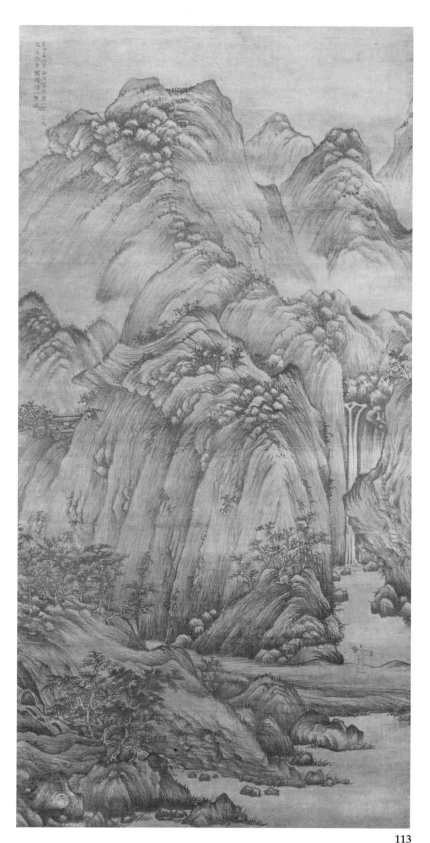

113

In Ch'ing-lung by the Sung River, there is a hermit, Mr. Tu. Inside, he has fine children to take care of his household. Under him, he has diligent servants to engage in production. Outside, he has wise relatives and friends to watch out and guard him. Thus he has been able to live peacefully, and to eat heartily, and to pass his time in rest and play. Surely his leisure was not stolen from the few moments when he has company. It was not derived from illness. It was not jeopardized by extensive holdings of real estate. Could anyone question my word if I said this is truly abundant enough to spare? Mr. Tu asked a common friend, Chang Meng-ch'en, to come to me for an essay. I herewith composed this for him as above. At the same time, others who are well versed in poetry have written poems as in the following.

Tung-wei-tzu wrote this on the first day of the second month of the *keng-tzu* year [1360]. By "Tung-wei" I mean the *chin-shih* graduate from the examination in the *ting-mao* year of T'ai-ting [1327], with the present rank of *Feng-hsün-ta-fu*, and in the office of Commissioner of Schools for the Chianghsi and other provinces, whose name is Yang Wei-cheng.

Remarks: According to the dated colophon by Meng Wei-ch'eng, some of the poems in the last section apparently were made before the essay and the painting, both of which must have been done at the same time. It is most interesting to find from the collected work of Yang Wei-cheng, *Tung wei-tzu wen-chi* (XXIX, 10b), a poem with a short introduction dedicated to a scholars' gathering which was held in the winter of 1359 at the villa of one of the poets whose work appears on this painting. The gathering included our artist, Yao T'ing-mei, as well as eight other people who contributed to the first part of the colophon section of the present painting. Accordingly, it could be suggested that the same group of literati probably paid a visit to the hermit, Mr. Tu, who lived in the same locality.

Apparently, the last group of poems, whose writers were not participants in the gathering, was presented separately in 1359. It was perhaps only one year later that Yang Wei-cheng and Yao T'ing-mei and the others were approached to compose something in memory of the occasion. The order of the poems was reversed either on account of Mr. Tu's preference or a mistake during the process of remounting. WKH

Literature
Wu Ch'i-chen, *Shu hua chi* (ca. 1677), ch. 3, pp. 272, 273.
Shih-ch'ü I (1745), ch. 33, pp. 34b-41a.
Ferguson, *Li-tai* (1934), II, 187.
Cheng Chen-to, *Yün-hui-chai* (1947), pls. 40-47.
Ch'en J. D., *Chin-kuei lun hua* (1956), p. 64; idem, *Ku-kung* (1956), p. 15b.
Sirén, *Masters and Principles* (1956-58), VII, *Lists*, 144.
Lee, *Chinese Landscape Painting* (1962), p. 53, no. 37; idem, *Far Eastern Art* (1964), p. 414, fig. 548.
Akiyama et al., *Chūgoku bijutsu* (1972), I, pt. 1, 229, color pl. 24, pl. 24.
Barnhart, "Yao Yen-ch'ing" (1977), pp. 107, 108, figs. 2, 9.

Exhibitions
Cleveland Museum of Art, 1954: Lee, *Chinese Landscape Painting*, cat. no. 34.
Cleveland Museum of Art, 1968: Lee and Ho, *Yüan*, cat. no. 260.
Asia House Gallery, New York, 1974: Lee, *Colors of Ink*, cat. no. 17.

Recent provenance: Chang Ts'ung-yu; Frank Caro.

The Cleveland Museum of Art 54.791

is against one's wish, this again could not be said to be abundant enough to spare. How vulgar is the poem by a man of late Sung who talks about buying plenty of farm and homestead land in preparation for the coming days of leisure. Now, if leisure has to depend on the extensive holding of real estate, this is precisely the kind of thing which will jeopardize one's leisure. Indeed, one will never have enough leisure that way, let alone enough to spare.

Ch'en Ju-yen, ca. 1331-before 1371, Yüan Dynasty
t. Wei-yün, *h.* Ch'iu-shui; from Suchou, Chiangsu
Province, moved to Chi-nan, Shantung Province

113 *The Woodcutter of Mount Lo-fou*
(Lo-fou-shan-ch'iao)

Hanging scroll, dated 1366, ink on silk, 106 ×
53.3 cm.

Artist's inscription: In the twenty-sixth year of
Chih-cheng [1366], the first month after the fifteenth
day, Ch'en Ju-yen of Lu-shan painted this *Woodcutter
of Mount Lo-fou* for Ssu-ch'i, the Judge.

2 colophons and 18 additional seals: 5 seals of Wang
Shih-min (1592-1680); 2 seals of Kung Hsiang-lin
(1658-1733); 1 colophon, dated 1684, of Yen Sheng-sun
(1623-1702); 1 colophon and 1 seal of Huang Jen
(1683-1768); 2 seals of Lu Shu-sheng (3rd son of Lu
Hsin-yüan); 2 seals of T'ao Kuang; 1 seal of T'an
Ching (20th c.); 3 seals of Chang heng (1915-1963); 2
seals unidentified.

WKH

Literature
Ku Fu, *P'ing-sheng* (preface 1692), *ch.* 9, pp. 116, 117.
Lu Hsin-yüan, *Jang-li-kuan* (1892), *ch.* 4, pp. 7, 8.
Ferguson, *Li-tai* (1934), III, p. 296.
Cheng Chen-to, *Yün-hui-chai* (1947), pl. 51.
Sirén, *Masters and Principles* (1956-58), IV, 93; VI, pl. 112,
 Lists, 165.
Lee, *Chinese Landscape Painting* (1962), p. 140, no. 38.
Cahill, *Hills* (1976), p. 130, pl. 60.
Ho, Iriya, Nakada, *Kō Kōbō, Gei San* (1979), p. 178, pl. 85.

Exhibitions
Cleveland Museum of Art, 1954: Lee, *Chinese Landscape
 Painting,* cat. no. 35.
Royal Ontario Museum, Toronto, 1956: Tseng, *Loan
 Exhibition,* cat. no. 8.
Haus der Kunst, Munich, 1959: *1000 Jahre,* cat. no. 40a.
Cleveland Museum of Art, 1968: Lee and Ho, *Yüan,* cat.
 no. 265.
Asia House Gallery, New York, 1974: Lee, *Colors of Ink,* cat.
 no. 19.

Recent provenance: C. T. Loo & Co.; Frank Caro.

Intended gift to The Cleveland Museum of Art,
Mr. and Mrs. A. Dean Perry

Ch'en Ju-yen

114 *The Land of Immortals*
(Hsien-shan t'u)

Handscroll, ink and color on silk, 33 × 102.9 cm.

1 inscription, 3 colophons, and 37 seals: 1 inscription,
dated 1371, by Ni Tsan (1301-1374); 17 seals of Hsiang
Yüan-pien (1525-1590); 4 seals of Chu Chih-ch'ih
(late Ming Dynasty); 1 seal of Liang Ch'ing-piao
(1620-1691); 1 seal of Kao Shih-ch'i (1645-1704); 4 seals
of Lu Hsin-yüan (1834-1894); 1 colophon, dated 1908,
and 5 seals of Ching Hsien; 1 colophon, dated 1915,
by Lung Yu; 1 colophon, dated 1932, and 2 seals of
Wu Mei; 3 seals unidentified.

Inscription by Ni Tsan:

The picture of *The Land of Immortals* was painted by
Ch'en Wei-yün [Ch'en Ju-yen]. Its refinement, mel-
lowness, and purity have succeeded profoundly in
capturing the brush ideas of Chao Meng-fu. Now the
gentleman is no longer with us. One will never be
able to acquire such a painting again. Ni Tsan wrote
this on the second day of the twelfth month of the
hsin-hai year, the fourth year of Hung-wu [1371].

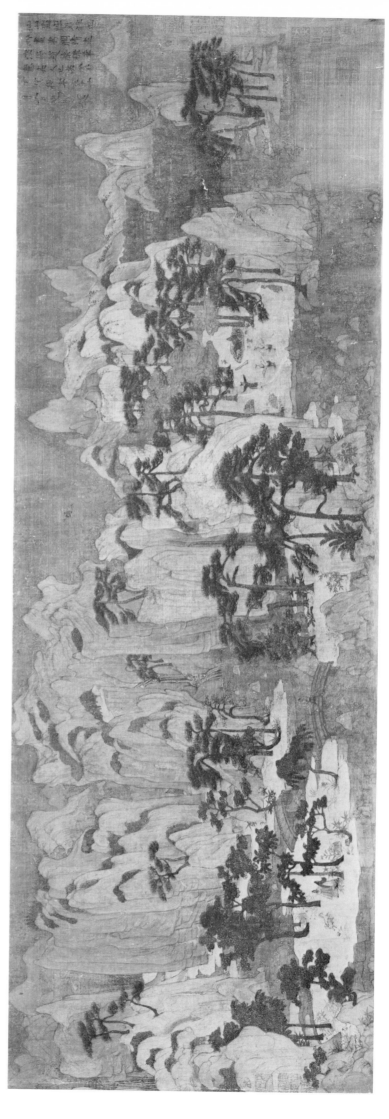

114

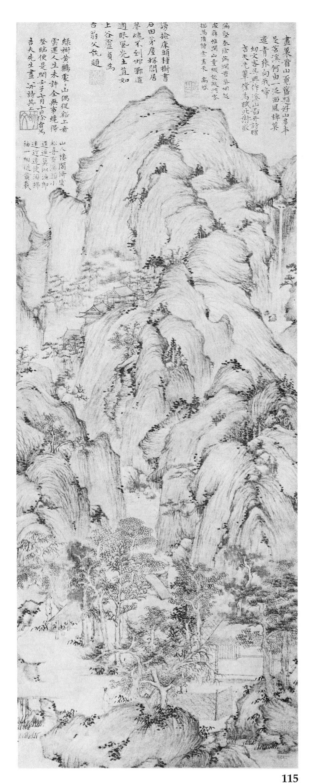

115

masterpiece such as this. Ching Hsien recorded this in the second month of the *mao-shen* year [1908].

Remarks: The dates for Ch'en Ju-yen are not known, but according to Ni Tsan's inscription dated to 1371, Ch'en Ju-yen had passed away by this time. A note on the history of this painting appeared in Tu Mu's *Yü-i-pien* (ca. 1500) as follows: "*The Land of Immortals* by Ch'en Wei-yün in green and blue with an inscription by Ni Tsan. By tradition the painting was presented to Mr. P'an, the Left Executive Assistant to the Chief Minister, on his birthday. The Executive Assistant was a brother-in-law of Chang Shih-ch'eng (a rebellious leader whose reign was Wu, dominating the lower Yang-tzu valley between 1356 and 1366 with P'ing-chiang [Su-chou] as his capital), and Ch'en Wei-yün at that time was an aide of Chang Shih-ch'eng and a friend of the Executive Assistant. This painting, together with the same artist's *A Clear Autumn Day over the Streams and Mountains*, and Huang Kung-wang's *Rocky Precipice at the Heavenly Pond*, was in the collection of Ch'en Meng-hsien, who was a descendant of Ch'en Wei-yün." WKH

Literature
Tu Mu, *Yü-i-pien* (ca. 1500).
Wang K'o-yü, *Shan-hu-wang* (preface 1643), *ch.* 23, p. 1336.
Wu Ch'i-chen, *Shu hua chi* (ca. 1677), *ch.* 1, pp. 71, 72.
Pien, *Shih-ku-t'ang* (1682), *ch.* 2, p. 94.
Ku Fu, *P'ing-sheng* (preface 1692), *ch.* 9, p. 117.
Tu (trad. attr.), *T'ieh-wang* (preface 1738), *ch.* 5, p. 10(a)
Li Tiao-yüan, *Chu-chia* (preface 1778), *ch.* 8, p. 12.
Ferguson, *Li-tai* (1934), III, 296(b).
Vinograd, "Blue-and-Green Manner" (1979), pp. 130, 131, fig. 18.

Exhibitions
Cleveland Museum of Art, 1968: Lee and Ho, *Yüan*, cat. no. 264.

Intended gift to The Cleveland Museum of Art, Mr. and Mrs. A. Dean Perry

Hsü Pen, 1335-1380, Yüan Dynasty
t. Yu-wen, *h.* Pei-kuo-sheng; from Ssuch'uan, lived in Suchou, Chiangsu Province

115 *Streams and Mountains*
(*Ch'i-shan t'u*)

Hanging scroll, dated 1372, ink on paper, 67.9 × 26 cm.

Artist's poem, inscription, and seal:

Green trees, yellow orioles,
 everywhere are mountains;
Aimlessly I return from the stream,
 where I watched the clouds.
Man's life does not allow unbroken ease,
But to be able to be high up in the mountain,
 this is leisure.

Hsü Pen painted this for Mr. Chi-fu together with a poem, on the tenth day of the seventh month of the *yin-tzu* year [1372]. [seal] Yu-wen.

Label on mounting probably by Liang Ch'ing-piao (1620-1691).

4 additional inscriptions and 9 additional seals: 1 poem of Hsieh Hui (ca. 2nd half 14th c.); 1 poem and 1 seal of Kao Ch'i (1336-1374); 1 poem and 1 seal of Lu Chen (ca. late 14th c.); 1 poem of Huang Tsai; 3 seals of Liang Ch'ing-piao; 1 seal of Wang Chi-ch'ien (20th c.); 3 seals unidentified.

WKH

Colophon by Ching Hsien:

The preceding *Land of Immortals* is an authentic work of the Yüan master, Ch'en Wei-yun. According to the *Yü-i-t'ien* by Tu Mu of the Ming Dynasty, the painting was seen at the home of Ch'en Meng-hsien [ca. 1500], a hermit. It is also recorded in *Yü-i-lu* of the present [Ch'ing] era. The dimensions and the seals are all correct. When the painting went into the possession of Liang Ch'ing-piao, the silk was already quite dilapidated. The only thing now missing, however, is the one line of writing by Hsiang Tz'u-ching [Hsiang Yüan-pien] who records the original price he paid, being fifteen taels of silver. This must have been cut off by the dealer, which nevertheless did no harm to a

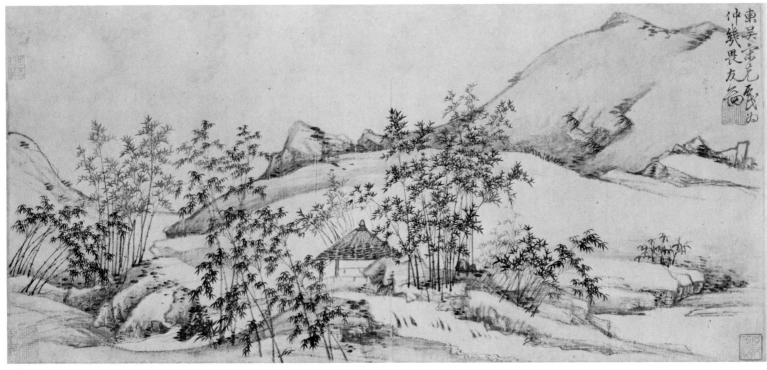

116

Literature

Sirén, *Masters and Principles* (1956-58), IV, 94; VII, *Lists*, 194 (as *A Windy Pass over High Mountains*).
Goepper, *Im Schatten* (1959), pl. 10.
Lee, *Chinese Landscape Painting* (1962), p. 55, no. 39.
Goepper, *Essence* (1963), pp. 74, 176, 218, pls. 51, 52.
Lee, *Far Eastern Art* (1964), p. 426, fig. 569.
Cahill, *Hills* (1976), pp. 130, 131, pl. 64.

Exhibitions

Cleveland Museum of Art, 1954: Lee, *Chinese Landscape Painting*, cat. no. 36.
Haus der Kunst, Munich, 1959: *1000 Jahre*, cat. no. 40.
J. B. Speed Art Museum, Louisville, 1965: *Treasures*, cat. no. 25.

Recent provenance: Walter Hochstadter.

Intended gift to The Cleveland Museum of Art, Mr. and Mrs. A. Dean Perry

Sung K'o, 1327-1387, Yüan Dynasty
t. Chung-wen, *h.* Nan-kung-sheng; from Suchou, Chiangsu Province

116 *Landscape with Bamboo*
(*Chu-kang t'u*)

Handscroll, ink on paper, 27.5 x 60.8 cm.

Artist's inscription, signature, and seal: Sung K'o of Tung-wu painted this playfully for Chung-chi, a friend I hold in awe. [seal] Chung-wen.

2 colophons and 14 additional seals: 1 seal of Yü Chung-chi (14th c.); 1 seal of Wu Ch'eng (1469 *chin-shih*); 1 colophon and 2 seals of Wu K'uan (1435-1504); 1 colophon and 9 seals of Ch'eng Ch'i (20th c.); 1 seal unidentified.

Remarks: Sung K'o is yet another typical paragon of the scholarly *wen-jen* tradition. Born of a Ch'ang-chou family, he was early a wastrel. But as the Yüan Dynasty became more a time of troubles, he abjured his friends, retreated to study military strategy, and became an advisor to a general guarding one of the northern areas. His physical strength, hunting and riding abilities, and swordsmanship were exemplary; but he is most famous as a calligrapher who revived the cursive *Chang-ts'ao* style of the early Six Dynasties. He survived the fall of Yüan and served briefly as calligrapher at the Hanlin Academy and as a deputy prefect in Shenhsi. He is usually classified as a literatus in the group of Ten Friends of the North Wall, which included Hsü Pen (see cat. no. 115) and centered about the poet-historian Kao Ch'i.

Sung's paintings, all bamboo landscapes, are exceedingly rare, and only two genuine works are known and published – the present example and the more famous similar scroll in the Freer Gallery of Art, dated 1369, when Sung was forty-two. The Cleveland scroll, judging by its somewhat more cursive but derivative Ni-Tsan-style inscription and signature, must be slightly earlier. Stylistic and brush details seem to confirm this, for the Cleveland scroll has a typical Ni-type pavilion eliminated in the Freer painting. The latter has a use of "hemp" *ts'un* in the foreground rocks that, while derived from Huang Kung-wang, seems closely related to the *ts'un* characteristic of Sung's friend Hsü Pen and of Wang Fu (see cat. nos. 117, 118) of the next generation.

The artist's inscription is characteristically self-deprecatory, but it does indicate the distinctly informal nature of the composition. While the debt to Ni Tsan in landscape formulae – such as the dots, rock outlines, and water-splits – is clear, the treatment of bamboo as an integral part of a well-organized landscape as well as the small-leafed, graceful, and bountiful bamboo, seems derived from Kuan Tao-sheng, the wife of Chao Meng-fu. The dry and glossy ink – rich and sooty in the bamboo, crumbly and grained in the rocks – is characteristic of most of the *wen-jen* artists of late Yüan and early Ming. The informal "playful" nature of this composition contrasts with the more formal and carefully organized composition of the Freer scroll.

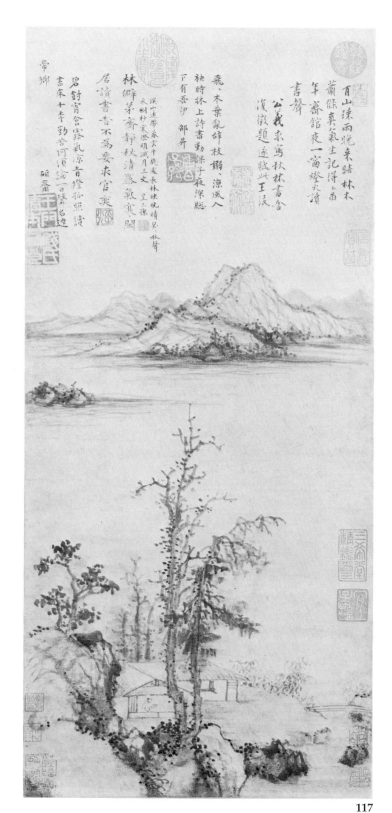

117

The colophon by Wu K'uan, the friend of Shen Chou, is an excellent and typical example of his calligraphy, although it recites only the already-known facts of Sung's career and interests. It does, however, allude to the sound of the breeze in the bamboo, a subject dear to the scholar's heart and the complete subject of a later classic bamboo by Wen Cheng-ming (see cat. no. 173). SEL/LYSL

Recent provenance: Ch'eng Ch'i.

Intended gift to The Cleveland Museum of Art, Mr. and Mrs. A. Dean Perry

142

Wang Fu, 1362-1416, Yüan Dynasty
 t. Meng-tuan, h. Yu-shih-sheng; from Wu-hsi, Chiangsu Province

117 *A Scholar's Retreat Amidst Autumn Trees (Ch'iu-lin shu-she)*

Hanging scroll, ink on paper, 58.1 x 26.7 cm.

Artist's inscription, signature, and 3 seals:

A fine evening visits the green mountains after a
 light autumn rain.
Trees are washed and amidst spare branches, the
 cool air rises.
Remember still those nights in the bygone days,
 alone in my study,
With a window of flickering lamplight as the only
 companion to the sound of my reading.

Kung-i asked for a painting of *A Scholar's Retreat Amidst Autumn Trees* and a poem to go with it. Accordingly I composed this. Wang Fu. [seals] Meng-tuan; P'o-yen-chai; Yu-shih-sheng.

4 additional inscriptions and 20 additional seals: 1 poem and 1 seal of Shao Sheng (1491-1534); 1 poem and 1 seal of Huang-san-sun (the 3rd imperial grandson); 1 poem and 1 seal of Han I (act. 2nd half 14th c.); 1 poem and 2 seals of Ch'ien Tzu-liang; 5 seals of the Ch'ien-lung emperor (r. 1736-95); 1 seal of T'ang Hsün (dates unknown); 2 seals of Ho Cheng (dates unknown); 3 seals of Ch'eng Ch'i (20th c.); 2 seals of Li Kuo-ch'ao (20th c.); 2 seals unidentified.

Remarks: With the customary five imperial seals, this painting was supposedly designated as a first-class painting in the imperial collection of Ch'ien-lung. However, it is not recorded in the first part of the catalogue *Shih-chü pao-chi* (1745). In the *Hao-ku-t'ang shu-hua-chi* (preface 1699, *ch.* 2, p. 88) by Yao Chi-heng, this painting with inscriptions and colophons is listed as a large leaf from an assorted album of Ming masters. WKH

Literature
Yao Chi-heng, *Hao-ku-t'ang* (preface 1699), *ch.* 2, p. 88.
Nihon genzai Shina (1938), p. 128.
Ho, Iriya, Nakada, *Kō Kōbō, Gei San* (1979), p. 178, pl. 87.

Exhibitions
Cleveland Museum of Art, 1968: Lee and Ho, *Yüan*, cat. no. 266.

Recent provenance: Ch'eng Ch'i.

Intended gift to The Cleveland Musuem of Art, Mr. and Mrs. A. Dean Perry

Wang Fu

118 *Bamboo and Rocks (Chu-shih t'u)*

Handscroll, ink on paper, 35.5 × 232.5 cm.

Artist's inscription, signature, and 2 seals: Wang Meng-tuan of Pei-ling painted these bamboo and rocks for Mr. Ting-hsien. [seals] Chiu-lung shan-jen; Meng-tuan.

2 colophons and 18 additional seals: 1 seal of Chu Chih-ch'ih (17th c.); 1 seal of Ch'en Ting (mid-17th c.); 1 seal of So-o-t'u (mid-17th c.); 2 seals of Pien Yung-yü (1645-1712); 1 colophon and 2 seals of Wang Wen-chih (1730-1820); 2 seals of Liang Ting-fen (1859-1919); 1 colophon and 3 seals of Kō Nagao (1846-1942); 6 seals unidentified.

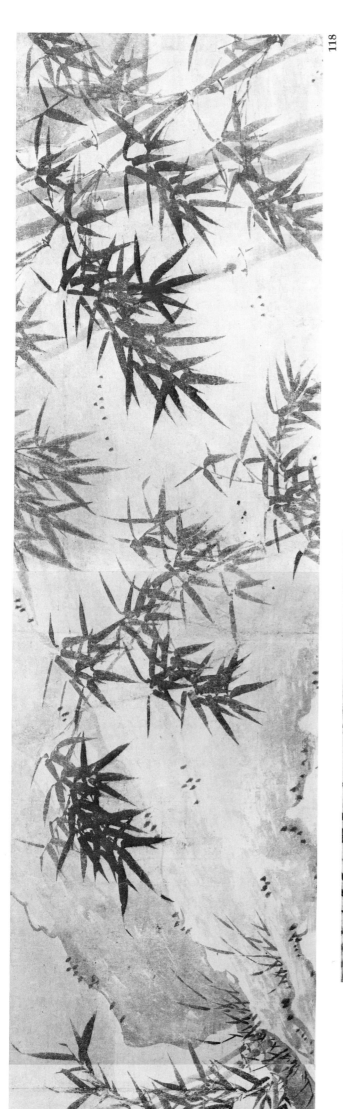

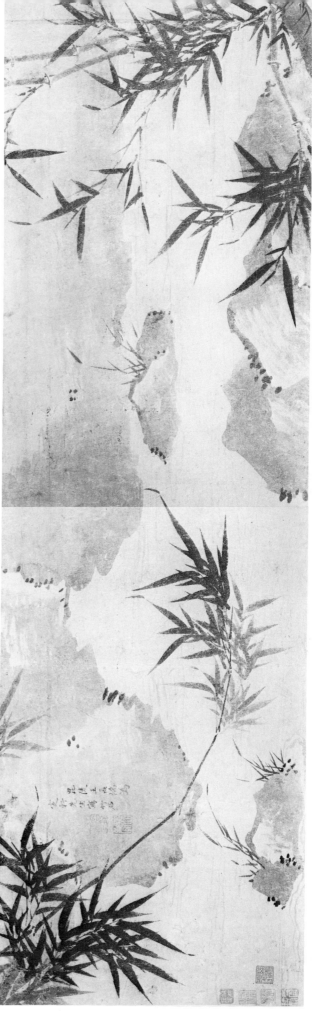

Remarks: The man to whom the painting is dedicated was Chao Ting-hsien, a native of Suchou. Wu K'uan (1435-1504) wrote two poems entitled "Ink-bamboo by Wang Meng-tuan dedicated to Chao Ting-hsien" (*P'ao-weng chia ts'ang chi*, earliest preface 1508, *ch.* 22, p. 135).

In his paintings of bamboo, Wang Fu followed in the tradition evolved during the Yüan Dynasty by such masters as Li K'an, K'o Chiu-ssu, and Ku An. Building on these predecessors, Wang Fu developed his own distinctive style expressed through faultless technique. No painters of the Ming Dynasty surpassed him, and the best were strongly under his influence. The foremost of these, Hsia Ch'ang (1388-1470), occasionally adapted elements from Wang Fu's compositions – for example, the branch of bamboo dipping in a stream that occurs in his scroll of 1441, *Pine Trees and Bamboo*, now in The Art Institute of Chicago (Sirén, *Masters and Principles*, 1956-58, vi, pl. 134). KSW/LS

Literature
NG-AM Handbook (1973), ii, 61 and cover (detail).

Exhibitions
Philadelphia Museum of Art, 1963: Clifford, *World of Flowers*, pp. 180, 181.

Recent provenance: Kō Nagao; Kinjirō Harada; Kōzō Harada.

Nelson Gallery-Atkins Museum 58-8

119

Artist unknown, late thirteenth-early fourteenth century, Yüan Dynasty

119 *Hunting Falcon Attacking a Swan (Ying-chi yeh-o)*

Hanging scroll (paneled), ink and color on paper, 152.5 × 106.1 cm.

2 seals: 1 of Yin-hsiang (1st Prince I, 1686-1730); 1 of Hung-hsiao (2nd Prince I, d. 1778).

Remarks: The painting is a continuation of the Southern Sung Academy tradition where, in the twelfth century, the theme of a falcon attacking her prey was a popular subject employed by Li Ti (act. ca. 1150-after 1197) and other court artists. On the right the angular millet leaves are done with a broken, discontinous line characteristic of twelfth-century brushwork, while the branches of flowering peach on the left recall certain paintings by Ma Yüan and Ma Lin. But these elements, as well as the bamboo, reeds, and grasses, are painted in a manner slightly more heavy-handed than would be found in the high style of the twelfth-century Academy.

The wild swan and gyrfalcon, however, are painted with care, precision, and accuracy matching well the standards of the Academy. The fierce falcon has made one strike, as evidenced by the few white feathers drifting down, and is shown stooping with great force for a diving kill as the swan seeks cover in the stand of millet.

The jesses of the falcon were originally a deep blue, but most of the color is now lost. Also, the dramatic action is so cramped for space there can be little doubt but that the painting has been cut down by a number of inches on all four sides, probably in the nineteenth century. LS

Exhibitions
Fogg Art Museum, Cambridge, Mass., 1951: Rowland, *Bird and Flower*, cat. no. 24, p. 24, pl. Vb.

Recent provenance: Herbert Mueller.

Nelson Gallery-Atkins Museum 33-86

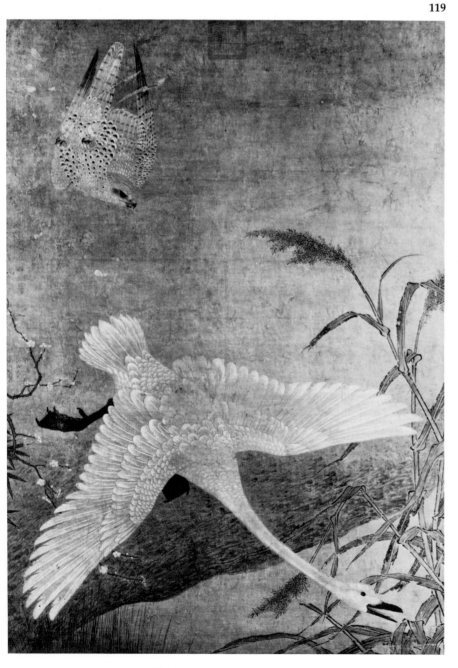

Hsüan-tsung, 1399-1435, the Hsüan-te emperor
 (r. 1426-35), Ming Dynasty
 Personal name Chu Chan-chi; from Peking

120 *Dog and Bamboo*
 (I hsiao t'u)

Hanging scroll, dated 1427, ink and slight color on
paper, 202 x 72 cm.

Label: *An Amusing Picture (I hsiao t'u)*

Artist's inscription and seal: In the second year of the
Hsüan-te era [1427], the imperial brush playfully wrote an
amusing picture. [seal] Kuang-yün chih pao.

Remarks: For the next-to-last character of the inscription,
hsiao (amusing), the emperor has substituted an archaic
form, made up of the radical components "dog" and
"bamboo," for the then-current form composed of the
radical component "bamboo" and the phonetic compo-
nent *yao* (young). The character *hsiao* thus becomes a pun
on the subject of the painting.
 A number of Chinese rulers painted as a polite pastime.
Ming Hsüan-tsung was one of the very few, however,
who possessed real talent. He is known for paintings of
animals – especially of dogs, cats, sheep, monkeys – and
birds and fish. LS

Literature
Sirén, *Masters and Principles* (1956-58), IV, 113; VI, pl. 124.

Exhibitions
Wildenstein Galleries, New York, 1949: Dubosc, *Ming and Ch'ing*,
 cat. no. 2, pp. 11, 22.
Palazzo Brancaccio, Rome, 1950: Giuganino and Dubosc, *Mostra
 di Pitture*, no. 1, p. 45, pl. 1.
San Francisco Museum of Art, 1957: Morley, *Asia and the West*, no.
 180, p. 34.
Philadelphia Museum of Art, 1963: Clifford, "World of Flowers,"
 p. 183.

Recent provenance: Jean-Pierre Dubosc.

Nelson Gallery-Atkins Museum 45-39

Pien Wen-chin, ca. 1354-1428, Ming Dynasty
 t. Ching-chao; from Sha-hsien, Fuchien Province

121 *Hundred Birds and the Three Friends*
 (San-yu pai-ch'in)

Hanging scroll, ink and color on silk, 152.1 x 95.3 cm.

Artist's 3 seals: Pien yin Ching-chao; Sha-yang shih-chia;
Ch'in shu ch'ing-lo.

Remarks: Pien Wen-chin served as painter-in-attendance
to the Yung-lo emperor (r. 1403-24) at the Wu-ying-tien, a
building sometimes set aside for painters and callig-
raphers first at Nanking, then in Peking, whence the
capital was transferred in 1421 (Vanderstappen, "Early
Ming Court," 1957, p. 317). Still recorded among the
coterie of artists attending the Hsüan-te emperor (r. 1426-
35), Pien was dismissed from service while in his seven-
ties for involvement in a bribery case. Pien's surviving
works indicate a familiarity with literati culture of Yüan
China as well as the conservative academic renditions of
flower-and-bird subjects so favored at the Sung court.
 The subject, style, and size of this hanging scroll are
closely related to two works in the National Palace
Museum, Taipei (*The Three Friends and the Hundred Birds*,
signed and dated 1413; and *A Hundred Sparrows at New
Year*, with no seals, erroneously attributed to an unknown
artist of the Yüan Dynasty). Paintings of this type were
suitable for hanging in a large chamber at the appropriate

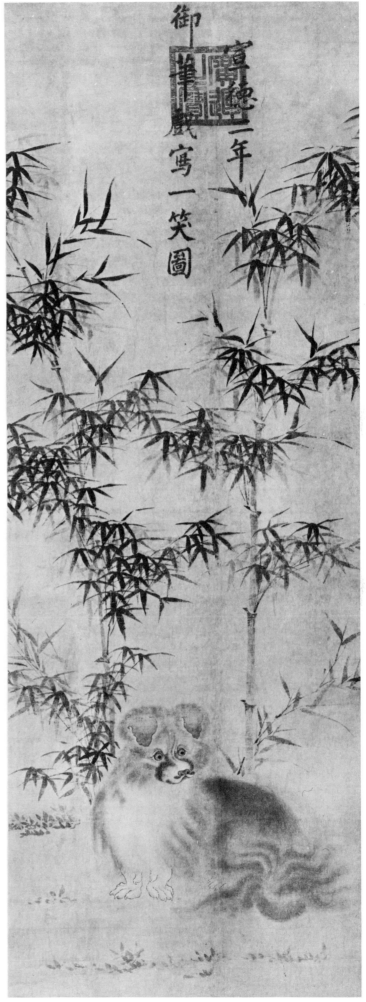

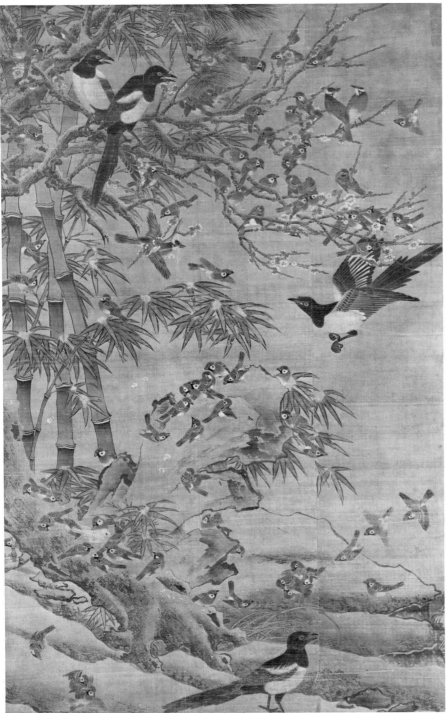

121

122

122

occasions. The signed and dated scroll, despite the richer coloring on some of the birds, and the Cleveland scroll with its three seals of Pien are particularly close in their decorative adaptation of a tradition going back to Huang Ch'üan of the Five Dynasties period, Ts'ui Po and Emperor Hui-tsung of the Sung Dynasty, and Wang Yüan (see cat. no. 87) and Meng Yü-chien (Cahill, *Hills*, 1976, color pl. 8) of the Yüan Dynasty.

The treatment of the rocks in all three pictures is of particular significance in the development of the Che school of painting (see cat. nos. 123-127, 136-142). The loose, calligraphic and wet-wash shading is freely adapted from Southern Sung academic traditions of the Ma Yüan-Hsia Kuei types. Just because of this conservative outlook, the manner may have been particularly acceptable to the new Ming court at Nanking, and later at

146

Peking. The early date (1413) of the signed Taiwan painting would seem to give Pien Wen-chin an early position in the establishment of this manner so soon to be standard with the painters of the Che school, whether at court or not.

A second group of pictures by Pien, notably *Flowers and Birds*, dated 1427, in the National Palace Museum, Taipei (*KKSHL*, 1965, *ch.* 5, p. 292); the *Magpie on a Chestnut Branch* (Sirén, *Masters and Principles*, 1956-58, vi, pl. 122a); *Three Turtle Doves*, in the Sumitomo collection (ibid., pl. 122b); and *Eagle on an Old Tree*, in the Hashimoto collection (*Hashimoto*, 1972, pl. 1), seem slightly more careful in the brushwork of rocks, branches, and bamboo than the three early hanging scrolls, with a peculiar evenly graded ink wash for shading and a marked sharpness of outline strokes. These may well represent a change towards greater precision and neatness encouraged by the Hsüan-te emperor, a painter himself with a predilection for a rather careful mixture of Yüan and earlier bird and animal manners (see cat. no. 120).

Pien Wen-chin should certainly be credited with the initiation of a consistent, tradition-minded style of bird-and-flower painting continued by his successors – Lin Liang (see cat. no. 123) and Yin Hung (see cat. no. 124), in addition to the most famous of all, Lü Chi. SEL

Recent provenance: Kozo Yabumoto.

The Cleveland Museum of Art 80.12

Pien Wen-chin

122 *Sleeping Bird on a Prunus Branch*
(*Han-mei shui-ch'üeh*)

Album leaf, ink on silk, 24.3 x 21 cm.

Artist's inscription, signature, and 2 seals: Painted by
Pien Ching-chao of Lung-hsi, painter-in-attendance of
[Wu]-ying-tien. [seals] I-ch'ing-tung-chih; Pien shih
Wen-chin.

Remarks: Reputedly a good poet, Pien collaborated with
Wang Fu (see cat. nos. 117, 118) on a painting of *Bamboo and
Cranes,* now in Peking. In format and approach, the
Cleveland album leaf draws upon the inheritance of the
Sung Academy; but, like the *Flower and Birds* of 1427, in
Taipei, it exhibits a lushness and fluidity of wet-ink ap-
plication which Pien transmitted to such academic paint-
ings as those of Lin Liang (see cat. no. 123). HK

Literature
Lee, "Early Ming Painting" (1975), pp. 254, 255, fig. 16.

Exhibitions
Asia House Gallery, New York, 1974: Lee, *Colors of Ink,*
 cat. no. 25.

Recent provenance: Dr. and Mrs. Sherman E. Lee.

The Cleveland Museum of Art 67.249

Lin Liang, active ca. 1450-1500, Ming Dynasty
t. I-shan; from Nan-hai, Kuangtung Province

123 *A Pair of Peacocks*
(*Kung-ch'üeh chu-shih*)

Hanging scroll, ink on silk, 154 x 107 cm.

Artist's signature and seal: Lin Liang [seal]
I-shan t'u-shu.

Remarks: According to traditional histories of Ming
painting, the Kuangtung painter Lin Liang arrived at the
Peking court during the Hung-chih era (1488-1505), after
his painting caught the attention of officials in the provin-
cial administration. Recent research places his arrival at
the capital about thirty years earlier (Li T'ien-ma, "Lin
Liang," 1962). Although a few of his highly colored paint-
ings survive, far more celebrated in Lin's own time were
his monochrome bird-and-flower studies. To these Lin
contributed new vivacity and drama through dynamic
stance, broad brushstroke, and strong tonal contrast.
While the peacocks of his contemporary, Yin Hung (see
cat. no. 124), convey a somewhat static reality despite
their careful delineation and bright hues, Lin's *Pair of
Peacocks* strut and preen their plumage in a monochrome
world sparely but boldly defined. Lin's striking imagery
and overt display of technique equal in intensity those
elements associated with the Che school figures
and landscapes. HK/SEL

Literature
Sirén, *Masters and Principles* (1956-58), VII, *Lists,* 210.
Goepper, *Chinesische Malerei* (1960), p. 44. illus. p. 45.
Lee, *Far Eastern Art* (1964), pp. 425, 426, fig. 568; idem,
 Colors of Ink (1974), fig. 1. (not exhibited).
Cahill, *Parting* (1978), p. 55.

Exhibitions
Nanking Art Gallery, 1937: *Chiao-yü-pu,* I, cat. no. 114.
Haus der Kunst, Munich, 1959: *1000 Jahre,* cat. no. 44.

Recent provenance: Kao Chien-fu.

Intended gift to The Cleveland Museum of Art, Mr. and
Mrs. Severance A. Millikin

123

Yin Hung, late fifteenth-early sixteenth century, Ming Dynasty

124 *Hundred Birds Admiring the Peacocks*
(Kung-ch'üeh mu-tan t'u)

Hanging scroll, ink and color on silk, 240 x 195.5 cm.

Artist's signature and seal: Yin Hung [seal] Chin-t'ai shih-chia.

Remarks: This painting's subject matter – a probable allusion to the emperor surrounded by his courtiers – and grand scale represent a type of palace wall-decoration only rarely encountered in Western collections of Chinese painting. The artist, Yin Hung, is recorded for his skill in "feathers and fur," basing his style on that of Pien Wen-chin (see cat. nos. 121, 122), and his student, Lü Chi. The only other surviving Yin Hung so far identified – another flower-and-bird composition formerly in the King Kwei collection (Ch'en, J.D., *Chin-kuei ts'ang-hua chi,* I, pl. 29) – exhibits such marked resemblance to Lü Chi's court paintings of the Hung-chih era (1488-1505) that the two men may well have been contemporaries. Certain elements in the Cleveland picture also reflect the influence of Lü Chi and his teacher: the wet, rounded contour strokes of the

tree trunks; the sharp, fine ink outlines and vivid colors in the flowers and birds; even the severely constricted space. Although the Southern Sung academic landscape which fascinated the early Ming court painters contributed the near-far view in this painting, other elements in the foreground allude to a more archaic tradition. The placement of the splendidly shaded T'ai-hu rock near the flowers and birds surrounding it can be traced to the compositional organization of the tenth-century painter Huang Chü-ts'ai, but Yin Hung probably had no access to such an original. On the contrary, the subtle interplay between patches of grass – drawn in boneless, dark green brushstrokes – and an isolated dandelion – done in ink outline – indicate a debt to the Wang Yüan revival of the Huang Chü-ts'ai style during the Yüan Dynasty (see Cahill, *Hills,* 1976, pp. 157, 158). HK

Literature
Satake koshukuke [sale cat.] (1917), no. 46.
Lee, "Early Ming Painting" (1975), pp. 297, 298, cover (color), fig. 18.
CMA *Handbook* (1978), illus. p. 348.

Recent provenance: Marquis Yoshitaka Satake; Fugendo Company.

The Cleveland Museum of Art 74.31

124

Artist unknown, fifteenth century, Ming Dynasty

125 *Flowers and Birds in an Autumn Setting*
(Ch'iu-ching hua-niao)

Hanging scroll, ink and color on silk, 189.4 x 111.5 cm.

Spurious signature: Ts'ui Po [ca. 1024-1068].

Remarks: This scroll is probably the autumn scene from a set of *Flowers and Birds of the Four Seasons* painted by the well-known academic bird-and-flower painter Lü Chi (act. mid- to late 15th c.), or by a member of his studio. The present whereabouts of the other three panels from the set is unknown. The two white swans and other birds on this scroll are executed with meticulous brushwork, which, like the coloring, follows a manner associated with the Southern Sung Academy. The hibiscus flowers are especially close to those in Lü Chi's complete set of the *Four Seasons* in the Tokyo National Museum *(Min-Shin no kaiga,* 1964, p. 17; Harada, *Shina,* 1936, pls. 535-39). The rocks, which are done with "large axe-stroke" texturing *(ta-fu-p'i-ts'un),* and the brushwork of the willows are typical of Lü Chi's method of painting.

Judging from the density of the composition, some inches have been trimmed from all four sides during later remountings. Ku Fu in the late seventeenth century remarked that many paintings by Lü Chi had been altered by removing the original signature and seals and substituting the name of a Sung Dynasty master. Ku (in *P'ing-sheng,* preface 1692, *ch.* 10, pp. 34-36) mentions some Lü Chi paintings he had seen changed into "Sung paintings" by adding the name Huang Ch'üan (d. 965) or Li Ti (act. ca. 1150-after 1197). KSW/LS

Nelson Gallery-Atkins Museum 35-249

125

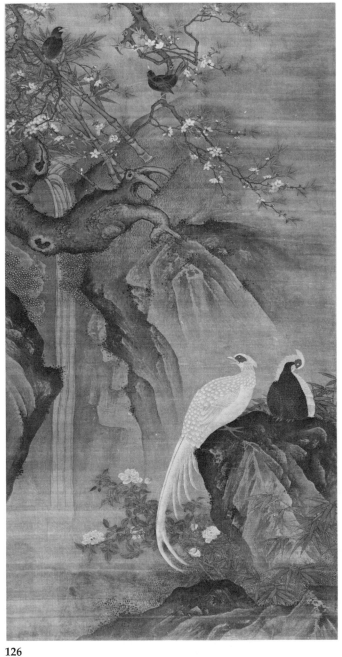

126

Artist unknown, sixteenth century, Ming Dynasty

126 *Flowers and Birds of Spring*
(*Ch'un-ching hua-niao*)

Hanging scroll, ink and color on silk, 183.5 x 97.8 cm.

Spurious signature: Painted by Huang Ch'üan [d. 965].

4 seals: 1 of the Liang family of An-ting (17th c.); 1 of Liu
Ch'eng (late 17th c.); 2 unidentified.

Remarks: It appears that this painting is the spring scene
from a set of *Flowers and Birds of the Four Seasons*. Although
this scroll follows closely the style of Lü Chi (cf. cat. no.
125), certain details, such as a softness in the painting of
the rocks, suggest a later date – possibly a generation
after Lü Chi. LS

Exhibitions
Fogg Art Museum, Cambridge, Mass., 1951: Rowland, *Bird and
Flower*, cat. no. 27.

Recent provenance: Chung-ku-chai.

Nelson Gallery-Atkins Museum 33-613

Artist unknown, fifteenth century, Ming Dynasty

127 *Ducks under Reeds*
(*Lu-ya t'u*)

Hanging scroll, ink and color on silk, 122.5 x 79.4 cm.

1 label on mounting, dated 1796, by Yung Hsing (Prince
Ch'eng, 1752-1823), and 7 seals: 1 of Sung Lo (1634-1713); 1
of Kung Erh-to (Ch'ing Dynasty, 18th c.?); 5 unidentified.

Remarks: A number of surviving "feathers and fur" com-
positions like this pair of mallards were painted on a large
scale for use as interior decoration. Because their unclut-
tered, natural settings and animal physiognomies were
carefully and painstakingly rendered, such works came
to be associated with Sung court artists such as Ts'ui Po or
Wu Yüan-yü (*Three Hundred Masterpieces*, 1959, II, no. 80;
Sirén, *Masters and Principles*, 1956-58, III, pls. 213, 216). This
scroll, once owned by the discriminating collector Sung
Lo, has an attribution on its label to Sung Hui-tsung (r.
1101-26), written by the famous prince-calligrapher Yung
Hsing.

149

Likewise, the *Call of Autumn* (Detroit Institute of Arts, 31.282), markedly similar in rendering of foliage and fowl, bears the signature of the eleventh-century painter Liu Yung-nien. Nevertheless, the airless landscape setting, static foliage, and flatly silhouetted birds in both examples hardly match the tensely alive animal world characteristic of genuine eleventh-century works. Moreover, the rippling water in the Detroit painting and the grasses in both examples exhibit an unrealistic patterning, while the evenness of ink tonality throughout — forcing background and foreground elements to the same visual plane — further negates the sense of depth that their placement within the composition implies. Such works probably make better sense in the context of early fifteenth-century decorative programs, painted by artists like Pien Wen-chin (see cat. no. 121) or his son-in-law, Chang K'o-hsin, in the revived Sung academic manner (see Kohara, "Chō Kokushin," 1969, pp. 93-97). HK

Recent provenance: Charles L. Freer.
The Cleveland Museum of Art 15.117

Artist unknown, ca. 1400, Ming Dynasty

128 *Fish*
(*Yü tsao t'u*)

Hanging scroll, ink and slight color on silk, 35 x 53 cm.

Remarks: This painting bears no seals or artist's signature. Instead, the old box labels preserved with the scroll attribute it to the thirteenth-century fish painter Fan An-jen. Monochrome works of fine quality treasured in Japan since the sixteenth century have often been associated with his name. Unfortunately, no firm documentation exists for authentic works from his hand.

A close comparison to the Cleveland composition can be found in one of a pair of album leaves (formerly in the Baron Dan Collection, Tokyo), also given a traditional attribution to Fan An-jen ("Fish and Weeds," 1938, pl. 3). The second album leaf of the pair appears to be by a different and later painter (see "Den Han Anjin," 1935, pl. 3). The water weeds in the Cleveland scroll and the first Dan album leaf are rendered identically with one-stroke, boneless color and hairline ink strokes; there are strong similarities in the articulation of the fish as well, all of which seems to indicate that they were painted by the same artist.

Despite subtleties of execution, the attribution of these paintings to Fan An-jen seems unfounded. Somewhat closer in spirit are the fish of the sixteenth-century Liu Chieh (cat. no. 129; see also Toda, *Mokkei, Gyokukan*, 1973, pls. 96, 97, pp. 136, 137). There are similarities in the relation of the fish to the unobtrusively placed water weeds, and a controlled, arching surface rhythm which develops from the placement and posture of the fish, further contributing to the calm and silent mood which each painting evokes. However, certain details of technique separate the "Fan An-jen" group from the Liu Chieh paintings. Although both painters continued the same Sung tradition, the fish of the "Fan An-jen" painter approximate more vividly the realistic concern of the Sung. The unknown painter of these *Fish*, displaying a transitional style between the Fan An-jen and Ming court traditions, fits into the period around 1400. HK/WKH

Recent provenance: Howard C. Hollis and Company; Mr. and Mrs. Herbert F. Leisy.
The Cleveland Museum of Art 77.201

Liu Chieh, active ca. 1485-ca. 1525, Ming Dynasty
From An-ch'eng, An-fu hsien, Chianghsi Province

129 *Swimming Carp*
(*Yü-tsao t'u*)

Hanging scroll, ink and slight color on silk, 141 x 84.2 cm.

Artist's signature and seal: Liu Chieh hsieh [seal] Chin-i-chih-hui chih chang.

Remarks: According to the histories of Ming painting, Liu Chieh served as a painter within the Forbidden City before and during the Chia-ching reign (1522-66). Liu's seal and signature on this, and a painting in the Metropolitan Museum, New York (Sirén, *Bahr Collection*, 1938, pl. xx), indicate that he held the rank of commander of the Gold Embroidered Guard. This unit originally served as the personal bodyguard of the earliest Ming emperors, but, with the accession of Hsüan-te (r. 1426-35), included painters particularly favored by the emperor. The Guard served in the Wen-hua-tien, one of several palaces set aside for court painters and calligraphers. Liu's father also held rank within the Gold Embroidered Guard, and both seem to have secured their reputations for paintings of fish. At present, only the son's works have been identified in Western and Oriental collections.

Liu's combination of waterweeds rendered in transparent color, with carp drawn in fine ink line and graded wash, continues an approach to the subject matter seen earlier in the Yüan Dynasty painting in Kansas City (see cat. no. 75). A pair of fish paintings (Toda, "Ryū Setsu," 1965, pp. 18-25; idem, "Ryū Setsu...hotei," 1965, p. 162) in a Japanese private collection bear seals by Liu Chieh and poetic inscriptions written by the scholar-calligrapher Pien Jung (1419-1487). This pair of hanging scrolls, stylistically very close to the Cleveland and Metropolitan paintings, not only enlarge the number of works attributed to the artist but also document his activity at least forty years earlier than the official histories indicate.

The excellent quality of these conservative works should give pause to those who would place unsigned examples of this genre almost uniformly into the Yüan or earlier periods. All derive from the Sung academic style and from such a masterpiece of that period as the Liu Ts'ai scroll in St. Louis (*Saint Louis Art Museum*, 1975, p. 289). But the tradition was tenacious and so, doubtless, were the traditions in other conservative subjects remaining in demand. HK/SEL

Recent provenance: Kozo Yabumoto.
The Cleveland Museum of Art 77.55

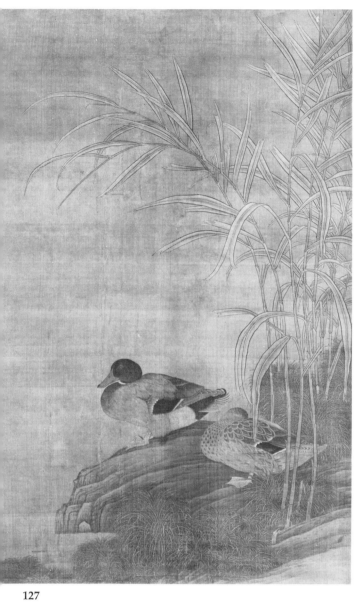

127

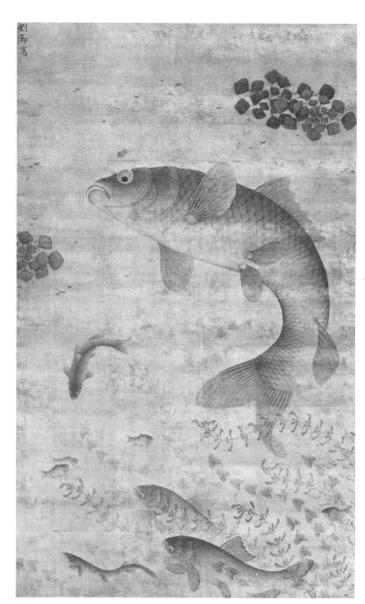

129

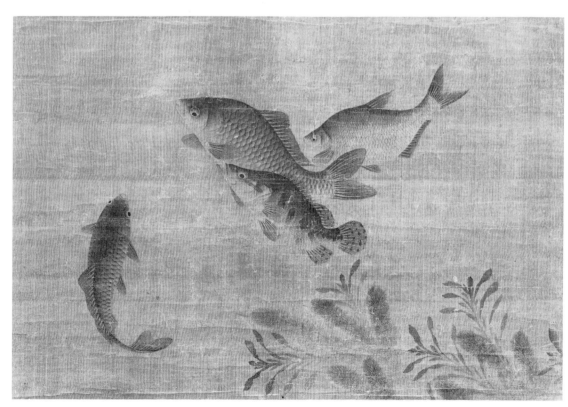

128

Artist unknown, fourteenth century, Yüan Dynasty

130 *Taoist Deities Paying Court*
(Ch'ao-yüan t'u)

Hanging scroll, ink and color on silk, 128.3 x 89.5 cm.

Remarks: When this scroll was painted, it must have been but one from a very large set of scrolls. The theme of such a group would have been the court of any one of a number of Heavenly Lords who throng the Taoist pantheon. Such a theme richly embellishes the walls of a great Taoist temple in southwestern Shanhsi, the Yung-lo-

130

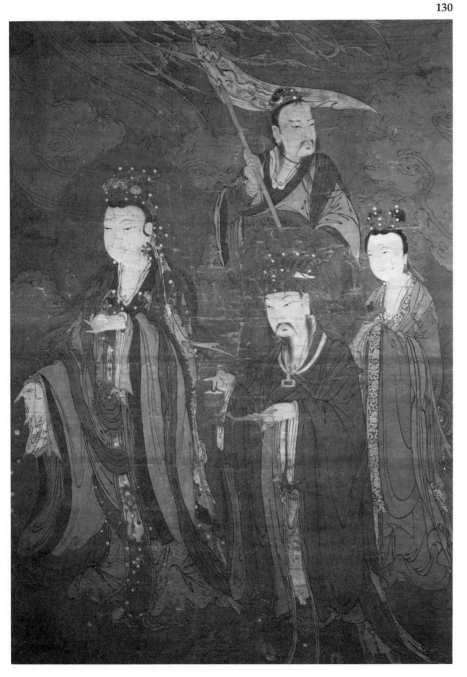

152

kung (Palace of Eternal Delight), the main hall of which was built in 1262 and then lavishly decorated with wall paintings in 1325. The decorations on the side wall are 41 feet long and 14 feet high. Three principal personages, seated and spaced equally from one other, occupy each side wall, with the intervening spaces filled by a vast concourse of lesser deities, marshalled in rows, one behind the other, and mounting up to the top of the composition. Among the seated high gods are: "The Ruler of the Mansion of the Heavenly Star, etc.," the polar star of the northern dipper; "The Eastern Resplendent One, Duke of Wood, etc.," the ruler of the eastern quadrant; and "The Golden Mother of the White Jade Terrace, etc.," who is none other than Hsi-wang-mu, known in ancient lore as Queen Mother of the West. These august personages are surrounded by their courts – literally, a swarm of celestial bureaucrats that included the deified planets and constellations, the Eight Trigrams, countless offering bearers, immortals, guardians, and demons.

The composition of the Nelson Gallery scroll is considerably more restrained than the Yung-lo-kung wall paintings and gains visual merit from its comparative simplicity. At the left, a stout lady of great dignity, richly dressed and ornamented, casts down jewels with prodigality from her right hand and cherishes a large pearl in her left. Behind her stands a stately gentleman in full court garb who is placing a bit of incense in a long-handled, lotus-shaped burner. (A similar burner in silver, also from the Yüan Dynasty, is in the Nelson Gallery collection.) He wears a flat necklace from which is suspended a rectangular badge or talisman of a kind worn by many of the figures in the fourteenth-century wall paintings of the Yung-lo-kung. At the extreme right, a young girl in relatively simple dress carries a bowl or basket containing an offering. The streaming banner borne by the fourth figure, above, is ornamented with a three-toed dragon.

None of the four figures carries or wears identifying marks or symbols and so must be, like many of the figures in the Yung-lo-kung paintings, simply Taoist immortals serving to swell a progress.

By the Yüan Dynasty (1279-1368), the time had long passed when Buddhist and Taoist wall paintings and icons were subjects for the leading masters of the day. Such religious themes had, in large part, become the charge of groups of craftsmen, professional studios possessed of pattern books and iconographic guides. For example, the hugh fresco cycle that decorates the San-ch'ing Hall of the Yung-lo-kung was the work of eleven professionals, seven with the same surname of Ma, who were imported from Loyang in Honan Province to the south. The work of such groups – and there are many examples in Shanhsi Province – naturally vary in quality; there is evidence of a decline in workmanship with the passage of time. Later work is marked by a loss of volume in the figures, whose gestures become congealed, and the whole is characterized by an overall flatness and dryness, but with little or no diminution in ornate detail.

The Taoist figures and clouds in the Nelson Gallery scroll still retain more than a little of the free and flowing brush manner of an earlier time, and the deities move easily in an open, well-organized composition. These qualities, as well as certain similarities in detail with paintings of the Yung-lo-kung, suggest a date well within the Yüan Dynasty. LS

Nelson Gallery-Atkins Museum 73-29
Anonymous gift

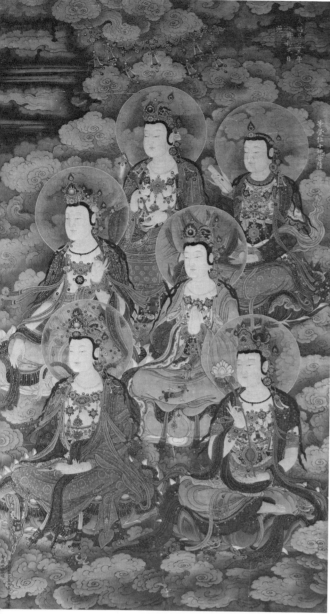

131A

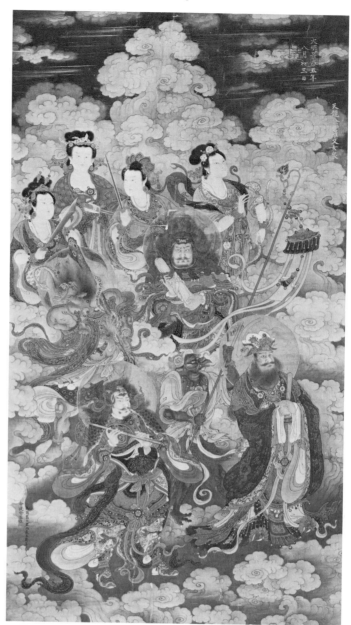

131B

Artist unknown, active ca. 1454, Ming Dynasty

131 *Bodhisattvas of the Ten Stages of Enlightenment (Shih-ti-p'u-sa) and*

The Eight Hosts of Celestial Nagas and Yakshis (T'ien-lung pa-pu yao-ch'a nü-chung)

Pair of hanging scrolls, dated 1454, ink and color on silk, 141 x 79.4 cm. (73.70), and 141 x 79.2 cm. (73.71)

1 seal of the Ching-t'ai emperor (r. 1450-56) and 1 inscription on each painting: [upper right corner] Offered on the third day of the eighth month, the fifth year of Ching-t'ai [1454] of the Great Ming Dynasty. [seal] Kuang-yün chih-pao. [lower left corner] By imperial order, directed and supervised by the Senior Eunuchs of the Directorate of Imperial Household Service, Shang I and Wang Ch'in.
trans. WKH

Remarks: A notation written in German on the exterior label of *Bodhisattvas of the Ten Stages of Enlightenment* indicates that the two paintings were obtained from the Imperial Palace in Peking. The provenance cannot be confirmed, since the only seal on each painting is that of the

Ching-t'ai emperor of Ming. Diagonally below each seal a title identifies iconography. One scroll, inscribed *Teng-chüeh-wei Shih-t'i-p'u-sa*, represents bodhisattvas of the ten stages of enlightenment, undergone in the final process toward Buddhahood. Its companion piece, inscribed *T'ien-lung pa-pu yao-ch'a nü-chung*, represents the Eight Hosts of Celestial Nagas and Yakshis described in the *Lotus Sutra* (see cat. no. 49).

Immediate prototypes for the two hanging scrolls appear in murals of the same subject matter within the Fa-hai Monastery in the eastern suburbs of Peking, built between 1439 and 1444 under the patronage of the eunuch Li T'ung. In fact, the similarity between the scrolls and murals is so marked — particularly in the seated postures of the ten bodhisattvas, the whitened faces and bee-stung lips of the female yakshis, the broken ink outline and pastel interior shadings of the cloud-filled setting — that both may have been designed in the same palace workshop (see *Pei-ching Fa-hai-ssu*, 1958).

The differing facility in facial characterization evident in the two hanging scrolls indicates that they must have been a workshop production by at least two different

153

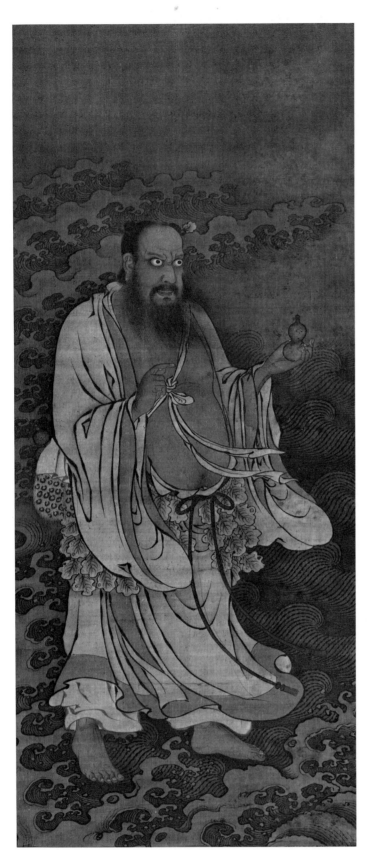

132

artists: each of the seated bodhisattvas bears an identically modelled face, while the hosts and their accompanying personages show varied physiognomies and facial expressions rendered by a much more versatile painter.

Both paintings share a remarkable state of preservation, with their bright, opaque color grounds and fineline gilt decoration intact and virtually unfaded. They reflect the incredibly rich visual atmosphere which must have surrounded the Ming worshipper or visitor within the numerous temples and spirit halls throughout the country. At the same time, the sinuous curves of scarf and drapery, the layering of garment upon garment, the sheer weight of minute detail are all meant to consciously evoke the figural compositions of the T'ang Dynasty (618-906). During that golden age of Buddhist patronage, artists such as Yen Li-pen and Wu Tao-tzu received acclaim for their figural murals, painted on the walls of palaces and temples of the imperial capital. In the succeeding Sung and Yüan periods, major talents preferred such formats as the handscroll, hanging scroll, and the fan.

Mural painting was consigned to anonymous professional painters who continued the compositional formulas of the T'ang epoch without major innovation (for Yüan murals of this type see Ch'in, *Chung-kuo pi-hua i-shu*, 1960, pls. 60-67, 70-81). These scrolls and the contemporary fresco cycle on the walls of the Fa-hai Monastery in Peking represent a continuation of that ancient tradition into the fifteenth century. HK

Literature
CMA *Handbook* (1978), illus. p. 348.

Recent provenance: S. Yabumoto Co.

The Cleveland Museum of Art 73.70, 73.71

Chao Ch'i, active ca. 1488-1505, Ming Dynasty

132 *Taoist Immortal Chung-li Ch'üan*
(Chung-li tu-hai t'u)

Hanging scroll, ink and color on silk, 134.5 x 57.2 cm.

Remarks: The subject of this painting is Chung-li Ch'üan, one of the Taoist *Pa Hsien* (Eight Immortals), and traditionally an official through the Han, Wei, and Chin Dynasties. Characterized by his beard and "handsome" eyes, he styled himself *T'ien-hsia Tu-san* – "Chief Vagabond of the World" (*Tz'u-hai*, 1938, II, unpaginated). The girdle of leaves is a common Taoist immortal-recluse attribute.

The closest parallel to this work is a scroll of another Taoist immortal, Liu Hai-ch'an (carrying his attribute, a three-legged toad), in the Nezu Museum, Tokyo (*Gendai Dōshaku*, 1975, cat. no. 58). The scroll is signed Chao Ch'i and bears the seal Jih-chin ch'ing-kuang, a Ming court title also used by Liu Chün. The latter artist executed at least two paintings of Taoist immortals very similar to those of Chao Ch'i (ibid., cat. nos. 55, 56). Liu is briefly recorded as serving with Wu Wei in the Hung-chih era (1488-1505), and his other preserved works reveal an early Ming style (*Tō-Sō-Gen-Min*, 1928, pp. 392-94; *Kokka*, no. 432; *Shimbi taikan*, 1899-1903, III, no. 28). This would appear to be confirmed by a painting by Liu at Saidai-ji, Nara-ken, with his signature and the name of the Wen-hua palace, the location during the Hung-chih era for artists active at court. These dates seem right for Liu Chün – and, by extension, for the unknown Chao Ch'i.

The brushwork in the waves, draperies, and leaves is identical in the Nezu and Cleveland scrolls, leaving little doubt that the two paintings are by the same hand. They may well be two scrolls from a set depicting the Taoist immortals. The Nezu picture is wider, but the Cleveland one seems to have been markedly narrowed and slightly shortened in the course of several remountings.

The origins of Chao's and Liu's style lie primarily in three sources: the Southern Sung academic style of Ma Yüan as evidenced by the mannered system of representing waves (see the album of wave studies, Palace Museum, Peking, *Sung Ma Yüan Shui t'u*, 1958); the "realistic" and large-scale figure style of Yen Hui (cf. Li T'ieh-kuai in the Palace Museum, Peking; and the Li T'ieh-kuai – Liu Hai-ch'an pair in the Chion-in, Kyoto), which also has connections in Yen's early years of activity with the late Southern Sung Academy; and the figure style relying on late Sung traditions developed by the Ming court painters and the representatives of the Che school (see cat. nos. 133, 134). SEL

Literature
CMA *Handbook* (1978), illus. p. 347.

Recent provenance: Kozo Yabumoto.

The Cleveland Museum of Art 76.13

Hsieh Huan (attributed to), active 1426-1452,
 Ming Dynasty
t. T'ing-hsün; from Yung-chia, Chechiang
 Province

133 *The Nine Elders of the Mountain of Fragrance
(Hsiang-shan chiu-lao t'u)*

Handscroll, ink and color on silk, 29.8 x 148.2 cm.

4 seals: 2 of Hsiang Yüan-pien (1525-1590); 1 of the Ch'ien-lung emperor (r. 1736-95); 1 of Wang Chi-ch'ien (20th c.)

Remarks: Although the provenance of this scroll can be traced through the Ch'ien-lung imperial collection to that of the celebrated Ming connoisseur Hsiang Yüan-pien, the early Ming artist who painted it has not been identified. The presentation of the subject matter – a gathering of old friends at the home of the T'ang poet Po Chü-i in AD 845 – exudes the flavor of poetic gatherings painted by the Southern Sung academicians (see cat. no. 51; for a more complete description of the subject see Laing, "Scholars and Sages," 1967, I, pp. 16, 17). Yet these nine elders inhabit a much more literally defined world within a garden wall than their forbears strolling amidst Ma Yüan's evocative mists. There is the same narrative element that entered a number of Ming court painters' renditions of Southern Sung themes. Individual groups of figures are clustered in a subtle zig-zag movement back and forth into the picture plane, their pastel garments played off against the rich red and blue accents of foliage and furnishings.

The carefully controlled brush outlines and color harmonies of the figures, the richly varied ink tonalities in the gnarled trees and faceted rocks are so close to those painted in 1437 by Hsieh Huan in his *Literary Gathering in the Apricot Garden*, that it seems likely that both handscrolls are by the same hand. Hsieh Huan's *Apricot Garden*, known in two versions (Weng collection – see Cahill, *Parting*, 1978, color pl. 2; and Chen-chiang Museum – see Lu Chiu-kao, "Hsieh T'ing-hsün," 1963, pls. III, IV), records a gathering of high officials from the

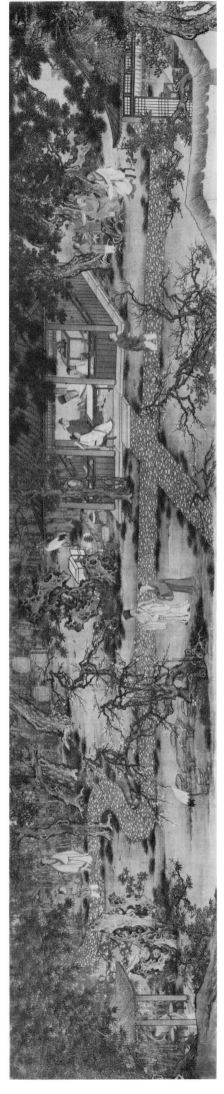

Grand Secretariat, one of the most powerful institutions within the newly formed Ming government. In addition to ministerial patronage, Hsieh Huan also served during the Yung-lo and Hsüan-te eras as a favored court painter. His influence was said to be so great that he crushed the court career of the painter Tai Chin (see cat. no. 134). Surprisingly enough, the rejected painter's works survive in large numbers, while Hsieh's activity can be documented only by a now-lost landscape painted in 1452, the two versions of the *Literary Gathering in the Apricot Garden*, and this beautifully preserved handscroll in Cleveland. LYSL/HK

Recent provenance: Wang Chi-ch'ien.

Intended gift to The Cleveland Museum of Art, Mr. and Mrs. A. Dean Perry

133 Detail

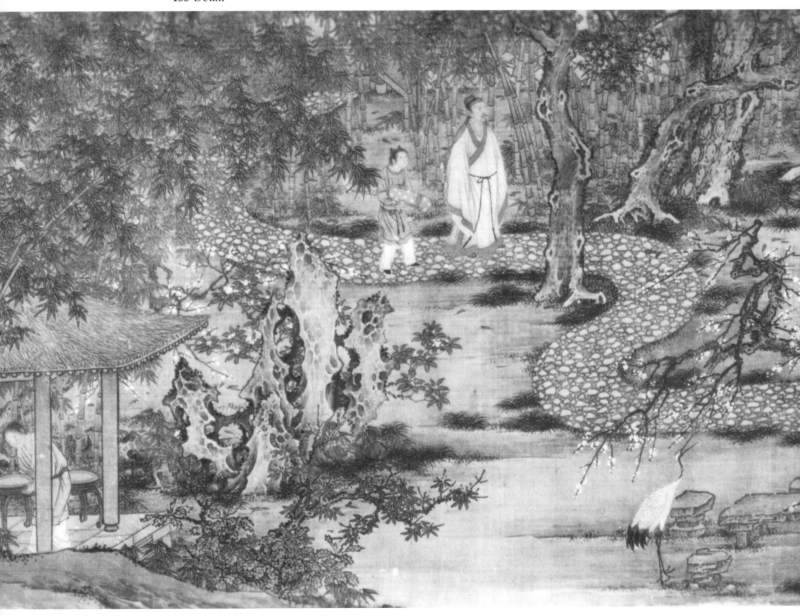

Tai Chin, 1388-1462, Ming Dynasty
*t.*Wen-chin, *h.* Ching-an; from Ch'ien-t'ang,
Chechiang Province

134 *Hermit Hsü Yu Resting by a Stream*
(*Ying-pin kao-yin*)

Hanging scroll, ink and slight color on silk, 138 x
75.5 cm.

5 seals: 1 of Huang Lin (early Ming Dynasty);
4 unidentified.

Remarks: According to official biographies, the artistic
talents of Tai Chin were sufficiently recognized in his
native province of Chechiang to prompt a recommenda-
tion as painter to the early Hsüan-te court (1426-35).
Unfortunately, his ability also aroused the envy of paint-
ers already in attendance, particularly that of the
emperor's trusted artistic adviser Hsieh Huan (see cat.
no. 133). Forced to leave Peking after his paintings were
rejected, Tai fled to Hangchou, then to Yunnan Prov-
ince, where he received the patronage of the connois-
seur Mu Ch'en and the help of the painter Shih Jui (see
cat. nos. 136, 137). Tai eventually reestablished himself
successfully in Peking, fulfilling commissions for impor-
tant members of government. He died in Hangchou in
1462 (see Cahill, *Parting*, 1978, pp. 45-48). His forty-year
career so affected the artistic environment of early Ming
China that he is traditionally credited as the founder of
the Che school.

The subtly tinted washes, the landscape setting and
placement of *The Hermit Hsü Yu Resting by a Stream* bow
to the conventions of Ma Yüan's *Composing Poetry on a
Spring Outing* (cat. no. 51) or Ma Lin's *Listening to the
Rustling of Pines* in the National Palace Museum, Taipei
(*Three Hundred Masterpieces*, 1959, III, no. 117). At the
same time, Tai Chin transforms the deep spatial implica-
tions of Southern Sung figural landscapes into a decora-
tive unity by integrating the surface of the picture with
juxtaposed, vigorous bruststrokes and rich ink washes.
A similar balance pervades another Tai Chin composi-
tion of practically identical size and related subject mat-
ter in the National Palace Museum, *Wen Wang of Chou
Visiting T' ai-kung Wang on the Banks of the Wei River*
(Sirén, *Masters and Principles*, 1956-58, VI, pl. 145). Wen
Wang was the first and model King of Chou, while T'ai-
kung Wang stood ae a paragon of humble virtue and
accomplishment. The hermit Hsü of our painting re-
fused both the throne offered by the legendary Emperor
Yao (r. 3rd millenium BC), and the governorship of nine
states, thereby illustrating the Confucian concept of
serving the government at the right time and under the
right circumstances. Thus, both paintings might have
been part of a set of "Worthies" or "Paragons" of good
government – a fit subject for a painter in the newly
revived court. HK

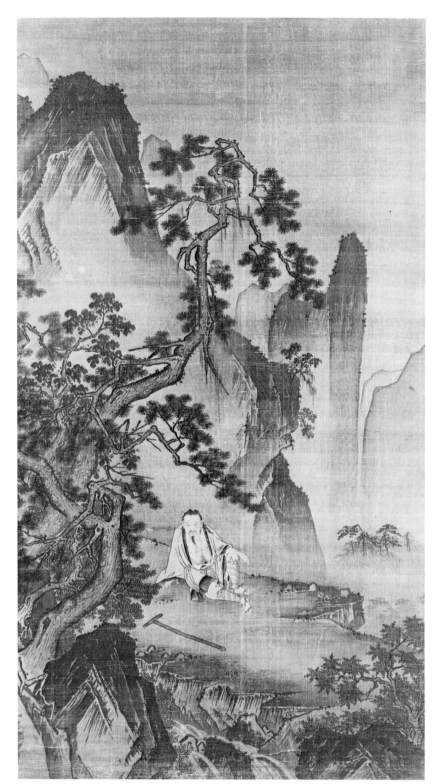

134

Literature
Lee, "Early Ming Painting" (1975), pp. 248-50, fig. 8.
Cahill, *Parting* (1978), p. 47, pl. 12.
CMA *Handbook* (1978), illus. p. 348.

Recent provenance: Shōgorō Yabumoto.

The Cleveland Museum of Art 74.45

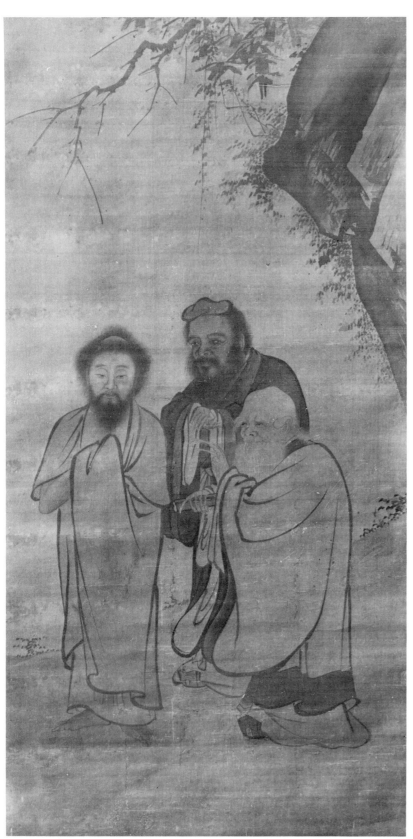

135

Artist unknown, late fifteenth-early sixteenth
century, Ming Dynasty

135 *The Three Religions*
(San-chiao t'u)

Hanging scroll, ink and color on silk, 146.7 x
73.7 cm.

3 colophons and 8 seals: 1 seal of Hou-an (unidentified,
19th c.); 1 colophon, dated 1858, and 1 seal of Yü Wen-
chao (act. mid-19th c.); 1 seal of K'ung Kuang-yung
(elder brother of K'ung Kuang-t'ao); 1 colophon,
1 label, and 4 seals of K'ung Kuang-t'ao (1832-?);1 seal
unidentified.

Remarks: In his colophon on the mounting of the scroll,
K'ung Kuang-t'ao, a collector from Canton who signs
himself as a descendant of Confucius in the seventieth
generation, attributed the painting to Ma Yüan (act. ca.
1190-after 1225), but in his catalogue calls it a work by an
unknown painter of the Northern Sung Dynasty. His
attribution to Ma Yüan may stem from the fact that Ma
was known to have painted the subject, but from the
description of it given by Chou Mi in the thirteenth cen-
tury, it was a quite different composition *(Ch'i-tung yeh-
yü*, preface 1291, *ch.* 17, p. 14).

Judging from the present proportions of the scroll,
some four to six inches have been trimmed from the left
side. This area may very well have contained a signature
which had to be removed before the scroll could pass as
a "Sung painting."

The rocks, tree limbs, and vegetation occupying the
upper right are executed in a loose, broad manner close
to the style of the well-known Che school painter Chang
Lu (ca. 1464-d. 1538). There were a number of highly
competent Che school painters, and although it is not
possible to assign the Nelson Gallery scroll to a specific
artist, the similarity of the landscape elements to Chang
Lu and other like painters of the time gives a most prob-
able date of late fifteenth century to first half of the six-
teenth century. While the landscape elements are done
in the moist, free manner of the Che school, the figures
are executed with more precision. The brushstrokes de-
lineating the garments are done with vigorous assurance
and good description of form.

The figure of Confucius dominates the composition;
his height and dark complexion conform to the descrip-
tion of the sage given by Ssu-ma Ch'ien (d. 85 BC) in the
Records of the Grand Historian (Shih-chi, ch. 47, p. 1925).
The Shakyamuni Buddha, completely withdrawn and in
deep meditation, has the soft beard and lightly curling
hair with a slight bald spot of a Southern Sung pro-
totype, of which the most perfect example is the *Shaky-
amuni Buddha Coming out from the Mountains* by Liang
K'ai (act. early 13th c.) (Kawakami et al., *Ryō Kai, Indara*,
1975, pl. 3).

The Three Religions, depicting the founders of Bud-
dhism, Taoism, and Confucianism, had become a theme
for artists in the Southern Sung period in response to
certain aspects of the neo-Confucianism of Chu Hsi
(1130-1200). The blending of thought from the three reli-
gions was further emphasized by the Ming philosopher
Wang Yang-ming (1427-1529). Under one of his follow-
ers, Lin Chao-en (1517-1598), the amalgamation became
a doctrine that has been described as a "religious orga-
nization with Confucianism as its principal doctrine and
Buddhism and Taoism as its subsidiary teachings...."
(Liu Ts'un-yan, "Taoist Self-Cultivation," 1970, p. 319).
The Nelson Gallery scroll ably reflects this aspect

of Ming thought current around the turn of the sixteenth century. LS/KSW

Literature
K'ung, *Yüeh-hsüeh-lou* (1889), *ch.* 2, pp. 20, 21.

Nelson Gallary-Atkins Museum 76-10/12

Given in memory of John B. Trevor by his son, Bronson Trevor

Shih Jui, active ca. 1426-ca. 1470, Ming Dynasty
t. I-ming; from Hangchou, Chechiang Province

136 *Greeting the New Year*
(Sui-chao t'u)

Handscroll, ink, color, and gold on silk, 25.5 x 170.2 cm.

Artist's 2 seals: Shih shih I-ming; Yu-hsi han-mo.

Title on frontispiece by Chu Ch'ang-i, dated 1849: *Pavilions in the Mountains of the Immortals (Hsien-shan lou-kuan)* by the Junior General of the T'ang Dynasty.

1 inscription, dated 1639, and 1 seal of Hsiao Yün-ts'ung (1596-1673). 4 colophons and 30 additional seals: 1 seal of Hsü Ch'ien-hsüeh (1631-1694); 1 seal of Li Chien (1747-1799); 1 seal of Chang Chin-fang (18th c.); 2 seals of Sun Erh-chun (1770-1832); 1 colophon and 2 seals of Chang Wei-p'ing (1780-1859); 1 seal of Wu Yung-kuang (1773-1843); 1 colophon and 2 seals of Lo T'ien-ch'ih (1826 *chin-shih)*; 7 seals of Wu Yüan-kui (19th c.); 2 colophons and 4 seals of P'ang Cheng-wei (19th c.); 9 seals unidentified.

Inscription by Hsiao Yün-ts'ung:
This is a painting by the Junior General Li. The painting is damaged and cracked at many places. Many of the paper strips for backing have been missing since long ago, but the colors are still as fresh as if they had just been applied and the ink still looks moist.

During the reign of T'ien-pao (742-756) of the T'ang Dynasty, the Imperial Klansman Li Ssu-hsün was summoned to paint the walls of the Ta-t'ung Hall. He was known as the "Senior General." His son, who came to be known as the "Junior General," was named Chao-tao.

Of the stone epitaph [*Li Ssu-hsün pei,* or the "epitaph of Li Ssu-hsün," one of the best-known calligraphic monuments of the T'ang Dynasty], engraved with the calligraphy of Li Pei-hai [Li Yung, 678-747], more than half has fallen off. Why, in contrast, was this painting able to survive? Or could it be that despite the fact that the stone is hard and the silk is soft, their preservation or destruction depends on some other factors? Moreover, since they were titled nobility of imperial descent, it is doubtful that they had the leisure and the mood to indulge in such decorative and descriptive blue and gold painting for the mere amusement of their fellow men. Recently, I read the *I-chou Ming-hua lu* [by Huang Hsiu-fu, preface 1005]. I found a certain Li Chin-nu who compared himself with Li Chao-tao and was called by the Ssuch'uan people the Junior General Li. In a painting which he did, entitled *Mt. Ch'ing-ch'eng*, the architectural structure of the pavilions, terraces, bridges, and boats are meticulous and accurate. The horsemen on a spring outing are as small as grain and the wild geese among the clouds as tiny as dust. It was also said that he painted on silk of any length in accordance to specific commissions. Is it possible that this painting is one of his? Since that time 700 years have passed. Yet one of the two Junior General Li's must be our painter.

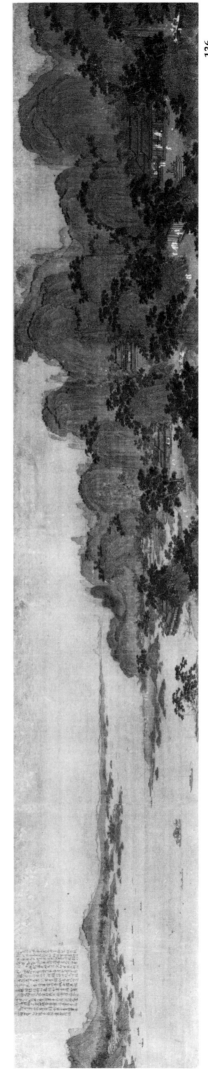

Formerly, there were the so-called "Four Excellents" in the Hall of Portraits of the Buddhist monk Wu-ta Kuo-shih: the [portrait] painting by Ch'ang Ts'an [act. ca. 881-888], the calligraphy by Priest Tao-ying, the eulogy by Li Shang-yin [813-858], and the landscape by Li Sheng [act. ca. 908-925]. This Li Sheng was styled Chin-nu and was also called Junior General Li.

In the tenth month of the *chi-mao* year, the twelfth year of the Ch'ung-chen era [1639], recorded by Hsiao Yün-ts'ung of Ch'ü-hu.

trans. WKH

Remarks: The first seal of Shih Jui has the same characters as his first seal on the signed handscroll by Shih Jui in the Hashimoto collection (*Hashimoto,*1972, no. 2). The inscription by the well-known, late-Ming master Hsiao Yün-ts'ung, dated 1639, contains the expected attribution to and comments about T'ang Dynasty artists Li Ssu-hsün and his son, Li Chao-tao, who traditionally originated the "blue-and-green" category of painting (see Lee, "River Village," 1979, pp. 274-80). This inscription is almost certainly the one recorded in confused form in *T'ing-fan-lou shu-hua chi* of 1843, the catalog of P'an Cheng-wei's collection (see Lovell, *Annotated Bibliography*, 1973, p. 114). The seal of Hsiao Yün-ts'ung is in Contag and Wang, *Seals*, 1966, p. 476, no. 4.

The seal of Li Chien reads "Li Chien investigated the antique," clearly indicating his function on this occasion. His own manner of painting (see cat. no. 279) was in the archaic blue-and-green style.

The second colophon by P'an Cheng-wei implies that Hsiao's ascription of the painting to Li Chao-tao may be doubted. The colophon by Chang Wei-p'ing recognizes the fine-line style and associates it with the description of the Li family style in Chang Yen-yüan's *Li-tai ming-hua chi* (AD 847). The final colophon by Lo T'ien-ch'ih mentions Chao Po-chü in connection with the figures, but still retains the connection with the Li family style in other particulars.

This painting has been considered one of the great art treasures in South China since the turn of the eighteenth century. Its attribution to a late T'ang master – initiated by Hsiao Yün-ts'ung and endorsed by eminent scholars, artists, and critics such as Hsü Ch'ien-hsüeh, Li Chien, and Chang Wei-p'ing – has never been seriously questioned. From the T'ing-fan lou (Tower for Listening to the Sailboats) of the P'an family to the Nan-hsüeh chai (Studio of Southern Snow) of the Wu family, the scroll went from one famous Cantonese collection to another. None of these owners or their advisers recognized the seal of Shih Jui.

SEL/WKH

136 Detail

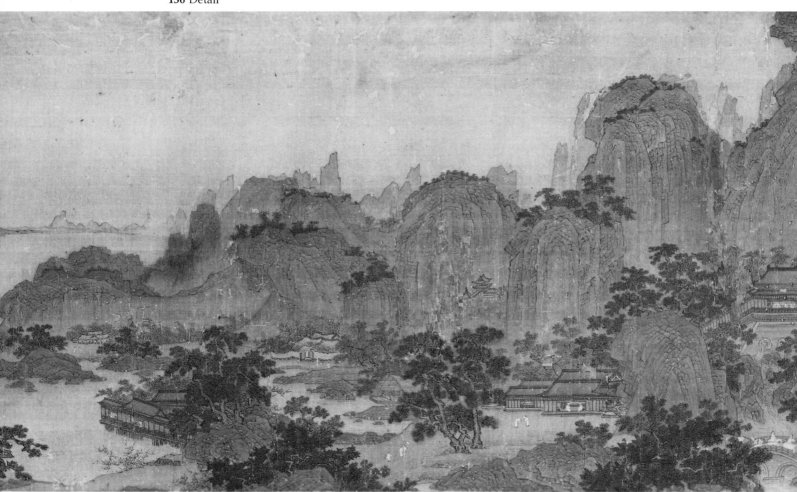

Literature
P'an, *T'ing-fan-lou* (1843).
Lee, "Early Ming Painting" (1975), pp. 245, 246, figs. 3-6.
Cahill, *Parting* (1978), p. 26, n. 8.
Sullivan, *Arts of China* (1979), p. 211.
CMA *Handbook* (1978), illus. p. 348 (detail).

Recent provenance: A. W. Bahr; Robert Ellsworth, Inc.

The Cleveland Museum of Art 73.72

Shih Jui (attributed to)

137 *The Haven of the Peach-Blossom Spring*
(*Wu-ling T'ao-yüan*)

Album leaf, ink and light color on silk,
24.6 x 22.1 cm.

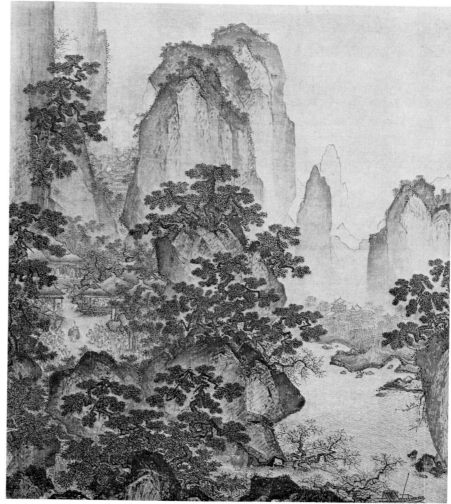

137

Remarks: The title and subject matter allude to a
famous literary composition by the poet T'ao Yüan-
ming (365-427), wherein an old fisherman stumbles
upon a Shangri-la of peace and happiness, located
beyond a mountain pass at the source of a stream. This
album leaf was previously published with an attribution
to the early sixteenth-century artist Chou Ch'en. With
the discovery of the handscroll *Greeting the New Year* by
Shih Jui (cat. no. 136), the Chou Ch'en attribution of *The
Haven of the Peach-Blossom Spring* has been revised. Care-
ful scrutiny of both paintings reveals striking similarities
in the architecture of the thatched huts, the angular
silhouettes of the twisting pine trees, and the crystalline
mountain formations.

While each painting differs in the type of texture
stroke employed to define the volume of the mountain
forms, the stroke is repeated uniformly on the same
scale in each example. Even the placement of pine upon
rock and mountain top, as these elements recur in the
compositions, betrays such a common formula that both
paintings must be the work of Shih Jui. Finally, the meti-
culous precision of line observed in the figures and
architecture of both paintings establish Shih Jui as a mas-
ter painter on the miniature scale – a talent hitherto un-
known in his larger-scale surviving works. LYSL/HK

Literature
Sirén, *Masters and Principles* (1956-58), VII, *Lists*, 178.
Lee, "Some Problems" (1957), pp. 472, 473, pls. 1, 2
 (figs. 1, 2); idem, "The Haven" (1958), pp. 211-14, illus. pp.
 213, 214; idem, *Chinese Landscape Painting* (1962), p. 62, no. 47;
 idem, "Scattered Pearls" (1964), pp. 37, 38, no. 12.

Exhibitions
Cleveland Museum of Art, 1954: Lee, *Chinese Landscape Painting*,
 cat. no. 45.

Recent provenance: Vladimir G. Simkovitch.

The Cleveland Museum of Art 52.283

Artist unknown, late fourteenth-early fifteenth
century, Ming Dynasty

138 *Landscape*
(Shan-shui)

Handscroll, ink and light color on silk,
23.8 x 475.5 cm.

23 seals: 3 of An Ch'i (1683-ca. 1746); 6 of the Ch'ien-lung emperor (r. 1736-95); 1 of Yung-hsing (1752-1823, eleventh son of the Ch'ien-lung emperor and first Prince Ch'eng); 1 of Sun Er-chun (1770-1823); 4 of Ch'ing-hsi (act. 1840-60); 3 of I-hsin (1832-1898, sixth son of the Tao-kuang emperor and first Prince Kung); 1 of Tsai-ying (b. 1861, second son of Prince Kung); 1 of Hsiao Feng-chün (20th c.); 3 unidentified.

Remarks: The outer label on the scroll, written by the well-known scholar-calligrapher Pao-hsi (b. 1871), reads: "A famous Sung landscape of the Northern School, [this] rare silk scroll is treasured and preserved by Hsin-yü [P'u-ju, 1896-1964]." Despite this attribution to an unknown master of the Sung Dynasty, there is reason to believe the painting may be of a somewhat later date. Although the style is highly personal, with striking technical individuality, no comparable painting that could be attributed to the same hand has yet been found. Some aspects derive from the Northern Sung tradition, but the composition, the texturing strokes *(ts'un),* the trees in wet ink, and the dark rocks, among other features, relate more closely to paintings of the Southern Sung Dynasty. The scroll is a successful amalgam of technical and stylistic elements comparable to certain works of Tai Chin (see cat. no. 134), suggesting a date for the scroll in the early Ming Dynasty. A thirteenth-century date, however, should not be ruled out. LS/KSW

Literature
K. Suzuki, *Ri Tō* (1974), pp. 173, 174, pls. 126, 127.

Exhibitions
Tokyo National Museum, 1931: *Sō-Gen-Min-Shin,*I, pl. 10.

Recent provenance: P'u-ju, Peking (1896-1964; a descendant of Prince Kung).

Nelson Gallery-Atkins Museum 35-262

138 Detail

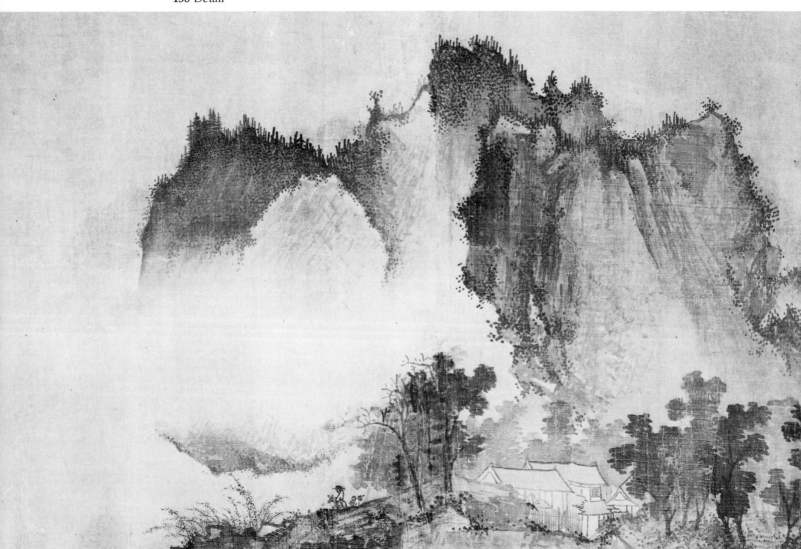

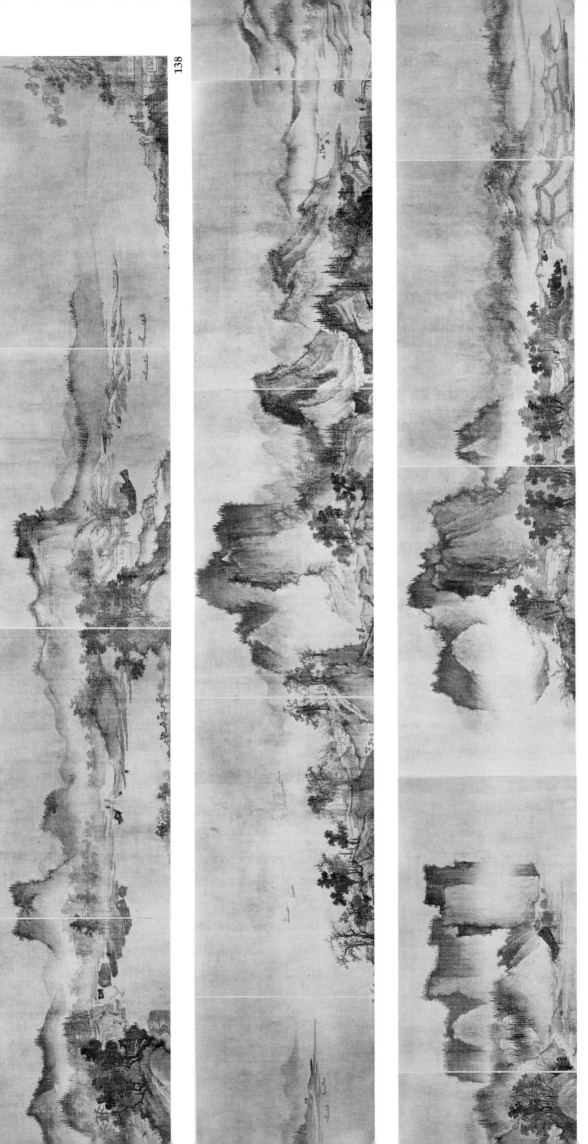
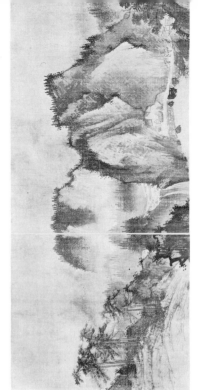

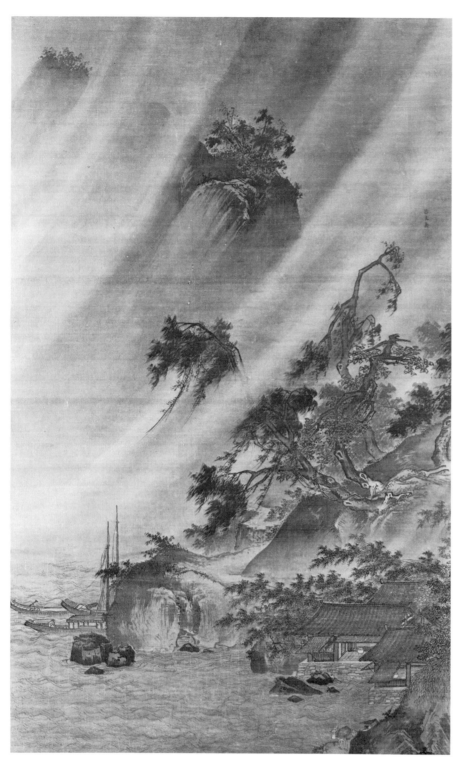

Lü Wen-ying, active until 1507, Ming Dynasty
From Kuo-ts'ang, Chechiang Province

139 *River Village in a Rainstorm*
(*Chiang-ts'un feng-yü*)

Hanging scroll, ink and slight color on silk, 169.2 x 103.5 cm.

Artist's signature and seal: Lü Wen-ying [seal] Jih-chin ch'ing-kuang.

Remarks: By birth and stylistic association a Che painter, Lü Wen-ying served with the bird-and-flower master Lü Chi as court painter during the Hung-chih era (1488-1506). In fact, Ming painting histories sometimes paired the two contemporaries who shared the same surname–Lü Wen-ying being known as "Little Lü." Both men also enjoyed the privilege of working in the presence of the emperor himself, since each employed the seal Jih-chin ch'ing-kuang ("daily approaching the pure and radiant," trans. WKH; see Cahill, *Parting*, 1978, p. 108).

Until recently, Lü Wen-ying's paintings were represented only by two surviving examples–pictures of toy peddlers based on Southern Sung prototypes (see cat. no. 35). Therefore, the appearance of this previously unrecorded work, *River Village in a Rainstorm*, broadens considerably the known scope of Liu's talent as a painter. Its sharply focused foreground brushwork echoes the precision of his toy peddlers, while its general theme and color harmonies allude dimly to the quiet and atmosphere-laden landscapes of Southern Sung and Yüan. Much closer in time, emotional vigor, and lush ink play is a *Rainstorm* in the National Palace Museum, Taipei, painted by Tai Chin (Sirén, *Masters and Principles*, 1956-58, VI, pl. 148). Yet Lü 's gusting rain, bent trees, and choppy waters surpass even Tai Chin's in palpable force and drama. HK

Literature
Akiyama et al., *Chūgoku bijutsu* (1973), II, pt. 2, 215, 216, color
 pl. 3.
K. Suzuki, *Ri Tō* (1974), p. 168, pl. 73.
Lee, "Early Ming Painting" (1975), p. 251, figs. 11-13.
Kawakami and Tsuruta, *Chūgoku* (1977), X, 38, color pl. on p. 36.
Cahill, *Parting* (1978), p. 108, pl. 51.
CMA *Handbook* (1978), illus. p. 348.

Recent provenance: Kinzen Company, Ltd.

The Cleveland Museum of Art 70.76

Artist unknown, early to mid-fifteenth century,
 Ming Dynasty

140 *Temple Hidden among Lofty Cliffs*
 (Ch'ung-yen ku-ssu)

 Screen or hanging scroll (now paneled), ink and
 color on silk, 188 x 153.2 cm.

Spurious signature: Hsia Kuei [act. 1180-1225].

Remarks: The subject and composition of this painting
hark back to Southern Sung album leaves by such mas-
ters as Li T'ang, Ma Yüan, and Hsia Kuei. A number of
the early Ming academic painters followed this practice
of enlarging Southern Sung compositions to form a large
hanging scroll or a single-panel screen of the kind de-
picted by Liu Kuan-tao (see cat. no 92). Here the textur-
ing of the mountains and rocks combines the small and
large axe-stroke method of Li T'ang and Hsia Kuei.
However, the brushwork is rather coarse and loose com-
pared to Southern Sung antecedents, and suggests a
date around the time of Tai Chin (1388-1462). KSW

Nelson Gallery-Atkins Museum 34-267

Chu Tuan, active ca. 1501-51, Ming Dynasty
 t. K'o-cheng, *h.* I-ch'iao; from Hai-yen, Chechiang
 Province

141 *Retreat among Streams and Mountains*
 (Hsi-shan kao-i)

 Hanging scroll (now paneled), ink and color on silk,
 183 x 128 cm.

Artist's signature and 3 seals: Chu Tuan [2 seals]
I-ch'iao Chu K'o-cheng; Hsin-yu cheng-shih. [1 seal,
upper right corner] Ch'in-tz'u i-ch'iao t'u-shu.

Remarks: The signature is so badly rubbed that it can
only be discerned with difficulty. The second seal below
the signature indicates that the artist was called to court
in 1501, while the seal on the upper right indicates that
he was given a seal by the emperor. The painting has
suffered some damage, particularly in the central part
where the tree, waterfall, and clouds are clumsily
restored.
 In many of his paintings, Chu Tuan followed the style
of Kuo Hsi (ca. 1020-1090), whereas this example is close-
ly modelled in color, brush manner, and composition on
the paintings of the Yüan Dynasty artist Sheng Mou (see
cat. no. 107). KSW

Recent provenance: Tonying and Co.
Nelson Gallery-Atkins Museum 35-153

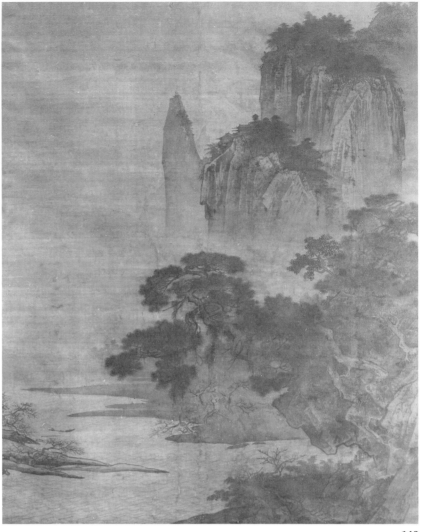

140

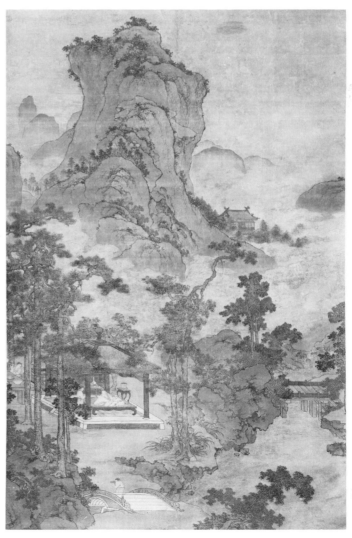

141

Artist unknown, late fourteenth-early fifteenth century, Ming Dynasty

142 *Festival of the Peaches of Longevity (P'an-t'ao t'u)*

Handscroll, ink, full color and gold on silk, 52 x 476 cm.

Remarks: The subject is the celebration of the birthday of the Queen Mother of the West (Hsi-wang-mu), one of the leading deities in the Taoist pantheon. The site is the fabled home of the immortals, K'un-lun-shan, where, at the time of the festival (P'an-t'ao hui), the Peaches of Longevity–having taken three thousand years to ripen– are finally gathered. The composition opens with the guests, gods, goddesses, and immortals arriving, some from across the sea. The gathering of the peaches occupies the center of the composition, which concludes with Hsi-wang-mu and her attendants standing on a high terrace gazing toward a pink cloud.

It seems reasonable to postulate that the Nelson Gallery scroll is a relatively close version of a thirteenth-century composition by the Southern Sung artist Fang Ch'un-nien (act. 1228?-after 1260). Another version of the Nelson scroll is in the Freer Gallery of Art, Washington (no. 08.170); it cannot be earlier than mid-eighteenth century, but is clearly a copy–possibly at second or third hand. At the end of the Freer scroll is a signature in seal characters of Fang Ch'un-nien: Hua-yüan tai-chao Fang Ch'un-nien tsao. Fang, a native of Hangchou, achieved the rank of official-in-waiting (*chih-hou*) in the Imperial Painting Academy during the Ching-ting era (1260-64).

Some editions of Hsia Wen-yen's *T'u-hui pao chien* (preface 1365) report that he was a painter-in-attendance (*tai-chao*) in the Academy as early as the Shao-ting era (1228-33). Fang specialized in Taoist themes, illustrations of religious stories, and landscapes in full color (Li O, *Nan-Sung*, 1721, *ch.* 8, p.73a).

The Nelson Gallery scroll is the same height as that in the Freer Gallery but is some 230 centimeters shorter. A comparison of the composition in the two scrolls and a physical examination of the Nelson scroll reveals that some 170 centimeters at the beginning and 60 centimeters at the end have been removed; consequently, whatever seals, signature, or colophons the painting may have had originally are lost. There is good reason to believe that the scroll was cut in Japan before or after it entered the collection of Izō Fujii, Fukuoka Prefecture.

In spite of this mutilation, the remainder–it is the major part of the painting–reveals a close similarity to works in a meticulous blue-and-green style of the Southern Sung Academy. It is executed with notable skill and gives a vivid portrayal of the Land of the Immortals in a style traditionally associated with that of the earlier, and no doubt greater, master, Chao Po-chü (act. ca. 1127-62).

LS

Literature

Nihon genzai Shina (1938), p. 228, under artist unknown.
Keswick, *Chinese Garden* (1978), pl. 88.

Recent provenance: Izō Fujii.

Nelson Gallery-Atkins Museum F72-39

Gift of the Herman R. and Helen Sutherland Foundation Fund

142 Detail

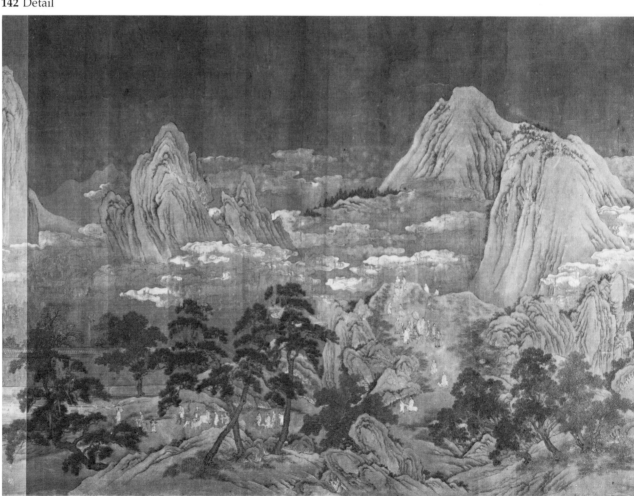

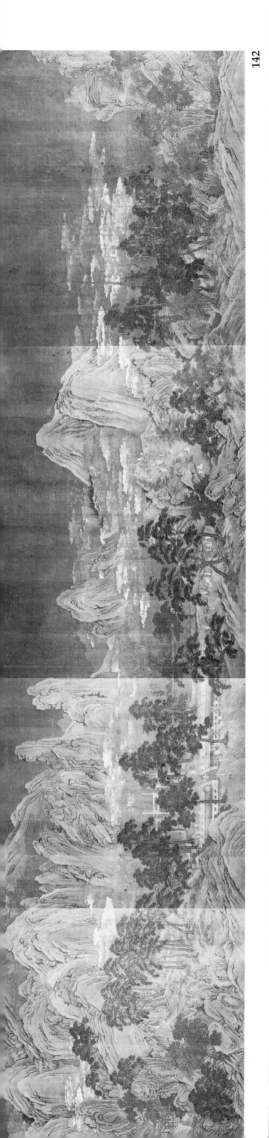

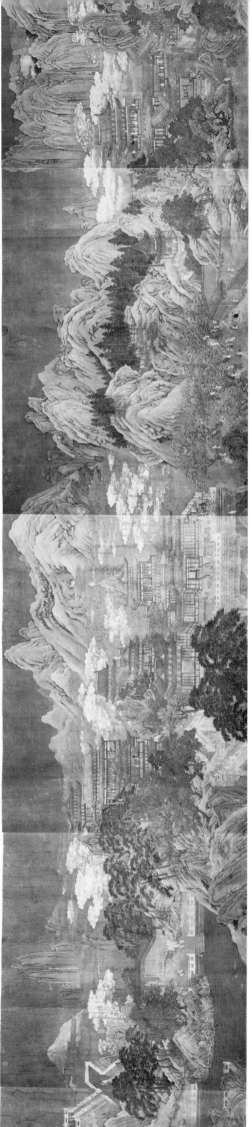

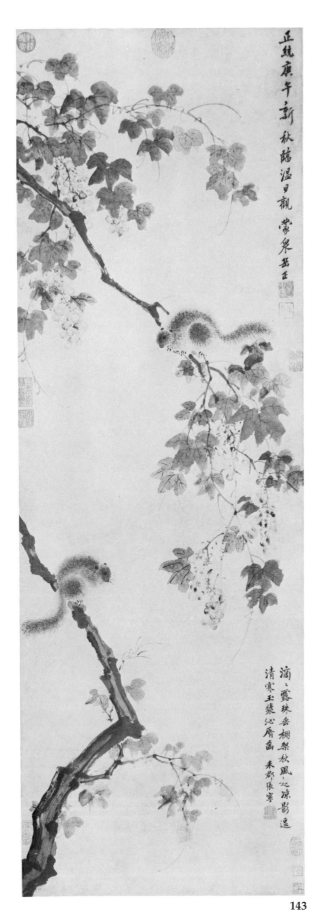

Yüeh Cheng, 1418-1473, Ming Dynasty
 t. Chi-fang, h. Meng-ch'üan; from Kuo-hsien,
 Hopei Province

143 *Squirrels and Grapes*
 (P'u-t'ao sung-shu)

Hanging scroll, dated 1450, ink and color on paper,
122.6 x 41.7 cm.

Artist's inscription, signature, and 2 seals along upper
right edge: Following [the style of] Wen Jih-kuan [act.
late 13th c.], in the early autumn of the *keng-wu* year of
the Cheng-t'ung era [1450]. Meng-ch'üan, Yüeh Cheng
[seals] Yüeh Cheng chih-yin; Meng-ch'üan.

1 additional inscription and 12 additional seals: 1 in-
scription and 1 seal of Chang Ning (1427-ca. 1495); 1 seal
of Ch'en Cho (1733-after 1782); 5 seals of the Ch'ien-lung
emperor (r. 1736-95); 1 seal of Mien-i (1764-1815, grand-
son of the Ch'ien-lung emperor); 1 seal of I-hui (1799-
1838, son of Mien-i); 1 seal of the Chao family, uni-
dentified; 1 seal of Wu Shih-hsien (d. 1916); 1 seal
unidentified.

Inscription by Chang Ning:
Beads of dew, drop on drop, hang down,
The lattice frame tottering in the autumn wind.
Cool shadows retain a crystalline cold,
Jade-like nectar penetrating the lips and teeth.
Chang Ning of Ho-chün [modern Chia-hsing,
Chechiang].

<div align="right">trans. MFW</div>

Remarks: Wen Jih-kuan, whose manner Yüeh Cheng
says he followed in this painting, was a late thirteenth-
century artist famous for his painting of grapes.

The date in Yüeh Cheng's inscription may be puz-
zling. In September 1449, Chu Ch'i-chen, ruling with the
imperial-reign title Cheng-t'ung, was taken prisoner by
the Oriat Mongols when his army was defeated in a
disastrous battle. Before leaving on the campaign, the
Cheng-t'ung emperor charged his younger half-brother,
Chu Ch'i-yü, to care for the defense of the capital. The
emperor remained a prisoner for twelve and a half
months and was not released until September 1450. He
arrived back in Peking on September 20 of that year, but
rather than being restored to the throne, he was placed
in confinement by his half-brother, who had been in-
stalled as emperor on September 22, 1449, with the reign
title of Ching-t'ai, beginning January 1450. When Yüeh
Cheng wrote his inscription, using the reign title Cheng-
t'ung, the released emperor must have been on his way
back to Peking since Yüeh Cheng's expression *hsin-ch'iu*
(early autumn) could refer to a time in early to mid-
September. He owed his office at court to the Cheng-
t'ung emperor and out of loyalty must have assumed,
prematurely and over boldly, that the erstwhile captive
would be restored to the throne on his entry into
the capital.

Although the painting carries five seals of the Ch'ien-
lung emperor, it is not listed in either the first or second
part of the catalogue *Shih-ch'ü pao-chi*. Since the painting
has the seals of both Mien-i (the emperor's grandson)
and I-hui (his great-grandson), it seems probable that
the emperor gave the painting either to his fifth son,
Yung-ch'i (the father of Mien-i), or directly to Mien-i
before the publication of Part II of the catalogue in 1793.
The scroll then passed from Mien-i to his son I-hui.

<div align="right">LS/KSW</div>

Literature
Shina meiga senshū (1926-27), II, pl. 6.
Tōan-zō (1928), p. 49, pl. 16.
Harada, *Shina* (1936), p. 137.
Nihon genzai Shina (1938), p. 137.
Lee, "To See Big within Small" (1972), pp. 320, 321, fig. 65.

Recent provenance: Etsuzō Saitō; Fran-Nell Gallery, Tokyo.

Nelson Gallery-Atkins Museum 68-43

P'eng Hsü, active ca. 1488-1521, Ming Dynasty
t. Te-mien, *h.* Shih-chu; from K'un-shan, Chiangsu
Province

144 *Ink Prunus*
(Mo-mei)

Hanging scroll, ink on silk, 127 x 67.3 cm.

Artist's 2 seals at left middle edge of painting:
P'eng shih Te-mien; Shih-chu.

Remarks: P'eng Hsü, in a sense, inherited Wang Mien's
manner of painting prunus (see cat. no. 88). P'eng was
reputedly trained by his uncle, Chou Hao (act. 2nd half
15th c.), considered by his own generation as the fore-
most interpreter of the Wang Mien tradition. P'eng's *Ink
Prunus* confirms those literary accounts in the use of a
heavily inked wide brush for the silhouette of the tree
trunk; *fei-pai* and massed pepper dots for the gnarled
bark; long, swelling strokes for the needle-like twigs;
and jumping, discontinuous lines for the blossoms and
buds. A gray wash covers the entire surface except for
the flower petals. HK

Literature
CMA *Handbook* (1978), illus. p. 350.

Exhibitions
Asia House Gallery, New York, 1974: Lee, *Colors of Ink*, cat.
no. 30.

Recent provenance: Yamanaka and Co., Ltd.

The Cleveland Museum of Art 70.80

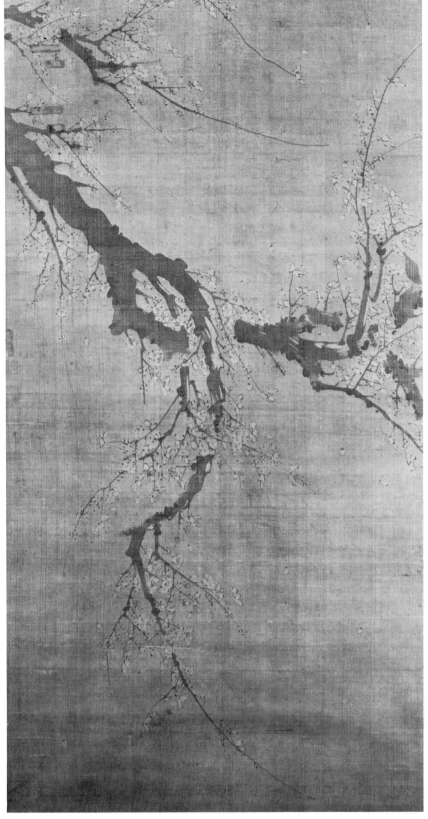

144

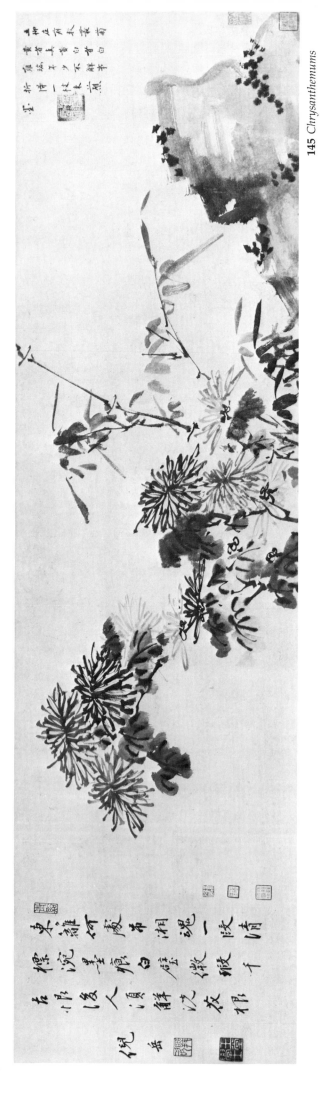

145 *Chrysanthemums*

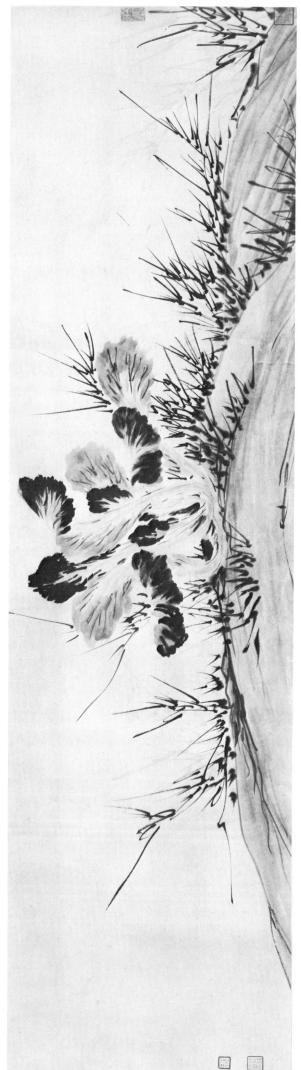

145 *Cabbages*

T'ao Ch'eng, active 1480-1532, Ming Dynasty
t. Meng-hsüeh, *h.* Yun-hu hsien-jen; from Pao-ying,
Chiangsu Province

145 *Chrysanthemums* and *Cabbages*
(*Chü-hua pai-ts' ai*)

Handscroll, ink on paper, 28.6 x 152.1 cm.
(*Chrysanthemums*); ink and light color on paper, 28.6 x
101.9 cm. (*Cabbages*).

Artist's seal at beginning of painting: Yun-hu.

16 inscriptions and 52 additional seals: 1 poem and 1 seal
of Chang Yüan-chen (1437-1507); 2 poems and 6 seals of
Ni Yüeh (1444-1501); 2 poems and 4 seals of Chao Hsiang
(n. d.); 2 poems and 2 seals of Wu Hsi-hsien (1437-1489); 2
poems and 2 seals of Lü Ch'ang (1449-1511); 2 poems and 6
seals of Fu Han (1435-1502); 2 poems and 2 seals of Feng
Chüeh (n. d.); 1 poem and 1 seal of Ts'ai Ch'i (n. d.); 1
poem and 3 seals of Chiao Fang (act. 1464-1517); 1 poem
and 3 seals of Li Tung-yang (1447-1516); 2 seals of Wang
Wen-chih (1730-1802); 3 seals of Ku Yün (n. d.).

Poems after *Chrysanthemums:*
Several bushes of chrysanthemums grow in front
 of the Five-Willow Cottage,
The yellow ones are really yellow and the white ones
 white.
This affable and decent fellow, young in years and
 unsophisticated,
Has snapped one of the branches to dip in ink.
 Chang Yüan-chen

[The Five-Willows Cottage was the home of the poet T'ao
Ch'ien (Tao Yüan-ming, 365-427).]

Where at the Eastern Fence can you grieve for the Soul of
 the Hsiang River?
A man of upright character is mourned within the traces
 of ink.
White jade with a slight flaw would be a grievance
 forever,
Later men should understand why even the roots of the
 flowers are washed. Ni Yüeh

[Eastern Fence refers again to the poet T'ao Ch'ien, while
the Soul of the Hsiang River refers to the poet Ch'u Yüan,
(4th-3rd c. BC).]

A clump of chrysanthemum grows in front of the
 bamboo pavilion,
The winds of many autumns have blown since we parted
 beyond the river.
Straining wine through the official's cap of T'ao [Ch'ien]
 to prolong autumn's pleasures,
The mists and clouds of ten thousand miles belong to the
 intoxicated. Chao Hsiang

It is a different spring if mulberry is planted during the
 latter part of the year,
The dust of the world originally did not drop on clothing.
Who spills out ink under the Eastern Fence
And paints so freely this portrait of chrysanthemums for
 the venerable Sir T'ao? Wu Hsi-hsien

This full tray of ink for painting [flowers] at the Eastern
 Fence;
Their whiteness or yellowness is not essential in captur-
 ing their beauty.
I don't have to go to Chiang-nan to see them myself.
At my old house grow two or three branches.
 Lü Ch'ang

Who daubed autumn flowers with ink
As if they were dark dew on a branch tip only vaguely
 seen at evening?
After the lazy clouds disperse, no one paints;
A certain unconventionality pervades this painting.
 Fu Han

To satisfy his hunger, [the chrysanthemums]
 have at times entered the poetry of Ch'ü Yüan;
Taking up the wine cup, it felt close to T'ao Ch'ien.
[With them I am like] a lonely root sustained by
 deep water
Or an old man to whose hair the color of youth returns.
 Feng Chüeh

Poems after *Cabbages:*
The ink splashes are fresh from a frosty brush dipped in
 pond water;
I can visualize that time when Yün-hu [T'ao Ch'eng] first
 showed his talents.
I lament the places where I scribbled before,
Who would open them to inscribe a poem?
 Ts'ai Ch'i

[The first line is an allusion to the famous Chin callig-
rapher Wang Hsi-chih (303-379), who practiced calligra-
phy so diligently at the edge of a pond that the water
turned black with ink.]

After rain the vegetables begin to grow;
How are the colors of the masses lately!
Once you get used to them, the tastiest parts are the ends
 of the roots;
I don't know if they can be used for "seasoning soup."
 Ni Yüeh

["Seasoning soup" is an allusion to the statesmanship of
a chief minister.]

This crop of purple stalks and green leaves is late and
 irregular;
Now the rainy season is over for the Eastern Garden.
All the nobles nowadays dine on meat;
Who of them knows the flavor of this [cabbage].
 Chiao Fang

How many times has a new crop grown green in the
 vegetable plot;
It's always helped the honest man to sober up after
 drinks.
I intend to go to the deepest part of the stream-crossed
 garden
To refresh myself in the fragrance and dew of evening.
 Li Tung-yang

After rain, the white silk is filled with fragrant vegetables;
How many times this happens in Mr. T'ao's paintings.
On whom will you depend to present a memorial to
 the ruler?
Don't let this color emerge on the faces of the people.
 Wu Hsi-hsien

[The last line is meant as a warning to officials: the color of
the vegetables (green) may be pleasing in itself, but when
it emerges on the faces of the starving poor, it signifies a
badly governed world.]

For twenty years I have feasted on the excellent mutton of
 an official;
Yet I talk and dream about the garden and its vegetables.
Do not merely say it is good to chew the root of the
 cabbage--
You must taste to understand what poverty is.

 Fu Han

The capital is never a place for an apprentice in the "gar-
 den of scholarship."
Who would write about gardens and vegetables on an
 examination paper?
I've walked throughout the country in spring;
Make sure the people don't show this color.

 Lu Chang

After a wash of rain, the spring garden is still in order;
The flavor [of the cabbage] is more suitable with a small
 drink and the hum of a tune.
The rich and powerful in their mansions consume dish
 after dish of meat;
Vegetarian food is known only by the scholars.

 Chao Hsiang

A new cabbage is nourished with dew;
It takes a long time to grow and mature.
The business of "seasoning the soup" is your respon-
 sibility;
Better command the gardener to take care [of the cab-
 bages].

 Feng Chüeh
 trans. HK/LYSL/WKH

Remarks: Information about T'ao Ch'eng is brief and his
surviving works are few. Although he passed the *chu-jen*
provincial examinations in 1471, he evidently shunned a
career in government service, favoring a spendthrift ex-
istence while earning a reputation as painter, poet, and
eccentric. Exiled from Peking for some amorous indiscre-
tion, he returned there under the protection of Li Tung-
yang, a Hanlin academician who eventually rose to the
rank of Imperial Grand Secretary. Li Tung-yang authored
and wrote one of the poems accompanying this pair of
paintings which must have been produced at an actual
literati gathering. Of those who inscribed the poems and
who have recorded histories, Ni Yüeh, Wu Hsi-hsien, Fu
Han, and Chiao Fang were all awarded their *chin-shih*
degrees in 1464. Moreover, Chiao Fang, Li Tung-yang,
Chang Yüan-chen, Ni Yüeh, Wu Hsi-hsien, Lü Chang,
and Fu Han all held various positions within the Hanlin
Academy during the 1480s. The paintings and the inscrip-
tions must have been completed sometime between 1481
and 1486. In 1481 Ni Yüeh returned to Peking to resume
his official duties after the death of his father. Chiao Fang
was implicated in a bribery case in 1486 and in the same
year was demoted and reassigned in the provinces.

 The reactions of these men to their official positions are
reflected in the content of the painting and the poems
which they wrote to accompany it. The pairing of ink
monochrome chrysanthemums with cabbages in color
constitutes a metaphor for the life of the scholar-official.
The chrysanthemum was cultivated by the poet T'ao
Ch'ien, who retired to his Five Willows Cottage after
disenchantment with the thankless burdens of official
life. The cabbage, on the other hand, represents the hum-
ble life of the poor. Each guest at this gathering makes
some allusion to the theme – some playing upon lines
composed by other members of the party, others alluding
to T'ao Ch'eng's talent as a painter.

Despite the compliments paid by these poet-officials to
the artist T'ao Ch'eng, his status within that group re-
mains somewhat nebulous. Was he considered an equal,
in recognition of his education and poetic talents, or was
he simply associated with the group as a quasi-
professional artist? The conflicting approaches to paint-
ing which his surviving works illustrate hardly help to
clarify his position. His *Leave-Taking for Yün-chung* (Palace
Museum, Peking; see Yonezawa and Kawakita, *Paintings
in Chinese Museums*, 1970, no. 85), was painted in 1486 as a
parting gift to his friend Ko K'ao, who was to take a new
office in Shanhsi. T'ao Ch'eng renders the mountain
landscape and figures in ink on paper with the same
cursory realism of the colored *Cabbages* and rich tonal
variety displayed in the Cleveland scroll. Similar literati
predilections characterize another ink monochrome on
paper, *Chrysanthemums, Rock, and Playing Cat* of 1493
(National Palace Museum, Taipei; *KKSHL*, 1965, *ch.* 5,
p. 314).

 Other works, however, larger and on silk, are painted
with an illustrative facility equal to his professional con-
temporaries of the Che school: *Rabbits and Bamboo in
Moonlight* dated 1495 (Palace Museum, Peking; see *Ku-
kung . . . hua-niao*, 1965, no. 43), and *Chrysanthemums and
Rabbits* dated 1496 (National Palace Museum, Taipei;
KKSHL, 1965, *ch.* 5, p. 313).

 T'ao Ch'eng's shadowy career seems related to that of
his slightly younger contemporary, T'ang Yin. Each had a
surprising versatility in painting techniques which cut
across stylistic and social bounds. HK

Literature
Sirén, *Masters and Principles* (1956-58), IV, 221; VII, *Lists*, 241.
Akiyama et al., *Chūgoku bijutsu* (1973), II, pt. 2, 248, color pl. 75.
CMA *Handbook* (1978), illus. p. 349.

Exhibitions
Nanking Art Gallery, 1937: *Chiao-yü-pu*, I, cat. no. 133.
Haus der Kunst, Munich, 1959: *1000 Jahre*, cat. no. 43.
Cleveland Museum of Art, 1960: Chinese Painting, no catalogue.
Smith College Museum of Art, Northampton, Mass., 1962:
 Chinese Art, cat. no. 19.
Asia House Gallery, New York, 1974: Lee, *Colors of Ink*, cat. no. 29
 (*Chrysanthemums*).

Recent provenance: Chang Heng; Hsü Pang-ta; Walter Hoch-
stadter; Mr. and Mrs. Severance A. Millikin; Mr. and Mrs. Court-
ney Burton.

The Cleveland Museum of Art 60.40

Chang Ning, 1427-ca. 1495, Ming Dynasty
t. Ching-chih; from Te-ch'ing, moved to Hai-yen,
 Chechiang Province

146 *Empty Arbor and Rapid Waterfall*
 (Hsü-t'ing fei p'u)

Hanging scroll, dated 1468, ink and color on paper,
109.8 x 38.1 cm.

Artist's inscription, signature, and 2 seals: Painted in the
summer, the fifth month of the *wu-tzu* year, the fourth
year of the Ch'eng-hua era [1468]. Empty Arbor and
Rapid Waterfall. Fang-chou, Chang Ning [seals] Ching-
chih; Fang-chou ts'ao-t'ang.

2 additional seals: 1 of Ch'eng Ch'i; 1 unidentified.

Remarks: A *chin-shih* degree recipient in 1454, Chang
Ning achieved a reputation for uprightness in the unen-
viable government position of Supervising Secretary
(Chi-shih-chung) within the office of Scrutiny for the
Board of Rites. Although low in rank, his appointment
carried great authority in its censorial right over the
documents, memorials, and decision-making processes
of the Board (see Hucker, "Governmental Organiza-
tion," 1958, pp. 52, 53). Because his integrity provoked
the anger of other high officials, his advancement in
office was impaired. Sometime during the early Ch'eng-
hua era (1465-87), possibly in 1467, Chang resigned
his post and lived as a private citizen for another
thirty years.

 Painting and poetry appear to have been Chang
Ning's avocations. His biography mentions artistic facil-
ity with landscape and figures.

Empty Arbor and Rapid Waterfall, one of five known
surviving paintings, dates from Chang's period of retire-
ment in Chechiang. The hemp fiber *ts'un* in the rockery
and the poet's empty hut by the waterfall indicate the
artist's acquaintance with contemporary literati conven-
tions. At the same time, the overall composition, dry-ink
brushwork, and pleasantly light-color washes reveal the
hand of a talented amateur who combined *wen-jen* and
academic elements (see particularly Tai Chin and Tu
Chin, cat. nos. 134, 157). The present work is rather dry
and massive, recalling Northern Sung prototypes; while
one of Chang's other works, dated twenty-two years
later *(1000 Jahre,* 1959, cat. no. 41), displays a more fluid
and sophisticated manner, owing much to Ma Wan,
Wang Fu (see cat. nos. 117, 118), and Tu Ch'iung (see cat.
no. 147).

 Chang Ning inscribed a poem on a painting, dated
1450, by Yüeh Cheng (cat. no. 143). HK/SEL

Literature
Ch'eng, *Hsüan-hui-t'ang* (1972), *Hua,* p. 55.

Recent provenance: Ch'eng Ch'i.

Intended gift to The Cleveland Museum of Art,
Kelvin Smith

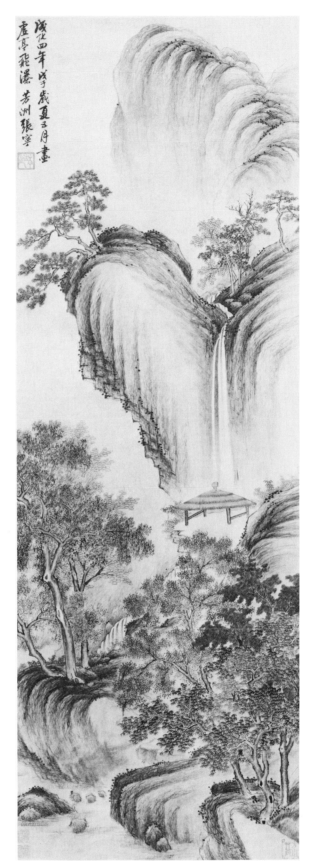

146

Tu Ch'iung, 1396-1474, Ming Dynasty
t. Yung-chia, *h.* Lu-kuan tao-jen, Tung-yüan;
from Suchou, Chiangsu Province

147 *Mt. T'ai-po in the Style of Wang Meng*
(*T'ai-po shan t'u*)

Handscroll, dated 1442, ink and light color on
paper, 29.8 x 591.8 cm.

Artist's inscription, signature, and 11 seals: [1 seal]
Tung-yüan chai.

Huang-ho shan-ch'iao [Wang Meng] painted a painting
called *T'ai-po Mountain*. Its brushwork is superior and
admirable, which is very close to Yu-ch'en [Wang Wei,
699-759]. The cleverness of its composition, the maple
groves and rustic temples, the inaccessible ravines and
autumnal plateaus, the perilous peaks and strange
rocks, etc., all seem to be so natural. The paper is only a
little over eight feet, but the landscape has the range of a
thousand miles. Once you open and note the contents, it
is as if one were roaming among the mountain peaks
enveloped in mist and clouds, and forgot the dusty
world. When I first saw this, I was so mixed with excite-
ment and joy that I could not take my hands off the
painting. So I put it on the table, and tried my best to
imitate it, forgetting sleeping and eating for about three
months before it was completed. Although I do not dare
to tread in the footsteps of Huang-ho shan-ch'iao, I took
great pains to capture his spirit in composition and col-
ors. I do not know whether it would pass the judgment
of the experts.

On the fifteenth day of the fifth month, the seventh
year of the Cheng-t'ung era [1442], inscribed by Tung-
yüan, Tu Chiung. [2 seals] Yung-chia; Ching-chieh
ming-men. [8 seals on painting] Tung-yüan chai; Ching-
chieh ming-men; Yung-chia; Tu Ch'iung yin; Tung-yüan
(repeated 5 times).

trans. WKH/LYSL

3 colophons and 7 additional seals: 1 colophon and 2
seals of Chou Ting (1401-1487); 1 colophon and 2 seals of
Wu K'uan (1435-1504); 1 colophon, dated 1655, and 2
seals of Lan Ying (1585-after 1664).

Remarks: Tu Ch'iung experienced, on a reduced scale,
the censure of early Ming rule. In 1419, having recovered
his censured father's library and presumably his wealth,
he resumed a position of influence, but one purposefully
outside official recognition. His friends included the
most distinguished literati of Suchou – Wu Kuan and
Shen Chou, who authored his epitaph.

The handscroll, with the hanging scroll *Listening to the
Waterfall* (1443) in Taipei, is significant as an important
link between the early *wen-jen* masters and the effloresc-
ence of the style in the work of the founder of the Wu
school, Shen Chou (see cat. nos. 148-156). Tu Ch'iung's
inscription described his preoccupation with a scroll of
T'ai-po mountains by Wang Meng. If we are to judge by
the relationship of this scroll to an impressive
one of the same subject, probably by Wang Meng (Liao-
ning Provincial Museum; *Liao-ning sheng*, 1962, I, pls. 92-
95) and possibly the one so inspiring for Tu Ch'iung, this
work is an extremely free variation on the prototype.

147 Detail

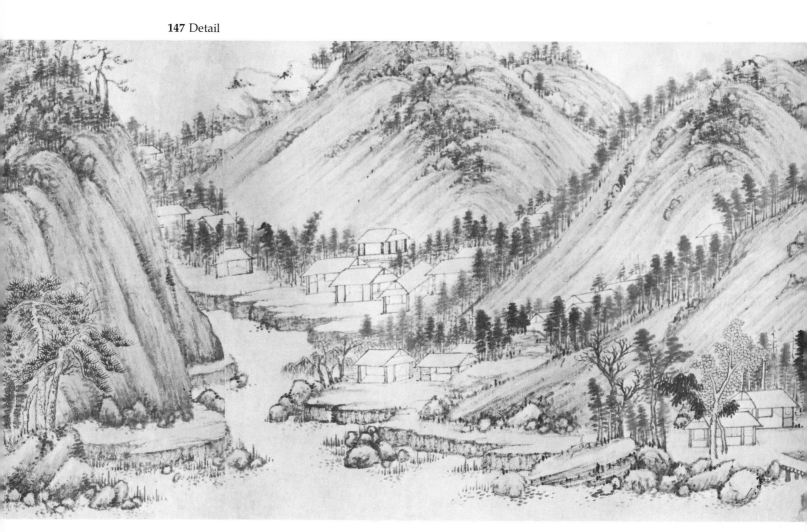

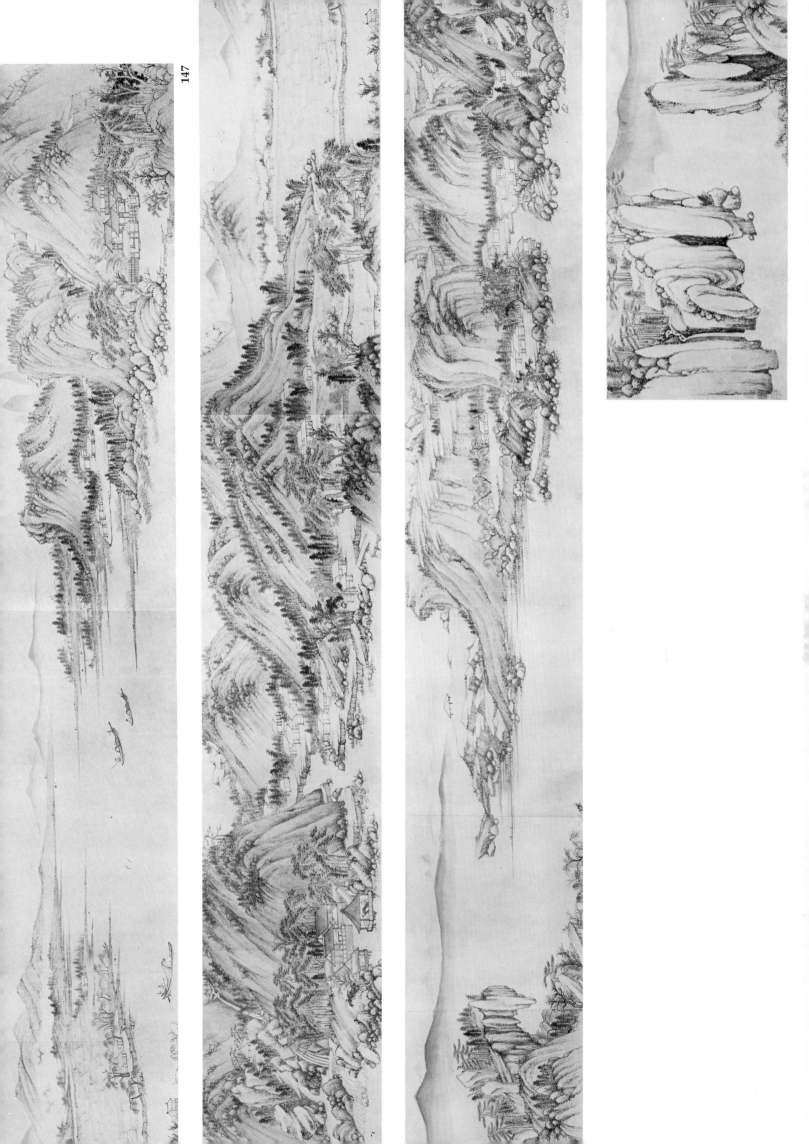

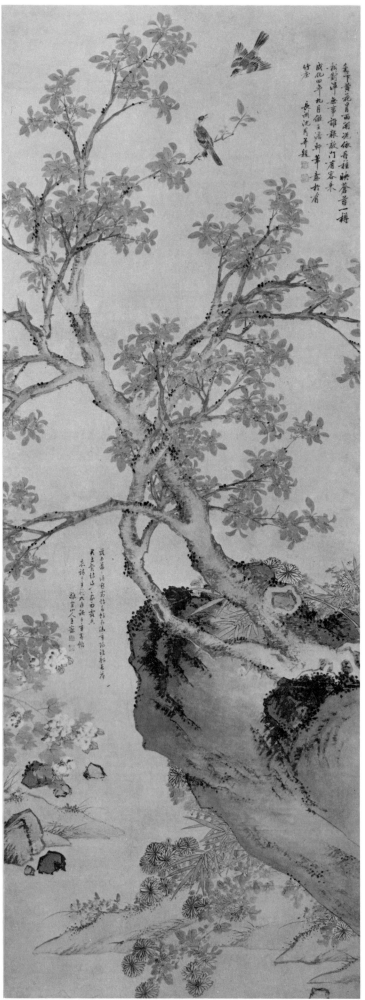

The colophon by Wu K'uan identifies Tu as the teacher of Shen Chou and acknowledges that the painting was "copied" after Wang Meng. While elements derived from Wang are present in the pine trees, the basic derivation is from Huang Kung-wang, which may well account for Wu K'uan's mention of the four early predecessors of Huang – Tung Yüan, Chü-jan, Ching Hao, and Kuan T'ung – whose influences, partly real and partly only traditional, were so important in the establishment of the early *wen-jen* style.

Tu Ch'iung's T'ai-po scroll is a complex reconstitution of the leading Yüan literati tradition, but it ends in an extremely unusual and prescient rendering of grotesque rocks anticipating such late Ming idiosyncracies as those of Hsiang Sheng-mo (see cat. no. 195). Wu K'uan mentions these as "unusually strange rocks," so that even in the mid-fifteenth century this concluding element of the scroll was considered unusual.

It should be mentioned that a third colophon, dated 1474, by Chou Ting (1401-1487) mentions the "loss" of Tu Ch'iung, thus establishing a final date for that artist's career. SEL

Recent provenance: Mrs. Angela Tseng.
The Cleveland Museum of Art 68.195

Shen Chou, 1427-1509, Ming Dynasty
 t. Ch'i-nan, *h.* Shih-t'ien; from Suchou, Chiangsu
 Province

148 *Yellow Chrysanthemums and Red Osmanthus in
 the Style of Wang Yüan
 (Huang-chü tan-kuei)*

Hanging scroll, dated 1468, ink and light color on paper, 228 x 106 cm.

Artist's inscription, signature, and 2 seals at upper right:

Beneath the fence yellow [chrysanthemum] flowers
 brave the rain to blossom;
Still others lean on the red osmanthus tree and dazzle
 the deep green moss.
With a goblet [of wine] I face them, entirely without
 concern;
Who will answer the knocking at the gate where a guest
 has arrived?

In the ninth month of the fourth year of the Ch'eng-hua era [1468] I followed the brush-conception of Wang Tan-hsüan [Wang Yüan] at the Yu-chu-chuang [House with Bamboo].

Inscribed and [painted] by Shen Chou of Ch'ang-chou. [seals] Shih-t'ien; Shen shih Ch'i-nan.

trans. HR

1 additional inscription, dated 1523, and 2 seals of Wang Ch'ung (1494-1533).

Remarks: The Suchou painter Shen Chou was descended from a prominent land-owning family with strong ties to contemporary literati culture. His father and grandfather were amateur painters, themselves the students of Ch'en Chi, a grandson of Ch'en Ju-yen (see cat. nos. 113, 114). Shen Chou, in turn, received scholarly instruction from Ch'en Ch'i's son as well as from another of Ch'en Ch'i's pupils, the scholar-painter Tu Ch'iung (see cat. no. 147). Thus, his exposure to the art of the Yüan literati could almost be considered a birth-

right. Because Shen Chou never entered government service – he used the excuse of caring for his aging, widowed mother who died three years before him – he had ample opportunity to cultivate the arts of painting, poetry, and calligraphy, as well as the company of some of the most prominent scholar-officials of his day.

According to his inscription on the painting, Shen Chou sought to imitate the style of the Yüan painter Wang Yüan (see cat. no. 87). The twin birds in the treetop, the rubbed-ink texture strokes of the tree trunk and its rocky support, the juxtaposition of boneless and outlined methods in the definition of flowers and foliage, all attest to his knowledge of the prototype. At the same time, Shen transformed the spirit of Wang Yüan's approach by incorporating light and transparent pigments within Wang Yüan's essentially ink mono-chrome manner. Shen's color-filled brushstrokes and washes inaugurated a new method within the long tradition of flower-and-bird painting (see cat. no. 149).

The sheer size and spatial complexity of this composition betray another source quite different from the avowed Wang Yüan inspiration. The huge mass of a rocky promontory jutting from the right foreground, played against the smaller-scaled, middle-ground shoreline, creates a decorative and spatial tension exploited by Shen's Che school contemporaries, such as Lü Chi and Lin Liang, and ultimately traceable to the Southern Sung Academy (see cat. no. 54). HK

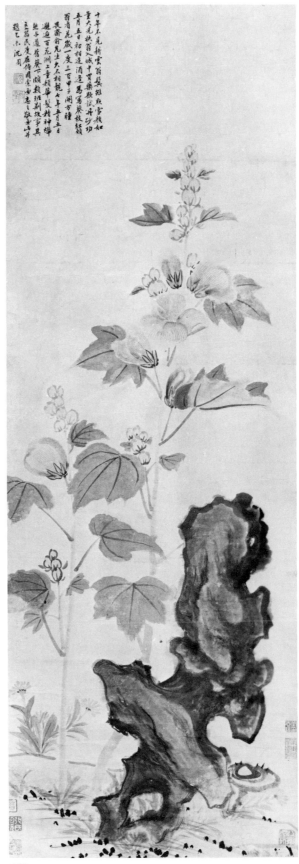

149

Literature
Sirén, *Masters and Principles* (1956-58), IV, 153; VI, pl. 170-B; VII, Lists, 223.
Edwards, *Field of Stones* (1962), p. 15, pls. 9-C, 10-B.
Lee, "To See Big within Small" (1972), p. 321, fig. 64; idem. "Early Ming Painting" (1972), p. 254, fig. 15.
Edwards et al., *Shin Shū, Bun Chōmei* (1978), pp. 149 (signature), 154, pl. 3 (color).

Exhibitions
Wildenstein Galleries, New York, 1949: Dubosc, *Ming and Ch'ing,* cat. no. 6.
Palazzo Ducale, Venice, 1954: Dubosc, *Mostra,* cat. no. 789.

Recent provenance: Jean-Pierre Dubosc.

Intended gift to The Cleveland Museum of Art, Mr. and Mrs. A. Dean Perry

Shen Chou

149 *Rose Mallows*
(*Shu-k'uei t'u*)

Hanging scroll, dated 1475, ink and color on paper, 126.5 x 36.9 cm.

Artist's inscription, signature, and 2 seals in upper left corner:
For ten years I had not seen Keng-yün-weng;
White hairs at his temples, his face young as a child's.

His elder son assisted him into the city
To buy medicine, wishing to test the efficacy of ground cinnabar.

On the fifth day of the fifth month I encountered them,
And as we drank I limned for him this stalk of mallow scarlet.

I hope he will view this flower each year,
The square pupil of longevity, his for three hundred cycles.

I had not seen Mr. Yü Wei-chai for a long time. Now on the fifth day of the fifth month, we met by chance on the Isle of a Hundred Flowers. With a youthful face, but hair

grayed, his vitality is ample. Under the rose mallow we talked of times past, something like the *pan-ching* story of old. His elder son, Min-tu, attended us and so asked for a painting to commemorate [our meeting]. Painted and inscribed with respect in the *i-wei* year [1475]. Shen Chou [seals] Shen; Ch'i-nan.

trans. MFW

6 additional seals: 3 of Chang Yüan (early to mid-17th c.); 1 of Pi Yüan (1730-1795); 2 of Yeh Chih-hsien (1779-after 1863).

Remarks: Although Yü Wei-chai remains unidentified, the Keng-yün-weng of the first line must be one of his sobriquets. The expression *pan-ching* comes from the *Tso-chuan* (Hsiang-kung, 26th year) and alludes to an unexpected meeting of old friends, whose conversation turned to bygone times. Because of the chance nature of the meeting, a sitting mat was improvised from available brush (*pan-ching*).

The proximity of an actual rose mallow to the place of Shen's meeting with his friend may have prompted him to use it as the subject for this painting. Nonetheless, the rose mallow bears symbolism appropriate to the theme of his friend's advanced but still vital years. Since the T'ang Dynasty (618-906), the mallow and hibiscus have been associated with purity, vitality, and long life. References in poetry often speak of them as being born of heaven or as issuing from an immortal's placenta.

The Chinese term *mo-ku* designates the kind of painting employed by Shen Chou in this picture. Usually translated in a semi-literal way as "boneless," it connotes interdependent technical and stylistic features. It applies only to those paintings in which the motifs are rendered directly in colored washes, without an isolable structure of outline and interior drawing. *Mo-ku* painting most likely originated with the grandsons of Hsü Hsi (d. after 975) — Hsü Ch'ung-hsün, Hsü Ch'ung-chü, and Hsü Ch'ung-ssu — who were active in the Sung court in the last quarter of the tenth century and early years of the eleventh.

The influence of Shen Chou directly and indirectly through sixteenth-century Wu school painters reshaped the course of *mo-ku* color painting. However, the dominance of literati preferences in subject matter and stylistic concerns served to limit *mo-ku* color painting, both in terms of its popularity and its variety of treatment.

The unassertive, bland quality of *Rose Mallows* is indicative of Shen's formulation. Other components of his formulation are the reduction of the number of compositional elements and the variety of colors, the clarification of the rhythmic structure of the picture, the elimination of vibrant modulation of color intensities, and a further departure from representational fidelity. One other feature is Shen's insistence upon using very pale values.

Shen's *mo-ku* paintings and stylistically related pictures in broadly brushed ink may be divided roughly into early and late styles. *Rose Mallows* typifies his earlier approach, at a time in his career when, by his own admission, painting flowers, vegetables, birds, and animals was an occasional pastime secondary to landscape painting (T'ien, "Nan-Sung Mu-ch'i," 1964, pp. 36, 37). In *Rose Mallows* he emphasizes the unifying flatness of the picture surface and the shallowness of the spatial stage, characteristics which are echoed by the flatness of the mallow leaves themselves. The spare, pruned look of the plant is typical, as is the rather stark isolation and pale color of the leaves and the convoluted form of the rock, painted only with ink.

It seems likely that Shen's early style drew upon his immediate predecessors in the mid-fifteenth century rather than upon the styles of the Yüan or earlier periods which would mark his later paintings. It also seems likely that an important early influence on Shen's *mo-ku* color-painting style was Yüeh Cheng (1418-1473), one of the most accomplished artists in such painting. The link between the two artists is confirmed by a comparison of *Rose Mallows* with Yueh Cheng's *Squirrels and Grapes* (cat. no. 143), and by Wang Ao (1450-1524), who acknowledges that Shen Chou studied Yüeh Cheng's paintings of grapes (*Chen-tse chi*, early 16th c., *ch.* 8, p. 32b).

Shen's passage from early to late style seems to have occurred, at least in part, in response to two decisive influences. The first was that of Wu Chen's style (see cat. no. 109), which resulted in abandoning convoluted garden rocks with their complex interior modelling in favor of slab-like, layered rocks of squared profile. These he painted in a simplified brush manner adapted from Wu Chen.

A second identifiable influence was a scroll entitled *Hsieh-sheng shu-kuo t'u-chüan*, considered at the time to be by Mu-ch'i (1177-1239), and which belonged to Shen's friend and patron, Wu K'uan (1435-1504). In its long colophon, Shen praises the painting and ranks Mu-ch'i above hallowed masters of the past. This scroll, whether or not a genuine work by Mu-ch'i, seems to have led Shen to create more daring compositions, with which he exploits the tension of asymmetry. Shen's directions in his later work are best summarized by two of his albums — one in the Palace Museum, Peking, entitled *Wo-yu ts'e* (see *Shen Shih-t-ien Wo-yu-ts'e*, 1953), and one in the National Palace Museum, Taipei, entitled *Shen Chou hsieh-sheng ts'e* (*KKSHL*, 1965, *ch.* 6, pp. 36-38). MFW

Literature
Omura, *Bunjin gasen* (1921-22), I, pl. 21.
Naitō, *Min shi-taika gafu* (1924), pl. 21.
Yamamoto, *Chōkaidō* (1932), *ch.* 2, pp. 104, 105.
Harada, *Shina* (1936), pl. 496.
Nihon genzai Shina (1938), p. 144.
Cheng Ping-shan, *Shen Shih-t'ien* (1958), pl. 2.
Edwards, *Field of Stones* (1962), p. 88, pl. 44a.
NG-AM Handbook (1973), II, 62.

Exhibitions
Tokyo Imperial Museum, 1928: *Tō-Sō-Gen-Min*, pl. 254.

Recent provenance: Teijirō Yamamoto; Michelangelo Piacentini.

Nelson Gallery-Atkins Museum 49-14

Shen Chou

150 *Landscape in the Style of Ni Tsan
(Fang Ni Tsan shan-shui t'u)*

Hanging scroll, dated 1484, ink on paper, 137.8 x 61.9 cm.

Artist's inscription, signature, and seal in upper left corner:

Here I am on the winter solstice with no money for wine;
Awaking, amused with myself for slumbering in an attic loft.

I just trust to a string to keep track of the day's length;
Why esteem the insects' understanding of long and short years?

In vain I plant jade in a field of stones;
Long has my pursuit of the Immortal's ways entered the
 purple seal registry.
Through a crack in the sash I see only the moon of the
 dormant months;
My scholarship is but a record of what passes year after
 year.

Written following the rhyme of the poem "About Myself
in Living at Leisure" on the day of the solstice in the
chia-chen year of the Cheng-te era [1484]. Shen Chou
[seal] Shih-t'ien.

<div align="right">trans. MFW</div>

1 additional seal of Torajirō Naitō (1866-1934).

Remarks: Shen's poem is essentially a summary evalua-
tion of his life and his place in a Confucian society that
set a premium on official service and on historical and
literary learning. The self-deprecatory tone rests in
Taoist alternatives of withdrawal and personal cultiva-
tion. Claims of idleness and uselessness appear in each
couplet. The "attic loft" of the second line literally
appears in the Chinese as "high pavilion," and refers to
a common phrase in poetry about useless items being
relegated to an inaccessible place high in a building. The
entire couplet is an allusion to the fact that he had never
held an official position and lived in retirement without
benefit of official salary.

In using the phrase "field of stones" — a literal transla-
tion of his sobriquet — Shen is explicitly referring to him-
self. Planting jade in a field of stones implies his lack of
success in cultivating normal, public Confucian virtues,
such as raising worthy sons or serving the state
with distinction.

"Purple sealed registry" is a book kept in the Taoist
heaven in which the names of all the immortals are
entered.

The composition of the picture, with its exaggerated
split between foreground and background and with the
single group of trees isolated on the near spit of land,
marks Shen's appreciation for the great Yüan master Ni
Tsan (see cat. no. 110). Even the shapes of the rock
groupings in the foreground; the scattering of dots; and
angled, pointed strokes recalling the movement of a
whiplash hark back to Ni's landscape prototypes. And
yet, there are telling differences between the two. Shen's
brushwork is broader, heavier and more muscular —
each stroke being more assertive. Shen also compresses
the sense of recession, thus lending more weight to the
flat picture surface. The background mountains have be-
come far more massive and more commanding than Ni
would have allowed. These changes bring an intensified
visual activity, tinged with a feeling of immanent insta-
bility and a certain self-conscious striving for
artistic affect.

Shen harmonizes the overt iconography of the picture
with the poem. The angler in his flat boat and the gentle-
man gazing idly from a pavilion across the water em-
body the notion of retirement from the rancorous, offi-
cial world to nurture one's personal wellsprings through
pursuit of the arts and letters in a refined environment
conducive to harmonizing oneself with Nature's princi-
ples. As such, these two figures symbolize China's elite
literati class and its values.

<div align="right">MFW</div>

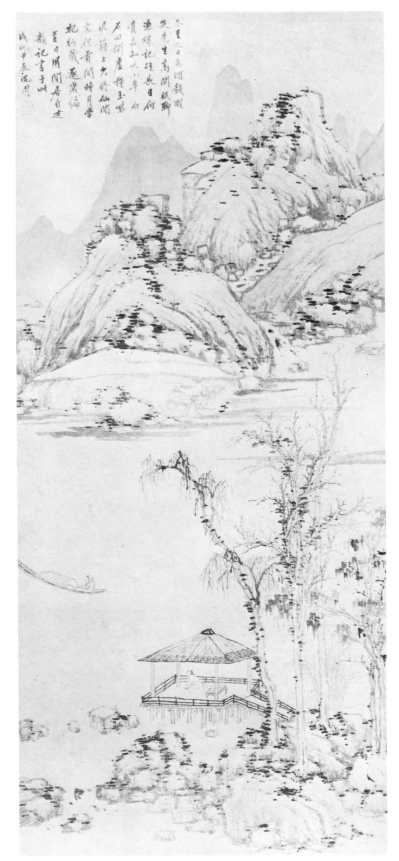

150

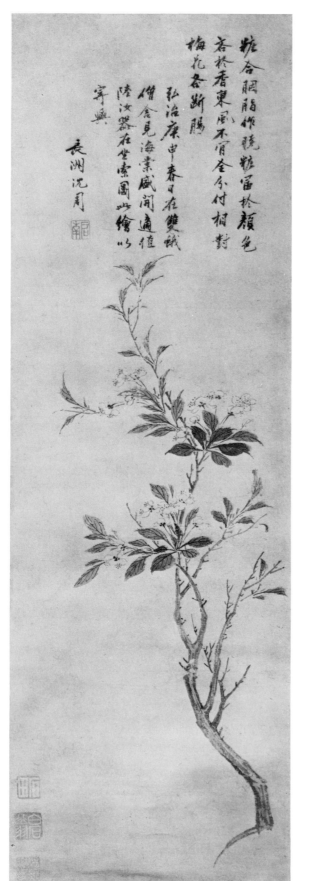

151

Literature

Shih-t'ien hsien-sheng (preface 1644), *ch.* 6, p. 11b (prints Shen's poem).

Geien shinshō (1915-18), vol. XII.

Omura, *Bunjin gasen* (1921-22), I, pl. 9.

Yamamoto, *Chōkaidō* (1932), *ch.* 2, p.99.

Sirén, *Later* (1938), I, 77 (under *The Solitary Angler on the Wintry River*); idem, *Masters and Principles* (1956-58), IV, 154, and VI, pl. 174.

Edwards, *Field of Stones* (1962), no. xx, pls. 23A, 25A (detail).

NG-AM Handbook (1973), II, 62.

Sulivan, *Arts of China* (1973), p. 195, fig. 172; idem, *Symbols of Eternity* (1979), p. 120, fig. 71.

Exhibitions

Wildenstein Galleries, New York, 1949: Dubosc, *Ming and Ch'ing*, cat. no. 7, p. 15.

Cleveland Museum of Art, 1954: Lee, *Chinese Landscape Painting*, cat. no. 52, pp. 55, 150.

Smith College Museum of Art, Northampton, Mass., 1962: *Chinese Art*, cat. no. 6.

Recent provenance: Teijirō Yamamoto; Michelangelo Piacentini.

Neslon Gallery-Atkins Museum 46-45

Shen Chou

151 *Flowering Crab Apple*
(Hsieh-sheng Hai-t'ang)

Hanging scroll, ink on paper, 87.5 x 28.6 cm.

Artist's inscription, signature, and 3 seals:

Adorned with rouge for dressing-up in the morning,
Rich in colors but spare in fragrance.
The east wind was not yet completely in command,
Though facing flowering plums, they are mutually heartbroken.

On a spring day in the *keng-shen* year of the Hung-chih era [1500], I was at Shuang-ngo [twin-moth] monks' residence where crab apples are blossoming abundantly. Mr. Lu Ju-ch'i was also visiting then, and asked for a painting of mine, so I painted this to express my feelings. Shen Chou of Ch'ang-chou [seal] Ch'i-nan.
[2 seals, lower left corner] Shih-t'ien; Po-shih weng.

<div align="right">trans. LYSL</div>

1 additional seal of Wu Yün (1811-1883)

Remarks: As the poem and inscription of the artist suggest, this is an informal and rapidly done presentation picture. Nevertheless, the artist has captured the somewhat soft shape and texture of the crab-apple leaves by means of sketchy but disciplined brushstrokes. Unlike the much earlier and more formal work of 1468 (see cat. no. 148), this is a late *che-chih* (picked-branch) picture; that is, a specially selected branch or fragment of nature rather than the fragment seen as growing in nature. The arrangement of the branch and its subtle, serpentine movement up to the calligraphy are noteworthy. SEL

Literature

Naitō, *Min shi-taika gafu* (1924), p. 18.

Tōan-zō (1928), pl. 20.

Shina meiga senshū (1926-27), vol. III.

Siren, *Later* (1938), I, *Lists*, 227; idem, *Masters and Principles* (1956-58), VII, *Lists*, 225.

Edwards, *Field of Stones* (1962), pp. 77, 105, pl. 47-A.

Recent provenance: Saitō Tōan Collection, Sumiyoshi; Elm & Co.

Intended gift to The Cleveland Museum of Art, Mr. and Mrs. A. Dean Perry

Shen Chou

152 *Famous Sights of Wu*
(*Wu-chung sheng-lan t'u*)

Handscroll, ink and color on paper, 35.5 x
1799.5 cm.

Artist's inscription, signature, and 12½ seals:
[1 seal] Chu-shih-t'ing.

The Suchou area has no majestic peaks or high ranges.
All are but rolling hills spreading continuously in mutual
enhancement on the western periphery of the city.
Those such as T'ien-p'ing, T'ien-ch'ih and Tiger Hill are
the most scenic places and are within range of a day's
outing. As for those that are distant, Mt. Kuang-fu and
Teng-yü, overnight will suffice.

I know a route intimately, and not a year goes by
without a visit to familiar spots. Those I have committed
to brush in response to my eye are manifold, whether as
pictures or as poems. This scroll is one of them. If one
speaks of circulating it to other places, then a general
idea of the landscape of the Suchou area may be seen,
thus to acquaint those who have never toured there.

As for the skillfulness or awkwardness of my paint-
ing, I haven't time to give it a thought. Shen Chou [2
seals] Shen Chou t'u-shu; Ch'i-nan. trans. MFW/KSW

[9½ seals on each seam beginning with the second seam]
Shen shih Ch'i-nan. [1½ additional forged seals on the
first and second seam] Shen shih Ch'i-nan. [2 forged
seals at the right end] Shih-t'ien sheng; Shen shih Ch'i-
nan.

1 frontispiece, 5 colophons, and 19 additional seals: 1
frontispiece, dated 1833, and 3 seals of Li Yao (early 19th
c.); 1 colophon and 2 seals of Takeshi Inokai (1855-1932);
1 colophon, dated 1927, and 2 seals of Tora Naitō (1865-
1933); 1 colophon, dated 1928, and 1 seal of Ko Nagao
(1864-1942); 1 colophon, dated 1929, and 2 seals of Toru
Namekawa (early 20th c.); 1 colophon, dated 1953, and 2
seals of Chang Ta-ch'ien (1899-); 6 seals unidentified.

Remarks: There are two complete versions of this hand-
scroll in ink and color on paper. The other version is in
the National Palace Museum, Taipei, and has recently
been published under the title *The Scenery Around Suchou*
(*Wu-p'ai-hua*, 1975, cat. no. 201, pp. 226-29, 319, 380).
Differences in the placement and arrangement of motifs
are slight between the two scrolls. The principal differ-
ence lies in the brushwork, which is slightly lethargic
and looser in the Taipei version, and in the color, which
is fresher and treated with a more self-conscious sense of
pattern and style in the Nelson Gallery version. Shen
Chou's inscription appears as a separate colophon on
the Taipei version rather than as an inscription on the
same paper, as in the Nelson scroll.

Neither version is considered to be an assured work
by the hand of the master. The insistence on reducing
architectural and landscape motifs to clear-cut pattern,

152 Detail

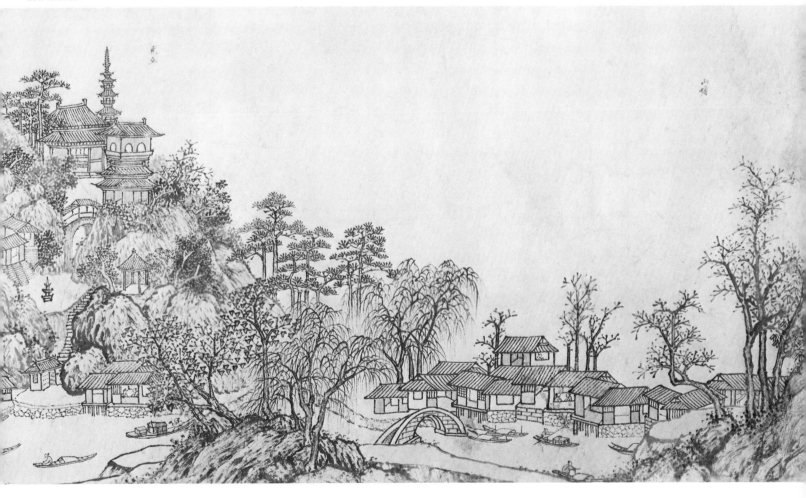

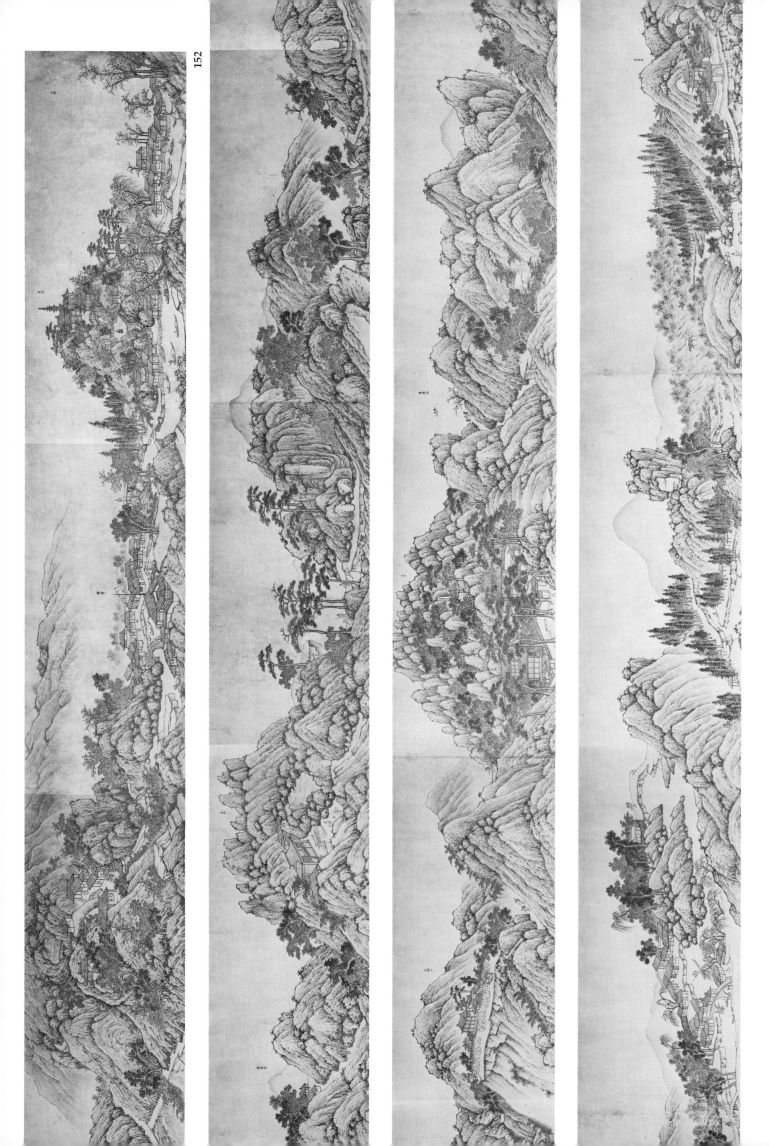

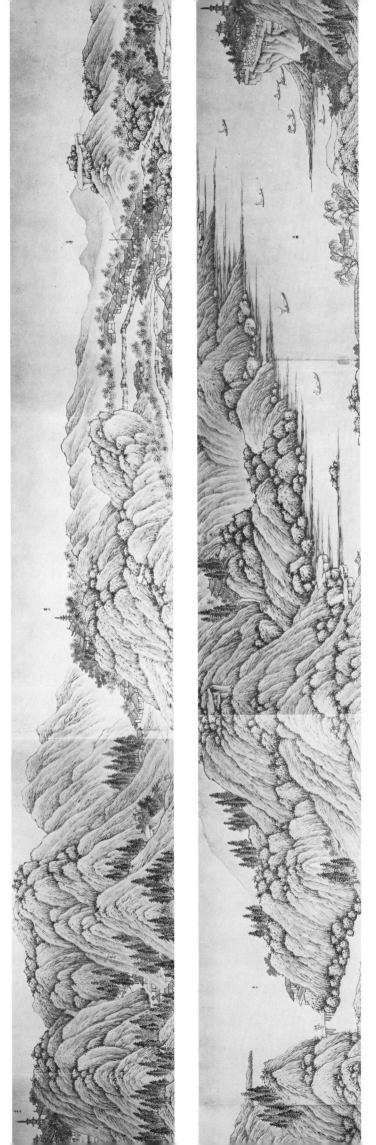
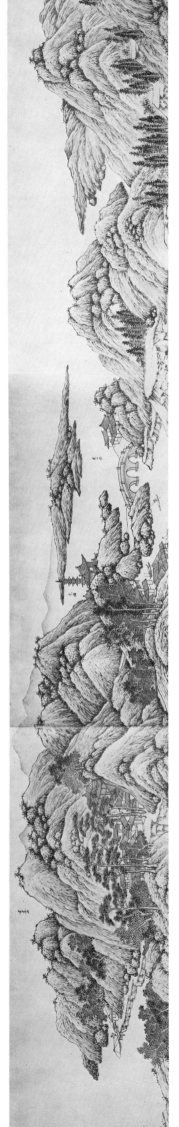
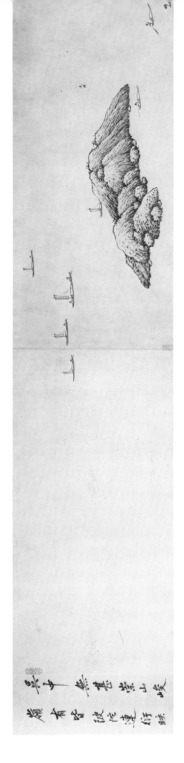

183

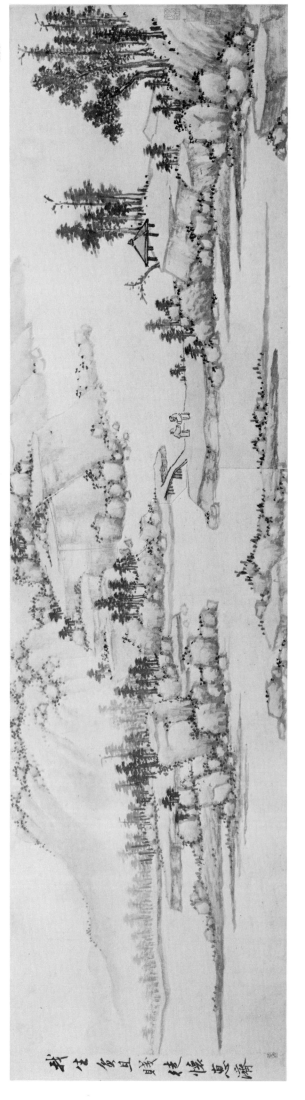

and the taut quality of the architectural drawing in the Nelson scroll are features which are open to further study.

The first two lengths of paper of the Nelson version cannot be by Shen Chou; they are clearly by a different, coarser hand working on similar but perceptibly different paper.

A partial version of the composition, bearing the title *The White-Cloud Spring* (Cahill, *Parting*, 1978, fig. 41), was until recently boxed together with the Nelson version. Painted on reddish-brown dyed silk, the captions and inscription are clearly apocryphal, while the inarticulate and unschooled brushwork suggest an inexperienced painter. Certain mannerisms bring to mind a painter acquainted with the works of Hsieh Shih-ch'en (see cat. nos. 168, 169). MFW

Literature
Yonezawa, "Go-chū shō-ran zu" (1954), pp. 271-77; idem, *Painting in the Ming Dynasty* (1956), pl. 10.
NG-AM Handbook (1973), II, 63.

Recent provenance: S. Kawai & Co.

Nelson Gallery-Atkins Museum 70-25

Shen Chou

153 *Farewell to Lu Chih*
(Sung-pieh t'u)

Handscroll, ink and color on paper, 148 x 26.4 cm.

Artist's inscription, signature, and 2 seals on a separate sheet of paper:

Having been born of poor and humble station,
I hold in vain to a kind and helpful heart.

Contributing money or giving grain for the
commonweal,
These things I cannot undertake.

Would that I could devote myself to medicine;
Of universal application, virtue and compassion
will deepen.

A dose of medicine may take a person's life,
Or bedding give rise to groans of pain.

How their art differs from that of charlatans;
Profound and abstruse, I have nothing but admiration.

Tsung-yin is a master of the medical arts;
Early on his native town revered his good name.

Recently, Hsü Kung-ya
Recovered from a grave illness thanks to him.

Returning, he relinquished his duties;
And caring for [Hsü], accompanied him from the south.

Whereupon he returns to his medical office,
Like a bird quitting its former wood.

Raising your strong wings high in the autumn sky,
I'll gladly pour again more farewell wine.

A man should treat his art with care,
To cure the nation and earn the esteem of all.

Shen Chou of Ch'ang-chou [seals] Ch'i-nan; Shih-t'ien.
trans. MFW

13 additional seals and 1 colophon: 1 colophon and 3 seals of Wang Tsung-hsi (1481 *chin-shih)*; 3 seals of Ch'en Chi-te (act. mid-19th c.); 2 seals of Wu Yün (1811-1883); 4 seals of P'ang Yüan-chi (1864-1949); 1 seal unidentified.

Remarks: Lu Chih (*t.* Tsung-yin, act. ca. 1495-1515), for whom Shen Chou painted this scroll, was a medical official at the Ming court in the late fifteenth and early six-

teenth century. Lu apparently moved with ease in the elite artistic and official circles of Suchou. Among his friends he counted not only Shen Chou but also Wu K'uan (1435-1504) and Lu Wan (1458-1526), both of whom reached high office and were known for their calligraphy and large collections of art.

In addition to this scroll, Shen Chou also painted a hanging scroll for Lu Chih when Lu contributed wine to celebrate the artist's birthday in the eleventh lunar month of 1498 (Pien, *Shih-ku-t'ang*, 1682, IV 423b). *Farewell to Lu Chih* was probably painted not long after this visit, because Shen Chou mentions in his inscription that Lu was returning to serve the emperor. A date early in 1499, when Lu was given a farewell party by his friends, seems likely.

Through some misfortune the scroll has been cut at the left end, just in front of Shen's inscription. How much cannot be determined, but in its present state it ends rather abruptly for a Shen Chou composition.

<div align="right">KSW/MFW</div>

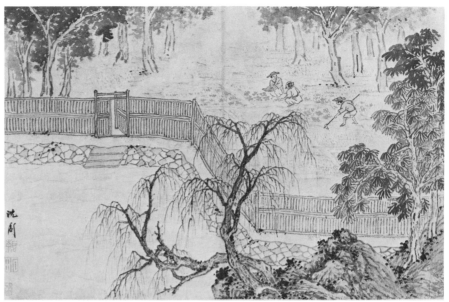

154A

Literature
P'ang, *Hsü-chai* (1909), *ch.* 3, p. 7.
Edwards, *Field of Stones* (1962), no. XXXVIII, pp. 58,102, pl. 34A.

Exhibitions
Los Angeles County Museum, 1948: Trubner, *Chinese Paintings,*
 cat. no. 30, p. 22.
San Francisco Museum of Art, 1957: Morley, *Asia and the West,*
 no. 18s, p. 24.

Recent provenance: P'ang Yüan-chi; Tonying and Co.

Nelson Gallery-Atkins Museum 46-90

Shen Chou

Wen Cheng-ming, 1470-1559, Ming Dynasty
Original name Pi, *t.* Cheng-chung, *h.* Heng-shan;
 from Suchou, Chiangsu Province

154 *Landscape Album: Five Leaves by Shen Chou, One Leaf by Wen Cheng-ming*

 (Shen Shih-t'ien Wen Cheng-ming shan-shui ho -chüan)

Six album leaves mounted as a handscroll, ink on paper or ink and light color on paper, 38.7 x 60.2 cm. each. (See also cat. no. 170.)

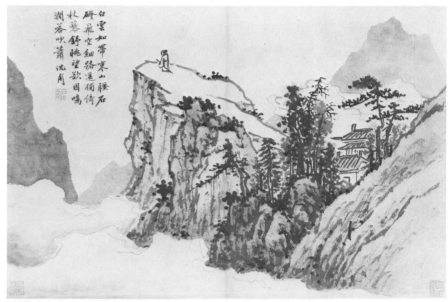

154B

SHEN CHOU

A. *Gardeners (Liu-wai ch'un-keng)*, ink and light color on paper. Artist's signature and 2 seals: Shen Chou [seals] Ch'i-nan; Shih-t'ien.

B. *Poet on a Mountain Top (Chang-li yüan-t'iao)*, ink on paper. Artist's inscription, signature, and 2 seals:

White clouds like a belt
 encircle the mountain's waist

A stone ledge flying in space
 and the far thin road.

I lean alone on my bramble staff
 and gazing contented into space

Wish the sounding torrent
 would answer to your flute.

Shen Chou [1 seal] Ch'i-nan. [1 seal, lower right corner] Po-shih-weng.

<div align="right">trans. Richard Edwards, with changes</div>

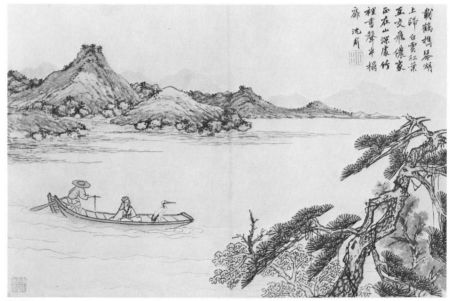

154C

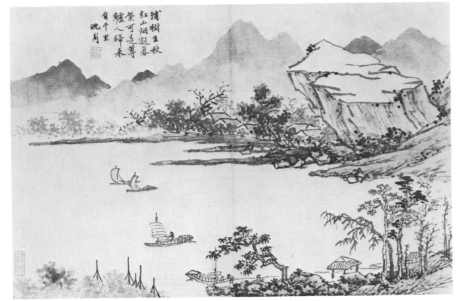

C. *Scholar and Crane Returning Home (Tsai-ho fan-hu)*,
ink and color on paper. Artist's inscription, signature,
and seal:

Carrying a crane and my *ch'in*
 homeward bound on the lake
White clouds and red leaves
 flying together
My home right in the very
 depths of mountains
The sound of reading within bamboo,
 a tiny couch, a humble gate.
Shen Chou [seal] Shih-t'ien.

trans. Richard Edwards

D. *Return from a Thousand Li (Yang-fan ch'iu-p'u)*, ink on
paper. Artist's inscription, signature, and seal:

The red of autumn comes to river trees
The mountain smokes freeze fast the purple evening.
Are those who long for home,
Returning from a thousand *li?*
Shen Chou [seal] Ch'i-nan.

trans. Richard Edwards, with change

154D

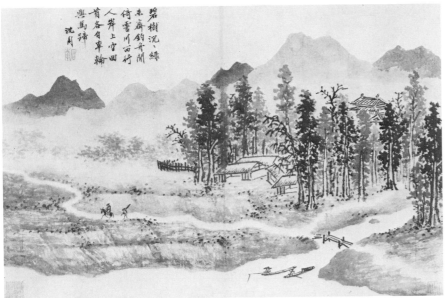

E. *Mountain Travelers (K'uang-yeh ch'i-lü)*, ink on paper.
Artist's inscription, signature, and 2 seals:

Deep and dark, emerald trees of mottled green,
Anglers' punts loll at the Cha's western shore.
Travelers on the bank look back in vain,
Each departing, by horse's hoof or carriage wheel.
Shen Chou [1 seal] Ch'i-nan. [1 seal, lower right corner]
Shih-t'ien. trans. MFW

WEN CHENG-MING

F. *Storm over the River (Feng-yü ku-chou)*, ink and
light color on paper. Artist's inscription and 2 seals at
upper left:

The spring flood carried the rain,
 swifter by evening.
And at the wild ford, no one–
 only the empty, lurching boat.
[seals] T'ing-yün-sheng; Wen Pi yin.

trans. Richard Edwards, with change

154E

35 additional seals and 2 colophons: 1 colophon, dated
1516, and 3 seals of Wen Cheng-ming (1470-1559); 1 col-
ophon, dated 1824, and 2 seals of Hsieh Lan-sheng
(1760-1831); 1 seal of Wu Po-tzu (act. early 19th c.); 2
seals of Li K'o-fan (19th c.); 2 seals of Huang Yün-ch'ao
(19th c.); 1 seal of Tzu-an (19th c.); 1 seal of Lu Ying-p'u
(act. early 19th c.); 6 seals of P'an Cheng-wei (1791-1850);
1 seal of Ho K'un-yü (mid-19th c.); 2 seals of Liu Shu-
chün (late 19th c.); 3 seals of Li Shih-ch'üan (early
20th c.); 5 seals of Jean-Pierre Dubosc (20th c.); 6 seals
unidentified.

Colophon by Wen Cheng-ming:

Venerable Shih [Shen Chou] was lofty in spirit when
 wielding the brush;
He was by nature placid as the languorous clouds.
Do not think he follows Yüan-hui's [Mi Yu-jen] style,
For he himself depicted Suchou's mountains after rain.
What Suchou place did he portray in drippy wet ink?
Pre-eminent were the western hills, so striking
 after rain.
Who can capture even one part of this scenery's mood?
In a thousand years, only the painted poetry of Mo-chi
 [Wang Wei].

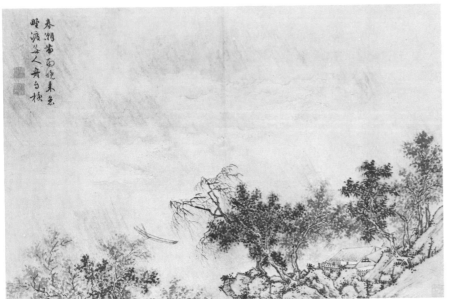

154F

Years ago his poetry was noted for its excellence;
In later years greatness in painting all but obscured
 this earlier fame.
Life's affairs are vast and uncertain, who knows what
 will obtain?
Your old pupil, though white-headed now, is still inept
 and ashamed.
Shen Hsiu-wen [Shen Yüeh], that noble man, is no
 longer seen;
And how many times since has the sun set on
 Yü-tzu-sha?
Looking, through tears, at the broken ink and
 remnants of his work;
Emerald peaks, rank on rank, melt into the sad clouds.
<div align="right">trans. James Robinson/MFW/KSW</div>

Shen Chou was a man of the highest integrity. His writings were perceptive and rich, and his scholarship, deeply grounded. Emerging during odd moments of spare time, his paintings afforded an amusing diversion. They are not, indeed, something which indifferent artisans or commonplace craftsmen can realize. In his early years he followed Wang Meng [1308-1355] and Huang Kung-wang [1269-1354] and proceeded on into the chambers of Tung Yüan [d. 962] and Chü-jan [act. ca. 960-980], his creations becoming ever more profound. There is no knowing what its genesis might be.

These six leaves were done for Wu K'uan [1435-1504]. In brushwork and compositional placement especially do they surpass his usual. Venerable old P'ao [Wu K'uan] bade me fill in the extra leaves. I declined with thanks, pleading inadequacy. However, I could not brush aside his request. With four T'ang couplets casually in mind, I smeared and scribbled in a desultory way. But how could such clumsy and inferior skills as mine bear being attached to a renowned brush? The disciple was sincerely embarrassed.

By now it has been several years since the venerable old P'ao passed on, and the venerable old Shih, too, is dead. His [Wu's] nephew Ssu-yeh [Wu I] brought the album to show me. I cannot help sighing over the fact that the *ch'in* remains but the man is gone. And so, I have composed four poems and inscribed these remarks.

Written by the pupil Wen Cheng-ming in the Yü-ch'ing shan-fang during the eighth lunar month in the autumn of the *ping-tzu* year of the Cheng-te era [1516].
<div align="right">trans. MFW/KSW, based on Richard Edwards</div>

Remarks: Mi Yu-jen (see cat. no. 24) was the son of the famous calligrapher, painter, and critic Mi Fu (1051-1107). A famous painter and connoisseur in his own right, Mi Yu-jen perpetuated and developed literati painting concepts established by painters of his father's generation.

Wang Wei (699-759) was considered the patriarch of literati painting. It has often been said that his painting is interchangeable with his poetry.

Shen Yüeh (441-513) was a noted scholar. Wen Cheng-ming's mention of Shen Yüeh is simply a literary device for referring to Shen Chou.

Yü-tzu-sha is the place not far from Suchou where Shen Chou's villa was situated.

Wu K'uan was a close friend and patron of Shen Chou's (see cat. no. 153). His nephew, Wu I (1472-1519), was a prominent member of Suchou's artistic circles and is chiefly remembered for his excellence in seal script (see Wilson and Wong, *Friends*, 1974, no. 17).

It is apparent that the album was in its present state by 1824, when Hsieh Lan-sheng appended his colophon. The pertinent section reads: "Originally it had six leaves, with four other leaves added by Wen Heng-shan [Wen Cheng-ming], based on couplets from T'ang Dynasty poems. In the album now there are only five of Shen's and one of Wen's left."
<div align="right">KSW/MFW</div>

Literature
Hsieh, *Ch'ang-hsing-hsing-chai* (19th c.), pp. 27, 28.
P'an, *T'ing-fan-lou, hsü* (1849), *ch.hsia*, pp. 565-68.
Sickman, "Unsung Ming" (1946), pp. 24, 25.
Munsterberg, *Short History* (1949), pl. 48.
Dubosc, "New Approach" (1950), p. 51, fig. 1.
Munsterberg, *Landscape Painting* (1955), pp. 67, 68, pls. 54, 55.
Sickman and Soper, *Art and Architecture* (1956), pp. 167, 177, pls. 132, 133.
Lee, "Some Problems" (1957), pl. 6, fig. 9.
Reischauer and Fairbank, *East Asia* (1960), pl. 35.
Moskowitz, ed., *Great Drawings* (1962), IV, pl. 901.
Edwards, *Field of Stones* (1962), no. XXIV, pls. 14B, 17A, 18A, 18B, 19A.
Lee, *Far Eastern Art* (1964, 1973), pp. 434, 435, figs. 574-76.
Horizon, Arts (1969), p. 160.
Akiyama et al., *Chūgoku bijutsu* (1973), II, 233, pls. 17, 18.
NG-AM Handbook (1973), II, 63.
Sullivan, *Arts of China* (1973), p. 195, fig. 173.
Wilson, "Vision" (1973), no. 9, pp. 236, 237.
Sullivan, *Three Perfections* (1974), pls. 29, 30.
Kawakami and Tsuruta, *Chūgoku* (1977), X, 38, 39.
Wilson and Wong, *Friends* (1974), p. 27, fig. 3.
Sullivan, *Symbols of Eternity* (1979), p. 122, fig. 72.

Exhibitions
Detroit Institute of Arts, 1952: Grigaut, *Arts of the Ming Dynasty*, cat. nos. 12-17, p. 9.
Cleveland Museum of Art, 1954: Lee, *Chinese Landscape Painting*, cat. nos. 53 and 53a, pp. 78, 79, 150.
University of Michigan Museum of Art, Ann Arbor, 1976: Edwards, *Wen Cheng-ming*, no. II, pp. 28-34, illus. II A-F.

Recent provenance: Jean-Pierre Dubosc.

Nelson Gallery-Atkins Museum 46-51 A-F

Shen Chou

155 *Twelve Views of Tiger Hill, Suchou*
 (Hu-ch'iu t'u)

 Album of twelve leaves, ink on paper or ink and
 slight color on paper, 31.1 x 40.2 cm.

The following titles are taken from *Hu-ch'iu-shan chih (Gazetteer of the Tiger Hill):*

A. *Distant View of Tiger Hill from the Canal Mooring*
B. *The Fool's Spring*
C. *The Pine Retreat*
D. *The Enlightened Stone Retreat*
E. *The Nodding Stone Terrace, Tiger Hill, and the Thousand-Man Seat*
F. *The Sword Spring, Tiger Hill*
G. *The Thousand Buddha Hall and the Pagoda of the "Cloudy Cliff" Monastery*
H. *The Five Sages Terrace*
I. *The Thousand Acres of Clouds*
J. *Tiger-Flight Spring at the Back Gate*
K. *Bamboo Pavilion, Tiger Hill*
L. *Cloud-Climbing Pavilion*

Artist's seals: Ch'i-nan (1 on each leaf); Shih-t'ien (1 on first and fourth leaves).

1 colophon and 4 additional seals: 1 colophon and 1 seal of Yao Yüan-chih (1776-1852); 3 seals of Hou Shih-kung.

155L

155B

155C

155D

155E

155F

Colophon by Yao Yüan-chih:

The brushwork of this album is aged and powerful. It is so vigorous that it gives you a feeling of the mist and clouds when looking at it. It could not be done by any other than the old master, Shen Chou. Formerly the album was in the collection of Hu Tzu-shou's family. After many changes of hands, it came finally into the possession of Li-keng, the Keeper of the Imperial Stable [that is, Pin Liang, Manchurian poet-calligrapher, later the Imperial Resident in Lhasa, Tibet, 1784-1847]. Not long ago, when its former owner Tzu-shou came to visit me and found the album in my study, he sighed in nostalgia and told me that there were originally an inscription and colophons in the album which are now lost. Sung Lo [1634-1713] once had a poem by Shen Shih-t'ien on the painting of Tiger Hill. [The poem is missing from the album.] It must be a poem written for this album. However, according to Sung's own title, the poem was composed after the rhymes and meter of the original poem on the album. Now there is no poem whatsoever in the frontispiece or at the end of the album. Is this what Tzu-shou meant – that the original colophons and inscription are missing?

Li-Keng, the Keeper of the Imperial Stable, has asked me for a colophon. The album has been left on my desk since last year. How time has passed! On the first day of the *chia-shen* year [1824], I returned from the Court Audience. The plum trees in the pots have started to blossom with their first fragrance. How much has this added to my enjoyment of the painting! I therefore write down a few words for your criticism. [signed] the Student of the Grass Leaf Pavilion, Yao Yüan-chih. trans. WKH

Remarks: Yao Yüan-chih was a prominent calligrapher, famous particularly for writing in the li style. He served between 1814 and 1838 as examiner in many provinces and was promoted to an academician of the Privy Council in 1841 after a short period of duty on the Board of Censorship.

The undated *Twelve Views of Tiger Hill, Suchou* must have been the product of Shen Chou's mature years, after 1490, when he had synthesized quotes from specific Yüan masters into a more personal style, with strong brushstrokes and rich ink playfully and economically combined. In this album the site and its visitors are presented in an abbreviated manner which subordinates outward appearance to the abstract rhythms of individually defined brushstrokes, even though the topography as represented is sufficiently accurate to identify extant buildings. Figures climb steps or sit to rest, their movements caught with cartoon-like simplicity. Thick seal-character strokes shape the architecture, while wet and dry contrasts of ink define the surface of the hill – as much a tourist site for today's traveller as it was for the sixteenth-century visitor who journeyed the ten miles from Suchou.

Tiger Hill was later painted by the friends and followers of Shen Chou's pupil, Wen Cheng-ming (see Lee, "Some Problems," 1957, p. 474, pl. 4 [figs. 4, 5], pl. 6 [fig. 5], for three leaves from a Tiger Hill album by Ch'ien Ku), but since these renderings approximate Shen Chou's version of the place, the earlier master must be given credit for introducing the subject for use by Ming painters from the Suchou area. HK

Literature
Sirén, *Masters and Principles* (1956-58), VII, *Lists,* 229 (one unidentified leaf in Hobart collection).
Lee, "Some Problems" (1957), pp. 474-76, pl. 5 (fig. 7 [B]), pl. 6 fig. 8 [E]).

155G

155H

155I

155J

155K

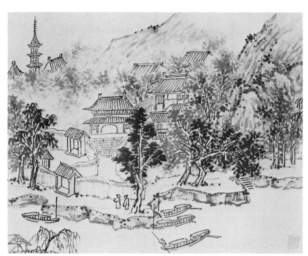

155A

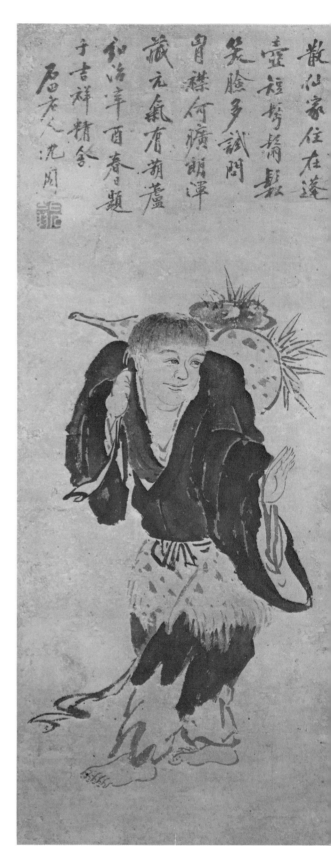

156

Goepper, *Im Schatten* (1959), pl. 12 (B).
Hochstadter, "Shen Chou" (1959/60), pls. II (F), III (B), IV (I), V (L).
Fontein, "Chinese Art" (1960), p. 554, pl. 283 (B).
Edwards, *Field of Stones* (1962), p. 52, n. 74 (B, E, F, J).
Lee, *Chinese Landscape Painting* (1962), pp. 67, 68, no. 52 (B, E, F, J), B illus. on p. 69.
Goepper, *Essence* (1963), fig. 60 (B).
Lee, "Literati and Professionals" (1966), p. 47, figs. 4-15 (A-L).
Goepper, *Kunst* (1968), pl. 97 (L).
Horizon, Arts (1969), illus. p. 323 (G).
Wilkinson, "The Role of Sung" (1975), p. 128, fig. 5 (I).
Cahill, *Parting* (1978), pp. 91, 92, pls. 39 (G), 40 (B).
CMA *Handbook* (1978), illus. p. 349.
Edwards et al., *Shin Shū, Bun Chōmei* (1978), p. 162, pls. 38 (J), 39 (B), 40 (G), 41 (D).

Kessler, "Function of *Tien*" (1980), p. 34, fig. 8 (B).
Hochstadter, *Compendium* (forthcoming).

Exhibitions

Cleveland Museum of Art, 1954: Lee, *Chinese Landscape Painting*, cat. no. 51: 1-4 (B, E, F, J).
Asia House Gallery, 1974: Lee, *Colors of Ink*, cat. nos. 26 (B), 27 (E).

Recent provenance: Walter Hochstadter; Richard B. Hobart (B, E, F, J); Walter Hochstadter.

The Cleveland Museum of Art 64.371

Shen Chou

156 *The Bottle-Gourd Immortal*
(Hu-lu hsien)

Hanging scroll, dated 1501, ink and slight color on paper, 69.9 x 31.7 cm.

Artist's inscription, signature, and seal at top:

This carefree immortal, without post or portfolio, makes his home on P'eng-lai Isle and Fang-hu Mountain;
Thatch-headed, hair a mess, a jolly face is always his.
You ask how he is endowed with understanding so broad and content;
It is the bottle gourd — there he preserves his vitality pristine.

Inscribed by Shih-t'ien-lao-jen, Shen Chou, in the Cloister of Propitiousness on a spring day in the *hsin-yu* year of the Hung-chih era [1501]. [seal] Po-shih weng.

Remarks: The picture has suffered considerable damage near the borders of the paper; this undoubtedly prompted a weak and insufficient hand to retouch the characters Shen and Chou of the signature, thus rendering them rhythmically inconsistent with the seasoned casualness of the brushwork seen in the remainder of the inscription.

Figure paintings by Shen Chou are rare, and although the subject matter is Taoist in the strictest terms, the ideals expressed in the accompanying poem also speak for Confucian values of withdrawal from the frustrations of official life and of cultivating a spontaneous truth to self found in one's basic nature. Appropriately, the treatment of the figure feigns an unaffected quality whose prototype is usually associated with Ch'an figure painting of the Southern Sung and early Yüan periods. The brushwork and modulated ink wash of the garments find their closest parallels, however, in Shen's album paintings of plants, flowers, and domestic animals and fowl. MFW

Literature
Harada, *Shina* (1936), pl. 502.
Nihon genzai Shina (1938), p. 144.

Exhibitions
Detroit Institute of Arts, 1952: Grigaut, *Arts of the Ming Dynasty,* cat. no. 6, p. 9.

Recent provenance: Takuji Ogawa; Michelangelo Piacentini.

Nelson Gallery-Atkins Museum 47-69

Tu Chin, active ca. 1465-ca. 1509, Ming Dynasty
t. Chü-nan, *h.* Ch'eng-chü, Ch'ing-hsia t'ing-chang, Ku-k'uang; from Chen-chiang, Chiangsu Province

157 *The Poet Lin Pu Wandering in the Moonlight*
(P'ei-yüeh hsien-hsin t'u)

Hanging scroll, ink and slight color on paper, 156.5 x 72.4 cm.

Artist's inscription, signature, and seal at upper left:

Leisurely walking with the moon, both my stick and my shoes are slow;
It is particularly suited for my half-awakened mood.
Finishing a verse on the sparse shadow and the cool fragrance,
I would like to know if the plum blossoms will understand.

Ch'eng-chü, Tu Chin [seal] I-shu-sheng.

trans. WKH

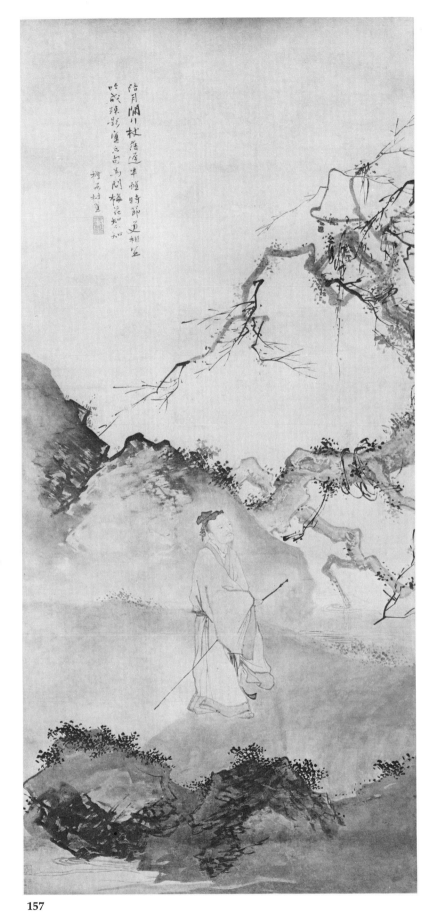

157

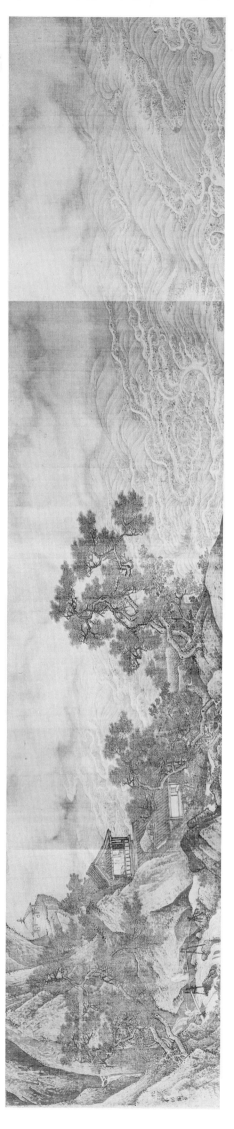

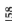
158

3 additional seals: 1 of Chang Heng (b. 1915); 1 of Wang Chi-ch'ien (20th c.); 1 unidentified.

Remarks: The poet Lin Pu (965-1026) lived as a recluse near the West Lake in Chechiang. In this large hanging scroll the painter Tu Chin depicts the poet on a moonlit walk, composing a verse on the prunus, a frequent subject of his poetry. The line "sparse shadow and cool fragrance" within Tu Chin's poetic inscription is based on a couplet (trans. WKH) from one of Lin Pu's most famous poems:

> Over the shallow water, sparse shadows are
> intertwining,
> Under the dim moonlight, secret fragrances are
> floating.

Tu Chin himself was known for his learning and verse but, after low placement in the *chin-shih* examinations, chose to earn his living as a painter instead of pursuing a government career.

The *Poet Lin Pu* demonstrates Tu Chin's knack for capturing the individuality of the human figure, despite the rather conventionalized landscape setting reminiscent of Southern Sung prototypes such as Ma Yüan (see cat. nos. 52, 53) and Ma Lin. While such traits mirror formulae employed by the Che school professionals, Tu's playful brush is equally typical of Suchou literati painting, particularly in the massing of brushstrokes to shape rocks or gnarled tree boughs. This ambiguous and carefully balanced position between scholar and professional unfolds within Tu Chin's preserved work in much the same way as that of his younger contemporary, T'ang Yin (who befriended the painter in his old age), and of Ch'iu Ying. HK/SEL

Literature
Sirén, *Masters and Principles* (1956-58), IV, 145; VII, *Lists*, 245.
Goepper, *Chinesische Malerei* (1960), p. 42, illus. p. 43.
Lee, *Chinese Landscape Painting* (1962), p. 61, no. 44.
Goepper, *Essence* (1963), pp. 60, 72, 74, pl. 53.
Lee, *Far Eastern Art* (1964, 1973), p. 425, fig. 567.
Li Dun, *Ageless Chinese* (1965), p. 305.
Lee, "Portraiture" (1977), p. 132, fig. 20.
Cahill, *Parting* (1978), p. 155.
CMA *Handbook* (1978), illus. p. 349.

Exhibitions
Nanking Art Gallery, 1937: *Chiao-yü-pu*, I, cat. no. 138.
Cleveland Museum of Art, 1954: Lee, *Chinese Landscape Painting*, cat. no. 42.
Haus der Kunst, Munich, 1959: *1000 Jahre*, cat. no. 42.
Cleveland Museum of Art, 1960: Chinese Painting, no catalogue.
Indiana University Art Museum, Bloomington, 1968: Bowie, *One Thousand Years*, cat. no. 27.

Recent provenance: Chang Ts'ung-yu; Wang Chi-ch'ien.

The Cleveland Museum of Art 54.582

Chou Ch'en, ca. 1455-after 1536, Ming Dynasty
t. Shun-ch'ing, *h.* Tung-ts'un; from Suchou, Chiangsu Province

158 *The North Sea*
(Pei-ming t'u)

Handscroll, ink and light color on silk, 28.4 x 136.6 cm.

Artist's inscription, signature, and seal in lower left corner: Pei-ming t'u, Tung-ts'un Chou Ch'en [seal] Chou shih Shun-ch'ing.

3 additional seals: 2 of Tetsujō Kuwana (early 20th c.); 1 unidentified.

Remarks: Like the title of Chou Ch'en's *Clear Pool (Pai-t'an t'u)* (cat. no. 159), the title of this scroll could be the sobriquet of the man for whom the picture was painted and who is shown seated in the pavilion. The title comes from the first chapter of *Chuang-tzu*, "Hsiao-yao-yu," that tells of a great fish, called K'un, living in the North Sea. This fish transforms itself into a monstrous bird called P'eng. With a mighty effort the bird rises, and its wings obscure the sky as it flies south, mounting on a typhoon to a height of ninety thousand *li*. Through this story, the North Sea (or Dark Ocean) with its towering waves becomes a symbol of the man who has high ambitions to succeed, and so *Pei-ming* may serve as a man's *hao* or a suitable name for his studio.

Among Chou Ch'en's surviving works this scroll is a splendid example of the artist's command of the Southern Sung style of Li T'ang. But, as James Cahill points out (*Parting*, 1978, pp. 168, 189), the painting is in no way a conscious archaism but rather the employment of "a mode of painting that concerns itself with sensory experience in a palpable world."

The composition is one of the most dramatic to be found among paintings of the Ming Dynasty. It opens on the right with a vast sweep of tumultuous waves; low-hanging, scudding clouds; and windswept trees; all made the more dynamic by contrast with the closing passage where, in the serenity of a mountain valley shielded from the storm by the seaside cliffs, ancient pines grow, a waterfall feeds a splashing stream, and a guest approaches crossing a rustic bridge. LS

Literature
Tōyō bijutsu taikan (1908-18), x, pl. 54.
Nihon genzai Shina (1938), p. 154.
Moskowitz, ed., *Great Drawings* (1962), IV, pl. 900.

Speiser, Goepper, and Fribourg, *Chinese Art*, III, (1964), fig. 65.
Maeda, "'Water' Theme" (1972), p. 262, pls. 18a, 18b.
Wilson, "Vision" (1973), pp. 237, 238, pl. 10.
Akiyama et al., *Chūgoku bijutsu* (1973), II, 219, 220, pl. 11.
NG-AM Handbook (1973), II, 64.
Cahill, *Parting* (1978), pp. 168, 189, pl. 94 and color detail on jacket.
Sullivan, *Symbols of Eternity* (1979), pp. 116, 117, fig. 68.
Exhibitions
Asia House Gallery, New York, 1970: *Masterpieces II*, pls. 104-7.

Recent provenance: Tetsujō Kuwana; Gizan Ueda.

Nelson Gallery-Atkins Museum 58-55

Chou Ch'en
159 *The Clear Pool*
(Pai-t'an-t'u)

Hanging scroll, ink and slight color on silk, 33.3 x 63.4 cm.

Artist's inscription, signature, and seal at lower left: Pai-t'an-t'u. Tung-ts'un Chou Ch'en [seal] Chou shih Shun-ch'ing.

Remarks: It was common practice in the Ming Dynasty for an artist to be asked to paint a picture with the title of a man's garden, studio, or sobriquet. Such may well be the case here, with the gentleman who requested the scroll represented by the figure seated on a mat contemplating the pool.

In this composition Chou Ch'en has concentrated masses of trees, rocks, and hills on the right and left, leaving a relatively open area in the middle. An H-shaped design of this kind is rarely found in hanging scrolls but is more common in handscrolls. Originally,

158 Detail

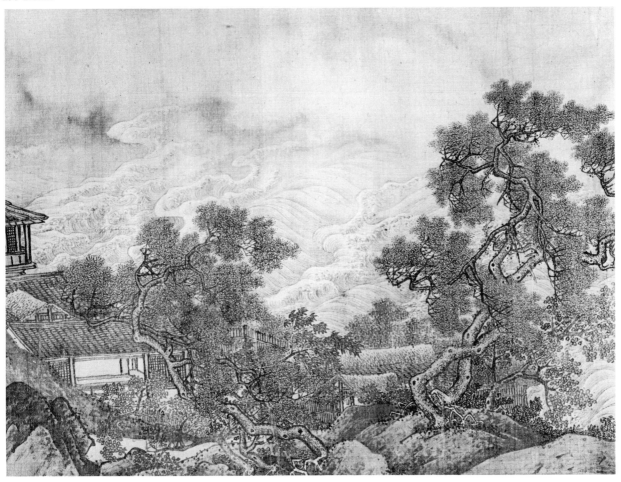

this painting must have been a short handscroll, possibly with colophons. When remounted in Japan as a hanging scroll, at least several inches were trimmed from the right side in the process, making the opening passage too abrupt.

Chou Ch'en was an artist of some complexity who in his career employed a number of styles derived from the works of other painters. Regardless of his sources, however, all his works bear, in varying degree, the mark of his own talents. He mastered the Southern Sung style that had been codified around the name of Li T'ang (ca. 1050-after 1130), combining the use of the "small axe-stroke" *(hsiao-fu-p'i-ts'un)* in texturing with meticulous drawing of trees, buildings, and figures. In other works his brush and ink are employed in a far freer, looser manner, probably influenced by Wu Wei (1459-1508). Here in *The Clear Pool* Chou Ch'en employs a style somewhat between the two masters. He makes use of the small axe-stroke texturing but combines it with longer, irregular strokes of the "hemp-fiber" kind *(p'i-ma-ts'un)*. The brushwork is looser, stronger, and more fluid than that in *The North Sea* (cat. no. 158), and the drawing is more angular and rapidly executed. While *The North Sea* is notable for its elegance and consistency, *The Clear Pool* exemplifies a more personal manner and a style in Chou Ch'en's art that is closer to the mainstream of Ming painting. KSW

Literature
Harada, *Shina* (1936), pl. 547.
Nihon genzai Shina (1938), p. 153.

Exhibitions
Tokyo National Museum, 1931: *Sō-Gen-Min-Shin*, pl. 108.

Recent provenance: Katsudairō Inabata; Michelangelo Piacentini.

Nelson Gallery-Atkins Museum 53-62

Chou Ch'en

160 *Beggars and Street Characters*
(Liu-min t'u)

Handscroll, dated 1516, ink and light color on paper, 31.9 x 244.5 cm.

Artist's inscription, signature, and 3 seals, at end of scroll:

In the autumn of the eleventh year of Cheng-te [1516], in the seventh month, I was idling under the window, and suddenly there came to my mind all the appearances and manners of the beggars and other street characters whom I often saw in the streets and markets. With brush and ink ready at hand, I put them into pictures in an impromptu way. It may not be worthy of serious enjoyment, but it certainly can be considered as a warning and admonition to the world.

Recorded by Tung-ts'un, Chou Ch'en. [seals] Tung-ts'un; Shun-ch'ing; O-ch'ang san-jen.

trans. WKH

Title on frontispiece by Chao Hou-ch'in (20th c.).

3 colophons and 10 additional seals: 1 colophon, dated 1564, and 2 seals of Huang Chi-shui (1509-1574); 1 colophon and 3 seals of Chang Feng-i (1527-1613); 1 colophon, dated 1577, and 1 seal of Wen Chia (1501-1583); 4 seals unidentified.

Remarks: This composition was originally painted on a long sheet of paper, folded in accordian fashion, and then mounted as an album. Traces of the folds which separated the figures in the original format still remain on the present handscroll. At some time the original

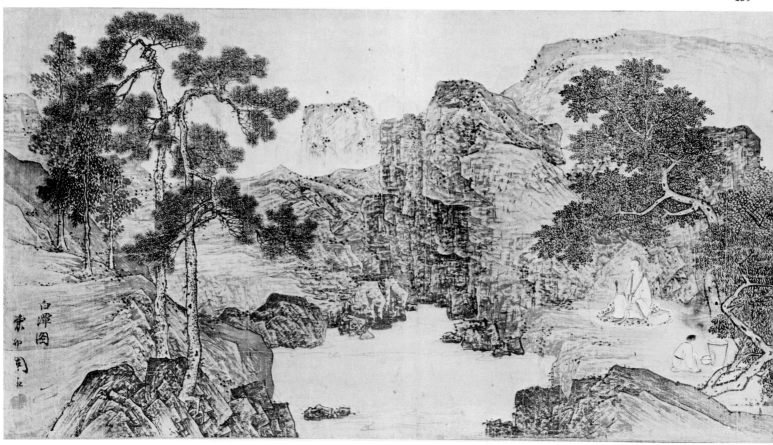

album was divided and remounted as two handscrolls. The second half of the album, along with the artist's inscription and three colophons, constitutes the Cleveland handscroll. The opening section of the original, along with copies of the inscription and colophons, belongs to the Honolulu Academy of Art (Ecke, *Hawaii*, 1965, III, pl. LX). Two other versions are known to exist: one in the Field Museum of Natural History, Chicago, which includes six figures not found in either the Cleveland section or the Honolulu section, and one once in the collection of Viceroy Tuan Fang (published erroneously as a T'ang painting; see Ferguson, *Outlines*, 1919, p. 200). The latter is a handscroll of unknown authorship which incorporates two of the figures from the Cleveland section and two from the Honolulu section. The sequence of figures is varied in all three versions. Because of these differences and omissions, it seems possible that the original album may have been cut up and divided into more than two parts, with at least six figures now missing.

In his inscription, Chou Ch'en states that his painting could be considered a warning or admonition. Although low-life depictions as admonitory instructions have precedent in Buddhist hell scenes, contemporary writers who viewed the original album felt that Chou Ch'en's painting carried political overtones. Huang Chi-shui saw the painting in the collection of the official Wo-yün (possibly Cheng Kuo-pin, who used that studio name). In his colophon of 1564 Huang extended Chou's "warning" from street beggars to those who "come around on dark nights, begging and wailing in their desire for riches and high position" (trans. Cahill, *Parting*, 1978, p. 192).

Chang Feng-i, the second colophon writer, indicates that Chou must have been using the street characters as a commentary on the destitution of the common people under the harsh misrule and taxation imposed by the "seditious" eunuch Liu Chin and his cohorts early in the reign of the youthful Cheng-te emperor, adding: "...this work by Chou Ch'en has the same intent as Cheng Hsia's *Destitute People*: it was meant as an aid to government and is not a shallow thing – one can't dismiss it as a 'play with ink'" (ibid.). (Cheng Hsia was the Sung scholar-official-painter who submitted to the emperor a painting of victims of the 1073/74 famine in order to move the ruler to take action to relieve the people's suffering – namely, to remove the prime minister, Wang An-shih, whose reforms Cheng Hsia felt precipitated the famine.)

In the third colophon, dated 1577, the painter Wen Chia acknowledges the merit of the two previous writers' insights into the nature of Chou's warning, then goes on to speak of T'ang Yin's veneration of his teacher's "inspired wonders" and says, "I am in complete agreement with T'ang Yin's heartfelt admiration. Such a piece is not to be acquired easily. The qualities that Huang and Chang point to must be considered beyond the painting – they are not to be found in formal likeness, or in brush and ink" (ibid.).

The role of trenchant social critic which these contemporary writers cast for the artist Chou Ch'en is certainly at odds with his other surviving works – *Beggars and Street Characters* being unique. (An album leaf of similar subject matter is in the National Palace Museum, Taipei; see Lawton, "Scholars and Servants," 1966, pp. 8-11). Perhaps more such works were painted but have failed to survive. Cahill (*Parting*, 1978, p. 191) speculates that

these uncomfortable subjects would hardly appeal to most patrons in traditional China who preferred, and thus preserved, those things they found beautiful and pleasing to themselves. Such prejudice might explain why this painting bears no seals of famous connoisseurs or collectors. Moreover, as a professional artist, Chou Ch'en could hardly have expected to make his living by producing documents of social import. *Beggers and Street Characters* could therefore be considered the private, personal expression of a painter with a social conscience.

HK/WKH

Literature
Sirén, *Masters and Principles* (1956-58), VII, *Lists*, 177.
Lee, "Beggars and Street Characters" (1965), pp. 162, 163 (illus., detail).
"Mostra de Arte Straniera" (1965), p. 264.
Lee, "Literati and Professionals" (1966), pp. 9, 10, fig. 3.
Lawton, "Scholars and Servants" (1966), pp. 8 (illus., detail), 10.
Huggins, "Monkey" (1969), illus. p. 12.
Lee, "Water and Moon" (1970), p. 56, illus. p. 27; idem, "Portraiture" (1977), pp. 133, 134, figs. 21, 22.
Cahill, *Parting* (1978), p. 191.
CMA *Handbook* (1978), illus. p. 350 (detail).
Hochstadter, *Compendium* (forthcoming).

Recent provenance: Walter Hochstadter; N.V. Hammer, Inc.

The Cleveland Museum of Art 64.94

T'ang Yin (attributed to), 1470-1523, Ming Dynasty
t. Po-hu, Tzu-wei, *h.* Liu-ju chü-shih; from Suchou,
Chiangsu Province

161 *Listening to the Ch'in*
(T'ing-ch'in t'u)

Hanging scroll, ink and light color on silk, 35.9 x
29 cm.

Artist's seal at lower left corner: Wu [remainder cut off].

Remarks: This painting is signed on the right margin
with the name Chou Wen-chü (see cat no. 16), but both
the seal and the execution suggest that its real author is
T'ang Yin. Although little more than one-fourth of a
four-character seal remains, the configuration of the first
character (*wu*) conforms to that on the *Wu-chün* seal used
by T'ang Yin on a handscroll in the collection of the
National Palace Museum, Taipei (*Signatures and Seals,*
1964, II, 184). The two-character Wu-chün seal is seldom
encountered, and the Cleveland painting is the first
known instance of a four-character seal incorporating
the same characters.

A comparison between *Listening to the Ch'in* and *Scholar-
Hermits in Stream and Mountain* (cat. no. 162) provides
further confirmation for a T'ang Yin authorship. The first
architectural complex in the *Scholar-Hermits* handscroll
exhibits an identically bound thatched roof line and
meticulously drawn walls with similar tiles holding
down the thatch. Minute dotting in transparent color on
the ground planes appears in both paintings, while
many root-exposed trees in the handscroll follow a con-
figuration similar to the bare tree of *Listening to the Ch'in*.
The sensitivity of fine line and light color also unites the
figures in both paintings even though the line employed
to shape the clothing of the *Scholar-Hermits* appears a bit
more self-assured and effortless.

In this album leaf, T'ang Yin employed a subject
which had appeared earlier in a large hanging scroll,
Listening to the Ch'in, in the National Palace Museum,
Taipei (*KKSHL, ch.* 5, p. 142; illustrated and discussed by
Wang Shih-hsiang, "Ku ch'in ch'ü Kuang-lin san," 1957,
p. 28). Both artists seem to allude to a legendary incident
from the life of Chi Kang, the expert lutenist included
among the third-century Seven Sages of the Bamboo
Grove (see van Gulik, *Hsi K'ang,* 1941, p. 31). While play-
ing the *ch'in* late one evening, Chi Kang was visited by a
stranger who taught him the air *Kuang-lin san*. This
melody, famous within the *ch'in* repertoire, was so
haunting that later generations believed its composer to
be a visitor from the spirit world. T'ang Yin and his Sung
predecessor illustrate the scene with an other-worldly
audience emerging from underground, drawn by the
sound of Chi Kang's lute.

LYSL/HK/SEL

Recent provenance: Howard C. Hollis; Mr. and Mrs. Herbert
F. Leisy.

The Cleveland Museum of Art 77.199

161

T'ang Yin

162 *Scholar-Hermits in the Autumn Mountains*
(Ch'iu-shan kao-shih)

Handscroll, ink and light color on silk, 28.6 x 232.4 cm.

Artist's signature and 2 seals at end of scroll: T'ang Yin [seals] T'ang Po-hu; T'ang Tzu-wei t'u-shu.

Title on frontispiece by Li Cho-kung (dates unknown).

1 colophon and 11 additional seals: 1 colophon of Wu Tso-hsi(19th-20th c.); 2 seals of Kao Ch'i-feng (20th c.); 5 seals of Wang Chi-ch'ien (20th c.); 4 seals unidentified.

Remarks: This little-known and unrecorded handscroll is of some importance in understanding the origins of the conservative and accomplished art of T'ang Yin. One can only echo the content of the sole colophon (dated 1915) by Wu Tso-hsi, recording his initial doubts but ultimate belief in the authenticity of the scroll, confirmed by the opinion of the well-known collector P'ei Ching-fu (1894 *chin-shih*).

The frontispiece title by Li Cho-kung is much worn, owing to the extreme fragility of its coated paper surface, but the painting on silk is in excellent condition. The style of the scroll is clearly derived from that of Li T'ang of the early twelfth century and one that is dominant in the numerous preserved works by, and attributed to, T'ang Yin. The complex representation is close to that of the famous handscroll in Taipei, *Secluded Fishermen on an Autumn River* (Cahill, *Parting*, 1978, pl. 90). But the latter–though similar in its autumnal coloring, sharp brush-strokes, and narrative detail–is bolder in brushwork and, in particular, uses wide and wet strokes *(ts'un)* to blend in the modeling of rocks and mountains.

The Cleveland scroll must be an earlier work, for its dry, thin, and sharp *ts'un* are closer to those used by the originator of the manner: Li T'ang. The layered (oyster-like) brushstrokes and the graceful figures are clearly in T'ang Yin's characteristic style. Although dated works are scarce, one can propose 1500 to 1510 for this forma-tive style, which is also discernible in a landscape hang-ing scroll (known only from a photograph – Cahill no. L3-6, Suchou Museum) that is done in a style strongly reminiscent of Li T'ang. The Cleveland handscroll is conservative in its overall organization, beginning quietly, growing in complexity and massiveness at the center, and ending quietly, with a final *repoussoir* in a Northern Sung manner. However, the nervous energy of the brush details is all T'ang Yin and reflects his acknowledged "mad and stubborn" heterodox character.

SEL

Literature
CMA *Handbook* (1978), illus. p. 351 (detail).

Recent provenance: Wang Chi-ch'ien.

The Cleveland Museum of Art 76.94

162 Detail

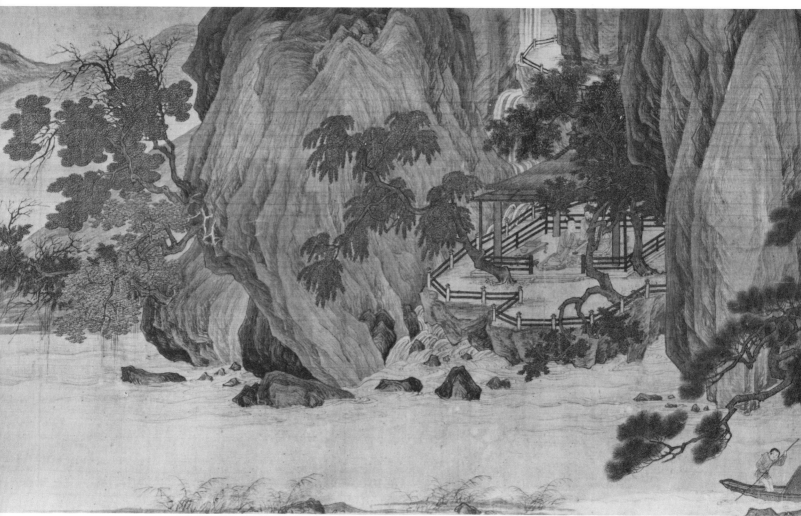

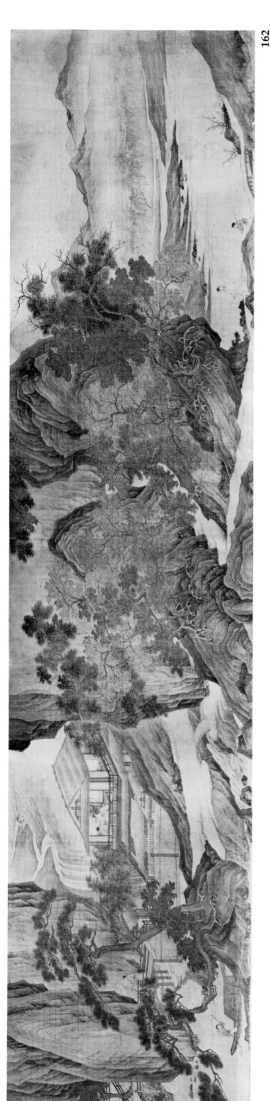

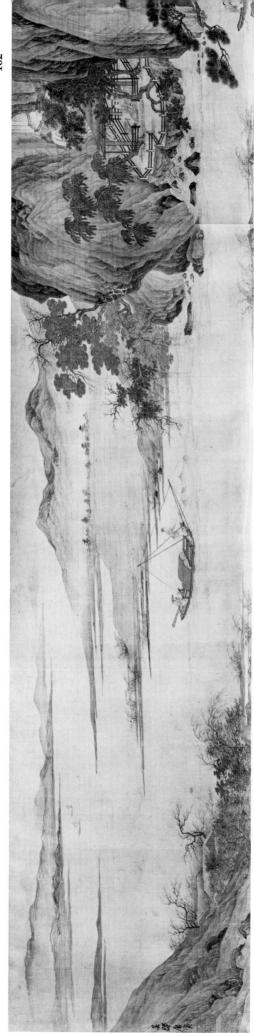

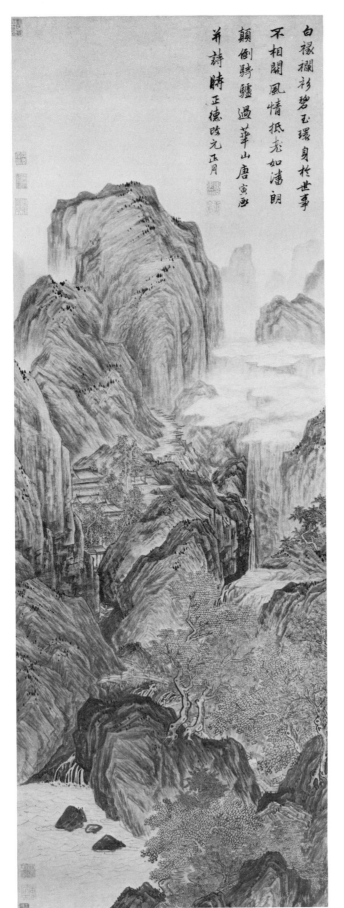

T'ang Yin

163 *Mount Hua*
(Hua-shan t'u)

Hanging scroll, dated 1506, ink and light color on paper, 111.1 x 41.5 cm.

Artist's inscription, signature, and 4 seals:

Wearing a white-bordered scholar's robe and green
 jade pendants,
His life is unconcerned with worldly fame.
Like P'an Lang resisting old age through
 high spirits,
Crazy and clumsy he rides his donkey past Mount Hua.

T'ang Yin painted this and composed the poem, the first month of the first year of the Cheng-te era [1506]. [2 seals] T'ang Tzu-wei yin; T'ang. [2 seals, lower left corner] Po-hu T'ang Yin ssu yin; T'ang Chü-shih.

<div align="right">trans. LYSL</div>

12 additional seals: 2 of Wang Shan (1645-1728); 5 of Liu Shu (1759-1816); 1 of Yeh Ao (19th c.); 1 label and 2 seals of Lu Hui (1851-1920); 2 seals unidentified.

Remarks: Only seven years prior to the completion of this painting, T'ang Yin's potentially brilliant career was shattered. In 1499 he had gone to the capital to take the *chin-shih* examination. He kept the company of a fellow entrant, Hsü Ching, who was alleged to have bribed the servant of the chief examiner for a copy of the examination questions and shared them with T'ang Yin. (The presiding judge at T'ang Yin's trial, Li Tung-yang, contributed poetry and calligraphy on another scroll in the collection by T'ao Ch'eng; see cat. no. 145). After his release from jail, T'ang returned to Suchou, resumed his dissolute life style, and settled on a career as a professional painter, under the guidance of Chou Ch'en.

One of T'ang's few dated works, *Mount Hua* was painted shortly after his reputation became well established. In this work he employs the landscape conventions of the Sung master, Li T'ang (cf. *Three Hundred Masterpieces*, 1959, III, pls. 95, 98), to capture the monumental presence of his subject. Both artists emphasize solidity of form and sharply angled mountain contours. But whereas Li T'ang's firm, rubbed, short axe-cut *ts'un* literally describes the bulk and texture of chipped rock, T'ang Yin modifies and elaborates that brush method with greater surface interest — accumulations of hooked and straight lines, and ink washes of varied intensity that accent the play of light. These creative, somewhat decorative liberties with the Li T'ang style are taken also by T'ang Yin's teacher, Chou Ch'en (see cat. no. 158), as well as by Ch'iu Ying and Lu Chih of the next generation (Wilkinson, "The Role of Sung," 1975, pp. 126-35). HK

Literature

P'ang, *Hsü-chai* (1909), *ch.* 8, pp. 1(a), 1(b).
Omura, *Bunjin gasen* (1921-22), II, 4.
Naitō, *Min shi-taika gafu* (1924), p. 40.
Spieser, *T'ang Yin* (1935), p. 10, pl. 2.
Harada, *Shina* (1936), pl. 548.
Nihon genzai Shina (1938), p. 155.
Sirén, *Later* (1938), I, 122, pl. 83, and VII, *Lists*, 232; idem, *Kinas Konst* (1943), pp. 528, 529, fig. 489.
Cheng Chen-to, ed., *Yü-wai so-ts'ang* (1947), ser. 6, pt. 2, pl. 1.
Chūgoku meigashu (1947), III, pl. 18.
Sirén, *Masters and Principles* (1956-58), IV, 197; VI, pl. 220; VII, *Lists*, 237.

163

Kuo Wei-chu, *Sung Yüan Ming Ch'ing* (1958), p. 143.
Hsü Pang-ta, *Li-tai liu chüan* (1963), p. 286.
Chiang Chao-shen, "Liu-ju chü-shih" (1969), p. 36, pl. 6-B
 (inscription only).

Exhibitions
Tokyo Imperial Museum, 1928: *Tō-Sō-Gen-Min*, II, 265.

Recent provenance: P'ang Yüan-chi; Heizō Hayashi; Ch'eng Ch'i.

The Cleveland Museum of Art 69.116

Ch'iu Ying, 1494/5-1552, Ming Dynasty
 t. Shih-fu, *h.* Shih-chou; from T'ai-ts'ang, active in
 Suchou, Chiangsu Province

164 *Saying Farewell at Hsün-yang*
 (Hsün-yang sung-pieh)

Handscroll, ink and full color on paper, 33.6 x 399.7 cm.

Artist's signature and 2 seals at lower left edge: Painted by Ch'iu Ying Shih-fu [seals] Ch'iu Ying chih yin; Ch'iu shih Shih-fu.

Frontispiece and 3 seals of Chu Chih-fan (1558-1624 or later).

1 colophon and 8 additional seals: 1 colophon, probably dated 1614, and 3 seals of Hsieh Kung-piao (act. early 17th c.); 3 seals of Sun Kuo-t'u (act. 1736-55); 2 seals of Jean-Pierre Dubosc (20th c.).

Remarks: The painting illustrates a famous poem, "The Lute Song" *(P'i-p'a hsing)*, written by Po Chü-i in 816 (see also cat. no. 185). The poem relates how Po Chü-i went to Hsün-yang (Chiang-chou) to say farewell to a friend whose boat was moored by the riverbank. It was evening, and across the water he heard the sound of a lute from another boat. The instrument was played with such skill that he knew the musician must have been trained in the capital. Indeed, the player had been a famous courtesan in the capital until her beauty faded and she was married off to a tea merchant who lived at Hsün-yang. She was invited to join the two friends on the boat and, as night drew on, she entertained them with a song of moving sadness and beauty.

 The theme was popular among painters of the Wu school: T'ang Yin (1470-1523), Wen Po-jen (1502-1575), Lu Chih (1496-1576), and Wen Chia (1501-1583) all painted the subject, but chose to depict only the main theme of the figures in the boat. Ch'iu Ying, however, in this scroll employs not only an archaistic landscape, recalling the time of Po Chü-i, but also the ancient device of continuous narrative. In a long section of landscape, the poet is shown first approaching on horseback, then dismounted by the river after hearing the lute. This is followed by the climactic scene of the two men and the lute player in a boat, where a servant is preparing food.

 Traditionally, the blue-green style with full color and delicate detail all finely drawn harked back to antiquity and such masters of the T'ang Dynasty as Li Ssu-hsün

164 Detail

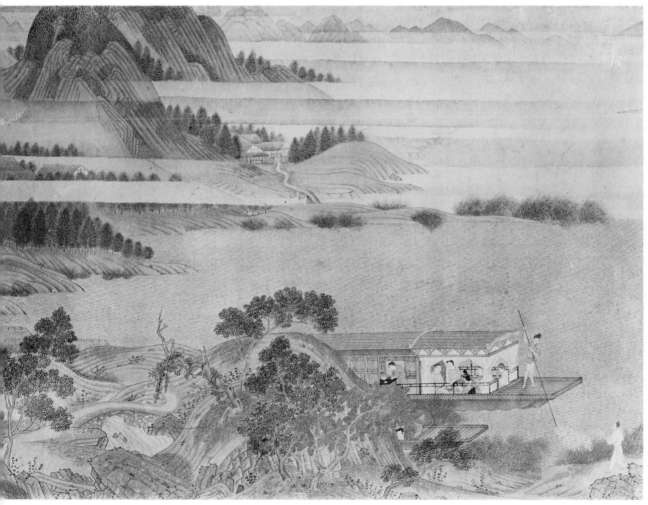

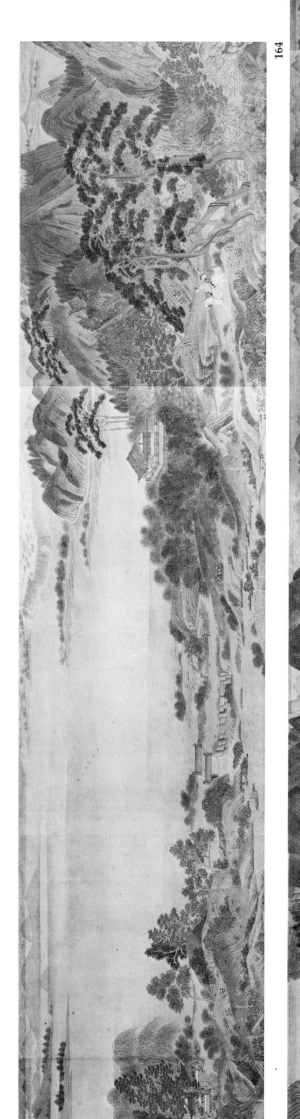

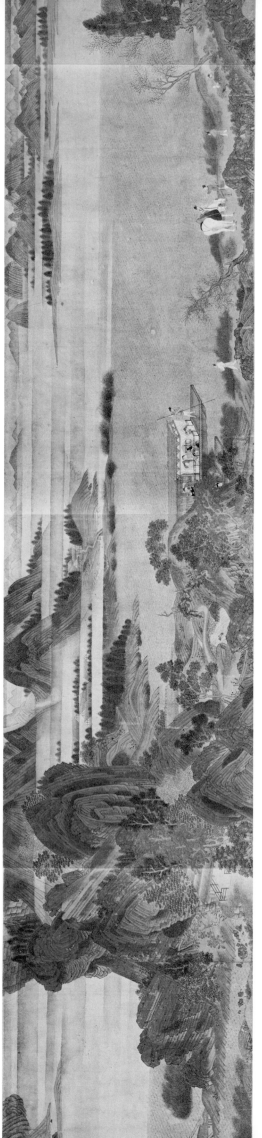

(651-716). In *Saying Farewell at Hsün-yang*, it is highly improbable that Ch'iu Ying derived the particular style from any painting as ancient as the T'ang Dynasty. The most likely source appears to be a much later artist, the Yüan Dynasty master Ch'ien Hsüan (ca. 1235-after 1300), who in a few uncharacteristic handscrolls originated, or at least codified, an archaistic manner that reflected current concepts of a classical style. Included in this group of handscrolls are *Wang Hsi-chih Watching the Geese* and *Home Again*, both in the Metropolitan Museum, New York (Lee and Ho, *Yüan*, 1968, cat. nos. 184, 185); *Awaiting a Ferry by a Misty River*, in the National Palace Museum, Taipei (*Ku-kung ming-hua*, 1966-69 IV, pl. 25/1, 2); and *Dwelling in the Mountains*, now in the Ku-kung, Peking (Koyama et al., *Kokyū hakubutsuin*, 1975, pl. 32). In all of these, as in the Nelson Gallery scroll, the blue and green pigments are applied heavily in some areas and in a variety of intensities, and are combined with washes in a rich ochre color. All are on paper–an unusual ground, since the thick pigments adhere better to silk.

Among the stylistic elements Ch'iu Ying appears to have borrowed from Ch'ien Hsüan are the overlapping, pointed chevrons delineating some of the mountain forms, and, from the Peking scroll, the juxtaposing of a tree with blue leaves next to one with red leaves and a third with leaves in a deep chrome yellow.

It is significant that two of these Ch'ien Hsüan paintings, *Awaiting a Ferry* and *Home Again*, were in the collection of Ch'iu Ying's great friend and patron Hsiang Yüan-pien (1525-1590). Ch'iu Ying must have seen these, and very likely others as well, in the hands of notable Suchou collectors. Ch'iu Ying has modified the style with imaginative elaboration, a wealth of detail, and an accuracy of drawing in the architectural elements. Also, he made extensive use of light ink washes to create an atmosphere of mists arising from the river as dusk deepens into night. The concluding passage, where the entire scene is engulfed in banks of mist, rendered in broad washes of pale ink, is a tour de force of painting in the blue-and-green style. LS

Literature
Lee, *Some Problems* (1957), pl. 8, figs. 12A, B.
Grousset, *Chinese Art and Culture* (1959), pl. 54.
Capolavori nei secoli (1962), no. 29, p. 82.
Sickman and Soper, *Art and Architecture* (1956), pp. 181, 182, pl. 142.
Horizon, Arts (1969), pp. 162, 163.
Akiyama et al., *Chūgoku bijutsu* (1973), II, 221, pls. 14, 15.
NG-AM Handbook (1973), II, 64.
Art Chinoise, Les Editions Braun et Cie (Paris, n.d.), no. 39696 (full-scale color repr. of a section).
Cahill, *Parting* (1978), pp. 209, 210, color pl. 9.

Exhibitions
Wildenstein Galleries, New York, 1949: Dubosc, *Ming and Ch'ing*, cat. no. 20, pp. 36, 37.

Recent provenance: Jean-Pierre Dubosc.

Nelson Gallery-Atkins Museum 46-50

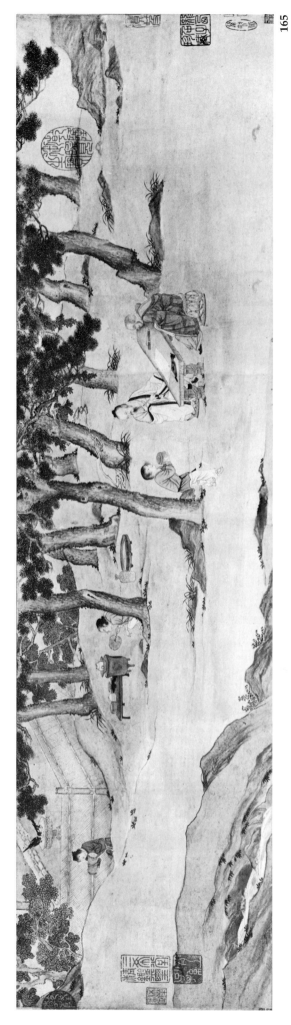

Ch'iu Ying

165 *Chao-Meng-fu Writing the "Heart" (Hridaya) Sutra in Exchange for Tea*
(Chao Sung-hsüeh hsieh-ching-huan ch'a t'u)

Handscroll, ink and light color on paper, 21.1 x 77.2 cm.

Accompanying text of "Heart" sutra written by Wen Cheng-ming (1470-1559).

4 colophons and 23 seals: 1 colophon, dated 1543, and 2 seals of Wen Peng (1498-1573); 1 colophon, dated 1543, and 2 seals of Wen Chia (1501-1583); 1 colophon, dated 1584, and 3 seals of Wang Shih-mou (1536-1588); 2 seals of Chou Feng-lai (16th c.); 3 seals of Sung Lo (1634-1713); 5 seals of the Ch'ien-lung emperor (r. 1736-95); 1 colophon, dated 1902, and 1 seal of Fei Nien-tz'u (1885-1905); 4 seals of Weng Wan-go (20th c.); 1 seal unidentified.

Wen Cheng-ming's written text of the *Mahā Prajñā-pāramitā hridaya sūtra (Mo-ho-pang-jo po-lo-mi-to hsin-ching* or *The Heart of the Perfection of the Great Wisdom*, commonly known as the "Heart" sutra) is the short form of the original Sanskrit text translated by the Buddhist pilgrim Hsüan-chuang in 649 (*Taisho Shinshu Daizokyō*, 1930 VIII, 848; for English translation see Conze, *Prajñāpāramitā Texts*, 1974, pp. 142-43). He wrote in his famous small, regular style (*hsiao-k'ai*) and signed it: "Cheng-ming, written in a boat at K'un-shan, on the twenty-first day of the ninth month, in the *jen-yin* year, the twenty-first year of the Chia-ching era [1542]."

Colophon by Wang Shih-mou:

Chou Yü-shün [Feng-lai] of K'un-shan was a scholarly, refined connoisseur of antiquities. He had acquired the poem written by Chao Ch'eng-chih [Chao Meng-fu] about the exchange of tea for Chao's calligraphy of the *Prajñā* sutra. But the sutra itself, also written by Chao Meng-fu, is lost. He therefore asked Ch'iu Shih-fu [Ch'iu Ying] to do a painting, and had Wen Cheng-ming, the artist-in-attendance, write the *Hridaya Sūtra* in the "small, regular" style for replacement. Both works are so excellent that even Chao Meng-fu himself would certainly applaud if he should be reborn to see them. I, Shih-mou, had gotten possession of this scroll from the family of Chou Yü-shün, and since it was so wonderfully matched with one of the treasures in my collection, the *Hridaya Sūtra* written by Chao Meng-fu for Priest Li in "running script," like the reuniting of two halves of a jade *pi*, I completed the scroll with the several colophons written for the "tea-exchange" poem. I did this because the painting of Ch'iu Ying and the calligraphy of Wen Cheng-ming are definitely masterpieces by themselves, with absolutely no need to depend on any of the colophons written for the Chao Meng-fu poem. Furthermore, the two sons of Wen Cheng-ming, Shou-ch'eng [Wen P'eng] and Hsiu-ch'eng [Wen Chia], have each written a colophon explaining the reason for replacing the calligraphy. As their writings are both acceptable for high standard, I didn't want to throw them away. [So by separating these into two scrolls] I was able to get two complete works of art in one clever stroke. I was quite pleased with myself, and hope that those who see this scroll shall not get suspicious because of the missing colophons.

Wang Shih-mou wrote in his Jih-sun-chai study, on the first day of the tenth month, in the *chia-shen* year of the Wan-li era [1584].

Colophon by Wen P'eng:

I-shao [Wang Hsi-chih] wrote in exchange for a flock of geese. Su Tung-po wrote in exchange for meat. Both episodes have become legends of a thousand years. Sung-hsüeh [Chao Meng-fu] "teased" Priest Kung for tea, and the story was immediately immortalized in the poems by all the famous scholars of the times. Indeed, how could one say his humor and elegance are not equal to the ancient worthies? Unfortunately, the poetry has survived but the writing of the sutra is lost. Yü-shün [Chou Feng-lai] therefore asked my father to make up the writing, and so here is the complete work of art.

Respectfully inscribed by Wen P'eng in the mid-summer of 1543.

Colophon by Wen Chia:

Sung-hsüeh [Chao Meng-fu], in exchanging tea leaves for his writing of the *Prajñā*, had put himself in the company of Yu-chün [Wang Hsi-chih] who exchanged geese for his writing of the *Huang-t'ing* sutra [the *Yellow Chamber*, or the *Wai-ching ching*, a Taoist text attributed to the Yellow Emperor]. However, was this romantic and cultivated gesture really intended for such small things? Actually he was only proud that the excellence of his calligraphy had made him worthy to be the successor of the Ch'in Dynasty master. Since, very unfortunately, Chao Meng-fu's writing [of the *Prajñā*] was already lost, my father therefore agreed to replace it, and did the calligraphy in the style of the *Yellow Chamber*. In addition, Yu-shün [Chou Feng-lai] had asked Mr. Ch'iu Shih-fu [Ch'iu Ying] to do a painting of the sutra writing story in the style of Li Lung-mien at the head of the scroll. Now it would seem the entire episode should go down in history for immortality.

Respectfully recorded by Wen Chia, on the eighth day of the eighth month, in the year of *k'uei-mao* [1543].

trans. WKH

Remarks: Born in T'ai-ts'ang and raised in Wu-hsien, Chiangsu, Ch'iu Ying came from a very humble and uneducated background. Yet, during his short career as a professional painter, he came to know the literati circle around Wen Cheng-ming (see cat. nos. 170-176) and the patronage of the leading private collectors of his day (Goodrich and Fang, *Ming Biography*, 1976, I, 255-57). He may have entered that world as the student of Chou Ch'en (see cat. nos. 158-160), who recognized the potential of the young apprentice's talent. By the early 1530s Ch'iu was already independently established, with a reputation based on an amazing facility for providing accurate copies of old paintings.

Ch'iu spent the remainder of his mature career as a sort of painter-in-residence at the homes of various patrons, copying original works by earlier generations of Chinese painters. These exercises in duplication must have been tedious, but the experience imbued his own designs with a subtlety of brushwork and color, with a mastery of earlier painting techniques normally unavailable in the training process of a professional painter. His most influential patron during his later years was Hsiang Yüan-pien (1525-1590). In the years preceding his death, Ch'iu was also supported by a collector from nearby K'un-shan, Chou Feng-lai, for whom Ch'iu painted *Chao Meng-fu Writing the "Heart" Sutra*. Despite his high reputation among contemporaries, the date of Ch'iu Ying's death is still not firmly established.

Given the information supplied in the colophons, Ch'iu Ying must have finished this handscroll for his

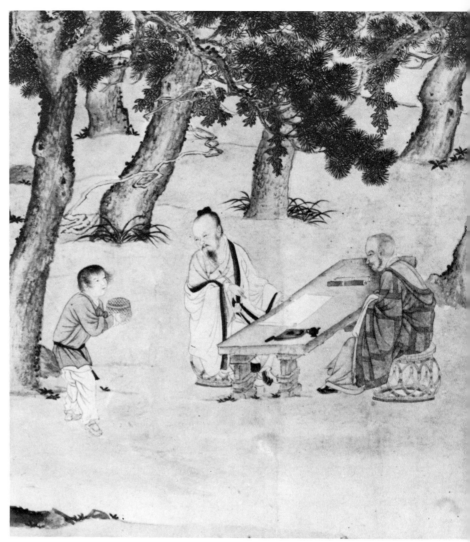

165 Detail

patron Chou Feng-lai sometime between 1542 and 1543: Wen Cheng-ming had completed writing the "Heart" sutra in the fall of 1542 and it had been mounted along with Ch'iu's painting by the summer of 1543 when Wen P'eng wrote his colophon. Originally, the scroll also contained Chao Meng-fu's written transcription and colophons by other writers in praise of Chao Meng-fu's calligraphy, which were removed when Wang Shih-mou, the writer of the fourth colophon, obtained the scroll from the family of the original owner. The poem and its colophons were then mounted with another "Heart" sutra written by Chao. The whereabouts of that second scroll is unknown.

To fulfill the commission of Chou feng-lai, Ch'iu Ying used a variety of sources. Feng-lai evidently specified that the figures be drawn in the manner of Li Lung-mien (Li Kung-lin, ca. 1040-1106), so Ch'iu Ying rendered the faces of the figures, the folds of their garments, the outlines of the foliage, and the furnishings in a tense, hair-thin line (*pai-miao*) associated with that Northern Sung master and also employed by Sung court painters such as Li Sung (see cat. nos. 36, 37), and later revived in purer form by Chang Wu (see cat. no. 96). The characterization of the monk and serving boys bears an even more striking resemblance to similar subjects of the Southern Sung painter Liu Sung-nien (act. ca. 1174-ca. 1224; *Three Hundred Masterpieces*, 1959, III, nos. 109-10).

The grimacing faces and tousled hair of the two attendants in the left section of Ch'iu's scroll and the eager look of the seated priest form a perfect foil for the benign and gentle countenance of Chao Meng-fu. By imbuing the scene with a touch of Liu Sung-nien's humor, the artist subtly highlights the irony of the event taking place: Chao Meng-fu, the venerated public servant, is exchanging his highly valued calligraphy for tea. Yet the sutra chosen as the vehicle of exchange between these two Buddhist adepts maintains that the "heart" of perfect knowledge is the total denial of the reality of the world known by our senses. Thus, Ch'iu Ying displays brilliant intuition in his choice of models. His reliance on the past is nevertheless tempered by his own varied virtuosity with the brush. The subdued color and restraint which characterizes *Chao Meng-fu Writing the "Heart" Sutra* are a contrast to the brightly painted and minutely detailed scenes of Han palace ladies or the blue-and-green landscapes (see cat. no. 164) with which Ch'iu Ying is more often associated.

Closer in spirit, and probably close in date, to the *Chao Meng-fu* handscroll is his *Garden of Self-Enjoyment* (cat. no. 166), where similar figure types, controlled brushwork, and selective, naturalistic details appear. Also comparable are a pair of hanging scrolls, each nine feet tall, now in Taipei in the collection of the National Palace Museum: *Passing the Summer Beneath the Shade of Banana Palms* (Sirén, *Masters and Principles*, 1956-58 VI, pl. 242), and *Conversation in the Shade of Wu-t'ung Trees* (*Three Hundred Masterpieces*, 1959, VI, pl. 242), originally the Summer and Autumn segments from a *Four Seasons* series, commissioned by Hsiang Yüan-pien. Despite their grand dimensions, both scrolls exhibit that restraint of color and simplicity of form which Ch'iu Ying condensed within the diminutive format of the *Chao Meng-fu* scroll. HK

Literature

Shih-ch'ü II (1793), *ch*. 29, p. 79(b).
Ch'ung, *Hsüan-hsüeh-chai* (1921), I, 10 (a,b).
Sirén, *Masters and Principles* (1956-58), VIII, *Lists, 174.*
Lee, "Literati and Professionals" (1966), pp. 23-25, figs. 16,17.
CMA *Handbook* (1978), illus. p. 351 (detail).
Laing, "Ch'iu Ying's Three Patrons" (1979), p. 51.
Oertling, "Ting Yün-p'eng" (1980), pp. 186, 189, 192-94, 211, 215, 216, fig. 107.

Exhibitions

Palazzo Ducale, Venice, 1954: Dubosc, *Mostra*, cat. no. 815.
University of Michigan Museum of Art, Ann Arbor, 1976: Edwards, *Wen Cheng-ming*, cat. no. 39 (calligraphy only).

Recent provenance: Wan-go H.C. Weng.

The Cleveland Museum of Art 63.102

Ch'iu Ying

166 *The Garden for Self-Enjoyment*
(*Tu-lo yüan t'u*)

Handscroll, ink and light color on silk, 27.8 x 381 cm.

Accompanying text of an essay together with seven poems of Ssu-ma Kuang and one poem of Su Shih written by Wen Cheng-ming in 1558.

2 colophons and 82 seals: 4 seals of Wen Cheng-ming (1470-1559); 59 seals of Hsiang Yüan-pien (1525-1590); 1 colophon, dated 1644, and 7 seals of Hsiang Yü-k'uei (16th-17th c.); 1 colophon, dated 1880, and 2 seals of Weng T'ung-ho (1830-1904); 2 seals of Ch'eng Chen-i (19th c.); 1 seal of Han Ch'ung (19th c.); 4 seals of Weng Wan-go (20th c.); 3 seals unidentified.

Colophon by Hsiang Yü-k'uei:

The painting of *The Garden for Self-Enjoyment* on the right by Shih-chou, Mr. Ch'iu [Ch'iu Ying], is in the style of Li Lung-mien. Its mood is peaceful, as if meeting the ancient gentleman face to face among the brushes and silk; it lifts one above the sordid bustle of life. Formerly, my late father handed me this scroll which had only the painting without the written essay. I considered asking a good calligrapher to write the essay to add to it but was afraid that the quality of writing would not match the painting. Several years later, I saw at a friend's house this essay and poems [of Ssu-ma Kuang] written by Heng-shan [Wen Cheng-ming], once owned by my grandfather; so I spared no expense to obtain it. I rejoiced at this and said, "The divine swords are finally united. How things are pre-destined!" Now my friend Chang Kung-chao's technique for mounting [painting and calligraphy] is excellent. Therefore by daring to take them out and join them together, I can preserve this beautiful story of singular reunion.

Hsiang Yü-k'uei recorded at Hai-yeh-t'ang [hall] two days before New Year's Eve in the *chia-sheng* year of the Ch'ung-chen era [1644].

trans. LYSL/HK/WKH

Remarks: The subject of Ch'iu Ying's painting and the calligraphy following it by Wen Cheng-ming is the essay with poems of the great Northern Sung statesman and historian Ssu-ma Kuang (1019-1086) in which he memorializes his Garden for Self-Enjoyment built in 1073. By that time, Ssu-ma-Kuang, the conservative leader of the Sung Confucian political revival, had left his high office and retired to Loyang in opposition to the new reforms brutally enforced under the sponsorship of Wang An-shih. His essay opens with historical references to the meaning of happiness and then continues with a description of the garden's topography.

In the poems following the essay, Ssu-ma Kuang associates each of the seven divisions in the garden with a specific historical figure whom he admires. He relates the *Reading Hall (Tu-shu t'ang)* to the Western Han Confucianist scholar Tung Chung-shu (179-93 BC), who became so engrossed in his studies that he never looked out on his garden for three years. The *Pavilion for Playing with Water (Lung-shui hsien)* is identified with the late T'ang poet and statesman Tu Mu (803-852), who washed his ink stone in the water next to his study pavilion. Yen Kuang, the childhood friend of the Eastern Han Emperor Kuang-wu, is the subject of the third poem on the *Hut of the Angling Fisherman (Tiao-yü an)*. When the emperor

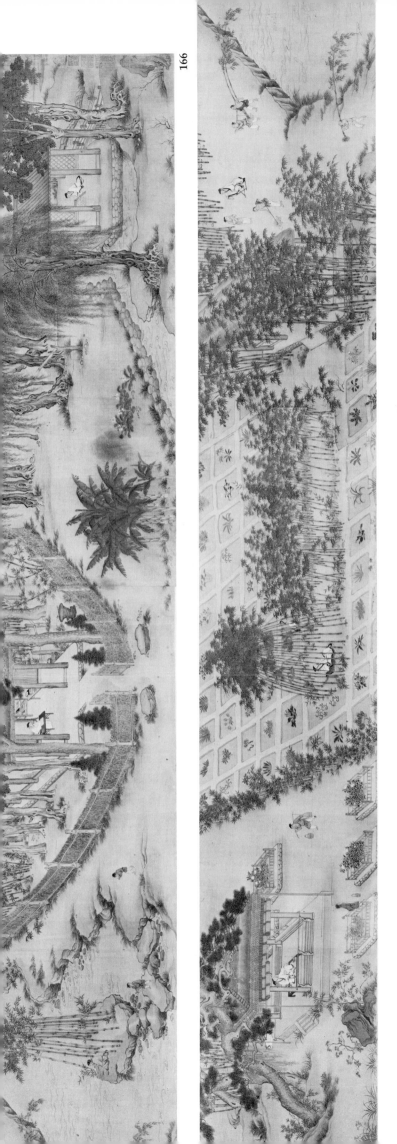
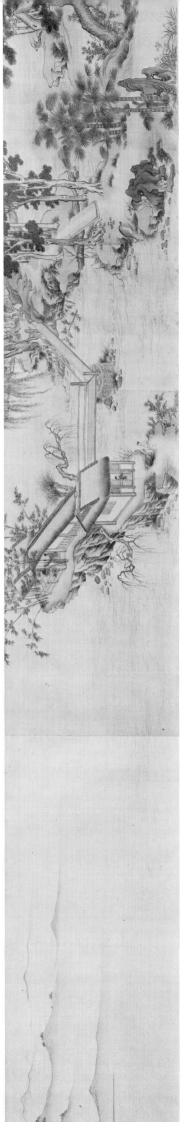

took power in AD 25, Yen Kuang refused his summons to serve, preferring a life of fishing and farming. Next, the *Studio for Planting Bamboo (Chung-chu chai)* was inspired by Wang Hui-chih (d. AD 388), son of the famous calligrapher Wang Hsi-chih (321-379). Wang Hui-chih retired from the world and surrounded himself with bamboo. Ssu-ma Kuang quotes Wang Hui-chih's compliment to his favorite plant: "How can I pass one day without these gentlemen?" The fifth poem, *Plot for Picking Herbs (Ts'ai-yao p'u)*, discusses Han K'ang. For thirty years this Eastern Han figure sold herbs in the Ch'angan marketplace, charging the same honest price. When a young woman told him that everyone knew his name as the result of his honesty, he fled to the mountains for fear that his virtuous reputation would bring him trouble. Ssu-ma Kuang alludes to the bibulous T'ang poet Po Chü-i (772-846) in his sixth poem, the *Pavilion for Watering Flowers (Chiao-hua t'ing)*. Demoted to the position of magistrate of Chiang-chou, Po Chü-i built a garden retreat at Hsiang-shan to grow flowers, make wine and poetize in the company of eight good friends (see cat. no. 133). *Terrace for Seeing the Mountains (Chien-shan t'ai)*, the final poem, was inspired by a famous line, "I pluck chrysanthemums at the eastern hedge; easily the Southern Mountain comes into view," written by the Chin recluse T'ao Yüan-ming (365-427), who refused the service of the Liang emperor to nurture his soul in the mountains. Thus, as Ssu-ma Kuang walked about his

garden in retirement, each place he would stop to rest provided him with an example of Confucian virtue facing predicaments similar to his own.

According to the colophon of Hsiang Yü-k'uei, the calligraphy by Wen Cheng-ming and painting by Ch'iu Ying were separate items in his grandfather's collection — it was Yü-k'uei who joined the two pieces together in their present form. Ch'iu Ying followed Ssu-ma Kuang's essay when he painted the picture, even though he reverses the order in the garden by placing the *Pavilion for Playing with Water* before the *Reading Hall*. Otherwise, he constructs each scene with remarkable fidelity to the literary description (for an English translation see Sirén, *Gardens*, 1949, pp. 77, 78).

At the age of eighty-nine, Wen Cheng-ming wrote Ssu-ma Kuang's essays and poems in a firm, yet graceful, draft script *(hsing-shu)* modeled upon that of Chao Meng-fu. Wen notes that he finished the essay on the last day of the second month in 1558 (a year before he died). He added the poems on the thirteenth day of the seventh month. This calligraphy became the property of Hsiang Yüan-pien, whose many seals appear upon it.

Written among Hsiang Yüan-pien's seals at the beginning of the painting in the lower right-hand corner is the character *shu*, part of a code of characters which frequently appear on paintings he owned. The meaning of the code remains unknown because no catalogue of Hsiang's collection was published. However, since

166 Detail

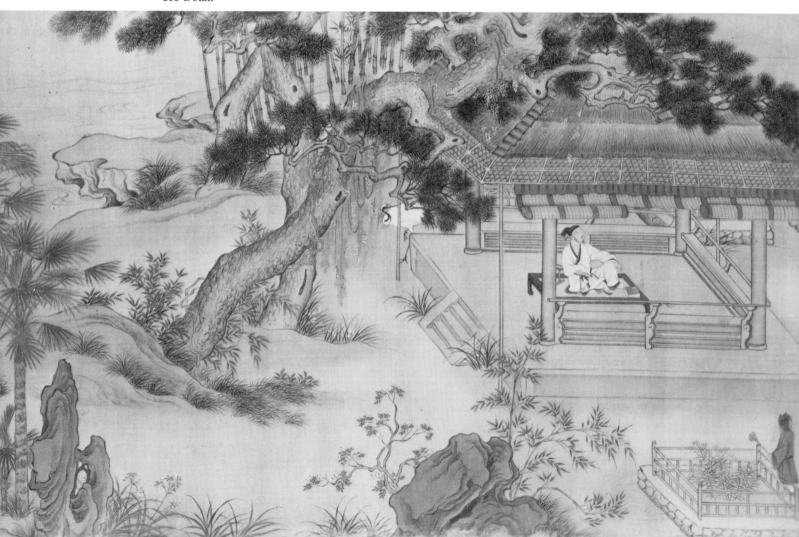

Hsiang Yüan-pien's cataloging of his own collection was based on the system of the *Ch'ien-tzu wen* (Thousand-Character Classic) in which the character *shu* is numbered 681, the present painting should have entered Pien's collection prior to the year 1547 (see Weng T'ung-wen, "Hsiang Yüan-pien," 1979, pp. 157-77).

It is possible that Tung Ch'i-ch'ang knew the Cleveland scroll when it was in the collection of Hsiang Yüan-pien. Tung records examining a scroll of the same title painted by Ch'iu Ying after a Sung model (*Jung-t'ai chi, pieh chi, ch.* 6). Ch'iu Ying returned to the same theme on at least two other occasions. Ch'en Chi-ju (1558-1639) mentions seeing a large Ch'iu Ying scroll of the *Garden* at the home of the late-Ming literary and political figure Wang Shih-chen (1526-1590; Ch'en, *Ni-ku lu*, ca. 1635, *ch.* 4, pp. 258,259). A third version, this time painted on paper, was accompanied by a transcription of the essay, written by Wen Cheng-ming in his small, official script (*li shu*), a month after finishing the Cleveland and Taipei versions in draft script. This scroll on paper survived into the mid-nineteenth century (Shao, *Ku-yüan*, 1904, *ch.* 4, pp. 12b,13b).

Wen painted his own picture of *The Garden for Self-Enjoyment*, with an accompanying text of Ssu-ma Kuang's essay written out one week after he had completed the Cleveland version. This monochrome ink painting and calligraphy are now in Taipei in the National Palace Museum (*Wu-p'ai hua*, 1975, no. 190, illus. pp. 288, 289).

The only record of the Cleveland scroll during the Ch'ing Dynasty, before it entered the collection of Weng T'ung-ho, was made by P'an Chün-ch'i. In his diary (published 1955) he recorded that the Ch'iu Ying painting, together with Wen Cheng-ming's calligraphy and Hsiang Yü-k'uei's colophon, was seen by his father in the collection of Mei-lu on the twenty-fifth day of April in 1822. Mei-lu was the *hao* of Ch'i Yen-huai (1774-1841), a native of Anhui whose collection enjoyed considerable reputation in the first half of the nineteenth century.

LYSL/HK/WKH

Literature
P'an Chün-ch'i, *Sui-ching-chai Yün-yen-kuo-yen-lu* (1855), under 1822-4-25.

Exhibitions
China House Gallery, New York, 1968: Weng, *Gardens,* cat. no. 6, figs. 6, 8.

Recent provenance: Wan-go H.C. Weng.

The Cleveland Museum of Art 78.67

Yu Ch'iu, active ca. 1540-90, Ming Dynasty
t. Tzu-ch'iu, *h.* Feng-ch'iu; from Suchou, active at T'ai-ts'ang, Chiangsu Province

167 *Elegant Gathering in a Garden*
(*Yüan-lin ya-chi t'u*)

Handscroll, ink on paper, 25.1 x 771.4 cm.

167 Detail

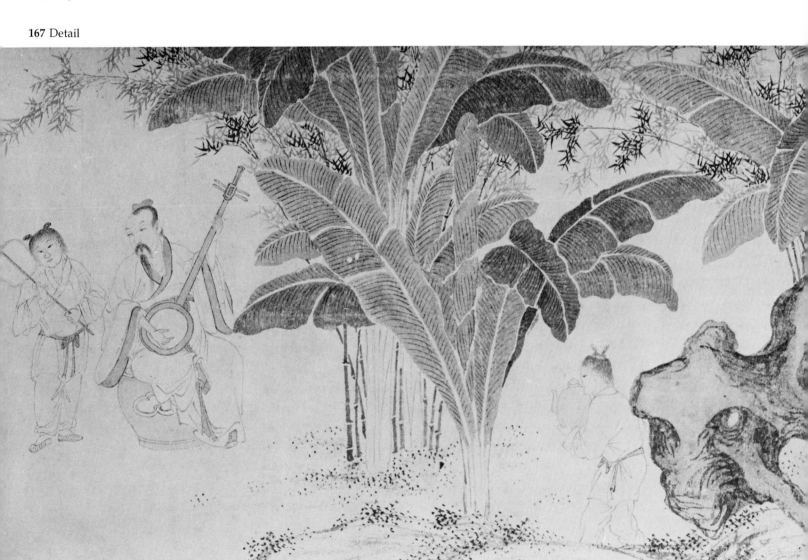

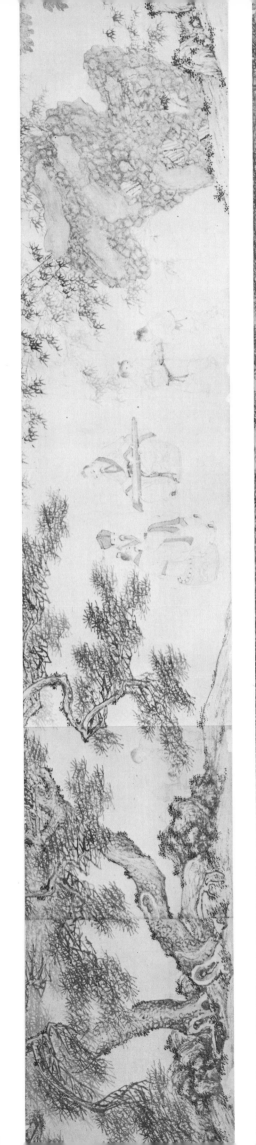
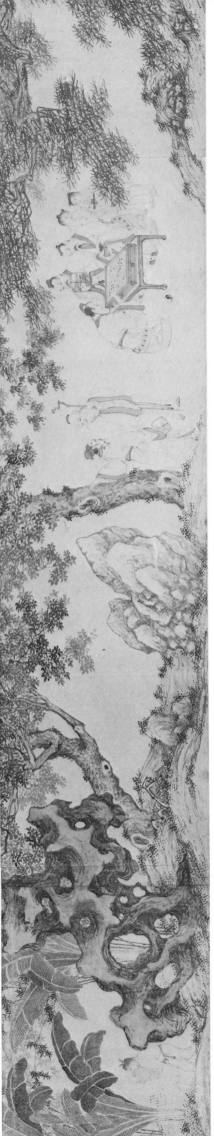
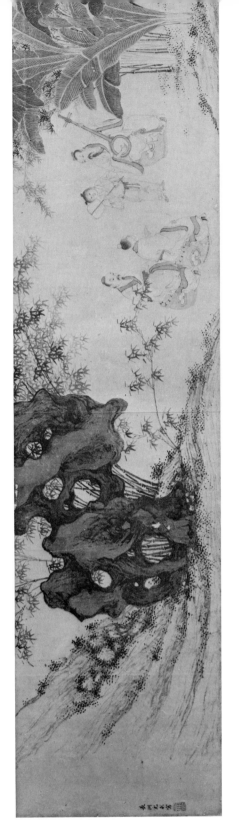

211

Label: *Ch'ün-hsien hsiu-hsi t'u*

Artist's signature and seal at lower left edge: Painted by Yu Ch'iu of Ch'ang-chou. [seal] Feng-ch'iu.

1 frontispiece, 2 colophons, and 8 additional seals: 1 colophon and 4 seals of Fang Ch'eng (unidentified, possibly 17th c.); 1 frontispiece plus colophon and 4 seals of Ch'ien Yung (1759-1844).

Colophon by Ch'ien Yung:

Although Yu Ch'iu was the son-in-law of Ch'iu Ying [1494/5-1552], he did not follow his father-in-law's method. In fact, Yu Ch'iu's work is closer to the style of the Younger General Li [Li Chao-tao, ca. 670-730]. I doubt that painters like Chou Tung-ts'un [Chou Ch'en, ca. 1455-after 1536] and T'ang Yin [1470-1523] can surpass him.

The Plum-Flower Hermit, Ch'ien Yung, has seen this scroll and written the above at the age of seventy-seven [*sui*].

Remarks: Yu Ch'iu was the most gifted follower of Ch'iu Ying and excelled in painting figures in the *pai-miao* manner (plain drawing without color), done with a sure line of great elegance in the tradition of the Northern Sung style of Li Kung-lin (1049-1106). In the Nelson Gallery scroll he has combined his delicate drawing with rich tonal patterns of ink wash and dense brushwork in the trees and garden rocks. Each group of savants is dominated by a single kind of tree – willow, pine, *wu-t'ung*, bamboo, cassia, or banana. LS

Literature
Sirén, *Masters and Principles* (1956-58), IV, 216; VI, pl. 245.
Keswick, *Chinese Garden*, (1978), fig. 197.

Exhibitions
Detroit Institute of Arts, 1952: Grigaut, *Arts of the Ming Dynasty,* cat. no. 35, p. 15.

Recent provenance: C. T. Loo & Co.

Nelson Gallery-Atkins Museum 50-23

Hsieh Shih-ch'en, 1487-ca. 1560, Ming Dynasty
t. Ssu-chung, *h.* Shu-hsien; from Wu-hsien, Chiangsu Province

168 *Returning to the Village in a Rainstorm (Feng-yu kuei-ts'un t'u)*

Handscroll, dated 1530, ink and light color on silk, 40.3 x 425.4 cm.

Artist's inscription, signature, and seal: Returning to the Village in a Rainstorm. On an autumn day, the *keng-yin* year of the Chia-ching era [1530]. Shu-hsien, Hsieh Shih-ch'en [seal] Hsieh Shih-ch'en yin.

3 additional seals unidentified.

Remarks: Hsieh Shih-ch'en spent most of his life in the Suchou area. Although details of his career are scant, his comfortable family background apparently allowed him to pursue an interest in painting rather than to follow the usual channel of government examination and serv-

168 Detail

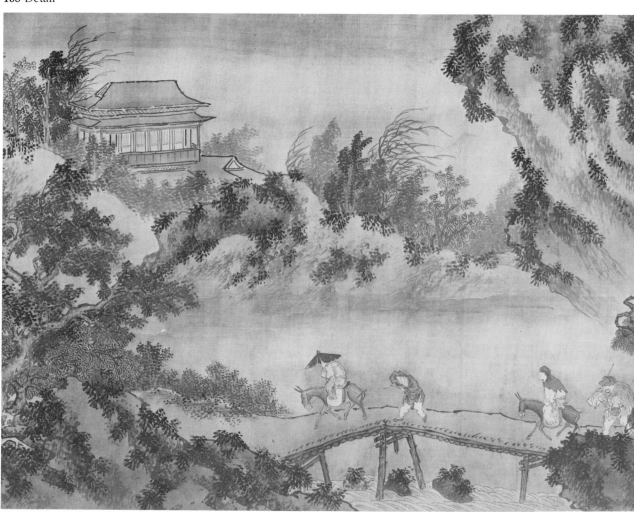

ice. The large scale of many of his extant works and his recorded facility with the format of decorative screens suggest that he made his living as a professional painter (Sirén, *Masters and Principles*, 1956-58, IV, 167). However, his professional status did not disbar him from contact with the Suchou literati, since colophons and inscriptions by Wen Cheng-ming and his circle appear on a few of his works (ibid., VII, *Lists*, 191, 192). Moreover, the fluid social situation in the art world of middle-Ming Suchou allowed Hsieh great breadth in the choice of models on which to form his painting style.

According to his biographers, the strong influence of Shen Chou, tempered by exposure to the Che masters Tai Chin and Wu Wei, characterizes the majority of Hsieh's works. A recent study also identifies compositional precedents from the Yüan literati and Sung landscapists (Lawton, *Hsieh Shih-ch'en*, 1978). *Returning to the Village in a Rainstorm* displays all the Che flair for drama and anecdotal observation, caught in a warm color range of transparent wash and angular, broken ink outlines. The subject matter of this handscroll recalls that of his earliest-dated work – *Storm over the River* of 1508 – a hanging scroll now in the Mirei Shigemori collection, Kyoto (ibid., fig. 22). The Shigemori scroll, in turn, follows closely Tai Chin's *Boat Returning in a Storm* from the National Palace Museum, Taipei (ibid., p. 18, fig. 8), with its axe-cut *ts'un* in the angular rockery, graded wash for flat land and mist-laden background, and tree branches bent sharply by the wind. When Hsieh returned to the subject for this scroll of 1530, he retained much of the Tai Chin manner, except for the crystalline rocks and the axe-cut texture strokes. He drew the rolling topography and its carpet of vegetation in a series of short, staccato strokes. Furthermore, the rounded "alum-lump" skeleton of those hills is derived from the Tung-Chü landscape tradition which Hsieh Shih-ch'en had observed in the works of Shen Chou. HK

Literature

Sirén, *Later* (1938), I, 91,92 pl. 64, and II, *Lists*, 214; idem, *Kinas Konst* (1943), pp. 519, 520, pl. 114; idem, *Masters and Principles* (1956-58), IV, 58, and VI, pl. 195, and VII, *Lists*, 191.

Exhibitions

Smart Gallery, University of Chicago, 1978: Lawton, *Hsieh-Shih-ch'en*, cat. no. 3.

Recent provenance: Dr. H. Müller, Peking; Tseng Hsien-ch i.

The Cleveland Museum of Art 75.94

Hsieh Shih-ch'en

169 *Clouds and Waves in the* [*Yangtze*] *Gorge of Wu-shan* (*Wu-hsia yün-t'ao*)

Hanging scroll, ink and light color on paper, 242 x 89.8 cm.

Artist's title, signature, and 2 seals at upper left corner: Clouds and Waves in the Wu Gorge. Hsieh Shih-ch'en painted. [seals] Ku-su-t'ai hsia i-jen, Shu-hsien.

5 additional seals of Ch'eng Ch'i (20th c.).

Remarks: In addition to copying the works of earlier masters, Hsieh Shih-ch'en also repeated a number of his own compositions. This painting illustrates both sources. The scudding waves which propel the ferryboat in the foreground through the perilous Yangtze River rapids at the Wu gorge appear to be borrowed from a painting executed by the thirteenth-century painter Li

Sung (Lawton, *Hsieh Shih-ch'en*, 1978, p. 15, fig. 2). The alum-lumped walls of the gorge and the towering mountain in the upper right corner recall those of Shen Chou (see cat. no. 152). Certainly the limited use of color and understated variety of ink tones in washes and brushstrokes to form the rocks and waves are also redolent of Shen Chou's mastery. The same composition appears as the Autumn segment from a set of *Four Seasons* completed in 1650, now in a New York private collection, and another in the collection of the Osaka Municipal Museum (ibid., p. 16, fig. 4, and cat. no. 2, p. 32). A variation in a more horizontal format survives in the Nanking Museum (*T'ang Sung Yüan Ming Ch'ing*, 1963, pl. 53). None of the scrolls is a line-for-line copy of the other, although it is interesting that all but the Cleveland version retain the motif of two boats passing through the gorge, as originally illustrated in the Li Sung source from the thirteenth century. The number of versions, as well as the grand scale of the Cleveland *Gorge* and the *Four Seasons* scrolls, mark the professional status of the artist — they are successful compositions repeated for use as decorations in large halls. The vigorous execution of his brushwork on so large a scale as the Cleveland painting contributes much to our appreciation of his considerable talent. HK

Literature
Harada, *Shina* (1936), pl. 605.
Nihon genzai Shina (1938), p. 172.
Sirén, *Later* (1938), I, *Lists*, 215.
Cheng, Chen-to, ed., *Yü-wai so-ts'ang* (1947), ser. 6, pt. 2, pl. 57.
Sirén, *Masters and Principles* (1956-58), VII, *Lists*, 192.
CMA *Handbook* (1978), illus. p. 351.

Exhibitions
Tokyo National Museum, 1931: *Sō-Gen-Min-Shin*, I, 134.
Smart Gallery, University of Chicago, 1978: Lawton, *Hsieh-shih-ch'en*, cat. no. 1.

Recent provenance: Bunhee Tanaka; Ch'eng Ch'i.

The Cleveland Museum of Art 68.213

Wen Cheng-ming, 1470-1559, Ming Dynasty
Original name Pi, *t.* Cheng-chung, *h.* Heng-shan;
 from Suchou, Chiangsu Province

170 *Storm over the River*
 (*Feng-yü ku-chou*)

 Album leaf F mounted on a handscroll, ink and light color on paper, 38.7 × 60.2 cm. See cat. no. 154, *Landscape Album: Five Leaves by Shen Chou, One Leaf by Wen Cheng-ming.*

Remarks: Born into one of the old official families of Suchou, Wen Cheng-ming followed a course of classical literary study to prepare himself for a career in government service. His intentions were thwarted through ten unsuccessful attempts to pass the second-degree *chü-jen* examinations. In 1523 he was exempted from the examinations and appointed *tai-chao* in the Hanlin Academy in Peking. The political intrigue and pressures of the court did not suit him, and after only two years he applied for permission to retire, finally doing so in 1526. In 1527 he returned to Suchou.
 Although Wen's early training was largely in literature, he also studied calligraphy, seal carving, and painting. Shen Chou was his teacher from around 1489 through the 1490s (Clapp, *Wen Cheng-ming*, 1975, pp. 4,5). Their friendship continued until Shen's death in

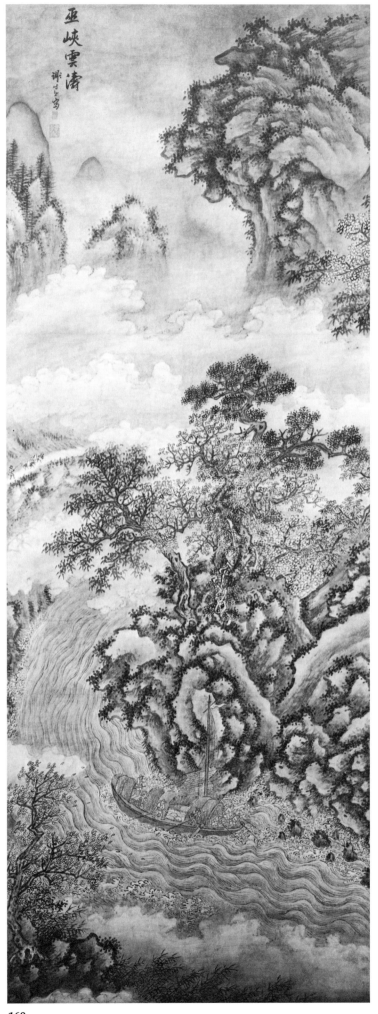

1509. From 1527 Wen devoted the remainder of his life to painting and literary pursuits.

Wen explored an eclectic variety of themes and styles in his early career: blue-and-green landscape of T'ang and Sung; the "wintry forest" tradition of Li Ch'eng; the work of Yüan painters Chao Meng-fu, Wu Chen, Wang Meng, Ni Tsan, and Huang Kung-wang. These influences and others continued to interest Wen, but over the years his interpretations evolved into his own unique style. A circle of followers gravitated around him, and he became the central focus of the Suchou art world. Among his students were his son Wen Chia, his nephew Wen Po-jen (see cat. nos. 184-186), Lu Chih (see cat. nos. 181-183), Ch'en Shun (see cat. nos. 177-179), Ch'ien Ku (see cat. no. 187), Wang Ku-hsiang (see cat. no. 180), and Chü Chieh; included in his circle of admirers and friends were Wang Shih-chen and his brother, Wang Shih-mou, both distinguished officials, collectors, and connoisseurs of painting.

Wen Cheng-ming

171 *Playing the Ch'in a Secluded Valley*
(*Chueh-ho ming-ch'in*)

Hanging scroll, dated 1548, ink and light color on paper, 132 x 50.5 cm.

Artist's title, inscription, signature, and 4 seals:

Playing the Ch'in in a Secluded Valley

Ten thousand layered lofty mountains are presented to
 the cultivated eye,
A thousand feet of cascading falls cleanse the dusty
 heart.
May the harmonies of my red-stringed tune
Be the humble answer to the pine wind's ancient song.

In the summer, the fourth month of the *wu-shen* year of the Chia-ching era [1548]. Cheng-ming painted. [2 seals] Cheng-ming; Cheng-chung-fu-yin. [2 seals, lower right corner] Wu-yen-shih yin; Heng-shan.

 trans. WKH/LYSL

4 additional seals: 3 of Ch'eng Ch'i (20th c.): 1 unidentified.

Remarks: *Playing the Ch'in in a Secluded Valley* is based on an earlier composition, of which three versions are recorded. The first, completed in the fourth month of 1537 and inscribed with a similar poem, was once in the Ch'ing imperial collection (*Shih-ch'ü*, I, 1745, *ch.* 8, pp. 37b-38a). Its present whereabouts is unknown. A second version was completed in mid-summer of the same year. Only a description survives, which indicates a similarity with the composition of the Cleveland picture (Shao, *Ku-yüan*, 1904, *ch.* 3, p. 32a-b). A third version, apparently unrecorded and known only by a photograph, was painted in 1538 (Edwards, *Wen Cheng-ming*, 1976, p. 160, fig. 26). Most of the elements from the third scroll were

170

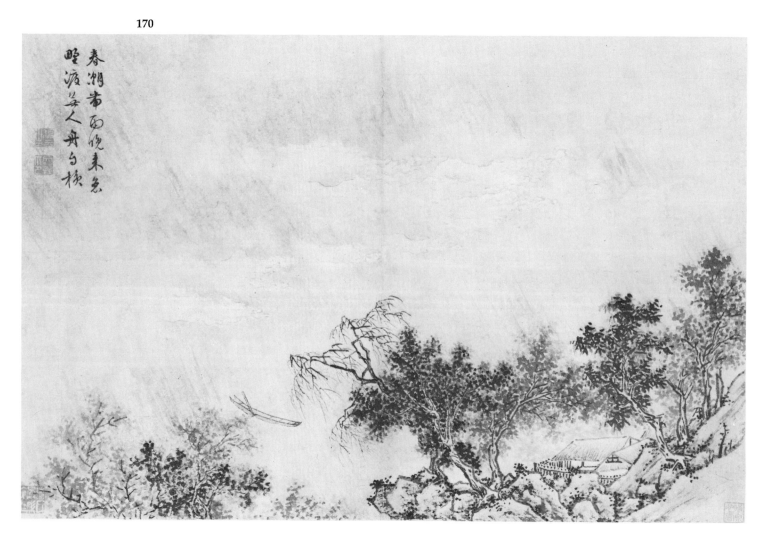

retained in the Cleveland version, although the two compositions create different spatial effects. In the 1538 painting the waterfall cascades down the background mountains in an almost uninterrupted view, while the figures are placed upon a fairly uncluttered promontory in the left foreground. The dark tonalities in the foreground contrast sharply with the background to create a sense of unfolding space.

In the 1548 version Wen closes the spatial gap between foreground and background by practically obliterating the course of the waterfall and enlarging the foliage of the tree grove, producing a much more compact space. By limiting the local color washes to hues of equal intensity, Wen further emphasizes the flatness of the picture plane and the abstract rhythms of his brush. In the unusual solidity of mass and spatial tension which predominate in this picture, Wen seems to strive for the monumentality found in such Sung landscape masters as Fan K'uan or Li T'ang. Unfortunately, it is on this basis that the authenticity of this work has been questioned, since its volumetric preoccupations appear more characteristic of Lu Chih, Wen's pupil. Although rare within the art of Wen Cheng-ming, this type of work influenced Lu Chih's development (see cat. nos. 181-183). HK

Literature
Lu, *Jang-li-kuan* (1892), *ch.* 17, pp. 13(b)-14(a).
Oertling, ''Ting Yün-p'eng'' (1980), pp. 308, 310.

Exhibitions
University of Michigan Museum of Art, Ann Arbor, 1976: Edwards, *Wen Cheng-ming*, cat. no. 45.

Recent provenance: Jean-Pierre Dubosc.

The Cleveland Museum of Art 69.60

Wen Cheng-ming
172 *Old Pine Tree*
(*Hua-sung*)
Handscroll, ink on paper, 27.3 x 138.8 cm.

Artist's inscription, signature, and 2 seals:
Constantly its form is changing;
chances are it never could be caught;
Its dragon-whiskers bristle like lances,
rank after rank.
Cheng-ming [seals] Wen Cheng-ming yin; Heng-shan.
trans. WKH

10 additional seals: 2 of Ch'ien Shih-sheng (1575-1652); 6 of the Ch'ien-lung emperor (r. 1736-95); 1 of the Chia-ch'ing emperor (r. 1796-1821); 1 of the Hsüan-t'ung emperor (r. 1909-11).

Remarks: The *Old Pine Tree* is a theme Wen explored throughout his life as a painter (see cat. nos. 174-176). The natural appearance of a gnarled and vine-entangled pine has been transformed into formal rhythms of opening and closing, rising and falling, into repetitive and forceful patterns of brushstrokes and ink tonalities.

Chan Ching-feng, who as a youth had studied with Wen Cheng-ming, wrote in *Chan Tung-t'u hsüan-lan pien*, n.d., *ch.* 4, p. 180) of Wen's calligraphy on a painting done in 1532 (a ''leave-taking'' picture for Wang Ku-hsiang) that it ''was the same as the painting. If it had been mandated that Cheng-chung [Wen Cheng-ming] die at that time, then neither [his painting nor his calligraphy] would necessarily have been capable of transmittal for long. For at that time he had barely ma-

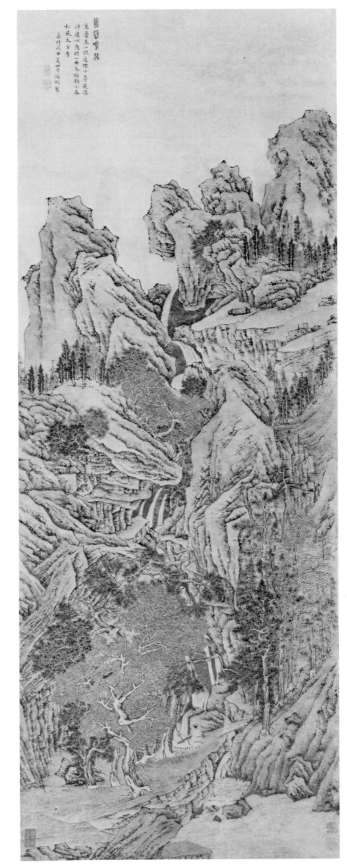

171

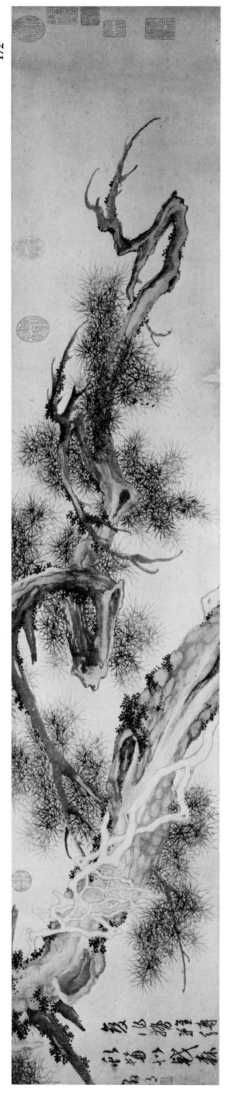

tured and was not yet great. His great synthesis was after age sixty-five or six" (i.e., after 1535 or 1536).

Wen himself seems to have been aware of a personal metamorphosis that resulted in paintings ever more individual and spontaneous in conception and execution, and in 1533 he wrote of his new insight (*KKSHL*, 1965, *ch*. 6, p. 47): "In general the ancients were between the conceptual and the spontaneous in drawing from life... In [painting] this album I knew of nothing to equal the ancient method, and when I took up the brush I too became conscious of a conceptual urge coming of itself and was not one who followed the tracks of old, made in one's youth." Wen's free treatment of the subject and his assured brushwork seem to correspond with the stylistic changes described by Chan Ching-feng in 1533, suggesting a date for this painting in the later 1530s. HR

Literature

Shih-ch'ü I (1745), *ch*. 15, pp. 19b-20a.
Ferguson, *Li-tai* (1934), p. 23.
Sirén, *Masters and Principles* (1956-58), VII, *Lists*, 263 (as *A Branch of an Old Juniper-tree*).
Lee, "Literati and Professionals" (1966), pp. 7, 8, fig. 2.
Clapp, *Wen Cheng-ming* (1975), pp. 75, 76, fig. 39.
CMA *Handbook* (1978), illus. p. 350.
Edwards et al., *Shin Shū, Bun Chōmei* (1978), p. 168, pl. 61.
Watson, *L'Ancienne Chine* (1979), pl. 150 (detail).

Exhibitions

Palazzo Ducale, Venice, 1954: Dubosc, *Mostra*, cat. no. 811.
Asia House Gallery, New York, 1974: Lee, *Colors of Ink*, cat. no. 28.
University of Michigan Museum of Art, Ann Arbor, 1976: Edwards, *Wen Cheng-ming*, cat. no. 17.

Recent provenance: Jean Pierre Dubosc.

The Cleveland Museum of Art 64.43

Wen Cheng-ming

173 *Listening to the Bamboo*
(*T'ing chu t'u*)

Hanging scroll, ink on Sung sutra paper,
94.5 x 30.5 cm.

Artist's inscription, signature, and 2 seals on separate sheet of paper above painting:

In the empty studio sitting in deep loneliness;
Like cool sound sending pure beauty,
Or pendants swinging in the wind,
Or a solitary *ch'in* suggesting running water.
Where is that sound from?
The green poles in the courtyard,
Clear and light like an echo,
The sound and ears are in tune.
The sound of bamboo now very beautiful;
My ears are also clear.
Who says the sound is in the bamboo?
To know it depends on oneself.
A noble person is like a tall bamboo;
A thin bamboo is like the noble man.
When the sound enters, the mind responds,
Only one thing but artificially separated.
A bystander searching for the sound,
But the sound can only be found in silence.
Otherwise I am still I,
Bamboo is still bamboo.
Even if I live with bamboo every day,
Still the music will be a thousand miles away.
Look at sound's most primeval source:
Did it enter a zither or a lute?

Composing a poem on *Listening to the Bamboo*. Written by Cheng-ming at the T'ing-yün kuan. Wen Cheng-ming [2 seals] Wen Cheng-ming yin; Wei keng-yin wu i chiang. [2 seals on middle right edge of painting] Wen Cheng-ming yin; Wei keng-yin wu i chiang.

<div align="right">trans. LYSL/WKH</div>

7 additional seals: 5 of the Ch'ien-lung emperor (r. 1736-95); 2 unidentified.

Remarks: Wen's prose poem echoes the philosophy of Chuang-tzu – specifically the discussion between Tzu-ch'i and Yen Ch'eng Tzu-yu which opens section two of the philosopher's work (*Chuang Tzu*, 1964, pp. 31, 32). Wen inscribed the same poem on four of his other works, giving them the same title (Yü, *Shu-hua*, 1634, *ch.* 10, p. 23; Wang K'o-yü, *Shan-hu-wang*, preface 1643, *ch.* 15, p. 5; Pien, *Shih-ku-t'ang*, 1682, *ch.* 28, p. 6; *P'ei-wen-chai*, 1708, *ch.* 100, p. 39).

Although undated, this *Listening to the Bamboo* must have been completed in the latter part of Wen's career. One of the artist's seals – Wei keng-yin wu i chiang ("It was the year of *keng-yin* that I was born," a line quoted from *Li Sao* by Ch'ü Yuan, the greatest poet of the Warring States period) – does not appear on his works before the 1520s (Edwards, *Wen Cheng-ming*, 1976, no. XXII). The seal commemorates the date of his birth, the *keng-yin* year (1470) in the sexagenary system which recurred on his sixtieth birthday (1530).

Another seal, Chin-su shan ts'ang ching chih, indicates that the ground for the painting and calligraphy is sutra paper, made during the Northern Sung Dynasty for the Chin-su shan monastery at Hai-yen, Chechiang. An expensive luxury by the sixteenth century, the paper was highly prized by calligraphers. Because of its heavily sized and hand-polished surface, the paper did not absorb the ink brushed upon it – the ink simply pooled on the surface. A sharp, clear edge to each stroke would result when the brush of a practiced calligrapher moved across the surface; otherwise, the slightest hesitation in movement would result in an obvious wavering edge. In this example, Wen's mastery of the subject and the material is revealed by the deep richness of ink tonality and subtle variation in the stroking of the bamboo leaves. The tonality of the ink varies little from top to bottom of the paper, ignoring any obvious suggestion of the branch projecting or receding in space. Nevertheless, the leaves appear to grow naturally from their stems as they bend in the implied gentle breeze.

By limiting the tone of his ink, Wen follows an approach to bamboo that the Yüan painters Chao Meng-fu (see cat. no. 81), Wu Chen (see cat. no. 109), and Ni Tsan (see cat. no. 110) discovered in the work of the Chin painter Wang T'ing-yün (Lee and Ho, *Yüan*, 1968, fig. 19b and pp. 99 ff.). This so-called Liao-chiang school reflects the attitude of the Sung poet-painter Su Shih, who valued the free brush play of a gentleman and the poetic allusion of bamboo more than an outward resemblance to nature. Su's contemporary bamboo painter and friend, Wen T'ung, placed more emphasis on a realistic approach, varying the tone of the ink to differentiate the top from the bottom of a bamboo leaf, or near branch from far branch in a clump of bamboo. Wen T'ung's manner survives not in this example by Wen Cheng-ming but in the subtle ink harmonies of Li K'an's *Ink Bamboo* (cat. no. 83) or Wang Fu's *Bamboo and Rocks beside a Stream* (cat. no. 118).

<div align="right">LYSL/HK</div>

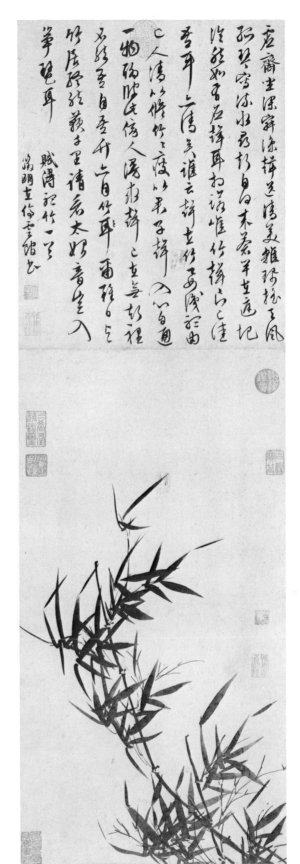

173

174

Literature
Edwards et al., *Shin Shū, Bun Chōmei* (1978), p. 168, pl. 62.
Exhibitions
University of Michigan Museum of Art, Ann Arbor, 1976:
 Edwards, *Wen Cheng-ming*, cat. no. 33.
Recent provenance: Jean-Pierre Dubosc.
The Cleveland Museum of Art 77.172

Wen Cheng-ming

174 *Magpies and Junipers*
 (Ku-po hsi-ch'in)

 Hanging scroll, ink on paper, 54 x 32.7 cm.

Artist's seal in lower left corner: Heng-shan.

Remarks: The attribution to Wen Cheng-ming is not en-
tirely based on the single seal, Heng-shan, in the lower
left corner. In addition there is the theme of old cypress
or juniper trees with gnarled trunks and downward
bending branches – a theme Wen used frequently – and
the high technical skill of the painter, apparent in both
the brushwork and ink tonalities. Moreover, the general
appearance of the painting and its physical characteris-
tics are those of a work of the sixteenth century and the
time of Wen. Objections to the attribution can be based
on the richness of detail, as in the turbulent stream, and
also on the overall delicacy of the drawing and rich
variety of ink washes. These are features associated
with a style more academic than is found in the ma-
jority of works by Wen Cheng-ming.

 Both Richard Edwards and Richard Barnhart give
good reasons for assigning the painting to an early
period in Wen's career, a formative time when he was
engrossed in his study of the old masters. In Suchou he
had the opportunity to see many great paintings pre-
served from the past; he studied these assiduously, con-
cerning himself not only with his predecessors of the

175

220

Yüan Dynasty but also with the landscape painters of the Northern and Southern Sung. It is our suggestion that the Nelson Gallery scroll not only reflects such antiquarian studies, but is, in fact, a version of a Southern Sung painting that is closer to the model than would be a free and personal interpretation by Wen.

As a careful study of the antique, but with unavoidable overtones of his own epoch, the scroll fits well into the formative period of Wen Cheng-ming's life as described by Edwards (*Wen Cheng-ming*, 1976, p. 13): "He accepted the essential necessity of invention and change, but clung in his youth to the lifeline anchoring him to the traditional canons. Only slowly did he free himself of these bonds and in later work finally reveal a power of invention equal to the idols of the past."

The Nelson Gallery painting would most likely have been executed between 1500 and 1520. A small rectangle of the original paper has been cut from the upper left corner and replaced; perhaps this area contained either a jotting about the picture that was the basis of this study or something of specific interest to Wen Cheng-ming. Also, since the painting was a personal mnemonic for the artist, he has identified himself with it by the use of only one seal. LS

Literature
Naitō, *Min shi-taika gafu* (1924), pl. 52.
Yamamoto, *Chōkaidō* (1932), ch. 3, p. 13.
Sullivan, *Introduction* (1961), pl. 119.
Speiser, Goepper, and Fribourg, *Chinese Art*, III (1964), fig. 59.

Exhibitions
China House Gallery, New York, 1972/73: Barnhart, *Wintry Forests*, no. 14, pp. 25, 51, 52.
University of Michigan Museum of Art, Ann Arbor, 1976: Edwards, *Wen Cheng-ming*, no. XVI, pp. 78-80.

Recent provenance: Teijirō Yamamoto; Michelangelo Piancentini.

Nelson Gallery-Atkins Museum 46-47

Wen Cheng-ming

175 *Old Cypress and Rock*

(*Ku-po t'u*)

Handscroll, datable to 1550, ink on paper, 26.1 x 48.9 cm.

Artist's inscription, signature, and seal in upper left corner:

Crushed by snow, oppressed by frost, as the years and
 months pass,
Branches twisted, its crown bent down – its strength is
 still majestic!
An old man remembers Tu-ling's words:
"[The Cypress] impressed the world even before
 revealing its rich bark pattern."
Cheng-ming sketched this to send to the graduate
Po-ch'i. [seal] Cheng-ming.
 trans. Richard Barnhart, with changes

12 colophons and 35 additional seals: 1 poem and 1 seal of Wang Ku-hsiang (1501-1568); 1 poem and 1 seal of Chou T'ien-ch'iu (1514-1595); 1 poem and 1 seal of Lu Shih-tao (1511-1574); 1 poem and 1 seal of Yüan Tsun-ni (1523-1574); 1 poem of Huang Chi-shui (1509-1574); 1 poem and 1 seal of Yüan Chiung (mid-16th c., uncle of Yüan Tsun-ni); 1 poem and 1 seal of Lu An-tao (mid-16th c., brother of Lu Shih-tao); 1 poem and 2 seals of Wen P'eng (1498-1573); 1 poem and 1 seal of Wen Chia (1501-1583); 1 poem plus colophon, dated 1550, and 2 seals of

P'eng Nien (1505-1566); 1 poem plus colophon, dated 1613, and 2 seals of Chang Feng-i (1527-1613); 11 seals of Liu Shu (1759-1816); 1 poem plus colophon, dated 1862, and 4 seals of Ku Wen-pin (1811-1889); 3 seals of Fan Tseng-hsiang (1846-1931); 4 seals of Jean-Pierre Dubosc (20th c.).

Colophon by P'ien Nien:

In the early summer of the *keng-hsü* year of the Chia-ching reign [1550], I chanced to pass by the Yü-ch'ing shan-fang of the venerable old Heng [Wen Cheng-ming]. He asked of news concerning Po-ch'i [Chang Feng-i]. At that time Po-ch'i lay ill in a room of the Leng-chia Monastery. The venerable gentleman sorrowed a long while. He then lit a candle and made this [painting] to send [to Po-ch'i]. The meaning of the poem is deeply sincere, and it is not only to wish Chang's recovery from illness. He [Wen] was already eighty-one *sui* at the time, yet this shows deep concern for the younger generation. In admiration I have chanted it many times and respectfully record this.

Remarks: Tu-ling refers to the great T'ang Dynasty poet Tu Fu (712-770), from whose poem "Song of an Old Cypress" a line is quoted by Wen Cheng-ming. Chang Feng-i, the ill Po-ch'i for whom Wen painted the picture, was a young man at the time; and the line quoted from Tu Fu must be understood as a metaphor for a young talent whose promise impresses even before that talent has fully flowered – just as the cypress tree impresses the world when young, even though the beautiful bark textures of maturity have not yet developed.

The Leng-chia Monastery mentioned in P'eng Nien's colophon was located at Suchou's Stone Lake and was a popular retreat for members of Suchou's artistic circles, some of whom resided there for considerable periods of time.

Wen's painting has many layers of symbolism. First, there is the complimentary metaphor of the cypress, mentioned above, for which Wen used Tu Fu's well-known line. Then in the first two lines of Wen's poem the ability of the cypress to endure hardship can be seen as encouragement to Chang Feng-i during his illness. A less obvious bit of symbolism may be found in the fact that the cypress, powdered and mixed with other ingredients, figures prominently in ancient Chinese pharmacopoeia. KSW/MFW

Literature
Dubosc, "New Approach" (1950), p. 52, fig. 2.
Tseng Yu-ho, "'Seven Junipers'" (1954), p. 25, fig. 2.
Myers, ed., *Encyclopedia of Painting* (1955), p. 108.
Sickman and Soper, *Art and Architecture* (1956), pl. 136.
Grousset, *Chinese Art and Culture* (1959), pl. 55.
Huyge, ed., *L'art et l'homme* (1957-61), III, 228, pl. 826.
Elsen, *Purposes of Art* (1962), p. 37.
Moskowitz, ed., *Great Drawings* (1962), IV, pl. 902.
Barnhart, "Wintry Forests and Old Trees" (1972), pp. 282, 283, pl. 7.
NG-AM Handbook (1973), II, 65.
Cahill, *Parting* (1978), p. 231, pl. 118.
Sullivan, *Symbols of Eternity* (1979), p. 126, fig. 74.

Exhibitions
Wildenstein Galleries, New York, 1949: Dubosc, *Ming and Ch'ing*, cat. no. 16, pp. 22, 26.
Palazzo Brancaccio, Rome, 1950: Giuganino and Dubosc, *Mostra di Pitture*, cat. no. 13, pp. 49, 50.
Detroit Institute of Arts, 1952: Grigaut, *Arts of the Ming Dynasty*, cat. no. 26, p. 12.
Cleveland Museum of Art, 1954: Lee, *Chinese Landscape Painting*, cat. no. 56, pp. 82, 84, 150, 151.

176

Smith College Museum of Art, Northampton, Mass., 1962: *Chinese Art*, cat. no. 7.
Jewett Arts Center, Wellesley, Mass., 1967: Loehr, *Symbols and Images*, cat. no. 32, pp. 57-59.
China House Gallery, New York, 1972/73: Barnhart, *Wintry Forests*, cat. no. 15, pp. 27, 53, 54.
University of Michigan Museum of Art, Ann Arbor, 1976: Edwards, *Wen Cheng-ming*, no. XLVIII, pp. 166-68.

Recent provenance: Jean-Pierre Dubosc.

Nelson Gallery-Atkins Museum 46-48

Wen Cheng-ming

176 *Old Trees by a Wintry Brook*
 (Ku-mu han-ch'üan)

Hanging scroll, dated 1551, ink and slight color on paper, 71.5 x 27.5 cm.

Artist's inscription, signature, and 2 seals: In the *hsin-hai* year [1551], fifth month, fifteenth day, Cheng-ming playfully sketched these old trees by a wintry brook, aged 82 *sui*. Wen Cheng-ming [seals] Cheng-ming; T'ing-yün.

2 additional seals of Miu Yüeh-ch'i (17th-18th c.).

Remarks: *Old Trees by a Wintry Brook*, painted in 1551, represents another instance of the elder Wen Chengming returning to and changing his earlier compositions, much as he had done in 1548 (see cat. no. 171). This pair of ropy cypresses dominating a sparely rendered rocky shore appears to be a simplified version of his 1549 *Old Trees and Cold Stream* in the Yamaguchi collection (Sirén, *Masters and Principles*, 1956-58, VI, pl. 211a). Both compositions have in turn been related specifically to his copy of the tenth-century painter Li Ch'eng's *Wintry Woods*, painted in 1542 (Clapp, *Wen Cheng-ming*, 1975, pl. XXVII, fig. 41), and an even earlier composition of 1531 (ibid., fig. 40). Although the Li Ch'eng original which initially inspired Wen no longer exists, bare-branched trees placed along a rocky winding rivulet mirror the foreground compositions that were maintained into the Yüan Dynasty by Li Ch'eng followers such as Lo Chih-ch'üan (see cat. no. 101) and Li Shih-hsing (see cat. no. 104).

By 1551 Wen eliminated all non-essential details; twisting trees and spare rock forms are given both texture and volume with a minimum of rubbed strokes. Yet each stroke offers the same subtle variation in shape and ink tonality already evident in his *Old Cypress and Rock* (cat. no. 175) of 1550. In the process of returning to these earlier preoccupations, he transforms the Li Ch'eng theme of wintry trees into one of the most eloquent masterpieces from his aged brush. HK

Literature
Naitō, *Min shi-taika gafu* (1924), p. 50.
Sirén *Later* (1938), I, 110, pl. 78, and *Lists*, 241; idem, *Kinas Konst* (1943), p. 525, fig. 486; *Masters and Principles* (1956-58), IV, 184, and VI, pl. 211-B, and VII, *Lists*, 260.
Ecke, "Wen Cheng-ming" (1967), pl. 408.
Clapp, *Wen Cheng-ming* (1975), pp. 85, 86, fig. 46.
Edwards et al., *Shin Shū, Bun Chōmei* (1978), pp. 151, 170, pl. 76.
Loehr, *Great Painters* (1980), p. 281, fig. 150.

Exhibitions
Asia House Gallery, New York, 1970: *Masterpieces II*, cat. no. 42.
University of Michigan Museum of Art, Ann Arbor, 1976: Edwards, *Wen Cheng-ming*, cat. no. 50.

Recent provenance: Hiyoshi Collection; Jean-Pierre Dubosc.

Intended gift to the Cleveland Museum of Art, Mr. and Mrs. A. Dean Perry

Ch'en Shun, 1483-1544, Ming Dynasty
t. Tao-fu, Fu-fu, h. Po-yang-shan-jen; from Suchou, Chiangsu Province

177 *Lotus*

(Ho-hua)

Handscroll, color on paper, 30.5 x 583.5 cm.

Artist's 2 seals at lower left edge: Po-yang-shan-jen; Ch'en shih Tao-fu.

Artist's colophon (consisting of 3 poems), signature, and 2 seals:

Golden lotuses cockling on the waters of T'ai-i Lake,
Brocaded cushions on the cool evening shore, like a
 break against the lapping waves.
To and fro, festooned boats sport among the isles,
Just as autumn waters rise beneath the silver bridge.

Green galleries, over the water's edge, sparkle on
 pavilions red,
And beaded curtains, all ablaze with colors gay.
On spans of sand, dancers' sleeves incline, welcoming
 the wind,
And at the rail, garments made gossamer by the moon's
 bright light.

Gone with wine, the Lord returns not to his boat,
But tarries more, among flasks of jade and golden flutes.
How touching – couples' shadows share the autumn
 colors,
Remembered ever more, outings on the lake in the
 Yüan-chia reign.

Tao-fu [seals] Po-yang-shan-jen; Ch'en shih Tao-fu.

trans. MFW

1 frontispiece and 20 additional seals: 1 frontispiece and 3 seals of Wang Chih-teng (1535-1612); 4 seals of Kuei Hun-o (early 17th c.); 2 seals of Pi Nan-ku (unidentified, 17th c.?); 2 seals of Chiang Hsiang (unidentified); 6 seals of the Chia-ch'ing emperor (r. 1796-1820); 3 seals of the Hsüan-t'ung emperor (r. 1909-11).

Remarks: T'ai-i was a large artificial lake first built by Emperor Wu (r. 140-87 BC) of the Western Han Dynasty at the Chien-chang Palace. Centuries later, during the reign of Emperor Ming-huang (r. 713-756) of the T'ang Dynasty, another T'ai-i Lake was constructed near the Ta-ming Palace in the capital, Ch'angan (Hsian), which was provided with elaborate pleasure pavilions, including some situated in the middle of the lake. According to the T'ang poet Po Chü-i (772-846), the lake was famous for its lotus. Yüan-chia (424-453) was the reign title of Emperor Wen of the Liu Sung Dynasty. Ch'en Shun is probably alluding here to a famous poem, "Gathering on the Western Pond," written about that time by Hsieh Hun (d. ca. 412).

Ch'en Shun employed *mo-ku* color-painting techniques more than any other major Wu school painter (see also cat. no. 149). Even his ink-wash paintings partake of technical and stylistic features seen in his color-wash paintings. Whether in washes of color or washes of ink, ambiguity in the depiction of motifs prevails over realism. Eschewing the essentially linear manner of Wen Cheng-ming (see cat. nos. 170-76) or, even more, of Lu Chih (see cat. nos. 182, 183), Ch'en's mountains and rocks, trees and flowers are broadly defined with a limited palette. Variety of form and shape is similarly restricted, resulting in a rhythmic structure in which major and minor themes echo one another throughout.

177 Detail

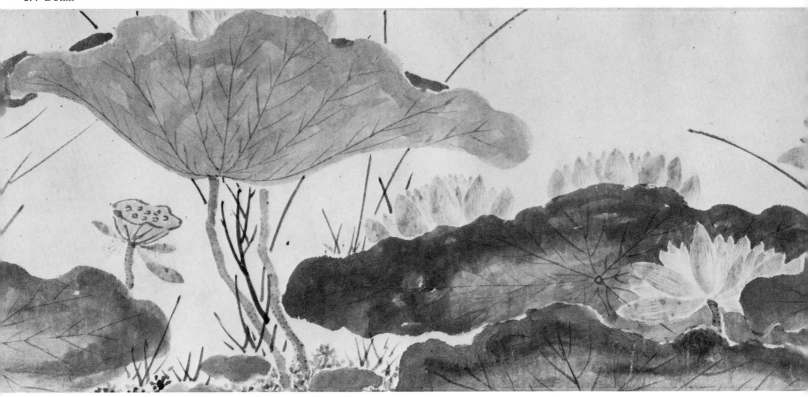

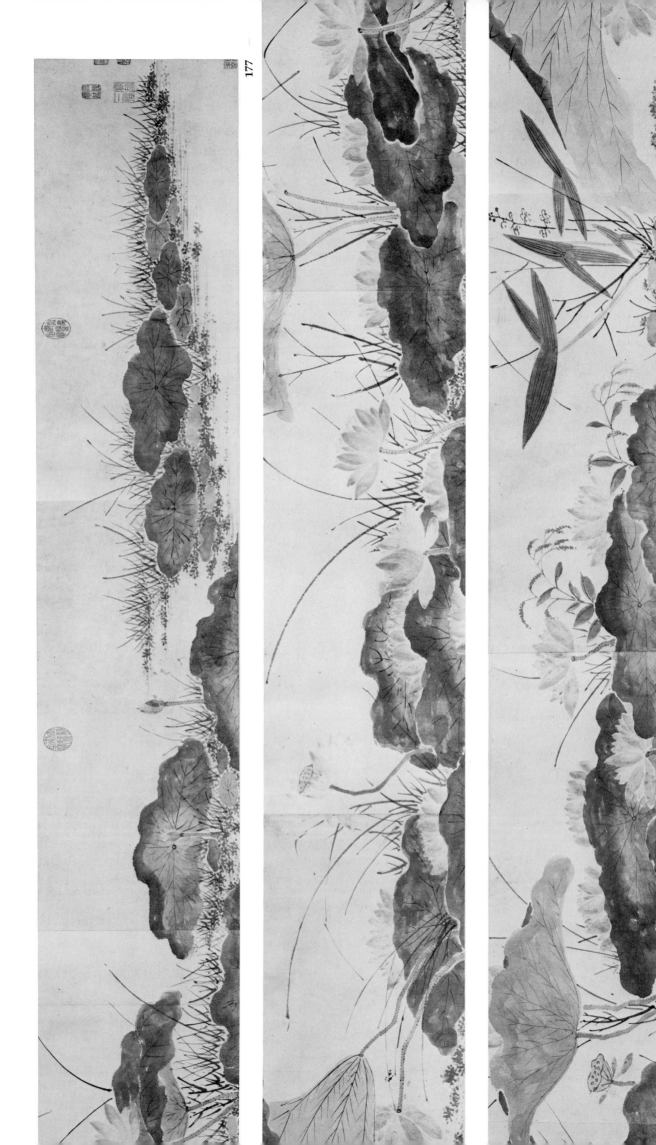

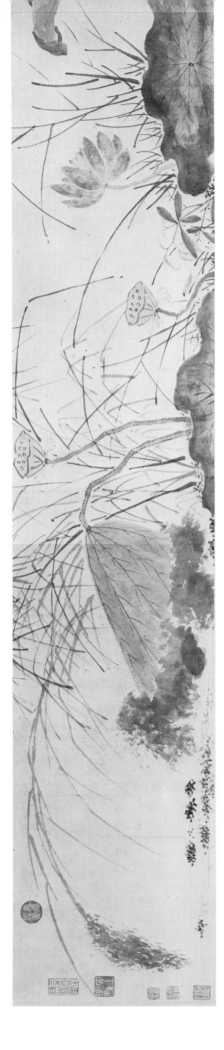

Ch'en's paintings are seldom ingratiating, charming, or the sort that rely for their appeal on a winsome handling of color or deftness of elegant brushwork. Probably because of technique and his own artistic impulses, Ch'en's pictures usually reflect slower rhythms and rely upon the interaction of broad masses. Within the broad masses of form, such as in the curling leaves of lotus in the present scroll, there appears considerable interest in textural plays and in variety of color values within a single hue, both of which serve to model and to define further forms which would otherwise remain flat and inarticulate. Although his style of *mo-ku* color painting of flowers derives from Shen Chou, Ch'en imbues his forms with much more volume and with a greater sense of modelling than does Shen. This he achieves through puddling, a technique of suffusing broad areas of wet color or wet ink. On a preliminary underlayer of lighter value he superimposes a darker layer while the first layer is still quite damp. The different layers drying at different rates and the different density of pigment in each layer cause a contraction of the pigment in discontinuous jumps, forming a grain-like pattern that recalls layers of cumulus clouds.

Ch'en's preference for broadly painted form and sluggish rhythms carries over into the drawing of the water grasses in *Lotus*, where from the beginning to end of the scroll he has depicted the life cycle of the lotus – from tender buds, through the strength of full maturity, and on to withering decay. MFW

Literature
Shih-ch'ü III (1816), p. 1949.
Sickman and Soper, *Art and Architecture* (1956), p. 179, pl. 137a.
Grousset, *Chinese Art and Culture* (1959), p. 55.
Lee, *Far Eastern Art* (1964, 1973), p. 439, color pl. on p. 430.
NG-AM Handbook (1973), II, 65.
Murray, ''Album of Paintings by Yün Shou-p'ing'' (1978), pp. 18, 19, fig. 5.

Exhibitions
San Francisco Museum of Art, 1957: Morley, *Asia and the West*, no. 18u, p. 34.
Philadelphia Museum of Art, 1963: Clifford, ''A World of Flowers,'' p. 184.
J.B. Speed Art Museum, Louisville, 1965: *Treasures*, cat. no. 29.

Recent provenance: P'u-i, the Hsüan-t'ung emperor.

Nelson Gallery-Atkins Museum 31-135/34

Ch'en Shun

178 *Hills and Streams after Rain*
(*Hsi-shan yü hou*)

Handscroll, ink and color on paper, 26.3 x 167.1 cm.

Artist's signature and 2 seals: Tao-fu [seals] Fu-fu-shih; Ch'en shih Tao-fu.

Artist's colophon (consisting of 3 poems) and seal (not translated).

1 additional colophon and 2 seals of Wu Ch'ang-shih (1844-1927).

Remarks: The three poems by Ch'en Shun, in his much-admired cursive script, follow the painting on a separate piece of paper. The poems, designated by the author as a ''draft'' (*kao*), contain several slight differences from the printed versions in his collected works, *Ch'en Po-yang chi* (preface 1615). The three poems are: ''Returning Home'' (*Huan-she*) (ibid., p. 126); ''From a Rustic Dwelling to the Cottage South of Town'' (*Yu t'ien-she tao ch'eng-nan ts'ao-t'ang*) (ibid., p. 130); and ''Lodging at the Fou-chiu Villa of Mr. Chin'' (*Su Chin shih Fou-chiu pieh-yeh* (ibid., p. 113).

The colophon by Wu Ch'ang-shih (1844-1927), an accomplished painter, seal carver, and calligrapher, is in the form of a poem praising the painting and the genius of Ch'en Shun. The colophon concludes: "Written for Er-feng in the second *jun* month of the *ting-ssu* year [1917]. Wu Chang-shih at the age of seventy-four *sui*."

Er-feng, the person for whom the colophon was written, is the well-known Japanese collector Teijirō Yamamoto.

The painting is in the style most frequently employed by Ch'en Shun in executing landscapes, that of the Sung father and son painters Mi Fu (1051-1107) and Mi Yu-jen (see cat. no. 24), and the Yüan Dynasty master Kao K'o-kung (1248-1310). In the Mi style, mountains and foliage are rendered in terms of soft oval dots with the side of a worn brush. Almost every Wu school artist tried the style as something of a school exercise, but only Ch'en Shun absorbed it thoroughly and at least from his middle years onwards made it the basis of his own style in landscape painting.

It is not necessary to look far afield to other contemporary painters or schools of painting to find the root of Ch'en's interest in the Mi style. Given the artistic sensibilities that emerge in his flower paintings, the Mi style would have been congenial to him. More decisive,

however, is the fact that Ch'en's home village of Ta-yao-ts'un, located in part of Lake Ch'en, maintained a kind of local pride in its long association with Mi Yu-jen, which made possible the sort of personal identification with local historical traditions and past heroes so beloved by China's literati. Mi Yu-jen's sister married a man from Ta-yao-ts'un and passed her life there. Mi once painted a scroll for her entitled *Ta-yao-ts'un* that became a celebrated example of the master's work by the fifteenth century. That very scroll had belonged to Ch'en Shun's family since the time of his grandfather, Ch'en Yü, and it was still part of the family treasure in Ch'en Shun's day. Although the scroll has not survived, it is tempting to see archaistic elements in *Hills and Streams after Rain*, like the clouds painted in white, as registering the direct influence of Mi's *Ta-yao-ts'un*. MFW/KSW/LS

Literature
Yamamoto, *Chōkaidō* (1932), *ch.* 3, pp. 66, 67.
Sirén, *Masters and Principles* (1956-58), IV, 220.

Exhibitions
Cleveland Museum of Art, 1954: Lee, *Chinese Landscape Painting*, cat. no. 64, pp. 91, 92.

Nelson Gallery-Atkins Museum 46-42

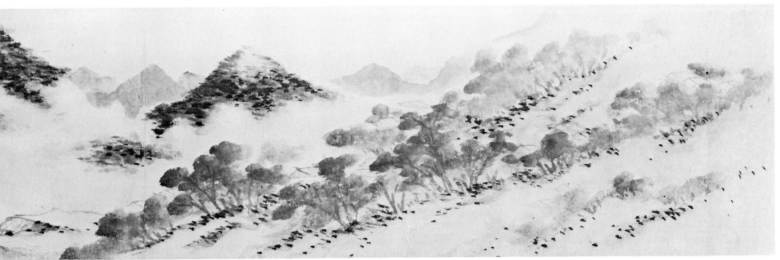

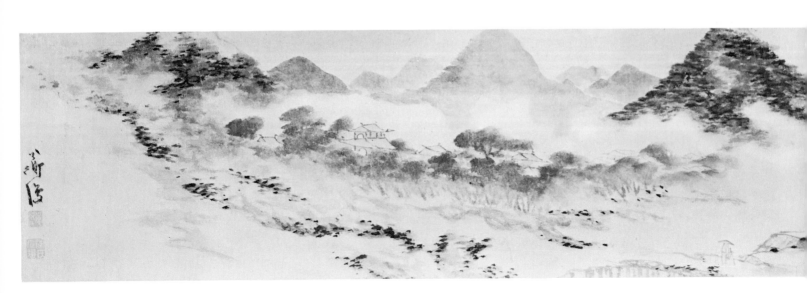

Ch'en Shun

179 *Looking for a Monastery in the Misty Mountains (Yen-ssu hsin-yu)*

Hanging scroll, ink on paper, 158 x 63.5 cm.

Artist's inscription, signature, and 2 seals:

Row after row of misty trees envelop the Buddhist
 monastery.
But the rustic who comes to find it will not lose his way.
Just across the wooden bridge, the dusty world is cut off;
Among the countless falling petals, birds are singing
 confusedly.

Tao-fu composed [this]. [seals] Fu-fu shih; Po-yang
shan-jen.

trans. WKH/LYSL

3 additional seals unidentified.

Remarks: The artist's poem is recorded in his collected
work, *Ch'en Po-yang chi* (preface, 1615, p. 271).

This is one of the largest and most complex hanging
scrolls by Ch'en Shun. The closest comparable work is
the far more diffuse and open *Mountain Ridges after Rain*
(*Hua-yüan to-ying*, 1955, I, pl. 37). The rich, wet ink and
rapid brushwork combining elements of the Mi Fu — Kao
K'o-kung "dotted" manner (see cat. no. 197) and the
tree, plateau, figural and architectural vocabulary of
Ch'en's friend and mentor, Shen Chou, are characteristic
of Ch'en Shun and in marked contrast to the more intro-
spective and controlled manner of his major contemporary,
Wen Cheng-ming. The various elements of Ch'en's
vocabulary are to be seen in almost dictionary form in
the eighteen-leaf album in the National Palace Museum,
Taipei (*KKSHL*, 1965, *ch.* 6, pp. 50, 51), where his famous
running calligraphy, as bold as his painting style, is also
displayed.

The Nelson Gallery landscape and flower handscrolls
(cat. nos. 177, 178) are equally significant for an evalua-
tion of Ch'en's art along with the Cleveland landscape
hanging scroll. All reveal a large-scale method, not only
in vigorous brushwork but also in the scale and richness
of overall organization. Because of this quality — atypical
for the sixteenth century — Ch'en's art has been largely
overlooked, and when noticed, underrated. His flower
painting has been emphasized at the expense of his
landscape efforts. Perhaps he should be considered as a
major link in the monumental tradition of later Chinese
painting, passing from the late Yüan masters through
Shen Chou to Tung Ch'i-ch'ang. This is in keeping with
Ch'en's biography (Chiang Shao-shu, *Wu-sheng-shih
shih*, postface 1720, *ch.* 3), where the influence of Yüan
masters in his youth is mentioned, as well as the later
influence of the Mi-dot style. SEL

Recent provenance: James J. Freeman, Kyoto.
The Cleveland Museum of Art 79.28

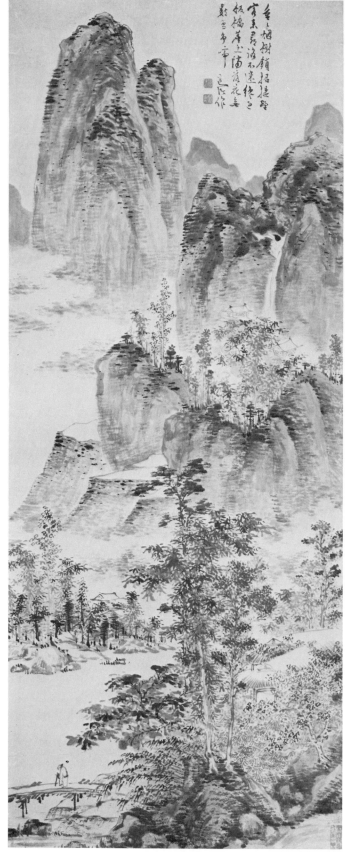

179

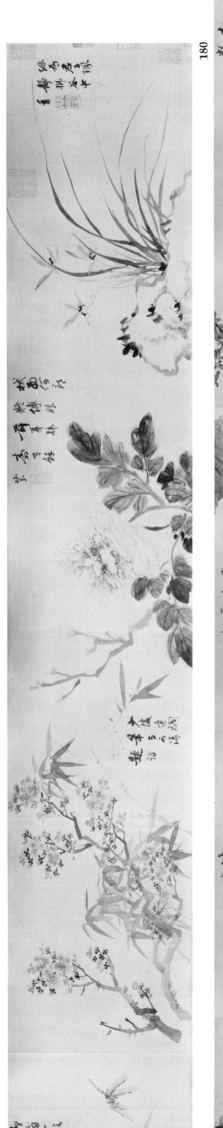
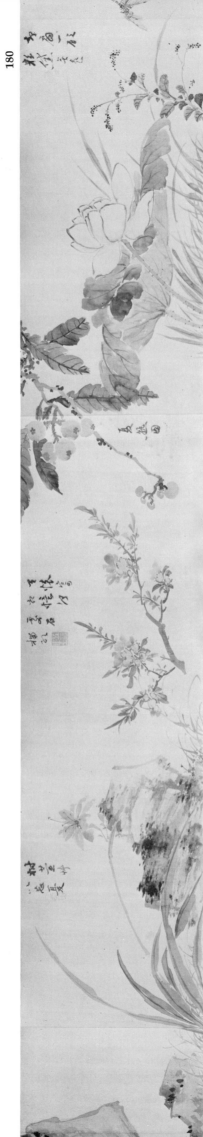
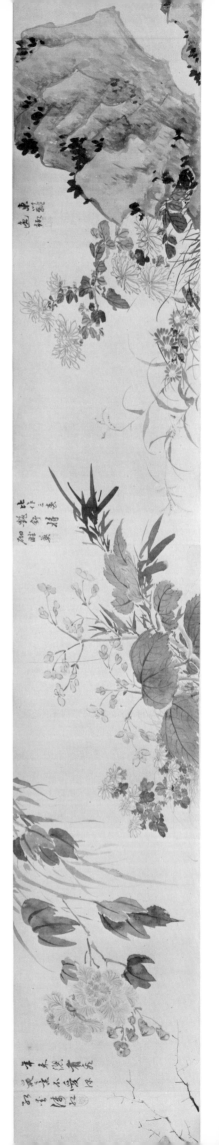

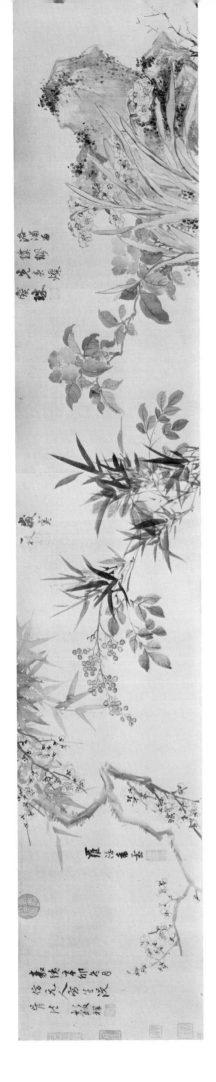

Wang Ku-hsiang, 1501-1568, Ming Dynasty
t. Lu-chih, *h.* Yu-shih; from Suchou, Chiangsu
Province

180 *Flowers of Four Seasons*
(*Ssu-shih hua-hui*)

Handscroll, dated 1531, ink and light color on silk,
24 x 545 cm.

Artist's inscriptions, signature, and 15 seals:

Ink Orchids. Sewn as pendants for the man of worth,
swaying quietly, fragrance in the valley. [seal] Hsiao-chu
ts'un.

Peony. Wiping his face, the young gentleman Ho [Ho
Yen of Wei, Three Kingdoms] appears to have been pow-
dered. His previous life was the perfume-stealing Han
Shou [of Chin, 265-419], the fragrance still lingers. [seal]
Ts'un-wu chai.

Flowering Crab Apple, New Bamboo. Shao-lin [Tu Fu,
712-770] had to put down his brush. [Flowering Crab
Apple]. Yü-k'o [Wen T'ung, d. 1079] in vain wrote
poems about [Bamboo]. [seal] Yu-shih.

Lotus Flowers. When she turns her head, half-hidden
by a fan, and casts a glance, all the beautiful women
become colorless. [seal] K'ang yüeh huai.

Loquat. Ripeness in summer. [seal] Lu-chih.

Pomegranate Flower. Whenever I remember you I will
send my thoughts, but where have you gone – the
[skirt] of pomegranate red? [seal] Wu-ho Sheng.

Day Lily. Plant the day lily to forget sorrow. [seal]
Yu-shih.

Chrysanthemum. The untrammelled joy at the eastern
fence. [seal] Lu-chih.

Begonia. Comparing it to the beauties of Spring, and
spreading them out as trimming for the stone steps.
[seal] Yu-shih.

Hibiscus. In recent years I have always enjoyed looking
at flowers; instead of dark red I preferred pink ones.
[seal] Jen-sheng i-lou.

Narcissus, Camellia. The jade girdle left behind at Lo
River. [Narcissus].
The precious pearls glitter before Spring. [Camellia].
[seal] Lu-chih.

Heavenly Bamboo (*Nandina domestica*). A single branch
in the wintry season. [seal] K'ang yüeh huai.

Plum. Fragrant snow in the Lo-fou Mountains. [seal]
Ts'un-wu chai.

 In the eleventh lunar month of the *hsin-mao* year of the
Chia-ching era [1531], [I] imitated the boneless style of
Yüan masters in sketching from life. Ku-hsiang [seals]
Yu-shih; Lu-chih.

<div align="right">trans. WKH/LYSL</div>

2 colophons and 23 additional seals: 1 colophon, dated
1632, and 2 seals of Li Jih-hua (1565-1635); 1 colophon
and 2 seals of Hsiang Sheng-mo (1597-1658); 3 seals of
Liang Ch'ing-piao (1620-1691); 6 seals of the Chia-ch'ing
emperor (r. 1796-1820); 9 seals of Ch'eng Ch'i (20th c.).

Remarks: Wang Ku-hsiang grew up in a prominent
Suchou medical family with close personal ties to the
family and friends of Wen Cheng-ming. Wen himself
taught the young child prodigy classical literature. After
passing the *chin-shih* examinations in 1526, Wang served
the government in Peking from 1528-35. Disappointed
with his positions, Wang retired from office and re-

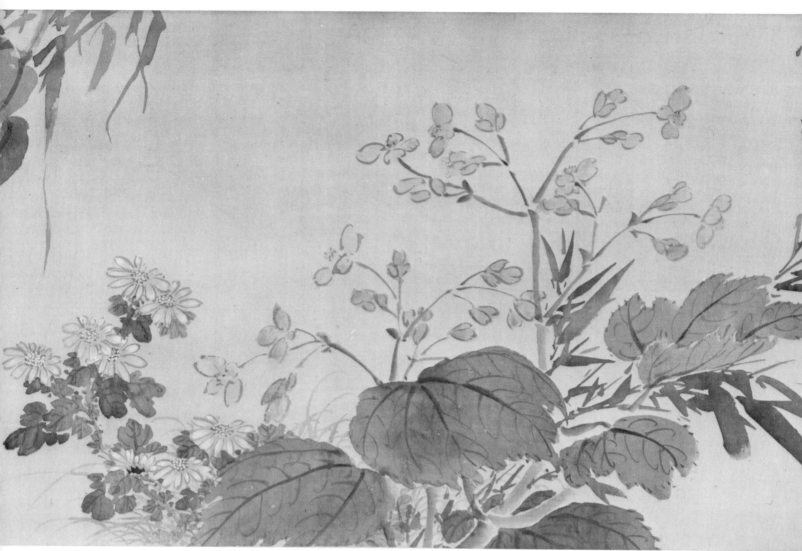

180 Detail

turned to his native city to pass the remainder of his life in community with poets and painters. He collaborated with Lu Chih; verses to his paintings were added by Wen Cheng-ming, Wen Chia, and Wen Po-jen; his works were valued by contemporary collectors.

This handscroll entered the imperial collection after being owned by Li Jih-hua and Liang Ch'ing-piao. In fact, Li Jih-hua mentions in his colophon dated 1632 that this *Flowers of the Four Seasons* was the favorite among the many scrolls in his collection painted by Wang Ku-hsiang.

In contrast to other works by the artist, such as *Narcissus*, now in Cologne (*1000 Jahre*, 1959, cat. no. 58), the present one is remarkably free and spontaneous, going beyond traditional Yüan and especially Sung renditions of flowers with their more careful brushwork and literal realism. Wang renders the unfolding sprays of flowers with a virtual absence of ink outline, relying instead upon a brush loaded with transparent pigment to define the contours of twigs and branches. In this, he follows the monochrome ink manner of Wang Yüan (see cat. no. 87) and its polychrome counterpart in Shen Chou (see cat. nos. 148, 149). Still, the artist preserves the spirit of Sung, real but somehow romantic, implying more than the representation of a particular plant. Perhaps this quality is one that endeared him to the great conservative collector of the seventeenth century, Liang Ch'ing-piao, who owned this and the Cologne scroll. HK

Literature

Shih-ch'ü III (1816), Yen-ch'ung-ko (24), pp. 1976, 1977.
Ferguson, *Li-tai* (1934), I, 63(a).
Ch'en Jen-t'ao, *Ku-kung* (1956), p. 22(a).
Ch'eng, *Hsüan-hui-t'ang* (1972), pp. 77(b)-78(a).

Exhibitions

City Museum and Art Gallery, Hong Kong, 1970: Urban Council and the Min Chiu Society, *Ming and Ch'ing*, cat. no. 16.

Recent provenance: Ch'eng Ch'i.

The Cleveland Museum of Art 77.4

Lu Chih, 1496-1576, Ming Dynasty
t. Shu-p'ing, *h.* Pao-shan; from Suchou, Chiangsu
Province

181 *The Jade Field*
(*Yü-t'ien t'u*)

Handscroll, dated 1549, ink and color on paper,
24.1 x 136.1 cm.

Artist's inscription, signature, and 2 seals: Made by Pao-
shan Lu Chih on the fifteenth day of the third month of
the *chi-yu* year of the Chia-ching era [1549]. [seal] Pao-
shan-tzu. [seal, lower right corner] Lu shih Shu-p'ing.

Forged artist's colophon, signature, and 2 seals:
Cultivating jade knows no season,
Where vast springs water Lan-t'ien.
In a thousand years, but a single leaf matures;
The nine-fold transformation, a cycle in a slip of time.
Divinely enriching waters fashion the cinnabar potions;
Elysian jade flowers bring forth purple mists.
Within the empyrean gather all lustrous eminences;
How long have they cast their clear light?

Inscribed as well by Lu Chih. [2 forged seals] Pao-
shan-tzu; Lu shih Shu-p'ing. trans. MFW

1 additional forged colophon, dated 1632, and seal of
Tung Ch'i-ch'iang (1555-1636).

Remarks: Parts of the poem are extremely difficult to
understand, much less render into meaningful English.
The terms are drawn from ancient Taoist literature deal-
ing allusively with concepts about the cosmos, change,
and the relationship between the phenomenal world of
man and a larger body of forces governing the universe.
At least two layers of meaning may be attached to many
of the terms. Some may be understood literally as
rhemical practices aimed at producing an elixir of
immortality. In this sense, the concocting of compounds
using jade and cinnabar figures prominently in Taoist
medical and alchemic writings. However, the same
terms may be understood as metaphors referring to
mystical, meditative, and even ecstatic, practices de-
signed to harmonize one's personal forces with the uni-
versal forces governing nature — the idea being to
strengthen oneself and achieve longevity by harnessing
those forces.

Lan-t'ien is a place in Shenhsi Province that was
thought in ancient China to be the source of jade,
although it appears that little, if any, jade ever came
from there.

181 Detail

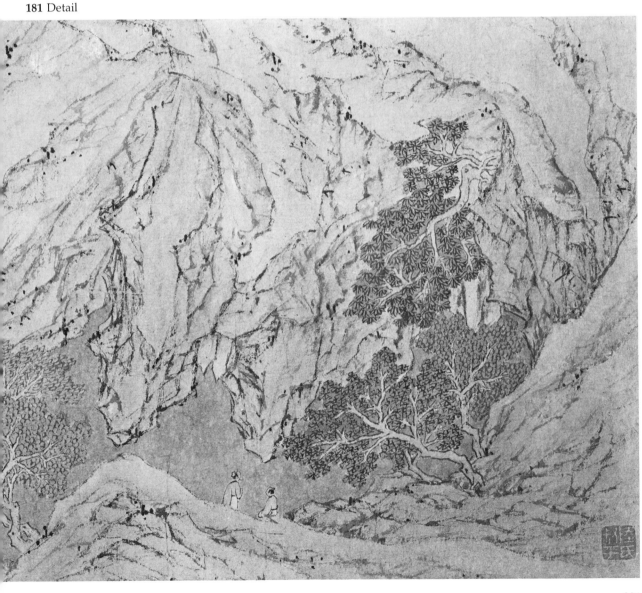

231

Because the title of the picture, *Yü-t'ien*, is the sobriquet of Wang Lai-pin (1509-after 1550), one of Suchou's foremost physicians and the man for whom the picture was painted, the poem may also be seen as a eulogistic comment on Wang's curative powers.

This picture has long been recognized as one of Lu Chih's most satisfying paintings, but its true title was lost, and for some time it was known only as *Landscape*. However, it can now be identified as *The Jade Field* painted in 1549 for Wang Lai-pin; and although Lu Chih's colophon is a forgery, the scroll once carried the original colophon.

Two other handscroll versions, supposedly by Lu, are recorded in collection catalogues. One is found in the *Shih-ch'ü pao-chi* (pt. I, 1745, Ch'ien-ch'ing kung, *ch.* 6 pp. 55a-58b). Painted on silk with color, it is unsigned but bears two seals of Lu Chih at the end of the silk panel. Following the painting on a separate sheet (of paper?), Lu's undated poem appears first, then a short, undated poem in praise of Wang Lai-pin by Wen Cheng-ming (1470-1559). The essay, "The Jade Field Account," written by P'eng Nien (1505-1566) and dated the sixth day of the sixth lunar month of 1549, concludes the colophons. The painting has disappeared from the former imperial collection and its present whereabouts is unknown.

The second recorded handscroll version appears in the collection catalogue of Teijirō Yamamoto (*Chōkaidō*, 1932, *ch.* 3, pp. 85a-87b). It too is painted on silk with color. It is signed with only slight variations from the signature on the Nelson Gallery scroll. The date given is the middle of the third lunar month of 1549. Two of Lu Chih's seals follow the signature. Lu Chih's poem is on a separate sheet of paper, followed by "The Jade Field Account," written this time by Wen Cheng-ming, but bearing exactly the same date (sixth day of the sixth lunar month of 1549) as scrolls in which the account was supposedly written by P'eng Nien. The scroll concludes with poems by other luminaries of the Suchou artistic world: Wang Shou (d. 1550; brother of Wang Ch'ung),

Huang Fu-fang (1529 *chin-shih*), Lu Shih-tao (1511-1574), and Chou T'ien-ch'iu (1514-1595). Unfortunately, this scroll, too, has disappeared.

The problem of different handscroll versions is further complicated by the record of a handscroll of the same title, supposedly painted by Ch'iu Ying (1494/5-1552). It is similarly followed by "The Jade Field Account," written in this instance by Wen Cheng-ming and bearing the usual date. Poetic colophons by Lu Shih-tao and Chou T'ien-ch'iu follow.

Two vertical versions of the scroll are known, the first of which appears in Liang Chang-chü's *T'ui-an so-ts'ang chih-shih shu-hua pa* (preface 1845, *ch.* 16, pp. 25a-b). On this scroll, Lu's poem is dated 1561 and, like all other versions, bears "The Jade Field Account" — in this case, written by P'eng Nien. Two Ch'ing Dynasty imperial collection seals are recorded as being on the painting; however, the painting is not recorded in the *Shih-ch'ü pao-chi*. Whenever Lu's poem or signature appears with a date in other versions, that date corresponds to the middle of the third lunar month of 1549. In all other recorded versions "The Jade Field Account" is dated the sixth day of the sixth lunar month, whether written by P'eng Nien or by Wen Cheng-ming.

In the second vertical version, reproduced in the first decade of this century in *Kuo-ts'ui hsüeh-pao* (v, 1909, no. 1, unpaginated), Lu Chih's poem is identical but undated. "The Jade Field Account" was written by P'eng Nien at the top of the scroll and is dated the sixth day of the sixth lunar month of 1549.

The authenticity of either vertical version seems doubtful. The first one is suspect because the date is at variance with the others, because the seals fail to follow Ch'ing court practices, and because of the lack of a recording in the *Shih-ch'ü pao-chi*. The brushwork in the second vertical scroll fails to convince upon examination of the reproduction.

Typologically, *The Jade Field* scroll is the same as Lu's *Streams and Rocks* (cat. no. 182). It was made as a eulogistic ensemble for Wang Lai-pin, probably at his request as

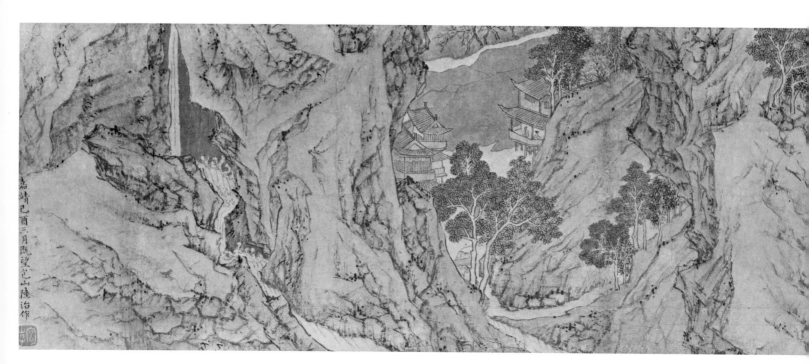

a favor to a friend or as compensation for medical services. Such scrolls were frequently done by Lu Chih and other Suchou artists of the day. From a review of those that can be identified in literature and through surviving examples, one gets the impression that they were not generally duplicated by the same artist. It is possible, however, for a second ensemble on the theme to be made by another artist or group of artists. It is, therefore, very unlikely that more than one of the handscrolls can be genuine. It is equally improbable that P'eng Nien and Wen Cheng-ming would both take credit for "The Jade Field Account" and retain the same date of composition from scroll to scroll.

A thoroughgoing study of the Nelson Gallery version leaves no doubt that it is an original work by Lu Chih at his top level of achievement. But precisely what combination of colophons — apart from Lu's poem — it originally bore and who really composed and wrote "The Jade Field Account" cannot be determined at this time.

<div align="right">MFW/KSW</div>

Literature

Myers, ed., *Encyclopedia of Painting* (1955), p. 104.
Lee, "Some Problems" (1957), pl. 9, fig. 14; idem, *Far Eastern Art* (1964, 1973), p. 437, fig. 579.
Wilkinson, "Lu Chih's Views" (1969, pp. 31-33, fig. 7.
NG-AM Handbook (1973), II, 67, 68.

Exhibitions

Wildenstein Galleries, New York, 1949: Dubosc, *Ming and Ch'ing*, cat. no. 24, pp. 28-31.
Detroit Institute of Arts, 1952: Grigaut, *Arts of the Ming Dynasty*, cat. no. 30, p. 12.
Cleveland Museum of Art, 1954: Lee, *Chinese Landscape Painting*, cat. no. 60, pp. 87-89, 151.
Arts Council Gallery, London, 1957: Garner, *Arts of the Ming Dynasty*, cat. no. 22, pl. 14.

Recent provenance: Jean-Pierre Dubosc.

Nelson Gallery-Atkins Museum 50-68

Lu Chih

182 *Streams and Rocks*
(Hsi-shih t'u)

Handscroll, ink and color on silk, 31.3 x 85.7 cm.

Artists's 2 seals at lower right edge: Lu shih Shu-p'ing; Pao-shan-tzu.

Frontispiece and 1 seal of Lu Shen (1477-1544).

3 colophons and 88 additional seals: 1 colophon and 2 seals of Wen Cheng-ming (1470-1559); 1 colophon and 39 seals of Hsiang Yüan-pien (1525-1590); 1 seal of Hsieh Sung-chou (act. 1723-35); 2 seals of Tung Kao (1740-1818); 5 seals of Yin Shu-po (1769-1847); 3 seals of Huang Shih-ch'en (early 19th c.); 30 seals of Yang Chi-ch'en (act. ca. 1861-65); 1 colophon and 2 seals of Pao Kuei-sheng (act. late 19th c.); 4 seals unidentified.

Remarks: According to Wen Cheng-ming, in his essay written in clerical script (li-shu) following the scroll, Streams and Rocks (Hsi-shih) was the sobriquet of Wu Yün-sheng, a man from Hsin-an in Anhui who lived for some time in Suchou. The laudatory essay praises Mr. Wu for his untrammeled character and as one who, rather than seeking fame and fortune, was devoted to streams and rocks.

Wang K'o-yü, in his *Shan-hu-wang* (preface 1643), records a painting done by Lu Chih in 1541 for a man named Wu Hsi-yang, also from Hsin-an. This man may well have been a brother, or otherwise closely related, to the Wu Yün-sheng mentioned by Wen Cheng-ming. Farther on, in the same entry, Wang K'o-yü states that he had seen another painting by Lu Chih, entitled *Hsi-shih-t'u*, done for a Mr. Wu of Hsin-an with an essay by Wen Cheng-ming; this in all likelihood is the Nelson Gallery scroll. The other scroll painted for Wu Hsi-yang, described by Wang K'o-yü, is now in the Kuo-t'ai Art Museum, Taipei (*Kuo-t'ai*, 1978, no. 6, pp. 17-22).

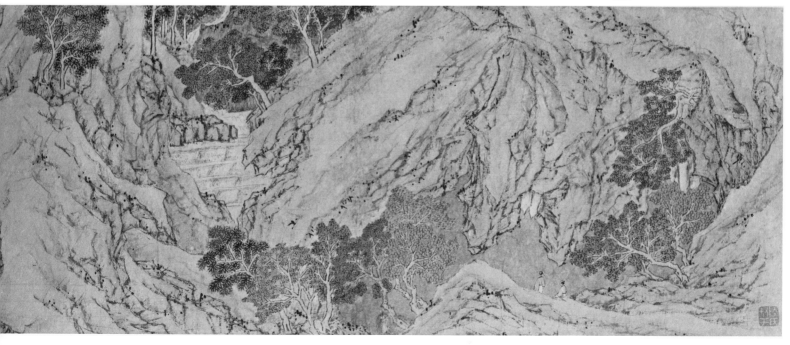

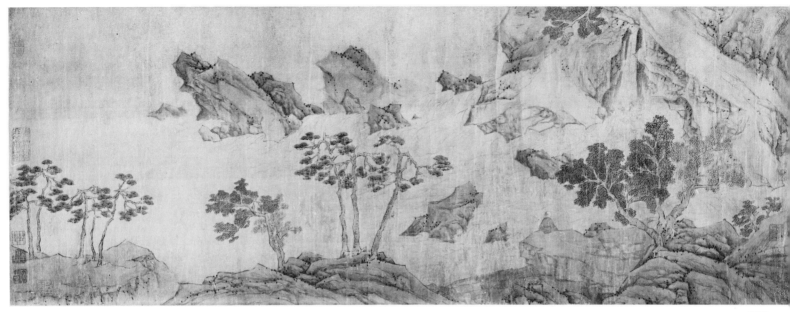

Clearly, the three components of the scroll — the frontispiece, the painting and the essay by Wen Cheng-ming — were all done at approximately the same time and intended as a unit. Consequently, the painting must antedate the death of Lu Shen in 1544. Moreover, in style it seems to be somewhat earlier than the scroll done for Wu Hsi-yang in 1541 and very likely can be dated to the 1530s. KSW/LS

Literature
Wang K'o-yü, *Shan-hu-wang*, preface 1643, *ch*. 17, pp. 1156, 1157.
Exhibitions
Museum für Kunst und Gewerbe, Hamburg, 1949/50: Contag, *Chinesische Malerei*, p. 37, no. 16.
Yale University Art Gallery, New Haven, 1977: S. Fu, *Traces*, pp. 273, 274, no. 53a, illus. p. 65; no. 53b, illus. p. 74.

Recent provenance: Victoria Contag von Winterfeldt.
Nelson Gallery-Atkins Museum F75-44

Lu Chih

183 *Taoist Retreat in Mountain and Stream* [*Landscape after Ni Tsan*]
(*Hsi-shan hsien-kuan t'u*)

Hanging scroll, dated 1567, ink on paper, 109.1 x 45.8 cm.

Artist's inscription, signature, and 3 seals:

In my youthful days I liked to imitate the ink method of Yün-lin [Ni Tsan]. Mr. Wen, the academician [Wen Cheng-ming], remarked that I barely succeeded in achieving some resemblance. He once honored me with the inscription "lofty and imperturbable indeed was the personality of Ni Yü [Ni, the Odd]. Pale ink and blue smoke were formed by his scribbling brush. His surviving works have become so rare in the last two hundred years; only Pao-shan [Lu Chih] carries on his true tradition." In my older years, having to comply with frequent requests for paintings, my brushwork has become stronger than before and I thought to myself that I may have surpassed the Old Master. In the *ting-mou* year of the Lung-ch'ing era [1567] a friend brought a small painting [by Ni Tsan] and showed it to me in the mountains. I studied and enjoyed it for a long time, then realized that I was actually inferior. This gave me second thoughts about my earlier style, so I selected a piece of old window paper and did this painting in imitation. My friend was kind enough to say that it was truly a quick and close resemblance. I then wrote a colophon and presented the painting to him. My poem says:

High mountains and distant waters are the thoughts coming from the lute;
The drunken leaves and the sparse woods are merely flowers in the mirror.
This idea, I'm sure, will be understood by Tzu-ch'i, one who appreciates my art,
It is for him that I have painted on thin paper with light touches,
The cloudy color of an autumn evening.

This is in the winter solstice of the same year. By then, Pao-shan, Mr. Lu, was already over seventy years of age. Could it be that one's brush also gets old together with one's age, as the saying goes. I put down my brush with a laugh. [2 seals] Lu Shu-p'ing shih, Pao-shan tzu. [seal, bottom left corner] Lu Chih shu-p'ing.

<div align="right">trans. WKH</div>

6 additional seals of Chu Ching-hou (n.d.).

Remarks: The Tzu-ch'i referred to in the artist's poem is Chung Tzu-ch'i, the best-known ancient expert in lute music in the Spring and Autumn Period, who alone was able to understand the art of his friend Po-ya.

The brushwork of this painting is characteristic of the artist, and though clearly derived from Ni Tsan, is smaller in scale, even more crystalline and jewel-like than the brush of the earlier master. The painting is unusual among Lu's works in that it is a "copy" of a smaller work by Ni Tsan (see translation of inscription). The original source is reputed to be the painting on silk formerly in the collection of Chiang Er-shih (*Chinese Paintings from the Chiang Er-shih Collection,* 1971, no. 12). While the two compositions are similar, there are many discrepancies, and despite Lu's disclaimer — "I was actually inferior" — his work is far more spacious, well-integrated, and natural than that attributed to Ni Tsan with its awkward cliffs, a waterfall with no source, and a straight pathway making a gash across a rather repetitively rock-strewn foreground lowland. Either we have here an instance, not necessarily uncommon in Chinese painting, of a free and superior variation on an earlier work, or the smaller painting (with no collector's seal before the seventeenth century and no record before 1600; the earliest record is Chang Ch'ou's *Ch'ing-ho shu-hua-fang,* preface 1616, vol. II) is yet another late Ming imitation of a still-lost painting by the great Yüan master.

<div align="right">SEL</div>

Literature
Sirén, *Masters and Principles* (1956-58), VII, *Lists,* 214.

Exhibitions
Royal Ontario Museum, Toronto, 1956: Tseng, *Loan Exhibition,* cat. no. 21.
Smith College Museum of Art, Northampton, Mass., 1964: Fifteen Chinese Paintings from The Cleveland Museum of Art, no catalogue.
Asia House Gallery, New York, 1974: Lee, *Colors of Ink,* cat. no. 31.

Recent provenance: Chu Ching-hou; Frank Caro.

The Cleveland Museum of Art 62.43

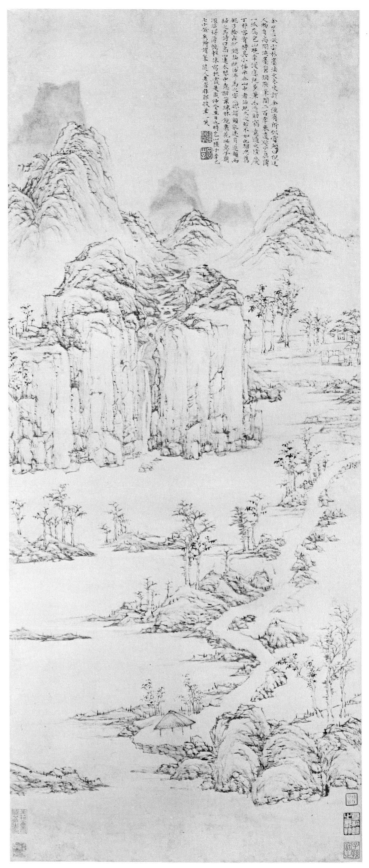

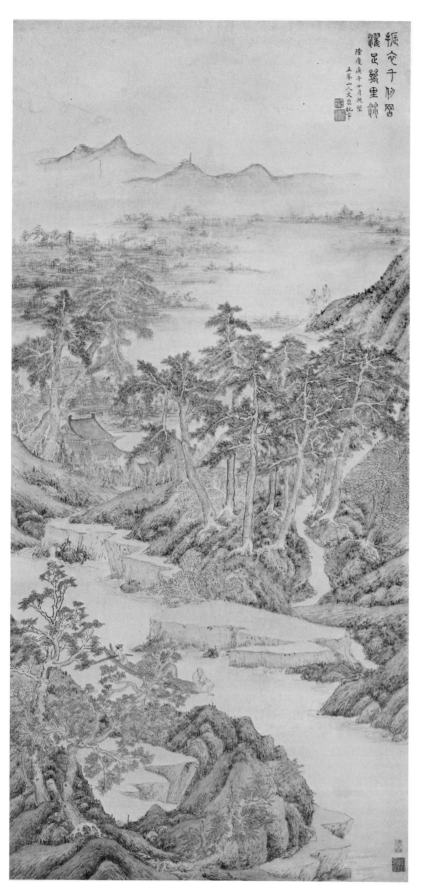

Wen Po-jen, 1502-1575, Ming Dynasty
t. Te-ch'eng, *h.* Wu-feng, Pao-sheng, She-shan lao-nung; from Suchou, Chiangsu Province

184 *Washing the Feet (from the Dusty World)*
(Cho-tsu t'u)

Hanging scroll, dated 1570, ink and light color on paper, 141.9 x 67.2 cm.

Artist's inscription, signature, and 4 seals:

Shaking one's clothes on a thousand-*jen* peak,
Washing one's feet in a ten-thousand-*li* stream.

In the *keng-wu* year of the Lung-ch'ing era [1570], fifteenth day of the tenth month, Wu-feng shan-jen, Wen Po-jen recorded a special occasion. [2 seals] Wu-feng shan-jen; Wen Po-jen Te-ch'eng chang. [2 seals, lower right corner] Te-ch'eng; She-shan chang.

trans. HR

2 additional seals of Chang Heng (1915-1963).

Remarks: Wen Po-jen, a nephew of Wen Cheng-ming, continued the literati tradition of the Wu school into its third generation, in company with his cousins, Wen P'eng and Wen Chia, as well as Lu Chih (see cat. nos. 181-183), and others. Throughout his career, Wen Po-jen varied the content of his landscapes, sometimes filling broad spaces with a multiplicity of sharp detail in the manner of his uncle or the Yüan masters, at other times using line, color, and motif sparingly.

Wen Po-jen's seal script inscription quotes a couplet from the poem *Yung-shih shih (In Praise of History)* by the Chin Dynasty poet Tso Ssu (3rd c.). In this late work, Wen imaginatively combines the Yüan tradition with more recent modes inaugurated by Wen Cheng-ming. The background mountain chain placed at the top of the picture and the water coursing through the middle-ground create a tilting plane favored by many a Yüan master (see cat. no. 106), while the hilly contours of the landscape are rendered with the short *ts'un* of Wang Meng (see cat. no. 111). In the manner of the sixteenth-century Wu school, the middle ground is filled with a richly detailed land mass, its palpable bulk enforced by the application of color washes. Wen thereby creates a complicated positive-negative surface pattern by alternating land and water stretches from the foreground through the background.

The rich complexity of this composition, combining wet washes with crisp, dry, defining brushstrokes, is comparable to that in the famous set of the *Four Ten-Thousands (Ssu-wan t'u),* dated 1551 — especially the scroll representing *Pine Trees and Summer* — now in the Tokyo National Museum (*Min-Shin no kaiga,* 1964, cat. no. 46). The poem on this scroll also stresses the *wan* idea of the myriad, an example of combined complex literary and visual imagery. HK/SEL

Recent provenance: Frank Caro.
Intended gift to The Cleveland Museum of Art, Mr. and Mrs. A. Dean Perry

184

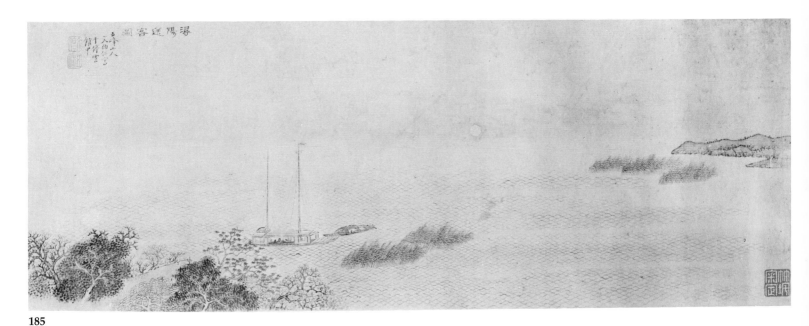

185

Wen Po-jen

185 *The Lute Song: Saying Farewell at Hsün-yang*
(*Hsün-yang sung-k'e t'u*)

Handscroll, ink and slight color on paper, 20.7 x
59.2 cm.

Artist's inscription, signature, and 2 seals: Saying
Farewell at Hsün-yang. Wu-feng shan-jen, Wen Po-jen
painted [this] at T'ing-yün kuan. [seals] Wen Po-jen;
Wu-feng.

2 colophons and 9 additional seals: 1 transcription of
"The Lute Song" and 3 seals of Chu I-tsun (1629-1709); 2
seals of Wu Yung-kuan (1773-1843); 1 colophon, dated
1826, and 3 seals of Wu Hsi-chia (early 19th c.).

Remarks: Of the two colophons following the painting,
the first, written by the early Ch'ing scholar Chu I-tsun,
is a transcription of Po Chü-i's poem, "The Lute Song,"
from which Wen Po-jen's title is taken (see also cat. no.
164; for translations of the poem see Waley, *Life and
Times*, 1949, pp. 45-49, and "Song of the P'i-p'a," 1978,
pp. 155-59). Wu Hsi-chia added a second colophon in
1826, stating that the painting was a gift to him from Wu
Yung-kuang (1773-1843) and had once belonged to the
famous collector Sung Lo (1634-1713).

The small scale and obliquely ordered space of this
painting recall the near-far views of Southern Sung,
while its delicacy of touch reappears in another of Wen's
works, a hanging scroll from the *Ssu-wan* of 1551, *A
Myriad Hectares of Sunlit Waves* (Tokyo National Museum;
Cahill, *Parting*, 1978, pls. 131, 133).

Wen Po-jen records that he completed *The Lute Song* at
the Chamber of Lingering Clouds (Ting-yün kuan), the
studio of his uncle. The T'ang poet's long prose poem
appealed to other middle-Ming masters but each pro-
vides a different interpretation. Ch'iu Ying, for exam-
ple, chose to evoke the poet's own period with a bril-
liantly colored rendition in the T'ang blue-and-green
landscape manner (see cat. no. 164). In contrast, pale
color tonalities and quiet, empty spaces in Wen Po-jen's
version evoke the sadness of the poem. The central
theme of the painting is an illustration of two lines from
"The Lute Song":

We are both unhappy – to the sky's end.
We meet. We understand. What does acquaintance
matter?

The emptiness in the picture suggests the emptiness
of life. The potentially disturbing and extraneous ele-
ment of the party bidding farewell to the nostalgic
official is suppressed into an unobtrusive detail of a
banner finial just visible above the foreground trees.

If the brush and texture are that of a follower of Wen
Cheng-ming, the subtlety and restraint of this painting
adds a new and favorable element to the reputation of
Wen Po-jen. One can reasonably say that he has cap-
tured the quiet understatement of the Southern Sung
within a hardening *wen-jen* idiom. HK/SEL

Literature
Yamamoto, *Chōkaidō* (1932), III, pl. 94.
Sirén, *Masters and Principles* (1956-58), VII, *Lists*, 266.
Lee, *Chinese Landscape Painting* (1962), p. 78, no. 59.

Exhibitions
Cleveland Museum of Art, 1954: Lee, *Chinese Landscape Painting*,
cat. no. 58.

Recent provenance: Teijirō Yamamoto; Howard Hollis.
The Cleveland Museum of Art 54.581

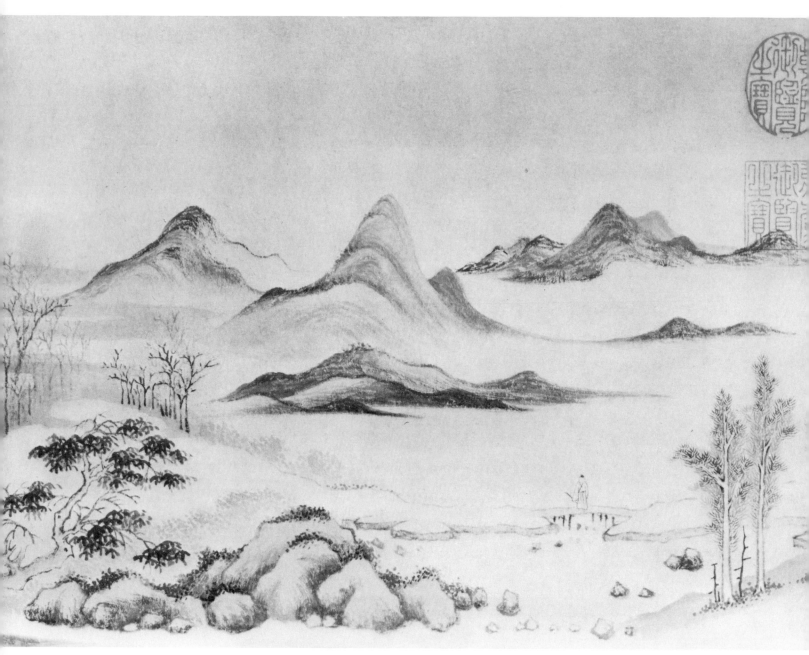

186 Detail

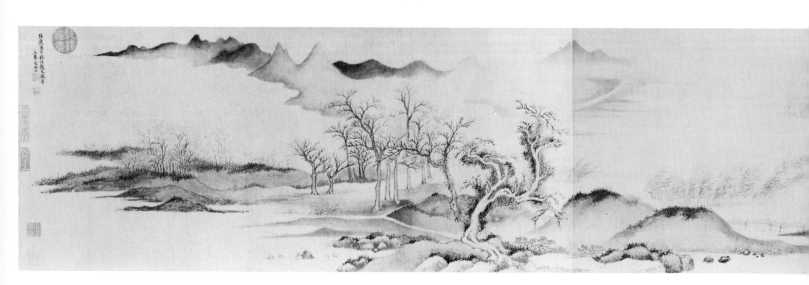

Wen Po-jen

186 *Water Village*
(Shui-ts'un t'u)

Handscroll, dated 1570, ink and light color on paper, 26.7 x 183 cm.

Artist's inscription, signature, and 2 seals at end of scroll: Imitating Chao Wen-min's [Chao Meng-fu] brush in autumn, the *keng-wu* year of the Lung-ch'ing era [1570]. Wu-feng, Wen Po-jen [seals] Wu-feng shan jen; Wen Po-jen yin.

1 colophon and 16 additional seals: 5 seals of the Ch'ien-lung emperor (r. 1736-95); 1 seal of the Chia-ch'ing emperor (r. 1796-1820); 1 seal of the Hsüan-t'ung emperor (r. 1909-11); 1 colophon and 5 seals of Ch'eng Ch'i (20th c.).

Remarks: Also known as *Flat Bridge and Distant Water (P'ing-ch'iao yüan-shui)*, this painting is, according to the artist's own inscription, an imitation of a work by Chao Meng-fu (1254-1322). The previous owner of this scroll suggests in his colophon that Wen actually had at hand a copy by Wen Cheng-ming (his uncle), of Chao's *Water Village* (Cahill, *Hills*, 1976, pl. 13). Wen Cheng-ming's copy of Chao's *Water Village* was recorded in the eighteenth century (Lu Shih-hua, *Wu-Yüeh*, preface 1776, *ch.* 3, pp. 23, 24). It may be the same painting that entered the imperial collection under the title *Clearing Weather over Mountains and Lakes (Shih-ch'ü* I, 1745, *ch.* 6, pp. 49b-53a), although there are discrepancies in sizes and listings of colophons between the two sources (see also Clapp, *Wen Cheng-ming*, 1975, pp. 22, 23).

Unfortunately, Wen Cheng-ming's painting has not survived; but Chao Meng-fu's *Water Village* is in the collection of the Palace Museum, Peking, so the previous owner's comments on Wen Po-jen's scroll can be evaluated. Using only ink on paper, Chao Meng-fu paints a clear and deep panorama of low-lying marshlands and islets which recede in horizontal paths parallel to the picture plane toward a background chain of rounded mountains. Trees and architecture remain minute in scale and summary in detail, further contributing to the sense of broad, expanding space. Wen Po-jen in his painting prefers an abbreviated close-up view with large-scale foreground elements in a more constricted space. All that Wen retains of his avowed model are the gentle rolling rhythms and parallel spatial recessions of the land masses–features which Chao Meng-fu borrowed from the tenth-century Southern landscape tradition of Tung Yüan (Cahill, *Hills*, 1976, pl. 90). Since Tung was supposedly influenced by the T'ang poet-painter Wang Wei, the colophon on this painting acknowledges the transmission of the Southern landscape tradition via Chao Meng-fu to the Ming Wu school masters.

By citing Chao Meng-fu as the basis for his work, Wen Po-jen simply meant to evoke that scholar-painter tradition by incorporating some of Chao's motifs within the vocabulary of his day. Certainly the influence of Wen Cheng-ming can be seen in the twisting silhouette and pepper-dot "halo" of the foreground tree (cf. cat. nos. 175, 176). HK

Recent provenance: Ch'eng Ch'i.

Intended gift to The Cleveland Museum of Art, Kelvin Smith

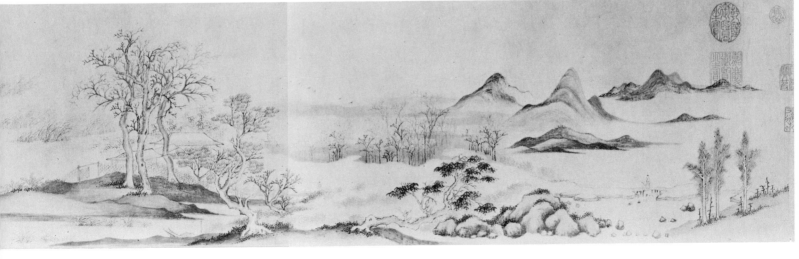

Ch'ien Ku, 1508-ca. 1578, Ming Dynasty
t. Shu-pao, *h.* Ch'ing-shih; from Suchou,
Chiangsu Province

187 *Fisherman's Joy*
(*Yü-le t'u*)

Handscroll, dated 1572, ink and light color on paper,
31.4 x 355.2 cm.

Artist's inscription, signature, and seal: On the autumn day of the *jen-shen* year [1572], P'eng-ch'eng, Ch'ien Ku painted [this]. [seal] Hsüan-ch'ing shih.

2 colophons, both dated 1689, and 5 additional seals of Yün Shou-p'ing (1633-1690).

Remarks: The poet-painter and bibliophile Ch'ien Ku was fortunately favored with the friendship and scholarly tutelage of Wen Cheng-ming, the presiding force within literati culture of sixteenth-century Suchou. In addition to the use of the Wen family library, Ch'ien obviously had access to collections of Chinese painting in the area, for a number of his extant paintings are based upon compositions of Shen Chou, Wen Cheng-ming's own teacher. For example, there is a version by Ch'ien Ku of Shen Chou's *Twelve Views of Tiger Hill* (cat. no. 155).

A more generalized Wu school spirit pervades Ch'ien's *Fisherman's Joy,* with its cursory development of landscape and figure in soft-toned colors or gray ink line and wash. Yet Ch'ien also departs from the featureless physiognomies typical of the Wu style. A certain wry humor in some of the faces is more in keeping with the narrative approach to the subject of *Fishermen's Joy* encountered in the Che school paintings of Tai Chin (Freer Gallery of Art, Washington, D.C.; Cahill, *Parting,* 1978, color pl. 3) and Wu Wei (Ching Yüan Chai collection; ibid., color pl. 6).

HK

Recent provenance: Gimpoh W. King.

The Cleveland Museum of Art 77.56

187 Detail

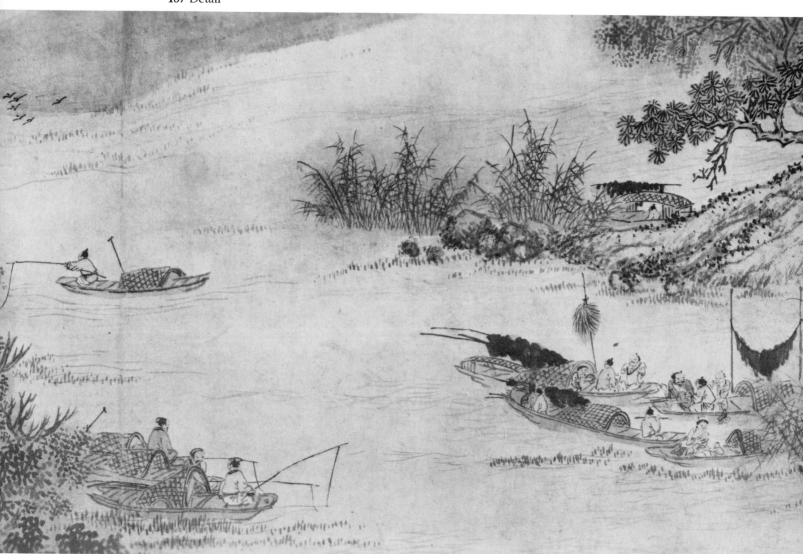

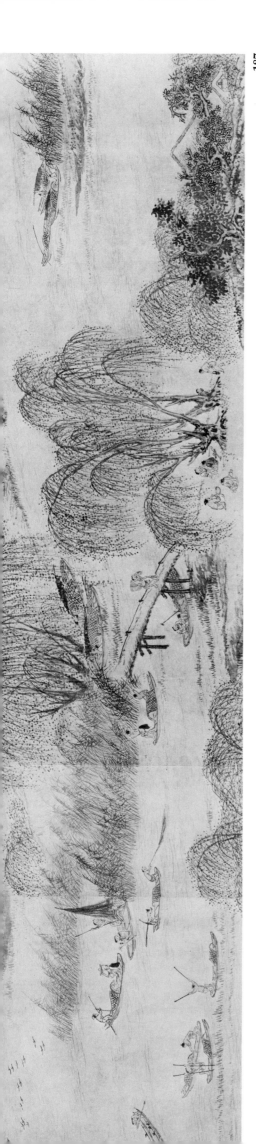

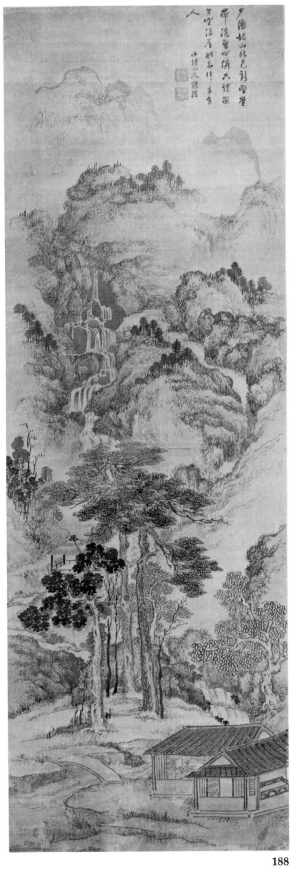

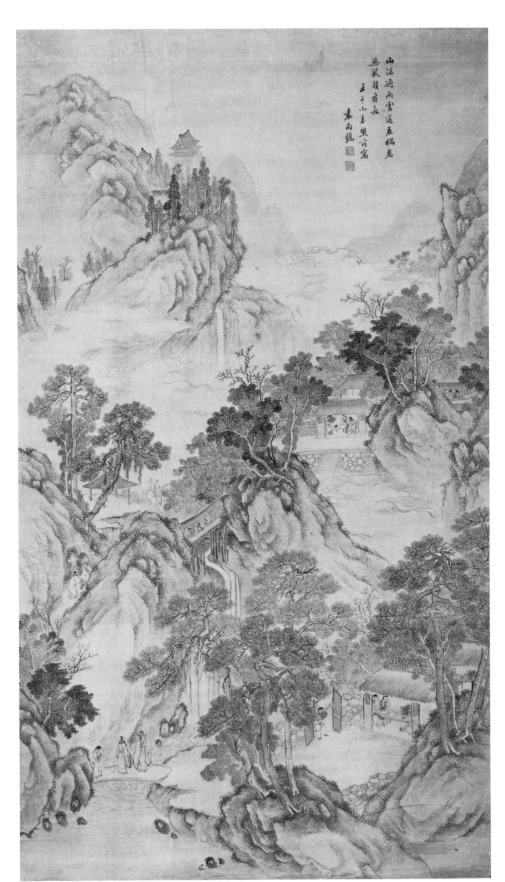

188 189

Chang Fu, 1546-1631 or later, Ming Dynasty
t. Yüan-ch'un, *h.* Ling-shih, Chung-t'iao-shan-jen;
from T'ai-ts'ang, Chiangsu Province

188 *Visiting a Hermit in the Autumn Mountains
(Ch'iu-shan fang-yin)*

Hanging scroll, ink and slight color on silk, 147.4 x
50.5 cm.

Artist's inscription, signature, and 2 seals at upper right:

At twilight, how charming the mountain
In its fresh autumn colors.

A rustic cottage stands alone
By the encircling stream.

It might be said
Books vainly fill the room,

Yet men of distinction
Are often drawn to visit.

Chung-t'iao-shan-jen, Chang fu [seals] Chang-fu chih
yin; Chang Yüan-ch'un.

trans. MFW

Remarks: Wang Shih-chen (1526-1590) lamented the de-
cline of the Wu school in the late Ming period. He re-
marks, however, that of the paintings he had seen from
the Lung-ch'ing and Wan-li eras, none surpassed those
by Chang Fu. He comments on that artist's eclecticism
in drawing upon the styles of a large number of great
masters of the past (quoted in T'ao Liang, *Hung-tou-
shu-kuan,* 1882, *ch.* 6, p. 12a). *Visiting a Hermit in the
Mountains,* done in the late Ming concept of the style
of Wang Meng, well illustrates the point. KSW

Exhibitions
Museum für Kunst und Gewerbe, Hamburg, 1949/50: Contag,
 Chinesische Malerei, cat. no. 24, p. 20 (titled *Landscape with
 Waterfall).*
Kunstsammlungen der Stadt Düsseldorf, 1950:
 Speiser and Contag, *Ausstellung,* cat. no. 29, p. 39 (titled
 Landscape).

Recent provenance: Victoria Contag von Winterfeldt.

Nelson Gallery-Atkins Museum F75-34

Yüan Shang-t'ung, 1570-1661 or later, Ming Dynasty
t. Shu-ming; from Suchou, Chiangsu Province

189 *Misty Calm Deep in the Mountains
(Shan-shui)*

Hanging scroll, dated 1642, ink and light color on
silk, 174.4 x 100 cm.

Artist's inscription, signature, and 2 seals at upper right:

In the mountain deep, clouds remain, though the rain
 has passed;
Whilst the song of aged pines lingers long, even without
 the wind.

Painted on the fourteenth day of the tenth [lunar] month
of the *jen-wu* year [1642]. Yüan Shang-t'ung [seals] Shu-
ming; Yüan Shang-t'ung yin. trans. MFW

Remarks: Yüan Shang-t'ung's paintings are significant
for trends shared by many late Ming conservative mas-
ters of the Wu school. Continuous connection between
compositional elements that had earlier provided a
plausible, if not strictly logical, unity in which landscape
units echoed in concert to major and minor rhythms has
been abandoned here in favor of isolation of fragmen-
tary units dispersed across the picture in a way that

emphasizes the flatness of the surface and plays upon
patterned, brocade-like rhythms. Plastic modelling of
volume has given way to the surface vibrancy of clusters
of small, reiterated texture strokes that effect an
ornamental alteration of light and dark. A similar sense
of well-choreographed design is also apparent in the
placement of groups of trees and in the decorative
changes of ink value in the foliage. MFW

Exhibitions
Museum für Kunst und Gewerbe, Hamburg, 1949/50: Contag,
 Chinesische Malerei, cat. no. 65, p. 44.
Kunstsammlungen der Stadt Düsseldorf, 1950: Speiser and
 Contag, *Ausstellung,* cat. no. 31, p. 21.

Recent provenance: Victoria Contag von Winterfeldt.

Nelson Gallery-Atkins Museum F75-35

Tung Ch'i-ch'ang, 1555-1636, Ming Dynasty
t. Hsüan-tsai, *h.* Ssu-po, Ssu-weng; from Hua-t'ing,
 Chiangsu Province

190 *Boneless Landscape after Yang Sheng
(Fang Yang Sheng mo-ku shan-shui)*

Hanging scroll, dated 1615, color on silk, 92.1 x 34.4
cm.

Artist's inscription, signature, and 2 seals at upper left:

[1 seal] Hua-ch'an. I once saw a genuine work by Yang
Sheng with mountains done in colored wash without
outline [*mo-ku*]. From this, one realizes the striking im-
pact of the ancients' spontaneous brush, that, like the
fleeting glow of vermilion clouds, is something rarely
seen in this world.

Inscribed by Tung Ch'i-ch'ang in the spring of the
i-mou year [1615]. [seal] Tung Ch'i-ch'ang.

3 additional seals of An Ch'i (1683-ca. 1746).

Remarks: A painting with the same title by Tung Ch'i-
ch'ang is recorded in An Ch'i's catalogue, *Mo-yüan hui-
kuan* (preface 1742), but since the painting carries a differ-
ent inscription by the artist, it cannot be the scroll now
in the Nelson Gallery. An Ch'i's entry (ibid., p. 32; trans.
MFW), however, is interesting and relevant: "Tradition
has it that landscape in color without outline [*mo-ku*]
originated with Chang Seng-yu of the Liang Dynasty
[503-556]. However, having checked through the records
of connoisseurs and collections through successive
dynasties down to the *T'u-hui pao-chien* [preface 1365],
no mention has been made of landscapes by Seng-yu.
Nor have I had any first-hand experience with Yang
Sheng's works. Although this [boneless] manner has
existed ever since the T'ang, Sung, and Yüan Dynasties,
I have only occasionally come across such a picture.
Among these, the concept is but slightly used, and most
must be faulted for a labored, meticulous style. Never
before have I seen one in which the modelling strokes
and tinted washes have been melded together complete-
ly in heavy color. Truly, this technique may be said to be
the most marvelous of all time. Had Wen-min not picked
it out, it would have perished in obscurity without fur-
ther transmission. Now, Ssu-weng's efforts have yielded
something new through the old. I have in all seen five of
his works in this technique, all of which are excellent;
but I consider this hanging scroll the most attractive."

An Ch'i's remarks make it clear that Tung Ch'i-ch'ang
became engrossed in the ancient manner he had discov-
ered and that he painted at least six versions of land-

243

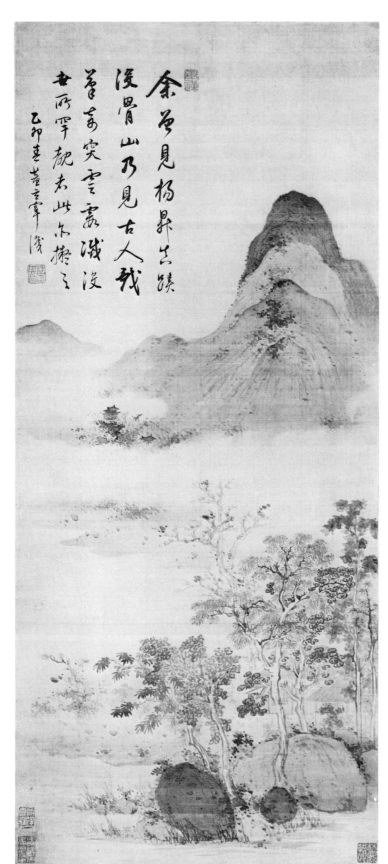

190

scape in this technique–the one recorded by An Ch'i and the other five that he had seen. An Ch'i's seals on the Nelson Gallery scroll are in good order, making it apparent that at some time this version was also in his collection.

KSW

Literature
P'ang, *Hsü-chai* (1909), *ch.* 8, p. 4.
Shina Nanga taisei, (1935-37), IX, pl. 171.
Kawakami, "Tō Ki-shō" (1955), pp. 36-38, pl.1.
Shodō zenshū (1954-61), XXI, 17, fig. 23.
Kawakami, "Min Shin ga no shiryō" (1963), p. 33, pl. 3.
Mei-shu, no. 36 (July 1969), cover illus.
Wu et al., *Jo I, Tō Ki-shō* (1978), p. 168 pl. 24.

Exhibitions
Tokyo Imperial Museum, 1928: *Tō-Sō-Gen-Min*, II, pl. 356.

Recent provenance: P'ang Yüan-chi; Teijirō Yamamoto; Ch'eng Ch'i; Mayuyama and Co.

Nelson Gallery-Atkins Museum 58-46

Tung Ch'i-ch'ang

191 *River and Mountains on a Clear Autumn Day (Chiang-shan ch'iu-chi)*

Handscroll, ink on Korean paper, 38.4 x 136.8 cm.

Artist's inscription and signature at left: Huang Tzu-chiu's [Huang Kung-wang's] *River and Mountains on a Clear Autumn Day* is like this. It is indeed regrettable that the old Masters cannot see mine. Ssu-weng.

4 colophons, 2 additional inscriptions, and 35 seals: 2 colophons and 10 seals of Kao Shih-ch'i (1645-1704); 1 colophon and 4 seals of Sung Lo (1634-1713); 1 colophon and 2 seals of Shao Ch'ang-heng (1637-1704); 2 inscriptions and 14 seals of the Ch'ien-lung emperor (r. 1736-95), 1 seal of the Chia-ch'ing emperor (r. 1796-1820); 3 seals of the Hsüan-t'ung emperor (r. 1909-11); 1 seal unidentified.

First inscription by Kao Shih-ch'i:
Whenever Tung Wen-min [Tung Ch'i-ch'ang] came across any Korean paper with its mirror-smooth surface, his calligraphy and painting would become particularly

inspired. This handscroll was originally a paper used for memorializing the emperor [Wan-li, r. 1572-1620]. The traces of characters are still visible, as is the seal of the Korean [king]. His brushstrokes are rounded and elegant, developed directly out of Ni [Tsan] and Huang [Kung-wang]. How could Shen [Chou] and Wen [Cheng-ming] be compared with him?

On the day after the mid-autumn festival [the sixteenth day of the eighth lunar month], in the *keng-wu* year of the K'ang-hsi era [1690], the weather is clear. The remounting has just been finished. I inscribe the colophon at P'ing-lu.

Second inscription by Kao Shih-ch'i:

On the twenty-third day of the ninth month, the *chia-hsü* year of the K'ang-hsi era [1694], I packed my bags to head north. When my boat passed Wu-ch'ang [Suchou], Mr. Man-t'ang [Sung Lo] brought wine to bid me farewell so that we could share our thoughts on our separation in the last few years. I showed him the paintings and calligraphy which I collected and asked his opinions. Since Mr. Man-t'ang does not own any handscrolls by Wen-min [Tung Ch'i-ch'ang], I leave this one for him in commemoration of our parting; thus the painting will have a worthy owner and our meeting will become a beautiful story in the future. It is the fourth day after the beginning of winter, with the sky clear and sober. Trees under frost have turned red and yellow, seemingly echoing the brush and ink in the painting. I also ask Mr. Man-t'ang to inscribe a poem to commemorate our meeting so that it will survive forever.

Colophon by Sung Lo:

Who is the foremost art connoisseur of our dynasty?
T'ang-ts'un [Liang Ch'ing-piao, 1620-1691] is dead, so the title passes to Chiang-ts'un [Kao Shih-ch'i].
Leaving office, you retired for five years in the Lake region.
Fondling handscrolls and hanging scrolls from morning to evening.
You sent me your collection catalogue *Hsiao-hsia lu* last year;
It is indeed the true equal of [Chou Mi's] *Yün-yen kuo-yen.*

This year you returned to the capital by imperial order;
Your boat with calligraphy and paintings anchored at the river bank in Suchou.
When we met each other you did not waste any time for conversation but poured out immediately
From your "coral net" extraordinary treasures.
You produced incomparable scrolls, with gold-inscribed labels and jade rollers,
Pouring out from bags and trunks, they were spread in disarray.
Without a word, I rolled and unrolled until my fingers were numbed,
We sat straight, facing each other quietly, and never felt tired.
For three days we forgot about sleeping and food.
And at times we shouted our joy out loud, forgetting who is host or guest.
Your *Dwelling in the Fu-ch'un Mountains* and the *Yüan-sheng* manuscript
These peerless works I myself examined with delight.
As an added pleasure to the farewell dinner under the Maple Bridge,
You allowed me to hold again this handscroll by Tung Ch'i-ch'ang–
The *Misty River and Piled Peaks* [by Chao Meng-fu], and this *Clear Autumn Day* are two extraordinary masterpieces.
In showing such life and spirit with "ch'i-yün," the artists were truly "men of heaven."
The *Clear Autumn Day* is not even three feet long,
Painted on tributary Korean paper, it shines like silver.
Every building up and every turn of the mountains imitates nature,
Every tree and every rock is removed from the commonplace.
From the beginning, the theory of poetry is the theory of painting,
Like the lotus and the morning sunshine, they complement and refresh each other.
The artist's inscription regrets that "the Old Masters cannot see my scroll."

191

Huang Kung-wang would have agreed in his grave.
The vermilion of the seals glitter and dazzles the eyes,
These added accessories are as valuable as jade.
You are very kind to give it to me,
The feelings expressed in your inscription are so sincere.
Wanting to refuse, but unable, I accept it to respect
 your wish,
And taking off my gown and cap I wrapped it with care.
You asked me to write a long poem in commemoration
 of this beautiful occasion,
I am too ashamed that my effort in response is so poor
 and inadequate.
Returning home, I unrolled it under candlelight, trying
 to write the colophon,
The light of the waning moon shines at the foot of the
 mossy wall.
Earnestly humming and brows knit in deep thought, I
 try to compose;
The verses are not outstanding, but the facts are real.
With this poem recorded at the end of the scroll, I mail it
 to you for approval,
This poem and this painting shall outlast a thousand
 springs.

[signed] The old man herding ducks at the Western
Mountain slope, Sung Lo.

<div align="right">trans. LYSL/HK/WKH</div>

Remarks: The long and significant colophons by the famous collectors Kao Shih-ch'i and Sung Lo make further comment rather superfluous. Still, one should remark upon the designation of the recently deceased Liang Ch'ing-piao as the greatest of seventeenth-century collectors–an evaluation one can readily support since no less than twelve paintings in the Cleveland collection were owned, and in many cases saved, by Liang. It is also worth underlining the evaluation of this handscroll by Kao and Sung–placing it with masterpieces by Chao Meng-fu and Huang Kung-wang and above the achievements of Shen Chou and Wen Cheng-ming. The simplicity of Tung's composition reinforces the impact of the varied ink tones. If one can speak properly of "essences," then this handscroll is a distillate of Tung's hard-won intellectual and moral victory in the sensuous medium of painting. It should be compared with the complex and monumental hanging scroll (cat. no. 192) to arrive at a just and sympathetic understanding of the art of Tung Ch'i-ch'ang.

<div align="right">SEL</div>

Literature
Shih-ch'u II (1793), *ch.* 38, pp. 53(b)-54(a).
Ch'en Jen-t'ao, *Ku-kung* (1956), p. 24(a).
Lee, *Chinese Landscape Painting* (1962), pp. 86, 87, no. 66; idem, *Far Eastern Art* (1964, 1973), p.439, fig. 580.
W. Fong, "Orthodox Master" (1967), illus. p. 135; idem, "Structural Analysis" (1969), p. 7, pl. VIII-B; idem, "Tung Ch'i-Ch'ang" (1969), pl. V; idem, "Wang Hui" (1969), pl. I.
Contag, *Chinese Masters* (1970), p. 16, pl. 15.
Lee, "Water and Moon" (1970), p. 50, fig. 8.
Sullivan, *Three Perfections* (1974), p. 39, figs. 21 (detail), 22.
Cahill, "Chūgoku kaiga-I" (1975), fig. 2.
CMA *Handbook* (1978), illus. p. 352.
Wu et al., *Jo I, Tō Ki-shō* (1978), pp. 167, 168, pl. 23, seal p. 157.
Capon, *Chinese Painting* (1979), p. 44.
Cahill, *Compelling Image* (forthcoming).

Exhibitions
Haus der Kunst, Munich, 1959: *1000 Jahre*, cat. no. 64.
Cleveland Museum of Art, 1960: Chinese Paintings, no catalogue.
Smith College Museum of Art, Northampton, Mass., 1964: Fifteen Chinese Paintings from The Cleveland Museum of Art, no catalogue.

Asia House Gallery, New York, 1967: Cahill, *Fantastics and Eccentrics*, cat. no. 2.
Asia House Gallery, New York, 1974: Lee, *Colors of Ink*, cat. no. 32.
Fogg Art Museum, Cambridge, Mass., 1979: The Compelling Image: Nature and Style in Seventeenth-Century Chinese Painting, no catalogue.

Recent provenance: Wang Chi-ch'ien.

The Cleveland Museum of Art 59.46

Tung Ch'i-ch'ang

192 *The Ch'ing-pien Mountains
(Ch'ing-pien shan t'u)*

Hanging scroll, dated 1617, ink on paper, 224.5 x 67.2 cm.

Artist's 2 inscriptions, signatures, and 2 seals:

A painting of the Ch'ing-pien Mountains in the manner of Pei-yüan [Tung Yüan].

In the summer of the *ting-ssu* year [1617], on the last day of the fifth month, [I] send this to my senior, Chang Shen-ch'i. Tung Hsüan-tsai [seals] Chih-chih-kao jih-chiang-kuan; Tung yin Ch'i-ch'ang.

Second inscription:

Piling irons for ten thousand feet guard the purple sky;
Where puppies are seen on top of clouds, villages and
 marketplaces lie.
In the splendor of autumn, where is the most worthy
 spot to spend the day?
Amid the rustling sounds of mountain streams, with a
 volume in hand, meditating on the Way [Tao].

Inscribed by Ch'i-ch'ang. trans. WKH/LYSL

4 additional seals: 3 of Li Yün (n. d.); 1 of Weng Wan-go (20th c.).

Remarks: The puppies in the second line of Tung's poem are a reference to the legend of Prince Liu An of the Han Dynasty, who rose to be an immortal and brought with him his whole household, including chickens and dogs. In Tung's collected literary work the character for "small dog" was corrected to read "chicken and dog" in accordance with the original story.

In size and complexity, the only hanging scroll by the artist comparable to this example is the one in the National Palace Museum, Taipei, *In the Shade of Summer Trees (Chinese Art Treasures*, 1960, no. 104). *The Ch'ing-pien Mountains is*, in a sense, the reverse of the *Summer Trees* scroll. The middle section, both as a flat surface and as suggested mass in space, is solid and projects into the viewer's space, while the Taipei work emphasizes the lower and upper parts of the picture, producing a hollow where there is projection in the Cleveland painting. Both works reveal that probing intensity, chilling and forbidding to many, characteristic of the great innovator of the seventeenth century.

The inscriptions on both paintings refer to Tung Yüan. Certainly that giant of the Five Dynasties period can be seen to have influenced the sizes of the scrolls; the clear, monumental intention; the vocabulary of foliage representation; and the peculiar, small, rolling plateaus in the folds of the mountains. But the homage to Tung is primarily an intellectual and qualitative one. The genius of Tung Ch'i-ch'ang lies in the absolutely unmistakable imprint of his willful and overreaching personality on his work, which looks like no other creative work before or after him.

<div align="right">SEL</div>

Literature
Sirén, *Masters and Principles* (1956-58), VII, *Lists*, 247.
Lee, *Chinese Landscape Painting* (1962), no. 67.
N. Wu, "Tung Ch'i-ch'ang" (1962), pl. 4.
Goepper, *Essence* (1963), pls. 61-63.
Lee, *Far Eastern Art* (1964, 1973), p. 439, fig. 581.
Cahill, "Chūgoku kaiga-I" (1975), color pl. 2 (detail).
Wu et al., *Jo I, Tō Ki-shō* (1978), p. 170, pl. 38 (color), pl. 39 (detail), p. 157 (seals).
Sullivan, *Symbols of Eternity* (1979), p. 134, pl. 80.
Cahill, *Compelling Image* (forthcoming).

Exhibitions
Haus der Kunst, Munich, 1959: *1000 Jahre*, cat. no. 63.
Asia House Gallery, 1967: Cahill, *Fantastics and Eccentrics*, p. 19, cat. no. 1.
Fogg Art Museum, Cambridge, Mass., 1979: The Compelling Image: Nature and Style in Seventeenth-Century Chinese Painting, no catalogue.

Recent provenance: Wan-go H. C. Weng

The Cleveland Museum of Art 80.10

Li Liu-fang, 1575-1629, Ming Dynasty
t. Ch'ang-heng, *h.* T'an-yüan; from Hsi-hsien, Anhui Province, moved to Chia-ting, Chiangsu Province

193 *Thin Forest and Distant Mountains
(Shu-lin yüan-shan)*

Hanging scroll, dated 1628, ink on paper, 114.3 x 40.3 cm.

Artist's inscription, signature, and 2 seals:

Thin forest and distant mountains have always attracted me;
As if they were from the brush and ink of Ni Tsan, left behind by the master in this mortal world.
Now that the quiet recluse has chosen to live in the South of the City,
He paints the spring breeze—over a curve of the river.

In the spring day of the *wu-ch'en* year [1628] I made this painting and attached an old poem. Li Liu-fang [seals] Li Liu-fang-yin; Chang-heng shih.

trans. WKH

1 additional seal of Chung Wen-ming (17th c.).

Remarks: The artist's inscription mentions Ni Tsan, and although the tall trees and the thatched hut are gentle reminders of that master, this rough and abbreviated painting owes more to Tung Ch'i-ch'ang (cat. no. 192) in its arbitrary ink play and to Tung Yüan in the soft and rounded contours of the mountains. But the composition is somewhat banal, and the ink play, though wet and free, is rather monotonous in the similar weights of ink assigned to all areas of the picture. The summary execution may well be due to failing health or lack of concentration on the artist's part, since this is his last-known dated work, painted the year before his death.

SEL

Literature
Harada, *Shina* (1936), pl. 674.
Liu Hai-su, *Ming-hua* (1936), III, pl. 59.
Sirén, *Later* (1938), I, *Lists*, 220.
Cheng Chen-to, ed., *Yü-wai-so-ts'ang* (1947), ser. 6, pt. 3, pl. 39.
Sirén, *Masters and Principles* (1956-58), V, 46, 47; VII, *Lists*, 208.
Lee, *Chinese Landscape Painting* (1962), p. 89, fig. 88.
Goepper, *Essence* (1963), pp. 74, 77, 218, pls. 68, 69 (detail).
Lee, *Far Eastern Art* (1964), p. 440, fig. 582.

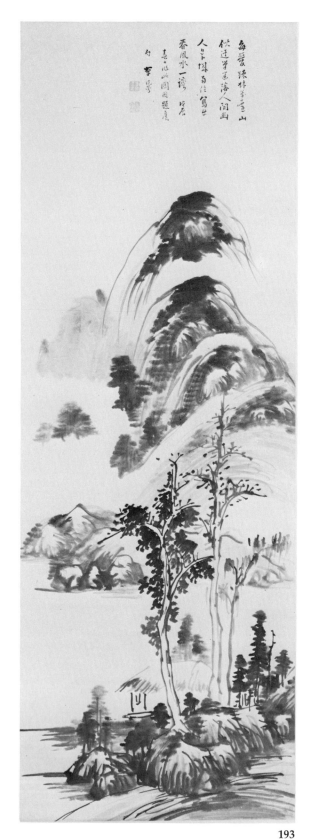

毎覺陳林未老山

供迷筆墨落人間画

人品俱高落人間画

香風水一灣 菴

丁酉山圖圖題

193

Exhibitions
Tokyo Imperial Museum, 1928: *Tō-Sō-Gen-Min*, II, 360.
Cleveland Museum of Art, 1954: Lee, *Chinese Landscape Painting*, cat. no. 71.
Haus der Kunst, Munich, 1959: *1000 Jahre*, cat. no. 71.
Cleveland Museum of Art, 1960: Chinese Paintings, no catalogue.
Asia House Gallery, New York, 1974: Lee, *Colors of Ink*, cat. no. 33.

Recent provenance: Shinozaki Collection; Howard C. Hollis.

The Cleveland Museum of Art 53.630

Ku T'ien-chih, active ca. 1649, Ming-Ch'ing
 Dynasty
t. Tung-lu; from Hua-t'ing, Chiangsu Province

194 *Landscape in the Style of Huang Kung-wang
 (Fang Ta-ch'ih shan-shui)*

Handscroll, dated 1649, ink and light color on paper,
25.5 x 717.5 cm.

Artist's inscription, signature, and 3 seals:
[1 seal] P'ao-yin shan-fang.

Wu Li-fu [the Yüan philosopher Wu Lai, 1297-1346]
said: "If in the mind there are not ten thousand books or
in the eyes are not the wondrous mountains and rivers
of the world, then one is probably not capable of creative
writing." I would say the same applies to painting. I
have studied the Tao for ten years, as lonely as a se-
cluded monk. I travelled only as far north as Chin-ling
[Nanking] and as far south as Ch'ien-t'ang [Hangchou].
All the beautiful scenery in the world would not be
enough to satisfy me. So when I finish this scroll, I'll
pack up my brush to seek the mountains, travelling light
and carefree as a wandering Buddhist monk.

 Recorded by Tung-lu in the *chi-ch'ou* year [1649], fif-
teenth day of the tenth month. [2 seals] Ku yin T'ien-
chih; Tung-lu. trans. LYSL/HK/WKH

2 additional inscriptions, 5 colophons, and 15 additional
seals: 1 inscription and 1 seal of Ku Ying-kuang (16th-
17th c.); 1 inscription and 3 seals of Shan Hsün (17th c.?);
4 colophons and 8 seals of P'ei Ching-fu (1854-after
1924); 1 colophon of Hu Pi-ch'eng (19th-20th c.); 3 seals
unidentified.

Colophon by Shan Hsün:

The Ku clan has been known in the world for its excel-
lence in painting. After [Ku] K'ai-chih, the Taoist and
Buddhist subjects by [Ku] Te-ch'ien, the figure paintings
by [Ku] Pao-kuang and [Ku] Hung-chung, the flowers
by [Ku] Ching-hsiu and [Ku] Yeh-wang, were all high
peaks in the park of painting in their own times. As for
specialists in landscape painting, Mr. Chi-yüan must be
considered a true master of the present age. The Tung-lu
brothers were deep-rooted in their family tradition, but
each modified that tradition with their own innovations.
This handscroll by Tung-lu is so somber and remote [in
concept] and elegant and lustrous [in execution] that it
has already gone beyond the limit of the "wondrous"
class and entered the "untrammelled" category. If this
painting is placed in the forest of art treasures of the Ku
family, it may well be compared with the poetry of
[Hsieh] Hsüan-hui [464-499, Southern Ch'i Dynasty],
[the best] among the three Hsieh brothers. Tung-lu
should treasure this for his own enjoyment. Don't let
the rascal and bully swindle it away from you–as hap-
pened to [Wang Hsi-chih's] *Preface to the Orchid
Pavilion.*

 On the day of cold stove [day before the Ch'ing-ming
Festival], in the *keng-yin* year [1650], inscribed leisurely
by Shan Hsün.

 trans. WKH

Remarks: Ku T'ien-chih's inscription is an indirect
"apology" for his work. Since he had not yet viewed
"the wondrous mountains and rivers beneath the
heavens," and had only studied in seclusion like a medi-
tating monk (literally "a monk who has sworn off walk-
ing"), he could not be expected to produce a good
painting.

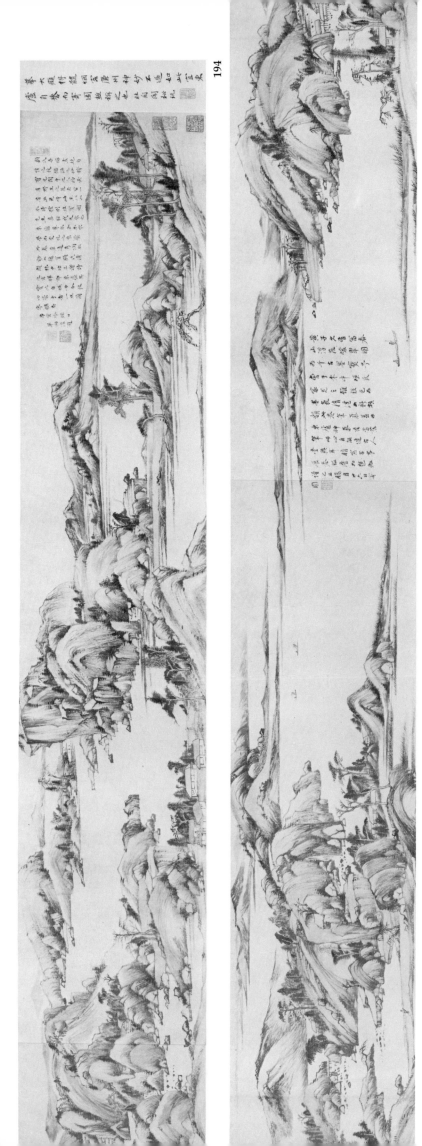
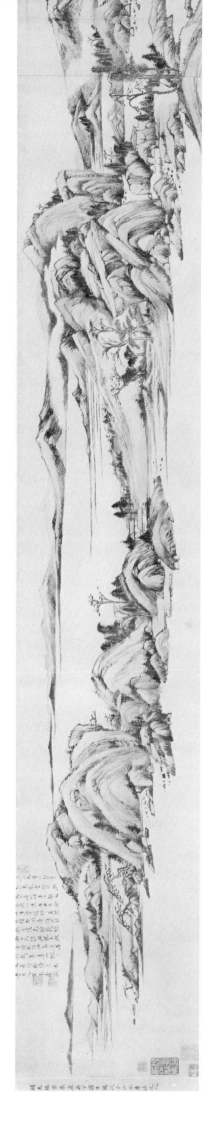

Ku T'ien-chih represents the third generation of his family connected with the artistic life of Hua-t'ing. His great uncle, Ku Cheng-i (act. 1575-96), in company with fellow townsmen Tung Ch'i-ch'ang (see cat. nos. 190-192), Mo Shih-lung (act. 1552-87), and Ch'én Chi-ju (1558-1639), established the town's preeminence as a regenerative force in Chinese painting. Ku T'ien-chih, in turn, was the pupil of his uncle, Ku Yin-kuang, himself a student and nephew of Ku Cheng-i. Thus Ku T'ien-chih fell heir to the philosophical and artistic theories formulated by Tung Ch'i-ch'ang and the first generation of Hua-t'ing painters (Cahill, *Restless Landscape*, 1971, pp. 90-94). Ku's stylistic debt to them is readily apparent in his solid structuring of individual forms and clear articulation of the formal relationships between them. However, the intellectual emphasis to be found in some works by Tung himself is here greatly softened by Ku's involvement with the purely visual properties of subtle color and sensuous line, an interest that relates him to the Yün-chien school of Chao Tso and Shen Shih-ch'ung.

Ku T'ien-chih does not mention the source of inspiration for this handscroll, one of his few known works; however, his uncle, Ku Yin-huang, credits Huang Kung-wang in his laudatory colophon on this work. Ku T'ien-chih appropriated the Yüan master's "hemp fiber" strokes, severely simplified architecture and tree forms, and then, following the practice of Tung Ch'i-ch'ang,

combined these specific motifs to form a vast river landscape of interlocking water voids and mountain solids that stretches across the long scroll. The result is a quite individual statement, more angular and extended in its masses than either Kung-wang's surviving *Fu-ch'un Mountain* scroll (*Three Hundred Masterpieces*, 1959, IV, pl. 161), or Tung Ch'i-ch'ang's variation on Huang's style (see cat. no. 191). Finally, Ku's use of light color–decorative alternations of soft gray-blue and light orange applied to the mountains, touches of deeper red in the trees and architecture–provides an unusual counterpoint to the normally monochrome world painted by the Hua-t'ing masters. Over a century later, the orthodox painter Wang Yüan-ch'i (see cat. no. 251) painted his own colored variation after the Yüan master, but he organized hues to complement the inherent structure of the mountains rather than in the decorative manner of his predecessor, Ku T'ien-chih. HK/HR

Literature
P'ei, *Chuang-t'ao-ko* (preface 1924), XVI, 37(a)-38(b).
Rosenzweig, "A Landscape Handscroll" (1974-75), p. 49, fig. 14.
Hochstadter, *Compendium* (forthcoming).

Exhibitions
University Art Museum, Berkeley, Calif., 1971: Cahill, *Restless Landscape*, cat. no. 41.

Recent provenance: P'ei Ching-fu; Walter Hochstadter.

The Cleveland Museum of Art 70.3

194 Detail

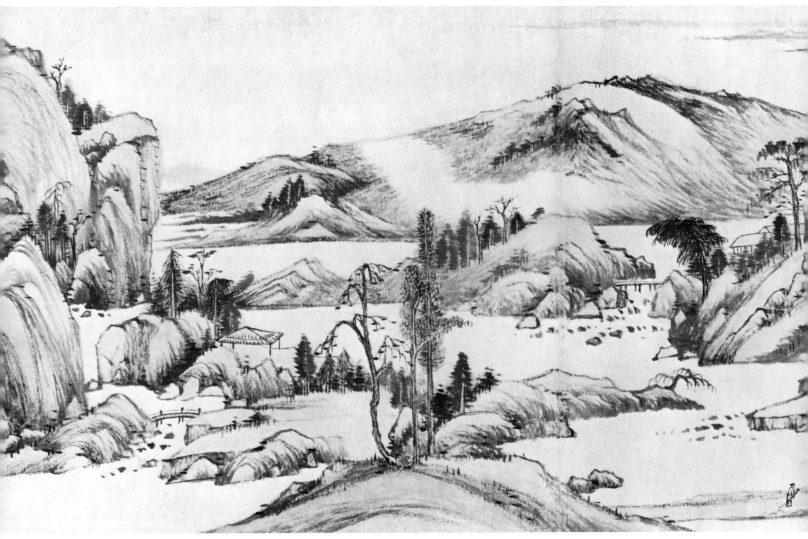

250

Hsiang Sheng-mo, 1597-1658, Ming Dynasty
t. K'ung-chang, *h.* I-an; from Chia-hsing,
Chechiang Province

195 *Meditative Visit to a Mountain Retreat*
(Yen-ch'i ssu-fang)

Handscroll, dated 1648, ink on paper, 30.5 x 273 cm.

Artist's title and 3 seals (in front of painting): Meditative Visit to a Mountain Retreat. [seals] T'ien-lai-ko-chung wen-sun; Hsiang shih K'ung-chang tsui-hsin han-mo; Ch'ing-fu-yüan-chung ti-i-miao-yeh.

Artist's inscription, signature, and 5 seals (at end of painting): [2 seals] T'u-wu-shou; K'ao-ku cheng-chin.

Look at this person–how carefree he is;
He is not carefree but yearning for his friend.
Yearning for his friend who is at the other side of the
 horizon,
Longing to visit him, but it seems so remote to turn
 my head.
Pine or cypress? You are known for your endurance;
Where, in grottos hidden by misty rain, is your haven?
Mountains after mountains and waters after waters,
 how far away is this man,
So far beyond reach that I wonder if it's possible to
 communicate even in spirit.
Rivers and mountain passes all but obscure my view.
No one now whom I can talk to and laugh with together.
Ask the swimming fish at what depth dwells their
 happiness.
Ask the flying birds to what grove they are returning.
Ask the gibbons and cranes how closely they are related.
Ask the deer and swine who are shorter or longer lived.
Ask the white clouds where they are from.
Ask the rustling spring where it is going.
Ask the fishermen and woodcutters who owns these
 rivers and mountains.
Ask the plants and woods what measures their acres
 and hectares.
Ask the spring and autumn seasons why the heat and
 the cold.
Ask the mortals how long their world will last.
Ask the sun and moon what separates the dark and
 the light.
Have they ever seen the Old Man of Crow and Hare
 from the days gone by?

In the *wu-tzu* year [1648], at the beginning of the twelfth month, I happened to do this painting, so did the inscription. Hsü-ch'ao, Hsiang Sheng-mo [3 seals] T'u-wu-sou; Hsiang shih K'ung-chang; Wei-sang ssu-wen.

 trans. LYSL/WKH

13 additional seals: 4 of T'ang Tso-mei (late 18th-early 19th c.); 3 of Chang Pai-hsi (19th c.?); 4 of Chang Heng (1915-1963); 2 unidentified.

Remarks: The combination of the two radicals, sun and moon, makes the character "ming" a thinly-veiled hint at the fallen house of Ming. This is hardly accidental, in view of the name "Old Man of Crow and Hare," meaning the "Old Man of Sun and Moon," which appears in the last sentence of the poem–a name used by Hsiang Sheng-mo himself, probably after the dynastic change as a gesture of his deeply felt nostalgia and loyalty. A seal with the same legend, obviously for self-identificaton, is applied on the upper right corner of the poem.

This well-preserved handscroll is most characteristic of Hsiang's detailed, dry style: the opening passage with

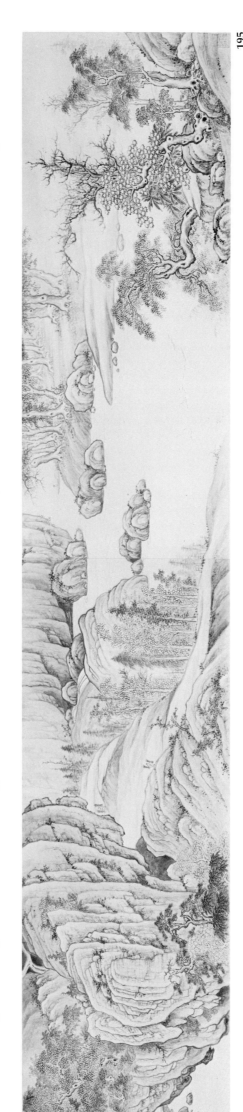
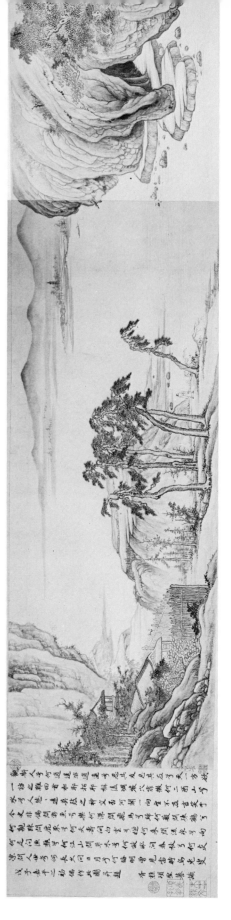

its sharp leafage distinctions and the final scene with the pine grove (the artist was known as Hsiang Sung– "Hsiang the Pine") are classic expressions of this style. Further, there is a strong dependence on Sung paintings (perhaps those in the extensive and famous collection of Hsiang's grandfather, Hsiang Yüan-pien), not as mere copying, but rather in the careful observation and realism attempted in the details of the landscape as well as the Sung style of the architecture at the end of the scroll. Finally, there is Hsiang's characteristic shading of ink tones and atmospheric perspective which may well be due to the influence of Western engravings (see Cahill, *Restless Landscape*, 1971, p. 15, and Sullivan, "Sources of European Influence," 1972, pp. 603-10). Connections between Nanking and Chia-hsing in Chechiang, especially artistic ones, were not impossible.　　　SEL/WKH

Literature
Cheng Chen-to, *Yün-hui-chai* (1947), pls. 90, 91.
Li Chu-tsing, "Hsiang Sheng-mo" (1976), pp. 549, 550 (p. 558 in English summary), fig. 12.

Exhibitions
University Art Museum, Berkeley, Calif., 1971: Cahill, *Restless Landscape*, cat. no. 10.
Asia House Gallery, New York, 1974: Lee, *Colors of Ink*, cat. no. 35.

Recent provenance: T'ang Tso-mei; Chang Heng; Wang Chi-ch'ien.

The Cleveland Museum of Art　62.42

Lan Ying, 1585-ca. 1664, Ming Dynasty
t. T'ien-shu, *h.* Tieh-sou; from Ch'ien-t'ang, Chechiang Province

196 *Chih and Hsü's Pure Conversation (Chih-Hsü ch'ing-yen t'u)*

Hanging scroll, dated 1643, ink on paper, 140.8 x 55.9 cm.

Artist's inscription, signature, and 2 seals:

In the Six Dynasties there were many extraordinary people,
They all retreated into Taoism and Buddhism.
[The Buddhist monk] Chih-tun and the Taoist Master Hsü [Hsün]
Were quite compatible with each other in ideas and temperament.
Beneath aged pines and ancient cliffs
They would engage for the whole day in lofty conversation.
Worldly ambition they pitched like a stone into the flowing water,
Instead, they would rather enjoy their own company in search of good poetry.
Worldly affairs should be left outside of the world–
This I understand, even though we are separated by a thousand autumns.

195 Detail

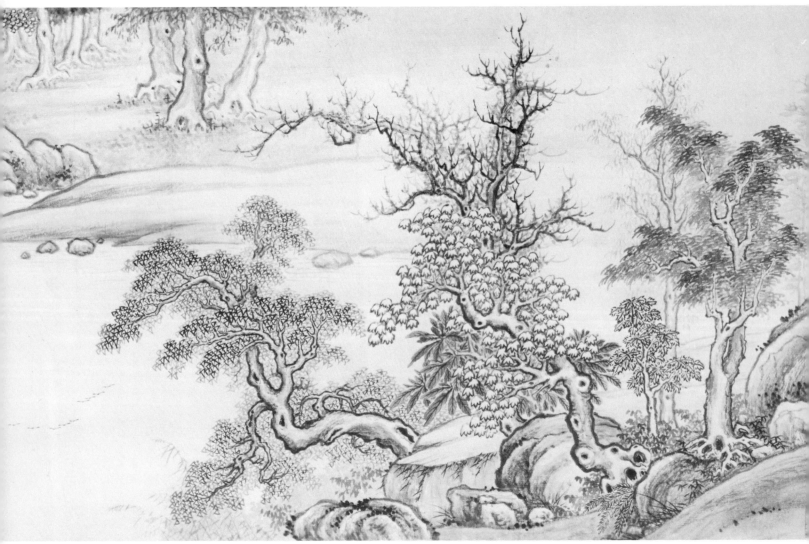

The Ch'an master Wu-yün is a man of high moral attainments and does not involve himself with worldly affairs. He takes pleasure in landscape, enjoys literature. The older he gets, the more energetic he becomes. I am well acquainted with this priest; so I have done this "Shih and Hsü in Pure Conversation" begging for his instruction.

Tieh-sou, Lan Ying, in the *kuei-wei* year [1643], at the end of the seventh month. [seals] Lan Ying chih yin; T'ien-shu fu.

<div align="right">trans WKH/HK</div>

2 additional seals of Ch'eng Ch'i (20th c.).

Remarks: In his poetic inscription Lan Ying states that during the Six Dynasties certain recluses followed the Tao, others, Buddhism. He cites as examples the Eastern Chin-period monk Chih-tun (314-366) and the layman Hsü Hsün, two contemporaries who lived in the Nanking area and participated in a philosophical dialogue aimed at exploring the metaphysical similarities within the Taoist literature of Chuang-tzu and the Wisdom *(prajñā)* Sutras of Buddhism (see K. Ch'en, *Buddhism in China*, 1964, pp. 65-68). Following the poem, Lan writes that he depicted these two sages engaged in "pure conversation" as a gift to his friend, the Ch'an monk Wu-yün. Thus, the figure to the right, dressed in the robes of a Buddhist monk, must be Chih-tun, while the figure to the left would be Hsü Hsün. Evidently this is meant to be understood as an analogy of the friendship between the artist and Priest Wu-yuň.

The brushwork of this monochrome work is quite compatible with that of the colored Mi-style landscape (see cat. no. 197) — wet and free but descriptive and conventional — a compromise that attests to Lan Ying's historical positon as a late exemplar of the "professional" and "academic" Che school. HK/LYSL/WKH

Literature
Ch'eng, *Hsüan-hui-t'ang* (1972), II, 117(b)-118(a).

Exhibitions
New York, Asia House Gallery, 1974: Lee, *Colors of Ink*, cat. no. 34.

Recent provenance: Ch'eng Ch'i; Stephen O. K. Chen.

The Cleveland Museum of Art 70.128

Lan Ying

197 *Clearing Autumn Mists in the Ch'u Mountains (Ch'u-shan ch'iu-chi)*

Hanging scroll, ink and light color on silk, 184 x 48.9 cm.

Artist's inscription, signature, and 2 seals: Clearing Autumn Mists in the Ch'u Mountains, painted in the manner of Mi Hai-yüeh [Mi Fu]. Hsi-hu wai-shih, Lan Ying [seals] Lan Ying Chih-yin; Shih-wu t'ou-t'o.

Remarks: Lan Ying is usually considered the last representative of the Che school by nature of his birth and domicile in Hangchou and his professional status as an artist. Yet like other seventeenth-century painters, Lan Ying was heir not only to the wet-and wash-laden illustrations of the Che painters from Hangchou but also to the dry-ink manner of the Wu school in Suchou, or its Tung Ch'i-ch'ang variation at Hua-t'ing; even to the novelty of Western art, which was arriving in China in company with the missionaries (Cahill, *Restless Landscape*, 1971, p. 15, cat. no. 81).

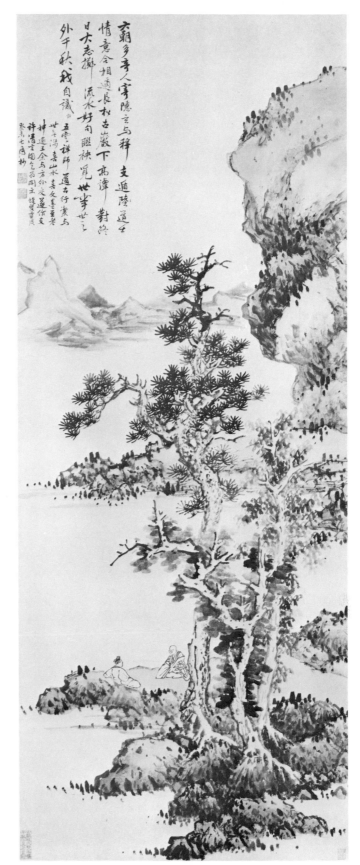

196

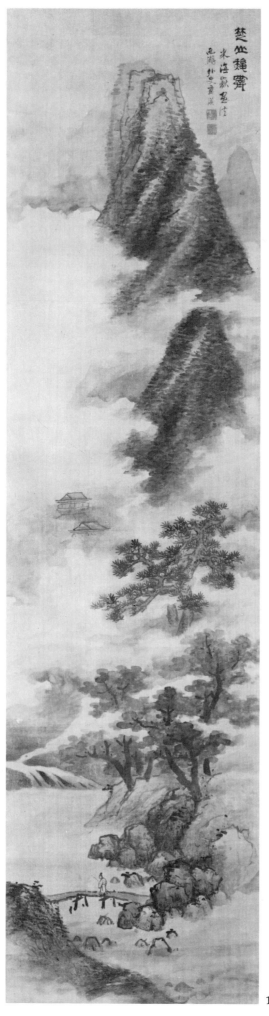

197

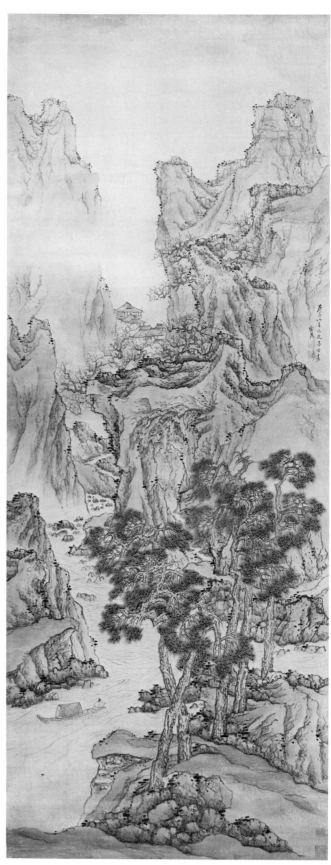

198

In his inscription on *Clearing Autumn Mists in the Ch'u Mountains,* Lan states that he used the the Mi Fu method of painting. All that remains from that Sung master are the ovoid "Mi" dots which shape the cloud-enveloped mountains and foreground tree grove. The "wet" ink and delicate colored washes which unify the whole surface of the composition likewise only dimly allude to the decorative conventions of Che school painting.

Despite the versatility and invention that works such as this display, Lan failed to found a school of any kind, although Ch'en Hung-shou (see cat. nos. 206-208) was reputedly his pupil. His eclectic use of earlier styles no doubt fell from fashion when the Orthodox school of the Four Wangs came to dominate early Ch'ing painting. A large number of his works survive in Japan, where his paintings were copied and adapted by the Nanga painters. HK

Recent provenance: Hugh Moss.

The Cleveland Museum of Art 71.23

Liu Tu, active ca. 1632-75, Ming Dynasty
 t. Shu-hsien; from Ch'ien-t'ang, Chechiang
 Province

198 *The Peach-Blossom Spring*
(T'ao-hua-yüan t'u)

Hanging scroll, dated 1650, ink and light color on satin, 136.7 x 52.2 cm.

Artist's inscription, signature, and 2 seals at middle right edge: In the tenth month of the *keng-yin* year [1650], painted in imitation of Chao Ch' eng-chih [Chao Meng-fu]. Liu Tu [seals] Liu Tu chih yin; Shu-hsien.

2 additional seals of Liu Tso-ch'ou (20th c.).

Remarks: Liu Tu, according to his biography (Hsia, *T'u-hui...hsü-chüan,* 1519, ch. 2, p. 17), "was from Ch'ien-t'ang [Hangchou]. His landscapes imitated Northern Sung [masters], especially Li Ying-ch'iu [Ch'eng]." The biography goes on to say that Liu was the only successor of Ch'iu Ying who was skillful in many formats, and in copying old masters.

The comparison with Ch'iu Ying is illuminating, for the output of both artists must in no small part have been designed to meet the growing demand from collectors for paintings done in the style of, or even with the names of, the classic T'ang, Sung, and Yüan masters. Their hands can yet be recognized in a number of works still attributed to the earlier masters in whose styles and names the paintings were done.

The wide range of Liu's earlier models was probably set by Lan Ying (see cat. nos. 196, 197), his Hangchou teacher. His certain favorites, however, were Li Ch'eng, whose wintry trees were transformed into vibrant, lively surfaces, and Chao Meng-fu, whose archaistic excursions into the colored styles of T'ang and Sung provided ample historical justification for Liu's own richly colored works. By mid-century this pleasing and difficult-to-achieve combination of historical overtones with decorative beauty had gained Liu considerable renown – such, in fact, that some maintained he had even surpassed his teacher. After that time, he seems to have painted less and to have repeated compositions that perhaps found special favor with his clientele.

While Liu writes in the inscription that he painted this work in imitation of Chao Meng-fu, actually Lan Ying

and his Che school predecessors are the sources for the soft washes and evenly balanced web of nervous brushwork in this painting. HR/HK

Recent provenance: Liu Tso-ch'ou.

The Cleveland Museum of Art 71.227

Sheng Mao-yeh, active ca. 1607-37, Ming Dynasty
 t. Nien-an, *h.* Yen-an, Yu-hua; from Ch'ang-chou,
 Chiangsu Province

199 *Lonely Retreat Overlooking a Misty Valley*
(Ku-mu yu-chü)

Hanging scroll, dated 1630, ink and slight color on silk, 181.2 x 93 cm.

Artist's inscription, signature, and 2 seals: In the tenth month of the *keng-wu* year of the Ch'ung-chen era [1630]. Sheng Mao-yeh [seals] Sheng yin Mao-yeh; Yü-hua shih.

4 additional seals of Liu Shu (1759-1816).

Remarks: Despite a significant number of extant paintings and a discussion of their merits in contemporary biographical notices, little is known about the life of Sheng Mao-yeh. Apparently a professional painter by trade, he was heir to the Wu school traditions of his native Suchou. At the same time, his early association with the painter Ting Yün-p'eng (see cat. nos. 202, 203) also exposed him to the artistic milieu of Tung Ch'i-ch'ang and the Hua-t'ing school. Sheng's *Lonely Retreat Overlooking a Misty Valley* therefore reflects a curious amalgam of source material, such as the pines of both Wen Cheng-ming and Tung Ch'i-ch'ang, which Sheng transformed into his own manner of painting. The portly figure in the mountain hut–the same, somewhat humorous type which peoples other of his landscapes–reflects the influence of his Suchou contemporary, Li Shih-ta.

Although praised in contemporary late Ming painting treatises, Sheng Mao-yeh's paintings lacked the tight discipline of brush and compositional formats necessary to endear him to the orthodox tradition of Ch'ing China. His penchant for grotesque figures and uninhibited brushwork parallels the Nanga painters of Japan, where the majority of his works are preserved. HK

Literature
Sirén, *Masters and Principles* (1956-58), VII, *Lists,*231.
Lee, *Chinese Landscape Painting* (1962), no. 69.
Goepper, *Essence* (1963), pp. 176, 224, pls. 70, 71.
Lee, *Far Eastern Art* (1964, 1973), p. 440, fig. 583 (as *Lonely Retreat Beneath Tall Trees*).

Exhibitions
Cleveland Museum of Art, 1954: Lee, *Chinese Landscape Painting,* cat. no. 72.
Haus der Kunst, Munich, 1959: *1000 Jahre,* cat. no. 73.

Recent provenance: Walter Hochstadter; Richard B. Hobart.

The Cleveland Museum of Art 61.88

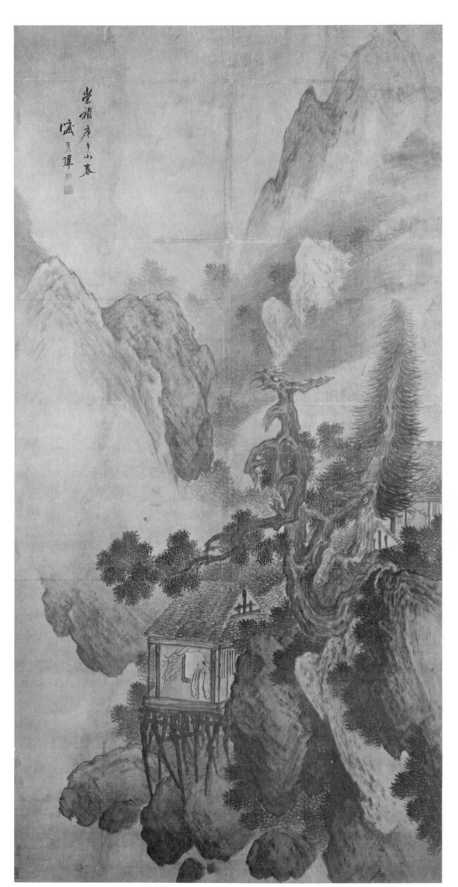

T'ao Hung, active ca. 1610-40, Ming Dynasty
t. Ch'iu-shui, *h.* Yen-shan; from Hunan Province, moved to Nanking, Chiangsu Province

200 *Clouds Visiting a Mountain Retreat*
(Fang Kao Shang-shu yün-shan t'u)

Hanging scroll, dated 1633, ink on silk, 176.4 x 100.3 cm.

Artist's inscription, signature, and 2 seals: Imitating Kao Fang-shan's [Kao K'o-kung's] brush at Liu-yün-ho [Valley of Lingering Clouds] during a spring day in the *kuei-yu* year [1633]. Yen-shan, T'ao Hung [seals] T'ao Hung chih-yin; tzu Ch'iu-shui. trans. WKH

1 additional seal unidentified.

Remarks: Very little is known of T'ao Hung's life. Recent research by Wai-kam Ho indicates that he was a contemporary of Sheng Mao-yeh (see cat. no. 199), who settled in Nanking in the latter part of his life. His son is known to have been a friend of Kung Hsien (cat. nos. 213-217), the leader of the Nanking school. When the Ming Dynasty collapsed in 1644, T'ao joined the loyalist resistance in Yunnan. By 1645 the Manchu conquerors of China finally defeated the Yunnanese resistance forces, forcing T'ao to flee to Burma, where he died shortly thereafter.

Only five of T'ao Hung's works have so far been identified: a series of four album leaves–one in New York and the remainder in Cleveland private collections–establish him as a master of detail on a small scale. The sharply defined rocks, trees, bamboo, and water grasses set within the misty, graded-wash landscapes of these leaves recall Sung academic conventions. T'ao's only large-scale landscape presently known is this *Clouds Visiting a Mountain Retreat*, dated 1633. T'ao constructs his fog-bound mountains with a dense accumulation of ovoid ink dots, a landscape style first defined by the Northern Sung masters Mi Fu and Mi Yü-jen (see cat. no. 24). Their style was revived during the Yüan period by Kao K'o-kung, who is mentioned in T'ao's inscription as his model for this painting. T'ao expands the brush vocabulary of that tradition with his rhythmic repetition of short, vertically oriented dots to form foliage, and arched connecting strokes to form marsh grasses. The resulting ink mosaic–very different from his sharply focused album leaves–parallels the early work of his contemporary, Ch'en Hung-shou, from Chechiang (see cat. no. 206), the paintings of Sheng Mao-yeh in Suchou (see cat. no. 199), and presages the work of the Nanking master Kung Hsien. HK

Literature
Lee, "To See Big within Small" (1972), p. 322, figs. 68, 69.
Vanderstappen, "Seventeenth Century" (1976), p. 155, fig. 4.
Exhibitions
Asia House Gallery, New York, 1974: Lee, *Colors of Ink*, cat. no. 37.

Recent provenance: Tseng Hsien-chi.

The Cleveland Museum of Art 71.19

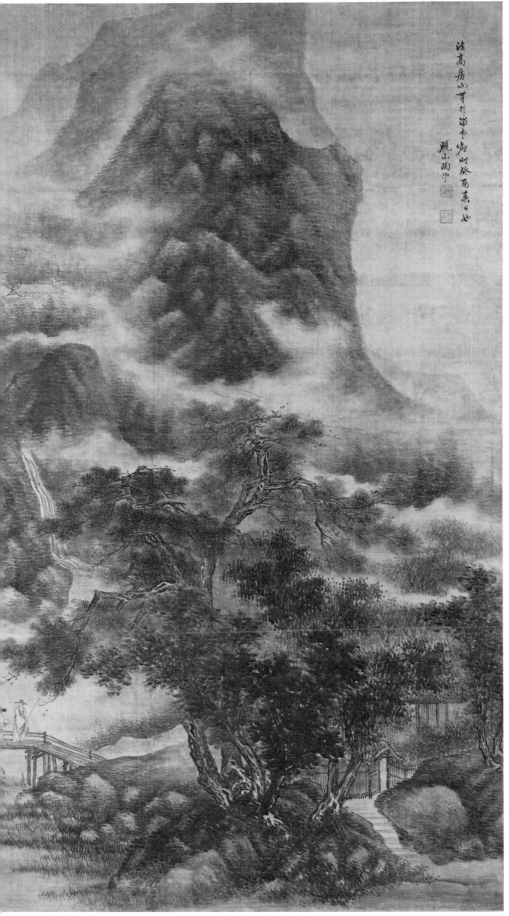

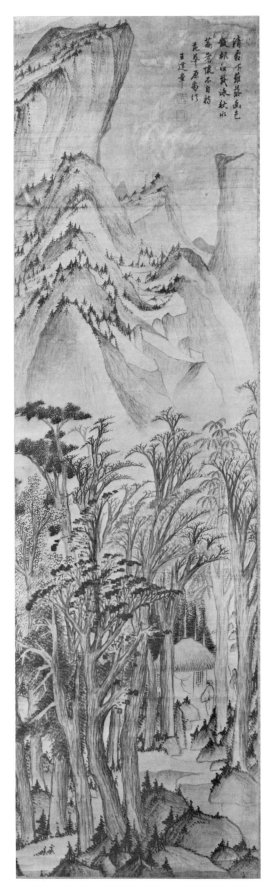

201

257

0

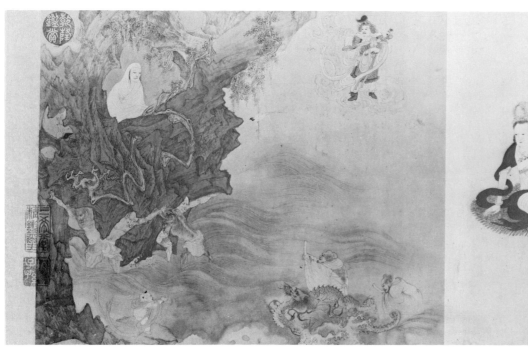
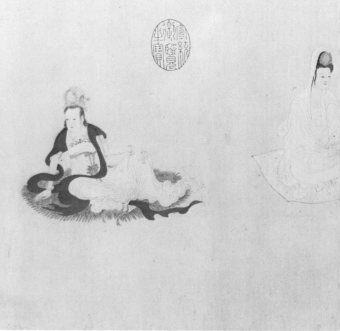

Wang Chien-chang, active ca. 1628-44, Ming Dynasty
t. Chung-ch'u, *h.* Yen-t'ien; from Ch'üan-chou, Fuchien Province

201 *Solitary Colors of the Autumn Woods (Ch'iu-lin yu-se)*

Hanging scroll, ink and light color on satin, 178 x 51.2 cm.

Artist's inscription, signature, and 2 seals:

Cold frost falls on the fences,
Solitary colors scatter on the maples.
Reciting the chapter of "The Autumn Water,"
I cannot still the emotion in my old heart.

> After the style of Fan Hua-yüan [Fan Kuan], Wang Chien-chang [seals] Wang shih chih yin; Chien-chang.
> trans. LYSL/HK/WKH

Remarks: The poem by the artist speaks of things associated with autumn, including "The Autumn Water" by Chuang-tzu (ca. 369-286 B C; see *Chuang Tzu,* 1964, pp. 96-110) and the aging of the artist.

The monumental style of the great early Northern Sung master Fan K'uan, cited by Wang as his stylistic source, can dimly be seen in this eccentric work. Admittedly, the two-part composition with no middle ground and the high, "towering" location of the mountains do go back to Fan's compositions as known through the great hanging scroll in Taipei (*Three Hundred Masterpieces,* 1959, no. 64). Perhaps the bareness of the trees, their striated trunks, and the small triangular bushes (like miniature fir trees) also allude to Fan–or at least were what Wang had in mind in mentioning him. Indeed, the sketchy and simplified nature of the present work, when compared with the more ambitious finished works cited by Sirén (*Masters and Principles,* 1956-58, VII, *Lists,* 250, 251), confirms its personal and informal character. SEL

Literature
Vanderstappen, "Seventeenth Century" (1976), p. 155, figs. 4, 5.

Recent provenance: Shogoro Yabumoto.

The Cleveland Museum of Art 72.68

Ting Yün-p'eng, 1547-ca. 1621, Ming Dynasty
t. Nan-yü, *h.* Sheng-hua chü-shih; from Hsiu-ning, Anhui Province

202 *Five Forms of Kuan-yin together with the Complete Lung-yen Sutra Written by Yü Jo-ying (Ting Yün-p'eng hua wu-hsiang Kuan-yin Yü Ro-ying shu Leng-yen-ching ch'üan-pu ho-pi)*

Handscroll, ink, color, and gold on paper: painting 28 x 134 cm., sutra 25.7 x 420.5 cm.

1 inscription, 1 colophon, and 20 seals: 1 inscription on the painting by Tung Ch'i-ch'ang (1555-1636); 1 colophon, dated 1626, following the sutra by Tung Ch'i-ch'ang; 2 seals of Wang T'ing-wu (17th c.); 14 seals of the Ch'ien-lung emperor (r. 1736-95); 1 seal of the Chia-ch'ing emperor (r. 1796-1820); 3 seals of the Hsüan-t'ung emperor (r. 1909-11).

Remarks: Ting Yün-p'eng's authorship is attested by the character and quality of the painting and by Tung Ch'i-Ch'ang's inscription, which reads: "Ting Nan-yü [Ting Yün-p'eng] painted this when he was staying at Ku Cheng-hsin's pavilion in Sung-chiang. He was [at that time] over thirty [*sui*] and the skill [exhibited here] is marvelous. From this time on he was never so skillful and he became careless. This is comparable to the change in Tu Fu's poetry after he entered Ssuch'uan. Ch'i-ch'ang" (National Palace Museum, Taipei, *Style Transformed,* exh. cat., 1978, p. 24).

Assuming Ting Yün-p'eng to have been around thirty-two or thirty-three *sui,* the scroll would have been painted about 1579 or 1580. This would place it in the same period, or only slightly later, as that of an album in the National Palace Museum, Taipei (curiously signed Ting Yün-t'u, but certainly by Ting Yün-p'eng) painted for Ku Chung-hsü between 1577 and 1587. There are a number of similarities between this album and the Nelson Gallery scroll, notably the striking composition of a white-robed figure seated in a cave on a rocky promontory surrounded by waves (ibid., pl. 002-1, p. 54).

The *Leng-yen-ching (Sūrangama Sūtra)* that follows the painting was copied in fly-head standard script by Yü

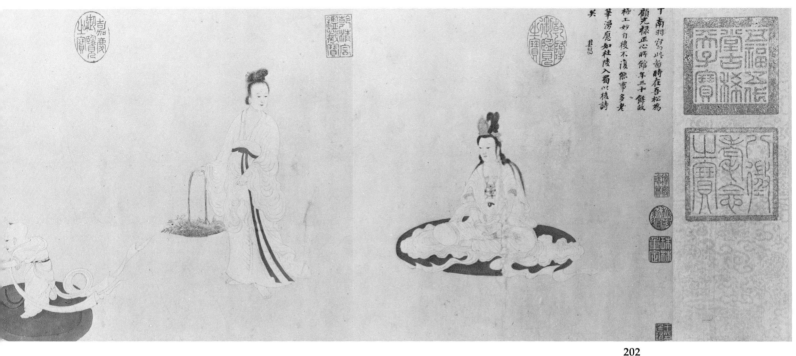

202

Jo-ying in 1584. This date, however, has no bearing on the date of the painting. It is most probable that the two were joined after 1626 by the dealer Wang T'ing-wu, whose seal appears on both the painting and the sutra. Had the two parts been joined when Tung Ch'i-ch'ang wrote a colophon for Wang T'ing-yu at the end of the sutra in 1626, Tung would certainly have mentioned the painting. Since both the Kuan-yin painting and the sutra had comments by Tung Ch'i-ch'ang and both were Buddhist in theme, Wang probably conceived the idea of having them mounted together.

The artist's selection of five forms and of the particular manifestations in the painting appears to have been arbitrary; some of them are from the iconography of a popular cult of Thirty-Three Forms of Kuan-yin.

All of the figures are distinctly feminine. The first, bejeweled and dressed in a white robe, is seated, her hands resting in her lap. The second figure, standing to the left, is without jewels and carries a basket containing a fish; this form is based on a Chinese folk tale of Kuan-yin's manifestation as Yü-lan, a maiden who sold fish and was the patron deity of mariners. The third figure is seated cross-legged on a white rug, the body, hands, and feet completely covered by a white robe that is also drawn up over the hair. At the lower left, Sudhana, the young religious prodigy and pilgrim, stands on a red mat facing Kuan-yin, his hands clasped and his head bowed in adoration. The meeting has a scriptural basis in the *Gandavyūha* section of the *Avatamsaka Sūtra* (Fontein, *Pilgrimage of Sudhana*, 1966, pp. 10, 101). The fourth form of the divinity is seated in the "royal ease" pose (*mahārajālila),* the left arm resting on the left flexed knee, the right hand pressing the ground. She is heavily jeweled, and the crown is of a kind frequently found on wood-sculptured images of Kuan-yin from the twelfth and thirteenth centuries. The figure turns slightly toward the left and introduces the fifth and climactic form of Kuan-yin.

A rocky promontory or island, supported by four semi-human demons, emerges from turbulent waves. Kuan-yin peers out from a cave festooned with gnarled and hanging vines. This is the Kuan-yin of Potalaka, the earthly home, off Southern India, of the bodhisattva. The manifestation is closely related to the iconography of the Water-Moon Kuan-yin (see cat. no. 67) and of the White-Robed Kuan-yin (see cat. no. 66). A surprising aspect is that Kuan-yin is shown as a woman advanced in years, completely wrapped in a white garment, strands of hair hanging about her face, her mouth drawn down in an unusual expression of severity. Golden rays emanate from the body and spread out over the entrance to the cave above. On the right, a red-billed parrot clings to a vine, and on the left, through an opening in the rock wall, a *kundika* bottle containing a willow branch and a text bound in red are visible. These attributes suggest two of the Thirty-Three Forms of Kuan-yin — that of holding a willow branch and that of holding a sutra. Wei-t'o, one of the guardian kings, stands on a cloud at the upper right, and at the lower left the young Sudhana appears again, bowing with hands raised. In the foreground where a dragon rears from the waves, the Dragon King and an attendant, clasping court sceptres, pay honor to Kuan-yin.

The drawing is done in a fine line of even width and, with the exception of the last figure, each form is isolated against a plain ground. The coloring is simple in the extreme, limited to red, green, white, and a sparse use of gold. The even line, wide spacing of the figures, and empty ground are a unique revival late in the Ming Dynasty of a manner perfected by the great master Li Kung-lin (ca. 1040-1106). The third among the figures of Kuan-yin, seated and entirely enveloped in a white robe is remarkably similar, though reversed, to a White-Robed Kuan-yin engraved on a stone in 1132 after an ink drawing by Li Kung-lin (Hackin et al., *Asiatic Mythology,* 1932, p. 345). Ting Yün-p'eng's skillful archaism, derived from a source so deeply revered by the literati, easily accounts for Tung Ch'i-ch'ang's admiration. LS

Literature
Pi-tien II (1793), *ch.* 3, p. 101a.
Sirén, *Masters and Principles* (1956-58), V, 60; VI, pl. 309.
Akiyama et al., *Chūgoku bijitsu* (1973), II, 253, pl. 88.
Oertling, "Ting Yün-p'eng" (1980), pp. 222, 249, 251, 276, 309, figs. 62, 63.

259

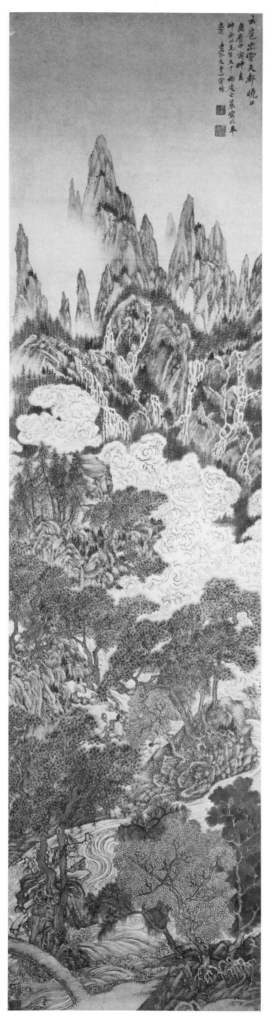

Exhibitions
San Francisco Museum of Art, 1957: Morley, *Asia and the West*,
 no. 18w, p. 34.
University Art Museum, Berkeley, Calif., 1971: Cahill, *Restless
 Landscape*, cat. no. 79, p. 148, pl. 156.

Recent provenance: C. T. Loo & Co.

Nelson Gallery-Atkins Museum 50-22

Ting Yün-p'eng

203 *Morning Sun over the "Heavenly Citadel"
(T'ien-tu hsiao-jih)*

Hanging scroll, dated 1614, ink and light color on
paper, 212.7 x 55.4 cm.

Artist's inscription, signature, and 2 seals:

Clouds arise from the dale of the "Dark Plateau,"
The morning sun is over the peak of the Heavenly
 Citadel.

In mid-spring of the *chia-yin* year of the Wan-li era
[1614], painted as a fiftieth birthday present to Mr.
Chung-lu. Junior Friend of Family Alliance, Ting Yün-
p'eng [seals] Yün-p'eng chih yin; Ting Nan-yü.

10 additional seals: 5 of Kao Hsiang-ling (dates un-
known); 5 unidentified.

Remarks: Born in southern Anhui, Ting Yün-p'eng
learned the art of painting from his father, an amateur
painter. By 1577 Ting settled in Sung-chiang (Hua-t'ing),
taking up residence at a Ch'an monastery. There he fre-
quented the local literary circle of Tung Ch'i-ch'ang,
Ch'en Chi-ju, and Mo Shih-lung. He was praised by
Tung in numerous colophons for his figure paintings of
Buddhist and Taoist figures (see cat. no. 202). Ting Yün-
p'eng collaborated with Sheng Mao-yeh on the same
subject (Cahill, *Restless Landscape*, 1971 , cat. no. 78). He
was also well versed in landscape.

In the artist's inscription, "Dark Plateau" refers to a
mountain in western Shenhsi, sacred to Taoism and
associated with the legendary Yellow Emperor. The
"Heavenly Citadel" is the sobriquet of the second high-
est peak within the Mt. Huang complex in Anhui (Li
Chi, *Travel Diaries*, 1974, p. 73). The famous mountain
appears within the background of the painting, its nee-
dle-like peak in roseate hue reflecting the dawning sun.

The poem was meant to flatter the recipient of the
painting. The first line implies that the gentleman's com-
passion as a government official was like the clouds that
herald saving rains for the farmer. The sunrise in the
second line intimates that even at the height of the
man's career, a rewarding life still awaits him at age fifty.
In its low-key color washes, charred ink tones, and lim-
ited vocabulary of texture strokes, Ting's 1614 land-
scape displays a conservative literati quatity which dif-
fers greatly from his early work. The foreground com-
position of this painting appears to be a variation of that
found in his *Lofty Mount Lu*, painted in 1575, now in the
National Palace Museum, Taipei. In both paintings, a
raging river zigzags up the surface of the picture, pass-
ing beneath an arching footbridge at the bottom and
skirting a land wedge in the upper foreground which
supports seated figures. However, the tightly controlled
serpentine lines that trace the river rapids and the thick-
er seal-script variety that fill the clouds, are both found
in the figural subjects which made him famous.

HK/LYSL

Literature
Shina (1935-37), III, fasc. 7, p. 2.
Sirén, *Later* (1938), I, Lists, 234; idem, *Masters and Principles*
(1956-58), VII, Lists, 242.
Akiyama et al., *Chūgoku bijutsu* (1973), II, pt. 2, 225, 226,
color pl. 26.
CMA *Handbook* (1978), illus. p. 356.
Oertling, ''Ting Yün-p'eng'' (1980), pp. 271, 348, 350, 410,
fig. 47.

Exhibitions
Wildenstein Galleries, New York, 1949: Dubosc, *Ming and
Ch'ing,* cat. no. 32.
Palazzo Ducale, Venice, 1954: Dubosc, *Mostra,* cat. no. 842.

Recent provenance: Chin Ch'uang-sheng; Jean-Pierre Dubosc.

The Cleveland Museum of Art 65.28

Wu Pin, active 1591-1626, Ming Dynasty
t. Wen-chung, h. Chih-yin, Chih-hsien; from
 P'u-t'ien, Fuchien Province

204 *Greeting the Spring*
 (Ying-ch'un t'u)

Handscroll, dated 1600, ink and light color on paper,
34.9 x 245.1 cm.

Artist's inscription, signature, and seal at upper right
corner: Painted in the mid-winter of the *keng-tzu* year
[1600], Chih-yin, Wu Pin [seal] Wen-chung.

9 additional seals: 5 of the Ch'ien-lung emperor (r. 1736-
95); 3 of the Chia-ch'ing emperor (r. 1796-1820); 1 of the
Hsüan-t'ung emperor (r. 1909-11).

Remarks: The Fuchien painter Wu Pin was active as a
court painter in Nanking in the early years of the Wan-li
era (1573-1600). Subsequently, he may have become a
Buddhist monk. In the 1620s he was humiliated and
imprisoned because of critical remarks about the eunuch
Wei Chung-hsien. His reputation among his contempor-
aries was based on his originality in drawing and beauti-
ful coloring, but his recent appreciation in the West is
largely due to the fantastic and grotesque flavor which
pervades his surviving landscape and figural composi-
tions (cf. cat. no. 205).

Greeting the Spring, painted in 1600, is one of Wu Pin's
few dated works which survive to document his activi-
ties at the Wan-li court. At least three earlier landscape
traditions are quoted in the painting. From opening to
close, successive mountains and hills allude in surface
treatment to Huang Kung-wang, Wang Meng (see cat.
no. 111), and T'ang Yin (see cat. nos. 162, 163). Despite
these self-conscious juxtapositions, the whole composi-
tion is remarkably unified. A thread of continuity is pro-
vided by a similarity in scale between accumulating tex-
ture strokes and minutely depicted figures.

Human activity throughout supports the painting's
identification with a traditional festival which, since the

204 Detail

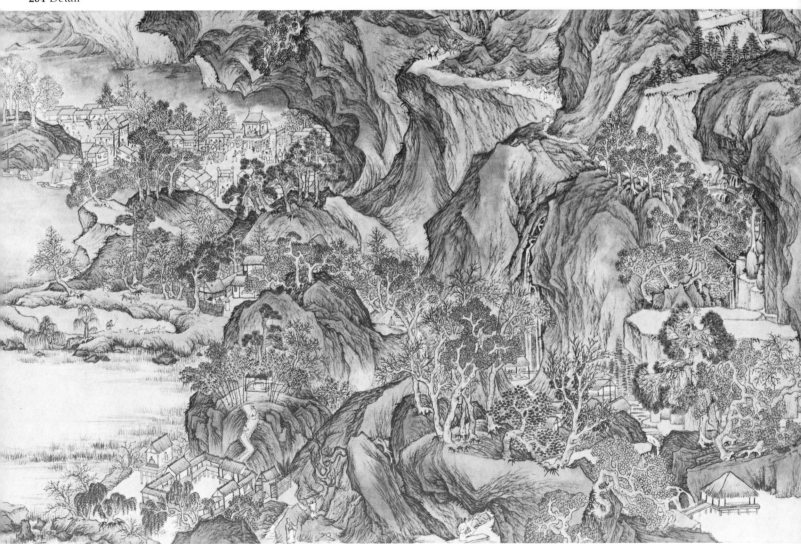

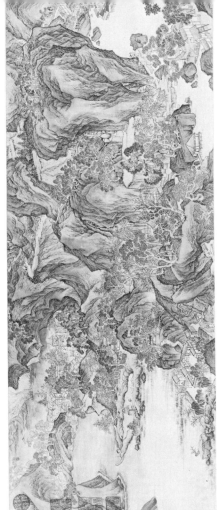

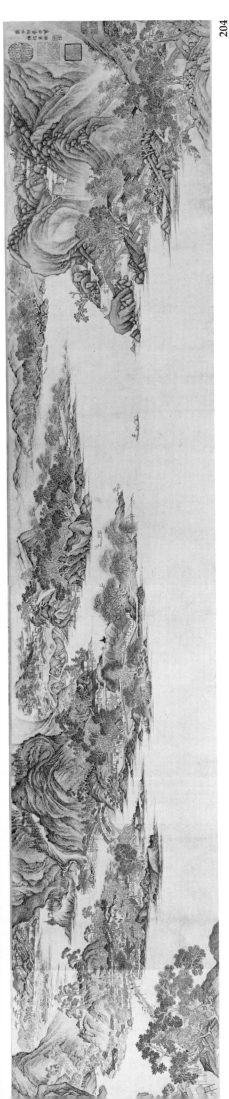

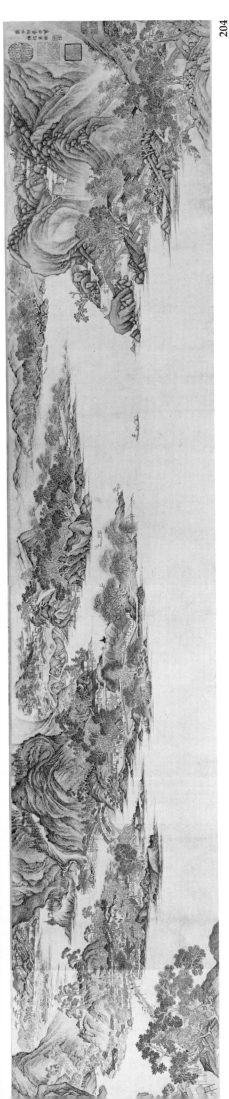

Han period, normally fell around early February. In order to "Greet the Spring," it was common practice for villagers to wheel a clay ox into the square and then whip it with sticks. Beating the ox was thought to stimulate the fruitfulness of spring for the village (Burkhardt, *Chinese Creeds*, 1958, pp. 11-15; Bodde, *Festivals*, 1975, pp. 204 ff.). The ritual is re-enacted here by officials cloaked in the blue color of spring who have just pulled the ox across the bridge into a square in front of a temple. The long bridge is filled with officials in state garb and farmers shouldering their scythes. Other officials and the villagers, armed with poles, surround the cart in the square which supports the ox. The activity of a festival continues at the end of the scroll, where a play is being performed on a raised stage in another village square.

Analogous themes, enacted in an equally minute scale, appear in Wu's *Diversions of the Twelve Months* in the National Palace Museum, Taipei (Cahill, "Wu Pin," 1972, pls. 6-12). Also common to both works is the decidedly conservative rendition of landscape elements. On the other hand, Wu Pin's earliest-dated landscape (of 1591) and a Buddhist figure painting completed only a year after *Greeting the Spring* are already replete with the unnatural landscape formations and grotesquely humorous figures so typical of the majority of his surviving works (ibid., figs. 1, 17). Cahill notes that the deep space which Wu Pin constructs within these works has no parallel among his contemporaries– either Wu meant to revive the cityscapes teeming with human activity painted in the Sung period, or he meant to incorporate into the native tradition new spatial possibilities illustrated in European religious prints which missionaries brought to Nanking at the turn of the seventeenth century (ibid., pp. 646-50). HK/LYSL

Literature
Shih-ch'ü III (1816), Ch'ien-ch'ing-kung, *ch.* 11, p. 573.
Hu, *Hsi-ch'ing* (1816), *ch.* 4, p. 31(b).
Ch'en Jen-t'ao, *Ku-kung* (1956), p. 23(a).
Sirén, *Masters and Principles* (1956-58), VII, *Lists,* 269.
Lee, *Chinese Landscape Painting* (1962), no. 75, color pl. V (detail).
Goepper, *Essence* (1963), pp. 47, 222, color pl. XIII (detail), pl. 76 (detail).
Lee, *Far Eastern Art* (1964), p. 441, fig. 585.
Speiser, *Chinese Art* (1964), IV, 54, pl. 23.
Sullivan, *Chinese and Japanese* (1965), pp. 85, 86, color pl. on p. 191 (detail).
Auboyer, *Oriental World* (1967), p. 106, no. 69.
Cahill, "Wu Pin" (1972), p. 639, fig. 5.
CMA *Handbook* (1978), illus. p. 352 (detail).
Hochstadter, *Compendium* (forthcoming).

Exhibitions
Haus der Kunst, Munich, 1959: *1000 Jahre,* cat. no. 70.
Cleveland Museum of Art, 1960: Chinese Paintings, no catalogue.
Osaka Museum of Fine Arts, Expo, 70, 1970: *Bankoku-haku,* IV, cat. no. 47.

Recent provenance: Walter Hochstadter.

The Cleveland Museum of Art 59.45

Wu Pin

205 *The Five Hundred Arhats*
(*Wu-pai lo-han t'u*)

Handscroll, ink and light color on paper, 33.7 x 2345.2 cm.

Artist's inscription, signature, and 50 seals: Chih-yin t'ou-t'o, Wu Pin purified his heart and respectfully painted. [2 seals] Wu Pin chih yin; Wen-chung fu. [48 seals on painting] Wen-chung fu (repeated 26 times); Wu Pin chih yin (repeated 22 times).

13 additional seals: 7 of the Ch'ien-lung emperor (r. 1736-95); 6 of Ch'eng Ch'i (20th c.).

Remarks: The closest parallels to the style and subject matter of this handscroll are the hanging scroll of six lohan in a landscape with a dragon and two warriors (guardians?), dated 1601, and the album of the twenty-five Universal Buddhas of the *Sūrangama Sūtra* of the same year, both in Taipei (Cahill, "Wu Pin," 1972, pp. 655-57, figs. 17-19). Cahill's advocacy of the artist's originality in landscape is confirmed by the inventiveness of his figure style. The gnarled and grotesque character of Wu's figures, presented in an even, thick, wire-like brush line, are surely derived from the T'ang and Five Dynasties conventions of artists such as Yen Li-pen and Kuan Hsiu. The same manner is adopted by his contemporary, Ting Yün-peng (see cat. no. 202) and two significant artists of the next generation, Ch'en Hung-shou (see cat. nos. 207, 208) and Ts'ui Tzu-chung (see cat. no. 209). The available pictorial documents put Wu

Pin's usage first, probably before Ting and certainly before Ch'en and Ts'ui. Wu's earliest arhat painting is 1583; Ting's, 1585. The latest work of Wu is the *Washing the Elephant* of 1621; the latest of Ting's extant works is 1638. This important archaistic revival and transformation was a part of the reaction against contemporary mores and events made even more specific in the second generation that witnessed the triumph of the foreign Manchus in 1644. It might be noted, particularly in relationship to Cahill's postulation of Western influence on Wu Pin's landscapes, that there is no trace of shading in the figure delineations of any of these four strange masters. Probably the most complex of the artist's figural compositions, this scroll maneuvers five hundred and nineteen figures, plus assorted animals, hybrids, and mythical beasts through their paces to achieve a unified but individually diverting sequence of disciples of the Buddha. There are depicted, literally, five hundred disciples, one Kuan-yin, and eighteen attendants. The result is one of the most inventive and amusing assortment of characters known in Chinese painting. SEL

Literature
Pi-tien II (1793), *ch.* 4, p. 55(b).
Ch'en Jen-t'ao, *Ku-kung* (1956), p. 40(a).
CMA *Handbook* (1978), illus. p. 351 (detail).

Exhibitions
University Art Museum, Berkeley, Calif., 1971: Cahill, *Restless Landscape,* cat. no. 77.

Recent provenance: Ch'eng Ch'i.

The Cleveland Museum of Art 71.16

205 Detail

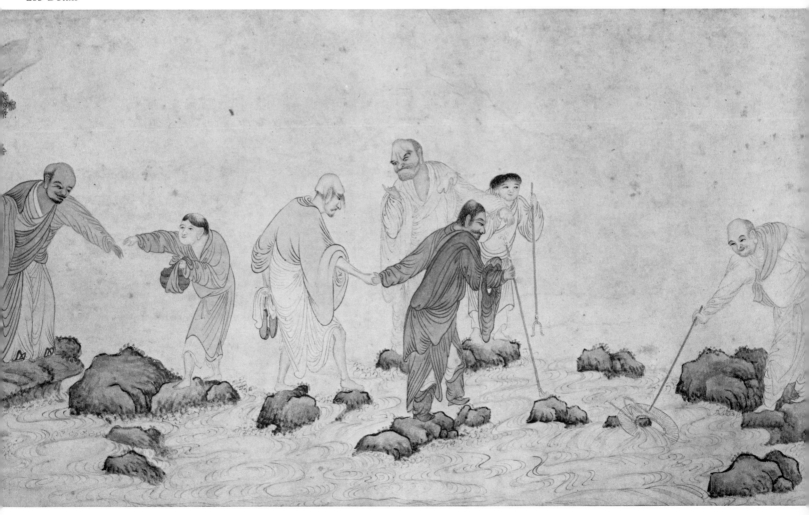

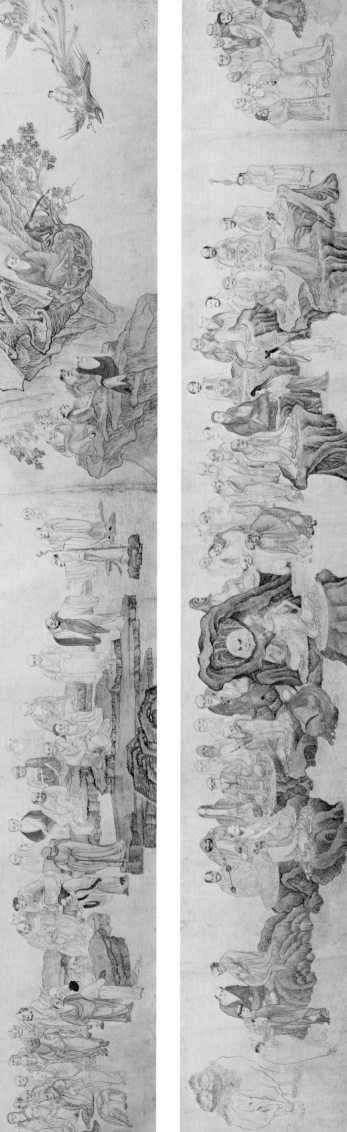

Ch'en Hung-shou, 1598-1652, Ming Dynasty
 t. Chang-hou, *h.* Lao-lien, Fu-ch'ih, and others;
 from Chu-chi, Chechiang Province

206 *The Mountain of the Five Cataracts*
 (Wu-hsieh shan)

 Hanging scroll, ink on silk, 118.3 x 53.2 cm.

Artist's signature and seal at middle right edge: Hung-shou [seal] Chang-hou.

1 inscription and 6 additional seals: 1 inscription and 5 seals of Kao Shih-ch'i (1645-1704); 1 double seal (undecipherable).

Inscription by Kao Shih-ch'i:

The Mountain of the Five Cataracts is bordered by three prefectures–Wu [Chin-hua], Hang[Hangchou], and Yüeh [Shao-hsing]–and is quite close to Chi-yang [Chu-chi] in Yüeh. The landscape there is extraordinary and precipitous, with ridges and peaks standing in circles. Rocks of strange shapes gaze down everywhere, while maple and bamboo provide shade. The water from five pools overflows and is suspended in five steps–that is why it is called "Five Cataracts." Hsieh Hsüan-ch'ing [Hsieh T'iao, ca. 464-499]of the Ch'i Dynasty gathered medicinal herbs here; Tiao Yo [11th century] of the Sung Dynasty also visited here; Sung Lien [1310-1381] and Hsü Wei [1521-1593] both wrote travel notes about the place; and Ch'en Hung-shou painted here. His mountains are done in the style of the Six Dynasties masters; the trees are after those of Tung Yüan [Five Dynasties]–the painting seems to be richly imbued with the primeval spirit. Hsü Wei said that the grotto is unique for the shade *(yin)* and the five cataracts unusual for the sun *(yang)*. There are seventy-two peaks, with a ravine between two cliffs. At times they are bright and at other times, gloomy; sometimes they seem to be open, sometimes closed, yet often border uniquely between shady *(yin)* and sunny *(yang)*. Chang-hou [Ch'en Hung-shou] really succeeded in capturing that spirit.

As a young man indulgently boating through Shan-yin
 [Shao-hsing],
I became familiar with the beauty of the Five Cataracts.
The cold streams, when level, become pools clear as
 crystal.
Pouring foam mingled with flying waterfall,
Its shapes constantly changing.
Water would flow downward without a sound,
Or become raging billows emitting echoes.
Sometimes the wind from the sky would wail,
The green forest during the day would turn dark.
Sometimes it was dangerous and difficult to ascend,
For the moss was slippery on the stone steps in those
 precipitous cliffs.
After reading the travel notes of Sung [Lien] and Hsü
 [Wei],
I'm afraid their descriptions are incomplete.
Yet when Lao-lien [Ch'en Hung-shou] was seized with
 the inspiration to paint,
His brush and ink moved with exhilaration.
It is as if mists have risen
From a hot cooking pot, gradually opened.
By hanging this on a plain wall,
One can clearly listen to the quiet night.
At the end of the year, ice and snow are deep;
The cold air in the quiet studio is frozen.
Near the fireplace, I make with it a silent, spiritual
 acquaintance,
Burning incense and striking a lucid *ch'ing* [stone
 chime].

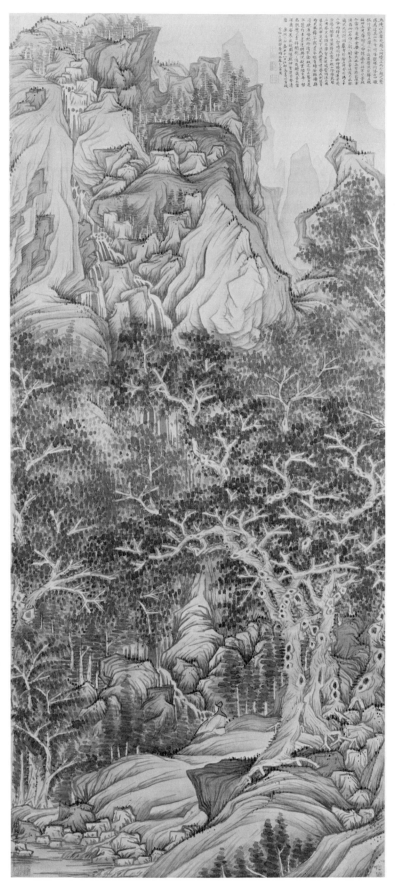

206

On the eighteenth day of the twelfth month in the *i-mou* year of the K'ang-hsi era [1699], Chiang-ts'un, Kao Shih-ch'i. Chu-ch'uang inscribed this at Che in the Chien-ching studio. It was the third day after the beginning of spring.

trans. LYSL/HK/WKH

Remarks: Ch'en Hung-shou was born in 1598 of an official-gentry family in Chu-chi, Chechiang. His father died early and an indulgent granduncle spoiled Ch'en with all of the accomplishments of *wen-jen* culture (including a lifelong love of drink), save the ability to go further in the examination system than the initial prefectural stage. His painting ability was highly developed, partly under the tutelage of Lan Ying (see cat. nos. 196, 197), the "last master" of the Che school. His fame began to rise after two trips to Peking in 1623 and 1638 to take the provincial examination; both times, he failed to pass. He declined with disdain offers to be painter-in-attendance, and later, in 1645, membership in the Hanlin Academy at the Nanking court of Prince Lu. He escaped the Manchu forces in 1646 and became a Buddhist monk at a monastery near Shao-hsing. He left this life, however, returned to his family, and became a professional painter in Shao-hsing.

This well-preserved work is one of the most unusual landscapes of the Ming Dynasty, with its exaggerated, sharp, linear *ts'un* and carefully patterned dots arranged principally in a vertical manner with horizontal counterpoint. The complex design mirrors the natural site with its five-stage waterfall and seventy-two peaks. While the origins of Ch'en's style are various, especially in his figure painting, here we can see elements taken from Lan Ying, especially the *ts'un* in the landscape dated 1624 (see Harada, *Shina*, 1936, p. 702); from Shen Chou (see cat. no. 155), in the shape of the dots with their hairy bottoms (*shu-tsu*, rat's feet); and from T'ang Yin (see cat. nos. 162, 163), with his layered *ts'un* forming planes and contours, and vertical, distant peaks in flat washes. Still, the strong-willed individuality clearly visible here justifies the comment by Mao Ch'i-ling (1623-1716) that Ch'en quickly surpassed his mentor, Lan Ying (T'ao Yüan-tsao, *Yüeh-hua*, preface 1795, p. 28a).

We can assume this to be an early work because the signature is small and modestly placed, and its style is quite different from Ch'en's mature works, dating after his return from Peking. In his book *Tu-hua lu* (ch. 1, pp. 11, 12) Chou Liang-kung (1612-1672) mentions that he was a childhood friend of Ch'en Hung-shou. When Chou was in his thirteenth year (by Chinese count), the two friends made frequent trips to Wu-hsieh shan. The visits took place between 1624 and 1625, thereby establishing a fairly close dating for the Cleveland painting.

SEL/HK

Literature
Kuan, *San-ch'iu-ko* (1928), *ch. shang*, p. 86a-b.
Ferguson, *Li-tai* (1934), p. 299(b).
Sirén, *Later* (1938), II, 47, pl. 159, and I, *Lists*, 205; idem, *Masters and Principles* (1956-58), V, 64, and VI, pl. 315, and VII, *Lists*, 164.
Huang Yung-ch'üan, *Ch'en Hung-shou* (1960), p. 25.
Lee, "Water and Moon" (1970), p. 56, fig. 28.
CMA *Handbook* (1978), illus. p. 353.
Oertling, "Ting Yün-p'eng" (1980), p. 414, fig. 134.
Hochstadter, *Compendium* (forthcoming).

Exhibitions
Tokyo Imperial Museum, 1928: *Tō-Sō-Gen-Min*, II, 373.
University Art Museum, Berkeley, 1971: Cahill, *Restless Landscape*, cat. no. 69.
Asia House Gallery, New York, 1974: Lee, *Colors of Ink*, cat. no. 36.

Recent provenance: Kuan Mien-chün; Walter Hochstadter.

The Cleveland Museum of Art 66.366

Ch'en Hung-shou

207 *Paintings after Ancient Masters (Fu-ku)*

Pair of ten-leaf albums, ink and light color on silk, leaves J and U ink on silk, A: 24.6 x 22.6 cm. B: 24.3 x 22.6 cm. C: 24.6 x 22.7 cm. D: 24.6 x 23.7 cm. E: 24.6 x 22.7 cm. F: 23.8 x 22.6 cm. G: 24.2 x 23.7 cm. H: 24.6 x 22.7 cm. I: 24.6 x 22.7 cm. J: 24.6 x 23.7 cm. L: 24.5 x 22.6 cm. M: 25.3 x 23.7 cm. N: 23.8 x 22.5 cm. O: 25.6 x 22.5 cm. P: 24.5 x 22.6 cm. Q: 23.6 x 22.6 cm. R: 24.6 x 22.6 cm. S: 24.5 x 22.6 cm. T: 24.5 x 22.6 cm. U: 24.6 x 22.6 cm.

Artist's titles, signatures, and 21 seals:

A. Scholars in a Garden. Hung-shou painted for old Chung. [seal] Chang-hou.
B. Lao-tzu Riding an Ox. Hung-shou respectfully painted. [seal] Ch'en yin Hung-shou.
C. Narcissus and Bare Trees. The Taoist Chung-ch'ing entrusted Lao-lien to paint [this]. [seal] Chang-hou.
D. Autumn Landscape. Lao-lien painted for Lao-ts'ang. [seal] Chang-hou.
E. Portrait of T'ao Yüan-ming. Lao-lien [seal] Hung-shou.
F. Lotus and Rocks. Hung-shou painted after the style of Ts'ui Po and presented it to the Buddhist disciple Lin Chung-ch'ing. [seal] Chang-hou.
G. Taoist and Crane in Autumn Landscape. The old man Fu-ch'ih painted for the Taoist Chung-ch'ing. [seal] Chang-hou.
H. Portrait of Chung-ch'ing in a Landscape. Lao-lien painted for Chung-ch'ing. [2 seals] Chang-hou; Ch'en yin Hung-shou.
I. Chrysanthemum and Rock. Hung-shou [seal] Hung-shou.
J. Landscape in the Style of Ni Tsan. Lao-lien [seal] Chang-hou.
L. Mr. Five Willows (Wu-liu), T'ao Yüan-ming. Mr. Five Willows Chung-ch'ing entrusted Hung-shou to paint [this]. [seal] Chang-hou.
M. A Lohan [after Kuan-hsiu]. Buddhist disciple Ch'en Hung-shou respectfully painted. [2 seals] Chun-t'i ti-tzu; Chang-hou.
N. A Bird and Peach-Blossom Branch. Hui-lun-shang painted after Tao-chün [Emperor Hui-tsung] and presented it to Ts'ang-fu chü-chih. [seal] Ch'en yin Hung-shou.
O. Travelers in an Autumn Landscape. Hung-shou [seal] Chang-hou.
P. A Lady. Hung-shou [seal] Hung-shou.
Q. Chrysanthemum. Hung-shou painted in imitation of the Northern Sung style for Taoist friend, Ts'ang-fu. [seal] Chang-hou.
R. Scholar Reading in a Thatched Hut by a Waterfall. Chung-ch'ing entrusted Hung-shou to paint. [seal] Chang-hou.
S. Scholar with Staff and Brush. Hung-shou [seal] Chang-hou.
T. An Ancient Tree. Hung-shou [seal] Chang-hou.
U. Rock, Old Tree, and Bamboo. Hung-shou [seal] Hung-shou.

2 colophons (leaves K and V) and 34 additional seals: 24 seals of Lin Chung-ch'ing (Lin Ts'ang-fu or Lin T'ing-tung, friend of Ch'en Hung-shou, for whom the album was painted); 2 colophons, dated 1893 and 1899, and 5 seals of Weng T'ung-ho (1830-1904); 2 seals of Weng T'ung-chüeh (older brother of Weng T'ung-ho); 2 seals of Weng Wan-go (20th c.); 1 unidentified.

207A

207B

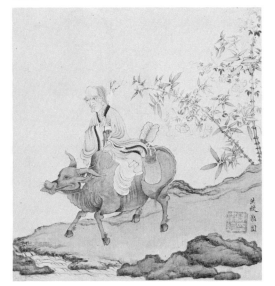

207C

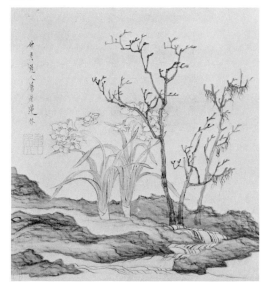

207D

207F

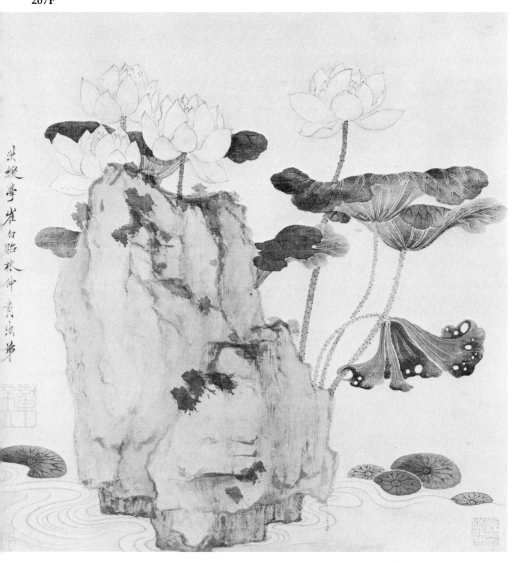

207E

207Q

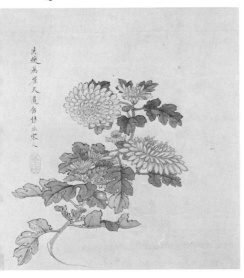

207R

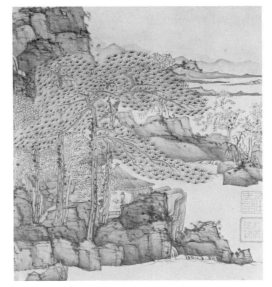

207T

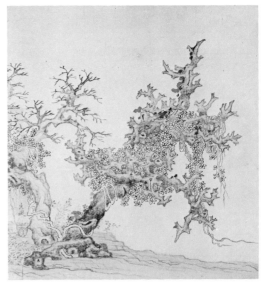

207U

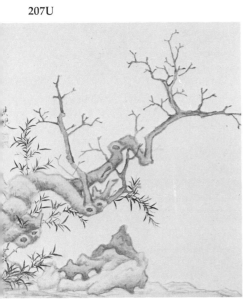

207S

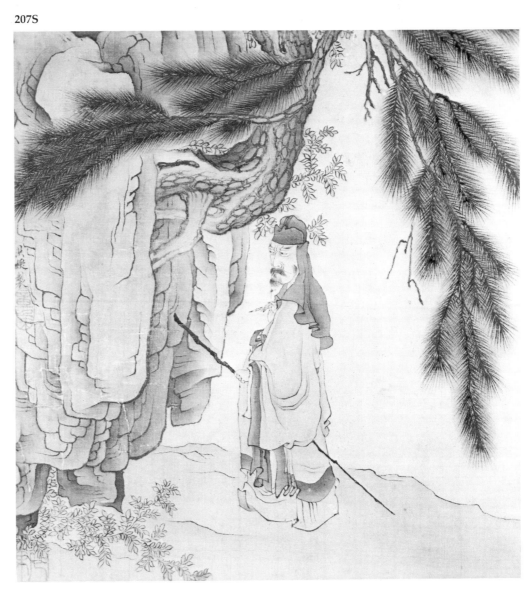

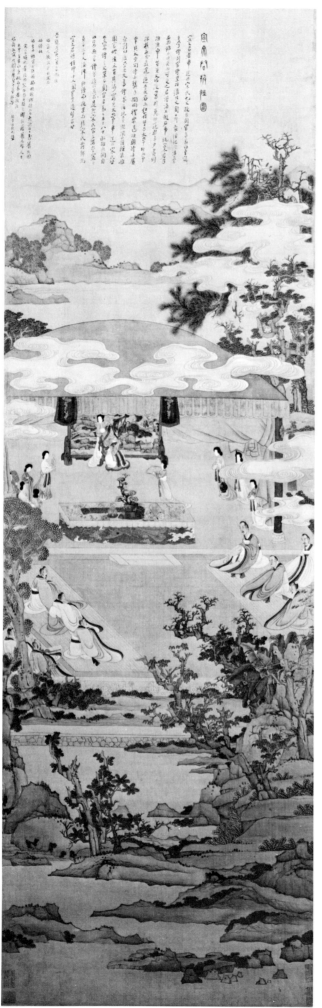

Remarks: This double album, comprising twenty pictures in all, was painted for a friend of the artist, Lin Chung-ch'ing. It belongs with two other late albums by the artist: one with eight leaves painted for a Buddhist monk, "Yu," now in Honolulu (Ecke, *Hawaii*, 1965 III, pl. LXII) and the twelve-leaf example in Nanking *(Ch'en Hung-shou hua-ts'e,* 1959). Each set seems equal in quality to the others and all are remarkably consistent in style and subject matter: landscapes, figures, flowers, and, in the case of the Nanking and Honolulu albums, birds and butterflies. The Cleveland album has one leaf with a painting of a woman, an often-used subject not found in the other two albums.

These late works are wonderful summations of Ch'en's peculiar and quirky art–archaistic, hyper-refined–but without acccompanying shallowness or sentimentality. Leaf L, in particular, reveals these qualities in the most direct way. The ancient Buddhist disciple is modelled after the well-known grotesque style of Kuan Hsiu of the early Five Dynasties period, as in the examples preserved in the Imperial Collection, Tokyo (Sirén, *Masters and Principles,* 1956-58, III, pls. 114, 115; Harada, *Shina,* 1936, p. 25); he has the wonderfully gnarled and aged character assigned to the lohans, the disciples of the Buddha.

Where Ch'en's art differs from his earlier model is in scale. His figures and landscapes in the late albums are miniaturized, not unlike the small Chinese gardens, or the carefully selected small table rocks or old roots used for contemplation to see the world in miniature. This loss of scale is quite deliberate and reflects the psychological situation of a depressed class like the Ming loyalist officials and scholars, deprived of their integrity and honor, and forced to lead a diminished and restricted existence. SEL

Literature
Sirén, *Masters and Principles* (1956-58), VII, *Lists,* 164.
Cahill, "Chūgoku kaiga-I" (1975), fig. 10-A (G), fig. 10-B (S).

Exhibitions
Dallas Museum of Fine Arts, 1954: *Five Centuries,* cat. no. 24.
Haus der Kunst, Munich, 1959: *1000 Jahre,* cat. no. 81 (leaves L-U).
Smith College Museum of Art, Northampton, Mass., 1962: *Chinese Art,* cat. no.25 (leaves A-J).
Asia House Gallery, New York, 1967: Cahill, *Fantastics and Eccentrics,* pp. 38, 39, cat. no. 10.

Recent provenance: Weng T'ung-ho; Wan-go H. C. Weng.

The Cleveland Museum of Art 79.27

Ch'en Hung-shou

208 [*Lady*] *Hsüan-wen chün Giving Instructions on the Classics*

(*Hsüan-wen-chün shou-ching t'u*)

Hanging scroll, dated 1638, ink and color on silk, 173.7 x 55.6 cm.

Artist's inscription and signature:

[Lady] Hsüan-wen-chün was the mother of Wei Ch'eng whose family name was Sung. Her father taught her *Chou-kuan yin-i* [pronunciations and interpretation of the Ritual of Chou Dynasty] and said, "We are of a family of hereditary scholars, specializing in the study of *Chou-kuan* which has been handed down in our family from one generation to another. This book, above all, was formulated by the Duke of Chou. All standards of con-

duct and regulations, canonical precedents and investitures, organization of government and classification of things, are complete in this one book. You shall therefore learn it." Thereupon, the lady studied it diligently allowing herself no interruption. Later, toward the end of the Posterior Chao period, the family was moved by the government to "Shangtung." [With her husband], the lady pushed a small carriage, carrying the books handed down to her by her father, and migrated to Ch'i-chou. [Wei] Ch'eng soon completed his study and established a reputation. He served Fu Chien [king of Former Ch'in] in the Board of Rites. When Fu Chien visited his National University and asked about the existing texts of the classics, he was saddened to find that the studies of ritual and music had been lost. Thereupon, a professor, Lu Hu, reported, "Since schools had been discontinued for too long, many texts and commentaries are missing. After years of collecting and compilations, the major classics are now more or less in good shape; only the subject of *Chou-kuan* is still in need of a teacher. It has been observed that Sung, the mother of Wei Ch'eng of the Board of Rites, who was a daughter from a family of hereditary scholarship, has succeeded her father in this specialized field of study, and has mastered the *Chou-kuan yin-i*. Now at the age of eighty, she was still good in eyesight and hearing. This old lady will be the only one capable of teaching the young scholars." Consequently, a lecture hall was built in the Sung family residence and 120 students were assigned to receive instructions, which were given from behind a red silk curtain. The lady, Sung, was ennobled with the title *Hsüan-wen chün* or Lady of Literary Propagation and was given ten maids as her personal attendants. Thereafter, the study of *Chou-kuan* was revived in the world.

[signed] Your nephew, Hung-shou, bowing his head nine times.

trans. WKH

5 additional seals: 2 of Hsu Wei-jen (dates unknown); 2 of Sun Po-sheng; 1 of Wang Chi-ch'ien (20th c.).

Remarks: The long internal struggle between Confucian responsibility and Buddhist retreat colors much of Ch'en's production, despite his deserved reputation as a wastrel and womanizer. Painting was certainly the outlet for his most serious thoughts and dangerous tensions. The present work, one of the most important of all his hanging scrolls, was made for Ch'en's aunt on her sixtieth birthday — the most significant of all — corresponding to the complete celestial cycle of years and the beginning of yet another life. It is significant that the occasion was celebrated by this edifying Confucian subject instead of the more customary Taoist ones. The complex landscape setting depends on T'ang prototypes for its clouds, while the gnarled trees are Ch'en's own marvelous adaptations of the North Chinese tradition of Li Ch'eng and Kuo Hsi. The figures of the old lady, her respectful male audience, and the numerous female attendants are in the Ku K'ai-chih mode of the early Six Dynasties period but surely leavened by the professional art of T'ang Yin (see cat. nos. 161, 162). Particular attention was given by the artist to the pure mineral colors of early tradition and to the antique accoutrements suitable for the occasion — the screen behind Lady Hsüan and the ancient vessels on the low altar.

While Ch'en Hung-shou's art is eclectic, it reforms its elements into the radical and peculiar mold of the painter, certainly the most original and significant figure

painter of the late Ming period. That he knew very well what he was up to can be judged from his own description of his art: "To enliven the rigidity of Sung with the charm of T'ang, and to apply the Yüan style within the Sung rationality — this indeed will be the ultimate" (Huang, *Ch'en Hung-shou*, 1960, II, 1a-2a; trans. WKH). SEL

Literature
Hsü Pang-ta, *Ch'üan-shih*, n.d.
Sirén, *Masters and Principles* (1956-58), V, 65; VI, pl. 318; VII, Lists, 163.
Huang Yung-ch'üan, *Ch'en Hung-shou* (1960), p. 56.
Ho, "Nan-Ch'en Pei-Ts'ui" (1962), pp. 5-9, cover (color), fig. 1-3.
Jobu, *Chūgoku bunka* (1967), p. 166 (detail).
Contag, *Chinese Masters* (1970), pp. 43, 44, pls. 81, 81A-B.
Akiyama et al., *Chūgoku bijutsu* (1973), II, pt. 2, 255, color pls. 93, 94 (detail).
Cahill, "Chūgoku kaiga-I" (1975), fig. 8.
CMA *Handbook* (1978), illus. p. 352.
Oertling, "Ting Yün-p'eng" (1980), p. 414.

Exhibitions
Asia House Gallery, New York, 1967; Cahill, *Fantastics and Eccentrics*, cat. no. 8.

Recent provenance: Wang Chi-ch'ien.

The Cleveland Museum of Art 61.89

Ts'ui Tzu-chung, active ca. 1594, died 1644, Ming Dynasty
t. Tao-mu, *h*. Pei-hai, Ch'ing-yin; from Lai-yang, Shantung Province, lived in Peking

209 *Hsü Cheng-yang Moving His Family*
(Hsü Cheng-yang i-chü t'u)

Hanging scroll, ink and color on silk, 165.6 x 64.1 cm.

Artist's 2 seals: Pei-hai; Ts'ui Tzu-chung yin.

9 additional seals: 2 of Hsiang Yüan (18th-19th c.); 1 of T'ang Tso-mei (late 18th c. -19th c.); 1 of Chang Heng (1915-1963); 1 of Wang Chi-ch'ien (20th c.); 4 unidentified.

Remarks: The Taoist legend depicted is of Hsü Cheng-yang, who attained the Tao by moving his family to the Land of the Immortals in AD 281, accompanied by a lucky dog and rooster. Hsü can be seen in the upper register of figures, while the servants below accompany the bird and dog.

The style of the painting, particularly of the figures, is characteristic for the artist and displays a willful but consistent combination of allusions to the great masters of the distant past. In this, Ts'ui is like his contemporary, Ch'en Hung-shou (see cat. nos. 207, 208) with whose name his was coupled as "Nan-Ch'en Pei-Ts'ui" — Ch'en of the South and Ts'ui of the North.

The fine line of the figures recalls Chang Seng-yu of the late Six Dynasties, as well as that of Chou Wen-chü of the Five Dynasties (see cat. no. 16), when it is shown in a rhythmically repeated "wavering" or "fluttering." The magical puppy at the lower left is almost a direct quotation from Ku K'ai-chih's *Admonitions* scroll in The British Museum. The widely scattered and precise dots of the rocks and mountains, as well as the sprightly but spare grasses and reeds, and the heavy green malachite pigment of the foliage recall the T'ang style of Li Ssu-hsün and Li Chao-tao, as known from works by or close to them preserved in Peking and Taipei. The combination, however, is Ts'ui's own; he has added to it an up-

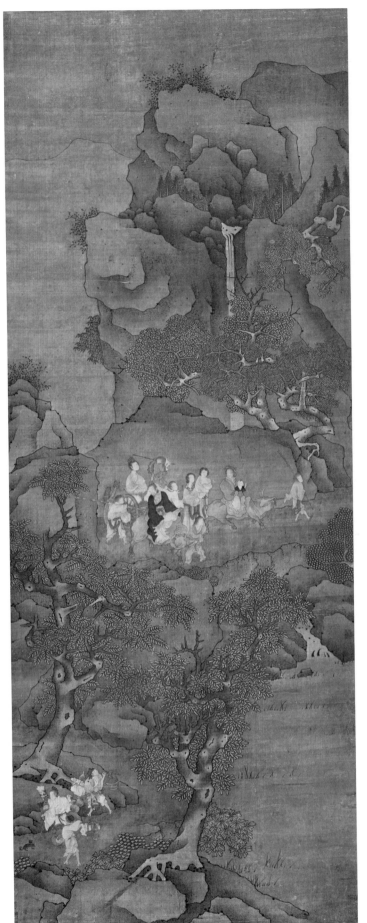

to-date, fashionable element of the mid-seventeenth century — a flickering light and shade effect on the surfaces of the rocks and trees.

A second picture of the same subject by Ts'ui in the National Palace Museum, Taipei (Sirén, *Masters and Principles*, 1956-58, VI, pl. 314), is quite different in concept: it is a simplified version set in a sparer, rougher landscape and with only the sage, his wife, and two servants with the legendary cock and dog. SEL

Literature
Ho, "Nan-Ch'en Pei-Ts'ui" (1962), pp. 9, 10, figs. 4-6.
CMA *Handbook* (1978), illus. p. 353.

Exhibitions
University Art Museum, Berkeley, Calif., 1971: Cahill, *Restless Landscape*, cat. no. 76.

Recent provenance: T'ang Yü-chao; Wang Chi-ch'ien.

The Cleveland Museum of Art 61.90

Artist unknown, first half of the seventeenth century, late Ming Dynasty

210 *Shakyamuni under the Bodhi Tree (Shu-hsia Shih-chia)*

Hanging scroll, ink and color on silk, 129 x 62.2 cm.

Artist's seal(?): Ta-fang-chih.

1 additional seal of Chiao Ping (dates unknown).

Remarks: In this painting the historical Buddha Shakyamuni is seated in meditative posture upon the backs of three demons under the bodhi tree, where he achieved enlightenment. Because the position of Shakyamuni's hands do not conform to any accepted gesture, the iconographic meaning of the event portrayed is unclear. The Buddha's cranial protuberance (*ushnisha*), broad face, and curling hair constitute changes within traditional iconography which took form during the Five Dynasties period in paintings such as those of Kuan Hsiu. By the Yüan period the facial type became quite conventional and was utilized for representations of Shakyamuni as well as other saintly figures within the Buddhist pantheon.

The label on this painting bears an attribution to the Yüan monk-painter P'u Yüan, whose *hao* "Ta-fang" appears in a seal affixed to the painting proper. The subdued color scheme of the figure as well as the blue-and-green landscape motifs also mirror an approach to Buddhist subject matter found in contemporary works of Chao Meng-fu (*Liao-ning sheng po-wu-kuan*, 1962, pl. 82). Nevertheless, the compositional methods are those of a seventeenth-century artist. For example, the variegated foliage throughout the picture is painted in extremely stylized clumps, each repeated in even ink lines and flat, opaque color. Another repeated stroke with a pronounced nail-head profile provides the interior modulation for the forms of the horned demons. Such severely constrained line work is then juxtaposed to freer brush passages in the rocks and tree trunks, or decorative dotting strokes on the ground plane, or the dots in ink and opaque malachite pigment grouped together to follow the silhouettes of the rocks. All these features appear in such works as the hanging scroll by an unknown artist in the National Palace Museum, Taipei (*KKSHL*, 1965, *ch.* 5, p. 258), and Ts'ui's *Hsü Cheng-yang Moving His Family* (cat. no. 209), suggesting that this *Shakyamuni under the Bodhi Tree* should also be placed within the first half of the seventeenth century.

Although unusual in its subject matter, the painting is not unique; the Yangchou eccentric Chin Nung employed similar iconography in a hanging scroll painted almost a century later (*Shina Nanga taisei*, 1935-37, VII, pl. 139). HK/LYSL

Recent provenance: Alice Boney.

The Cleveland Museum of Art 71.68

Chang Feng, active ca. 1636-62, Ch'ing Dynasty
t. Ta-feng, *h.* Shang-yüan lao-jen; from Nanking, Chiangsu Province

211 *Listening to the Sound of Autumn in a Misty Grove (Yen-lin ch'iu-sheng)*

Hanging scroll, dated 1657, ink and light color on paper, 96.5 x 34.6 cm.

Artist's inscription, signature, and 2 seals:

Frosty colors have just appeared throughout the countryside,
Autumn sounds echo unexpectedly through the trees.
The distant mountains cannot be seen,
As the evening mist spreads, thicker and deeper.

Casually painted at the bamboo window on the solstice day of the *ting-yu* year [1657]. Chang Feng. [seal] Feng. [seal, lower left corner] Shang-yüan lao-jen.
trans. LYSL/HK/WKH

3 additional seals: 1 of Fa Liang (Ch'ing Dynasty); 2 unidentified.

Remarks: Chang Feng, a native of Nanking, passed the local government examinations shortly before the fall of the Ming Dynasty. With the Manchu conquest, Chang joined the ranks of loyalists who refused to serve the new regime. He chose instead the impoverished life of a Buddhist adept, traveling to the temples of the North and eventually returning to Nanking. Poet and author of a work on Chinese pronunciation, he was also a painter. Although not included among the Eight Painters of Nanking, Chang was intimately connected with the artistic environment of the city. He appears in Chou Liang-kung's book of contemporary painters, the *Tu-hua lu* (epilogue 1673, *ch.* 3, p. 35). His brother, the Ming loyalist poet Chang I (Yao-hsing), wrote the preface to that book and was an intimate friend of the painter Kung Hsien. Within that environment, Chang Feng nevertheless remained independent in his artistic endeavors.

In his writings, Chang compares the art of painting to the strategy of a good *wei-ch'i* (chess) player; i.e., to build up a defensive position across the board in a loose and apparently unrelated manner so that the opposition realizes one's strength too late (Jao, *Ming I-min*, 1975, p. xii). In his later, more characteristic paintings, Chang implements that philosophy with a loose aggregation of long "flying white" ink strokes — of the same variety as his calligraphy — which gradually form a figure or landscape (Urban Council, *Ming and Ch'ing*, 1970, pl. 42; Sirén, *Masters and Principles*, 1956-58, VI, pl. 371). Among Chang Feng's contemporaries, only Chu Ta would take such liberties with his brush (cat. nos. 235-237).

The soft color, compact brushwork, and spatial unity of the Cleveland hanging scroll provide an unexpected contrast with the majority of Chang's extant works. Yet the Cleveland painting is not unique: Chang Feng employs the same short, dryly brushed strokes to form broad landscape vistas in a four-leaf album formerly in

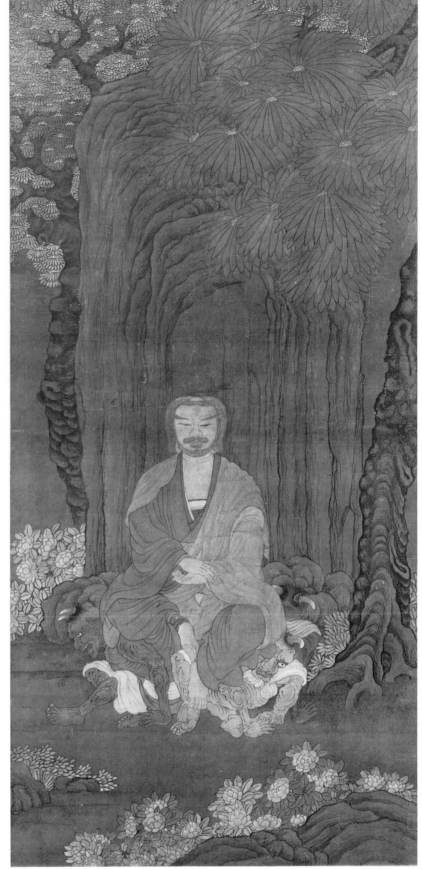

210

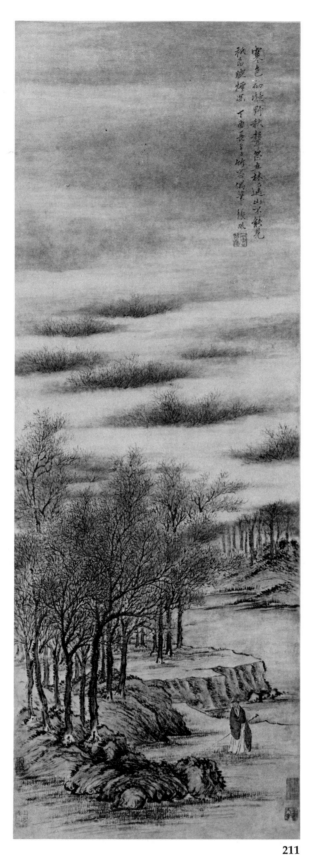

衷色初遊野歌樓于直林遠出不能見
祇為腕煙深 丁曰長至之竹密陽草 振威 [seal]

211

the Ma Chi-ch'uan collection (*Chiao-yü-pu*, 1943, I, pl. 282). Both works join Chang Feng to his more famous Nanking contemporaries, Kung Hsien (see cat. nos. 213-217), Wang Kai (see cat. no. 220), and Fan Ch'i (see cat. no. 219), all of whom were intrigued with the problem of rendering space. HK

Recent provenance: James J. Freeman, Kyoto.
The Cleveland Museum of Art 77.173

Tsou Che, 1636-ca. 1708, Ch'ing Dynasty
t. Fang-lu; from Suchou, Chiangsu Province

212 *Autumn Mist in the Countryside*
(*Chiao-yüan ch'iu-ai*)

Handscroll, dated 1647, ink and light color on paper,
29.5 x 280 cm.

Artist's inscription, signature, and seal: The first day of the sixth lunar month, the *ting-hai* year [1647], Tsou Che painted [this]. [seal] Fang-lu.

Remarks: Tsou Che was born in Nanking, where his father, Tsou Tien, established himself as an artist after moving from Suchou. Although somewhat reclusive, Tsou Tien maintained close friendships with a number of prominent Nanking painters and scholars such as Ko I-lung, Ku Meng-yu, Liu Hsiang-hsien, and Ch'eng Hsi-k'ung. Tsou Che thus grew up in a home poor in material comforts but rich in artistic and scholarly potential, and in a group of his paintings dated between 1641 and 1648 (*Landscape with Fisherman*, dated 1641, Ching Yüan Chai collection; *Conversation in a Pine Grove*, Shang-hai, 1959, pl. 69 [dated 1647]; *Landscape*, Shen-chou album, 1935), he can be seen to have already matured as an artist. According to Chou Liang-kung (*Tu-hua lu*, epilogue 1673, *ch.* 1, pp. 2042, 2043), Tsou Che "in painting followed his father, and his pictures of pines in particular were extraordinary and elegant."

Tsou's father probably died in the late 1640s, and when his mother died, Chou Liang-kung wrote that "he was able to observe the full proprieties; assembled for the burial were many famous scholars." A lacuna in Tsou's dated works from 1648 until 1666 testifies mutely to his withdrawal at that time from both art and society. Chou admonished Tsou Che in a poem (ibid.) to cease longing for the past and to face present reality by returning to painting.

Tsou Che evidently heeded this advice. Between 1666 and 1684 he produced many paintings and trained his son Tsou K'un to continue the family tradition in painting. Tsou had known Kung Hsien (see cat. nos. 213-217), Fan Ch'i (see cat. no. 219), and Kao Ts'en in earlier days, and in 1669 was present with them and other Nanking artists at the "retirement" celebration held by Chou Liang-kung that provided later historians with the roster of names from which the Eight Masters of Chin-ling were chosen.

This painting is described in a colophon now detached but recorded as originally following this painting: "The mountain ridges and peaks are steep and precipitous, and its tracks and paths are dark and deep. The animation of the figures and the luxuriant growth of the bamboo and trees have a northern air of heavy virility. Though a horizontal scroll in small format, his endless variations are no less [admirable] than Shih-ku [Wang Hui]" (Lu, *Jang-li kuan-hsü lu*, 1892, *ch.* 14). The sure handling of spatial recession, the skillful use of complex rock and mountain shapes to ensure lateral continuity, and the masterful use of expressive tree-groups and vibrant line to vitalize the whole, mark this as one of the finest works from the early period of Tsou Che's artistic activity. HR

Literature
Lu Hsin-yüan, *Jang-li kuan – hsü lu* (1892), *ch.* 14, pp. 11(b)-12(a) [with original colophon].
Ferguson, *Li-tai* (1934), IV, 373(b).

Recent provenance: Tseng Hsieh-chi.
The Cleveland Museum of Art 70.59

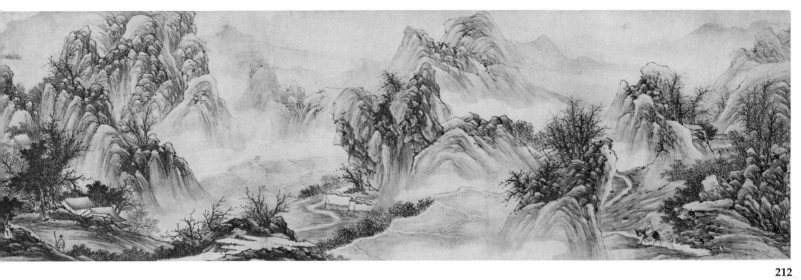

212

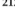

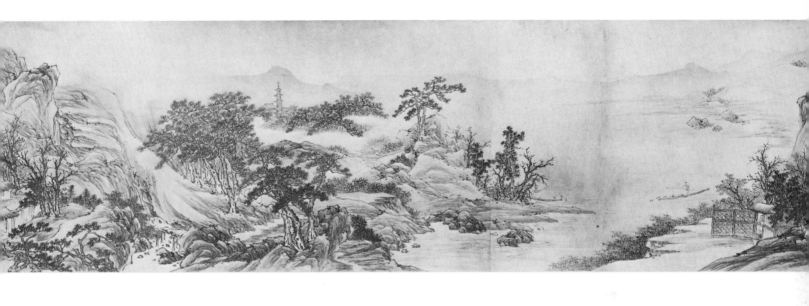

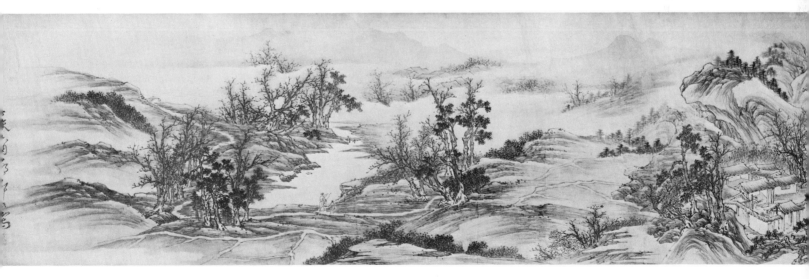

Kung Hsien, ca. 1619-1689, Ch'ing Dynasty
t. Yeh-i, h. Pan-ch'ien, Pan-mou chü-jen, and
others; from K'un-shan, Chiangsu Province, lived
in Nanking

213 *Landscape in the Style of Tung Yüan and Chü-jan (Fang Tung Chü shan-shui),*

Hanging scroll, inscription dated 1670, with artist's dating of the painting to ca. 1650, ink with white on silk, 216.4 x 57.5 cm.

Artist's inscription, signature, and 4 seals: Among [early] painters, Tung Yüan and Chü-jan were the actual founders of the Southern school. Their paintings display neither any air of ferocity and aggressiveness nor any trace of stiff meticulousness. Painters of later periods may be known for their natural talents or praised for their observance of established traditions. Only Tung Yüan and Chü-jan came close to the Tao. However, those who indulge in showing off their talent will deviate from the tradition, while those who adhere to tradition will alienate themselves from the Tao. The supreme Tao is inexplicable in words. Some critics argue that the Tao is nothing more than the suppression of personal talent [individuality] and the submission to the laws [traditions]. Should we have brought this question up to Tung Yüan and Chü-jan, I am afraid even they would have no answer. Alas, how difficultly subtle! This painting, which is an old work of mine done twenty years ago, has been in the collection of the Wu family in Hsin-an [Anhui Province]. Mr. Wu Tsin-ming has valued it as a family treasure. He brought it to Chin-ling [Nanking] and asked me to write an inscription. Since I discussed painting [theories] with Tsin-ming and touched upon the subject [of the Tung-Chü tradition], I shall record what I said − not that I dare to claim that this painting is an imitation of Tung-Chü with any merit.

At the end of winter of the *keng-hsü* year [1670]. Pan-mou chü-jen, Kung Hsien [2 seals] Kung Pan-ch'ien; Yeh-i Hsien. [seal, lower left corner] Kung Hsien. [seal above, undecipherable, but probably a seal of Kung Hsien].

trans. WKH

2 additional seals of Ch'eng Ch'i (20th c.).

Remarks: Kung Hsien, the best known of the later seventeenth-century painters in Nanking, was born in K'un-shan but spent most of his life in the vicinity of the southern capital. A well-known figure in Nanking intellectual circles, his long-lost compilation of poetry − the *Ts'ao-hsiang t'ang chi* − has recently been rediscovered (Wang Shih-ch'ing, "Kung Hsien ti 'Ts'ao-hsiang t'ang chi,'" 1978, pp. 45-49). The poetry he wrote and the circle of friends he kept indicate Kung Hsien to be an ardent Ming loyalist in the face of the Manchu conquest of China − a political stance which forced him into ten years of wandering before returning to the Nanking area in 1655. Kung spent the remaining years of his life eking out a living through painting and teaching. Despite his impoverished and reclusive life style, he maintained contacts with the scholarly and artistic world. In addition to his painting and poetry, Kung Hsien also compiled an edition of middle and late T'ang poems before his death in 1671.

Of the many paintings surviving from his hand, few can be dated to the early years of his career. In his inscription dated 1670, Kung states that he did the painting twenty years earlier. The tall vertical format, filled with curiously pointed peaks and severely simplified

foreground trees, is closely related to his earliest-dated composition of 1655 in the S. H. Hwa collection as well as a contemporary but undated work in the C. C. Wang collection (Cahill, "Early Styles," 1970, figs. 14, 15, p. 58). Because of the more successful integration of the spatial elements in the Cleveland scroll, Cahill suggests the possibility that it was painted later than the Hwa and Wang works.

Despite the painting's title, there are few tangible relations to be found between the seventeenth-century work and its tenth-century models. By building forms with repeated applications of ink strokes and wash, and avoiding obvious outlines, Kung successfully captures the monumental spirit of Tung Yüan and Chü-jan's moist Southern landscapes (see cat. no. 11). However, he takes great liberties with these tenth-century models, basing his reinterpretation on precedents set by the generation of Ming painters immediately preceding him. Kung Hsien follows Tung Ch'i-ch'ang's compositional methods by repeating simple abstract forms — here the squared-off peaks — to provide organic structure and unity in the unfolding landscape. As if to underscore that source, Kung borrows the freely brushed and simplified tree forms of Tung Ch'i-ch'ang. He also applies layer after layer of ink strokes to flesh out the mountain forms — a purposeful limitation of stroke types similarly employed in the works of Sheng Mao-yeh and T'ao Hung (see cat. nos. 199, 200). Yet the result departs from all of his models. T'ao's and Sheng's loosely painted works exhibit a shimmering, evanescent surface, while Kung Hsien's ink creates a solid, melancholic landscape.

HK

Literature
Cahill, "Early Styles" (1970), p. 61, fig. 17.
Ch'eng, *Hsüan-hui-t'ang* (1972), *Hua*, pp. 138(a)-138(b).
Lee, "To See Big within Small" (1972), p. 322, fig. 66.
Akiyama et al., *Chūgoku bijutsu* (1973), II, pt. 2, 233, color pl. 43.
CMA *Handbook* (1978), illus. p. 357.

Exhibitions
Aaia House Gallery, New York, 1974: Lee, *Colors of Ink*, cat. no. 40.

Recent provenance: Ch'eng Ch'i.

The Cleveland Museum of Art 69.123

Kung Hsien

214 *Landscape Album*
(*Shan-shui ts'e*)

Album of ten leaves mounted as hanging scrolls, dated 1671, ink or ink and color on paper, each 24.1 x 44.7 cm.

A. *High Peaks with Buildings in the Manner of Lu Hung*
Ink on paper. Artist's inscription and seal: Painting of the ancients compels respect and admiration from people when they view it. Like the Five Sacred Mountains, their peaks tower majestically upward. [From this] one knows for sure that they harbored no bits and pieces of mountains or tag ends of rivers in their breasts. This work derives from a study sketch by Lu Hao-jan [Lu Hung, act. 8th c.]. [seal] Ch'i-hsien.

2 additional seals: 1 of Pao-hsi (b. 1871); 1 of Chin Ch'eng (1878-1926).

B. *River Scene with Boats*
Ink and color on paper. Artist's inscription and seal: Some guests who came here from Ch'ang-shan and Yü-shan tell me of the strange marvels of the landscape there. Taking up my brush, I record them here. [seal] Yeh-i.

214A

214B

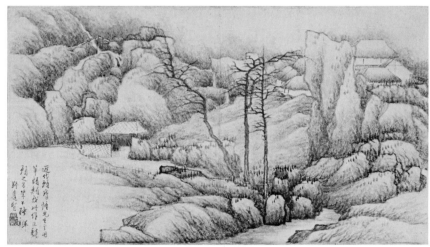
214C

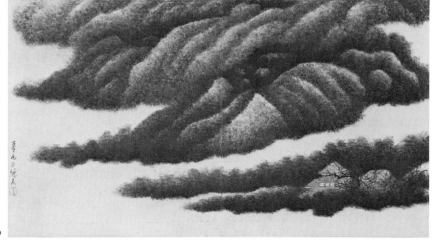
214D

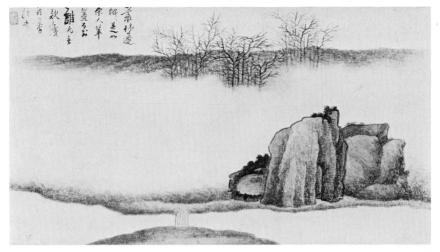

214E

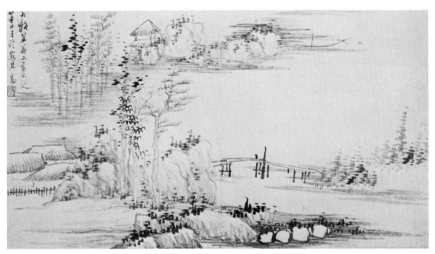

214G

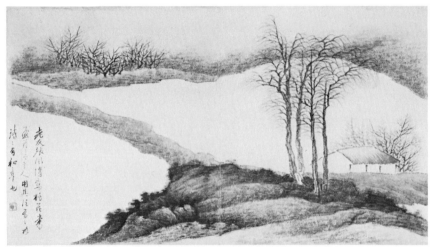

214H

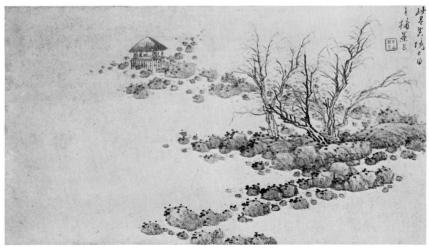

214I

C. *Mountain Valley with Cottages*
Ink on paper. Artist's inscription, signature, and seal: The brushwork of Mr. Ku Pao-ch'uang, a man of these times, quite resembles my own. The present work falls in the common ground between Kung and Ku. One can scarcely tell the difference. Yeh-i Hsien [seal] An-chieh.

D. *Mountains and Mist-Filled Valleys*
Ink and light color on paper. Artist's inscription and seal: Imitating Nan-kung's [Mi Fu, 1051-1107] [painting] on silk. [seal] Ch'ai-chang.

E. *Desolate Grove on the Far Bank*
Ink on paper. Artist's inscription and seal: *Desolate Grove on the Far Bank* is the brush and ink of a man of the Northern Sung. Yet we do not know who he is, there being neither inscription nor signature. It is now imitated here. [seal] Ch'en Hsien.

F. *Village on a Mountainous Lakeshore*
Ink on paper. Artist's inscription and seal: Having painted what I saw in a dream, a friend now says, "The shores of the lakes in my Che[chiang] frequently have spots like this." [seal] Yeh-i.

G. *Lakeshore with Cottages*
Ink on paper. Artist's inscription and seal: Ta-ch'ih's [Huang Kung-wang, 1269-1354] brush and ink always come from Tung Yüan and Chü-jan. This conveys the substance of his expressive meaning. [seal] Hsien.

H. *The Peach-Blossom Studio*
Ink and light color on paper. Artist's inscription and seal: My old friend Chang Feng used to paint the Peach-Blossom Studio. This grasps [the essence of] the man and uses his idiom. Doing this [sort of thing] is like adapting stanzas to harmony in poetry. [seal] Ch'ai-chang.

I. *Pavilion in a Lake*
Ink on paper. Artist's inscription and seal: The reality [of the scenery depicted] here does not come up to what emerges from the paper and brush. [seal] Pan-shan yeh-jen.

J. *Lone Tree in a Mountain Lake*
Ink on paper. Artist's inscription and seal: Ni Tsan [1301-1374] really did do this kind of picture, but people nowadays don't believe it. Because of this, I imitate it here, to wait for those who understand. [seal] Pan-ch'ien.

Artist's colophon, signature, and seal on leaf K: On New Year's Day of the *hsin-hai* year [1671], sprinkling some tea about that I had specially set aside, I made sacrifice in the mountains to the vast heavens. I sealed my door and sat quietly, communicating with neither relatives nor friends. Having washed my ink-stone and tried out my brush, I brought out this plain album. I painted away like this for some ten days, but then, my "flower activities" became somewhat burdensome, and it was already the end of spring before I finished it. I dare not say that I have enjoyed in full measure the unalloyed happiness of [this world of] man, and yet, compared with those who move attentively in the circle of ceremony and regulations, is not what I have attained much more? And so, I record this here with a smile. Resident of Half-an-Acre, Kung Hsien. [seal] Yeh-i.

trans. MFW

1 frontispiece with colophon and 5 additional seals: 2 seals of Pao-hsi (b. 1871); 1 seal of Chin Ch'eng (1878-1926); 1 frontispiece with colophon, dated 1918, and 2 seals of Lo Chen-yü (1866-1940).

Remarks: The leaves of the album were separated and mounted as individual hanging scrolls, suitable for the *tokonoma*, in Japan. The eleventh scroll now bears Lo Chen-yü's frontispiece with colophon, the album's former initial paper of the Ch'ien-lung era (1736-95), decorated with a landscape in gold against the blue ground, and the final leaf of the album, where Kung Hsien's own colophon appears.

The Ku Pao-ch'ang referred to in the inscription on leaf C is probably Ku Yüan, a painter and calligrapher who was active in Nanking at the end of the Ming period.

During the decade of the 1660s Kung Hsien developed his personal style of form and images created by means of reiterated dots and dabs made with the side of a soft, well-worn brush. Landscape motifs, often bizarre in shape, became the vehicle for soft, velvety textures and for graphically striking abstractions of light and dark. Kung Hsien is a master at exploiting the unpainted areas of paper as part of his design, which he often uses as a connective device or to introduce stunning effects of arbitrary irrationality. Kung's reliance on such narrowly limited technical means which he then exploits until all potential has been wrung from them is a practice typical of other early Ch'ing "individualist" painters. Kung Hsien's selection of a style based on reiterated dots may be tied to his admiration for Mi Fu, whom Kung seems to have selected from history to be something of a role model, as though confirming the validity and survival of Chinese cultural traditions in the face of the uncertainties of barbarian conquest.

The decade of the 1670s is the artist's best period. The hesitancy and experimentation of the 1660s had passed, while the straining for novelty that marks many of his works from the 1680s had not yet appeared. MFW

Literature

Naitō, *Shinchō shogafu* (1916), *Painters*, pl. 27.
Kyo Hansen sansui (chō) (1919).
Shina Nanga taisei (1935-37), sequel, I, pls. 62-71.
Shih, "Mad Ming Monks" (1967), p. 36, pl. 1.
Lippe, "Fantastics and Eccentrics" (1967), p. 134, pl. 4.
NG-AM Handbook (1973), II, p. 71.
Akiyama et al., *Chūgoku bijutsu* (1973), II, 233, pl. 46.
Cahill, "Chūgoku kaiga-I" (1975), pp. 5 (pl. 2), 30 (fig. 23).
Vinograd, *"Reminiscences"* (1977-78), p. 22, figs. 26-28.

Exhibitions

Asia House Gallery, New York, 1967: Cahill, *Fantastics and Eccentrics*, cat. no. 24, pp. 54, 55, 68, 69, 73, 116.
Nelson Gallery-Atkins Museum, Kansas City, Missouri, 1969: Wilson, "Kung Hsien," no. 8, pp. 27-30, 42-44.

Recent provenance: Kōzō Harada.

Nelson Gallery-Atkins Museum 60-36/1-11

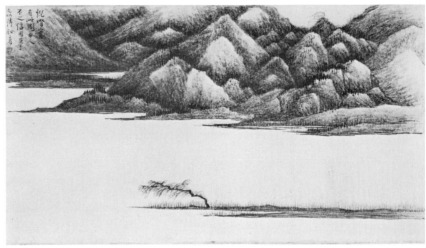

214J

214F

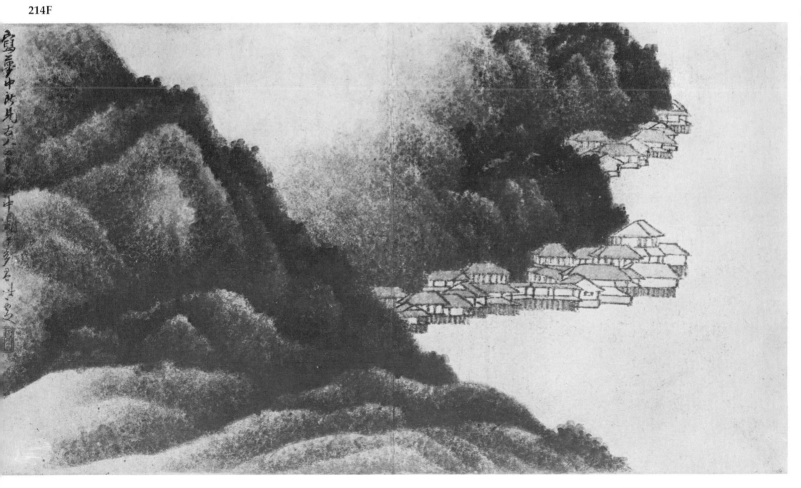

Kung Hsien

215 *Cloudy Peaks*
(*Yün-feng t'u*)

Handscroll, datable to 1674, ink on paper, 16.3 x
900.3 cm.

Artist's colophon dated 1674, signature, and 2 seals: Tung
Yüan is called the founding father of landscape. Fan
K'uan and the monk Chü-jan followed in his footsteps.
Yet again, there were Li Ch'eng and Kuo Hsi. Different
branches and schools came up with new stylistic types.
But Mi Fu of Hsiang-yang was unique, his [heroic]vitality
[*ch'i*] could consume an ox, his power was like that of a
tiger. Mi Yu-jen passed his methods on to Kao K'o-kung,
but in the end the three were of different approaches.

Later on, only Ni Tsan, Huang Kung-wang, and Wang
Meng [stand out] among the many; and Wang Fu and
Shen Chou can hold their own against anyone past or
present. Then came the Wen family, father and son, and
T'ang Yin. Their genuine works are few, and the spurious
many; so do not treat them lightly or ridicule them.

In my lifetime, I have had [the good fortune] of meeting
with Tung Ch'i-ch'ang. The two Li, Yün and Tsou are
men I especially approve of. In my later years I have
become exceedingly fond of the two Kueichou [painters].
The sound of the brush and the posture of the ink can sing
and dance. Yet, I still know little of this Tao [of painting].
For forty years I have striven bitterly [with the hardships
of this art].

A friend now asks me to paint a scene of cloudy peaks;
like lotuses that have not yet opened, they vie with one
another in shooting forth.

Whatever I have received from the heritage of the mas-
ters, I dare not forget. And so, one by one, I have re-
corded these illustrious greats.

In the fourth month of the *chia-yin* year [1674] Kung
Hsien of the Half-Acre painted this and inscribed it.
[seals] Kung Hsien; Chung-shan yeh-lao.

2 additional seals on the painting: 1 of P'an P'ei-shang
(late 19th c.); 1 of the Chung family of Nan-hai, Kuang-
tung Province.

Remarks: The painting's wrapper label was written by
Chao Chih-ch'en (1781-1860) for P'an Tseng-ying (1808-
1878), one of the most prominent collectors of Wu-hsien at
the time. The painting probably passed from P'an Tseng-
ying to P'an P'ei-shang, whose seal appears on the
painting.

The two Li, Yün, Tsou, and two Kueichou painters men-
tioned in Kung Hsien's colophon cannot be identified
definitely in all cases. Nonetheless, the Yün referred to
would have to be Yün Hsiang (1586-1655) who, although
from Wu-chin, Chiangsu, was well known in Nanking.
Tsou probably refers to Tsou Chih-lin (1610 *chin-shih*), who
devoted himself to painting after the fall of Nanking to
the Manchus. The two Li are probably Li Liu-fang (1575-
1629) and Li Jih-hua (1565-1635), both of whom moved in
Tung Ch'i-ch'ang's circle. One of the two Kueichou paint-
ers might be Yang Wen-ts'ung (1597-1645), who was from
Kueichou and was active in Nanking prior to the fall of
the city. MFW

Literature
Akiyama et al., *Chūgoku bijutsu* (1973), II, 233-36, pls. 44, 45.
NG-AM Handbook (1973), II, 70.
Wilson, "Vision" (1973), no. 11, pp. 237, 238.

Exhibitions
Nelson Gallery-Atkins Museum, Kansas City, Missouri, 1969:
 Wilson, "Kung Hsien," cat. no. 9, pp. 30, 31, centerfold pl.

Recent provenance: Lawrence Chan.

Nelson Gallery-Atkins Museum 68-29

215 Detail

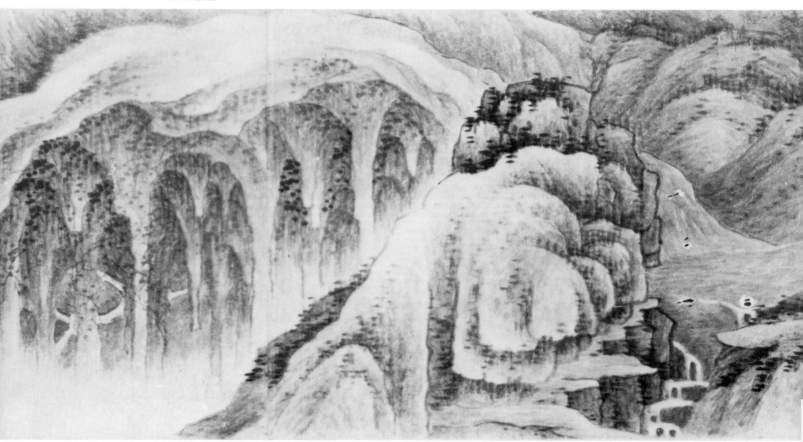

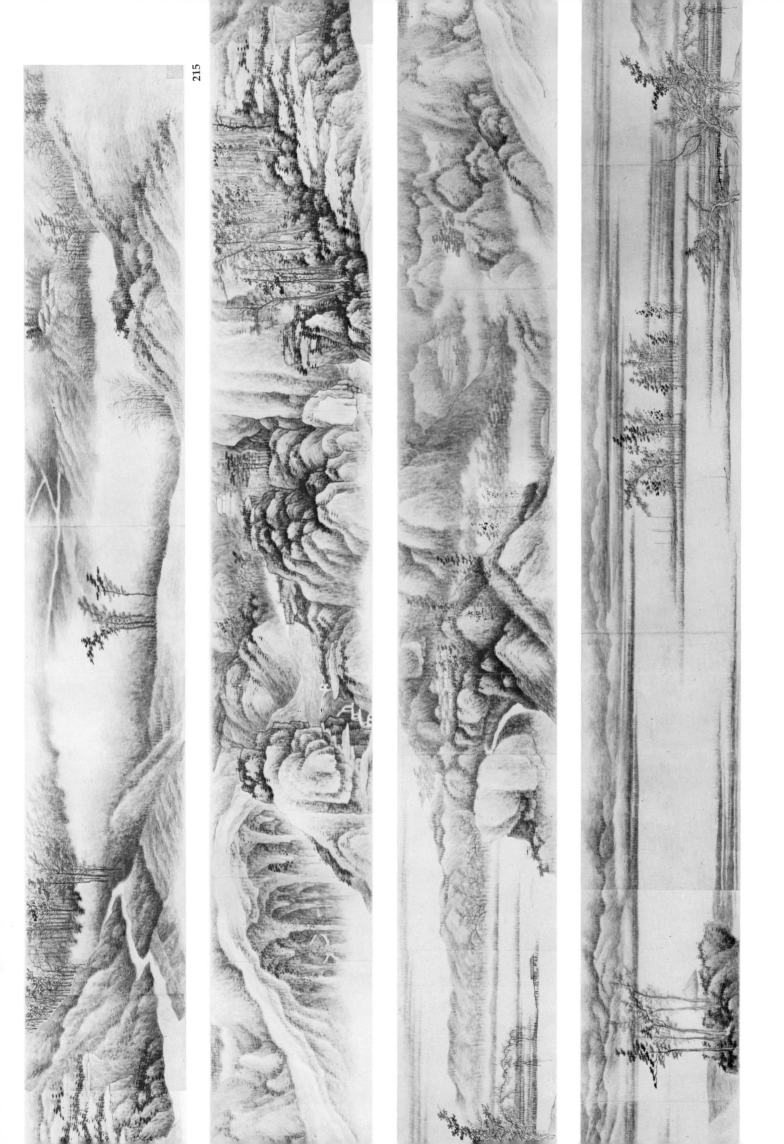

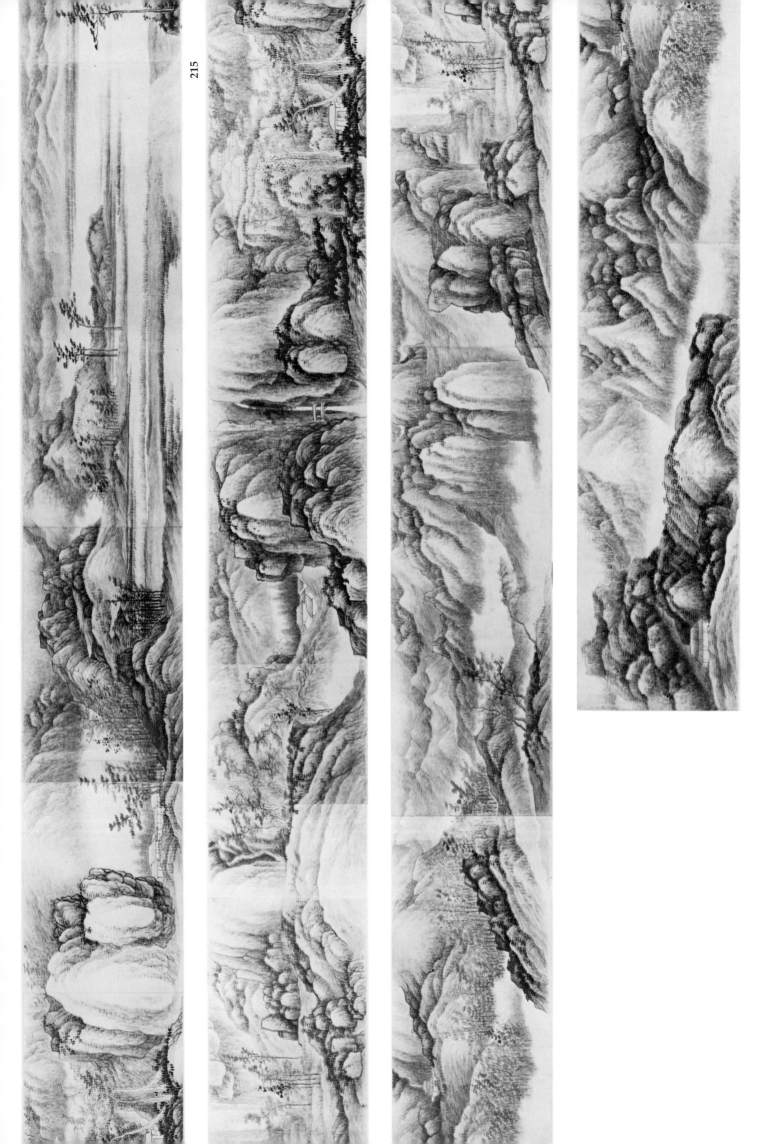

Kung Hsien

216 *Summer in the Water Country*
(Shui-hsiang ch'ing-hsia)

Album leaf, ink on paper, 25.6 x 32.8 cm.

Artist's seal: Pan-ch'ien.

1 additional seal unidentified.

Remarks: This album leaf bears only the seal of Kung Hsien; its method of execution suggests a date in the early 1670s. Here dry and wet, blunt brushstrokes accumulate in parallel planes to form a marine landscape of the same soft and diffuse character as the central section of his 1673 handscroll, *Thousand Cliffs and Ten Thousand Ravines (Nanching po-wu-yüan*, 1966, II, pls. VIII-XIII); his 1674 handscroll, *Cloudy Peaks* (cat. no. 215); or the Huang Kung-wang-inspired leaf, *Lakeshore with Cottages*, from an album (cat. no. 214) painted in 1671.

In inscriptions on the two Kansas City paintings, Kung Hsien states his continuing fascination with the Southern School tradition — a tradition which also appealed to his large circle of acquaintances, including Wang Hui (see cat. nos. 244b-247). However, the "individualist" and his "orthodox" contemporary approach the past in entirely different ways — Wang Hui hardly modifying the Yüan model for his work, while the four Kung Hsien paintings exhibit no direct quotes from specific Southern School compositions. HK

Literature
Lippe, "Kung Hsien", pt. I (1956), fig. 4.
Sirén, *Masters and Principles* (1956-58), VII, *Lists,* 370.
Goepper, *Im Schatten* (1959), p. 32.
Sutton, "New Oriental Art" (1970), p. 9.
Lee, "To See Big within Small" (1972), p. 322, fig. 67.
Impressionism (1973), repr. p. 224.

Exhibitions
China House Gallery, New York, 1955: *Kung Hsien,* cat. no. 8.
Haus der Kunst, Munich, 1959: *1000 Jahre,* cat. no. 125.
Asia House Gallery, New York, 1974: Lee, *Colors of Ink,* cat. no. 39.

Recent provenance: Richard Hobart; Parke-Bernet Galleries.

The Cleveland Museum of Art 70.19.

Kung Hsien

217 *Landscape in the Manner of Tung Yüan*
(Fang Pei-yüan shan-shui)

Handscroll, ink on paper, 26.7 x 941.7 cm.

1 colophon and 4 seals; 1 colophon, dated 1916, of Lo Chen-yü (1866-1940); 2 spurious seals of Hsiang Tu-shou (brother of Hsiang Yüan-pien, 1525-1590); 2 seals unidentified.

Remarks: A small area at the conclusion of the scroll has been washed and abraded, suggesting that a seal has been removed.

Lo Chen-yü's colophon states that Kung Hsien particularly followed the style of Tung Yüan (d. 962) in a strong, broad, and solid manner, and in his generation was only equalled by Yün Hsiang (1568-1655). Lo further calls attention to the spurious seals of Hsiang Tu'shou and points out that despite the lack of Kung's signature or seals, the work may be recognized at a glance as being genuine. Modern critics would not place Yün Hsiang on a par with Kung Hsien; nonetheless, the connection between the two is noteworthy because many of Kung Hsien's early works from the 1650s do register influence from Yün's late works. MFW

216

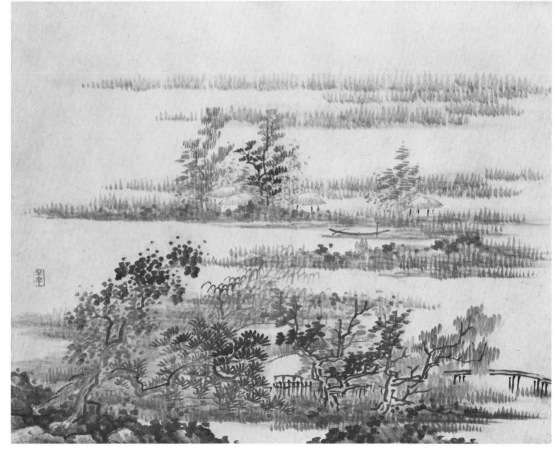
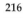

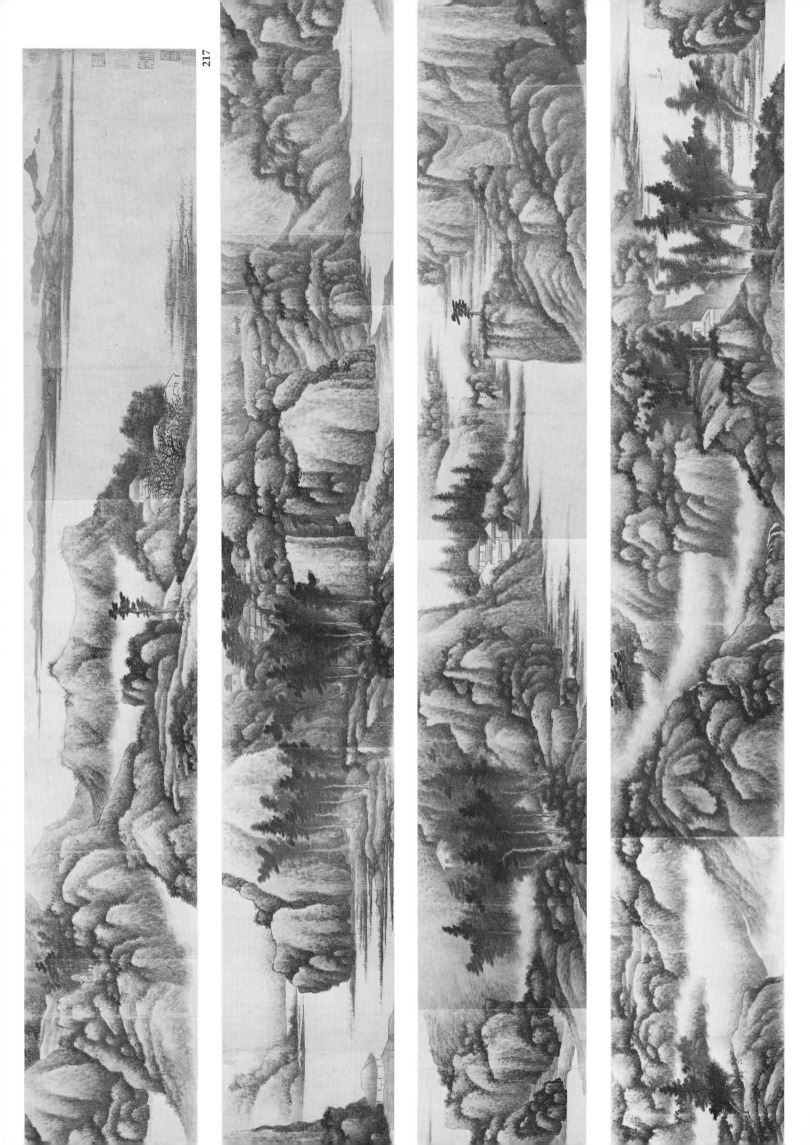

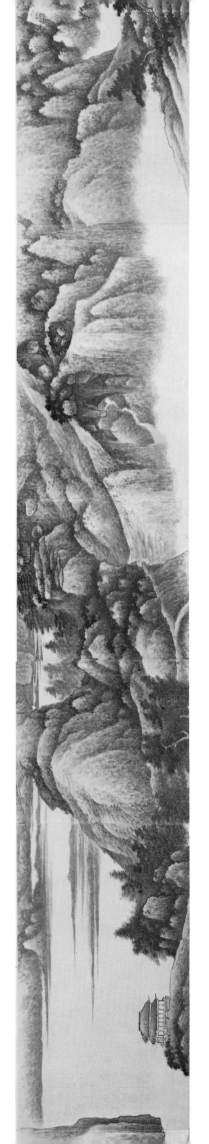

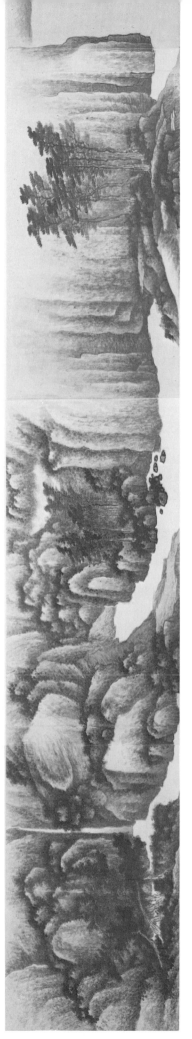

Literature

Yamamoto, *Chōkaidō* (1932), *ch.* 5, pp. 78, 79.
Sickman and Soper, *Art and Architecture* (1956), p. 196, pl. 148.
Lippe, "Kung Hsien" (1956), pt. I, p. 23, pl. 1.
Trubner, "Kung Hsien" (1957), p. 17, pl. 3.
Cahill, *Chinese Painting* (1960), p. 174.
Akiyama et al., *Chūgoku bijutsu* (1973), II, 233-36, pl. 47.
NG-AM Handbook (1973), II, 70.
Watson, *L'Ancienne Chine* (1979), p. 454, pl. 552.

Exhibitions

Cleveland Museum of Art, 1954: Lee, *Chinese Landscape Painting*,
 cat. no. 100, pp. 126, 156.
China House Gallery, New York, 1955: Lippe, *Kung Hsien*, cat.
 no. 7, p. 9, pl. 3.
San Francisco Museum of Art, 1957: Morley, *Asia and the West*, no.
 18y, p. 24.
Andrew Dickson White Art Museum, Ithaca, New York, 1965:
 Young, *Eccentric Painters*, cat. no. 24, p. 19.
Nelson Gallery-Atkins Museum, Kansas City, Missouri, 1969:
 Wilson, "Kung Hsien," cat. no. 6, pp. 26, 27, 40.

Recent provenance: Lo Chen-yü; Teijirō Yamamoto;
 Michelangelo Piacentini.

Nelson Gallery-Atkins Museum 48-44

Fan I, active ca. 1658-71, Ch'ing Dynasty
t. Yü-i, from Chiang-ning, Chiangsu Province

218 *Purification at the Orchid Pavilion*
 (*Lan-t'ing hsiu-ch'i*)

Handscroll, dated 1671, ink and color on silk,
28.1 x 392.8 cm.

Artist's inscription, signature, and 2 seals: Painted by Fan
I of Chung-fu during the second month of winter of the
hsin-hai year [1671]. [2 seals] Fan I chi yin, *tzu* Yu-I.

Title on the frontispiece by Yüeh-shan (1629-1709).

3 colophons and 13 additional seals: 1 colophon, dated
1707, and 6 seals of Yüeh-shan; 2 colophons and 3 seals of
Huang Chün-shih (20th c.); 2 seals of Fu Shen (20th c.); 2
seals of Tessai Tomioka (1836-1924).

Remarks: Fan I was the elder brother of Fan Ch'i, one of
the Eight Masters of Nanking (see cat. no. 219). Although
their mutual friend Chou Liang-kung praised equally the
works of both artists, Fan Ch'i is the brother more fre-
quently discussed, and his paintings survive in greater
numbers. In contrast, Fan I's *Purification at the Orchid
Pavilion*, among the most accomplished figural composi-
tions from the Nanking circle of early Ch'ing painters, is
one of only two paintings so far published from Western
collections (for the other painting, dated 1658, see *Chinese
Fans—Vannotti*, 1972, no. 19).

In the Cleveland scroll, Fan I combines two incidents
from the life of Wang Hsi-chih (321-379), perhaps the most
influential of all Chinese calligraphers. The first incident
took place in 353, when Wang invited forty-two scholar-
poets to celebrate the Spring Purification Festival at the
Orchid Pavilion (Lan-t'ing) in Shan-yin, Chechiang. Fan I
portrays the guests engaged in a poetry and drinking
contest while they sat along the bank of a stream. Ser-
vants set out wine-filled cups on lotus leaves to float
down the stream. Whenever one of the wine cups hit the
stream bank, the guest was required to compose a poem
and drink the wine. At the end of the scroll, Fan I includes
a portrait of the host seated in an open pavilion watching
the movements of geese in the water. This second episode
is unrelated to the Lan-t'ing gathering, but Wang Hsi-
chih is said to have developed a fluid movement to his
brush by observing the graceful movement of these birds.

217 Detail

After the Lan-t'ing celebration ended, Wang Hsi-chih collected his friends' poems and wrote a preface in which he described the great pleasure which the occasion afforded and the melancholy realization of its transitory nature (for an English translation of the preface, see Lin Yü-t'ang, *The Importance of Living*, 1932, pp. 156-58). His written transcription of the preface and the poems became one of the most famous specimens of calligraphy in China – long lost in its original form but preserved in a series of ink rubbings from early copies used as models for every succeeding generation of calligraphers.

Despite its importance, the Lan-t'ing gathering does not seem to have become the subject of painting until the Sung Dynasty. Ming painters such as Ch'iu Ying (*KKSHL*, 1965, *ch.* 5, p. 361), Ch'ien Ku (Whitfield, *In Pursuit*, 1969, cat. no. 4, pp. 76-83), Sheng Mao-yeh (*Eighty Works*, 1979, cat. no. 10), and even anonymous artisans working in lacquer (CMA 74.72; sale: The Frederick M. Mayer Collection of Chinese Art, London, Christie, Manson & Woods, June 24-25, 1974, lot 123) exhibit a fairly consistent pictorial approach to the Lan-t'ing episode. Fan I follows these prototypes, including the geese-watching incident seen in the CMA Ming lacquer.

The painting had a long and significant history in Japan. By 1707 Fan I's *Purification at the Orchid Pavilion* was in the possession of Yüeh-shan, a Ch'an Buddhist monk who emigrated to Japan in 1657 to join his religious community in exile (Hayashi, "Obaku-ryū," 1968, p. 2; Nishimura, "Obaku kōso," 1961, p. 17). This Ming loyalist community eventually established a monastery at Mampukuji, Uji. Called Obaku after the Japanese pronuncia-

tion of their Fuchien home, this Zen sect played an important role in the dissemination of Chinese literati culture in Japan, especially calligraphy. Yüeh-shan's frontispiece title and his poetic colophon following the painting are written with a fluid line of sober strength. Eventually the painting became the property of Tessai Tomioka (1836-1924), considered the last great master of Japanese literati painting. HK

Recent provenance: Tessai Tomioka; S. L. Wong.

The Cleveland Museum of Art 77.47

Fan Ch'i, 1616-ca. 1695, Ch'ing Dynasty
t. Hui-kung; from Chiang-ning, Chiangsu Province

219 *Album of Landscapes, and Flowers and Birds (Shan-shui hua-hui ts'e)*

Album of ten leaves, ink and light color on silk, each 12.6 x 17.3 cm.

Artist's signature on the tenth painting: Chung-ling Fan Ch'i. Artist's 10 seals, one on each painting: Fan Ch'i.

10 poems, 1 colophon, and 29 additional seals: 1 poem and 3 seals of Wang Wu (1632-1690); 2 poems and 6 seals of Han T'an (1637-1704); 2 poems and 6 seals of Hsü Fang (1622-1694); 4 poems and 10 seals of Chou I (act. 1644-61); 1 poem and 3 seals of Li Pin (dates unknown); 1 colophon and 1 seal of Yen K'o-chün (1762-1843).

Poem by Wang Wu:

A narrow path coiling, winds across rock foundations;
Old vines and ancient trees meet the sunset's slanting
 rays.

288

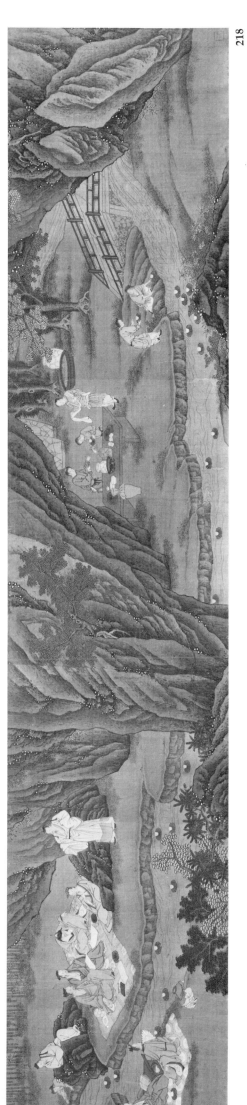
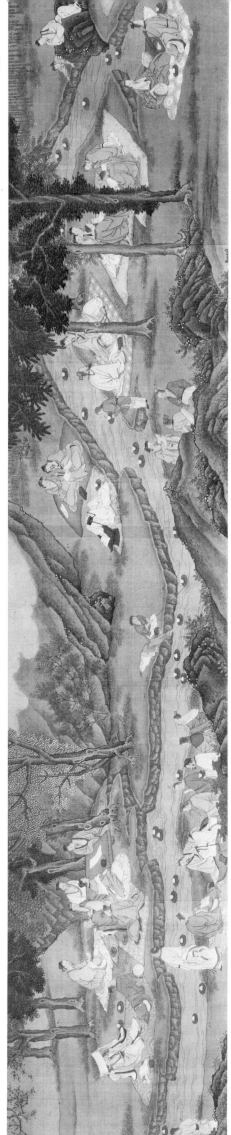

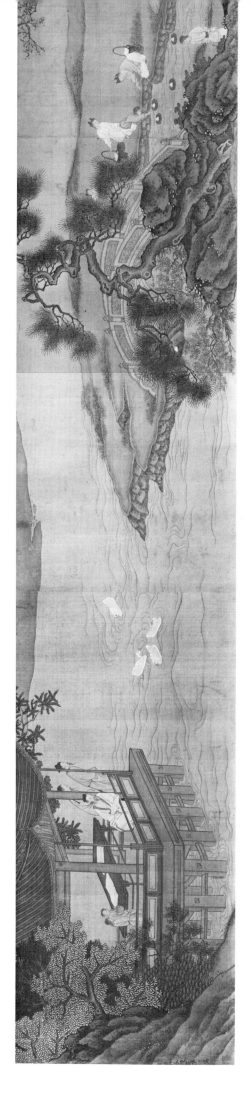

218 Detail

Unaware that my small boat has gone so far,
By the time it reverses its oars, the green mountains will
 be half-covered with clouds.

Poem by Han T'an:
A thousand feet of red cliffs look like a sculptured flower
 of Fu-yung;
In one glance, the long bridge joins adjacent ridges.
Furthermore a wine shop stands in a bamboo grove;
The fellow who bought some good wine is drunk on the
 eastern shore of the stream.

Poem by Hsü Fang:

Green are the reeds, the sun not yet set;
Tree foliage and mountain colors divide the lake in two
 halves.
A solitary recluse sits upon a flat bluff,
Occasionally observing white clouds rising from the
 mountain tops.

Poem by Hsü Fang:

By chance, I start my journey from the watershed to
 remote regions,
Suddenly I sight the silhouette of mountains – myriad
 expanses of green.
What is this "Come-flying" Peak which now does not
 recede,
Its rocky walls, linked to heaven, are drenched by a
 waterfall.
[Fei-lai (Come-flying) Peak, a rocky hill at West Lake,
Hangchou, was said to have flown there from its original
site, the Vulture Peak in Central India.]

Poem by Chou I:

That stone path surrounded by streams – for whom was it
 created?
Leaning on my staff, I walk and hum, arriving alone.
As soon as I ascend to gaze at these mountains, my
 happiness increases,
Every morning the moistening dew makes slippery the
 green moss.

Poem by Chou I:

The bright moon emerges through the willow,
The fragrance of flowers is already difficult to retain.
Listening above these tall branches,
I sense that faraway in my native place autumn has ar-
 rived.
Obstructed, all the diminished waters flow,
Abruptly the sound of a lute wafts to and fro.
A strong wind, unabated, blows among the willow
 branches.

Poem by Han T'an:

Thoughts of autumn in the nuptial chamber with the new
 chill arising,
The white frost all pervasive with a bright moon shining.
Outside the window, a crisp wind conveys the sound of
 crickets.
Within this quiet dream, I seem to sense the fragrance of
 orchids.
[Folk superstition holds that dreaming of orchids foretells
the birth of a son.]

Poem by Li Pin:

Maple leaves drift in the wind, the autumn gusts bracing,
Hibiscus flowers steeped with water, the evening breeze
 light.
The moonlight's slanting beams shine upon dreaming
 lovers.
No wonder that pair of fowl should dream of their absent
 partners.
[The poem is an allusion to a Ming play, *Yuan Yang Meng*,
by Yeh Hsiao-wan, b. 1613, in which two separated lovers
can meet each other only in their dreams.]

Poem by Chou I:

Ancient trees share the slanting rays of the setting sun.
Chilly ravens hover round their branches.
The leader of the flock thinks this a good place to rest,
Evening being the time for returning.
This flock is the so-called "filial crow,"

Who, in disgorging their food [to feed their young], have
 compassionate hearts.
Were the people in the world all like this,
Fine talent would be everywhere.

Poem by Chou I:

Green bamboo stand alone with a snowy covering,
In the deep recesses of a secluded valley, the evening
 breeze is light.
White egrets are lean as shadows with the cold ripples
 frozen,
They enter the gorge not just to admire the fish.

Colophon by Yen K'o-chün:

Of the paintings preserved from the Eight Masters of
Chin-ling [Nanking], those of Fan Hui-kung [Ch'i] are
the rarest. Because his moral principles were lofty and
pure, he lodged his emotions of joy in painting. Since he
wouldn't lift his brush to paint for anyone he considered
unworthy, his paintings are quite valuable. I can see from
looking at this album that he patterned himself after the
T'ang and Sung masters and was able to appropriate their
strength while avoiding mere superficial and faint imita-
tion. So his paintings capture the rhythm of life and
abound in spontaneity. Whenever I open this album, my
mind is pleased.

<div align="right">trans. HK/LYSL/WKH</div>

Remarks: Fan Ch'i is included among the Eight Masters
of Nanking — that disparate circle of artists associated
with the painter Kung Hsien (see cat. nos. 213-217) and
the influential patron-collector Chou Liang-kung. Slight-
ly older than Kung Hsien, Fan Ch'i gained a reputation as
a poet as well as a painter of varied subject matter—
landscape, flower and bird, and figures. Contemporary
literary accounts praise his finely detailed compositions
consonant with Sung and Yüan masters.

 The colophon written by Yen K'o-chün suggests T'ang
and Sung precedents for Fan Ch'i's painting. The land-
scape leaves exhibit generalized T'ang blue-and-green
color conventions, observable in the works of many
Ch'ing masters. Painted in light washes of color and ink,
each of the five landscape leaves display solidly con-
structed mountain chains where minute detail is sub-
ordinated to vast unfolding spaces and only subtle im-
plications of human habitation — a lone figure on a moun-
tain top, or the flag of a wine shop jutting out from a
bamboo grove. Despite their diminutive size, the broad,
deep landscapes of the first five leaves suggest an under-
standing of Western aerial perspective integrated with
traditional Chinese conventions. The other five leaves
reveal Fan Ch'i's purer Chinese manner in painting birds,
insects, and their intimate settings in closeup view and in
color. Leaves such as *The Flock of Crows* and *Egrets in Snow*
capture the Sung academic flavor specifically enough to
suggest that Fan Ch'i studied genuine Sung examples of
the genre (see, for example, cat. no. 26 and Ma Yüan's
Egrets in Snow in Li Lin-ts'an, "Landscape Paintings,"
1968, fig. 1). Both the sureness of his brush in the flower
and bird leaves and the simplified mountain forms in the
landscapes suggest a late date for this album. HK

Literature
CMA *Handbook* (1978), illus. p. 357.

Recent provenance: Robert G. Sawers.

The Cleveland Museum of Art 75.22

219A

219B

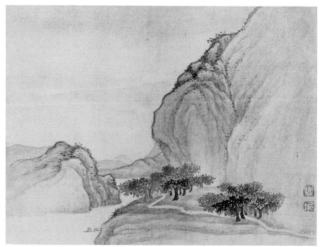

219C

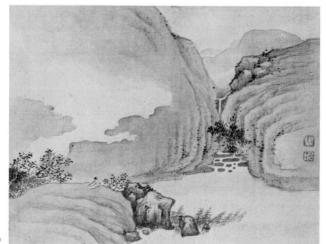

219D

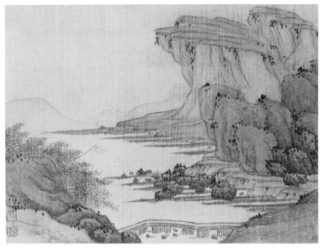

219E

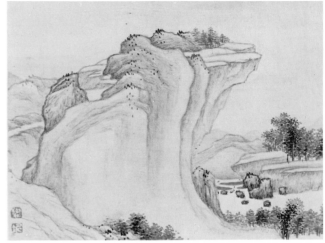

219F

219H

219I

219J

219G

Wang Kai, active ca. 1677-1705, Ch'ing Dynasty
t. An-chieh; from Hsiu-shui, Chechiang Province

220 *Album of Landscapes*
(Shan-shui ts 'e)

Album of eight leaves, dated 1677, ink or ink and
light color on paper, each 20 x 22.3 cm.

Artist's inscription, signature, and seal on leaf E: In imita-
tion of [T'ang] Wang Hsia's use of ink. Wang Kai of
Hsiu-shui [seal] Kai.

Artist's poem, signature, and seal on leaf G:

At an empty window sucking on a brush, the autumn
water nearby,
Green are the rushes, and bamboo reach to the sky.
For those who love hibiscus, river moonlight is best;
In this tiny shelter I keep company with sleeping egrets.
Wang Kai [seal] Wang yin Kai.

Artist's poem, signature, and 2 seals on leaf H:

The waters of the Hsün-yang River flow around the town
[Chiu-chiang in Chianghsi Province];
Yü Liang [Western Chin Dynasty general and statesman]
once made a night excursion here.
The air was fresh and cool – it must have been the eighth
month;
That noble gathering would still be known a thousand
years thereafter.
In the tantalizing ways we feast there is no difference,
past or present,
Lofty and pre-eminent talent still overflows in the ex-
change of verses,
Tall and large pavilions all share in good writing.
Joy winging through the air is no less than that in the
Southern Tower.
[The Southern Tower, in Nanch'ang, Hupei Province,
was where Yü Liang spent an evening with friends and
contemporaries exchanging poetry and ideas.]
 In the mid-autumn of the *ting-ssu* year [1677], these
paintings and comments are presented to the venerable
Meng Weng, leader of the literary circle, for criticism.
Wang Kai of Hsiu-shui [seals] Wang yin Kai; An-chieh.
8 colophons and 24 additional seals: 1 colophon and 2
seals of Shih Jun-chang (1618-1683); 1 colophon and 3 seals
of Wang Shih-chen (1634-1711); 1 colophon and 2 seals of
Li Lai-t'ai (dates unknown); 1 colophon and 3 seals of Mi
Han-wen (1661 *chin-shih*); 1 colophon and 3 seals of Tai
Wang-chin (17th c.); 2 colophons and 6 seals of Tai Wang-
lun (1655 *chin-shih);* 1 colophon and 2 seals of Wang Wan

(1624-1690); 1 seal of Chang Yin-huan (1837-1900); 2 seals
unidentified.

A. Poem by Shih Jun-chang:

Trees enmeshed in clouds darken the river ferry;
So grand a scene could only belong to the season of late
spring.
Looking upon the Five Lakes, fishermen are few,
You don't know who the oarsman is.

 Random comment for the venerable Meng Chih-weng
to correct. Shih Jun-chang.

B. Poem by Wang Shih-chen:

A valley stream winds around a hermit's home,
Over dark bamboo and yellow reeds leans one corner of
the house.
Watching the wake of a fishing boat off somewhere,
The ripples in the water are like wild geese nesting in the
sand.

 Inscribed for Meng Weng by his junior, Wang Shih-
chen.

C. Poem by Li Lai-t'ai:

A small bridge merged with clouds crosses the distant
water,
A few rosy clouds and autumn colors trim the clear river.
I stand alone at leisure in empty mists;
The mountains' verdant sides and misty peaks face the
small window.

 Inscribed for venerable Mr. Meng Weng, Li Lai-t'ao.

D. Poem by Mi Han-wen:

Coming and going time after time,
The front pavilion rests upon a great river.
Distant sails, the spring waters broad,
A tall temple, the afternoon sun strong.
Beneath the shadow of a butterfly, red peonies,
Amidst the chatter of birds, green vines.
Unable yet to return to the old mountains,
In vain I hum the "Picking *ling-chih*" song.

 Written for Meng Lao, Mi Han-wen.
[The last two lines refer to the Four Old Recluses of
Mount Shang who lived during the Ch'in Dynasty [221-
206 BC], and the song they sang about picking *ling-chih*,
the mushroom-like growth thought to produce
immortality.]

E. Poem by Tai Wang-chin:

Who picks up his unrestrained brush to write down misty
peaks?
To gaze at mountains from an empty house is a pleasure
inexhaustible.
I even wish I were physically within a painting.
Where floating clouds are not depicted, but only a vast
sea of waves.

 Written for the comments of Mr. Meng Weng, your
junior associate, Tai Wang-chin.

F. Poem by Tai Wang-lun:

Splashed ink, dripping wet, cannot be restrained.
Smartweed flowers are boundless, the water flowing
long.
The old fisherman moves his oar leisurely back and forth,
In ten thousand valleys and a thousand peaks, the air is
filled with fall.

 Written on one of the paintings for the venerable Meng
Weng, Tai Wang-lun of Ts'ang-chou.

220A

220C

220D

220E

220F

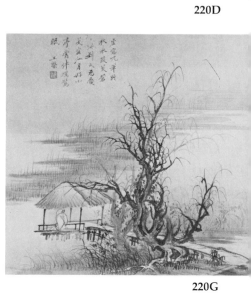

220G

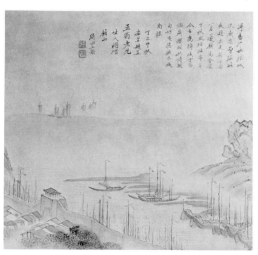

220H

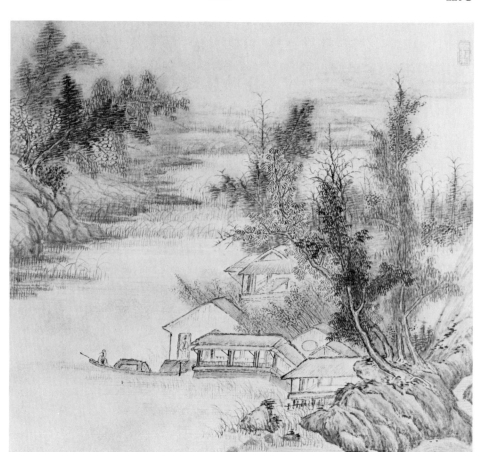

220B

G. Poem by Tai Wang-lun:

Precipitous slopes, distant peaks, and trees with forking
 branches,
Set apart are village huts for two or three households.
In one of them a recluse expounds from a book on
 the Tao,
Burning incense, alone he sits to chant the *Nan-hua*
 [*Chuang-tzu*].
 Written on a second painting for the venerable Meng
Ch'i, Tai Wang-lun of Ts'ang-chou.

H. Poem by Wang Wan:

Clouds like a landslide cover the boundless sky;
Year-round howling, the direction of the wind is
 ominous.
The boom has just been lowered with a hundred feet of
 sail;
Yet you can predict the violent wind from the direction of
 flying pennon tails.
Reed blossoms fly in disarray, their leaves badly battered;
Yangtze porpoises blow upon the waves, producing wild
 ripples.
You people of the land, don't sing about the joys of the
 trader,
Winds and waves like these will make their journey
 treacherous.
 Written for venerable Meng Weng, your junior friend
from Yao-fen, Wang Wan.

trans. HK/LYSL

Remarks: Wang Kai was a native of Hsiu-shui (present-
day Chia-hsing), Chechiang Province; his father,
however, eventually moved to Nanking. Wang is known
as the author of *The Mustard Seed Garden Manual of Paint-
ing*, the most influential of all Chinese instructional
manuals on painting (Ch'iu, "Chieh Tzu Yüan Hua
Chuan," 1951, pp. 55-69).
 Although Wang Kai is the only recorded pupil of Kung
Hsien, his contemporaries failed to include him among
the Eight Masters of Nanking. Nevertheless, this eight-
leaf album establishes his artistic fellowship with that
group of painters. Kung Hsien's influence pervades a
number of the leaves (especially C, E, and G), while the
remaining leaves agree with the more conservative
approach to landscape practiced by his contemporary Fan
Ch'i (see cat. no. 219) and other Nanking masters. Equally
reflective of the Nanking painting environment is the
introduction of Western spatial formulae into the estab-
lished conventions of Chinese landscape: this novelty
appears most clearly in the eighth album leaf where a fleet
of ships sails along a high horizon line.
 Wang Kai's contemporary, Chang Ken (1685-1760), im-
plies (in *Kuo-ch'ao*, 1793, *ch*. 2, pp. 37, 38; English transla-
tion in Sirén, *Masters and Principles*, 1956-58, v, 135) that
Wang was something of a status-seeker, often being seen
at the homes of important men. Some very well-known
figures contributed poems to Wang's album: Shih Jun-
chang and Wang Shih-chen both had distinguished offi-
cial careers but are better known for their poetry. Wang
Shih-chen, considered the foremost poet of early Ch'ing,
was himself the recipient of a painting done by Kung
Hsien (Wilson, "Kung Hsien," 1969, cat. no. 3). Shih
Jun-chang, Mi Han-wen, and Wang Wan were three of
fifty distinguished scholars who passed the special palace
examination of 1679 (see Wilhelm, "Po-hsüeh Hung-ju,"
1951, pp. 60-66). In this company, Wang Kai distinguishes
himself as an able poet with his verses written upon

leaves G and H. These same poems have also been pub-
lished, with slight variations in the characters, in the
biographical notes compiled on Chinese paintings in the
Yamamoto collection (Yamamoto, *Sō Gen Min Shin*, 1927,
ch. 7, p. 122). HK

Literature
Sirén, *Masters and Principles* (1956-58), VII, *Lists*, 432.
Lippe, "Kung Hsien" II (1958), p. 170, fn. 128.

Recent provenance: Chang Yin-huan; Ho Kuan-wu; Liu Ts'o-
ch'ou; Robert G. Sawers.

The Cleveland Museum of Art 75.64

Tso Chen, active seventeenth-early eighteenth
 century, Ch'ing Dynasty

221 *Fantastic Garden Rock*
 (*Ch'i-shih*)

 Hanging scroll, dated 1640 (?), ink on satin, 322.2 x
 78.8 cm.

Artist's signature and 2 seals: Painted by Tso Chen in the
keng-ch'en year [1640 or 1700]. [seals] Tso Chen chih yin; a
second seal is unreadable.

Remarks: The only information about Tso Chen is found
in the eighteenth-century writings of Chang Keng. He
remarks that Tso Chen, together with Wu Tan (act. ca.
1680-90) and Chu Hsü (*1647 chin-shih*), excelled in land-
scape painting and that Tso Chen's style followed the
great Northern Sung artist Kuo Hsi (ca. 1020-1090).
(Chang Keng, *Kuo-ch'ao — hsü-lu*, 1870, *ch*. 1, pp. 89, 90.)
It is doubtful that any of Tso Chen's landscape paintings
survive today.
 If one may judge from this single scroll, in painting
fantastic rocks Tso Chen followed the style of Kao Yang,
an artist of the early seventeenth century who did a
number of pictures of fantastic rocks for reproduction by
colored woodblock in the famous *Ten Bamboo Studio
Manual on Calligraphy and Painting* (*Shih-chu-chai shu-hua
p'u*, preface to the volume on stones dated 1627). Since
both Kao Yang and Wu Tan (mentioned above) were from
Nanking, it is possible Tso Chen worked in the same area
and was influenced by Kao Yang's style. KSW

Exhibitions
Museum für Kunst und Gewerbe, Hamburg, 1949/50: Contag,
 Chinesische Malerei, cat. no. 84, p. 46.

Nelson Gallery-Atkins Museum 67-17
Gift of Victoria Contag von Winterfeldt

Hsiao Yün-ts'ung, 1596-1673, Ch'ing Dynasty
 t. Ch'ih-mu, *h*. Wu-men tao-jen, Chung-shan
 lao-jen; from Wuhu, Anhui Province

222 *Striking Peak*
 (*Ch'i feng t'u*)

 Hanging scroll, ink and light color on silk,
 130 x 94.5 cm.

Artist's inscription, signature, and seal:

A single peak juts forth, soaring above the earth;
Clustered peaks lean toward it, reaching only the heel.
From chasm's edge, it seems so high, the others make
 it so;
From on high, small mounds, now so become, embrace it
 round.

221

Hanging, stretching, pine boughs rustle tunefully;
Under the natural bridge, alone and bereft, wind stirs the
water to sound.

Never have birds flown across the stone path;
Where tiled huts are cradled still by wisps of
mountain mist.

With upward view, drawn to the sky, solemn is my mood;
Looking down, bottomless from on high, my psyche
quivers in fear.

Spreading out in infinite form, all are but bands of clouds;
A thousand spires magically appear, seeming no more
than swells and mounds.

Scanning round, the mountains sprawl, linked like
bridges of stone;
Clustered peaks, erect and tall, converge at the vaulted
sky.

Thus is known the Creator's mastery of drama;
Whereupon the gods are made to reveal the heavens.

222

Shattering the void, parks and gardens are made;
Sculpturing the lumpen earth, fine jade is formed.

One knows ever more how great peaks and valleys are
 minute;
Mt. T'ien-p'ing's myriad slabs hover aloft beyond sight.

A large lake on first view is confined to a few rods;
A height of a thousand fathoms from afar is a wall waist
 high.

High hills and huge valleys are but a mass of wrinkles;
Metropolis or town, whole range or great plain, the dis-
 tinction is infinitesimal.

Calligraphic clouds, one stroke at a time, issue from Mt.
 Chu-tzu;
Chimney smoke, in sheets and threads, coils above Ch'ih
 yang city.

To and fro, immortals wander in the sky;
Walking the earth, Shu-hai exhausted its vast reaches.

Now it has taken form, written in leisure with brush
 and ink;
How at ease I am, when I enjoy it in comfortable repose.

Lush grove or enchantress fair, all these are a lower sort;
The two T'ien-mu mountains or three isles divine, how
 are they worth a word?

It is, moreover, that all the wonders gather in this
 painting;
Of all the world's striking sights, none compares.
[Painted] and inscribed by the Old Man of Mt. Chung,
Hsiao Yün-ts'ung. [seal] Ch'ih-mu.

 trans. MFW

6 additional seals: 3 of Na Hsing-a (19th c.);
3 unidentified.

Remarks: The poem inscribed by Hsiao on his painting is
difficult at best, dealing as it does with perception and
sudden shifts of first-person viewpoint. Much of the
poem, along with its quirky syntax, has been plagiarized
from a poem entitled "Climbing Shih-hsin Peak and Gaz-
ing back to Shih-sun Bridge," composed in 1641 by the
talented scholar-poet Ch'ien Ch'ien-i (1582-1664; see his
Mu-chai, preface 1643, *ch.* 19, pp. 199, 200). Hsiao has,
however, changed the poem in several places to suit the
imagery in his painting.

The date of Ch'ien's poem provides a *terminus a quo* for
dating the picture. Comparison with other pictures by
Hsiao, particularly a landscape of 1652 entitled *Southern
Peak without Clouds* (Urban Council, *Ming and Ch'ing*,
1970, no. 45), further suggests that the present picture
was probably painted just before mid-century.

The Shu-hai mentioned in the poem is a legendary
official of the Hsia Dynasty whom the Emperor Yü
ordered to walk the face of the earth to measure its extent.
Mt. T'ien-p'ing, a scenic spot near Suchou, is famous for
its autumn color and for an odd geological formation
which covers the face of the mountain with large slab-like
boulders. MFW/KSW

Exhibitions
Museum für Kunst und Gewerbe, Hamburg, 1949/50: Contag,
 Chinesische Malerei, cat. no. 63, pp. 28, 29, 43.
Kunstammlungen der Stadt Düsseldorf, 1950: Speiser and Con-
 tag, *Austellung*, cat. no. 42, p. 22.

Recent provenance: Victoria Contag von Winterfeldt.

Nelson Gallery-Atkins Museum F75-36

Hsiao Yün-ts'ung

223 *Pure Tones among Hills and Waters*
 (Shan-shui ch'ing-ying)

Handscroll, dated 1664, ink and light color on paper,
30.8 x 781.7 cm.

Artist's inscription, signature, and seal:

Planted pines to give forth mature beauty — all manifest
 the hearts of lofty men;
Drilled rock to erect a thatched house which year long is
 covered with green shade.
White clouds unexpectedly appear, and stretch and con-
 tract as there is space in the groove.
The myriad sounds for a time fall silent, and a trifling
 breeze drops a pure tone.
No one can describe this feeling, and who could appraise
 this scene?
One can only face the near side of a thousand peaks
 together with a five-stringed lute.
Peach blossoms will follow the green water — and, with-
 out one realizing it, spring will again be deep.

On the "Day of Flowers" in the *chia-ch'en* year [twelfth
day of the second lunar month of 1664], inscribed at the
Blue-Lotus Pavilion by the Old Man of Chung Mountain.
Hsiao Yün-ts'ung [seal] Chung-shan lao-jen.

4 colophons and 27 additional seals: 1 colophon, dated
1811, and 5 seals of Hsiang Yüan (18th-19th c.); 1 col-
ophon, dated 1858, and 2 seals of Ch'i Chün-tsao (1793-
1866); 1 colophon and 4 seals of Chang Ch'ien (18th c.); 4
seals of Chiang Hsün (18th c.); 1 colophon, dated 1943,
and 2 seals of Wang Chao-ming (19th-20th c.); 1 seal of
Ch'i Chih-liu (19th c.); 3 seals of Shen Feng (dates un-
known); 2 seals of Yü Chih-meng (dates unknown); 4
seals unidentified.

Remarks: Biographical information on Hsiao Yün-ts'ung
is meager. A native of Wuhu, Anhui, Hsiao competed in
the Ming civil service examinations for a place in govern-
ment service. When the government fell, he retired as a
"leftover subject" (*i-min*) to a hermit's existence of scho-
larship, poetry, and painting. As a painter, he became the
first in a succession of major talents to develop in Anhui,
a province hitherto undistinguished for nurturing a local
school (Li Chu-tsing, *A Thousand Peaks*, 1974, II, pp. 171-
79). His independent spirit eventually set the tone for
other Anhui painters such as his pupil Hung-jen (see cat.
no. 225); Hung-jen's follower, Cha shih-piao (see cat. nos.
226, 227); and Mei Ch'ing (see cat. nos. 228, 229).

Pure Tones among Hills and Waters, painted in 1664, rep-
resents a marked simplification of the somewhat fussy
brushwork and crowded detail which characterize
Hsiao's early landscapes (Jao, *Ming I-min*, 1975, no. 45,
pp. 107-8). Hsiao's painting would seem to be an accurate
illustration of the scene described in his poem. The house
perches on a shelf-like promontory shaded by tall, stately
pines. Fog hugs the lake shore and drifts about the grove
of willows. The painting further belies Hsiao's written
suggestion that the intangibles of mood and poignant
moment could not be captured, for his combination of
solidly massed forms with lack of specific detail provide a
firmly structured but evocative setting.

Chung Mountain, used by Hsiao in his signature, is
located near Nanking, and the loosely drawn contours of
Hsiao's rock-forms as well as the architectonic mode of
mountain construction used here suggests awareness of
the linear style of Kung Hsien as it appears in works dated
to the 1640s and early 1650s. Hsiao Yün-ts'ung was also

conversant with Sung styles (see his copies after Ma Ho-chih [of the 12th c.] in the National Palace Museum, Taipei). The elegant lineament of the figures in the Cleveland scroll suggests derivation from the style of Ma Ho-chih while the mist-in-the-willows is a convention closely associated with Chao Ling-jang (11th c.). HR

Literature

Trubner, "A Chinese Landscape" (1955), p. 104, fig. 6, 7 (sections).
Sirén, *Masters and Principles* (1956-58), VII, *Lists*, 337.
Lee, "Some Problems" (1957), pp. 480-82, pl. 13, fig. 17.
Goepper, *Im Schatten* (1959), pl. 26; idem, *Chinesische Malerei* (1960), p. 182, no. 105.
Lee, *Chinese Landscape Painting* (1962), pp. 119-21, no. 95; idem, *Far Eastern Art* (1964), p. 454, fig. 597.
Akiyma et al., *Chūgoku bijutsu* (1973), II, pt. 2, 231, 232, color pl. 40 (detail).
Rosenzweig, "A Landscape Handscroll" (1974-75), p. 47, fig. 17.
CMA *Handbook* (1978), illus. p. 356 (detail).

Exhibitions

Cleveland Museum of Art, 1954: Lee, *Chinese Landscape Painting*, cat. no. 102.
Haus der Kunst, Munich, 1959, *1000 Jahre*, cat. no. 105.

Recent provenance: Wang Chao-ming; Walter Hochstadter.

The Cleveland Museum of Art 54. 262

223 Detail

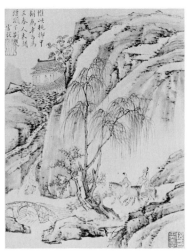

224A

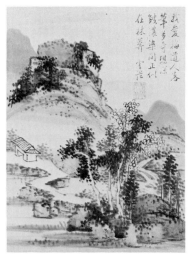

224B

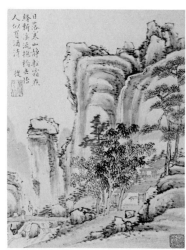

224C

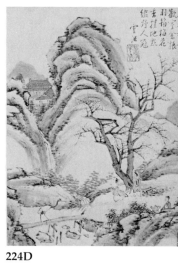

224D

224H

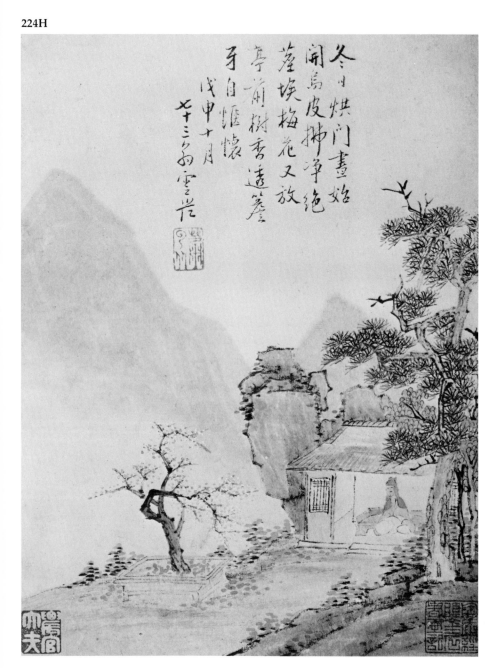

224F

224G

300

224E

Hsiao Yün-ts'ung

224 *Album of Seasonal Landscapes*
(*Shan-shui ts'e*)

Album of eight leaves, dated 1668, ink or ink and
light color on paper, each 21 x 15.8 cm.

Artist's inscriptions, signatures, and 8 seals:

A.

Alas why among these peach and willow trees,
Are there so many carriages and horses?
In spring, the people do not sit idle –
They tramp down all the bushes.
 Yün-ts'ung [seal] Hsiao Yün-ts'ung.

B.

I am fond of the Taoist of the Plum Blossoms [Wu Chen],
When he puts brush to paper, many strange ideas take
 form.
Among his dense brushstrokes and deep colors,
You really feel that you are in woods and wilderness.
 Yün-ts'ung [seal] Hsiao Yün-ts'ung.

C.

In the setting sun, the cold mountain is quiet;
Light frost dots the newly reddened leaves.
Rushing waters seem to embrace the bridge, then flow
 away;
The water is as pleasing and clear as wine.
 Ts'ung [seal] Hsiao Yün-ts'ung.

D.

In this perpetual spring, together we search out pleasure
While lively birds flap their feathers.
The fragrance of prunus strikes the ground;
Its blossoms adorn the caps of rustics.
 Yün-ts'ung [seal] Hsiao Yün-ts'ung.

E.

In the autumn wind's lonely soughing,
My thoughts are without limits.
Humming on the back of a donkey,
I write down my feelings.
 Ts'ung [seal] Hsiao Yün-ts'ung.

F.

Bit by bit, returning sails are lowered;
In the deserted village the sun begins to set.
I lead my donkey across a bridge,
I'll get drunk with friends at a country house.
 Yün-ts'ung [seal] Hsiao Yün-ts'ung.

G.

Only at the mountain top are there pines, at the water's
 edge, bamboo.
Old men from the country often come here to spend the
 night in the fog.
The hectic pace of worldly affairs is no more to me than
 drifting clouds;
My universe does not extend beyond my thatched hut.
What could be better than to grab a walking stick and
 head to the west of the river,
Striving to write a new poem that will tease the common
 crowd.
 Yün-ts'ung [seal] Hsiao Yün-ts'ung.

H.

When the winter sun warms up the door, the day begins;
I clean up my black leather shoes to break off from the
 dusty world.
Prunus blossoms again bloom on the tree in front of the
 pavilion;
Their fragrance penetrates the eaves and satisfies my
 innermost self.
 In the *wu-shen* year [1668], tenth month, the old man of
seventy-three, Yün-ts'ung. [seal] Hsiao Yün-ts'ung.
 trans. Wen Fong/HK/WKH

9 additional seals: 2 of Ch'en I-hsi (1648-1709); 4 of Li
Yün-ho (act. mid-19th c.); 3 unidentified.

Remarks: Completed four years after the Cleveland
handscroll (cat. no. 223), this well-preserved eight-leaf
album is more restrained in its brushwork. To suit the
reduced scale of the format, Hsiao uses a smaller brush
and abandons the broad sweeping rhythms so brilliantly
exploited in the long handscroll. Within this compact
framework, Hsiao Yün-ts'ung introduces few references
to the past. The mountains and land masses of leaves A
and D are tinted with the blue and green pigments of the
archaic landscape. In leaf B the artist names Wu Chen in
his inscription and imitates that Yüan master's method of
massing ink dots to form trees and mountain vegetation.
Actually, Hsiao seems more interested in capturing with-
in each playfully brushed view the lighthearted senti-
ments of his poems. HK

Literature
Lee, "An Album" (1957), pp. 121-25; idem,
 Chinese Landscape Painting (1962), p. 119, no. 96.
Rosenzweig, "A Landscape Handscroll" (1974-75), pp. 43, 44,
 51, figs. 10-12.

Exhibitions
Asia House Gallery, New York, 1974: Lee, *Colors of Ink*, cat. no.
 38 (B).
Indiana University, Bloomington, 1974: Conference on Oriental-
 Western Literary and Cultural Relations, no catalogue.

Recent provenance: Wu Hu-fan; Frank Caro.

The Cleveland Museum of Art 55.302

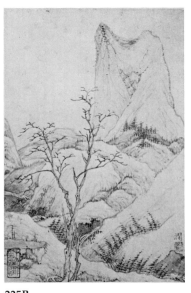

225B

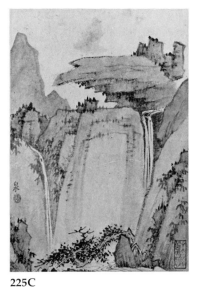

225C

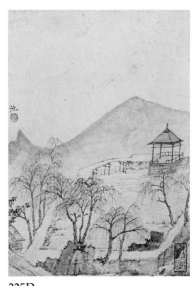

225D

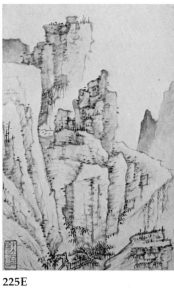

225E

225A

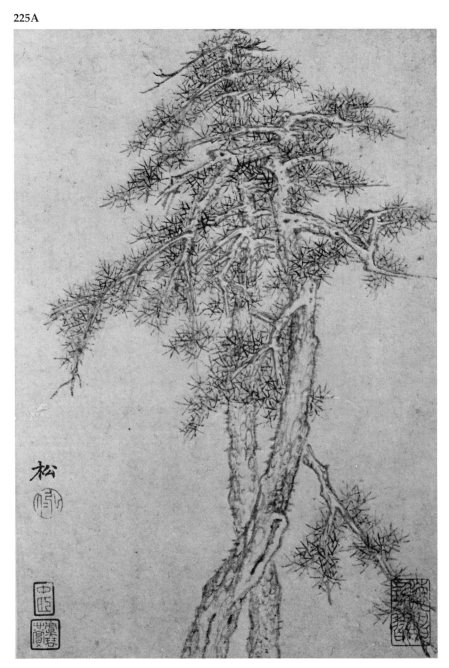

225G

225H

302

225F

Hung-jen, 1610-1664, Ch'ing Dynasty
Original name Chiang T'ao, *t.* Chien-chiang,
 h. Mei-hua ku-na, Yün-yin; from Hsieh-hsien,
 Anhui Province

225 *Landscape Studies*
 (Shan-shui hua-fan)

 Album of eight leaves, dated 1664, ink on paper, each
 24.6 x 17.1 cm.

Artist's titles, inscription and signature, and 8 seals:

A. *Pine (Sung).* [seal] Hung-jen.
B. *Pond (Ch'ih).* [seal] Hung-jen.
C. *Mountain Brook (Chien).* [seal] Chien-chiang.
D. *Spring (Ch'üan).* [seal] Hung-jen.
E. *Precipice (Yen).* [seal] Hung-jen.
F. *Rock (Shih).* [seal] Chien-chiang seng.
G. *Cliff (Pi).* [seal] Yün-yin.
H. *Mountain Crest (Kang)* Artist's inscription, signature
and seal: Painted by Hung-jen for Chung-weng chü-shih
on the eighth day of the *chia-p'ing* month of the *kuei-mao*
year [January 5, 1664]. [seal] Chien-chiang.

11 additional seals: 1 of Ni Ts'an (1627-1688); 2 of Yü Ch'in
(late 19th c.); 8 of Cheng Te-k'un (20th c.).

Remarks: That Hung-jen's death occurred unexpectedly
is confirmed by this album, which is dated only thirteen
days before his death on January 18, 1664. The album thus
becomes the latest-dated work among Hung-jen's known
surviving works. According to Huang Pin-hung (1864-
1955), Hung-jen was active to the very end, for his friend
T'ang Hsüan-i (mid-late 17th c.) records that Hung-jen
painted two paintings the day before his death (Huang
Pin-hung, *Chien-chiang*, 1947, xxv, 85). Huang notes that
the album was recorded under the title *Album of Pines and
Rocks* and once bore a colophon by Chang Kung-shu
(unidentified) which is now missing (ibid., p. 34). The
Chung-weng to whom the album is dedicated defies
identification. It is apparent, however, that the man was
well known in Anhui and Nanking artistic circles during
the 1650s and 1660s, for a number of surviving works by
major artists associated with those schools have been
dedicated to him. KSW/MFW

Literature
Huang Pin-hung, *Chien-chiang*, 1947, xxv, 85.

Recent provenance: Cheng Te-k'un; Lady Sedgwick; Jean-Pierre
 Dubosc.

Intended gift to the Nelson Gallery-Atkins Museum,
Mrs. George H. Bunting, Jr.

Cha Shih-piao, 1615-1698, Ch'ing Dynasty
 t. Erh-chan, *h.* Mei-ho; from Hsiu-ning, Hui-chou
 prefecture, Anhui Province, lived in Yangchou,
 Chiangsu Province

226 *Landscape Album in Various Styles*
 (Shan-shui ts'e)

 Album of twelve leaves, dated 1684, ink or ink and
 light color on paper, each 29.9 x 39.4 cm.

Artist's inscriptions, signatures, and 16 seals:

A. Ni Tsan was originally a follower of Tung Yüan. In
later years, he formed a style of his own. The followers of
Ni Tsan, however, try to imitate his dryness and light-
ness. This is to miss [Ni Tsan]. Shih-piao [seal] Shih-piao.
[seal, upper left edge] Erh-chan.

B. A picture of spring plowing. Painted by an Aging
Idler. [seal] Shih-piao.

C. "Boating in spring water is like sailing in the sky"
[from a poem by Lu Yu, 1125-1210]. While painting this, I
thought of the quotation and thus recorded it. The third
month of the *chia-tzu* year [1684]. Shih-piao [seal] Erh-
chan. [seal, upper right] Shih-piao.

D. The stream of Wu-ling. [Wu-ling is the mythic land
described in T'ao Ch'ien's "Record of the Peach-Blossom
Spring" (cf. cat. no. 137).] Cha Shih-piao [seal] Shih-piao.

E. After the idea of *Yangtze River Scenery* by Ta-ch'ih
[Huang Kung-wang]. [seal] Shih-piao. Shih-piao, while
visiting the Tai-yen lou [Tower of Waiting for the Wild
Geese] at Yangchou. [seal, lower left] Erh-chan.

F. A picture of traveling in autumn mountains. Shih-piao
[seal] Shih-piao.

G. Cha Shih-piao [seal] Erh-chan.

H. Pei-yüan's [Tung Yüan] paintings of ridges and peaks
are massive and rich. No one but the Elder Mi [Fu] was
capable of [painting] them. [seal] Shih-piao. [signed]
Erh-chan.

I. Pleasure in a mountain brook, in the manner of Wang
Meng-tuan [Wang Fu]. Shih-piao [seal] Shih-piao.

J. [seal] Shih-piao. Shih-piao imitating the Master of the
Plum-Blossom Hut [Wu Chen], second month of the
chia-tzu year [1684].

K. The ancients, when painting snow always empha-
sized the chilly wind to depict the coldness. Recent paint-
ers have not realized this. K'ang-hsi era, *chia-tzu* year
[1684], winter, the tenth month. Cha Shih-piao [seal]
Shih-piao.

L. Shih-piao waiting for the moon. [seal] Shih-piao.
 trans. Wen Fong/WKH

2 colophons and 12 additional seals: 1 colophon and 1 seal
of Ma Yüeh-kuan (1688-1755); 1 colophon, dated 1759, and
1 seal of Huang Ts'ou; 2 seals of Liu Hai-su (20th c.).

Remarks: The first colophon appended to the album was
written by Ma Yüeh-kuan, (1688-1755), one of the most
prominent scions of the Yangchou salt-merchant
aristocracy. He and his brother, Ma Yüeh-lu (1697-1766?),
were both talented poets who amassed the finest private

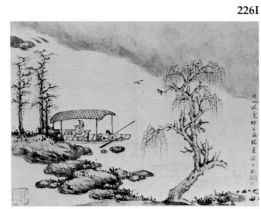

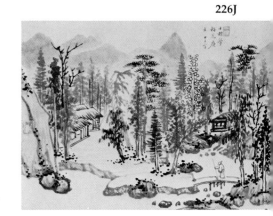

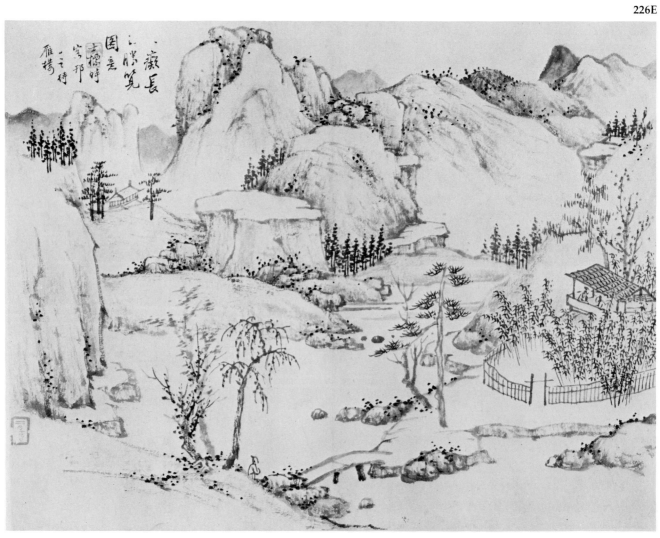

226D

226F

226G

226K

226L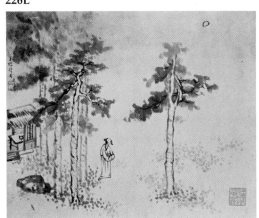

library of books and paintings in the Yangchou region. They also presided over one of the city's leading literary salons at their gardens, the Ling-lung shan-kuan or "Crystalline Mountain Cottage" mentioned in Ma Yüeh-kuan's colophon (see Ho, "Salt Merchants," 1954, p. 157; also note a famous painting by Fang Shih-shu [see cat. no. 275] in the background of the Hsing-an retreat).

Cha Shih-piao, one of the Four Masters from Anhui, was born into a wealthy mercantile family from that province. With the Ch'ing accession, he abandoned his studies to indulge his talent for painting and poetry and eventually assembled a sizeable personal collection of ancient bronzes and paintings. He spent most of his adult life in Yangchou, the great Chiangsu metropolis which provided generous patronage for leading Ch'ing literary and artistic figures from the profits of the Chiang-su-Anhui salt trade (for details of the trade see Spence, *Ts'ao Yin*, 1966, pp. 166 ff). There he befriended some of the most important figures in early Ch'ing intellectual life: the playwright K'ung Shan-jen, who supported Kung Hsien and other Nanking painters; Sung Lo, the Chiangsu governor who personally favored the Anhui masters; and the individualist Tao-chi (see cat. nos. 238, 239). He thought highly of Ch'eng Cheng-k'uei's calligraphy (see cat. no. 231) and even collaborated with the traditionalist Wang Hui (see cat. nos. 244b-247). From this diverse cosmopolitan culture, Cha emerged as a painter faithful to his Anhui heritage: his informal and personal views of his surroundings were grounded in first-hand study of the Yüan masters Huang Kung-wang, Ni Tsan, and their Ming champion, Tung Ch'i-ch'ang.

The names of five different masters appear in the artist's inscriptions within this twelve-leaf album, but Cha Shih-piao maintains a fairly consistent manner of execution throughout. The "Ni Tsan" and "Huang Kung-wang" leaves are broadly outlined and sparingly modelled, but when compared to a work by one of these Yüan masters (see cat. no. 110), Cha's interpretation seems more playfully and summarily executed. With consistently close-up views in these uncomplicated small landscapes, Cha ignores the intellectual rigor of the broader panoramas of Ni, Huang, and Tung. With slight additions of color on six leaves of the album, he displays another facet of the scholarly ideal — the simple enjoyment of painting as the pastime of a cultivated amateur.

HK

Literature

Sirén, *Masters and Principles*, (1956-58), VII; *Lists*, 284.
Lee, *Chinese Landscape Painting* (1962), p. 99, color pl. VIII; idem, *Far Eastern Art* (1964), pp. 454, 455, fig. 599; idem, "Water and Moon" (1970), p. 54.

Exhibitions

Cleveland Museum of Art, 1954: Lee, *Chinese Landscape Painting*, cat. no. 107.
Asia House Gallery, New York, 1974: Lee, *Colors of Ink*, cat. nos. 41 (H), 42 (E).
Indiana University, Bloomington, 1974: Conference on Oriental-Western Literary and Cultural Relations, no catalogue.

Recent provenance: C. T. Loo & Co.

The Cleveland Museum of Art 55.37

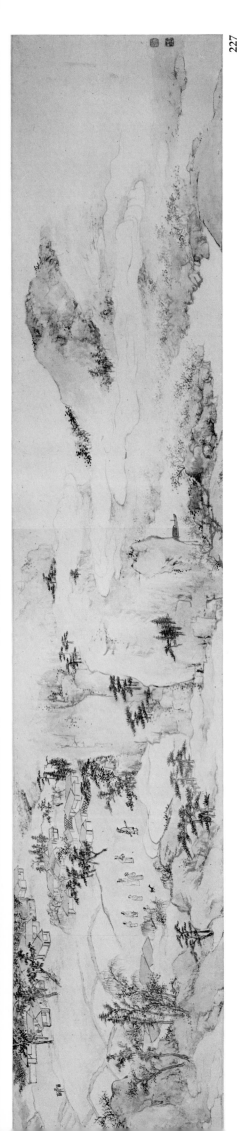

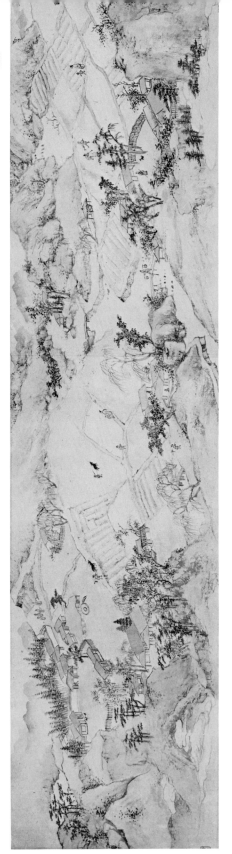

Cha Shih-piao

227 *The Peach-Blossom Spring*
(*T'ao-yüan t'u*)

Handscroll, datable to 1695, ink and light color on
paper, 35.2 x 312.9 cm.

Artist's 3 seals: [2 seals, lower right edge] Shih-piao ssu-
yin; Erh-chan. [partial seal, lower left edge] Huei shih ?-?.

Artist's colophon dated 1695, signature, and 3 seals: [seal]
Hou-i-mao-jen. The colophon consists of Cha's transcrip-
tion of T'ao Ch'ien's (365-427) ''Record of the Peach-
Blossom Spring,'' which is signed: Written by Cha Shih-
piao, the clansman at Han-shang, on the winter solstice
of the *i-hai* year [1695] of the K'ang-hsi era. [2 seals, left of
signature] Cha Shih-piao yin; Mei-huo shih i tzu yüeh
Erh-chan.

1 frontispiece, 7 additional colophons, and 19 additional
seals: 1 colophon, dated 1816, and 4 seals of Weng Fang-
kang (1733-1818); 1 colophon, dated 1927, by Chu Tsu-
mou (1857-1931) and Yü Chao-k'ang with 1 seal of Yü
Chao-k'ang; 2 colophons, one dated 1926, and 2 seals of
Tseng Hsi (1861-1930); 1 frontispiece dated 1929,
3 colophons, one dated 1928, and 12 seals of Ch'eng
Sung-wan (act. 1901-29).

Remarks: In much of his extant oeuvre Cha Shih-piao
strains, like so many ''individualist'' painters of his day,
for spontaneity and expressive forcefulness. His brush-
work often became incoherent and unkempt-looking,
and his compositions dangerously disintegrated. This is
especially true of pictures done with coarse, wet brush-
work that have the ring of works made to accommodate a
request or obligation and in which the artist had little
interest in testing his mettle or stretching his creative
powers. But in *The Peach-Blossom Spring*, a product of the
mellowness of old age, strained formal manipulations
give way to genuine naturalness. There is even a lyricism
about the picture that marks Cha Shih-piao at his best. It
illustrates T'ao Ch'ien's tale of the accidental discovery
by a fisherman of a Shangri-la that had been cut off from
the ''progress'' of civilization for centuries (cf. cat. nos.
137, 198, 227, 243). Life there was unspoiled and the peo-
ple innocently pure — a wistful ideal that might have
appealed to a painter who had witnessed the turbulence
of the barbarian conquest of his native dynasty.

The painting is technically and stylistically one of Cha's
most satisfying. It opens on a low-keyed note of elegance
suggestive of the peaceful spirit of the valley seen beyond
the large rocky cliff that fills the format from top to bot-
tom. Languidly drifting clouds, sketched loosely with a
soft, rolling brush, tie together mountains and cliffs,
much as the mallow red blossoms of the peach trees
below harmonize with the vigorously textured fore-
ground rocks. The drawing of the rocks and mountains
reflect Cha's sparse, lean style. Long, loose strokes of an
unevenly inked brush with rolling and dragging move-
ments contrast with dense, crisp patches in dark, dry ink
made with the side of a brush. These bare bones of land-
scape are drawn together and filled out with pale, trans-
parent washes of color whose streaked and off-hand look
leads to impressionistic images.

In the handling of the ground plane of the valley and its
fields Cha reveals his ability to exploit arbitrary distortion
of natural images to achieve striking visual interest: the
ground plane tips, tilts, and flattens, spiralling along the
length of the scroll. Field dividers, scarcely recognizable
to the uninitiated, form something of a leitmotif unifying

accent groupings of buildings, bamboo, and trees, which are painted and composed in a way that is characteristic of Hsin-an school painting in the latter part of the seventeenth century. MFW

Literature
Akiyama et al., *Chūgoku bijutsu* (1973), II, 239, pl. 55.
NG-AM Handbook (1973), II, 67, 68.
Kawakami and Tsuruta, *Chūgoku* (1977), pp. 60, 61.

Nelson Gallery-Atkins Museum 72-4

Mei Ch'ing, 1623-1697, Ch'ing Dynasty
t. Yüan-kung, h. Ch'ü-shan; from Hsüan-ch'eng, Anhui Province

228 *Landscapes after Various Styles of Old Masters (Fang-ku shan-shui ts'e)*

Album of ten leaves, dated 1690, ink or ink and light color on paper, each 28.6 x 44 cm.

Artist's inscriptions, signatures, and 35 seals:

A. [seal] San-mei yu.

Prunus blossoms from a thousand trees and an old hut—
The painting seems filled with their fragrance for a distance of ten miles.
In the wintry mountains I sit alone without company;
Having just finished a new poem, I think I'll taste some wine.

 Imitating Li Ying-ch'iu's [Li Ch'eng] "Prunus-Blossom Study." Ch'ü-shan [painted] and inscribed. [2 seals] Mei; Ch'ü-shan. [seal, lower left corner] Ch'ü-hsing hsien-i.

B.

I am fond of the old Taoist of the Plum Blossoms [Wu Chen];
His brush traces scattered upon the paper are all extraordinary.
He brought the nectar of the immortals from the oceans,
To get himself drunk in the everlasting spring of Chiang-nan.

 Ch'ü-shan jen [2 seals] Mei; Ch'ü-shan. [seal, lower right corner] Po-chien shan-k'ou jen-chia.

C.

For hundreds of years only Huang Ta-chih [Huang Kung-wang] has been handed down from generation to generation.
His cloudy mountains and scattered rocks continue to inspire the composing of poetry.
When frenzied inspiration came, he splashed ink as if pouring out wine;
Who says this wandering immortal wasn't a painting master?

 Ch'ü-shan [painted] and inscribed. [2 seals] Mei; Ch'ü-shan. [seal, lower right corner] Ch'ü-hsing hsien-i.

D. [seal] San-mei yu.

Massive in size, its trunk is truly grand,
Luxuriant in foliage, its color never fades.
Standing alone and still growing upwards,
The trunk intends to be beside the clouds.

 Mei Ch'ing of Ch'ü-shan [painted] and inscribed in imitation of old Shih-t'ien's [Shen Chou] brush idea in the *keng-wu* year [1690], summer, the sixth month. [2 seals] Ch'ü-hsing, Ch'ing; Yüan-kung. [2 seals, lower right corner] Hua-sung; Po-chien shan-k'ou jen-chia.

227 Detail

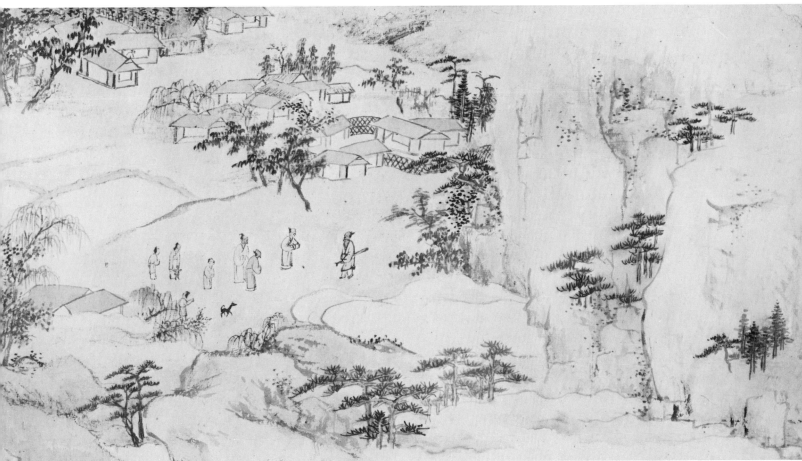

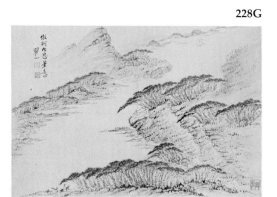
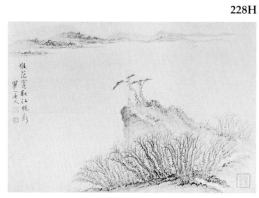
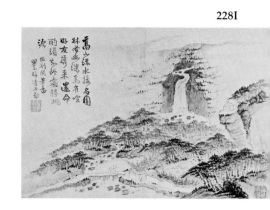

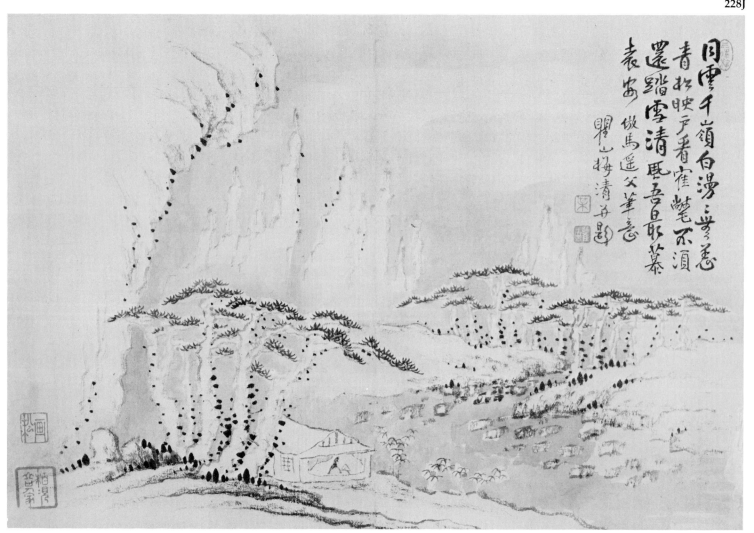

E.

Imitating Ni Kao-shih's [Ni Tsan] brush idea. Ch'ü-shan [seal] Yüan-kung. [2 seals, lower right corner] Hua-sung; Po-chien shan-k'ou jen-chia.

F.

The blowing of the fall wind decreases gradually,
Melancholy thoughts of autumn are, in the end, inexplic-
 able.
Where do I play my long flute
[and] at the same time hold a fishing pole?

 Imitating Sung-hsüeh's [Chao Meng-fu] brush idea. Ch'ü-shan [painted] and inscribed. [2 seals] Ch'ü-hsing, Ch'ing; Yüan-kung. [seal, lower right corner] Po-chien shan-k'ou jen-chia.

G.

Imitating K'o Chiu-ssu's brush idea. Ch'ü-shan [2 seals] Mei; Ch'ü-shan. [seal, lower right corner] Hua-sung.

H.

Imitating Fan K'uan's "Sailing on the Autumn River." Ch'ü-shan lao-jen [2 seals] Mei; Ch'ü-shan. [seal, lower right corner] Po-chien shan-k'ou jen-chia.

I.

Tall mountains and falling water adjoin a famous garden,
In a wooded gorge, deep and remote, small birds chirp.
Old friends who bring me along and entertain me at a
 feast
Should know this place is superior to the Peach Blossom
 Spring.

 Imitating Ching [Hao] and Kuan [T'ung] brush ideas. Mei Ch'ing of Ch'ü-shan [painted] and inscribed. [seal] Ch'ü-hsing, Ch'ing. [2 seals, lower right corner] Hua-sung; Ch'ü-hsing hsien-i.

J. [seal] San-mei yu.

Thousands of peaks like clouds — white, far and wide.
Green pines without a flaw — shining through the
 window.
I don't need a down coat to walk in the snow,
As for integrity, I admire Yüan An [of Eastern Han] the
 most.

 In imitation of Ma Yao-fu's [Ma Yüan] brush idea. Mei Ch'ing of Ch'ü-shan [painted] and inscribed. [2 seals] Mei; Ch'ü-shan [2 seals, lower right corner] Hua-sung; Po-chien shan-k'ou jen-chia.

 trans. HK/LYSL/WKH

Remarks: The Anhui master Mei Ch'ing grew up in an artistic but impoverished gentry family from Hsüanch'eng. The Manchu conquest of China did not deter him from seeking a government career; but despite repeated attempts at the civil service examination, Mei

Ch'ing never passed beyond the provincial *chü-jen* degree. The aspiring scholar, however, developed a reputation as a poet and became the most famous of the amateur painters within his family.

 Judging from the vertical line running through each leaf, this album was originally mounted so that each scene stretched across a folded leaf. The artist meant the leaves to be "imitations" of famous masters, but as Li Chu-tsing (*A Thousand Peaks*, 1974, I, 186-99) notes of another such album, the citations have little to do with the technical execution of various leaves. Following the example of the earlier Anhui master Hsiao Yün-ts'ung (see cat. nos. 222-224), Mei Ch'ing's associations with the past are highly selective, and, more often than not, are only dimly seen in his own inventive execution.

 Mei Ch'ing's allusions to the past must be considered the poetic reactions of an independent scholar-painter aware of, but not dependent upon, earlier masters. If any single influence pervades these leaves, it is the loosely painted, broad vistas and ornamental dotting of his close friend Tao-chi (see cat. nos. 238, 239). Yet by the time the Cleveland album was executed in 1690, Mei Ch'ing had long since absorbed this influence into his own style that is characterized by a playful miniaturization of selected landscape motifs. HK

Literature
Sirén, *Masters and Principles* (1956-58), VII, *Lists*, 386.
Fontein, "Chinese Art" (1960), pl. 291.
Lee, *Chinese Landscape Painting* (1962), p. 124, no. 100 (G illus.);
 idem, *Far Eastern Art* (1964), p. 455, fig. 600 (J).
Sullivan, *Chinese and Japanese* (1965), p. 95, fig. B.
Lee, "Water and Moon" (1970), p. 53, fig. 21 (G).
Cahill, "Chūgoku kaiga – II" (1975), color pl. 4 (J).
Fu, "Ming Ch'ing chih chi" (1976), p. 596, fig. 21 (D), fig. 22 (J).
Vinograd, "Reminiscences" (1977-78), p. 9, fig. 12 (G).
Watson, *L'Ancienne Chine* (1979), pl. 563 (H).

Exhibitions
Cleveland Museum of Art, 1954: Lee, *Chinese Landscape Painting*,
 cat. no. 109 (complete album, G illus.).
Haus der Kunst, Munich, 1959: *1000 Jahre*, cat. no. 110 (complete
 album, G illus.).
Smith College Museum of Art, Northampton, Mass., 1964: Fif-
 teen Chinese Paintings from The Cleveland Museum of Art,
 no catalogue.
Asia House Gallery, New York, 1967: Cahill, *Fantastics and Eccen-
 trics*, cat. no. 17.
Asia House Gallery, New York, 1974: Lee, *Colors of Ink*, cat. nos.
 43 (D), 44 (I).
Indiana University, Bloomington, 1974: Conference on Oriental-
 Western Literary and Cultural Relations, no catalogue.

Recent provenance: Richard B. Hobart.

The Cleveland Museum of Art 62.157

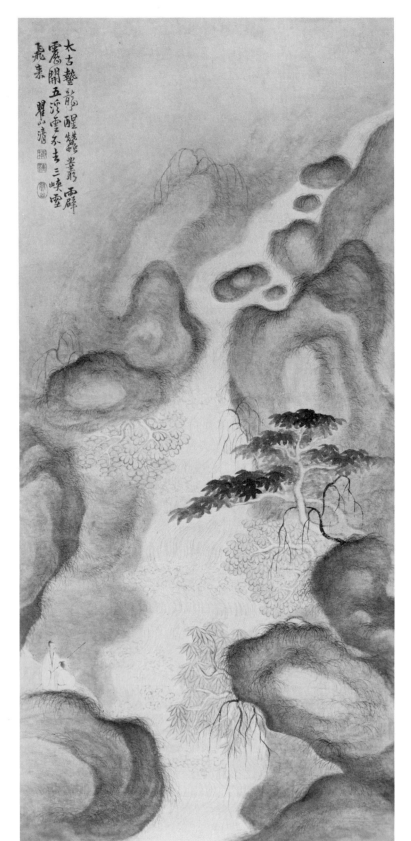

太古蟄龍醒蟄蟄羮形雨醒
震開五溪雲不去三峽蟄
瞿山清

229

Mei Ch'ing

229 *Nine-Dragon Pool*
(*Chiu-lung t'an*)

Hanging scroll, ink and light color on paper,
92 x 43.5 cm.

Artist's inscription, signature, and 2 seals:

From time immemorial, the hibernating dragon has
 awakened;
With a thunder-clap, the mountain path [to Ssuch'uan] is
 split open.
Along the Five Streams, clouds linger,
Over the Three Gorges, snows fly.
Ch'ü-shan, Ch'ing [seals] Mei Ch'ing; Yüan-kung.

 trans. WKH

2 additional seals: 1 of Tai Hsi (1801-1860); 1 of Liu (?).

Remarks: This striking and decorative composition is
known in at least two other versions, both horizontal in
format. One is very similar in style, but is probably a copy
(*Mei Ch'ü-shan Huang-shan*, 1910, pl. 19); the second de-
picts the same subject in a less decorative, more "stan-
dard" *wen-jen* manner (*Mei Ch'ü-shan*, 1960, pl. 8). All
three have the same poem by the artist, but the painting
title published in 1910 calls the scene *Nine-Dragon Pool*,
while that published in 1960 refers to a *White-Dragon Pool*.
The anonymous label on the Cleveland hanging scroll,
written in the not-too-distant past, says *White-Dragon
Pool*. Perhaps one should opt for *Nine-Dragon Pool*, since
in an album leaf by another Anhui master, Hung-jen, the
descending falls are carefully labelled *Nine-Dragon Pool*
(*Shina Nanga taisei*, 1935-37, XIII, pls. 12, 25).

 The reworking of subjects in different formats or on
different occasions is not surprising. What is unusual and
extreme about this hanging scroll is its markedly decora-
tive and rhythmic character, almost rococo in effect. This
element, often present in Mei's individualist work, here
has become the main subject of the picture.

 The scroll was once owned by Tai Hsi, who painted the
short handscroll of the *Rain-Coming Pavilion* (cat. no. 282).
Perhaps the topographical appeal of the painting explains
why so bold a work was collected by so gently orthodox a
painter. SEL

Literature
Harada, *Shina* (1936), pl. 775.
Mei Ch'ü-shan (1960), pl. 2.
Exhibitions
Tokyo National Museum, 1931: *Sō-Gen-Min-Shin*, II, pl. 256.
Recent provenance: Shōgorō Yabumoto.
The Cleveland Museum of Art 79.50

Mei Keng, active late seventeenth century, *chü-jen*
 1681, died after 1707, Ch'ing Dynasty
 t. Ou-ch'ang, Tzu-ch'ang, *h.* Hsüeh-p'ing,
 T'ing-shan-weng; from Hsüan-ch'eng, Anhui
 Province

230 *Boating on the Lien River*
(*Lien-hsi chou-fan*)

Handscroll, dated 1686, ink on satin, 25.4 x 81.3 cm.

Artist's inscription (partial), signature, and 4 seals: [seal]
Hsüeh-p'ing. On the day after the Festival of Bathing the
Buddha [Buddha's birthday] in the *ping-yin* year [1686],
the venerable old gentlemen Ch'i-yüan and Tung-yen
invited me to share in a boat trip on the Lien River with

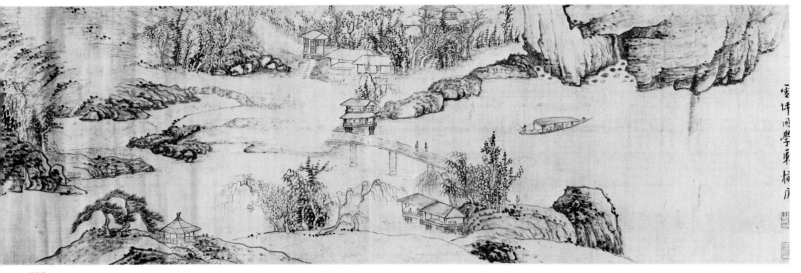

230

Li-t'ing, Chung-chiang, and others. The Taoist Pan-shui composed tunes to the accompaniment of flutes and lutes played by servants.

Although the wine course was not yet half over, I plucked up a brush and came up with ten quatrains to record the glorious events of a moment. May the senior poets who joined this outing correct me!

Hsüeh-p'ing t'ung-hsüeh, ti, Mei Keng. [2 seals] Mei Keng chih yin; Ou-ch'ang. [seal at end of scroll] Pi-yün ts'ao-t'ang.

<div align="right">trans. MFW/KSW</div>

Remarks: The above inscription follows ten quatrains, not translated here, composed by the artist. The imagery is banal and the sentiments tainted with more than a touch of cliché. Each quatrain does, however, refer to activities on the boat or to scenery that inspired the poem.

Mei Keng's reputation as a painter is far overshadowed by that of his more talented older brother, Mei Ch'ing (1623-1697), who was one of the leading masters of the Hsin-an school (see cat. nos. 228, 229). Mei Keng's poetry gained him greater prominence, and he moved easily in literary and artistic circles of the day. He had studied with the noted early Ch'ing scholar Chu I-tsun (1629-1709) and could count the famous collector Sung Lo (1634-1713) as a good friend. What scant records exist about Mei Keng indicate that his painting style followed that of Mei Ch'ing. While certain general connections to Mei Ch'ing's art and to other Hsin-an painters may be found in *Boating on the Lien River*, other elements suggest that Mei Keng was also familiar with Nanking school artists such as Kung Hsien (see cat. nos. 213-217). Mei Keng's works are too rare, however, to bear definitive statements about his stylistic affinities. MFW

Exhibitions

Museum für Kunst und Gewerbe, Hamburg, 1949/50: Contag, *Chinesische Malerei*, cat. no. 56, p. 42.

Kunstsammlungen der Stadt Düsseldorf, 1950: Speiser and Contag, *Austellung*, cat. no. 101, p. 30.

Recent provenance: Victoria Contag von Winterfeldt.

Nelson Gallery-Atkins Museum F75-45

Ch'eng Cheng-k'uei, active ca. 1630-74, Ch'ing Dynasty

t. Tuan-po, *h.* Chü-ling, Ch'ing-ch'i tao-jen; from Hsiao-kan, Hupei Province, moved to Nanking, Chiangsu Province

231 *Dream Journey among Rivers and Mountains (No. 90)* *(Chiang-shan wo-yu t'u)*

Handscroll, dated 1658, ink and light color on paper, 26 x 344.2 cm.

Artist's inscription, signature, and seal: Dream Journey among Rivers and Mountains, number 90. Ch'ing-ch'i tao-jen, *wu-hsü* year [1658], summer, the fifth month. [seal] Ch'eng Cheng-k'uei.

1 colophon and 12 additional seals: 3 seals of Huang I 3)9 3 seals of Tai Chih (19th c.); 1 colophon, dated 1914, and 3 seals of Yen Shih-ch'ing (late 19th-early 20th c.); 3 seals of Wang Nan-p'ing (20th c.).

Remarks: Ch'eng Cheng-k'uei was born in Hsiao-kan and passed the *chin-shih* examination in 1631. He served as an imperial diarist of the Banquet Court, and later rose to be director of the Court. With the Manchu invasion, Ch'eng went south to Nanking; when Nanking fell to the Ch'ing in 1645, he retired and spent his time in artistic pursuits. Eventually, he offered his service to the Manchus, and in his second official career rose to become vice president of the Board of Works. After retiring in 1657, Ch'eng devoted himself to art and his collection.

As a young man, Ch'eng studied painting with Tung Ch'i-ch'ang (see cat. nos. 190-192). In 1645 Ch'eng boasted that his collection included works done by each of the Four Great Masters of the Yüan. (The large handscroll by Chao Meng-fu, cat. no. 81, was once in Ch'eng's collection.) Although Ch'eng never owned the two scrolls by Huang Kung-wang that he most coveted, the *Scenic Views of Rivers and Mountains* (evidently destroyed in 1645; *Shih-pai-chai*, ca. 1800, pt. I, *ch.* 3) and *Fu-ch'un Mountains* (National Palace Museum, Taipei), he was able to see both during the 1630s and based his earliest paintings on those models. In 1657 Ch'eng renewed acquaintance with the *Fu-ch'un* handscroll and made a copy of it.

Yen Shih-ch'ing's colophon attached to this handscroll pairs Ch'eng with K'un-ts'an (see cat. nos. 232, 233), both

311

in brushwork and as Buddhist friends, and then adds that this painting is in imitation of Huang Kung-wang. He also mentions the praise given to Ch'eng by his former mentor, Tung Ch'i-ch'ang.

Ch'eng used the title *Dream Journey among Rivers and Mountains* for a whole series of handscrolls. In 1652, while still in government service, he wrote (ibid., pp. 28b-30a), "Recently I decided to do one hundred handscrolls of *Dream Journey among Rivers and Mountains* for my own pleasure. From the fall of the *hsin-mao* year [1651] until the spring of the *jen-ch'en* year [1652], I completed twenty scrolls."

In 1659 he added a note to a painting completed before his retirement, *Dream Journey (No. 74)* (now in the Museum of Fine Arts, Boston). Having stated that he intended to finish one hundred scrolls after retirement in 1658, he had little time to paint in the year following. Reexamining scroll number 74, he realized how short he had fallen of his goal because he had misused his new-found leisure. This may explain the long lapse of time between the Cleveland *Dream Journey (No. 90)* of 1658 and number 91, dated 1661 (formerly Seligman collection; Garner et al., *Arts of the Ch'ing*, 1963-64, cat. no. 23, pl. 13). Then, in a great spurt of activity, Ch'eng completed at least sixty-two more scrolls within a year. *Dream Journey (No. 153)* is dated in the first month of 1662 *(Shina Nanga taisei*, 1935-37, XV, pls. 46-49). His long inscription on that scroll, written in the eleventh month of the same year, states that he had completed about two hundred scrolls of varying quality, many of which had been lost or taken away by friends. Ch'eng may not always have inscribed and dated each scroll as it was completed, but it is clear that he surpassed his initial goal of one hundred scrolls. Chou Liang-kung *(T'u hua lu*, epilogue 1673, *ch.* 2, pp. 22, 23) tells us that ten years previous to the writing of his work on contemporary painters, he saw the three-hundredth such scroll on a visit with the artist and that Ch'eng Cheng-k'uei intended to paint five hundred in all. Chou probably saw the painter in the early 1660s; but his statement should not be accepted without question, because some of the scrolls presently known and dated are inconsistently numbered. One scroll, dated 1670, is number 20, while another scroll from the same year (Cahill, *Fantastics and Eccentrics*, 1967, cat. no. 18), is number 180. Two scrolls of the year 1661 (Bristol Art Museum and Los Angeles County Museum of Art) are numbers 91 and 150. Since we don't know if Ch'eng numbered the scrolls when they were painted or when they were presented, or if he dated and numbered the scrolls at the same time, there is considerable risk involved in trying to estimate accurately the number or the chronology of the paintings in the series. HK/HR/SEL

Literature
Sirén, *Masters and Principles* (1956-58), V, 112; VII, *Lists*, 302 (erroneously dated 1674).
Lee, *Chinese Landscape Painting* (1962), p. 90, no. 71; idem, *Far Eastern Art* (1964), p. 441, fig. 584; idem, "Water and Moon" (1970), p. 55, fig. 26.
Fu, "Ming Ch'ing chih chi" (1976), p. 594, fig. 15 (section).
Hochstadter, *Compendium* (forthcoming).

Exhibitions
Haus der Kunst, Munich, 1959: *1000 Jahre*, cat. no. 88.

Recent provenance: Walter Hochstadter.

The Cleveland Museum of Art 60.182

231 Detail

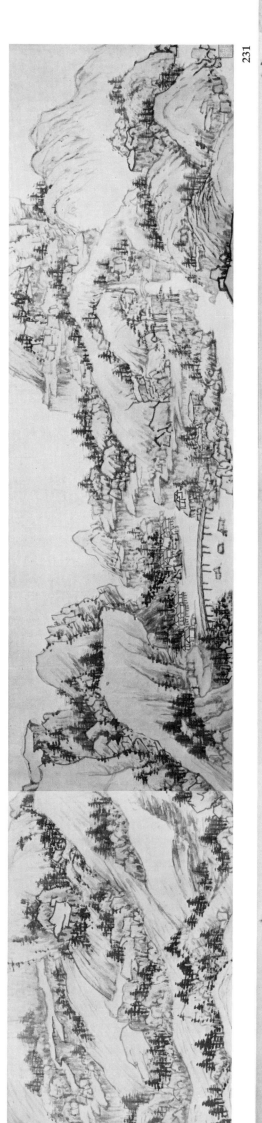

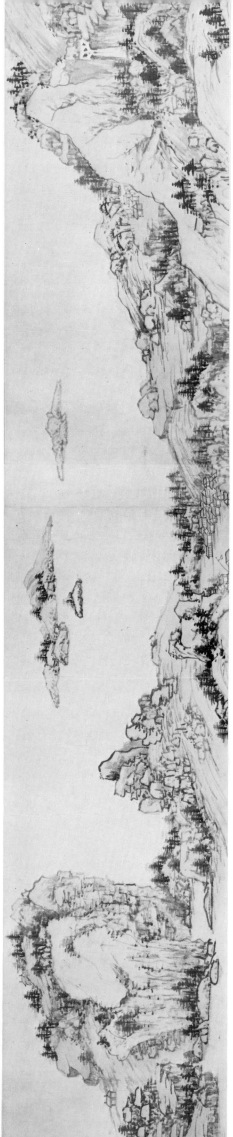

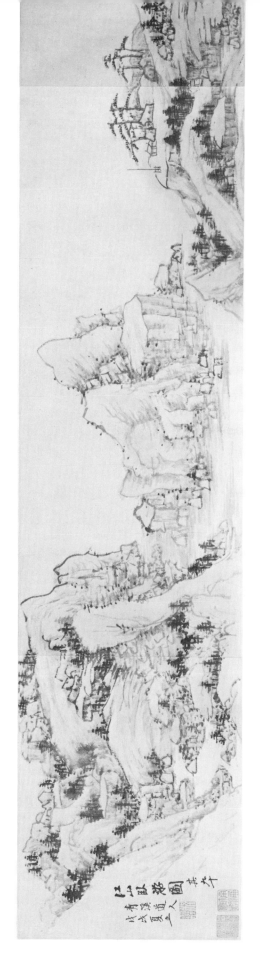

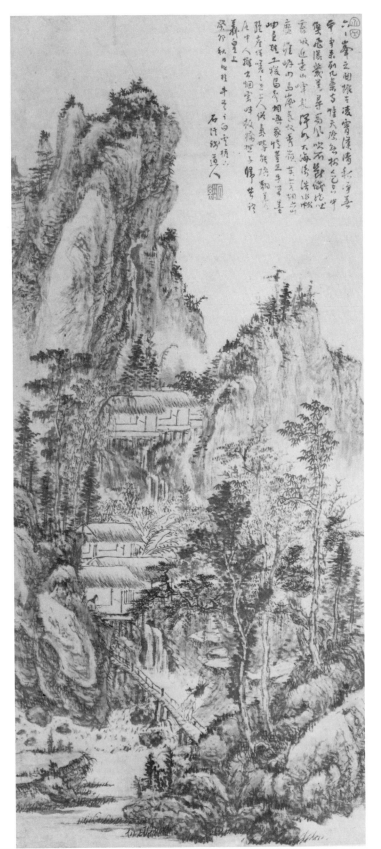

232

K'un-ts'an, 1612–1674 or later, Ch'ing Dynasty
Family name Liu, *t.* Shih-ch'i, Chieh-ch'iu, *h.*
Pai-t'u, Ts'an tao-jen, and others; from Wu-ling,
Hunan Province, lived in Nanking, Chiangsu
Province

232 *The Mood of Autumn among Streams and
Mountains*
(*Hsi-shan ch'iu-i*)

Hanging scroll, dated 1663, ink and light color on
paper, 108 x 48.3 cm.

Artist's inscription, signature, and 2 seals at upper right:
[seal] Chieh-ch'iu.

An expanse of mountain peaks, six times six,
Soaring heaven high, since the start of time.

In the cool autumn, clear without a cloud,
Jostling they come, serried round my desk.

Temple banners, suspended against the sky;
The colors of trees, splendid in the open air.

A waterfall plunges myriads of meters in the air,
Unbroken by the puffing of winds high aloft.

Suddenly, spewing forth mist and fog,
Mountain peaks lose their place near and far.

Swelling like great waves upon a sea,
A boundless expanse, with limits unfixed.

In a while, mountain vapors thin;
Delicate ranges shimmer like mallow flowers.

Hard it is to paint ridges and high clefts,
Where monkeys and birds call back and forth.

I recall the masterful hands of Tung [Yüan] and
Chü[-jan],
Whose brush and ink show no trace of the dusty
commonplace.

Alas for those men of the ordinary world;
For who can change their plebeian air?

Conversely, I envy the man in the house,
With writings spread out beside mists and clouds.

A woodcutter returns home on a bridge of boards;
And they converse about ancient days of Fu-hsi's time.

Done on an autumn day in the *kuei-mao* year [1663]
beneath eaves of white clouds on Ox Head [Hill]. Shih-
ch'i, Ts'an tao-jen [seal] Shih-ch'i. [seal at lower right]
Pai-t'u.

trans. MFW/KSW

Remarks: Like *Strolling Companions in the Autumn Moun-
tains* (cat. no. 233), this hanging scroll is typical of K'un-
ts'an's mature works, lush with textural effects of ragged,
stubbly brushwork. Nature is presented directly, un-
adorned, with little interest in reducing it to plays of
abstract patterning as seen in works by his contempo-
raries. It is luxuriant, thick, and dense — almost to an
excess that suggests an unkempt overripeness.

Ox Head Hill is a small mountain in Nanking on which
were situated a small number of Buddhist temples. In
1663 K'un-ts'an was living there in the Yu-chi Temple.

Unfortunately, abrasion has led to a loss of brilliance in
color and in richness in ink tones in the painting. MFW

Literature
Contag, *Zwei Meister* (1955), pp. 89, 90, pl. 26; idem, *Chinese
Masters* (1970), pp. 26, 27, 49, pls. 34, 34a.

Exhibitions
Kunstsammlungen der Stadt Düsseldorf, 1950: Speiser and Con-
tag, *Austellung*, cat. no. 98, pp. 29, 50, pl. 12.

Recent provenance: Victoria Contag von Winterfeldt.

Nelson Gallery-Atkins Museum F75-41

K'un-ts'an

233 *Strolling Companions in the Autumn Mountains (Ch'iu-shan yu-lü)*

Double album leaf mounted as a handscroll, ink and light color on paper, 31.8 x 64.5 cm.

Artist's inscription, signature, and 3 seals:

Wandering through the mountains and forgetting the years and months,
We make companions of each other in casual shoes and sandals.
Evening wind and morning dew perish where they were born.
The wisdom from meditation was cultivated in quietude.
We came together to knock at the gates of the Buddhist retreats.
We promised each other to spend our old age amidst the misty vines.
Why should we announce this to the world?
In woods and hills alone we'll find ourselves at ease.

In painting one must take instruction from the ancients. This is true also of calligraphy and in the assessment of a man. How much more should this be applied to the study of the Six Canons. Shih-ch'i, Ts'an Tao-jen [2 seals] Shih-ch'i; Pai-t'u. [seal, lower right edge] Chieh-ch'iu.

trans. WKH

Remarks: K'un-ts'an was a native of Hunan who, at a fairly young age, entered the monastic life of Ch'an Buddhism. By 1654 he was living in Nanking and was acquainted with the Ming loyalist literary and artistic circle. Nevertheless, he was ascetic and reclusive by nature and deeply committed to the spiritual values of Ch'an. He eventually rose to the position of abbot. Like many Ch'an monks before him, K'un-ts'an turned to

calligraphy and painting as extensions for his spiritual insights (Sirén, *Later,* 1938, II, 135, pl. 201; *Sō-Gen-Min-Shin,* 1931, II, pl. 227). Other surviving works consist of landscapes painted to commemorate visits and scenic excursions with friends – fellow monks or laymen such as Chou Liang-kung (Sirén, *Later,* II, 135, pl. 200) and the painter Ch'eng Cheng-k'uei (*Shina Nanga taisei,* 1935-37, ser. 2, supp. vol. IV, pls. 45-48). He is ranked with Chu Ta (see cat. nos. 235-237), Tao-chi (see cat. nos. 238, 239), and Hung-jen (see cat. no. 225) as one of the four great monk-painters of the seventeenth century.

Strolling Companions in the Autumn Mountains is now mounted as a handscroll, but the vertical fold mark running down the center of the paper indicates that the painting was initially a double album leaf. Cahill (*Fantastics and Eccentrics,* 1967, p. 63) suggests that the Cleveland painting may be part of an album which K'un-ts'an completed for his closest friend, Ch'eng Cheng-k'uei, during a visit at the T'ien-chüeh-shan-fang (The Gate of Heaven Mountain-Chamber) in the fall of 1666. The album was broken up sometime in the early twentieth century, so its original contents are impossible to verify. When first published in China, the Cleveland leaf did appear with three other leaves, two of which are now in The British Museum (Kao Yung-chih, *T'ai-shan,* 1926-29, portfolio 3, vol. 4, pl. 1 [Cleveland], pls. 2 and 4 [British Museum], pl. 3 [Staatliche Museen, Berlin]). All three leaves have the vertical fold mark, and the overall dimensions of the British Museum leaves agree with those of the Cleveland painting (Garner et al., *Arts of the Ch'ing,* 1963-64, cat. no. 10, pl. V). On one of the British Museum leaves (ibid; pl. Vb), K'un-ts'an writes that after the two close friends discussed the subtleties of Ch'an and the art of painting, Ch'eng Cheng-k'uei presented him with four sheets of special paper on which to capture the thoughts and flavor of the moment. Taking the artist's inscription literally, the album would seem to

233

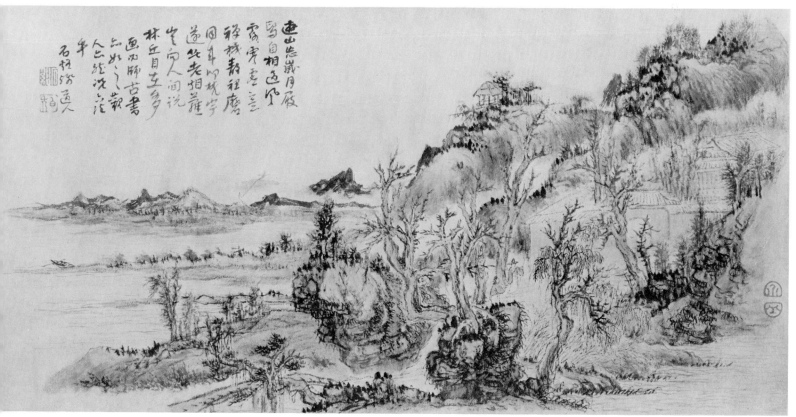

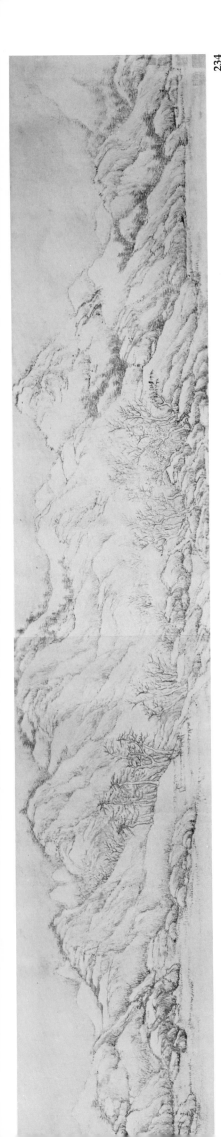

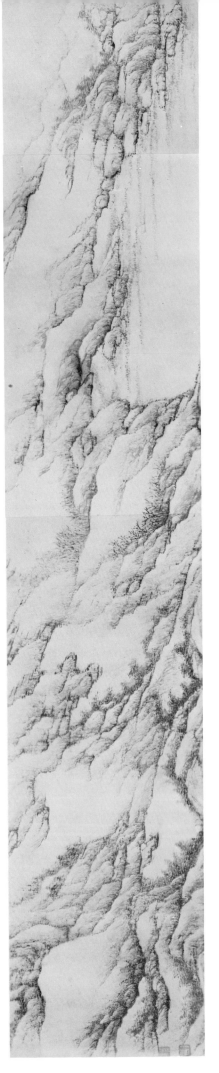

have been complete, even though four is an unusually small number of leaves for an album.

A few years later the album was published in Japan, but with a different leaf substituted for the Cleveland painting (*Shina Nanga taisei*, 1935-37, ser. 2, supp. vol. IV, pls. 45-48). This fifth leaf would be difficult to dismiss as superfluous, because it seems to have the same dimensions and the vertical fold mark as the others in the series. Moreover, all five leaves share a common method of execution.

K'un-ts'an wrote each inscription and developed each landscape in the same manner, evoking a lonely, remote mood in each of the lightly tinted leaves. Such remarkable unity of expression suggests that all the leaves were done fairly close in time, very possibly in the autumn of 1666. HK

Literature
Kao Yung-chih, *T'ai-shan* (1926-29), portfolio 3, vol. 4, unpaginated.
Chang and Hu, *Shih-ch'i* (1969), pl. 25.
Shih-ch'i shang-jen chi (n.d.), unpaginated.
Cahill, "Chūgoku kaiga-II" (1975), fig. 18.
Fu, "Ming Ch'ing chih chi" (1976), p. 595.
CMA Handbook (1978), illus. p. 356.
Hochstadter, *Compendium* (forthcoming).

Exhibitions
Asia House Gallery, New York, 1967: Cahill, *Fantastics and Eccentrics*, cat. no. 20.

Recent provenance: Walter Hochstadter; N.V. Hammer.

The Cleveland Museum of Art 66.367

Fa Jo-chen, 1613-1696, Ch'ing Dynasty
t. Han-ju, *h.* Huang-shih; from Chiao-chou, Shantung Province

234 *Snow Coloring the World White*
(*Hsüeh-se chieh t'ien pai*)

Handscroll, dated 1690, ink on paper, 29.3 x 297.2 cm.

Artist's title on frontispiece, colophon with 6 poems, and 7 seals: [seal] Ch'ien-k'un i ts'ao t'ing. Snow Coloring the World White. Huang-shan lao-jen, Jo-chen, at the age of seventy eight. [2 seals] Fa yin Jo-chen; Huang-shih shih. (Artist's poems are not translated.)

In the first month of the *keng-wu* year [1690], I was seventy-eight years old. On a snowy day I was pleased to have my good son-in-law Ch'eng-ssu and other gentlemen visiting me at my Tz'u-ching Hall at Yellow Hill. I did this snowscape to record the event. [2 seals] Fa Jo-chen; Tun Chai. [2 seals at end of painting] Fa yin Jo-chen; Huang-shih shih.

trans. LYSL/WKH

12 additional seals: 8 of Ho Kuan-wu (20th c.); 1 of Wang Nan-p'ing (20th c.); 3 unidentified.

Remarks: Fa Jo-chen was one of those scholar-officials unfortunate enough to have lived during the Ming-Ch'ing transition and to have "served two dynasties," according to later Ch'ing official records. This inconstancy, though praised at the time of his service with the Manchus, was sufficient to damage his reputation and position within official histories. Fa, a native of Chiao-chou, Shantung, is now considered one of the rare luminaries of that province in the late seventeenth century. Much of his checkered official career was spent in Fuchien, Chechiang, and finally, Anhui – thus, he is often conveniently but awkwardly placed with the

Anhui masters. He was more famous as a poet and official than as a painter, being a member of the Hanlin Academy and rising to be lieutenant governor of Anhui in 1668. His later official career was one of declining fortune and enforced leisure.

The best and most characteristic of Fa's rare works are from the last fifteen years of his life. Thus, a hanging scroll by him dated 1673 (*Hashimoto*, 1972, pl. 79) is an unexceptional late Ming landscape composition owing much to T'ang Yin (see cat. nos. 161-163) and Mo Shih-lung (ca. 1550-ca. 1585), but with little hint of the mannered and individual style to come.

The present handscroll, dated to 1690, is in the same individual manner as three other works: another very similar handscroll, dated 1690, titled *Mountains in Autumn Tinge*, in the Tokyo National Museum (*Tokyo Kokuritsu Hakubutsukan*, 1979, no. 140); a large hanging scroll dated 1692 (*Sō-Gen-Min-Shin*, 1931, II, 241); and an undated but clearly contemporary landscape, now in Stockholm (Cahill, *Fantastics and Eccentrics*, 1967, cat. no. 22). The Tokyo and Cleveland scrolls are so close in style and size as to invite the suggestion that they were conceived by the artist as complementary treatments of Autumn and Winter subjects.

All of these paintings of the 1690s share a nervous, trembling linear development of boundary lines and *ts'un*; a heavily and repetitively slanted (from upper left to lower right) treatment of the rocks and hills dominating the sparsely timbered topography; and rich, smoky ink applied in a dry-brush technique. The hanging scrolls are more dramatic with their "vast convulsion of nature which makes the very rocks tremble" (ibid., p. 64), while the handscrolls use the same idiom in a quieter way with more exposure of white paper. The Cleveland scroll opens quietly in what could be called a gentle Anhui manner; but by the end of the picture, Fa's personal vision of twisting nature becomes dominant. The scroll has additional importance because of the title and long inscription written by Fa, whose collected poetic works total more than four thousand (*Huang-shan shih-liu*, 1698). SEL

Literature
Important Chinese Ceramics (1979), sale no. 4296, lot 120.
Recent provenance: Mr. and Mrs. David Spelman.
The Cleveland Museum of Art 79.76

234 Detail

Chu Ta, 1624-1705, Ch'ing Dynasty

t. Hsüeh-ke, *h.* Pa-ta shan-jen; from Nanch'ang, Chianghsi Province

235 *Fish and Rocks*
 (*Chü-shih-yü t'u*)

Handscroll, ink on paper, 29.2 x 157.4 cm.

Artist's inscriptions and 4 seals:

A foot and a half from heaven,
Only white clouds are moving.
Why are yellow flowers painted?
"Amidst the clouds" [Yün-chung] is "the city of gold" [Chin-ch'eng].
[seal] Pa-ta-shan-jen.

In the Twin-wells is water formerly from mid-stream,
Above which the bright moon shines and lingers.
The two golden carp of the Huang family,
Where have they gone, to become dragons?
[seal] Pa-ta-shan-jen.

Under these thirty-six thousand acres [of lotus]
Day and night fish are swimming.
Arrived here is a single "yellow cheek,"
Ocean tide rises with the soaring notes of the flute.
[seal] Pa-ta-shan-jen. [seal, upper right corner] Tsai-fu.
 trans. WKH

5 additional seals: 2 of Chang Ta-ch'ien (20th c.); 1 of Ta-an Chü-shih; 2 unidentified.

Remarks: Chu Ta's artistic originality has been recognized for centuries, but his actual identity and activity still remain the subject of much speculation. Literary records give his surname as Chu – the family name of the Ming emperors – and verify his descent from a branch of that family, which was well established in Nanch'ang. At one time the painter was thought to be Chu Tao-lang, a Taoist abbot in the vicinity of Nanch'ang who was active in the Ming loyalist movement (V. Giacalone, "Chu Ta;" 1975, pp. 136-52). Recently, Chu Ta has been identified as Chu Chung-kuei, a descendent in the tenth generation of the I-yang branch of the Ming emperors (Wu Tung, "Ko-shan hsiao-hsiang," 1977, pp. 1-8).

In the early years of the Manchu conquest such an illustrious heritage became a liability. Chu Ta sought personal safety under the covering guise of an eccentric Buddhist monk. Although his paintings reveal a very

rational genius, surviving literary accounts portray the painter as half-mad, either unwilling or unable to speak. Certainly his cryptic pen names and often untranslatable poetic inscriptions suggest a purposely secretive individual.

The visual tensions Chu Ta could create in paintings such as *Fish and Rocks* indicate a conscious daring seldom attempted by other Chinese artists. Yet an unexpected balance of tone prevails in the artist's deceptively spontaneous and rapid brushwork. These qualities mark the undated *Fish and Rocks* as a product of the early 1690s, executed about the same time as his 1694 flower and landscape album in the Sumitomo collection (Wang, Fred Fang-yu, "Album of Flower Studies," 1972, pp. 543-45, pl. XI).

Despite brilliant contrasts of ink wash and line in the playfully depicted fish and flowers, the Cleveland scroll suggests a brooding mood. The three poetic inscriptions by the artist are a rarity within his surviving works, few of which have been inscribed. Chu Ta the poet appears to lodge within them the frustrating memories of the Ming reign common to all the *i-min* artists who survived the change of dynasties. Unfortunately, the ambiguity of the language Chu Ta used hinders complete translation; thus, the poems contribute to the painting some of the intentional and puzzling secrecy with which Chu Ta cloaked his whole life. HK

If even a few hints will be helpful for future studies of these poems, here are some tentative suggestions. The first line of the first poem clearly refers to a saying of the T'ang Dynasty: "The Tu-ch'ü in the southern part of the city is only one and a half feet away from the heavens" – alluding to the easy access to the throne of powerful families, such as the clan of Wei. The last two lines seem to be a heavily cloaked allusion to the anecdote involving Su Tung-po's misinterpretation of Wang An-shih's poem on chrysanthemums. The tricky part is the final line: "Amidst the clouds is the city of gold," which on the surface represents two geographical names in Shanhsi Province, Yün-chung and Chin-ch'eng – different names for the same city, Tatung, which in early Ch'ing was a hotbed for lingering pro-Ming sentiments, nourished by loyalists such as Fu Shan and Ku Yen-wu.

The meaning of the second poem is probably less evasive. The "Twin-wells" (in Chianghsi Province) refers to

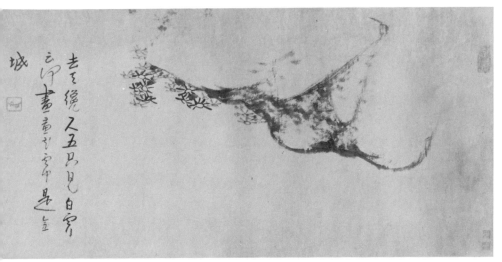

235

both the hometown of the Sung poet Huang T'ing-chien (1045-1105) and the name of a famous tea which should be brewed, ideally, with water from the "mid-stream" of the Yangtze River. As a matter of fact, the first two lines of the poem can be considered a syncopation of a celebrated poem by Su Tung-po, "The big vase, storing the moon, that is to be shared with the spring urn; a small ladle, cutting up the river, that will be poured into [the container of] the night stream." That Chu Ta's fantasy has a definite connection with Su Tung-po is beyond question. The motif of water from the "mid-stream" is an allusion probably derived from another story involving the same two historical personalities as in the first poem: Su Tung-po, the impatient and careless young genius, and Wang An-shih, the wise old man.

Then there is the third level of meaning: "Twin-wells" is located in the present provincial capital, Nanch'ang. Not only did Huang T'ing-chien and Wang An-shih come from its vicinity, but it was also Chu Ta's hometown, the seat of his ancestor's principality, where "the bright moon" − meaning the Ming Dynasty − "used to shine and linger." Such loyalist sentiments would have been much too conspicuous had they not been blurred both by the imagery of tea and water and by the Sung anecdote. In short, it is my opinion that Chu Ta's poems borrowed from the life stories and literary works of the three Sung statesmen and poets, and that their deliberately enigmatic language was designed to conceal a certain message. In addition, with the tonal opulence of his brush and ink, with his sense of humor and sensual appeal, the artist succeeded in hiding his message, whatever it might be. WKH

Literature
Sirén, *Masters and Principles* (1956-58), VI, pl. 384-B; VII, *Lists*, p. 325.
Lee, "Some Problems" (1957), pp. 483, 484, pl. 14, fig. 19; idem, "Two Styles" (1958), p. 215.
Goepper, *Im Schatten* (1959), pl. 31.
Sullivan, *Introduction* (1961), p. 195, pl. 137.
Goepper, *Essence* (1963), p. 138, pls. 30, 31.
Lee, *Far Eastern Art* (1964), pp. 451, 452, fig. 593.
Sullivan, *Chinese and Japanese* (1965), p. 262, fig. D.
Goepper, *Oriental World* (1967), pl. 84.
Horizon, Arts (1969), illus. p. 199.
Chang and Hu, *Pa-ta shan-jen* (1969), pl. 27.

Exhibitions
Haus der Kunst, Munich, 1959: *1000 Jahre,* cat. no. 118.
Cleveland Museum of Art, 1960: Masterpieces of Chinese Painting, no catalogue.
Vassar College Art Gallery, Poughkeepsie, New York, 1973: *Chu Ta,* cat. no. 8.
Asia House Gallery, New York, 1974: Lee, *Colors of Ink,* cat. no. 45.

Recent provenance: Chang Ta-chien; Walter Hochstadter.
The Cleveland Museum of Art 53.247

Chu Ta

236 *Landscape after Kuo Chung-shu (Fang Kuo Shu-hsien shan-shui)*

Hanging scroll, ink on paper, 109.9 x 56.4 cm.

Artist's inscription, signature, and 3 seals: Painting after Kuo Shu-hsien [Kuo Chung-shu]. Pa-ta shan-jen. [2 seals] Shan-jen; K'o-te shen-hsien. [seal, lower left corner] Yao-shu.

8 additional seals: 1 of Li Shih-feng (1821-1885); 4 of Chang Yüan (20th c.); 3 unidentified.

Remarks: Chu Ta's approach to painting had many facets. In a work such as *Fish and Rocks* (cat. no. 235), his brushwork appears to be spontaneous, with rich contrasts in ink tonality. His *Landscape after Kuo Chung-shu* reveals a more thoughtful bent, with masses and textures reasoned out over a prolonged period of time and the variety of his brushstrokes and ink tones severely limited. The work belongs to the artist's late years, as indicated by his signature: the painter assumed the pen name Pa-ta shan-jen later in his life and, after 1694, wrote the first character with two straight strokes (Wang Fred Fang-yu, "Album of Flower Studies," 1972, p. 537).

In his inscription, Pa-ta shan-jen specifies that the painting imitates Kuo Chung-shu, a tenth-century artist known for his "architectural paintings" (see cat. no. 77). Actually, the loosely brushed trees in the lower right foreground, the skeletal mountain devoid of specific detail, and the understated brushwork are derived from Tung Ch'i-ch'ang (see cat. no. 191). Among Chu Ta's works after earlier masters, a few are inscribed as after this Ming artist (Yonezawa, *Hachidai sanjin,* 1975, p. 181, figs. 80-81). Nevertheless, the force of Chu Ta's own personality is evident in his paintings after other artists.

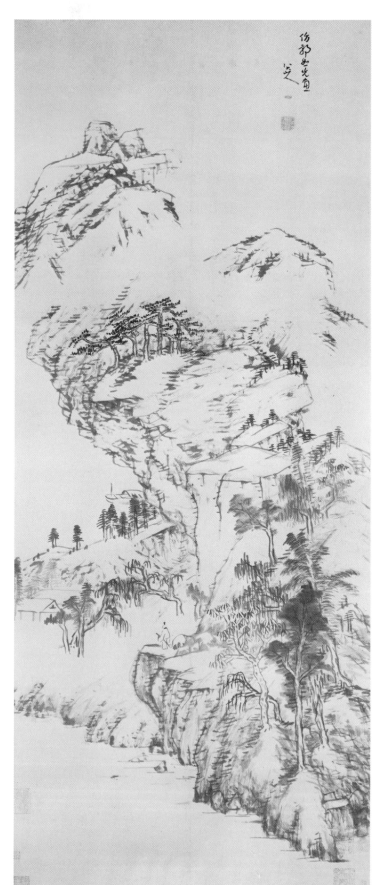

The edges and contours of the mountain in *Landscape after Kuo Chung-shu* appear solid at first glance, but at the same time, likely to collapse into a pile of ink strokes. Thus, into the intended calm and classical world of the monumental landscape tradition, Chu Ta introduced a suggestion of disquiet.

HK

Literature

Chang Yüan, *Ta-feng-t'ang shu-hua lu* (1943), p. 42(b).
Sirén, *Masters and Principles* (1956-58), v, 154; vii, *Lists*, 325.
Lee, "Two Styles" (1958), pp. 218, 219, illus. p. 210.
Grousset, *Chinese Art and Culture* (1959), pl. 58.
Lee, *Chinese Landscape Painting* (1962), p. 116, no. 92; idem, *Far Eastern Art* (1964), pp. 446, 451, fig. 592.
Chang and Hu, *Pa-ta shan-jen* (1969), i, pl. 11.
Giacolone, *Chu Ta* (1973), unpaginated; idem, "Chu Ta" (1975) pp. 136-52.
Yonezawa, *Hachidai sanjin* (1975), p. 156, pl. 68.
Fu, "Ming Ch'ing chih chi" (1976), p. 596.

Exibitions

Cleveland Museum of Art, 1954: Lee, *Chinese Landscape Painting*, cat. no. 98.
Smith College Museum of Art, Northampton, Mass., 1964: Fifteen Chinese Paintings from the Cleveland Museum of Art, no catalogue.
Vassar College Art Gallery, Poughkeepsie, New York, 1973: *Chu Ta*, cat. no. 2.

Recent provenance: Chang Ta-chien; Walter Hochstadter.

The Cleveland Museum of Art 55.36

Chu Ta

237 *Mynah Birds, Old Tree, and Rock*
(*Ch'ü-yü shu shih*)

and *Mynah Birds and Rocks*
(*Ch'ü-yü shih-pi*)

Pair of hanging scrolls, ink on satin, each 204.6 x 54 cm.

Artist's 3 seals on *Mynah Birds, Old Tree, and Rock:* [upper left] Pa-ta shan-jen. [lower right] She-shih; Ko-shan.

Artist's 2 seals on *Mynah Birds and Rocks:* [center right] She-shih; Ko-shan.

2 additional seals of Sung Lo (1634-1713) on each painting.

Remarks: These two paintings are from a set of four to eight hanging scrolls. Another two scrolls from the set, *Ducks by the Water,* are reproduced in Contag's *Chinese Masters* (1970, pl. 22); they measure 208 by 55 cm., slightly larger than the Nelson Gallery scrolls. They are also painted on satin, with each bearing the same two seals of the artist and two seals of Sung Lo as on the Nelson Gallery paintings. The brushwork and compositions are closely related. Chu Ta seldom painted on satin, and seldom in such size as these panels, which are probably the only known set of its kind.

One of Sung Lo's seals reads: T'ai-tzu-shao-shih (Vice-Tutor to the Crown Prince). According to Sung Lo's chronology of his life, *Man-t'ang nien-p'u* (in *Hsi-p'o lei-kao*, preface 1711, vi, 2530), he received this title from the K'ang-hsi emperor (r. 1662-1722) on the eighth day of the fourth lunar month in 1713, when Sung went to Peking to celebrate the sixtieth birthday of the emperor. Therefore, this seal must have been used by Sung from this time until his death on the sixteenth of the ninth month of the same year.

LS/KSW

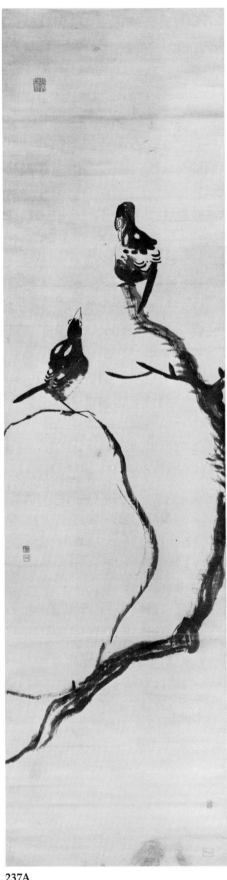

237A

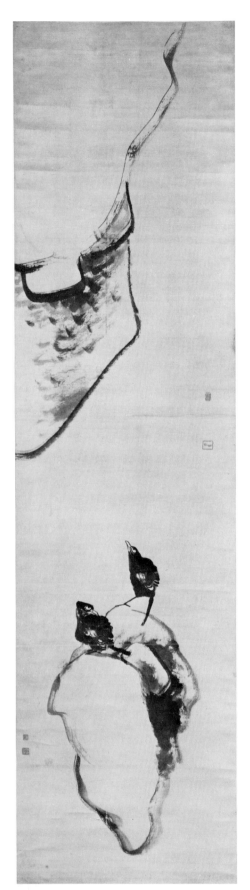

237B

Literature
Shih, "Mad Ming Monks" (1967), pp. 38, 72, pl. 6.
Wilson, "Vision" (1973), pp. 238, 239, pls. 12, 13.
NG-AM Handbook (1973), II, 69.

Exhibitions
Museum für Kunst und Gewerbe, Hamburg, 1949/50: Contag,
 Chinesische Malerei, cat. nos. 89, 90, pl. 4.

Kunstsammlungen der Stadt Düsseldorf, 1950: Speiser and
 Contag, *Austellung*, cat. nos. 94, 95, pp. 28, 46, pl. 8.
Asia House Gallery, New York, 1967: Cahill, *Fantastics and
 Eccentrics*, cat. no. 26, pp. 76, 117, pl. on p. 77.

Recent provenance: Victoria Contag von Winterfeldt.

Nelson Gallery-Atkins Museum 67-4/1-2

238A

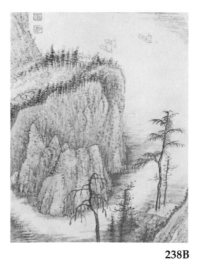

238B

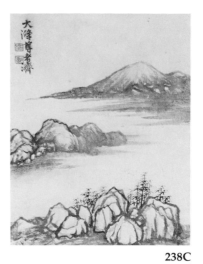

238C

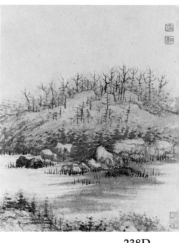

238D

238H

238F

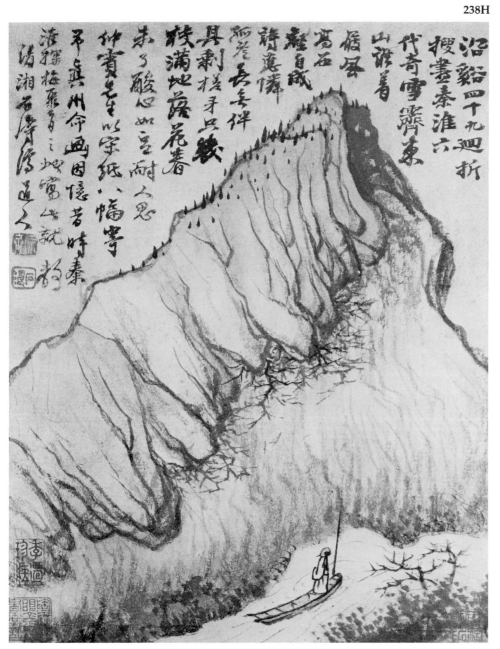

238G

322

238E

Tao-chi (Yüan-chi), 1642-1707, Ch'ing Dynasty
t. Shih-t'ao, *h.* Ta-ti-tzu, Ch'ing-hsiang ch'en-jen,
K'u-kua ho-shang, and others; from Kueilin,
Kuanghsi Province, lived in Chiangsu and
Anhui Provinces

238 *Reminiscences of Ch'in-huai River*
(Ch'in-huai I-chiu)

Album of leaves, ink and light color on Sung paper,
each 25.5 x 20.2 cm.

Artist's signature and 2 seals on leaf C:
Ta-ti-tsun-che, Chi [seals] Yüan-chi; Shih-t'ao.

Artist's inscription, signature, and 2 seals on leaf H:

Along the river with its forty-nine bends,
I search for the remains of the Six Dynasties along the
 Ch'in-huai.
Who walks in wooden clogs after the snow has cleared
 on the East Mountain
And composes poems while the wind roars through the
 west chasm?
One must sympathize with the plum tree's lonely state,
 forever without companions,
Its branches proudly stand, with only a few remaining.
Blanketing the ground with fallen flowers while spring
 is not yet over,
The plum's sour pit, now still small as a pea, causes men
 to ponder.

Mr. Chung-pin sent me at Chen-chou eight pieces of
Sung paper and asked for a painting. I recall the Ch'in-
huai region where long ago we got together to search for
plum blossoms, so I paint this and ask for his instruc-
tion. Ch'ing-hsiang Shih-t'ao Chi tao-jen [seals] Yüan-
chi; Shih-t'ao. 12 artist's seals, 2 on each of the remaining
6 leaves: Shih-t'ao; Yüan-chi.

 trans. LYSL/HK/WKH

2 colophons and 15 additional seals: 1 colophon, dated
1937, and 1 seal of Wu Hua-yüan; 1 colophon, dated
1938, and 2 seals of Wu hu-fan; 1 seal of Wang Chi-ch'ien
(20th c.); 11 seals unidentified.

Remarks: The monk-painter Tao-chi was born Chu Jo-
chi, prince of Ching-chiang, and twelfth-generation de-
scendent of the first Ming emperor. His long life became
intertwined with many major figures in Ch'ing history:
He was a distant cousin of Chu-ta (see cat. nos. 235-237)
and the close friend of the Anhui painter Mei Ch'ing
(cat. nos. 228, 229); he knew Kung Hsien (see cat. nos.
213-217); and he enjoyed the same circle of patrons who

protected the *i-min* painters of Nanking. Yet this former
Ming prince also twice met the K'ang-hsi emperor and
received the support of Manchu princes.

Unique among all figures in transcending the political
divisions of the early Ch'ing empire, Tao-chi trans-
cended its artistic conventions as well. He professed no
interest in continuing the earlier traditions of painting
which engrossed contemporaries such as Wang Yüan-
ch'i (see cat. nos. 249-252). Although his sparely
brushed early works can be identified loosely with the
Anhui school, his mature phase is remarkably free of
allusions to contemporary and past masters. Tao-chi
towers over Ch'ing painting as its most original genius.

The subject of this album is the scenery along the
Ch'in-huai River south of Nanking, where Tao-chi lived
from 1680 to 1687. Each leaf is painted with the vivid
hues and networks of massed dots so distinctive of Tao-
chi's works. The unusual solidity and compactness of
each landscape also occur in his 1694 album, now in the
Los Angeles County Museum (Edwards, *Painting of
Tao-chi*, 1967, cat. no. VII, illus. pp. 106-9).

The undated Cleveland album must have been com-
pleted in the late 1690s, because the signature on the
third leaf — Ta-ti-tsun-che, Chi — was one the artist fa-
vored after he renounced monastic orders in 1697. On
the other hand, Vinograd ("Reminiscences," 1977-78,
pp. 6-31) suggests that the album may have been com-
pleted as early as 1695, at the instigation of friends visit-
ing the artist in Yangchou at that time. One of those
guests, the unidentified Chung-pin (to whom the Cleve-
land album is dedicated), had accompanied Tao-chi ten
years earlier to search for plum blossoms in the vicinity
of Nanking. Moreover, Tao-chi's poem inscribed on the
eighth leaf of the album is virtually the same as the fifth
of nine poems he wrote on his 1685 handscroll *Searching
for Plum Blossoms* (Sackler collection; Fu and Fu, *Studies
in Connoisseurship*, 1973, pp. 175-79), which documents
his Nanking excursions. The Cleveland album repre-
sents a poetic and visual remembrance of the Nanking
region after ten years' absence.

The album was also known to the early eighteenth-
century painter-connoisseur Wang I-ch'en. His collec-
tion of Tao-chi's poetic colophons (*Ta-ti-tzu, ch.* 1, pp. 26,
27) states that the album consisted of six leaves from
what was originally a ten-leaf album. However, this
notation is probably erroneous. HK

Literature
Contag, *Die beiden Steine* (1950), pls. 5-8 (D, C, G, H); idem,
 Zwei Meister (1955), pls. 5-8 (D, C, G, H).
Giuganino, *La pittura Cinese* (1959), pls. 491, 492, 495, 497.
Lee, "Forest and Trees" (1966), p. 13, pl. XXXIV (D).
Edwards, "Painting of Tao-chi" (1968), p. 5, fig. 7 (H).
Contag, *Chinese Masters* (1970), p. 23, pl. 26 (C).
Lee, "Water and Moon" (1970), fig. 35 (H).
Fu et al., *Sekitō* (1976), p. 159, pls. 36-39 (B, F, G, H).
Vinograd, "Reminiscences" (1977-78), pp. 6-31, figs. 33-40 (com-
 plete album).
CMA *Handbook* (1978), illus. p. 357 (H).
Capon, *Chinese Painting* (1979), p. 59 (H).
Cahill, *Compelling Image* (forthcoming).

Exhibitions
University of Michigan Museum of Art, Ann Arbor, 1967:
 Edwards, *Painting of Tao-chi*, cat. no. 14.

Recent provenance: Wang Chi-ch'ien.

The Cleveland Museum of Art 66.31

Tao-chi (Yüan-chi)

239 *Spring on the Min River*
(Min-chiang ch'un-shih t'u)

Hanging scroll, dated 1697, ink and light color on paper, 39 x 51.9 cm.

Artist's inscription, signature, and seal:

Under the Yangtze Bridge, where the river overflows,
The willow tendrils show forth their hue, insensitive to man's gray hair.
Throughout spring, rain and snow have kept away the scenery lovers;
Yet throughout Ch'ing-ming season, the plum blossoms will preserve and flourish.
Aging and being useless, I have grown attached to my friends;
But year after year, my friends have scattered like stars and seagulls.
Suddenly Master Wang turns to me with an astonishing exclamation from his mind,
"I am about to leave for Fuchien to exploit its scenic beauties,
Before then, would you please put me in a picture for a preview?"
Before your eyes, you will see hills and valleys in one sweep.
Thousands and ten-thousands of miles are shown at the tip of my brush;
They are not ink, nor mist, but rather a presumptuous message:
Your respected father is a great man of a hundred eras,
One word of his spoken to the emperor resulted in storm and thunder.

The emperor has bestowed on him much extraordinary kindness;
And he is now coming south by the grace of the throne.
[Would he remember] how many poor scholars are awaiting him for recognition?
We are all counting on his efforts as the "inducer of dragons [talents]."

Ting-ch'ou [1697], spring, [I] write the colophon on the painting to give it to Master Wang Mu-t'ing, who is to leave for Min-hai, [and will] also present this to his Excellency the Commissioner of Examination, Mr. Ssu-po. Ch'ing-hsiang lao-jen, Chi, at Ta-ti-t'ang. [seal] Yüan-chi.

trans. WKH

2 colophons and 7 additional seals: 1 colophon and 4 seals of Ho Yüan-yü (19th-20th c.); 1 colophon and 2 seals of Li Hsin-hui (19th-20th c.); 1 seal unidentified.

Remarks: The long poem appended to this painting speaks directly of Tao-chi's circumstances at this time. The year 1697 was, for Tao-chi, a period of momentous personal change and thus also of emotional states that alternated between firm resolve and indecision, between self-confidence and overwhelming awareness of the complexities of the non-monastic world. Having decided to leave the confines of his monkhood, Tao-chi, then in lonely freedom, confronted the problems of secular life.

The Ta-ti-t'ang (Great Purification Hall) was the home Tao-chi had just established for himself in the city of Yangchou. Dependent on the emotional, and perhaps financial, support of his friends, in this year he was deprived by death of the company of the closest of these, Mei Ch'ing, while others like Wang Mu-t'ing travelled unceasingly. Beset by insecurity and concerned

239

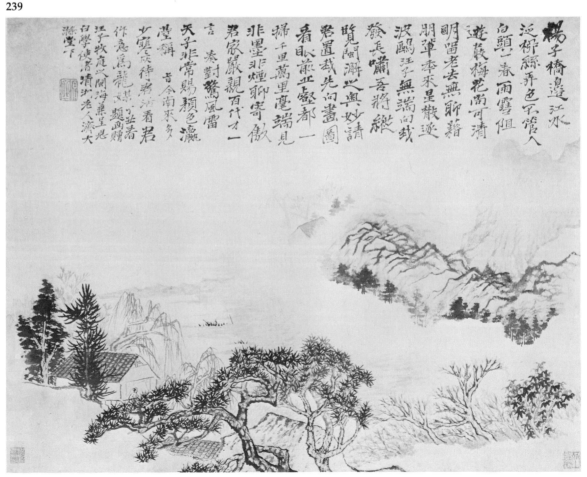

about his health after a winter's confinement, Tao-chi seized on the occasion of Wang's request for a painting of the Fuchien river area to petition Wang's father to recognize the merit of poor scholars. Tao-chi may have met the elder Wang during his 1690-92 sojourn in Peking, for he seems well acquainted not only with the formal status and mission of that worthy but also with his influence on and intimacy with the K'ang-hsi emperor.

Tao-chi's genius was such that paintings from his mature phase are seldom predictable in terms of their execution. This painting dates from the same period as the Cleveland album (cat. no. 238), yet his brush creates quite different effects. In the album leaves, strong colors impart a playful solidity to individual landscape elements, although each part is subordinated to a unified pictorial space because the hues are fairly close in value. In the *Min River* scene, a few touches of blue in the middle ground and a light orange wash are applied so lightly that the colors barely stain the surface of the paper. By reducing the color, Tao-chi allows each landscape unit to maintain a more separate, independent identity. Clumps of dark, vigorously brushed trees and a house grouped in the foreground reappear transformed, as though momentarily unveiled by mist, in the mountainous right middleground. This distinction between individual units also occurs in the charming *Junks on a Canal* (Ching-Yüan Chai collection; Edwards, *Painting of Tao-chi*, 1967, cat. no. x, illus. p. 117), probably completed at the same time as this composition. Nevertheless, a thread of continuity within these varied approaches to his medium can be found in similar brush modes — especially the blurred "hemp-fiber" strokes which appear in the mountains of *Spring on the Min River* and in leaves C and H of the Cleveland album. HR/HK

Literature
Sirén, *Masters and Principles* (1956-58), VII, Lists, 406.
Lee, *Chinese Landscape Painting* (1962), p. 111, color pl. VII, no. 88; idem, *Far Eastern Art* (1964), p. 453, color pl. 48.
Edwards, "Painting of Tao-chi" (1968), p. 5.
Chang and Hu, *Shih-t'ao* (1969), III, pl. 89.
Akiyama et al., *Chūgoku bijutsu* (1973), II, pt. 2, 241, 242, color pl. 61.
Fu et al., *Sekitō* (1976), p. 1956, color pl. 40.

Exhibitions
Cleveland Museum of Art, 1954: Lee, *Chinese Landscape Painting*, cat. no. 94.
Cleveland Museum of Art, 1960: Masterpieces of Chinese Painting, no catalogue.
Munson-Williams-Proctor Institute, Utica, New York, 1963: *Masters of Landscape*, cat. no. 13.
University of Michigan Museum of Art, Ann Arbor, 1967: Edwards, *Painting of Tao-chi*, cat. no. 12.

Recent provenance: Walter Hochstadter.

The Cleveland Museum of Art 54.126

Wang Shih-min, 1592-1680, Ch'ing Dynasty
 t. Hsün-chih, *h.* Yen-k'o, Hsi-t'ien chu-jen, Hsi-lu lao-jen; from T'ai-ts'ang, Chiangsu Province

240 *Mountain Village Embraced by the Summer*
 (*Hsia-ji shan-chü*)

Hanging scroll, dated 1659, ink on paper, 125.7 x 59.4 cm.

Artist's inscription, signature, and 3 seals: [seal] Ou-hsieh. In the *chi-hai* year [1659], the fourth lunar month, I painted this for T'o-weng, my senior in our literary club, for your amusement and correction. Your junior Wang Shih-min. [seals] Wang Shih-min yin; Sun-chih.

240

241

2 additional seals: 1 of Chiang Ku-sun (20th c.); 1 of Wang Chi-ch'ien (20th c.).

Remarks: The scion of a distinguished Chiangsu family of court officials, Wang Shih-min was appointed to office as an honor to his grandfather, a former Ming Imperial Grand Secretary. With the downfall of the dynasty, Wang retired from government life to devote his energies to painting. As a youth he received instruction in that art from Tung Ch'i-ch'ang (see cat. nos. 191, 192), and also had at his disposal a large collection of paintings formed by his grandfather.

Wang Shih-min's numerous surviving works owe much to the influence of Tung Ch'i-ch'ang, who viewed landscape painting as an art based on abstract compositional methods developed from the paintings of earlier masters. Among the masters championed by Tung Ch'i-ch'ang, Wang Shih-min especially favored Huang Kung-wang. While Wang does not mention a specific source for our painting, he employs a spatial organization and texture-stroke vocabulary that he had used in his 1647 landscape, inscribed as after Huang kung-wang (Vannotti collection, Lugano; see Dubosc, *Mostra*, 1954, no. 859, p. 237). In both paintings, by juxtaposing dark-toned, identically rendered strokes with lighter ones, Wang Shih-min imparts convincing density and volume and yet partially denies the deep space implied by relative positioning of elements in the compositions.

Wang Shih-min's approach to Yüan masters, grounded as it was on Tung Ch'i-ch'ang's interpretation, also mirrors that of his relative, Wang Chien (see cat. no. 241). HK

Literature
Whitfield et al., *Un Jūhei, O Ki* (1979), p. 165, pl. 77.

Recent provenance: Chiang Ku-sun; Wang Chi-ch'ien.

Intended gift to The Cleveland Museum of Art, Mr. and Mrs. A. Dean Perry

Wang Chien, 1598-1677, Ch'ing Dynasty
t. Yüan-chao, *h.* Hsiang-pi, Lien-chou, Jan-hsiang-an chu; from T'ai-ts'ang, Chiangsu Province

241 *Shade of Pines in a Cloudy Valley*
(*Yün-ho sung-ying*)

Hanging scroll, dated 1660, ink on paper, 88.3 x 37.5 cm.

Artist's inscription, signature, and seal: Painted at I-ya-ko in imitation of Wang Meng's *Shade of Pines in a Cloudy Valley* during the Ch'ing-ming Festival of the *keng-tzu* year [1660]. Wang Chien [seal] Wang Chien chih yin.

2 additional seals: 1 of Pi Lung (18th c.); 1 unidentified.

Remarks: The career of the painter Wang Chien followed much the same course as that of Wang Shih-min (see cat. no. 240). Born in the same town and brought up in the same atmosphere of books and old paintings, Wang Chien was appointed to civil office in recognition of the distinguished service rendered by his great-grandfather, Wang Shih-cheng. He apparently spent little time in public office, retiring instead to the leisurely study and practice of painting.

Under the influence of Tung Ch'i-ch'ang (see cat. nos. 191, 192), Wang mastered the brush methods of the Four Yüan Masters. He inscribed this *Shade of Pines in a Cloudy Valley* as an imitation of a Wang Meng painting of the same title, which has evidently not survived. This composition certainly echoes Wang Meng scrolls such as *Pass-*

ing a Summer Day in the Mountains, now in the Palace Museum, Peking (Sirén, *Masters and Principles*, 1956-58, VI, pl. 109b). Whether or not Wang Chien had a specific Wang Meng in mind or in hand, his Ch'ing variation is distinct from the Yüan prototype. While a soot-black richness pervades many of Wang Meng's compositions (see cat. no. 111), Wang Chien gives volume to his rolling landscape with wet strokes of much lighter tonality, emphasizing by contrast the large and dark "pepper dots" concentrated at selected intervals. Wang Chien thereby alludes to the techniques of Wang Meng but does not slavishly copy them. HK

Literature
Sirén, *Masters and Principles* (1956-58), VII, *Lists*, 421.
Lee, *Chinese Landscape Painting* (1962), p. 97, no. 78.
Goepper, *Essence* (1963), pp. 74, 219, pls. 78, 79 (detail).
Whitfield et al., *Un Jūhei, O Ki* (1979), p. 167, pl. 90.

Exhibitions
Cleveland Museum of Art, 1954: Lee, *Chinese Landscape Painting,*
 cat. no. 83.
Haus der Kunst, Munich, 1959: *1000 Jahre,* cat. no. 90.

Recent provenance: Wang Chi-ch'ien.

Intended gift to The Cleveland Museum of Art,
Mr. and Mrs. A. Dean Perry

Yün Shou-p'ing, 1633-1690, Ch'ing Dynasty
 t. Cheng-shu, *h.* Nan-t'ien ts'ao-i; from Wu-chin,
 Chiangsu Province

242 *Peonies*
 (*Wu-se shao-yao*)

 Hanging scroll, dated 1685, ink and color on silk,
 118.5 x 71.8 cm.

Artist's inscription, signature, and 3 seals: An old painting by an anonymous painter of the Northern Sung Dynasty has five varieties of flowers painted in the boneless manner. Its colors are so beguiling and beautiful, that even after several hundred years its lead pigments are like new. The skill with which the ink and colors were applied and the subtlety of its composition find no equal among modern followers.

 On an autumn day in the *i-chou* year [1685], Nan-t'ien, Shou-p'ing inscribed. [2 seals] Cheng-shu; Shou-p'ing chih yin. [Artist's poem is not translated, but is signed] Yüan-k'e [seal] Nan-t'ien ts'ao-i.

3 additional seals of Wang Chi-ch'ien (20th c.).

Remarks: Yün Shou-p'ing came from a Chiangsu family of scholars. His father, like the painter T'ao Hung (see cat. no. 200), was an ardent Ming loyalist, quite active in the resistance movement against the Manchu conquerors. As a result, his son refused to seek public office under the Ch'ing, and instead earned his livelihood with his brush. A fine poet and calligrapher, Yün Shou-p'ing was introduced to painting by his paternal uncle, the late Ming scholar-recluse Yün Hsiang (1586-1655).

 Yün Shou-p'ing developed a reputation among his contemporaries for his flower paintings. That genre occupied the greater part of his time and talent as he grew older. Conscious of the art of the past, Yün sought inspiration from the tenth and eleventh-century court flower painters. According to the artist's inscription, this painting of herbaceous peonies was inspired by an anonymous work of the Northern Sung. Actually, the work falls within the "boneless" tradition of Hsü Ch'ung-ssu (11th c.). Yün Shou-p'ing was hardly the first to revive

242

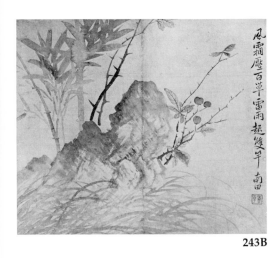

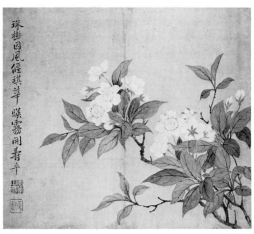

243C

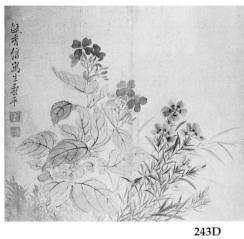

243D

243B

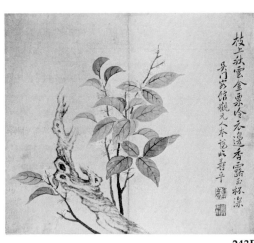

243E

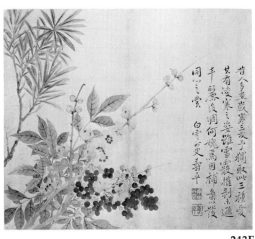

243F

243A

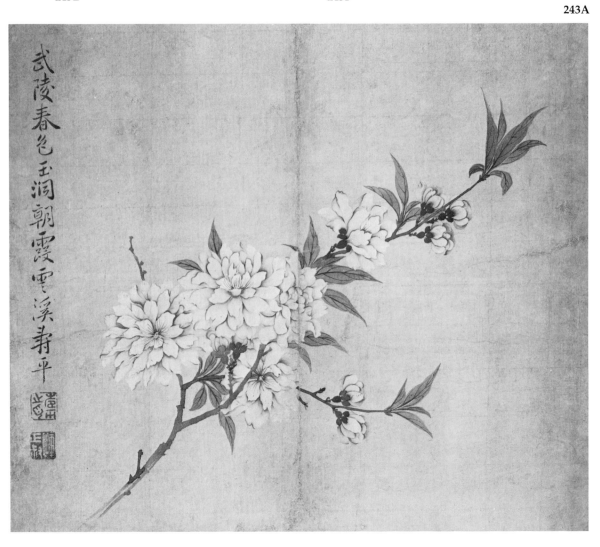

his method – it was already popular with Ming flower painters (see cat. nos. 148, 149, and 180).

Another Yün Shou-p'ing peony, one of a set of album leaves, dated 1672 and painted in collaboration with Wang Hui, is treated in the same manner as the Cleveland painting and is inscribed as after Hsü (*Three Hundred Masterpieces*, 1959, VI, pls. 265-68). In both compositions the blossoms, foliage, and stems are rendered in transparent color wash, colored line, and a minimum of lead-white opacifying pigment. Relying only on the positioning of each element – overlapping and curling leaves, stems, unfolding petals – Yün captures a sense of life and space rarely found in the flower paintings of the eighteenth and nineteenth centuries. HK

Recent provenance: Wang Chi-ch'ien.

The Cleveland Museum of Art 67.192

Yün Shou-p'ing

243 *Album of Flowers*
(*Hua-hui ts'e*)

Album of six leaves, ink and color on paper, each 24.5 x 29.3 cm.

A. *Peach Blossoms (T'ao-hua)*

Color on paper. Artist's inscription, signature, and 2 seals:

The color of spring at Wu-ling;
Auroral clouds at the Jade Cavern.

Yün-hsi, Shou-p'ing [seals] Shou-p'ing chih yin; Yün Cheng-shu.

B. *Bamboo and Rock (Chu shih)*

Ink and color on paper. Artist's inscription, signature, and seal:

Wind and frost [of autumn] crush the vegetation;
Thunderstorms [of spring] arouse a brace of bamboo stalks.

Nan-t'ien [seal] Shou-p'ing.

C. *Pear Blossoms (Li-hua)*

Ink and color on paper. Artist's inscription, signature, and 2 seals:

Like a tree of pearls, the pear nods in the wind;
Its blossoms open, shining like jade in the mist.

Shou-p'ing [seals] Shou-p'ing chih yin; Cheng-shu.

D. *Bean-Flowers and Pinks (Tou-hua shih-chu)*

Color on paper. Artist's inscription, signature, and 2 seals:

A depiction from life at [my studio] Ou-hsiang-kuan.
Shou-p'ing [seals] Shou-p'ing; Yüan-k'o.

E. *Cassia (Kuei-hua)*

Ink and color on paper. Artist's inscription, signature, and 2 seals:

Like autumn clouds upon a branch, the golden husks look cold;
Fragrant dew, from their deep jade cups, brushes my robe.

Playfully copied after a Yüan Dynasty version I saw in the Wu-men [Suchou] Guesthouse.

Shou-p'ing [seals] Shou-p'ing chih yin; Yün Cheng-shu.

F. *Three Friends of Winter (Sui-han san-yu)*

Ink and color on paper. Artist's inscription, signature, and 2 seals: Men of the past often painted "The Three Friends of Winter" [pine, plum, and bamboo]. I alone

choose these three varieties [oleander, winter sweet, and *nan-t'ien chu*], delighted with their aspect of winter. Though battered by snow and sleet, their complexions never fail, nor beauty fades. How can one be ashamed of them? And so, I add this picture to facilitate the enjoyment of like-minded persons. Pai-yün wai-shih, Shou-p'ing [seals] Nan-t'ien ts'ao-i; Shou-p'ing.

Remarks: Yün Shou-p'ing's inscription in leaf A alludes to the color of the peach blossoms and to the association of the peach with longevity. Wu-ling is the site of T'ao Ch'ien's (365-427) mythical utopia described in his prose masterpiece, "Record of the Peach-Blossom Spring" (see cat. nos. 137, 198, 227). In the second line Yün shifts the allusion from a utopia among men to the Elysium of the Immortals, to which the term "Jade Cavern" refers. MFW

Literature
K. Suzuki, *Yün Nan-t'ien* (1957), no. 10, pp. 22, 23; idem, "Un Nanden kaki zu," (1957), p. 346, pls. 1,2.
NG-AM *Handbook* (1973), II, 66.

Recent provenance: Mayuyama and Co.

Nelson Gallery-Atkins Museum 58-50

Yün Shou-p'ing
244a *Ink Chrysanthemums*
recto (*Mo chü*)

Folding fan, datable to 1690, ink on gold-speckled paper, 20.4 cm. radius x 60.3 cm. max. width.

Artist's inscription, signature, and 2 seals along upper right margin: [seal] Yüan-k'o.

Autumn leaves pile up, when first they fall from cassia branches;
Though with chrysanthemums at hand, one's name may yet be preserved on Double Nine Day.
In just a scattering, ink flowers form the five colors;
Don't be startled, Goddess of the Moon and Goddess of the Frost.

Shou-p'ing [seal] Shou-p'ing.

Artist's inscription, signature, and 2 seals at left edge: Many Yüan painters did chrysanthemums in ink. During the Ming period Po-shih [Shen Chou] and Po-yang [Ch'en Shun] are especially spoken of as having commanded the field. Though I am not able to combine the various masters all at once, I nonetheless do not enter the well-trodden paths of my contemporaries.
Inscribed again by Nan-t'ien. [seals] Shou-p'ing; Cheng-shu.

trans. MFW

Wang Hui, 1632-1717, Ch'ing Dynasty
 t. Shih-ku, *h.* Keng-yen san-jen, Wu-mu shan-jen, Chien-men ch'iao-k'o, and others; from Ch'ang-shu, Chiangsu Province

244b *Fisherman's Joy among Streams and Mountains*
verso (*Hsi shan yü lo t'u*)

Dated 1690, ink and color on gold-speckled paper.

Artist's inscription, signature, and 2 seals: [seal] T'ai-yüan. *Fisherman's Joy among Streams and Mountains*, imitating the brushwork of Chü-jan [act. ca. 960-980] on a summer day in the *keng-wu* year [1690]. Wu-mu shan-jen, Wang Hui [seal] Keng-yen.

244A

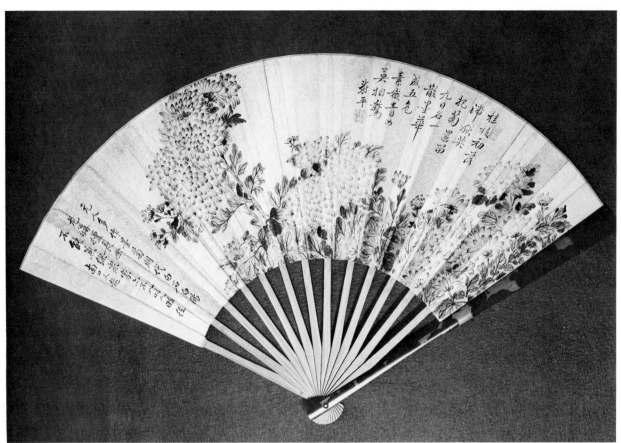

244B

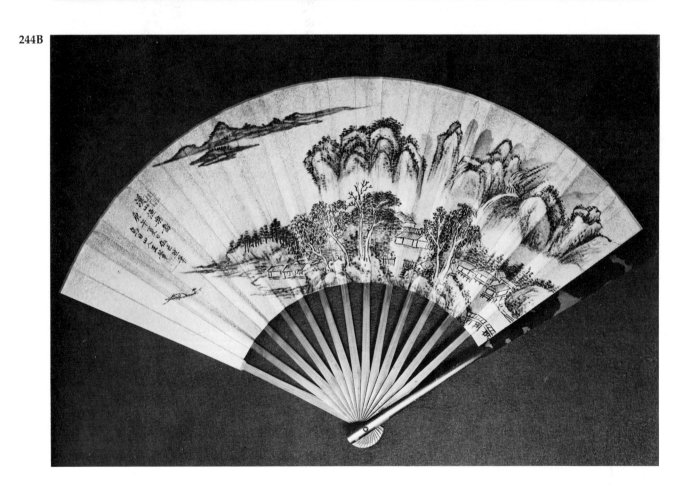

Remarks: *Ch'eng-shan* is the Chinese term for a folding fan mounted on flexible ribs, usually of bamboo. When decorated by a famous master, folding fans seldom retain their original form; usually the ribs are removed and the fans are flattened and remounted in an album-leaf format. This fan is thus a rare example retaining the original mounting as intended by Yün Shou-p'ing and Wang Hui.

Wang Hui's landscape is dated in the summer of 1690, and since there is no reason to suppose much of a time lapse between the execution of the two sides, Yün's *Ink Chrysanthemums* may reasonably be dated to the same year — thus making it one of his last works.

Apart from aesthetic considerations, the fan attains additional interest because it is a poignant symbol of the intimate friendship between two of the foremost artists of the Ch'ing Dynasty. It was Wang Hui who bore the expenses of giving his friend a decent burial when Yün Shou-p'ing died in 1690, after a summer in which he seems to have collaborated often with Wang.

The significance of Yün's chrysanthemums exceeds the appealing elegance of his composition and brushwork. There is a touch of melancholy in the allusions found in Yün's poem, which comments upon remembrance and the passing of life. The chrysanthemum has long been a symbol in China of endurance and persistence in the face of decline and death: other plants fade and wither with the coming of frost, but the chrysanthemum retains its strength and color. The reference to leaving one's name behind on Double Nine Day supports the general symbolism in a more specific way. The festival of the ninth day of the ninth lunar month involved notions of seeking longevity and averting catastrophe. Among varied activities associated with this festival was drinking chrysanthemum wine, which was thought to have life-prolonging properties, and climbing a high hill on a picnic outing, also suggestive of longevity. Small symbolic ''hills'' made by piling up chrysanthemum plants could even be constructed indoors in a reception room. Even more specifically, Yün Shou-p'ing is alluding to T'ao Ch'ien's (365-427) famous poem ''Spending the Ninth Day in Solitude,'' and to the moving sentiments expressed by T'ao about the brevity of human life, the sadness of the inevitability of decline, the sorrows of deprivation, and the contrast provided by chrysanthemums that ''know how to restrain declining years'' (William Acker, trans., *T'ao the Hermit*, 1952, pp. 50, 51). MFW

Literature
Tōan zō (1928), p. 48 (Wang), p. 51 (Yün).

Recent provenance: Kōzō Harada.

Nelson Gallery-Atkins Museum F68-34a,b
Gift of Mrs. Milton McGreevy

Wang Hui

245 *Tall Bamboo and Distant Mountains*
after Wang Meng
(Lin Wang Meng hsiu-ch'u yüan-shan)

Hanging scroll, dated 1694, ink on
paper, 79.3 x 39.5 cm.

Artist's incription, signature, and 2 seals: Previously, Wen Hu-chou [Wen T'ung, 1018-1079] painted a scroll called *A Horizontal View of the Evening Mist*, with an inscription by Emperor Kao-tsung [Ssu-ling] of the Sung

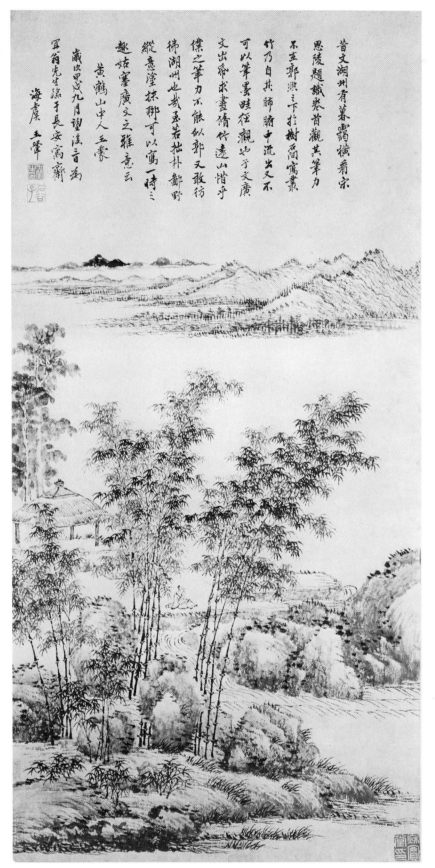

245

Dynasty later added on its beginning: "The strength of his brush is not inferior to Kuo Hsi; and the bamboos between the trees and rocks are beyond the usual criteria of brush and ink since they are the direct overflow of the artist's feelings." Professor Tzu-wen has provided the paper and asked me for a painting of tall bamboo and distant mountains. It is a pity that my brush cannot be compared with Kuo [Hsi], nor is it anywhere near that of Hu-chou. These few scribbles of rough and clumsy brush can only be taken as an expressions of a moment's interest painted for gratifying the professor's graciousness. Huang-he-shan-chung-jen, Wang Meng.

Chia-hsü [1694], ninth month, eighteenth day, copied for I-weng at Ch'angan. Hai-yü Wang Hui [seals] Wang Hui chih-yin; Shih-ku-tzu.

<div align="right">trans. WKH</div>

3 additional seals: 1 of P'ang Yüan-chi (20th c.); 2 unidentified.

Remarks: Wang Hui descended from a family of professional painters. His talent was recognized and nurtured first by Wang Chien (see cat. no. 241) and later by Wang Shih-min (see cat. no. 240). Both masters from the Tung Ch'i-ch'ang school provided the young painter with ample opportunity to know the most prominent literati and collectors of their day – Kao Shih-ch'i, Chou Liang-kung, Sung Lo, An Ch'i, Wu Wei-yeh, and Wang Hung-hsü. Using these great collections, Wang Hui studied and copied old, illustrious paintings. The process helped him form his personal style in conformity to the models espoused by Tung Ch'i-ch'ang. His long and prolific career as a painter so clearly reflected that tradition that Wang is included with Wang Chien, Wang Shih-min, and Wang Yüan-ch'i as one of the "Four Wangs" within the Orthodox school of Ch'ing painting.

Wang Hui based *Tall Bamboo* . . . on a Wang Meng composition once owned by An Ch'i (now in the Erickson collection; see Gyllensvard, "Ernest Erickson Collection," 1964, pp. 159-61, pls. 1, 2). Wang reversed the composition of the Yüan master's original, however, by shifting the mountain mass in the background to the right and reorganizing the foreground into a broader expanse of space, moving the seated scholar out from his pavilion onto a level plane. At the top of the painting, Wang Hui transcribed the Yüan painter's original inscription. There Wang Meng states that his painting, a gift to a Professor Tzu-wen, was inspired by Wen T'ung's *Horizontal View of the Evening Mist*. HK

Literature
P'ang, *Hsü-chai* (1909), Wang Hui 6a-6b, pp. 19(a)-19(b); idem, *Ming-pi* (1940), III, pl. 11.
Sirén, *Masters and Principles* (1956-58), VII, *Lists*, 427.
Grousset, *Chinese Art* (1959), pl. 56.
Sullivan, *Introduction* (1961), p. 193, pl. 135.
Lee, *Chinese Landscape Painting* (1962), p. 98, no. 79.
"Wang Hui" (1971), p. 2052.)
CMA *Handbook* (1978), illus. p. 357.
Whitfield et al., *Un Jūhei, O Ki* (1979), pp. 145 (fig. 26, detail), 157 (pl. 26).
Hochstadter, *Compendium* (forthcoming).

Exhibitions
Cleveland Museum of Art, 1954: Lee, *Chinese Landscape Painting*, cat. no. 84.
Asia House Gallery, New York, 1974: Lee, *Colors of Ink*, cat. no. 146.

Recent provenance: P'ang Yüan-chi; Walter Hochstadter.

The Cleveland Museum of Art 53.629

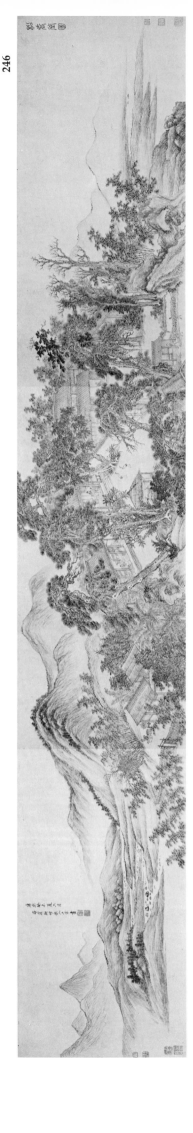

Wang Hui

246 *Hall of Lofty Pines*
(*Sung-ch'iao-t'ang t'u*)

Handscroll, dated 1703, ink and light color on paper,
39 x 237.2 cm.

Artist's inscription, signature, and 4 seals: Hall of Lofty
Pines. In the sixth month, summer, of the *kuei-wei* year
[1703] of the K'ang-hsi [era], painted by Keng-yen San-
jen, Wang Hui, from Hai-yü. [seals] Wang Hui chih yin;
Shih-ku. [2 seals at end of painting, lower left corner]
Lai-ch'ing ko; Keng-yen yeh-lao-shih nien ch'i-shih
yu erh.

1 colophon and 13 additional seals: 1 colophon and 3 seals
of Wang Hung-hsü (1645-1723); 1 seal of Li Tu-na (1628-
1703); 4 seals of Cha Ying (1766 *chin-shih*); 5 seals of Li Yün
(dates unknown).

Remarks: The long colophon following this painting was
written by the prominent Hanlin official Wang Hung-
hsü, a political ally of the immensely powerful Kao Shih-
ch'i, a good friend of the artist and a leading connoisseur
of painting in early Ch'ing. Wang records that the paint-
ing was commissioned in 1703 by the newly appointed
vice president of the Board of Punishments, Li Tu-na
(1628-1703), shortly before his death. Li's rise within the
Hanlin Academy was a result of his fine calligraphy. He
served for more than twenty years as a trusted advisor of
the K'ang-hsi emperor (r. 1662-1722). Wang mentions that
the title *Hall of Lofty Pines* is the name bestowed on Li's

home in a piece of calligraphy written by the emperor.
Evidently the painting was commissioned to evoke for
the owner visions of a peaceful retirement from public
life, which he knew the emperor would never grant him.

Wang Hui combines various landscape motifs from
particular Yüan masters with a sharply detailed picture of
human activity hardly ever seen in their works. The
scroll opens and closes with riverbanks and rounded
mountain chains brushed in the manner of Huang Kung-
wang. The towering pines and open pavilions of Wang
Meng are clustered together to form a rich architectural
setting between the mountains. Through the use of pale
color, rich ink tonalities, and a limited number of repeat-
ed texture strokes, Wang here achieves that "great
synthesis" (*ta-ch'eng*) of the narrative tradition in
Chinese painting with the pure landscape tradition of
the Yüan masters which he sought in so many of his
later paintings. HK

Literature
Sirén, *Masters and Principles* (1956-58), VII, *Lists*, 429.
Whitfield et al., *Un Jūhei, O Ki* (1979), pp. 145 (fig. 33, detail), 159
 (pl. 33).

Exhibitions
Dallas Museum of Fine Arts, 1954: *Five Centuries*, cat. no. 33.
Haus der Kunst, Munich, 1959: *1000 Jahre*, cat. no. 94.

Recent provenance: Wan-go H. C. Weng.

Intended gift to The Cleveland Museum of Art,
Mr. and Mrs. A. Dean Perry

246 Detail

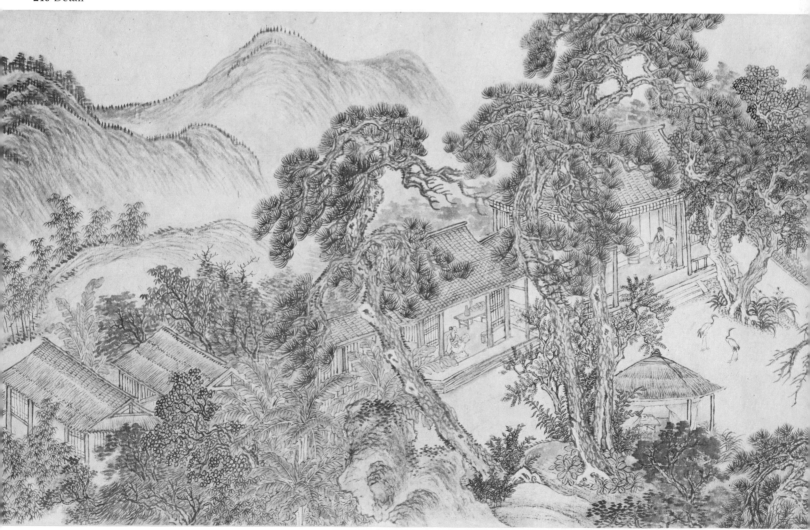

333

Wang Hui

247 *Scenic Views of Rivers and Mountains in the Style of Huang Kung-wang*
(*Fang Huang Kung-wang chiang-shan sheng-lan t'u*)

Handscroll, ink on paper, 29.2 x 549 cm.

Artist's inscription, signature, and 3 seals: [seal] Chi-hsing. *Scenic Views of Rivers and Mountains*, which I-feng lao-jen [Huang Kung-wang] painted for Yün-lin [Ni Tsan], was only completed after an interval of several years. Since it is a composition for Yün-lin in Ch'ih-weng's [Huang Kung-wang] superb ink, neither in conception nor in placement [of the landscape motifs], is it the same sort as the *Fu-ch'un*. Truly, its influence within artistic circles will last for a thousand ages. In this scroll I also have used its idioms. Rightly, I dare not make the absurd comparison between a nag trotting about and the celestial steed. And so, I just note my resolve, enduring in devoted pursuit [of his art]. Keng-yün san-jen, Wang Hui [seals] Wang Hui chih yin; Shih-ku.

trans. MFW/KSW

5 colophons and 15 additional seals: 2 seals of Ch'eng-hsün (18th c.); 1 seal of Huang Ho-t'ing (mid-19th c.); 1 colophon, dated 1859, and 4 seals of Wang Yü-chang (act. ca. 1820-60); 1 colophon, dated 1859, and 2 seals of Huang Chü (ca. 1798-1860); 1 colophon and 2 seals of T'ao Chao-yüan (1814-1865); 1 colophon, dated 1915, and 2 seals of Lo Chen-yü (1866-1940); 1 colophon, dated 1917, and 2 seals of Ko Nagao (20th c.).

Remarks: The colophon by the archaeologist and savant Lo Chen-yü gives some information about the recent history of the painting. A friend of Lo's, Fei Nien-ssu (1855-1905), a member of the Hanlin Academy, had acquired the scroll from a certain Huang Ho-t'ing. He regarded it highly and would show it to no one. The powerful official Tuan-fang (1861-1911) wished to acquire the painting and asked Lo to be his intermediary in purchasing it from Fei at a high price. Fei refused to part with it, begging Lo to tell Tuan-fang that he had never owned it. Later, after Fei's death, Lo bought the painting from the family for a large sum. After owning it for a year or so, he allowed his friend Teijirō Yamamoto to add it to his collection.

KSW/LS

Literature
Naitō, *Shinchō shogafu* (1916), *Painters*, pl. 10.
Yamamoto, *Chōkaidō* (1932), *ch.* 6, pp. 98,99.

Recent provenance: Lo Chen-yü; Teijirō Yamamoto; Michelangelo Piacentini.

Nelson Gallery-Atkins Museum 46-43

247 Detail

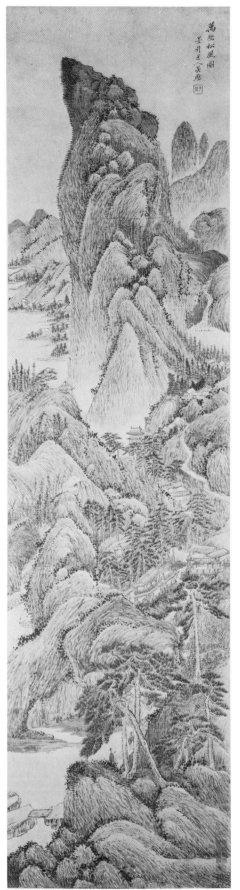

Wu Li, 1632-1718, Ch'ing Dynasty
t. Yü-shan, *h.* Mo-ching tao-jen; from Ch'ang-shu, lived in Chia-ting and Shanghai, Chiangsu Province

248 *Pine Wind from Myriad Valleys (Wan-ho-sung-feng)*

Hanging scroll, ink and light color on paper, 109.5 x 28.6 cm.

Artist's title, signature, and 2 seals: Pine Wind from Myriad Valleys. Mo-ching tao-jen [seals] Mo-ching tao-jen; Wu Li.

5 additional seals: 2 of Fang Kuan-ch'eng (1698-1768); 1 of Ma Chi-tso (20th c.); 2 unidentified. (Two seals of the Ch'ien-lung emperor [r. 1736-95], probably authentic, were believed spurious and removed by the previous owner.)

Remarks: Wu Li was a native of Ch'ang-shu, Chiangsu, also the birthplace of his friend and contemporary, Wang Hui (see cat. nos. 244b-247). In addition to his painting, he showed great talent in poetry and music. Both Wu and Wang Hui received instruction from Wang Chien (see cat. no. 241) and Wang Shih-min (see cat. no. 240). Under their guidance, Wu Li was exposed to landscapes of the Four Masters of the Yüan Dynasty, of whom Wang Meng (see cat. no. 111) proved the most influential in the formation of his style. Wu's paintings were highly praised and sought after by his contemporaries, but his reclusive nature eventually led him away from art to the investigation of philosophy and religion. At first schooled in Confucianism and Buddhism, Wu Li was eventually drawn to the Catholic missionary settlement adjacent to his family property in Ch'ang-shu. His conversion to Catholicism (before 1680), his ordination as a Jesuit priest in 1688, and his active missionary activity drastically curtailed the time he could devote to painting.

Very few works survive from Wu's later years. *Pine Wind from Myriad Valleys* is undated, but was probably executed towards the end of his life. The sooty blackness of the ink tones and the easy self-confidence with which they are set down on paper echo recognized late works such as the fine series of album leaves in the National Palace Museum, Taipei (*Chūgoku meigashu*, 1947, v, pls. 78-87), and an album dated 1707 (ibid., pls. 88-95). An almost identical version of the Cleveland painting, now in the Tokyo National Museum (*Chūgoku bijutsu-ten*, 1965, cat. no. 161), bears the artist's inscription dated 1670, as well as his signature and seal. The loose organization of its brushstrokes, the flickering tonal variations in its ink, and the calligraphy of its inscription suggest that the Tokyo painting is a late Ch'ing copy of an artist whose works were practically unobtainable even in his own lifetime. HK

Literature

Sirén, *Masters and Principles* (1956-58), VII, *Lists*, 449.
Goepper, *Im Schatten* (1959), no. 27.
Lee, *Chinese Landscape Painting* (1962), pp. 105, 106, no. 84; idem, *Far Eastern Art* (1964), p. 445, fig. 589.
Contag, *Chinese Masters* (1970), p. 34, pls. 57, 57A.
Watson, *L'Ancienne Chine* (1979), pl. 566 (color detail).
Whitfield et al., *Un Jūhei, O Ki* (1979), p. 168, pl. 98.

Exhibitions

Cleveland Museum of Art, 1954: Lee, *Chinese Landscape Painting*, cat. no. 91.
Haus der Kunst, Munich, 1959: *1000 Jahre*, cat. no. 99.

Recent provenance: Ma Chi-tso; Walter Hochstadter.

The Cleveland Museum of Art 54.584

Wang Yüan-ch'i, 1642-1715, Ch'ing Dynasty
t. Mao-ching, *h.* Lu-t'ai, and others; from T'ai-ts'ang,
Chiangsu Province

249 *The Three Friends of Winter*
(*Sui-han san-yu t'u*)

Hanging scroll, dated 1702, ink on paper, 85 x 47 cm.

Artist's inscription, signature, and 4 seals:
[seal] Yü-shu hua-t'u liu yü jen k'an.

The three gentlemen of winter
Entwine their roots on the cliff.
Atop high mountains they near the sun,
Tall and stately, they differ from common trees.

On the sixteenth day of the twelfth month in the *jen-wu*
year [1702], I sketched this concept on the way to Mount
Hsi [Wu-hsi, Chiangsu]. Lu-t'ai, Ch'i. [2 seals] Wang
Yüan-ch'i yin; Lu-t'ai. [seal, lower left corner]
Hsi-lu-hou-jen.

7 additional seals of the Chia-ch'ing emperor
(r. 1796-1820).

Remarks: The Three Friends of Winter are the pine, plum,
and bamboo, so called because each retains its vigor
during the harshest season of the year. They have long
been appropriated as a symbol of the ideal Confucian
scholar-official, who, like the pine, plum, and bamboo,
endures tenaciously in the face of adversity. The
metaphor becomes especially explicit in the second cou-
plet where the phrase "they near the sun" refers to vir-
tuous officials at court being close to the emperor.

The final line is a metaphor for the proper and dignified
bearing of the Confucian gentlemen that sets him apart
from the common lot. MFW

Literature
Shih-ch'ü III (1816), vol. IX, p. 4140.
NG-AM Handbook (1973), II, 72.

Recent provenance: Michelangelo Piacentini.

Nelson Gallery-Atkins Museum 51-77

Wang Yüan-ch'i

250 *Green Peaks under Clear Sky after Huang
Kung-wang*
(*Ch'ing-luan chi-ts'ui fang Huang Tzu-chiu*)

Handscroll, dated 1703-08, ink and light color on
paper, 37.5 x 267 cm.

Artist's inscription, signature, and seal: Green Peaks
under Clear Sky in imitation of Huang Tzu-chiu [Huang
Kung-wang]. Lu-t'ai [seal] Shih-shih tao-jen.

Artist's colophon and 4 seals: [seal] Yü-shu hua-t'u liu yü
jen k'an. Huang Kung-wang's paintings possessed ele-
ments of the great Sung masters such as Ching Hao,
Kuan T'ung, Li Ch'eng, Fan K'uan, Tung Yüan, and
Chü-jan. His brushwork is free of any artificiality. His
texture strokes start with light ink then change to dark
ink, and in the process eliminate all the traces of influence
of these old masters. In the year 1703 Mr. Hsü Tan-ming
chanced upon a simplified copy in six sections of a paint-
ing by Huang. He requested that I transform these into a
long handscroll incorporating some of the general idea of
the master's *Dwelling in the Fu-ch'un Mountains*. As I was
fully occupied by my official duties, I could paint only
during a few spare moments of leisure. After four to five
years, the painting was finally finished in the autumn of
1708. It took Ta-ch'ih [Huang Kung-wang] seven years to
paint the Fu-ch'un Mountains for the Taoist priest Wu-

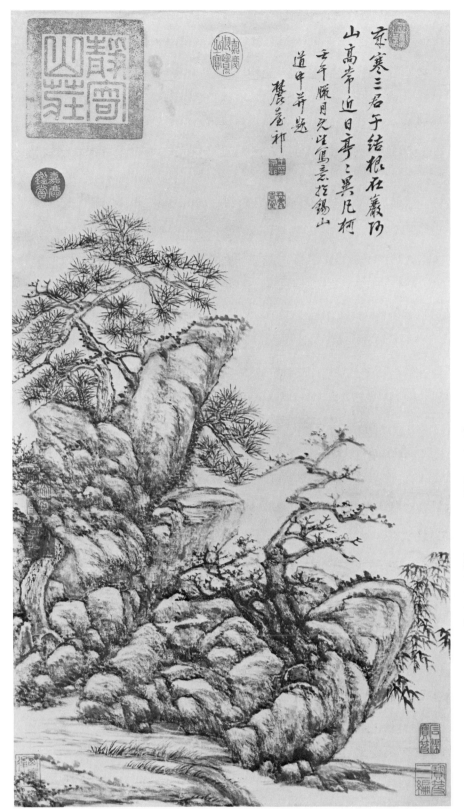

249

yung, resulting in a great masterpiece of a thousand generations. Now a clumsy work such as mine has also taken this long to complete. Knowledgeable people must think this is quite laughable.

Inscribed by Wang Yüan-ch'i. [seals] Wang Yüan-ch'i yin; Lu-t'ai. [seal at end of painting] Hsi-lu hou-jen.
trans. WKH/HK/LYSL

3 additional colophons and 15 additional seals: 1 colophon and 9 seals of Yang Shih-ts'ung (19th-20th c.); 1 colophon of Wu Hu-fan (20th c.); 1 colophon and 1 seal of Wu Mei (20th c.); 5 seals of Ch'eng Ch'i (20th c.).

Remarks: The scholar-painter Wang Yüan-ch'i was the offspring of a distinguished family of Chiangsu officials. Taught painting by his grandfather, Wang Shih-min (see cat. no. 240), Yüan-ch'i developed in the tradition of landscape methods that had been defined by Yüan and Ming painters and championed by Tung Ch'i-ch'ang. As a *chin-shih* graduate in 1670, Wang gained entry into government service, at first filling minor posts at the district level. He was appointed to the Hanlin Academy in 1700 and served as senior vice president on the Board of Finance until his death in 1715. He was highly regarded as a painter and enjoyed imperial patronage during his service in Peking.

In his inscription Wang Yüan-ch'i cites Huang Kung-wang's *Dwelling in the Fu-ch'un Mountains* as his inspiration for this handscroll. Huang painted his scroll late in life, after he had retired to the Fu-ch'un Mountains, south of Hangchou. The friend to whom he gave the scroll has been identified as the Taoist Cheng Wu-yung (*Yüan ssu ta-chia*, 1975, p. 38; English translation, p. 45). The painting was successively owned by Shen Chou, Tung Ch'i-

ch'ang, and Wang's contemporaries – Kao Shih-ch'i and Wang Hung-hsü (1645-1723). One of the most-copied paintings in the seventeenth century, the scroll now survives in two parts: the longer section is in the collection of the National Palace Museum, Taipei, and the short opening to the scroll is in the Chechiang Bureau of Cultural Relics (see Lovell, ''Wang Hui's 'Dwelling,''' 1970, pp. 217-40, pl. 7).

Wang's version is broadly based on the opening section of the Taipei scroll, where a flat land wedge in the lower right foreground is separated by a stretch of water from a multi-peaked mountain chain to the left. The innovation in Wang's approach rests on the manner in which he restructures its spaces. Wang breaks up the surface of Huang Kung-wang's rolling mountain ranges into a dense network of facets and introduces sharply angular buttes and mesas. The complex interplay of abstract voids and solids across the scroll is further accentuated by repeated applications of rubbed ink. With careful applications of light color, Wang enhances that sense of volume and underlying organic structure which Huang Kung-wang restored to the landscape tradition in the Yüan period and which Tung Ch'i-ch'ang revived in the late Ming (see cat. nos. 190-192).

Between 1931 and 1932 both the Cleveland handscroll and another famous handscroll by Wang Yüan-ch'i, *Spring Morning at the Yen-ling Rapids* (now in the Museum of Fine Arts, Boston), were acquired by Wang Po-yüan for his *I-mai hsüan* collection. The "Twin Wangs" became one of the most celebrated pair of Ch'ing paintings in southeastern China, until their dispersal during the Sino-Japanese War.
HK/WKH

250

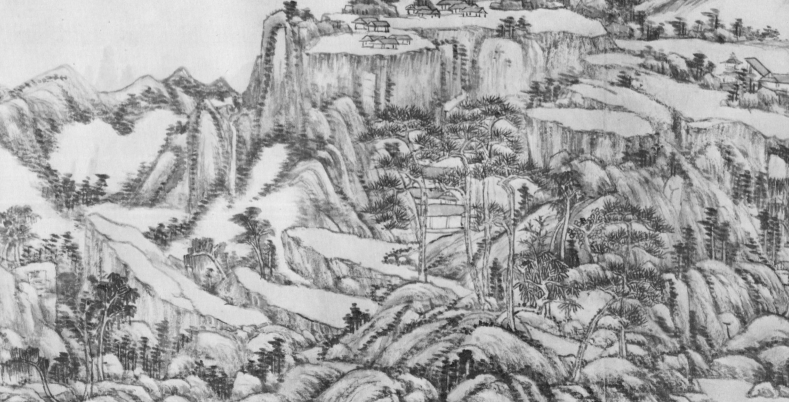

Literature
Ch'eng, *Hsüan-hui-t'ang* (1972), *Hua*, pp. 163(b)-164(b).
CMA *Handbook* (1978), illus. p. 357 (detail).
Whitfield et al., *Un Jūhei, O Ki* (1979), p. 66, pl. 86.

Recent provenance: Yang Shih-ts'ung; Wang Po-yüan; Ch'eng Ch'i.

The Cleveland Museum of Art 72.153

Wang Yüan-ch'i

251 *Landscape in the Color Style of Ni Tsan*
(*Fang hsieh-shih Yün-lin shan-shui*)

Hanging scroll, dated 1707, ink and light color on paper, 80.4 x 43.5 cm.

Artist's inscription, signature, and 4 seals: In the fourth month of the *ting-hai* year [1707], after attending the emperor on a tour and in the returning boat, I painted this in the color style of Yün-lin [Ni Tsan].

In recent years I have been hanging on to a government position like a [useless] gourd, with brush always at hand keeping myself busy. While day and night I attend to official duties, my family has nothing to spare, even for the cooking pot. Every day, in the "city of sorrow and the ocean of distress," there is nothing to relieve my worries. I can only play with the brush in imitation of the various masters of Sung and Yüan as if I were in the company of the ancients. Although I have been unable to come close to either their forms or spirits, an occasional "encounter" [with these masters] is nevertheless one way for self-expression and consolation. Lu-t'ai [2 seals] Yüan-ch'i chih yin; Lu-t'ai.

1 additional seal of P'ang Yüan-chi (ca. 1865-1949).

Remarks: The problem of restructuring early landscape traditions into an organic system of abstract volumes continued to fascinate Wang Yüan-ch'i in this 1707 hanging scroll. Here, the model chosen is the Yüan painter Ni Tsan. Probably the sparest of Yüan painters in his use of ink, Ni Tsan gives volume to his land masses with a few light, rubbed ink strokes and elongated "pepper dots." As in the previous painting (cat. no. 250), Wang Yüan-ch'i expands Ni Tsan's sparse topography by applying layer upon layer of light brushstrokes. As if to enforce the abstract structure and volume so painstakingly formed, Wang even distorts the horizon line: the right background seems to expand further beyond it, while the left background ends in an implied abyss below it. With great subtlety Wang differentiates flat planes in ochre from rounded masses in green wash, thereby producing a solid and convincing landscape structure. HK/SEL

Literature
P'ang, *Hsu-chai* (1909), IX, Wang Yuan-ch'i 15(b)-15(a), pp. 42(b)-43(a); idem, *Ming-pi* (1940), I, pl. 14.
Sirén, *Masters and Principles* (1956-58), VII, *Lists*, 441.
Lee, *Chinese Landscape Painting* (1962), p. 100, color pl. VI, no. 80; idem, *Far Eastern Art* (1964), p. 444, fig. 588.
Sullivan, *Chinese and Japanese* (1965), p. 91, color pl. 195.
Kuo Chi-sheng, "Wang Yüan-ch'i" (1974), p. 29, pls. 21, 21-A, 21-B.
CMA *Handbook* (1978), illus. p. 358.
Whitfield et al., *Un Jūhei, O Ki* (1979), p. 187, pl. 87 (color).
Hochstadter, *Compendium* (forthcoming).

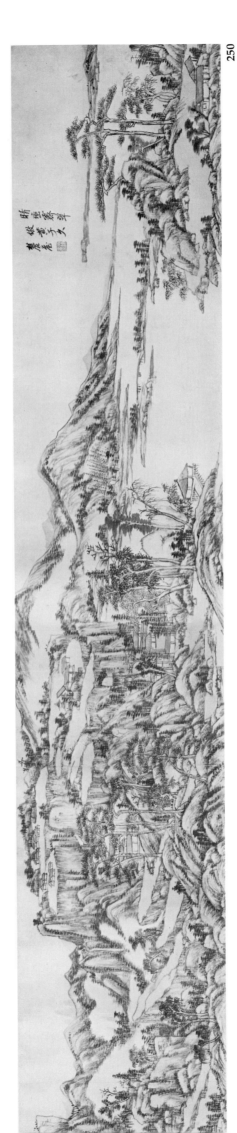

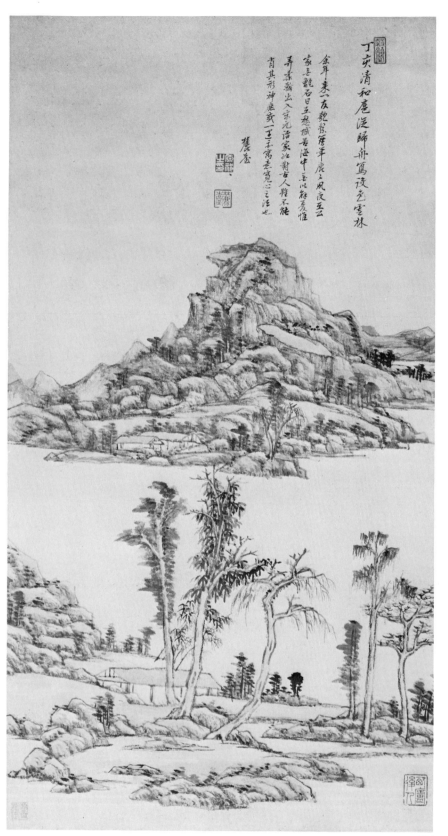

251

Exhibitions
Cleveland Museum of Art, 1954: Lee, *Chinese Landscape Painting*, cat. no. 86.
Haus der Kunst, Munich, 1959: *1000 Jahre*, cat. no. 95.
Cleveland Museum of Art, 1962: Chinese Paintings, no catalogue.
Smith College Museum of Art, Northampton, Mass., 1962: *Chinese Art*, cat. no. 29.

Recent provenance: P'ang Yüan-chi; Walter Hochstadter.

The Cleveland Museum of Art 54.583

Wang Yüan-ch'i

252 *Spring in the Chiang-nan Region*
(*Chiang-nan ch'un*)
and *Springtime at the Peach-Blossom Spring*
(*T'ao-yüan ch'un-chou*)

Pair of hanging scrolls, ink and color on paper, each 31 x 24.6 cm.

Artist's inscription and seal on first painting: Spring in the Chiang-nan region, after Hui-ch'ung [early 11th c.]. [seal] Lu-t'ai.

Artist's inscription and seal on second painting: Springtime at the Peach-Blossom Spring, after Chao Ch'eng-chih [Chao Meng-fu, 1254-1322]. [seal] Wang Yüan-ch'i.

2 additional inscriptions and 20 additional seals on each: 1 seal of Li Tsung-wan (1705-1759); 1 poem, dated 1766, on the painting with 1 inscription on the mounting and 12 seals of the Ch'ien-lung emperor (r. 1736-95); 6 seals of the Chia-ch'ing emperor (r. 1796-1820); 1 seal of the Hsüan-t'ung emperor (r. 1909-11).

Remarks: These two paintings are from an album of six leaves which were remounted as hanging scrolls, probably around 1766, when the Ch'ien-lung emperor appended his inscriptions. All purportedly are after the manner of different old masters. The other four followed Tung Yüan, Mi Yu-jen, Huang Kung-wang, and Wu Chen. MFW

Literature
Shih-ch'ü III (1816), vol. II, p. 974.
NG-AM Handbook (1973), II, 72.

Recent provenance: Arthur Rothwell.

Nelson Gallery-Atkins Museum 62-15, 62-16

Artist unknown, mid-seventeenth century,
Ch'ing Dynasty

253 *Many Deer*
(*To-lu t'u*)

Handscroll, ink and color on paper, 25.5 x 309.5 cm.

Spurious signature and seal at lower left end: Painted by the Hsüeh-shih of the Hanlin Academy, Chieh Hsi-ssu. [forged seal] Ssu-yin.

6 additional seals: 1 of the Shun-chih emperor (r. 1644-61); 1 of the Hsieh family (unidentified, probably 18th c.); 2 of Pi Lung (18th c.); 1 of Ming-ch'i (unidentified); 1 of Tuan Fang (1861-1911).

3 additional spurious seals: 1 of Sung Hui-tsung (r. 1100-25); 1 of Chao Meng-fu (1254-1322); 1 of Hsiang Yüan-pien (1525-1590).

Remarks: The scroll has been tampered with, probably in the nineteenth century. A signature at the end of the scroll has been rubbed out and a meaningless signature of a Yüan Dynasty scholar (who was not a painter) has been substituted. Equally absurd additions are the false seals listed above.

 The large square seal in the upper right corner reads: Kuang-yün chih pao. Seals with a similar inscription but notably larger and with different cutting were used by the Ming emperors Hsüan-te (r. 1426-35) and Ch'eng-hua (r. 1465-87). A smaller seal with the same inscription but different cutting was also used by the Ch'ing emperor, Shun-chih (r. 1644-61) (*Signatures and Seals*,

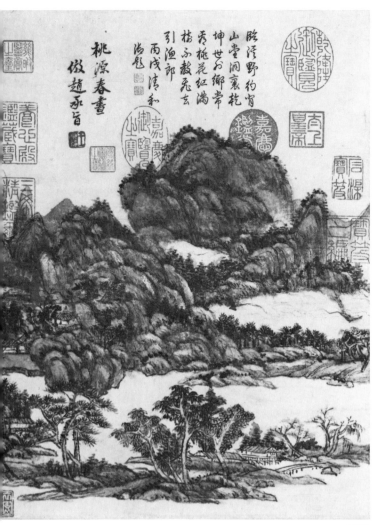

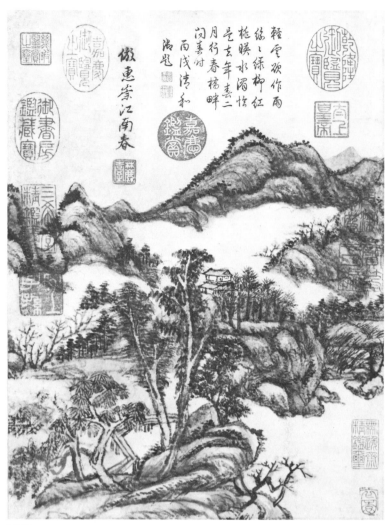

252A 252B

253 Detail

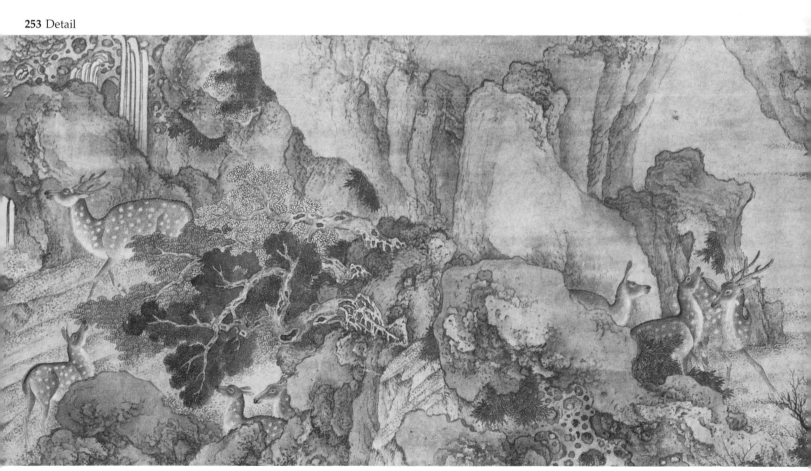

341

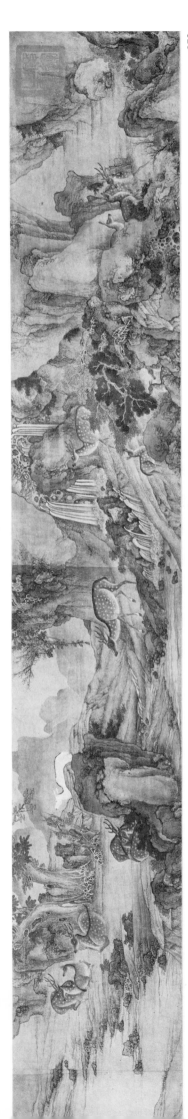

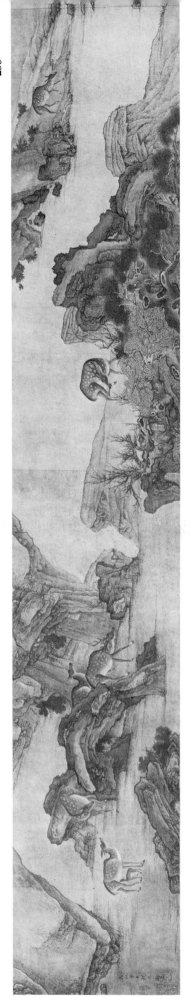

1964, II, 74, 82-84). As nearly as can be judged, the seal on the Nelson Gallery scroll is the same size and cutting as the Shun-chih seal and, if genuine, as it appears to be, would suggest a date around the middle of the seventeenth century, which would agree with the style and content of the painting.

The title *To-lu* allows a play on words in Chinese, since another character pronounced *lu* means "official rank" and "salary" — the message then being "may you enjoy high rank and much salary."

The drawing of the twenty-two deer, bucks, does, and fawns is faultless, the bodies textured with meticulous brushwork and the volume heightened by light color washes — a technical virtuosity descended from the Sung Dynasty Academy. The setting, on the other hand, has a number of elements derived from certain of the more imaginative Nanking artists of the late Ming such as Wu Pin (especially in his early work), Kung Hsien, and Ch'en Hung-shou. For example, the extensive use of ink and color washes models the complex jumble of rocks and ground planes; texture is provided by innumerable small dots and dabs rather than any of the more conventional texturing strokes *(ts'un)*. And there is the conspicuous presence of water-worn, fantastic rocks, complemented by the intricately contorted roots of trees. A certain aura of Western influence, particularly in the chiaroscuro, also comes from the Nanking school, where traces of such influence can be found as early as the late Ming period.

While the Nanking painters mentioned above were men of extraordinary originality and uninhibited self-expression, the *Many Deer* scroll exhibits a studied suppression of any personal statement by the artist: vitality of expression has given way to refinement, elegance, and a tapestry-like decoration. *Many Deer* is an academic court painting on a high level of accomplishment of a kind that persisted through the late seventeenth and eighteenth centuries parallel with, and independent of, the more creative artists in the literati tradition. LS

Recent provenance: Otto Burchard.

Nelson Gallery-Atkins Museum 33-649

Ku Chien-lung, 1606-1687 or later, Ch'ing Dynasty
t. Yün-ch'en; from T'ai-ts'ang, Chiangsu Province,
lived on Tiger Hill, Suchou, also active in Peking

254 *Assorted Sketches after the Old Masters*
(Mo-ku fen-pen)

Album of forty-six pages, ink or ink and color on paper, each 30.2 x 18.8 cm.

Artist's seals include: Yün-ch'en; Ku-chih chien-chi; Ku Yün-ch'en; and Pu-ch'ün.

Remarks: Wang Shih-min (see cat. no. 240) wrote a preface to Ku's collection of sketches and studies. From the rather detailed text of Wang's preface, one learns both how the sketches came to be made and the extent of the collection. Wang speaks of Ku as a man of the same native place who was devoted to drawing, even as a child. Determined to rise above the common level, he studied with a number of masters and developed a remarkable skill. In his early years Ku was known as a portrait painter (see cat. no. 255), but later he became proficient in Buddhist subjects, figures, landscape, trees, palace buildings, birds, animals, insects, and fish.

254-13 254-14 254-15 254-16

254-22 254-23 254-24 254-25

254-30 254-31 254-32 254-33

254-46

254-18

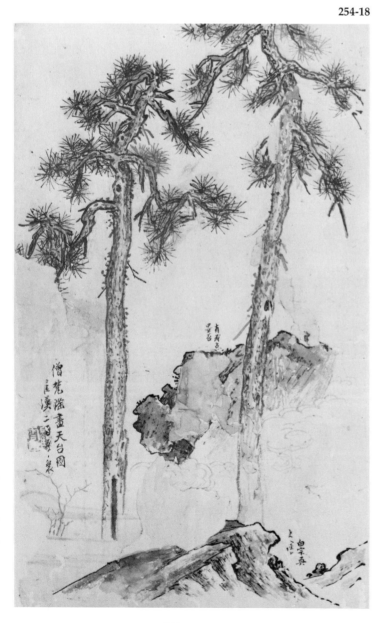

His skill was without equal in the Chiang-nan area. Wang writes that he had seen many of Ku's large albums, piled up as high as one's head, made up of numerous sketches from all the old paintings he had seen. These included studies of eyes, eyebrows, and ears, and studies of extended or contracted fingers and arms from various points of view, many arranged together on a single page. He depicted details from other subjects of painting in the same way. In landscape he favored the styles of Li T'ang, Ma Yüan, and Hsia Kuei because these painters were close to his own preferences.

Ku also put together an album of copies of the patterns of T'ang and Sung Dynasty brocades. Alongside each of his drawings he added, in small characters, notes about brushwork and methods of laying on color. He sought out designs of archaic chairs and tables, sketching whatever he saw (in old paintings) so that he might use the material in his own work (Li Yü-fen, *Wang Feng-ch'ang*, 1909, *ch. hsia*, pp. 15a-b).

In tune with his times, Ku Chien-lung, a court painter of the K'ang-hsi era, made no studies from nature (save in his portraits) but learned exclusively from the old masters, motivated by the same devotion to tradition that produced the well-known illustrated painting manuals, the *Ten Bamboo Studio Manual on Calligraphy and Painting (Shih-chu-chai shu-hua-p'u)*, first printed in 1633, and the *Mustard Seed Garden Manual of Painting (Chieh-tzu-yüan hua-chüan)*, part I printed in 1679, parts II and III in 1701.

These forty-six heavily damaged pages are all that remain, so far as we know, of what must have been a very large compendium filling a number of albums. All are worm-eaten, some so seriously that his notes and the characters of artists named are fragmentary or altogether lost. That Ku preferred the styles of Li T'ang, Ma Yüan, and Hsia Kuei is borne out by the fact that Li T'ang is named on eleven sketches, although only two or three minor details allude to Ma Yüan or Hsia Kuei.

All of the pages reveal a remarkably high level of skill in drawing and handling of ink, justifying Wang Shih-min's praise. The studies in blue-and-green landscape after Ch'iu Ying substantiate the comment that it took more than one glance to detect Ku Chien-lung's copies from the originals *(Chung-kuo hua-chia*, 1934, p. 741). So far, only one painting of which reproductions are available can be linked to one of Ku's studies. This is the scroll *The Scholar's Dream* by T'ang Yin, now in the Freer Gallery of Art, Washington (Cahill, *Chinese Painting*, 1960, pp. 138, 139, as Chou Ch'en). The two pine trees on Ku's page, based on this painting, are so close and accurate in detail that they must have been painted not from memory but directly from the original. Ku's note gives the title and artist and states that he saw the picture in 1673. Two other leaves are dated in the K'ang-hsi era, one to 1669, the other 1672. LS/KSW

Literature
Sullivan, *Symbols of Eternity* (1979), p. 10, fig. 2.

Recent provenance: J. D. Chen.

Nelson Gallery-Atkins Museum 59-24

Ku Chien-lung

255 *Portrait of Ma Shih-chi
(Ma Shih-chi hsiang)*

Hanging scroll, datable to 1687, ink and color on silk, 145.5 x 88.2 cm.

Artist's seal on rock at right: Ku Chien-lung.

Colophon, dated 1695, and 5 additional seals of Ma Shih-chi (1650-1714).

Remarks: Ma Shih-chi's poetic colophon is mounted above the painting; in it he recounts that ten years earlier the Kang-hsi emperor favored him with the presentation of an "imperial garment." Traveling constantly in government service caused him to age, and at forty-six *sui*, he recalls the past. His son won a good reputation and became a governor; and so, content, Ma Shih-chi enjoys the trees and streams, plays the *ch'in*, and reads. He says the picture of him in the enjoyment of life *(hsing-lo-t'u)* was done when he was thirty-eight *sui*; since then, some ten years have passed and he is nearing fifty. The colophon concludes: "Shih-chi, Wu-kuei chu-jen, wrote this in the summer, the fourth month of the *i-hai* year of the K'ang-hsi era [1695]."

Ma Shih-chi was the son of the famous patriot Ma Hsiung-chen (1634-1677), who was civil governor of Kuanghsi at the time of the revolt of Wu San-kuei and was taken prisoner and jailed by the rebel leader because he refused to join the revolt. In 1674 he secretly sent his eldest son, Ma Shih-chi, to Peking to explain the state of affairs and to ask for help. The situation was not relieved, and because Ma Hsiung-chen was steadfast in his allegiance to the Manchus, he and all his family were murdered by Wu San-kuei. Ma Shih-chi, who had not returned to Kuanghsi, escaped the massacre. In the government he rose to be director-general of grain transport (Hummel, *Eminent Chinese*, 1943-44, I, 556, 557). Since he was thirty-seven (thirty-eight *sui*) at the time the portrait was painted, it is datable to 1687. KSW/LS

Nelson Gallery-Atkins Museum 34-262

Yüan Chiang, active ca. 1690-1724, Ch'ing Dynasty
t. Wen-t'ao; from Yangchou, Chiangsu Province

256 Carts on a Winding Mountain Road
(P'an-ch'e t'u)

Hanging scroll (paneled), dated 1694, ink and color
on silk, 181 x 93.4 cm.

Artist's inscription, signature, and 2 seals: In the au-
tumn of the chia-hsü year [1694] I have made a copy of
Kuo Ho-yang's [Kuo Hsi] P'an-ch'e t'u for the pure
appreciation of the old gentleman Yü in his advanced
years. Han-shang, Yüan-chiang [seals] Wen-t'ao; Yüan
Chiang chih yin.

255

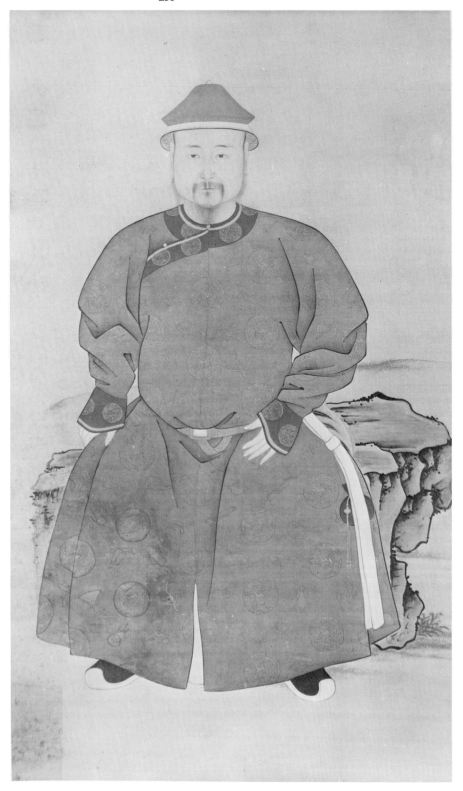

Remarks: Yüan Chiang was not held in high esteem by
the literati of his time, nor by later critics. He was a
professional painter, living by his art, and as such out-
side the circle of scholar-amateurs who prided them-
selves on their non-professional standing. Nor did he
indulge in the eccentric individualism that brought fame
to some of his contemporaries in Yangchou and nearby
Nanking.

Yüan Chiang's style was basically academic, stemming
from the tradition of such great Northern Sung masters
as Kuo Hsi (ca. 1020-1090), whom he follows in this
painting, according to the inscription. From this tradi-
tion he has drawn such elements as the large trees estab-
lishing the foreground, the twisted mountain forms and
mist-filled valleys. But by the time of Yüan Chiang, the
classic compositions had become worn clichés no longer
valid or of interest. Yüan Chiang sought to bring new
life, animation, and fresh intensity to the old formulae
by exploiting the fantastic to create landscapes from a
dream world of imaginative visions. His twisted, inter-
locking forms, almost devoid of texturing, mount up in
strong verticals to towering, irrational heights. But lest
his dream world overreach the bounds of credibility and
dissolve in pure fantasy, the artist incorporates a consis-
tent pattern of highly realistic details: the carefully
drawn carts and oxen, wheel tracks on the road, and the
house by the water with the plaster crumbling off the
walls. The result is a painting rich in detail and surface
pattern, arresting in its imaginative fantasy, yet quite
innocent of any profundity of thought or subtlety of
brush and ink.

Yüan Chiang was a man of his time, adding yet
another concept, another way of painting to the plethora
of styles and solutions that characterized Chinese paint-
ing in the late seventeenth and early eighteenth centur-
ies. Today Yüan Chiang, by reason of his technical pro-
ficiency and imaginative constructions, is given more
serious consideration than he enjoyed in the past.

The Nelson Gallery painting of a time-honored theme,
Carts on a Winding Mountain Road, is the earliest dated
work by the artist so far known. LS

Literature
Sirén, Later (1938), II, 76, 77; idem., Kinas Kunst (1942), II, pl. 138.
Munsterberg, Landscape Painting (1955), pp. 76, 77, pl. 67.
Sirén, Masters and Principles (1956-58), V, 93; VI, pl. 334B.
Sickman and Soper, Art and Architecture (1956), p. 194, pl. 146.
Cahill, "Yüan Chiang" (1963), pp. 266-68, figs. 9, 17.

Exhibitions
Cleveland Museum of Art, 1954: Lee, Chinese Landscape Painting,
cat. no. 89, p. 110.

Nelson Gallery-Atkins Museum 35-151

Wang Yün, 1652-1735 or later, Ch'ing Dynasty
t. Han-tsao, h. Wen-an, Ch'ing-ch'ih; from Kao-yu,
Chiangsu Province

257 The Fang-hu Isle of the Immortals
(Fang-hu t'u)

Hanging scroll, dated 1699, ink and color on silk,
142 x 60.3 cm.

Artist's inscription, signature, and 2 seals: The Fang-hu
Isle of the Immortals, copied after a version by a man of the
Sung in the summer months of the chi-mao year [1699]
for the venerable Huo to correct. Wang Yün of Han-
shang [Yangchou]. [seals] Wang Yün chih yin;
Han-tsao.

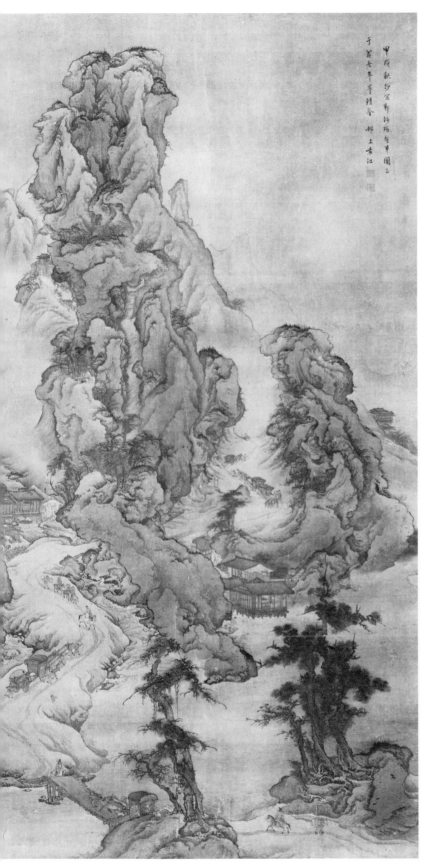

256

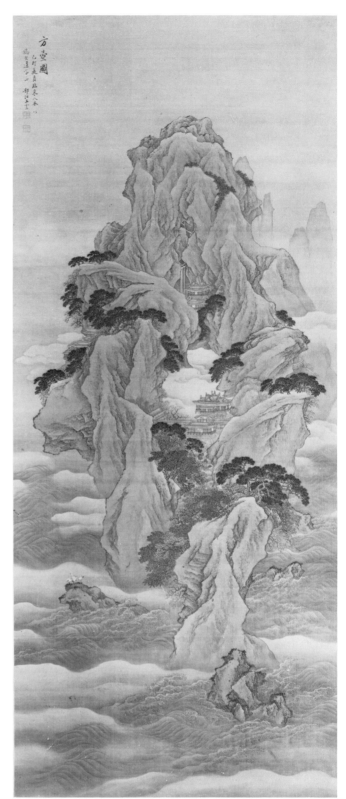

257

349

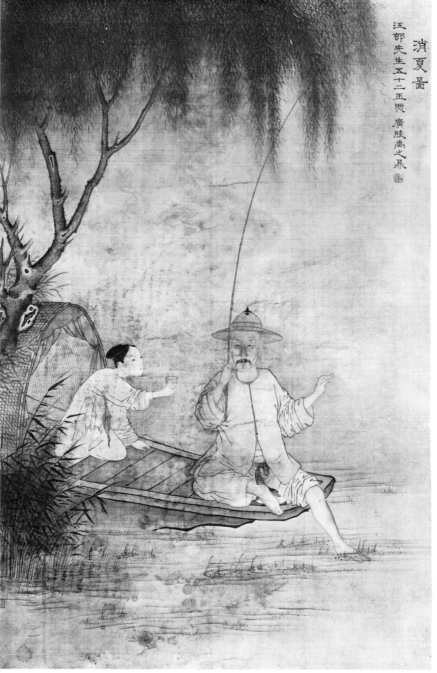

消夏圖

江郡先生五十二玉與 廣陵禹之鼎 [seal]

258

Remarks: Wang Yün, a professional painter from Yang-chou, is said to have been a follower of Ch'iu Ying (see cat. nos. 164-166). He specialized in figures, buildings, and landscape realistically painted with a fine brush. He often collaborated with Wang Hui (see cat. nos. 244b-247) and his pupils. Although his relationship with Wang Hui is not altogether clear, Wang Hui's influence can be seen in the rock, trees, and waves of this picture.

Fang-hu is the third of five legendary isles of the Taoist immortals thought to lie in the Eastern Sea. KSW

Exhibitions
Museum für Kunst und Gewerbe, Hamburg, 1949/50: Contag, *Chinesische Malerei*, cat. no. 68, p. 44.
Kunstsammlungen der Stadt Düsseldorf, 1950: Speiser and Contag, *Austellung*, cat. no. 85, p. 27.

Recent provenance: Victoria Contag von Winterfeldt.

Nelson Gallery-Atkins Museum F75-43

Yü Chih-ting, 1647-1710 or later, Ch'ing Dynasty
t. Shang-chi, *h.* Shen-chai; from Yangchou, Chiangsu Province

Shen Ying, active late seventeenth-early eighteenth century, Ch'ing Dynasty
t. Ts'an-san; unrecorded, probably a court painter active in Peking

258 *Kao Shih-ch'i Whiling away the Summer (Chiang-ts'un hsiao-hsia t'u)*

Hanging scroll (paneled), datable to 1696, ink and color on silk, 64.3 x 42.2 cm.

Yü Chih-ting's inscription, signature, and seal: *Whiling away the Summer*, a portrait of Mr. Chiang-ts'un [Kao Shih-ch'i] at the age of fifty-two [*sui*]. Yü Chih-ting of Kuang-ling [Yangchou]. [seal] Yü Chih-ting yin.

Shen Ying's 2 seals at lower right edge: Shen Ying chih yin; Ts'an-san.

2 additional seals: 1 of Prince I (probably Hung-hsiao, 2nd Prince I, d. 1778); 1 of the K'uang family (unidentified, 18th c. ?).

Remarks: It was first thought that this painting was entirely done by Yü Chih-ting. It now appears he painted only the landscape. The figures of Kao Shih-ch'i and the serving maid were done by Shen Ying. Evidence for this judgment comes from another painting in the Nelson Gallery (acc. no. 34-278) depicting a lady and two attendants in a garden. Here the inscription clearly states that the landscape only was done by Ku Fang (1690-1720), a pupil of Wang Hui; at the edge of the painting somewhat larger versions of the same two seals of Shen Ying are found. A comparison of the figures and their drapery in the two paintings shows that they are by the same hand. Yü Chih-ting was a noted painter of the K'ang-hsi era, but no artist with the name Shen Ying and the *tzu* Ts'an-san is recorded in any available source.

Kao Shih-ch'i (1645-1703), also known as Chiang-ts'un, was a close associate of the K'ang-hsi emperor, often traveling with him. He was also among the leading collectors of paintings in the early part of the Ch'ing Dynasty. In 1693 he completed the famous catalogue of his collection, entitled *Chiang-ts'un hsiao-hsia lu*. This portrait of him at the age of fifty-two [*sui*] must have been painted in 1696. The phrase *hsiao-hsia* means "whiling away the summer" and was used both in Kao's catalogue and again here in his portrait. To while away the summer implies the elegant pastime of a lofty gentleman. The painting by Liu Kuan-tao with this title (cat. no. 92) was at one time in the collection of Kao Shih-ch'i.
LS/KSW

Intended gift to the Nelson Gallery-Atkins Museum, Laurence Sickman

Wang Hui, 1632-1717, Ch'ing Dynasty
T'u Lo, dates unknown
Yang Chin, 1644-1728, Ch'ing Dynasty

259 *Portrait of An Ch'i*
(Lu-ts'un kao-i)

Hanging scroll, dated 1715, ink and light color on paper, 121.8 x 53.5 cm.

Artist's inscription, signature, and 3 seals: [seal] Shang-hsia ch'ien-nien. In late spring, the *i-wei* year [1715] of the K'ang-hsi era, T'u Lo of Kuang-ling painted the portrait, Yang Chin from Hai-yü designed the landscape, and the eighty-four-year-old Wang Hui added the bamboo and rocks. [seals] Keng-yen; Wang Hui chih yin.

7 colophons and 22 additional seals: 1 colophon and 3 seals of Sung Ting-yeh (ca. 17th-18th c.); 1 colophon and 3 seals of Ch'ien Ch' en-ch'ün (1686-1774); 1 colophon and 2 seals of Ts'ai Erh-chün (ca. 18th c.); 1 colophon and 1 seal of Miu Yüeh-ssu (ca. 18th c.); 1 colophon and 3 seals of Sung Shih-tseng (ca. 18th c.); 1 colophon and 2 seals of T'ung Hung (ca. 18th c.); 1 colophon and 2 seals of Chao (?); 6 seals unidentified.

Remarks: According to Wang Hui's inscription, this painting was the joint effort of three men. Nothing is recorded of T'u Lo, the artist who painted the face, but Yang Chin (from Ch'ang-shu, Chiangsu) frequently collaborated with his fellow townsman and painting master, Wang Hui. Several of Yang's paintings survive – among them, other works done in collaboration with Wang Hui (Sirén, *Masters and Principles*, 1956-58, VII, *Lists*, 453). The three artists' association over a period of at least thirty years may explain the homogeneity of ink and color which distinguishes the garden setting; it would be difficult to identify where Wang Hui left off and Yang Chin began, were it not for the inscription. Only the face of their patron, An Ch'i, exhibits a certain heaviness in the repetition of its color washes–necessary for the formation of precise physiognomy. Its subtle chiaroscuro, based on Western conventions, thus contrasts with the single-layered color washes and strong ink outlines with which the verdant garden was created.

An Ch'i, the subject of the portrait, was a second-generation salt merchant from Korea. An Ch'i's father made a fortune for himself and for Mingju, the powerful Manchu minister; An Ch'i was eventually included within management of that lucrative monopoly. Through its proceeds An Ch'i indulged in the collection of ancient and modern paintings, a number of which bear the distinguished pedigrees of collectors such as Hsiang Yüan-pien and Liang Ch'ing-piao (Hummel, *Eminent Chinese*, 1943-44, I, 11-13). At the time this painting was commissioned, An Ch'i was less than forty years old. He is represented in the time-honored guise of the Taoist recluse, a portrait convention first defined in the Six Dynasties period: dressed in informal attire, he sits upon a leopard skin, accompanied by his scrolls, a wrapped lute, and a servant (see Laing, "Neo-Taoism," 1974). Another symbol of the Land of the Immortals – the crane – enforces the flattering aura which the eighty-four-year-old Wang Hui and his assistants sought to provide for the young An Ch'i. The literati who inscribed the portrait about five years after its completion also elaborated on these visual allusions.

Aside from its importance as a finely wrought work commissioned by an equally discerning collector, An

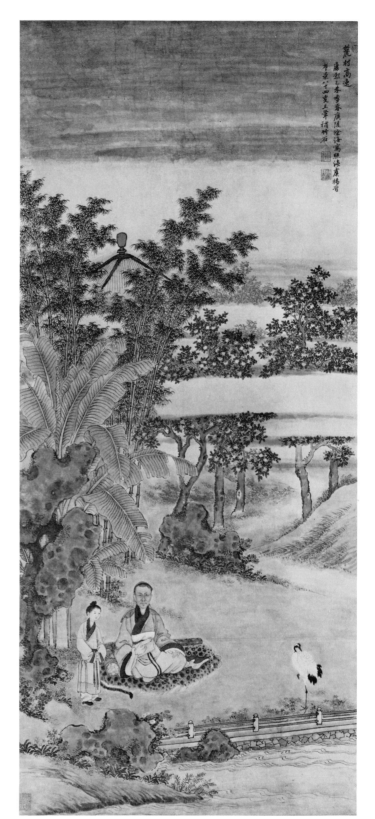

259

Ch'i's portrait provides evidence of the changed status of the successful merchant classes. Already in the early Ch'ing Dynasty, their services to the government monopolies were rewarded with a limited eligibility for competition within the civil examinations, thereby providing them entry into the official life of the realm denied them in earlier generations. At the same time, their sheer wealth provided acceptance by the established official families. Of those who provided inscriptions on this painting, two deserve special mention. Miu Yüeh-ssu was himself a collector of paintings – at one time he owned Wen Cheng-ming's *Old Trees by a Wintry Brook* (cat. no. 176). Ch'ien Ch'en-chün, later an important figure within the Hanlin Academy, wrote his inscription before he had obtained the *chin-shih* degree. He later provided An Ch'i with a birthday poem on his fiftieth birthday. In view of the fact that An Ch'i was the son of a former slave to a Manchu bannerman, the portrait constitutes an interesting social footnote within the evolution of Ch'ing society. HK

Literature
Chūgoku meigashu (1947), VIII, pl. 80.
Sirén, *Masters and Principles* (1956-58), VII, *Lists,* 430 (Wang Hui), 453 (Yang Chin).
Kuo Wei-chu, *Sung Yüan Ming Ch'ing* (1958), p. 321.
Lawton, "Mo-yüan hui-kuan" (1969), p. 27, pl. 1.
Ch'eng, *Hsüan-hui-t'ang* (1972), *Hua,* pp. 166(b)-168(b).
Hung, "Liu Hua Han-kuo" (1973), repr. p. 1165.
Lee, "Portraiture" (1977), pp. 124, 125, figs. 6, 7 (detail).
CMA *Handbook* (1978), illus. p. 358.
Whitfield et al., *Un Jūhei, O Ki* (1979), p. 150, fig. 18.
Loehr, *Great Painters* (1980), pp. 316, 319, figs. 181, 182 (detail).

Recent provenance: Hsü Po-chiao; Ch'eng Ch'i.

The Cleveland Museum of Art 71.17

260

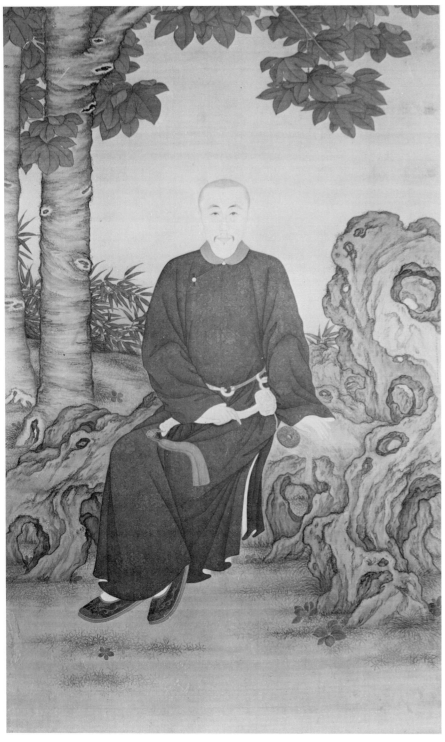

Mang-ku-li, 1672-1736, Ch'ing Dynasty
Surname I-er-ken-chüeh-lo; *t.* Cho-jan; from Manchuria, active in Peking and Tientsin, Hopei Province

260 *Portrait of Prince Kuo*
(*Kuo-ch'in-wang hsiang*)

Hanging scroll, dated 1729, ink and color on silk, 215 x 134 cm.

Artist's inscription, signature, and 2 seals: Painted with respect, Vice President of the Board of Foreign Affairs and Marshal [Tu-t'ung chien li-fa-yüan shih-lang], Mang-ku-li, in mid-summer of the *chi-yu* year [1729]. [seals] Mang-ku-li; Cho-jan.

1 colophon and 1 additional seal of Prince Kuo (1677-1738).

Remarks: In his colophon mounted above the painting, Prince Kuo speaks of his good fortune to have been born in peaceful times; of the pleasure he derives from trees and streams, spring flowers, and the changing seasons; and at the same time emphasizes his devotion to work and his determination to improve. The colophon concludes: "Written in the first decade of mid-winter [eleventh month] in the sixth year of the Yung-cheng era [1728], Kuo-ch'in-wang at the age of thirty-two *sui.*" At the top center is his large seal: Ho-shih Kuo-ch'in-wang chih-pao (Chinese on the right, Manchu on the left).

Prince Kuo, named Yin-li, was the seventeenth son of the K'ang-hsi emperor (r. 1662-1722), brother of the Yung-cheng emperor, and one of only three brothers who enjoyed imperial favor. In the first year of the Yung-cheng era (1723) he was made a prince of the first degree with the title of Kuo-ch'in-wang and was appointed president of the Board of Foreign Affairs. In 1729 he was made director of the Board of Public Works, and on the death of the emperor in 1735 he was one of the high officials appointed to serve the new emperor, Kao-tsung (r. 1736-95) (*Ch'ing-shih,* 1971, *ch.* 221, p. 3564).

Mang-ku-li, noted as a portrait painter, was a high official who served as vice president of the Board of Foreign Affairs, then headed by Prince Kuo. In 1725 when the painting collector An Ch'i and his father offered to rebuild the walls of Tientsin, it was Mang-ku-li, serving at the time as salt censor in Tientsin, who conveyed his offer to the emperor. Chang Keng, a contemporary, tells us that Mang-ku-li excelled at portrait painting, capturing the likeness and spirit of his subject. He used a method derived from Western painting in which he omitted the ink outline and worked directly with ink and color in wet washes (Chang Keng, *Kuo-ch'ao — hsü-lu*, preface 1739, ch. 1, p. 93).

In the present instance, Mang-ku-li has not followed this technique, but has made a traditional use of ink outline. His style of portrait painting is close to that of Tseng Ch'ing, but at the same time the trees and rocks of his garden setting show definite Western influence of the kind associated with Giuseppe Castiglione (Lang Shih-ning, see cat. nos. 261, 262), the Italian painter active at the court of Peking.

There is a discrepancy of some six months between the dates of Mang-ku-li's signature, the spring of 1729, and Prince Kuo's colophon of mid-winter 1728. This can be accounted for if the portrait was completed first, at which time Prince Kuo wrote his colophon, and if Mang-ku-li, occupied with his official duties, was unable to complete the elaborate garden scene until some six months later, when he signed the completed work.

A gulf separates a portrait like this from the stiff, formal, and generally lifeless so-called "ancestor portraits" so familiar in the West. This portrait belongs to a class called *hsing-lo t'u* (in the enjoyment of life) done from life and with a notable air of informality; the sitter usually is shown in a garden or open pavilion. Although Prince Kuo was an imperial prince, he is shown here without insignia of rank, simply dressed, and the *ju-i* sceptre he holds is of carved wood rather than of some precious material. KSW/LS

Literature
Mailey, "Ancestors" (1963), p. 103, fig. 2.

Nelson Gallery-Atkins Museum 33-1534

Lang Shih-ning, 1688-1768, Ch'ing Dynasty
Giuseppe Castiglione; from Milan, Italy, active in Peking, Hopei Province
Chiao Ping-chen, active ca. 1689-1726, Ch'ing Dynasty
t. Erh-cheng; from Chi-ning, Shantung Province

261 *Training a Horse on the Northern Frontier (Sai-shang yeh-ch'ü)*

Folding fan, ink and light color on paper, 18.9 x 52.1 cm., H. whole fan, 33 cm.

Artists' inscription, signatures, and 2 seals (1 of each artist): Training a Horse on the Northern Frontier. By imperial command, to sketch from life. Servants Chiao Ping-chen, Lang Shih-ning respectfully painted in collaboration. [seals] Ping-chen; Shih-ning.

2 additional seals of the Ch'ien-lung emperor (r. 1736-95). 13 additional inscriptions: 12 poems by the Ch'ien-lung emperor and inscribed by Wang Yu-tun (1692-1758); 1 poem incised on the outer ribs of the fan by Tung Pang-ta (1699-1769).

Remarks: Giuseppe Castiglione was born in Milan in 1688 and entered the Society of Jesus in 1707. During his training as a Jesuit brother in Genoa, and later in Portugal, he revealed his gifts and training as a painter of religious subjects painted in the late baroque manner of his day. Yet his chief interest was to enter the mission in China, where the Society had been active for over a century. Arriving in Macao in 1715, and in Peking late in the K'ang-hsi era, Castiglione would remain until his death among the enclave of missionary priests and brothers housed at the imperial court as advisors in Western art, technology, and science. Adopting the Chinese name Lang Shih-ning, Castiglione painted for three emperors and trained Chinese artists in Western techniques. He even participated in the design of the Yüan-ming-yüan, a palace complex built for the Ch'ien-lung emperor in Western baroque taste – unfortunately destroyed during the Franco-British incursions of 1860. Because of his ability to combine traditional Chinese watercolor techniques with Western methods of perspective and chiaroscuro, Castiglione remained the most favored and honored of the missionary artists who served the early Ch'ing emperors.

In addition to imperial demands for portraits and records of court events, Castiglione was also called upon to document the many rare animals sent in tribute to the Ch'ing emperors and to paint the favored imperial horses. These animal subjects reflect the desire of K'ang-hsi and his successors to celebrate the nomadic origins and to keep alive the martial prowess of the Manchu warriors in their new and sedentary world of conquered China. With his understanding of Western perspective and controlled light sources, the Jesuit painter could record events with what seemed an almost magic realism and, what is more, portray the imperial menagerie of animals accurately in almost life-size scale (see the series of *Ten Horses* and *Nine Dogs* in the collection of the National Palace Museum, Taipei; Beurdeley and Beurdeley, *Giuseppe Castiglione*, 1971, cat. nos. 18-22, pp. 165, 166, and cat. nos. 60-68, pp. 175, 176).

Here in the reduced scale of a fan, Castiglione collaborated with the court academician Chiao Ping-chen to paint the genre subject *Training a Horse on the Northern Frontier*. Castiglione's contribution, however, was limited to the depiction of the stallion (see the handscroll *Four Steeds of Ai-wu-han*, National Palace Museum; Beurdeley and Beurdeley, *Giuseppe Castiglione*, cat. no. 27, illus. p. 27 and pp. 177, 178). The remainder of the painting was executed by Chiao Ping-chen, whose name and seals appear before those of Castiglione on the lower left corner of the painting. Despite the suggestion of shadow within the hollows of the gnarled willow tree in the middle ground, the delicate strokes and dots of colored wash which define foliage and grass are all in a strictly Chinese idiom. Practically identical foliage appears in Chiao's album of *Palace Ladies* in the collection of the National Palace Museum (*Masterpieces of Chinese Figure Painting*, 1973, color pl. 46). Less obvious, but also from his brush, is the blue-coated groom. Chiao accurately paints the trainer's face with Western methods of carefully graded wash, but renders the groom's clothing in a conservative Chinese method of tense and even outline with folds in decorative, curvilinear patterns. Even the addition of graded wash fails to impart convincing bulk or underlying body structure to the figure. Yet the collaboraton produces a harmoniously unified composition.

Chiao Ping-chen's background made him an ideal collaborator for the Jesuit painter. His talent as a painter of portraits, figures, and architectural settings surfaced at court during the middle of K'ang-hsi's long reign. Chiao was also a skilled mathematician, appointed to assist the Jesuit scientists who had been appointed to the Imperial Astronomical Observatory by the K'ang-hsi emperor. It is therefore not surprising to find a grasp of Western concepts of perspective when Chiao was called upon to paint the K'ang-hsi emperor's visit to Tiger Hill during one of the "Southern Tours" at the turn of the eighteenth century (Yamamoto collection, Tokyo; see Yonezawa, "'Koki nanjun Kikyu angu zukan,'" 1949, p. 154). Thus, Chiao Ping-chen was already predisposed to Western techniques a good fifteen years before Guiseppe Castiglione entered the Imperial Painting Academy.

It is difficult to determine when Castiglione and Chiao Ping-chen completed this fan painting. The limited biographical information available on the Chinese painter suggests that he enjoyed a long career at the K'ang-hsi court and lived into the Yung-cheng era. Paintings recorded from his hand between 1689 until 1726 indicate that he must have been at least a generation older than Castiglione. It therefore seems likely that the joint commission was completed towards the end of K'ang-hsi's reign or the early years of Yung-cheng's rule.

The reverse side of the fan has been inscribed by Wang Yu-tun with twelve of the Ch'ien-lung emperor's poems. The wooden outer staves of the fan are carved with another imperial poem transcribed by Tung Pang-ta (1699-1769). Wang Yu-tun received his *chin shih* degree in 1724, and under Ch'ien-lung achieved the rank of Minister of Personnel. Tung Pang-ta (1731 *chin-shih*) had a distinguished career in the highest office of government. His own paintings and calligraphy were equally prized by the emperor. Ch'ien-lung's poems deal with various landscape motifs — mountains, pavilions, clouds, and the like — that have nothing to do with the frontier scene of horse training. In addition, given the disparity in age between the K'ang-hsi court painter Chiao Ping-chen and the two Ch'ien-lung calligraphers, the calligraphy must have been inscribed for Ch'ien-lung years after Chiao and Castiglione had completed their painting.

HK

Recent provenance: David Newman.

The Cleveland Museum of Art 79.18

261

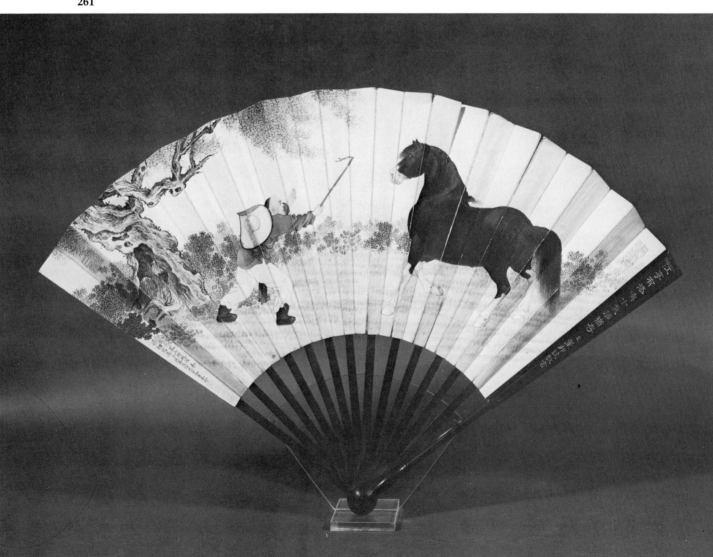

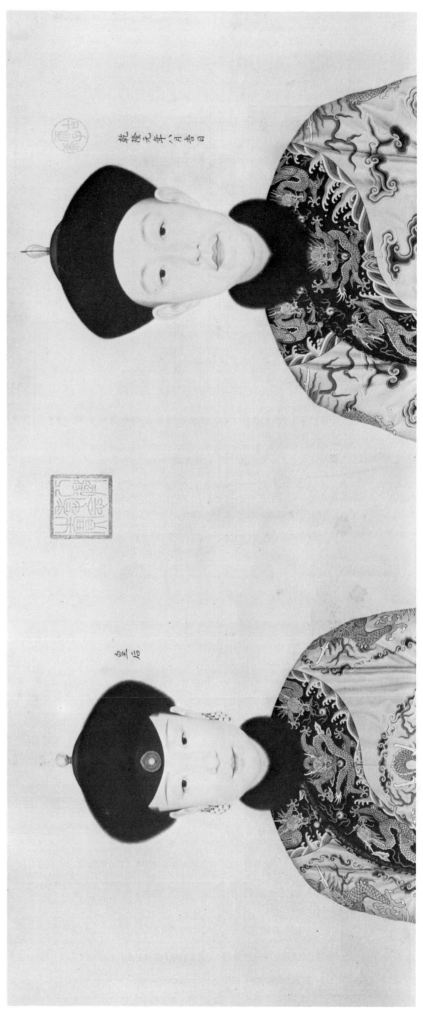

Lang Shih-ning and others

262 *Inauguration Portraits of Emperor Ch'ien-lung, the Empress, and the Eleven Imperial Consorts*

Handscroll, dated 1736, ink and color on silk, 52.9 x 688.3 cm.

9 seals of the Ch'ien-lung emperor (r. 1736-95).

Remarks: In 1736 Castiglione was called by the Ch'ien-lung emperor to paint his inaugural portrait as well as those of his empress and eleven imperial concubines. In this *Mind Picture of a Well-Governed and Tranquil Reign (Hsin-hsieh chih-p'ing)* – the title carved on the lacquer box made for its storage – Castiglione subtly blends the requirements of traditional Chinese portraits with Western techniques of shading. All the sitters gaze at the viewer in strict frontality, following the conventions of Chinese ancestor portraits (Lee, "Portraiture," 1977, p. 122, fig. 4). The curves of their facial planes are indicated through exceptionally subtle gradations of wash, with only the slightest hint of shadow around the outer edges of the jaw lines. Evidently Ch'ien-lung objected to the feature-obscuring and, therefore, character-hiding deep shadows, common Western devices which Jesuit painters heretofore had employed for the depiction of faces (see Beurdeley and Beurdeley, *Giuseppe Castiglione*, 1971, pp. 100, 101). Moreover, volume-suggesting folds within the richly embroidered dragon robes of the imperial retinue are minimized so that their exquisite designs could be fully appreciated. Castiglione nonetheless succeeds in capturing the tactile quality of flesh, gleaming pearls, and gorgeous robes in Chinese watercolor.

The differing levels of skill seen in this blend of East and West indicates that the scroll was the work of several hands: the emperor, his empress, and the first concubine were completed by Castiglione; the next seven concubines were painted by a talented student who understood Castiglione's methods; the last three concubines were done by a painter almost completely dependent on purely Chinese methods of facial delineation. Probably many of the surviving scenes of contemporary life at the Ch'ien-lung court were the product of such collaboration – Castiglione in charge of the portraits and Chinese court painters assisting with the clothing and the architectural and landscape settings (see, for example, *Kazaks Presenting Horses in Tribute*, Musée Guimet, Paris; ibid., illus. pp. 103-5).

Usually loquacious in his appreciation of paintings, the Ch'ien-lung emperor left no record of his attitude toward this work. He wrote only the date – 1 August 1736 – to the right of his own portrait and the names of his empress and eight concubines to the right of each of their portraits. His seals indicate that he viewed the scroll on his seventieth birthday and on the occasion of his retirement from the throne some fourteen years later. The portraits and names of the last three concubines appear to be a later addition; they were raised to the rank of imperial consorts only after the death of Ch'ien-lung. HK

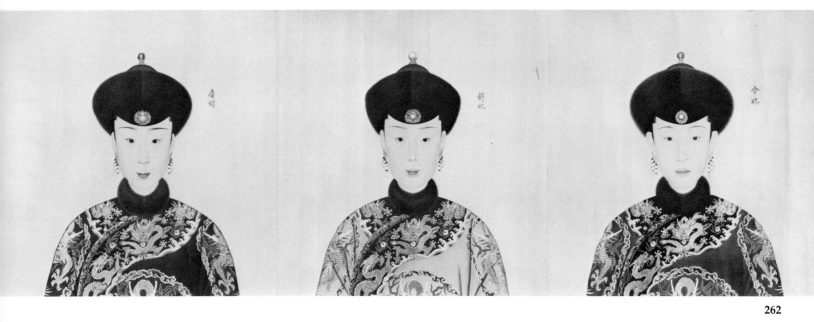

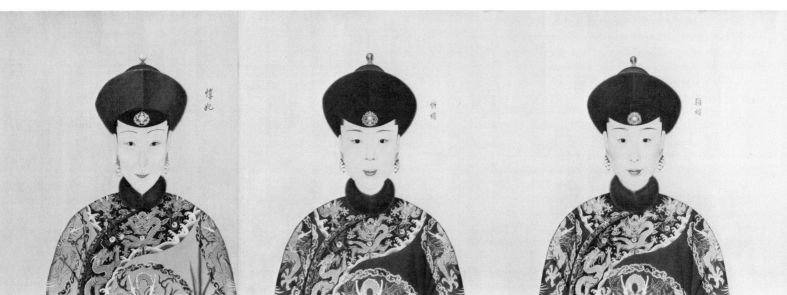

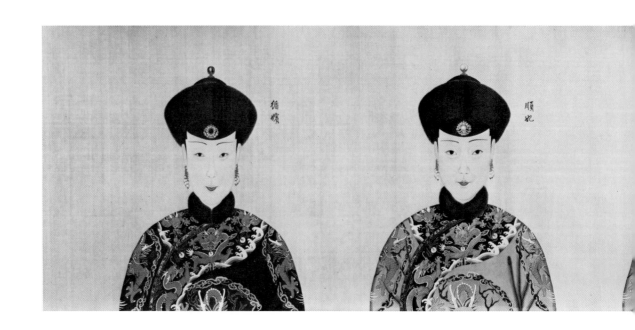

Literature:
Octagon III, No. 4 (Winter 1966), 12, 13.
Beurdeley, "Le fre Castiglione" (1971), p. 75 (color detail).
Beurdeley and Beurdeley, *Giuseppe Castiglione* (1971), repr. pp. 41, 43, 98-100, 178.
Toynbee, *Half the World* (1973), p. 268 (color detail).
Sung, "Chü jui t'u" (1976), fig. 2 (detail).
Lee, "Portraiture" (1977), pp. 119-22, cover pls., figs. 1, 2.

Recent provenance: Spink & Son.

The Cleveland Museum of Art 69.31

Chin T'ing-piao, died 1767, Ch'ing Dynasty
t. Shih-k'uei; from Wu-ch'eng, Chiangsu Province

263 *The Six Worthies of the Bamboo Stream*
(Chu-hsi liu-i)

Handscroll, ink and color on silk, 38.7 x 122.6 cm.

Artist's signature and 2 seals: Respectfully painted by your servitor Chin T'ing-piao. [seals] Ch'en; T'ing-piao.

15 additional seals: 13 of the Ch'ien-lung emperor (r. 1736-95); 1 of the Chia-ch'ing emperor (r. 1796-1820); 1 of the Hsüan-t'ung emperor (r. 1909-11).

Remarks: Chin T'ing-piao, an artist much favored by the Ch'ien-lung emperor, was active in the Painting Academy in the decade before his death in 1767. He was among the best figure painters of the Academy, excelling in historical and genre themes, although he also painted landscape, birds, and flowers.

The Six Retired Worthies of the Bamboo Stream were a group of gentlemen, including the great poet Li Po, who enjoyed themselves beside the bamboo stream at the foot of Mt. Ts'u-lai in southeastern Shantung during the T'ien-pao era (742-755). KSW

Literature
Shih-ch'ü II (1793), Ch'ien-ch'ing kung, p. 325.
Hu, *Kuo-ch'ao* (1816), *ch.* 11, p. 2b.

Nelson Gallery-Atkins Museum 31-135/31

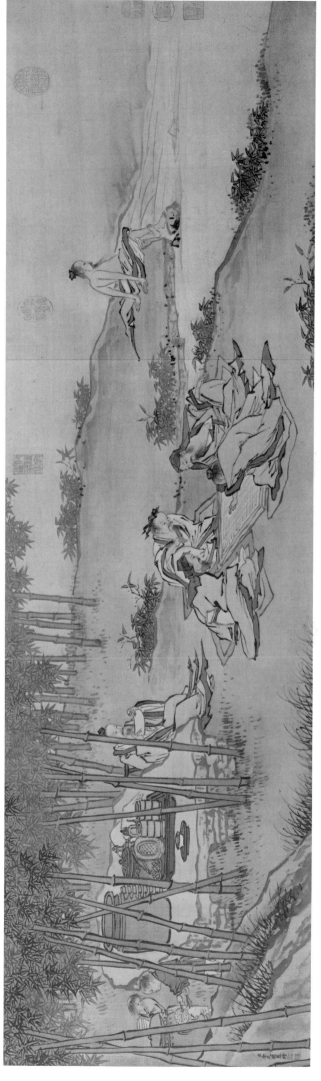

264A

264B

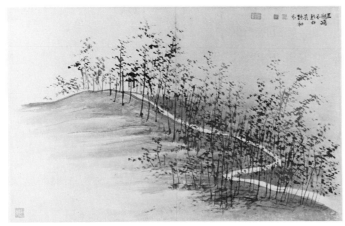

264C

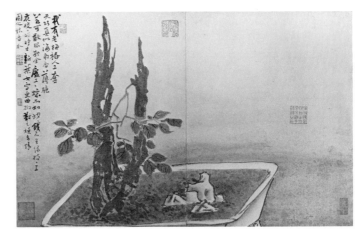

264D

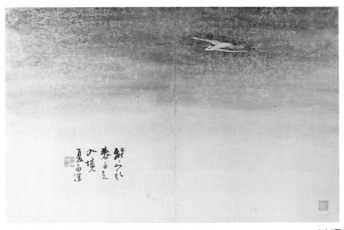

264E

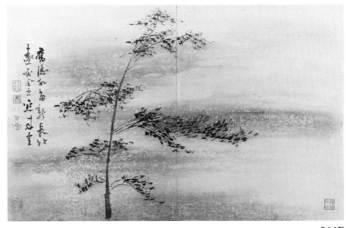

264F

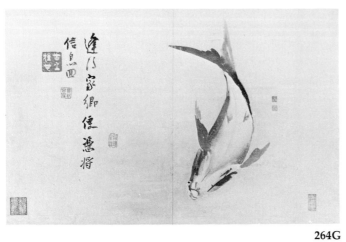

264G

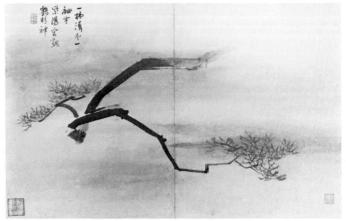

264I

Kao Ch'i-p'ei, 1672-1734, Ch'ing Dynasty
t. Wei-chih, *h.* Ch'ieh-yüan, Nan-ts'un, and others;
from T'iehling, Liaoning Province

264 *Finger Paintings of Assorted Subjects
(Chih-t'ou tsa-hua)*

Album of twelve leaves, before 1712, ink or ink and
light color on paper, each 36 x 57.5 cm.

A. *Dragon (Lung),* ink and light color on paper. Artist's
inscription and 3 seals:

Tradition has a story of the dragon's transformation;
It is absurd and contrary to right principles.

[seals] Ch'i-p'ei; T'ien ch'uan jen yeh; I ch'ui ?–?.
2 additional seals: 1 of Ch'eng-hsün (18th c.); 1 of
Ch'eng Ch'i (20th c.).

B. *A Striking Peak (Ch'i-feng),* ink and light color on
paper. Artist's inscription and 3 seals:

Along the whole way, streams and rocks;
A myriad layers of mountains, separated by clouds.

[2 seals right of inscription] T'ieh-ling; Ch'ieh-yüan
Ch'i-p'ei. [seal left of inscription] Pi pen chieh shou
shou ho chieh pi.
1 additional seal of Ch'eng-hsün (18th c.).

C. *Bamboo Stream (Chu-hsi),* ink and light color on
paper. Artist's inscription and 2 seals:

Wild geese do not come to San-hsiang;
The way begins to divide at Wu-ling.

[seals] Ch'i-p'ei; Chih-t'ou-hua.
1 additional seal of Ch'eng-hsün (18th c.).

D. *Old Plum in a Tray Garden (P'an-tsai lao-mei),* ink and
light color on paper. Artist's inscription and 5 seals:
[seal] Chih tz'u i-p'i.

I have an old trunk of plum,
In which man's craft rivals Nature's art.
It seems, truly, to be South Seas incense;
Thin and crisp, as if one could bite into it.
Its roots, improbably, disdain the soil,
Which, as though seared, is parched as well.
Iron-hard stones give forth green branches,
Where sprays of blossoms rest prettily.
Now is the time when new leaves appear,
Switching and bending more than the word for
 woman.
Facing it brings pleasure to my feelings;
Depicting it brings joy to my fingernails.

[3 seals] Ch'ieh-tao-jen chih-t'ou-hua; Kao Ch'i-p'ei;
Chen k'o ch'ien-hsing. [seal at center right] Sui fang-i hu
kuei-chü chih wai chiu pu li hu chun-sheng chih chung.
3 additional seals of Ch'eng-hsün (18th c.).

E. *White Egret (Pai-lu),* ink and slight color on paper.
Artist's inscription and seal:

As I left home, spring rains were sufficient;
As I return, summer sprouts are profuse.

[seal] Chih-t'ou chan-mo wei chih.
1 additional seal of Ch'eng-hsün (18th c.)

F. *New Bamboo (Hsin-chu),* ink and light color on paper.
Artist's inscription and 3 seals:

Many will be the new bamboo growing at an old
 retreat;
Totally absent are letters forthcoming from distant
 friends.

[seals] Kao Ch'i-p'ei chih-t'ou-hua; I te i fan hui sa;
K'o hu.
2 additional seals of Ch'eng-hsün (18th c.).

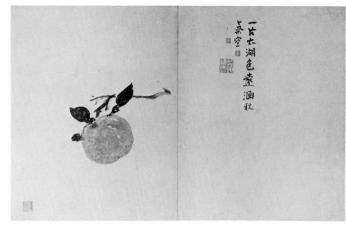

264J

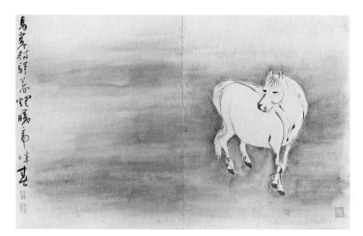

264K

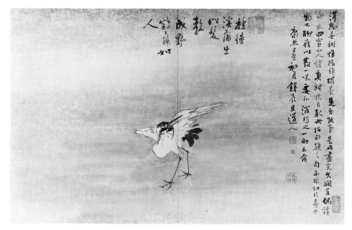

264L

G. *Leaping Fish (Yüeh-yü),* ink and light color on paper.
Artist's inscription and 3 seals:

If I encounter a messenger from my native place,
By this fish, I shall send a letter home.

[2 seals] Kao Ch'i-p'ei yin; Ku chih k'uang yeh. [seal
right of inscription] Chih-t'ou sheng-huo.
4 additional seals of Ch'eng-hsün (18th c.).

H. *Yellow Mallow (Huang-k'uei),* ink and light color on
paper. Artist's inscription and seal:

Suddenly I see the autumn winds arising;
And regret the imminent passing of the year.

[seal] Shou chi shih pi.
1 additional seal of Ch'eng-hsün (18th c.).

I. *A Branch of Pine (Sung-chih)*, ink and light color on paper. Artist's inscription and seal:

A brush of cool breezes, one sleeve of clouds,
And with features of the Immortal Tzu-yang, the spirit of a crane.

[seal] Ch'ieh-tao-jen chih-t'ou-hua.
2 additional seals of Ch'eng-hsün (18th c.).

J. *Tangerine (Kan)*, ink and light color on paper. Artist's inscription and 3 seals:

Just a sheet of tangerine is the color of Lake T'ai;
Distant images submerge in the empty autumn air.

[seals] Ch'i-p'ei; Ch'ieh-yüan; Chih-t'ou chan-mo.
1 additional seal of Ch'eng-hsün (18th c.).

K. *White Horse (Pai-ma)*, ink and light color on paper. Artist's inscription and 2 seals:

Horses shiver as the sun sets over the village post house;
Lamps warm the Imperial City in the spring.

[seals] Ch'i-p'ei; Chih-t'ou-hua.
1 additional seal of Ch'eng-hsün (18th c.).

L. *Dancing Crane (Wu-ho)*, ink and light color on paper. Artist's inscription at upper center:

Rushes planted in the stream grow like human hair;
Through teaching the wild crane dances like a man.

Artist's inscription and 4 seals along right edge: [seal] Wo yü wo chou-hsüan chiu. I have no way of alleviating sadness, for the only thing I can do is daub ink with my fingers. This album was set aside for a long time after it was finished. Occasionally I read the poems of the Four Ling recluses from Yung-chia. They refresh my spirit and gladden my eye. Taking out the album, I picked some lines of poetry to inscribe on the leaves. Basically,

these lines do not fit with the things in the paintings. I just did it for a laugh, and it may be a help in dispelling sadness.

Early summer of the *jen-ch'en* year of the K'ang-hsi era [1712]. Ch'ieh-tao-jen of T'iehling [3 seals] Kao Ch'i-p'ei; Ch'ieh-yüan; Chih-t'ou sheng-huo.

trans. KSW/MFW

5 additional seals on leaf L: 2 of Ch'eng-hsün (18th c.); 1 of Li Hung-chang's (1823-1901) descendant; 1 of Ch'eng Ch'i (20th c.); 1 unidentified.

1 colophon, dated 1785, and 1 additional seal of Wu Hsi-lin (act. late 18th c.) on a separate sheet of paper.

Remarks: Wu Hsi-lin's colophon, which appears on the thirteenth leaf of the album, offers a biographical sketch of Kao Ch'i-p'ei's life and a flattering appraisal of his painting.

From Kao's own inscription of 1712 we learn that the paintings were painted some time prior to the time he wrote the inscription, but whether he has months or years in mind is not indicated. He also notes that he selected lines from the group of Southern Sung poets known as the Four Ling of Yung-chia. However, those lines that have been identified with an existing poem have been drawn only from the works of Weng Ch'üan (act. late 12th-early 13th c.). Kao Ch'i-p'ei is known especially for finger painting, of which each of these leaves is an example. Most, if not all, of the inscriptions were done with a brush, however. KSW

Literature
Rogers et al., *Kin Nō* (1976), pp. 51, 173, pls. 56, 57.
Important Chinese Ceramics (1979), sale no. 4296, lot 123.

Recent provenance: Mr. and Mrs. David Spelman.

Nelson Gallery-Atkins Museum F79-48/1-12
Gift of Mrs. George H. Bunting, Jr.

264H

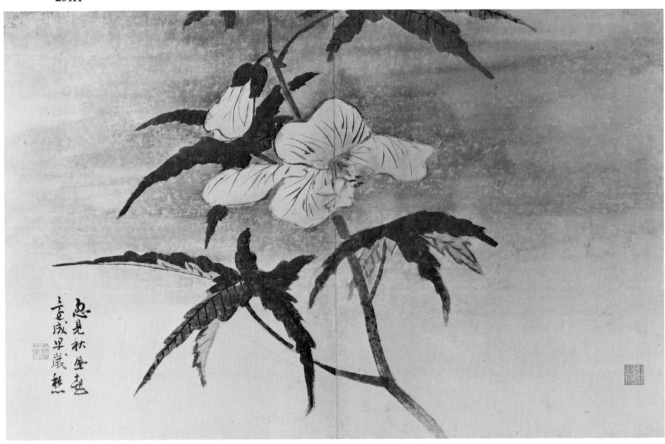

Hua Yen, 1682-ca. 1765, Ch'ing Dynasty
t. Ch'iu-yo, *h.* Hsin-lo shan-jen; from Lin-t'ing,
Fuchien Province, lived in Hangchou, Chechiang
Province, and Yangchou, Chiangsu Province

265 *Conversation in Autumn*
(*Chiang-ch'iu t'u*)

Hanging scroll, dated 1732, ink and light color on
paper, 115.3 x 39.7 cm.

Artist's inscription, signature, and 2 seals: On a winter
day in the *jen-tzu* year [1732], while leisurely sitting in
my mountain pavilion, I happened to have imitated the
brush style of Yüan masters on the two verses: "A guest
came from the dusty world for a visit; in the small cot-
tage we talked about the sound of autumn." [*The Sound
of Autumn* is the title of a famous rhymed prose by the
great Sung scholar, Ou-yang Hsiu, 1007-1072.] Hsin-lo
shan-jen [seals] Hua Yen; Ch'iu-yo.

3 colophons and 8 additional seals: 1 colophon and 2
seals of Chang T'ing-chi (1768-1848); 1 colophon, dated
1825, and 2 seals of Ch'en Wen-shu (1771-1842); 1 col-
ophon and 1 seal of __?__ Li-liang (dates unknown); 2
seals of Yeh T'ing-kuang (Ch'ing Dynasty); 1 seal
unidentified.

Colophon by Chang T'ing-chi:

Old Hua [Yen], in this painting, was able to evoke the
mood of desolation in nature and match the poetry
elegantly. If Fang-weng [Lu Yu, 1125-1210] saw this,
he would inscribe the painting with the two words
"idyllic world."

Colophon by __?__ Li-liang:

The highest achievement in the art of painting is to
penetrate deeply into the chamber of old masters, but at
the same time transcend the bounds of conventional
rules. This painting of Hsin-lo [Hua Yen] is derived from
[the style of] Pai-shih [Shen Chou] and Pao-shan [Lu
Chih] , with splashed-ink technique of Wang Hsia
[T'ang Dynasty], in addition to his own innovative
ideas. Hence the distinctive style. Truly, he is one of
those who passed through the net of the Six Canons [of
Hsieh Ho, 4th c.]; treasure it.

trans. LYSL/HK/WKH

Colophon by Ch'en Wen-shu:

Hsin-lo shan-jen was a senior of mine from my home-
town. A specialist of painting from life, he collected var-
ious kinds of birds and studied their [forms and move-
ments in] flight, singing, drinking, and eating. His
works therefore show an extraordinary flavor of liveli-
ness. He did not paint many landscapes. Last winter, at
Hsi-ling [by the West Lake], I saw a painting by him
entitled *White Clouds and Pine Cottage* which was unsur-
passed [in brush manner] – airy, fluent, spacious, and
free. It lingers fondly in my memory even until today.
This scroll excels in a sense of rugged elegance. In a
composition of desolate coolness, it is rich with a certain
kind of fascinating casualness that makes one feel as
though sitting right in the surroundings of an idyllic
landscape. My good nephew P'iao-sheng obtained the
painting from Yü-feng and showed it to me. So I write a
few lines here to commemorate this "ink-relationship."

In the *i-yu* year of the T'ao-kuang era [1825], at the end
of the autumn, the lay-Buddhist I-t'ao Chü-shih, [Ch'en]
Wen-shu wrote this at the cottage of Hsiang-ch'an-hua-
yin (Meditation in Fragrance and Reclusion among
Flowers).

trans. WKH

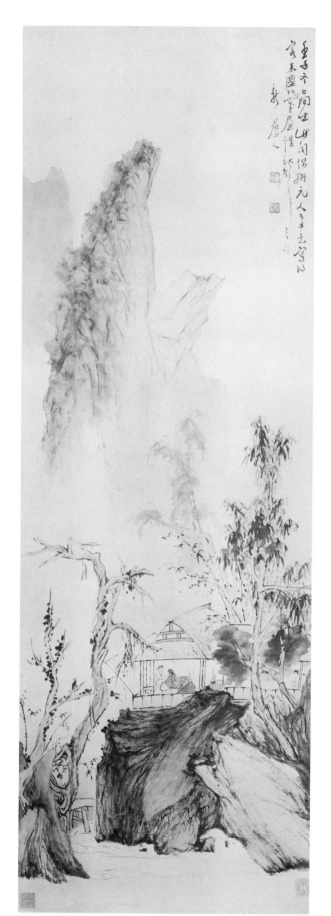

265

Remarks: Although born in the southern province of Fuchien, in the same prefecture as was Huang Shen (see cat. no. 269), Hua Yen had by 1703 moved to the city of Hangchou and joined with a number of poets, scholars, and bibliophiles in an important literary group of that city. The name of Hua's Hangchou studio, the Chiang-sheng shu-she (Sounds of Teaching Studio), appears on paintings dated from 1724 until the early 1730s. The Confucian and scholarly connotations of that name accord well with his predominantly literary interests during that period of time.

Hua Yen had passed through Yangchou as early as 1717, but his significant contacts in that city began only around 1730 when he met the Shanhsi merchant Yüan Kuo-t'ang, who became one of his closest friends. More important to Hua Yen's artistic development was the circle gathered around Yüan Kuo-t'ang: Yüan's son, Yüan Tun, registered in Yangchou as a merchant, who had been a direct pupil of Tao-chi's and contributed an important biographical colophon to the Ch'ing-hsiang lao-jen t'i-chi in 1758; Ch'en Chuan, who was one of the earliest to compile inscriptions from Tao-chi's paintings; Ting Ching, who was a close friend of Chang Yüan, whose colophon of 1728 is appended to Tao-chi's Hua-yü lu; Chou Erh-hsüeh, who owned not only a manuscript copy of the Hua-yü lu but also a collection of Tao-chi's paintings from which a number of inscriptions were included in Wang I-ch'en's compilation, Ta-t'i-tzu t'i-hua shih-pa.

Hua Yen himself first mentioned Tao-chi in his poetry collection in 1730, and his paintings done in the years immediately following testify to that master's influence. In this painting, one of the finest of these works, done in Yangchou during the winter of 1732, Hua Yen displays a technical virtuosity unmatched by other Yangchou painters, as well as a serious concern with form and structure equally rare among his contemporaries. Although in his inscription Hua cites a Yüan Dynasty artist as his prototype, he is here more truly a follower of Tao-chi in the indirect sense of attitude and method. He began not with a preconceived idea of style but rather confronted the subject directly, worked with it, and employed whatever means necessary to achieve his desired effect. HR

Literature
Shen-chou ta-kuan (1912), pl. (18).
Hsü Ching-chai (1934), pl. 12.
Shina Nanga taisei (1935-37), X, pl. 137.
Sirén, Later (1938), II, Lists, 253.
Lee, Far Eastern Art (1946), p. 455, fig. 601.
Chūgoku meigashu (1947), VIII, pl. 13.
Sirén, Masters and Principles, (1956-58), VII, Lists, 343.
Lee, Chinese Landscape Painting (1962), p. 126, no. 101.
Cahill, "Chūgoku kaiga - III" (1975), fig. 34.
CMA Handbook (1978), illus. p. 358.

Exhibitions
Cleveland Museum of Art, 1954: Lee, Chinese Landscape Painting, cat. no. 110.
Munson-Williams-Proctor Institute, Utica, New York, 1963: Masters of Landscape, cat. no. 16.
Asia House Gallery, New York, 1967: Cahill, Fantastics and Eccentrics, cat. no. 33.

Recent provenance: Yü Tzu-t'o; Walter Hochstadter.

The Cleveland Museum of Art 54.263

Kao Feng-han, 1683-1749, Ch'ing Dynasty
 t. Hsi-yüan, h. Nan-ts'un; from Chiao-chou, Shantung Province

266 *Plum Blossoms* and *Peonies*
 (*Mei-chu Mu-tan*)

Handscroll, dated 1741, ink on paper, 26 x 96.2 cm. (*Plum Blossoms*); ink on paper, 26 x 226 cm. (*Peonies*).

Artist's 2 inscriptions and 9 seals (the painting of *Peonies* with the artist's colophon and the colophon by Hou Chia-fan are on a single sheet of paper).

Artist's inscription and 2 seals (*Plum Blossoms*):
[seal] Ts'ai-yün. After finishing writing my colophon, I unrolled the painting to take another look, and it now seems that the composition here should have moved to the later part of the scroll. If that is the case, then the "Cool Beauty" [prunus] of the Solitary Hill is after all unable to take precedence over the "King of Flowers" [peony]. A laugh. Lao-fou inscribed. [seal] Feng-han.

Artist's colophon (*Plum Blossoms*):
[3 seals] Tun; Yen-yün-kung-yang, Hou-shang-tso-sheng. A few days after I painted this scroll for Shui-hsien [Yüeh Meng-yüan], the plum blossoms were in full bloom at his residence. He invited me over to enjoy them together for a long while, and I composed two additional poems and wrote them down here for his criticism. [Poems on the colophon are not translated.]

First month, twenty-first day, your junior, Kao Feng-han of Nan-fou drafted this with the left hand. [seal] Feng-han.

Artist's inscription and 4 seals (*Peonies*):
Brushed with the left hand in the *hsin-yu* year [1741]. [seal] Yu-hsi. [3 seals at end of painting] Hou-shang-tso-sheng; Yen-yün-kung-yang; Shih-tsao-wu.

Artist's colophon and seal (*Peonies*):
The imperial concubine from the Yang family loved
 to dress in red,
And from the emperor won the title of Hai-t'ang.
But ever since she became the new dream of the
 moon palace,
She changed into rainbow colors, while learning to
 dance.

After I wrote the poem on *Looking for Plum Blossoms in the Teng-wei Mountains*, I attached to it a few branches of prunus, some bamboo tips and a piece of rock, with a scattering of green [moss] here and there to fill up the scroll. Unexpectedly, my playful fascination [with these subjects] was still not quite satisfied, so I made up these amorous ideas and romantic images [of the peony], to follow the footsteps of the fair lady of the Ku-hsieh Mountain [prunus]. Furthermore, I picked out one poem to be my vanguard. Perhaps such luminosity of wealth and power will be enough to overwhelm the poor fellows, and [they] will not mind the comparatively short length [of paper] assigned to it. Amusingly inscribed. Please correct me again.

To Shui-hsien, my learned senior, your junior Han inscribed again. [seal] Tso-hua [left-handed painting].

1 additional colophon and 5 additional seals: 1 colophon, dated 1742, and 3 seals of Hou Chia-fan (act. ca. 1742); 1 seal of P'u Ch'üan (20th c.?); 1 seal of Li family (dates unknown).

Remarks: This painting was painted in the spring of 1741, a year of significant demarcation in Kao Feng-han's life. Before this date he had spent fourteen years

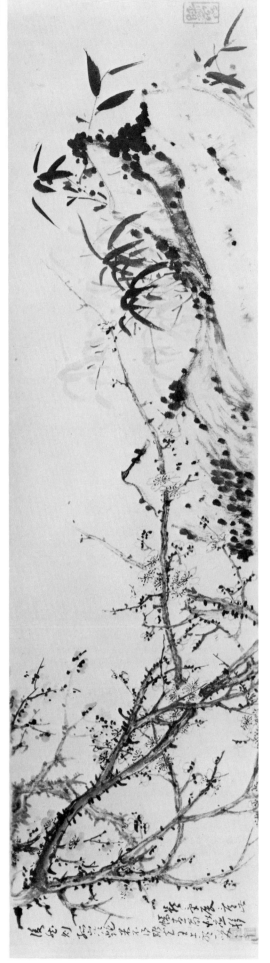

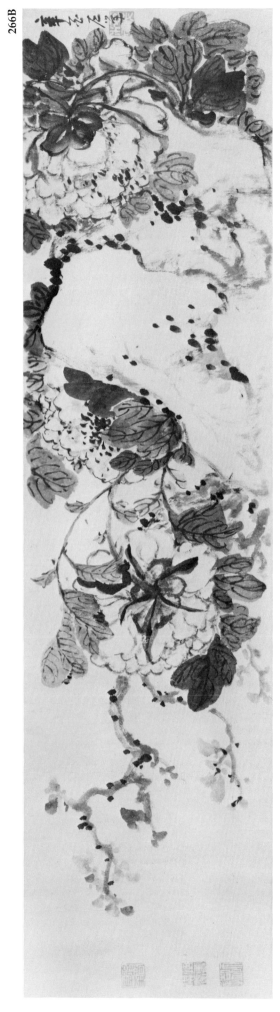

in the Chiang-nan area, leading a modest career as a petty bureaucrat in Anhui Province. Then in the early summer of that year, he finally decided to retire to his hometown in Shantung Peninsula. So in many ways the scroll was a song of farewell to the river country of the South, the land he had lived in and loved. The nostalgic character of the painting is evident, for in his inscription Kao Feng-han mentioned the poems *Looking for Plum Blossoms in The Teng-wei Mountains*, which were a series of poetic memorials he had made the year before (1740) in Suchou. Two months later in that same year his birthday was celebrated in a "peonies party" given by a group of friends, which may be the hidden theme for the second section of the scroll. In his usually obscure manner, Kao Feng-han jokingly remarked in the first colophon that after taking a second look he was wondering whether the prunus should have been removed to the later part of the scroll, following the peonies. He repeated the same alternation, partly as apology and partly as mockery, in the second colophon – which makes one wonder if he really meant what he said. In theory, the peonies were the dynastic flowers of T'ang, symbols of wealth and power; while the prunus were to be found only by a quiet stream or in a desolate valley, as companions for the recluses. To reverse the present compositional order and to allow the peonies to take precedence over the prunus seems to suggest the actual state of mind of one who was about to retire – that all worldly ambitions and passions would come to an end, that all ephemeral splendors must return to simplicity and quietude. At any rate, that was what Kao Feng-han was about to do. He left Yangchou in the early summer of 1741 for his ancestral home in the North and never returned.

Sometime in the years between 1737 and 1741, before his departure from the South, Kao Feng-han lived in a Buddhist monastery in Yangchou and made a living from his paintings. There he became close friends of the Eight Eccentrics, especially Chin Nung (1687-1763) and Cheng Hsieh (1693-1765). He was also very active in the literary circles centering around the Salt Commissioner Lu Chien-tseng (1690-1768) and the two Ma brothers (see cat. no. 275). His paintings, especially those painted with the left hand, were in such great demand that Cheng Hsieh was moved to declare in a poem: "The left-handed paintings by Hsi-yüan [Kao Feng-han] and the calligraphy by Shou-men [Chin Nung] are in constant demands that have rained upon me from my friends all over the country. Long scrolls and short letters have all gone, even forgeries by the old man [Cheng Hsieh himself]. I have nothing left" (*Cheng Pan-ch'iao chi*, 17th c., p. 87).

Obviously, such an unusual accomplishment was not accidental, but the result of a long struggle – mentally and physically. In this connection, the year 1737, when Kao Feng-han was fifty five years old, was the turning point in both his official and artistic career. Not only had he lost his government position in that year, but his right hand was suddenly paralyzed from acute rheumatism, and it was only his unyielding stubbornness that pulled him through and introduced him to the astonishing world of left-handed vision, which defies many of the right-handed rules. In a poem describing the process and the hardship in re-acquiring a painting and calligraphy technique, he said, "Between the two hands only one knows how to write. To take away one is to deprive the possibilities of the other. Amazing was the man's tenacity and physical hardiness, who would fight to

death to keep his left hand useful. Twisting his body to the south while pushing the brush toward the east, his cap is listing and his forehead [is tensed and gnarled] like a *tan-ch'i* chessboard. This ordeal for three years is a continuous struggle in a dark ocean – the closer to success, the deeper his feeling of tragedy" (Li Chi-t'ao, *Kao Feng-han*, 1963, p. 22).

Indeed, no one could have realized more than Kao Feng-han himself this tragic spirit behind his heroic struggle for an artistic resurrection, testified to by a seal often used in this period: K'u-shu sheng, or "scholar of bitter calligraphy." But once he mastered the technique, an exciting world of pictorial possibilities began to open up to him, as in a revelation. In a letter, he told a friend about the joy of new discoveries: "The crippling of my right hand has brought me indescribable pain. Recently I have tried to substitute with my left arm, and the result has been extraordinary and extremely fascinating. The crudeness, the resistance, the sluggishness and awkwardness [of the brushwork] are totally unequalled and unattainable by the right hand. [An artist] who devotes his whole life to the mastery of the brush should not be a stranger to this fascination" (ibid., p. 3).

There are few testimonies on left-handed painting that are more instructive than the two passages quoted above. Remember what Kao Feng-han said about the twisting of his body and the direction of his brush movement. Note his use of the term "left arm" (instead of "left hand"), both in his writings and in one of his favorite seals, which suggests his application of that particular calligraphic technique, the *t'i-wan fa* (arm lifted above the table to direct the movement of the brush) in his painting. The resultant effect is exactly the kind of "crudeness and sluggishness" produced by the "resistance" on the surface of the paper. And this increased friction between the paper and the brush must have endowed the textural and linear statements with certain special qualities, not the least of which is the "awkwardness" that may also compel a change in some conventional forms. The rocks in this painting, for instance, are invariably lopsided and thrusting toward the right. Far from deing depicted as solid masses, they are given a rather light and airy treatment, almost like a hole in the pictorial space defined by the surrounding profusion of ink dots and washes of the vegetation. This recalls the fact that Kao Feng-han was one of the few Chinese painters who was interested in "stone caves" as a passage between the reality and the unknown, the representational and the abstract. It is in such complementary harmonies that the distinction between symbolic and aesthetic values disappear in the interweaving of his poetic and visual metaphors.

WKH

Recent provenance: James J. Freeman, Kyoto.

The Cleveland Museum of Art 80.13

Wang Shih-shen, 1686-1759, Ch'ing Dynasty
t. Chin-jen. h. Ch'ao-lin; from Hsiu-ning, Anhui
 Province, lived in Yangchou, Chiangsu Province

267 *Plum Blossoms*
(Mei-hua)

Hanging scroll, ink on paper, 171.5 x 75.5 cm.

Artist's 4 poems, inscription, signature, and 3 seals:

Looking for plum blossoms with friends, enjoying the
 fresh clear day,
My black shoes and cotton socks feel light.
With fine groves in front of the ancient temple door,
I walk to and fro, as in a painting.

One clear chime breaks the silence in the mountains,
All the heroes of the Six Dynasties, after a thousand
 years, are forgotten.
Enjoy the idle days under a Buddhist window,
Plum blossoms monopolize the east wind with their
 branches.

Next to the little stone bridge is a path leading west,
Wherever you walk, your staff will touch some dike of
 the Sui Dynasty.
Tourists love only the Ch'i-ling temple,
So sea-gulls take to startled flight and horses neigh.

After ten years I revisited the I-su An,
The old plums are no longer on the southeast side of the
 garden.
I pass a peaceful night, though unable to offer fragrant
 flowers,
As bright moonlight cheerlessly falls upon the Buddhist
 shrine.

Four poems composed on our way from the Iron Bud-
dha Temple to the I-su An Retreat at P'ing-shan, while
looking for plum blossoms with friends. Ch'ao-lin,
Wang Shih-shen painted [this]. [2 seals] Wang Shih-
sheng; Chin-jen fu. [seal, lower right corner] Ch'ao-lin.
 trans. WKH/LYSL

3 colophons, 3 additional inscriptions, and 23 additional
seals: 1 inscription, dated 1739, and 2 seals of Mao Yin-
k'uei (17th-18th c.); 1 colophon and 3 seals of Lu K'uei-
hsün (17th-18th c.); 1 colophon and 3 seals of Chu Chin
(1686-1769); 1 colophon and 4 seals of Yü Pi-k'uei (17th-
18th c.); 1 inscription and 2 seals of Yao Shih-yü (1695-
1749); 1 inscription and 3 seals of ? Shu-teh; 1 seal of
Shen Wu (dates unknown); 1 seal of Lou Ts'un (19th c.);
2 seals of Ch'eng Ch'i (20th c.); 2 unidentified.

Remarks: The ''dike of the Sui Dynasty'' in the artist's
poem refers to the Great Canal built by Emperor Yang (r.
604-617) of the Sui Dynasty, to link the economic center
of the South with the political center of the North. The
sites mentioned are at Shu-kang in the outskirts of Yang-
chou. P'ing-shan [Hall] was built by Ou-yang Hsiu
(1007-1072) in 1048, when he was prefect of Yangchou.

Wang Shih-shen was born in She-hsien, Anhui, but
by the late 1720s he had moved to Yangchou and was
living as a guest of Ma Yüeh-kuan in the Grass Hut of
Seven Peaks. In the decade following that move, Wang
produced several paintings in which Yüan prototypes
for his subject were cited; in each, the balance between
naturalism and abstraction in his model was consciously
rejected; through knowing manipulation of that rela-
tionship, Wang set a new stylistic course for such tradi-
tional subjects as bamboo, garden rocks, and blossom-
ing plum.

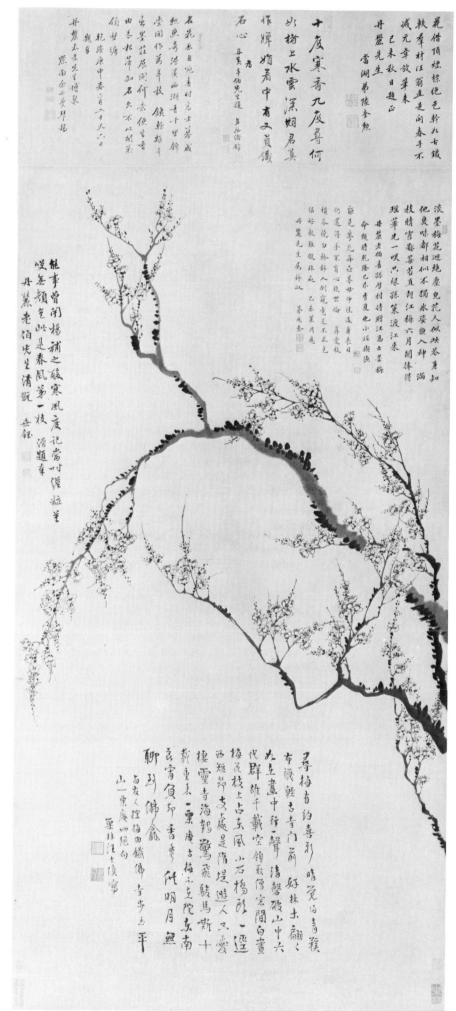

During the mid-1730s Wang adopted Ch'ao-lin (Nesting in the Grove) as his new literary name, reportedly derived from one used by Wu Chen (see cat. no. 109), the fourteenth-century artist known for his bamboo-and-rock pictures as well as for his reticent personality.

In the spring of 1739 Wang purchased a house near the city wall in the old section of Yangchou, as recorded in several poems; the house itself appeared in at least two paintings. Later that spring Wang went on a trip to Chechiang and wrote:

With brush and ink-stone I travel to Yüeh, and no luck,
While returning, the old illness rose up again.
Sorrows of all kinds came in bright daylight,
But one eye grew only icy flowers.

Wang Shih-shen's eye ailment was perhaps a cataract that, on this trip, finally covered the retina of his left eye. In an inscription on a painting by Kao Hsiang of Wang brewing tea, Li O alluded to this and indicated its effect: "Master Ch'ao-lin loves plum blossoms and is very fond of tea. Day after day, sipping tea, he paints plum blossoms. Wanting to manifest the bitterness within his heart, he sets them down on paper as ice and frost on a tree."

The inscription on the present painting by Mao Ying-kuei reads in part:

Is this Hua-kuang [Chung-jen] again in the world,
Or must not Chung-kuei [Wu Chen] be reincarnated?
Lost one eye but he still has an able hand,
His mind is not blind; that is still beyond compare.

Mao wrote at the behest of the painter Huang P'eng, who had obtained the painting the preceding month. His reference to Wang's blindness and continued ability to paint suggests that the painting was done during the summer of 1739.

In contrast to the plum blossoms painted by Chung-jen of the Sung, and Wu Chen of the Yüan, the visual characteristics of the subject are here distilled and reduced to an abstract system of Wang's invention. Lines are primarily arranged to demarcate shapes that are interesting in themselves, and ink values are modulated in accord with this formalistic interest. Equally self-confident juxtapositions between realistic blossoms and flattened transparent branches appear consistently in other Wang Shih-shen paintings of the same period, but never on so grand a scale as that of the Cleveland hanging scroll (*Shina Nanga taisei*, 1935-37, III, pl. 108 [dated 1736]; Sirén, *Masters and Principles*, 1956-58, VI, pl. 452b [dated 1739]; *Yang-chou pa-kuai*, 1970, VII, pl. 148 [dated 1741]). His unique approach to the prunus seems to have influenced the conception of some of Chin Nung's late works, executed after Wang's death (*Shina Nanga taisei*, III, pls. 137, 138).

HR/HK

Literature
Chang and Hu, *Yang-chou pa-kuai* (1970), IV, pl. 118.
Ch'eng, *Hsüan-hui-t'ang* (1972), *Hua*, pp. 200(b)-202(b).
Yonezawa, *Hachidai sanjin* (1975), p. 158, pl. 87.

Exhibitions
Osaka Municipal Museum, 1969: *Yoshu hakkai*, p. 38.

Recent provenance: Ch'eng Ch'i.

Intended gift to The Cleveland Museum of Art, Kelvin Smith

Li Shan, ca. 1686-1762, Ch'ing Dynasty
t. Tsung-yang; *h.* Fu-t'ang; from Yangchou, Chiangsu Province

268 *Five Pine Trees*
(*Wu-sung-t'u*)

Hanging scroll, dated 1747, ink on paper, 199.1 x 94 cm.

Artist's 5 poems (not translated), inscription, signature, and 4 seals: [seal] Chung-yang. A friend asked me to paint the five pines. I associated the straight pine with a statesman, the bald one with a famous general, the one leaning to one side and the one reclining with dragons, the short round one with foliage like a grass-mat with either an immortal or Buddha. And I composed a long poem as inscription.

In autumn, the ninth month of the *ting-mao* year [1747], the twelfth year of the Ch'ien-lung era, I imitated the style of T'ien-ch'ih sheng [Hsü Wei, 1521-1593], at the Sheng-hsien fu-ou Studio in the southern part of the city. Fu-t'ang, Ao-tao jen, Li Shan. [2 seals] Shan-yin; Tsung-yang. [seal, lower left corner] Fu-t'ang, Li Shan.

trans. LYSL/WKH

2 additional seals of Ch'eng Ch'i (20th c.).

Remarks: Li Shan was born into a prominent Hsing-hua (Yangchou) family of scholars and officials whose illustrious history of government service extended back to the sixteenth century. The wealth and status of Li's family assured him of every educational and cultural advantage, and he passed his *chü-jen* examination at the relatively early age of twenty-five. A poem submitted by Li in 1713 in celebration of the K'ang-hsi emperor's sixtieth birthday won imperial favor and assured his appointment to the Imperial Study, where the court painter Chiang T'ing-hsi was delegated to serve as his tutor in painting. By 1726, however, Li Shan had fallen from grace, had been dismissed from court, had squandered his inherited fortune, and was living in the T'ien-ning temple in Yangchou while struggling to earn his living as a professional artist.

Li Shan's initial success was based on his skill in calligraphy. After the accession of the Ch'ien-lung emperor in 1736, Li attempted to return to official service, and in 1738 he left Yangchou to serve as magistrate of T'eng-hsien, Shantung. He was dismissed after four years and returned to Yangchou. From this time onward, his reputation as a painter surpassed his earlier renown for poetry and calligraphy. His latest attributed paintings are dated 1756.

The subjects Li Shan chose to paint–orchids, bamboos, pines, and flowers–reflected his literati background. *Five Pine Trees*, painted late in his career, is a large, impressive work. It seems to be the last in a series of paintings which employ virtually the same poem and subject matter. Li must have returned to the theme many times, because his *Five Pines* poem is mentioned in a biographical note written by the early nineteenth-century author Chiang Pao-ling (*Mo-lin*, preface 1851, ch. 1, p. 3a-b). One undated example in the Tokyo National Museum, painted in ink and color on silk (Yonezawa, *Hachidai sanjin*, 1975, p. 25, color pl. 13), and the 1735 ink monochrome version in Nanking (*Nanching po-wu yüan*, 1966, II, pl. 98) both feature huge pines in a large vertical format. Their trunks and branches are loosely painted but sufficiently focused to suggest convoluted movement in space. In both, the artist's inscription is discreetly written in the upper left corner.

Li Shan creates quite a different effect in his 1735 album leaf (Yonezawa, *Hachidai sanjin*, p. 106, pl. 71), and in this much larger painting of 1747. A realistic treatment of the subject is subordinated to an abstracted interplay of richly modulated ink which forms the trees and the dashing semi-cursive script interspersed among the branches. Li enforces the kinship between calligraphy and the painted image wherein the calligraphy becomes an active compositional element. The lengths to which this Ch'ing individualist transposed the time-honored theme of the ancient pine can be appreciated by comparing his treatment to that of Yüan and Ming predecessors (see, for example, cat. nos. 104, 175, 176).

Li was not alone among the Yangchou painters in utilizing earlier literati models. A painting on the subject of bamboo by his close friend, Cheng Hsieh, and now in the Tokyo National Museum, is one of a number of his works which sets up a similar equivalence between poetic inscriptions and natural objects interspersed across a broad expanse (ibid., color pl. 15). In much the same vein, Chin Nung (see cat. no. 270), another Yangchou notable, magnifies the scholarly subject of ink prunus to a scale and density of composition equal to Li Shan's *Pines* (ibid., pls. 78-81). The audacious chances taken by these Yangchou painters with sacrosanct themes and brush techniques at times justly earned them the censure of conservative critics; but when successful, their efforts represented a healthy revival of tradition during the late creative years of Chinese painting history.

HK/HR

Literature
Ch'eng, *Hsüan-hui-t'ang* (1972), *Hua,* pp. 203(b)-204(a).

Recent provenance: Cheng Ch'i.

The Cleveland Museum of Art 76.112

Huang Shen, 1687-ca. 1766, Ch'ing Dynasty
t. Kung-mou, Kung-shou; *h.* Ying-p'iao,
Ying-p'iao-tzu; from Ning-hua, Fuchien
Province, lived in Yangchou, Chiangsu
Province

269 *Eagle on a Tree Trunk*
(Ku-ch'a ch'iu-ying)

Hanging scroll, dated 1755, ink and light color on paper, 123.3 x 45 cm.

Artist's inscription, signature, and 2 seals: Two days before the Lantern Festival in the *i-hai* year of the Ch'ien-lung era [1755], drawn by Shen, Ying-p'iao-tzu. [seals] Huang Shen; Kung-chou.

Remarks: Huang Shen was born in Ting-chou and received his early education at home. Following the death of his father, he turned to painting to secure a livelihood for himself and his mother. Shang-kuan Chou also lived in Ting-chou, and from him Huang Shen learned to paint figures, birds and flowers, landscapes, and architectural subjects. The grass-script calligraphy of the T'ang monk Huai-su (725-785) gave Huang Shen the impetus for an innovative approach of his own which prompted the comment from Shang-kuan Chou: "When first viewed, his painting was like a rough draft, with only a very few strokes and forms difficult to distinguish, but when viewed from a distance of ten feet or so, then the essential spirit and inner strength appeared" (Ch'ing-liang Tao-jen, *T'ing-yü-hsüan pi-chi,* ca. 1800,

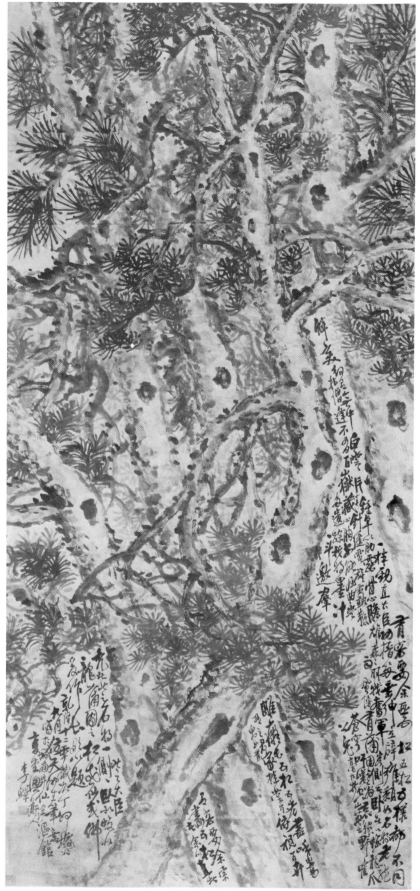

268

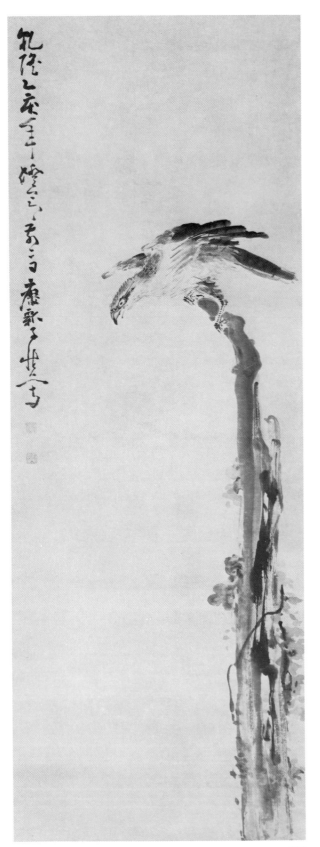

269

ch. 1). The praise of Shang-kuan Chou helped to establish Huang Shen as a well-known artist. Equipped with a rapid technique, a talent in poetry, and a calligraphy style modeled on Huai-su, Huang Shen left Ting-chou around 1710.

During the following decade Huang traveled around Chianghsi, Chechiang, and Chiangsu provinces, meeting support and praise everywhere; but it was in the lively city of Yangchou, where he lived during the early Yung-cheng period until 1730, that Huang found both a ready market for his paintings and an atmosphere congenial to his temperament. Among his friends during those years were Chen Hsieh and Li Shan (see cat. no. 268). Because of his mother's age, Huang returned with his family to Fuchien in 1730, where he established a shop which eventually supported them. His success as a painter continued, and he frequently returned to Yangchou in later years.

The works produced by Huang in his early years in Yangchou tended to fuse poetry, calligraphy, and painting into unified images. The Cleveland painting of 1755 continues this approach, and his calligraphic interpretation of the eagle perched on the tree stump is convincingly articulated with quick strokes of richly shaded inks. In contrast to the sharp-focus detail of the head and ruffled plumage, the branch upon which the eagle perches is set down in a long, daring stroke of a wide brush heavily loaded with ink. The reliance on spontaneous effects achieved during the actual execution of the painting removes it from present reality and into a world of Huang's own creation. HR/HK

Literature
Sirén, *Masters and Principles* (1956-58), VII, *Lists*, 348.
Rogers et al., *Kin Nō* (1976), p. 172, pl. 47.

Exhibitions
Nanking Art Gallery, 1937: *Chiao-yü-pu*, I, cat. no. 332.

Recent provenance: P'u Hsin-yü; Richard Nathanson.

The Cleveland Museum of Art 77.31

Chin Nung, 1687-1764, Ch'ing Dynasty
 t. Shou-men, *h.* Tung-hsin, Chi-chin, and others;
 from Hangchou, Chechiang Province, active at
 Yangchou, Chiangsu Province

270 *Blossoming Plum*
 (Mei-hua)

Hanging scroll, dated 1760, ink and slight color on paper, 116 x 60.3 cm.

Artist's inscription, signature, and 2 seals: Painted in the third month of the *keng-ch'en* year [1760]. Chin Nung. [seals] Chin Chi-chin yin; Sheng yü ting-mou.

2 additional seals: 1 of P'an Fei-sheng (1855-after 1933); 1 of Ch'eng Ch'i (20th c.).

 KSW

Literature
Akiyama et al., *Chūgoku bijutsu* (1973), II, 251, 252, pl. 84.
Rogers et al., *Kin Nō* (1976), p. 169, pl. 14.
Nichiyōbi bijutsu-kan (1978), IX, 118, 119.

Recent provenance: Ch'eng Ch'i.

Nelson Gallery-Atkins Museum 58-54

Lo P'ing, 1733-1799, Ch'ing Dynasty

t. Tun-fu, *h*. Liang-feng; from Hsi-hsien, Anhui
Province, lived in Yangchou, Chiangsu Province

271 *Scholar Watching the Waterfall*
(*Kuan-p'u t'u*)

Hanging scroll, dated 1764, ink and light color on
paper, 125 x 57 cm.

Artist's inscription, signature, and 2 seals: Watching the
Waterfall. Done in the *chia-shen* year [1764] for my senior,
the venerable Mr. Shou-t'ang. Chu-ts'ao shih lin-chung
jen, Lo P'ing [seals] Liang-feng hua yin; Shan-lin
wai-ch'en.

1 additional seal of Wang Chi-ch'ien (20th c.).

Remarks: Lo P'ing, the youngest of the Yangchou Eccen-
trics, was born to an Anhui family with some scholarly
background. Lo was orphaned at an early age after the
family moved to Yangchou, but his youthful talent in
literature caught the attention of the generous patrons
Ma Yüeh-kuan and his brother, Ma Yüeh-lu (see cat.
no. 275), who provided him entrance to the local literary
world. For spiritual and artistic guidance Lo turned to the
painter Chin Nung (see cat. no. 270), who directed his
studies in Ch'an Buddhism and molded his painting,
calligraphy, and poetry. Many of Lo P'ing's figure
compositions, scholar's subjects of bamboo and prunus,
and even his calligraphy bear the imprint of Chin
Nung's peculiar brush methods, based on the study of
Buddhist stele inscriptions of the Six Dynasties period
(cf. *Shu-fa ta-kuan*, 1971, nos. 14-16, pls. 32-36). The sharp
edges of their lines, whether in writing or painting, sepa-
rate Chin Nung and his pupil Lo P'ing from their contem-
poraries. Yet the younger painter was never a slavish
imitator. Many of his paintings reveal an independently
creative artist whose reputation in his own time was built
on his unique figure paintings, especially those of ghosts
(cat. no. 273; Urban Council, *Ming and Ch'ing*, 1970, no.
80, P. T. Huo collection). With Lo P'ing's death in 1699,
the last creative energies of the Yangchou painters seem
to have been exhausted.

In *Watching the Waterfall*, painted at his Yangchou stu-
dio (the Chu-ts'ao shih lin) in the year of Chin Nung's
death, Lo P'ing both acknowledges and transforms in-
fluential Yangchou masters. In his inscription Lo employs
his teacher's flattened and slanted brush-tip technique to
achieve sharp-edged strokes with squared beginnings
and terminations. The hair of the attendant and beard of
the venerable gentleman for whom this portrait was
painted are built up with thin, tense lines, but the result is
essentially flat. All the lines exude a curious static quality,
as if they were printed instead of drawn with a brush. An
even more striking example of this is Lo Ping's *Portrait of
the Ch'an Master T'an*, dated 1763 (*Su-chou*, 1963, pl. 87),
now in the Suchou Municipal Museum. HK/LYSL

Recent provenance: Chang Ting-chen.

The Cleveland Museum of Art 75.95

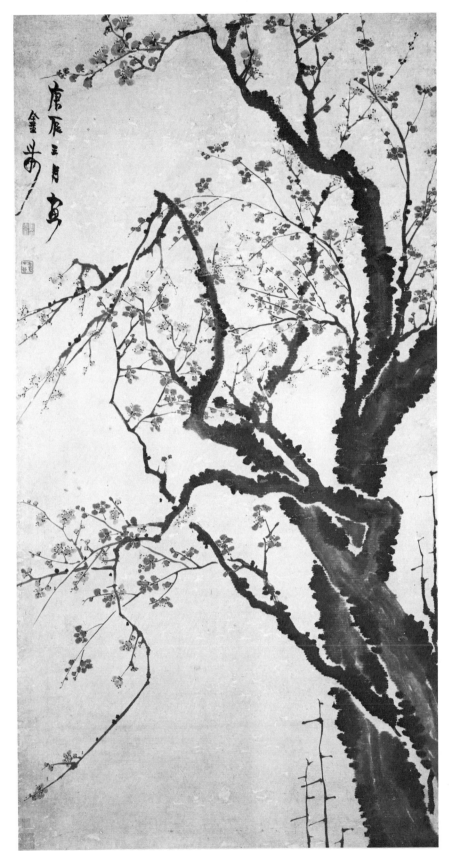

270

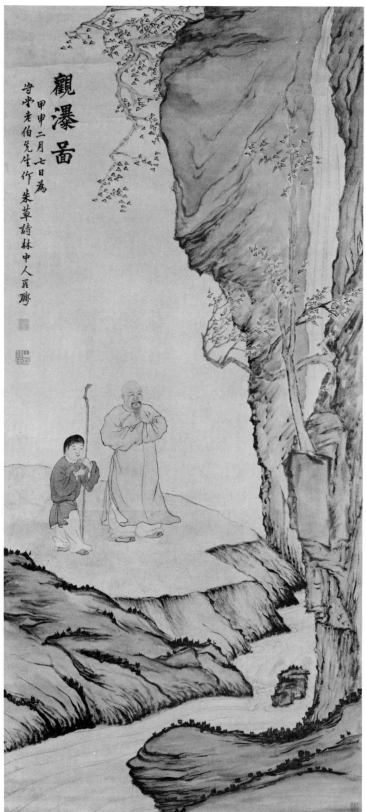

271

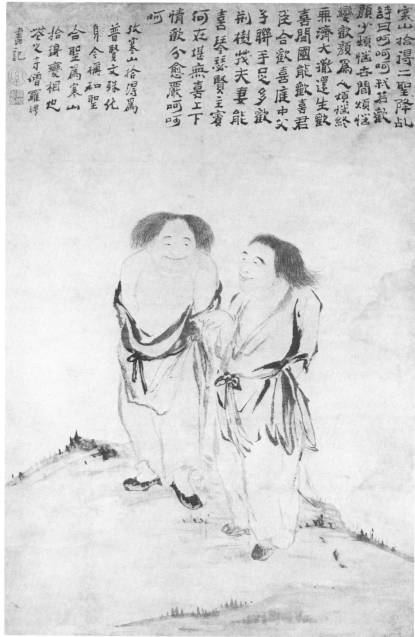

272

Lo P'ing

272 *Han-shan and Shih-te*
(Han-shan Shih-te)

Hanging scroll, ink and slight color on paper, 78.3 x 51.3 cm.

Artist's inscription, signature, and 2 seals: The two saints Han-shan and Shih-te, in response to divination, made a poem saying:

Ha! Ha! Ha!

If I display a happy face, I would seldom be distressed,
And the worry of the mundane world would become a happy expression.

It is useless for a person to worry;
The great Tao will still emerge in the midst of happiness.
If the nation can be happy, the sovereign and his ministers join together;
Happiness within the family unites father and son.

Abundant happiness among brothers makes the family
 prosperous, just as thorns and trees grow profusely;
If husband and wife are happy, they become in tune [like
 keyboard and string].
How can there be happiness when there is no difference
 between host and guest?
When the sentiments of superior and subordinate are
 happy, the [role] differentiation becomes stricter.
Ha! Ha! Ha!

 Accordingly, Han-shan and Shih-te are incarnations of
Samantabhadra and Manjushri. They are now called Ho-
sheng and Ho-sheng. They are variations of Han-shan
and Shih-te.
 Inscribed by Lo P'ing, monk of the Hua-chih Temple.
[seals] Lo; Lo P'ing ssu-yin.

 trans. Carla Zainie, with minor changes

Remarks: This undated painting is neither close in style
nor in calligraphy to other figure paintings by Lo P'ing.
Usually in such works, Lo follows the style of his teacher,
Chin Nung (see cat. no. 270). The present scroll is, on the
contrary, closer to certain styles of Ch'an Buddhist paint-
ings of the Sung and Yüan Dynasties, which he might
well have seen in temples. The calligraphy is similar to
that of another of the Eight Eccentrics of Yangchou,
Cheng Hsieh (1693-1765), a famous bamboo painter,
calligrapher, and friend of Chin Nung.
 A stone stele with images of Han-shan and Shih-te was
set up in the Han-shan Temple in Suchou in the middle of
the Ch'ien-lung era, about 1765. Rubbings of this en-
graved stone show that it has the same inscription and
seals as the Nelson Gallery scroll; while there are some
differences in details in the figures and landscape, it is
obviously based on our painting (*Wu-hsien chih*, 1933,
ch. 6, p. 1040). KSW

Literature
Shen-chou kuo-kuang-chi I (February, 1908), unpaginated.
Akiyama et al., *Chūgoku bijutsu* (1973), II, 257, pl. 100.
Wilson, "Vision" (1973), no. 14, p. 239.
NG-AM Handbook (1973), II, 73.
Zainie, "Eccentric Hermits" (1976), pp. 19, 29-31, fig. 3.
Rogers et al., *Kin Nō* (1976), pp. 88, 180, pl. 106.

Recent provenance: Shen Family, Suchou.

Nelson Gallery-Atkins Museum 72-5

Lo P'ing

273 *Chung-k'uei Supported by Ghosts*
 (*Chung-k'uei chui-kuei*)

 Hanging scroll, ink and light color on paper, 96.9 x
 48.9 cm.

Artist's signature and seal: Painted by Liang-feng tao-jen,
Lo P'ing. [seal] Liang-feng.

4 additional seals: 3 of Tai Chih (19th c.); 1 of Jen Po-nien
(late 19th c.).

Remarks: The influence of Hua Yen and Chin Nung is
more obvious in Lo P'ing's undated *Chung-k'uei Supported
by Ghosts* than in his *Watching the Waterfall* of 1764 (cat. no.
271). The light-colored washes and loose brushstrokes of
the flowering tree in the background appear in a number
of Hua Yen's paintings (*Shina Nanga taisei*, 1935-37, VII, pls.
126-28). Angular, fluctuating ink outlines for the rumpled
garments of the drunken Chung-k'uei and his band of
wizened demons, as well as for the foreground rocks and
grasses all duplicate Chin Nung's flattened-brush
method (ibid., pl. 139), although Lo P'ing tones down his
teacher's muscular draftsmanship and strong color.

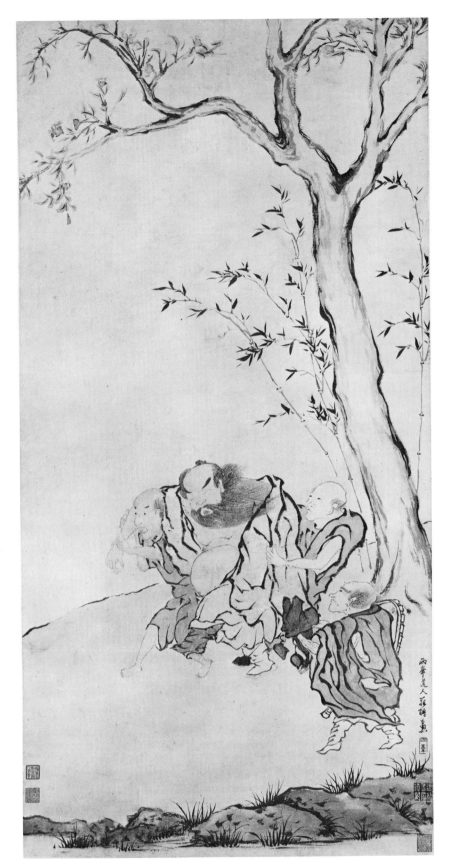

273

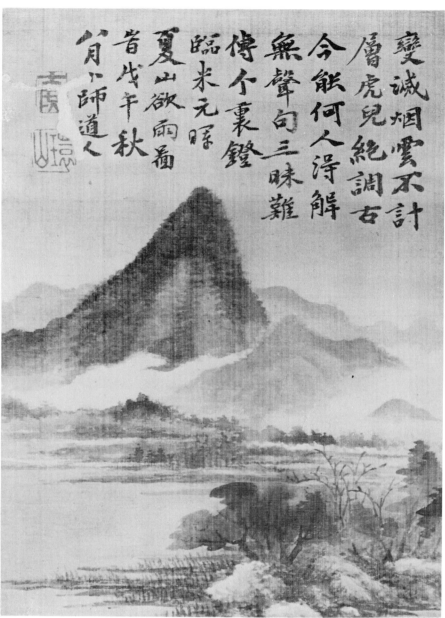

變誠煙雲不計
層虎兒絀調古
今能何人浮解
無聲句三昧難
傅个裏鑑
臨來元暉
夏山欲雨面
昔戈午秋
□月八師道人

274

Fang Shih-shu, 1692-1751, Ch'ing Dynasty
 t. Hsün-yang, h. Huan-shan, Hsiao-shih
 tao-jen; from Hsieh-hsien, Anhui Province, active
 at Suchou, Chiangsu Province

274 *Approaching Rain in the Summer Mountains in the
 Style of Mi Yu-jen*
 (*Fang Mi Yu-jen hsia shan yü yü*)

Hanging scroll, dated 1738, ink on silk,
22.8 x 17.8 cm.

Artist's inscription, signature, and 2 seals:

Mists and clouds shifting and dissolving in countless
 layers;
In surpassed harmonies, Hu-erh [Mi Yu-jen, 1074-1153] is
 a talent for all time.
Who can comprehend those soundless poems?
The master's perfect understanding, that inner lamp, is
 difficult to transmit.

 Copying Mi Yüan-hui's [Mi Yu-jen] picture *Approaching
Rain in the Summer Mountains*, in the eighth lunar month
during the autumn of the *wu-wu* year [1738]. Hsiao-shih
tao-jen [seals] Shih-shu; Huan-shan.

trans. MFW

Remarks: Fang Shih-shu, a pupil of Huang Ting (1660-
1731), had the opportunity to study many old paintings;
thus, a great part of his own work derived from the styles
of Sung and Yüan masters. Among the paintings he had
seen, Fang mentions a rainy landscape by Mi Yu-jen
(Fang, *T'ien-yung-an*, preface 1806, *ch. hsia*, p. 18).
Another painting, close in style to the Nelson Gallery
scroll, was executed by Fang in 1736 (Wang K'ung-ch'i,
ed., *Hsin-an*, 1948, pl. 30). Both may be free copies of the
Mi Yu-jen picture he had seen. KSW

Literature
Harada, *Shina* (1936), pl. 925.
Nihon genzai Shina (1938), p. 318.
Okamura, *Urinasu* (1939), p. 530.

Recent provenance: Saburō Yoshizawa; Michelangelo
 Piacentini.

Nelson Gallery-Atkins Museum 51-4

Fang Shih-shu

Yeh Fang-lin, late seventeenth-early eighteenth
 century, Ch'ing Dynasty
 From Wu-hsien, Chiangsu Province

275 *The Literary Gathering at a Yangchou Garden*
 (*Chiu-jih hsing-an wen-yen t'u*)

Handscroll, dated 1743, ink and light color on silk,
31.7 x 201 cm.

Fang Shih-shu's seal at beginning of painting: Ou-jan
shih-te. Yeh Fang-lin's seal at end of painting: Fang-lin.

Frontispiece title dated 1743 and 3 seals of Ch'en Pang-
yen (1678-1752). 8 colophons and 19 additional seals: 1
colophon, dated 1744, and 3 seals of Li O (1692-1752); 1
colophon, dated 1746, and 1 seal of Ch'üan Tsu-wang
(1705-1755); 1 colophon, dated 1746, and 1 seal of Huang
Chih-chün (1668-after 1746); 1 colophon and 2 seals of
Cha Hsiang (1718 *chin-shih*); 1 colophon, dated 1746, and 3
seals of Chang Ssu-wen (dates unknown); 1 colophon,
dated 1748, and 4 seals of Shao T'ai (1721 *chin-shih*); 1
colophon, dated 1753, and 2 seals of Fang Shih-chü (18th
c.); 1 colophon, dated 1808, of Juan Yüan (1764-1849); 3
seals unidentified.

 Both of Lo's compositions in Cleveland display a
similar sobriety of color. Here the pale washes which tint
the figures and the background foliage are even lighter
than those in *Watching the Waterfall*. In fact, the blue and
orange-colored hair, and the yellowish, whitened skin
tones are the only indication that the drunken
Chung-k'uei's companions are ghostly demons. Such
refinements of his master's methods suggest that Lo
P'ing painted *Chung-k'uei* in the period of his maturity.

HK

Literature
Lee, "Yen Hui" (1962), p. 41, fig. 5; idem, *Far Eastern Art*
 (1964), p. 455, fig. 602.
Chang and Hu, *Yang-chou pa-kuai* (1970), II, pl. 90.
CMA *Handbook* (1978), illus. p. 358.

Exhibitions
Haus der Kunst, Munich, 1959: *1000 Jahre*, cat. no. 138-B.

Recent provenance: Wang Chi-ch'ien.

The Cleveland Museum of Art 59.185

Colophon by Li O:

The Hsing-an [Temporary Retreat] is located at the northern outskirt of Yangchou, by the west corner of the T'ien-ning-ssu [temple] which was purchased by Ma Yüeh-kuan [1686-1755] and his younger brother Ma Yüeh-lu [1697-after 1766] from the unused land of the Buddhist monastery and built as a place for rest and recreation. The monastery was originally a country villa of Hsieh An [320-385] of the Chin Dynasty. Its west corner is especially luxuriant with ancient trees, densely wooded and shady. Once inside the secluded area of the wood, people would not know that they are actually not far from the city. The "retreat" is right at the center of this secluded spot, totally devoid of any artificial ornamentation of carving, engraving, lacquer, or bright colors, but rich in refreshing shades in its balconies and courtyards. For this reason, people who come here for a rest always linger on and do not want to leave.

On the Double-Ninth day of the *kuai-hai* year of the Ch'ien-lung era [1743], after a prolonged period of rains, the weather was pleasant and fine. So the members [of the poetry club] were all invited to gather together here. There, in the center, a portrait of T'ao Ch'ien by Ch'iu Ying was hung; yellow chrysanthemums were picked, and white wine was offered for libation. The fourteen words in [Tu Fu's] line of "Jen-shih nan-feng k'ai-k'ou hsiao, chü-hua hsü-ch'a man-t'ou kuei" [In this mortal world, there's hardly any occasion for a hearty laugh; so with chrysanthemums, let's go home full of flowers in our hair] were chosen as rhymes for making poetry. And so dizzily and merrily, we all drank and hummed for the whole day.

A month later, Mr. Yeh [*t*. Cheng-ch'u; Yeh Fang-lin], the portrait painter from Suchou, happened to be here and was asked to do a group portrait of the gathering on a scroll, with Mr. Fang Huan-shan [Fang Shih-shu] completing the background scenery. The painting was entitled *A Literary Gathering at the Temporary Retreat on the Double-Ninth Day.* Upon the completion of its mounting, every participant was to write down his own composition at the end of the scroll, and I was entrusted to record the event in an essay.

In the picture there are two gentlemen sitting together on a short couch. The one on the right who squats with outspread legs is Hu Fu-chai [Hu Ch'i-heng] from Wu-ling; and the one on the left who holds his right knee is T'ang Nan-hsüan [T'ang Ch'ien-chung] from T'ien-men. Two other gentlemen are sitting on matted chairs: the one holding a piece of writing is Fang Huan-shan [Fang Shih-shu] of Hsi-hsien; the other on the left who is looking up as if he is about to speak is Min Yü-cheng [Min Hua] of Chiang-tu. One gentleman sitting on a rattan stool and fingering his beard is Ch'uan Hsieh-shan [Ch'uan Tsu-wang, 1705-1755] of Ningpo. The other seated leaning against a rock as though he is deep in thought is Chang Yü-chuan [Chang Ssu-k'o] of Lin-t'ung. Two are standing under trees, away from other people. The one holding a chrysanthemum is Li Fang-hsieh [Li O, 1692-1752] from Ch'ien-t'ang; the other clasping his hands in the sleeve is Ch'en Chu-ting [Ch'en Chang] from Ch'ien-t'ang. One gentleman is playing the lute [*ch'in*] on a stone table. This is Mr. Ch'eng Hsiang-hsi [Ch'eng Meng-hsing] of Chiang-tu. Among the three listeners, the one standing behind with his sleeve down is Ma Pan-ch'a [Ma Yüeh-lu] of Ch'i-men. Two are sitting on porcelain stools. The one leaning against a tree on the left is Fang Hsi-ch'ou [Fang Shih-chieh]; the other on the right with legs crossed is Wang T'ien-chai [Wang Yü-shu]; both are from Hsi-hsien. Two gentlemen seated facing each other and unrolling a scroll are Ma Hsieh-ku [Ma Yüeh-kuan] of Ch'i-men on the left, and Wang Mei-i [Wang Tsao] of Wu-chiang on the right. One onlooker on the right with both hands clasped behind his back is Lu Nan-ch'i [Lu Chung-hui] of Chiang-tu. The other leaning forward, behind [Mr. Lu], is Hung Ch'ü-hsi [Hung-Chen-k'o] of Hsi-hsien. Among the boy-servants, three are planting chrysanthemums; one is

275 Detail

waiting among trees; one holds a walking staff; while the other holds a scroll. Plants in the painting are bananas, bamboo, and trees of various kinds. They are represented in colors of reddish-yellow and greenish-blue to give a seasonal feeling.

Now the auspicious name of the "Double Ninth" [a festival on the ninth day of the ninth month] is universally respected by tradition. But [the T'ang poet] Kao Shih [d. 765] had to scratch his head lamenting his loneliness, while Lu Kuei-meng [d. 881] shut himself indoors, dreaming the joy of *teng-kao* [mounting the high ground]. The reasons for their misfortune were simply the lack of the right time, the right place, and the right people. As for us, we are luckily born in a reign of peace, at a place of beauty, and in the company of friends who are cultured and understanding. How rare indeed are such gatherings in this world! On the other hand, among the sixteen of us, some are native [to Yangchou] and the others are only visitors. Our meetings and partings are irregular and unpredictable. Some days, when time has gone by, when we are brought back to memory by the change of seasons, we may unroll this painting and feel like seeing each other again. For the people in the future who get to see this painting, perhaps they will not feel differently from us.

In the *chia-tzu* year [1744], the fifty-fourth day in the summer, Li O recorded and inscribed.

Remarks: The "Temporary Retreat," which also served as the Ma's family temple, was located between the largest of the eight Buddhist monasteries in Yangchou, T'ien-ning-ssu, and another famous garden, Jang-p'u. All shared a common entranceway, known to the local people as "Village on a Branch" *(Chih-shang-ts'un)*. While these scenic spots were later taken over by the government and incorporated into the Imperial Villa toward the end of the Ch'ien-lung era, they had their great days as sites of some of the most celebrated literary gatherings of the early Ch'ing period.

Yangchou in early Ch'ing was a city of enormous economic and cultural vitality, the center of a prosperous salt trade, and the hub of the Grand Canal for south-north commercial traffic. Material wealth stimulated and nourished the continuous growth of a sophisticated, if at the same time middle-class, urban culture. Hosts of scholars, poets, dramatists, and painters were attracted to its temple-theatres, its tea houses, its lakes and rivers of "picture-boats," and its numerous gardens for both mundane pleasures and intellectual companionship. Among the most hospitable patrons, the Two Ma of Yangchou, Ma Yüeh-kuan and his younger brother, Ma Yüeh-lu, were perhaps best known for their literary accomplishments, their bibliophilic scholarship, and their extensive art collection (cf. the Yüan-dated silver raft-cup by Chu Pi-shan, CMA 77.7 [see Wang Ch'ang, ed., *Hu-hai shih-ch'uan*, 18th c., II, 242]). The library of the Ma family, Ts'ung-shu-lou, was ranked among the best in the country. Its great collection of rare books and manuscripts not only contributed over 700 titles for transcription to the Imperial Manuscript Library *(Ssu-k'u ch'üan-shu)* but was also a major research source for visiting scholars, some of whom would stay for years as house guests of the Ma family for this unequalled privilege (Yeh Ch'ang-chih, *Ts'ang-shu*, ca. 1900, p. 265).

Li O, one of the participants at the Double-Ninth gatherings, made numerous sojourns at the family's Studio of the Small Perforated Hill to complete two of his important works, *Nan-Sung Yüan-hua lu*, 1721 (literary

records for the Southern Sung Academy), and *Sung-shih chi-shih*, 1746 (an anecdotal anthology of Sung poetry), the latter co-authored by Ma Yüan-kuan (cf. Lu Ch'ien-chih, *Li Fan-hsieh nien-p'u*, 1936, pp. 19, 67).

The Double-Ninth literary gathering was widely published in Ch'ing literature, not only because it had inspired numerous poems and essays, but also because it was one of the very few among similar gatherings that happened to leave a pictorial record painted by one of its participants — Fang Shih-shu. This is reminiscent of another equally memorable event in the Ming Dynasty, the Literary Gathering in the Apricot Garden in 1437 (Cahill, *Parting*, 1978, p. 24). The parallel does not seem to be coincidental, however, for a scroll by Hsieh Huan (see cat. no. 133) recording that event was in the collection of the Ma family and might have served as a model (Ch'üan Tsu-wang, *Chieh-ch'i-t'ing chi*, 18th c., *ch.* 3, p.7a-b). Unlike the Ming gathering, however, few of the participants at Yangchou were high government bureaucrats. With the exception of two retired officials, the rest of the group were primarily commoners; although a number of them were qualified candidates and were recommended for the highly esteemed special examination, the *po-hsüeh hung-tz'u*, most had declined the honor. The economic and social changes in the eighteenth century had made it possible for some of the selected members of the merchant class to be accepted by, and integrated with, the intellectual elite.

In historical perspective, the significance of the Yangchou gathering rests precisely on its representation of a cross-section of the cultural upper society of East China in the eighteenth century, exemplified by two of the most prominent affiliates of the group: Ch'üan Tsu-wang, the foremost authority of the time on late Ming history, and Li O, a leading poet who was also a specialist in Sung painting and Liao history.

The participants of this gathering were all members of a poetry club, the Han-chiang ya-chi, whose background and activities were described by Li Tou in his *Yang-chou hua-fang lu (Picture-Boats of Yangchou*; preface 1795, *ch.* 3, 7, pp. 86-94, 168-172). In the scroll, they were arranged roughly into four groups, and each is related to the others in accordance to the first principle for Chinese traditional group-portraits, namely, "The correct order for seniority by age and social standing, and the proper arrangements for the relative positions and orientations" (Chü-chien, *Pei-chien chi*, 13th c., *ch.* 7, p. 28). Accordingly, the two ranking officials, possibly also the oldest members of the group, are seated on a couch at the beginning of the scroll: Hu Ch'i-heng was a retired provincial governor, and T'ang Chien-chung was a Hanlin academician. Sitting around a rock under banana trees are two very important members: Ch'uan Tsu-wang, the historian, and Chang Ssu-k'o, who was the owner of Jang-p'u (next door to the garden of the Ma family), founder of the poetry club, and a central figure in the cultural scene of Yangchou. Placed in between these two pairs are the poet Hua Min and the painter Fang Shih-shu, who seats himself at a corner in the back, apparently as a gesture of modesty. Watching chrysanthemums are two friends standing together in isolation from the other people: Li O and Ch'en Chang, perhaps two of the most admired poets of their time. The group listening to the playing of a *ch'in* includes the performer Ch'eng Meng-hsing, who was a Hanlin academician; Fang Shih-chieh, younger brother of the painter Shih-shu, who was a salt merchant and business associate of the Ma brothers; Wang Yü-shu, owner of Chiu-feng Yüan, one of the most famous gardens in

Yangchou, and the presiding member of another literary group; and Ma Yüeh-lu, who, being one of the hosts, chose to stand behind his musician guest. The last group (viewing a scroll) includes Wang Tsao, a rice merchant by profession but a poet and connoisseur of art by reputation, who shared a common interest with the Ma brothers in collecting rare books. Watching from behind are Lu Chung-hui, an epigraphist, and Hung Cheng-k'o, a Confucian scholar. And finally, the one holding the scroll for his guest is Ma Yüeh-kuan, host of the day, whose last position in the painting and deferential posture bespeak his role in the gathering.

The portrait painter Yeh Chen-ch'u was identified erroneously in Li O's colophon, but the mistake was corrected in his collected literary works (Fan-hsieh shan-fang wen-chi, 18th c., ch. 6, pp. 2-4). Although each individual is subtly characterized, no drama in expression or movement is allowed to upset the tranquility of the composition, whose unity is achieved by simple definition of space and rhythmical order. Likewise, all sitters are made to face the spectator regardless of their bodily orientations, and this gives a formal, representational air to the picture typical of a Chinese group portrait. But the formality is immediately softened by the gentle landscape of Fang Shih-shu. The outside world is completely shut off at the beginning of the scroll by a white wall, and at the end by the profusion of early autumn colors in the dense foliage. Within this enclosure, a special afternoon in eighteenth-century China was quietly celebrated by a group of friends whose subdued joy and contentment speak well of the character of that particular day — a day of friendship, of nostalgia, and of a philosophical reckoning with the impermanence of things, including life.

WKH

Literature

Li Tou, Yang-chou (preface 1795), IV, 6 (b).
Ch'en, Pao-yü-ko (preface 1855), III, 57(b)-61(b).
Ferguson, Li-tai (1934), I, supp., p. 9(b).
Rogers et al., Kin Nō (1976), pp. 176-78, pl. 82, fig. 28.

Recent provenance: Wan-go H. C. Weng.

The Cleveland Museum of Art 79.72

276A

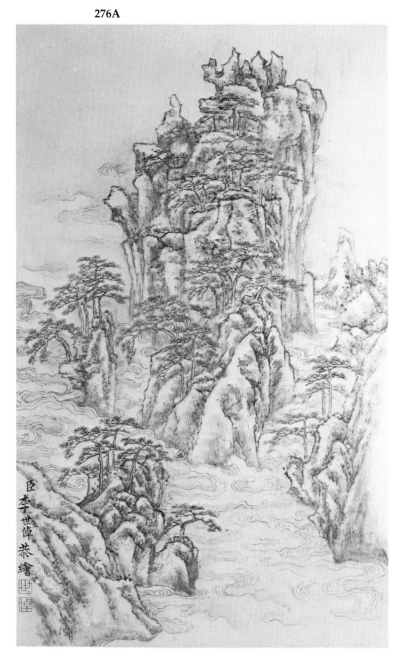

Li Shih-cho, ca. 1690-1770, Ch'ing Dynasty
 t. Han-chang, h. Ku-chai, Ch'ing-tsai chü-shih, and
 others; from T'iehling, Liaoning Province

276 *Landscape Album*
 (Shan-shui ts'e)

Album of twelve leaves, ink or ink and color on paper, each 24.1 x 14.5 cm.

A. *Clouds on the Pine Mountains (Sung-ling yün-t'ao).*
B. *Spring Mountains (Ch'un-shan t'u).*
C. *Lonely Temple in the Autum Mountains (Ch'iu-shan ku-ssu).*
D. *Morning Sun over the Isle of the Immortals (P'eng-tao ch'ao-jih).*
E. *Waterfall Cascading beneath Stone Bridges (Shih-liang fei-pao).*
F. *Plum and Bamboo Studio (Mei-chu ts'ao-t'ang).*
G. *Pointed Peaks and Strange Rocks (Ch'iao-feng kuai-shih).*
H. *Peach Blossoms along Rapids (T'ao-hua liu-shui).*
I. *Looking up the Stream from a Bridge in Evening (Hsi-ch'iao wan-t'iao).*
J. *Conversation atop Autumn Mountains (Ch'iu-shan hsien-hua).*
K. *Striking Pine on a Sheer Cliff (Ch'iao-pi ch'i-sung).*
L. *Imposing Overhang with Pavilion (Wei-yai t'ing-tzu).*

Artist's signatures and 12 seals, one on each leaf: Respectfully painted by Your Servitor, Li Shih-cho. [seal] Shih-cho.

5 additional seals: 2 of Tai-ch'üan (4th Prince Ting, d. 1854); 2 of Kung Wei-chiang (unidentified); 1 of Ko-min (unidentified).

Remarks: The character ch'en (Your Servitor) preceding each signature is a later, and probably recent, addition. The wording used by Li Shih-cho, without the character ch'en, would be appropriate to a work painted for a princely rather than imperial patron.

A number of scholars have identified Li Shih-cho as a Korean from San-han. San-han is an ancient Han period name for what is today part of the northwestern coastal region of North Korea, extending partly into the southern coastal section of Liaoning Province. However, as used in

276B

276C

276D

276E

276F

276G

276H

276I

276J

276K

276L

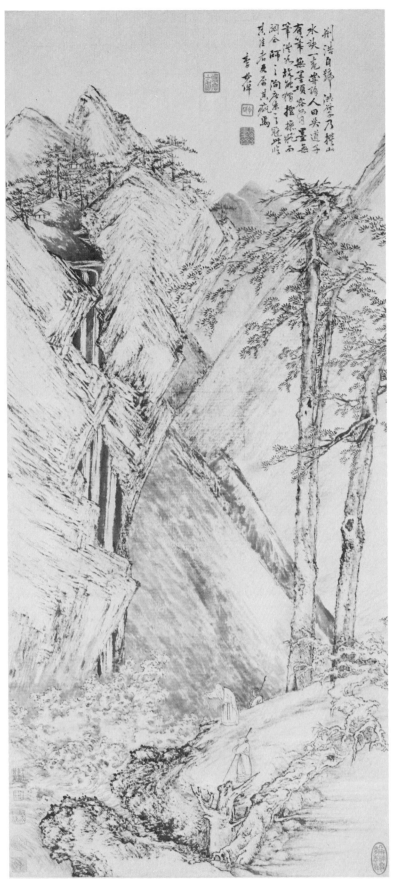

277

such Ch'ing Dynasty biographical accounts as Chang Keng's *Kuo-ch'ao hua-cheng-lu* (preface 1739, *ch. hsia,* p. 12b), the term refers to the region east of the Liao River centering on the modern city of Liaoyang. Li Shih-cho himself identified his native place as T'iehling, now a city of moderate size situated just east of the Liao River, about forty miles northwest of Shenyang (T'ao Liang, *Hung-tou-shu-kuan,* 1882, *ch.* 8, p. 80b). That Li should be associated with T'iehling in Liaoning Province rather than with some place in North Korea is supported by the fact that he was a nephew of Kao Ch'i-p'ei (see cat. no. 264), who also came from T'iehling. MFW/KSW

Recent provenance: Alexander To.

Nelson Gallery-Atkins Museum F78-18/1-12

Li Shih-cho

277 *Landscape with Waterfall*
 (Sung-yen huan-p'u)

Hanging scroll, ink on paper, 91.1 x 41.3 cm.

Artist's inscription, signature, and 4 seals: Ching Hao called himself Hung-ku-tzu and wrote an essay titled *Shan-shui Chüeh [The Secrets of Landscapes].* He had once criticized that Wu Tao-tzu had brush but no ink, and Hsiang Yung had ink but no brush. Therefore, Hung-ku [Ching Hao] has mastered both ink and brush, and later Kuan T'ung followed him. He was truly the best at the end of the T'ang Dynasty. I am here imitating the merits of Ching Hao while discarding his flaws. Li Shih-cho [3 seals] Cho-shih; Ku-chai; Yüan-chan-shang. [seal, lower right corner] Chi-yen ching-yen chien hsing-ch'ing.

5 additional seals: 1 of Wang Chi-ch'ien (20th c.); 4 unidentified.

Remarks: Li Shih-cho was born around 1690 within the territory beyond the Great Wall designated by the Ch'ing rulers as Manchuria. In 1621, when the Manchus overran the cities of Shenyang and Liaoyang, their Chinese captives, who included the ancestors of Li Shih-cho and Kao Ch'i-p'ei, were enrolled as hereditary bondservants in the Banners of their conquerors. After the fall of the Ming in 1644, the new rulers relied heavily on these servants, and especially on those enrolled in the Banners controlled directly by the emperor. Li Ch'eng-lung, Shih-cho's father, occupied the post of governor-general of Hu-kuang, and Li Shih-cho, while still in his twenties, served as an official in T'ai-ts'ang. While there, he received individual instruction in painting from Wang Hui (see cat. nos. 244b-247), the greatest expositor of orthodox principles outside court circles, and studied as well with Wang Yüan-ch'i (see cat. nos. 249-252), the greatest practitioner of the orthodox style within court circles. Li had also studied with his famous maternal uncle, Kao Ch'i-p'ei (see cat. no. 264), who was a member of the same Yellow Banner in which the Li family was enrolled.

By the late 1730s Li had been called to office in Peking and served in several important court positions while continuing to paint, frequently in response to imperial demand. His palace commissions can be identified by their carefully written signatures, always preceded by the character *ch'en* (subject), and by deep, bird's-eye-view perspectives (see Harada, *Shina,* 1936, no. 911; *Ku-kung shu-hua chi,* 1930-36, IX, pl. 191).

Suddenly and inexplicably Li Shih-cho left office around 1750, at the height of his career, and spent the last

twenty years of his life in impoverished retirement. Having freed himself from the demands of the court, Li Shih-cho matured as an artist and produced his finest paintings, among them the Cleveland hanging scroll. These works display not only superb technical control but also a new inner strength. Li's inscription makes clear that he is vying with the tenth-century artist Ching Hao in mastery of brush and ink. He created a formal pattern bowing to the monumentality of Ching Hao, while through simplification and abstraction he increased the aesthetic impact of the composition. However, his success relies less on the study of old masters and more on lessons well learned from Wang Hui. HR/HK

Literature
Fei Tun-lu (1935), pl. 10.
Lee, "Some Problems" (1957), pl. 12, fig. 16 (detail).
Sirén, *Masters and Principles* (1956-58), V, 224; VI, pl. 442; VII, Lists, 376.
Lee, *Chinese Landscape Painting* (1962), p. 132, no. 105.
Hung, "Liu Hua Han-kuo" (1973), unpaginated.

Exhibitions
Cleveland Museum of Art, 1954: Lee, *Chinese Landscape Painting*, cat. no. 114.
J.B. Speed Art Museum, Louisville, 1965: *Treasures*, cat. no. 47.
Asia House Gallery, New York, 1974: Lee, *Colors of Ink*, cat. no. 47.

Recent provenance: Fei Tun-lu; Walter Hochstadter.

The Cleveland Museum of Art 52.588

P'an Kung-shou, 1741-1794, Ch'ing Dynasty
t. Shen-fu, *h.* Lien-ch'ao; from Tan-t'u, Chiangsu Province

278 *Landscape in the Style of Wen Chia*
 (Fang Wen Chia shan-shui)

Hanging scroll, dated 1788, ink and light color on paper, 98 x 30.2 cm.

Artist's inscription, signature, and seal:

On a rainy spring day, cut a piece of Wu [Suchou] silk;
And wash it all with the color of mists.
Just a touch of the brush, and a thousand peaks emerge;
But none of this is due to nature's creative forces.

In the ninth month of the *wu-shen* year [1788], I followed the style of Wen Hsiu-ch'eng [Wen Chia, 1501-1583] for the appreciation of Hsi-yeh, the seventh brother. Kung-shou [seal] Lien-chü-shih.

Remarks: The Wen Chia referred to in the inscription was the celebrated sixteenth-century painter and son of Wen Cheng-ming (see cat. nos. 170-176). The general conformation of the hills and rocks in this painting as well as the forms of the trees derive from those earlier Ming masters. But decisiveness and solidity have given way to an over-all softness and delicacy, an elegance in the application of color, and an atmosphere of calm that matches well the character of the painter — an ardent Buddhist recluse. MFW

Exhibitions
Museum für Kunst und Gewerbe, Hamburg, 1949/50: Contag, *Chinesische Malerei*, cat. no. 128, p. 53.
Kunstsammlungen der Stadt Düsseldorf, 1950: Speiser and Contag, *Austellung*, cat. no. 125, p. 32.

Recent provenance: Victoria Contag von Winterfeldt.

Nelson Gallery-Atkins Museum F75-38

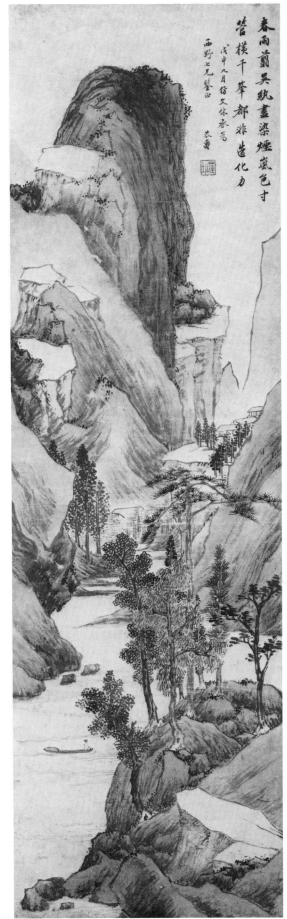

278

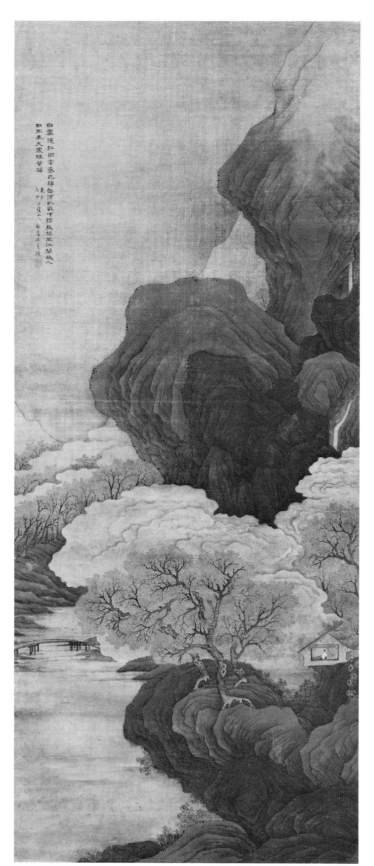

Li Chien, active 1747-99, Ch'ing Dynasty
t. Chien-min, *h.* Erh-ch'iao; from Shun-te,
Kuangtung Province

279 *White Clouds and Red Trees*
(Pai-yün hung-shu)

Hanging scroll, dated 1788, ink and color on silk,
126.2 x 52.7 cm.

Artist's inscription, signature, and seal:

White clouds surround red trees;
Mist has already returned to the valley.
Why not rest and let your mind be at peace with
the world,
With solitary *ch'in* [lute] sit in the river pavilion.
An old friend is expected but doesn't show up;
The day is cold, with maple leaves falling.

In the *wu-shen* year [1788], Erh-ch'iao shan-jen, Li
Chien copies and inscribes. [seal] Li Chien Chih yin.

trans. HK/LYSL

Remarks: The commercial prosperity from foreign trade
brought a cultural renaissance to the late eighteenth-
century Kuangtung region, much as the salt trade in-
vigorated the city of Yangchou a century earlier. Li
Chien was the first major artist to rise within this fresh
cultural milieu (*Ming-Ch'ing Kuang-tung, 1973*). He de-
voted the first part of his successful career to the study of
the Wu school, particularly the work of Wen Cheng-
ming; but after middle age he singlehandedly created an
atmosphere of appreciation for the paintings of Tao-chi
among contemporary and succeeding generations of
Cantonese painters.

The deep-hued mineral pigments, controlled ink out-
lines, and tight pictorial organization set this *White
Clouds and Red Trees* apart from most of Li Chien's loose-
ly painted and diffusely structured landscapes (ibid.,
cat. nos. 39-45). The alternating blue and green moun-
tain masses affirm the archaizing intention of the artist.
Li Chien states in his colophon that this work is a copy,
but he does not specify the source. The absence of tex-
ture strokes in the mountains probably allude to the
"boneless" manner of the sixth-century painter Chang
Seng-yu, whose landscapes are known only in literary
descriptions. For his variation on the ancient prototype,
Li Chien chose the tall, narrow Wu school format and
adopted T'ang Yin's oyster-shaped mountain masses
(see cat. nos. 162, 163). Yet by limiting himself to a few
repeated shapes – the angular mountain silhouettes, the
rounded contours of cloud banks and maple
foliage – and alternating his colors – blue against green,
red against unpainted silk – Li transforms his quotes
from earlier masters into an original interpretation. HK

Literature
Tanaka, *Tōyō bijutsu* (1968), II, pl. 39.

Recent provenance: Shōgorō Yabumoto.

The Cleveland Museum of Art 72.42

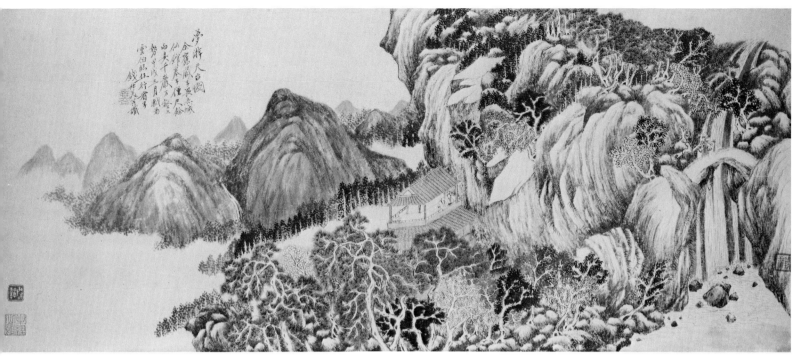

280

Ch'ien Tu, 1763-1844, Ch'ing Dynasty
t. Shu-mei, *h.* Sung-hu, Hu-kung; from
Ch'ien-t'ang, Chechiang Province

280 *Dream Journey to Mount T'ien-t'ai*
(*Meng-yu T'ien-t'ai*)

Handscroll, dated 1814, ink on paper, 29.8 x 72 cm.

Artist's inscription, signature, and seal: Dream Journey
to Mount T'ien-t'ai. I once had in my collection Tzu-
wei's [T'ang Yin's] *A Taoist Retreat at the Crimson Citadel.*
Although it measured barely more than a foot in length,
it had all the power of a thousand cliffs and myriad
ravines.

In the third month of the *chia-hsü* year [1814] I copied
this in a small, portable handscroll for the amusement of
Yün-po [Ch'en Wen-shu, 1771-1843]. Ch'ien Shu-mei
[painted] and inscribed. [seal] Hu-kung.

Artist's colophon: Ch'ien Tu transcribed a long poem on
a dream journey written by his friend Ch'en Wen-shu.
Following the poem he wrote:

In the spring of this year I did for Yün-po a *Meng-yu
T'ien-t'ai t'u* [Dream Journey to T'ien-t'ai picture], and
Yün-po had it mounted as a handscroll. In the seventh
month of this fall I came to visit him again at his Cassia-
leaf Library in Suchou and unrolled the painting for day-
long enjoyment. After that I wrote at the end of the
scroll the "Record of a Dream" he had previously com-
posed. Yün-po's poetry is quietly abstract and profound
and I fear that this picture cannot capture even a tiny
portion of its spirit. At this time the autumn heat is very
intense, and I sweat all over while writing this. The
strength of my wrist is weak, so my calligraphy is worse
than the painting. What can I do?

Shu-mei recorded. [seal] Shu-mei. Artist's seal at low-
er right edge of painting: Ch'ien Shu-mei.

trans. HK/LYSL/WKH

3 additional seals unidentified.

Remarks: Ch'ien Tu was born in Ch'ien-t'ang,
Chechiang, into a wealthy family of amateur painters.
His comfortable circumstances allowed him to travel ex-
tensively and to devote his life to painting. Whereas
many of his contemporaries followed models such as the
Four Wangs of the early Ch'ing era, Ch'ien Tu looked to
the sixteenth-century painters of Suchou as guides for
his personal style. His surviving works display a mas-
tery of the understated Wu school brush techniques –
especially those of T'ang Yin and Wen Cheng-ming –
applied to his very individual landscapes.

According to his inscription, Ch'ien Tu's *Dream Jour-
ney to Mount T'ien-t'ai* was freely copied after a T'ang Yin
composition and presented as a gift to his close friend,
the late Ch'ing poet-official Ch'en Wen-shu. The T'ang
Yin scroll which Ch'ien Tu used is unrecorded, but other
of this Ming master's surviving works on paper, *Mount
Hua* in Cleveland (cat. no. 163), and especially *Journey to
the South* in Washington (*Freer Gallery,* 1972, I: *China,* pl.
50), provide useful comparative material. Ch'ien Tu fills
his *Dream Journey* with similar forms and dry ink tones of
comparable richness, but the end result differs markedly
from his model. T'ang Yin's line unfolds energetically,
fluidly, and rhythmically in his *Journey to the South.*
Ch'ien Tu, however, applies ink in a more studied man-
ner and replaces T'ang Yin's closeup view with a wealth
of miniature detail. Dense forests, twisting trees, tiny
grass are all rendered in much shorter strokes than those
of his model. Ch'ien Tu's handscroll is therefore hardly
a copy of T'ang Yin – if anything, his controlled and
unassertive brushwork bears a closer relationship to the
works of Wen Po-jen (see cat. no. 186). HK

Recent provenance: Jean-Pierre Dubosc.

The Cleveland Museum of Art 75.75

Chang P'ei-tun, 1772-1842, Ch'ing Dynasty
t. Yen-ch'iao, h. Yen-shih shan-jen; from Suchou,
Chiangsu Province

281 *Copy of a Landscape by Chai Ta-k'un in the Manner of T'ang Yin*

(Mo Yün-p'ing fang Liu-ju shan-shui)

Hanging scroll, dated 1815, ink and light color on paper, 123.2 x 58.5 cm.

281

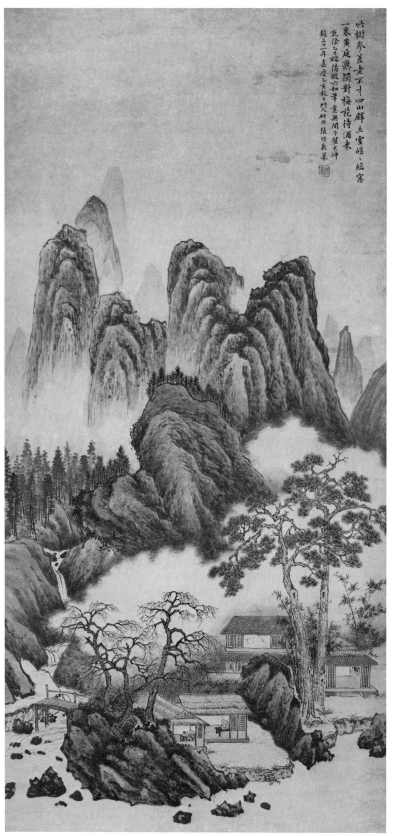

Artist's inscription, signature, and seal:

Amid bamboo and trees, jumbled high and low, I'm
old, but still no talent;
Mountains on all sides, erect and sheer, glistening
white with snow.
Near the window, learning well the Huang-t'ing
Scripture;
Facing the plum blossoms alone, I wait for
wine to come.

Imitating the conception of T'ang Yin's [1470-1523]
brush on the Tuan-yang Festival in the *i-ssu* year of the
Ch'ien-lung era [1785]. Wei-wen-tzu, Chai Ta-k'un [d.
1804]. Copied by [his] disciple Chang P'ei-tun, after the
passing of thirty-one years, on an autumn day in the
i-hai year of the Chia-ch'ing era [1815]. [seal] Yen-ch'iao.
MFW/KSW

Exhibitions
Museum für Kunst und Gewerbe, Hamburg, 1949/50:
 Contag, *Chinesische Malerei*, cat. no. 117, p. 51.
Kunstsammlungen der Stadt Düsseldorf, 1950: Speiser and
 Contag, *Austellung*, cat. no. 136, p. 33.

Recent provenance: Victoria Contag von Winterfeldt.

Nelson Gallery-Atkins Museum F75-40

Tai Hsi, 1801-1860, Ch'ing Dynasty
t. Shun-shih, h. Yü-an; from Ch'ien-t'ang,
Chechiang Province

282 *Rain-Coming Pavilion by the Stone Bridge at Mount T'ien-t'ai*

(T'ien-t'ai Shih-liang, Yü-lai-t'ing t'u)

Handscroll, dated 1848, ink on paper, 34.5 x 142.6 cm.

Artist's inscription, signature, and 2 seals: Painting of
Rain-Coming Pavilion by the Stone Bridge at Mount
T'ien-t'ai. In the twenty-eighth year of the Tao-kuang era
[1848], the third lunar month, requested by and painted
for P'an Kung-fu [P'an Tseng-i], a senior family friend.
[signed] Your Junior, Tai Hsi from Ch'ien-t'ang.
[seal] Ho-pi chien Tai. [seal, lower right corner] Shih-
ping yeh.

Title on frontispiece and 3 seals of Juan Yüan (1764-1849).
1 colophon and 10 additional seals: 1 colophon, dated
1838, and 8 seals of P'an Tseng-i (1792-1853); 2 seals
unidentified.

Colophon by P'an Tseng-i:

The T'an-hua [a flower that blooms only momentarily in
semi-tropical areas] Pavilion near Shih-liang [the natural
stone bridge] was built by the Grand Chancellor Chia [the
notorious Chia Ssu-tao, 1213-1275, who served during the
reigns of Emperor Li-tsung and Emperor Tu-tsung before
the end of the Southern Sung Dynasty]. It lasted over
seven hundred years. After it was destroyed this year, I
happened to be there, so I suggested it be reconstructed.
Among the six poems commemorating my visit, one
reads:

The career of the Prime Minister may be as great as the
 rivers and lakes,
Unaware himself of the fact there is leaking.
I had been all over the seventy-two peaks of P'eng-lai
 mountains
When the timely rain came to T'an-hua Pavilion.

It had not been raining for a long time there, then
unexpectedly, the rain came simultaneously with my
arrival; the old monk there asked me to change the name

to Rain-Coming Pavilion, in order to record the joy. The hilly fields at Mt. T'ien-t'ai have suffered by droughts. If, from this year on, they have the timely rain to bring along bountiful harvests and make people happy – so may this pavilion be our witness.

Hsiao-fu shan-jen, P'an Tseng-i recorded this on the first day of the twelfth lunar month in the *wu-hsü* year [1838]. Chiang Yung-ching copied respectfully on the first day of the sixth lunar month in the *wu-shen* year [1848].

<div align="right">trans. LYSL/WKH</div>

Remarks: A native of Hangchou, Tai Hsi became a member of the Hanlin Academy in 1832 and served both in the capital and in Kuangtung, where he was educational commissioner and participated in the suppression of the trade in opium. He retired as an official in 1848 with the rank of junior vice-president of the Board of War. In retirement at Hangchou he took an active part in the resistance against the T'ai-p'ing rebels; but their capture of the city in 1860 led Tai to drown himself, for which loyal deed he was posthumously rewarded with a temple built in his name. Thus, Tai's career was an exemplary and orthodox one. This is reflected in his art, which is largely indebted to the great orthodox master of early Ch'ing, Wang Hui (see cat. nos. 244b-247). Tai Hsi wrote a well-known commentary and catalogue of his work, *Hsi-k'u chai hua-hsü (Comments on Paintings from the Accustomed-to-Bitterness Studio)*, printed in 1893.

The present scroll is typical of his accomplished, if slightly dry, style. The extent of its orthodoxy within late Ch'ing painting may be judged by comparing the scroll by Ch'ien Tu (cat. no. 280) of exactly the same subject. Ch'ien's work is more distinctive in revealing something of his individual tendencies to compulsive but brilliant small-scale detail, while Tai's achieves an accomplished screen of blandness and propriety appropriate to a loyal and distinguished offical.

The subject is not just Mount T'ien-t'ai in Chechiang Province, the ancient seat of the most powerful Buddhist sect of Sui and T'ang, but records a specific occasion in 1838 when P'an Tseng-i, an only slightly less distinguished official than Tai, visited T'ien-t'ai following a long drought. There he prompted the rebuilding of a time-honored pavilion called T'an-hua. Celebrating the respite of rain that coincided with P'an's visit and the reconstruction, an old monk auspiciously renamed the pavilion Yü-lai (Rain-Coming). The importance of the visit to P'an is suggested by the fact that in 1839 he asked the famous calligrapher Juan Yüan to write a frontispiece title for an as-yet non-existent painting. Not until 1848 did a certain Chiang Yung-ching transcribe P'an's ten year-old record of the event and Tai Hsi paint the picture for his senior colleague.

This work, then, must have been executed in Peking just before Tai Hsi's retirement to the South, and thus commemorates a particularly significant occasion for the scholar-official-artist. The style of the Cleveland handscroll, much indebted to both Wang Meng (see cat. no. 111) and Wang Hui, is particularly close to another one, dated 1847, in a Japanese collection (*Shina Nanga taisei*, 1935-37, XIG, pls. 124, 125). Both paintings, in subject and technique, represent the artist at his highest, if orthodox, level of achievement. <div align="right">SEL</div>

Recent provenance: Wan-go H. C. Weng.

The Cleveland Museum of Art 79.54

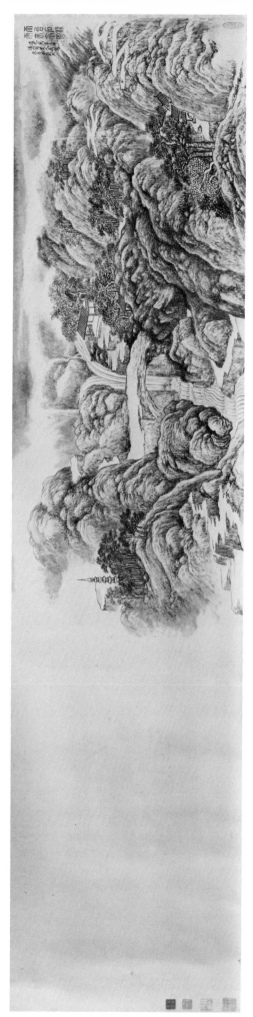

282

Addendum

Remarks to accompany catalogue numbers 20 and 54.

Kao Tao (?)

20 *Birds in a Grove in a Mountainous
Landscape in Winter*

Remarks: Few large-scale compositions with the major motif of old trees in a landscape remain from before the Yüan Dynasty (see cat. no. 104). That fact, taken together with the quality of the Cleveland painting, requires a more than casual examination of the presented evidence. While the subject derives from the Northern paintings of Five Dynasties or early Sung artists such as Li Ch'eng (see cat. no. 10), the treatment of the smaller trees and the birds inhabiting them recalls the work of such early Southern Sung artists as Li Ti (see cat. no. 34) or other anonymous masters. The crystalline brushwork of the rocky cliff seems halfway between the art of Li T'ang and the later Southern Sung painter, Hsia Kuei, particularly as observed in the classic examples in the National Palace Museum, Taipei.

This general historical position for the painting is at least partially confirmed by the external evidence of signatures and seals remaining on the painting. The large seal at the top of the scroll is that of the Prince of Chin (d. 1398), the third son of the Hung-wu emperor of the Ming Dynasty. This indicates that the painting would be of the fourteenth century or earlier. On the large tree trunk in the foreground is the erased signature of Wang Yüan (see cat. no. 87) and two erased seals—a rather peculiar placemenature and seals for a major artist of the Yüan period. Probably someone had added these, since Wang was a classic bird-and-tree master; but then someone even more intelligent removed them because they were obviously inappropriate. At the extreme dexter lower edge of the scroll the signature "Kao Tao" has been executed in ink that appears to be somewhat different from that on the rest of the scroll. This, then, would be an attribution, perhaps by the collector who removed the presumably spurious Wang Yüan attribution. Kao Tao was a Southern Sung academician from Shenhsi Province who "painted small scenes with his own individual style—fresh, distant, peaceful, and dense. He disregarded the artisans' ways. Those paintings by him featuring sleeping ducks and floating geese, fading willows and old stumps are the most precious and excellent" (Teng Ch'un, *Hua chi*, preface 1167, *ch*. 3, p. 21; trans. LYSL).

The attribution seems quite perspicacious. If one compares the peculiarly dotted foliage of the cypresses with that on the characteristic Southern Sung fan painting of the same subject (cat. no. 28), the congruency seems clear—as in the painting of the ducks, which resemble those in Ma Yüan's *Bamboo and Ducks* (cat. no. 54). The asymmetry of the composition, with the thrusting of the large, old trees to one side, combined with the obvious delight in the delicately rendered details of bushes and birds and the generalized, plainer snow-covered mountains, all speak of Southern Sung—not of Yüan—with its revival of more formal and centralized compositions. The importance and attractiveness of the composition to later Chinese artists is attested to by at least one close copy of the painting by an artist of the late Ming Dynasty, now in the Freer Gallery of Art, Washington (70.32). One cannot be far off if a date from about 1150 to 1200 is assigned to the Cleveland hanging scroll. Since no other paintings attributed to Kao have survived for comparison, the present work may stand at least as contemporary with him and possibly displaying his art. SEL

Ma Yüan

54 *Bamboo and Ducks by a Rushing Stream*

Remarks: The determined asymmetry and elegant but firm brushwork of this scroll accord well with the signature of Ma Yüan below the base of the bamboo on the sinister side of the painting. The brawling stream, the fresh bamboo, and the ducks indicate the presence of Spring, although some colleagues suggest Summer—not having experienced the low water associated with that season. The bamboo agrees in style with *Bamboo and Cranes* in the National Palace Museum, Taipei (*Ku-kung shu-hua lu*, 1965, *ch*. 8, p. 59), also signed by Ma Yüan and bearing the seal of the distinguished seventeenth-century collector Liang Ch'ing-piao. In addition, the Palace scroll carries the seals of the Empress Yang (1162-1232) and the early Ming "half-seal," Ssu-yin. Both paintings have a winding-river motif in their sinister corners. A further parallel is to be found in the small but beautiful album of tree studies also in the National Palace Museum. One leaf displays a small curling stream in brushwork congruent with that depicting the same motif on the Cleveland hanging scroll.

The original character of the Cleveland composition, not repeating the clichés of "standard" Ma formats, has much to recommend it. The subtle, if mannered, brushwork also is in keeping with what we know of believable paintings by Ma Yüan. Thus in the bamboo, for example, the outer line of the ink boundary is smooth; but the inner line is deliberately ruffled, imparting a degree of interior modelling to the stalk. Note, too, the wavering lines depicting the swirling rivulets of water.

Further confirmation comes from the happy and coincidental preservation of a widely accepted seasonal composition by Ma Yüan, *Egrets in a Snow Landscape,* in the National Palace Museum (ibid., *ch*. 5, p. 95). The two scrolls share seasonal implications—*Egrets* representing Winter, and *Bamboo and Ducks* representing Spring (or Summer?)—as well as similarly marked asymmetric dispositions with an occupied side and corners and reaching branches of tree and bamboo. Both are of the same dimensions—Cleveland, 57.8 x 36.4 cm.; Taipei, 59.1 x 40.2 cm. Even more, they share the same history of possession: both bear the same seals of An Kuo (1481-1534) and Hsiang Yüan-pien (1525-1590) on the painting. Both were at one time evidently stored under the same adverse conditions, for both have the same horizontal marks of mildewing at approximately the same locations on each scroll. The combined serendipity of all these factors is beyond a reasonable doubt, and we must conclude that we have here two of four paintings of the seasons painted by the great Academy master of Southern Sung.

Are there any others extant? One candidate has been considered: a scroll of bamboos and swallows now preserved in the Yamato Bunka-kan near Nara (Etō, "Ba en kan Chikuen zu," 1969, pl. 46). It has no Chinese collectors' seals; therefore, if it is one of the set, it must have left China for Japan before the arrival of the other two in the collection of An Kuo sometime soon after 1500—a distinct possibility. The measurements of the Yamato Bunka-kan example are 64.7 x 32.4 cm.—narrower, but a possible match, if we assume that it was cut down upon re-mounting in Japanese style. The composition permits this assumption, and the Ma Yüan signature is much closer to the edge than in the Cleveland and Taipei examples. The Japanese scroll is possibly one of the set (Summer, or perhaps Spring), but the relationship must be considered far less sure than that of the other two scrolls.

The recent history of the Cleveland Ma Yüan can be extended to include previous ownership by Marianne Dinsmoor and her uncle, Charles Vignier, both of Paris. SEL

Chronological List of Artists

For those artists whose dates are only known approximately, the order here reflects the best estimate of their relative periods of activity. Numbers below artists' names refer to catalogue entries.

Ch'en Hung, act. K'ai-yüan era
5 (713-742)–after 756

Chou Fang. act. 766–after 796
6

Ching Hao, ca. 870/80-935/40
9

Li Ch'eng, 919-967
10

Chü-jan, act. ca. 960-985
11

Hsü Tao-ning, ca. 970-1051/52
12

Chiang Shen, ca. 1090-1138
23

Li An-chung, act. ca. 1100-1140
19

Wang Li-yung, act. 1120–after 1145
18

Mi Yu-jen, 1072-1151
24

Yen Tz'u-p'ing, act. ca. 1164-1181
31

Wu Ping, act. 1190-1194
32

Li Ti, ca. 1100–after 1197
34

Ch'en Chü-chung, act. 1201-04
40

Hsia Kuei, act. ca. 1180-1224
58, 59

Ma Yüan, act. before 1189–after 1225
51, 52, 53, 54, 55

Li Sung, act. 1190-1230
35, 36, 37

Kao Tao, 1st quarter of 13th c.
20

Liang K'ai, early 13th c.
61

T'ai-ku i-min, 1st half of 13th c.
25

Ma Lin, act. mid-13th c.
56, 57

Li Yung, 13th c.
42

Hsia Sheng, 13th c.
60

Mu-ch'i, act. mid-13th c.
63

Ch'en Jung, ca. 1200-1266
62

Chang Yüeh-hu, late 13th c.
66

Liu Kuan-tao, act. ca. 1279-1300
92

Yen Hui, 1st half of 14th c.
90, 91

Chüeh-chi Yung-chung, 13th-14th c.
97

Li K'an, 1245-1320
83

Chao Meng-fu, 1254-1322
80, 81

Jen Jen-fa, 1255-1328
94, 95

Li Shih-hsing, 1283-1328
104

Lo Chih-ch'üan, d. before 1330
101, 102

Wang Yüan, act. ca 1328–after 1347
87

Wu Chen, 1280-1354
109

Wang Mien, 1287-1359
88, 89

Chang Yen-fu, act. 1st half of 14th c.
84

Yin-t'o-lo, act. ca. mid-14th c.
98

P'u-ming, act. mid-14th c.
85

Li Sheng, act. ca. mid-14th c.
105

"Sung-t'ien," 14th c.
79

Yao T'ing-mei, act. 14th c.
112

Liu Shan-shou, act. ca. 14th c.
82

Chao Yung, 1289-ca. 1360
106

Chang Wu, act. 1335-1365
96

Sheng Mou, act. ca. 1330-ca. 1369
107, 108

Ch'en Ju-yen, ca. 1331–before 1371
113, 114

Ni Tsan, 1301-1374
110

Hsü Pen, 1335-1380
115

Wang Meng, 1301-1385
111

Sung K'o, 1327-1387
116

Chao Chung, act. ca. 2nd half
72 of 14th c.

Wang Fu, 1362-1416
117, 118

Pien Wen-chin, ca. 1354-ca. 1428
121, 122

Emperor Hsüan-tsung, 1399-1435
120

(Lü) T'ien-ju, act. 1st half of 15th c.
86

Hsieh Huan, act. 1426-1452
133

Tai Chin, 1388-1462
134

Shih Jui, act. ca. 1426-ca. 1470
136, 137

Yüeh Cheng, 1418-1473
143

Tu Ch'iung, 1396-1474
147

Chang Ning, act. ca. 1427-ca. 1495
146

Lin Liang, act. ca. 1450-1500
123

Yin Hung, late 15th–early 16th c.
124

Chao Ch'i, act. ca. 1488-1505
132

Lü Wen-ying, act. until 1507
139

Shen Chou, 1427-1509
148, 149, 150, 151, 152,
153, 154, 155, 156

Tu Chin, act. ca. 1465-ca. 1509
157

P'eng Hsü, act. ca. 1488-1521
144

T'ang Yin, 1470-1523
161, 162, 163

Liu Chieh, act. ca. 1485-ca. 1525
129

T'ao Ch'eng, act. 1480-1532
145

Chou Ch'en, ca. 1450–after 1535
158, 159, 160

Ch'en Shun, 1483-1544
177, 178, 179

Chu Tuan, act. ca. 1501-1551
141

Ch'iu Ying, ca. 1494-ca. 1552
164, 165, 166

Wen Cheng-ming, 1470-1559
170, 171, 172, 173, 174, 175, 176

Hsieh Shih-ch'en, 1487-ca. 1560
168, 169

Wang Ku-hsiang, 1501-1568
180

Wen Po-jen, 1502-1575
184, 185, 186

Lu Chih, 1496-1576
181, 182, 183

Ch'ien Ku, 1508-ca. 1578
187

Yu Ch'iu, act. ca. 1540-1590
167

Ting Yün-p'eng, 1547-ca. 1621
202, 203

Wu Pin, fl. 1591-1626
204, 205

Li Liu-fang, 1575-1629
193

Chang Fu, 1546-1631 or later
188

Tung Ch'i-ch'ang, 1555-1636
190, 191, 192

Sheng Mao-yeh, act. ca. 1607-1637
199

T'ao Hung, act. ca. 1610-1640
200

Ts'ui Tzu-chung, act. ca. 1594,
209 d. 1644

Wang Chien-chang, act. ca. 1628-1644
201

Ku T'ien-chih, act. ca. 1649
194

Ch'en Hung-shou, 1598-1652
206, 207, 208

Hsiang Sheng-mo, 1597-1658
195

Yüan Shang-t'ung, 1570-1661 or later
189

Chang Feng, 1636-1662
211

Lan Ying, 1585-ca. 1664
196, 197

Hung-jen, 1610-1664
225

Fan I, 1658-1671
218

Hsiao Yün-ts'ung, 1596-1673
222, 223, 224

K'un-ts'an, 1612-1674
232, 233

Liu Tu, ca. 1632-1675
198

Wang Chien, 1598-1677
241

Ch'eng Cheng-kuei, 1604-1677
231

Wang Shih-min, 1592-1680
240

Tsou Che, act. ca. 1641-1684
212

List of Collectors

List of Cleveland Donors

Acknowledgements for individual donors and funds do not appear at the end of the Cleveland entries. However, our gratitude must be expressed to the following donors, without whom this collection of Chinese paintings would not be possible. The numbers refer to catalogue entries.

Important Imperial and Government Collections

SUNG DYNASTY

Council of State *(Shang-shu sheng)* 10, 11
Emperor Hui-tsung (r. 1101-25) 5, 6
Emperor Kao-tsung (r. 1127-62) 12
Empress Yang (1162-1232) 58
Emperor Li-tsung (r. 1225-64) 57
Empress Hsieh (1208-1282) 58

YUAN DYNASTY

Imperial Secretariat *(Chung-shu sheng)* 18, 44, 56
Emperor Wen-tsung (r. 1328-29, 1330-32) 46

MING DYNASTY

Palace Bureau for Ceremonies and Discipline *(Tien-li chi-ch'a ssu)* 11, 42, 53, 56, 77

CH'ING DYNASTY

Emperor Shih-tsu, the Shun-chih emperor (r. 1644-61) 253
Emperor Kao-tsung, the Ch'ien-lung emperor (r. 1736-95) 5, 21, 22, 23, 25, 46, 68, 77, 87, 88, 94, 112, 117, 133, 138, 143, 165, 172, 173, 186, 191, 202, 204, 205, 248, 252, 261, 262, 263
Emperor Jen-tsung, the Chia-ch'ing emperor (r. 1796-1820) 5, 21, 22, 23, 25, 46, 68, 77, 94, 112, 172, 177, 180, 186, 191, 202, 204, 249, 252, 263
Pu-i, the Hsüan-t'ung emperor (r. 1908-12) 5, 22, 23, 25, 46, 68, 77, 94, 112, 172, 177, 186, 191, 202, 204, 252, 263

John L. Severance Fund 14, 16, 20, 38, 49, 50, 56, 57, 59, 61, 64, 65, 71, 72, 73, 79, 81, 85, 99, 112, 129, 131, 134, 136, 137, 139, 144, 147, 157, 160, 163, 165, 166, 171, 179, 180, 185, 193, 194, 198, 205, 206, 207, 211, 212, 223, 224, 228, 234, 235, 236, 238, 239, 245, 248, 251, 259, 262, 265, 277
Purchase from the J. H. Wade Fund 17, 24, 39, 54, 82, 86, 96, 97, 98, 104, 124, 132, 183, 191, 195, 197, 201, 204, 210, 219, 220, 229, 233, 268, 279
Purchase, Leonard C. Hanna Jr. Bequest 48, 66, 80, 88, 94, 109, 110, 155, 169, 173, 192, 250
Mr. and Mrs. William H. Marlatt Fund 7, 47, 69, 91, 168, 199, 208, 209, 231, 271
Andrew R. and Martha Holden Jennings Fund 35, 90, 162, 172, 200, 203, 213, 216, 266, 269
Gift of Mr. and Mrs. Severance A. Millikin 19, 41, 46, 108, 226
Gift of Katharine Holden Thayer 11
Gift of Hanna Fund 21
Severance and Greta Millikin Purchase Fund 121, 187, 275
Gift of Mr. and Mrs. Wilbur Cowett 55
General Income Fund 102
Norman O. Stone and Ella A. Stone Memorial Fund 273, 282
Anonymous Gift 145
Gift from the Junior Council of The Cleveland Museum of Art 26
Charles W. Harkness Endowment Fund 40
Gift of The John Huntington Art and Polytechnic Trust 101
Gift of The American Foundation for the Maud E. and Warren H. Corning Botanical Collection 242
Gift of Charles L. Freer 127
Gift of Mary B. Lee, C. Bingham Blossom, Dudley S. Blossom, III, Laurel B. Kovacik, and Elizabeth B. Blossom in memory of Elizabeth B. Blossom 78
Gift of Dr. and Mrs. Sherman E. Lee 28, 122
Gift of Herbert F. Leisy in Memory of His Wife, Helen Stamp Leisy 76, 128, 161
Gift of Stephen O. K. Chen 196
Gift of the Junior Council of The Cleveland Museum of Art, and of Mrs. Wai-kam Ho in the Name of the Junior Council 218
In memory of M.K. Heeramaneck by his son and daughter-in-law, Nasli and Alice Heeramaneck 3
Gift of Mr. and Mrs. Harold T. Clark in memory of Flora L. Terry 1
Gift of Homer H. Tielke, Jr. in honor of the 40th Wedding Anniversary of Mr. and Mrs. Homer H. Tielke, Sr. 2
Gift of Jean-Pierre Dubosc 280
Gift of Eleanor and Morris Everett 261

Bibliography

This bibliography comprises only those sources cited or otherwise consulted for the catalogue entries. Sources are listed by title, author, or editor, according to shortened forms in the entries. Frequently used sources have been shortened as follows:

Sirén, *Masters and Principles* (1956-58), VII, *Lists* refers to:
 Sirén, Osvald. *Chinese Painting: Leading Masters and Principles.* 7 vols. New York, 1956-58. Vol. VII, "Annotated Lists of Paintings and Reproductions of Paintings by Chinese Artists."

Shih-ch'ü I (1745), *ch.* 18, Yang-hsin-tien (3) refers to:
 Shih-ch'ü pao-chi, completed 1745, *chüan* 18, Yang-hsin-tien [hall], category 3. Cf. sequels: *Shih-ch'ü* II (1793) for *Shih-ch'ü pao-chi hsü-pien* and *Shih-ch'ü* III (1816) for *Shih-ch'ü pao-chi san-pien.*

Likewise, *Pi-tien* I (1744) refers to *Pi-tien chu-lin; Pi-tien* II (1793) to *Pi-tien chu-lin hsü-pien;* and *Pi-tien* III to *Pi-tien chu-lin san-pien.*

Different editions of the same book consulted by the Cleveland Museum and Nelson Gallery or by individual authors are distinguished by initials (e.g., Mi Fu, *Hua shih.* CMA: TSCC ed./NG-AM: MSTS ed. Collectanea(*ts'ung-shu*) are abbreviated as follows:

CKFCTS	*Chung-kuo fang-chih ts'ung-shu*
CKHCTS	*Chung-kuo hua-chia ts'ung-shu*
CPTCTS	*Chih-pu-tsu-chai ts'ung-shu*
HFLPC	*Han-fen-lou pi-chi*
HSTS	*Hua-shih ts'ung-shu*
ISTP	*I-shu ts'ung-pien*
KCSH	*Ku-chin shuo-hai*
KHCPTS	*Kuo hsüeh chi-pen ts'ung-shu*
LTHCSWC	*Li-tai hua-chia shih-wen chi*
MSTS	*Mei-shu ts'ung-shu*
SKCP	*Ssu-k'u chen-pen*
SKCSCPCC	*Ssu-k'u ch'üan-shu chen-pen ch'u-chi*
SKCSCPSC	*Ssu-k'u ch'üan-shu chen-pen san-chi*
SKSLHP	*Shih-k'e shih-liao hsü-pien*
SPTK	*Ssu-pu ts'ung-k'an*
TSCC	*Ts'ung-shu chi-ch'eng*
WLCKTP	*Wu-lin chang-ku ts'ung-pien*
YTCPWCHK	*Yüan-tai chen-pen wen-chi hui-k'an*

A Ying. "Ch'ü Yüan chi ch'i shih-p'ien tsai mei-shu shang ti fan-ying" [Chü Yüan and his poetry as represented in fine arts]. In *Ch'u-tzu yen-chiu lun-wen chi*, pp. 309–17. Peking, 1957.

Acker, William, ed. and trans. *Some T'ang and Pre-T'ang Texts on Chinese Painting.* 2 vols. Sinica Leidensia, no. 8. Leiden, 1954.

Akiyama, Terukazu et al., eds. *Chūgoku bijutsu* [Chinese art in Western collections]. Tokyo, 1972–. Vol. I, *Kaiga* [paintings], edited by Kei Suzuki and Terukazu Akiyama, 1972. Vol. II, *Kaiga*, edited by Kei Suzuki and Teisuke Toda, 1973.

An Ch'i. *Mo-yüan hui-kuan* [Ink remains, examined and classified; descriptive catalogue of the author's collection]. Preface dated 1742. TSCC ed. Reprint. Shanghai, 1909.

The Art of the T'ang Dynasty. See Trubner, Henry.

The Arts of the Ch'ing Dynasty. See Garner, Harry M. et al.

Arts of the Han Dynasty. See Trubner, Henry.

The Arts of the Ming Dynasty. See Garner, Harry M. et al.

The Arts of the Sung Dynasty. See Gray, Basil et al.

Bachhofer, Ludwig. *A Short History of Chinese Art.* New York, 1944.

Bankoku-haku bijutsu ten mokuroku; chōwa no hakken [Comprehensive catalogue of Expo Museum of Fine Arts; discovery of harmony]. Exh. cat.: Osaka Museum of Fine Arts. Osaka, 1970. Vol. IV, *Jiyu hen ayumi* [The march toward freedom].

Barnhart, Richard M. "*Marriage of the Lord of the River*": A Lost Landscape by Tung Yüan. Artibus Asiae Supplementum XXVII. Ascona, 1970.

———. "The 'Snowscape' Attributed to Chü-jan." *Archives of Asian Art* XXIV (1970-71), pp. 6–22.

———. "Li T'ang (c. 1050-ca. 1130) and the Kōtō-in Landscapes." *The Burlington Magazine* CXIV, no. 830 (May 1972), 305–14.

———. "Wintry Forests and Old Trees, Some Landscape Themes in Chinese Painting." *The Connoisseur* CLXXXI (December 1972), pp. 275–83.

———. "Survivals, Revivals, and the Classical Tradition of Chinese Figure Painting." In *Proceedings of the International Symposium on Chinese Painting*, pp. 143–210. Taipei, 1972. (Symposium at the National Palace Museum, Republic of China, 1970)

———. *Wintry Forests, Old Trees: Some Landscape Themes in Chinese Painting.* Exh. cat.: China House Gallery. New York, 1972.

———. "Yao Yen-ch'ing, T'ing-mei, of Wu-hsing." *Artibus Asiae* XXXIX, 2 (1977), 105–23.

Barnhart, Richard M.; Iriya, Yoshitaka; and Nakada, Yūjirō. *Tō Gen, Kyonen* [Tung Yüan, Chü-jan]. Bunjinga suihen [Essence of Chinese and Japanese literati painting], vol. II. Tokyo, 1977.

Beurdeley, Cécile and Michel. *Giuseppe Castiglione: A Jesuit Painter at the Court of the Chinese Emperors.* Translated by Michael Bullock. Rutland, Vt. and Tokyo, 1971.

Binyon, Lawrence. *The Spirit of Man in Asian Art.* Cambridge, Mass., 1935.

Bodde, Dirk. *Festivals in Classical China.* Princeton, 1975.

Bowie, Theodore. *One Thousand Years of Chinese Painting, T'ang to Ch'ing (800 to 1800).* Exh. cat.: Indiana University Art Museum. Bloomington, 1968.

Brinker, Helmut. "Shussan Shaka in Sung and Yüan Painting." *Ars Orientalis* IX (1973), 21–39.

———. *Die Zen-Buddhistische Bildnismalerei in China und Japan* [Zen Buddhist portrait painting in China and Japan]. Münchener Ostasiatische Studien, Bd. 10. Weisbaden, 1973.

———. *Zauber des Chinesischen Fächers* [Exhibition of Chinese fans]. Exh. cat.: Museum Reitberg. Zurich, 1979.

Bulling, Annaliese. "Hollow Tomb Tiles: Recent Excavations and Their Dating." *Oriental Art*, n.s. XI (Spring 1965), 27–42.

———. "Historical Plays in the Art of the Han Period." *Archives of Asian Art* XXI (1967–68), 20–38.

Burkhardt, V. R. *Chinese Creeds and Customs.* Hong Kong, 1958.

Burling, Judith and Arthur H. *Chinese Art*. New York, 1953.

Bush, Susan. " 'Clearing After Snow in the Min Mountains' and Chinese Landscape Painting." *Oriental Art*, n.s. XI, no. 3 (Autumn 1965), 163–72.

Bush, Susan and Mair, Victor. "Some Buddhist Portraits and Images of the Lü and Ch'an Sects in Twelfth and Thirteenth-Century China." *Archives of Asian Art* XXXI (1977-78), 32–51.

Cahill, James. *Chinese Painting*. Geneva, 1960.

——. "The Plum Tree…and the Buffalo." *Art News* LX, no. 10 (February 1962), 26–29, 49–50.

——. *The Art of Southern Sung China*. Exh. cat.: Asia House Gallery. New York, 1962.

——. "Yüan Chiang and His School." *Ars Orientalis* V (1963), 259–72.

——. *Fantastics and Eccentrics in Chinese Painting*. Exh. cat.: Asia House Gallery. New York, 1967.

——. "The Early Styles of Kung Hsien." *Oriental Art* XVI, no. 1 (Spring 1970), 51–71.

——. "Wu Pin and His Landscape Painting." In *Proceedings of the International Symposium on Chinese Painting*, pp. 637–85. Taipei, 1972. (Symposium at the National Palace Museum, Republic of China, 1970)

——. Chūgoku kaiga niokeru kisō to gensō'' [Fantastics and eccentrics in Chinese painting]. *Kokka* (1975): no. 978, pp. 9–20 (pt. I); no. 979, pp. 2–21 (pt. II); no. 980, pp. 23–32 (pt. III).

——. *Hills Beyond a River: Chinese Painting of the Yüan Dynasty, 1279-1368*. New York and Tokyo, 1976.

——. *Parting at the Shore: Chinese Painting of the Early and Middle Ming Dynasty, 1368-1580*. New York and Tokyo, 1978.

——, ed. *The Restless Landscape: Chinese Painting of the Late Ming Period*. Exh. cat.: University Art Museum, University of California. Berkeley, 1971.

Capolavori nei secoli [Masterworks through the centuries]. Milan, 1962.

Capon, Edmund. *Art and Archaeology in China*. South Melbourne, Australia, 1977.

——. *Chinese Painting*. Oxford, 1979.

Chan Ching-feng. *Chan Tung-t'u hsüan-lan pien* [The author's descriptive record of paintings]. N.d. [16th c.]. Peking, 1947.

Chang Ch'ou. *Ch'ing-ho shu-hua fang* [The Ch'ing-ho boat-studio of painting and calligraphy; catalogue of works known to the author]. Preface dated 1616. Reprint. Sun-hsi, 1875.

——. *Chen-chi jih-lu* [Daily notes on authentic works seen by the author]. Text datable to ca. 1620–30. SKCSCPSC ed. Reprint. Taipei, 1972.

——. *Ch'ing-ho shu-hua piao* [List of calligraphy and painting in the family collection of the author]. N.d. [early 17th c.].

Chang Keng, comp. *Kuo-ch'ao hua-cheng lu, hsü lu* [Record of painters of the Ch'ing Dynasty, with sequel]. Preface dated 1739. HSTS ed. Reprint. Shanghai, 1963.

Chang Kuang-yuan. "An Investigation into the Dates of Chang Yü, Wai-shih of Kou-ch'ü." *National Palace Museum Bulletin* X, no. 5 (November-December 1975), 1–13; X, no. 6 (January-February 1976), 1–17.

Chang Pang-chi. *Mo-chuang man-lu* [Random notes on T'ang and Sung]. Completed 1144. *Pi-hai* ed. Reprint. Taipei, 1968.

Chang P'eng-ch'uan. "Ho-hsi ch'u-t'u te Han Chin hui-hua chien-shu" [Notes on the paintings of the Han and Chin dynasties unearthed west of the Yellow River]. *Wen wu*, 1978, no. 6, pp. 59–71.

Chang Ta-ch'ien. See Chang Yüan.

Chang Tai. *Shih-kuei-shu hou-chi* [Supplement to *Shih-kuei-shu*]. 17th c. Reprint. Peking, 1959.

Chang Tzu. *Nan-hu chi* [Collected works of the author]. Preface dated 1189. CPTCS ed. Reprint. Taipei, 1964.

Chang Wan-li and Hu Jen-mou, comps. *Pa-ta shan-jen shu-hua chi* [Selected paintings and calligraphy of Pa-ta shan-jen]. Li-tai ming-hua-chia tso-p'in hsüan-chi [Selected works of famous painters in Chinese history]. Hong Kong, 1969.

——. *Shih-ch'i hua chi* [Selected paintings of Shih-ch'i]. Li-tai ming-hua-chia tso p'in hsüan-chi. Hong Kong, 1969.

——. *Shih-t'ao shu hua chi* [Selected paintings and calligraphy of Shih-t'ao]. Li-tai ming-hua-chia tso p'in hsüan-chi. Hong Kong, 1969.

——. *Yang-chou pa-kuai shu-hua chi* [Selected paintings and calligraphy of the Eight Eccentrics of Yangchou]. Li-tai ming-hua-chia tso p'in hsüan-chi. Hong Kong, 1969.

Chang Yüan (Chang Ta-ch'ien). *Ta-feng-t'ang shu-hua lu* [Catalogue of painting and calligraphy in the Great Wind Hall collection]. Ch'engtu, 1943.

——. *Ta-feng-t'ang ming-chi ti i chi* [Masterpieces of Chinese painting selected from the Great Wind Hall of the Chang family]. Kyoto, 1955–56.

Chao Fang. *Tung-shan ch'uan-kao*. 14th c. SKCSCPCC ed.

Chavannes, Edouard. *Mission archéologique dans la Chine Septentrionale* [Archaeological expedition through northern China]. Vol. I, *La sculpture à l'époque des Han* [The sculpture of the Han period]. Paris, 1909.

Chaves, Jonathan. "A Han Painted Tomb at Loyang." *Artibus Asiae* XXX, 1 (1968), 5–27.

Ch'en Chi. *I-pai-chai kao, wai-chi* [Collected works of the author, supplement]. SPTK ed. Reprint. Taipei, 1975.

Ch'en Chi-ju. *Ni-ku lu* [Intimacy with antiquity; notes on painting and other objects seen by the author]. N.d. [ca. 1635]. MSTS ed. Reprint. Shanghai, 1937.

Ch'en Ch'ing-kuang. "Yüan-tai hua-chia Wu Chen" [The Yüan Dynasty painter Wu Chen]. *Mei-shu hsüeh-pao*, no. 11 (January 1977).

Ch'en, Ho Chih-hua. "Discussion of the Authenticity of the *Yün-shan te-i t'u* Owned by Wu Yung-kuang." *Ta-lu tsa-chih* XLIX, no. 5 (1974), 31–42.

Ch'en Huan. *Nan-Sung ch'u Ho-pei hsin Tao-chiao k'ao* [A study of the "New Taoism" in Hopei Province at the beginning of the Southern Sung period]. Peking, 1958.

Ch'en Hung-shou hua-ts'e [An album of paintings by Ch'en Hung-shou]. Introduction by Hsü Pang-ta. Peking, 1959.

Ch'en, J. D. (Ch'en Jen-t'ao). *Chin-kuei lun-hua* [Essays on paintings in the King Kuei collection]. Hong Kong, 1956.

——. *Chin-kuei ts'ang-hua chi* [Chinese paintings from the Chin-kuei (King Kuei) collection]. 2 vols. Kyoto, 1956.

——. *Chin-kuei ts'ang-hua pien-shih* [Notes and comments on paintings in the Chin-kuei (King Kuei) collection]. 2 vols. Hong Kong, 1956.

——. *Ku-kung i-i shu hua mu chiao-chu* [An annotated list of lost calligraphy and painting from the (Ch'ing) Palace Collection]. Hong Kong, 1956.

Ch'en, Kenneth. *Buddhism in China*. Princeton, 1964.

Ch'en Ku. *Hsi-t'ang ch'i-chiu hsü-wen* [Miscellaneous notes recorded from the elders of Hsi-t'ang]. Late 12th c. TSCC ed.

Ch'en K'uei. *Nan-Sung kuan-ko lu* [Record of the Southern Sung imperial library]. Compiled in 1177. WLCHTP ed. Reprint. Taipei, 1967.

Ch'en K'uei-lin. *Pao-yü-ko shu-hua lu* [Catalogue of the Pao yü-ko collection of calligraphy and painting]. Preface dated 1855. Shanghai, n.d.

Ch'en Pao-chen. "Kuan Tao-sheng ho t'a te 'Chu shih t'u' " [Kuan Tao-sheng and her *Bamboo and Rock*]. *National Palace Museum Quarterly* XI, no. 4 (Summer 1977), 51–84; English summary, 39–45.

Ch'en Shao-feng and Kung Ta-chung. "Lo-yang Hsi-Han Pu Ch'ien-ch'iu mu pi-hua i-shu" [The art of the wall paintings in the Western Han tomb of Pu Ch'ien-ch'iu at Loyang]. *Wen wu*, 1977, no. 6, pp. 13–22.

Ch'en Shun. *Ch'en Po-yang chi* [Poetry by the author]. Preface by Ch'ien Yün-shih dated 1615. Reprint. Taipei, 1973.

Cheng Chen-to. *Yün-hui-chai ts'ang T'ang Sung i-lai ming-hua-chi* [Paintings of the T'ang, Sung, and later periods in the collection of Chang Ts'ung-yü]. Shanghai, 1947.

————. *Wei-ta-te i-shu ch'uan-t'ung t'u-lu* [The great heritage of Chinese art]. 2 vols. Shanghai, 1951–52.

————, ed. *Yü-wai so-ts'ang Chung-kuo ku-hua-chi* [Ancient Chinese paintings in foreign collections]. Shanghai, 1947.

————, ed. *Ch'u-tz'u t'u* [Illustrations for the *Songs of Ch'u*]. Peking, 1953.

————, ed. *Chung-kuo ku-tai hui-hua hsüan-chi* [A selection of ancient Chinese paintings]. Peking, 1963.

Cheng, François. *Vide et plein, Le langage pictural chinois* [Empty and full, Chinese pictorial language]. Paris, 1979.

Cheng Hsieh. *Cheng Pan-ch'iao chi* [Collected works of the author]. Introduction by Fu Pao-shih. 17th c. Reprint. Shanghai, 1962.

Cheng Ping-shan. *Shen Shih-t'ien* [Shen Chou]. Shanghai, 1958.

Ch'eng Ch'i. *Hsüan-hui-t'ang shu-hua lu* [Catalogue of calligraphy and painting in the author's collection]. 2 vols. Hong Kong, 1972.

Ch'eng Kuan. *Hua-yen-ching su*] Commentaries on the Avatamsaka]. Completed 787.

Ch'eng Tsu-ch'ing. *Wu-chin chin-shih mu* [Catalogue of epigraphical material from Wu-chin]. TSCC ed. Reprint. Shanghai, 1936.

Chia-hsiang hsien Wu-shih-tz'u wen-kuan-suo [Committee for the Preservation of Ancient Monuments, Wu-shih Temple, Chia-hsiang County]. "Shan-tung Chia-hsiang Sung-shan fa-hsien Han hua-hsiang shih" [Notes on the Han Dynasty stone relief unearthed at Sung-shan in Chia-hsiang County, Shantung]. *Wen wu*, 1979, no. 9, pp. 1–6.

Chiang Chao-shen. "Some Album Leaves by Liu Sung-nien and Li Sung." *National Palace Museum Bulletin* I (September 1966), 1–12.

————. "The Identity of Yang Mei-tzu and the Paintings of Ma Yüan." *National Palace Museum Bulletin* II, no. 2 (May 1967), 1–14; no. 3 (July 1967), 9–14.

————. "Liu-ju chü-shih chih shu-hua yü nien-p'u" [Liu-ju chü-shih's (T'ang Yin's) calligraphy, painting, and chronological biography] *National Palace Museum Quarterly* III, no. 3 (January 1969), 35–79; English summary, 27–29.

Chiang Liang-fu. *Wu-chung Ch'u-tzu shu-mu* [Five bibliographical collections on *Ch'u-tzu*]. Peking, 1961.

Chiang Pao-ling. *Mo-lin chin-hua* [Comments on contemporary painters]. Preface dated 1851. N.p., 1923. Reprint. Shanghai, 1925.

Chiang Shao-shu. *Wu-sheng-shih shih* [A history of voiceless poems]. Postface dated 1720.

Chiang Wen-kuang. "T'an Lou Chu 'Keng-chi t'u' Ch'ing-tai ke-shih" [The Ch'ing Dynasty stone carving of Lou Chu's *Keng-chi t'u*]. *Wen wu*, 1979, no. 3, pp. 61–63.

Chiang-su chin-shih chih [Catalogue of epigraphical material from Chiangsu Province]. 19th c. SKSLHP ed.

Chiao-yü-pu ti-erh-tz'u ch'üan-kuo mei-shu chan'lan hui chüan chi: A Special Collection of the Second National Exhibition of Chinese Art under the Auspices of the Ministry of Education. Part 1, *Chin-T'ang-Wu-t'ai-Sung-Yüan-Ming-Ch'ing ming-chia shu-hua chi: The Famous Chinese Painting and Calligraphy of Tsin, T'ang, Five Dynasties, Sung, Yüan, Ming, and Ch'ing Dynasties.* Exh. cat.: Nanking Art Gallery (1937). Shanghai, 1943.

Ch'ien Ch'ien-i. *Mu-chai ch'u-hsüeh chi* [Collected works of the author]. Preface dated 1643. SPTK ed. Reprint. Taipei, 1975.

Ch'i-kung. "Li-chia K'ao." *I-lin tsung-lu* V (1964), 196–205.

Chin Wei-no. "Tan Ch'ang-sha Ma-wang-tui san hao Han mu po hua" [Discussion of the silk paintings from the Han tomb no. 3 at Ma-wang-tui, Ch'angsha]. *Wen wu*, 1974, no. 11, pp. 40–44.

Ch'in Ling-yün. *Chung-kuo pi-hua i-shu* [The art of Chinese wall painting]. 1960.

Chinese Art: An Exhibition of Paintings, Jades, Bronzes, and Ceramics. Exh. cat.: Smith College Museum of Art. Northampton, Mass., 1962.

Chinese Art Treasures: A Selected Group of Objects from the Chinese National Palace Museum and The Chinese National Central Museum, Taichung, Taiwan. Exh. cat.: National Gallery of Art, Washington, D.C. Geneva, 1961.

The Chinese Exhibition: A Commemorative Catalogue of the International Exhibition of Chinese Art. Exh. cat.: Royal Academy of Arts, Burlington House. London, 1935.

Chinese Fans (from the Collection of Dr. and Mrs. Franco Vannotti of Lugano). Foreword by Wang Chi-ch'uan. Lugano, 1972.

Chinese Painting. Introduction by Alfred Salmony. Exh. cat.: Vassar College Art Gallery. Poughkeepsie, N.Y., 1940.

Chinese Paintings from the Chiang Er-shih Collection. Sale catalogue, Sotheby Parke Bernet, New York, 5 March 1971.

Ch'ing-liang tao-jen. *T'ing-yü-hsüan pi-chi* [Miscellaneous notes written in the chamber listening to the rain]. N.d. [ca. 1800]. Shanghai, 1931.

Ch'ing-shih [History of the Ch'ing Dynasty]. Taipei, 1962. Ch'eng-wen ed. Reprint. Taipei, 1971.

Chin-shih [History of the Chin Dynasty]. Compiled by Ou-yang Hsüan, 1343–44.

Ch'in-tu Hsien-yang k'ao-ku kung-tso-chan [The Ch'in Capital Hsienyang Archaeological Team]. "Ch'in-tu Hsien-yang te I-hao Kung-tien chien-chu i-chih chien-pao" [Excavation of the architectural remains of the Palace No. 1 at the Ch'in capital Hsienyang]. *Wen wu*, 1976, no. 11, pp. 31–41.

Ch'iu, A. K'ai-ming. "The Chieh Tzu Yüan Hua Chuan [Mustard Seed Garden Painting Manual]: Early Editions in American Collections." *Archives of the Chinese Art Society of America* V (1951), 55–70.

Choshunkaku kansho: Masterpieces of Far Eastern Art from Baron Kawasaki's Collection. 6 vols. Tokyo, 1913.

Chou Liang-kung. *Tu-hua lu* [A recollection of the painter-friends of the author]. Epilogue dated 1673. HSTS ed.

Chou Mi. *Ch'i-tung yeh-yü* [Rustic tales told by a native of Shantung]. Preface dated 1291. CMA: TSCC ed./NG-AM: *Pi-hai* ed. Reprint. Taipei, 1968.

————. *Chih-ya-t'ang tsa-ch'ao* [Miscellaneous notes of Chih-ya-t'ang]. N.d. [ca. 1295]. MSTS ed.

————. *Wu-lin chiu-shih* [Reminiscences of Hangchou during the Southern Sung period]. N.d. [late 13th c.] CPTCTS ed. Reprint. Taipei, 1964.

————. *Yün-yen kuo-yen lu* [Clouds and mist drifted before the eyes; catalogue of objects seen by the author in various collections]. N.d. [late 13th c.]. CMA: TSCC ed./NG-AM: MSTS ed. Reprint. Taipei, 1963.

Christie, Anthony. *Chinese Mythology.* London, 1968.

Chu Ching-hsüan. *T'ang ch'ao ming-hua lu* [Famous painters of the T'ang Dynasty]. N.d. [early 840s]. MSTS ed. Reprint. Taipei, 1963.

Chu Kuei. *Ming-chi lu* [A record of famous paintings]. 16th c. SKCSCP ed.

Chu Sheng-chai. *Sheng-chai tu-hua chi* [Notes on paintings seen by the author]. Hong Kong, 1952.

————, ed. *Chung-kuo shu-hua* [Chinese painting and calligraphy]. Hong Kong, 1961.

Chu Ta: Selected Paintings and Calligraphy. Exh. cat.: Vassar College Art Gallery. Poughkeepsie, N.Y., 1973.

Chu Ts'un-li. *Shan-hu mu-nan* [Inscriptions and colophons on paintings seen by the author]. Early 16th c. SKCP ed.

Chu Yün-ming. *Chu shih chi-lüeh* [Survey of works by the author]. Preface dated 1557. Taipei, 1974.

Ch'üan Tsu-wang. *Chi-ch'i-t'ing chi* [Collected works of the author]. 18th c. SPTK ed.

Chuang Su. *Hua chi pu-i* [Supplement to *Hua chi*]. Preface dated 1298. Reprint (with Teng Ch'un, *Hua chi*). Peking, 1963.

Chuang Tzu: Basic Writings. Translated by Burton Watson. New York and London, 1964.

Chu-chai shih-chi [Collected poems of Wang Mien]. LTHCSWC ed. Taipei, 1970.

Chü-chien. *Pei-chien chi* [Collected works of Priest Chü-chien]. 13th c.(?). SPTK ed.

Chūgoku bijutsu-ten, Takashima Kikujirō shi kizō [Chinese art, the gift of Kikujirō Takashima. Exh. cat.: Tokyo National Museum. Tokyo, 1965.

Chūgoku meigashū [Famous Chinese paintings]. Tokyo, 1947. Reprint of *Chung-kuo ming-hua chi*. Shanghai, 1909.

Chūgoku Sō Gen bijutsu ten mokuroku [Chinese arts of the Sung and Yüan dynasties]. Exh. cat.: Tokyo National Museum. Tokyo, 1961.

Chūka Jimmin Kyowakoku shiroku rōdo bunbutsu ten: Sansei, Kanshu-ku, Shinkyo shutsudō [Exhibition of ancient art treasures of the People's Republic of China: archaeological finds of the Han to T'ang dynasty unearthed at sites along the Silk Road]. Exh. cat.: Tokyo National Museum. Tokyo, 1979.

Ch'ung I. *Hsüan-hsüeh-chai shu-hua yü-mu pi-chi* [Record of calligraphy and paintings owned or seen by the author between 1896 and 1921]. N.p., 1921.

———. *Hsüan-hsüeh-chai shu-hua yü-mu chi hsü pien* [Supplement to the record of painting and calligraphy owned or seen by the author]. N.p., 1931.

Chung-kuo hua-chia jen-ming ta tz'u-tien [Biographical dictionary of Chinese painters]. Shanghai, 1944.

Chung-kuo ming-hua [Famous Chinese paintings]. Shanghai, 1904-25.

Clapp, Anne De Coursey. *Wen Cheng-ming: The Ming Artist and Antiquity.* Artibus Asiae Supplementum XXXIV. Ascona, 1975.

The Cleveland Museum of Art. *Handbook.* Cleveland, 1978.

Clifford, Henry. *A World of Flowers.* Exh. cat.: Philadelphia Museum of Art. (Published as *Philadelphia Museum of Art Bulletin* LVIII, no. 277 [Spring 1963])

CMA *Handbook.* See Cleveland Museum of Art.

Cohn, William. *Chinese Painting.* London, 1948.

Coleman, John D., trans. "The Song of the P'i-p'a" [by Po Chu-i (722-846)]. *Renditions,* no. 10 (Autumn 1978), pp. 155-59.

Contag, Victoria. *Die sechs berühmten Maler der Ch'ing Dynastie* [Six famous painters of the Ch'ing Dynasty]. Leipzig, 1940.

———. *Chinesische Malerei der letzten vier Jahrhunderte* [Chinese painting of the last four centuries]. Exh. cat.: Museum für Kunst und Gewerbe. Hamburg, 1949.

———. *Die beiden Steine; Beitrag zum Verständnis des Wesens chinesischer Landschaftsmalerei* [Two stones; a contribution toward the understanding of the essence of Chinese landscape painting]. Braunsschweig, 1950.

———. *Zwei Meister chinesischer Landschafsmaleri* [Two masters of Chinese landscape painting]. Baden-Baden, 1955.

———. *Chinese Masters of the Seventeenth Century.* Translated by Michael Bullock. Rutland, Vt. and Tokyo, 1970.

Contag, Victoria and Wang Chi-ch'ien. *Maler-und Sammler-Stempel aus der Ming-und Ch'ing-zeit* [Seals of painters and collectors of the Ming and Ch'ing dynasties]. Shanghai, 1940.

Conze, Edward, trans. *The Short Prajñāpāramitā Texts.* London, 1974.

Crawford, Robert. "Eunuch Power in the Ming Dynasty." *T'oung Pao* XLIX (1961-62), 115-48.

Creel, Herlee G. *The Origins of Statecraft in China.* Vol. I, *The Western Chou Empire.* Chicago, 1970.

Crump, James I. Jr., trans. *Chan-kuo Ts'e.* London, 1970.

Daibi [The great beauty]. Exh. cat.: Osaka Art Club. Osaka, 1960.

"Den Han Anjin hitsu rigyo zukai" [A carp ascribed to Fan An-jen]. *Kokka,* no. 530 (January 1935), pp. 11, 12.

Dōnomae, Tanematsu. "Ri Ei-kyu shu-suo gyo-ho zu" [*Fishing on a Stream in the Autumn Frost* by Li Ch'eng]. *Garon* XIII (September 1942), 21-26.

Dubosc, Jean-Pierre. *Great Chinese Painters of the Ming and Ch'ing Dynasties.* Exh. cat.: Wildenstein Galleries. New York, 1949.

———. "A New Approach to Chinese Painting." *Oriental Art* III, no. 2 (1950-51), 50-57.

———. *Mostra d'arte cinese: Settimo centenario di Marco Polo* [Exhibition of Chinese art: 700th anniversary of Marco Polo]. Exh. cat.: Palazzo Ducale. Venice, 1954.

———. "Plum Blossoms in Moonlight–A Round Fan Painting Signed Yen Hui." *Archives of Asian Art* XXVI (1972-73), 67-70.

Ecke, Gustav. *Chinese Paintings in Hawaii.* Honolulu, 1965.

Ecke, Tseng Yu-ho. See also Tseng Yu-ho.

———. "Wen Cheng-ming." In *Encyclopedia of World Art,* vol. XIV, cols. 834, 835. New York, 1967.

———. *Chinese Calligraphy.* Exh. cat.: Philadelphia Museum of Art. Philadelphia, 1971.

Edwards, Richard. *The Field of Stones: A Study of the Art of Shen Chou (1427-1509).* Smithsonian Institution, Freer Gallery of Art, Oriental Studies no. 5. Washington, D.C., 1962.

———. "Mou I's Colophon to His Pictorial Interpretation of 'Beating the Clothes'." *Archives of the Chinese Art Society of America* XVIII (1964), 7-11.

———. "The Painting of Tao-chi: Postscript to an Exhibition." *Oriental Art* XIV, no. 4 (Winter 1968), 261-70.

———. *Li Ti.* Freer Gallery of Art, Occasional Papers, vol. III, no. 3. Washington, D.C., 1968.

———. "The Yen Family and the Influence of Li T'ang." *Ars Orientalis* X (1975), 79-92.

———. *The Art of Wen Cheng-ming (1470-1559).* Exh. cat.: University of Michigan Museum of Art. Ann Arbor, 1976.

———, ed. *The Painting of Tao-chi.* Exh. cat.: University of Michigan Museum of Art. Ann Arbor, 1967.

Eighty Works in the Collection of the University of Michigan Museum of Art: A Handbook. Ann Arbor, 1979.

Elsen, Albert E. *Purposes of Art.* New York, 1962.

Etō, Shun. " 'Ba En kan Chikuen zu' Kinuhon bokuga tansai" [*Bamboo and Swallows* attributed to Ma Yüan]. *Yamato bunka,* no. 51 (November 1969), pp. 32-36.

Fa Jo-chen. *Huang-shan shih-liu* [Collected poetic works of the author]. Compiled 1698 by Chiang Ch'ien-i.

Fang Shih-shu. *T'ien-yung-an pi-chi.* Preface by Chao Hsün dated 1806. ISTP ed. Taipei, 1962.

Fa-yüan chu-lin. See Tao-shih.

Fei Tun-lu tsang ming-jen shan-shui hua chu [Landscapes by famous painters in the Fei Tun-lu collection]. Shanghai, 1935.

Ferguson, John C. *Outlines of Chinese Art: The Scammon Lectures for 1918.* Chicago, 1919.

———. *Li-tai chu-lu hua mu* [Index of recorded Chinese paintings in all periods]. Nanking, 1934.

Fernald, Helen E. "Ladies of the Court: An Early Chinese Scroll Painting." *The Museum Journal* [University of Pennsylvania] XIX, no. 4 (December 1928), 333-49.

Five Centuries of Chinese Painting: Ming and Ch'ing Dynasties. Exh. cat.: Dallas Museum of Fine Arts. Dallas, 1954.

Fong, Mary H. "A Probable Second 'Chung K'uei' by Emperor Shun-chih of the Ch'ing Dynasty." *Oriental Art,* n.s. XXIII, no.4 (Winter 1977), 423-77.

Fong Wen. "The Orthodox Master." *Art News Annual* XXXIII (1967), 33-39.

———. "Tung Ch'i-ch'ang yü cheng-tsung-p'ai hui-hua li lun" [Tung Ch'i-ch'ang and the orthodox theory of painting]. *National Palace Museum Quarterly* II, no. 3 (January 1968), 1-26.

———. "Wang Hui chih chi ta-ch'eng" [Wang Hui: The Great Synthesis]. *National Palace Museum Quarterly* III, no. 2 (October 1968), 5-10.

———. "Towards a Structural Analysis of Chinese Landscape Painting." In *Symposium in Honor of Dr. Chiang Fu-tsung on His 70th Birthday,* pp. 1-12. National Palace Museum Quarterly, Special Issue no. 1. Taipei, 1969.

———. *Summer Mountains: The Timeless Landscape.* New York, 1975.

Fong Wen and Fu, Marilyn. *Sung and Yüan Paintings.* Exh. cat.: Metropolitan Museum of Art. New York, 1973.

Fontein, Jan. "Chinese Art." In *Encyclopedia of World Art (Enciclopedia Universale Dell'Arte)* III, cols. 466-578. New York, 1960.

———. *The Pilgrimage of Sudhana.* The Hague, 1966.

Fontein, Jan and Hickman, Money L. *Zen Painting and Calligraphy.* Exh. cat.: Museum of Fine Arts, Boston. Boston, 1970.

Fontein, Jan and Wu Tung. *Unearthing China's Past.* Exh. cat.: Museum of Fine Arts, Boston. Boston, 1973.

Franke, Herbert, ed. *Sung Biographies.* Münchener Ostasiatische Studien, Bd. 16. 4 vols. Weisbaden, 1976.

The Freer Gallery of Art. Vol. I, China. Tokyo, n.d.

Fu, Marilyn and Fu Shen *Studies in Connoisseurship: Chinese Paintings from the Arthur M. Sackler Collection.* Exh. cat.: Art Museum, Princeton University. Princeton, 1973.

Fu Shen. "Chü-jan ts'un shih hua chi chih pi-chiao yen-chiu" [A preliminary study of the extant works of Chü-jan]. *National Palace Museum Quarterly* II, no. 2 (October 1967), 51-79.

———. "Ming Ch'ing chih-chi te k'e-pi kou-le feng-shang yü Shih-t'ao te tsao-ch'i tso-pin" [An aspect of mid-seventeenth-century Chinese painting: the "dry linear" style and the early work of Shih-t'ao (Tao-chi)]. *The Journal of the Institute of Chinese Studies of the Chinese University of Hong Kong* VIII, no. 2 (1976), 579-615.

———. *Traces of the Brush: Studies in Chinese Calligraphy.* Exh. cat.: Yale University Art Gallery. New Haven, 1977.

———. "Yüan-tai Huang-shih shu-hua shou-ts'ang shih-lüeh" [A history of the Yüan imperial art collections]. *National Palace Museum Quarterly* XIII, no. 1 (Autumn 1978), 25-52 (pt. I); no. 2 (Winter 1978), 1-24 (pt. II); no. 3 (Spring 1979), 1-12 (pt. III).

Fu Shen; Miyazaki, Ichisada; Nakada, Yūjirō; and Iriya, Yoshitaka. *Sekitō* [Shih-t'ao]. Bunjinga suihen [Essence of Chinese and Japanese literati painting], vol. VIII. Tokyo, 1976.

Fu Yüeh-chin. *Fu Yu-li shih-chi* [Collected works of the author], 14th c. SKCSCP ed.

Fu Yung-k'uei and Yü K'an-tseng. "Tsang-shuang shang ti 'liang-ke shih chüeh'" [The two worlds as seen in ancient burials]. *Wen wu,* 1976, no. 8, pp. 90, 91.

A Garland of Chinese Paintings (I-yüan i-chen). Edited by Wang Shih-chieh, Na Chih-liang, and Chang Wan-li. 2 vols. Hong Kong, 1967.

Garner, Harry M. et al. *The Arts of the Ming Dynasty.* Exh. cat.: The Arts Council Gallery, London, 1957. *Transactions of the Oriental Ceramic Society* XXX (1955-57).

———. *The Arts of the Ch'ing Dynasty.* Exh. cat.: The Arts Council Gallery, London, 1964. *Transactions of the Oriental Ceramic Society* XXXV (1963-64).

Geien shinshō [Selected masterpieces of painting, sculpture, and industrial arts of the Orient]. 2 vols. in 12 pts. Tokyo, 1915-18.

Gendai Dōshaku Jinbutsu ga, tokubetsu tenrankai [Chinese paintings of the Yüan Dynasty on Taoist and Buddhist figure subjects, special exhibition]. Exh. cat.: Tokyo National Museum. Tokyo, 1975.

Giacalone, Vito. *Chu Ta: A Selection of Paintings and Calligraphy.* N.p. 1973.

———. "Chu Ta (1626-c. 1705): Towards an Understanding of His Art." *Oriental Art,* n.s. XXI, no. 2 (Summer 1975), 136-52.

Giles, Herbert A. *A Chinese-English Dictionary.* 2nd ed., rev. and enl. Shanghai and London, 1912.

———, ed. and trans. *Gems of Chinese Literature: Prose and Poetry.* London, 1923.

Giuganino, Alberto and Dubosc, Jean-Pierre. *Mostra di Pitture Cinesi Ming e Ch'ing* [Exhibition of Chinese painting of the Ming and Ch'ing]. Exh. cat.: Palazzo Brancaccio. Rome, 1950.

Goepper, Roger. *Chinesische Malerei* [Chinese painting]. Bern, 1960.

———. *Vom Wesen chinesischer Malerei* [Of the essence of Chinese painting]. Munich, 1962.

———. *The Essence of Chinese Painting.* Translated by Michael Bullock. London, 1963.

———. *Kunst und Kunsthandwerk Ostasiens* [The arts and crafts of East Asia]. Munich, 1968.

———. ed. and trans. *Im Schatten des Wu-T'ung Baumes* [In the shade of the Wu-t'ung tree]. Translated from *T'ang yin hua-chüeh* by Ch'in Tsu-yung. Munich, 1959.

Goodrich, L. Carrington and Fang Chaoying, eds. *Dictionary of Ming Biography.* New York and London, 1976.

Gray, Basil. *Buddhist Cave Paintings at Tun-huang.* Chicago, 1959.

——— et al. *The Arts of the Sung Dynasty.* Exh. cat.: The Arts Council Gallery, London, 1960. *Transactions of the Oriental Ceramic Society* XXXII (1959-60).

Grigaut, Paul. *The Arts of the Ming Dynasty.* Exh. cat.: Detroit Institute of Arts. Detroit, 1952.

Grousset, René. *Chinese Art and Culture.* New York, 1959.

Gulik, Robert Hans van, ed. and trans. *Hsi K'ang and His Poetic Essay on the Lute.* Tokyo, 1941.

Gyllensvard, Bo. "Some Chinese Paintings in the Ernest Erickson Collection." *Bulletin of the Museum of Far Eastern Antiquities* XXXVI (1964), 159-70.

Hackin, J. et al. *Asiatic Mythology.* London, 1932.

Hackney, Louise W. and Yau Chang-foo. *A Study of Chinese Paintings in the Collection of Ada Small Moore.* London and New York, 1940.

Han T'ang pi-hua [Wall paintings of the Han and T'ang dynasties]. Peking, 1974.

Harada, Kinjirō. *Shina meiga hōkan* [The pageant of Chinese painting]. Tokyo, 1936.

Harada, Yoshitō. *Kan Rokuchō no fuku shoku* [Chinese dress and personal ornaments of the Han and Six Dynasties]. The Toyo bunko ronso, ser. A, vol. XXIII. Rev. ed. Tokyo, 1967.

Hashimoto shūzō Min-Shin-ga mokuroku [Ming and Ch'ing paintings in the Hashimoto collection]. Tokyo, 1972.

Hayashi, Minao. "Sengoku jidai no gazō mon" [Pictorial designs of the Warring States period]. *Kokogaku Zasshi* XLVII, 3 (December 1961), 27-49; 4 (March 1962), 20-48; XLVIII, 1 (June 1962), 1-21.

Hayashi, Ryōichi. "Tamamushi-no-zushi no seisaku nendai" [On the date of production of the Tamamushi shrine]. *Kokka,* no. 939 (1971), pp. 16, 17.

Hayashi, Sekko. "Obaku-ryū shōfu no dentō" [The tradition of the calligraphic styles of the Obaku sect]. *Bokubi,* no. 178 (1968), pp. 2, 3.

Henderson, Gregory and Hurvitz, Leon. "The Buddha of Seiryōji: New Finds and New Theory." *Artibus Asiae* XIX, 1 (1956), 5-55.

Hibino, Takeo et al. *Chūgoku bunka no seijuku* [The maturity of Chinese culture]. Sekai rekishi shirīzu [The world history series], edited by Susumu Suzuki, vol. XIII. Tokyo, 1967-.

Ho Ping-ti. "The Salt Merchants of Yang-chou: A Study of Commercial Capitalism in Eighteenth-Century China." *Harvard Journal of Asiatic Studies* XVII (1954), 130-68.

Ho Wai-kam. "Nan-Ch'en Pei-Ts'ui: Ch'en of the South and Ts'ui of the North." *The Bulletin of The Cleveland Museum of Art* XLIX (January 1962), 2-11.

———. "Religious Paintings." In *Traditional and Contemporary Painting in China: A Report of the Visit of the Chinese Painting Delegation to the People's Republic of China*, edited by the Committee on Scholarly Communication with the People's Republic of China, pp. 24-34. Washington, D.C., 1980.

Ho Wai-kam; Iriya, Yoshitaka; and Nakada, Yūjirō. *Kō Kōbō, Gei San, O Mō, Go Chin* [Huang Kung-wang, Ni Tsan, Wang Meng, Wu Chen]. Bunjinga suihen [Essence of Chinese and Japanese literati painting], vol. III. Tokyo, 1979.

Hochstadter, Walter. "The Real Shen Chou." *Journal of Oriental Studies* V, nos. 1-2 (1959/60), 98-121.

———. *Compendium of Chinese Painting*, forthcoming.

Ho-nan sheng po-wu-kuan [The Honan Provincial Museum]. "Ho-nan sheng Hsiang-hsien Hsi Chou mu fa-chüeh chien-pao" [Brief report on the excavation of a Western Chou tomb in Hsiang-hsien, Honan]. *Wen wu*, 1977, no. 8, pp. 13-16.

Ho-nan sheng wen-hua chü wen-wu kung-tso tui [The Archaeological Team, Bureau of Culture, Honan Province]. "Lo-yang Hsi-Han pi-hua mu fa-chüeh chien-pao" [Excavations of a Western Han tomb with wall paintings at Loyang]. *K'ao-ku hsüeh-pao*, 1964, no. 2, pp. 107-26.

Horizon magazine, ed. *Arts of China*. New York, 1969.

Hsia Wen-yen. *T'u-hui pao-chien* [Mirror of painting]. *Chüan* 1-5, preface dated 1365. *Chüan* 6 and *hsü-chüan* [supplement] compiled 1519 by Han Ang. CMA: TSCC ed./HR: HSTS ed.

Hsieh Chih-liu, comp. *T'ang Wu-tai Sung Yüan ming chi* [Famous paintings survived from the T'ang, Five Dynasties, Sung, and Yüan dynasties]. Shanghai, 1957.

Hsieh Lan-sheng. *Ch'ang-hsing-hsing-chai shu-hua t'i-pa* [Inscriptions and colophons written by the author on paintings and calligraphies]. N.d. [19th c.]. Reprint of manuscript copy. Macao, n.d.

Hsieh Shou-hao. *T'ai-shang Lao-chün nien p'u yao-lüeh* [An outline chronology of the Supreme Lao-chün]. 1191. Reprint. Taipei, 1962.

Hsieh Yung-mien. "T'an Chang Wu ti Chiu-ko t'u" [A discussion of Chang Wu's *Nine Songs*]. *Wen wu*, 1977, no. 11, pp. 64-68.

Hsin Yüan-shih. See K'o Shao-min.

Hsü Ch'in. *Ming-hua lu* [Biographical notes on Ming painters]. K'ang-hsi period, 17th c. Reprint. Taipei, n.d.

Hsü Pang-ta. *Chiu-ko-t'u* [Illustrations to the *Nine Songs*; the author's copy of the CMA scroll]. Peking, 1956.

———. *Li-tai liu-ch'uan shu-hua tso-p'in pien-nien-piao* [Chronological table of recorded and dated Chinese calligraphy and painting]. Shanghai, 1963.

———. *Ch'uan shih li-tai fa-shu ming-hua lu*. Unpublished MS, n.d.

Hsüan-ho hua-p'u [Catalogue of paintings in the collection of Emperor Hui-tsung of Sung]. Preface by the emperor dated 1120. HSTS ed. Reprint. Shanghai, 1963.

Hsü-ching-chai so ts'ang ming-hua chi [Paintings of the Hsü-ching-chai collection]. Shanghai, 1935.

Hu Ching. *Hsi-Ch'ing tsa-chi* [Notes on painting and calligraphy examined by the author]. 1816.

———. *Kuo-ch'ao Yüan-hua lu* [Record of court painters of the Ch'ing Dynasty]. 1816. Reprint.

———. *Hu-shih shu-hua-k'ao san-chung* [Three studies on calligraphy and painting by the author]. 19th c. Reprint. Shanghai, 1924.

Hua chi. See Teng Ch'un.

Hua chi pu-i. See Ch'uang Su.

Huang Hsiu-fu. *I-chou ming-hua lu* [Record of artists active in I-chou (Ssuch'uan Province), 8th-10th c.]. Preface by Li T'ien dated 1006. HSTS ed. Reprint. Shanghai, 1963.

Huang Pin-hung. *Chien-chiang ta-shih wai-chuan* [Supplementary biography of the Master Hung-jen]. 1947. MSTS suppl. ed. Reprint. Taipei, n.d.

Huang Shu. *Fa-t'an chi* [Collected works of the author]. Preface dated 1053. In *Liang-Sung ming-hsien hsiao-chi*. SKCSCP ed. Taipei, 1976.

Huang T'ing-chien. *Huang Shan-ku shih chi-chu* [Collected poetry of the author, annotated]. Preface dated 1111. Reprint. Taipei, 1967.

Huang Yung-ch'üan. *Ch'en Hung-shou nien-p'u* [A chronological biography of Ch'en Hung-shou]. Peking, 1960.

———, ed. *Li Kung-lin sheng-hsien-t'u shih-k'e* [Li Kung-lin's portraits of sages and worthies in stone engraving]. Peking, 1963.

Huang-Sung shu-lu [A history of calligraphy of the imperial Sung]. 13th c. CPTCTS ed.

Hua-yen-ching su. See Ch'eng Kuan.

Hua-yüan to-ying [Gems of Chinese painting]. Compiled by Hsü Shen-yu. 3 vols. Shanghai, 1955.

Hucker, Charles O. "Governmental Organization of the Ming Dynasty." *Harvard Journal of Asiatic Studies* XXI (December 1958), 1-66.

Hummel, Arthur W., ed. *Eminent Chinese of the Ch'ing Period (1644-1912)*. 2 vols. Washington, D.C., 1943-44.

Hung Shou-hao. "Liu Hua Han-kuo shu-hua-chia yü shou-ts'ang-che t'an-k'ao" [Investigation of the Korean calligraphers, painters, and collectors in China]. *Mei-shu hsüeh-pao*, no. 7 (January 1973), pp. 1071-1186.

Hu-she yüeh-k'an [Hu-she art magazine]. Peking, 1927-33.

Huyge, René, ed. *L'art et l'homme* [Art and the man]. Paris, 1957-61.

I-lin yüeh-k'an [Arts monthly]. Peking, 1930-38.

Illustrated Catalogue of Chinese Government Exhibits for the International Exhibition of Chinese Art in London. Exh. cat.: Royal Academy of Arts, Burlington House, London. Shanghai, 1936.

Important Chinese Ceramics, Archaic Jades, Bronzes, Sculpture, Works of Art, and Painting. Sale catalogue, Sotheby Parke Bernet, New York, 2 November 1979.

Important Japanese Paintings, Buddhist Sculpture, and Other Works of Art, The Property of Howard C. Hollis. Sale catalogue, Christie, Manson & Woods, London, 8 June 1976.

Impressionism. See *Réalitiés* magazine, ed.

I-yüan chen-shang chi [Collection of Chinese paintings]. Shanghai, 1914-20.

I-yüan i-chen. See *A Garland of Chinese Painting*.

Janson, H.W., ed. *Key Monuments of the History of Art*. New York, 1959.

Jao Tsung-i. *Ch'u-tzu shu-mu*. Hong Kong, 1956.

———. *Chih-lo Lou ts'ang Ming i-min shu-hua* [Painting and calligraphy by Ming i-min from the Chih-lo Lou collection]. Exh. cat.: Chinese University of Hong Kong Art Gallery. Hong Kong, 1975.

Jayne, Horace H.F. "The Chinese Collections of the University Museum." *University Musuem Bulletin* [University of Pennsylvania] IX, nos. 2-3 (June 1941), 7-62.

Jojin. *San Tendai Godaisan ki* [Diary on a pilgrimage to Mt. T'ien-t'ai and Mt. Wu-t'ai in China]. 1072. In *Dai Nippon Bukkyo zenshu*.

Juan Yüan [Yüan Yüan]. *Shih-ch'ü sui-pi* [Notes on calligraphy and painting in the Imperial collection]. Compiled 1791-93. Published 1842.

Juliano, Annette L. *Art of the Six Dynasties: Centuries of Change and Innovation*. Exh. cat.: China House Gallery. New York, 1975.

———. *Teng-hsien: An Important Six Dynasties Tomb*. Artibus Asiae Supplementum XXXVII. Ascona, 1980.

Justema, William. *The Pleasures of Pattern*. New York, 1968.

Kannon no kaiga: sono bi to rekishi [Kannon painting: its beauty and its history]. Exh. cat.: The Museum Yamato Bunkakan. Nara, 1974.

Kao Shih-ch'i. *Chiang-ts'un hsiao-hsia lu* [Paintings and calligraphy seen by the author, 1690-93]. Completed and preface dated 1693. K'ang-hsi period ed. N.p., n.d.

———. *Chiang-ts'un shu-hua mu* [Paintings and calligraphy in the collection of the author]. N.d. [17th-18th c]. Shanghai, 1924. Reprint of MS copy. Hong Kong, 1968.

Kao Ssu-sun. *Wei lüeh* [Miscellaneous notes on the lesser classics]. Early 13th c. TSCC ed.

Kao Yung-chih. *T'ai-shan ts'an-shih lou ts'ang hua* [Painting collection of the T'ai-shan ts'an-shih]. 4 vols. in 4 port. Shanghai, 1926-29.

Kawakami, Kei. "Tō Ki-shō hitsu 'Hō Yō Shō bokkotsu sansui zu'" [A *mo-ku* landscape in the style of Yang Sheng by Tung Ch'i-ch'ang]. *Bijutsu kenkyu*, no. 180 (March 1955), pp. 36-38.

———. "Min Shin ga no shiryō: kenkyū to kanzō no ichi sokumen" [Study and appraisal of Ming and Ch'ing paintings]. *Museum*, no. 150 (September 1963), pp. 31-34.

Kawakami, Kei; Toda, Teisuke; and Ebine, Toshio. *Ryō Kai, Indara* [Liang K'ai, Yin-t'o-lo]. Suiboku bijutsu taikei [Complete collection of ink monochrome painting], vol. IV. Tokyo, 1975.

Kawakami, Kei and Tsuruta, Takeyoshi. *Chūgoku no meiga* [Selected Chinese master paintings]. Tokyo, 1977.

Kawakami, Kei and Yonezawa, Yoshiho. *Tōyō bijutsu* [Asiatic art in Japanese collections]. Tokyo, 1967. Vol. I, *Kaiga* [painting].

Kawasaki, Yoshitaro. *Choshunkaku kansho: Masterpieces of Far Eastern Art from Baron Kawasaki's Collection.* 6 vols. Tokyo, 1913.

Kessler, Miles B. "The Function of *Tien* in Selected Chinese Landscape Paintings." *Apollo* CXI (January 1980), 30-35.

Keswick, Maggie. *The Chinese Garden.* New York, 1978.

KKSHL. See *Ku-kung shu-hua lu.*

K'o Shao-min. *Hsin Yüan-shih* [A new history of the Yüan Dynasty]. Completed 1920. Jen-shou ed. 1955-56.

Kodai Chūgoku [Ancient China]. Sekai rekishi shirīzu [The world history series], edited by Suzuki Susumu and compiled by Kaida Yūji et al., vol. III. Tokyo, 1967-.

Kohansha Shina meiga senshū. See *Shina meiga senshū.*

Kohara, Hironobu. "Chō Kokushin hitsu rogan-zu" [Geese and reeds by Chang K'o-hsin]. *Kobijutsu*, no. 27 (1969), pp. 93-97.

Koyama, Fujio et al. *Kokyu hakubutsuin* [The Palace Museum, Peking]. Tokyo, 1975.

Ku Fu. *P'ing-sheng chuang-kuan* [The great sights in my life; a record of paintings and collections]. Preface dated 1692. Shanghai, 1962.

Ku Wen-pin. *Kuo-yün-lou shu hua chi* [Catalogue of calligraphy and painting in the Kuo-yün Pavilion]. Preface dated 1882.

Kuan Mien-chün. *San-ch'iu-ko shu-hua lu* [Catalogue of calligraphy and painting in the author's collection]. N.p., 1928.

Ku-kung jen-wu-hua hsüan ts'ui. See *Masterpieces of Chinese Figure Painting in the National Palace Museum.*

Ku-kung ming-hua [Selected Chinese paintings in the National Palace Museum]. Edited by Wang Shih-chieh. Taipei, 1966-69.

Ku-kung ming-hua san-pai chung. See *Three Hundred Masterpieces of Chinese Painting in the Palace Museum.*

Ku-kung po-wu-yüan ts'ang hua-niao-hua hsüan [Selected flower-and-bird paintings in the Palace Museum (Peking)]. Peking, 1965.

Ku-kung shu-hua chi [Record of painting and calligraphy in the Palace Museum]. 45 vols. Peking, 1930-36.

Ku-kung shu-hua lu [Catalogue of calligraphy and painting in the Palace Museum]. Compiled by the National Palace Museum and National Central Museum. NG-AM: Taipei, 1956/CMA: 2nd ed., rev. Taipei, 1965.

Kundaikan-sayū-chōki [(Naomi's) Catalogue of the Higashiyama collection of the Ashikaga shogunate]. Manuscript dated 1559, blockprint dated 1511. In *Gunsho ruijū*, pt. XIX, pp. 648-70. Reprint. Tokyo, 1933.

Kung Hsien and the Nanking School: Some Chinese Paintings of the 17th Century. Introduction by Aschwin Lippe. Exh. cat.: China House Gallery. New York,, 1955.

K'ung Kuang-t'ao. *Yüeh-hsüeh-lou shu-hua lu* [Catalogue of painting and calligraphy in the author's collection]. Preface dated 1861, before compilation. Canton, 1889.

Kung-hsien chih [Gazetteer of Kung district]. Compiled 1937 by Liu Lien-ch'ing. CKFCTS ed. Reprint. Taipei, 1968.

Kuo Chi-sheng. "Wang Yüan-ch'i te shan-shui hua i-shu" [The landscape style of Wang Yüan-ch'i]. *National Palace Museum Quarterly* VIII, no. 4 (Summer 1974), 17-52; English summary, 7-10.

Kuo Jo-hsü. *T'u hua chien-wen chih* [Experiences in painting]. Completed ca. 1075. CMA: TSCC ed./NG-AM: HSTS ed. Shanghai, 1963.

Kuo Mo-jo. "Lo-yang Han mu pi-hua shih-t'an" [An investigation of the wall paintings in a Western Han tomb at Loyang]. *Wen-wu ching-hua*, no. 3 (1964), pp. 27-29.

Kuo Pi. *Ke-Hang jih-chih* [Diary for a sojourn at Hangchou]. 1308. CPTCCTS ed.

Kuo Wei-chu. *Sung Yüan Ming Ch'ing shu-hua chia nien-piao* [Chronology of painters in Sung, Yüan, Ming, and Ch'ing]. Peking, 1958.

Kuo-t'ai mei-shu-kuan hsüan-chi [Selections from the Kuo-t'ai Art Museum]. Taipei, 1978.

Kuo-ts'ui hsüeh-pao [Chinese learning]. Shanghai, 1905-11.

Kyo Hansen sansui (chō) [Landscape album by Kung Hsien]. Kyoto, 1919.

Laing, Ellen Johnston. "Scholars and Sages: A Study in Chinese Figure Painting." Ph. D. dissertation, University of Michigan, 1967.

———. *Chinese Paintings in Chinese Publications, 1956-1968: An Annotated Bibiliography and An Index to the Paintings.* Michigan Papers in Chinese Studies, no. 6. Ann Arbor, 1969.

———. "Six Late Yüan Dynasty Figure Paintings." *Oriental Art* XXX, no. 1 (Autumn 1974), 305-16.

———. "Neo-Taoism and the 'Seven Sages of the Bamboo Grove' in Chinese Painting." *Artibus Asiae* XXXVI, 1/2 (1974), 5-54.

———. "Li Sung and Some Aspects of Southern Sung Figure Painting." *Artibus Asiae* XXXVII,1/2 /1975), 5-38.

———."Ch'iu Ying's Three Patrons." *Ming Studies*, no. 8 (Spring 1979), pp. 49-56.

Laufer, Berthold. *T'ang, Sung, and Yüan Paintings Belonging to Various Chinese Collections.* Paris, 1924.

Lawton, Mary S. *Hsieh Shih-ch'en: A Ming Dynasty Painter Reinterprets the Past.* Exh. cat.: David and Alfred Smart Gallery, University of Chicago. Chicago, 1978.

Lawton, Thomas. "Scholars and Servants." *National Palace Museum Bulletin* I, no. 5 (November 1966), 8–11.

———.The Mo-yüan hui-kuan by An Ch'i." In *Symposium in Honor of Dr. Chiang Fu-tsung on His 70th Birthday*, pp. 13–35. National Palace Museum Quarterly, Special Issue no. 1. Taipei, 1969.

———.*Chinese Figure Painting.* Exh. cat.: Freer Gallery of Art. Washington, D.C., 1973.

Lee, Sherman E. "Chinese Landscape Painting." *The Bulletin of The Cleveland Museum of Art* XLI (November 1954), 199–201.

———.*Chinese Landscape Painting.* Exh. cat.: Cleveland Museum of Art. Cleveland, 1954. 2nd ed., rev. 1962.

———. "A Bamboo in the Wind by P'u-ming." *The Bulletin of The Cleveland Museum of Art* XLIII (February 1956), 22–24, illus. p. 18.

———. "An Album of Landscapes by Hsiao Yün-ts'ung." *The Bulletin of The Cleveland Museum of Art* XLIV (June 1957), 121–25.

——. "Early Chinese Painted Shells with Hunting Scenes." *Archives of the Chinese Art Society of America* XI (1957), 69–75.

——. "Some Problems in Ming and Ch'ing Landscape Painting." *Ars Orientalis* II (1957), 471–85.

——. "The Two Styles of Chu Ta." *The Bulletin of The Cleveland Museum of Art* XLV (November 1958), 215–19.

——. *Japanese Decorative Style.* Exh. cat.: Cleveland Museum of Art. 1961. Reprint (paperback). New York, 1972.

——. "Yen Hui: The Lantern Night Excursion of Chung K'uei." *The Bulletin of The Cleveland Museum of Art* XLIX (February 1962), 36–42.

——. "Contrasts in Chinese and Japanese Art." *Journal of Aesthetics and Art Criticism* XXI (Fall 1962), 3–11.

——. "Hsia Kuei." In *Encyclopedia of World Art (Enciclopedia Universale Dell'Arte)* VII, cols. 650–54. New York, 1963.

——. *Tea Taste in Japanese Art.* Exh. cat.: Asia House Gallery. New York, 1963.

——. "Scattered Pearls Beyond the Ocean." *The Bulletin of The Cleveland Museum of Art* LI (February 1964), 22–39.

——. *A History of Far Eastern Art.* New York, 1964. 2nd ed., rev. 1973.

——. " 'Beggars and Street Characters' by Chou Ch'en." *The Burlington Magazine* CVII, no. 744 (March 1965), 162, 163.

——. "Literati and Professionals: Four Ming Painters." *The Bulletin of The Cleveland Museum of Art* LIII (January 1966), 2–25.

——. "The Forest and the Trees in Chinese Painting." *National Palace Museum Quarterly* I, no. 2 (October 1966), 1–14; Chinese translation, 1–11.

——. "Kleinkunst: Two Early Chinese Wood Sculptures." *Archives of Asian Art* XX (1966–67), 66–69.

——. "Painting." In *Quality: Its Image in the Arts*, edited by Louis Kronenberger, pp. 113-45. New York, 1969.

——. "The Water and the Moon in Chinese and Modern Painting." *Art International* XIV, no. 1 (January 1970), 47–59.

——. "To See Big within Small: Hsiao-Chung-Chien-Ta." *The Burlington Magazine* CXIV, no. 830 (May 1972), 314–22.

——. *The Colors of Ink: Chinese Paintings and Related Ceramics from The Cleveland Museum of Art.* Exh. cat.: Asia House Gallery. New York, 1974.

——. "Early Ming Painting at the Imperial Court." *The Bulletin of The Cleveland Museum of Art* LXIII (October 1975), 243–59.

——. "Varieties of Portraiture in Chinese and Japanese Art." *The Bulletin of The Cleveland Museum of Art* LXIV (April 1977), 118–36.

——. "River Village–Fisherman's Joy." *The Bulletin of The Cleveland Museum of Art* LXVI (October 1979), 271–88.

Lee, Sherman E. and Fong Wen. *Streams and Mountains without End: A Northern Sung Handscroll and Its Significance in the History of Early Chinese Painting.* Artibus Asiae Supplementum XIV. Ascona, 1955; 2nd ed., 1967.

Lee, Sherman E. and Ho Wai-kam. "Three Horses and Four Grooms." *The Bulletin of The Cleveland Museum of Art* XLVIII (April 1961), 66–71.

——. *Chinese Art under the Mongols: The Yüan Dynasty (1279–1368).* Exh. cat.: Cleveland Museum of Art. Cleveland, 1968.

Li Chi. *The Travel Diaries of Hsü Hsia-k'o.* Hong Kong, 1974.

Li Chih (Li Chai). *Te-yu-chai hua-p'in* [Catalogue of the painting collection of Chao Ling-chih]. Late 11th or early 12th c.

Li Chi-t'ao. *Kao Feng-han.* Shanghai, 1963.

Li Ch'i-hsien. *I-chai chi* [Collected works of the author]. N.d. [14th c.]. TSCC ed. Shanghai, 1936.

Li Chiu-kao. "Hsieh T'ing-hsün 'Hsing-yüan ya chi t'u' chüan" [Hsieh T'ing-hsün's scroll *Elegant Gathering in the Apricot Garden*]. *Wen wu*, 1963, no. 4; p. 24; pls. III, IV.

Li Chu-tsing. *A Thousand Peaks and Myriad Ravines: Chinese Paintings in the Charles A. Drenowatz Collection.* 2 vols. Artibus Asiae Supplementum XXX. Ascona, 1974.

——. "Hsiang Sheng-mo chih chao-yin shih-hua" [Hsiang Sheng-mo's poetry and painting on eremitism]. *The Journal of the Institute of Chinese Studies of the Chinese University of Hong Kong* VIII, no. 2 (1976), 531–59.

Li, Dun J. *The Ageless Chinese.* New York, 1965. 3rd ed., rev. 1978.

Li E. See Li O.

Li Eikai. *Chōsen ko-shoga sōran* [Conspectus of old Korean paintings and calligraphy]. Kyoto, 1972.

Li, H.L. *The Garden Flowers of China.* Chronica Botanica: An International Biological and Agricultural Series, no. 19. New York, 1959.

Li Jih-hua. *Liu-yen-chai pi-chi* [Miscellaneous notes of the Studio of Six Inkstones]. Early 17th c. (Sequels: *Liu-yen-chai erh-pi, Liu-yen-chai san-pi*).

Li Lin-ts'an. "Chung-kuo mo-chu hua-fa te tuan tai yen-chiu" [A study of Chinese ink bamboo painting]. *National Palace Museum Quarterly* I, no. 4 (April 1967), 25–95.

——. "The Landscape Paintings of the Northern and the Southern Sung Dynasties." *National Palace Museum Bulletin* III, no. 3 (July-August 1968), 1–11.

——. "Ming Huang hui-ch'i t'u" [Ming Huang playing chess – a painting]. In *Symposium in Honor of Dr. Chiang Fu-tsung on His 70th Birthday*, pp. 219-38. National Palace Museum Quarterly, Special Issue no. 1. Taipei, 1969.

Li O. *Nan-Sung Yüan-hua lu* [Literary records of the Southern Sung Academy of Painting]. 1721. CMA: HSTS ed. Shanghai, 1963. NG-AM: Ch'ient'ang, 1884.

——. *Fan-hsieh shan-fang wen-chi* [Collected literary works of the author]. 18th c. SPTK ed.

——. *Yün-lin-ssu chih* [Monastic records of the Yün-lin-ssu]. 18th c. WLCKTP ed.

Li Tiao-yüan. *Chu-chia ts'ang-hua pu* [Catalogue of paintings in various collections]. Preface dated 1778. Adopted from *Shih-ku-t'ang shu hua hui-k'ao*.

Li T'ien-ma. "Lin Liang nien-tai k'ao" [On the dates of Lin Liang]. *I-lin ts'ung-lu* III (1962), 35–38.

Li Tou. *Yang-chou hua-fang lu* [Picture-boats of Yangchou]. Preface dated 1795. Reprint. Peking, 1960.

Li Tso-hsien. *Shu-hua chien-ying* [Reflections on calligraphy and painting]. Preface dated 1871.

Li Yü-fen, comp. *Wang Feng-ch'ang shu-hua t'i-pa* [Wang Shih-min's inscriptions and colophons on paintings and calligraphies]. N.p. [T'ung-chou?], 1909.

Liang Chang-chü. *T'ui-an so-ts'ang chin-shih shu-hua pa* [Notes on calligraphy, painting, inscriptions on bronze and stone owned by the author]. Preface dated 1845. Reprint. Taipei, 1972.

Liao-ning-sheng po-wu-kuan ts'ang-hua chi [Paintings in the Liaoning Provincial Museum]. Peking, 1962.

Lin Yü-t'ang. *The Importance of Living.* New York, 1932.

——. *Imperial Peking.* London, 1961.

Lippe, Aschwin. *Kung Hsien and the Nanking School: Some Chinese Paintings of the Seventeenth Century.* Exh. cat.: China House Gallery. New York, 1955.

——. "Kung Hsien and the Nanking School." *Oriental Art*, n.s. II, no. 1 (Spring 1956), 21–29; n.s. IV, no. 4 (Winter 1958), 159–70.

——. "Fantastics and Eccentrics in Chinese Painting." *Oriental Art* XIII, no. 2 (Summer 1967), 133–35.

Li-tai jen-wu-hua hsüan-chi [Selected figure paintings of various dynasties]. Shanghai, 1959.

Liu Chi. *Fei-hsüeh lu* [Notes in driven snow]. Late 14th c. KCSH ed.

Liu Ch'iu-an. "Chu T'an mu ch'u-t'u hua chüan te chi-ge wen-t'i" [Some questions regarding the paintings excavated from the tomb of Chu T'an]. *Wen wu*, 1972, no. 8, pp. 64–66.

Liu Hai-su, comp. *Ming-hua ta-kuan–Chin T'ang Sung Yüan Ming Ch'ing* [Collection of famous paintings of the Chin, T'ang, Yüan, Ming, and Ch'ing]. 4 vols. Shanghai, 1936.

Liu I-chih. *T'iao-hsi chi* [Collected works of the author]. N.d. [12 th c.]. SKCP ed. Reprint. Taipei, 1971.

Liu Sung. *Ch'a-weng shih-chi* [Collected poetry of the author]. N.d. [late 14th c.]. SKCP ed. Reprint. Taipei, 1974.

Liu Tao-ch'un. *Sung-ch'ao ming-hua p'ing* [Critical account of early Northern Sung painters]. N.d. [3rd quarter of 11th century]. SKCSCP ed. (Also known as *Sheng-ch'ao ming-hua p'ing*)

Liu Ts'un-yan. "Taoist Self-Cultivation in Ming Thought." In *Self and Society in Ming Thought*, edited by W. Theodore de Bary, pp. 291–330. New York, 1970.

Lo Chen-yü. *Erh-shih-chia shih-nü hua ts'un* [Paintings of ladies by twenty masters]. N.p., 1918.

Loehr, George R. "Missionary-Artists at the Manchu Court." *Transactions of the Oriental Ceramic Society* XXXIV (1962–63), 51–68.

——. "Chinese Paintings with Sung Dated Inscriptions." *Ars Orientalis* IV (1961), 219–84.

——. *Chinese Painting After Sung*. Ryerson Lecture, Yale Art Gallery, March 2, 1967. New Haven, 1967.

——. *Chinese Art: Symbols and Images*. Exh. cat.: Jewett Arts Center. Wellesley, Mass., 1967.

——. *The Great Painters of China*. Oxford, 1980.

Lou Yao (Lou Yüeh). *Kung-k'uei chi* [Collected works of the author]. Late 12th-early 13th c. TSCC ed.

Lovell, Hin-cheung. "Wang Hui's 'Dwelling in the Fu-ch'un Mountains': A Classical Theme, Its Origin and Variations." *Ars Orientalis* VIII (1970), 217–42.

——. *An Annotated Bibliography of Chinese Painting Catalogues and Related Texts*. Michigan Papers in Chinese Studies, no. 16. Ann Arbor, 1973.

Lo-yang po-wu-kuan [The Loyang Museum]. "Lo-yang Hsi-Han Pu Ch'ien-ch'iu pi-hua mu fa-chüeh chien-pao" [Excavation of the Western Han tomb of Pu Ch'ien-ch'iu with wall paintings at Loyang]. *Wen wu*, 1977, no. 6, pp. 1-12.

Lu Ch'ien-chih. *Li Fan-hsieh nien-p'u* [Chronological biography of Li O]. Shanghai, 1936.

Lu Hsin-yüan. *Jang-li-kuan kuo-yen lu* [Notes on calligraphy and painting which passed before the author's eyes, together with transcriptions and seals on them]. Wuhsing, 1891.

——. *Jang-li-kuan kuo-yen hsü-lu* [Notes on painting and calligraphy which passed before the author's eyes, supplement]. Wuhsing, 1892.

Lu Shih-hua. *Wu-Yüeh so-chien shu-hua lu* [Calligraphy and painting seen in the Wu and Yüeh districts (Chechiang and Chiangsu)]. Preface dated 1776. Reprint. Taipei, 1972.

Ma Tuan-lin. *Wen-hsien t'ung-k'ao* [An institutional history of the Sung Dynasty]. Early 14th c. Reprint. 1959.

MacKenzie, Finlay. *Chinese Art*. London, 1961.

Maeda, Robert J. "The Chao Ta-nien Tradition." *Ars Orientalis* VIII (1970), 243-54.

——. "The 'Water' Theme in Chinese Painting." *Artibus Asiae* XXXIII, no. 4 (1971), 247-90.

——. "*Chieh-hua*: Ruled-Line Painting in China." *Ars Orientalis* X (1975), 123-41.

——. *Two Sung Texts on Chinese Painting and the Landscape Styles of the 11th and 12th Centuries*. New York, 1978.

Mailey, Jean E. "Ancestors and Tomb Robes." *Metropolitan Museum of Art Bulletin* XXI (November 1963), 101-15.

Man and His World. Exh. cat.: International Fine Arts Exhibition, EXPO 67. Montreal, 1967.

Masterpieces of Asian Art in American Collections II. Exh. cat.: Asia House Gallery. New York, 1970.

Masterpieces of Chinese Figure Painting in the National Palace Museum — Ku-kung jen-wu-hua hsüan ts'ui. Compiled by She Ch'eng. Translated by Louise Yuhas. Taipei, 1973.

Masters of Landscape: East and West. Exh. cat.: Munson-Williams Proctor Institute. Utica, N.Y., 1963.

Mayuyama, Seventy Years. Vol. II. Tokyo, 1976.

Medley, Margaret. "Certain Technical Aspects of Chinese Painting." *Oriental Art*, n.s. V, no. 1 (Spring 1959), 20-28.

Mei Ch'ü-shan hua-chi [A collection of paintings by Mei Ch'ü-shan (Mei Ch'ing)]. Shanghai, 1960.

Mei Ch'ü-shan Huang-shan sheng-chi t'u-ts'e [Mei Ch'ü-shan's (Mei Ch'ing's) album paintings of well-known scenes of Huang-shan]. Shanghai, 1910.

Mei Yao-ch'en. *Wan-ling hsien-sheng chi* [Collected poetry of the author]. SPTK ed. Reprint. Taipei, 1975.

Mei-shu shu-k'an chieh shao [Chinese art]. Peking, 1954-.

Mendelowitz, Daniel M. *Drawing*. New York, 1967.

Mi Fu (Mi Fei). *Hua shih* [History of painting]. Completed ca. 1103. CMA: TSCC ed./NG-AM: MSTS ed. Reprint. Taipei, 1963.

Ming-Ch'ing Kuang-tung ming-chia shan-shui hua-chan; Landscape Paintings by Kuangtung Masters during the Ming and Ch'ing Periods. Text by Li Chu-tsing. Exh. cat.: Art Gallery, Institute of Chinese Studies, Chinese University of Hong Kong. Hong Kong, 1973.

Min-Shin no kaiga [Paintings of the Ming and Ch'ing dynasties]. Tokyo, 1964.

Mizuno, Seiichi. *Kandai no kaiga* [Painting of the Han Dynasty]. Tokyo, 1957.

Morley, Grace. *Art in Asia and the West*. Exh. cat.: San Francisco Museum of Art. San Francisco, 1957.

Moskowitz, Ira, ed. *Great Drawings of All Time*. 4 vols. New York, 1962.

Mote, F. W. *China von der Sung-Dynastie bis zur Ch'ing-Dynastie*. [China from the Sung Dynasty to the Ch'ing Dynasty]. Proplaen-Weltgeschichte Eine Universalgechichte. Berlin, n.d.

Munakata, Kiyohiko. *Ching Hao's "Pi-fa-chi": A Note on the Art of the Brush*. Artibus Asiae Supplementum XXXI. Ascona, 1974.

Munsterberg, Hugo. *A Short History of Chinese Art*. East Lansing, Mich., 1949.

——. *The Landscape Painting of China and Japan*. Rutland, Vt., 1955.

——. *Dragons in Chinese Art*. Exh. cat.: China House Gallery. New York, 1972.

Museum of Fine Arts, Boston. *Portfolio of Chinese Paintings in the Museum, Han to Sung Periods*. Descriptive text by Kojiro Tomita. Cambridge, Mass., 1933.

——. *Portfolio of Chinese Paintings in the Museum, Yüan to Ch'ing Periods*. Descriptive text by Kojiro Tomita and Hsien-chi Tseng, in English and Chinese. Boston, 1961.

Murray, Julia K. "An Album of Paintings by Yün Shou-p'ing, the Recluse of Nan-t'ien." *Record of the Art Museum, Princeton University* XXXVII, no. 1 (1978).

Mutō, Sanji, ed. *Chōsho seikan* [Catalogue of ancient Chinese and Japanese paintings in the Mutō Collection]. Osaka, 1928.

Myers, Bernard S., ed. *Encyclopedia of Painting*. New York, 1955.

Nagahiro, Toshio. *Nanyō no gazōseki* [Han mural art of Nanyang]. Tokyo, 1969.

——. *Rokuchō jidai bijutsu no kenkyū – The Representational Art of the Six Dynasties Period*. Report of the Research Institute for Humanistic Studies, Kyoto University. Tokyo, 1969.

Naitō, Torajirō. *Shinchō shogafu* [Painting and calligraphy of the Ch'ing Dynasty]. Osaka, 1916.

——. *The Wall Paintings of the Hōryūji*. Translated and edited by W. R. B. Acker and Benjamin Rowland, Jr. Baltimore, 1943.

——, comp. *Min shi-taika gafu* [Paintings by the Four Great Masters of the Ming Dynasty]. Osaka, 1924.

Nan-ching po-wu-yüan ts'ang-hua chi [A collection of paintings from the Nanking Museum]. 2 vols. Peking, 1966.

Nan-Sung kuan-ko hsü-lu [Supplement to the *Nan-Sung kuan-ko lu* (see under Ch'en K'uei)]. N.d. [late 13th c.]. WLCKTP ed. Reprint. Taipei, 1967.

National Palace Museum, Taipei. *Style Transformed – Wan-Ming pien-hsing chu-i hua-chia tso-p'in chan*. Taipei, 1978

NG-AM Handbook. See Taggart, McKenna, and Wilson, eds.

Nichiyōbi bijutsu-kan [The Nichiyōbi Museum]. Tokyo, 1978.

Nihon Bukkyo bijutsu no genryu [Sources of Japanese Buddhist art]. Exh. cat.: Nara National Museum. Nara, 1978.

Nihon genzai Shina meiga mokuroku [Chinese paintings now in Japan]. Compiled by Bizan Harada. Tokyo, 1938.

Nihonga taisei [Comprehensive collection of Japanese painting]. Edited by Bei'u Iizuka. Tokyo, 1931–34.

Nishimura, Nangaku. "Obaku kōsō no bokuseki o tankyū shite" [A study of the calligraphy of eminent monks of the Obaku sect]. *Bokubi*, no. 105 (1961-63), pp. 6–18.

Octagon III, no. 4 (Winter 1966). (Published by Spink & Son [dealer], London)

Oertling, Sewall Jerome II. "Ting Yün-p'eng: A Chinese Artist of the Late Ming Dynasty." Ph.D. dissertation, University of Michigan, 1980.

Okamura, Ikura. *Urinasu* [Essays of Far Eastern art by the author]. Kyoto, 1939.

Omura, Seigai, ed. *Bunjinga-sen* [Selection of literati paintings]. Tokyo, 1921–22.

1000 Jahre Chinesische Malerei. See [*Tausend*].

P'an Cheng-wei. *T'ing-fan-lou shu-hua chi* [Catalogue of calligraphy and painting in the Listening to the Sails Tower]. Preface dated 1843. Supplement dated 1849.

P'ang Yüan-chi. *Hsü-chai ming-hua lu* [Catalogue of paintings in the collection of the author]. Shanghai, 1909.

———. *Hsü-chai ming-hua hsü-lu* [Catalogue of paintings in the collection of the author, supplement]. Shanghai, 1924; Addendum, 1925.

———. *Ming-pi chi-sheng* [Illustrated catalogue of Chinese paintings in the author's collection]. Shanghai, 1940.

P'ang Yüan-ying. *Wen-ch'ang tsa-lu* [Miscellaneous notes on Shang-shu sheng]. N.d. [ca. 1085]. TSCC ed.

P'ao-weng chia-ts'ang chi. See Wu K'uan.

Pchelina, Rudova. "The Descent of Amida Triad from Khara-khoto." *Bijutsu shi*, 1969, no. 3, pp. 104–6.

P'ei Ching-fu. *Chuang-t'ao-ko shu-hua lu* [Catalogue of calligraphy and paintings owned by the author]. Preface dated 1924. Shanghai, 1937.

Pei Ch'iung. *Ch'ing-chiang chi* [Collected works of the author]. Late 14th-early 15th c. SPTK ed.

Pei-ching Fa-hai-ssu Ming-tai pi-hua [Wall paintings in the Fa-hai temple, Peking]. Peking, 1958.

P'ei-wen-chai shu hua p'u [Encyclopedia of calligraphy and painting commissioned by the K'ang-hsi emperor]. Compiled 1708 by Wang Yüan-ch'i et al. Reprint. Shanghai, 1883.

Pien Yung-yü. *Shih-ku-t'ang shu-hua hui-k'ao* [Notes and records on calligraphy and painting]. 1682. Facsimile reprint of the original K'ang-hsi edition. Shanghai, 1921.

Pi-tien chu-lin [Catalogue of Buddhist and Taoist paintings and texts in the imperial collection]. Compiled by Chang Chao et al.; commissioned by the Ch'ien-lung emperor and completed 1744. Reprint. Shanghai, 1918.

Pi-tien chu-lin hsü-pien [Catalogue of Buddhist and Taoist paintings and texts in the imperial collection: sequel (part II)]. Compiled by Wang Chieh et al.; commissioned by the Ch'ien-lung emperor 1791, completed 1793. Facsimile reprint with the *Shih-ch'ü pao-chi hsü-pien*. Shanghai, 1948.

Pi-tien chu-lin san-pien [Catalogue of Buddhist and Taoist paintings and texts in the imperial collection: final sequel (pt. III)]. Compiled by Hu Ching et al.; commissioned by the Chia-ching emperor and completed 1816. Facsimile reprint with the *Shih-ch'ü pao-chi san-pien*. Taipei, 1969.

Réalitiés magazine, ed. *Impressionism*. Preface by René Huyghe. New York, 1973.

Reischauer, Edwin O. and Fairbank, John King. *East Asia: The Great Tradition*. A History of East Asian Civilization, vol. I. Boston, 1960. 2nd ed., rev. 1965.

"Ritsu Tenjo hitsu suisen baika zu" [*Narcissus and Plum Blossoms* by Lü T'ien-ju]. *Kokka*, no. 625 (December 1942), p. 368, pl. V.

Rivière, Jean Roger. "El Arte de la China" [The art of China]. In *Summa Artis Historia General del Arte*, vol. XX. Madrid, 1966.

Rogers, Howard L.; Fukunaga, Takehiko; Nakada, Yūjiro; and Iriya, Yoshitaka. *Kin Nō* [Chin Nung]. Bunjinga suihen [Essence of Chinese and Japanese literati painting], vol. IX. Tokyo, 1976.

Rosenfield, John and Shimada, Shūjirō. *Traditions of Japanese Art: Selections from the Kimiko and John Powers Collection*. Exh. cat.: Fogg Art Museum. Cambridge, Mass., 1970.

Rosenzweig, Daphne Lange. "A Landscape Handscroll by Hsiao Yun-ts'ung." *Allen Art Museum Bulletin* [Oberlin College] XXXII, no. 1 (1974-75), 34–55.

Rowland, Benjamin. *Masterpieces of Chinese Bird and Flower Painting*. Exh. cat.: Fogg Art Museum. Cambridge, Mass., 1951.

The Saddharma-pundarika, or The Lotus of the True Law. Translated by H. Kern. The Sacred Books of the East, vol. XXI. Oxford, 1884.

The Saint Louis Art Museum: Handbook of the Collections. Saint Louis, 1975.

San Tendai Godaisan ki. See Jojin.

Satake koshukuke ozoki nyūsatsu mokuroku. Sale catalogue of the collections of Marquis Yoshitaka Satake, Tokyo Art Club, 3–5 November 1917.

Seize peintures de maîtres chinois XIIe-XVIIIe *siècles: collection Chiang Er-shih* [Sixteen paintings by Chinese masters of the 12th-18th centuries in the collection of Chiang Er-shih]. Exh. cat.: Musée Cernushi. Paris, 1959.

Sekai bijutsu zenshu [Survey of world art]. Tokyo, 1928.

Sekino, Tadashi. "Ryō no dō shō" [A Liao bronze bell]. *Bijutsu kenkyu* XXVI (1934), 14–17.

Sekino, Tadashi and Takeshima, Takuichi. *Ryō-Kin jidai no kenchiku to sono butsuzō* [Architecture and its Buddhist images of the Liao and Chin periods]. 2 vols. Tokyo, 1934–36.

Shang Ch'eng-tso. *Kuang-chou Kuang-hsiao-ssu ku-tai mu-t'iao-hsiang t'u-lu* [Early wooden sculpture in the Kuang-hsiao-ssu (monastery) in Canton]. Shanghai, 1955.

Shang-hai po-wu-kuan ts'ang-hua [Paintings in the Shanghai Museum]. Shanghai, 1959.

Shao Lo-yang. *Wu Li*. Shanghai, 1962.

Shao Sung-nien. *Ku-yüan ts'ui-lu* [Catalogue of calligraphy and paintings owned by the author]. Shanghai, 1904.

Shen Kua. *Meng-ch'i pi-t'an chiao-cheng* [Notes taken in Meng-ch'i]. 11th c. Annotated edition by Hu Tao-ching. Peking, 1957.

Shen Shih-t'ien Wo-yu ts'e [The album *Imaginary Excursion* by Shen Chou]. Peking, 1953.

Shen Shu-yung. *Yang-hua-kuan shu-hua mu* [List of calligraphy and painting in the author's collection]. N.d. [before 1873]. Taipei, 1974.

Shen-chou kuo-kuang chi [Selected works of Chinese art]. Shanghai, 1908–12.

Shen-chou ta-kuan [Continuation of *Shen-chou kuo-kuang chi*]. Shanghai, 1912–22.

Shih Hsio-yen. "Early Chinese Pictorial Style: From the Later Han to the Six Dynasties." Ph.D. dissertation, Bryn Mawr College, 1961.

———. "Arts of the Han Dynasty." *Oriental Art*, n.s. VIII, no. 1 (Spring 1962), 20–28. (Reply, Sherman E. Lee [Autumn 1962], 143–44)

———. "Mad Ming Monks and Eccentric Exiles." *Art News* LXVI, no. 2 (April 1967), 36, pl. 1.

Shih-ch'i shang-jen chi [Reproductions of works by K'un-ts'an owned by Chang Ts'ung-yü]. N.p., n.d.

Shih-ch'ü pao-chi [Catalogue of painting and calligraphy in the imperial collection]. Compiled by Chang Chao et al.; commissioned by the Ch'ien-lung emperor 1744, completed 1745. Facsimile reprint. Shanghai, 1918.

Shih-ch'ü pao-chi hsü-pien [Catalogue of painting and calligraphy in the imperial collection: sequel (part II)]. Compiled by Wang Chieh et al.; commissioned by the Ch'ien-lung emperor 1791, completed 1793. Facsimile reprint. Shanghai, 1948.

Shih-ch'ü pao-chi san-pien [Catalogue of painting and calligraphy in the imperial collection: final sequel (part III)]. Compiled by Hu Ching et al.; commissioned by the Ch'ien-lung emperor and completed 1816. Facsimile reprint. Taipei, 1969.

Shih-huang ling Ch'in yung k'eng k'ao-ku fa-chüeh tui [Ch'in Dynasty Pit Archaeological Team]. "Ch'in Shih-huang ling tung-tse ti-erh hao ping ma yung k'eng tsuan-t'an shih-chüeh chien pao" [Excavation of the Ch'in Dynasty pit containing pottery figures of warriors and horses at Lin-t'ung, Shenhsi Province]. *Wen wu*, 1978, no. 5, pp. 1–19.

Shih-pai-chai shu hua lu [Record of calligraphy and painting in the Shih-pai-chai]. N.d. [ca. 1800].

Shih-t'ao hua-yü lu. See Tao-chi. *Hua-yü lu*.

Shih-t'ien hsien-sheng shih-wen chi [Collected works of Shen Chou]. Preface dated 1644. T'ung-wen ed. Reprint. Shanghai, 1915.

Shimada, Shujiro and Yonezawa, Yoshiho. *Painting of the Sung and Yüan Dynasties*. Tokyo, 1952.

Shimbi taikan—Selected Relics of Japanese Art. 20 vols. Kyoto, 1899-1908.

Shina koki zukō [Chinese antiquities]. Edited by Yoshito Harada and Komai Kazuchika. Tokyo, 1932–37.

Shina meiga senshū [Collection of famous Chinese paintings exhibited by the Kohansha Society]. 3 vols. Kyoto, 1926–27.

Shina Nanga taisei [Conspectus of Chinese paintings of the Southern School]. Tokyo, 1935–37.

Shobi shiryo. 12 vols. Tokyo, 1917.

Shodō zenshū [A collection of calligraphic works]. Edited by Kichijiro Kanda and Takami Tanaka et al. 25 vols. Tokyo, 1954–61.

Shōsōin no kaiga [Paintings of the Shōsōin]. Tokyo, 1968.

Shu-fa ta-kuan: Chung-ting, shih-ku, Hsi-an pei-lin, Sung Yüan Ming Ch'ing ming-chia mo-chi [A comprehensive collection of calligraphy: inscriptions on bronzes, stone drums, epitaphs from Hsian and calligraphy of Sung, Yüan, Ming, and Ch'ing masters]. Hong Kong, 1971.

Sickman, Laurence. "The Unsung Ming." *Art News* XLV, no. 9 (November 1946), 24–26, 52, 53.

———. "Four Album Leaves by Li Sung." *The Nelson Gallery and Atkins Museum Bulletin* II (March 1959), 5–10.

———, ed. *Chinese Calligraphy and Painting in the Collection of John M. Crawford, Jr.* Exh. cat.: Pierpont Morgan Library. New York, 1962.

Sickman, Laurence and Soper, Alexander. *The Art and Architecture of China*. The Pelican History of Art, edited by Nikolaus Pevsner. Harmondsworth, England, 1956. 3rd ed., rev. 1968.

Signatures and Seals on Painting and Calligraphy: The Signatures and Seals of Artists Connoisseurs and Collectors on Painting and Calligraphy since Tsin Dynasty. Compiled by The Joint Board of Directors of The National Palace Museum and the National Central Museum, Taichung, Taiwan, The Republic of China. 6 vols. Hong Kong, 1964.

Sirén, Osvald. *A History of Early Chinese Painting*. 2 vols. London, 1933.

———. *The Chinese on the Art of Painting: Translations and Comments*. Peking, 1936. 2nd ed., New York, 1963.

———. *Early Chinese Paintings from the A. W. Bahr Collection*. London, 1938.

———. *A History of Later Chinese Painting*. 2 vols. London, 1938.

———. *Kinas Konst Under Tre Artusenden* [Chinese art through three millenia]. Stockholm, 1943.

———. *Gardens of China*. New York, 1949.

———. *Chinese Painting: Leading Masters and Principles*. 7 vols. New York, 1956–58.

———. *The Chinese on the Art of Painting: Translations and Comments*. Peking, 1936. 2nd ed., New York, 1963.

"Sobo shū Bunku Kyūchū zu" [A note on Hsüeh-ch'uang's *Orchid and Bamboo*]. *Kokka*, no. 424 (1926), pp. 68, 75, pl. v.

Sofukawa, Hiroshi. "Go-dai Hoku Sō shoki sansui-ga no ichi kōsatsu" [An inquiry into Five Dynasties and early Northern Sung landscape painting]. *Toho gakuhō*, no. 419 (February 1977), pp. 113–214.

———. "Kyo Dō-nei no denki to yōshiki ni kansuru ichi kōsatsu" [An inquiry into the biography and landscape style of Hsü Tao-ning and their relationships]. *Tōhō gakuhō*, no. 512 (March 1980), pp. 451–500.

Sō-Gen no kaiga [Paintings of the Sung and Yüan dynasties]. Edited by Benrido, supervised by Tokyo National Museum. Kyoto, 1962.

Sō-Gen-Min-Shin meiga taikan [Catalogue of old and new paintings of the Sung, Yüan, Ming, and Ch'ing dynasties]. Exh. cat.: Tokyo National Museum. Tokyo, 1931.

"The Song of the P'i-p'a." See Coleman, John D.

Soper, Alexander C. "Early Chinese Landscape Painting." *Art Bulletin* XXIII, no. 2 (1941), 141–64.

———. "Life-Motion and the Sense of Space in Early Chinese Representational Art." *Art Bulletin* XXX (1948), 167–86.

———. "A Northern Sung Descriptive Catalogue of Paintings (The *Hua P'in* of Li Ch'ih)." *Journal of the American Oriental Society* LXIX, no. 1 (January-March 1949), 18–33.

———. *Kuo Jo-hsü's Experiences in Painting (T'u-hua chien-wen chih): An Eleventh-Century History of Chinese Painting*. American Council of Learned Societies, Studies in Chinese and Related Civilizations, no. 6. Washington, D.C., 1951.

———. "T'ang Ch'ao Ming Hua Lu, Celebrated Painters of the T'ang Dynasty by Chu Ching-hsüan of T'ang." *Artibus Asiae* XXI (1958), 204–30.

———. "South Chinese Influence on the Buddhist Art of the Six Dynasties Period." *Bulletin of the Museum of Far Eastern Antiquities* XXXII (1960), 47–112.

———. "A New Chinese Tomb Discovery: The Earliest Representation of a Famous Literary Theme." *Artibus Asiae* XXIV, 2 (1961), 79–86.

Speiser, Werner. *T'ang Yin*. Berlin, 1935.

Speiser, Werner and Contag, Victoria. *Austellung Chinesische Malerei 15–20 Jahrhundert* [Exhibition of Chinese painting of the 15th-20th century]. Exh. cat.: Kunstsammlungen der Stadt Düsseldorf. Düsseldorf, 1950.

Speiser, Werner; Goepper, Roger; and Fribourg, Jean. *Chinese Art*. Vol. III, *Painting, Calligraphy, Stone Rubbing, Wood Engraving*. New York, 1964.

Spence, Jonathan D. *Ts'ao Yin and the K'ang-hsi Emperor: Bondservant and Master*. New Haven, 1966.

Ssu-ma Ch'ien. *Shih-chi* [Historical records]. Ca. 100 BC. Reprint. Shanghai, 1959.

Strehlneek, E. A. *Collection E. A. Strehlneek*. Sale catalogue. Shanghai, 1930 (?)

Style Transformed. See National Palace Museum, Taipei.

Su Ch'i. *Hsü Han-lin chih* [A supplementary record of the Hanlin Academy]. Early 11th c. CPTCTS ed.

Su Jui-p'ing. "Ku-kung ts'ang ts'e chung chih chiu chang Sung hua" [Nine Sung Dynasty album paintings in the collection of the National Palace Museum]. *National Palace Museum Quarterly* VI, no. 4 (Summer 1972), 23–56; English summary, 11–17.

Su Sung. *Wei-kung t'i-pa* [Colophons by the author]. 11th c. TSCC ed.

Su T'ien-chüeh. *Tzu-hsi wen-kao* [Collected works of the author]. 14th c. YTCPWCHK ed.

Su-chou po-wu-kuan ts'ang-hua chi [A collection of paintings in the Suchou Museum]. N.p., 1963.

Sullivan, Michael. *An Introduction to Chinese Art.* London, 1961.

———. *The Birth of Landscape Painting in China.* London, 1962.

———. *Chinese and Japanese Art.* The Book of Art, IX. New York, 1965.

———. *The Cave Temples of Maichishan.* Berkeley, 1969.

———. "Some Possible Sources of European Influence on Late Ming and Early Ch'ing Painting." In *Proceedings of the International Symposium on Chinese Painting*, pp. 595–636. Taipei, 1972. (Symposium at the National Palace Museum, Republic of China, 1970)

———. *The Arts of China.* Berkeley, 1973. 2nd ed., rev. 1978.

———. *The Three Perfections: Chinese Painting, Poetry and Calligraphy.* London, 1974.

———. *Symbols of Eternity: The Art of Landscape Painting in China.* Stanford, 1979.

Sun Ch'eng-tse. *Ken-tzu hsiao-hsia chi* [Record of calligraphy and painting of the Chin, T'ang to Ming dynasties]. Written 1660, prefaces dated 1755 and 1761.

Sung hui-yao kao [Important documents of the Sung Dynasty]. Begun 10th c., re-collected from the *Yung-lo ta-tien* by Hsü Sung, 1809–10. Reprint. Peking, 1957.

Sung Lien. *Sung-Hsueh-shih ch'uan-ch'i.* Late 14th c. WKH: SPTK ed./ HR: TSCC ed.

Sung Lo. *Man-t'ang nien-p'u* [Chronology of the author's life]. In *Hsi-p'o lei-kao* [Collected works of the author], vol. VI. Preface dated 1711. Reprint. Taipei, 1973.

Sung Ma Yüan Shui t'u [Water paintings by Ma Yüan of the Sung Dynasty]. Peking, 1958.

Sung T'ai-tsung shih-lu. See *T'ai-tsung huang-ti shih-lu.*

Sung Yu. "A Comparison of Two Versions of the *Chü jui t'u* by Giuseppe Castiglione." *National Palace Museum Bulletin* XI, no. 3 (July-August 1976).

Sung Yüan pao-hui [Rare paintings of the Sung and Yüan dynasties]. Shanghai, 1930.

Sung Yü-hsiu, comp. *Han-fen-lou pi-chi* [Collectanea of rare books from earlier periods]. 10 vols. 1916–24. Reprint. Taipei, 1967.

Sung-chiang fu-chih [Gazetteer of Sung-chiang prefecture]. 1817. Reprint. Taipei, 1970.

Sung-jen hua-ts'e [Sung Dynasty album paintings]. Compiled by Cheng Chen-to, Chang Heng, and Hsü Pang-ta. Peking, 1957.

Sung-jen hua ts'e–Paintings of the Sung Dynasty (960–1279). 10 vols. Peking, n.d. Continuation plates: vols. XI-XIII, 1958; vols. XVII-XIX, 1962.

Sung-shih [History of the Sung Dynasty]. Compiled 1943-45 by Ou-yang Hsüan. Pa-na ed.

Suzuki, D. T. *Zen and Japanese Culture.* London, 1959.

Suzuki, Kei. "Un Nanden kaki zu" [An album of flowers by Yün Nan-t'ien]. *Kokka*, no. 788 (November 1957), p. 346.

———. *Yün Nan-t'ien* [Yün Shou-p'ing]. Tokyo, 1957.

———. "Hsia Kuei and the Academic Style in Southern Sung." In *Proceedings of the International Symposium on Chinese Painting*, pp. 417–60. Taipei, 1972. (Symposium at the National Palace Museum, Republic of China, 1970)

———. "Shō-Shō Gakuyū Zukan ni tsuite (ge)" [A stylistic analysis of Dream Journey to the Hsiao and Hsiang Rivers]. *Toyo bunka ken kyusho kiyo, Memoirs of the Institute of Oriental Culture*, no. 61 (March 1973), pp. 1–62.

———. *Ri Tō, Ba En, Ka Kei* [Li T'ang, Ma Yüan, Hsia Kuei]. Suiboku bijutsu taikei [Complete collection of ink monochrome painting], vol. II. Tokyo, 1974.

———. "Nihon no sansui-ga–Chūgoku ga no juyō to kyohi" [Japanese landscape painting–acceptance and rejection of Chinese influence]. *Museum*, no. 313 (April 1977), pp. 14–24.

Suzuki, Kei and Machida, Kōichi. *Geijutsu.* Chūgoku bunka sōsho, vol. VII. Tokyo, 1971.

Swann, Peter. *Chinese Painting.* New York, 1958.

Taggart, Ross; McKenna, George L.; and Wilson, Marc F., eds. *Handbook of the Collections in the William Rockhill Nelson Gallery of Art and Mary Atkins Museum of Fine Arts*, vol. II. 5th ed., rev. Kansas City, Mo., 1973.

Tai Hsi. *Hsi-k'u chai hua-hsü* [Comments on paintings from the Accustomed-to-Bitterness Studio]. Edited by Hui Nien. N.p., 1893.

Tai Piao-yüan. *Yen-yüan-chi* [Collected works of the author]. 14th c. TSCC ed.

T'ai-chou chin-chih lu [Epigraphical records from T'ai-chou prefecture]. Edited by Huang Jui. 1853. SKSLHP ed.

T'ai-p'ing yü-lan [Encyclopedia]. Compiled by Li Fang et al., completed 983. Facsimile reprint of a Sung edition. Shanghai, 1960.

Taisho Shinshu Daizokyo (The Tripataka in Chinese). Edited by Prof. Dr. Takakusa and Prof. Dr. K. Watanabe. Tokyo, 1930. Also cited as *Taishokyo.*

T'ai-tsung huang-ti shih-lu [Official chronicle of Emperor T'ai-tsung of Sung]. Completed 998. In *Ku-hsüeh hui-k'an.* Reprint. Taipei, 1964.

Takeishi, Seiichi. "So ga sō-shū yahaku-zu heidai sankai" [The Sung painting of *Lying at Anchor on an Autumn Night* in the collection of Masao Suzuki]. *Kokka*, no. 537 (August 1935), pp. 216, 219; pls. I, II.

Tanaka, Ichimatsu. *Tōyō bijutsu* [Asiatic art in Japanese collections]. Vol. II, *Kaiga: Sho* [Painting: Calligraphy]. Tokyo, 1968.

T'ang Hou. *Hua-chien* [Survey of paintings from the Three Kingdoms through the Sung and Chin periods]. 1329. Completed by Chang Yu. MSTS ed. Taipei, n.d. Also known as *Ku-chin hua-chien.*

T'ang Sung Yüan Ming Ch'ing hua-hsüan [Selected paintings of the T'ang, Sung, Yüan, Ming, and Ch'ing dynasties]. Canton, 1963.

T'ang Sung Yüan Ming min-hua ta-kuan [A collection of famous Chinese paintings of the T'ang, Sung, Yüan, and Ming dynasties]. Taipei, 1976.

T'ao Liang. *Hung-tou-shu-kuan shu hua chi* [Catalogue of painting and calligraphy in the author's collection (*ch.* 1–7) and seen by the author in other collections (*ch.* 8)]. Preface dated 1836; printed 1882.

T'ao, the Hermit: Sixty Poems by T'ao Ch'ien. Translated by W. R. B. Acker. London, 1952.

T'ao Yüan-tsao. *Yüeh-hua chien-wen lu.* Preface dated 1795.

Tao-chi. *Hua-yü lu.* Written ca. 1700; printed ca. 1790. Reprint. Peking, 1959.

———. *Ta-ti-tzu t'i-hua shih-pa* [Tao-chi's poetic colophons]. Compiled by Wang I-ch'en. N.d. [early 18th c.]. ISTP ed. Reprint. Taipei, 1962.

Tao-shih. *Fa-yüan chu lin* [An encyclopedia of Buddhism]. 8th c.

[Tausend] 1000 Jahre Chinesische Malerei [1000 years of Chinese painting]. Exh. cat.: Haus der Kunst. Munich, 1959.

Te-yü-chai hua-p'in. See Li Ch'ih.

Teng Ch'un. *Hua chi* [Treatise on painters and paintings of the period 1070–1160]. Preface dated 1167. HSTS ed.

Teng Pai and Wu Fu-chih. *Ma Yüan yü Hsia Kuei* [Ma Yüan and Hsia Kuei]. Shanghai, 1958.

T'eng Ku. *T'ang Sung hua-shih kang yao* [An outline of the history of T'ang and Sung paintings]. Reprint. Hong Kong, n.d.

Three Hundred Masterpieces of Chinese Painting in the Palace Museum–Ku-kung ming-hua san-pai chung. Compiled by the Editorial Committee of the Joint Board of Directors of the National Palace Museum and the National Central Museum. Wang Shih-chieh, editor-in-chief. 6 vols. Taichung, 1959.

T'ien Hsiu. "Nan-Sung Mu-ch'i 'Hsieh-sheng shu-kuo t'u chüan' " [The scroll of vegetables and fruit sketched from life by Mu Ch'i of the Southern Sung]. *Wen wu*, 1964, no. 3, pp. 36, 37.

T'ien-chin shih i-shu po-wu-kuan ts'ang-hua chi [Collection of paintings in the T'ientsin Municipal Art Museum]. Peking, 1959.

Tōan-zō shogafu [Painting and calligraphy in the Saito Tōan collection]. Compiled by Torajirō Naitō. Osaka, 1928.

Toda, Teisuke. "Ryū Setsu hitsu 'Mouo-zu' ni tsuite" [Some notes on Liu Chieh's *Fish and Water Plants*]. *Bijutsu kenkyu*, no. 240 (May 1965), 18–25. "Ryū Setsu hitsu 'Mouo-zu' ni tsuite, hotei" [Some notes on Liu Chieh's *Fish and Water Plants*, Addendum]. *Bijutsu kenkyu*, no. 243 (November 1965), p. 162.

———. *Mokkei, Gyokukan* [Mu-ch'i, Yü-chien]. Suiboku bijutsu taikei [Complete collection of ink monochrome painting], vol. III. Tokyo, 1973.

Tokiwa, Daijō and Sekino, Tadashi. *Chūgoku bunka shiseki* [Cultural monuments of China]. Kyoto, 1975–.

Tokyo kokuritsu hakubutsukan zuhan mokuroku: Chūgoku kaiga hen. Illustrated Catalogues of the Tokyo National Museum: Chinese Paintings. In Japanese and English. Tokyo, 1979.

Tomioka, Tessai and Tomioka, Matsutaro, eds. *Shi-O Go-Un* [The Four Wangs, Wu (Li) and Yün (Shou-p'ing)]. Osaka, 1919.

Tomita, Kojiro. See Museum of Fine Arts, Boston.

Tō-Sō-Gen-Min meiga taikan [Conspectus of famous paintings of the T'ang, Sung, Yüan, and Ming Dynasties]. Exh. cat.: Tokyo Imperial Museum (1928). Tokyo, 1930.

Tō-Sō-Gen-Min meiga-ten go [Exhibition of the painting masterpieces from the T'ang, Sung, Yüan, and Ming dynasties]. Tokyo, 1928. (Special issue of *Asahi shimbun-sha*).

Toynbee, Arnold, ed. *Half the World: The History and Culture of China and Japan.* London, 1973.

Tōyō bijutsu taikan [Survey of Far Eastern Art]. Edited by Shiichi Tajima. 15 vols. Tokyo, 1908–18.

Treasures of Chinese Art. Exh. cat.: J. B. Speed Art Museum. Louisville, 1965.

Trubner, Henry S. *Chinese Paintings Lent by American Museums, Collectors, and Dealers.* Exh. cat.: Los Angeles County Museum. Los Angeles, 1948.

———. "A Chinese Landscape by Hsiao Yün-ts'ung." *Oriental Art*, n.s. I, no. 3 (Autumn 1955), 104–7.

———. "A Chinese Landscape by Kung Hsien." *Oriental Art*, n.s. III, no. 1 (Spring 1957), 16–18.

———. *The Art of the T'ang Dynasty.* Exh. cat.: Los Angeles County Museum. Los Angeles, 1957.

———. "The Arts of the T'ang Dynasty." *Ars Orientalis* III (1959), 147–52.

———. *Arts of the Han Dynasty.* Exh. cat.: Asia House Gallery. New York, 1961.

Ts'ai Ngo. *Fan-t'ien-lu ts'ung-lu* [Miscellaneous notes of the Retreat of the Brahma's Heaven]. Anhui, 1925.

Tseng Hsien-ch'i. *Loan Exhibition of Chinese Paintings.* Exh. cat.: Royal Ontario Museum of Archaeology. Toronto, 1956.

Tseng Yu-ho. " 'The Seven Junipers' of Wen Cheng-ming." *Archives of the Chinese Art Society of America* VIII (1954), 22–30.

Tseng Yu-ho. See also Ecke, Tseng Yu-ho.

Tsung Tien. "Yüan Jen Jen-fa mu-chih te fa-hsien" [The discovery of the epitaph of Jen Jen-fa of the Yüan]. *Wen wu*, 1959, no. 11, pp. 25, 26.

Tu Mu. *Yü-i-pien* [The dwelling of ideas; notes on painting and calligraphy]. Text ca. 1500. Reprint. Shanghai, 1947.

Tu Mu (traditional attribution). *T'ieh-wang san-hu* [Corals in an iron net]. Preface by Shen Te-ch'ien dated 1758. Reprint. Taipei, 1970.

T'u-hua chien wen chih. See Kuo Jo-hsü.

T'u-hui pao chien. See Hsia Wen-yen.

Tung Ch'i-ch'ang. *Jung-t'ai chi, pieh chi* [Collected works of Tung Ch'i-ch'ang, sequel]. Compiled by Tung T'ing. n.d. [ca. 1630].

Twentieth Anniversary Exhibition. Exh. cat.: Cleveland Museum of Art. Cleveland, 1936.

Tz'u-hai [Sea of phrases]. Compiled by Shu Hsin-ch'eng et al. Shanghai, 1938.

Vanderstappen, Harrie. "Some Seventeenth-Century Chinese Paintings." In *Artists and Traditions: Uses of the Past in Chinese Culture,* edited by Christian F. Murck, pp. 149–68. Princeton, 1976. (Colloquium at The Art Museum, Princeton University, 1969).

———. "Painters at the Early Ming Court (1368–1435) and the Problem of a Ming Painting Academy." *Monumenta Serica* XV (1956), 258-302; XVI (1957), 315–46.

Vandier-Nicolas, N. "Le carnet d'un Connaisseur d'Art sous les Song: Mi Fou (1051–1107) et le "Houa-che" [The notebook of a Sung art connoisseur: Mi Fu and the *Hua-shih*]. *Arts Asiatiques* VII (1960), 121–30.

Vinograd, Richard. *"Reminiscences of Ch'in-huai:* Tao-chi and the Nanking School." *Archives of Asian Art* XXXI (1977-78), 6–13.

———. *"River Village–The Pleasures of Fishing* and Chao Meng-fu's Li-Kuo Style Landscapes." *Artibus Asiae* XL, 2/3 (1978), 124–34, figs. 1–12.

———. "Some Landscapes Related to the Blue-and-Green Manner from the Early Yüan Period." *Artibus Asiae* XLI, 2/3 (1979), 101–31.

Waley, Arthur. *The Life and Times of Po Chu-i, 772-846 A.D.* London, 1949.

Walmsley, Lewis and Dorothy. *Wang Wei, the Painter Poet.* Tokyo, 1968.

Wang Ao. *Chen-tse chi* [Collected works of the author]. N.d. [early 16th c.]. SKCP ed. Reprint. Taipei, 1974.

Wang Ch'ang. *Chin-shih tsui-pien* [A comprehensive collection of inscriptions on metal and stone]. 18th c.

———, ed. *Hu-hai shih-ch'uan* [Collection of important poetic works of the early Ch'ing period]. 18th c. Reprint. Peking, 1958.

Wang Chi-ch'ien. "Introduction to Chinese Painting." *Archives of the Chinese Art Society of America* II (1947), 21–27.

———. *Authenticated Chinese Paintings from the Collection of Chang Ts'ung-yu.* Exh. cat.: C. T. Loo & Co. New York, 1948.

———. "Ni Yün-lin chih-hua" [The paintings of Ni Yün-lin]. *National Palace Museum Quarterly* I, no. 3 (January 1967), 15–46.

———. *Album Leaves from the Sung and Yüan Dynasties.* Exh. cat.: China House Gallery. New York, 1970.

Wang Chih-teng. *Wu-chün tan-ch'ing chih* [Discussion of Suchou painters]. Preface dated 1563. CKHSTS ed.

Wang Feng. *Wu-hsi chi* [Collected works of the author]. Preface dated 1346. CPTCTS ed. Reprint. Taipei, 1964.

Wang, Fred Fang-yu. "The Album of Flower Studies Signed 'Ch'uan-ch'i' in the National Palace Museum and the Early Work of Chu Ta." In *Proceedings of the International Symposium on Chinese Painting,* pp. 529–94. Taipei, 1972. (Symposium at the National Palace Museum, Republic of China, 1970).

Wang I-ch'en, comp. See Tao-chi. *Ta-t'i-tzu t'i-hua-shih-pa.*

Wang K'o-yü. *Shan-hu-wang hua-lu* [The coral net; a record of calligraphy and painting]. Preface dated 1643. KHCPTS ed. Taipei, 1958.

Wang K'ung-ch'i, ed. *Hsin-an hua-p'ai* [Hsin-an school of painting]. Nanking, 1948.

Wang P'i-chih. *Sheng-shui yen-t'an lu*. Preface dated 1095. TSCC ed.

Wang Po-min. *Chou Fang*. CKHCTS ser. Shanghai, 1958.

Wang Shih-ch'ing. "Kung Hsien ti 'Ts'ao-hsiang t'ang chi' " [Kung Hsien's collected works]. *Wen wu*, 1978, no. 5, pp. 45–49.

Wang Shih-hsiang. "Chinese Ink Bamboo Painting." *Archives of the Chinese Art Society of America* II (1947), 49–58.

———. "Ku ch'in ch'ü Kuang-lin-san shuo ming" [Explanation of the *Kuang-lin-san* (melody) composed for the ancient *ch'in*]. In *Min-tsu yin-yüeh yen-chiu lun-wen chi*. Peking, 1957.

Wang Shih-jen. " 'Yung-lo-kung' te Yüan-tai ch'ien-kung ho pi-hua" [The Yüan Dynasty architecture and wall paintings of the "Yung-lo-kung"] *Wen wu*, 1956, no. 9, pp. 32–40.

Wang Shih-lun. *Che-chiang ch'u-t'u t'ung-ching hsüan-chi* [Selection of bronze mirrors excavated in Chechiang Province]. Peking, 1957.

Wang Shih-yüan. *Lu-yün-lou shu hua chi* [Catalogue of calligraphy and painting in the author's collection]. 1922.

Wang Wei. *Wang Chung-wen-kung chi* [Collected works of the author]. Late 14th c. TSCC ed.

Wang Yün. *Ch'ing-hsiang lao-jen t'i chi* [Colophons by Tao-chi]. MSTS ed.

Wan-Ming pien-hsing chu-i hua-chia tso-p'in chan. See National Palace Museum, Taipei.

Wan-yen Ching-hsien. *San-yü-t'ang shu hua mu* [Paintings and calligraphy recorded at the Hall of Three Fish]. Edited posthumously with preface by Su Tsung-jen. Peking, 1933.

Watson, William. *L'Art de L'Ancienne Chine* [The art of ancient China]. L'Art et les Grandes Civilisations. Paris, 1979.

Weber, Charles D. "Chinese Pictorial Bronze Vessels of the Late Chou Period." *Artibus Asiae* XXVIII, 2/3 (1966), 107-40; 4 (1966), 271-302; XXIX, 2/3 (1967), 115-74; XXX, 2/3 (1968), 145-214.

Wei Su. "Hsiu-ning hsien-yin T'ang-ch'ün ho-t'ien chi" [Registration of farmland by Mr. T'ang, Magistrate of the Hsiu-ning District]. In *Shuo-hsüeh-chai kao* [Collected works of the author]. Late 14th c. SKCPCC ed.

Wen Chia. *Ch'ien-shan-t'ang shu-hua chi* [The painting and calligraphy collection of Yen Sung]. Preface dated 1568. MSTS ed. Taipei, 1963.

Weng T'ung-wen. " 'T'u-hui pao-chien' ts'uan-kai chiu-wen chi-wu chiu-li' " [Examples of errors in the *T'u-hui pao-chien* caused by its corruption of older texts]. *Ta-lu tsa-chih* XXXIX, no. 1-2 (1969), 33.

———. "Hua-jen sheng-tsui-nien k'ao" [An investigation on the dates of some artists]. Part II. *National Palace Museum Quarterly* IV, no. 3 (January 1970), 45-72.

———. *I-lin ts'ung-k'ao* [Collected papers on Chinese art]. Taipei, 1977.

———. "Hsiang Yüan-pien chien-wen-pien hao shu-hua mu k'ao" [On Hsiang Yüan-p'ien's catalogue of painting and calligraphy based on the Thousand Characters numbering system]. *Suchou University Journal of Chinese Art* IX (February 1979), 157-77.

Weng, Wango H. C. *Gardens in Chinese Art from Private and Museum Collections*. Exh. cat.: China House Gallery. New York, 1968.

Whitfield, Robert; Ogawa, Tamaki; Nakada, Yujirō; and Iriya, Yoshitaka. *Un Juhei, O Ki* [Yün Shou-p'ing, Wang Hui] Bunjinga suihen [Essence of Chinese and Japanese literati painting], vol. VII. Tokyo, 1979.

Wilhelm, Hellmut. "The Po-hsüeh Hung-ju Examination of 1679." *Journal of the American Oriental Society* LXXI (1951), 60-66.

Wilkinson, S. "Lu Chih's Views on Landscape." *Oriental Art*, n.s. XV, no. 1 (Spring 1969), 27-37.

———. "The Role of Sung in the Development of Ming Painting; and the Relation of the Che, Wu, and Professional Schools." *Oriental Art*, n.s. XXI, no. 2 (Summer 1975), 126-36.

Willetts, William. *Foundations of Chinese Art from Neolithic Pottery to Modern Architecture*. New York, 1965.

Wilson, Marc F. "Kung Hsien: Theorist and Technician in Painting." *The Nelson Gallery and Atkins Museum Bulletin* IV (May-July 1969).

———. "The Chinese Painter and His Vision." *Apollo*, n.s. XCVII (March 1973), 226-39.

Wilson, Marc F. and Wong, Kwan S. *Friends of Wen Cheng-ming: A View from the Crawford Collection*. Exh. cat.: China House Gallery. New York, 1974.

Wittfogel, Karl A. and Feng Chia-sheng. *History of Chinese Society: Liao*. Philadelphia, 1949.

Wu Chen. *Mei-hua tao-jen i-mo* [Collected poetry of Wu Chen]. Taipei, 1970.

Wu Ch'i-chen. *Shu hua chi* [Record of calligraphy and painting]. Completed ca. 1677. Reprint. Shanghai, 1962.

Wu Hsiu. *Ch'ing-hsia-kuan lun-hua chüeh-chü* [The Blue-Cloud Studio's poems on paintings]. Preface dated 1824. ISTP ed. Taipei, 1962.

Wu Hsiu-chih, ed. *Wu-hsien chih* [Gazetteer of Wu County]. Preface dated 1933. Reprint. Taipei, 1970.

Wu K'uan. *P'ao-weng chia-ts'ang chi* [Collected works of the author]. Prefaces dated 1508 and 1509. SPTK ed. Reprint. Taipei, 1975.

Wu, Nelson I. "Tung Ch'i-ch'ang (1555–1636): Apathy in Government and Fervor in Art." In *Confucian Personalities*, edited by A. F. Wright and D. C. Twitchett, pp. 260-93. Stanford, Cal., 1962.

Wu, Nelson I.; Kohara, Hironobu; Ch'en Shun-ch'en; Nakada, Yūjirō; and Iriya, Yoshitaka. *Jo I, Tō Kishō* [Hsü Wei, Tung Ch'i-ch'ang]. Bunjinga suihen [Essence of Chinese and Japanese literati painting], vol. V. Tokyo, 1978.

Wu Sheng. *Ta-kuan lu* [The record of wonderful sights]. Prefaces dated 1712. First ed. collated by Li Tsu-nien. Shanghai, 1920.

Wu Tse-li. *Pei-hu chi* [Collected works of the author]. N.d. [early 12th c.]. HFLPC ed. Reprint. Taipei, 1967.

Wu Tung. "Ts'ung 'Ko-shan hsiao-hsiang' lun Pa-ta-shan-jen shih te wen-t'i" [The portrait of Ko-shan and the question of Pa-ta shan-jen (Chu Ta)]. *Ta-lu tsa-chih* LIV, no. 6 (1976), 1-8.

Wu-hsien chih [Gazetteer of Wu county]. Compiled 1933 by Ts'ao Yung-yüan. CKFCTS ed. Reprint. Taipei, 1970.

Wu-p'ai hua chiu-shih-nien chan — Ninety Years of Wu School Painting. Exh. cat.: National Palace Museum (1973-74). Taipei, 1975.

Yabe, Yoshiaki. "Dragon Motives in the Sung and Yüan dynasties." *Museum*, no. 242 (May 1971), pp. 4-26.

Yamamoto, Teijirō, comp. *Sō Gen Min Shin shoga meiken shōden* [Biographical catalogue of the Yamamoto collection]. Tokyo, 1927.

———. *Chōkaidō shoga mokuroku* [Chinese calligraphy and painting in the collection of the author]. Tokyo, 1932.

Yamane, Yuzo. *Kōetsu, Sōtatsu, Kōrin*. Suiboku bijutsu taikei [Complete collection of ink monochrome painting], vol. X. Tokyo, 1975.

Yang Hung. "Chan-che yü che-chan" [Warring chariots and chariot warfare]. *Wen wu*, 1977, no. 5, pp. 82-90.

Yang Wei-chen. *T'ieh-yai chi* [Collected poetry of the author]. n.d. [mid-14th c.]. In *Yuan-shih hsüan* [A selection of Yüan rhymed poetry], compiled 1694. Reprint. Taipei, 1967.

Yang Wei-cheng. *Tung-wei-tzu wen-chi* [Collected works of the author]. 14th c.

Yao Chi-heng. *Hao-ku-t'ang shu hua chi* [Catalogue of calligraphy and painting in the Love of Antiquity Hall]. Preface dated 1699. Supplement dated 1707. MSTS ed.

Yashiro, Yukio. "So bo Shū-Bunku Kyūchū zu" [A Sung copy of the scroll *Ladies of the Court* by Chou Wen-chü]. *Bijutsu Kenkyū* XXV (January 1934), 1-12; pls. VII, VIII.

———. *Tōyō bijutsu ronkō* [Collected studies in Eastern art]. Tokyo, 1942.

———. *Nippon bijutsu no saikentō* [Japanese art reexamined]. Tokyo, 1978.

Yeh Ch'ang-ch'i. *Ts'ang-shu chih-shih shih* [A poetic history of important book collectors and libraries]. Reprint. Shanghai, 1958.

Yeh Kung-cho. *Hsia-an ch'ing-pi-lu* [Catalogue of calligraphy and painting in the author's collection]. Preface dated 1960. Hong Kong, 1964.

Yeh Meng-te. *Shih-lin yen-yü* [Miscellaneous notes at the Stone Forest]. Completed 1136. TSCC ed.

Yen Chüan-ying. "Ch'ien Hsüan ho Chao Meng-fu" [Ch'ien Hsüan and Chao Meng-fu]. *National Palace Museum Quarterly* XII, no. 4 (Summer 1978), 63-80. (Translated from James Cahill, *Hills Beyond a River*)

Yonezawa, Yoshiho. "Shō Jōtei hitsu 'Koki Nanjun Kokyū Angū Zukan' " [The K'ang-hsi emperor's temporary palace at Hu Ch'iu (Tiger Hill) on his southward tour]. *Kokka*, no. 687 (June 1949), pp. 151-57.

———. "Jin Shu hitsu 'Go-chū shō-ran zu' " [Shen Chou's pictures of *Sights of Wu*]. *Kokka*, no. 750 (September 1954), pp. 271-77.

———. *Painting in the Ming Dynasty.* Tokyo, 1956.

———. "Ryōan Seiyoku san, Royō Daruma zu" [The painting of Daruma crossing on a reed by Ryōan Seiyoku]. *Kokka*, no. 827 (1961), pp. 79, 80, pl. 8.

———. *Hachidai sanjin, Yōshū hakkai* [Pa-ta shan-jen, Yang-chou pa-kuai; Chu Ta and the Eight Eccentrics of Yangchou]. Suiboku bijutsu taikei [Complete collection of ink monochrome painting], vol. XI. Tokyo, 1975.

Yonezawa, Yoshiho and Kawakita, Michiaki. *Paintings in Chinese Museums.* Translated by George C. Hatch. Arts of China, vol. III. Tokyo, 1970.

Yōshū hakkai [Eight Eccentrics of Yangchou]. Exh. cat.: Osaka Municipal Museum. Osaka, 1969.

Young, Martie W. *The Eccentric Painters of China.* Exh. cat.: Andrew Dickson White Art Museum, Cornell University. Ithaca, N. Y., 1965.

Yü Chi. *Tao-yüan hsüeh-ku-lu* [Collected works of the author]. Preface dated 1346. SPTK ed. Reprint. Taipei, 1975.

Yü Feng-ch'ing. *Shu-hua t'i-pa-chi* [The author's collection of inscriptions from calligraphy and painting]. Postscript dated 1634.

Yüan Hua. *Keng-hsüeh-chai shih-chi* [Collected poetry of the author]. 14th c. SKCSCP ed.

Yüan Yüan. See Juan Yüan.

Yüan-jen hua-ts'e [Album-leaf paintings by Yüan masters]. 2 vols. Peking, 1959.

Yüan-ssu ta-chia [Four Great Masters of the Yüan Dynasty]. Exh. cat.: National Palace Museum. Taipei, 1975.

Yung-lo-kung [Palace of Eternal Joy]. Edited by Shan-hsi-sheng wen-wu kuan-li kung-tso wei-yüan-hui [Shanhsi Bureau of Cultural Affairs]. Peking, 1964.

Zainie, Carla M. "The Eccentric Hermits Han-shan and Shih-te: Three Late Paintings in the Nelson Gallery." *The Nelson Gallery and Atkins Museum Bulletin* V (February 1976), 17-34.

Index

This index is limited to catalogue entries only; all numbers are catalogue numbers.